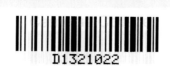

First published in the United States of America by
Rockport Publishers, Inc.
33 Commercial Street
Gloucester, Massachusetts 01930-5089
Telephone: (978) 282-9590
Fax: (978) 283-2742
www.rockpub.com

Library of Congress Cataloging-in-Publication Data

Cullen, Cheryl Dangel.
 Design secrets. Products 2: 50 real-life projects uncovered : projects chosen by IDSA
(Industrial Designers Society of America) / Cheryl Dangel Cullen and Lynn Haller.
 p. cm.
 ISBN 1-59253-071-0 (hardcover)
 1. Design, Industrial. I. Haller, Lynn, 1965- II. Industrial Designers Society of
America. III. Title.
TS171.6.C85 2004
745.2—dc22 2004006845

ISBN 1-59253-071-0

10 9 8 7 6 5 4 3 2 1

Cover: Madison Design & Advertsising, Inc.
Layout: Raymond Art & Design

Printed in China

Motorola NFL Headset

contents

OPTIONS:

1. COULD ADD DIALABLE COMPRESSION SPRING FOR ADJUSTABILITY

OPTIONAL CUFF

2. OR: DIFF. DUROMETER RUBBER PLUGS FOR CUSTOMIZED SPRING

MOLDED PLASTIC 1 PIECE

SLIDER

3. RIDE WALK
STIFF LOOSE

Hang Rod.

Wave shape to avoid sink mark

Leg attachment

center

L/R Corner screen. F. Glass Rod

Screw/Slot L or R corner.

3 Stud Rods

Center tube.

Adj. Leg.

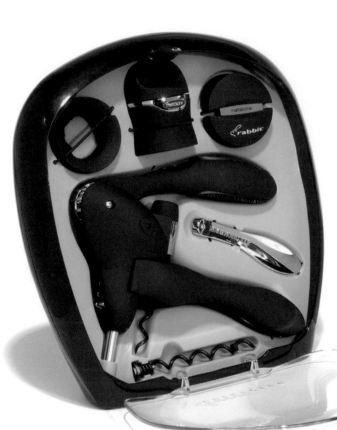

The Rabbit Corkscrew

Introduction

Design, a secret? In far too many ways, yes.

If you think industrial designers lay out factories, or if you consider them an anachronism in your company because they show you sketches and talk about the product experience, you—like most people—are having trouble pinpointing the contribution of industrial designers to business and the world around us.

"Secret" no more. This book, Rockport Publishers' second in this series, reveals the thinking and processes, the concepts, hurdles, and outcomes of industrial design's best efforts from the past three years. You'll see sketches, models, and final products. You'll read about how material choices were made to create a useful and pleasant feel, permit a particular form, or improve cost-effectiveness and ecological responsibility. You'll understand the approaches taken by designers in their user research, how they draw in cultural anthropologists, human factors engineers, other experts, and the users themselves to better understand what the user really needs and wants, not just what the user thinks would be best. You'll get a designer's first-hand view of these issues and more, and you'll never look at the products you use with the same eye again!

Perhaps most importantly, you'll have at your fingertips case studies, soup to nuts, of 50 designs that you can feel certain are excellent because they have been honored by the jurors of the Industrial Design Excellence Awards (IDEA). Sponsored by *Business Week* magazine, the IDEA honors work that excels in design innovation, benefits to the user, benefits to the company, ecological responsibility, and appropriate aesthetics.

That means that winning designs are more than dressed-up technological breakthrough, although these often create an opportunity for design breakthroughs. It also means that winners aren't just styling solutions with no depth of thought regarding use, manufacturability, shelf presence, recycling, toxicity, and shipping. The winners have solved the entire problem presented in the analysis of an opportunity.

Who needs to read this book? Anyone who has ever said—or heard—the following remarks.
- "I love the way this thing feels. I wonder how it got to be this way?"
- "Who decided to make this handle rubber? It's great, but why did it take so long to do it?"
- "I need case studies showing industrial design's impact on business strategy and branding for my MBA students" (or board of directors, for that matter).
- "We need case studies on great design solutions so industrial design students can learn from the best."

Design is a secret no longer. This book reveals the stories behind the world's most remarkable products, with fresh depth and visuals that go far beyond what all but the products' own designers are privy to. It's a new read in every way, even for the most experienced industrial designers, and the Industrial Designers Society of America (IDSA) is proud to endorse this book—and this series—and to cooperate in its production.

Kristina Goodrich
Executive Director
Industrial Design Society of America

BMW MINI Cooper How do you **redesign** an **icon?** That was the **daunting task** set before the design team at **BMW** after the company purchased the **Rover Group** and decided to **redesign** the **Mini Cooper** for the new **millennium**— to turn the Mini into a MINI (as the **new version** is designated).

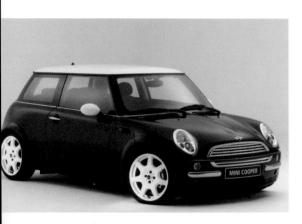

The MINI Cooper was voted Car of the Year by *Auto Express* magazine immediately upon its release in 2001.

The original Mini—designed by Alec Issigonis in response to the needs of a British public faced with gasoline rationing—was released in 1959 and quickly became both a design and an engineering icon to car enthusiasts throughout the world. While celebrities loved the Mini's chic look, the affordability of the car made it equally popular with less wealthy people. Issigonis' revolutionary design, which included cabin space–saving measures such as a transverse engine with surmounted transmission and wheels positioned on the far corners of the chassis, went virtually unchanged for decades. In 1995, *Autocar* voted the Classic Mini "Car of the Century," and in 1998, *The Guinness Book of World Records* named the Mini the most successful British car of all time. The Mini Cooper model, engineered by race car constructor John Cooper in 1961, capitalized on the original Mini's roadworthiness and developed that aspect further; the Mini Cooper's triple Monte Carlo rally wins between 1964 and 1967 added to the prestige of this model, and thus it was the first Mini chosen for relaunch.

The MINI team had a challenge on its hands—they had to keep the spirit of the original, much-loved design while making the new model fit for the twenty-first century. As Gert Hildebrand, head of MINI Design, points out, "Ninety percent of the car is determined by outside factors—legislation, engineering, production capabilities, materials, costs, marketing, and brand relevance." And many of these factors had changed dramatically since 1959.

One fact was clear: This MINI would have to be larger than the original model. The law now requires air bags; consumers expect high-fidelity audio components, plush seating, and air conditioning. These features—none of which were included in the original Mini—require space. There were demographic issues, too. Says Hildebrand, "People are 4 inches (10 cm) larger than they were in 1959, so the car had to be bigger."

With these parameters in mind, the MINI team decided on the theme of this new model: "From the original to the original," an acknowledgment of the Mini's iconic status and the team's desire to preserve the design features that made the original such a classic. "There was so much unique aesthetic capital for this brand that was important to keep," explains Hildebrand, "because no other car has these design features, like round headlamps incorporated in a big hood or an add-on roof that you can paint in different colors."

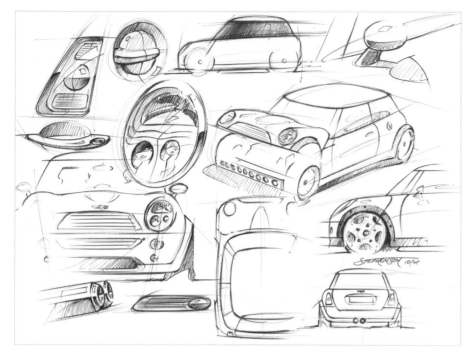

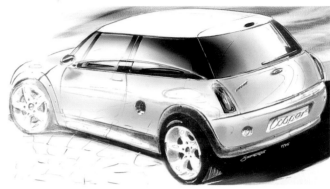

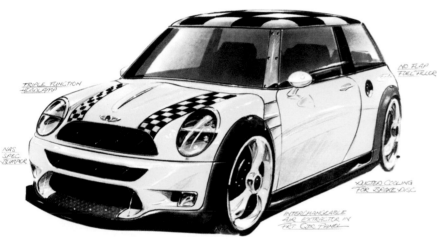

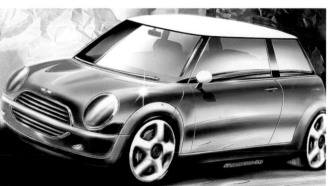

TRIPLE FUNCTION HEADLAMP

NO FLAP FUEL FILLER

NAS SPEC BUMPER

X.UTRA COOLING FOR BRAKE DISC

INTERCHANGEABLE AIR EXTRACTOR IN FRT GRS PANEL

STEPHENSON 10/97

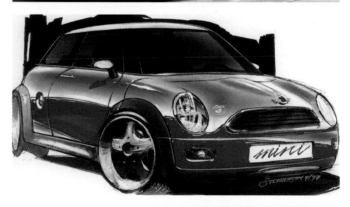

⌃ Above: In these early sketches, the designers began brainstorming about how the circular and semicircular "form recipe" would be carried out in the new model.

⌃ Below: This early sketch, featuring a mesh grille, tips its hat to the racing history of the Mini. The team ultimately rejected the design because they felt it looked too aggressive.

▷ Sketches of the MINI, from the original idea (top) through ideation to presentation (bottom). Hildebrand calls the sketch (top)—drawn by Frank Stephenson—the one where the basic design of the new MINI was born. Further sketches show this idea as it continues to be refined.

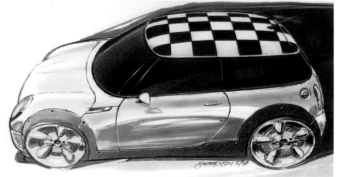

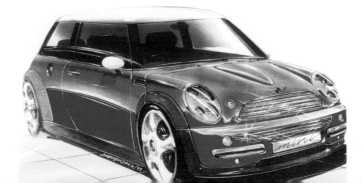

In 1995, three teams—one at Designworks in Los Angeles, one at the BMW Group headquarters in Munich, and one at Rover in Longbridge, England—began sketching and brainstorming ideas. Along the way, BMW decided that 10 iconic features would be taken from the classic Mini and transferred to the new model; those features included front-wheel drive, round headlamps, short overhangs, and spats. The team agreed that the "form recipe" of the Mini—both old and new—was its circular and semicircular elements. Hildebrand says, "You have the round headlamps, the round wheels—everything is created around the most functional geometrical element [the circle], so even the door, which is ellipsoid, has circular elements, such as the speakers and the handles."

Nine designs were selected to be made into clay models. While these models featured fully functional interiors, they did not actually run. The models only enabled management to get an idea of how each proposed design would look and feel.

The design team continued to sketch and refine the details of the interior and exterior design. "Modeling is a very expensive process; sketching isn't," says Hildebrand. "The more you sketch, the faster you can model. That's why car designers must have a greater ability to draw than normal designers, because designing a car is a very expensive and time-consuming process."

Throughout this phase, the team worked to reinterpret the Mini's classic styling for a new era. An average car has 7,000 parts—roughly half of which are visible—so thousands of design decisions must be made at this stage. For instance, some early design sketches featured a futuristic control pod that was ultimately rejected as being too modern to look right in the new car. A center console flanked by down tubes—which brought to mind the roll cages on the old racing Minis—was selected instead. Often, the team explored new interpretations for the MINI but rejected them in favor of the original design solution. For instance, they explored body-colored fenders but ended up choosing the contrast-color fenders of the original Mini.

After reviewing all the ideas, MINI selected a design developed by the Munich team as the design that best exemplified what they were looking for. They based the first, very primitive running prototype on this design. While the prototype was created primarily

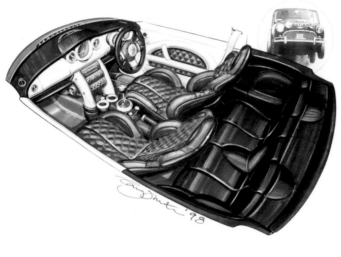

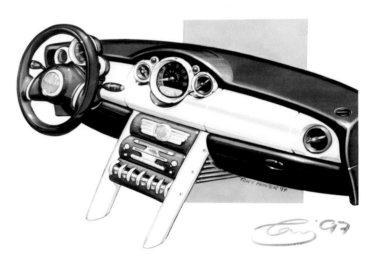

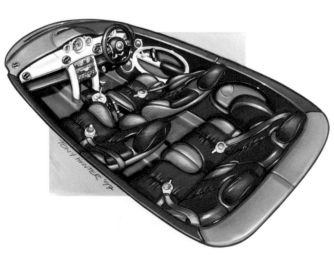

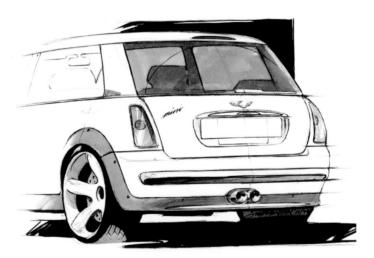

 Two of the hundreds of sketches the team created while refining the interior. Since there are more parts in the interior than on the exterior, the interior is more complex; the bottom sketch is closer to the final interior of the car. Both sketches show how the designers attempted to carry out the circular theme in even the smallest details of the interior, such as the air vents and the buttons for the radio.

Above: While the team considered a three-spoke steering wheel, they went with this two-spoke steering wheel because they thought it looked more distinctive. The team also considered putting the speedometer with the rev counter above the steering wheel but ultimately preferred the symmetry of this design.

Below: "The car has three main sides: the side, the front, and the rear," explains Hildebrand. "Normally, when designing, you start with the side and the front, and a lot of designers forget the rear. The rear is a very important part, especially on the MINI, because it's so fast that you normally see it from the back."

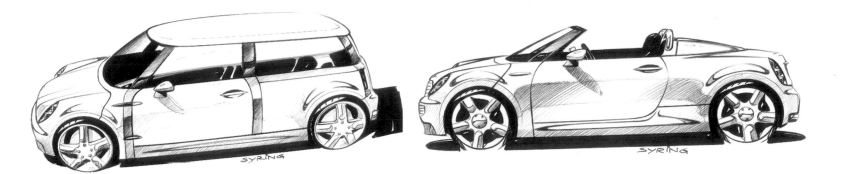

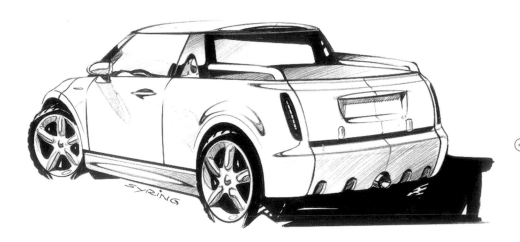

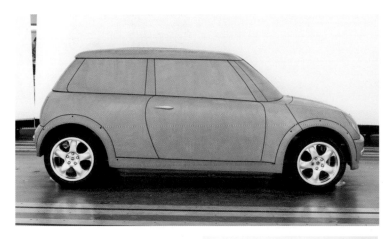

These early brainstorming sketches, by Marcus Syring of the Munich team, provide a peek at where the MINI may be headed; a variation on these ideas—the MINI as a convertible—is scheduled to become a reality in summer 2004.

for engineering purposes, it also enabled the design team to see how the car looked and felt when driven. Engineers then built other running prototypes that could be driven on test tracks to test the car's performance.

While Hildebrand acknowledges that a good part of the design team's work is done by the time the running prototype is developed, he notes, "We follow this process with our colleagues from engineering to the start of production, because all this improvement always means there are design issues—you have to change surfaces, or materials, or gaps, or you have to hide screws, or you have to change mounting directions. It never stops until the car is on the road."

Was this reinterpretation of an icon a success? The BMW Group would likely say yes. From a financial standpoint, in 2002—the first full sales year after the relaunch—more than 144,000 MINIs were sold, exceeding expectations by 40 percent. The MINI also grabbed many major design and automotive awards, including *Auto Express* magazine's Car of the Year award (2001) and Edmunds.com Most Significant Vehicle of the Year award (2002). Apparently, the MINI also has some of the star power of its predecessor—it was prominently featured in the 2003 film *The Italian Job*.

Hildebrand expresses satisfaction with the team's work. "If Issigonis had done the car 40 years later," he says proudly, "it would have looked the way it looks now." Even so, the team can't rest on its laurels; as Hildebrand reminds us, "The design process never stops. Even though this car has been in production for two years, we continue to work on improvements." The team is also developing a MINI four-seater convertible, due out in mid-2004.

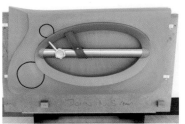
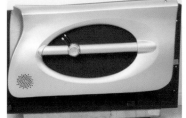

Above: This was only one of the nine clay design models developed by the MINI design team.

Below: The clay model of the door panel, unpainted and painted. Since clay models can be painted, they provide the team with a good opportunity to test various colors and trim. Says Hildebrand, "Color and trim are big issues, especially for the MINI, because it has separate roof colors."

Chrysler's PT Cruiser (PT is short for **personal** transportation) came about when **senior management** tasked a team of **designers** with exploring what they called a **"tall car** package,"

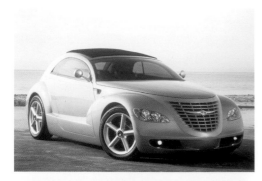

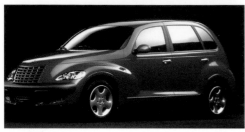

⊘ "The beauty of PT Cruiser is everyone can see a different era in it, but ultimately the vehicle stands on its own for its interior flexibility", says Ferrerio. "Some may look at it and see scenes from a 1930's street scene in Chicago; others may look at it and see Frankie and Annette on a beach in the 1960's; but a younger audience may just fall for the vehicle because it's cool and they can fit their stuff in. And, no matter what you see in the exterior, the interior delivers on that promise by providing a flexibility that makes PT Cruiser a cool vehicle that you can live in."

⊘ The instrument panel is symmetrical, with a 'heritage look." Designers wanted to bring the outside in and originally considered exposing the painted interior door sheet metal, but when this proved impractical, they color-keyed the symmetrically opposite instrument cluster bezel and passenger door air bag for a distinctive appearance.

hoping to create a compact-size vehicle that would offer distinct interior advantages over the usual car in that class.

Despite the PT Cruiser's unique exterior appearance, the car was actually designed from the inside out. The intent was to provide the customer with surprising roominess combined with unexpected seating and cargo-carrying flexibility.

But not just any vehicle would do. The vehicle had to be distinctive and offer the customer greater value than others in its class, so the decision to design a tall car package made perfect sense. A tall car package gives the customer a large-car interior combined with unsurpassed flexibility. DaimlerChrysler called upon its designers' expertise to make the unusually proportioned tall car attractive, both inside and out.

With its heritage-look exterior, the PT Cruiser presented a unique challenge to the interior designers, a team headed by Jeff Godshall, senior manager of interior design, DaimlerChrysler. "From an appearance standpoint, the interior design team operated with the idea that the aesthetic function of the interior is to complete the promise made by the exterior," Godshall says. "Thus the instrument panel is symmetrical, both as a 'heritage look' statement and to easily accommodate right-hand drive conversion with a minimum of additional tooling. We also wanted to bring the outside, inside. We originally considered exposing the painted interior door sheet metal, but when this proved impractical, we color-keyed the symmetrically opposite instrument cluster bezel and passenger air bag door for a distinctive appearance."

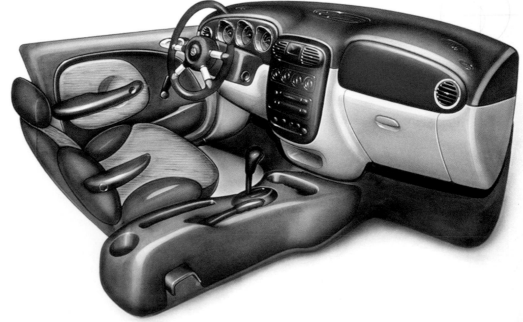

To unify disparate elements within the interior, a circular theme was chosen for the cluster dials, A/C outlets, steering wheel hub, and map pocket detailing. "We considered several different instrument panels, one of which featured large removable speakers at either end. Another panel utilized a motorcycle-style instrument cluster grouping, which clinic participants viewed as fragile. The chosen design featured a 'browless' cluster with the curricular dials recessed in bright-ringed tunnels, thus avoiding the usual overhanging brow," says Godshall.

For functionality, each door trim panel was fitted with a large integral map pocket, but the map pockets' circular see-through holes were the result of the designer's experience with his own children, who were notorious for leaving things behind in the pockets.

When the original manual transmission shift knob and boot looked too conventional, the team came up with the heritage 'cue-ball' shift knob, to the delight of customers. And when the initial corporate steering wheel was judged not in keeping with the interior theme, a new four-spoke steering wheel with a compact circular hub was designed and approved. To improve the vehicle's cargo-carrying ability, a new suspension system was specially designed that enabled the rear wheelhouses to move

further outboard, expanding the width of the rear cargo compartment. In each case, the team, with the backing of engineering and product planning, was able to do what was right for the vehicle. Much attention also was given to the five-position shelf panel, a blow-molded plastic tray with carpet on one side. Designed to move as easily as an oven rack, the shelf panel fits into specially designed recesses in the left and right rear quarter panels. In its "tailgate party" position, the panel protrudes beyond the liftgate opening, supported by a simple plastic leg that swivels into position. Owners can use this waist-high shelf as a table for food and beverages. Careful detailing and choice of materials, including chrome exterior and interior door handles and a thoughtfully chosen variety of interior textures and finishes, impart a feeling of quality above customer expectations.

Challenges involved with the design of the PT Cruiser's exterior were also numerous. "Combining the unlikely common elements of a truck and small car was not easy," says Steve Ferrerio, design director of the Advanced Design Studio, DaimlerChrysler Corporation. "The exterior was unlike anything on the road, so when you break into new territory, there's always a bit of tension in the marketplace. Clearly, we hit a sweet spot with the vehicle, and it turned heads.

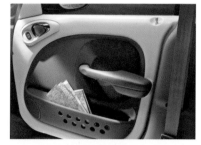

⊽ Additional advantages of the "tall car package" include improved ingress/egress, "command of the road" seating for the driver, raised "theater seating" for rear seat passengers, and generous leg and headroom all around.

▷ Since kids sometimes leave candy bars and other undesirables in the map pockets, designers integrated see-through holes in them. During development, they also modified the design of each door slightly so each side door armrest and door bolster could be used on both the front and left rear doors, reducing tooling costs.

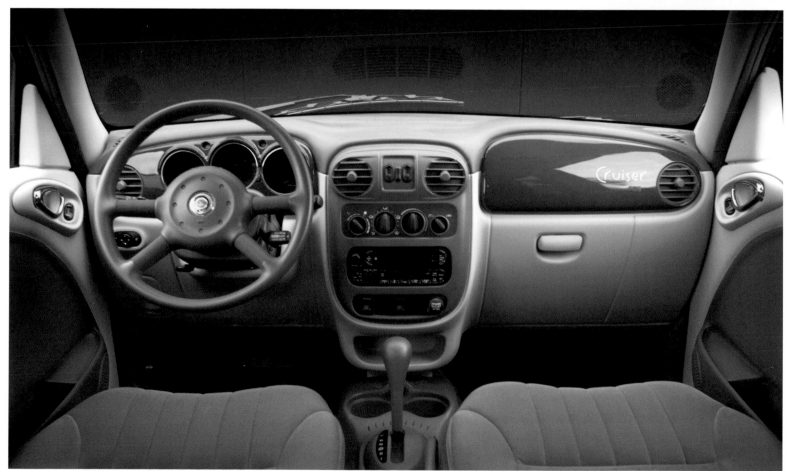

"Part of that appeal, ironically, was there was a true love/hate out there—those that loved the vehicle really loved it and had to have it. Those that hated it on first glance were captivated. That tension created a draw or appeal, and that is what drew the attention to the vehicle."

Ferrerio, who headed up the exterior design, says that the secondary challenge was for the vehicle to deliver on the interior and not just be seen as a novelty. "The PT Cruiser has all the fun and jaw-dropping exterior cues but will also fit an 8-foot (2.4 m) stepladder from the front seat through to the rear based on the seating," says Ferrerio.

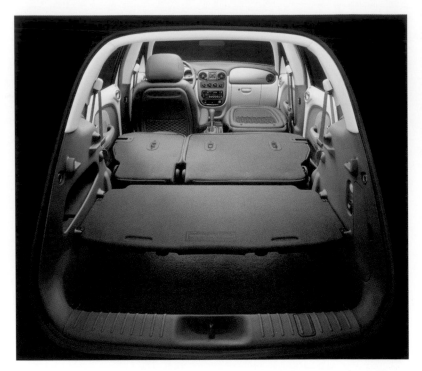

"The ideation process is especially critical when it comes to a project like this," Ferrerio adds. "Normally when a designer searches for a concept or idea, he or she wants the most flexible tool as possible and that is a pencil or ballpoint. 'Something much tighter' is what is used in the rendering of a completed idea. Once a sketch is chosen, the standard three-view orthographic drawing is usually done to communicate that idea to start the 3-D process. In this instance, we worked with a modeler or team of modelers to create a full-size clay model. The model is made to look like a real car as much as possible, including darkened windows, painted body, and a lot of detail, with 2-D mockups to complete the image. They are pretty convincing and can be evaluated by upper management to ensure our objectives are being met."

Throughout the design process, Chrysler engineers used the CATIA system. Designers used a combination of freehand sketching and computers. Some tasks, such as the interior door remote handle, however, demanded real-world interaction between the designer and a clay sculptor.

"The design of the interior of the PT Cruiser was a liberating experience. Since both the package and the exterior were so unconventional, the interior design team had to look at designing an interior from an entirely new viewpoint. Nothing was set," says Godshall. "While our initial thinking was to design an interior with a place for everything and everything in its place, our customer focus groups demanded instead a 'duffel bag' approach. 'Give us the space,' they told us, 'and we'll decide how to use it.' Thus we designed the flexible fold-flat/removable seats and the five-position shelf panel, which demonstrate what is possible through creative design. One clinic participant even asked, 'Why don't all cars do that?' Most of all, the PT Cruiser interior is a prime example of the joy of working with a team of people, all of whom spelled the word 'no' K-N-O-W."

"The beauty of PT Cruiser is that everyone can see a different era in it, but ultimately the vehicle stands on its own for its interior flexibility," says Ferrerio. "Some may look at it and see scenes from a 1930s street scene in Chicago; others may look at it and see Frankie and Annette on a beach in the 1960s; but a younger audience may just fall for the vehicle because it's cool and they can fit their stuff in it. And, no matter what you see in the exterior, the interior delivers on that promise by providing a flexibility that makes PT Cruiser a cool vehicle that you can live in."

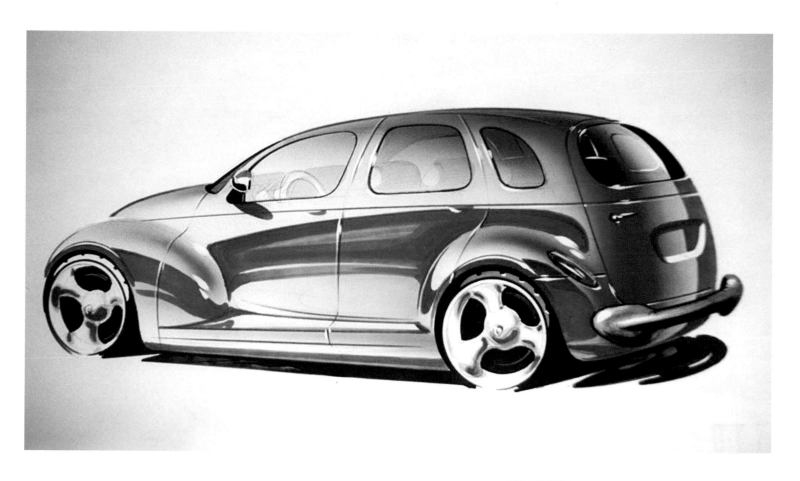

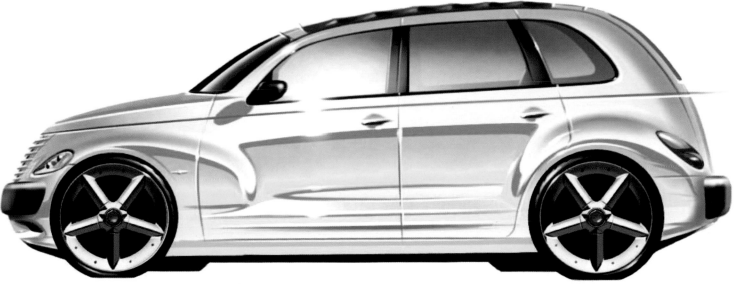

Opposite top: The PT Cruiser can carry five people in comfort or can be converted into a four-, three-, two-, or even one-person vehicle. The passenger front seat can be folded flat. The rear seats can be folded flat, tumbled forward, or removed entirely. When combined with the innovative five-position movable rear shelf panel, over thirty interior combinations are possible. The flexible interior can even accommodate an 8-foot (2.4 m) ladder with the liftgate closed. Despite its shorter wheelbase, the Cruiser's 120 cubic feet (37 m^3) of interior space is equal to that of the larger Dodge Intrepid sedan.

Opposite middle and bottom: To arrive at the desired shape of the interior door remote handle, from both an aesthetic and a functional perspective, a clay sculptor took the designer's sketch and carved a model from balsa wood, permitting evaluation by both the eye and the hand. After numerous iterations, the final handle design was determined, satisfying both ergonomic and aesthetic considerations.

"The exterior was unlike anything on the road, so when you break into new territory, there's always a bit of tension in the marketplace. Clearly, we hit a sweet spot with the vehicle and it turned heads," says Steve Ferrerio, design director, Advanced Design Studio, DaimlerChrysler Corporation, of these early renderings.

Segway Human Transporter If you **lean forward**, do you **fall down**? Well, not usually—your sense of **balance** will **trigger** you to put your leg forward, **preventing** a fall.

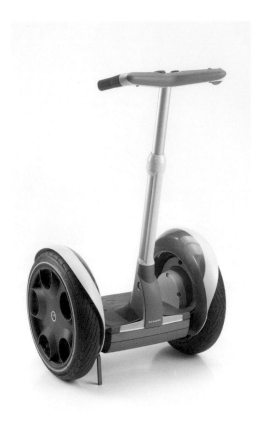

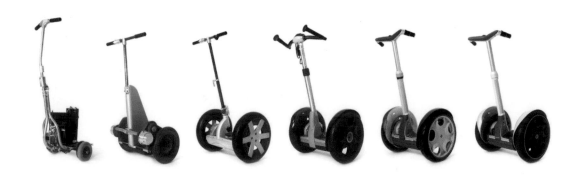

The Segway Human Transporter is designed to take up no more space on the sidewalk than the average person.

Here, the evolution of the Segway from prototype to final version displays the design team's efforts to turn an impressive piece of technology into a user-friendly consumer product.

If you keep leaning forward you will intuitively keep putting your legs forward, keeping you upright. This principle of balance is what lies behind the Segway Human Transporter, which uses this principle to keep itself upright while transporting people.

Dean Kamen, an entrepreneur and inventor who holds over 150 patents, observed the problems wheelchair-bound people had with climbing stairs and negotiating sand, curbs, and rocks, and he realized that balance was key to giving these people mobility. In response, he developed the IBOTTM Mobility System, a transport device that restores users' balance while enabling them to see the world at standing eye level. He then saw an opportunity to apply this technology to solve one of the biggest problems faced in twenty-first century urban settings—moving people (and products) relatively short distances while using less energy. As Kamen noted on the Segway's release, "With over 80 percent of the world's population soon to be living in urban areas, we believe that the Segway HT can, over time, play a vital role in these areas."

The system Kamen envisioned also had numerous commercial applications: It could improve the speed and efficiency of mail and product delivery, manufacturing and warehousing operations, and public safety. Kamen put together a team to make his vision a reality.

The engineering team worked to hone a breakthrough technology that the company termed *dynamic stabilization*, a system of gyroscopes and tilt sensors that monitor a user's center of gravity 100 times a second, working seamlessly to maintain the user's balance. Since this was a brand-new technology, the industrial design team worked closely alongside engineering with their own goal in mind: to make the technology less intimidating to users. Says Scott Waters, industrial design manager for Segway, "Our feeling was that, when you're introducing something as new as this, you run the risk of scaring people, and we didn't want this robot with motors hanging off of it and wires everywhere; we wanted it to be very clean and simple and honest."

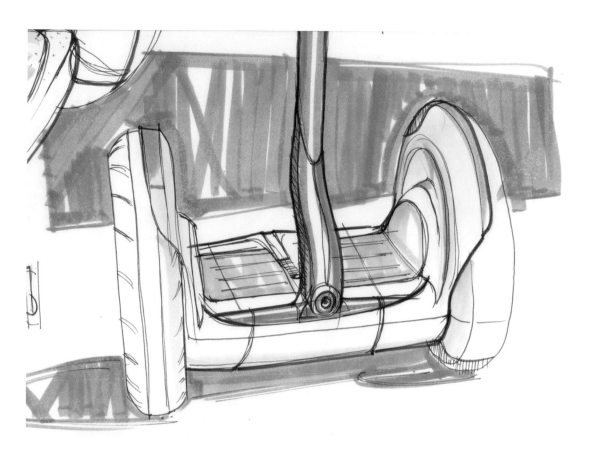

Three illustrations of the detail of the inner wheel of the Segway: at the top is an early sketch; the photo above is of a $\frac{1}{3}$ scale sketch model crafted in foam; the photo at right shows a detail of the finished product. The close integration of design and engineering throughout the process negated the need for radical changes in design direction through the process of product development.

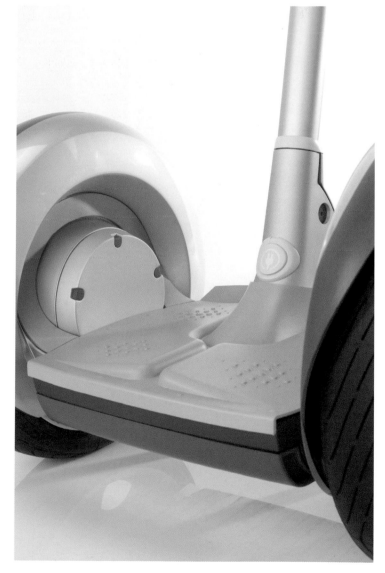

They developed a design philosophy document to guide them in the product's creation. One of the primary guiding principles laid out in this document was one they called "man max, machine min," which Waters explains as "the idea that the hardware of the machine shouldn't take up any more space than is necessary, that any space that could be dedicated to the user should be taken away from the hardware, so the idea literally was to just shrink-wrap the hardware around the technology." The original prototype exposed its mechanical elements to the user, and subsequent early prototypes were boxy and unwieldy. The design team worked to hide the technology and to reshape the vehicle, carving out the airspace behind the fender to minimize the space between the wheel and the body of the machine.

While the feel and the aesthetics played their part in reshaping the vehicle, functionality could not be forgotten: The curve of the fender was reshaped to carefully balance the need to shield users from spray with the need to minimize any bulk that would cause the fender to hit other objects or to be torn off. A round tube was chosen for the control shaft because it was the easiest shape to make both adjustable and sealed.

Planning the materials to be used for the manufacture of each piece also required a careful balance of functionality and aesthetics. While the designers originally planned to make the control shaft from metal tubing, the part did not have the appearance they sought, and combining the electronics and wiring with the handlebar proved difficult. In the end, they decided to make the control shaft plastic; the clamshell was vibration-welded shut, which made it watertight and helped prevent electromagnetic interference.

Many of the other parts were planned to be plastic, both for durability and ease of manufacture, but that created other problems. For the sake of durability, the team had wanted the wheels to be plastic, but aesthetically, this choice proved challenging: Though they planned for the part to be a light color, the team discovered that UV exposure to plastic caused it to yellow. A painted finish was not an option—it would add cost and would chip and scratch easily—so the wheel was changed to a dark color to compensate.

The core structural components are die-cast aluminum, which again created challenges: The design team sought a finish that would hold up to the elements while looking good, so after some experimentation, they chose a powder coating for most of the metal surfaces. Waters says they wanted the finish of the Segway to be as beautiful as the surface of a car or bicycle, but more durable: "We wanted it to be a useful item; we didn't want it to be something you had to constantly be caring for and worrying about. We wanted it to be subservient to the user, not vice versa."

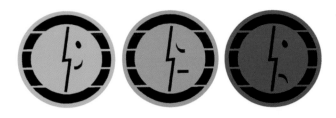

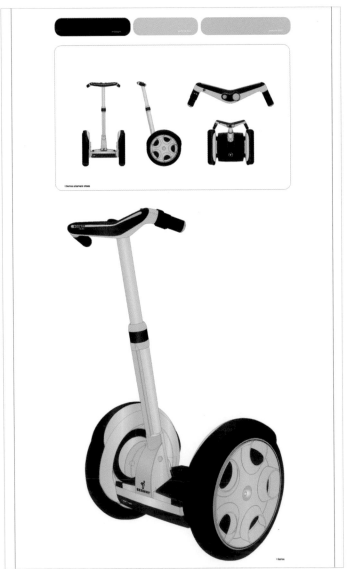

⊘ Above: The use of a human face came out of a desire to have a universal means of communication. The expression-based user interface is universal, requiring minimum learning worldwide.

⊘ Above and right: These images show the user interface housing as it develops from CAD surface generation and a full-size sketch version to the final product. It is vibration-welded closed around a tight cluster of electronics. No wires come through the housing, making it watertight.

⊘ Far right: The concept for the color scheme was internally called Stealth. The warm metallic grays disappear underneath the rider, supporting the product's principles of approachability and subservience to the user.

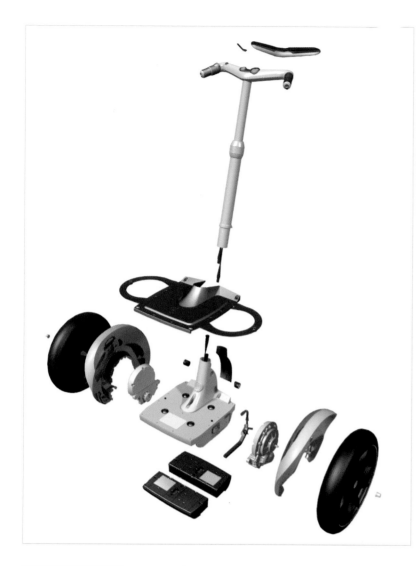

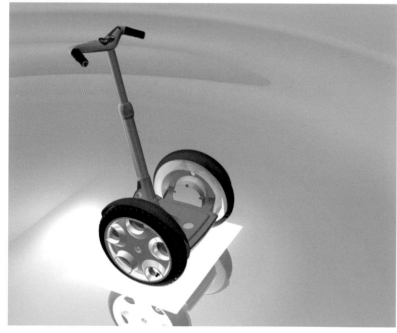

These CAD renderings show the Segway exploded and assembled. It has approximately 20 subassemblies and can be assembled in 20 minutes. Parts such as the motors, transmissions, wheels, and fenders are shared by the left and right sides of the machine, greatly reducing the cost of inventory.

Making the user interface simple and seamless was another key goal. While early prototypes conveyed technical information about heat dissipation off certain components and status of the balancing technology, in the end, the team wanted to distill this technical information and to tell users only what they needed to know. Since they planned to sell the Segway internationally, the team brainstormed ways to communicate to the user without language. "As we were developing this, we discovered that the easiest way to communicate information is through human expression," says Waters. "It's built into all of us—a baby can recognize the smile on its mother's face and smile back, so that was the icon that we used to convey the status of the machine to the user." To signal that the Segway is operating properly, a smiling face appears on the display. If the machine overheats or experiences a malfunction, the display turns red and the face frowns; a simple battery gauge indicates whether the battery is empty or full. The smile on the display has since become an icon for Segway users—at a recent Segway user conference in Chicago, one user proudly displayed the face as an ankle tattoo.

Attention to detail is manifest in every part of the Segway, even in the sound the gears make when it is in motion; the meshes in the gearbox produce tones exactly two musical octaves apart. "The best products out there are crafted to be this experience so every time you push a button it feels a certain way. There are all these tactile and audible qualities that make something what it is," says Waters. "It's not something you would necessarily pick up on unless you were told, but if it's done wrong, you definitely know it."

Throughout the process, the group relied on their own instincts for what the product should be and how it should work; they did not work with focus groups. "Different people have different philosophies here, but it's my opinion that consumers don't necessarily know what they want until you show it to them," says Waters. "And there's kind of a power in having a good group of people together who have strong, intuitive qualities to making something good. I don't believe that a lot of great products are born out of focus groups." The team did do user testing, primarily centered on safety issues.

While it would be hard for the Segway to meet the lofty goals Kamen set for it on its introduction, the Segway has become a product with passionate devotees. It has been adopted or tested by a number of municipalities—including Seattle and Atlanta—and has been tested for more widespread use by the U.S. Post Office. Commercially, it is being used for many of the applications Kamen had envisioned—on college campuses, for public safety, and in manufacturing warehouses. Two new versions have been developed since the product's introduction: the p series is a lighter version, and the e series has cargo capabilities, including a cargo rack, storage bags, and an electronic parking stand.

Waters himself expresses satisfaction with the Segway: "The thing that I like most about it is that I never grow tired of it. It kind of grows with me, which is another principle that we call depth. It should be easy for a beginner to pick up instantly and immediately understand it, but then at the same time you also want it to be like a Stradivarius, you want it to be this beautiful tool that grows with you as you grow in your abilities."

BMW StreetCarver It's extreme. Anyone **bold enough** to take a ride on the **BMW StreetCarver** will experience the **sensation** of snowboarding and surfing on the **street**.

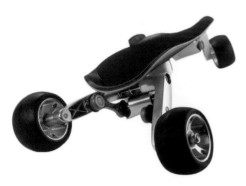

⊘ The unique appearance of the StreetCarver caught on among its target market of anyone over 10 years old. It is aesthetically pleasing and functional, too. For instance, the wings protect fingers on sharp curves.

Until now, snowboarders and surfers who wanted a thrill required either snow or water. The experience was possible only in the right season and the right location.

BMW has succeeded in capturing this ride feel and offers all fans of the so-called gliding or soul sports the new BMW Street-Carver—the chance to transfer this passion directly to the road. The idea for the StreetCarver was born more than a decade ago, when a sports accident grounded Rudi Müller, a snowboarding enthusiast and head of chassis construction at BMW, for a week due to a broken rib. "Outside it was still snowing, but for me, the winter was over. So I started thinking that I needed something for the summer, so that I could speed down the mountain meadows." Müller built the first prototypes in his garage. Among his priorities were wheels that could compensate for uneven surfaces and potholes as well as tilt into bends. He decided on single-wheel suspension and a composite steering axle using foam rubber cushions that distort, bringing about a steering movement. In 1994, he registered the patent.

Meanwhile, Stephan Augustin, a design student, was experimenting with scooters, mounting from two to fourteen wheels on their decks. In 1997, he joined BMW. By then, the StreetCarver was out of Müller's garage and past the "U-Boot" stage—BMW's name for products designed without an official development commission. Augustin was teamed with Müller. With no fixed launch date for the product, they worked on it at a leisurely pace with BMW's support. Four years later, the scooter was ready to go into serial production. However, it didn't handle the way the designers wanted it to. Models produced in the mid-1990s were huge by today's standards, weighing 22 pounds (10 kg) and measuring 5 feet (1.5 m) long. They had large rubber tires to allow them to negotiate bumpy mountain meadows without too many falls and correspondingly large turning circles.

Designers didn't like the steering either. It was imprecise, with too much play. They wanted their scooter to be more compact and easier to handle. Augustin experimented with different steering components using his Fisher technical construction kit. That's when he hit on the solution: ball-and-socket joints that function like a hip joint.

Müller took a serial part from the rear axle of the BMW 5 Series chassis, where it acted as a stabilizer for wheel control. Then, he replaced the previous model's foam rubber cushion with four pendular supports. With that, he and Augustin got the result they were after.

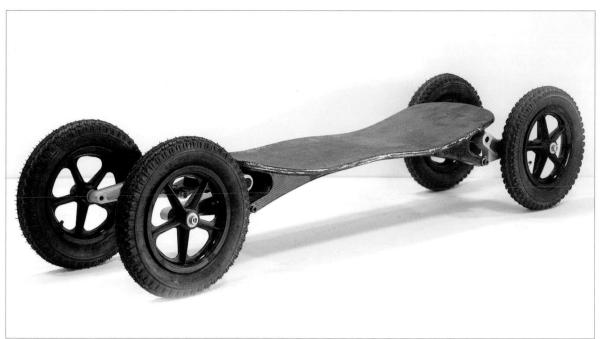

The 1995 model was too big. It had 12.5-inch (32 cm) wheels, weighed 22 pounds (10 kg), and measured more than 5 feet (1.5 m) long.

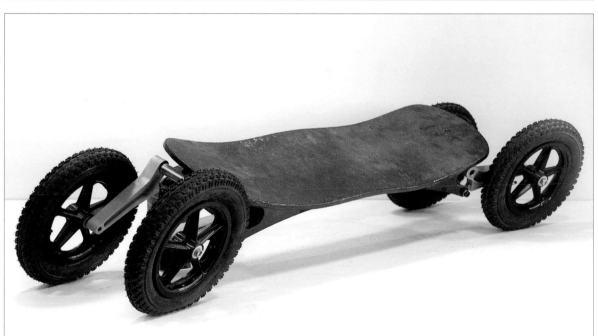

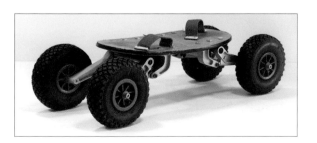 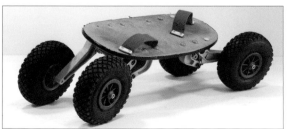

The wooden successor was only 3.25 feet (1 m) long. The wide wheels and loops for the feet were intended to provide safety on tough terrain.

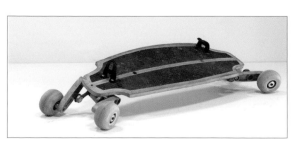

The steering geometry was perfected for this model. The ball-bearing polyurethane wheels stem from the running sections of escalators.

With its progressive steering response, the rider can precisely change the direction of the StreetCarver by merely shifting his or her weight, or "carving." This makes possible spectacular, rapid steering maneuvers that heighten the excitement of the ride. When traveling at high speeds, the StreetCarver stabilizes itself using the rider's weight. This provides a calm and controlled ride feel even when taking extreme corners.

The symmetrical deck or standing surface is manufactured exclusively for BMW. The ride is cushioned thanks to a sophisticated combination of wood and fiberglass inserts, while nonslip rubber Grip-Tapes offer the rider stability. After all, "if you're going fast, you need a firm surface under your feet," says the product literature.

The tires are actually low-profile rollers made of polyurethane. When the running surfaces of the rollers wear down to a certain depth, in-dicators become visible. At this stage, the dual-section aluminum rim can be dismounted and the running surface replaced.

The StreetCarver, offering a high-speed thrill ride that defies gravity without fuel consumption, debuted on the market in spring 2001. By September of that year, BMW had sold 3000 units via their website and won numerous design prizes.

"To work on an exotic project like this with the professional background support of BMW was unique and exciting, and I learned that BMW is not only a car company—it has also a great design culture in combination with perfect engineering," says Augustin. "Skateboards and long boards existed, but nobody expected a board from BMW, so the product was a first."

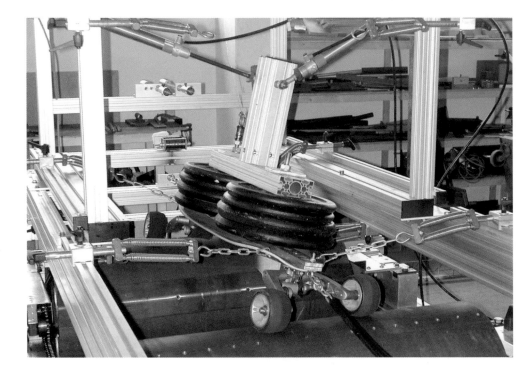

⊘ Prior to market launch, a testing agency ran the StreetCarver across asphalt rollers for more than 37 miles (60 km) bearing a load of 220 pounds (100 kg). An uneven bounce simulated peak loads that a rider would encounter when riding over curbs.

⊘ In 1997, the developers discovered an alternative to foam rubber—a pendular support like that on the BMW 5 Series automobile, only smaller. Integrated with the aluminum chassis of the StreetCarver, the supports provide the wheel suspension and enhance the ride response.

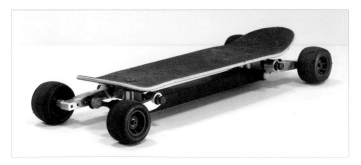

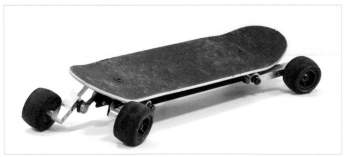

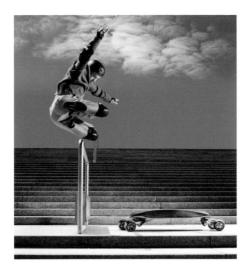

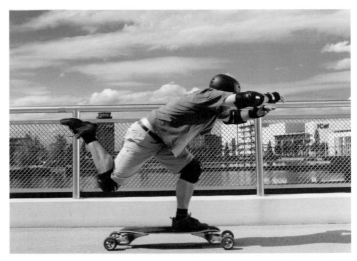

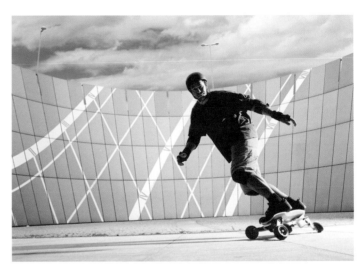

⌂ Above: The primary design challenge was to create an easy-to-use long board with the built-in agility of a skateboard. The designers strove to obtain the movement of a surfboard or snowboard.

⌂ Above right: The StreetCarver ushers in a new generation of roller sport, offering high speed with precise curving quality, a real snowboard feeling with radical curve possibilities thanks to its steering mechanism.

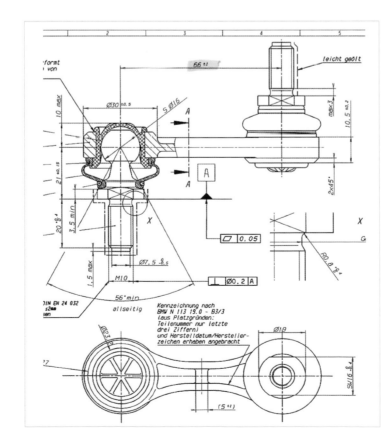

⌂ As with the gripping edge of a snowboard, the running board lifts in a curve. Weight and pressure shift along with the user's body weight. The board then automatically lowers into the straight-running position.

◁ ▽ The pendular supports that replaced the foam rubber cinematics of the earlier prototype look like hip joints and came from the rear axle of the BMW 5 Series automobile, where it was used to help stabilize the wheel alignment.

Wahoo Sailing Dinghy Everyone can set sail for adventure with this revolutionary sailing vessel that makes sailing fun—even for the novice.

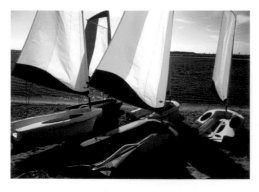

⊘ The production Wahoo—the easiest dinghy to sail—features eye-catching colors and a friendly design.

⊙ Designers created the original M-hull as a vaporetto to suppress waves, and therefore erosion, on the fabled waterways of Venice, Italy.

Anyone who has sailed knows the drill: "Whatever you do, do not sail in shallow water with the centerboard down and pull it up when beaching." This stern caution, coupled with the high skill level required to operate most sailing dinghies, keeps people at bay, intimidating even the most experienced sailors.

The Wahoo Sailing Dinghy was created to make the sport easier and open it up to children of all ages and women in particular. "Bringing a dinghy up on the beach requires the skills of an acrobat," says William Burns, managing partner, Mangia Onda Company. "One must let the sails out, pop up the rudder, and pull up the centerboard, all while trying to keep the boat sailing in the right direction."

Burns, and his partner, Chuck Robinson, both avid sailors, knew first-hand that the sailing market needed an easy-to-sail dinghy. "Many people are afraid to try sailing because there are too many lines and handles or because they are afraid of turning over the boat and being unable to right it safely," says Burns.

"Sailing a Wahoo is simple—just grab the tiller, pull in the sail sheet, and go!" he says.

Interestingly, the solution to simplified sailing is in the hull—and specifically, the patented M-hull. Burns and Robinson formed the Mangia Onda Company in 1997 to develop the M-hull as a solution to the wave damage problem along the walls of the canals in Venice, Italy, created by water buses, or vaporetti. Their collaboration produced the Mangia Onda Vaporetto, which features an M-shaped hull that captures the bow wave with skirts on either side of the boat and rides on a cushion of air moving through two tunnels spanning the length of the hull. This design not only minimized the boat's wake but also increased its stability.

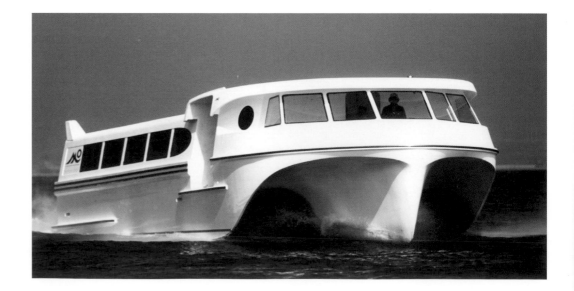

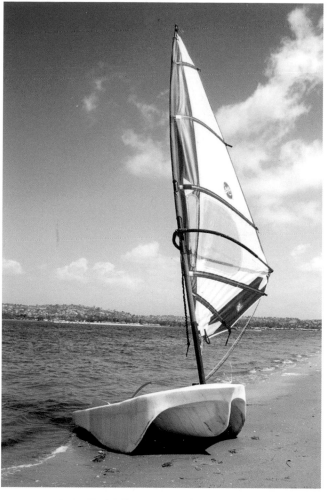

The pair realized that the same hull features that made the powerboat successful could be modified slightly to make a superior sailing dinghy. "By exaggerating and reshaping the skirts, we could create a sailboat that didn't need a centerboard—a huge step toward simplified sailing," says Burns, explaining that when a sailboat sails upwind, it needs to resist the sideways push of the sails with a centerboard for leeway control. The skirts of the Wahoo automatically provide this self-regulating leeway control. The harder the wind pushes, the more the boat heels and the deeper the skirts bite into the water. The tunnels of the M-hull provide dynamic stability by capturing the bow wave and making the dinghy more stable. Additionally, the skirts provide a convenient point of leverage to right a flipped dinghy.

The Wahoo has a cantilevered sail with a single line, a simple rudder system, and large, easy-to-grasp connections. The single batten and lack of boom means sailors don't have to worry about head injuries from a swinging boom. "These features create a nonthreatening sailing experience—something the sailing market has lacked," Burns adds.

The Wahoo consists of only four parts: the rudder, sail, mast, and hull. Nevertheless, even simple product designs don't always run smoothly. The first challenges were to adapt the M-hull design from a powerboat application to a sailing one and to prove that the concept would indeed make sailing easier. The designers began with pencil concept sketches, diagramming the side force and righting moment objectives and then explored variations of the M-hull powerboat design for a sailing dinghy.

Throughout the process, the designers relied on naval architecture and graphic design programs to design and develop the dinghy. For example, they created a computer model of the concept and shaped the hull with Maxsurf Professional and performed virtual hydrodynamic and hydrostatic tests and stability analysis with Hydromax Professional. They built the first full-size prototype out of foam and fiberglass and used a windsurfer mast and sail to evaluate the concept on the water.

⊘ From the computer models, a prototype consisting of foam and fiberglass was developed and built. A simple windsurfing sail was used.

⊘ It wasn't all smooth sailing for the Wahoo. A problem was discovered with the bow of the prototype, requiring modifications.

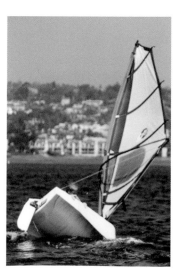

Once the hull was proven, designers tackled the other parts of the dinghy, completely redesigning the sails, rudder, tiller, and lines to make sailing easier. They used Ashlar-Vellum's Cobolt to design and model the rudder and other components.

"We started with a clean slate and were not hindered by designs of the past," remembers Burns. "The sail development required five prototypes. We wanted a sail that eliminated the boom, was controlled by one line, and automatically unloaded the wind when overpowered to prevent capsizing."

Getting the battens to line up correctly was another hurdle. Designers attempted different angles and finally found the right location for the single vertical batten. The final sail shape is a box-head style, meaning it has extra area near the top that induces a twist when the wind increases, reducing the heeling force. Designers added flotation to the top of the sail to prevent the boat from flipping completely upside down.

The rudder system was tricky, too. "We wanted the connections to be easier to grasp and install, especially in bumpy conditions with significant waves," says Burns. The resulting rudder system has a large handle with a large hole into which the rudder fits, making it easy to use. Designers replaced the small $\frac{1}{4}$-inch (0.5 cm) hinge pins typically found on a rudder with an easy-to-use 2-inch (5 cm) connection. The final rudder design is both cost-effective and efficient.

The final challenge was an aesthetic one. Because the designers wanted to attract more people to sailing, especially children, the boat had to look "less like a science experiment and more like a toy," says Burns. So far, that wasn't the case. Early drawings gave the boat an aggressive look with sharklike characteristics.

They brought in Greg Siewert of Siewert Design to give the boat a friendly look. He developed a second prototype and with modifications to the rudder, sail, and other components, the boat took on a more rounded appearance, with fewer hard edges. This alone makes the design more friendly looking and safer. We also decided to increase the height of the seats and add thick neoprene padding for a more ergonomic sailing position and to keep the sailors drier," explains Burns.

Inching closer to actual production, the designers choose five fun colors for the boat, packaged it with a matching sail, and gave it a whimsical name, Wahoo. By the time it went into production, designers had built the mold and produced five working prototypes.

In the end, the Wahoo is remarkable for its nonthreatening design, innovative M-hull, and simple-to-use controls. The M-hull design eliminates the need for a centerboard and improves stability with its manta ray wings. The kick-up rudder and lack of centerboard make beaching a breeze, according to designers. "The setup and operating controls have been simplified like no other sailing dinghy on the water," says Burns. "In a matter of minutes, even first-time sailors can be off the beach and having fun. By creating a comfortable and simple boating experience, we hope to encourage kids of all ages to adopt sailing.

"We had great fun developing the Wahoo, and it shows in the final product," says Burns. "The most valuable lesson we take from this project is that a simple design is not necessarily simple to design. The final product uses only a handful of parts, but the simple and easy operation of the Wahoo belies the large design effort that went into creating it. Even on a small project like the Wahoo, working with quality partners on a team is the best insurance for success."

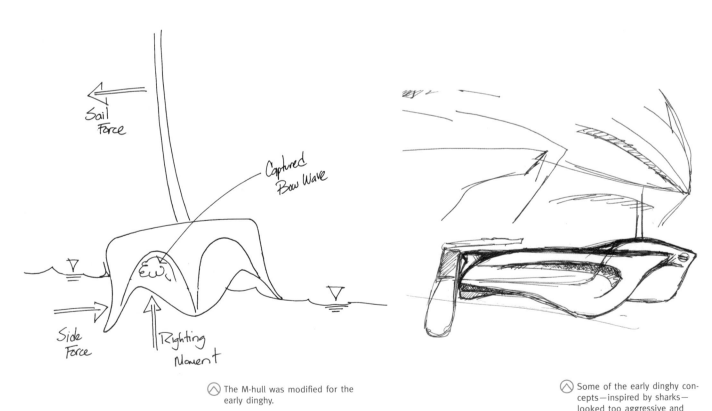

⬦ The M-hull was modified for the early dinghy.

⬦ Some of the early dinghy concepts—inspired by sharks—looked too aggressive and intimidating.

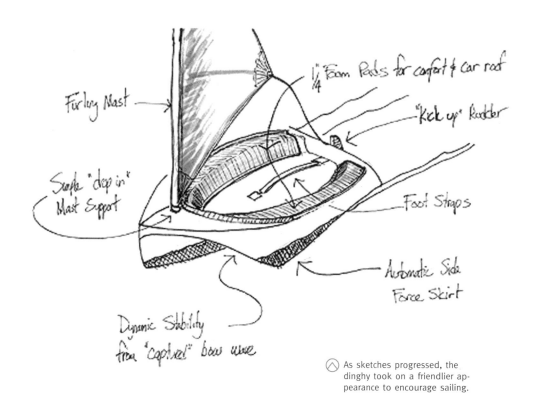

Furling Mast

1/4" Foam Pads for comfort & car roof

"Kick up" Rudder

Scupta "drop in" Mast Support

Foot Straps

Automatic Side Force Skirt

Dynamic Stability from "captured" bow wave

⬦ As sketches progressed, the dinghy took on a friendlier appearance to encourage sailing.

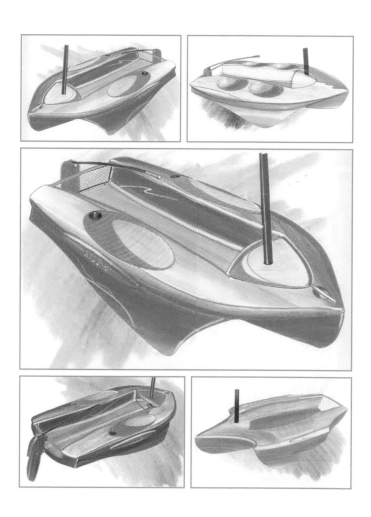

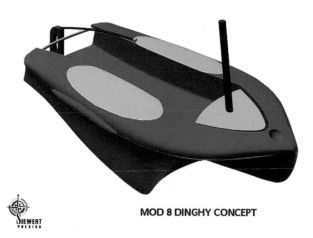

MOD 8 DINGHY CONCEPT

⬦ Left and top: With the help of Greg Siewert, several friendly versions were rendered in color.

⬦ Above: Once the look of the dinghy was finalized, designers modeled the hull and various components in Maxsurf and Ashlar-Vellum Cobalt.

Windsurfing Sails Collection "We held a microscope to the **windsurfing** experience in order to **design** the 2003 **Neil Pryde** windsurfing **sail collection.**

We wanted to create an unconscious meaning of performance," says Thomas Meyerhoffer, who heads Meyerhoffer, the design studio retained to assist Neil Pryde, the number-one sailmaker in the world of windsurfing, in developing a recognizable silhouette that would become a company hallmark and convey the performance standard that Pryde owns in the market.

What Meyerhoffer saw under the microscope was unremarkable. "The windsurfing market has been stagnant in the last 10 years. It was in a spiral that went deeper and deeper, with designers using the basic shape of the sail and plastering it full of graphic elements from flames and circles to fairly tacky images. Sails ended up looking like your basic Hawaiian shirt. That was the commonality for the market. The challenge was to break out of the mold."

For Meyerhoffer, an avid surfer, breaking out of the mold meant going the opposite direction. If the market was glutted with flashy graphics, he would go for utter simplicity. "For me, the sail had two components: the technical/functional and the emotional. This is a very high-tech product. It has excellent materials, excellent performance that has been purified in the last 20 years. It is very efficient; you can sail very fast with these things, even at speeds in excess of 60 miles (66 km) per hour. Through the design, I wanted to connect on an emotional level, too, with the shapes and how it was cut."

The studio first stripped the sail to its core and composed a zero-graphic model before reintroducing design elements to coexist with each model's inherent performance requirements. Meyerhoffer utilized the sail's frame as the signifier that informed all visual clues in the design process. A visual language was developed to articulate the streamlined efficiency that the racer would expect and how that might differ from the wave surfer's desire for maneuverability.

Defining the windsurfing experience enabled the design to follow the narrative of each surfer's ambition with particular visual content. "A product needs to touch one's dream," notes Meyerhoffer. The collection consists of nine sails, from those built for speed to those built for waves. As Meyerhoffer conceptualized the line, he saw the commonality of the models as an outline that encircles

◯ Above: This freestyle sail, called Expression, is built to be a lighter sail because freestyle surfers need to be able to move it around a lot more in the water. Less frame equals less weight for a lighter sail, so again, the transparent window changes to meet the form and function.

◯ Below: This signature model was developed as a high-performance wave sail. It has a simple shape and is almost entirely transparent. The element common to this sail and others in the line is the border, which works in different ways for different models but provides a unified look.

◇ This wave sail, called Core, has a more graphic look and a smaller transparent window. "It's for the Hawaii dude who does a lot of freestyle moves," says Thomas Meyerhoffer, designer. It is showy and appeals to a young demographic that wants something expressive that still works within the frame concept.

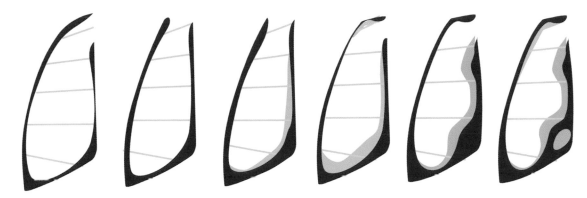

frame concept_line

speed
sleek

wave
energy

⊗ Meyerhoffer's concepts on a continuum from the sleek sails built for speed to those requiring reinforcement and strength to handle high-energy waves. The red frame is basic to every sail in the collection, and it opens up more and more depending on the type of sail. The speed sail is wide open as opposed to the wave sail, which is closed and reinforced.

⊗ The sails are made of high-tech fabric and are stitched with pockets into which fiberglass battens are inserted. The mechanism that protrudes from the pocket is used to adjust the tension.

a frame; inside the outline, the sail would be totally devoid of design—transparent. He sketched this concept on a continuum from the sleek sails built for speed to those requiring reinforcement and strength to handle high-energy waves.

"The line goes from the racing sail to the more intermediate to specific wave sails, which will do different things for the user. The wave sail needs to be more reinforced. It's a high-energy style, and it is emotionally a different thing than speed sailing, which is very efficient, light, and fast," says Meyerhoffer. He developed a red frame around the sail. This frame is basic to every sail in the collection, and it opens up more and more depending on the type of sail. In speed it is wide open, whereas the wave sail is closed and reinforced.

There are those "looking for function, while other wave sails in range are more emotionally decorated and lively and [the latter] are for surfers who want to have more impact on the water," says Meyerhoffer.

"These new sails are particularly subtle and elegant," states Simon Narramore, Neil Pryde brand manger. "This is really what I see as the Neil Pryde trademark. The purely aesthetic parts of the product design have now been elegantly engineered into the sail themselves rather than layered on at the end with colored materials."

What did Meyerhoffer learn from this experience? "I got a little bit better at windsurfing," he jokes. "But more important, I learned that it is worth fighting for something you believe in. We had a lot of resistance from within the organization, and when you think of windsurfing, you think of it as a younger sport, yet everybody in the industry is very conservative.

"They are very wary and didn't seem to believe in the concept to start because they are traditionalists. They can't change. It is really interesting. You'd think they'd be ahead of their time, but to the contrary. What worked for me was staying true to the original concept and elaborating and refining it until I had a product that worked and a design story that is complete. Then, people understood."

People do understand. Meyerhoffer's designs were well received by the public. "This is the second year, and the reception is still growing. Neil Pryde's total market share has grown more than 20 percent in a down year. We are now starting to see other people take after this. It is important to continue to work to create the design story. Ultimately, it will prevail."

Burton Ion Snowboard Boot
It's not often that an **industrial design** firm gets to play a role in winning an **Olympic** gold **medal**. But that's what **happened** when **One & Co.**

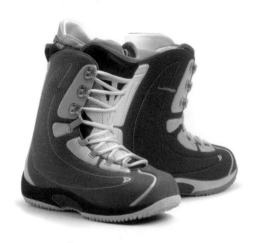

⊗ This version of the Burton Ion snowboard boot uses high-end European textiles and radio frequency welding to create structure and reduce weight—improving comfort and performance.

⊗ In these initial thumbnail sketches, the design team brainstormed how to incorporate what they learned about progressive power into a snowboard boot design.

designed the Burton Ion snowboard boot: While wearing this product, American Ross Powers won the 2002 Olympic gold medal in the snowboarding halfpipe competition—arguably the ultimate testimony to the performance capabilities of the boot.

Such an achievement would not surprise snowboarders, however; Burton has long been the market leader among companies creating equipment for this burgeoning sport, and Ion is its top-of-the-line product. Burton's market expects a lot from the company's products, but that carries with it its own rewards. Says Jonah Becker, partner at One & Co., "One of the benefits of working with Burton, which is such a respected market leader, is that people look to them for innovation—both functional innovation and style leadership—so that gives us a certain amount of leeway." One & Co.'s six-year relationship with Burton had already familiarized them with the general goals of designing a new product for this line—increased performance and comfort and a new look.

Tasked to create a boot that was the most progressive on the market, both functionally and aesthetically, One & Co. began by consulting Burton's teams of pro riders. From them, the design team found out what worked and what didn't on the previous year's models, what new tricks and new types of riding the riders were doing, and how they dress when riding and how that affects their interactions with the products. The One & Co. team—all snowboarders themselves—also spent time riding with the pros at Burton's testing facility at Mount Hood in Oregon. Says Becker, "A lot of them are putting their lives at risk, when it comes down to it, and they want whatever is going to function the best when they're dropping off 60-foot (18 m) cliffs or snowboarding in back country in Alaska."

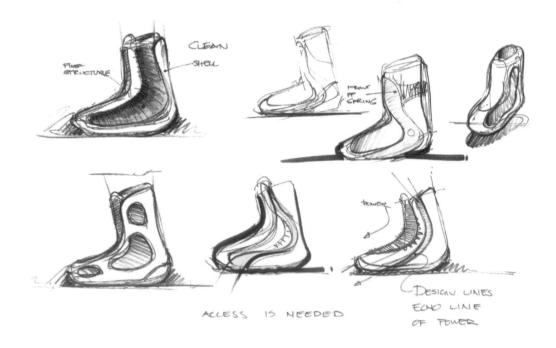

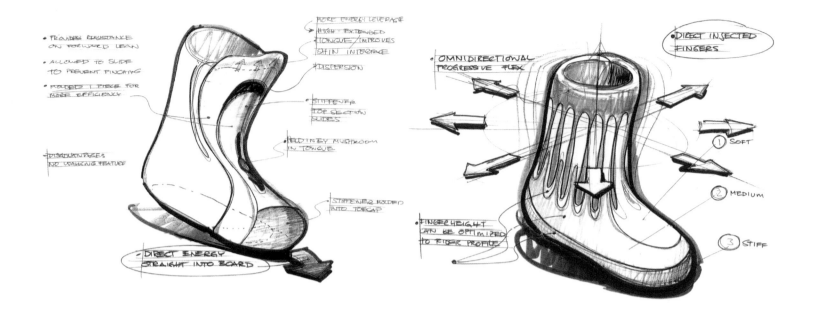

- PROVIDES RESISTANCE ON FORWARD LEAN
- ALLOWED TO SLIDE TO PREVENT PIVOTING
- MOLDED 1 PIECE FOR MORE EFFICIENCY

- DISADVANTAGES NO WALKING FEATURE

- MORE ENERGY LEVERAGE
- HIGH EXTENDED TONGUE / IMPROVES SHIN INTERFACE
- DISPERSION

- STIFFENER TOP SECTION SLIDES

- MOLDING BY MUSHROOM IN TONGUE

- STIFFENER MOLDED INTO TOECAP

- DIRECT ENERGY STRAIGHT INTO BOARD

- OMNIDIRECTIONAL PROGRESSIVE FLEX

- DIRECT INJECTED FINGERS

① SOFT

② MEDIUM

③ STIFF

- FINGER HEIGHT CAN BE OPTIMIZED TO RIDER PROFILE

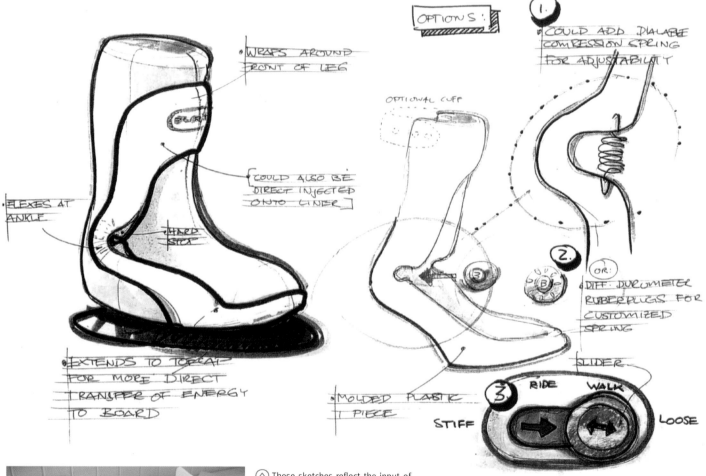

- WRAPS AROUND FRONT OF LEG

- FLEXES AT ANKLE

- HARD SPOT

- COULD ALSO BE DIRECT INJECTED ONTO LINER

- EXTENDS TO TOECAP FOR MORE DIRECT TRANSFER OF ENERGY TO BOARD

OPTIONS:

OPTIONAL CUFF

- MOLDED PLASTIC 1 PIECE

①

- COULD ADD DIALABLE COMPRESSION SPRING FOR ADJUSTABILITY

②

OR:

- DIFF. DUROMETER RUBBER PLUGS FOR CUSTOMIZED SPRING

③

SLIDER

STIFF RIDE WALK LOOSE

⌃ These sketches reflect the input of the mechanical engineers on devising a way of harnessing progressive power. Understanding how the boot would perform was the design team's first priority. The sketches show a variety of ideas about how the cut and shape of the boot lining could affect performance.

⌃ These early engineering prototypes, made with extruded foam tubing, were used to help the team study how the boot would be flexed as well as how power would transfer from the boot to the board.

Of course, as with most athletic gear, style was also an important consideration, and the pro riders provided useful feedback in this area too. "Their riders are, for the most part, very well informed, they're traveling internationally, they're very tech-savvy," says Becker. "I can't tell you how many times I've asked pro riders what their favorite thing is, and they answer, 'An iPod.' " Finding out what these sophisticated trendsetters were wearing, driving, and listening to helped the One & Co. design team ensure that the look of the boots would be as leading-edge as their function.

The design team also began analyzing how to improve the performance of the boot. "It's not very often that you have actual mechanical engineers working on footwear," says Becker, but that is exactly what happened on the Ion: Engineers were called in to cultivate what Burton calls the "progressive power" of the boot. Together, engineering and design analyzed the creation of the appropriate biometric flex in the boot while efficiently transferring power to the board—in particular, judging the interplay of hard and soft materials. "What's interesting about snowboarding is you have this progression of materials and hardness, starting with the human body and the foot, which although it is strong and structural has some soft points," says Becker. "And then you wrap it in a boot that has a combination of textiles and molded parts, and then you go into a fully molded binding and press-board that are made of very hard materials."

To test how both power and flex could be attained, design and engineering tore up old boots and, with hot gluing and riveting, created their first engineering prototypes. Further prototypes were created with extruded foam tubing; a variety of cut patterns and support braces were tested with the foam tubing to see how they affected function. The prototypes were then tested by the pro team, alongside the designers; whenever part of the boot wasn't flexing right or was creating a "hot spot" for the rider, the designers would take a dremel or knife to the boot—sometimes right on the mountain—and reshape the prototype, later integrating the change into the design of the boot. The team went back and forth a number of times until they were satisfied with the boot's function. The final version of the design features a liner that uses radio frequency welding rather than layered fabric to create stiffness and structure.

One & Co. also looked for ways to eliminate mass from the outsole, to keep the boot as light as possible. Through research and trial and error, the team discovered that the lugs, which were of a heavy rubber, were needed only on the heel and toe of the outsole—the places that touch the board. Traction on the shank area is less important than it would be on a hiking boot—since snowboarders walk mostly on snow, not logs—but arch support is still crucial, so injected plastic, which is both more structured and lighter than rubber, was used for arch support on the shank.

Concurrently, the designers refined the look of the new boot. The team considered using radio frequency welding technology, which was already being used in the construction of the interior of the boot, to stiffen and add structure to the exterior textile. The initial concept included a pixelated pattern, meant to make for a smooth transition from the welded material into the textile, but, in the end, this idea was too difficult to implement consistently on the large array of sizes they needed to offer. In the final design for the Ion, the designers allowed the high-quality materials

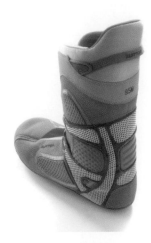
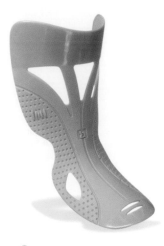

For the liner of the boot, radio frequency welding is used to directly mold an elastomeric structure to the textile upper, yielding more support at a lighter weight. Eliminating as many overlapping layers of fabric as possible strengthened the boot while minimizing possible hot spots caused by overlapping material edges.

The Burton Ion is lined with a molded tongue insert. Its tapered hourglass shape flexes with the rider while adding stiffness, transferring power from the front of the leg through the toe of the boot directly to the board. This increases the response time between boot and board and improves the rider's performance.

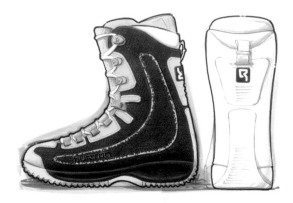

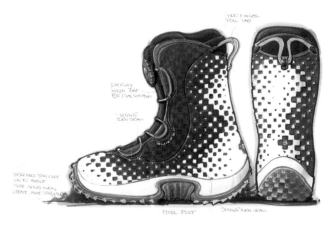

These preliminary style sketches explored ways of marrying style and function in the boot.

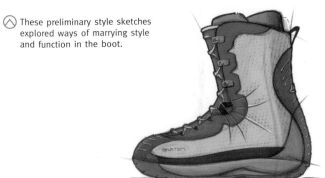

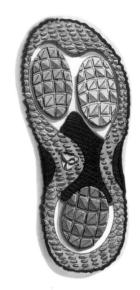

On this near final version of the outsole, the team has settled on the minimum number of rubber lugs necessary to create the proper traction on the board, since rubber makes the boots heavier. Varying the durometers of the EVA midsole optimized impact and power transfer.

Two-dimensional CAD modeling of the outsole; the cross section shows the injected plastic arch support, which is crucial to both performance and comfort.

Section A-A

Section B-B

and processes used in the construction of the boot to speak for themselves. This styling decision began to edge the look of the Ion away from its original skateboarding influence and toward the high-quality, high-performance look of gear for other winter sports. "There's always been a very strong skateboarding influence in the snowboarding market," says Becker. "I think what's interesting about the Ion is it's a bit of a break from that, and I think it was the start of a new trend."

Once the total design was refined, the team provided their 2-D CAD drawings to the manufacturer, who redrew them at the factory and then produced multiple samples until the designers were satisfied. The pro riders continued to test the samples through the spring and summer on Mount Hood. Since that is where all the other snowboard manufacturers test, the final samples are covered during testing to keep the look of the new line a secret from the competition. The boots also have to please the toughest critic of them all. Says Becker, "The founder of the company, Jake Burton, is probably still riding 200 days a year and is very closely involved with the pro team and all the product development. I believe he may have been testing in Argentina in the summer."

The verdict? During testing, Burton had this to say: "The stuff I'm testing is ruling. The Ions somehow continue to improve. The bottom line is the stuff keeps getting better and the sport gets more and more fun." Gold medalist Ross Powers might agree with that.

Lateral

View F-F
See Page 2

STX Fuse Lacrosse Stick
Products can be overdone and **overhyped**, but when it came to the **design** of the **STX Fuse Lacrosse Stick** that uses **overmolding**, the industry saw a real **breakthrough**.

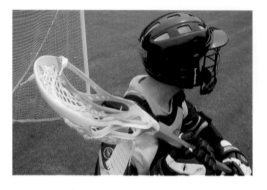

⊗ The STX Fuse in play.

⊗ Paul Kolada believed his concept for an overmolded lacrosse stick had merit, so he filed away the idea but never forgot about it.

Priority Designs had developed a variety of STX lacrosse sticks, and among the many concepts they presented was one where a soft material was fused to the nylon head to create both hard and soft areas in a process called overmolding. "They liked it and filed it away," says Eric Fickas, designer. "Paul Kolada, the principal of our firm, kept pursuing it because he thought it had merit."

Kolada had taken a Proton, one of STX's most successful sticks, and dug into it to create cavities. He poured material on it to create an overmolded prototype. "I don't know a lot of approaches where the cart led the horse," says Fickas, "but it clicked. STX saw this could be special and unique and no one was doing anything that could remotely come close to this on the market."

Coincidentally, STX had been thinking the time was right to update this very stick. Using the basic form of the Proton, designers created early sketches and suggested the idea of repeating ribs that would be less abusive to players and would cushion the impact of the ball rather than deflect it off the hard nylon. "We learned where we'd get the most bang for the buck in placing the overmolding details," Fickas says.

While overmolding was proving to be a great idea, designers were challenged when it came to bonding the materials. They needed to achieve a chemical bond so that the molecules of both materials would fuse. Because nylon is resistant to chemical bonds, they had to help the process along by placing pinholes in the nylon structure that allowed the overmolding material to flow through the head of the stick, producing both a mechanical and a chemical bond.

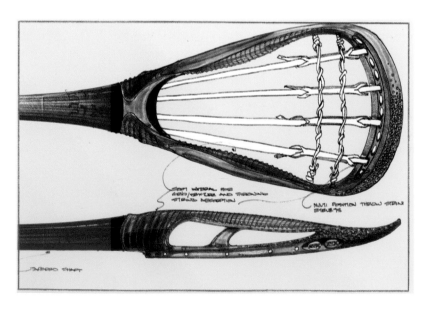

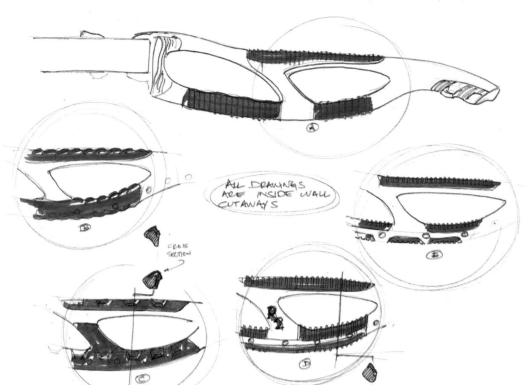

ALL DRAWINGS ARE INSIDE WALL CUTAWAYS

CROSS SECTION

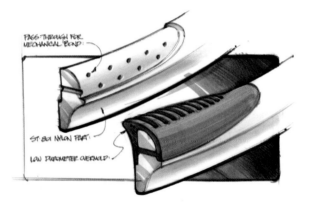

◁ A collection of initial brainstorm sketches showing the location of the overmolding details.

▽ Bottom: The first drawing that cemented the design direction shows a side view of stick, identifying the top rail where the overmolding would be and how it would creep through the sidewalls.

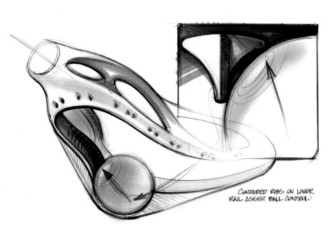

CONTOURED RIBS ON LOWER RAIL ASSIST BALL CONTROL

PASS THROUGH FOR MECHANICAL BOND

ST 801 NYLON PART

LOW DUROMETER OVERMOLD

SOFT, RUBBER-LIKE RIBS AID IN CATCHING THE BALL

◁ Designers needed to find a way to bond the softer overmolding material to the nylon base. The solution was to put pinholes in the base nylon so that the overmold material would flow through, resulting in both a mechanical and a chemical bond.

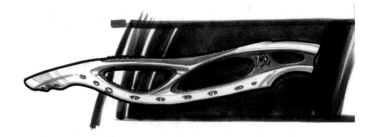

Next, the design team met with their overseas vendors. "After the meeting, we made sketches of how the mold would go together so everyone would be on the same page," says Fickas.

From there, they developed a computer model using Alias software, being careful to stay within the parameters of the sport. "The rules we needed to abide by are very strict as to the size, shape, and materials used," says Fickas. "We created a model in Alias and that let us control the geometric and sculptural form that we came up with."

While aesthetics are important, a big part of developing a lacrosse stick is its functionality and playability. "If it looks great but fails in practice, who have we helped?" Fickas asks. To ensure a stick with the right balance of weight and stiffness, designers used a software program to evaluate the model for stress, among other attributes. The program "tells us where the stick is not strong enough, so we can add material, or where it is too strong,

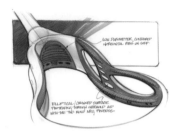

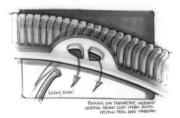

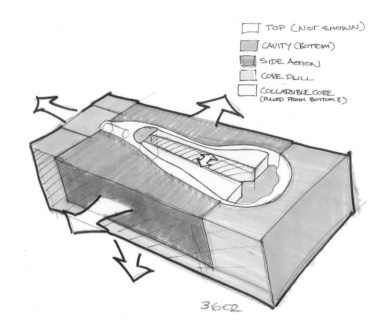

Whenever possible, designers avoided placing overmolding in exposed areas or around the product's lace holes, where it would be prone to wear off.

so that we can balance weight and stiffness. We want a stick that is as light and as strong as possible." Half a dozen tweaks later, they got it right.

Designers went back to Alias, refined the model, and presented it to the client for approval. Before getting final client approval prior to sending it to manufacturing, designers put the P2, as it was called originally, into Pro/Engineer software. Eventually, the stick's name was changed to Fuse.

To ensure they had everything right, the team prepared sales samples in-house for final user feedback. If anything could be tweaked, now was the time to do it.

Designers made their final revisions and shortly after that, actual Fuse lacrosse sticks went into production. "You don't think about what is hard and what is easy when you're working on a product, you just get the job done," says Fickas. "Looking back, the research was tough. It was hard to locate materials to do the job." "This product is the result of a lot of tenacity," adds Kevin Vititoe, designer. "Paul made it happen by continually pushing what he knew was a good idea. He didn't just file it away. He kept his eye on the market and found the right time to make that idea work. He also kept his eyes open for new materials and new processes, and he looked at other products to find how he might use those design ideas and materials in another arena."

That's what happened with the Fuse. "Now the Fuse has become a catalyst for a new market," says Fickas. "Other sticks have come out because of this. The market is still growing where these processes may be used. The Fuse has opened a floodgate."

Left and above: Designers met with their vendors and created a sketch of how the mold, comprising seven pieces, would go together.

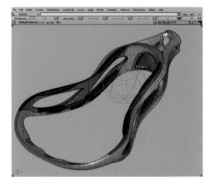

To help refine the form, the designers developed a computer model in Alias that let them control the geometric and sculptural form of the product.

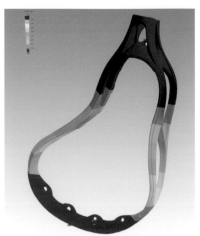

To achieve the right balance of weight and stiffness, designers used software that evaluated the stick for stress.

⊘ While most sticks are made of one piece of material, this stick is made of two. The nylon base (which is ghosted in this view) was developed first, followed by the overmolding. "The overmolding didn't add any stiffness or structure to the part, while the nylon had to bear all the stress of the product," explains Vititoe.

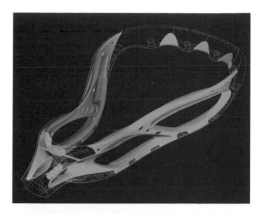

⊘ STX's marketing group used this rendering of the new lacrosse stick to gauge consumer interest in the product. "It gave the client something to use to start marketing," says Kevin Vititoe, designer. "They had not yet invested money in tooling and things, so with this rendering in hand, they could get the heads-up on how popular the stick might be."

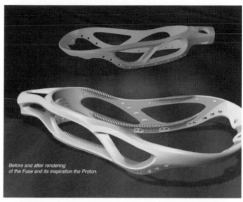

Before and after rendering of the Fuse and its inspiration the Proton.

⊘ Final parts were not ready for a catalog shoot, so designers created another sample, strung it, and took the photo.

⊘ Priority Designs created 50 sales samples in-house. From top left, the basic nylon structure formed the base of the unit; next, the overmolded material was added; and finally, the parts were cleaned up by hand.

⊘ Research indicated where the overmolding should be placed. Ribs along the top rail where it contacts players on the forearm make the stick less abrasive. In addition, when the ball hits hard nylon, it tends to be deflected, whereas the ribs cushion the impact, allowing the ball to bounce off the rib and back into the pocket, keeping it safer and more secure.

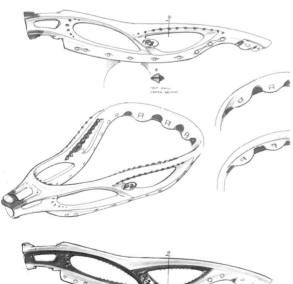

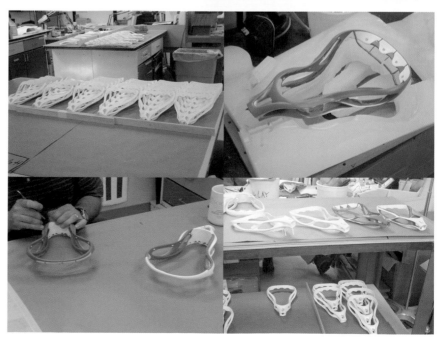

GALAXY Systems

"It should **spin**, it should be **crazy**, and it's cool if it makes you **throw up**." That was the feedback **KOMPAN** got during user testing to develop a second **generation** of GALAXY playground systems, **designed** for six- to twelve-**year-olds**.

The GALAXY system consists of five families of play equipment. Four of them—stabiles, anchors, links, and accesses—can be connected at various angles and directions to make constellations of various sizes. The fifth family—mobiles—are freestanding components that can help widen the options for play.

While keeping these words of their user base in mind, KOMPAN had goals of its own. Unlike the first edition of the system—a limited set of fixed solitary products sold as supplements to play areas—this new generation of GALAXY would be modular, to allow buyers to adjust the equipment to accommodate site variation or to expand user capacity at will. This new generation would also improve on the previous edition by providing a wider and less repetitious array of play experiences for users. The system would be accessible from the ground, allowing children in wheelchairs to approach and use the systems without assistance. And, of course, the design would look good both in urban and natural settings and would be visually appealing both to children and to the adults who would be buying the equipment.

In rethinking the system, the team was not starting from scratch; they hoped to retain and build on principles that were integral to the success of the first version. Both the aesthetics and concept of the original system were inspired by the work of the sculptor Alexander Calder. His colorful and playful style was a natural for a playground. There was a reason for his famous statement, "My fan mail is enormous. Everyone is under six." The mobiles and stabiles (mobiles that are planted in the ground rather than hanging) that he invented inspired an architecture distinct from the post-and-platform structure so prevalent in playground equipment design. The steel-pole construction of the previous GALAXY system differentiated it from the systems KOMPAN offered for younger children, which are made from wood.

In researching their target market for GALAXY, KOMPAN had an advantage they weren't used to—many of their previous playground lines targeted two- to eight-year-olds, but targeting older children meant better communication. "This age group is different in that you can talk to them and get feedback," says Ulla Hansen, a designer at KOMPAN. Through talking with these users as well as with teachers and child development experts, KOMPAN's design team discovered that children this age were both independent and social—interested in relating to, and competing with, their friends during play. These children love to explore and be challenged by their world—Hansen calls them "little world pilots." To suit these users, the equipment had to be open, both to enable a variety of creative approaches and to allow the children to relate to and learn from each other. In addition, it must continue to provide a challenge to the children or they will quickly become bored, especially in a school setting, where they might be faced with the same playground equipment for years.

This small-scale model of the Meteor Shower was built to help the team visualize this piece of equipment.

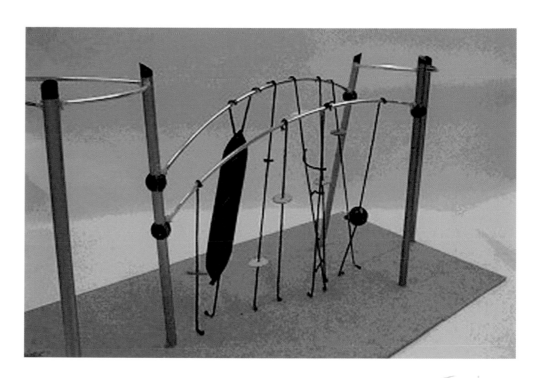

This first sketch of the Meteor Shower mobile already has the playful feel of the work of Alexander Calder, one of the visual inspirations for the GALAXY system.

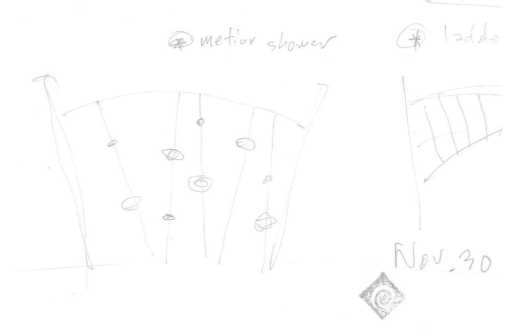

metior shower ladde

Nov. 30

A CAD model of the Meteor Shower.

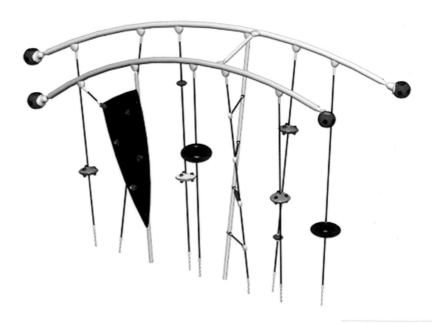

Armed with this knowledge, the designers began by building on the stabile and mobile architecture they had used so successfully for the first generation of GALAXY. They wanted to avoid using the word *structure* to describe the new GALAXY system: While this word is used commonly for playground equipment, the team at KOMPAN felt it didn't fit the dynamic nature of the GALAXY line of equipment. They came up with the idea of calling the systems *constellations* and began brainstorming ways they could make the system more flexible and adaptable; three sizes of constellations would be offered.

They started working on developing a geometry for the system. The stabiles were planned to act as the centerpiece of each constellation of play equipment. Stabiles are built on a frame of three galvanized poles, each positioned at a corner of an equilateral triangle, with each pole leaning toward the center of the triangle and bound together by a top frame; up to five connector balls, which are used to join the poles, can be mounted on each pole, creating numerous attachment points at a variety of heights and angles for play components. The design team had to find a way to make the stabiles expandable and flexible; they decided on a radial system generated by two types of lines, those intersecting two legs of a stabile and those entering the center point and one leg of a stabile. With this system in place, the team was able to begin developing link activities that would span the stabiles.

As development progressed, the team realized they needed to create a system of smaller stabiles, both for visual and price differentiation, and created a new family of equipment called *anchors*. Another family of equipment, the link family, was developed to join stabiles and anchors to one another. Members of a fourth family of access activities flow out in different directions and engage with the surroundings. The fifth type of equipment, the mobiles, are solitary activities that can supplement a constellation.

Within each of these categories, the designers brainstormed ways they could create a dynamic play experience. They came up with a number of innovative equipment ideas that would challenge and grow along with children. One piece of equipment that reflects this strategy is the Supernova, an orbiting ring, mounted on six secure legs, that turns around a 10-degree tilted axis; the slope of the ring ensures that it spins faster for larger children and slower for younger children, so the piece retains its interest for the same child over a longer period. The patent-pending Nebula orb is mounted to angled stainless-steel augers and can be rotated in a helical movement up and down the augers; the child has the choice of creating a personal climbing track, taking a softly spinning tour from top to bottom, or simply engaging in the tactile experience of spinning the orb.

The team first built smaller models out of cardboard, for internal presentations, and then set about building full-scale, working prototypes that could be tested with children. They tested the equipment on a site they had rented, then took the equipment to schools in both rural and urban settings. By watching the children interact with the equipment, they quickly found out which concepts the children approved of. "Children are merciless consumers," says Hansen. "They are not polite."

Breaking the mold in playground equipment has paid off for KOMPAN. The system was rapidly accepted, both in North America and in Europe, and with the release of GALAXY Extreme, KOMPAN continues to extend the possibilities of the system.

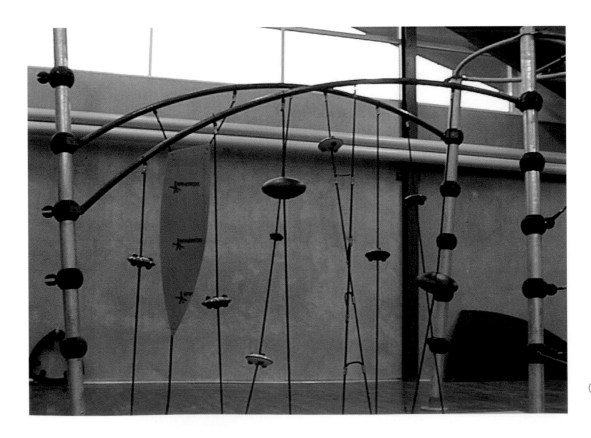

In this scale model, the team has refined the details of the ladders on the pillars on either end of the Meteor Shower.

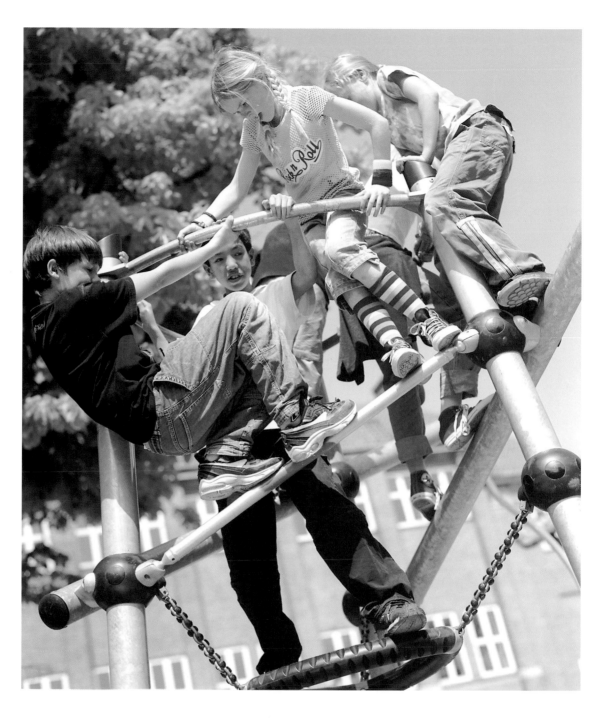

The GALAXY system was built to be ground accessible, opening it to children who use wheelchairs. Since compliance with the Americans with Disabilities Act is an important decision factor for product selection, this feature makes the GALAXY system more marketable.

Left: One of three versions of the Spica, one of the items in the mobile family. Each of the three types reacts in a different way to the child's movement.

Right: The Skygame cultivates strength and coordination; its multiple tracks also allow children to compete with one another. The plastic handgrips are carefully designed so the child's hand never comes into contact with the bar, preventing the pinching of fingers.

Neurosmith Musini Toys aren't just toys anymore, the well-designed ones entertain, engage, and educate.

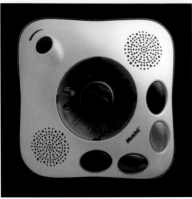

⊘ The Musini, whose name combines the words *music* and *Houdini*, the legendary magician, transforms vibration into music and in doing so, can play to any rhythm or vibration it receives.

⊘ Opposite: Early sketches of the Musini resemble the traditional flying saucer from outer space that sits on the floor and is supported by four short legs.

The Musini does just that. Named for music and the legendary magician, Houdini, the Musini is a musical instrument that children age three and up can play simply by dancing or tapping on a surface on or around the product. That's because it transforms vibration into music and in doing so, can play to any rhythm or vibration it receives.

"The technology is a revolutionary and highly inventive adaptation of Piezo technology that essentially creates a seismograph for less than a dollar, as opposed to hundreds of dollars. The technological solution came about in one of the most unusual ways that we as designers had ever been exposed to," says Ravi K. Sawhney, founder and CEO of RKS Design, Inc.

"The chief technologist of Neurosmith was challenged by his teenage son to codevelop, as a parent and child activity, a sensing device that would alert him when his sister was approaching so, sight unseen, he could surprise her or anyone else. Playing around with technologies, the two of them came up with one that worked. Taking it further, the technologist took the device to work, connected it with music, and allowed it to compose music based on the length and intensity of the signal generated. When the new president and CEO of Neurosmith saw the device and what it was doing, he flipped. The rest is history," Sawhney says.

The primary challenge with the design of the product was homing in on the target age group and then developing a product that could be priced competitively. "The technology and play of the concept had been incorporated into a juvenile aesthetic and was being received extremely well. However, the product had initially been targeted at three- to five-year-olds. In testing the product, the audience revealed itself to be primarily three- to thirteen-year-olds but extended to sixty-year-olds and beyond," Sawhney remembers. "The cost of technology for three- to five-year-olds was typically between $10 to $20 due to their boredom factor. The play in the product could be endless with the possibilities for its integration of the total universe of music and sounds, but the product needed to sell for $60 at retail, significantly higher than the initial target audience's product offerings would command." Tasked with getting the product ready to ship in time for Christmas 2002—just four short weeks away—the design team had to reposition the product for this new price point and audiences consisting of both parents and children. "The design team was inspired with a new and unique interface experience, and after dancing around a test model, fell in love with the playfulness of the technology," says Sawhney. "From that point, everything was on a super-accelerated time frame to get a new and market-appropriate design to the marketplace. This was your typical four-week cradle-to-grave design program."

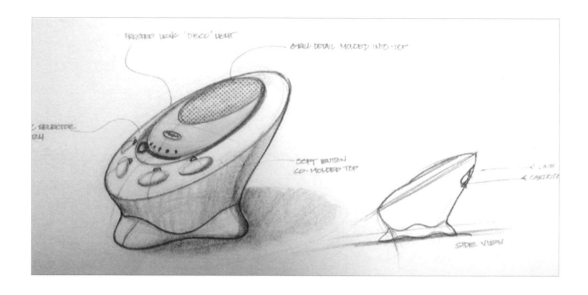

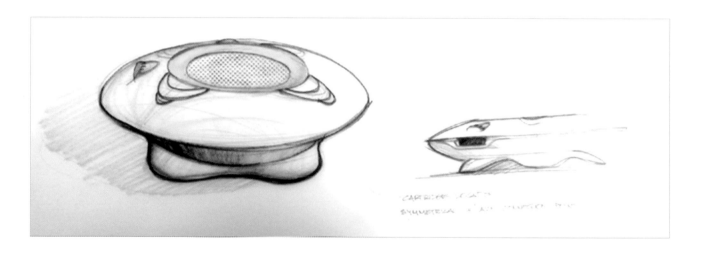

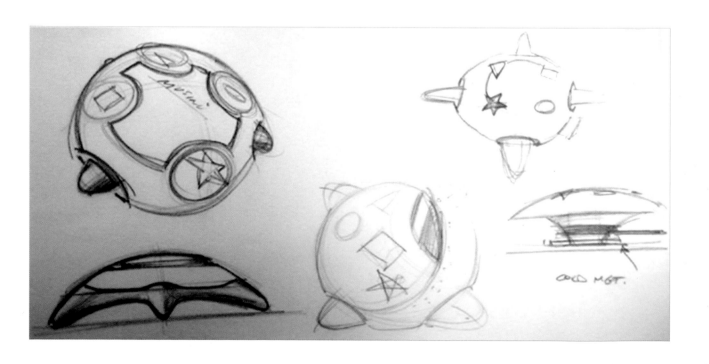

Designers tackled the project using CoCreate's SolidDesigner, Alias Studio Tools, and ProEngineer as their primary tools. Surf-cam CNC software running on Windows NT was used to create the prototype and models.

Designers used PsychoAesthetic to map related products within the market segment. Then they started sketching, developing CAD and study models and CNC-machined prototypes, and performing graphics and color studies while they engineered and continuously critiqued and modified the designs. All this activity led to creating a full prototype in ProEngineer for production tooling.

On its release, the Musini was targeted to a broad market and designed so users could select from a variety of music options that come with the product and as well as purchase additional cartridges if they want more choices of musical and instrument selections. Neurosmith's revenues climbed from $5 million a year to more than $50 million after the launch, Sawhney reports.

"As we think back on that first meeting with Neurosmith's CEO, we knew we were getting ourselves involved in a very special project," he says. "Little did we know then just how challenging the project would become. But, as with the Musini, it's usually the most challenging projects that prove also the most rewarding."

Above and bottom: As the design was fleshed out, colors and detailed design elements were added, including the on/off switch, a translucent frosted housing, and lights that glow from beneath.

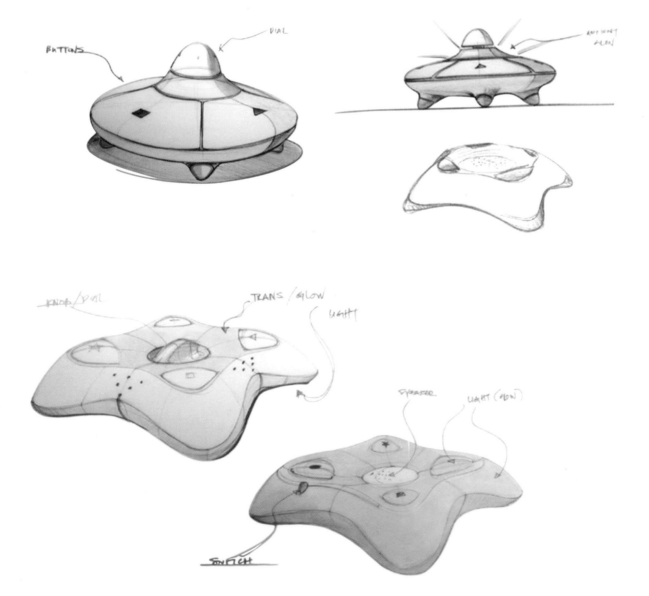

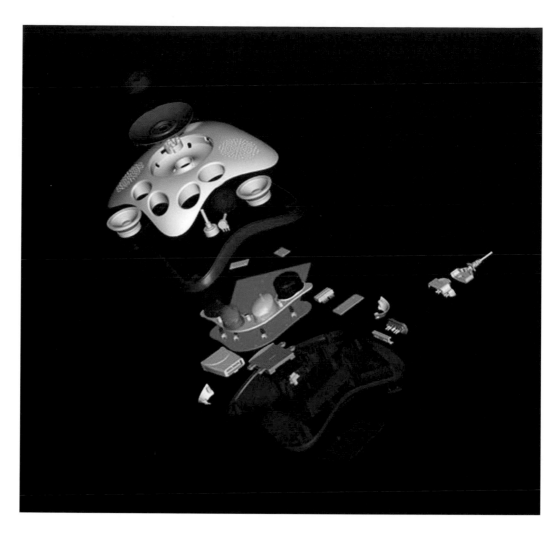

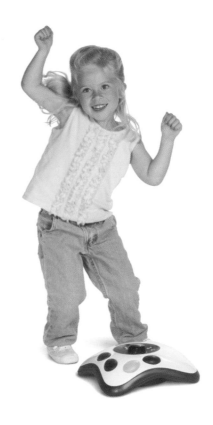

An exploded view of the Musini looks complex, but the technology that makes it work is relatively simple.

Originally thought to be a product for three- to five-year-olds, the Musini, which can play simply by dancing or tapping on a surface on or around the product, was found to be equally as popular with children at heart who are aged 60 and up. Users can select from a variety of music selections that come with the Musini or purchase additional cartridges with other musical and instrument selections.

Fisher-Price Intelli-Table When Fisher-Price decided to partner with **Microsoft Corporation** to develop **toys**, **Fisher-Price** saw an opportunity to **update its image** in this increasingly **technology**-oriented market.

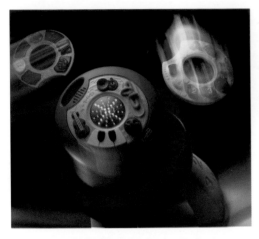

⌃ The final version of the Intelli-Table, shown with all three of the disks that came with it when the product was launched; since the original launch, one of the disks has been eliminated.

⌄ An Alias modeling of the original concept; this table features a more typical color palette for Fisher-Price, which favors the clean, pure look of white on many of their toys. The designers at Microsoft worked to broaden the palette on this product; though this image shows the table as white, Fisher was pleased that in the final design, white was used only for one of the disks, not the table itself.

⌄ Early sketches showing the original concept—a ballchute mechanism that was ultimately rejected for safety reasons.

Microsoft was already involved in the toy area—its technology had a hand in top-selling toys such as Barney and the Teletubbies—and Fisher-Price was especially interested in capitalizing on technological developments such as the LED featured in Microsoft's Teletubbies dolls, which light up in a variety of different ways, depending on the child's interaction with the doll. The two companies formed a team of industrial designers, project managers, electrical engineers, software engineers, and a child psychologist. Brainstorming a number of ideas utilizing Microsoft's patented LED and software, the team decided that they wanted a product that would grow with the children and continue to challenge and involve them for years. They wanted something interactive and educational as well as durable and safe for their target market, toddlers. Microsoft would design and produce the product (with input from Fisher-Price), and Fisher-Price would distribute the product and pay Microsoft a royalty for it.

The team hit on the idea of a table that featured a disk with the interactive LED on top. The toy would be for children from ages nine months to thirty-six months; the disk could be removed so that a younger child could play with it on the floor, while older children could pull up on the table and interact with it while standing. The original concept featured a ballchute mechanism—the child would drop a ball in a hole in a disk, and the ball would then hit a sphere inside the table, which would direct it into an interior bowl, where it would swirl around and come out into one of the six pockets in the legs or sides. The team explored a variety of interactive elements: A sensor in the hole might be able to recognize different shapes or colors and play different songs for each kind of ball, or the bottom bowl could be transparent, allowing the child to see the ball rolling by before it finally emerged from of the pocket.

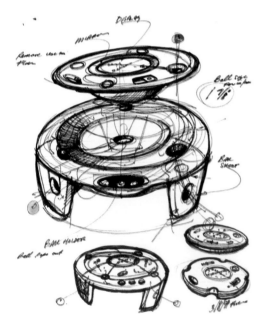

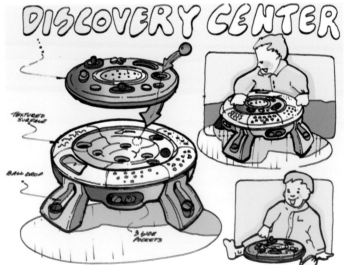

Right: Here, the design team was examining different ways of detailing the legs. Since they had decided that the product would be packaged with its legs detached from the table, the designers also worked on developing a key feature that would allow consumers to lock the legs securely onto the table.

Below:Once the ballchute concept had been rejected, the interior of the toy was freed up for other uses; the team decided to use this space to store the additional disks, and in sketches like this one started exploring how the pieces would fit together.

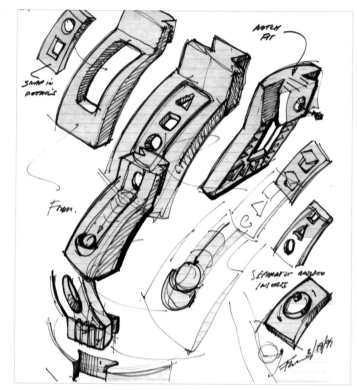

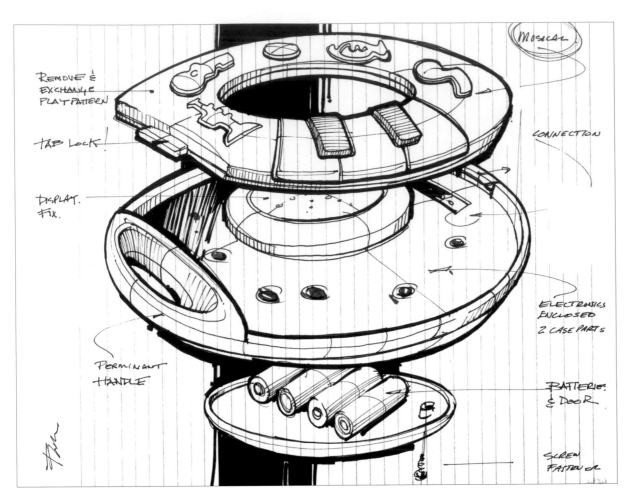

REMOVE &
EXCHANGE
PLAY PATTERN

TAB LOCK!

DISPLAY.
FIX.

PERMINANT
HANDLE

MUSICAL

CONNECTION

ELECTRONICS
ENCLOSED
2 CASE PARTS

BATTERIES
& DOOR

SCREEN
FASTENER

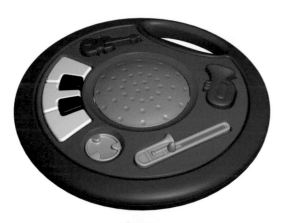

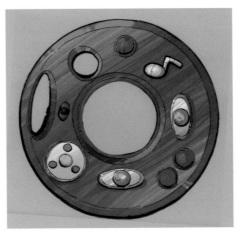

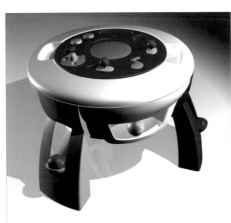

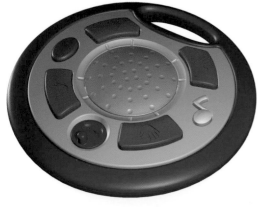

⌃ Top: An exploded view of the second prototype of the Intelli-Table, now without the ballchute.

⌃ Above: This computer sketch used Macromedia Director to mock up sounds and light arrays for presentation to Fisher-Price.

⌃ Two early designs for the disks showing the more iconic treatment of buttons favored by Microsoft but rejected by Fisher-Price.

The team thought that a slightly space-age look for the product would update Fisher-Price's image. Steven Fisher, senior industrial designer for Microsoft and lead designer on this project, says, "As a designer, I wanted to come up with an aesthetic that was a little bit more sophisticated than Fisher-Price would typically do. I think Fisher-Price was interested in us doing something new." This design direction was also apparent in the sophisticated surfacing details that were chosen for the original design.

"We built a full-functioning prototype and presented that to Fisher-Price, and everybody was really excited about it," says Fisher. "We wanted to take it through Fisher-Price's safety group, and it was determined that there was too much risk of children sticking their arms through the openings, so we actually bagged the whole idea of this balldrop, which was unfortunate, because we thought it really was a cool added feature."

The team went back to the drawing board and realized that eliminating the ballchute meant eliminating the spherical shape inside as well, freeing up space to develop additional disks that could be stored in that part of the table. They also experimented with other ways of adding value to the product, such as putting additional features on the other side of the disks and putting letters on the outside of the bowl.

They also worked on fine-tuning the features that would be included on the disks. In designing elements such as buttons, "we were really interested in trying not to play down to the children," says Fisher. "We felt like we could represent an instrument, but it didn't need to be really cutesy. And we disagreed with Fisher-Price on that." Fisher says that though the Microsoft team preferred an iconic treatment, and the Fisher-Price team wanted a more-cartoonlike approach, the cartoon approach that won out ended up complementing the final product better.

The appearance of the disks was not the team's only concern; fine-tuning how the children would interact with, and learn from, the disks was also a high priority. The team had two aces in the hole: Fisher-Price's extensive testing facility and child psychologist Erik Strommen. Strommen was able to organize testing and research with children at Fisher-Price's testing facility. "He had a lot of information about the kinds of things that kids at certain ages were interested in," says Fisher, "so we probably had a bit of an advantage with his knowledge." While the original interactive elements were presented to Fisher-Price using Macromedia Director files, the prototypes used for testing on the children were built by a Chinese company called Jetta, which had extensive experience engineering electronic toys. With these prototypes, the team was able to test how the sliders and buttons on the products would feel and work.

A second round of full-scale prototyping followed. Says Fisher, "This program went so fast—we built a working prototype of this in two weeks, a full-scale version of it." This second version of the table was smaller than the first, at Fisher-Price's request; there were practical considerations, such as the cost of materials and packaging for the larger version, but Fisher-Price also wanted to make sure that the product wasn't too overwhelming and unwieldy for parents. At this stage, the team also worked to refine

the mechanism by which the table was able to recognize which disk was installed (a certain combination of bumps on the disk would hit buttons in the table) as well as the way the buttons and switches on the disk interacted with the table.

In the end, through trial and error and close collaboration, the team created a toy that was selected by the *Today* show as the Best Toy of 2000. Sales far exceeded Fisher-Price's expectations, leading to an extension of the product line with the addition of the Photo Fun Learning Smart Screen Intelli-Table. Though Microsoft has gotten out of the toy arena, Fisher-Price continues to express interest in working with Microsoft.

"I think we came a long way, and the project turned out to be very successful," says Fisher, "and I think that has a lot to do with the collaborative relationship with Fisher-Price and brainstorming the opportunities we had after we took the ball play out."

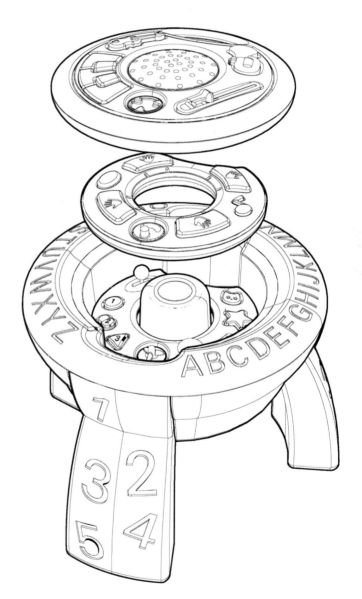

A sketch where some of the surface detailing is being finalized.

KI Intellect Classroom Furniture

Ask people about their **experiences** in school, and you'll get a variety of reactions: Some will wax **nostalgic**, while others will **shudder with dread**. But there's one memory that everyone will share: the discomfort of the **classroom furniture** they **encountered.**

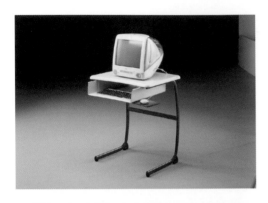

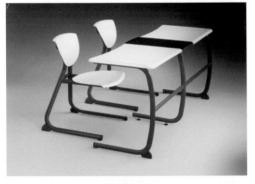

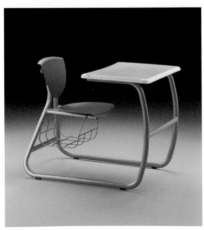

The KI Intellect line of classroom furniture is designed to meet the needs of the modern classroom. Its lightness and flexibility of design helps students and teachers reconfigure the classroom; its ergonomics allow students to learn in comfort.

The KI Intellect line of classroom furniture works to eliminate that experience for today's students. By increasing the ergonomic performance of classroom furniture, KI hopes to reduce the "fidget factor" and increase students' ability to learn.

While ergonomics were a key goal of this line, functionality was equally important—the furniture had to be strong enough to withstand the rough usage it was bound to receive while lightweight enough to be moved easily, even by children. Because it was intended for the preschool through adult school market, it had to be flexible enough to work for a wide variety of body sizes and types. It had to be nestable and stackable; it also had to be adaptable to today's high-tech classroom, with accommodations made for keyboards, mousepads, and wires. And visually, because classroom furniture isn't replaced very often, "it had to be simple and clean and kind of timeless," says Scott Bosman, an industrial designer at KI.

Initial sketches included a wide array of ideas for chair and leg configurations. Making the seat and back out of one large piece of plastic turned out to be less cost-effective than separating the two parts. Bending the legs so they crossed under the seat and screwing the shell directly onto the frame proved weaker as well as less distinctive than other solutions.

The designers also brainstormed ways to make the system adjustable in size, but that idea was rejected when market research revealed that once the furniture was sized, it was never changed. Says Bosman, "Why have all these exposed holes and a butchered-up look when you can have just one size that fits, and make four sizes? And costwise, it came out that we could do that."

Early in the process, marketing requested that the design team add the option of a personal bin—a book box that slid out of the desk so students could easily access their own supplies. Design took this idea a few steps further by imagining a lid for the box so that it could serve as a lap desk as well. In the end, the lap desk concept wasn't pursued, but the storage bin was. The drawer holding the book box can also serve as a keyboard tray, further improving the functionality of the desk. The addition of built-in wrist rests and field-installable mousepads adds both functionality and ergonomics to the desk.

PIVOT

MOVABLE

5° BACK TILT TO REDUCE MUSCULAR FATIGUE AND INCREASE ATTENTIVENESS

LUMBAR SUPPORT

5° SLOPED TO RESIST SLIDING FORWARD

8° FORWARD SLANT OPENS TRUNK/THIGH ANGLE TO OPTIMUM 135°

FLATTER BACK ALLOWS FOR EASIR ENTRY & EGRESS

TRANSVERSELY SEAT IS ALMOST FLAT TO ALLOW VARIOUS POSITIONS WITHOUT PRESSURE AT EDGES.

SADDLE STYLE

ADJUSTABLE HEIGHT GRADE/SIZE RATIOS

ERGONOMICS - COMFORT

Top and center: These early conceptual sketches show the variety of solutions the designers considered when trying to design an ergonomically sound chair. Among the ideas considered were a saddle-style chair, as shown in the center left-hand corner, and a pivoting back. The lower right-hand sketch shows that they were considering adjustable chair sizes. The solution on the top is the design direction that ultimately was pursued. The 5-degree tilt of the back and the 8-degree tilt of the seat were retained in the final design.

Above: Early sketches, where the designers considered a wide variety of shapes for the back and seat of the chair.

Asked by marketing to develop a removable book box (here termed a "personal bin") for the desk, the design team took the idea further by designing a centralized bin storage solution meant to keep the bins organized. While the final desk design includes these options, the lap desk concept shown here was not implemented because marketing decided the lid was not necessary.

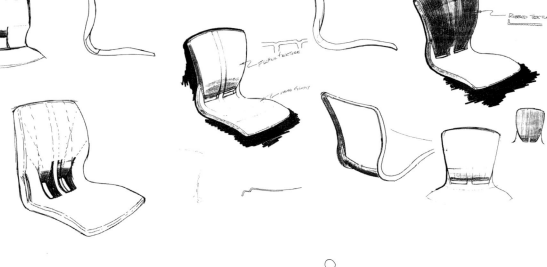

LAP DESK

CENTRALIZED BIN STORAGE

STORAGE - PERSONAL BIN CONCEPT

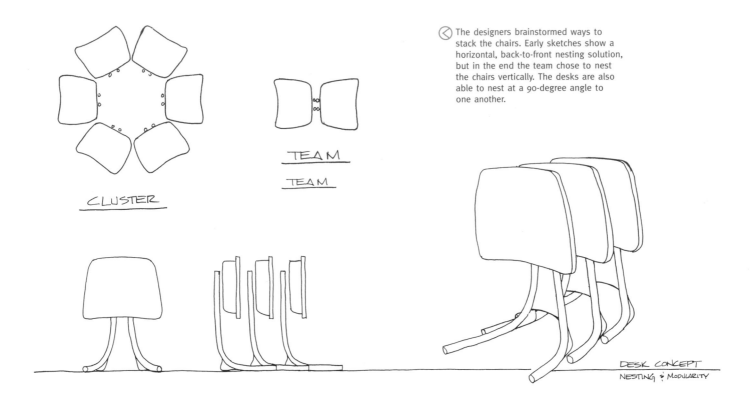

CLUSTER

TEAM

TEAM

DESK CONCEPT
NESTING & MODULARITY

The designers brainstormed ways to stack the chairs. Early sketches show a horizontal, back-to-front nesting solution, but in the end the team chose to nest the chairs vertically. The desks are also able to nest at a 90-degree angle to one another.

Stackability was another important requirement for the system; the chairs had to stack at least six high. But initial prototypes would not stack. It turned out that the crossbar, which had been positioned across the back two legs of the chair to ensure stability, prevented the chairs from stacking properly. The team discovered that moving up the crossbar enabled the chairs to stack without sacrificing stability.

Mobility was another important requirement for the furniture. Handles on the back of the chairs were designed to make it easier for students and cleaning staff alike to move them while giving students a place to hang personal items. The handle was originally nylon, but when testing showed that more strength was needed, a tougher grade of nylon was substituted.

The floor glides were also designed to ensure the mobility of the chairs and desks. The glides in the back are nylon, which slides easily, while the glides in the front are polyethylene, which is stickier; as a result, the chairs and desks slide smoothly when pulled yet grip when stationary. In testing, the glides worked well; however, some issues arose with marketing, so the designers developed customer-specific materials that are easily adaptable to the glide.

While the line was in the prototyping stage, Metaphase Design Group was brought in to give guidance on the ergonomic features and functionality of the product line. Bryce Rutter, founder and CEO of Metaphase, compares the ergonomics of classroom furniture to

that of office furniture: "We don't have the luxury that we have in office chair programs, where there's room for springs and cylinders and all kinds of adjustments; we've got to find a solution that really integrates what we call passive ergonomics, where the chair is scaled and has some flexure in the way in which it's designed that would make it seem like it is a high-quality task chair for the student."

Though the budget didn't allow for extensive user testing, Metaphase's team included experts in industrial design, kinesiology, and physical ergonomics. Among their recommendations was to modify the front curve of the desk to fit the curvature of the body. Says Rutter, "It's a lot more sympathetic and inviting for the child to get into their work and get into it in a comfortable way." The team also recommended modifying the waterfall edge on the front of the seat; increasing the radius of the edge to make it softer would reduce pressure on legs, keeping them from falling asleep. Likewise, the edge in the book box was eased for greater comfort when a keyboard was in use. The geometry of the relative distance between the seat back and the seat pan was closely scrutinized and changed to improve both the comfort and the posture of students. More clearance was recommended for the back handle on the chair to suit the larger, stronger hands of cleaning staff. Metaphase passed these recommendations along to the design and engineering team, marking up prototypes and passing along drawing files showing cross sections of the chair. Engineering then modified the molding tools and produced a new prototype for Metaphase to evaluate.

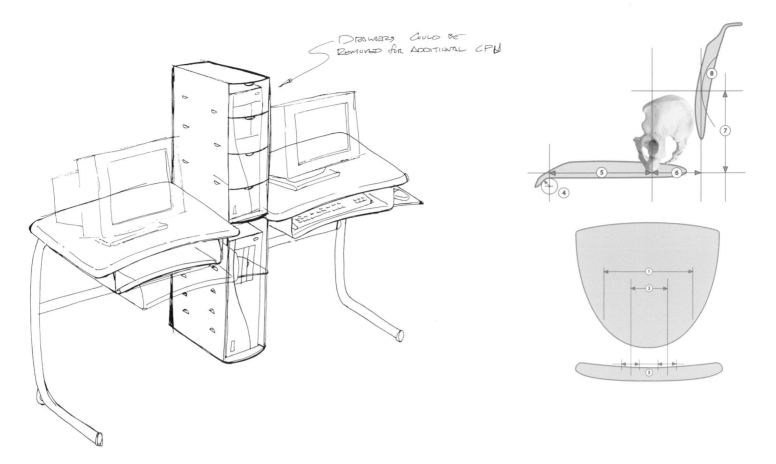

DRAWERS COULD BE REMOVED FOR ADDITIONAL CPU

Top left: An early concept for CPU shelving for the computer desks; due to lack of demand, this concept was never implemented.

Top right: Illustrations like these helped Metaphase Design Group analyze the ergonomics of the chair's seat pan and of the distance between the seat and the back relative to the shape of the pelvic bone of a child.

The final version of the chair can stack up to six high—one of the original requirements set out for the design team.

Throughout the process, the furniture underwent KI's rigorous safety testing. When the furniture was close to production, prototypes were beta-tested in classrooms near the company's headquarters in Wisconsin. KI got feedback on the furniture from students and staff, and the schools got a discount on the furniture.

Early in the process, the team had agreed on ABS plastic for the seat and back—to provide both strength and flexure—and elliptical steel tubing for the legs. But during manufacture, KI discovered that high-quality, cost-effective manufacturing was more difficult to source than expected. The seats and backs of the chairs produced by KI's vendor in Poland were marred by white marks; KI eventually bought the mold and produced the ABS parts in-house. The team invested in an expensive bending machine, but it required a lot of fine-tuning before it would produce what the team envisioned. Welding the cantilevered seat to the frame took a lot of trial and error, too. "It was done by hand in the beginning," says Bosman, "but the welds just weren't looking like we wanted them to, so we finally got a robot that would do it very well, and it visually looks very nice and is very strong."

The team's attention to detail has paid off. As Rutter says, "It's all these little details that really convert the experience from just another chair into, 'Wow, I really like this, this is nice stuff,' which has resulted in astronomical sales for KI in this category."

Cachet Chair

Plush, ergonomically correct **chairs are** now standard at most desks. But **how many** of us spend all our time at our **desks?** With the large amount of time **most office** workers

The two versions of the Cachet chair: the four-leg stacking version and the five-star-based swivel chair on casters. The chair is available both with upholstery and without (as shown here).

spend in conference rooms, training facilities, auditoriums, and other common areas, Steelcase Inc. could see that there was a need for an ergonomically—and economically—sound chair for the rest of an employee's day.

So when Peter Jon Pearce of Pearce Research and Design—an industrial designer who has worked extensively with space frame structures, playing a role in the designs of Chicago's Navy Pier and Tucson's Biosphere—approached Steelcase with a chair design that met their requirements for an all-purpose office chair, they agreed to work with him to refine his initial concept. "He came to us with a fairly complete idea, at least conceptually," says Bruce Smith, manager of design for Steelcase. "Our role in this was to help clarify a lot of that vision, to make it work from a functional standpoint, an operational standpoint, in terms of production, and from a market standpoint, in terms of form and cost."

Pearce had hit on the idea of achieving a comfortable design by using what he terms a "balanced action-rocker mechanism," which allows individuals to gently recline as the seat flexes and which relies on physics to let individuals find a position that suits them without having to adjust the chair manually. Crucial to this concept was the notion of using advanced polymer materials throughout the chair's construction. Compared to the metal framework used in the construction of most chairs, a polymer construction would weigh less; it would also allow the chair to conform to the user's body, making it more comfortable.

Pearce initially conceived of the construction as entailing a shell-type base in a single-shot mold. Smith describes the original concept: "If you can imagine the structure of a chair beam formed out of a skin that was a constant $\frac{1}{8}$ inch (3 mm) thick, if it could be formed in a particular way, you would not only have strength but you'd have thinness and lightness, and when you want a high-density stacking chair, thinness is very important."

Pearce constructed initial concepts in wire and wood and, along with computer and paper sketches and a model, presented his initial design to the Steelcase design team. At their request, he went on to develop full-scale prototypes, to explore both the aesthetics and the practicalities of the chair's form. "We are a prolific model-building organization here, especially when it comes to seating," says Smith. "Nothing can replace actually seeing a physical piece, something you can walk around full-scale, because chairs are just so sculptural."

Pearce used this first scale model—only 6 or 8 inches (16 or 20 cm) tall—to present the initial concept to Steelcase.

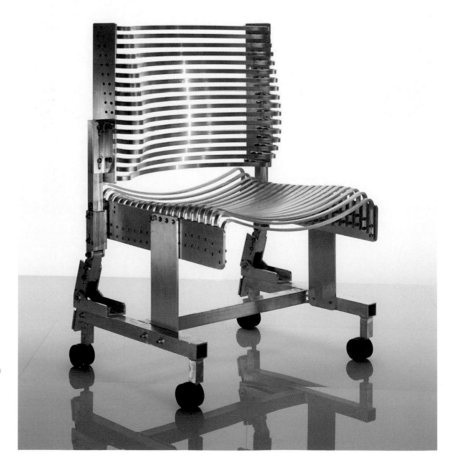

After his initial consultation with Steelcase, Pearce made this second aluminum prototype to refine pivot positioning in the chair. For the following nine months, as Pearce continued to work on the Cachet chair, he sat in this prototype to prove to himself that the surfaces were comfortable and that the pivot points worked.

The first scale model led to two discoveries. The first was that Pearce was less restricted than he had thought in locating the pivots required by the chair's action-rocker mechanism, which freed up design possibilities he had not considered. The second was that the shell-style frame he had envisioned would be hard to manufacture.

Another wave of modeling helped the team revise and refine the locations of the pivots. The team also decided to replace the leaf spring mechanism they had been using to achieve the chair's rocking action with an elastomeric torsion spring, or rubber pack. The rubber pack was not only quieter than the leaf spring mechanism; it also performed better and was more durable. Says Smith, "It's literally going to last the entire life of the chair without any change."

During the next generation of proof-of-principle modeling, the team discovered that the chair's seat and back surfaces required very specific contouring to be comfortable. Early design concepts were driven by the choice of single-shot processing as the manufacture system for the product. The process would require a vertical flow channel in both the back and the seat to allow the material to flow to the outer seat structure. However, including this channel in the design constrained compliance and restricted the team's design choices. Design and engineering worked together closely to choose a manufacturing process better suited to the product's needs. In the end, they chose two-shot polypropylene and glass-filled polypropylene for the seat and back to achieve strength, stiffness, and compliance.

Concurrently, the team built half-scale models to explore the aesthetic possibilities of the chair. Some of the chairs explored what Smith calls the "skin structure" concept, while others explored a more stick-built direction, which is what the team pursued in the end. Smith says of this phase, "This really is a testimony to our passion for modeling and seeing these things physically." The first model that Pearce presented to Steelcase was closer in appearance to the final chair than many of the models that followed. Smith notes, "That's the amazing thing about product design and development—it's an iterative process, and you learn a lot of things along the way, and like a lot of things in life, sometimes your first ideas are the best. But it's important to go down those paths to find what really works."

Integral throughout the design process was the 3-D database the team had developed at the start of the project. The ProE modeling enabled the team to predict how changes in the design would affect the material flow mold; some base designs were rejected when the team found they couldn't be manufactured properly.

The end result was a chair that, because it's made essentially out of one material, is 99 percent recyclable. Moreover, the chair follows through on Pearce's original concept—a chair where no unseen structures or mechanics are responsible for its performance—while being comfortable with or without its optional upholstery.

The four-leg side chair was designed to be stackable.

These half-scale stereolithographed models were developed concurrently with the full-scale models to further explore the aesthetic details of the chair. The chair on the far right and the chair second from the left explore Pearce's idea of a skin structure; the chair second from the right was designed by Smith "using [Pearce's] constraints, but with a different language." The chair on the left was designed by Pearce, using more of a stick-built language rather than a skin structure; the team ended up choosing this one for the final design.

Below: This full-scale version of the model helped convince the team to eliminate the skin structure concept as an option, as the molding it required was too thick, negating one of the goals for the chair's design—creating a high-density stacking chair.

Bottom: This functional prototype was developed by the engineering group concurrently with the half-scale stereolithography (SLA) models.

Bottom right: "The slats seen here are molded in polypropylene, and the lid on the mold is lifted, the bottom of the mold is rotated to a different position, the new lid is put on it, and then the outside rim is molded, and then gas assisted," says Smith.

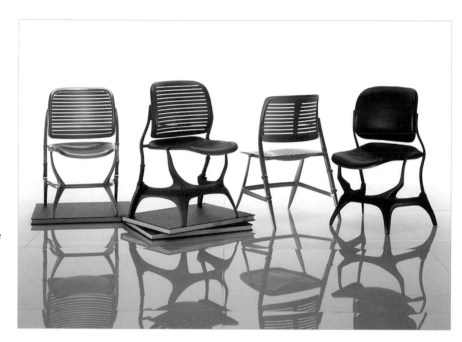

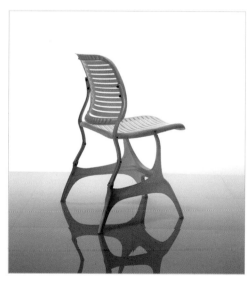

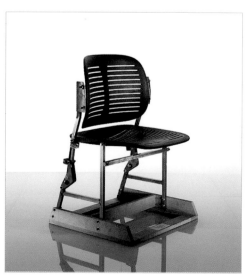

Wharton Lectern

The **quality** of the next speech you hear may not be due solely to the **public speaking** skills of the **presenter** but to the **high-tech** innovations built into the lectern.

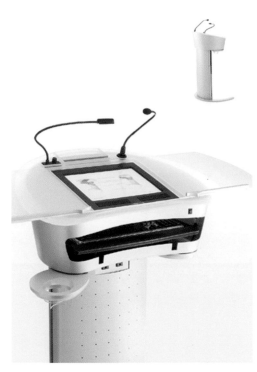

The Wharton Lectern's Creston control panel allows the presenter to operate every aspect of the presentation environment directly from the lectern, including lights, blinds, and projection screens and cameras.

When the Wharton School of Business at the University of Pennsylvania was looking for 60 lecterns that would be both a signature mark and the educational technology nerve center for its new Jon M. Huntsman Hall, not just any lectern would do—but time was of the essence, as the move-in date was fast approaching.

The Wharton School researched available lecterns and found that none incorporated the attributes they desired—height adjustment, expandable surfaces, and electronic/data capabilities. They took their concerns to Krueger International (KI). The design firm didn't produce this type of product at the time, but they were known to address specific customer needs, especially in the area of one of its core markets, furniture for the education market.

Wharton turned the project over to KI, which initiated discussions with the customer to identify general and specific criteria before developing initial concepts. At that point, KI enlisted the help of Aaron DeJule, an industrial design consultant, for brainstorming and initial concepts.

"Initially, the concepts were somewhat boxy because of the technology equipment and surface space requirements," says Lon Seidl, senior project manager. Designers proposed using semi-transparent and perforated materials to make the lectern appear lighter and smaller, two features desired by Wharton. The recommended materials—a mix of frosted acrylic, sculpted and powder-coated aluminum, perforated steel, and fiberglass—were approved, and designers went back to the drawing board to come up with ideas for new shapes.

Using input provided by the Wharton team and creative problem solving, designers developed a new set of shapes that reflected current thinking and directly addressed the issues of height adjustment and how best to conceal the high-tech hardware.

Stability and strength were the next considerations. These, in turn, dictated the shape of the foot. "Some initial concepts took on shieldlike forms, but they were abandoned in favor of a more interactive and a less defensive posture. The common thread was that all of the forms were much more slender than traditional lecterns," says Seidl. "Ultimately, the more organic shape was selected. It was stately yet approachable."

Finally, a direction was chosen, but now the move-in date was only eight months away. Timing was critical. Designers built electronic, form core, and real material models and shared them with Wharton over the next three months. During this period, designers made changes and alterations, specifically to the slope of the surface, which was thought to be too steep, and overall size, which was deemed too large. Designers incorporated details of

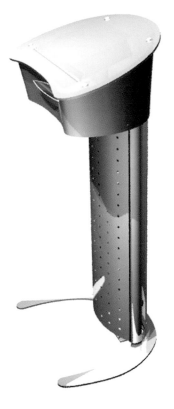
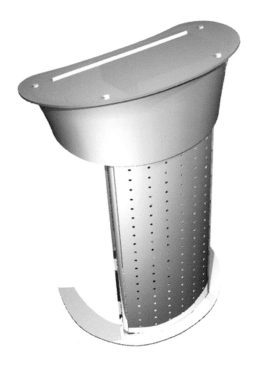

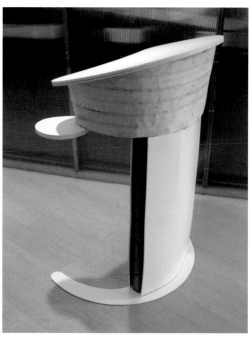
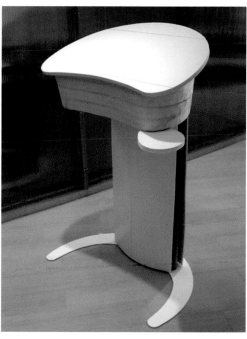
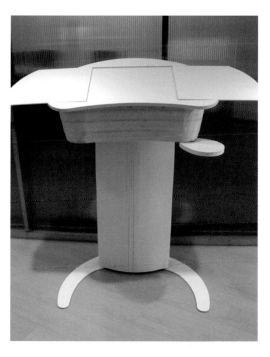

Renderings show the use of 18-gauge perforated sheet steel. The bottom shroud can be slid upward to allow limited access to the wiring that connects the lectern to a floorbox.

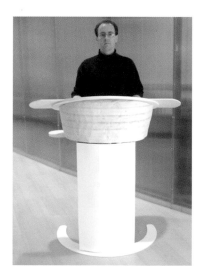
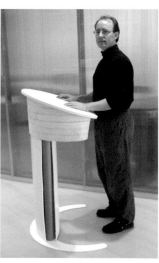

Early mock-ups were made of electronic, form core, and real material to test height adjustability, stability, and other criteria.

components and internal mechanisms into the computer model. One month later, a final prototype was delivered for review, receiving high marks from the professors. It wasn't long before Wharton formally approved the lectern and the team began the final engineering development of the product.

To help speed the entire process and make communicating as efficient as possible, the teams at KI and Wharton shared notes, images, and 3-D models from an extranet site established by KI at the outset. "Basic ergonomic conditions such as the height adjustment range, top angle, activation, and location of controls were studied and shared digitally. The two teams rapidly resolved most of the open design issues," says Seidl.

"The design team had their hands full, as there was now less than five months to ship the first order. All aspects of the product design were influenced by the short timeline. Low volume and fast turnaround required the use of materials that could be readily machined, formed, or laid up by hand, yet were elegant enough to be at the head of the class."

Next, designers looked into alternative materials and production methods. "The 3-D CAD geometry was used extensively for the creation of flat patterns for steel parts, cutting negative mold patters for the fiberglass basin, and direct machining of the aluminum components," explains Seidl. "In addition, the team was able to leverage components and techniques from two existing adjustable table product lines."

These steps all saved time, allowing the product to come together smoothly the first time—"with only a couple of minor tweaks," says Seidl. That was good news. The first order shipped on time, and the lecterns were installed for the fall 2002 semester.

"Product development can be done in many ways, from customer-driven to exploratory brainstorming," adds Seidl. "Initially, this project was thought be a substantial investment of development time while not necessarily fitting with the product development efforts already underway that would have to be put on hold. Eventually, the universality of the solution broadened our horizons. The product is a mainstream offering that embodies all the latest technologies in a stunning visual presence. Be open to the possibilities."

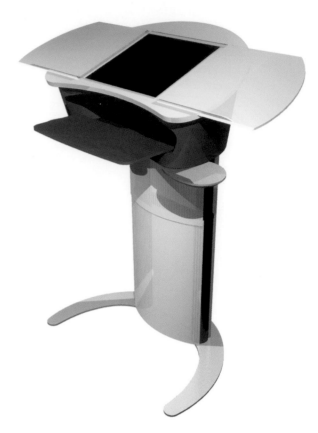

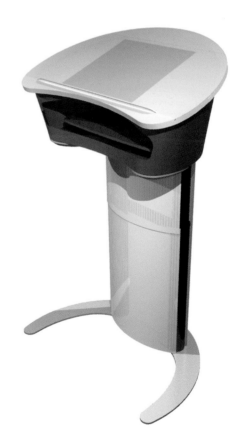

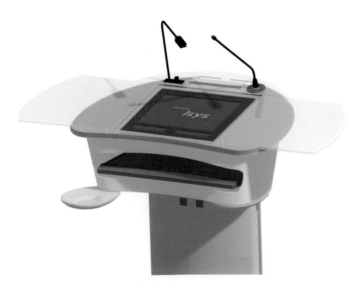

◁ The frosted acrylic top has two recessed doors that slide open to expose a touch-screen control panel that operates every aspect of the presentation environment, or a laptop.

△ The top has built-in extensions to accommodate the speaker's notes or other supporting materials. The basin of the lectern is constructed of fiberglass and painted to match metal components. It supports the acrylic top and houses the control panel and the keyboard tray; it also functions as the technology well for the adjustment motor and controller.

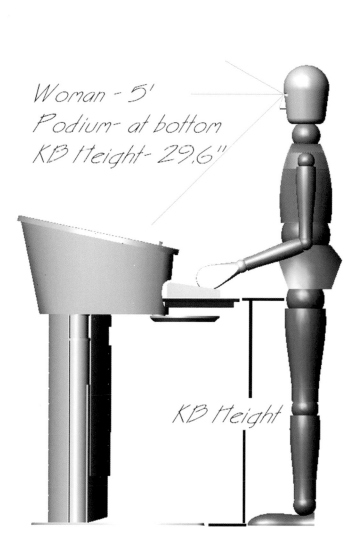

Woman - 5'
Podium- at bottom
KB Height- 29.6"

KB Height

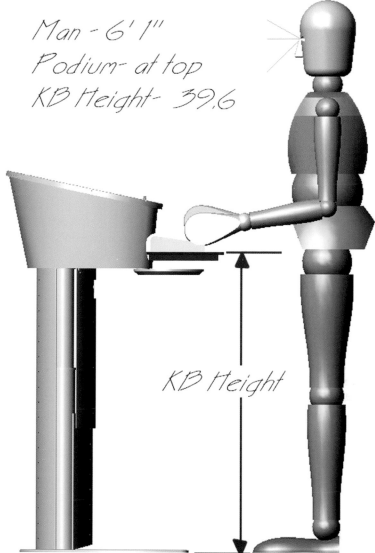

Man - 6' 1"
Podium- at top
KB Height- 39.6

KB Height

⌃ Top: The adjustability of the lectern's height was a key design element. The presenter has to touch only one button to raise or lower the lectern between a range of 37 inches (94 cm) and 47 inches (119 cm).

⌃ Above: The speaker can easily adjust the gooseneck microphone and light for individual preference.

⌄ Right: The lectern was designed so that speakers could access their LAN, surf the Web, or access the hard drive of their personal laptop.

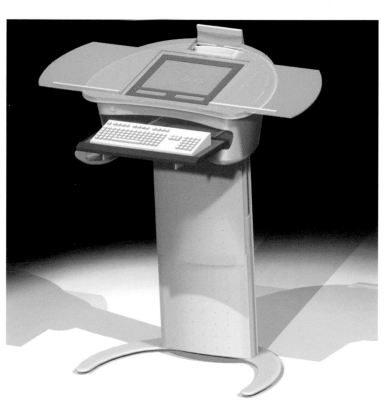

The **HP Workstation zx6000** was **created** when the Hewlett-Packard Company **needed** a new line of products to go with the **introduction** of a new chip from Intel, the **Itanium chip**. The company tasked **Lunar Design** with the job.

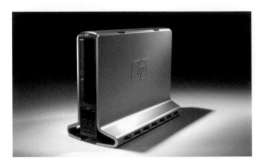

The mission: create a workstation for the computer-aided engineering (CAE), life sciences visualization, scientific research, government/military, software development, digital content creation (DCC), and mechanical computer-aided design (MCAD) markets. While users would range from creative animators to engineers, the station was to be designed primarily for aerospace and mechanical engineers—people who demand a system that is powerful, fast, sophisticated, stable, and robust.

Among designers' goals was easy transformation from racked graphics workstation to deskside unit. It was also important that the design language be applied to other HP workstations of different size.

Using software programs such as Alias and Vellum, designers set to work. Not unlike other design teams, this task force began by thoroughly analyzing the customer. However, while identifying concepts, they actually identified customers and developed fictional scenarios of likely users along with profiles of their needs, likes, and dislikes, which they matched to each concept. From there, they developed sketches, mock-ups, and CAD models, keeping them matched to the personalities they developed.

"As the new product had to use an existing-rack mount enclosure, and none of the components within it could be rearranged, the design team decided to treat the existing enclosure as a performance-driven black computing engine," says Max Yoshimoto, vice president of design. "User-accessible components such as the hot swappable hard drives and CD door were left as is, with a raw yet functional feel. Contrasting silver metallic side panels

⊗ The upright orientation minimizes the time required for servicing; the alternative is having to remove all the access panels and turning the unit on its side. To perform basic servicing tasks such as memory and expansion upgrades, customers can remove the side panels of the HP Workstation zx6000 without tools, and the hard drives are hot swap accessible without removing access panels.

⊗ In developing concepts, designers created a story using people, products, and artifacts to give likely users a personality. "This combination of imagery creates a demographic caricature of who might be using this product and the experience they desire. The goal is to have the form of the concept communicate the desired personality," says Max Yoshimoto, vice president of design at Lunar Design.

⊗ Opposite top: Designers created a series of concepts and matched each with a fictional potential user with a scenario of preferred features and characteristics. "Part of how we describe a concept is to try to attach an idea with a few words and attach a personality to the concept as well, like a small demographic," says Yoshimoto.

⊗ Opposite bottom: Here is a preliminary take at developing different personalities for one of the concepts presented. In this scenario, designers also show preliminary thumbnails to support the imagery.

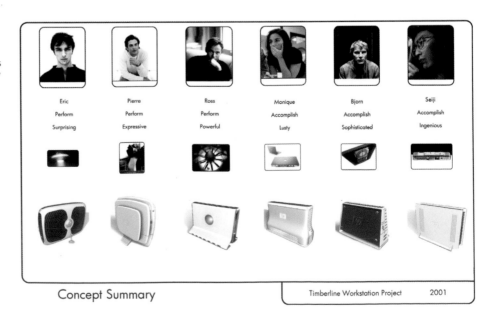

Concept Summary

Timberline Workstation Project 2001

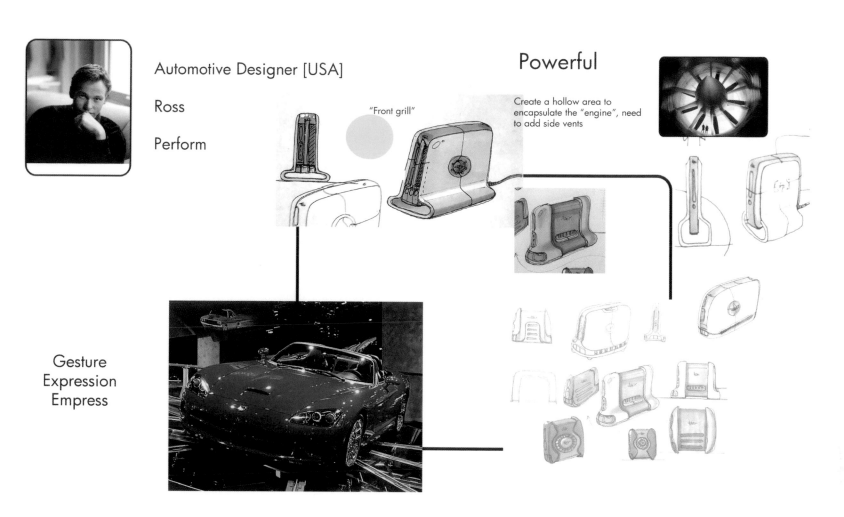

Automotive Designer [USA]

Ross

Perform

Powerful

"Front grill"

Create a hollow area to encapsulate the "engine", need to add side vents

Gesture
Expression
Empress

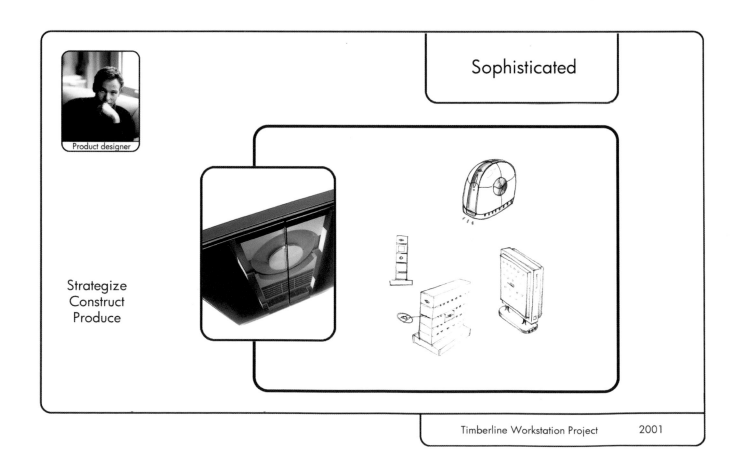

Product designer

Sophisticated

Strategize
Construct
Produce

Timberline Workstation Project 2001

were introduced to the design for an element of sophistication and to reinforce the messages of speed and power. The side panels lift the engine off the ground to provide proper ventilation. They also give the product more presence and importance."

Ultimately, the concept chosen featured an upright orientation that is easily serviced without tools or having to turn the unit on its side. To perform basic servicing tasks such as memory and expansion upgrades, customers simply remove the side panels of the HP Workstation zx6000 without tools. The hard drives are hot swap accessible without removing access panels.

The operating procedure is quite simple, too. The user connects the power cord to an outlet, connects the network cable, and powers up the machine, at which point the operating system software and application software take over.

"The HP zx6000 is designed to be flexible. It can be used as a single-unit deskside system or as a multiple-unit system in a rack mount configuration. The side panel design also helps highlight how easy it is to repurpose a rack-mount unit into a deskside unit. It is ideal for users who need racked graphics workstations

or who require cluster nodes that can later be redeployed as deskside units," says Yoshimoto. Lunar Design has heard that customers have been very pleased with the product's design.

"Most products have but one life and then are either recycled or end up in a landfill. Giving the product a second life by repurposing it from a rack-mount unit to a deskside unit has a positive impact on society by extending the usage of resources in the product," says Yoshimoto.

What did Yoshimoto and the rest of the design team learn from this experience? "Don't think that ideas are too wild, and don't make assumptions. Show some wild, pushy ideas along with ones that are more grounded," he says. "This tends to open the discussion and keep people on their toes.

"Have a clear sense of why your designs—wild or mild—are noteworthy. Create emotion, reason, and meaning behind a design. Because it looks cool is just makeup or a nice haircut; the effect is pretty light and wears off quickly. Enhance and expose the product's personality by telling a complete story, and when you tell that story, know who your audience is."

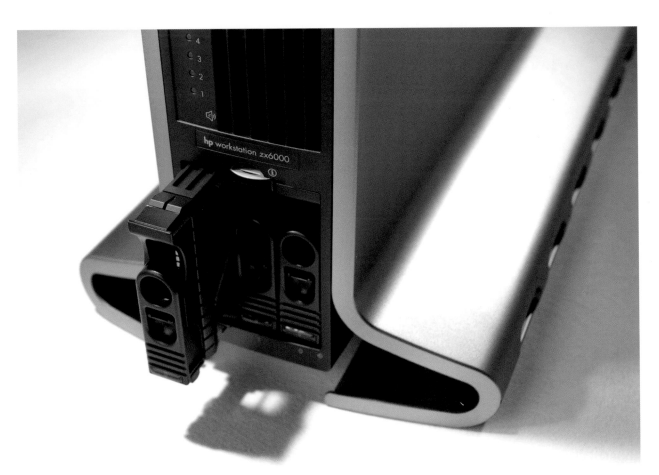

⬙ A close-up of the HP Workstation zx6000 drive.

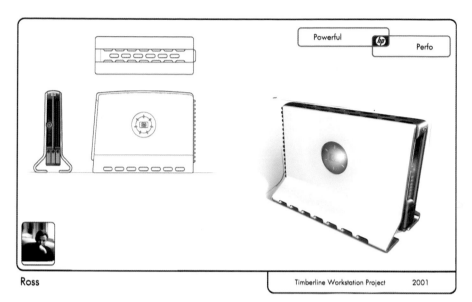

Ross Timberline Workstation Project 2001

⊗ This concept, developed for the fictional Ross, an automotive product designer, is based on a selected demographic and personality. His concept was liked by the client and is shown here in further development.

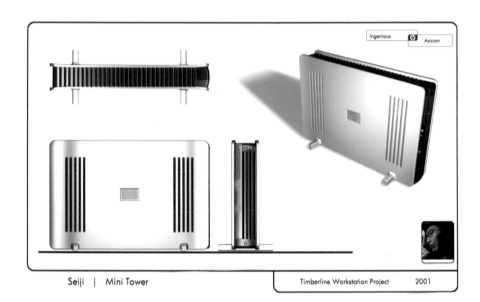

Seiji | Mini Tower Timberline Workstation Project 2001

⊗ Ultimately, the concept developed for Ross was chosen as the final direction, but before it was granted final approval, it competed against an alternative concept, developed in parallel for Seiji, which also featured an upright workstation.

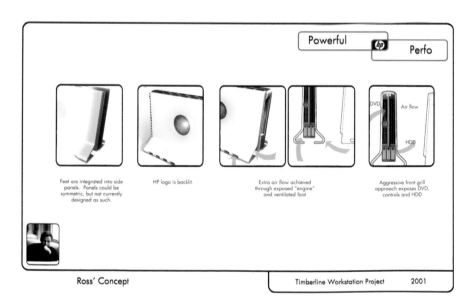

Feet are integrated into side panels. Panels could be symmetric, but not currently designed as such.

HP logo is backlit.

Extra air flow achieved through exposed "engine" and ventilated foot

Aggressive front grill approach exposes DVD, controls and HDD

Ross' Concept Timberline Workstation Project 2001

⊗ These sketches further develop Ross' concept and describe how the forms provide solutions for the technical requirements of the project.

The **Spider table** and Accessories for Herman Miller is easily assembled in just **15 minutes** with only six Phillips screws and a **screwdriver**. More important, for **less than $500**, a start-up business can set up a **workstation** with accessories that **looks professional**.

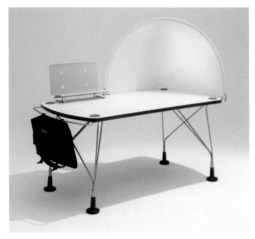

Lightweight legs and disk-shaped feet allow for 3 inches (8 cm) of height adjustability. They make gliding easy for office reconfiguration and individualized table height. The metal rod tool bar is good for hanging everything from umbrellas to laptop bags to purses to blazers. Herman Miller also supplies an attachable bag that can be used for daily active file storage.

That was the goal when Herman Miller, a manufacturer of office furniture, asked ECCO Design to create a reasonably priced, high-performance desk that would fill a major gap for start-up businesses headed by young and hip buyers.

"The idea for Spider originated from observing the number of start-up companies with little capital that needed creative design solutions for their diverse needs of office privacy, mobility, and personalized space," says Eric Chan, president of ECCO Design. "Spider is a big step forward from corporate desk systems that have little character, are immobile, and take a great deal of time and money to obtain. This new tool allows individuals to challenge the traditional furniture status quo of corporate-dominated style, function, and price."

Of course, that also posed designers' biggest challenge: how best to offer innovative and highly functional solutions for young, spontaneous users while keeping the prices low and affordable. With that in mind, designers embarked on the project. The first step was to conduct a project download with the client. Then, they did in-depth research, including site visits, interviews, online investigation and surveys, and extrapolation, to understand the market and key problems. With research in hand, they started brainstorming and developing sketches of table ideas.

These sketches explored different tabletops, keeping in mind the client's priorities—that the desk provide storage, cable management, cable function, and independent form and structure. Likewise, designers explored various accessories in hand sketches as well as how the table legs would fold to facilitate portability.

With dozens of hand sketches completed, designers created scale mock-ups, which they refined before putting the design into 3-D CAD modeling. With client approval, they created full-size mock-up to test structural schemes, of which there were multiple iterations. Ultimately, they had their final creation—a simple, streamlined desk that met all the client's criteria and then some.

The desktop cover acts like a giant picture frame. Users can personalize their table by placing photos, art, wallpaper, or whatever else they want beneath the free-floating plastic sheet indexed between the four corner caps. An ample document stand snaps onto the table to hold books, CDs, and documents upright. Pens and files nestle beneath.

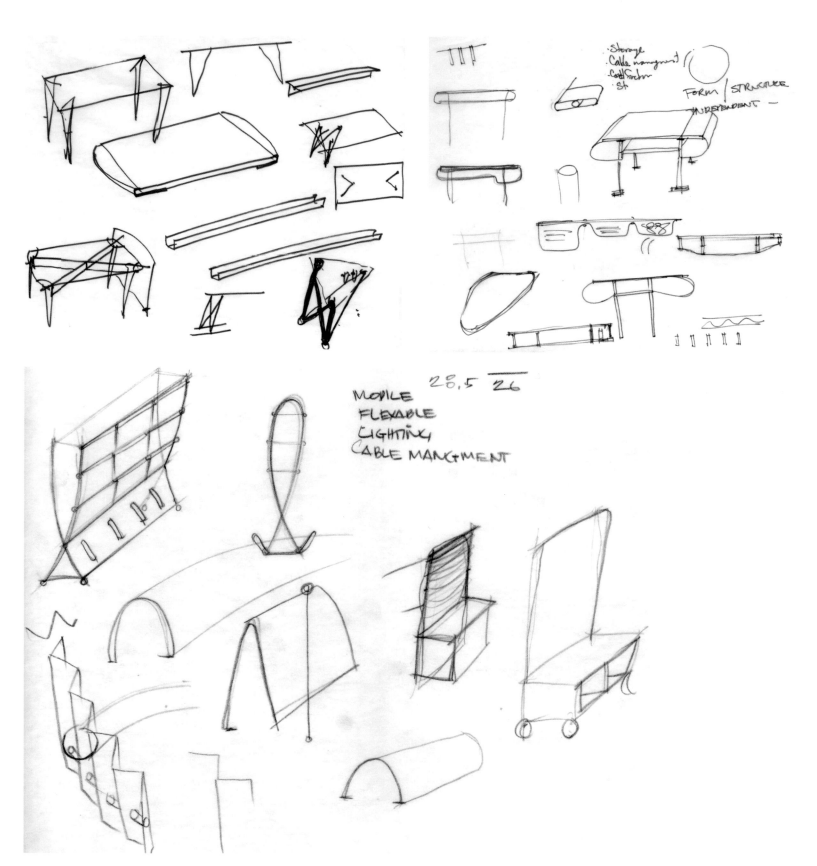

28,5 26

MOBILE
FLEXABLE
LIGHTING
CABLE MANGTMENT

⌒ Top left: Once they had their research in hand, designers played around with rough sketches of various table ideas.

⌒ Above: Mobility, flexibility, and cable management were treated as accessories in this sketch, which also explored lighting.

⌒ Top right: Designers explored different tabletops, keeping in mind that the client wanted a desk that provided storage, cable management, cable function, and independent form and structure.

"Spider's corner screen adds just enough privacy to hide both a monitor and wandering eyes," says Chan. Monitor cables easily tuck under the elastic canopy, creating free-form cable management. Slightly transparent, the screen retains that big loftlike space start-ups desire. With just one Velcro closure, it is easy to remove and wash.

The Spider and its accessories can be ordered online and shipped door to door in about a week. "This new and innovative approach is backed by a smart product that offers not only essential features but also great performance and flexibility," says Chan.

"Spider is a democratizing piece that everyone can afford and feel good using, whether they are the company owner or the intern," he adds. "For under $500, a young firm can set up a complete workstation with accessories."

Does Chan offer any advice for the design intern? "Conceive of the fantastic and make it feasible, or conceive of the feasible and make it fantastic," he says. "Either of these may be the right approach, depending on the endeavor. It pays to know in advance which to pursue. In this case, with a tight time frame for production and an aggressive price target, it was wise to use the tried-and-true affordable methods and materials—then push the limits for a surprising result."

This sketch includes sample storage and easily hidden computer cable chaos, but the concept still required refinement.

Opposite top: Designers sketched various leg shapes before hitting on the final structure, which is shown here.

Opposite bottom left: The legs attach to the underside of table with the help of a tabletop cap. All totaled, the Spider table is assembled with only six Phillips screws.

Opposite bottom right: A sketch of the final concept aptly illustrates the table's simplicity and details, including all accessories, legs, and points of attachment.

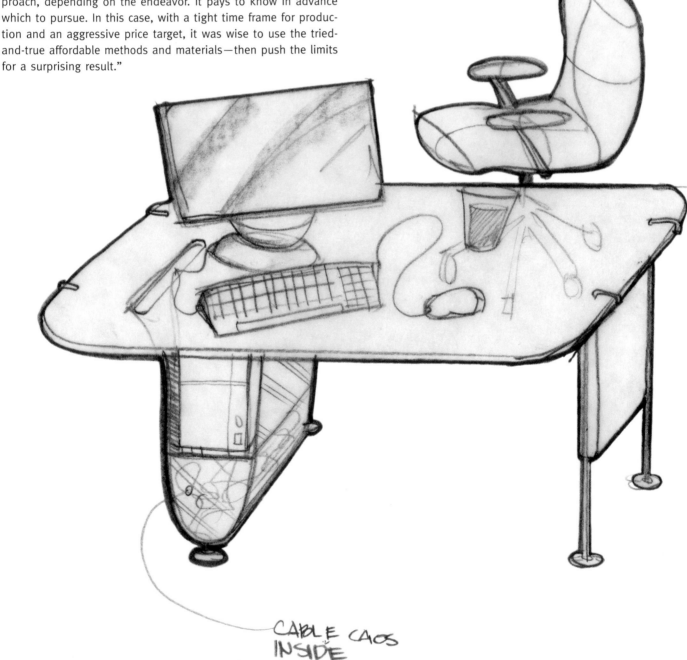

CABLE CAOS
INSIDE

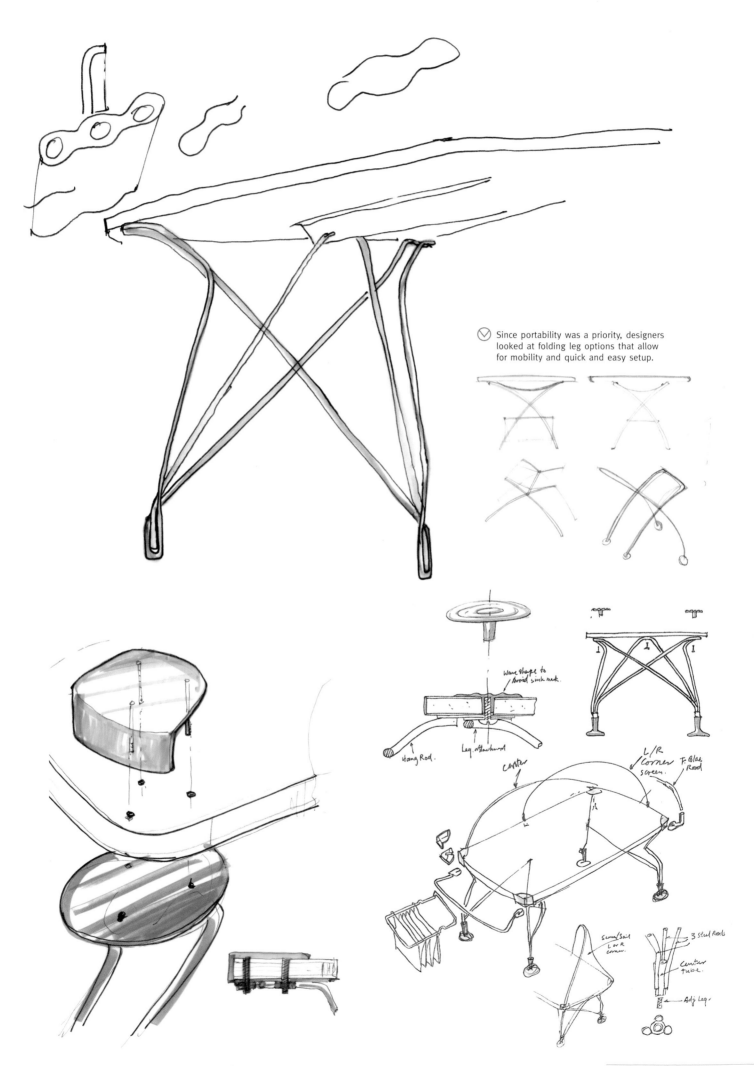

Since portability was a priority, designers looked at folding leg options that allow for mobility and quick and easy setup.

IBM Transnote

What if your **notepad** were **as smart as** your laptop computer? **That was the idea** behind IBM's **TransNote,** a device that immediately **digitizes** notes taken on paper, with all the **functionality** that implies.

The TransNote follows in the footsteps of the ThinkPad, both in its use of ThinkPad brand colors and in the way its simple exterior opens to reveal a surprise.

Opposite top: In these early concept sketches, the design team attempted to fit the TransNote into the clamshell form factor IBM had established with the ThinkPad; all of these ideas were rejected when the team realized they were too complicated for users.

Opposite bottom: This sketch reveals some of the details behind the TransNote's configuration. The right side shows how the display is positioned over the TransNote's keyboard; the left side shows the unique Z-shape of the TransNote, which allows the user to view only one side of the TransNote while protecting the other side.

John Karidis, an IBM Distinguished Engineer, says the idea behind the TransNote was "to use the paper for what it's good for, which is quick and natural expression and sketches, but to add the value of the computer, which is organizing, searching, communicating, image sending and storing, and retrieving." When users open the TransNote, all they see is the LED touchscreen and a pad of paper. While there is a keyboard underneath the screen if needed, users are meant to interact with the TransNote primarily through the pen—making the device an ideal companion at meetings, where the clicking of a keyboard might be distracting. Notes, sketches, and forms can be shared instantaneously by printing copies or emailing them.

The TransNote evolved from two existing IBM products. The CrossPad, which IBM developed with A.T. Cross, allowed users, with the help of a special pen and pad, to make handwritten notes digital. However, the fact that it was a peripheral device made its use less than seamless: If users wanted to email a sketch during a meeting, they would have to bring their computers, hook up their CrossPad to the computer, and download the information before they could proceed. Ron Smith, project manager for the IBM Corporate Strategic Design Program, says, "All along, we had the idea that there was some way to marry the computer world and this digitized paper world together into one thing that would be in itself a little bit greater than the individual pieces." IBM had already designed the ThinkPad, an early version of a laptop computer, so combining it with the CrossPad was a natural fit.

Extensive user research identified a list of things the new product had to do well: easy note taking, storage, and retrieval; easy sharing of handwritten information; simplification of personal information management; and automation of paper-based forms. These goals were the benchmark of all further research and development; if a feature was proposed that did not support these objectives, it was discarded. Says Smith, "One thing that's always a danger with any computer product is that there's so many things that you can make it do that it's quite easy to achieve doing none of them very well." Two primary user groups were targeted: note-takers and graphic-intensive users such as architects, journalists, designers, lawyers, and engineers; and business users who fill out forms regularly in the line of work, such as members of the pharmaceutical, insurance, and real estate industries.

Research had shown that users wanted a pad of paper no smaller than 8 $\frac{1}{2}$ x 11 inches (21.5 x 28 cm) to write on. Coincidentally, that size matched the clamshell shape and size characteristic of IBM's ThinkPad, so many of the initial explorations of the team, both in sketches and prototypes, explored concepts based on that form

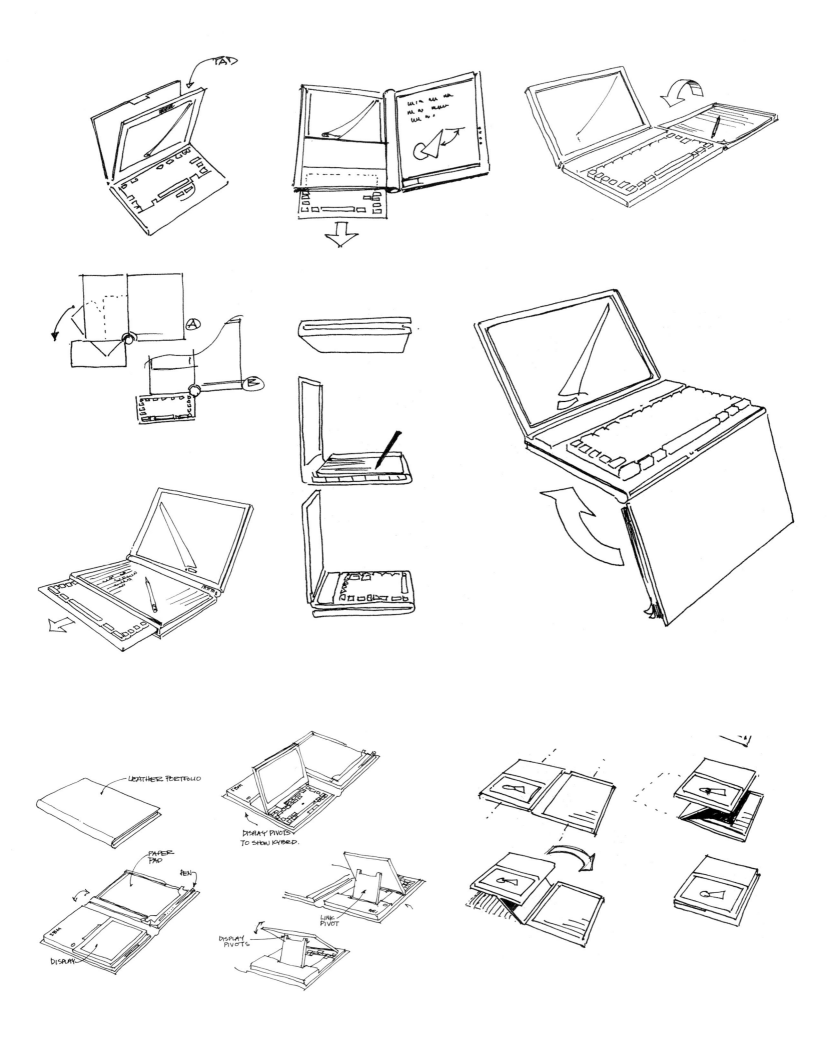

LEATHER PORTFOLIO

DISPLAY PIVOTS
TO SHOW KYBRD.

PAPER
PAD

PEN

DISPLAY

LINK
PIVOT

DISPLAY
PIVOTS

factor. But while that was the easiest design to do, it wouldn't be the easiest product to use. Says Karidis, "We stopped and said, look, the user cannot be required to rotate things or do a lot of reconfiguration to switch modes. The keyboard has to be accessible without rotation. The paper has to be vertically oriented in its normal mode, and we have to figure out a way to put all that stuff together without it being too big or too thick." That meant the computer and the pad would have to be side by side—and that meant the computer side would have to be shrunk. A display 10.4 inches (26 cm) wide, plus an optimized keyboard of the same width, was the smallest the team felt they could go and still have a workable device.

With the width of both sides of the TransNote defined, just a small vertical strip down the left-hand side of the digitizer remained for both the electronics and the user interface. To keep everything on the computer side no thicker than $\frac{3}{4}$ inch (2 cm), the designers set the display directly on top of the keyboard and put all of the thicker components, like the battery and disk drive, toward the back of the left-hand side. In addition to keeping the device thin, this configuration also de-emphasized the importance of the keyboard. Users have the option to use an onscreen keyboard, if they have a small amount of text to type in, or they can pull out the screen and type on a traditional keyboard if necessary. This configuration also allows users to use the TransNote in a group setting without imposing the physical barrier of a screen between themselves and others—an important benefit in cultures where imposing such a physical barrier is considered rude. The arm required by this configuration allowed the team to add a feature that enables users to rotate the screen.

Once the team had settled on the configuration, a new problem appeared: Clearly, the TransNote would still be too large to use on an airplane and in similar situations. In such settings, users would have to fold the TransNote in half, which would either rub the computer side against the table or crumple the paper. Says Smith, "It was going to be a major obstacle to using this product if we didn't come up with a good solution for that." After creating dozens of cardboard models, the team finally hit on a concept that worked: By integrating a unique soft cover into the hinge and adding two other hinge locations, the IBM team created a solution that would allow users to follow their natural instinct to stack one side on top of the other rather than to fold the TransNote in half.

Another discovery was that the TransNote would be difficult for left-handed users to negotiate. For this market in particular, that was a problem. "Five percent of the general population is left-handed, but 10 or 15 percent of the creative and artistic population—those who might be interested in sketching—is left-handed," says Karidis. It was clear that a reversed version of the product was necessary.

The TransNote hardware was not the only area of concern for the team; its proprietary InkManager Pro software was equally important to the product's usability. The product was so new and different that, according to Smith, "It really required a lot of participation and buy-in from different areas, including the software guys really believing in the product and trying to understand what it would be like physically to use the thing." The team closely analyzed the various ways that people organize their notes so they could understand what features would be valuable to users. The software team also kept the four main goals of the product in mind and discarded or minimized features—such as handwriting recognition—that couldn't be done well enough or that didn't relate to the product's core aims. To help users find the notes they were looking for, the software enabled users to get a thumbnail view of their documents, long before Windows included such a feature. Other features, such as the feature which allowed the user to organize their notes into folders, proved to be more problematic, and rollout of the product was delayed until the team felt the software successfully achieved the goals they had for the product.

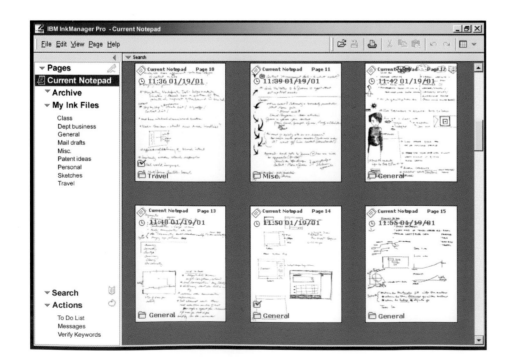

This image of the TransNote's proprietary InkManager Pro software demonstrates its ability to allow users to search by keyword and organize their notes in folders.

In the end, the TransNote didn't meet with the market success IBM expected: Just as the product was released there was a downturn in the economy; the vertical markets IBM had targeted were hit hard and, thus, were unwilling to invest in new technology. But there were collateral benefits to the project. Says Karidis, "We learned a lot about customers' usage and requirements and issues around tablet-oriented computing. It's one of the reasons why to date IBM is not selling a tablet PC. It is a niche market, but a very large number of people is going after that market, and so based on our understanding of the marketplace, we're watching and waiting." Smith adds, "I have to really applaud IBM for taking the risk to develop this."

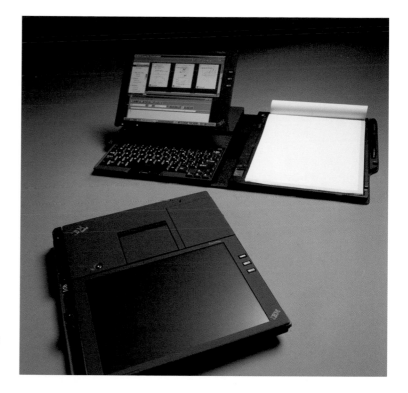

The many faces of the TransNote: right, closed and opened, with the display up; below, when the user first opens the TransNote; below right, with only the writing side visible.

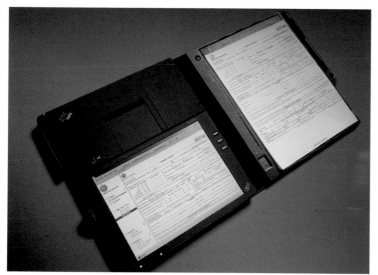

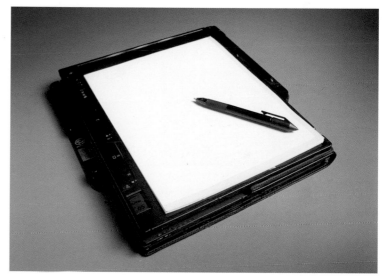

The arm on the screen of the TransNote allows users to easily share the display with others.

All photos—Jimmy Williams Productions

IBM NetVista X41 What do you get when you take the "desktop" out of "desktop computer"? You get IBM's NetVista X41, a personal computer that, through its revolutionary design, doesn't require a desktop.

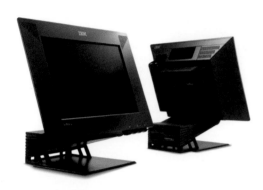

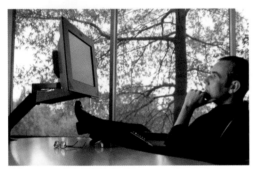

⊘ The NetVista X41 in both its arm-mounted and desktop versions. Paired with a cordless keyboard and mouse, it offers a uniquely convenient and freeing user experience.

The integrated flat-screen computer, which gives consumers the choice of arm-mounting or desktop placement, was IBM's response to requests from customers to develop a computer for placement in a variety of previously unthought-of spaces. Traditional personal computer designs were not well-suited for highly space-constrained work environments such as hotel registration desks, bank teller counters, and work cubicles; additionally, they were not optimized for sharing information in the highly dynamic and collaborative work environments common today. IBM saw the need for a space-saving, easily serviced, and ergonomically sound computer, and a team convened with a mission: to create a design that would revolutionize not only the way a computer looked but also how and where people could use it.

IBM enlisted the help of world-renowned designer Richard Sapper, who also designed IBM's first ThinkPad, and started to rethink the idea of the desktop computer. One of the first priorities of the team was to hide the technological components of the computer. "We felt that people weren't really interested in looking at their computer," says David Hill, director of design for IBM's personal computing division. "They were more interested in the experience of *using* a computer, which is really primarily all about the screen, so our idea from the beginning was to make the computer appear as though it was only a display."

What the user would see was not the team's only concern; how the user would use the machine was also at the top of their minds. Having the CD-ROM/DVD drive at the front of the system was a design concept that can be seen even in the earliest sketches. "The idea of hiding everything and making it invisible yet having everything you need right at your fingertips was really the core concept of the actual physical configuration," says John Swansey, senior industrial designer for IBM.

To brainstorm how to configure the interior to take up the smallest possible space, the team took the physical volumetrics of the core internal components and, on pieces of paper on a light table, moved them around until they hit on a configuration that would work on both technical and design levels. Says Swansey, "In our team-based, cross-disciplinary group that was doing the development, we had very close interaction with the marketing department, engineers, and mechanical and electrical experts that could let us configure those components exactly the way that would best support the user experience we were trying to create." The team identified an innovative configuration in which the system board, option cards, and hard drive were placed directly behind the screen, allowing them to jettison the separate box for those components that was standard in most computers at that time.

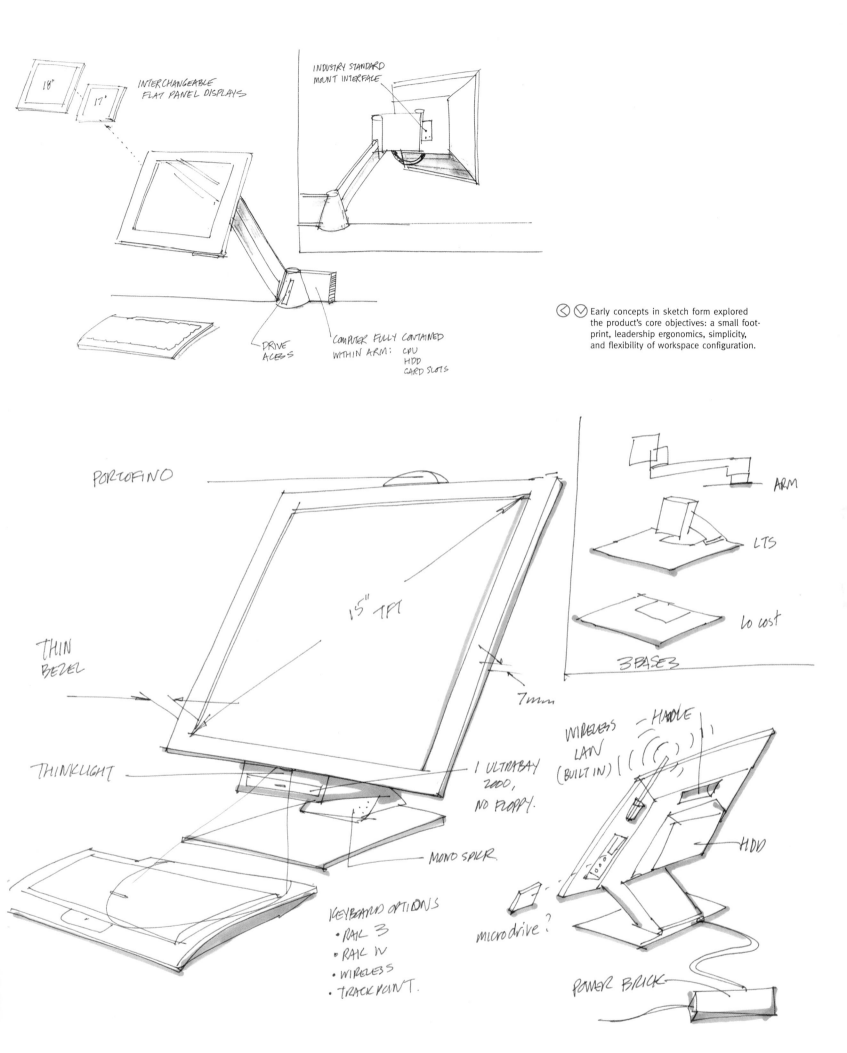

18" 17"

INTERCHANGEABLE
FLAT PANEL DISPLAYS

INDUSTRY STANDARD
MOUNT INTERFACE

Early concepts in sketch form explored the product's core objectives: a small footprint, leadership ergonomics, simplicity, and flexibility of workspace configuration.

DRIVE ACCESS

COMPUTER FULLY CONTAINED
WITHIN ARM: CPU
 HDD
 CARD SLOTS

PORTOFINO

15" TFT

THIN
BEZEL

7mm

THINKLIGHT

I ULTRABAY
2000,
NO FLOPPY.

MONO SPKR.

KEYBOARD OPTIONS
• RAIL 3
• RAIL IV
• WIRELESS
• TRACKPOINT.

microdrive?

ARM

LTS

Lo cost

3 BASES

WIRELESS
LAN
(BUILT IN)

HANDLE

HDD

POWER BRICK

Sapper worked closely with the IBM team from his studio in Milan and was instrumental in devising the computer's bold geometric form. Advancing his goal of creating a "floating" computer that gave the screen the highest priority, he sketched a number of designs that followed through on that idea. One concept featured a removable base that was called the Eiffel Tower base because of its lightness and openness; another featured a counterbalanced arm. Both of these ideas were selected for further development and user testing.

Testing revealed that users were sharply divided between those who preferred the arm-mounted design and those who preferred a free-standing design. More low-tech users preferred the plug-and-play aspect of the free-standing model, while larger businesses with technical support staff preferred the elegant, space-saving design of the arm-mounted version. As a result, the team decided to offer the arm-mounting mechanism as a separately sold accessory, so consumers can choose the configuration that best suits their needs.

Midway through the process, the team was asked to integrate the latest, highest-performance processors, and as a result had to reconfigure the internal components to allow for a larger processor and a larger cooling mechanism. While this change could have been disruptive, the IBM team was able to react quickly because the changes were kept within what Swansey calls a "very tight loop" of design and engineering. Hill says of the design team, "We had our finger on the pulse of everything that was going on and were active in all of the decisions."

Numerous models and prototypes followed, all designed to handle the new technical demands while keeping the computer as quiet as possible. The end result was the finlike design, complete with air slots surrounding the back of the monitor and the component case, that can be seen on the back of the final product; Hill thinks that the team turned a negative into a positive by translating these technical demands into a design that was a visual manifestation of the power of the computer. The look of the back of this computer was particularly critical, since it often would be placed facing business users' clients.

Other features of the computer required fine-tuning during prototyping. Says Swansey, "The arm took a fair amount of engineering to make sure it was strong enough to withstand movement and that it could be adjusted to balance properly at any height the user chose." The team also worked hard to make sure the design looked integrated but that the rear cover could be removed without tools for easy access to the computer components; however, the shape and pressure of the latch mechanism used to make that happen required several iterations before the team was satisfied.

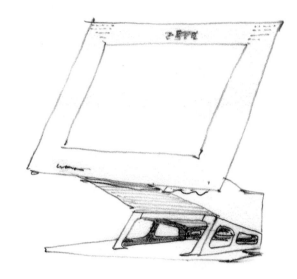

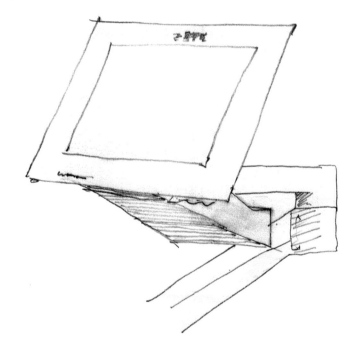

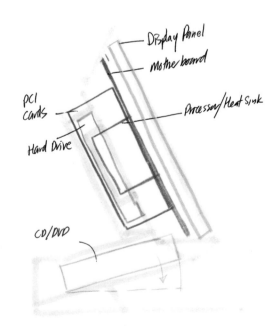

⊘ Early Richard Sapper concept sketches. One shows a proposal for the removable Eiffel Tower base, whose openings emphasize a sense of lightness; the other envisions the computer mounted on an arm.

⊘ A sketch showing some of the early thinking behind the arrangement of the computer's internal components. This compact and innovative configuration conceals most of the elements behind the display panel but places the CD/DVD drive where it is most accessible. The close-fitting external contours enabled by this arrangement create a slim and distinctive profile.

Display Panel
Motherboard
PCI cards
Processor/Heat Sink
Hard Drive
CD/DVD

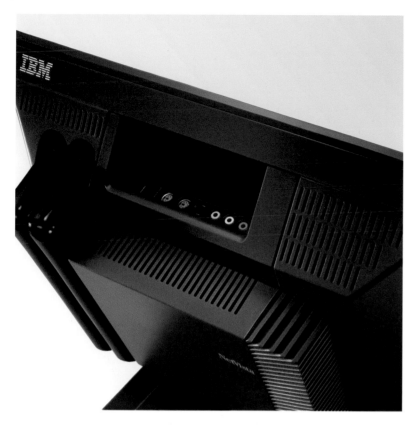

While the NetVista X41 was a successful product at the time of its release in 2001, IBM has decided to discontinue its line of all-in-one computers with flat screens, for two reasons. First, the increased size, speed, and cooling requirements of processors has made it increasingly difficult to configure both processor and cooling mechanism in such a small space. The team also received feedback after the product's release that some customers wanted to be able to preserve their investment in the flat-panel screen, and an integrated product doesn't allow for that. For the moment, IBM products with flat-panel displays and a smaller computer size are able to deliver a similar user experience while allowing customers to upgrade as needed. However, IBM has not abandoned the idea of an all-in-one flat-screen computer entirely. Since IBM's design process is, according to Hill, "very iterative, very customer-focused, getting customer feedback, modifying products, and making them better and better," the company remains open to whatever customers might demand in the future.

◁ Final detail of the top rear showing cooling air exits, convenience jacks for headphones, retractable handle, and black cylindrical covers over the expansion card slots.

▽ The range of motion possible with the optional arm permits the X41 to be shared by two users and accommodates both sitting and standing use positions. A touchscreen option facilitates stand-up use.

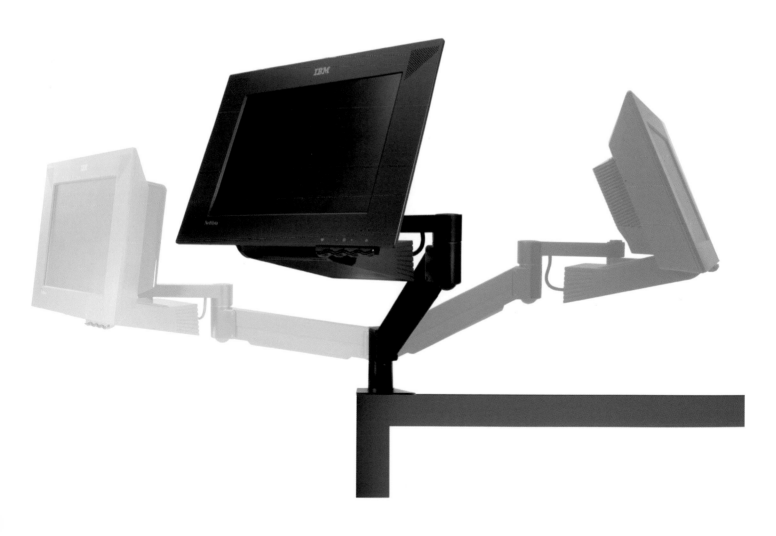

Labtec Desk Microphones Verse 504 and 514

They stand only 8 **inches** (20 cm) **high**, but the diminutive **Desk Microphones** pack a **mighty punch**, especially in terms of their **high-end** design versus **low price point.**

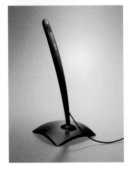

⬡ Demand outpaced supply for both the Labtec 504 (top left and right) and 514 products, however the higher-end 514 premium product did surprisingly well.

Labtec, their manufacturer, wanted to take advantage of the growing market for desktop microphones used with personal computers for Internet telephony and for software applications that support voice recording or voice recognition. However, to do so, it needed to replace an existing desktop model that looked dated and appeared too similar to competing products with something new and more eye-catching.

"Desktop PC microphones had been around for awhile, but momentum had been growing in the year leading up to this program," says Steve Rodden, partner, Fiori product design. "Labtec knew that they had an opportunity to capitalize on these trends, but they also knew that they needed an improved product to take advantage of increasing demand." Labtec assigned the job to Fiori and stated their two priorities: Get it done fast, and make sure the cost of the new product was no more than the current one.

"When we began, we established some priorities of our own, first, this is a simple product, let's keep it simple in both function and design. Second, this may be a low cost product, but low cost doesn't have to mean low design. Let's demonstrate that great design doesn't have to add cost to a product," says Rodden.

Designers began the process by deciding on one-word attributes they wanted to communicate through the design. Rodden remembers that "*simple* was obvious; *valuable* was an attribute to balance the product's low cost; *natural* because we felt that nature was missing on the desktop; *personal* because the product would be in close proximity to the person using it; and *striking* to capture the attention of people walking by a store shelf.

"While the schedule was tight, and it may have seemed frivolous, taking ample time to debate, discuss, and document what we wanted to achieve in this product was critical in proving both fuel and guidance for the design that followed," Rodden says.

The brainstorming process came next. Four to six designers sketched together around a large table but worked individually. Afterward, the group discussed each concept and offered opinions on its promise and how it might be refined. "The work was collective and unselfish. Many of the ideas were taken up and refined by someone other than the originator. We continued the process of developing form concepts over the course of about a week and a half," says Rodden.

With almost 100 concepts to choose from, designers narrowed the field by grouping similar concepts using the attributes they had defined earlier. Next, they prepared hand-sculpted foam models and 2-D orthographic renderings of each of six selected concepts

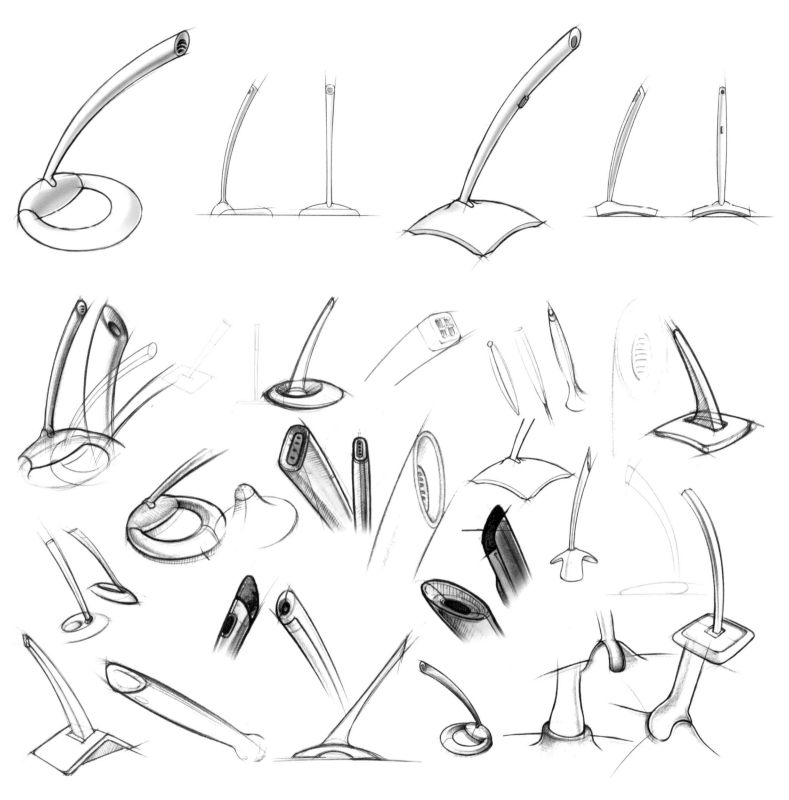

◇ Top: Labtec liked two of the initial concepts presented, both utilizing tall, elegant, slender booms and distinctive bases.

◇ Bottom: During the brainstorm phase, designers produced almost 100 possibilities. They narrowed the field by grouping similar concepts using the attributes they had defined early in the program. Interestingly, a majority of the concepts selected had strong influences in nature. "This attribute became increasingly compelling to us as we moved through the process. Product design inspired by nature is nothing new, but with this product, we felt that we had a unique opportunity to stay true to natural inspirations," says Chris Valentine, a designer with Fiori.

for presentation to the client. They also included a construction diagram for each concept that outlined the probable method of molding and assembling the product. "This step was important in demonstrating that each concept could be produced," says Rodden. "This enabled the client to focus on the design of each concept without concern for its feasibility."

During the review, Labtec gravitated to two of the concepts, both utilizing tall, elegant, slender booms and distinctive bases. "After much discussion, evaluation, and debate, the client still couldn't decide which of the concepts to move forward with. They were absolutely in love with both," remembers Rodden. "With the tight schedule, we had planned to narrow to a single concept in this review, but because of the impasse, we agreed to carry both concepts forward in the next phase of refinement."

Next, designers refined the details. "With products so simple and forms so pure, the details become even more important," says Rodden. "We spent the next week developing and evaluating countless options for each facet of the product. We worried over each parting line location and trajectory, agonized over vent shape and spacing, and argued over the perfect pivot."

In the next client review, Labtec still could not decide on which of the two concepts to pursue, so once again, designers kept working on both. "Both clearly had enormous potential, but each represented a different take on the attributes—one was more playful, the other more sophisticated. In the midst of the discussion, someone suggested producing both," says Rodden.

Labtec liked the idea and conducted a quick market study, concluding that there was an opportunity to offer two microphones, one priced at about $10.00 and the other at $15.00. Adding two microphones to the line would require a significant and unplanned investment, but Labtec decided to move forward with both concepts.

"With the higher-end model to be priced with a 50 percent premium, we needed to draw a clear value distinction between the two products," explains Rodden. "We used the more sophisticated form for the higher-end version. We applied a darker, richer color to this model and added a mute control. While we added only pennies of additional cost, combining advanced form, color, and a new feature were plenty to communicate its place at the top of the line. We used the more playful form for the lower-end model. We developed a much lighter color for this model, a color that was consistent with other PC peripherals of the day."

The products, named the Labtec Verse 504 and 514 microphones, were an immediate hit. Retailers offered new space for these products, and demand outpaced supply. "The program demonstrated that exceptional design and quality don't have to reside in the realm of high-priced products only," says Rodden. "It was design almost entirely that differentiated these new products from those of competitive products—dramatic design differentiation that led to Labtec dominating the category."

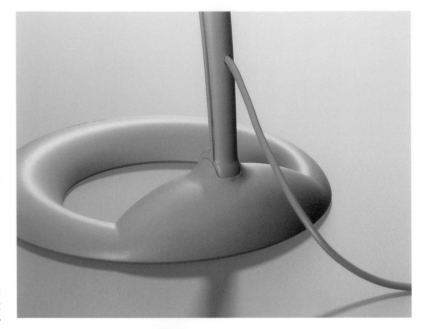

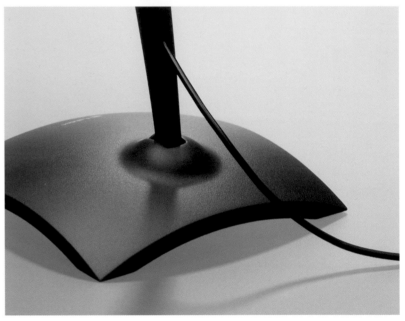

Labtec decided to pursue both concepts—one of which was more playful and the other more sophisticated, as shown in this comparison of their bases.

⬡ The Labtec Verse 504 and 514 desktop microphones were differentiated by small details and their colors. The 514 model was thought have a more sophisticated form, so it became the higher-end version. Designers thought it needed a darker, richer color.

⬿ Designers added a mute control to the higher-end version, as it would command a premium price.

All photos—Michael Jones Photography

The Treo 270 Smart Phone is, indeed, smart. It is a **mobile communicator** that includes a **cellular phone**, wireless access to **email and Web browsing**, and a Palm OS personal **organizer**, all in one small **hand-held** device.

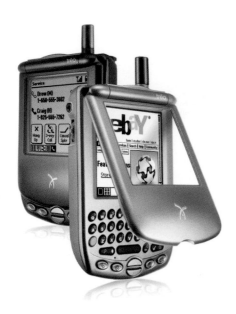

The Handspring Treo 270 is a full-color communicator that seamlessly integrates a mobile phone, a Palm OS organizer, and wireless applications like email, short messaging, and Internet browsing in one device. And it's an amazingly small communicator even with a built-in, backlit QWERTY keyboard and vivid color screen. Now text and graphics are crisper and more readable. Plus, Web browsing, photos, and games are more fun in color. The keyboard makes data entry and one-handed navigation a breeze. You can even look up a number and dial it with just one hand.

Jeff Hawkins, chief product officer and chairman of Handspring as well as founder of palmOne, met a financial analyst at a road show who dumped a phone, Palm Organizer, and Blackberry email device out of her purse and asked Hawkins, "Please fix this! I need one device that allows me to manage my life on the road!"

That incident propelled the project. The Handspring team focused on the user interface and the integration of phone and organizer, while the IDEO product design team focused on the product architecture, hardware, and industrial design.

"The market need was the clear driver in this case, but the product timing was facilitated both by evolving small form factor telecommunications technology (especially digital cellular networks) and The new demographics of an increasingly mobile workforce," says Peter Skillman, director of product design at Handspring.

Keyboard usability at a small scale was the biggest challenge. "We had to make the product as small as possible so it was iconically a phone, but still enable full email and keyboard usability," says Skillman. "Doing this meant building the smallest keyboard ever made. What's wonderfully counterintuitive here is that making the keyboard smaller is better. Compared to a traditional organizer, you can type with one hand and look up an address in three steps rather than two hands requiring six or more steps. At the same time, the IDEO team did a great job making the aesthetics discreet and professional, hiding the complex keyboard when the flip lid is closed."

The IDEO and Handspring teams together made hundreds of sketches and built more than 50 prototypes using Pro Engineer, Photoshop, and various custom user-interface bucks (nonfunctional form factor devices with a cable connected to a PC.) Each prototype was designed to validate a particular question such as product architecture, form factor, keyboard usability, or form. "These models were carried into meetings, worn in pockets, and treated like they were real," Skillman says. "This process helped validate user interface questions like lid integration with call answering functionality and test the overall portability of the product against social and personal expectations of scale and aesthetics."

Designers created more than fifty prototypes, some of which are shown here, that were carried into meetings, worn in pockets, and treated as if they were the real thing.

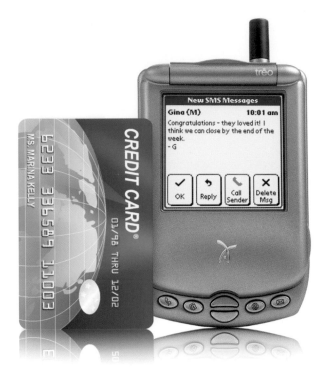

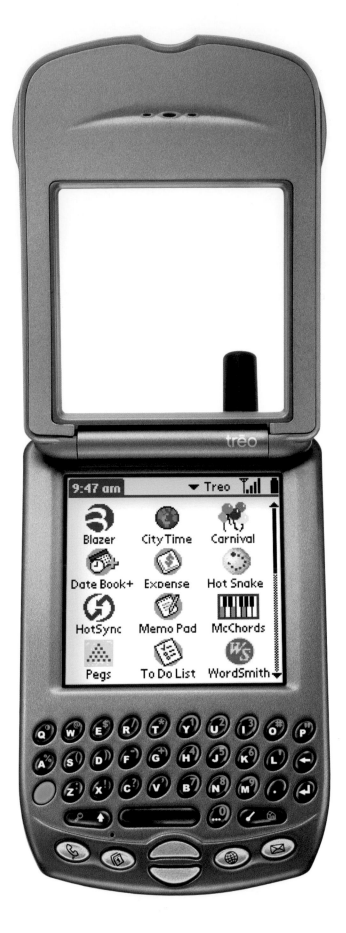

Top: The clear flip-up display cover protects the screen when stored while proving quick access to information such as emails, caller ID, and more. When flipped open, the speaker in the cover acts as the phone's earpiece or a speaker phone for hands-free and conference calling.

Above: The Treo's small size makes integrating this products with one's life effortless.

Right: In the familiar flip-phone configuration, the phone is opened to make a call, but the flip cover contains a transparent window to allow one-handed browsing of the phone book, date book, text messages, or Web pages using the jog rocker on the side.

Working side by side with Handspring's in-house development group, the multidisciplinary design team at IDEO delivered the finished product in a highly compressed time schedule, going from concept to completion in just six months. "The goal just has to be clear from the beginning," remembers Skillman. "Jeff Hawkins declared, 'We are building a phone first.' That forced the teams to take big risks on product and keyboard size we never would have taken otherwise."

In the end, the product solved the common problem among the wired workers of the world—having to juggle multiple devices. "People carrying two or more devices is a common sight, and just as common is their fervent wish that all their devices be combined into one.

"Listen to and observe frustrations that people express every day," says Skillman. "These things are easily overlooked, but buried here are opportunities to lead, build lasting businesses, and enable better communication."

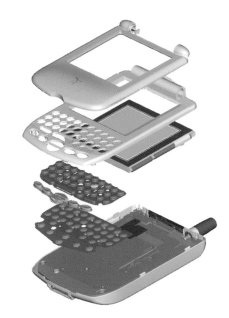

⊘ Right: An exploded view of the Treo 270.

⊘ Bottom right: The Treo 270 has a pen that tucks neatly away in a pocket next to the antenna.

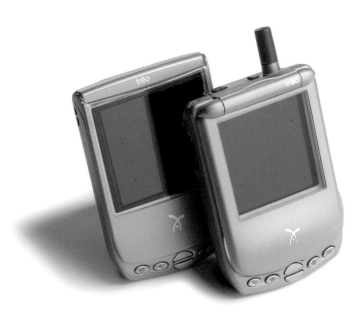

Terabeam 7200 Optical Transceiver—Elliptica If you feel like everything today moves at the speed of light, you may very well be right.

◁ Terabeam 7200 Optical Transceiver—Elliptica

▷ Opposite top left and right: When designers mapped Terabeam's competitive products on axes ranging from "contemporary to outdated" and "extreme to traditional," they could see clearly where they wanted their new product to be. "Although the product can be described as a simple laser, we did not want consumers to be intimidated by having this product in their office," says Brady Olason.

▷ Opposite middle left and right: Designers created mood boards labeled "crisp tech" and "soft tech" to communicate the differences in how the technical product could be portrayed. After discussions with the client, they agreed that the soft-tech approach would set the product apart from its competitors and fit with the brand image created in the second generation of the optical transceiver product.

▷ Opposite bottom left and right: In the concept exploration phase, a team of three designers began sketching concepts for the optical transceiver head and the mounting solution. After about two and a half weeks, designers selected three sketch directions to develop.

The so-called information superhighway connects cities around the world via a high-speed fiber-optic network that provides tremendous bandwidth and enables large amounts of data to be transmitted at extremely high speeds. However, just as car and truck traffic gets heavier and slower as it approaches a city, so does data on the information superhighway.

"Copper wire in the existing infrastructure is slow, and the cost of laying new fiber-optic cable under city streets is high, not to mention the bureaucratic red tape," says Brady Olason, senior designer at Teague, which developed the Terabeam 7200 Optical Transceiver, a revolutionary technology that eliminates the information bottleneck by using lasers to transmit and receive data. Place a Terabeam 7200 near a window, plug it in, align it with another unit in a building across town, and you've established high-speed data link, extending the optical network into the city and providing fiber-optic speed and bandwidth to customers. "The Terabeam system is robust, and it remains unaffected by atmospheric conditions. It can best be described as fiber-optic cable without the cable," says Olason.

The hardware that establishes this high-bandwidth data link is a device called an Elliptica, which is used at both the provider and the customer site. The idea of the system came from Elliptica's predecessor, a successful product "that helped the company secure half a billion dollars in funding, build out networks across the nation, as well as being honored with multiple international design awards. The assignment was simply stated: 'Top this,'" says Olason.

Part of the challenge was making the new device much smaller than its predecessor. The first two iterations, while successful, were large and required a mounting stand, which ate up valuable floor space. The first Terabeam Optical Transceiver was more than 24 inches (61 cm) in diameter and approximately 6 inches (15 cm) thick. The second generation was smaller, but it was still approximately 18 inches (46 cm) in diameter.

Working with Terabeam, Teague's design team dug into their five-phase design process: (1) design research, (2) concept exploration, (3) concept development, (4) concept refinement, and (5) implementation.

During the first phase, designers examined competitive products, creating a visual map of competitors along axes labeled "contemporary to outdated" and "extreme to traditional." "By mapping the products on these axes, we were able to communicate with Terabeam and understand where they saw their new product placed relative to the competitors," says Olason.

At this stage, designers also created mood boards labeled "crisp tech" and "soft tech" to communicate the differences in how the technical product could be portrayed. Crisp-tech products focus on small footprint, sharp details, and a strong materials story,

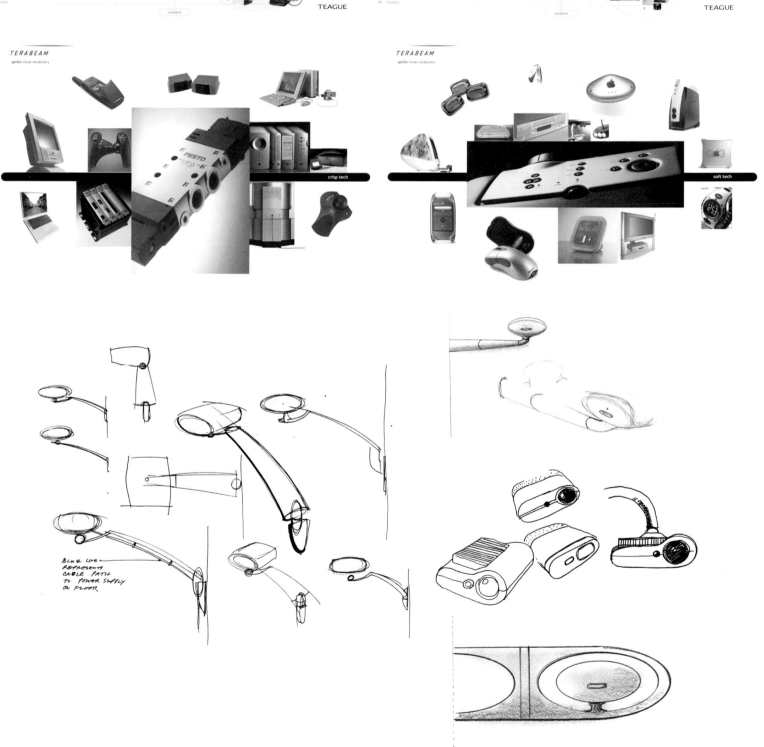

while soft-tech products focus on an integrated form that is broken up graphically with materials and colors to highlight innovation, features, or ergonomics, emphasizing a human aspect that appeals to the end user. The designers ultimately agreed that the soft-tech approach would set Terabeam apart from its competitors and fit with the brand image created in the second generation of the optical transceiver product.

In the concept exploration phase, a team of three designers sketched concepts for the optical transceiver head and the mounting solution. "It was important to understand how we could achieve a high-design look and feel for the mounting solution at a cost-effective price," Olason says. "We researched security cameras to better understand what mounted technology boxes look like. There were concerns that the new product might be perceived as a security camera, and we wanted to understand how to avoid this connotation."

In the next phase, concept development, designers chose three of the sketches and started giving each a visual design while considering the mechanical complexity of the mounting solution. They worked closely with Terabeam so that they would fully understand how the development of the optical assembly would affect packaging size, access for service, and installation and setup of the unit. Ultimately, they presented three CAD models to the client so Terabem could choose the direction for further development.

With the final direction in hand, designers focused on refining the key design details. "At this point, Terabeam had created a detailed database of the optical assembly package, and we were working with their accurate database files to generate all the exterior parts," remembers Olason. "Our goal was to create a detailed CAD model of all critical exterior industrial design elements that would be visible to the end user. We agreed to deliver a shelled CAD file with part breaks and accurate surfacing to their engineering team to use as a starting point for the detailed part design."

Teague consulted on industrial design issues that arose after the files were delivered. When there were problems with mounting location, ventilation, thermal issues, and assembly, Terabeam consulted with Teague to find the best solution.

Throughout the process, designers wrestled with numerous challenges, including ensuring the device could be mounted to a wall or ceiling to achieve any view out the window and that it be adjustable, simple, and cost-effective.

In the end, designers achieve their goals. This third-generation product came in at a reduced-to-package size of 12 x 14 x 12 inches (30 cm x 36 cm x 30 cm)—a fraction of the size of its predecessors—which enabled it to be mounted fairly discreetly.

"Creating a successful technical product requires an intense and intimate collaboration between the design consultant and the client's in-house design team," says Olason. "As individual entities, we can each create strong work, but collaboration produces great work."

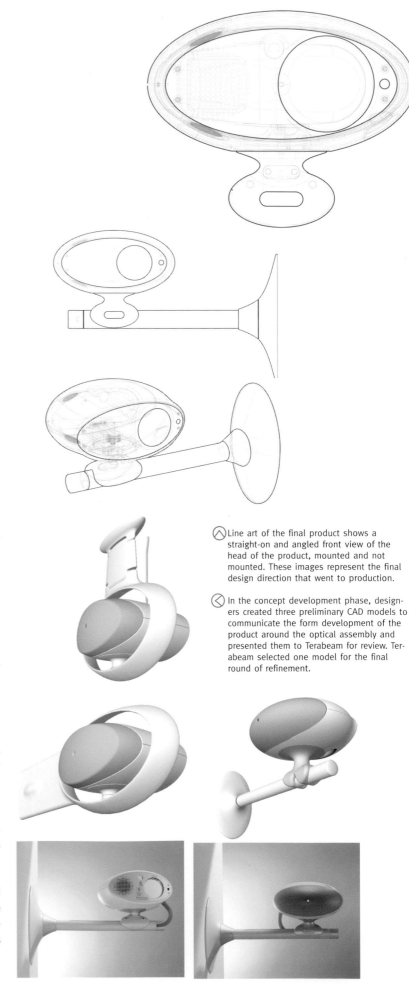

Line art of the final product shows a straight-on and angled front view of the head of the product, mounted and not mounted. These images represent the final design direction that went to production.

In the concept development phase, designers created three preliminary CAD models to communicate the form development of the product around the optical assembly and presented them to Terabeam for review. Terabeam selected one model for the final round of refinement.

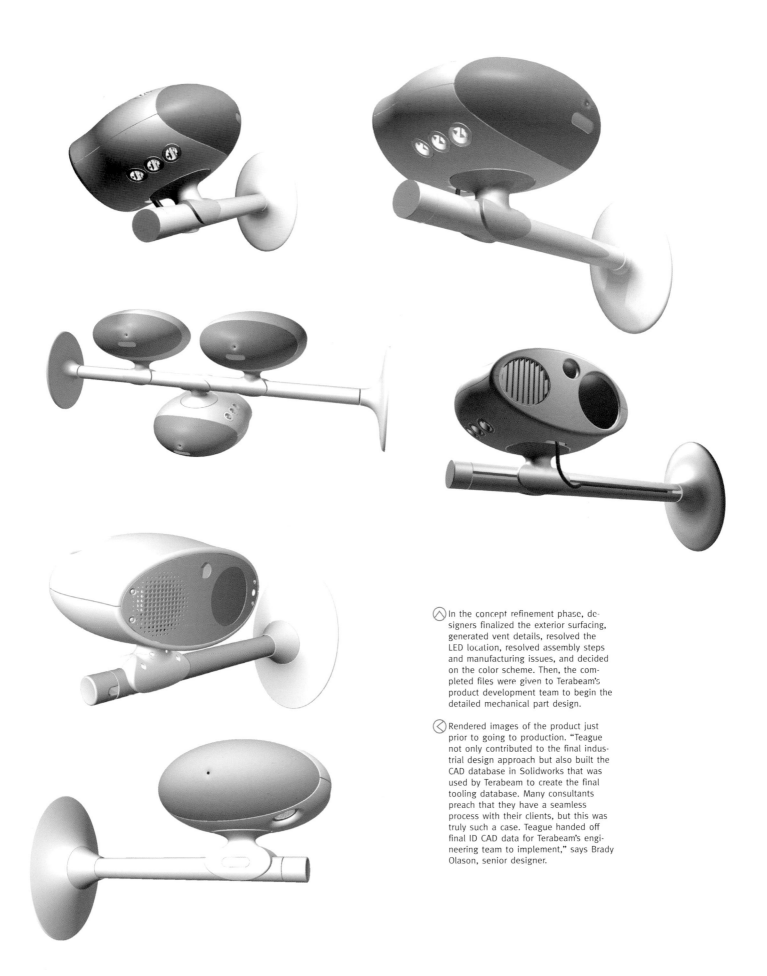

In the concept refinement phase, designers finalized the exterior surfacing, generated vent details, resolved the LED location, resolved assembly steps and manufacturing issues, and decided on the color scheme. Then, the completed files were given to Terabeam's product development team to begin the detailed mechanical part design.

Rendered images of the product just prior to going to production. "Teague not only contributed to the final industrial design approach but also built the CAD database in Solidworks that was used by Terabeam to create the final tooling database. Many consultants preach that they have a seamless process with their clients, but this was truly such a case. Teague handed off final ID CAD data for Terabeam's engineering team to implement," says Brady Olason, senior designer.

The **Logitech** Pocket Digital Camera's compact **size** is its **best asset**. Half the battle in **photography** is being at the **right place** at the right **time** with a camera.

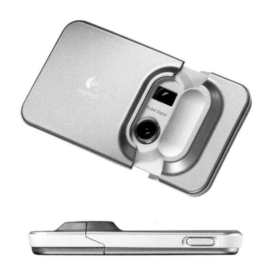

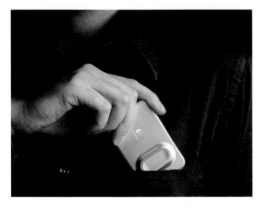

This battle is frequently lost, though, because even "portable" cameras are often too big to fit in a pocket or small purse—meaning most of us are caught without a camera when the right time comes.

Likewise, half the battle of product design is coming up with the right product at the right time. When Logitech saw SMaL's ultra-slim photo technology at the International Consumer Electronics Show in 2001, they knew the time was right for an inexpensive, point-and-shoot digital camera that people could carry everywhere. Though SMaL had presented their own camera using this technology and Fuji had already licensed the technology, Logitech thought they could produce a sleeker, more sophisticated product than SMaL's camera and beat Fuji to market, so Logitech licensed the technology and asked IDEO to develop the camera.

Because they knew they would be using the same technology as their competitors, Logitech identified design as their leverage on the product. According to Rico Zörkendörfer, IDEO's project manager and designer of the camera, "One reason they gave me so much freedom is because they said that this is something that has to be completely driven by design and if people don't look at it and say this is something I want to have, then we've failed." Because the team had only six weeks to produce a final design, only four designs were presented, and none of the designs were user-tested during the product development phase. Zörkendörfer and IDEO had worked with Logitech before, so the client trusted them with this streamlined design process.

"From the get-go, Logitech wanted to highlight the thinness of the camera," says Zörkendörfer. As a result, the team immediately chose aluminum as their material of choice because of its thinness and durability, and it had the same sleek, polished look as their design inspiration for the camera—metal credit card holders. Early on, the team decided that to keep costs down and to preserve the simplicity of the camera, it would not feature a LCD screen, a feature included on most digital cameras. While Zörkendörfer originally hesitated about this, he points out, "Before we had digital cameras, that's how we took pictures—we didn't have a chance to review them."

"The original thought was that we'd create something that was completely flat when it was off and had a lens pop out when turned on. That lens mechanism was where we put most of our effort," says Zörkendörfer. Getting the lens mechanism correct was especially crucial because the distance had to be constant between the lens and the chip in the back that would record the image; if the distance were slightly off, then picture quality would suffer.

Concept A

Key features
Lens and viewfinder are fully protected when camera is not in use
Approx. thickness 9 - 10 mm when closed
Push/push mechanism exposes viewfinder/lens mount
Outer camera metal housing is extruded and machined

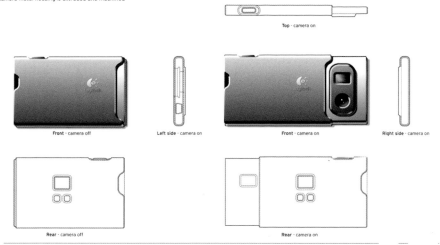

Top · camera on

Front · camera off Left side · camera on Front · camera on Right side · camera on

Rear · camera off Rear · camera on

Concept B

Key features
Lens and front viewfinder are fully protected when camera is not in use
Approx. thickness 8.5 - 9 mm when closed
One motion sliding door exposes and extends viewfinder/lens mount
Outer camera metal housings are stamped and mounted to a center plastic frame
Stamped grip feature

Front · camera off

Top · camera on

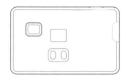

Rear Left side · camera off 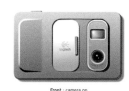 Right side · camera on

Front · camera on

Bottom · camera on

Concept C

Key features
Lens and viewfinder are fully protected when camera is not in use
Sliding door exposes fixed viewfinder and lens
Approx. thickness 11 mm with fixed lens and viewfinder
Outer camera metal housings are stamped and mounted to a center plastic or metal frame

Top · camera on

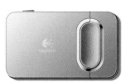 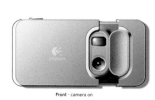

Front · camera off Left side · camera on Front · camera on Right side · camera on

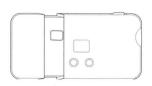

Rear · camera off Rear · camera on

While the flat designs were aesthetically pleasing and emphasized the thinness of the camera, cost and time restraints precluded the development of the retractable lens shown at the top and center. The initial design concept on the bottom—the only one with a lens that did not retract—was ultimately chosen for refinement.

Only one of the original concepts featured a lens that didn't retract, so that design was chosen for refinement because, given the short time frame, it would be the easiest to produce quickly, inexpensively, and successfully. There were aesthetic advantages to this choice too, according to Zörkendörfer: "Given that the form was so radically new compared to what was out there, I wanted to have something that had some elements that picked up on traditional camera features, and I thought the bump in the front with the integrated grip is reminiscent of older cameras that had a sliding mechanism."

After the design was chosen, refinement came mostly in the form of "tons of work that went into noodling, getting the thickness right—literally, we're talking about half a millimeter here and there, making sure everything fit inside," remembers Zörkendörfer. Foam models were created to make sure the measurements were accurate as well as to get a sense of how well the user interface worked on this small scale.

The designer originally planned for some areas, such as the grip area in front of the lens and the inserts, to be polished aluminum. "We wanted to put highlights on the camera, especially around the lens," says Zörkendörfer. "It turned out, though, that in production, it was really hard to do. The samples weren't turning out like we wanted, so we went with a somewhat untouched finish— the standard anodized aluminum finish." The final product was made of stamped brushed-aluminum sheet bonded to an injection-molded polycarbonate frame.

According to IDEO, the product launch was well-timed—the Logitech Digital Camera kicked off the compact digital camera subcategory before mainstream camera makers developed their own models. The novelty of the item gained Logitech entry into press outlets usually closed to technology firms, such as ads in fashion magazines, gift bags for award shows and celebrity sporting events, and plugs on the TV entertainment program *Extra*—entry Logitech hopes to exploit with future products.

Zörkendörfer expresses satisfaction with the project. Because of the short design cycle, he says, "The original design intent wasn't diluted at all." He likes the product so much, in fact, he carries one with him every day. "It's a piece of technology that completely disappears on your body," he says. "I have some really great, surprising pictures that I normally wouldn't have had because I wouldn't have brought a camera. It becomes like your wallet; you carry it around all the time, and that's the beauty of it."

> ⊗ Since the camera was so small, the scale and placement of all the features in relationship to one another was crucial. Many iterations, and a number of foam models, were created to get a sense of how these details would work on such a small scale. However, the demands of the photo technology restricted Zörkendörfer's freedom when designing the interface.

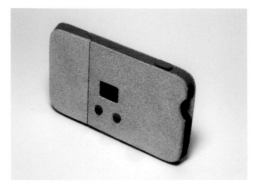

Rear—camera off

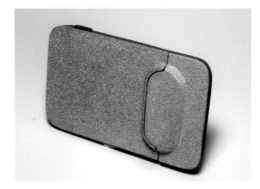

Front—camera off

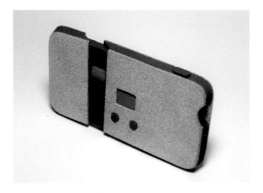

Rear—camera on

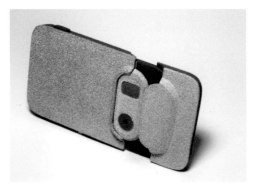

Front—camera on

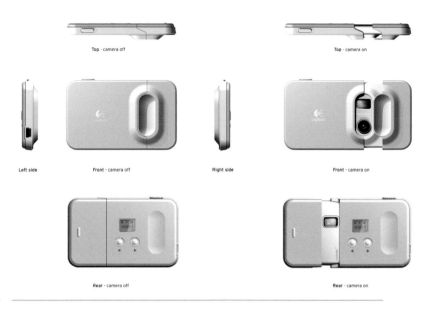

Top · camera off

Top · camera on

Left side

Front · camera off

Right side

Front · camera on

Rear · camera off

Rear · camera on

1

⊘ Top and middle: In this refined version of one of the original concepts, the bump for the lens became wider and details such as the buttons and the grip feature were refined. This design also reflects later decisions made by the team, such as the decision to exclude an external memory card. The team decided that the 52 images on the camera's internal memory was sufficient.

Refined Camera ID layout

Closed Configuration

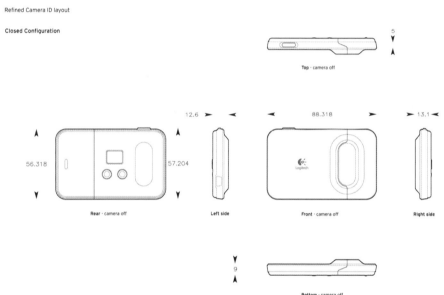

5

Top · camera off

12.6 88.318 13.1

56.318 57.204

Rear · camera off

Left side

Front · camera off

Right side

9

Bottom · camera off

Color/Finish Proposal

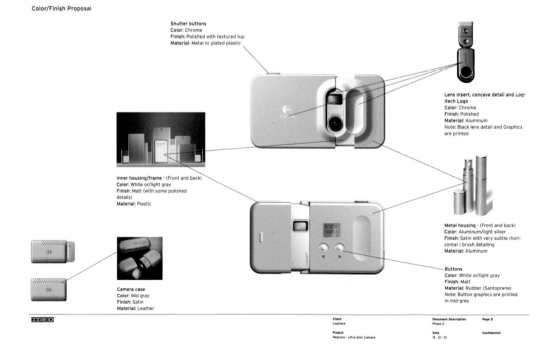

Shutter buttons
Color: Chrome
Finish: Polished with textured top
Material: Metal or plated plastic

Lens insert, concave detail and Logitech Logo
Color: Chrome
Finish: Polished
Material: Aluminum
Note: Black lens detail and Graphics are printed

Inner housing/frame · (Front and back)
Color: White or/light gray
Finish: Matt (with some polished details)
Material: Plastic

Metal housing · (Front and back)
Color: Aluminum/light silver
Finish: Satin with very subtle (horizontal) brush detailing
Material: Aluminum

Buttons
Color: White or/light gray
Finish: Matt
Material: Rubber (Santoprene)
Note: Button graphics are printed in mid-grey

Camera case
Color: Mid gray
Finish: Satin
Material: Leather

IDEO

Client	Document Description	Page 8
Logitech	Phase 2	
Project	Date	Confidential
Neptune · Ultra-Slim Camera	12 . 21 . 01	

⊘ While this original color and finish proposal reveals that the team considered developing a leather case for the camera, they ended up rejecting the idea because of cost constraints. Zörkendörfer says it probably wasn't necessary anyway: "The clever lens mechanism hides all the internals, so as long as you don't care too much about small scratches on the camera, then it's perfectly fine."

Motorola NFL Headset, Generation II When **Motorola** first became sponsors of the **National Football League** (NFL) in 1999, they asked Herbst LaZar Bell (HLB)—a **product design** firm they had **worked** with since the 1970s—to design a headset for the **head coaches** that featured the **Motorola** logo.

Though other venues have wanted to purchase it, the Motorola NFL headset is exclusive to the NFL; only 1800 units are produced per year. The headset can be manufactured in single or dual ear-cup configurations; the single ear-cup configuration can be worn on the right or left side.

The first generation had to be done within a very short period, so HLB didn't have time to refashion the headset from the ground up, and the headset they ended up with for that season was fairly traditional. When the following season rolled around, Motorola decided that they were missing an opportunity: Coaches are highly visible to millions of fans every week. Moreover, their status as team commander-in-chief carries a cachet that is hard to beat. "How could you have a more positive product placement than a commander marshalling his army down the field using technology to succeed?" asks Mark Dziersk, vice president, design at HLB. Motorola asked HLB to create a new version of the headset that made the most of this visibility by prominently featuring their logo on a new, higher-tech headset.

The team at HLB faced a long list of requirements for the headset: It had to feature the logo in a way that would cut through the clutter of the competing visuals of the TV sports environment and that would be easy to read from a variety of camera angles. Visually, the headset had to reference Motorola's consumer line. As Howard Kavinsky, director of corporate design strategy for HLB, says, "Ultimately, the goal was for consumers to see these products on the heads of head coaches and link them to [Motorola's] consumer products, so that consumers who see the headset on TV and then walk into a retail establishment and see a product that's similar will buy it." The headsets also had to work for their toughest clients—the coaches themselves.

The HLB team was already aware of some of what the coaches would require. They knew the headset had to be sturdy enough to survive what they called "the Ditka test"—referring to Coach Mike Ditka's habit of tearing off his headset and slamming it on the ground. The headset also had to make the coaches look good. And since they would be wearing the headsets for over three hours at a stretch, comfort was key.

HLB began by brainstorming a number of concept sketches and then narrowing their ideas to a group of more refined concepts. These concepts were presented one on one to the coaches during a meeting in Atlanta, where HLB discovered that the coaches preferred a rugged design to a futuristic or sleek design. "With any technology, you have to be careful about how you move people forward, and in this case they were extremely particular about how advanced-looking this was going to be," says Dziersk. While many of the concepts HLB presented featured a yoke that wrapped around the back of the head—allowing one more placement of the Motorola logo—the coaches felt the configuration

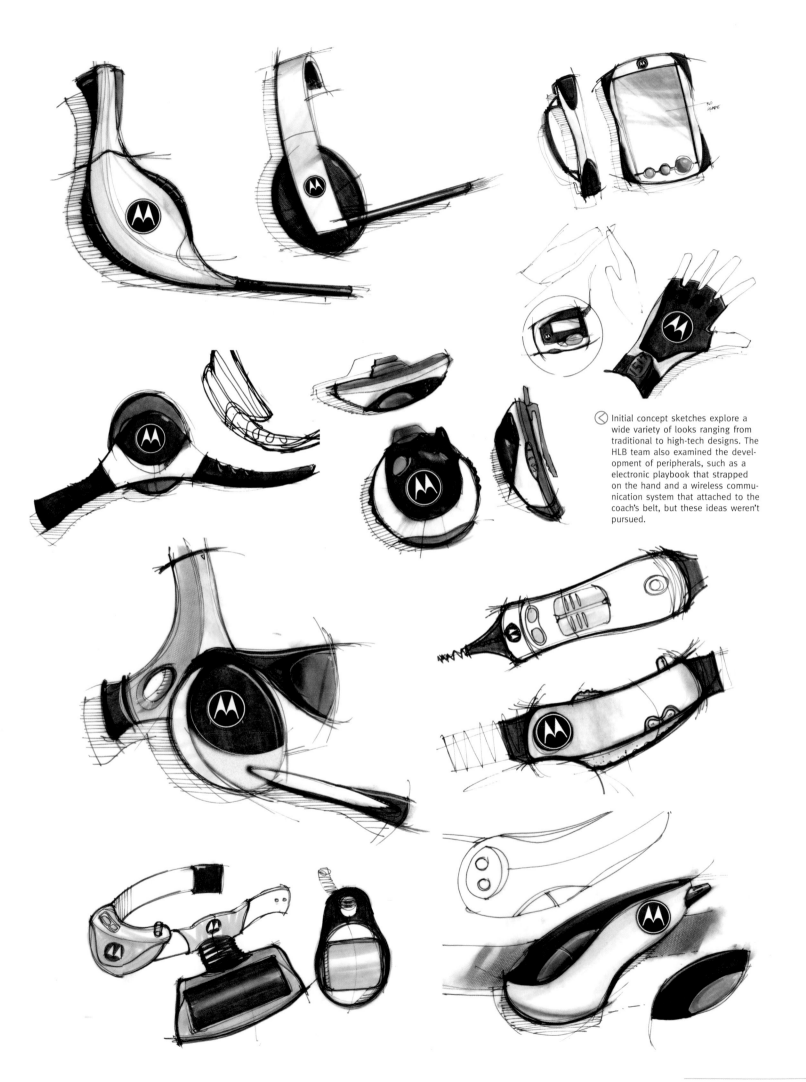

Initial concept sketches explore a wide variety of looks ranging from traditional to high-tech designs. The HLB team also examined the development of peripherals, such as a electronic playbook that strapped on the hand and a wireless communication system that attached to the coach's belt, but these ideas weren't pursued.

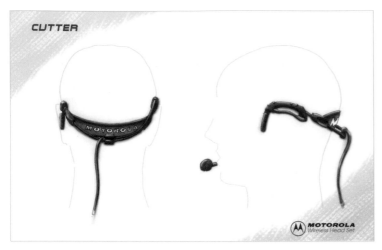

CUTTER

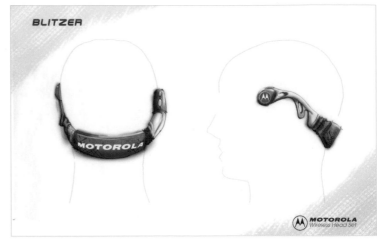

BLITZER

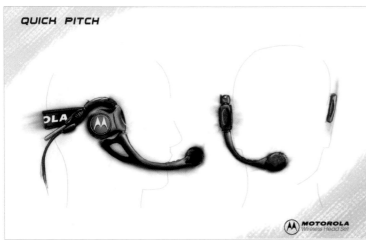

QUICK PITCH

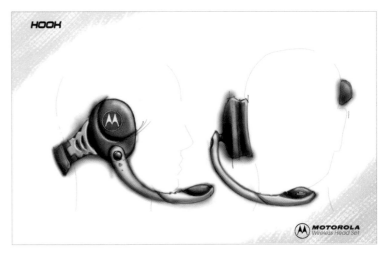

FLANKER

More refined concept sketches were presented to the coaches. The team explored a number of variations on a configuration where the yoke of the headset wrapped around the back of the head rather than the top, to allow for one more logo placement. The coaches expressed concern about the security of the headset in that configuration, especially when hats or sunglasses were removed. The style of some of these early concepts was considered too futuristic and not rugged enough by the coaches.

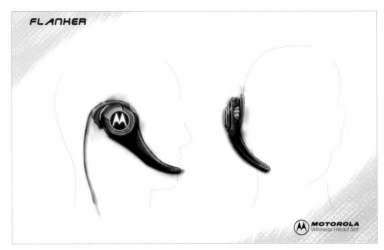

HOOK

A wide variety of shapes and colors were contemplated for the ear-cup. The HLB design team worked to find a shape that felt comfortable and blocked out noise well. A larger version of the ear-cup ended up working better for these purposes; to counteract the cup's size and to make it less visible, the designers chose to make it black.

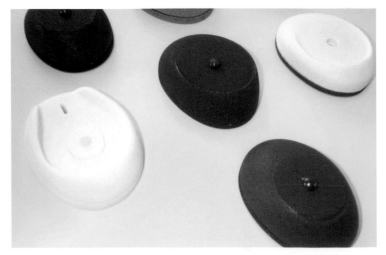

would not be secure. The coaches also wanted a large mouthpiece, to prevent the other coaches from lipreading when they were calling a play.

The team at HLB also did qualitative research centering around the impressions and opinions of the fans themselves. Fans were asked for their comments on the look of the previous headset, on Motorola, and on their game-viewing experiences.

All of this research informed the CAD and foam modeling that followed. Using the first generation of the headset as a starting point—as research had shown that it would serve both coaches and fans better not to go too far with the second generation—the designers looked for ways to improve both aesthetics and functionality. To prevent lipreading and to take into account the fact that coaches might remove their headsets up to 100 times during a game (almost always grabbing the headset by the boom), the designers made the new boom more substantial. The mouthpiece was overmolded with Sandoprene TPE to give it a tactile grip. The microphone boom was coated with elastomer, which is easy to bend and twist, allowing the coaches to adjust the placement of the microphone. Using automotive and high-end consumer products as their inspiration, HLB added a metallicized finish to the polycarbonate yoke of the headset; this finish—similar to that used in some of Motorola's phones—imparts a sense of quality and sophistication and ensures that the headset looks good on television.

The first generation of the headset had attached the boom to a conventional set of headphones. The redesign more seamlessly integrated the boom with the rest of the headset, attaching the boom to the yoke instead of to the ear-cup. Both the yoke and the boom are metallicized, creating a sweep from the yoke to the microphone and giving the headset a streamlined look.

The ergonomics of the headset were carefully examined. For comfort, removable foam temple supports were added to the yoke. The headset was designed to rise from the top of the wearer's head, allowing air to flow and reducing pressure on the top of the head. When it turned out that a larger version of the ear-cup would be more ergonomic, the designers specified that it be black, to call less attention to it.

Research had shown that, while some of the coaches preferred a dual ear-cup version, others preferred a single ear-cup configuration, so the headset was designed for easy manufacture of either. For maximum flexibility for the coaches as well as ease of inventory for the teams, the single-cup version of the headset was designed to be reversible, allowing the coach to position the ear-cup on either side. This feature meant that the mouthpiece had to have two logos on it to ensure visibility in either configuration; the designers had to carefully scrutinize the logo placement to ensure that both logos wouldn't be visible at the same time. The pivot mechanism of the boom also required extra thought: a full 360-degree rotation, done several times, would damage the wires, so a mechanical stop prevents the full rotation.

Did HLB's efforts pay off? Dziersk thinks so, and the proof is in the recognizability of the headset. "We've been making products for forty-two years, and especially with men, when you mention that product, everybody knows what it is." Kavinsky calls the campaign "one of the most successful invisible Motorola marketing campaigns that the company has launched." The headset will continue to be featured weekly before millions of fans for the length of Motorola's sponsorship. The headset has even gone on to pass a real-life Ditka test: it still worked after Coach Ditka threw the headset down in frustration during a game—perhaps the ultimate testament to the product.

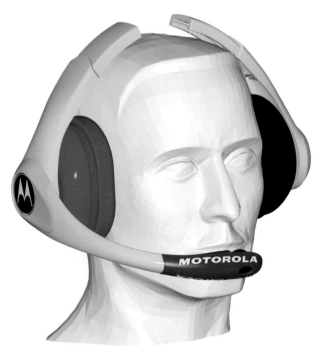

Three-dimensional CAD modeling of a human head was used to help the designers visualize the interaction of the ear-cups and microphone as well as the fit of the headset.

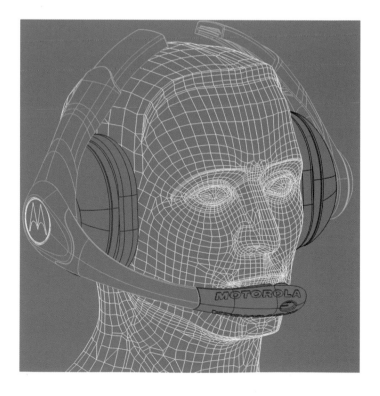

Maxim Sport Safety Eye Gear Eyewear makes a **big fashion** statement, and the same is true of protective **eye gear**. There is no need to wear bulky, **uncomfortable** goggles when **instead** you can wear Maxim Sport **Safety Eye Gear**.

These glasses are a part of the Maxim series of safety eyewear developed by Insight Product Development LLC for the Aearo Company. The product line shares parts, such as the lens, to reduce production costs while still providing different looks, adjustability, and comfort features from model to model.

The market called for this product. "The need for companies to encourage their employees to wear safety gear has sparked on-going development in the safety eyewear business. Current safety eyewear designs aim to increase a user's comfort," says James McGee, industrial designer, Insight Product Development. "As a general rule, if comfort increases, users are less bothered and less likely to remove their safety gear, thus increasing compliance. Durability is also important; the longer the eyewear stays usable, the less pairs per employee the company will have to purchase over time. Safety eyewear must meet these needs while appearing to be comfortable, durable, and safe. Often the purchase of safety eyewear is made on appearance alone."

When Aearo sought Insight's help to develop a family of eyewear with shared parts that explored a range of features and styles, the primary challenge was to achieve the goals within the stated budget. "In the world of safety eyewear, cost reigns supreme. The benefit of each aspect or feature added to a pair of safety glasses is measured against its cost," says McGee. "Development and production costs are compared with an added feature's ability to improve compliance, comfort, durability, safety, and sales. Adjustability and aesthetics are weighed against part or piece count. Creating eyewear with less adjustment yet achieving a level of comfort similar or superior to other products in the Maxim series was a big challenge."

⊽ The Maxim Sport brings together a variety of features to create a functional, affordable, and stylish pair of safety eyewear. The glasses are both comfortable and sporty in appearance, which helps increase user compliance. In addition, the eyewear meets and exceeds safety standards while being reasonably priced.

A E A R O C O M P A N Y I N S I G H T P R O D U C T D E V E L O P E M T

A O S A F E T Y M A X I M™ S P O R T

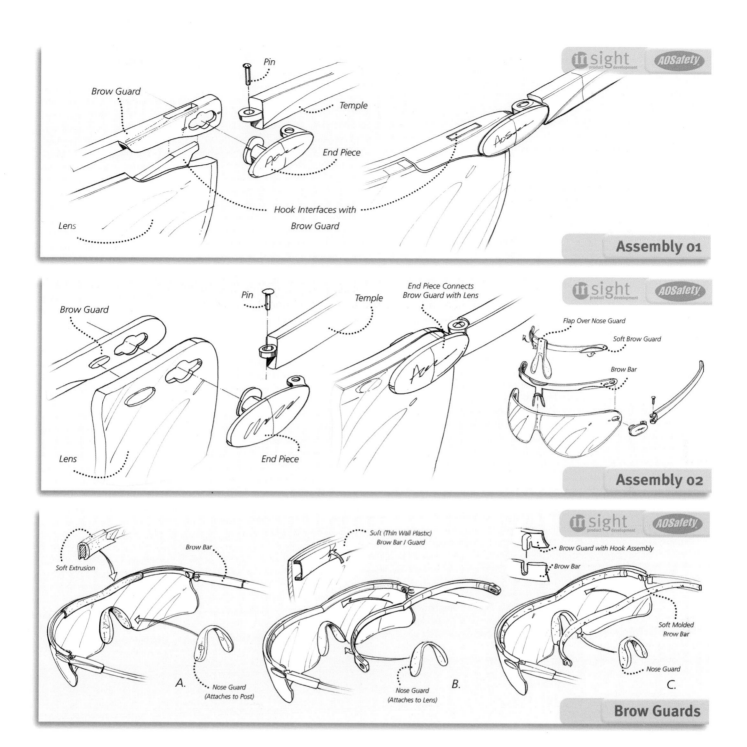

Assembly 01

Pin
Brow Guard
Temple
End Piece
Hook Interfaces with Brow Guard
Lens

Assembly 02

Pin
Temple
End Piece Connects Brow Guard with Lens
Brow Guard
Lens
End Piece
Flap Over Nose Guard
Soft Brow Guard
Brow Bar

Brow Guards

Soft Extrusion
Brow Bar
A.
Nose Guard (Attaches to Post)

Soft (Thin Wall Plastic) Brow Bar / Guard
B.
Nose Guard (Attaches to Lens)

Brow Guard with Hook Assembly
Brow Bar
Soft Molded Brow Bar
Nose Guard
C.

concept a

SPORT

Ballistic

Early on, the Insight team created rapid prototypes to evaluate and tweak every curve, tangent line, and surface to minimize stress and friction points and improve overall fit and feel. They tackled the project by leveraging previous research and brainstorming experiences with Aearo to help form a list of features that could potentially add value to a new series of eyewear. Next, the design team explored three concepts for the line—a traditional look, an athletic-inspired look, and a rugged style. "Even at this early stage, the team worked closely with Aearo and our own engineers to conceptualize how these concepts could be made," remembers McGee.

⬦ Even though the concepts were in the early stages of design, members of Insight and Aearo's product team worked out the details of manufacturing them.

⬦ Designers explored three concepts for the new line: a traditional look, an athletic-inspired look, and a rugged look.

Soon, concepts turned into something much more concrete, an actual product they named the Maxim Sport. While most of the Insight designers' work on this product seems quite tight from even the earliest concepts, they typically begin with loose sketches and quickly move into 2-D CAD and PhotoShop. With this completed, they presented the client with concepts for a range of looks. "The end of this phase resulted in a concept development presentation in which we showed a variety of possible looks. During the presentation the design team discussed the pros and cons of particular concepts based on aesthetics and manufacturing," McGee says. "With this information, Insight and the client decided which direction to pursue."

Aearo chose to go with concept two, which featured two-tone materials that made the eyewear look a little more expensive than average safety glasses. "They found the form athletic-looking but not too aggressive to dissuade older demographics," says McGee. With the client's decision in hand, Insight began refining the design, taking into account the concerns and feedback they received from Aearo's marketing and engineering people.

Their chief concern: making the Maxim Sport visually distinct from other Maxim products. As the designers refined the design, they tweaked the concept and decided to put the nosepiece in front of the lens, creating a two-lens appearance instead of the traditional monolens commonly seen in most inexpensive safety eyewear.

Once Aearo approved this modification, it was time to build prototypes so they could see the product in three dimensions. "During this phase, it was key to constantly reference human factors and safety specifications. This was a highly iterative process," recalls McGee. "Insight produced prototypes and then tested them

out. The team evaluated each one on fit and finish, while Aearo ran a variety of tests and offered their own engineering, marketing, and production concerns. We made adjustments and repeated the process."

Next, Insight's engineers and designers worked closely with Aearo to create robust 3-D geometry that met all production concerns while maintaining design intent. Finally, everything was as it should be.

In the end, the Maxim Sport design brings together a variety of features to create a functional, affordable, and stylish pair of safety eyewear. Its electrometric browguard and temple accents provide comfort and impact absorption while creating a color and texture break. The nose section provides a visual break, creating a two-piece lens appearance while serving as a mount for the universal-fit nosebridge. The wraparound temple pieces grip the head firmly without needing mechanical adjustment. The patented lightweight dual-aspheric plano lens reduces visual distortion. "The sum of these elements establishes a comfortable feeling and athletic inspired eye gear that helps increase user compliance and meets and exceeds safety standards while maintaining a reasonable price point," says McGee.

"Sometimes, it's one great big idea that gets you a good design. Sometimes, it's the sum of many well-implemented small ideas that gets you a good design," he adds. "The Maxim Sport is the result of a big goal supported by lots of small ideas. Every little detail was painstakingly revisited and refined by consultant and client, researcher, designer, and engineer to turn out a well-designed, well-engineered, and well-executed product. Its success is in the details."

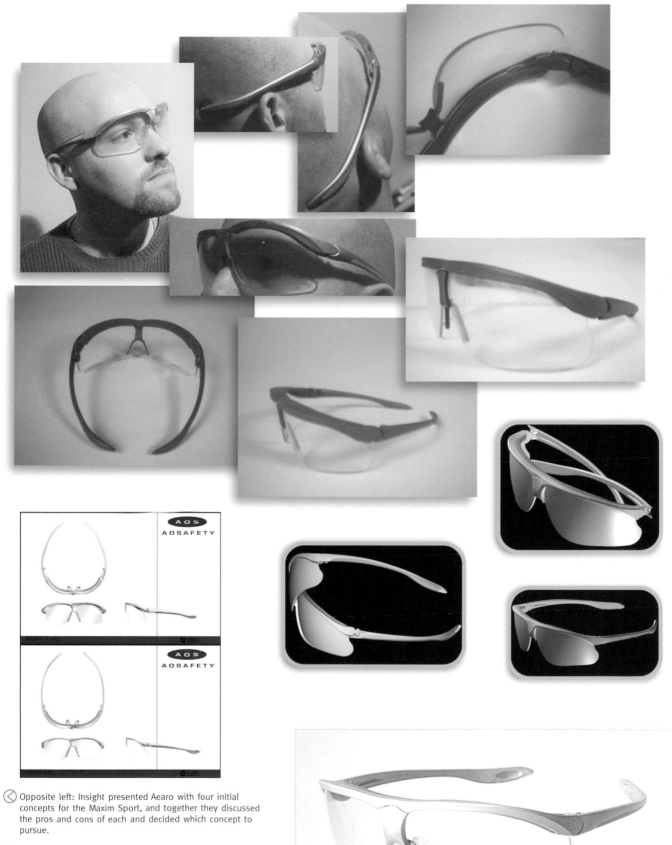

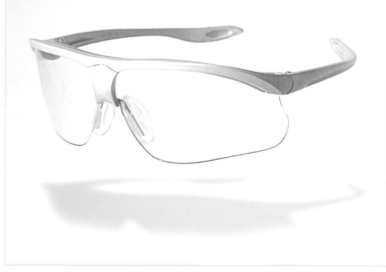

Opposite left: Insight presented Aearo with four initial concepts for the Maxim Sport, and together they discussed the pros and cons of each and decided which concept to pursue.

Opposite right: To set the Maxim Sport apart visually from other Maxim products, designers chose to place the nosepiece in front of the lens, creating a two-lens appearance that departs from the traditional monolens commonly seen in inexpensive safety eyewear.

Top: Insight's designers build several prototypes, each of which was tested thoroughly by Insight and Aearo, resulting in adjustments that were made before the process was repeated yet again.

Above and right: With the prototype finalized, Insight's engineers and designers worked with Aearo to create 3-D geometry that met all production concerns while remaining true to the original design.

CDI Dial Torque Wrench Why **redesign** a product when the **current version** of the product has **80 percent** of the **North American** market?

CDI's dial torque wrench, shown in their company's color, light blue; models distributed by CDI's clients are made in the clients' colors instead.

The previous dial torque wrench, designed in house at CDI 30 years ago. Its uncomfortable handle and passé look made it overdue for an update.

That was the question when Consolidated Devices Incorporated, a subsidiary of Snap-on Tools, approached Tor Petterson Associates (TPA) and asked them to redesign their CDI dial torque wrench.

Despite the success of the product, a specialized industrial tool used in precision assembly and in inspections where breakaway torque is measured, customers had been complaining about the grip for years. "It didn't have any sort of comfortable grip at all; it was just kind of a square block," says Charles Davis, principal and managing director of TPA. Moreover, both the client—who had designed the product in house 30 years earlier—and its customers felt that the design needed to be updated for today's market. Finally, the product in its original form was expensive to produce, relying as it did on technologies such as aluminum castings and flat plate stamping that require extensive machining and finishing.

Spurred by these factors, CDI reviewed competitors' products and discovered that most of them were also overdue for a design update, and they realized that a redesign would help them keep their place as a market leader. CDI's further research with its customers revealed additional functional requirements for the redesign, such as protection for the dial and head and high measurement accuracy.

Armed with this set of requirements, the design team at TPA started to brainstorm the look and construction of the wrench. Some early concepts had the feel of a precision instrument, while others had the rugged appearance of a tool. A design that found a happy medium between these two extremes ended up being chosen by the client. However, as Davis says, "They still weren't happy with the handle designs. We explored several directions on different grips, because that was something they really wanted to pay attention to."

At this stage, construction of the wrench was still being debated. "We were playing with covering the entire unit in plastic versus exposing metal, bending the metal, in order to get the ears to protect the dial," says Davis.

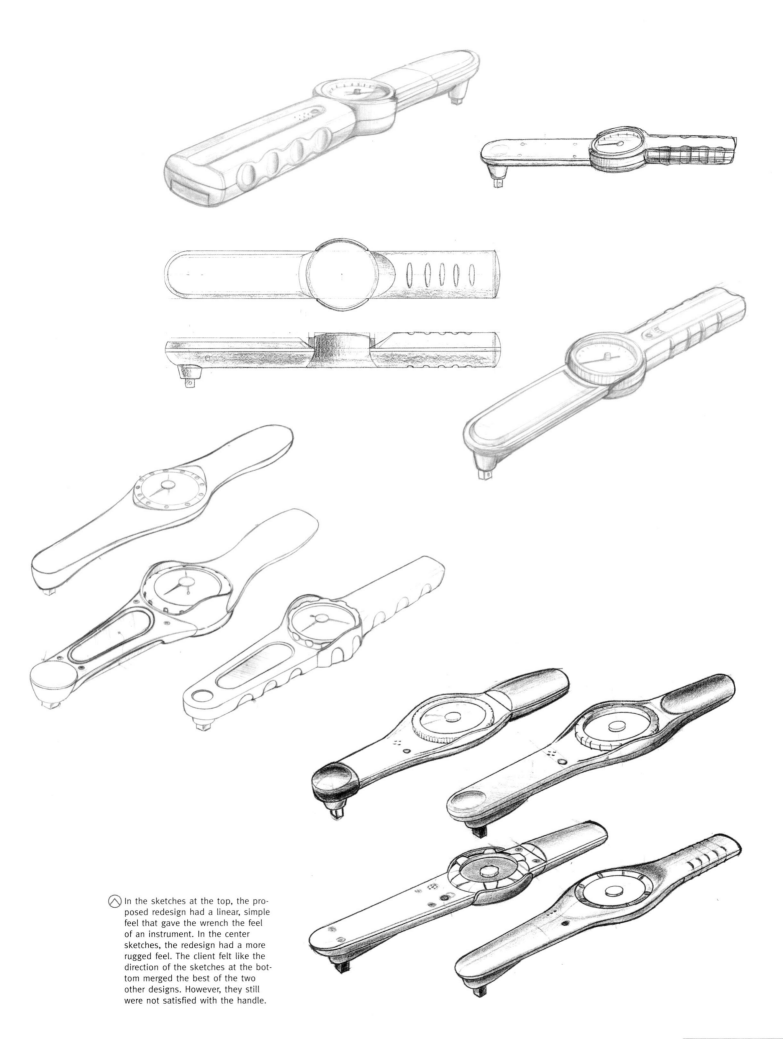

In the sketches at the top, the proposed redesign had a linear, simple feel that gave the wrench the feel of an instrument. In the center sketches, the redesign had a more rugged feel. The client felt like the direction of the sketches at the bottom merged the best of the two other designs. However, they still were not satisfied with the handle.

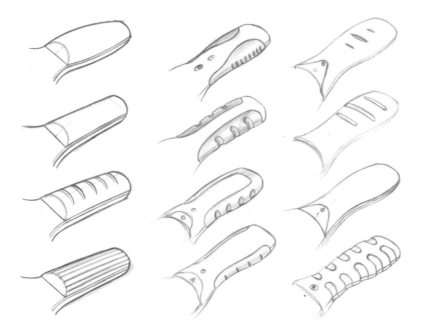

One thing was certain: Whatever material was chosen, it had to be very strong and stiff to avoid affecting the tool's measurements. "It was interesting for me to learn how sensitive a little dial like this would be to the up-and-down flexing of the housing and how, if you crank on this thing, you're not really putting true linear force to it because of the way it goes at an angle," says Davis. "So we spent a lot of time doing structural analysis, just to make it stiff enough so that it wouldn't throw off the accuracy."

The concept of an impact-modified polycarbonate housing and a press-formed steel skeleton—bent into an upside-down U-shaped channel for structural integrity—won out for a variety of reasons. First, it was less expensive to produce than the aluminum casting and chrome-plated steel that had originally been contemplated, but it still provided the stiffness needed to ensure that the tool's measurements were accurate. The plastic exterior allowed for comfortable handling of the tool; it also made it possible for CDI to produce the wrench in the colors of their customers, expanding the market for private brand sales. Says Davis, "It was really an important sales tool, to be able to show them that it looks like their wrench already. It allows CDI to sell a lot more product than they could if the wrenches were just black and silver."

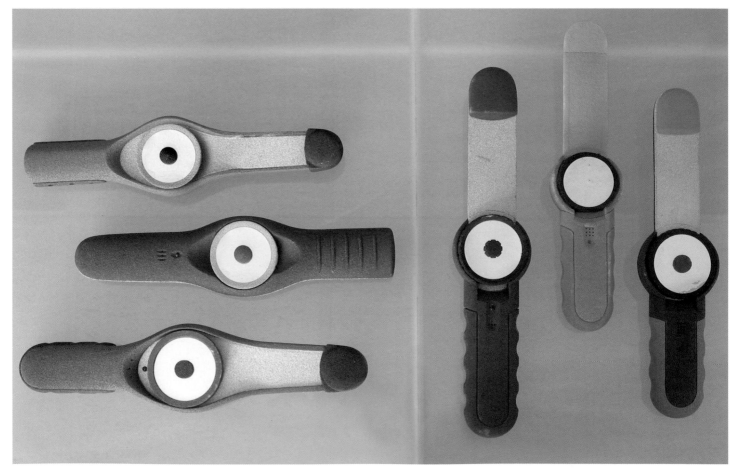

⊗ Top: These sketches show the further development of the handle that was requested by the client.

⊗ Above: When CDI was presented with these foam models of the wrench, they preferred the look of the model on the left, but they preferred the handles on the right. "It was an unusual design process because we went in so many directions and then merged a couple of them," says Davis. "The final result was better than either of the two originals."

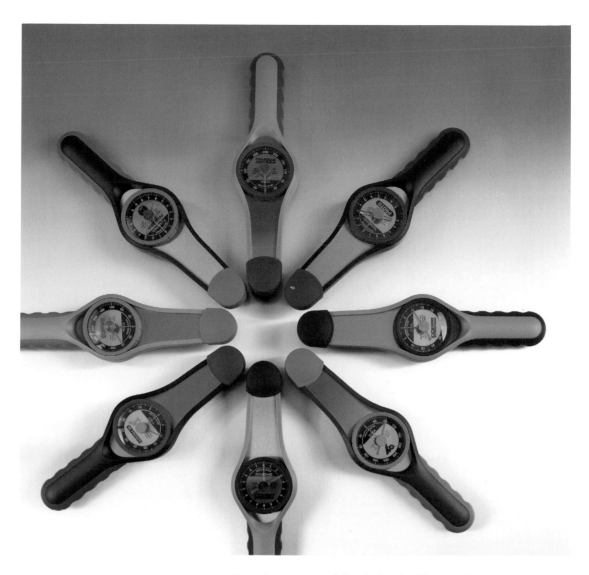

Once the concept of the design had been defined, TPA created a 3-D SolidWorks model of it and made stereolithographed models from the 3-D data. Several prototypes were then created out of silicone molds; these prototypes were cast in a variety of client colors, which were then shown to (and heartily approved by) CDI's customers.

While it would have been difficult for CDI to increase its North American market share by very much, its redesigned product was able to create new markets for CDI. The increase in private sales that resulted from the redesign helped CDI increase its world market share from 30 percent to 50 percent while reducing manufacturing costs and satisfying the needs of its customers—proving that even for products that dominate their niche, there's always room for improvement.

In this CAD rendering, the details of the assembly have been refined.

Instead of using testing and focus groups to judge whether the wrench would be a success, CDI took prototypes like these out to customers, who had driven the redesign in the first place. The customers responded favorably, giving CDI the confidence to go ahead with production of the redesign.

John Deere Spin-Steer Technology Lawn Tractor For many people, **mowing** the lawn is a **time-consuming** chore; even if you own a **tractor**, the lack of maneuverability

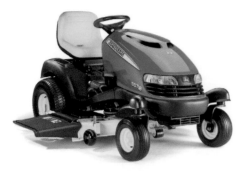

The John-Deere Spin-Steer Technology Lawn Tractor is the first tractor to combine the maneuverability of a zero-turn-radius tractor with the look and feel of a lawn tractor.

of the traditional consumer models means that you'll have to go back and trim the edges after you're done. But what if you could marry the usability of a traditional lawn tractor with the maneuverability of a professional-grade, zero-turn-radius (ZTR) tractor?

That's just what John Deere did with its Spin-Steer Technology Lawn Tractor—a tractor that aims to make lawn care more fun and less time-consuming than ever before.

John Deere worked closely with Henry Dreyfuss Associates (HDA), an industrial design firm with whom they have a long relationship, to consider how this new breed of tractor would fit visually into the John Deere heritage. William Crookes, partner at HDA, describes one of the biggest issues they faced: "How close does this have to be to the traditional agricultural or lawn and garden product in appearance? The function of the vehicle is identical, but the operation is considerably different, so what you want to do is create a design that conveys that notion but is still in the family of John Deere tractors."

To achieve this, the designers began by looking at the concept from a consumer's point of view. They test-drove lawn tractors and traditional ZTR mowers and quickly agreed on one point: This model would have to have a steering wheel. Crookes observes, "You'll notice that quite a number of the commercial operators have lever-operated configurations, and users have the time to spend to learn how to use it, but if you were to just jump on the seat and go out and mow, you'd find yourself a little frustrated."

Adding a steering wheel had a ripple effect on the rest of the design, starting with the transmission. ZTR mowers are propelled by two separate motor systems, one for each side of the vehicle. These units, since they operate separately and at different efficiencies, can be difficult to operate in a straight line or tight turn situation, and the steering wheel—by taking away the refinements of operation possible with the lever controls traditional for ZTR mowers—would compound the problem. John Deere worked with their transmission supplier to develop a new drive system where both systems were contained in one case.

The steering wheel would signal to consumers that this tractor would operate like their car, but that wasn't the case; when reversing a ZTR tractor, turning the wheel to the left means the front—not the rear—of the machine goes to the left. The team felt that confounding the consumer's expectations of how the mower would work would undermine their goal of designing a user-friendly vehicle. They developed a reverse logic system that automatically switches the steering to react as a consumer expects it will. Since this would head off possible operator mistakes that could have resulted from standard ZTR operation, it was also a built-in safety feature of the tractor.

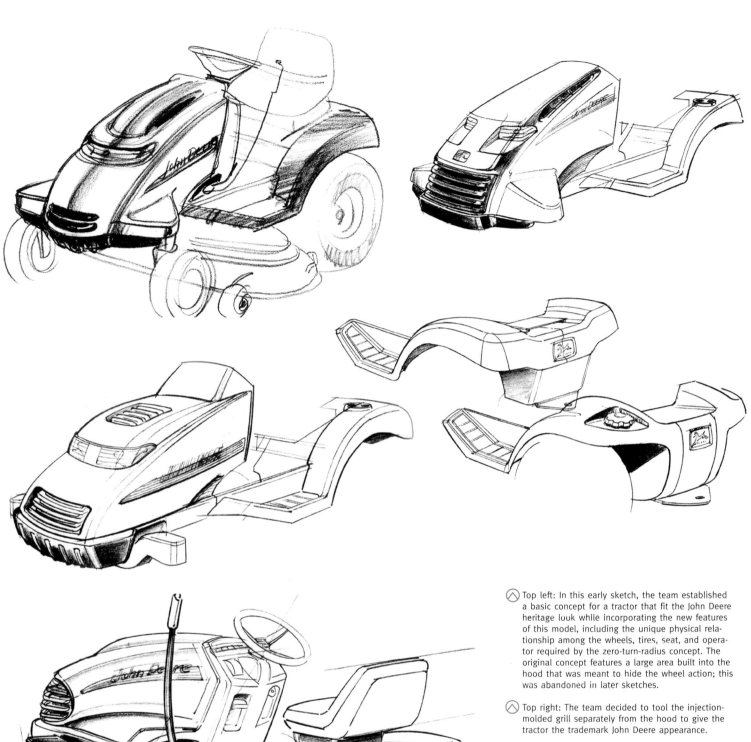

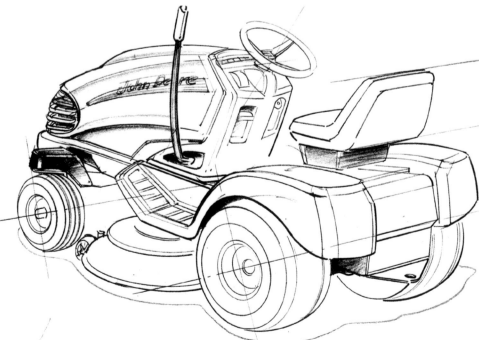

⬦ Top left: In this early sketch, the team established a basic concept for a tractor that fit the John Deere heritage look while incorporating the new features of this model, including the unique physical relationship among the wheels, tires, seat, and operator required by the zero-turn-radius concept. The original concept features a large area built into the hood that was meant to hide the wheel action; this was abandoned in later sketches.

⬦ Top right: The team decided to tool the injection-molded grill separately from the hood to give the tractor the trademark John Deere appearance.

⬦ Middle left: This sketch imagines the wheel coverings as separate from the hood rather than integrated with it. To integrate support for the steering column without enlarging the entire hood, the height of a smaller area in the back of the hood was increased.

⬦ Middle right: This sketch plays with the possible functions of this part, which merges the fender covering and tow board. The top version also includes a fuel tank, making use of the double-walled nature of the rotomolded part.

⬦ Bottom: More details of both the rear of the vehicle and the instrument panel are being decided here: The sketch imagines an instrument panel that mirrors the form of existing models, to save costs, while integrating details specific to this model, such as the lift lever that controls the elevation of the mowing deck.

Another change that resulted from the team's desire to make a ZTR tractor fit into a consumer line was the position of the engine. The engines of typical ZTR tractors are behind the operator, but the team moved the engine of this model up front to match the design of other consumer tractors. In response, the rest of the tractor was reconfigured to redistribute weight to the back of the tractor to keep it balanced.

Throughout the HDA process, the designers had to consider how every change would affect the look of the machine and to balance the need for the tractor to fit in visually with the rest of the John Deere line and the need for it to work well for the user. For instance, the rectangular shape of a traditional Deere vehicle was abandoned for a sleek, rounded shape designed to increase visibility and to reflect the nimbleness of the tractor's movement. Atypical wraparound headlights were also planned to provide the additional light to the side needed on a tractor that can pivot.

To compensate for the new design elements required by the tractor's functionalities, the design team looked to cultivate other visual cues that would signal this tractor's place in the John Deere family. Color—specifically, a careful application of the traditional John Deere green and yellow—was one of the key ways they chose to do that. Complicating this strategy, however, was the plan to use plastic for areas traditionally manufactured in sheet metal, such as in the rear fenders. There were a number of practical reasons for this choice: Plastic is both more cost-effective and more durable, especially in areas that might be scraped by rocks or rosebushes. But it can be difficult to rotomold colors accurately, a problem that only increases as the tractor is exposed to the elements. Says Crookes, "Ultraviolet exposure and aging of the part causes the color to shift. When it appears alongside an adjacent green material, you'll see a mismatch between those two colors that increases with time." The HDA designers carefully planned so that green rotomolded parts didn't abut green injection-molded parts, while maintaining the proper balance of green and yellow that would give this tractor the characteristic John Deere appearance.

The steering wheel, which had been identified as the model's signature feature, was given special attention by the design team: It is coinjected and overmolded in a three-barrel, 1,000-ton molding machine; the subwheel is polypropylene that is coinjected with a blowing agent and then overmolded with a softer green material, providing users with a comfortable grip.

In the end, as with other well-designed products, the seamless incorporation of technology in the tractor might go unnoticed by users—but an experience that had been a chore for them has now become a delight.

Top: To help them visualize the correct proportions of green, yellow, and black on the tractor, the design team produced this illustration; the white area at the rear of the tractor can be overlaid with any of these colors. Since rotomolded parts tend to be black, the team needed to decide which parts had to be rotomolded and to plan the rest of the color scheme around that.

Middle: With this sketch, the design team attempted to redistribute the balance of colors by splitting the rear into two parts so that one part could be green and the other black, and by making the rotomolded part above the wheel green. In the end, however, the rotomolded parts above the wheels had to be black to prevent problems matching the rotomolded green to other green parts of the tractor.

Bottom: The HDA design team responded to the new information they had from John Deere about the cooling and exhaust requirements of the engine by adding large air vents on the top of the hood. This design allows for the air to come in from the top and out the front, as the John Deere engineers now planned.

09 Plan

09 Front

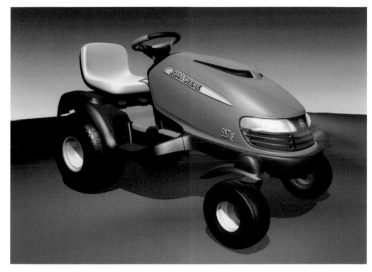

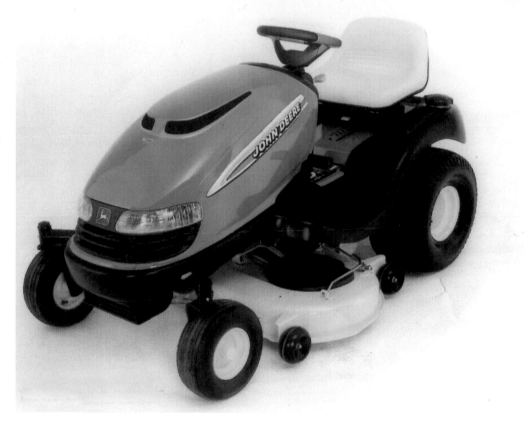

◈ Above left: Toward the end of the design process, the CAD modeling got very specific about where the outside surfaces are relative to the internal package.

◈ Above right: A 3-D CAD model of the tractor in a close-to-final version.

◈ This first build of the product was used for advertising and market research purposes and was presented to focus groups. To keep costs down, the team decided to eliminate the part that covered the front wheels, but the focus groups thought that the tractor looked unfinished without the covering.

The Water-Gate We all know the **fable** of the **little boy** who put his finger in a hole in a dike and **saved** his town from a **flood**.

 The final version of the Water-Gate in action. An undeployed version is shown rolled up next to inventor Daniel Déry; smaller versions of the Water-Gate, when rolled up, can be carried on a person's back.

In the real world, rescue workers trying to save buildings from flooding need a lot more than a finger—they need hundreds (or thousands) of sandbags, a time-consuming and costly solution.

Until now: MegaSecur's Water-Gate has turned the fable into a reality by making it possible for a single person to stop a flood in minutes. The system consists of a polyethylene tarp covered in PVC; a barrier system on the edge of the polyethylene sheet is designed to catch the water as it flows, unfurling and activating the system. As Jacques Lauzon, sales manager for MegaSecur, describes the ingenious principle behind the design, "It's the water that stops the water."

As with many other great inventions, the idea came to its creator in a flash of inspiration. Daniel Déry, an award-winning industrial designer and inventor, was watching video footage of floods of the Red River in Winnipeg, Ontario, Canada. "He was amazed at how much labor had to be put in to erect those sandbag dikes, and all the water that was running through the sandbags, and he thought, 'We've got to have a better way of doing this,'" says Lauzon. Déry had an idea: If he joined a series of plastic bags together, maybe the water would fill up the bags and stop its own flow. He quickly sketched a plastic barrier featuring a number of vertical and horizontal partitions, with a floating device on top, and set out to test this idea with simple miniature prototypes.

After the inspiration, the perspiration: Déry spent over a year experimenting with the construction of the miniature prototypes before getting to a full-scale working prototype. Though initial prototypes proved he was on the right track, he continued to refine the construction and choice of materials for the barrier, trying various weights and kinds of plastic, fabric, and tarp before settling on polyethylene.

The first full-scale prototype was a success, but Déry wondered if the design could be simplified; eliminating the multiple vertical partitions would decrease the weight of the barrier and make it cheaper and quicker to produce. Simplifying it would also make it more rugged, as fewer joins mean fewer opportunities for tears or leakage. Déry tested a second prototype with this simplified design and was delighted to discover that it worked.

So far, the prototypes had primarily been tested on small brooks near MegaSecur's headquarters in Victoriaville, 130 miles (209 km) east of Montreal. With Déry's first test of the prototype on asphalt, he discovered that the barrier—now crafted out of polyethylene—was too slick to stay down on this relatively smooth surface. To prevent the barrier from sliding with the first onslaught of water, metal anchoring and sandbags were required—a solution that was far from desirable, since eliminating the need for sandbags was one of the goals of the barrier. Further prototypes revealed that coating the polyethylene in PVC gave the barrier sufficient traction to adhere to asphalt or concrete, eliminating the need for the anchor system.

Ø 1000 mm

350 mm

Plastikfolie

pflanzliche Stoffe

Becher

Desert Survival Still

Above left: Initial experiments with evaporation and condensation were conducted in the desert.

Above right: The desert tests had problems: The condensation that formed ran back into the sand, and the plastic foil device wasn't wind-resistant. Nevertheless, the tests yielded important information that was used as the design evolved.

A prototype of the vacuum tool used to make the device.

The first units were made—conical, self-supporting, and stable devices made from transparent, thermo-formable polycarbonate outfitted with a screw-cap spout at the tip and an inward circular collecting trough at the base.

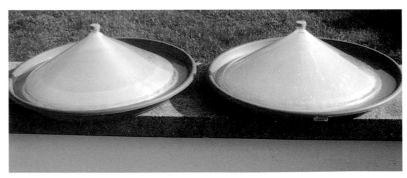

In spring 2002, construction began on a prototype vacuum tool. Later that summer, the first working products came out of this tool "after lots of failures because the material was stretched so much at the outer trough areas that it came out as a thin foil," Augustin says. "After about 100 tests, we found the right temperature and airspeed to get a perfect result."

Winter 2002 brought a license agreement with that same company to produce and distribute the product, and in spring 2003, Bayer AG, Leverkusen became the supplier and partner for the polycarbonate, Makrolon, which was the primary material.

"As we had no PR and headcount budget, the company we were working with and I were using international awards and press reports about this product resourcefully and abundantly to increase public awareness about the global water situation and our innovative product to get manufacturing and distribution started—and it worked!" says Augustin.

"There is a big potential for innovations that fulfill humanitarian, ecological, and economical aspects in one product...and I hope concern for humanity is the next new trend."

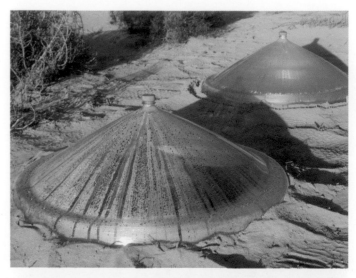

◈ Top: The revised device was tested again under desert conditions.

◈ The evaporated water condenses in the form of droplets on the inner wall of the cone. These droplets trickle down the inner wall into a circular trough at the inner base of the cone.

◈ The Watercone works by a combination of solar activity, condensation, and evaporation. In short, it is a solar still.

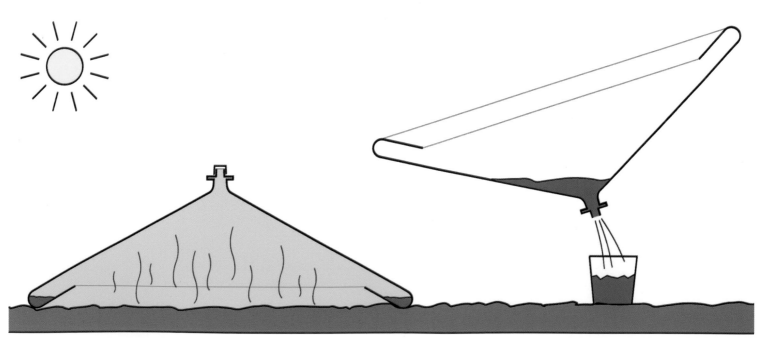

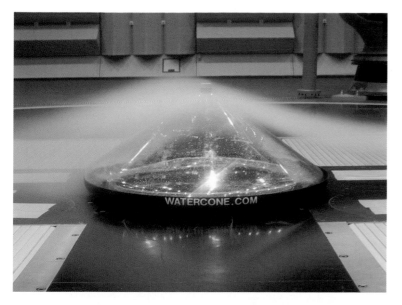

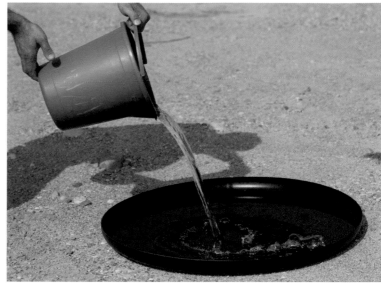

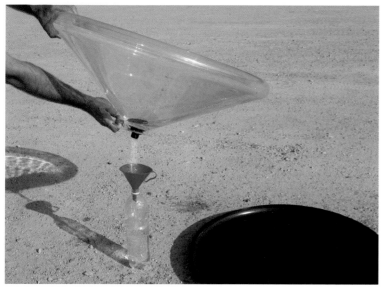

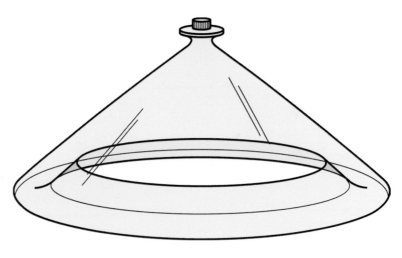

= max. 1,5 l/day

Top: Tests were run to ensure that the device would be wind resistant. Here it is withstanding winds of 34 miles (55 km) per hour.

Above: By unscrewing the cap at the lip of the cone and turning the cone upside down, one can empty the potable water gathered in the trough directly into a drinking device.

Top right: To use the Watercone, simply pour salty or brackish water into the pan. Float the Watercone on top. The black pan absorbs the sunlight and heats the water to support evaporation.

Right: The Watercone has proven to be tremendously successful at creating drinking water from condensation and solar energy, and in fact, can produce as much as 1.5 liters of water a day.

Dutch Boy Twist & Pour Paint Container The design of the paint can has been an industry standard for more than 100 years, but longevity doesn't necessarily mean perfection.

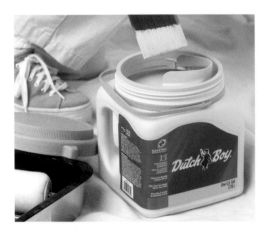

A pourable plastic paint container provided numerous advantages over the traditional metal can, yet the industry resisted.

However, when anything has been around that long, changes are bound to be resisted. The paint industry was no different when John Nottingham and John Spirk, principals of Nottingham-Spirk Design Associates, Inc., suggested improvements in paint can design.

Let's face it, there isn't a consumer around who enjoys using a metal paint can. It requires a tool to open it and a hammer to close it. The metal handle digs into your palm. The paint is difficult to pour and inevitably runs down the entire can, messes up the label, and must be wiped down to store. When it's time to touch up your paint job, you find that the can has rusted and particles of dried paint are floating on top of what would otherwise be perfectly usable paint. Why, again, has the can been the mainstay for 100 years?

The team at Nottingham-Spirk didn't have the answer to that question, but they did have revolutionary solutions to offer. "Overcoming 100 years of inertia in paint packaging posed serious challenges. It seemed that everyone in the paint trade could only think of reasons why a plastic, pourable container wouldn't work," says Nottingham. "There were issues of fitting existing shakers in retail stores, stacking in warehouses, filling line equipment, and perceived drop test concerns."

Since the paint industry is complex, the design team opted to partner with a large paint manufacturer rather than develop the product independently. They approached the Sherwin-Williams Company, which owns brands such as Dutch Boy, Pratt & Lambert, and Martin Senour in addition to the Sherwin-Williams brand. They pitched their idea and showed prototypes to Chris Connor, the new CEO of Sherwin-Williams, in early 2000, and the project was given the go-ahead.

At first, the team met with plenty of naysayers who touted all the reasons why the new packaging concept would not work. Nottingham and Spirk needed a champion and found one in Adam Chafe, the leader of Sherwin-Williams' team and now vice president of marketing for the company. "He had an open mind and could sense the potential consumer demand if the two development teams could overcome the inevitable obstacles in the creative process," says Spirk.

The design team began by studying the life cycle of the paint can from manufacturing to the filling lines, from the warehouse to the store, through the tinting process to the ride home and eventual storage, disposal, or recycling. Early brainstorming concepts ran the gamut from "mild to wild," exploring round and square shapes and a variety of product features.

Next, the designers researched consumers' reaction to a new container. "It has been recognized that the key decision makers and product drivers have been consistently changing in the last 10 years. In particular, more women are making décor decisions and actually taking part in painting. These consumers are more

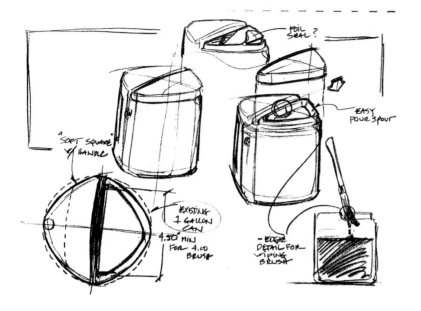

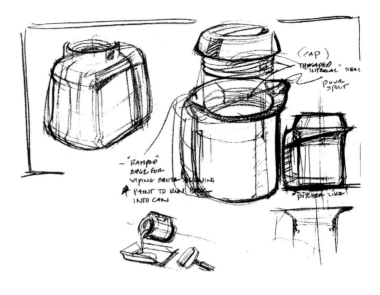

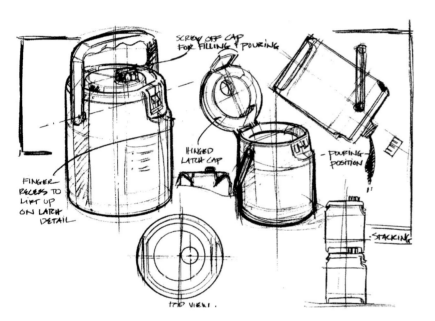

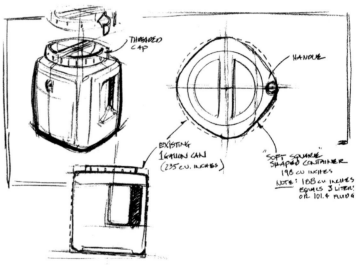

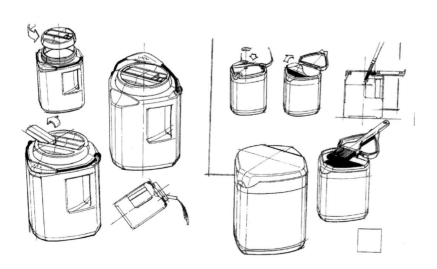

Early sketches ran the gamut from "mild to wild" concepts that played with a variety of shapes. The constants were the easy-pour spout and easy carrying handle.

The idea of the threaded screw cap wasn't a part of the concept from the beginning. Designers played around with the idea of several product openings to find the one that provided the easiest method of pouring.

demanding of ease-of-use and neatness of do-it-yourself projects, being used to liquid laundry detergent bottles and other convenient household packages," says Nottingham.

"One of the early constraints we imposed on the project was to stay within the standard gallon can footprint so that warehouse and retail shelves wouldn't need to be changed," Spirk remembers. "By making the container square, we were able to buy free space in the corners to make room for a hole-through side handle. In this case, we had to test how tight the corners could be within bold molding parameters. We also challenged ourselves to connect the plastic bail handle to fit within the footprint."

Aside from the merchandising issues, designers had to maximize the screw-threaded opening to fit a standard 4-inch (10 cm) brush while accommodating a flow-back, pourable feature. This was done using an injection-molded insert. The lugs on the lid were positioned diagonally across the corners, staying within the footprint and allowing for thumb leverage while holding the side handle. The stepped lid allows for nesting in the underside of another container for stacking and also provides a smaller diameter for gripping while twisting off the lid.

The design seemed to be coming together as the negatives were eliminated one by one. Finally, the time was right to take the container to a series of focus groups, who compared it to the standard metal paint can. "The overwhelmingly positive reaction to the plastic pourable can gave us the impetus to continue to tackle the distribution system," says Nottingham.

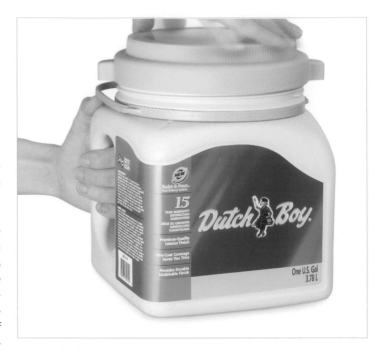

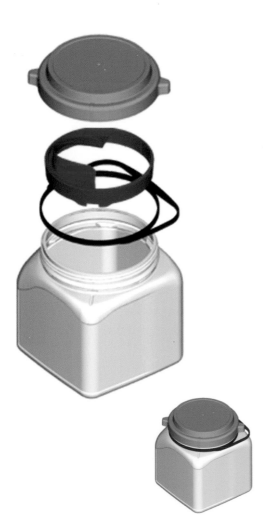

The threaded opening had to be large enough to accommodate a standard 4-inch (10 cm) paintbrush.

Top and middle: Designers used a Finite Element Analysis program to help maximize the container's structure while using a minimum amount of material.

Bottom: Designers finessed the product design in Pro/Engineer.

Far left: A product rendering as a whole and exploded show how the chosen design goes together.

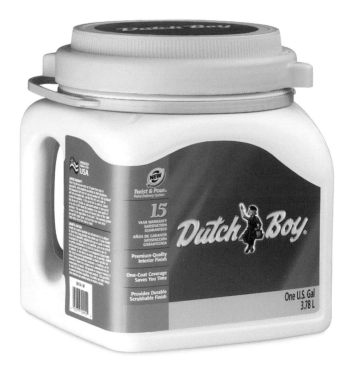

Store shaking machines had to be outfitted with square inserts, paint filling lines had to be converted to the square plastic containers, and warehouse shelving and pallets had to be configured for the new package. "The trade and distribution concerns have been met and exceeded," says Spirk. "For instance, the store tinting process has improved. Opening and closing when adding the tint is not only faster, but also the flat sides of the container provided more complete mixing of the tinted color."

Another advantage proved to be the new can's square shape. The container requires less shelf space because it doesn't have side ears for the bail handle. Retailers can place 14 linear facings of the new container on store shelves, one more than was possible with the round can. "The flat front face also produced a strong visual effect for merchandising. In a drop test, the plastic container actually bounced and fared better than the metal," Nottingham adds.

The container was launched as part of the Dutch Boy brand in July 2002. Since then, the number of retail outlets that carry the brand has tripled. In addition, the container is being distributed throughout Sherwin-Williams paint stores. According to Adam Chafe, "Sales are far exceeding our expectations."

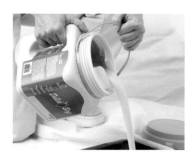

⊘ Top: The square shape of the new container accommodates 14 linear facings in the same area previous occupied by 13 metal gallon cans.

⊘ Above: While observing the habits of consumers using metal paint cans, the design team noticed that men typically hold the metal bail with one hand and pivot the can from the bottom with the other hand to pour, while women tend to hold both sides of the can and pour by pivoting their wrists. To provide a more secure grip and pouring experience for both sexes, designers added a side handle to the container.

⊘ The easy-pour spout couldn't be neater. It includes a built-in lip for wiping excess paint from the brush, and it won't rust or dent like typical paint cans.

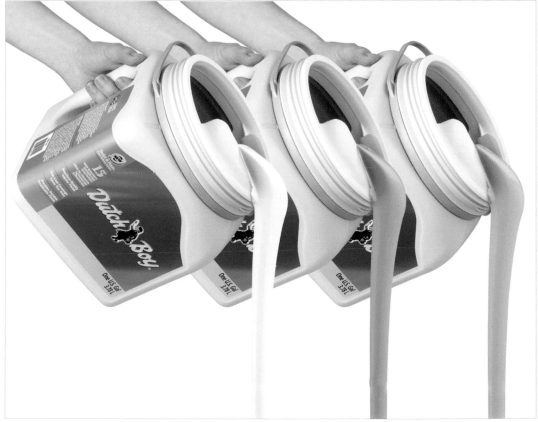

Handy Paint Pail

Mark Bergman had **an idea** for a paint pail that would take some of the **hassle** out of an unpleasant **chore**—it would provide a place to wipe off the **paintbrush** or to place it, it would be **comfortable** to hold,

The main container of the Handy Paint Pail is composed of two parts, an injection-molded polypropylene bucket and an injection-molded flexible PVC top ring and strap. A ceramic magnet functions as a brush holder.

Opposite: These sketches resulted from half a day of brainstorming by Worrell's design team. They explore the idea of a plastic lid with a hole in it meant for swiping off extra paint and holding the brush. Some of the sketches also show the early idea of an accordion-shaped flexing handle.

and it would be easy to clean. He went to Worrell Design with preliminary sketches and asked them to refine and produce his product. Bob Worrell, president, says, "This was an entrepreneur who had an idea, and there's enough of us here that do DIY home projects anyway that we understood what was going on, and could do this very quickly and very simply."

Since turnaround had to be quick, as Bergman's budget for the product was limited, the designers at Worrell Design spent only half a day coming up with sketches that refined the original idea. The client's original concept was a cup with a separate, rounded lid made of the same injected molded polypropylene planned for the cup; it would have a hole on the top that could be used both to hold the brush and to wipe paint off it. The team had an alternate idea: a design that featured an edge and handle made of thermoplastic rubber, which is an injection-moldable material with a soft durometer; the material would give the product a distinct look and make the handle more flexible.

To keep the handle flexible, early sketches also considered a handle with an accordion-like flexing mechanism on top, but the team ended up favoring the idea of an adjustable strap, which gives users the ability not only to adjust it to their own hand size but also to attach it to a ladder or any other convenient place. The team decided to take both Bergman's idea and their variation into modeling to see which one they all preferred.

Worrell points out that, given the time and budget limitations on this project, they skipped the solid modeling that their designers would usually do in Alias or Rhino, and instead went straight into engineering, where the engineers built a ProE solid model based on the sketches. "If we give the engineers a database out of our Alias system, the engineers cannot actually work productively on that database—they have to almost redraw it," says Worrell. And that would have taken time the client couldn't afford to pay for.

Once solid modeling was complete, stereolithography models were made. The designers then built temporary mold boxes from room temperature vulcanizing, a process that can be used to build prototypes quickly, and used the master parts to create a mold. From the mold, the team made urethane prototypes, which the engineers examined to be sure the parts fit together properly.

In the end, Worrell Design's variation on Bergman's idea won out; it was felt that Bergman's version would be too rigid to work with the wide variety of sizes and shapes of brushes that users employ. The thermoplastic rubber of Worrell's version had other advantages, too. "That particular part allowed for a lot more utility in

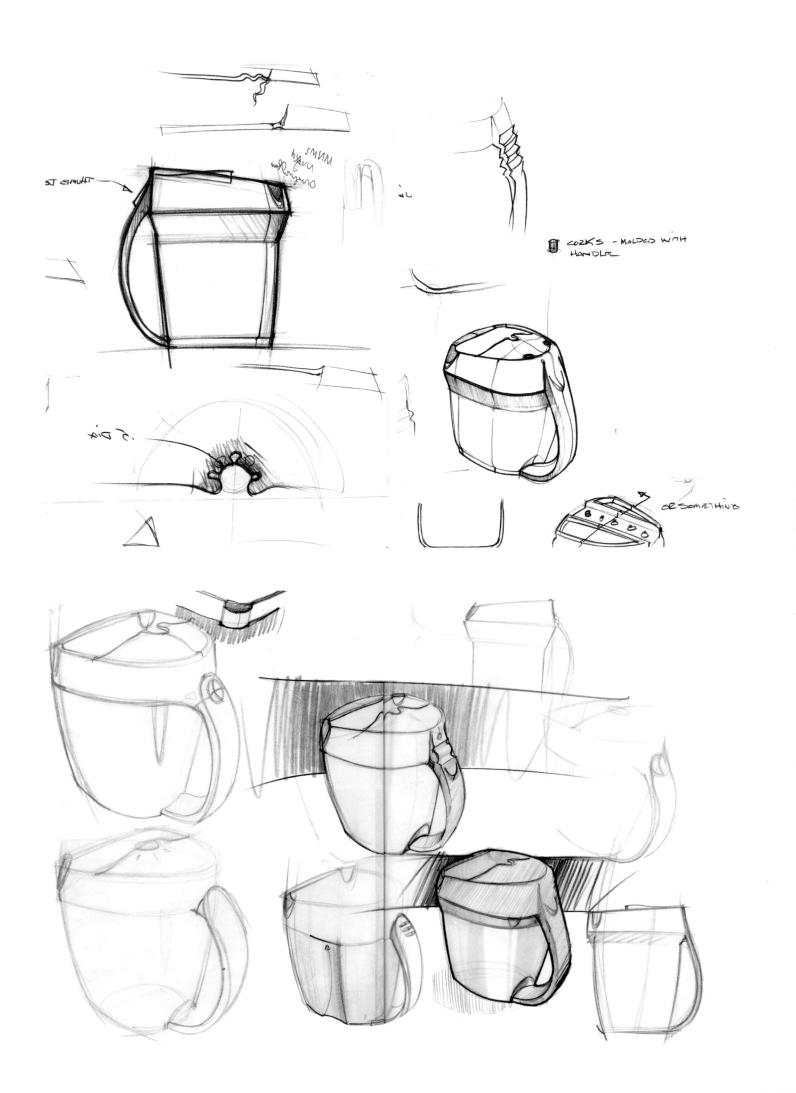

CORKS – MOLDED WITH
HANDLE

or SOMETHING

that it created a distinct aesthetic image, and we could color it differently than the rest of the bucket; it acted as a paint drip edge, and it allowed and accommodated different hand sizes," says Worrell.

Since the idea of a rigid dome over the pail opening had been rejected, the team came up with another way to hold a brush conveniently within reach of the user: the simple addition of a magnet inside the rim of the pail to hold the brush clear of the paint. The magnet has a metal back with a lip; the magnet slides into a slot near the handle, where the metal lip holds it in place.

The engineers then put together drafting documents for the molders. While not strictly necessary—molders can work from ProE documents—Worrell feels that providing better detail ensures the quality of the products the molders produce. "We produced the line art as a quality tool. That helps the client approve and verify that what they got from the molder was in fact accurate," says Worrell. Bergman approved the design, and the molder asked for minor refinements to make the design more efficient to produce.

Bergman ended up striking a deal with a local molder to produce the product. Color was decided by Bergman and the molder; Bergman had decided that he wanted the colors to be neutral be-

cause of the variety of hues of paint that might go in the pail. The part for the handle and lip went to a darker gray to distinguish it from the rest of the pail and to avoid color-matching problems that may have resulted from the lip and the cup being made from different materials.

Small local hardware stores started carrying the Handy Paint Pail, then larger chains; sales took off when Home Depot began carrying it, and since then, sales have zoomed into the hundreds of thousands. Says Worrell, "Who would have thought that you'd want to pour paint out of a can into another bucket that you have to clean up, but it's so comfortable, and it's such a simple idea, that it just really caught on."

Mark Bergman wasn't the first entrepreneur Worrell Design has worked with, and he probably won't be the last: Worrell feels that working with start-up companies as well as corporate clients "keeps us on our toes and fresh." But there's a special excitement in working with entrepreneurs. Says Worrell, "The business we're in is creating people's futures. It's an exhilarating idea. There's a lot of promises inherent in what we do of wealth and excitement, and whenever we do concept sketches or drawings or models, it's like Christmas—you can't open the package fast enough."

⊘ This sequence shows the process by which stereolithographed parts are used as masters for creating urethane models; these models help the engineers ensure the seamless assembly of the final parts.

⊘ Top: A ProE model of the serrated edge; the edge is designed to receive the rubber cup lip, which is screwed into the screw bosses on the front and back of the cup.

⊘ Above: A ProE model of the rubber cup lip and its adjustable strap handle, here attached to the serrated edge of the cup.

SECTION TOP-TOP

| | | | PAINT_PAIL | | A | 1.000 | B | | SHEET 6 OF 6 |

WORRELL DESIGN INC.
PRODUCT DEVELOPMENT AND GRAPHIC DESIGN · 6900 CITY WEST PARKWAY — EDEN PRAIRE, MN 55344

NOTES:
1. MATERIAL: SEE TITLE BLOCK.
2. COLOR: BLACK.
3. FINISH: TEXTURE ALL EXTERIOR SURFACES.
4. REFER TO THE CAD MODEL FOR ALL DIMENSIONS.
5. ALL UNSPECIFIED DRAFT TO BE 1 DEGREE.
6. ALL UNSPECIFIED RADII TO BE .015 EXCEPT AT PARTING LINE.
7. EJECTOR PIN MARKS TO BE FLUSH TO .005 RECESSED.
8. GATE TRIM TO BE .005 MAXIMUM.
9. PART TO BE FREE OF FOREIGN MATERIAL INCLUDING
 BUT NOT LIMITED TO MOLD RELEASE OR OIL.
10. FLASH NOT TO EXCEED .005.
11. MOLD TO BE THE PROPERTY OF HARBER SUPPLY COMPANY.
12. PART TO BE FREE OF SINK, SPLAY, AND OTHER COSMETIC
 DEFECTS ON THE APPEARANCE SURFACE.
13. TOLERANCES ARE PER THE STANDARDS AND PRACTICES OF PLASTIC MOLDERS FOR
 THIS MATERIAL, COMMERCIAL GRADE.

REVISIONS

REV	ECN NO	DESCRIPTION	DRAFT	DATE	APPR'D	DATE
A	00000	INITIAL RELEASE	XXX	00/00/00	XXX	00/00/00

RAISED LETTERING

HARBER SUPPLY COMPANY — HANDY PAINT PAIL
SCALE 0.500
BUCKET.TOP
PAIL -- TOP
PAIL_TOP — A
SHEET 1 OF 1

WORRELL DESIGN INC.
PRODUCT DEVELOPMENT AND GRAPHIC DESIGN · 6900 CITY WEST PARKWAY — EDEN PRAIRE, MN 55344

NOTES:
1. MATERIAL: SEE TITLE BLOCK.
2. COLOR: GRAY.
3. FINISH: TEXTURE EXTERIOR SURFACES, EXCEPT WHERE INDICATED.
4. REFER TO THE CAD MODEL FOR ALL DIMENSIONS.
5. ALL UNSPECIFIED DRAFT TO BE 1 DEGREE.
6. ALL UNSPECIFIED RADII TO BE .015 EXCEPT AT PARTING LINE.
7. EJECTOR PIN MARKS TO BE FLUSH TO .005 RECESSED.
8. GATE TRIM TO BE .005 MAXIMUM.
9. PART TO BE FREE OF FOREIGN MATERIAL INCLUDING
 BUT NOT LIMITED TO MOLD RELEASE OR OIL.
10. FLASH NOT TO EXCEED .005.
11. MOLD TO BE THE PROPERTY OF HARBER SYPPLY COMPANY.
12. PART TO BE FREE OF SINK, SPLAY, AND OTHER COSMETIC
 DEFECTS ON THE APPEARANCE SURFACE.
13. TOLERANCES ARE PER THE STANDARDS AND PRACTICES OF PLASTIC MOLDERS FOR
 THIS MATERIAL, COMMERCIAL GRADE.

REVISIONS

REV	ECN NO	DESCRIPTION	DRAFT	DATE	APPR'D	DATE
A	00000	INITIAL RELEASE	XXX	00/00/00	XXX	00/00/00

NO TEXTURE IN THIS AREA

ADD INSERTS FOR PART MARKING

HARBER SUPPLY COMPANY — HANDY PAINT PAIL
MATERIAL: POLYPROPYLENE
FINISH: MT 11335
SCALE 0.500
BUCKET.BOTTOM
PAIL -- BOTTOM
PAIL_BOTTOM — A
SHEET 1 OF 1

WORRELL DESIGN INC.
PRODUCT DEVELOPMENT AND GRAPHIC DESIGN · 6900 CITY WEST PARKWAY — EDEN PRAIRE, MN 55344

Though ProE modeling is sufficient for the molder to work from, Bob Worrell believes that architectural blueprints like these help ensure the quality of the products the molder produces.

REVISIONS

REV	ECN NO	DESCRIPTION	DRAFT	DATE	APPR'D	DATE
A	00000	INITIAL RELEASE	XXX	00/00/00	XXX	00/00/00

HARBER SUPPLY COMPANY — HANDY PAINT PAIL
MATERIAL: N/A
FINISH: N/A
SCALE 0.500
PAINT_PAIL
PAINT PAIL
PAINT_PAIL — A
SHEET 1 OF 6

WORRELL DESIGN INC.
PRODUCT DEVELOPMENT AND GRAPHIC DESIGN · 6900 CITY WEST PARKWAY — EDEN PRAIRE, MN 55344

Master Lock Titanium Series Home and Yard Padlocks

Can **brand awareness** be a **double-edged** sword? It can indeed, **when** used against you by your **competition**.

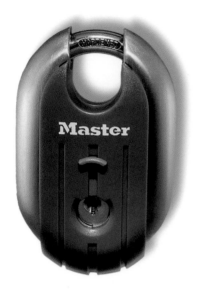

The Titanium Series Home and Yard Padlock, like other locks in the Titanium series, features an ABS/rubber bumper to protect the lock from rust as well as to prevent the padlock from scratching whatever it protects. The interior of the lock is primarily zinc and brass, so it won't corrode.

That's precisely what happened to Master Lock. After decades as leader of the padlock market, and with over 90 percent brand awareness, Master Lock was starting to see its market share dwindle because of cheap knockoff products that confused consumers into thinking they were high-quality Master Locks—and buying them instead of the real thing. In the face of the pricing pressure they were receiving from mass-merchant customers such as Wal-Mart and Home Depot, Master Lock had to make a decision.

"Master Lock came to us saying, is there a design solution to this business problem that we have?" says Harry West, vice president of strategy and innovation at Design Continuum. "One way to deal with low-cost foreign competition is simply to lower your prices, but of course the downside of that is it reduces the value of your company. So the question was, was there some way through design to maintain Master Lock's share, or even grow their share, and not have to lower their prices?"

To answer that, Design Continuum researched the padlock category to see where Master Lock's leverage might be; in doing so, they identified three major issues that the brand would have to address. First, they found out that, while the average person has a lot of padlocks, no one spends much time thinking about them. Second, people had trouble finding them in stores; padlocks are generally located in the hardware aisle, but that's not where people looked for them. Finally, people couldn't distinguish between the Master Lock brand and the knockoffs. These initial findings led to what West calls an "epiphany" about the product: It wasn't the padlocks that were important to people, it was what the padlocks protected. This revelation led to the team's strategy for the design: "It had to do more than just be a good security device, it also had to fit into the fabric of consumer's lives in a way that the current padlock did not," says West.

To find a way to do that with the product's redesign, Design Continuum sought to answer two questions: What did consumers think about security, and where did consumers use locks? To answer the first question, the team conducted focus groups and interviews; in doing so, they discovered that most people believe that locks are broken into with bolt cutters. A lock where less shackle is exposed would appear more secure to consumers—and would give Master Lock a competitive advantage. The team also discovered that people were reluctant to lock up outdoor equipment because the prominent display of locks signaled mistrust of one's neighbors—indicating that there could be a demand for locks without the archetypal lock appearance.

To answer the second question, the team identified the primary areas consumers used padlocks and decided that they needed to target each of these areas—beginning with the home and yard and automotive categories—with products designed specifically for them.

⊽ Left: This early sketch was where the concept of the Master Lock Titanium series began. West describes this first concept as "sort of like a padlock, but a padlock like you've never seen before."

⊳ Right: A more refined version of the original sketch.

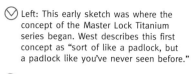

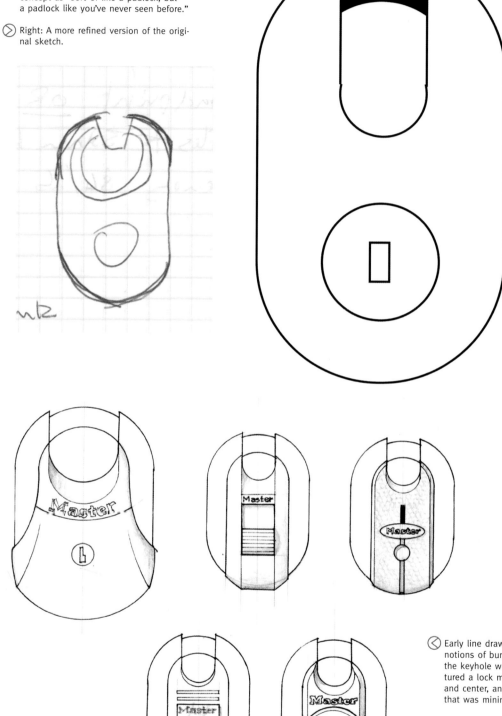

⊲ Early line drawings explored different notions of bumper shape and of how the keyhole would be covered; all featured a lock mechanism that was front and center, and all featured a shank that was minimally exposed.

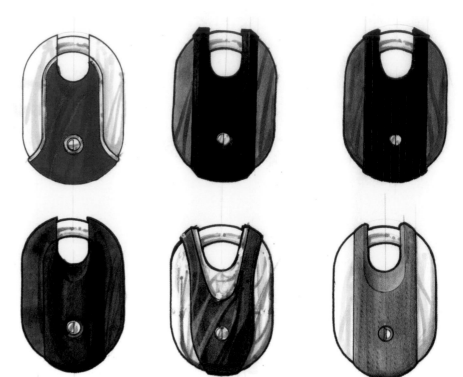

⊘ Further sketches continued to explore bumper configurations as well as a variety of color applications.

⊘ An early color illustration of the lock with the plastic configuration retained in the final version.

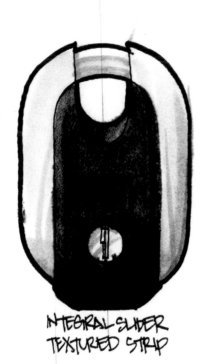

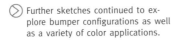
INTEGRAL SLIDER
TEXTURED STRIP

Armed with this research, Design Continuum's team of consumer researchers, business analysts, and designers began brainstorming solutions to Master Lock's business—and design—problem. This led to a simple line sketch and a simple concept: Says West, "We wanted to make one core product that would be what we called Swatchifiable [a reference to the famous line of watches]— it's basically all the same product, but with an application of color and texture you make the user see it as a completely different product. We wanted to take that notion and apply it to padlocks." This concept would allow Design Continuum to target a number of consumer areas while keeping manufacturing simple and cost-effective. Even in the initial sketch, the lock also managed to address some consumer concerns: The front-facing lock was easier for users to reach; the small amount of exposed shank looked secure; and the shape was graceful and unobtrusive.

The team had hit on a rubber bumper as their vehicle for "Swatchifying" the lock; not only did the bumper allow Design Continuum to tailor the look of the lock for a number of different uses, it also added value for the consumer. It also protected the lock from rust, it prevented the objects that were being protected by the lock from being scratched by it, and it protected users' hands from cold and heat. Further sketches refined the shape of the bumper itself as well as how the lock mechanism would be protected by it.

The team fashioned various appearance models out of foam and plastic and showed them to consumers. Consumers said they liked it, but for the team, actions spoke louder than words: "As they were talking, they always had it in their hand," says West. "There's something about the form that people wanted to pick up and hold, and that made us confident that we were going in the right direction." The team then built and gave working models to consumers to test; their response to both the form and the feel of the lock was positive.

To help refine the look of each line, the design team created separate image boards for the home and yard and automotive lines; inspired by the boards, the team created new appearance models for each line, and then went back to consumers with the image boards and the appearance models. When challenged to match the home and yard model to the home and yard image board and the automotive model to the automotive image board, consumers could do it right away—and the design team knew they were on the right track.

At this point, Design Continuum started to tweak the design for manufacturing. The cylinder of the locks came from Master Lock, but Design Continuum's engineers were responsible for the rest of the lock design. While they were refining the design to minimize manufacturing costs, they were also putting it through the standard security tests that a padlock has to pass. West describes this phase as "a fairly lengthy, iterative process whereby, as designers, we can see the difference, but consumers I think really cannot see the difference."

By designing a new breed of padlock, Design Continuum was successful in getting Master Lock's products out of the hardware aisle; mass merchants like Target and Wal-Mart now spread Master Lock products throughout their stores. Says West, "If you want to get your products into another part of the store, you have to make them so they don't look like hardware; when they looked like hardware, that's where they were put." In some stores, this has resulted in double-digit sales gains for Master Lock.

But West has a different way to measure success: "I think the best way of looking at success is not product by product but by the total story that all of those products together tell the consumer. The story they tell here is that Master Lock is now innovating, and in a category where there's basically been no innovation for decades." That innovation has paid off; the Titanium Series has a utility patent and several design patents, meaning that knockoffs of the product can no longer be sold in the United States. Moreover, as West says, "We took that category and we made some absolutely beautiful products."

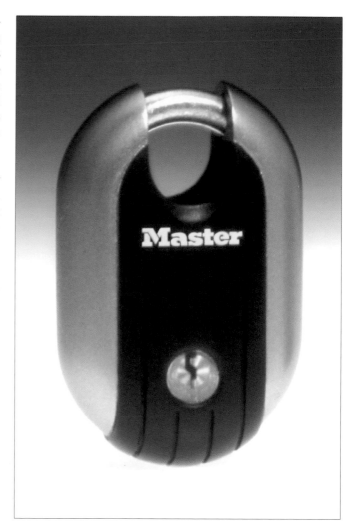

⊗ This model of the Titanium Series Home and Yard Lock is very close to the final design for the lock.

⊗ These appearance models experimented with different configurations and colors of the plastic bumper. "Ninety-five percent of the cost is in the stuff other than the plastic bumper," says West. "The plastic bumper changes the context, so the one on the left is appropriate for an automotive application and the one on the right is appropriate for a more professional series application, like a building yard."

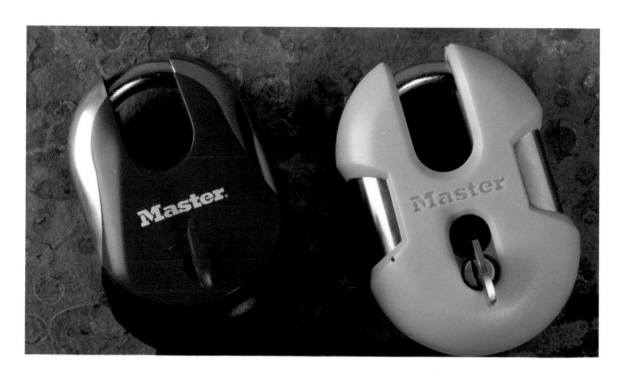

Soft Edge Ruler

When was the last time you saw the **beauty** in the ruler that lies in your **desk drawer**? If it is your typical **ruler**, you probably **didn't** even realize you **had it until** you look for it and was **missing**.

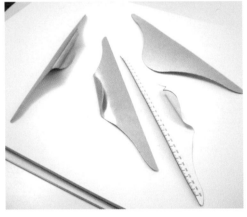

Top: The Soft Edge ruler is among the products credited with creating market demand for beautifully designed everyday objects.

Above: The trickiest part of the product's design was achieving the right fold and ergonomic turn of the handle while using the minimum amount of stainless steel.

However, if you had a Soft Edge ruler, you wouldn't only notice it; it would command your attention. "It was designed to be so much more than just a desktop ruler," says Eric Chan, president, ECCO Design, Inc. "It was created efficiently and economically for precise functionality by taking full advantage of the material from which it is made. Soft Edge's lyrical and curvilinear gesture is a reflection not only of the inherent precision of a ruler but of our hands, our bodies, and the landscape of our desks."

It is obvious that Chan sees beauty in everyday objects that don't necessarily possess a beauty of their own—that is, until a designer takes a look at them from another perspective. The idea came from a "need for poetry, simplicity, and beauty in our everyday objects," he says. "Simple poetry in everyday objects was missing in the high-tech work environment. In the digital information age, many of our desktop products have become sterile, full of buttons, screens, and clicks. The goal was to design something beautiful, with beauty lying in the natural form of the object."

The market wasn't demanding the Soft Edge ruler, but Chan felt that it was crying out silently for one. So he and his team went to work on a design for a different ruler, a ruler with a twist—literally.

"While most rulers are have hard edges and are rectilinear, physically reflecting their metaphorical purpose—to measure within a straight Cartesian world—Soft Edge was designed with another focus—to improve user experience and function while remaining precise," he says.

The design began as a sketch, and from that designers made paper and cardboard models. "We went back and forth between the sketches and models to find the right overall shape and the desirable curve and bend of the handle," Chan remembers."

The team used Ashlar-Vellum and Illustrator 9.0, along with Prisma colored pencils, paper, and cut cardboard to design the product. "While technology helped in the design process, it was not the only tool used," Chan is quick to point out. They experimented with the material, using a single sheet of stainless steel, and continued to make models.

The primary challenge Chan identified was creating the right fold and turn of the handle. "We wanted to maximize the ergonomics of the product while using the minimum amount of stainless steel material," he says.

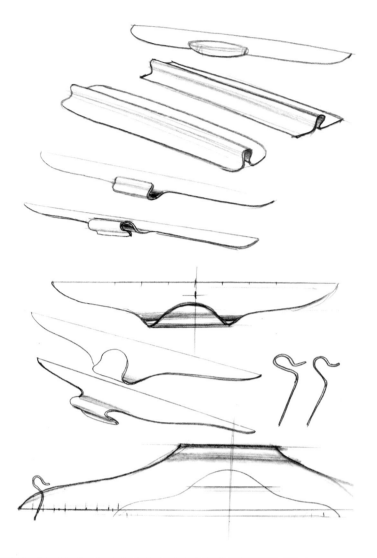

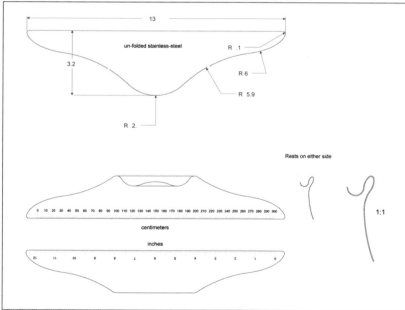

The design called for the Soft Edge to be stamped from a single sheet of stainless steel. Leftover material is recycled. The sheet is polished to remove imperfections. Precise logos are laser-etched, and measurements are silk-screened. The parts are bent in steel tool dies.

After a lot of tweaking, designers achieved the right fold and, in the end, the ruler, stamped from a flat sheet, delicately curls up for an easy grasp while easily flipping over to reveal both inches and centimeters. "Its curved and angled surface makes viewing easier as well," Chan says. "It achieves subtle beauty through the marriage of a high degree of industrial process informed with user sensitivity and lifestyle."

Because the Soft Edge is bent from a single sheet of metal, the product cost the client little to produce, yet it still reflects a high degree of quality and craftsmanship. "The perceived value is much higher than actual manufacturing cost, so the client gained a high sales margin," Chan says, noting that the suggest retail price is $14.00.

The ruler is durable and rustproof, user friendly, and elegant, and because of these things, Chan says that it will likely never be discarded. However, if it is, it is fully recyclable.

"Its soft, undulating form allows it to blend into a multitude of environments, from a CEO's desktop to a secretary's reception table. As a desktop object, Soft Edge communicates functional beauty and a passion for work. It negates the more commonly sought attributes of status. The ruler is a simple reminder of our bodies; it is a permanent tool much needed in our temporal technologically burdened lives."

What is the most outstanding feature of this product? Its simplicity. "A powerful design can come from a very simple material. The foundation of design is to provoke internal emotions and to show the emotional expression of the creator. Challenge simple, everyday objects and elevate them to a higher ground," says Chan. "I learned that poetry and technology could actually coexist, even in a ruler. Perhaps especially in a ruler. That poetry rules over technology."

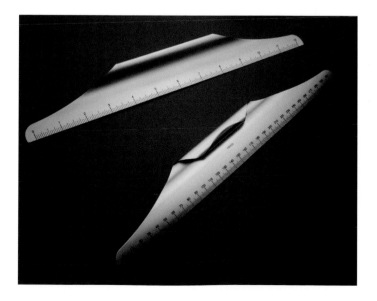

⊘ Top: Designers tackled the Soft Edge ruler by creating a variety of sketches that took the traditional straightedge ruler to more poetic realm.

⊘ Middle: The team used technology daily but also relied on Prisma colored pencils, paper, and cut cardboard to design the product.

⊘ Bottom: This diagram shows the unfolded stainless steel, the degree of the fold, and how the inch and centimeter marks will be laser-etched on the stainless steel.

⊘ Although the fold proved the most challenging aspect of the project, designers overcame the problem. As a result, the ruler, made from a single sheet of stainless steel, delicately curls up for an easy grasp while easily flipping over to reveal both inches and centimeters.

The Rabbit Corkscrew We **never** really **pay** **much attention** to a corkscrew—that is, unless it **doesn't** **work**, which is **frequently** the **case**.

The Rabbit can pull a wine cork in three seconds. To use, simply remove the foil cap with a knife or foil cutter. Raise the corkscrew by bringing the top handle forward. Position the corkscrew over the cork and grip the top of the bottle with the gripping handles. Insert the corkscrew into the cork by bringing the top handle up and back. Remove the cork by bringing the top handle forward and down. To release the cork from the corkscrew, bring the top handle up and back. Then, grip the cork with the gripping handles and bring the handle forward and down. The entire process takes only five to six seconds.

It's a little-known fact that the lever-action corkscrew was invented in the 1970s by Texas oilman/inventor Herb Allen, who made his fortune creating many innovations in oil drilling and spent years developing the lever mechanism for a corkscrew. He tried to sell his invention without much success. Upon his death, his estate sold the company, Hallen, to French cookware manufacturer Le Creuset, which named his invention the LeverPull professional corkscrew and sold it for $140 to high-end specialty shops.

In 1997, Le Creuset sued Metrokane, based in New York, for manufacturing a self-pull corkscrew with a faucet handle. It looked different than Le Creuset's product but used a Teflon coating, which violated the patent, and the case was settled out of court. During the process, Metrokane's marketing director and co-owner, Bob Larimer, discovered that the patent on the Lever-Pull was due to expire in 1999. He remembered meeting Ed Kilduff, a 27-year-old designer who had already designed many housewares products for companies like OXO and EKCO and had just started Pollen Design in New York with Dean Chapman, an English designer.

"At first, the plan was to simply reshape it, make it in China, and sell it for $70, half the price of ScrewPull," says Kilduff. "But I convinced Bob to spend a bit more on the materials and beautiful packaging."

Kilduff broke the project down into three phases: concept sketches, design/model, and mechanical drawing. "After choosing one of the concepts from the drawing phase, I tried to match that sketch while building the model. I had the drawing pinned up at my studio, constantly looking at it for reference," remembers Kilduff. "After painting and assembling the prototype, I remember showing it to my girlfriend, who said, 'It's really nice, but it looks like a rabbit!' I was not very happy about that. I wanted it to look like a corkscrew, not an animal."

The whole process from first meeting to finished prototype took three weeks. The next day, Kilduff presented the prototype to Metrokane. "They loved it! But I reluctantly told them that it looked like a rabbit," says Kilduff. "A lightbulb went off in Bob's head—people would associate it with speed. Bob was an advertising and marketing mogul who had created many famous TV campaigns. He sold his worldwide agency in 1982 before starting Metrokane. So we tried to make it look *more* like a rabbit by using a rubber spray on the body that would simulate the furry feel of hair and a rubber grip pad on the handle. We also moved the pivot axle to the place where the eye would be."

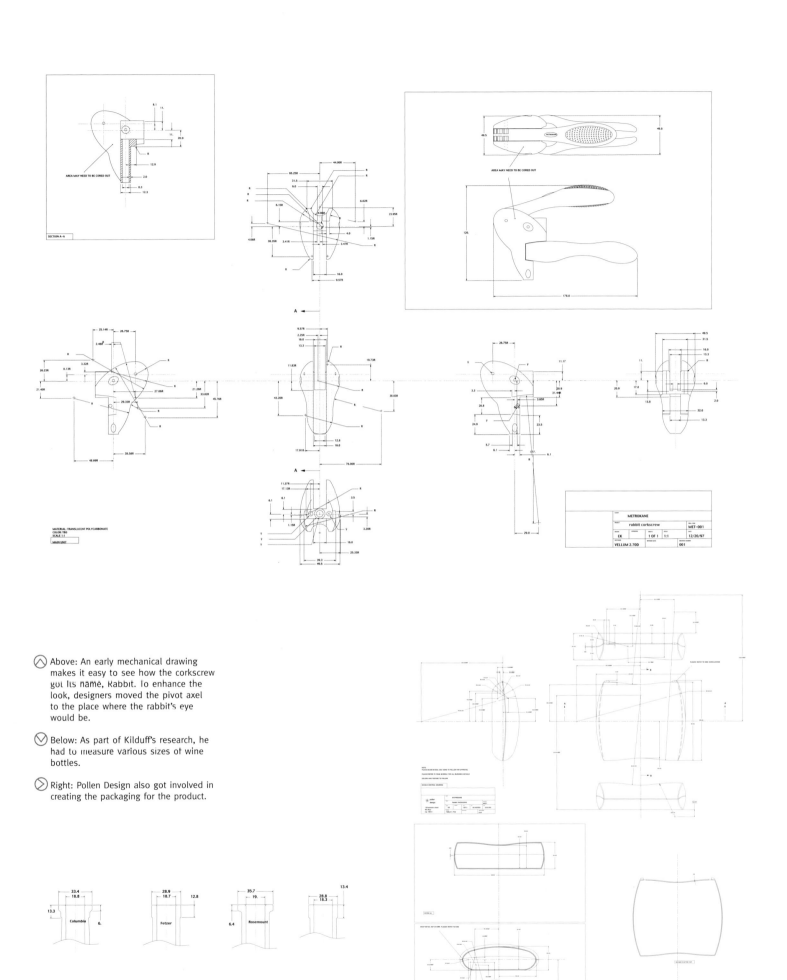

◇ Above: An early mechanical drawing
makes it easy to see how the corkscrew
got its name, Rabbit. To enhance the
look, designers moved the pivot axel
to the place where the rabbit's eye
would be.

◇ Below: As part of Kilduff's research, he
had to measure various sizes of wine
bottles.

◇ Right: Pollen Design also got involved in
creating the packaging for the product.

Kilduff sent the drawings off to Metrokane's factory in China, which had about two years to perfect it until the patent was due to expire.

The Rabbit was finally introduced at the Housewares show in January in 2000 and was successful at the suggested retail price of $80. In early 2003, Metrokane sold its millionth Rabbit. Metrokane went from $3 million in annual sales to $20 million in 2002. The line consists of about 30 products and is growing. "The Rabbit was my first design project for Pollen Design," Kilduff says. "We were lucky to have a great client that let us design the product, packaging, graphics, identity, advertising, and so on. Because this product took two years to hit the market, we've learned to be patient and focused.

"I've learned that being a successful designer is really about forming a tight bond with your client. You will have to earn their trust—in which they will invest hundreds of thousands of dollars based on your decision making and recommendations."

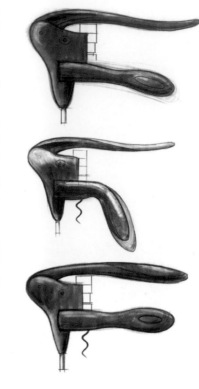

Ed Kilduff created several sketches of the new lever-pull corkscrew in the first phase of the project.

Kilduff pinned this sketch of the concept chosen by the client on the wall in his studio and worked from it to build the first prototype.

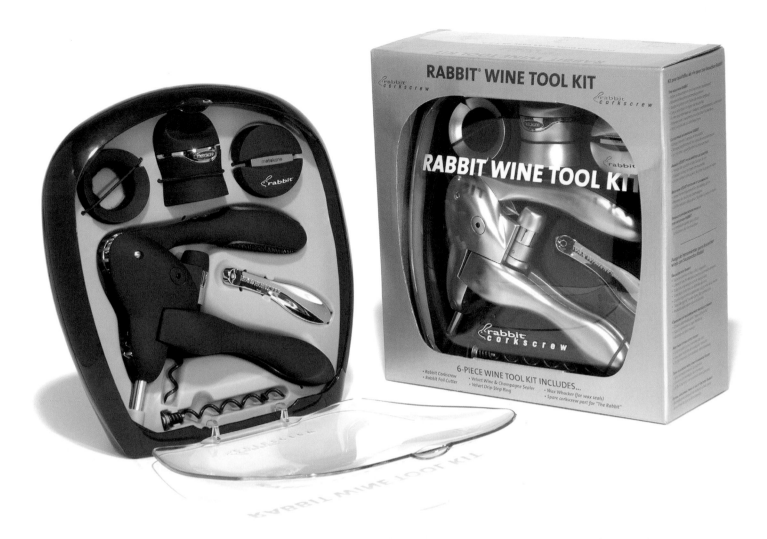

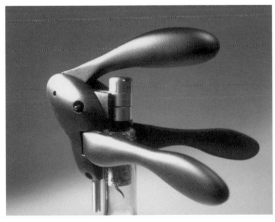

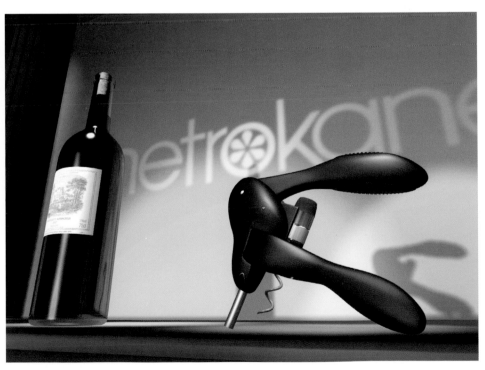

⌃ Top: Kilduff also designed the Rabbit Hutch, a Lucite case that holds the Rabbit Corkscrew and the Rabbit Foil Cutter. The Rabbit is available in black and silver.

⌃ Above: After building the first prototype, Kilduff's girlfriend commented that it looked like a rabbit. Embarrassed at first by the resemblance, Kilduff and the client found that it worked in their favor.

⌄ To make the corkscrew look more like a rabbit, a rubber spray was applied to the body to simulate a furry feel, and a rubber grip pad was added to the handle.

Malden Mills Polartec Heat Blanket Who doesn't enjoy **snuggling** beneath a **toasty** warm **blanket** on a cold night?

⊗ The wireless remote control clips onto the blanket so that you don't lose it in the night.

⊗ Altitude's brainstorming process is where designers indulge in blue-sky thinking. They consider related products and get as broad as possible in that first initial conceptualization.

Of late, however, concerns about large electrical fields, high voltage, and the dangers to pets and children caused by electric blankets are pushing many people to shiver beneath a pile of ordinary blankets and comforters.

Malden Mills, a textile company, felt the time was right to develop its own heat blanket and tapped Altitude for its design expertise. One of the initial challenges designers encountered was the price point versus feature set. "Since Malden Mills had never developed a product before, we had to work through what their needs were and what that would cost them," says Heather Andrus, Altitude's engineering director. "One of the first decisions we made was that the blanket would have a wireless remote control. It was an expensive option, but they knew about it up front so it was calculated into the necessary price point. That did add a significant amount of cost, but it gave us a lot of options."

A secondary challenge was deciding how the blanket would be powered. Most blankets require high voltage and produce a significant electric field. "It was important that it be a low-voltage product, so that kids wouldn't be hurt and pets could chew on it and still be safe. It took a lot of design to incorporate this feature, but safety was a priority at the outset," says Andrus.

Designers approached this project like they do any other—with a brainstorming session where "we get as blue-sky as possible," says Andrus. They consider related products and get as broad as possible in that first initial conceptualization. "Some ideas may not be practical, but there will be a spark of an idea. It is really an opportunity to not have any boundaries on the problem," Andrus says.

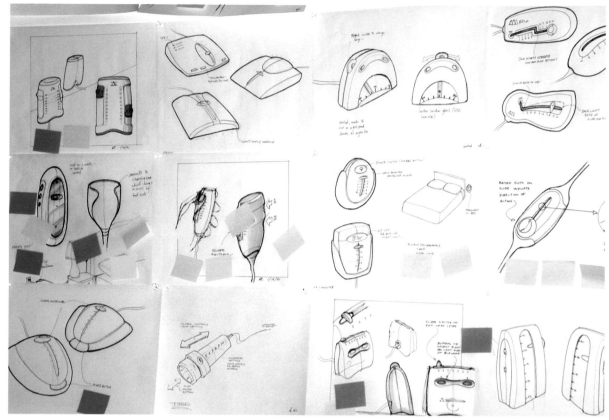

Ideas resulting from the brainstorming may not be practical, but designers usually find plenty of gems among them. These early sketches explored how the remote, the transformer, and the blanket might look.

Designers may present as many as 30 concepts to the client to make sure they are on the same page. From these, two, three, or four concepts are selected. In this case, the concept in the center of this layout was one that ultimately was pursued.

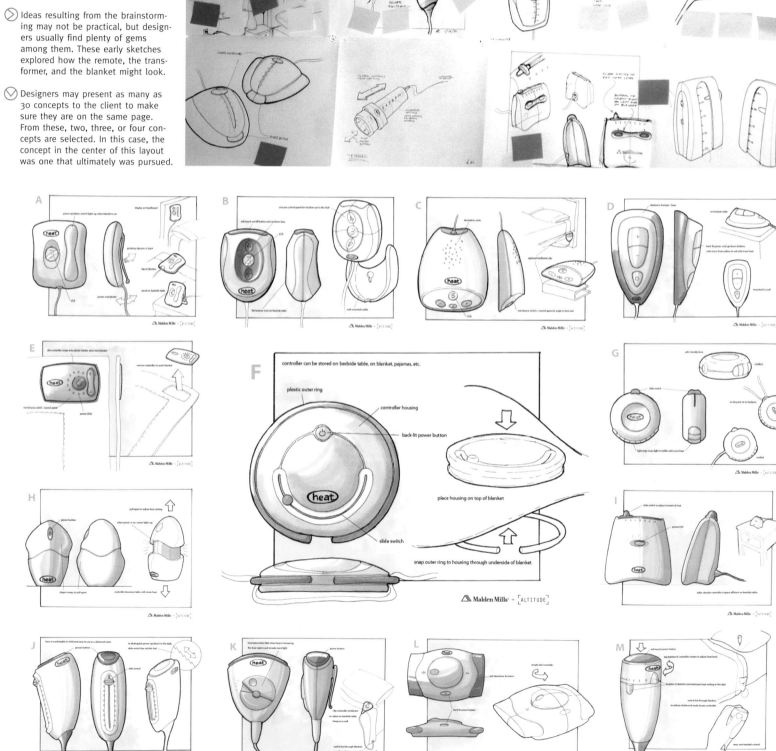

The result was plenty of sound ideas, and Altitude took as many as 30 quick sketches to the client to discuss. "This helps us get on the same page as the client," Andrus explains. "Some ideas may not be feasible, but this approach allows us to say what we think is important. Then we'll select two, three, or four concepts."

In the case of the heat blanket, a lot of early exploration centered around the remote control. Designers wanted to understand how a user would interact with it at night. Users had to be able to adjust it without turning on the light.

In early sketches, they explored the feasibility of using a round or elliptical controller and produced prototypes for testing. They wanted to see how the remote would "live" in its actual environment. Since it was not tethered to a cord, how would a user find it at night? The answer: It could be clipped to the blanket, sheets, or the user's pajamas. Designers walked through usage scenarios with both models, evaluating the intuitiveness of the controls and the feel of the remote in the hand. Feedback revealed that the elliptical controller was difficult to orient in the dark, whereas users could approach the round remote from any direction. Designers also found that they didn't need the power button, which just added an unnecessary level of complexity. The results drove the decision to pursue the round unit.

Creating the transformer was another challenge. Safety was the primary objective. Since the blanket uses very low power, designers needed a transformer that could turn the voltage from

the wall into something safe. "The transformer ended up being big next to the remote," says Andrus. You don't want a lot of electronic stuff cluttering up a bedroom, so the question became, where do you put the transformer to get it out of the way? Designers did their research and developed an inconspicuous transformer with vents on top to keep the unit cool to the touch.

The last component to consider was the blanket itself. While most blankets have threaded through the fabric a heavy wire that delivers the heat, designers opted to weave tiny wires, no thicker than thread, through the Polartec fleece so that it looks and feels like any other fleece blanket. "We run very small amounts of power through the wires, which makes for a much safer product," says Andrus. In fact, the voltage is so low that a dog can chew on the blanket, get it wet, and still be completely safe.

It took eight months to complete this project and, when it was done, the result was an electric blanket that is cozy, soft, warm, and safe. "It is really important to think about everything early on," says Andrus. "In the middle of the process, we went through a number of iterations thinking about the safety of the blanket, which affected the usage scenario. Very early on there are a lot of trade-offs. The team has to know what all the factors are and rate their importance. The team must be in agreement on the priorities for the product. You need to have a cohesive view of all the implications of each decision that you make."

⊙ Designers explored developing a round and an elliptical controller, but user testing found that the round controller was easier to orient in the dark, so it was chosen over the elliptical shape for further development.

round controller

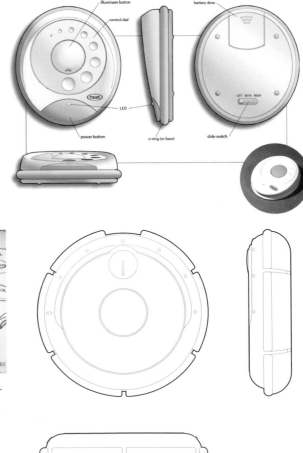

elliptical controller

⊙ Above and right: The engineering department developed its own sketches that homed in on how big the remote had to be to fit everything inside.

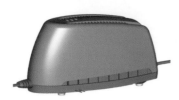

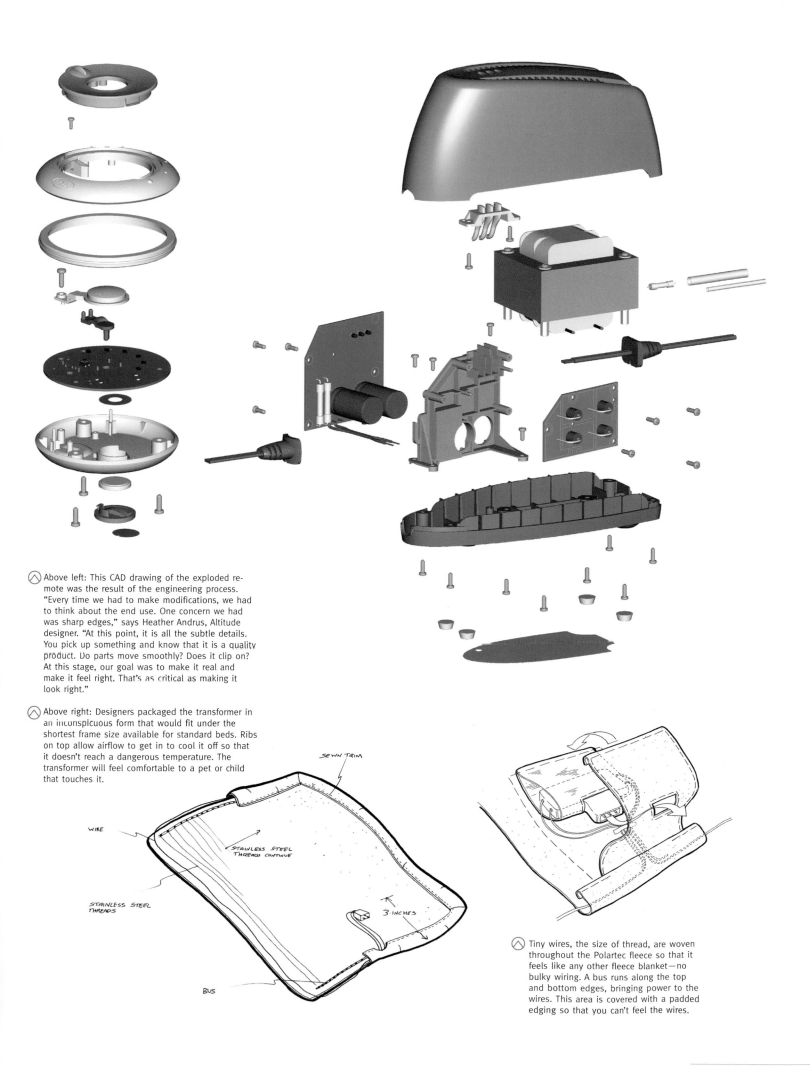

△ Above left: This CAD drawing of the exploded remote was the result of the engineering process. "Every time we had to make modifications, we had to think about the end use. One concern we had was sharp edges," says Heather Andrus, Altitude designer. "At this point, it is all the subtle details. You pick up something and know that it is a quality product. Do parts move smoothly? Does it clip on? At this stage, our goal was to make it real and make it feel right. That's as critical as making it look right."

△ Above right: Designers packaged the transformer in an inconspicuous form that would fit under the shortest frame size available for standard beds. Ribs on top allow airflow to get in to cool it off so that it doesn't reach a dangerous temperature. The transformer will feel comfortable to a pet or child that touches it.

SEWN TRIM

WIRE

STAINLESS STEEL THREADS CONTINUE

STAINLESS STEEL THREADS

3 INCHES

BUS

△ Tiny wires, the size of thread, are woven throughout the Polartec fleece so that it feels like any other fleece blanket—no bulky wiring. A bus runs along the top and bottom edges, bringing power to the wires. This area is covered with a padded edging so that you can't feel the wires.

Duet Fabric Care System

Doing the **laundry** has never topped **anyone's** list of favorite **household chores**, but with the advent of **Whirlpool's** Duet Fabric Care System, there **certainly** won't be as much grumbling about the **job**.

Early sketches homed in on the key requirements of the new fabric care system. It had to have the largest opening into the wash drum in the industry, the highest possible position for the wash drum to make loading and unloading simple, and a detergent dispenser that is robust and easy to use.

Bottom left: This rendering details the control, which is tailored for the person who wants to wash clothes as quickly as possible as well as for the person who wants to modify the process to exact personal preferences.

Bottom right: Designers' goals were to tie all the features desired into a consumer-friendly, easy-to-care-for, attractive, aesthetically pleasing design.

Consumers clamoring for a front-loading laundry system that provides greater water and energy efficiency, ease of use, and gentler handling of laundry items prompted Whirlpool's fabric care marketing department to propose the idea for the Whirlpool Duet Fabric Care System.

"One of the main challenges for this project, from a design perspective, was to coordinate all of the consumer requirements," says Mark Baldwin, category lead for Whirlpool Global Consumer Design. "These requirements included the largest opening into the wash drum in the industry, the highest possible position for the wash drum to make loading and unloading simple, and a detergent dispenser that is robust and easy to use. In addition, the desire was for a control tailored for both the person who wants to wash clothes as quickly as possible and the person who wants to modify the process to exact personal preferences. Finally, we had to tie all of these together in a consumer-friendly, easy-to-care-for, attractive aesthetic design."

During the first phase of the project, designers created hand sketches that tried to take into account not only all of the consumer requirements but also the manufacturing and marketing requirements. A cross-functional team was established right from the start that included design, marketing, engineering, and manufacturing. From there, using ProEngineer software, designers embarked on phase two, which included moving the sketches into the 3-D CAD system. "This allowed us to see very quickly if the direction we were working on was feasible or not," says Baldwin.

In phase three, designers went to consumers one on one to gather specific feedback on several concepts. During the fourth phase, designers used the consumer input to further refine the concepts, narrowing the field to two, both of which were built as mock-ups.

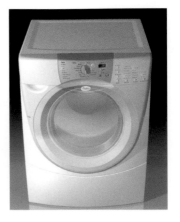

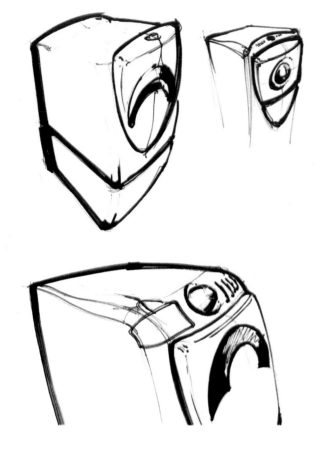

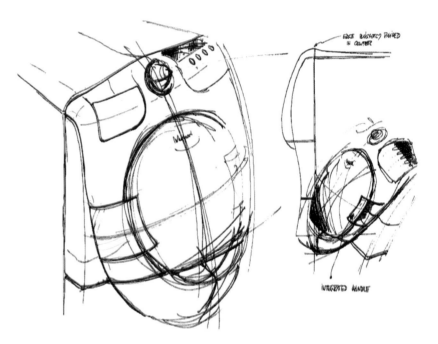

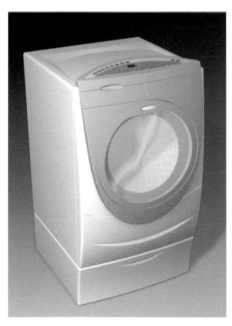

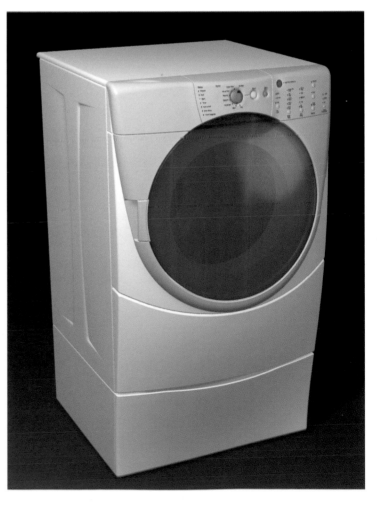

⌃ Top: In early hand sketches, designers tried to take into account not only all of the consumer requirements but also the manufacturing and marketing requirements.

⌃⌄ Above and right: Designers wanted to get the sketches into their 3-D CAD system as soon as possible because it could tell them right away if what they were creating was feasible.

"At this point we were heavily involved with engineering to confirm that the design directions that we were proposing were feasible and manufacturable," says Baldwin. "Extensive usability studies were conducted at this and in other phases to ensure a consistent and pleasant experience for the consumer with the product."

In phase five, designers conducted quantitative design research with their mockups as well as competing products. At this point, they also researched color choices with consumers to determine the correct palette for the Duet system.

Throughout the latter portion of the project, designers continued to work closely with engineering to finalize extraneous details. The intent was to bring the design to fruition in the most efficient manner possible while following all of the details right into production.

"This product is unique in a number of ways," says Baldwin. "The design, forms, and colors help reinforce the whole concept of laundry—clean, fresh, and new. The combination of forms and color help give the user the feeling that the product is gentle on clothes and is a superior performer.

"To create a winning product takes more than just looking at the design aspects of a product; you must integrate holistically all of the disciplines, including engineering, manufacturing, human factors, marketing, and business. When all of these work together, you can achieve new milestones in design," says Baldwin.

"The main thing I learned from this project was that a dedicated team of people working together toward one goal and thinking outside of the box can break longstanding paradigms of design."

⬯ Designers worked directly with consumers and used their feedback to further refine the design. This rendering shows how the machine looks with an optional pedestal that raises the unit by 12 inches (30 cm) and functions as a storage area for detergent or other items.

⬯ When designers created these renderings, they were interacting extensively with engineering to confirm that the design directions being proposed were feasible and manufacturable.

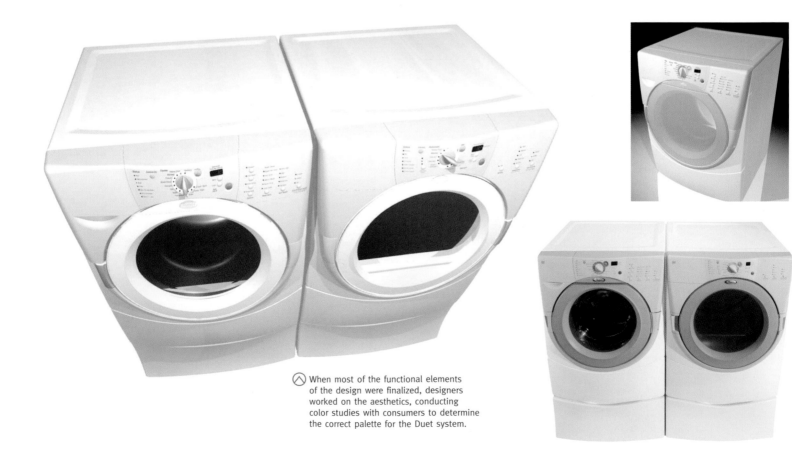

⬯ When most of the functional elements of the design were finalized, designers worked on the aesthetics, conducting color studies with consumers to determine the correct palette for the Duet system.

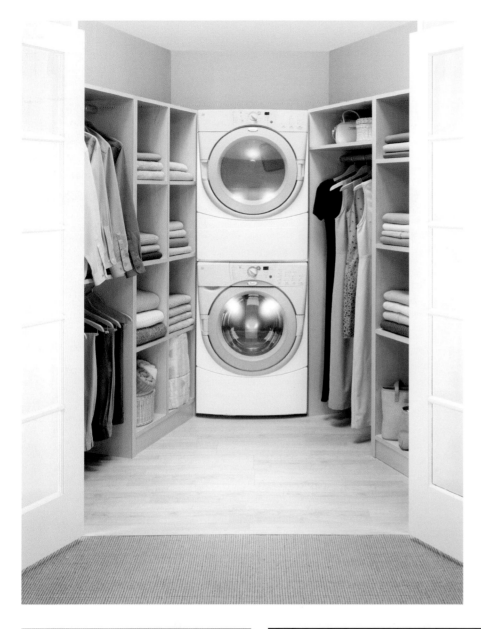

The Duet system is stackable and designed to fit in with existing furnishings, whether in a laundry room or a closet.

Bottom left: The cabinet, including the customizable front panel, is stamped steel with a combination of highly durable paint and porcelain finishes. The front body panels and the outer door are molded from engineering polymers with a fine texture. The control panel graphics are pad printed using high performance inks.

Below: The Duet Fabric Care System not only looks good but is efficient, too. The washer uses 67 percent less water than conventional washers do—only 15.8 gallons (60 L) of water per load compared to the usual 40 to 45 gallons (150 to 170 L) in top loaders. It also uses 68 percent less energy than conventional washers, saving the consumer as much as $120 a year.

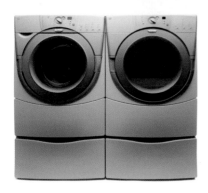

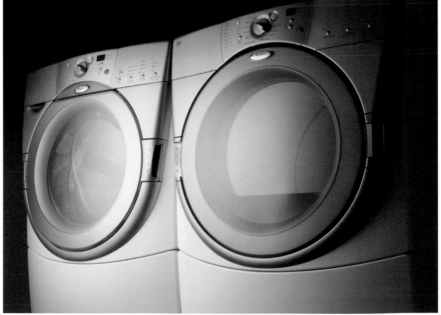

Photographs used with permission from Whirlpool Corporation.

Wolf Convection Oven Line Your **mission:** to design a complete line of **ovens** and cooktops from the **ground up**—a total of **18** products must be **designed** and **engineered** in a mere 16 **months**.

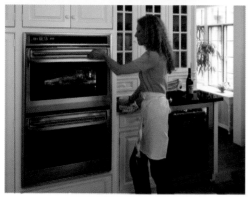

The Wolf line of convection ovens, owned by Sub-Zero, lives up to the quality and performance the Sub-Zero line of refrigeration is known for.

And these can't be just any ovens—you're designing this new line for a high-end manufacturer with high expectations. Are you up to the challenge?

Jerome Caruso was, when Sub-Zero Freezer Company, Inc., a maker of high-end refrigeration units, decided to enter the cookware business. Spurred by consumer demand—consumers loved their aesthetically and technically advanced Sub-Zero refrigeration units and wanted a complete Sub-Zero kitchen—Sub-Zero bought Wolf Appliance Company and hired Jerome Caruso Design, Inc., to design the new line from the ground up, with engineering assistance from Arthur D. Little in Boston. But this wasn't a new challenge for Caruso—over the previous 20 years he had almost singlehandedly designed everything in Sub-Zero's refrigeration line, so Sub-Zero felt confident trusting him with their new line.

Caruso began by thinking about how he would translate the qualities he already knew were important to Sub-Zero into the new line of cookware. Sub-Zero is known as a pioneer in built-in refrigeration, so Caruso examined how he could apply that to cooking appliances. "I believe sense of purpose is very important in maintaining a long-term success in a company's philosophy, and that was of course to blend or integrate the units into the kitchen," says Caruso. "I examined what was on the market, and of course I saw these flat designs with handles sticking out and a lack of integrity with the kitchen, so the first approach was to design the door and control panel."

From market surveys, Caruso already knew there would be two oven widths, a 30-inch (76 cm) and a 36-inch (91 cm) model. He also knew that an important objective for the ovens was to have a larger interior capacity than other ovens of the same width. To make that possible, Caruso decided to design a horizontal control panel and worked to fit the controls on the panel in a way that was both aesthetically appealing and intuitive to use. Caruso designed as many as 50 variations, which were presented on a computer to focus groups comprising consumers, kitchen designers, and architects. With input from these focus groups as well as from the team at Arthur D. Little, Caruso was able to finalize the layout.

Caruso also worked to implement another of his ideas for the control panel—having it revolve at the touch of a button to hide the display, further integrating the oven seamlessly into its environment. The idea was presented to focus groups, who responded enthusiastically, so Caruso and Arthur D. Little added this to the list of features they wanted to incorporate. Caruso also recessed the door handle to avoid projecting it into the room.

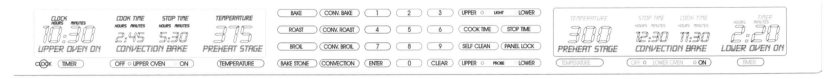

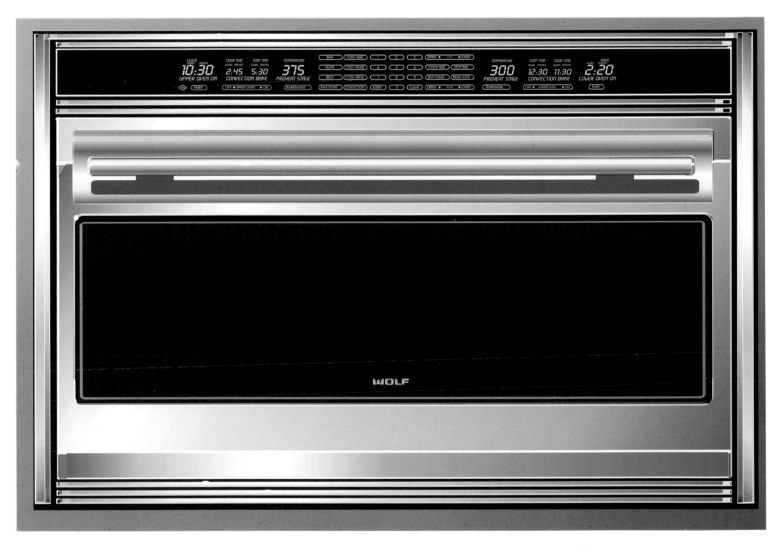

Control panels like this one at top were shown on a computer to consumer and commercial customers in order to test usability; the computer rendering at bottom shows the panel in the context of the entire oven.

Arthur D. Little had benchmarked the top European makes of oven—such as Gaggenau and Miele—with the objective of meeting or exceeding the functioning of these state-of-the-art ovens. The engineering team developed a new system of convection cooking that utilized two fans (mirroring the dual compressors in the Sub-Zero refrigeration units); the fans were controlled by a microprocessor chip that turned them on and off at intervals to keep the oven's temperature constant overall and consistent within the unit.

Meanwhile, Caruso worked on adding features to the ovens that would make them more ergonomic. When the oven door is opened, the bottom rack glides onto rails on the door and can be easily pulled out farther, making the handling of larger items easier and safer. The round door handles rotate in the user's hand when opening or closing the door. A hydraulic cylinder in the door creates a soft landing, even when the door is released abruptly. Caruso likens Sub-Zero's attention to detail to that of another client, Herman Miller: "Both have a way of focusing on details and things they believe matter in the marketplace. In both cases, ergonomics is a very important feature."

Since fit and finish is another important trademark of Sub-Zero that Caruso aimed to bring to the Wolf line of ovens, the oven door was designed so it could be inset, making it flush with the kitchen counters. The beveled, tinted glass on the door of all units has a graphic pattern that matches all the other Wolf products, giving continuity to the design of the line. The glass control panel is bonded on the back with capacity-switch film, tinted to change the color of the vacuum-fluorescent display to a proprietary blue-green. Feedback from additional focus groups, where CNC (Computerized Numerical Control) aluminum appearance models were presented, led Caruso to explore finishes beyond the traditional stainless steel. He added two finishes: platinum (wherein stainless steel is lightly sandblasted; the resulting finish doesn't show fingerprints) and carbon (a black, brushed stainless steel).

Manufacturing the Wolf line proved as challenging as designing it had been: When Sub-Zero was not able to buy a manufacturing plant that met their specifications, they built their own 350,000-square-foot (32,500 sq m) plant and hired a staff of 75 to get it up and running. Most of the parts and materials were sourced locally in Wisconsin; says Caruso, "If you visit the Sub-Zero plant, it's delightful, because you can see raw steel coming in one door and finished units going out the other." Sub-Zero envisioned their Wolf plant operating in the same way, with the same degree of quality control that such centralization allows.

This quality control was necessary for the manufacture of the Wolf line, many of whose parts were composed of deep-drawn, stamped stainless steel: "When you deep draw stainless steel, it's critical where you get that steel from to stretch it into these shapes," says Caruso. Among the biggest manufacturing challenges were the stamping of the recessed door handle and keeping both door and handle insulated and cool to the touch, even through the self-cleaning process, where temperatures can reach up to 900°F (482°C). Manufacturing the rotating panel proved challenging too, but the new staff was up to the task.

Details of one of the finished ovens show the revolving control panel in action. The control panel is a clamshell—two die-cast aluminum parts finished to match the finish of the oven. Also visible is the recessed handle of the oven; the handle rotates in the user's hand when he or she is opening and closing the oven door.

In the end, manufacturing of the line—which had expanded from the original goal of 18 to 25 products—began 28 months after design had begun. Caruso credits his accomplishment to two factors. In his eyes, the leanness of his operation was a boon: "One person was an advantage—I didn't have to discuss it with anybody else except my client, and an awful lot of decisions were made in a very short time on my computer under my direction only." His long relationship with his client, and the trust they put in him, not only saved time but also added to the quality of the final design. "I felt that what has been done for Sub-Zero throughout the years has been quite distinctive, and I thought it was necessary that this be a criterion for the ovens, that they not look like anybody else's," says Caruso. "I think they kept adding to it, to my surprise, in saying, go there, do it, and make it distinctive, and carry it to the top of the line."

⌃ A dual-fan convection system was invented for this line of ovens to maintain evenness of temperature. The interior is porcelainized to a rich blue—a proprietary color that contrasts with the speckled gray of many other self-cleaning ovens.

⌄ The bottom rack glides onto the door of the oven, making the handling of larger items easier and safer.

sōk Overflowing Bath A long, **hot soak** in a bath is one of life's **simple pleasures**, or so it would seem. In **practice**, we all know the **difficulty** of keeping **submerged** and warm,

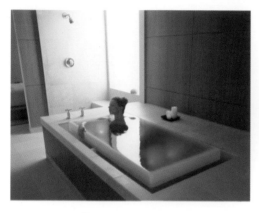

⬡ The sōk overflowing bath provides a relaxing alternative to a whirlpool.

and of keeping the bath at a constant temperature—not so simple, after all. That is, until the introduction of the sōk overflowing bath.

This reinvention of the soaking bath uses an overflow channel to recirculate water, creating a waterfall effect that soothes and engages the bather. While the water is recirculated, it is filtered and heated, so bathwater stays warm and clean; the recirculation also creates a natural effervescence that is more low-key than that created by a whirlpool.

"The initial idea of the bath came to us because, listening to our customers, we were hearing that people could not get a bath deep enough to keep them warm and to give them a really deep soak," says Carter Thomas of Kohler Co. Consumers also wanted a new experience—a bath that would be visually interesting, quiet, restful, and reminiscent of bathing outside. Adds Thomas, "Obviously, they didn't say, I want something that overflows into a channel and has color—we had to discern that." The bath also fit into Kohler's strategy of marketing the concept of a home spa—a dedicated area in the house similar to a home gym or home theater—to give new interest to an overlooked category and to provide interior designers with a more engaging product to offer their customers.

The team came up with a number of concepts for a soaking bath; the bath that mimicked some of the qualities of an infinity pool was the one the team chose to develop. After initial brainstorming, Kohler quickly went into crude modeling of the bath in cardboard and plywood. "We're a very hands-on organization where we go right to the three-dimensional very quickly, and then we may follow up with the computer work," says Thomas, "because ultimately the experience is what we're after here, and you really can't get that from the computer."

The rough prototypes were used to get an idea of what the size and shape of the bath would be, how many people it would hold comfortably, and how the depth felt. The data was adjusted and put into the computer model; then, the team built a rough model that would hold water. This model did not yet have pumps or motors; it was simply used so the team could evaluate the experience of the bath itself.

In evaluating this experience, the team had help from Kohler's human factors lab, which has access to a database of information about employees throughout the company. Employees were called and asked to spend half a day in the lab evaluating the bath. "The different sizes of people and the different volumes and

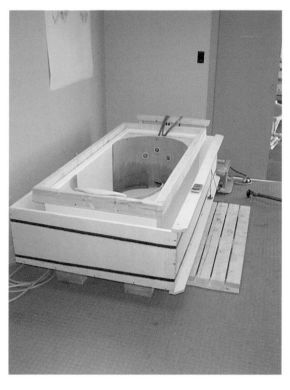

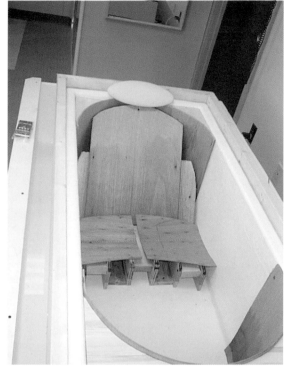

⊘ This model enabled users to evaluate the experience of sitting in the tub; Kohler was able to draw on its own employees to test the sōk, both without water and with it.

the way people feel in different vessels of water surrounding them can be quite interesting," says Thomas. The team put that feedback into a third set of models, which now had detailing close to what the team wanted for the final design as well as working electronics.

From this testing, the team learned that the speed with which bathers entered the bath was a big variable in the proper functioning of the channel overflow. If bathers got in quickly, there was a good chance that the resulting water displacement wouldn't be caught by the channel and instead would end up on the floor. "We tried to go wide and shallow with the overflow channel, but that just did not work," says Thomas. "We had to go deep and narrow to make sure the water would stay in the channel, go down to the bottom of the channel, curl up on itself, and then stay in there and not ramp back out." The overflow channel also affected another of the team's primary objectives: keeping the bath quiet. The height the water fell from the interior well into the overflow channel turned out to make a big difference in the noise level of the bath, so the team had to take that factor into account when refining the overflow channel.

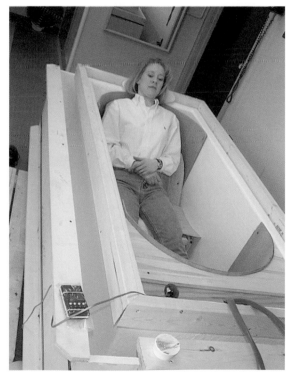

Every change in a crucial element—the size of the pump, the volume of water contained in the bath, the size and shape of the overflow channel—affected all the others, and more adjustments had to be made to the rest of the design. As Thomas puts it, "These variables are all interdependent, and if you change one of them, the applecart really gets upset." At the same time, the design had to allow for a wide variation in one of the most crucial variables—the person using the bath, a factor that affects both the volume and the speed of the water displacement.

One of the biggest challenges facing the team was perfecting the manufacture of the product. The chosen material—fiberglass-reinforced plastic (commonly used in the manufacture of boats)—had many advantages: It allowed for high-strength, thin, cross-sectioned parts, which were necessary to allow room for the electrical components contained within the walls of the bath; it could be crafted with the precise geometrical detailing necessary to make the overflow channel work; and it allowed for a colorful and highly durable surface. There was one major drawback, however: The choice of this material meant Kohler would have to reinstitute manufacturing processes that they had not performed in years. The team was worried that it might be difficult to get right, especially on a product where precise manufacture was critical to success.

Because of Kohler's unfamiliarity with the material and the intricacy of the overflow channel mechanism, the team decided to set up an independent manufacturing cell at their headquarters in Wisconsin and do a small prototype run, much as the auto industry does. They brought up personnel from their manufacturing facility in Texas to assist. In doing so, they particularly wanted to prove two parts of the process—that the water would sheet out sharply and consistently into the overflow channel, and that the manufacture cycle time would be as planned. The manufacture is a complex, multistep process—the bathing well and the overflow channel are cured, demolded, and trimmed separately, and then bonded together with high-strength methacrylate structural adhesive and reinforced by support brackets—so it was critical that the timing of each step could be predicted accurately.

In the test run, the team found out that all the assumptions they had made in CAD modeling were correct—the prototypes did indeed work as envisioned, and they could be manufactured within the range of time the team had predicted. "Everyone on the team and also executive management breathed a huge sigh of relief," says Thomas. "We were confident about it before, but I think until you actually see that part come off a prototype line, you don't really know what you have." The prototypes—fewer than a half-dozen in all—were then sent to a packaging lab so packaging and shipping specifics could be determined.

The sōk overflowing bath was an immediate hit with consumers—while the sales team had projected a sales goal of just 100 units in the first seven months of release, at the end of that time they had sold quadruple that number, putting them close to surpassing their third-year sales projections. A year after its initial release, Kohler added chromatherapy, which allowed users to enhance their bathing experience with a variety of colored lights; this feature had been planned from the start, but the team didn't have time to incorporate it into the product's first incarnation.

⊘ An early version of the overflow channel (left) was too wide and shallow to enable the recirculation to work as the team had envisioned; the final version (right) was deeper and narrower.

⊘ The sōk was designed to be flexible enough to be easily incorporated in any style of room, whether traditional or contemporary.

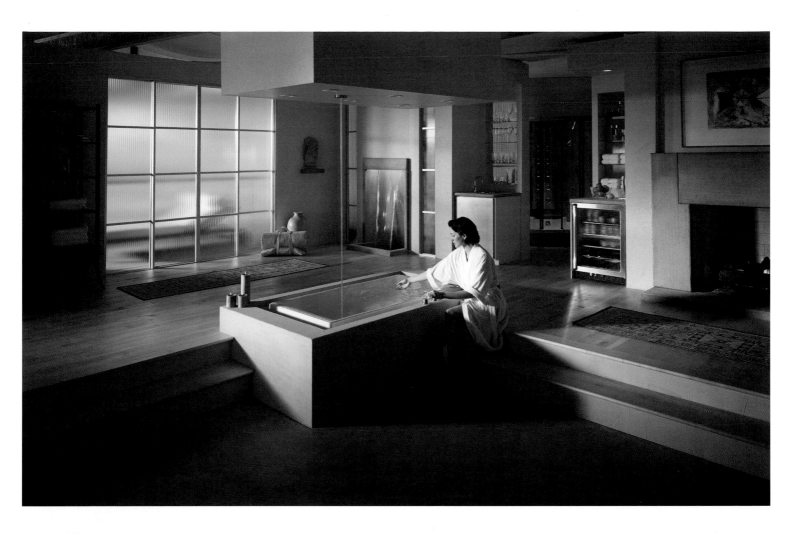

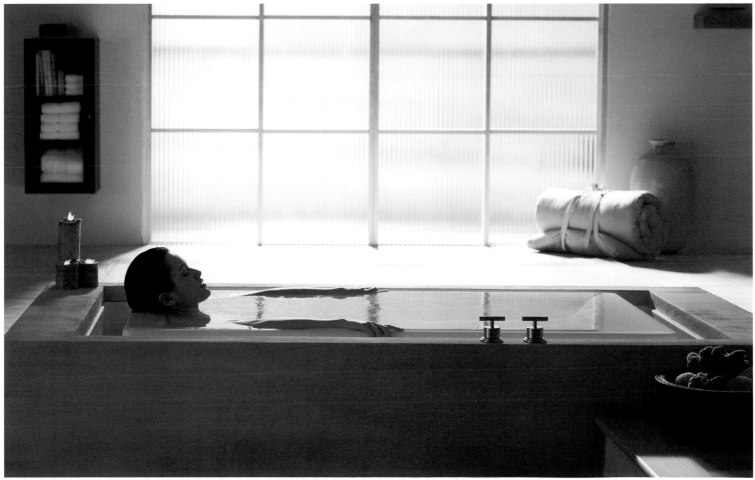

New Century Maytag Neptune Washer When the first version of the **Maytag Neptune** washer was **released** in 1997, it featured a **number** of progressive **design** and performance features:

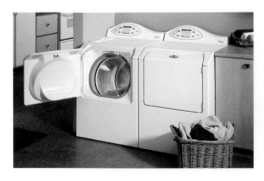

The New Century Maytag Neptune saves energy—while saving clothes from wear and tear and user guesswork.

It saved energy and cleaned clothes gently, and its patented cabinet design allowed better access and visibility into the units.

Nevertheless, the original design still featured mainstream elements such as a control panel with pushbuttons and a timer. When it came time to redesign the washer—in a version dubbed the New Century Neptune—Maytag knew there was room for improvement. Says Steve Schober, manager of industrial design, laundry, for Maytag, "We realized we needed to make sure that we were providing the user with enough information; we wanted to do better for consumers in terms of giving them what they needed to understand the complexities of the machine, and one way would be the control system." Testing revealed that users didn't like that the unit itself didn't feature instructions on how to do laundry and that they had to rely on the user pamphlet or their box of detergent for help. "With the New Century Neptune, the goal was to provide users with a lot more comprehensive information at the touch of their fingers," says Schober.

The user interface team—which consisted of representatives from research and development, marketing, product testing, survey research, service, and industrial design—brainstormed ways that a redesigned control screen could benefit users. They used Macromedia Director to test various concepts before deciding to develop a touchscreen that would allow users to touch the letter their stain began with, find the stain, and select it. This feature, called the "Stain Brain," would include 55 kinds of stain that the washer would be programmed to handle. Owners would also be able to customize the settings to include "Favorites": types of laundry loads they did often.

The overall goal of the redesign was to incorporate these new features and maximize consumer appeal while maintaining the integrity of the design. Since the new controls took up much less space in the control console, Schober and his team were given more latitude with its shape than they'd had in the previous model.

Schober began sketching ideas for a reshaped panel. Previously, Maytag's design of the Admiral had featured a wave shape that began in the washer's fascia and that continued to the dryer; says Schober, "We actually found out that it caused a little bit of a boost in sales of the dryers, because people wanted the matching dryer." This fact, along with Maytag's goal of developing laundry systems that could be moved out of the basement and into a family's living space, informed the design team's earliest sketches of the New Century model. Other areas that received attention in the sketches included the shape of the door and of the detergent dispenser. Another early concept for the design was eliminating the traditional back panel for the control system, instead placing the controls on the door of the machine.

⌃ Top right: This early sketch for the Neptune featured the flow the Maytag team was looking for; however, that the design limited the flexibility of placement—the washer would have to be to the left of the dryer for the design to work—was seen as a drawback, and the idea wasn't pursued.

⌃ Top left: An early concept sketch of the control panel.

⌃ Above: To address internal concerns that a dip in the back panel of the washer might not be desirable to consumers trying to hide flaws in their laundry area, this playful sketch imagines a vase in that spot.

⌄ Right: These more refined computer illustrations show the wavelike shape of the control panel as well as the reshaping of the detergent dispenser.

The team chose four early concepts to develop and fashioned appearance models out of existing Neptune models that they modified with carved, primed, and painted Styrofoam; they used Bondo putty to reshape the door handle. The models were presented internally and to consumers; consumers rejected the model with the controls on the door as a bit too progressive but liked the wave shapes of the other consoles. They also approved of the new door design, which featured a swelled handle on the top that both carried out the flowing design of the control panel and allowed the door to be reversible. Based on the consumer research as well as internal feedback, the team chose to explore a snail-shaped control panel as well as a back panel that flowed in an arc from the washer to the dryer. "The idea is that you could set a bunch of them together in a store, or just two together, and show a bit more of the dynamics of the design and a more sweeping, flowing feeling than a plain rectangular box has," says Schober.

The design team began rethinking the shape and configuration of the control panel with this snail shape, with a smaller screen, in mind. Complicating matters was the fact that two versions of the Neptune were planned—a higher-priced version with an LCD control panel and a lower-priced version with an LED control panel. Says Schober of the LED control panel design, "That posed quite a few more problems from a design standpoint. We had to have so many functions—as many functions as we had on regular rotary knob controlled or pushbutton controlled units—that it was hard to fit everything into the small area." Designing for the LCD control panel was equally challenging, but for different reasons. While Schober had originally envisioned the LCD display screens to feature wavy lines that mirrored the wavy lines of the control panel and door, the low resolution of the LCD screen restricted him to straight lines. He envisioned color in the LCD, as well as movies that showed the washing action, but those ideas were ultimately too expensive. One new feature that did make the cut was a display showing the number of minutes left in the cycle; no longer would users have to squint at a pointer on a dial and try to guess how far they were into a cycle.

According to Schober, no fewer than 50 layouts of the control panel were presented to the interface group, which evaluated both form and content of the screens. Usability was closely scrutinized; even the wording used on the interface had to be changed due to copyright issues.

Another area of the unit that was redesigned for both visual and practical reasons was the detergent dispenser, which was reshaped to reflect the waves and swells of the control panel and the door. User testing had shown that the dispenser lid on the original model was difficult to open, particularly as users often opened the lid with their left hands. The team attempted to address this with a spring-loaded lid, but users weren't impressed by this feature, so the team instead opted for a simpler solution, restyling the lid with a better grip area.

◇ Top: This early model features a square control panel; internally, the team decided that the square panel wasn't big enough—especially as the same design had to work for the LED control panel, which required more space—and that it didn't complement the flowing lines of the design.

◇ Middle and bottom: These early appearance models were presented both internally and to consumers.

Left: When designing the Neptune's LCD display, the designers had to map out a complicated array of controls. Some early designs featured wavy lines in the display, to carry out the organic lines of the washer, but the design was constrained by the limits of the low-resolution LCD screen. In the final design for the LCD display, the waves were replaced with straight lines.

Right: An image of the LCD screen in its final form.

These final versions of the LCD (top) and LED (middle and bottom) control panels show the design team's attention to detail in following through on the organic lines of the rest of the washer, even in the button design and layout.

The medallions featured on the washer were designed to mirror the shape of the control panel.

The medallion on the door panel was redesigned to reflect the shape of the control panel, and a new medallion was created for the control console. Says Schober, "I got some ribbing for this from engineering, who tries to cut every penny out of the unit that they can, but it really was something that was favorable to the consumer."

The new control panel was designed to lock into the plastic console, as the conventional version had; the only difference was that the new version had fewer parts to snap in, thus simplifying manufacture. The ease of assembly that had been designed into the newer Neptune meant it was easier to service too; repair personnel could easily unscrew and take apart the control panel when needed. In the end, while the Maytag team added innumerable features to the New Century Neptune, the engineering and design incurred no additional factory costs.

By designing a washer with both beauty and brains, Maytag was able to maintain its position as leader of the high-end laundry category. But Maytag refuses to rest on its laurels: A redesign of the New Century Neptune is already in the works.

Birkenstock Footprints: The Architect Collection

When **fuseproject**, a San Francisco **design** studio, created a **"learning shoe"** for the "Design Afoot" show

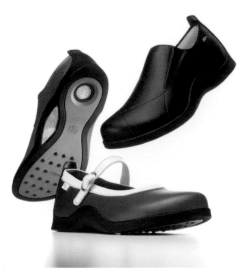

Designers paid homage to Birkenstock's history of green design and quality manufacturing by creating "branded windows." These clear, biodegradable windows reveal the interior of the shoe and allow a peek at the sole's cork-latex technology.

Opposite top left: This is the concept shoe that started it all. Created by fuseproject for the San Francisco Museum of Modern Art, this "learning" shoe is embedded with a chip that collects data about the ergonomic needs of the wearer. Birkenstock liked the idea and asked fuseproject to develop its Birkenstock Footprints: The Architect Collection.

Opposite top middle: The insoles, which are part of Birkenstock heritage, are made out of a mixture of cork and latex that affords comfort and creates a distinctive look. Designers started with this base and reshaped it in 3-D, adding new front and heel padding made of biodegradable gel.

Opposite top right and center: Designers sculpted the sole to lighten its mass and to create a more dynamic and modern silhouette. The overall result is a more fitted, sporty, and elegant shoe with a modern, urban attitude.

at the San Francisco Museum of Modern Art, it had no idea that it would catch the attention of Birkenstock, a company that had been manufacturing comfort shoes for 232 years.

Fuseproject's concept shoe "learns" its wearer's ergonomic needs through a reactive sole embedded with a chip that collects data about the wearer's feet and walking style. This information is stored on the chip and, when removed, can be used to customize the wearer's next model.

This kind of thinking appealed to Birkenstock, which tasked fuseproject with developing a new line—Footprints: The Architect Collection, which would bring their key brand attributes of comfort, green design, recyclability, and sustainable manufacturing to a new generation and specifically, appeal to the new urbanite consumer without betraying the brand's heritage.

"The primary challenge was to go beyond—basically invent—a new direction while staying true to the history and the principles of the brand," says Yves Behar, founder and principal of fuseproject. "We had to blend the existing technology and fit with new comfort features and a new design direction." Specifically, while the new line had to respect the traditional wide fit of the Birkenstock brand, Behar wanted a design that lightened the visual bulk of the shoe and made it distinctively different from Birkenstock's other styles. At the same time, designers had to ensure that the new assemblies and manufacturing techniques would be feasible within European Union and German labor and environmental standards.

The team started working on the shoe, "designing from the inside out, which is not the typical way that shoes are designed," Behar says. Throughout the process, designers asked, Can comfort be elegant and modern? Can green design go beyond the aesthetic clichés of green design?"

"Our approach to these challenges was to introduce innovation to the brand by adapting new recyclable technologies, creating new comfort features, and presenting these with a stylish, fashion-forward look," says Behar.

They began by reshaping the insole in 3-D and adding comfort and stabilizing features like the heel pad and front pad, using a renewable mixture of recycled cork and natural rubber lined with natural vegetable-died suede. A recessed, biodegradable polyurethane techno gel was integrated with the insole to provide added shock absorption, comfort, and stability.

Next, designers sculpted the sole to lighten its mass and to create a more dynamic and modern silhouette. "While the original wide fit of the Birkenstock offering was respected, the new design is fluidly sculpted around the insole, minimizing extra material and making the shoe appear more sleek and the mass visually lighter," says Behar.

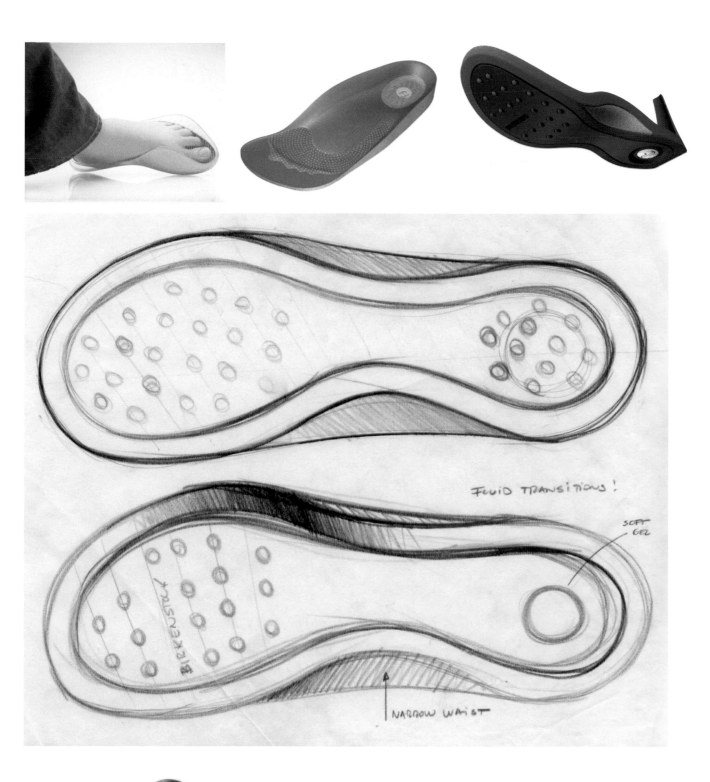

FLUID TRANSITIONS!

SOFT GEL

BIRKENSTOCK

NARROW WAIST

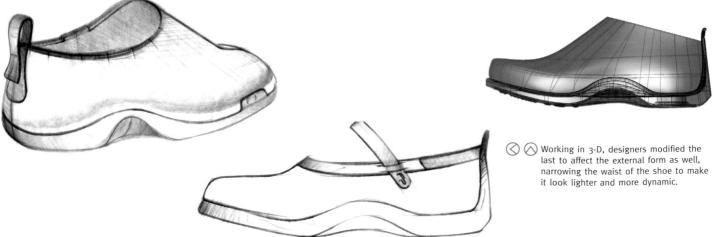

⊗ ⊗ Working in 3-D, designers modified the last to affect the external form as well, narrowing the waist of the shoe to make it look lighter and more dynamic.

Color scheme Fluid W

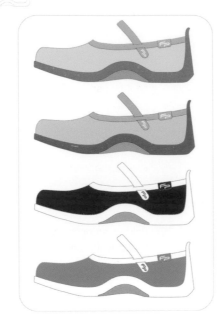

Sole	details	stitch	lining	upper	
PANTONE Cool Gray 8	PANTONE 360	PANTONE 360	FAYTEX 2000 / PANTONE 579	PANTONE 579	Custom Color Nappa Gold
PANTONE 445	PANTONE 445	PANTONE 443	FAYTEX 2000 / PANTONE 467	PANTONE 467	Lana Nappa Gold
WHITE	WHITE	PANTONE 200	FAYTEX 2000 / PANTONE 200	PANTONE 200	Cherry Nappa Gold
WHITE	WHITE	PANTONE 298	FAYTEX 2000 / PANTONE 298	PANTONE 298	Custom Color Nappa Gold

Color scheme Architect W

Sole	details	stitch	lining	upper	
WHITE	PANTONE 200	PANTONE 200	FAYTEX 2000 / PANTONE 200	PANTONE 467	Lana Nappa Gold
PANTONE 5743	PANTONE 583	PANTONE 583	Da-lux Ara Spator 684 / PANTONE 583	PANTONE 5757	Custom Color Nappa Gold
WHITE	PANTONE 2975	PANTONE 2975	FAYTEX 2000 / PANTONE 2975	PANTONE Cool Gray 9	Ramarro Capretto Gold

Color scheme Fluid M

Sole	details	stitch	lining	upper	
PANTONE 445	PANTONE 452	PANTONE 200	Da-lux Ara Spator 684 / PANTONE 200	PANTONE 417	Rana Nappa Gold
PANTONE 467	PANTONE 145	PANTONE 200	Da-lux Ara Spator 684 / PANTONE 145	PANTONE 1615	Lombrico Capretto Gold
PANTONE Cool Gray 8	PANTONE Cool Gray 8	PANTONE 200	Da-lux Ara Spator 684 / PANTONE 200	PANTONE 467	Donnola Nappa Gold

⊙ Designers mixed up materials, playing around with leathers, elastic, and neoprene. Color choices include a range of existing Birkenstock colors and new colors whose bright, affirmative look is also elegant.

They modified the last to affect the form on the outside as well. "The main constraint is that Birkenstock is mainly a wide shoe that allows for as much room as possible for your foot and toes inside the shoe," says Behar. "We were able to design it to narrow the waist of the shoe and create aesthetics that broke it down in shape. The result is that it looked a lot lighter and a lot more dynamic."

For the uppers, designers created different end-use styles, some of which are quite simple and mix materials including leather, elastic, and neoprene. The look is comfortable but also streamlined. Color studies were done with the range of colors that Birkenstock had been using. "We went with new colors that are very modern but not considered completely loud. The result is a new brightness and affirmative look that the colors give to the brand while being somewhat elegant," says Behar.

Fuseproject's work didn't stop there. While the shoe was complete, they continued to work on the project, going so far as to develop its logo and the balance of the branding materials including merchandisers and point-of-purchase materials. They even orchestrated the product's launch.

From start to finish, the entire project took more than two years, but the wait was worth it. The new Birkenstock Footprints line has introduced a new generation of customers to the company's philosophy of green design and comfort. New customer comments have been along the lines of "I never thought I would be wearing Birkenstocks," while the pool of traditional Birkenstock customers, a loyal asset, have been reenergized by the company's innovations.

"I learned how powerful design can be with respect to supporting brand evolution and change," says Behar. "Even though we started from an industrial design standpoint, we carried it through all the other aspects of the Footprints brand. That is what makes fuseproject quite unusual. We integrate the brand strategy, and we are able to do a version of industrial design that includes and considers all of the aspects and all of the touchpoints that a consumer will experience about the brands we work with."

Top and middle: Unlike most product design studios, fuseproject did not end their involvement with Birkenstock Footprints with the final manufacturing designs; the firm also created the new line's logo and all of its branding. "The logo represents a fluid continuum, simply expressing the circular element of Birkenstock's ecological product and company principle," says Yves Behar, designer. The mark appears on all Footprints product, packaging, point-of-purchase, and collateral materials and serves to distinguish the Footprints line without alienating the Birkenstock tradition.

The display fuseproject created for the Birkenstock Footprints: The Architect Collection.

While the **expression** might be **"ladies first,"** in the world of **sports** apparel and **accessories**, the situation has often been **anything but**.

From top to bottom: The small, medium, and large versions of the Presto Digital Bracelet. The silhouette of each size is unique, both for aesthetic reasons and for practical ones—it makes it easier at the retail level for both clerks and customers to differentiate between sizes quickly.

In the past, Nike has been no different: As Scott Wilson, creative director for Nike's Timing and Monitoring business, observes, "In our timing business, we essentially have all men's watches. When we did a women's watch, we would take a men's watch, scale it down a little bit, color it a more feminine color, and say that's a women's watch." But then Nike introduced the Presto shoe—a revolutionary concept in athletic footwear. The Presto shoes came in sizes small, medium, and large rather than being sized numerically, and many styles had no laces. They were supremely comfortable, lightweight, and wearable.

When the Presto shoe became a $400 million phenomenon, Nike saw the opportunity to tap into a market hungry for products specifically designed for the active-life consumer. Nike decided to take the qualities that made the Presto shoe such a success (especially with women)—its retro yet futuristic styling and its lightweight and comfortable construction—and translate them into other categories to create a Presto collection. Wilson saw this as an opportunity to create an alternative choice for the active woman by designing a sport watch specifically for her. In addition to being comfortable, the watch needed to possess the same sense of duality as that of the original Presto shoe—a quality that made the shoe as appropriate for a night on the town as it was for the gym.

The timing division started brainstorming ideas for a Presto watch; they considered a wide variety of strap styles, including sweatbands and elastic cords, but had difficulty finding a strap that a wearer would forget she had on. Wilson realized that sunglasses aren't felt by their wearers and took further inspiration from the lightweight nylon Nike's own sunglasses are made of.

The team began exploring the notion of a concept that they called a C-bracelet, a bangle shaped like a C that would slip on and off easily. Initial sketches explored having the opening of the bracelet at any number of points on the wrist, and the team went pretty far in exploring a form factor where the opening of the bracelet was on the side of the wrist. But having the opening at the center underside of the wrist turned out to be the most logical choice—the two indentations of the wrist would serve as natural resting points for the ends of the bracelet, avoiding the wearer's carpal tunnel. This shape was also deemed more secure than having the opening on the side, which the team felt would more easily be caught on something.

For the ends of the bracelet, Wilson took another cue from eyewear and planned on rubberized fins to provide grip as well as a sport-influenced aesthetic. "Nike is a little sensitive to the f-word: which is fashion," says Wilson. "We know it's going to be bought by a lot of people as a fashion watch, but—and this goes for any Nike product—the designs that do the best are the ones that are

◇ Right: Two inspirations for the Presto Digital Bracelet: the Presto shoe and a lightweight pair of Nike sunglasses.

◇ Below: Early on, a variety of styles of C-bracelet were considered.

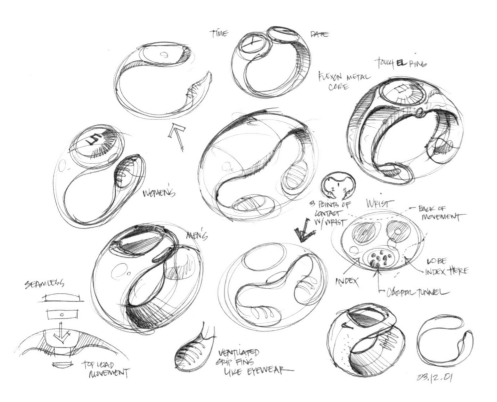

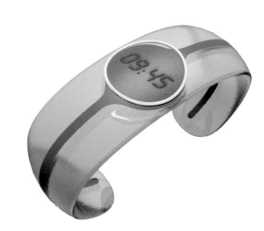

△ One of the first ideas for a C-bracelet was to use a memory metal (called Flexon), which was being used in a new line of Nike eyewear. The idea was to cover with a polyurethane skin, but this was rejected because of its cost and because of the possibility of it popping out of the skin and injuring the wearer. But the team liked, and cultivated, the seamlessness and sleekness of this design.

◇ When Wilson realized that a bracelet with an opening at the bottom of the wrist would be well placed to avoid the wearer's carpal tunnel, he developed this more detailed sketch to explore the possibilities of the concept.

performance-inspired." To aid in the flow of air between the wrist and the bracelet—another performance-inspired detail—a bump on the underside of the watch face provides a third point of contact on the wrist.

Early in the process, the team had settled on a sleek, seamless style for the watch and contemplated a variety of materials that would aid in achieving that. Memory metal coated in polyurethane was considered but was rejected because of its cost; also, the metal was at risk for popping through the polyurethane. Amorphous, or liquid, metal would look sleek but would easily be shattered when overstressed. In the end, a custom polymer was chosen for the initial line; this polymer, as with that used in eyewear, responds to the user's body heat, allowing the watch to gradually mold to the user's body over time for a more comfortable fit. The polymer also allows for a wider array of colors and special styling—such as back-painting, hand decoration and embellishment, and laser etching—than polyurethane, allowing for easy customization.

In keeping with the simplicity and ease of use they wanted for the watch, the designers thought of combining a digital timepiece with an analog-style dial for adjustment. "The great thing about analog watches is that you really don't need a manual, because everybody knows how to adjust an analog watch," says Wilson. But Timex held a patent on the idea, so the designers worked instead on developing a digital watch that was simple and intuitive to use. The final model features a two-button interface: The button on the left sets the watch to one of its three modes—time, date, and chronograph; the button on the right lights up the numerals and, when held down, changes the watch settings. With its scoreboard-inspired font and the odometer action of the numerals as they change, the watch face underlines the influence of sport on the bracelet.

A number of models were created to help the team determine the best size and shape for the watch. The black models in the back of this photo are wax printouts; the white models in the middle are SLS, which are sturdier than SLA models and can be flexed; the clear models in front are cast urethane, and the model front and center was a prototype made by Nike's vendor, Seiko.

The team also considered spring steel, but rejected it because it wasn't lightweight or aesthetically appropriate.

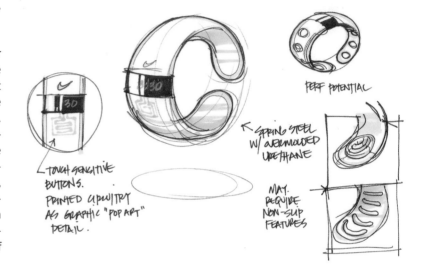

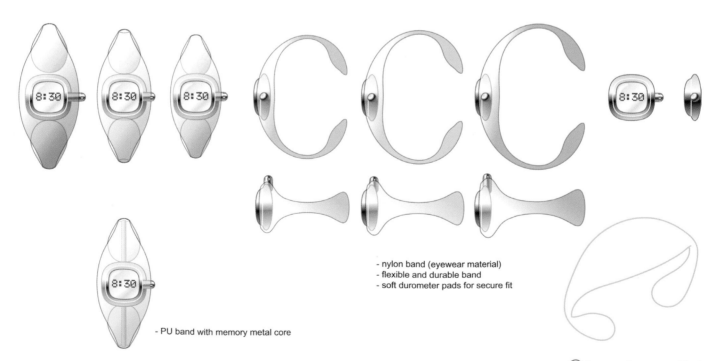

- PU band with memory metal core

- nylon band (eyewear material)
- flexible and durable band
- soft durometer pads for secure fit

For ease of use, a combination of a digital face and an analog crown was considered, but the idea was rejected because of patent issues.

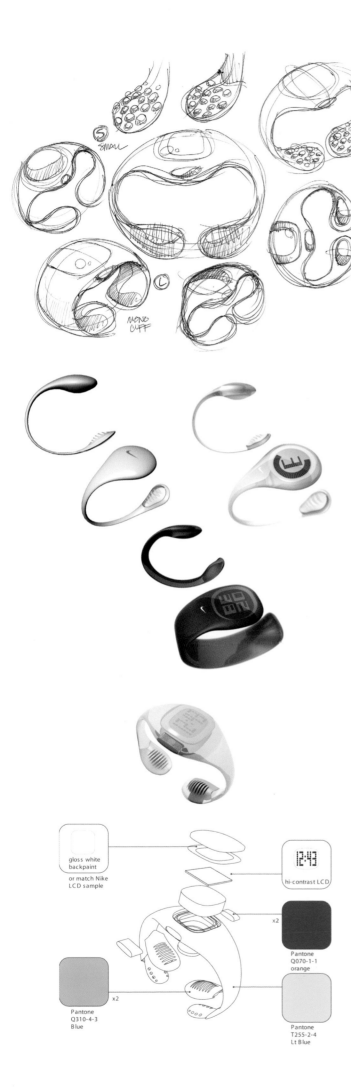

To determine the best sizes and shapes, the designers created wax models, then SLS models that had flexing properties similar to that of custom polymer used for the watch. Nike's sports research lab assisted by researching fit and sizing across the widest variety of people and providing the team with relevant sizing data. Finally, working prototypes were created by Nike's vendor, Seiko. Throughout the process, the Nike team eschewed focus groups, and even the feedback they received from their sales reps (a majority of whom are male, and thus not the primary market for this watch) proved unreliable. Instead, the team relied largely on Nike's consumer, immersive, and trend research—as well as their own design instincts—to shape the product.

Keeping the seamless styling of the watch proved to be one of the designers' biggest challenges, especially because Nike expects their watches to have a high degree of water resistance. To keep the watch's face seamless, the designers had originally planned for it to be loaded from the back, but in that way compromised water resistance. The designers then had to plan for front-loading while still keeping the sleek look they were shooting for—even for the back, which Wilson points out is sleeker than the backs of most watches. "You have to dive in deep. I think one of the things we do at Nike, especially in our tech group, is design inside out with the vendors, and we rearrange components and challenge construction techniques, and we look at how to shave a quarter-millimeter out of here and there," says Wilson. "It's a lot different than watch companies who just throw an Illustrator sketch over to Asia and get the watch made." The watch's seamlessness is further cultivated by the snap-fit assembly designed into it as well as by the hand-polishing each unit receives to eliminate parting lines.

This attention to detail has paid off for Nike: In an industry where selling 50,000 to 100,000 watches is considered phenomenal, over a million Presto digital bracelets were sold in its first year. Nike has continued to explore extensions to the line, including an analog version. Out of the 60 styles and 180 SKUs Nike has in the timing area, the Presto accounts for over 40 percent of their business. "You'd think, in an industry where everything's been done, that there would be no more open segments," says Wilson. "We realized that this is a big opportunity, and we've seen it with the success of the watch now. Women think, wow, that was designed for me."

◁ Top: Various stylings were considered for the rubberized pads at the end of the watch, but in the end, a fin shape was chosen both because it satisfied the design team from an aesthetic standpoint and because it could be tooled seamlessly.

◁ Middle: Further studies of the concept of a bracelet with an opening on the side of the wrist rather than underneath it; the illustration [above left] is a form factor study, while the illustrations [above right and left] are the male and female versions. While the team felt this concept had a distinctive Nike style, they were concerned that it wouldn't be as secure on the wrist as it would be if the opening were underneath the wrist.

◁ An exploded view of the near-to-final watch. The construction allows for a wide array of color combinations; colors can be specified to match colors in other areas of the Presto line.

gloss white backpaint
or match Nike LCD sample

hi-contrast LCD

12:43

x2

Pantone Q070-1-1 orange

x2

Pantone Q310-4-3 Blue

Pantone T255-2-4 Lt Blue

First Years Comfort Care Baby Products Designed in the face of **daunting** challenges, the **First Years** Comfort Care product line features the **easiest-to-use**, safest, and most **innovative** baby care **products** on the market, **combining** adult and **infant ergonomics** in a single shape.

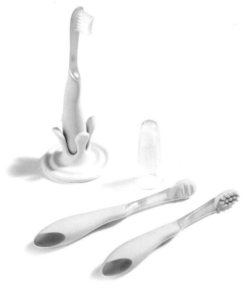

⊗ Oral hygiene starts before the first tooth comes in, and the Comfort Care Gum & Toothbrush Set covers oral needs from newborn to toddler. The set includes a fingertip toothbrush that slips comfortably on an adult finger to access hard-to-reach areas. The infant and toddler brushes are ergonomically designed to fit easily into adult hands, while toddlers will love the feature that shows them how much toothpaste to use on their toothbrush.

⊗ The early sketches all show placement of overmolding to ensure a sure grip on everything from the toothbrush to the hairbrush.

⊗ Below right: Early sketches of three toothbrushes that progress as the child grows place them in a suction cup base.

"Baby care is stressful, especially for first-time parents who are afraid of hurting their newborn. Tiny fingernails need trimming. Soft skulls need washing. Delicate hair needs brushing. Early teething needs soothing. Baby's temperature needs to be taken many ways. Medicine needs to be delivered, and mucus needs to be removed. All these tasks need to be performed with tools that present a design paradox: They must be large enough for the parent to operate yet small enough to accommodate a baby," says Anthony Pannozzo, director of design, Herbst LaZar Bell, Inc.

The market and parents demanded a product like this one. Taking care of babies doesn't need to be made more difficult than it already is by clumsy, ill-made products. To be successful, designers knew that they had to deliver the features most needed by parents and childcare experts alike.

"Every parent of an infant or toddler knows how difficult it is to take their temperature, clip their nails, or remove mucus from a stuffy nose—in fact, research indicates that many parents dread this task," says Pannozzo. "That's why we shaped and sized these products for adults to hold securely and comfortably and why we used materials that ensure a steadfast, sure grip. The ease of use and the safety of these products was the number-one focus, because taking care of a baby can be much easier and calming for baby when a parent feels at ease."

Interestingly, it wasn't the products themselves that provided the biggest challenge to designers; it was the time frame they were given. The entire project was done inside of four weeks. "The

FROSTED TRANSLUCENT FINISH

TPE OVERMOLD GRIP

SUCTION CUP BASE IS USED FOR ALL 3 PRODUCTS THROUGH ORAL CARE SEQUENCE.

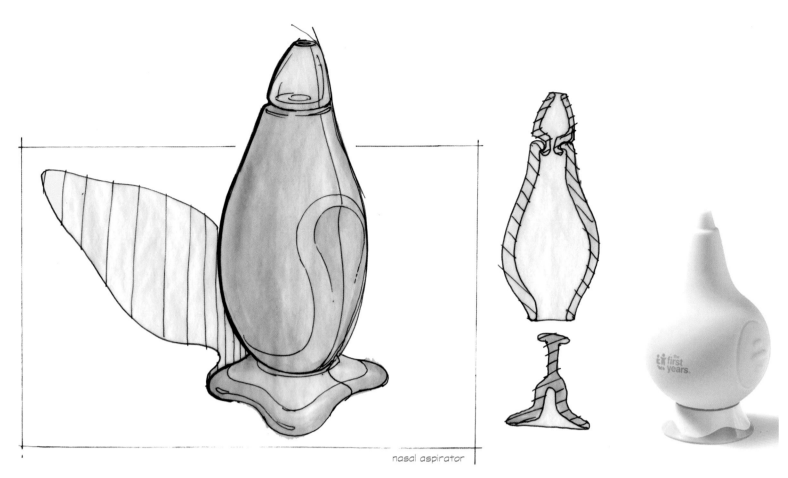

nasal aspirator

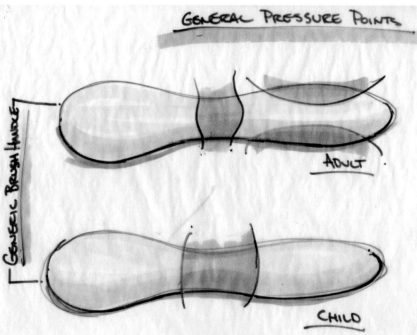

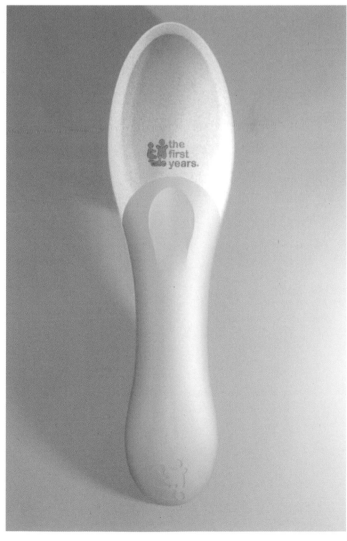

⊗ Above left: From the outset, the nasal aspirator was designed to stand upright in a base for user-friendly storage and use.

⊗ Above right: The Comfort Care Nasal Aspirator sits in a base, making a messy process more convenient and comfortable with its easy-to-rinse interior. Its comfort tip only reaches as far as it is comfortable for baby. Bulb grip guides on the side ensure the right compression and suction to make it easy on the baby.

⊗ Above: Designers studied the pressure points of a hairbrush to create a brush that works ergonomically for the hand of an adult and the head of a child. The final product at right achieved all it's early design goals.

toughest part of this project was definitely the time frame. We had to collect all the data we needed, generate ideas, and find the areas in which we could be innovate without being gimmicky," recalls Pannozzo.

Given the short timetable, designers had to condense their normal process and take shortcuts wherever they could without compromising the product. "We had to be far more subjective than objective in our research," says Pannozzo. As a result, while designers spoke with childcare experts to obtain input, they didn't go from city to city conducting focus groups. There was no time. Instead, the designers assigned to the project were those with children in the target age groups. "We didn't have a lot of time to observe parents and how they took care of their children, so in order to get what we needed, we made sure that the designers on the team had young children. We learned first-hand the frustrations parents had taking care of young children."

They solicited feedback from the team of designers/parents and worked with childcare experts to identify features that would aid parents in performing routine tasks. Many features, such as the

temperature alerts on the thermometers, the removable base of the nasal aspirator for inside cleaning, and the magnifying lens on the nail clippers, were the direct result of input from the designers themselves and childcare experts.

Next, the designers identified a list of parental anxieties rooted in the fear of hurting a child. "Then we brainstormed around them to find ways to reduce that anxiety and, as important, create the perception that the product would take away that anxiety," says Pannozzo.

They brainstormed with words first, then sketches. "We created a language for most of these products," he says. They also jumped into color studies right away, earlier than they usually do, to find wellness colors. "From the sketches, they took the designs into CAD. We rarely build hand models anymore," says Pannozzo. "Once we had scale and ergonomics correct, we sent our files to China.

"Early reports reveal that sales have been through the roof in just a few short weeks since market introduction, far exceeding the

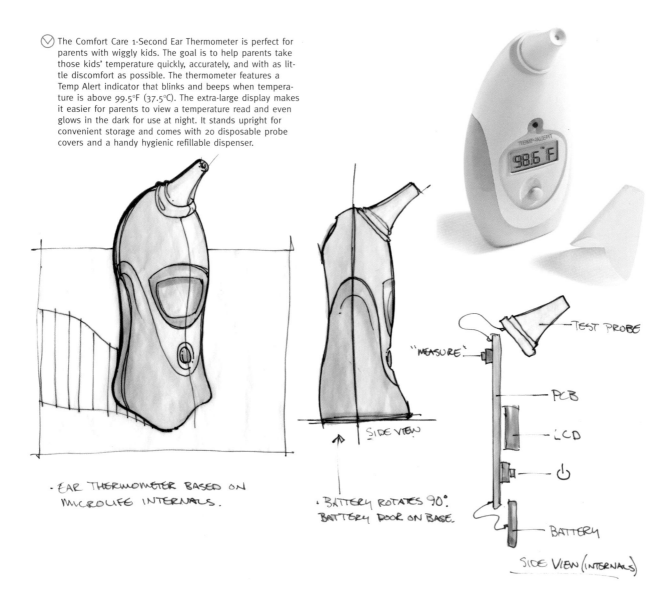

The Comfort Care 1-Second Ear Thermometer is perfect for parents with wiggly kids. The goal is to help parents take those kids' temperature quickly, accurately, and with as little discomfort as possible. The thermometer features a Temp Alert indicator that blinks and beeps when temperature is above 99.5°F (37.5°C). The extra-large display makes it easier for parents to view a temperature read and even glows in the dark for use at night. It stands upright for convenient storage and comes with 20 disposable probe covers and a handy hygienic refillable dispenser.

Parents who dread trimming a baby's tiny nails or who constantly lose the equally tiny nail clippers will welcome the Comfort Care Nail Clipper, whose size is easy for adult hands to hold and that has a high-quality magnifier lens that allows parents to focus on the nails instead of the clippers. The cushioned, ergonomically styled grips provide a comfortable hold, and the magnifier lens folds away for compact storage and travel ease.

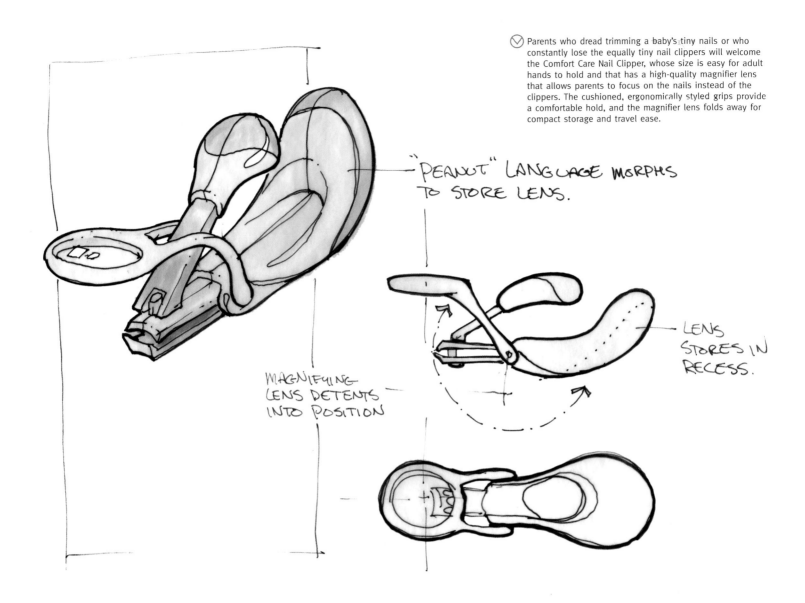

"PEANUT" LANGUAGE MORPHS TO STORE LENS.

MAGNIFYING LENS DETENTS INTO POSITION

LENS STORES IN RECESS.

client's initial projections," says Pannozzo. In the end, not only did the client benefit from the design, but Pannozzo and his team benefited, too, in an unexpected way. "I learned that we could do really good work in less time than I thought. I imagine any designer wants what feels like a sufficient amount of time to explore and solve problems, but after you've been doing this for 10 years, it is surprising what you are able to accomplish when you don't have the luxury of time and the ability to play by the book. You make decisions based on previous research efforts and previous projects when you did have the time.

"The First Years products were probably one of the best products we've ever done, and the irony is we did it without having the time frame we're accustomed to."

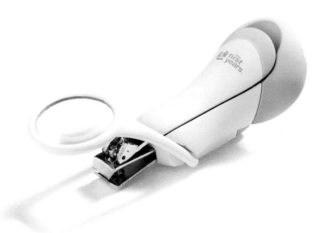

Perfect Portions Getting **infants and toddlers** to eat can be **among** the most rewarding and **frustrating** ventures a **parent** undertakes.

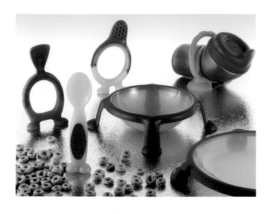

⬡ Interviews with parents helped designers accommodate their needs, such as products that were portable and easy to clean. Left to right: 3 Step Spoons, Friendly Feet Bowl, Helping Handlers Starter Cup, and Friendly Feet Plate.

Training infants and then toddlers to transition from liquids and purees to solid foods eaten by hand—and eventually with utensils—isn't as easy as it looks.

Dorel Design & Development (Safety 1st) asked Dot Studio to create a series of sketches for a line of infant-to-toddler tableware consisting of bowls, plates, and utensils. They liked what they saw; Wayne Marcus' sketches were engaging, and the client asked that the ideas be developed further—but not before they researched the interaction between parents and children in their homes during mealtime.

"Parents know the challenges of helping babies and small children learn the skills they need to eat on their own. They are also painfully aware of the problems associated with measuring, mixing, storing, pouring, and transporting their child's food and preparation gear," says Wayne Marcus, formerly the principal of Dot Studio, Inc., which designed the Perfect Portions product line, and now the design director at Product Ventures Ltd.

The researchers examined the types of feeding products that were used, how parents and children used the products and their preferences, dislikes, frustrations, and desires with respect to the feeding process. "Traditionally, the infant and toddler feeding product category has included basic items intended to function across broad age ranges," says Marcus. "This has resulted in products that may work well for one stage but not for another. The existing market presented an excellent opportunity for innovation."

The findings pinpointed four distinct feeding stages: birth to six months, when infants derive their nourishment primarily from liquids via a bottle or nursing; four to twelve months, when solids are introduced; six to eighteen months, when children begin learning to feed themselves; and twelve to thirty-six months, when toddlers begin using utensils.

The consensus was that the feeding products on the market failed to give children the features they need at each stage while addressing measuring, spilling, storage, portability, and other requirements of parents. Equally important, "Dorel wanted products that children would find endearing—that would be fun to see, touch, and use," says Marcus. "In addition, the products had to appeal to parents. Dorel sought a refreshing offering in a marketplace overcome with licensed cartoon characters and unappealing aesthetics.

"A rapid flurry of sketches was faxed back and forth during the following weeks as the two companies worked together to identify the balance of style, form, fun, and function that would result in a successful product line," Marcus adds. "From the very start of the project, Dorel's design management knew it wanted the personality and character of simplified human forms to be the unifying stylistic element of the product line. It was up to Dot

BOWL

Wayne Marcus created these whimsical inspirational sketches during the exploratory phase of the project.

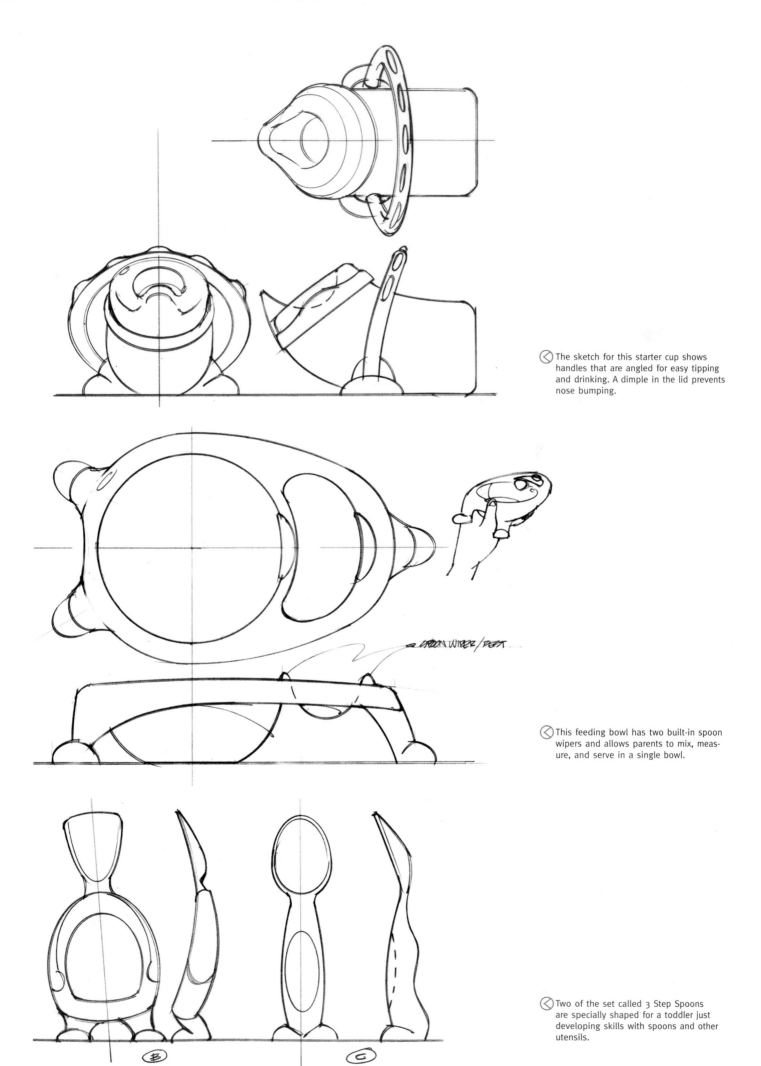

The sketch for this starter cup shows handles that are angled for easy tipping and drinking. A dimple in the lid prevents nose bumping.

This feeding bowl has two built-in spoon wipers and allows parents to mix, measure, and serve in a single bowl.

Two of the set called 3 Step Spoons are specially shaped for a toddler just developing skills with spoons and other utensils.

All photos Jay Carlson
All sketches Wayne Marcus

Studio to find the right balance of abstraction and literal interpretation that would work well with the functionality of these useful objects."

Dot Studio used quick clay and foam board mock-ups to transform their sketches into rough 3-D. Since everything from the utensils to the bowls, cups, and plates took on a whimsical personality and even body parts, designers explored several styles of legs, feet, arms, and tummies through this process until the right look and feel was captured.

At this time, designers had to decide where they would place overmolded thermoplastic elastomer on injection-molded polypropylene and blow-molded polyethylene to ensure a good grip in an often wet and slippery environment. Finally, they produced a series of orthographic drawings to document the designs for subsequent detailed product development, models, and prototypes. "With significant development support by Velocity Product Development and expert sculpting by Danebroch Studios, the animated character of Dot Studio's original sketches and orthographic drawings remained virtually intact throughout," says Marcus.

The completed line, finished just 11 months after the project was launched, boasts a rainbow of colors and eye-popping designs with real kid appeal and all the features weary parents want, too. They include easy-to-read measurement calibrations, built-in spoon rests, and easy-to-hold shapes, and are made of slip-resistant materials.

For Marcus, the most challenging aspect of this project was capturing the appropriate balance of fun and function. "Too much silliness or overt saccharine cuteness would overshadow and devalue the innovative and well-researched functional benefits of the product line. Conversely, an overly functional or clinical appearance would neither be relevant to the category nor possess much kid appeal.

"I was reminded of how clear client vision, fast decision making, and rapid, open dialog between client and consultant is critical for achieving success within a severely compressed schedule," he continues. "It was also personally rewarding to have had the opportunity to explore and harmonize so many shapes, textures, and combinations of materials."

In short, these utensils for the young at heart are just perfect.

⊗ Top: The Perfect Portions cups are designed to help children master the art of drinking from a cup. Used as a system, the product line transitions a child through the bottle-feeding stage, the sippy cup, and, finally, to drinking with a straw.

⊗ Second: Left to right: The Mix & Measure Bowl allows parents to measure ingredients and mix them in a single bowl with sturdy feet that won't slide or tip. A set of three Pack-a-Bowls makes it easy for parents to take a meal on the go.

⊗ Third: Left to right: Friendly Feet Plate, Jar Topper with Feeding Spoon, Second Chance Bowl.

⊗ Bottom: Left to right, back row: Friendly Fit Toddler Fork and Spoon, Stay Clean Travel Spoons, and Feeding Spoons (three sizes).

Evenflo Triumph Convetible Car Seat The function of some products is **so vital** that few people give **much thought** to how they look. **Infant** car seats are a **good example**:

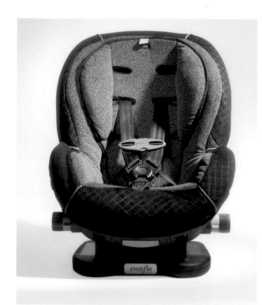

The Evenflo Triumph convertible car seat has a number of features that enhance ease of use for parents; designed to accommodate children from 5 to 40 pounds (2.2 to 18 kg), it converts from rear-facing for small children to front-facing for older children.

Parents are so focused on protecting their children that they have long taken for granted the minimal aesthetics of many of the products offered in this category. When Evenflo approached IDEO with the idea of developing a convertible car seat (as well as a booster seat), IDEO aimed to change that—to use aesthetics and brand identity, as well as increased usability, to distinguish the product in a category that seemed to overlook these qualities. That was the idea behind the development of the Evenflo Triumph convertible car seat.

IDEO began with extensive research conducted by their human factors lab. Annetta Papadopoulos, senior mechanical engineer at IDEO, describes the role of human factors research at her company: "We're not really trying to validate problems in the market per se, we're just looking for inspiration of what problems there are to solve, and maybe different ways to go about solving them." IDEO's human factors team observed parents buying and installing car seats and went to schools to watch parents loading and unloading their children. While this aspect of their research turned out to be touchier than anticipated—parents were suspicious of the strangers following them and observing their interactions with their children—it proved invaluable to IDEO in highlighting both parents' and children's relationships with car seats. The team was able to observe the difficulty most parents had installing car seats properly—a key safety issue. The team also observed that, to adjust the harnesses on some car seats— for instance, to allow extra room when the child was wearing a bulky coat—the car seats had to be completely uninstalled; parents often avoided the adjustment hassle by leaving the straps a little loose—another safety issue. Watching parents buying a car seat and then having to unpack it in the parking lot of the store just to fit it in their car spurred the designers to rethink the car seat's packaging.

Armed with this initial research, the design team began to create sketches with points of view that emphasized various aspects of the product. "We had this array of drawings going from very maternal at one end and moving through minimal, and then by the time we got to the other end it was very rugged and athletic," says Frank Friedman, senior industrial designer at IDEO. Reaction from parents to these illustrations, coupled with the work of the

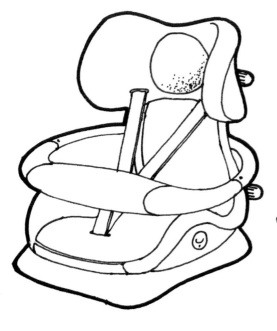

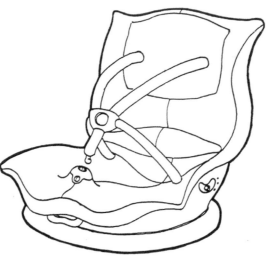

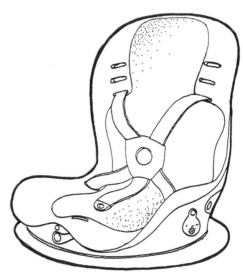

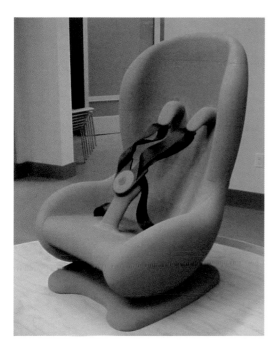

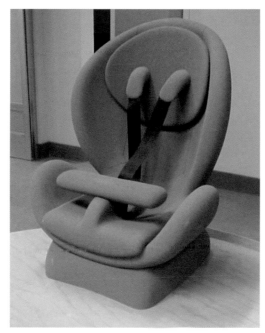

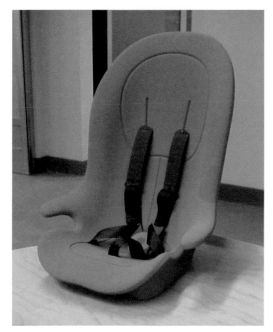

These sketches explored pushing various goals of the product further. The sketch at left is meant to envelop the child; the headrest wraps around the child's head and the body wraps up, cradling the child. The middle sketch emphasizes the comfort aspect of the product and has a more pillowlike quality. The sketch at right emphasizes giving users feedback as to whether the seat is latched in correctly and includes an LED display to help with that.

To explore aesthetic and functional directions, the IDEO team crafted these foam models. The model at top left had the enveloping look they wanted the car seat to have but was too large across the base; the top right model was closer to the scale they wanted. The third model at lower left was deemed more appropriate for the booster seat the IDEO team was also developing for Evenflo, since research revealed that older children preferred a more open configuration. All models featured a sleekly finished back, lower right. The team decided to pursue a merger of the best qualities of the models at top left and right.

human factors lab, helped the team compile a list of what they called "big ideas" that would shape the car seat's design.

Obviously, the car seat had to keep the child safe, but it also had to make its safety apparent visually. Papadopoulos says, "Parents perceive that their children are quite fragile at that age, and that was a big element in how happy they would be with that seat." Another big idea was "comfort for contentment": Parents want their children to be comfortable so they will be contented. Since car seats are often improperly installed and used, the team wanted to simplify installation and to build in feedback to help parents know whether or not the seat was properly secured. The seat had to be large enough to hold a child but not so big that it took over the car. Visually, the designers aimed for a unique look and a strong brand identity, to distinguish it from other car seats. Finally, keeping in mind that the car seat would sometimes face backward in the vehicle, the designers wanted the outside of the unit to look as finished as the interior—something they knew would distinguish their car seat from others on the market, which often have exposed ribs on the back.

Feedback from the sketches helped the team prioritize the importance of these ideas: Safety and envelopment of the child were parents' first priority; comfort followed closely. High-tech features that were contemplated for the product—such as an LED display giving parents feedback on whether they had installed it correctly—were jettisoned because parents didn't see the need for them.

Armed with this information, the designers proceeded to create more refined sketches and foam models of concepts shaped by these ideas. All the models incorporated an idea the IDEO team knew would distinguish their car seat from the competition: The team decided to turn the traditional car seat structure inside out, internalizing the ribs and allowing a finished surface on the back of the seat. Not only would this improve the appearance of the seat, it also would prevent damage to the vehicle interior.

Three concepts were implemented. One version was deemed not enveloping enough for an infant and was instead considered appropriate for the booster seat IDEO was also developing for Even-flo. Another version had the enveloping feel the team was seeking but was larger across the base than they wanted; the third version was of the scale they wanted, but its appearance wasn't cozy enough. The designers chose to merge the best qualities of these two versions in the next iteration of modeling. Achieving a proper balance between a seat wide enough to be comfortable for a growing child but narrow enough to allow two car seats to fit side by side in the back seat (a necessary consideration, since children are now riding in car seats longer, so families are now more likely to include more than one child that is riding in a car seat) was a thorny problem for IDEO, requiring a number of iterations before the team was satisfied.

IDEO continued to explore additional features, many of which revolved around the harness system. The team worked to build flexibility into the system so that parents wouldn't have to uninstall the car seat simply to adjust the harness. They developed a system where a knob allows parents to easily tighten and loosen the harness, increasing both the child's safety and comfort and the parents' convenience. They also developed a memory feature that snaps the harness back to its original position after it has been loosened, minimizing the need for continual manual adjustment of straps. They considered a system that would use numbers to help parents track and remember settings for their child, or for any other children they might transport, but the team decided that this had little utility for the average parent. A detail that did make it into the final product was a system where colors were used to signal when the buckle was secured properly. The team continued to consider both lap bars and five-point harnesses, but in the end, Evenflo felt that the five-point harness system was lower-risk and perceived as safer by parents.

At this point in the process, IDEO presented the final model to Evenflo, who took over the final design and engineering. During the presentation, however, the IDEO team got a surprise: Evenflo commented that the seat was now too small. Evenflo went on to enlarge the seat; they also took over the engineering of the harness system and the reclining of the seat as well as the final choice of fabrics.

The result of all this effort was a car seat that is both easy to use and easy on the eyes, and that still meets or exceeds every safety standard—proof positive that safety and style can indeed coexist.

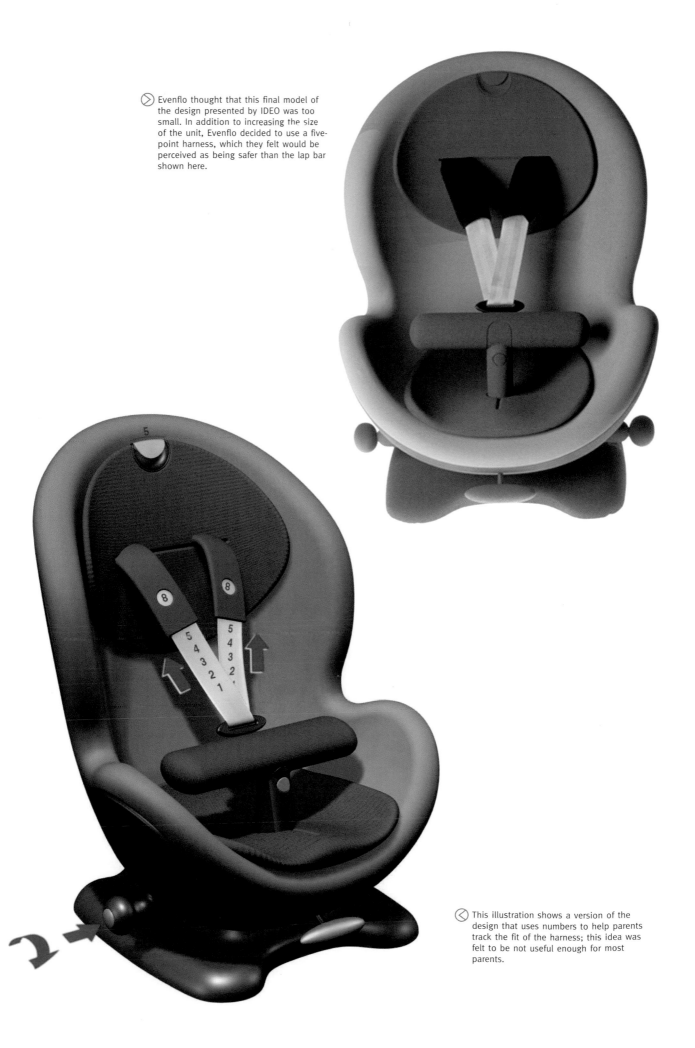

Evenflo thought that this final model of the design presented by IDEO was too small. In addition to increasing the size of the unit, Evenflo decided to use a five-point harness, which they felt would be perceived as being safer than the lap bar shown here.

This illustration shows a version of the design that uses numbers to help parents track the fit of the harness; this idea was felt to be not useful enough for most parents.

East3 Thoughtcaster Are **video games** the cause of **attention disorders**, or could they be their **cure?**

⊘ The East3 Thoughtcaster at rest on its base station. Not only does the base station receive EEG signals from the helmet and transmit it to the computer software, it also serves as a safe and convenient place to keep the helmet when not in use.

⊘ A photo of the original NASA-developed technology in use by a child. Says Montague, "It was an interesting process to start with that laboratory set of wires and electronics and convert it to something that a kid would actually be willing to put on and parents would be willing to pay for."

While East3 doesn't claim their Thoughtcaster—which uses a video game interface to train children to concentrate—is a permanent cure for these disorders, it does believe its product can help minimize the problem and alleviate the need for treatment with drugs.

The Thoughtcaster system has three components: a wireless helmet, a base station, and computer software. The base station is connected to the computer, and the helmet, through a system of sensors, reads the child's electroencephalogram (EEG) and transmits the brainwaves to the base station, allowing the child to play the computer game hands free; when the child is able to concentrate on the game, he wins.

The technology used in the Thoughtcaster was originally developed by NASA's Langley Research Center to train pilots to extend their attention span. East3 saw the application this technology could have in aiding children with attention deficit disorders and licensed it for this purpose. They then approached BOLT, an industrial design and research firm based in Charlotte, North Carolina, and New York City to help them develop the product.

In its original form, the technology was bulky and laden with wires, and it required a trained technician to set up and use. BOLT's challenge was to develop a product suitable for the consumer market—wireless, easy to set up, compatible with a home computer (to which it would be attached), and, most of all, appealing both to its young users and their parents. East3 would provide electrical engineering and software expertise, while BOLT would research and design the product, with additional engineering assistance provided by its strategic partner, Spark Engineering.

Researching the target market was the first step in the product development process. The client was already in contact with doctors and other clinical organizations specializing in attention disorders, and through these venues had access to a sample of boys in the target age range (ages six to twelve) who were affected with attention issues. A team from BOLT went into the homes of over 30 of these boys and interviewed them and their parents. Since the technology requires systematic and repeated use to be effective, it had to appeal to the users—or as Monty Montague, principal of BOLT, says, "We wanted to make sure that we did something that at least wasn't uncool, and if possible, was cool, so they might actually want to wear it for a while and they might tolerate it after the 38th time." BOLT also videotaped and photographed the subjects' homes to better understand how the product might be integrated into its use environment.

The team knew that the final product would have to be some sort of headpiece, since the proprietary technology used sensors to pick up and transmit brainwaves from the scalp. As Montague points out, "The interesting thing about the heads of kids is that they're all over the map in terms of size and shape." BOLT's in-

BUTTON PUMP
TO INFLATE AIR CUSHION ON
TOP OF THE HEAD.
[CAN ASSIST IN ACHIEVING
PROPPER CONNECTION]

ADJUSTMENT FOR
POSITIONING OF SENSOR.

INNER BAND
ADJUSTS TO
ELONGATION OF
HEAD.

E^3
GEMINI

SPEAKERS
LIGHTS

REAR
INDICATOR
LIGHT

BOLT

HARD PART STITCHED
INTO BASEBALL HAT.

SENSOR SLIDES IN
TRACK FOR SIZE
ADJUSTMENT.

FLEXIBLE MOLDED HOUSING
STITCHED INTO
FITTED CAP.

EMBROIDER CUSTOM
GAME GRAPHICS
OR PERSONALIZE

COULD BE AN
INSERT FOR
ANY STANDARD
BASEBALL HAT

INTEGRATED BASEBALL ①

BOLT 2/00

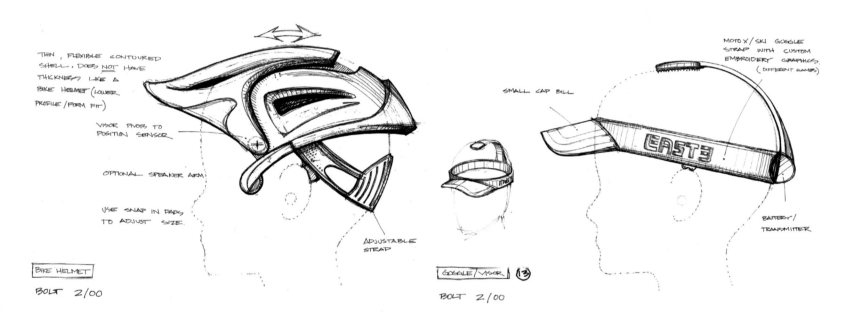

THIN, FLEXIBLE CONTOURED
SHELL. DOES NOT HAVE
THICKNESS LIKE A
BIKE HELMET (LOWER
PROFILE / FORM FIT)

VISOR PIVOTS TO
POSITION SENSOR

OPTIONAL SPEAKER ARM

USE SNAP IN PADS
TO ADJUST SIZE.

ADJUSTABLE
STRAP

BIKE HELMET

BOLT 2/00

SMALL CAP BILL

MOTO X / SKI GOGGLE
STRAP WITH CUSTOM
EMBROIDERY GRAPHICS.
(DIFFERENT GAMES)

EAST3

BATTERY /
TRANSMITTER

GOGGLE / VISOR ⑬

BOLT 2/00

△ Above: Sketches of some of the first
concepts the BOLT team came up with,
including the earliest version of the hel-
met style that became the final design
for the Thoughtcaster.

◁ An example of the research BOLT did on
children's head sizes.

house research department put together an anthropometric database of kids' head sizes. For the product to work properly, says Montague, "the sensors had to be located on a specific spot on the head, and that specific spot changes as the head grows—that is, the location of the spot relative to the shape of the head changes. We needed only specific dimensions of the head to work this thing out, so we collected those that we needed."

Armed with this research, the creative process began. The team started with roughly 20 concepts, and through internal and client review narrowed this group to six or eight concepts, which the team then developed into more detailed illustrations. BOLT took these illustrations back to the children and their parents for in-depth one-on-one interviews; they also did additional testing via focus groups.

BOLT's research helped the designers focus on what the end-user wanted. "We weren't trying to create our own visual statement," says Montague. "We were trying to think about what a young person might find appealing and come up with ideas that would meet that need, which is a tough thing to do."

BOLT's team also had to keep in mind the opinions of the parents, who would be paying for the product. Early designs that were considered included an earphone and a baseball cap, but in both cases, parents had reasons to resist the concepts. "You always get conflicting information, and we definitely had that," says Montague. "Some of the kids thought the baseball cap was great, but the parents said, 'Well, I'm not going to spend $900 for a baseball cap,' and that's what it was going to cost." The parents had other concerns about the earphone concept, according to Montague: "The earphone looked like it could fall off, and even though we felt confident that we could design it so that it would not fall off, parents were still nervous."

In the end, the helmet concept was deemed to best satisfy the needs of both parents and kids; it was sturdy and substantial enough to allay the fears of parents while still appealing to children. "It had a little bit of familiarity to the kids, a little bit of a bicycle helmet look to it, and that's why they liked it," says Montague. "And most of the kids who have this problem are males; it was kind of a warrior helmet look, a cool thing for a boy."

Based on this feedback, they narrowed the concept list to two and started to make foam models. These were taken back to the children, who evaluated the look, feel, and fit of the helmet. The team used ProE to make further refinements in the design and to create a rapid prototype.

Throughout the design process, engineering was being done concurrently. "A complex set of engineering issues had to be dealt with," says Montague. "We didn't want it to become this big thing, we wanted it to be svelte and to hug the head. We were able to move things around within the confines of the spaces of those yellow and blue plastic helmet pieces and tailor it to a fairly small, compact size."

Once the design team had selected the helmet concept, the choice of materials fell into place quickly. Since they knew the helmet had to be lightweight yet electronic, injection-molded construction was a given. The team explored a number of plastics and chose ABS plastic because they felt it would be strong

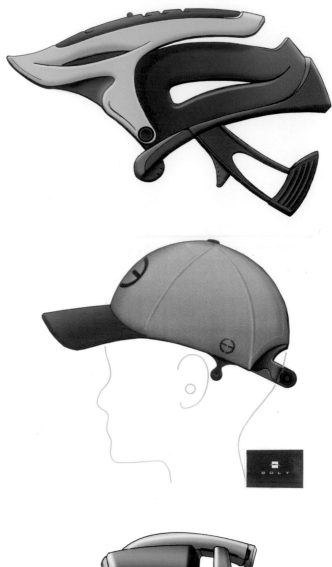

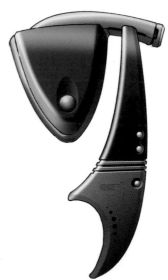

More refined versions of three of the concepts that were chosen for further development.

Opposite top right: An illustration showing where the three groups of sensors, consisting of seven filaments each, are placed on the scalp. While other neurofeedback systems use single-use sensors that rely on messy conductive gel applied by a technician, this proprietary system of sensors uses filaments that are similar to the tip of a felt pen; when sensors no longer provide the required signal strength, they can be replaced.

Opposite left: Exploded views of both the helmet and the base station; visible here is the ability of the base station to store replacement sensors.

Opposite bottom: An image comparing the CNC (Computerized Numerical Control) machine foam model—a process where a programmer used CAD data to program a machine tool to cut a model—(back) and the rapid prototype (middle) to the final product (front).

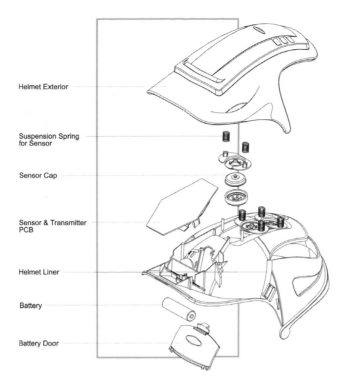

Helmet Exterior

Suspension Spring
for Sensor

Sensor Cap

Sensor & Transmitter
PCB

Helmet Liner

Battery

Battery Door

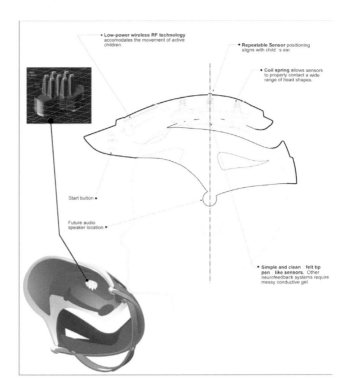

- Low-power wireless RF technology accomodates the movement of active children.

- Repeatable Sensor positioning aligns with child's ear.

- Coil spring allows sensors to properly contact a wide range of head shapes.

Start button •

Future audio
speaker location. •

- Simple and clean felt tip pen like sensors. Other neurofeedback systems require messy conductive gel.

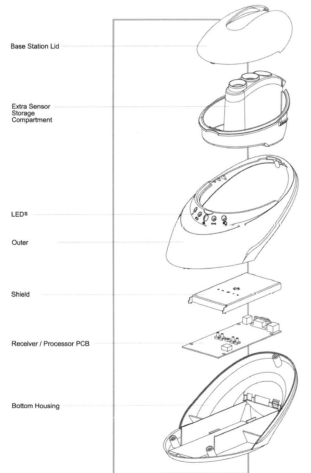

Base Station Lid

Extra Sensor
Storage
Compartment

LEDs

Outer

Shield

Receiver / Processor PCB

Bottom Housing

enough to withstand the rough treatment of its users. BOLT helped their client find a molder and went to Asia to supervise the toolmaker during the production process.

To address the issue of head size variation, BOLT designed an adjustable strap on the back of the helmet with a molded rubber grip on the back under the cranium and pads on the front and sides. On-screen prompts from the software alert the technician to make adjustments when necessary—the software is able to gauge this when it stops getting a reading from the helmet. Other ways to customize the helmet for various head sizes were explored—including removable Velcro pads, a strap that runs radially around the head, and an under-the-chin strap—but the final choice was the most comfortable and unobtrusive.

While the product was in final production, the client decided to reorient its marketing focus to clinics and schools rather than in the home. Though no official explanation was given to BOLT, Montague believes that the client recognized that for the product to work, a technician would need to make sure it was being used correctly and consistently. Montague thinks that their extensive end-user testing made this change almost irrelevant to the product design; BOLT had research that proved its user market approved of the product and could benefit from it, and that was all that mattered to the purchaser, whether parent or clinic.

In the end, BOLT was not only able to design, engineer, and test a complex product in 10 months, it also was able to get its young audience excited by something that was good for them—no small feat indeed, as any parent can attest.

Joey Clamp & Cutter The process of **cutting and clamping** a newborn's **umbilical** cord has **changed** very little since the **introduction** of the Hollister clamp years and years **ago**.

⊘ The Joey Clamp & Cutter comes in a variety of colors, which aids in identifying infants in multiple births and provides a cute keepsake for parents to save in their baby book.

This narrow device, with its hard-to-handle alligator-type clamps, requires disposable surgical cutting tools to use. It also requires more than one hand to complete the procedure while safely supporting a wet, slippery, and wiggling infant. Putting it on can be time-consuming, particularly at a multiple birth where time is critical. There's also the concern of blood spray. The Hollister clamp can produce elevated pressures inside the umbilical cord that can result in a biohazardous blood spray when the cord is cut. Finally, the baby goes home with the Hollister clamp in place until it falls off with the umbilical remnant and is discarded along with the diapers.

Dr. Richard Watson, chief medical director of Maternus Medical, figured the time was right for something better. He invented the Joey Clamp & Cutter, which he took to Design Edge, Inc., to design. "It is a single, integrated device that replaced three separate instruments required for cutting and clamping a newborn's umbilical cord. It performs both the surgical cutting and clamping procedure in one single-handed action while attaching a friendly koala character to clamp the newborn's navel," says Philip Leung, senior industrial designer at Design Edge. Moreover, it is simple enough for physicians, midwives, and even unskilled birthing partners who participate in the birthing experience to use.

"The client, a new obstetric products company, saw an opportunity to resolve these issues with a cost-effective, ergonomically feasible, and visually captivating design. This new company's objective is to use effective design to not only meet the cost and functional needs of physicians and hospitals but to also address and enhance the experience of the newborn child and its family," adds Leung. "Using an outside design consultancy instead of a specialized medical design consultancy gave us a unique perspective and a fresh new look at things. Building the product not only around the doctor but the end user, the newborn, allowed us to create a strong, recognizable identity and brand for the client."

As work on the project began at Design Edge, designers proceeded with two mandates from Watson. The device had to be an improvement in terms of safety and ease of operation, and it needed to be mom friendly. With their charter, designers embarked on their own research, performing competitive product searches and subject matter searches, watching nursing videos, reading delivery brochures, and reviewing literature to ascertain the pros and cons of the new device versus the commonly used Hollister clamp.

⊗ Opposite: Dozens of concept ideas came out of the first round of sketches.

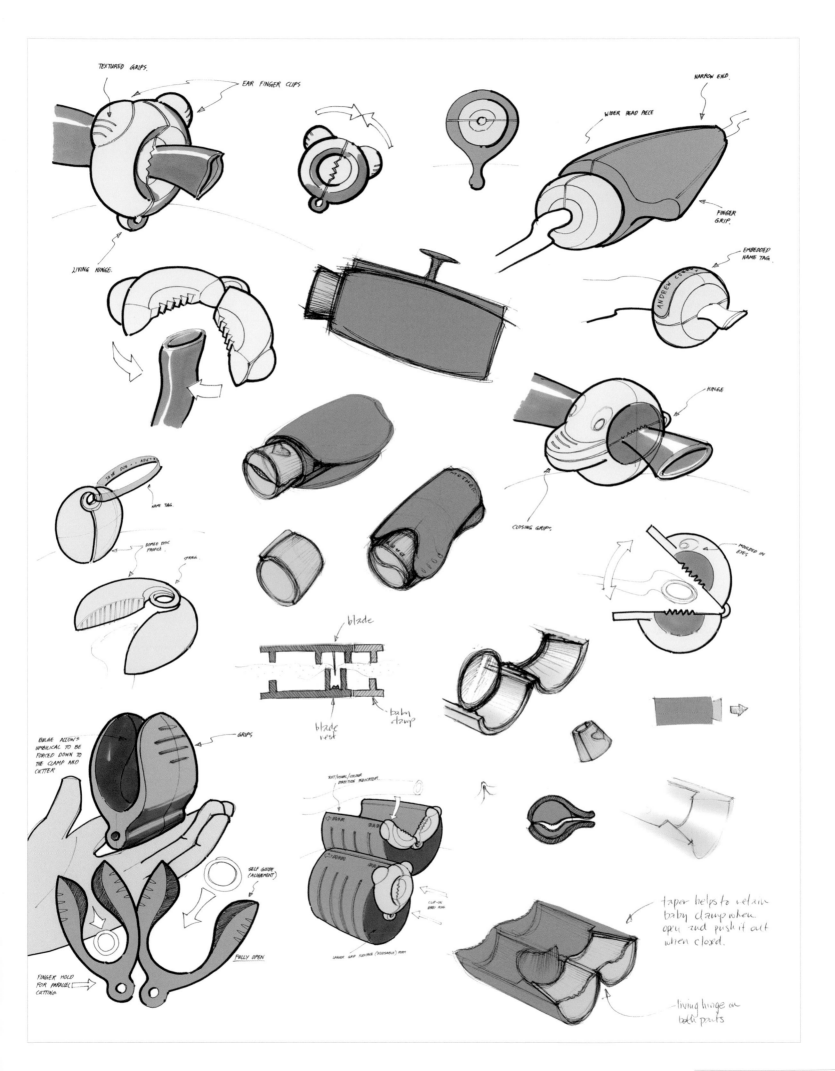

TEXTURED GRIPS.

EAR FINGER CLIPS

NARROW END.

WIDER HEAD PIECE

FINGER GRIP.

LIVING HINGE.

EMBEDDED NAME TAG

ANDREW C•••

HINGE

NAME TAG.

DOMED DISC PROFILE.

SPRING.

CLOSING GRIPS.

MOULDED IN EYES

blade

baby clamp

blade rest

BULGE ALLOWS UMBILICAL TO BE FORCED DOWN TO THE CLAMP AND CUTTER

GRIPS

SELF GUIDE (ALIGNMENT)

TEXT/VISUAL/COLOUR POSITION INDICATOR.

CLIP-IN BABY RING

SOFTER GRIP TEXTURE (SQUEEZABLE) FOAM

taper helps to retain baby clamp when open and push it out when closed.

FINGER HOLD FOR PARALLEL CUTTING

FULLY OPEN

living hinge on both parts.

Next, they did usability studies. "We created several rough mock-ups to simulate the size and action of an all-in-one clamp and cutter system to create a use model. How would it be held? How much pressure would be needed to close? How would you separate the clamp? Would it self-eject? and so on," says Leung. Designers performed end-user tests using a weighted baby doll with a rope as its umbilical cord. They quickly concluded that the device had to be simple, straightforward, and require just one hand. "We delivered dozens of babies at Design Edge," says Leung of their testing, "and created a number of prototypes to get a sense of how users would navigate their way around the umbilical cord, newborn, and clamp. The challenge was to cater to just about every way in which a newborn can be delivered."

The testing led to brainstorming sessions, both internal and with the client, that inspired idea sketches for how the device might work. Eventually, as sketches for the belly clamp evolved, the one part of the system the baby would keep became more oval and took on the face of a smiling baby koala—a joey. The designers continued to refine the sketches, developing and expanding on earlier ideas in detailed sketches and CAD.

Now came the hard part: narrowing the directions. They continued to build in more detail, working in Alias and ProE for prototyping, and ultimately readied the selected concept to go into mechanical design by refining the design based on tooling issues. They made more prototypes, and the client finalized the choice. Now that the design was final, the Joey was submitted it for Food and Drug Administration (FDA) and patent approvals.

"The Joey clamp design affords an unexpected emotive element to an otherwise clinical device," says Leung. Moreover, it "is proactive; it reduced by five times blood exposures in the delivery environment by shielding the blood spray inside the housing of the maternal clamp."

What advice would Leung give to design students? "Question the obvious! Not only were we able to satisfy the needs of the doctor but also to enhance the experience of the parents....The project created unique challenges that only a lot of user testing and mechanical testing were able to solve," he adds. "The Joey functions better than previously accepted systems and methods. It allows more people of varying experience to use it safely. It also happens to make people smile."

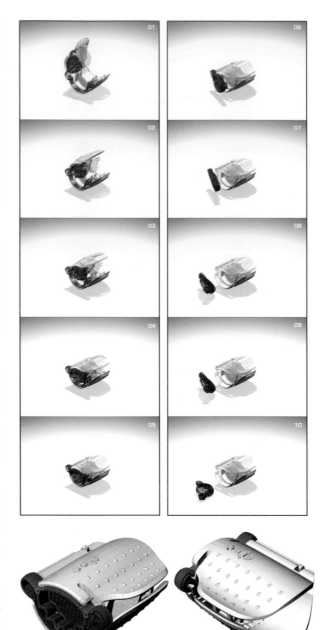

⬙ Top: This animation sequence shows the motion and closure steps of the final design.

⬙ Above: The final direction was chosen and then created as a 3-D shaded wire-frame model.

◁ A 2-D drawing made from the 3-D database submitted for FDA approval.

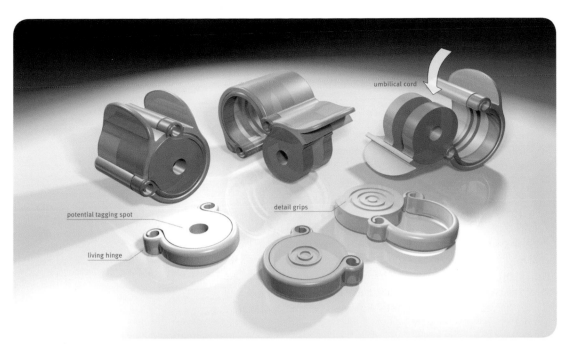

potential tagging spot

living hinge

detail grips

umbilical cord

User testing consisted of designers employing a weighted baby doll with a rope as its umbilical card and a mocked-up clamp.

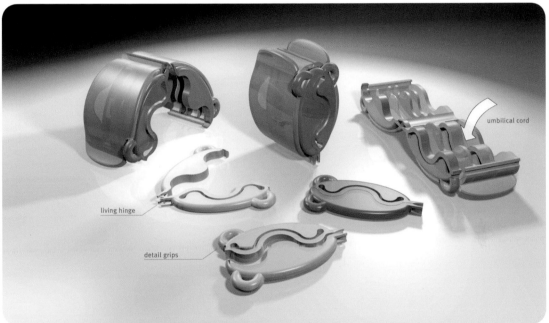

living hinge

detail grips

umbilical cord

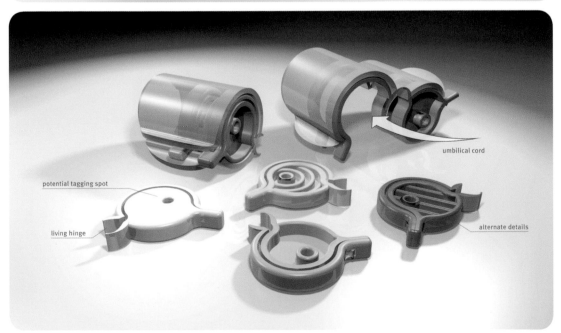

potential tagging spot

living hinge

umbilical cord

alternate details

At last, the design team and the client narrowed the field to three leading directions, each of which was refined in Alias.

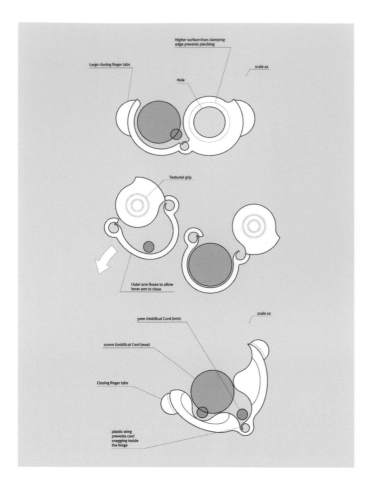

Large closing finger tabs

Higher surface than clamping edge prevents pinching

Hole

scale x2

Textured grip

Outer arm flexes to allow inner arm to close

5mm Umbilical Cord (min)

20mm Umbilical Cord (max)

scale x2

Closing finger tabs

plastic wing prevents cord snagging inside the hinge

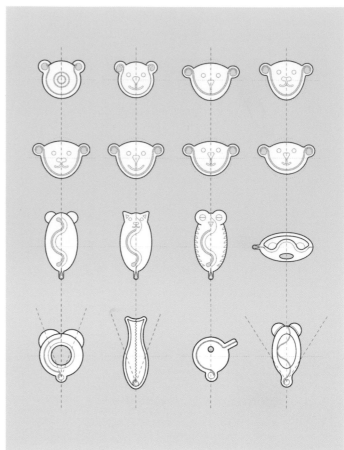

Top: The Joey Clamp & Cutter is designed for easy, one-handed operation.

Above: The commonly used Hollister clamp alongside the Joey Clamp & Cutter.

Left: "The simple, endearing face (of the Joey) has become the brand statement for Maternus Medical as well as a great marketing hook for their flagship product," says Philip Leung, senior industrial designer at Design Edge, Inc. "What is mom going say—'No, I'd prefer the ugly clothespin on my baby, please'?"

Opposite top: When designers refined the concepts, the belly clamp, the one part of the system the baby would keep, took on an oval shape and the face of a smiling baby koala—a joey.

Opposite middle and bottom left: When the umbilical cord is aligned in the v-shaped groove, the clamp can be closed shut, confirmed by two audible snaps. Once closed, the infant clamp can be ejected by pushing on the ears, leaving the Joey Clamp on the newborn.

Opposite bottom right: The blade is contained within the housing of the maternal clamp, protecting the doctor from potential injury. The blade remains attached to the placenta side of the cord.

SpeedBlocks Head Immobilizer In the world of health care, where the **technological advances** of the past **50 years** have been **dazzling**, some areas remain surprisingly **low-tech**.

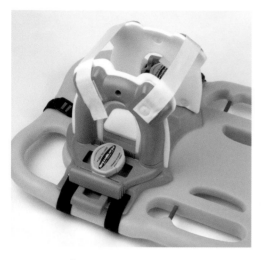

The SpeedBlocks Head Immobilizer, shown attached to a backboard, immobilizes patients suspected of having spinal injuries.

Even in this first model, the basic concept of the structure—a universal base that can attach to any type of backboard, with plastic blocks to hold the head—is apparent.

Take the area of head immobilization: Only 20 years ago, emergency medical technicians (EMTs) were still placing sandbags on either side of the head to immobilize patients suspected of having incurred a spinal injury. This inelegant solution didn't always achieve the desired result—the bags were so heavy that if the patient had to be held sideways on the backboard, the bags often moved the patient's head. The vinyl-coated foam blocks that became popular in the 1980s were a step forward—they were at least light enough not to move the head when the patient was moved—but they had other problems: They were easily punctured, and their straps and buckles were hard to keep clean, but they were too expensive to be thrown away. So in 1989, Laerdal Medical Corporation's design team introduced a cheap, disposable system called the Stifneck HeadBed; this system effectively immobilized patients, but because it was made of corrugated cardboard, many EMTs remained unconvinced of its effectiveness and stuck with the foam blocks.

Laerdal, a world leader in creating products for the EMT and paramedic community, saw a need for a head immobilization product that was easier to keep clean than the foam blocks and that had a more convincingly sturdy appearance than the HeadBed, but that was still cheap enough to discard when needed. Says Jim Traut, director of design and development for Laerdal, "The idea was to give them something that could be reused on multiple patients until they did get into a really serious accident that was very traumatic; then, when the product got very messy, it would be inexpensive enough that they could throw it out if they wanted to." This was similar to the way EMTs used extrication collars, another product in Laerdal's line of spine immobilization products, so Laerdal thought EMTs would be receptive to the idea.

Further research—through focus groups, field studies, and close examination of videotapes of EMTs on the job—uncovered a number of other requirements for the product. It had to be quick and easy to use in the field, since time, obviously, is of the essence for EMTs. The product would have to be attachable to a variety

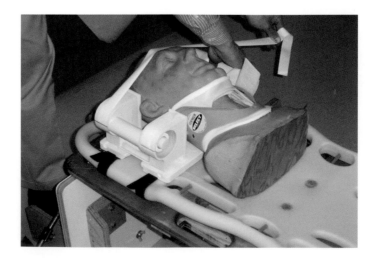

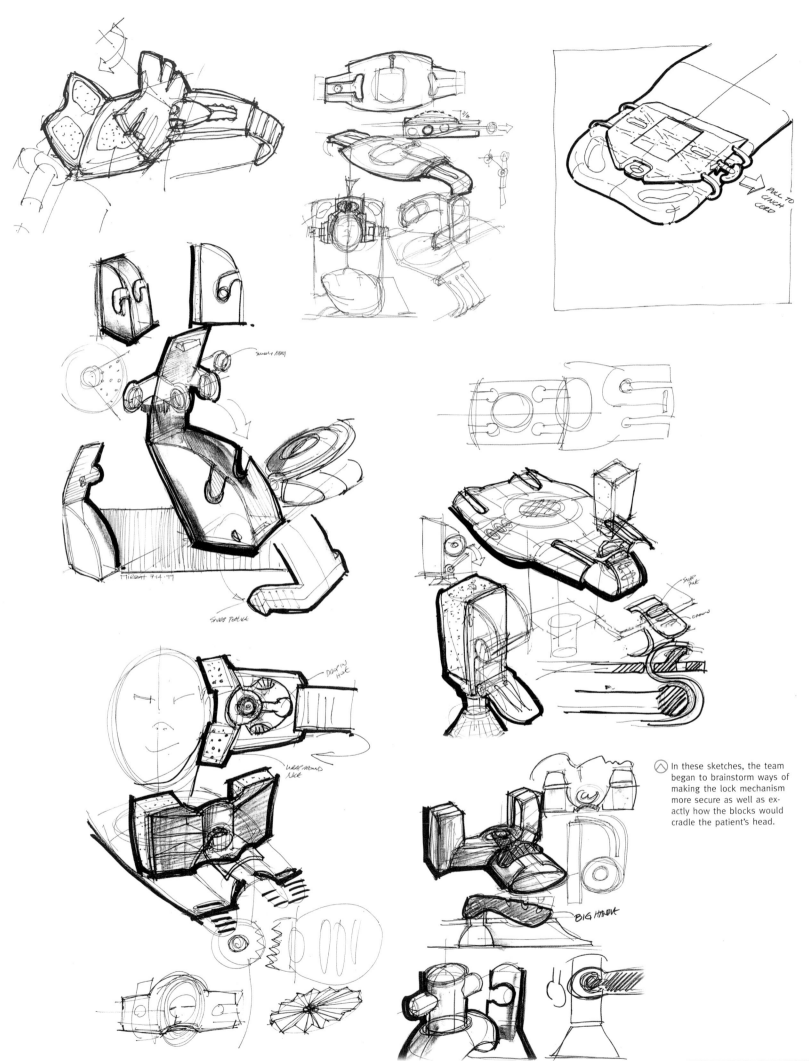

In these sketches, the team began to brainstorm ways of making the lock mechanism more secure as well as exactly how the blocks would cradle the patient's head.

of styles of backboards, as backboards are not standardized. Ideally, the product would be of open enough construction to give doctors physical and verbal access to the patient and to not interfere with x-rays. It had to be easily cleaned and stored, and flexible enough to be used on a two-year-old child or a helmeted motorcyclist. Most importantly, of course, it had to immobilize the patient's head, even if the patient was disoriented and struggling.

Early in the process, the team experimented with ways to attach blocks directly to the board. "We looked at things that stuck down, that were permanent changes to these backboards, like a panel that you would adhesively bond to the board that contained some kind of detail that you could attach the blocks to," says Traut, "and they all didn't work for some reason, or it was asking too much of the customer to make permanent modifications to their boards." At this point, the designers decided that the most practical structure for the product would be a universal base that could be affixed to any size or style of backboard, with a pair of blocks to cradle the head. For the material, Laerdal chose the same injection-molded plastic they used on the extrication collars. They knew the plastic would be strong and easy to clean; moreover, because they already purchased the material, they were able to take advantage of volume discounts from their suppliers.

Once the basic architecture of the system was decided, the team worked on attaching the blocks to the base. At this point, because Laerdal's team didn't include engineers, they enlisted the help of Machineart Corex to devise a mechanism that would lock the blocks to the base quickly, securely, and in three axes of motion. The system had to be secure, yet flexible enough to adjust to different sizes and shapes of heads; devising a system that could do that, yet not use Velcro (which is difficult to keep sterile), was a challenge.

The team also worked on structuring the blocks so they didn't interfere with x-rays. "We bought a bunch of children's toys and took them to the vet," says Traut, "and had him x-ray these toys to get an idea of how the shapes of these plastic products—the wall thicknesses and transitions and shapes—showed up on x-ray, and we used what we learned from that to shape the product in ways that we knew wouldn't show up on x-ray."

⊘ In this later model, the team kept the base and block concept but started refining the strapping mechanism used for the head. Through trying this model out on team members, they discovered that its straight-across strapping mechanism was not as effective as a slanted mechanism.

Later models were used to adjust the fit of the device to a wide variety of patients. Through trial and error, the team discovered that straps that slanted across the patient's face at an angle were more effective in holding a patient secure in the device than straps that went straight across. Because patients may spend hours in a device such as this one awaiting evaluation or treatment, comfort was also a high priority, especially because an ill-fitting device can cause secondary injuries that can mask the very trauma physicians are looking out for in this kind of patient.

The team also tried to address the need of EMTs to save space in ambulances; they developed a model in which the blocks folded down for better storage, but feedback from EMTs indicated that saving time in the field was a higher priority for them than saving space. It was also difficult to develop a foldable block mechanism that was as stable as one that didn't fold, so the designers abandoned this concept.

Having decided on the basic shape and structure of the device, the design team started to refine it. They made stereolithography models, and from them made molds and cast fully functioning prototypes out of urethane. These prototypes were once again fitted onto a wide variety of people, and comfort was checked; load-testing with mannequins was done in a lab to ensure the product wouldn't flex under pressure.

⊘ The team explored the concept of a head immobilizer that folded to save space on a crowded ambulance. Ultimately, the idea was rejected because feedback in the field from EMTs was that speed of use was more important to them than saving space, so any additional assembly would be undesirable; the team also had trouble ensuring the stability of this concept in action.

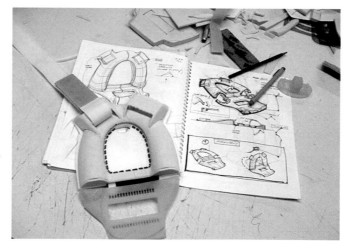

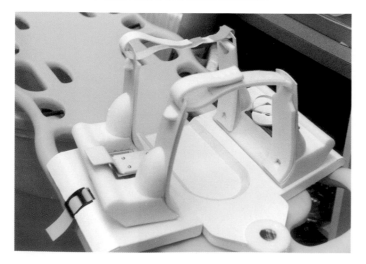

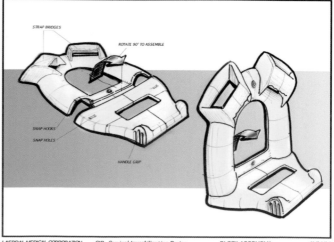

LAERDAL MEDICAL CORPORATION CID- Cervical Immobilization Device BLOCK ASSEMBLY 11/01/99

Two final prototypes were field tested, and the feedback the team got was surprising. Though the cost of the SpeedBlocks system was significantly less than that of reusable immobilizers, it looked like such a high-quality product that EMTs had a difficult time accepting the disposability of the system. Says Traut, "What we heard from a lot of people was that they wanted us to make the pads and straps replaceable, so they had the option of throwing the whole thing out if they wanted to or just throwing out the pads and cleaning the plastic parts." Not only did this solution further lower the cost per use of the product, it also reduced the amount of material waste associated with the product by an average of over 80 percent compared to disposable head immobilizers.

In a field study done with SpeedBlocks after its release, the reactions of the EMTs were resoundingly positive. They immediately appreciated the gap that SpeedBlocks filled in the market and commended its simplicity of use and ease of cleaning. "When they try it for themselves, they're almost surprised by how well it works in terms of immobilization," says Traut, "because it looks fairly minimal, and it doesn't have a big, hefty structure, which is what they're used to with these gigantic foam blocks." Now that SpeedBlocks has gained a foothold in the market, Laerdal is examining extending the line to include backboards with integral SpeedBlocks mounting slots.

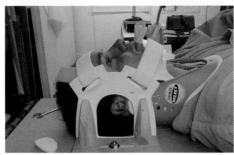

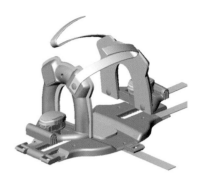

Top: This photograph shows field testing; note that the patient is also wearing an extrication collar, the Laerdal product that gave the team the idea of using plastic to manufacture SpeedBlocks. The field testing confirmed the security of the lock mechanism and the ease of use and cleaning, but the team discovered that their customers preferred the option of disposable pads and straps.

An exploded view of the final product, which shows the blocks separated from the base. Though the yellow board shown here is Laerdal's own model, the base can be strapped to any kind of backboard ahead of time.

Above left: The team tested the comfort and efficacy of the arch mechanism on a wide spectrum of people, trying to find the construction that suited the largest number of people; they also wanted to align the hole with patients' ears, if possible, which would aid physicians both in diagnosing trauma and communicating with patients.

Above right: A CAD model of one of the final prototypes.

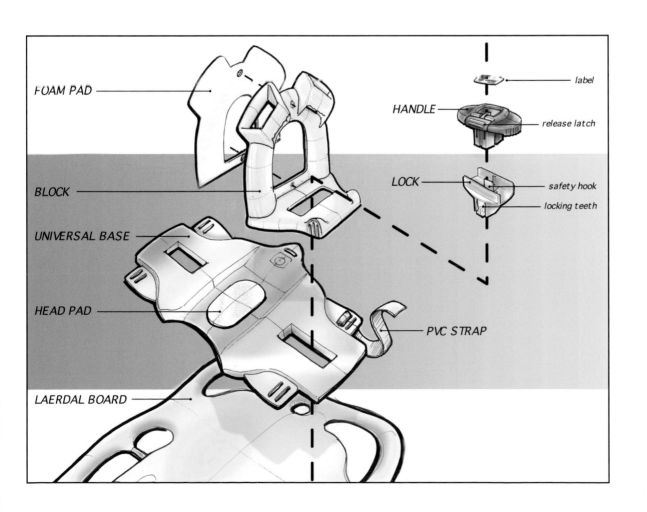

FOAM PAD

BLOCK

UNIVERSAL BASE

HEAD PAD

LAERDAL BOARD

HANDLE

LOCK

label

release latch

safety hook

locking teeth

PVC STRAP

IV House UltraDressing
Most people would rank a **hospital** stay as one of their most disliked and **feared** experiences, and one of the most **unpleasant** aspects of this unpleasant **experience** would have to be **getting stuck** with a needle.

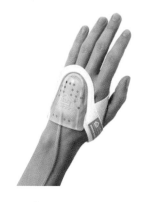

Top: The plastic dome-shaped IV House UltraDressing has ventilation holes and a flange to which the fabric dressing is ultrasonically welded. Rutter says that though the design of the device looks simple, "If you took the last five years of all the products that we've had through here, maybe 100 products, I'd say that this dressing would be in the top five most complicated products we've worked on."

Above: The fabric dressing is designed to fit either hand and, as a result, possesses two thumbholes.

Opposite top: This concept utilizes a covered adhesive patch but involves a flap that turned out to have no good landing.

Opposite bottom: This sketch is an early exploration in the use of thin Velcro strips, which later were replaced with a single patch.

"There's been enough research to show that we've got a needle-phobic society," says Bryce Rutter, founder and CEO of Metaphase Design Group, "and the last thing that people want is to be pricked with a needle numerous times when they're in the hospital." Because needles are so feared, patients often pick at their intravenous site, dislodging the needle. But studies have shown that increasing needle dwell time increases the effectiveness of a patient's treatment—and reduces the length and cost of the hospital stay.

After years of watching nurses construct makeshift IV covers out of plastic cups and tape, Lisa Vallino, an IV therapy nurse herself, saw the need for a product that protected intravenous sites; along with her mother, Betty Rozier, she started IV House, a company founded to market a polyethylene dome that did just that. But after seven years, sales had plateaued. The founders of IV House recognized the problems associated with the use of tape to attach the product to patients—it prevented easy visual access to the site and caused trauma to some patients—and they knew that if they could provide a way to attach the product to the site without tape, they could improve both the product's quality and its sales. They approached Metaphase Design Group and asked them to come up with a simple, elegant attachment system for the dome that would allow access to the site while holding the dome securely enough that it would not come loose and knock out the catheter or get twisted. Keeping the number of product SKUs (stock keeping units) to a minimum was another goal. "One of the issues that we know is important to hospitals is simplicity in purchasing," says Rutter, "and the last thing they want to do is buy into a solution where they have to have 13 different sizes to fit all the different people."

Over the next several months, Metaphase began intensive research into the anthropometrics of the hand, trying to determine where and how hands varied in size. And since the product was intended for everyone from pediatric patients to morbidly obese adults, the team discovered that variation was wide indeed. "We know from the leading experts in handheld products that the one-size-fits-all paradigm is a really tough one to solve," comments Rutter. Complicating matters was the fact that the device would have to work on both left and right hands.

The design team sketched a number of initial ideas, including using die-cut tabs on the dome and affixing it with adjustable straps, and wrapping a utility strap around the middle and ring fingers to hold the dome tightly onto the hand. But these solutions weren't simple enough—additional straps and lock mechanisms would both complicate use of the product and drive up manufacturing costs. This product was intended to be a disposable, not high-end, product, so in the end, Metaphase ended up

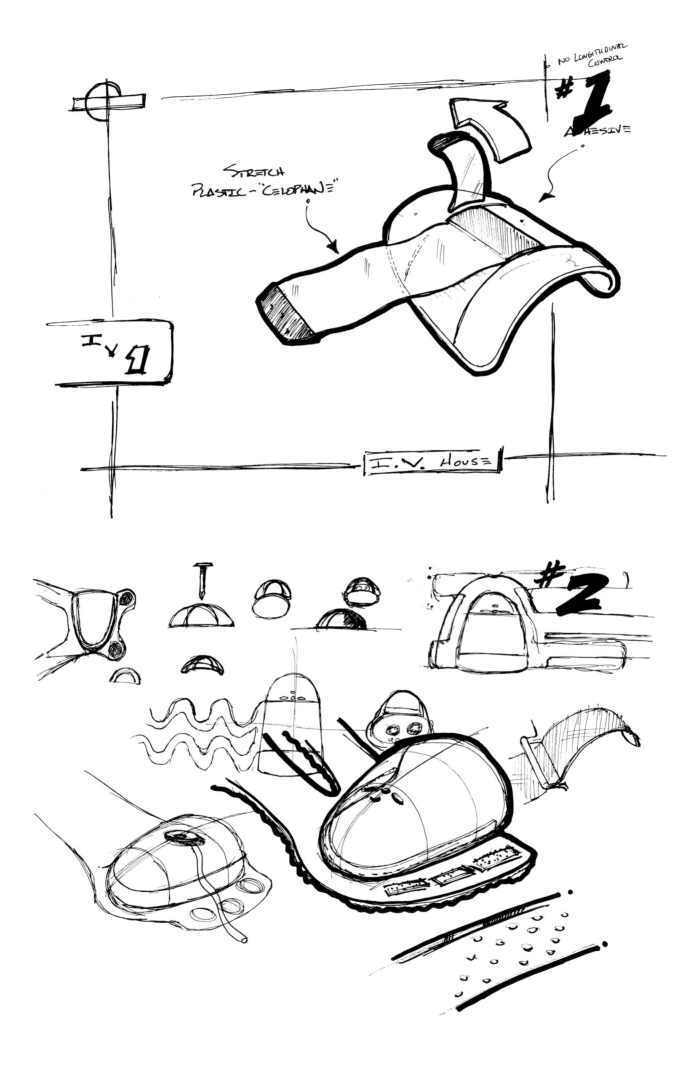

NO LONGITUDINAL CONTROL

#1

ADHESIVE

STRETCH PLASTIC - "CELOPHANE"

IV 1

I. V. HOUSE

#2

primarily exploring the idea of affixing the dome with an elastic fabric joined by Velcro. The give of the fabric would, the team hoped, accommodate hands of a wide variety of sizes while coddling patients and making them feel secure.

Now came the tough part: determining the correct combination of shape and material to fit as many sizes as possible. "The most ticklish part of this whole process was working in parallel with the anthropometry and the ergonomics of the product and trying to address the materials that we could use," says Rutter. There were a lot of requirements for the material: It had to be soft but have a bit of traction, so it wouldn't slip off; it couldn't cause allergic reactions, so latex was eliminated as a possibility; it had to have enough stretch memory that it could withstand the four to eight times a day a nurse might open and close the device without losing its shape; it had to be able to withstand the die-cutting process. To cut costs, the team wanted to use Velcro on only one side on the fabric—"when you're looking at a disposable product, a tenth of a cent matters enormously," says Rutter—so they also wanted a fabric that Velcro could attach to.

At the same time, the team was trying to determine the best pattern for the material. They had decided to use the thumb as an anchor to keep the device from rotating and as a vertex for sizing the product, but determining exactly where, and what size, the die-cuts where the thumb would go through the fabric should be, as well as the shape of the pattern itself, was a challenge. Accommodating various hand sizes was one thing; accommodating hands alternately in use and at rest also meant the same hand might change shape a number of times. And not only did the device have to fit properly, the dome had to be centered properly over the vein, and the size and placement of the die-cut hole directly affected that. According to Rutter, the team went through at least 50 prototypes. "Every time we'd change a material, all the fit factor elements would have to be in total readjusted because now the stretch factor would be different, it would be different in the warp and the weave of the product, it may have more or less traction."

Prototypes were tested on hands of all shapes and sizes. In the end, one size didn't fit all: The minimum number of sizes that would work for all the targeted patients was four. For upper-arm sites, an alternative dressing pattern was designed with integral notches in 1-inch (3 cm) increments along its length to provide

easy cut-to-length cues for nurses. The fabric that was ultimately chosen was made of 60 percent Tyvek, 30 percent nylon, and 10 percent Lycra, possessing 100 percent stretch in one direction.

The device passed its initial small-scale testing, but when a larger-scale clinical study was done, the team discovered that having Velcro on only one side of the dressing wasn't secure enough. "If it fails on a small percentage, that's unacceptable; it's got to be 100 percent successful," says Rutter. The additional Velcro was added to the device.

Ensuring that the sizing system was easy for hospitals to implement, and for nurses to use, was key to the product's success. Metaphase decided that offering a starter kit for the program that contained the various sizes in proportions that corresponded to the size breakdown of the population would give hospitals a painless entry point into the system. The team also carefully assessed the needs of nurses, the actual user population. The product's sizing system and usage had to be immediate and intuitive because nurses are highly stressed—as Rutter says, "Every moment of their day, they're late." They don't have time to read directions, and they don't have a tape measure, so the team devised a chart that allows nurses to measure the patient directly from the package. The labels on the product that indicate size match the standard sizing colors in the vascular access industry.

The UltraDressing has been a successful product for IV House. In the first year after its introduction, national sales increased 15 percent over sales of the previous version. Moreover, with this device and with others like it, Rutter believes that design has the power to make a positive contribution to the quality of patients' lives. "The reason why people are coming to us in the health care domain is because there is an emerging awareness that we can't treat humans as animals," says Rutter. "We need to be able to be much more sympathetic with the psychology of health care and we also can, through good, intelligent design, develop products that alleviate a lot of the stress." IV House founder Lisa Vallino speaks with pride about the value of her product: "I did it for nurses, and I did it for patients—especially pediatric patients, as a way to make medical care less frightening to them. But geriatric patients can benefit, too. In fact, it's hard to imagine any patient who wouldn't benefit from an IV House dressing."

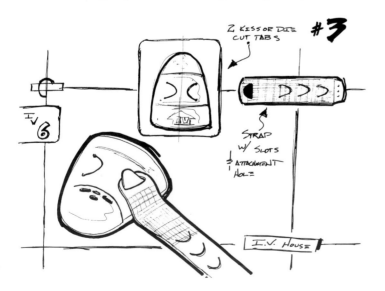

◁ Here, the team explores the use of a keyhole fastener system, which added wingtips that ended up doing a poor job of retaining the strap.

▷ Opposite top: In this sketch, the Metaphase design team considers the benefits of twin straps designed to better follow the surface of the hand. They later discovered that they could achieve the same effect with a simpler single strap of high-stretch fabric.

▷ Opposite bottom: This sketch explores the use of a clear paper-backed sterile pack; the paper back provides an excellent billboard for product use graphics and branding.

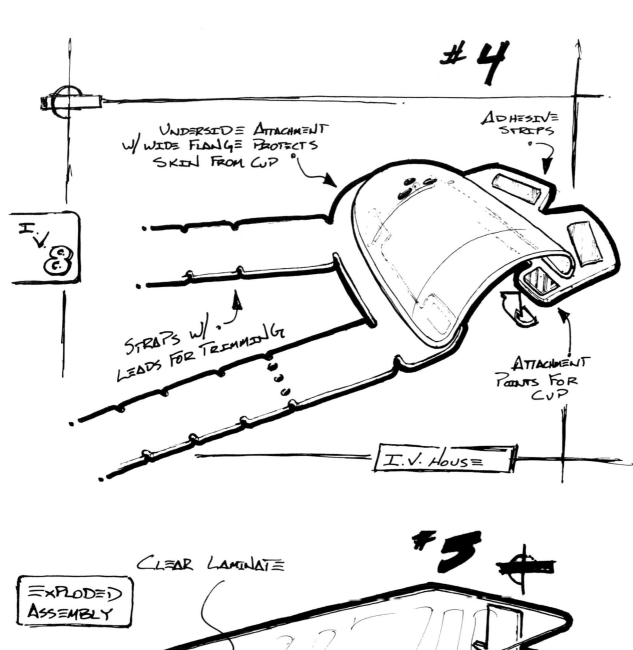

4

UNDERSIDE ATTACHMENT
W/ WIDE FLANGE PROTECTS
SKIN FROM CUP

ADHESIVE
STRIPS

I.V.
8

STRAPS W/.
LEADS FOR TRIMMING

ATTACHMENT
POINTS FOR
CUP

I.V. HOUSE

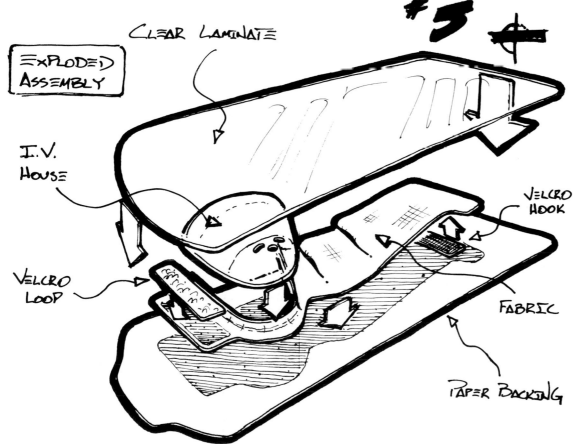

5

CLEAR LAMINATE

EXPLODED
ASSEMBLY

I.V.
HOUSE

VELCRO
HOOK

VELCRO
LOOP

FABRIC

PAPER BACKING

SenseWear Armband and Innerview Software "Most of us know more about **what's** going on in our **cars** than in our **bodies**.

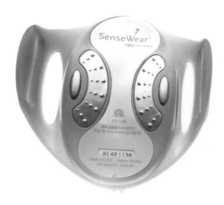

The SenseWear armband, which is a wearable computer, is worn on a part of the body where skin-touching wearble monitors have never occupied—the upper arm.

SenseWear, worn on the upper arm, collects clinically accurate caloric burn and sleep data from the wearer whether he or she is working out in a gym, jogging, or sitting at a computer.

The dashboard displays data about fuel, oil, engine temperature, even when the vehicle is due for a checkup. That's what we're hoping to do for the body," says Astro Teller, CEO of BodyMedia, Inc.

That kind of thinking gave rise to the SenseWear Armband. Chris Kasabach, vice president of industrial and mechanical design for BodyMedia, Inc., which designed the product, describes it as "the first multisensor body monitor for collecting clinically accurate energy expenditure (calorie burning), sleep quality, and activity states (such as walking, driving or watching TV) in a free-living environment."

SenseWear produces a physiological documentary of the wearer, providing researchers with a continuous and accurate view of the body over as many as five days. The information SenseWear collects is wirelessly communicated to BodyMedia's Web-based Innerview software. "Because SenseWear works outside the lab, problems such as insomnia, weight gain, and obesity can be viewed in the context of lifestyle patterns, permitting new insights previously impossible in conventional lab settings," says Kasabach.

BodyMedia recognized that existing physiological monitors were limited, notably because of the lack of attention paid to how the monitors are worn on the body and the limited ability of single-sensor devices to collect data and present information. That, together with "the increased desire for medical professionals and individuals with health concerns to better monitor and understand the body and the coming of age of several technologies and systems" led to the development of the produced, says Kasabach. The technological advances included decreased size and cost of key hardware and sensing technologies, maturing artificial intelligence capabilities, and improved materials, manufacturing processes, and design software. In addition, the designers capitalized on a proprietary body-mapping system, first presented at the International Symposium on Wearable Computing (ISWC) in 1998, for determining the best locations for wearing and sensing.

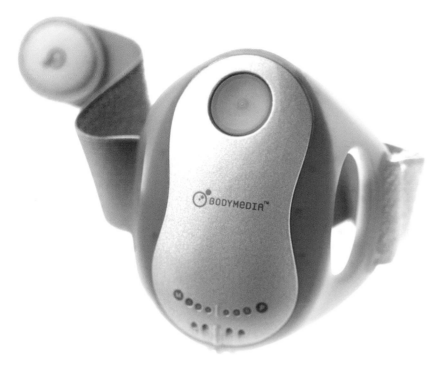

Recognizing that the time was right for this revolutionary product, designers tackled the job head on. They began by translating market requirements into a "preferred experience."

"The team conceived what the ideal process of using the product should be, given the constraints set up by the market requirements," says Kasabach. "The SenseWear Armband is a wearable computer and medical device in one, but both of these categories carry heavy perceptual stigmas. The challenge was to build a system that was as advanced as the newest wearable computer and as accurate as a clinical medical device while feeling like neither. The challenge was to design a wearable accessory that would be inviting even if it didn't do anything."

Specifically, designers had to find a way to collect clinically accurate caloric burn and sleep data from an extremely diverse range of adult body types in all environments. Moreover, the device—to be effective—had to be comfortable enough to wear for an extended period.

Until the advent of BodyMedia's SenseWear, body monitors were far from comfortable, so it was the design team's top priority to make wearing the sensor as comfortable as wearing a watch. "This was an enormous challenge, as SenseWear's technology is much larger than a watch movement," Kasabach says, who wanted the act of data collection to "feel less like a medical experience and more like a self-discovery experience."

With these objectives in mind, designers developed concepts and played around with the options of making the system largely textile-based or molded. The textile approach presented performance problems involving moisture, oils, odor absorption, and long-term cleaning. Designers spent considerable time selecting materials and processes to make the armband hypoallergenic, small, comfortable, and durable—using, among other materials, surgical-grade hypoallergenic stainless steel, FDA-approved polyester, and UV-stabilized thermoplastic urethane, along with a custom-developed, latex-free nylon-polyester blend for the adjustable strap. Together, these features made the SenseWear water resistant and easy to clean.

The SenseWear Armband is the first multisensor body monitor for collecting clinically accurate energy expenditure (calorie burning), sleep quality, and activity states (such as walking, driving or watching TV) in a free-living environment.

The information SenseWear collects is wirelessly communicated to BodyMedia's Web-based Innerview software.

Sense maps, which show the best locations for accurate free-living sensing, were analyzed by designers choosing where to place the body sensor.

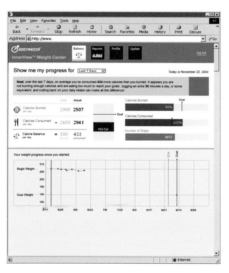

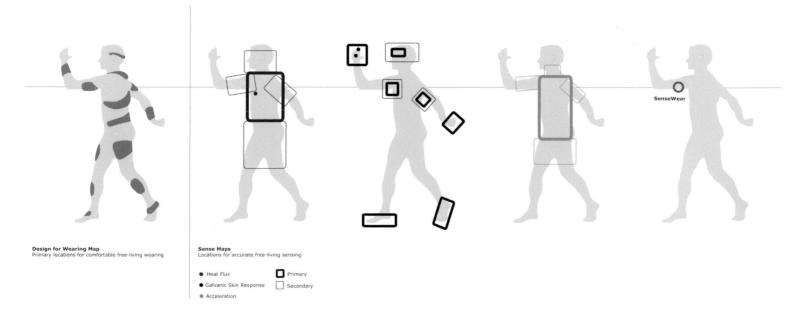

Design for Wearing Map
Primary locations for comfortable free-living wearing

Sense Maps
Locations for accurate free-living sensing

- Heat Flux
- Galvanic Skin Response
- Acceleration

- ■ Primary
- □ Secondary

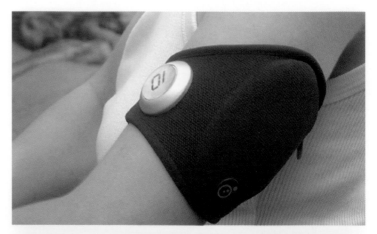

Where the sensor was placed on the body was an all-important factor in determining comfort and ease of use, so designers chose to position the SenseWear on the upper arm—a new location for skin-touching wearable monitors. They developed custom, skin-sensitive elastic capable of fitting a wide range of arm sizes and compositions. Numerous design studies were generated to define the topology of the product's underside for maximizing sensor-to-skin contact and minimizing pressure and heat buildup.

Next, designers collected hours and hours of data on wearers of different sizes in diverse conditions to provide the informatics team with enough input to develop algorithms that intelligently translated the raw sensor data into useful information. During this data collection phase, the SenseWear armband and a medical gold-standard product were tested simultaneously on users to validate SenseWear's accuracy.

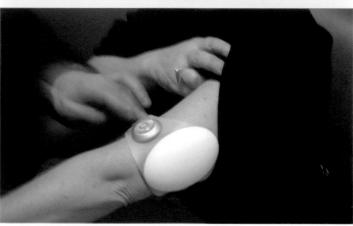

Once the design was finalized, a part file and detailed drawing were created for each part. Designers relied on computer programs such as Ashlar-Vellum, Pro/Engineer, Adobe Illustrator, and Adobe Photoshop to execute and finesse the design before it went to manufacturing.

On its debut, the SenseWear earned positive reviews. Its battery is rechargeable, it can be easily repaired and maintained, and, despite its small size, it does what once required much larger and more expensive lab equipment. "From top to bottom, SenseWear was designed to move with the body. The gentle curves, stretch materials, smooth texture, and soft colors made the product feel more like a fitness product and less like a medical device, an important perceptual requirement in this market," says Kasabach.

⌃ Designers spent considerable time selecting materials and processes to make the armband hypoallergenic, small, comfortable, durable, water resistant, and easy to clean.

⟩ Opposite top left and middle: Once designers determined that the SenseWear would be fitted to the upper arm, they developed custom, skin-sensitive elastic capable of fitting a wide range of arm sizes and compositions. Numerous design studies were generated to define the topology of the product's underside for maximizing sensor-to-skin contact and minimizing pressure and heat buildup.

⟩ Opposite bottom left: The SenseWear armband and a medical gold-standard product were tested simultaneously on users to validate SenseWear's accuracy.

⟩ Opposite far right: Once the design was finalized, a part file and detailed drawing were created for each part.

⟨ Designers opted to design the sensor for placement on the upper arm, a new location for skin-touching wearable monitors.

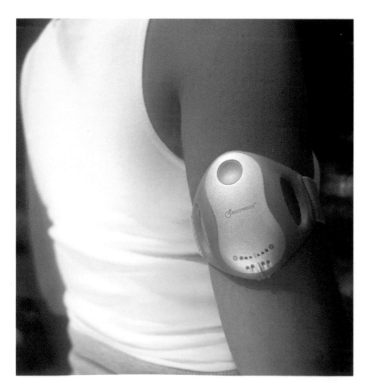

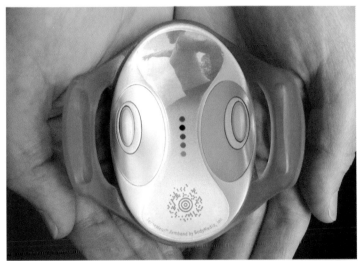

Infiniti 500 Rollator With the baby boomers reaching their senior years, the demand for rollators, or wheeled walking aids, is increasing.

The Infiniti 500 Rollator incorporates a cableless braking system, a large and comfortable flip-up seat, and a unique sliding tuck-away basket. Due to innovative manufacturing techniques, the Infiniti is also more easily customized and less expensive to produce than traditional rollator designs.

Until recently, manufacturers of these products competed primarily on price. The Infinity 500 Rollator changed all that.

The idea for the Infiniti 500 Rollator came from Doug MacMillian, president of Dana Douglas, Inc. "Doug had been listening and documenting the feedback from therapists, dealers, and end users for ten years," says Bjarki Hallgrimsson, principal of Hallgrimsson Product Development. "Most of the competitors in the market were trying to compete by lowering their prices, whereas Doug wished to establish Dana Douglas as a key innovator in the market. He approached us to see if innovative manufacturing techniques could be combined with novel ideas that would enhance the performance of the product."

Hallgrimsson was given the objective: to create a new line of rollators that incorporated all the features and benefits that for years had topped users' wish lists. This meant eliminating brake cables; adding a flip-up seat; offering a range of walker heights and widths; allowing for a wider seat; and above all, making the rollator lightweight and easily portable. Hallgrimsson's goal was to achieve these objectives *and* find a way to lower production costs in terms of manufacturing and inventory.

"We knew that the product would be put to the test by end users who really depend on it," remembers Sarah Dobbin, design project manager. "The feel of the brakes had to be just right, the seat had to be comfortable, and the product had to be easily foldable into a compact position to fit in the trunk of a car. The product also had to withstand the strain and stress of constant use in a wide variety of environments and climates. The product development was very focused on the needs and expectations of the end user."

Designers started by exploring ways to eliminate the costly process of welding and bending aluminum tubing, which is how these products are typically produced. Designers developed a plastic seat frame into which straight tubing for legs and handle-

The Dana Douglas Infiniti 500 rollator is a wheeled walker that allows people with mobility problems to maintain an active lifestyle both indoors and out.

Opposite top: Designers eliminated the need for welding and tube bending by developing a plastic seat frame into which straight tubing for legs and handlebars was connected. This design modification, compared to traditional rollators, resulted in a bulkier, less robust product. They tweaked the concept and investigated using an aluminum die-cast seat frame instead.

Opposite bottom: The concept sketches evolved from an injection-molded seat frame toward a die-cast connection system.

TO PREVENT TWISTING-
EXTRA BAR TO CONNECT
L & R

JULY 28/98

LARGER
BASIC

JULY 3/98

DETAIL IN CASTING
TO ACCEPT & REGISTER
FLANGE

INSIDE OF
TUBE TO FREE
FOR BRAKE ROD

METAL FLANGES
WELDED ONTO
TUBING

.JULY 28/98

SIMPLE MOLD!

SIMILAR TREATMENT FOR
TUBES
(VERTICAL PLATE?)

HOLE FOR CANE
WITH WHEEL

SPECIAL CAP SO NO
SLIDERS ARE NECESSARY

V2 BOLTS PUT IN FROM
INSIDE TO SECURE
BAR

BAR CAPTURED
IN THIS CHANNEL

HOLE FOR OPTIONAL BACKREST
CAN BE COVERED WITH A PLASTIC CAP
WHEN NOT USED.

Plastic
On its own, little resistance to torsion

Steel plate
resists torsion

Because Rear leg is
now connected to the
steel plate that is
welded to the seat
support bar, the
plastic does not need
to absorb torsion

STEEL TO
STEEL
CONNECTION

NOW WITH FLANGES ON TOP!
LITTLE CHANCE OF PINCH!

COULD BACK REST BE
SOMEHOW ATTACHED HERE?

BECOMES FUNCTIONAL AS
WELL AS A DESIGN
DETAIL!

PINS INTEGRATED & ONE CUT OFF
DEPENDING ON L/R PART, OR
JUST MAKE A HOLE W/ PIN
TO BE INSERTED LATER?

bars were be connected, eliminating the need for welding and tube bending. "Our initial concept sketches revolved around this idea. It quickly became clear that this approach would likely result in a bulkier and less robust product," says Hallgrimsson, who, based on his experience in designing cast-aluminum parts for the medical and telecommunications industries, investigated using an aluminum die-cast seat frame instead.

A trip to a die-caster confirmed the idea of using die-cast aluminum as the main connector for the legs of the product, as it would provide a much stronger and more reliable connection.

Having achieved two of their goals, simplifying assembly and lowering costs, designers turned their attention to making the rollator more user-friendly than any other on the market. "The first challenge was to develop a braking system that would eliminate the external brake cables, which tend to get caught on things and require frequent adjustments due to the cable stretching," says Dobbin. Through a series of trials, designers developed a new type of system, which they eventually patented. One evening, in Hallgrimsson's basement, they built a crude mock-up out of bits of styrene that was enough to prove the concept. They continued to refine the design in 3-D in Solidworks, which allowed constant evalution of the product's weight and strength through Finite Element Analysis (FEA).

Next, designers tackled the flip-up seat. "Not only was this an important feature for easier navigation around areas of the home like the kitchen—users can get closer to counters and cupboards—but Doug MacMillan knew that therapists were looking for this feature to help their patients," says Hallgrimsson.

Two years after its design start, the new rollator was completed. "The longer than usual timeframe allowed new ideas to incubate and later become incorporated as a part of the product," says Hallgrimsson. Examples of features that came to fruition late in the process are the retractable shopping basket and the rotating back strap that lets users sit on the walker facing either way.

In the end, the Infiniti 500 represents a brand new rollator technology that incorporates all the features—and then some—requested by users and therapists. Thanks to innovative manufacturing techniques, the Infiniti is also more easily customized and less expensive to produce than traditional rollator designs. In fact, it increased Dana Douglas's sales by 30 percent and made it a leader in the field.

"A product such as this one has to work flawlessly," Hallgrimsson says. "Users depend on it for their safety and mobility. Because the product has new features and functionality, it was paramount to do a lot of testing, to make sure that the new innovations would be accepted, and also to make sure that everything would work in a reliable fashion. Once we understood where the weak spots where, we could improve the design prior to releasing the product to market. I guess the thing to keep in mind is to be your product's harshest critic."

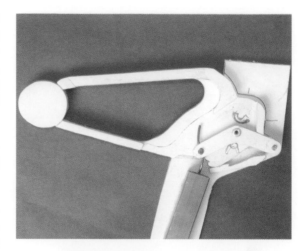

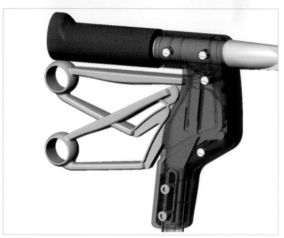

⬙ More elaborate prototypes, such as this one, were created in Solidworks software.

◁ Opposite top: Hallgrimsson's team developed many of the product's most innovative features through a hands-on approach. Some of the early mock-ups of the brake mechanism were crude—this one was built one evening in Hallgrimsson's basement—but they proved the idea and allowed for faster, more reliable product development.

◁ Opposite bottom: A folding lock handle was integrated as a visual and safety element in the seat. This area is easily accessible from both the front and the back of the rollator.

△ Top left: The flip-up seat was a must-have feature requested by physical therapists so patients learning to walk after a stroke could see their feet during gait training.

△ Top middle: A shopping basket can be easily accessed, yet it is designed to slide underneath the seat to secure belongings.

△ Top right: A rotating back strap allows the user to sit on the walker facing either way. This means the walker can be pulled up closely to a table for convenient seating.

▷ Right: The rotating back strap makes seating easier by eliminating the need for the user to turn the rollator 180 degrees or back into a table.

HeartStart Home Defibrillator Can good product design **save lives**? It can, if it makes a **life-saving** medical device **accessible** to the general public.

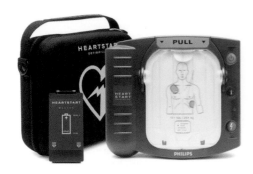

The final product, shown with its thermoformed foam and fabric carrying case, also includes a pediatric cartridge so it can be used on children.

That was the idea behind Philips Medical Systems' development of the HeartStart Home Defibrillator, the first defibrillator designed for use in the home to receive FDA clearance.

Every two minutes, someone in the United States needs a defibrillator. Without defibrillation, the chance of survival of a person having a heart attack decreases 7 to 10 percent per minute, and research has shown that the average distance most people live from emergency professionals with defibrillators is six minutes. It is no surprise, then, that of the 250,000 people killed each year by sudden cardiac arrest, 70 percent die in their homes. The mission before Philips Medical Systems was clear: Get defibrillators into the home.

The challenges behind designing the device, however, were equally clear. Traditional defibrillators are heavy, complex machines that take extensive training to operate. The design for a home defibrillator had to address the sight, hearing, and dexterity issues that face its potentially elderly market. The design team also had to keep in mind that users may be panic stricken, especially since they would likely be using the device on a friend or family member. Or, as Kurt Fischer, one of the designers of the HeartStart, states, "Users need to be guided very explicitly in a very straightforward and nonthinking manner at probably the worst moment of their lives."

The design team had a previous product, a defibrillator called the FR2 whose market was primarily medical response teams (MRTs), to use as a jumping-off point for their design. The team wanted to make the home defibrillator smaller and more intuitive than the FR2, yet it had to display more information, as users would have less training. As Fischer says, "How do you add more information and make a product simpler? That's a tough problem."

Early on, the HeartStart team decided to simplify the device by eliminating features home users didn't need, such as the electrocardiogram (ECG) screen, and by preconnecting the defibrillator pads. To add information, the team decided that the defibrillator would employ voice prompts to help users through the process as efficiently as possible.

While the design team initially felt a shield metaphor would be an appropriate way to convey the ruggedness of the product as well as the protection it provides, it was difficult to integrate that with the heritage of the product line, which marketing felt was important to emphasize. Some of the early designs referenced the "1, 2, 3" user interface employed on the FR2, while others used an interface similar to that of a fire alarm. Versions of both interfaces were chosen for prototyping.

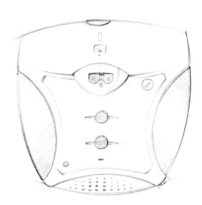

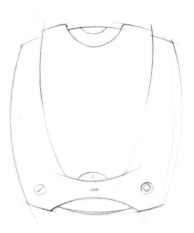
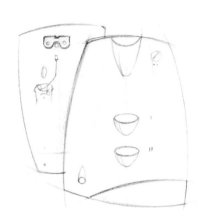

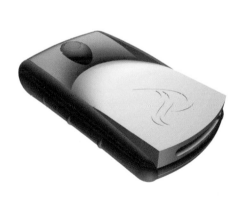

◁ ◉ In these initial sketches, the design team brainstormed the device's shape and user interface. Four of the concepts all featured an external connection to the defibrillator pads; the version at the bottom left has preconnected defibrillator pads, a feature the team decided was important for this market. This design was chosen for further development.

◉ Below: "We wanted a bit more of a consumer aesthetic, a power tool look as well as a consumer electronics look," says Fischer. The early design shown here reflects this influence. At this stage, the design includes a proposed UI that would work in a high-noise environment or during a speaker failure, allowing users to follow the LED to guide them through the process.

◉ Bottom: These further explorations resulted from internal concerns that the design, as it had been developed so far, was too large. The design team worked on reorienting the circuit board horizontally to make it appear more compact. At this point, the team worked on developing a top-to-bottom order of operation of the user interface.

a b c d e

The team then began to test six variations of the product on a total of 260 users—starting with MRTs and other advanced users as well as untrained laypeople and senior citizens. "We wanted to really push the cognitive and physical boundaries of our product," explains Fischer. "If it could work fine for [untrained laypeople] in a pinch, then we knew we had something that everyone could use." The prototype consisted of a stereolithographed model with a bread-board user interface (UI) and power source mounted inside. A wireless speaker system and LEDs, controlled by remote, were also inserted. The team transmitted the voice prompts by computer through the speakers as users went through each step, realistically replicating (yet invisibly controlling) the user's experience.

Testing uncovered four major hurdles for users: They often had difficulty turning the device on, they didn't know what electrodes were or how to access them on the device, they had trouble placing the electrode pads properly, and they could not always hear the instructions the first time.

To address the first two problems, the team made use of two interfaces everyone can navigate: a fire alarm and a peelable foil seal. While untrained users often searched for a way to turn on the device, they had difficulty seeing a green button and turning it on—but they had no difficulty understanding a handle labeled "pull" (just as on a fire alarm) and colored green, which is synonymous with "go." Fischer says, "We thought that since some people were having trouble turning the device on but everyone was getting the lid open, why not just work with that and have the device turn on when they get the lid open? Let's cater to what

people do naturally." Then, instead of referring to electrode pads, which most users couldn't identify in testing, voice prompts directed them to remove a "protective cover," which gave access to the pads. Fischer says, "They saw a foil tab, and they intuitively knew what to do with that."

To address the problem of users placing the electrode pads incorrectly, the team tested various types of labeling on the face, but initial attempts proved confusing. "One of them was a real upfront reference of how this device works, and people ended up pressing the graphics, kind of like a microwave," recalls Fischer. The team discovered that simply having the voice prompts tell users to look carefully at the pictures on the white adhesive pads immensely enhanced proper pad placement.

Finally, to address the fact that some users need to hear the instructions more than once, the team honed the reactivity of the device. If the device sensed that a user had not moved on to the next step in the process, it would repeat the audio instruction, and if the user still did not proceed, it assumed that the user was stuck and gave more detailed instructions.

Fischer cites these tests—especially team members' presence at them—as being crucial to the product's successful development: "We were able to watch the people we were designing for. It really brings the mission home—you can see how what you do is affecting the people you're trying to help." Even better, since the product's release, the team has received living proof that good product design *can* save lives—they've met grateful owners whose lives have been saved by the HeartStart product.

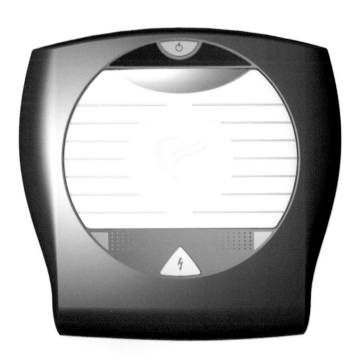

⬡ This iteration features the top-to-bottom UI orientation favored by the team. The black background at the top of the face of the device was planned to serve as a UI dashboard; the icons would show up at each phase as needed. However, the group felt that this version was still too large, since the footprint was the same as on the FR2. It then became the mechanical engineers' mission to make the electrical components smaller. Engineering was also told to work on the preconnected pads cartridge so that it would be modular and replaceable.

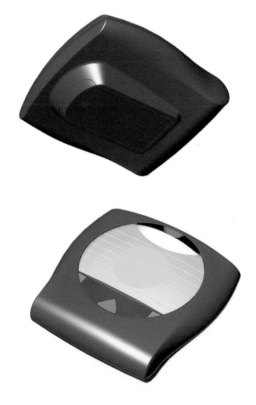

These designs tried to bring back the design connection between this product and the FR2 that the team felt was lacking, including the "1, 2, 3" button concept. The top right and the lower left versions were chosen for further development. The team was still unsure whether the "1, 2, 3" concept should be kept or whether it would be distracting to this audience.

Two variations of the design on the top right and three of the one on the bottom left were prototyped and given over to user testing. In testing, the biggest problem of the device on the top left was that the on button was not prominent enough. "We needed something blaring and overwhelming to get people over that first hurdle in a hurry," says Fischer. The team continued to develop variations of the bottom left version, further developing the fire alarm theme and testing various colors and shapes.

directory

Page 90
PRODUCT: Logitech Pocket Digital Camera
DESIGN TEAM: IDEO
100 Forest Avenue
Palo Alto, CA 94301
Phone: 650-289-3400
Fax: 650-289-3707
www.ideo.com

Page 94
PRODUCT: Motorola NFL Headset, Generation II
DESIGN TEAM: John Hartman, Steve Remy, Elliott Hsu, Jason Billig, Don Wolf (Herbst LaZar Bell, Inc.); Terry Taylor, Dan Williams, Luigi Flori, Connie Kus, David Weisz, Geoff Frost (Motorola, Inc.)
Herbst LaZar Bell, Inc. (HLB)
355 North Canal Street
Chicago, IL 60606
Phone: 312-454-1116
Fax: 312-454-9019
www.hlb.com

Page 98
PRODUCT: Maxim Sport Safety Eye Gear
DESIGN TEAM: James McGee, Dave Honan, Todd Taylor, Ngee Lee (Insight Product Development); Keith Fecteau, Chet Nadkarni, Glen Stanley, Art Salcy (Aearo Company)
Insight Product Development, LLC
23 Bradford Street
Concord, MA 01742
Phone: 978-371-7151
www.insightpd.com

Page 102
PRODUCT: CDI Dial Torque Wrench
DESIGN TEAM: Tor Petterson Associates, Inc.
31248 Palos Verdes Drive West
Rancho Palos Verdes, CA 90275
Phone: 310-544-6000
Fax: 310-544-6002
www.tpa-design.com

Page 106
PRODUCT: John Deere Spin-Steer Technology Lawn Tractor
DESIGN TEAM: Henry Dreyfuss Associates
5 Research Drive
Ann Arbor, MI 48103
Phone: 734-222-5400
Fax: 734-222-5417
www.hda.net

Page 110
PRODUCT: Water-Gate
DESIGN TEAM: MegaSecur, Inc.
145, Jutras Boulevard East
Bureau 3
Victoriaville, Quebec
G6P 4L8 Canada
Phone: 819-751-0222
Fax: 819-751-5550
www.megasecur.com

Page 114
PRODUCT: Watercone
DESIGN TEAM: Stephan Augustin
Augustin Product Development
Eengstrasse 45
80796 Munich
Germany
Phone: 49 89 2730690
www.watercone.com

Page 118
PRODUCT: Dutch Boy Twist & Pour Paint Container
DESIGN TEAM: Nottingham-Spirk Design Associates, Inc.
11310 Juniper Road
Cleveland, OH 44106
Phone: 216-231-7830
www.ns-design.com

Page 122
PRODUCT: Handy Paint Pail
DESIGN TEAM: Worrell, Inc.
6569 City West Parkway
Eden Prairie, MN 55344
Phone: 952-946-1966
Fax: 952-946-1967
www.worrell.com

Page 126
PRODUCT: Master Lock Titanium Series Home and Garden Padlocks
DESIGN TEAM: Roy Thompson, Noelle Dye, Harry West, Ph.D., Maryann Finiw, Joe Geringer, David Chastain, John Fiegner (Design Continuum); John Heppner, Jesse Marcelle, Paul Peot (Master Lock)
Design Continuum, Inc.
1220 Washington Street
West Newton, MA 02465
Phone: 617-928-9501
Fax: 617-969-2864
www.dcontinuum.com

Master Lock
2600 North 32 Street
Milwaukee, WI 53210
Phone: 414-444-2800
Fax: 414-449-3142

Page 130
PRODUCT: Soft Edge Ruler
DESIGN TEAM: Eric Chan, Jeff Miller, Rama Chorpash
ECCO Design, Inc.
16 West 19th Street
New York, NY 10011
Phone: 212-989-7373
www.eccoid.com

Page 132
PRODUCT: The Rabbit Corkscrew
DESIGN TEAM: Pollen Design, Inc.
128 Wooster Street, 4th floor
New York, NY 10012
Phone: 212-941-5535
www.pollendesign.com

Page 136
PRODUCT: Malden Mills Polartec Heat Blanket
DESIGN TEAM: Heather Andrus, Dan Cuffaro
Altitude
363 Highland Avenue
Somerville, MA 02152
Phone: 617-723-7600
www.altituteinc.com

Page 140
PRODUCT: Whirlpool Duet Fabric Care System
DESIGN TEAM: Global Consumer Design, Whirlpool Corporation
Whirlpool Corporation
1800 Paw Paw Avenue
Benton Harbor, MI 49022
Phone: 269-923-4671
www.whirlpool.com

Page 144
PRODUCT: Wolf Convection Oven
DESIGN TEAM: Jerome Caruso Design, Inc.
470 Stable Lane
Lake Forest, IL 60045
Phone: 847-295-2995
Fax: 847-295-2919

Page 148
PRODUCT: sōk Overflowing Bath
DESIGN TEAM: Kohler Co.
444 Highland Drive
Kohler, WI 53044
Phone: 920-457-4441
Fax: 920-457-6952
www.kohler.com

Page 152
PRODUCT: New Century Maytag Neptune Washer
DESIGN TEAM: Maytag Laundry Industrial Design
403 West Fourth Street N
Newton, IA 50208
Phone: 641-787-8738
Fax: 641-787-8839
www.maytag.com

Page 156
PRODUCT: Birkenstock Footprints: The Architect Collection
DESIGN TEAM: Yves Behar, Johan Liden, Geoffrey Petrizzi
fuseproject
123 South Park
San Francisco, CA 94107
Phone: 415-908-1492
Email: info@fuseproject.com
www.fuseproject.com

Page 160
PRODUCT: Nike Presto Digital Bracelet
DESIGN TEAM: Scott Wilson, Garth Morgan, Mark Eastwood (Nike, Inc.)
One Bowerman Drive
Beaverton, OR 97005-6453
Phone: 800-344-6453

Nike European Headquarters
Colosseum 1
1213 NL Hilversum
The Netherlands
Phone: 31 35 626-6453
www.nike.com

Page 164
PRODUCT: First Years Comfort Care Baby Products
DESIGN TEAM: Will Wear, Anthony Pannozzo, Matthew Marzynski
Herbst LaZar Bell, Inc. (HLB)
355 North Canal Street
Chicago, IL 60606
Phone: 312-454-1116 (Main Office)
781-890-5911 (Boston Office)
www.hlb.com

Page 168
PRODUCT: Perfect Portions
DESIGN TEAM: Wayne Marcus, Dot Studio, Charles H. Keegan and Brian Sundberg, Safety 1st Inc. (Dorel), Elizabeth Lewis, Insight Product Development, Steven L. Trosian, Velocity Product Development, and David O'Connell of Danebroch Studios for Safety 1st Inc. (Dorel).
DESIGN FIRM: Dot Studio, Inc.
For more information, contact Wayne Marcus, Director, Design
Product Ventures Ltd.
55 Walls Drive
Suite 400
Fairfield, CT 06824
Phone: 201-319-5916
wmarcus@pvldesign.com

Page 172
PRODUCT: Evenflo Triumph Convertible Car Seat
DESIGN TEAM: IDEO
100 Forest Avenue
Palo Alto, CA 94301
Phone: 650-289-3400
Fax: 650-289-3707
www.ideo.com

Page 176
PRODUCT: East3 Thoughtcaster
DESIGN TEAM: Jay K. Fording, Ian Cunningham,
Keith Savas (BOLT); Bill Riley, Sean Anderson
(SPARK Engineering)
BOLT
1415 South Church Street, Suite 5
Charlotte, NC 28203
Phone: 704-372-2658
Fax: 704-372-2655
www.boltgroup.com

Page 180
PRODUCT: Joey Clamp & Cutter
DESIGN TEAM: Philip Leung, Carrie Bader, Carrie
Labunski Shimek (Design Edge); Dr. Richard Watson,
Ron Hicks (Maternus Medical)
316 North Lamar Boulevard
Austin, TX 78703
Phone: 512-477-5491
www.designedge.com

Page 186
PRODUCT: SpeedBlocks Head Immobilizer
DESIGN TEAM: Jim Traut, Sean Phillips (Laerdal Medical
Corporation)
Andrew Serbinski, Mark Rosen, Mirzat Kol (Machineart
Corex)
167 Myers Corners Road
Wappingers Falls, NY 12590
Phone: 800-648-1851
Fax: 845-298-4555
www.laerdal.com

Page 190
PRODUCT: IV House UltraDressing
DESIGN TEAM: Bryce G. Rutter, Ph.D.
Metaphase Design Group, Inc.
12 South Hawley Road
St. Louis, MO 63105
Phone: 314-721-0720
Fax: 314-863-2480
www.metaphase.com

Page 194
PRODUCT: SenseWear Armband and Innerview Software
DESIGN TEAM: Chris Kasabach, Vanessa Sica, Ivo
Stivoric, Scott Boehmke of BodyMedia, Inc., Jason
Williams of K Development, Inc.
INTERFACE DESIGN: Chris Pacione, John Beck, Steve
Menke, Eric Hsiung of BodyMedia, Inc.
BodyMedia, Inc.
4 Smithfield Street, 12th Floor
Pittsburgh, PA, 15222
Phone: 412-288-9901 x1217
www.bodymedia.com

Page 198
PRODUCT: Infiniti 500 Rollator
DESIGN TEAM: Bjarki Hallgrimsson, Sarah Dobbin
Hallgrimsson Product Development
360 Summit Avenue
Ottawa, Ontario, K1H 5Z9
Canada
Phone: 613-858-4363
www.hallgrimssonproduct.com

Page 202
PRODUCT: HeartStart Home Defibrillator
DESIGN TEAM: Kurt Fischer, Seiya Ohta, Jon Bishay
Philips Medical Systems
2301 Fifth Avenue
Seattle, WA 98121
Phone: 866-DEFIBHOME
www.heartstarthome.com

ACADEM'S FURY

Ace Books by Jim Butcher

FURIES OF CALDERON
ACADEM'S FURY

ACADEM'S FURY

BOOK TWO OF THE CODEX ALERA

JIM BUTCHER

ACE BOOKS, NEW YORK

THE BERKLEY PUBLISHING GROUP
Published by the Penguin Group
Penguin Group (USA) Inc.
375 Hudson Street, New York, New York 10014, USA
Penguin Group (Canada), 10 Alcorn Avenue, Toronto, Ontario M4V 3B2, Canada
(a division of Pearson Penguin Canada Inc.)
Penguin Books Ltd., 80 Strand, London WC2R 0RL, England
Penguin Group Ireland, 25 St. Stephen's Green, Dublin 2, Ireland (a division of Penguin Books Ltd.)
Penguin Group (Australia), 250 Camberwell Road, Camberwell, Victoria 3124, Australia
(a division of Pearson Australia Group Pty. Ltd.)
Penguin Books India Pvt. Ltd., 11 Community Centre, Panchsheel Park, New Delhi—110 017, India
Penguin Group (NZ), Cnr. Airborne and Rosedale Roads, Albany, Auckland 1310, New Zealand
(a division of Pearson New Zealand Ltd.)
Penguin Books (South Africa) (Pty.) Ltd., 24 Sturdee Avenue, Rosebank, Johannesburg 2196, South
Africa

Penguin Books Ltd., Registered Offices: 80 Strand, London WC2R 0RL, England

This book is an original publication of The Berkley Publishing Group.

This is a work of fiction. Names, characters, places, and incidents either are the product of the author's imagination or are used fictitiously, and any resemblance to actual persons, living or dead, business establishments, events, or locales is entirely coincidental.

First edition: July 2005

Library of Congress Cataloging-in-Publication Data

Butcher, Jim.
 Academ's fury / Jim Butcher.— 1st ed.
 p. cm.
 ISBN 0-441-01283-3
 1. Title.

PS3602.U85A63 2005
813'.6—dc22

 2005042814

PRINTED IN THE UNITED STATES OF AMERICA

10 9 8 7 6 5 4 3 2

For all the old gang at AmberMUSH and on Too.
We all wasted way too much time together,
and I wouldn't have it any other way.

ACKNOWLEDGMENTS

There are always lots of people to thank for helping out with any project as lengthy as a novel, but this time I want to thank the one person who always does the most for me, and who never expects anything in return.

Thank you, Shannon. For too many things for me to even remember, much less list.

I don't know how you put up with me, my angel, but I hope you don't stop.

ᴄ⃞ᴄ⃞ᴄ⃞PROLOGUE

If the beginning of wisdom is in realizing that one knows nothing, then the beginning of understanding is in realizing that all things exist in accord with a single truth: large things are made of smaller things.

Drops of ink are shaped into letters, letters form words, words form sentences, and sentences combine to express thought. So it is with the growth of plants that spring from seeds, as well as with walls built of many stones. So it is with mankind, as the customs and traditions of our progenitors blend together to form the foundation for our own cities, history, and way of life.

Be they dead stone, living flesh, or rolling sea; be they idle times or events of world-shattering proportion, market days, or desperate battles, to this law, all things hold:

Large things are made from small things.

Significance is cumulative—but not always obvious.

> FROM THE WRITINGS OF GAIUS SECONDUS,
> FIRST LORD OF ALERA

Wind howled over the rolling, sparsely wooded hills of the lands in the care of the Marat, the One-and-Many people. Hard, coarse flecks of snow fled before it, and though the One rode high in the sky, the overcast hid his face.

Kitai began to feel cold for the first time since spring. She turned to squint behind her, shielding her eyes from the sleet with one hand. She wore a brief cloth about her hips, a belt to hold her knife and hunting pouch, and nothing else. Wind threw her thick white hair around her face, its color blending with the driving snow.

"Hurry up!" she called.

There was a deep-chested snort, and a massive form paced into sight.

Walker the gargant was an enormous beast, even of its kind, and its shoulders stood nearly the height of two men above the earth. His shaggy winter coat had already come in thick and black, and he paid no notice to the snow. His claws, each larger than an Aleran saber, dug into the frozen earth without difficulty or hurry.

Kitai's father, Doroga, sat upon the gargant's back, swaying casually upon the woven saddlecloth. He was dressed in a loincloth and a faded red Aleran tunic. Doroga's chest, arms, and shoulders were so laden with muscle that he had been obliged to tear the sleeves from the red tunic—but as it had been a gift, and discarding it would be impolite, he had braided a rope from the sleeves and bound it across his forehead, tying back his own pale hair. "We must hurry, since the valley is running from us. I see. Maybe we should have stayed downwind."

"You are not as amusing as you think you are," Kitai said, glowering at her father's teasing.

Doroga smiled, the expression emphasizing the lines in his broad, square features. He took hold of Walker's saddle rope and swung down to the ground with a grace that belied his sheer size. He slapped his hand against the gargant's front leg, and Walker settled down amicably, placidly chewing cud.

Kitai turned and walked forward, into the wind, and though he made no sound, she knew her father followed close behind her.

A few moments later, they reached the edge of a cliff that dropped abruptly into open space. The snow prevented her from seeing the whole of the valley below, but for the lulls between gusts, when she could see all the way to the bottom of the cliff below them.

"Look," she said.

Doroga stepped up beside her, absently slipping one vast arm around her shoulders. Kitai would never have let her father see her shiver, not at a mere autumn sleet, but she leaned against him, silently grateful for his warmth. She watched as her father peered down, waiting for a lull in the wind to let him see the place the Alerans called the Wax Forest.

Kitai closed her eyes, remembering the place. The dead trees were coated in the *croach,* a thick, gelatinous substance layered over and over itself so that it looked like the One had coated it all in the wax of many candles. The *croach* had covered everything in the valley, including the ground and a sizeable portion of the valley walls. Here and there, birds and animals had been sealed into the *croach,* where, still alive, they lay unmoving until

they softened and dissolved like meat boiled over a low fire. Pale things the size of wild dogs, translucent, spiderlike creatures with many legs once laid quietly in the *croach,* nearly invisible, while others prowled the forest floor, silent and swift and alien.

Kitai shivered at the memory, then forced herself to stillness again, biting her lip. She glanced up at her father, but he pretended not to have noticed, staring down.

The valley below had never in her people's memory taken on snow. The entire place had been warm to the touch, even in winter, as though the *croach* itself was some kind of massive beast, the heat of its body filling the air around it.

Now the Wax Forest stood covered in ice and rot. The old, dead trees were coated in something that looked like brown and sickly tar. The ground lay frozen, though here and there, other patches of rotten *croach* could be seen. Several of the trees had fallen. And in the center of the Forest, the hollow mound lay collapsed and dissolved into corruption, the stench strong enough to carry even to Kitai and her father.

Doroga was still for a moment before he said, "We should go down. Find out what happened."

"I have," Kitai said.

Her father frowned. "That was foolish to do alone."

"Of the three of us here, which has gone down and come back alive again the most often?"

Doroga grunted out a laugh, glancing down at her with warmth and affection in his dark eyes. "Maybe you are not mistaken." The smile faded, and the wind and sleet hid the valley again. "What did you find?"

"Dead keepers," she replied. "Dead *croach*. Not warm. Not moving. The keepers were empty husks. The *croach* breaks into ash at a touch." She licked her lips. "And something else."

"What?"

"Tracks," she said in a quiet voice. "Leading away from the far side. Leading west."

Doroga grunted. "What tracks?"

Kitai shook her head. "They were not fresh. Perhaps Marat or Aleran. I found more dead keepers along the way. As if they were marching and dying one by one."

"The creature," Doroga rumbled. "Moving toward the Alerans."

Kitai nodded, her expression troubled.

Doroga looked at her, and said, "What else?"

"His satchel. The pack the valleyboy lost in the Wax Forest during our race. I found it on the trail beside the last of the dead spiders, his scent still on it. Rain came. I lost the trail."

Doroga's expression darkened. "We will tell the master of the Calderon Valley. It may be nothing."

"Or it may not. I will go," Kitai said.

"No," Doroga said.

"But father—"

"No," he repeated, his voice harder.

"What if it is looking for him?"

Her father remained quiet for a time, before he said, "Your Aleran is clever. Swift. He is able to take care of himself."

Kitai scowled. "He is small. And foolish. And irritating."

"Brave. Selfless."

"Weak. And without even the sorcery of his people."

"He saved your life," Doroga said.

Kitai felt her scowl deepen. "Yes. He is irritating."

Doroga smiled. "Even lions begin life as cubs."

"I could break him in half," Kitai growled.

"For now, perhaps."

"I despise him."

"For now, perhaps."

"He had no right."

Doroga shook his head. "He had no more say in it than you."

Kitai folded her arms, and said, "I hate him."

"So you want someone to warn him. I see."

Kitai flushed, heat touching her cheeks and throat.

Her father pretended not to notice. "What is done is done," he rumbled. He turned to her and cupped her cheek in one vast hand. He tilted his head for a moment, studying her. "I like his eyes on you. Like emerald. Like new grass."

Kitai felt her eyes begin to tear. She closed them and kissed her father's hand. "I wanted a horse."

Doroga let out a rumbling laugh. "Your mother wanted a lion. She got a fox. She did not regret it."

"I want it to go away."

Doroga lowered his hand. He turned back toward Walker, keeping his arm around Kitai. "It won't. You should Watch."

"I do not wish to."

"It is the way of our people," Doroga said.

"I do not wish to."

"Stubborn whelp. You will remain here until some sense soaks into your skull."

"I am *not* a whelp, father."

"You act like one. You will remain with the *Sabot-ha*." They reached Walker, and he tossed her halfway up the saddle rope without effort.

Kitai clambered up to Walker's broad back. "But father—"

"No, Kitai." He climbed up behind her, and clucked to Walker. The gargant placidly rose and began back the way they had come. "You are forbidden to go. It is done."

Kitai rode silently behind her father, but sat looking back to the west, her troubled face to the wind.

Miles's old wound pained him as he trudged down the long spiral staircase into the depths of the earth below the First Lord's palace, but he ignored it. The steady, smoldering throb from his left knee was of little more concern to him than the aching of his tired feet or the stretching soreness of weary muscles in his shoulders and arms after a day of hard drilling. He ignored them, his face as plain and remote as the worn hilt of the sword at his belt.

None of the discomfort he felt disturbed him nearly as much as the prospect of the conversation he was about to have with the most powerful man in the world.

Miles reached the antechamber at the bottom of the stairs and regarded his distorted reflection in a polished shield that hung upon the wall. He straightened the hem of his red-and-blue surcoat, the colors of the Royal Guard, and raked his fingers through his mussed hair.

A boy sat on the bench beside the closed door. He was a lanky, gangling youth, a young man who had come to his growth but recently, and the hems of his breeches and sleeves both rode up too far, exposing his wrists and ankles. A mop of dark hair fell over his face, and an open book sat upon his lap, one finger still pointed at a line of text though the boy was clearly asleep.

Miles paused, and murmured, "Academ."

He jerked in his sleep, and the book fell from his lap and to the floor. The boy sat up, blinking his eyes, and stammered, "Yes, sire, what, uh, yes sire. Sire?"

Miles put a hand on the boy's shoulder before he could rise. "Easy, easy. Finals coming up, eh?"

The boy flushed and ducked his head as he leaned down to recover the book. "Yes, Sir Miles. I haven't had much time for sleep."

"I remember," he said. "Is he still inside?"

The boy nodded again. "As far as I know, sir. Would you like me to announce you?"

"Please."

The boy rose, brushing at his wrinkled grey academ's tunic, and bowed. Then he knocked gently on the door and opened it.

"Sire?" the boy said. "Sir Miles to see you."

There was a long pause, then a gentle male voice responded, "Thank you, Academ. Send him in."

Miles walked into the First Lord's meditation chamber, and the boy shut the soundproof door behind him. Miles lowered himself to one knee and bowed his head, waiting for the First Lord to acknowledge him.

Gaius Sextus, First Lord of Alera, stood in the center of the tiled floor. He was a tall man with a stern face and tired eyes. Though his skills at watercrafting caused him to resemble a man only in his fifth decade of life, Miles knew that he was twice that age. His hair, once dark and lustrous, had become even more heavily sown with grey in the past year.

On the tiles beneath Gaius, colors swirled and changed, patterns forming and vanishing again, constantly shifting. Miles recognized a portion of the southern coastline of Alera, near Parcia, which remained in place for a moment before resolving into a section of mountainous wilderness that could only have been in the far north, near the Shieldwall.

Gaius shook his head and passed his hand through the air before him, murmuring, "Enough." The colors faded away completely, the tiles reverting to their usual dull, stationary colors. Gaius turned and sank down into a chair against the wall with a slow exhalation. "You're up late tonight, Captain."

Miles rose. "I was in the Citadel and wanted to pay my respects, sire."

Gaius's greying brows rose. "You walked down five hundred stairs to pay your respects."

"I didn't count them, sire."

"And if I am not mistaken, you are to inspect the new Legion's command at dawn. You'll get little sleep."

"Indeed. Almost as little as you will, my lord."

"Ah," Gaius said. He reached out and took up a glass of wine from the bureau beside his chair. "Miles, you're a soldier, not a diplomat. Speak your mind."

Miles let out a slow breath and nodded. "Thank you. You aren't getting enough sleep, Sextus. You're going to look like something the gargant shat for the opening ceremonies of Wintersend. You need to get to bed."

The First Lord waved one hand. "Presently, perhaps."

"No, Sextus. You're not going to wave this off. You've been here every night for three weeks, and it shows. You need a warm bed, a soft woman, and rest."

"Unfortunately, I'm likely to have none of the three."

"Balls," Miles said. He folded his arms and planted his feet. "You're the First Lord of Alera. You can have anything you want."

Gaius's eyes flickered with a shadow of surprise and anger. "My bed is unlikely to be warm so long as Caria is in it, Miles. You know how things stand between us."

"What did you expect? You married a bloody child, Sextus. She expected to live out an epic romance, and she found herself with a dried-up old spider of a politician instead."

Gaius's mouth tightened, the anger in his eyes growing more plain. The stone floor of the chamber rippled, the tremor making the table beside the chair rattle. "How dare you speak so to me, Captain?"

"You ordered me to, my lord. But before you dismiss me, consider. If I wasn't in the right, would it have angered you as much as it did? If you weren't so tired, would you have revealed your anger so obviously?"

The floor quieted, and Gaius's regard grew more weary, less angered. Miles felt a stab of disappointment. Once upon a time, the First Lord would not have surrendered to fatigue so easily.

Gaius took another sip of wine, and said, "What would you have me do, Miles? Tell me that."

"Bed," Miles said. "A woman. Sleep. Festival begins in four days."

"Caria isn't leaving her door open to me."

"Then take a concubine," Miles said. "Blight it, Sextus, you need to relax and the Realm needs an heir."

The First Lord grimaced. "No. I may have ill-used Caria, but I'll not shame her by taking another lover."

"Then lace her wine with aphrodin and split her like a bloody plow, man."

"I didn't realize you were such a romantic, Miles."

The soldier snorted. "You're so tense that the air crackles when you move. Fires jump up to twice their size when you walk through the room. Every fury in the capital feels it, and the last thing you want is for the High Lords arriving for Wintersend to know you're worried."

Gaius frowned. He stared down at his wine for a moment, before he said, "The dreams have come again, Miles."

Worry struck Miles like a physical blow, but he kept it from his face as best he could. "Dreams. You're not a child to fear a dream, Sextus."

"These are more than mere nightmares. Doom is coming to Wintersend."

Miles forced a note of scorn into his voice. "You're a fortune-teller now, sire, foreseeing death?"

"Not necessarily death," Gaius said. "I use the old word. Doom. Fate. Wyrd. Destiny rushes toward us with Wintersend, and I cannot see what is beyond it."

"There is no destiny," Miles stated. "The dreams came two years ago, and no disaster destroyed the Realm."

"Because of one obstinate apprentice shepherd and the courage of those holders. It was a near thing. But if destiny doesn't suit you, call it a desperate hour," Gaius said. "History is replete with them. Moments where the fate of thousands hangs at balance, easily tipped one way or the next by the hands and wills of those involved. It's coming. This Wintersend will lay down the course of the Realm, and I'll be blighted if I can see how. But it's coming, Miles. It's coming."

"Then we'll deal with it," Miles said. "But one thing at a time."

"Exactly," Gaius said. He rose from the chair and strode back onto the mosaic tiles, beckoning Miles to come with him. "Let me show you."

Miles frowned and watched as the First Lord passed his hand over the tiles again. Miles sensed the whisper of subtle power flowing through the tiles, furies from every corner of the Realm responding to the First Lord's will. From upon the tiles, he got the full effect of the furycrafted map, colors rising up around him until it seemed that he stood like a giant over the

ghostly image of the Citadel of Alera Imperia, capital of Alera itself. His balance wavered as the image blurred, speeding westward, to the rolling, rich valley of the Amaranth Vale, and past it, over the Blackhills and to the coast. The image intensified, resolving itself into an actual moving picture over the sea, where vast waves rolled under the lashing of a vicious storm.

"There," Gaius said. "The eighth hurricane this spring."

After a hushed moment, Miles said, "It's huge."

"Yes. And this isn't the worst of them. They keep making them bigger."

Miles looked up at the First Lord sharply. "Someone is crafting these storms?"

Gaius nodded. "The Canim ritualists, I believe. They've never exerted this much power across the seas before. Ambassador Varg denies it, of course."

"Lying dog," Miles spat. "Why don't you ask the High Lords on the coast for assistance? With enough windcrafters, they should be able to blunt the storms."

"They already are helping," Gaius said quietly. "Though they don't know it. I've been breaking the storm's back and letting the High Lords protect their own territory once it was manageable."

"Then ask for further help," Miles said. "Surely Riva or Placida could lend windcrafters to the coastal cities."

Gaius gestured, and the map blurred again, settling in the far north of the Realm, along the solid, smooth stone of the Shieldwall. Miles frowned and leaned down, looking closer. Leagues away from the wall, he could see many figures moving, mostly veiled by clouds of finely powdered snow. He started making a count and quickly realized the extent of the numbers there. "The Icemen. But they've been quiet for years."

"No longer," Gaius said. "They are gathering their numbers. Antillus and Phrygia have already fought off two assaults along the Shieldwall, and matters are only growing worse. The spring thaw was delayed long enough to promise a sparse crop. That means the southerners will have the chance to gouge the Shield cities for food, and with matters as tense as they are already, it could well trigger further unpleasantness."

Miles's frown deepened. "But if more storms strike the southerners, it will ruin their crop."

"Precisely," Gaius said. "The northern cities would starve, and the southerners would be unprepared to face the Icemen that pour over the wall."

"Could the Canim and the Icemen be working together?" Miles asked.

"Great furies forbid," Gaius said. "We must hope that it is merely coincidence."

Miles ground his teeth. "And meanwhile, Aquitaine makes sure everyone hears that your incompetence is the cause of it all."

Gaius half smiled. "Aquitaine is a rather pleasant, if dangerous opponent. He is generally straightforward. I am more concerned with Rhodes, Kalare, and Forcia. They have stopped complaining to the Senate. It makes me suspicious."

The soldier nodded. He was quiet for a moment, the worry he'd felt before settling in and beginning to grow. "I hadn't realized."

"No one has. I doubt anyone else has enough information to understand the magnitude of the problem," Gaius said. He passed his hand over the mosaic tiles again, and the ghostly image of the map vanished. "And it must remain that way. The Realm is in a precarious position, Miles. A panicked reaction, a single false step could lead to division between the cities, and leave Alera open to destruction at the hands of the Canim or the Icemen."

"Or the Marat," Miles added, not bothering to hide the bitterness in his voice.

"On that front I am not unduly worried. The new Count of Calderon seems to be well advanced into forming friendly relations with several of their largest tribes."

Miles nodded his head, but said nothing more of the Marat. "You've much on your mind."

"All that and more," Gaius confirmed. "There are all the usual pressures of the Senate, the Dianic League, the Slaver's Alliance, and the Trade Consortium. Many see my reactivation of the Crown Legion as a sign of growing weakness, or possibly senility." He drew a breath. "Meanwhile the whole of the Realm worries that I may already have seen my last winter, yet have appointed no heir to succeed me—while High Lords like Aquitaine seem ready to swim to the throne through a river of blood, if necessary."

Miles considered the enormity of it for a moment in silence. "Balls."

"Mmm," Gaius said. "One thing at a time indeed." For a moment, he looked very old and very tired. Miles watched as the old man closed his eyes, composed his features, and squared his weary shoulders, steadying his voice to its usual brusque, businesslike cadence. "I have to keep an eye on that storm for a few more hours. I'll get what sleep I can then, Miles. But there is little time to spare for it."

The soldier bowed his head. "My words were rash, sire."

"But honest. I should not have grown angry with you for that. My apologies, Miles."

"It's nothing."

Gaius let out a pent-up breath and nodded. "Do something for me, Captain."

"Of course."

"Double the Citadel guard for the duration of Festival. I have no evidence to support it, but it is not beyond reason that someone might attempt dagger diplomacy during Wintersend. Especially since Fidelias left us." The First Lord's eyes grew more shadowed at this last, and Miles winced with sympathy. "He knows most of the passages in the Citadel and the Deeps."

Miles met Gaius Sextus's eyes and nodded. "I'll take care of it."

Gaius nodded and lowered his arm. Miles took it as a dismissal and walked toward the door. He paused there and looked back over his shoulder. "Rest. And think on what I said about an heir, Sextus. Please. A clear line of succession might lay many of these worries to rest."

Gaius nodded. "I am addressing it. I will say no more than that."

Miles bowed from the waist to Gaius, then turned and opened the door. A grating, buzzing sound drifted into the meditation chamber, and Miles observed, "Your page snores very loudly."

"Don't be too hard on him," Gaius said. "He was raised to be a shepherd."

CHAPTER 1

Tavi peeked around the corner of the boys' dormitories at the Academy's central courtyard, and said to the young man beside him, "You've got that look on your face again."

Ehren Patronus Vilius, a young man barely more than five feet tall, skinny, pale-skinned, and dark-eyed, fidgeted with the hems of his flapping grey academ's robes and overcoat. "What look?"

Tavi drew back from the corner, and tugged idly at his own student's uniform. It seemed that no matter how many times he got the garment adjusted, his body kept a pace ahead of the seamstress. The robes were too tight in the shoulders and chest, and the arms didn't come close to touching Tavi's wrists. "You know it, Ehren. The one you get when you're about to give someone advice."

"Actually it's the one I get when I'm about to give advice I'm sure will be ignored." Ehren peeked around the corner too, and said, "Tavi, they're all there. We might as well leave. There's only the one way to get to the dining hall. They're going to see us."

"Not all of them are there," Tavi insisted. "The twins aren't."

"No. Just Brencis *and* Renzo *and* Varien. Any one of whom could skin both of us together."

"We might be more of a handful than they think," Tavi said.

The smaller boy sighed. "Tavi, it's only a matter of time before they hurt someone. Maybe bad."

"They wouldn't dare," Tavi said.

"They're *Citizens*, Tavi. We aren't. It's as simple as that."

"That's not how it works."

"Do you ever actually listen to your history lessons?" Ehren countered. "Of course it's how it works. They'll say it was an accident, and they're terribly sorry. Assuming it even gets to a court, a magistrate will make them pay

a fine to your relatives. Meanwhile, you'll be walking around missing your eyes or your feet."

Tavi set his jaw and started around the corner. "I'm not missing breakfast. I was up at the Citadel all night, he made me run up and down those crows-eaten stairs a dozen times, and if I have to skip another meal I'll go insane."

Ehren grabbed his arm. His lanyard, sporting one white bead, one blue, and one green bounced against his skinny chest. Three beads meant that the furymasters of the Academy thought Ehren barely had a grasp of furycrafting at all.

Of course, he had three beads more than Tavi.

Ehren met Tavi's gaze and spoke quietly. "If you go walking out there alone, you're insane already. Please wait a few minutes more."

Just then, the third morning bell sounded, three long strokes. Tavi grimaced at the bell tower. "Last bell. If we don't get moving, we won't have time to eat. If we time it right, we can walk past them when some others are coming out. They might not see us."

"I just don't understand where Max could be," Ehren said.

Tavi looked around again. "I don't know. I didn't leave for the palace until just before curfew, but his bed hadn't been slept in this morning."

"Out all night again," Ehren mourned. "I don't see how he expects to pass if he keeps this up. Even I won't be able to help him."

"You know Max," Tavi said. "He isn't big on planning." Tavi's belly cramped with hunger and made a gurgling noise. "That's it," he said. "We need to move. Are you coming with me or not?"

Ehren bit his lip and shook his head. "I'm not that hungry. I'll see you in class?"

Tavi felt a swell of disappointment, but he chucked Ehren on the arm. He could understand the smaller boy's reluctance. Ehren had grown up among his parents' quiet books and tables, where his keen memory and ability with mathematics far outweighed his lack of strong furycrafting. Before coming to the Academy, Ehren had never been faced with the kind of casual, petty cruelty that powerful young furycrafters could show their lessers.

Tavi, on the other hand, had been facing that particular problem for the whole of his life.

"I'll see you at class," he told Ehren.

The smaller boy fumbled at his lanyard with ink-stained fingers. "You're sure?"

"Don't worry. I'll be fine." With that, Tavi stepped around the corner and started walking across the courtyard toward the dining hall.

A few seconds later, Tavi heard running footsteps and Ehren puffed into place beside him, his expression nervous but resolved. "I should eat more," he said. "It could stunt my growth."

Tavi grinned at him, and the two walked together across the courtyard.

Spring sunlight, warmer than the mountain air around the capital of Alera, poured down over the Academy grounds. The courtyard was a richly planted garden with walkways of smooth white stone set in a number of meandering paths across it. The early blooms had accompanied the green grass up from the earth after winter's chill, and their colors, all reds and blues, decorated the courtyard. Students lounged at benches, talking, reading, and eating breakfast, all dressed in the uniform grey robes and tunics. Birds dipped and flashed through the sunshine, perching on the eaves of the buildings framing the courtyard before diving down to strike at insects emerging from their holes to gather in the crumbs dropped by careless academs.

It all looked peaceful, simple, and lovely beyond the scale of anything outside of the mighty capital of all Alera.

Tavi hated it.

Kalarus Brencis Minoris and his cronies had settled in their usual spot, at a fountain just outside the entrance to the dining hall. Just looking at the other boy seemed to make Tavi's morning grow darker. Brencis was a tall and handsome young man, regal of bearing and narrow of face. He wore his hair in long curls, considered fashionably decadent in the southern cities—particularly in his home of Kalare. His academ's robes were made of the finest of cloth, tailored personally to fit him, and embroidered with threads of pure gold. His lanyard shone with beads of semiprecious stones rather than cheap glass, and lay heavily on his chest with multiple representatives of all six colors—one for each area of furycrafting: red, blue, green, brown, white, and silver.

As Tavi and Ehren approached the fountain, the group of students from Parcia, golden brown skin shining in the morning sun, started passing between them and the bullies. Tavi hurried his steps. They only needed to avoid notice for a few more yards.

They didn't. Brencis rose from his seat at the fountain's edge, his lips curling into a wide and cheerful smile. "Well, well," he said. "The little scribe and his pet freak out for a walk. I'm not sure they'll let the freak into the dining hall if you don't put him on a leash, scribe."

Tavi didn't even glance toward Brencis, continuing on without slowing his steps. There was a chance that if he simply took no notice of the other boy, he might not bother to push.

Ehren, though, stopped and glowered at Brencis. The small boy licked his lips, and said, in a crisp tone, "He isn't a freak."

Brencis's smile widened as he came closer. "Of course he is, scribaby. The First Lord's pet monkey. It did a trick once, and now Gaius wants to show it off, like any other trained beast."

"Ehren," Tavi said. "Come on."

Ehren's dark eyes glistened abruptly, and his lower lip trembled. But the boy lifted his chin and didn't look away from Brencis. "H-he isn't a freak," Ehren insisted.

"Are you calling me a liar, scribe?" Brencis asked. His smile became vicious, and he flexed his fingers. "And I thought you had learned proper respect for your betters."

Tavi ground his teeth in frustration. It wasn't fair that idiots like Brencis should get to throw their weight around so casually, while decent folk like Ehren were constantly walked upon. Brencis obviously wasn't going to let them pass without incident.

Tavi glanced at Ehren and shook his head. The smaller boy would not have been here to begin with if he hadn't been following Tavi. That made Tavi responsible for what happened to him. He turned to face Brencis and said, "Brencis, please leave us alone. We just want to get some breakfast."

Brencis put his hand to his ear, his face reflecting feigned puzzlement. "Did you hear something? Varien, did you hear anything?"

Behind Brencis, the first of his two lackeys stood up and meandered over. Varien was a boy of medium height and heavy build. His robes were nowhere near so fine as Brencis's, though still superior to Tavi's. The extra fat gave Varien's face a petulant, spoiled look, and his baby-fine blond hair was too lank to curl properly, like Brencis's. His lanyard bore several beads of white and green that somehow clashed with his muddy hazel eyes. "I might have heard a rat squeaking."

"Could be," Brencis said gravely. "Now then, scribe. Would you prefer mud or water?"

Ehren swallowed and took a step back. "Wait. I'm not looking for trouble."

Brencis followed the small boy, his eyes narrowing, and grasped Ehren by his academ's robe. "Mud or water, you gutless piglet."

"Mud, my lord," urged Varien, eyes lit with an ugly sparkle. "Leave him up to his neck in it and let those clever wits of his broil in the sun for a while."

"Let me go!" Ehren said, his voice rising to a panicked pitch.

"Mud it is," said Brencis. He gestured to the ground with one hand, and the earth heaved and shivered. Nothing happened for a moment, then the ground began to stir, growing softer, a bubble rising up through the sudden mix of earth and fury-called water with a sodden "bloop."

Tavi looked around him for help, but there was none to be seen. None of the Maestros were passing through, and with the exception of Max, none of the other students were willing to defy Brencis when he was amusing himself at someone else's expense.

"Wait!" Ehren cried. "Please, these are the only shoes I have!"

"Well then," Brencis said. "It looks like your little freeholder family should have saved up for another generation before they sent someone here."

Tavi had to get Brencis's attention away from Ehren, and he could only think of one way to manage it. He bent over, dug up a handful of sodden earth into one scooped hand, and flung it at Brencis's head.

The young Kalaran let out a short sound of surprise as mud plastered his face. Brencis wiped at the mud and stared, shocked, at his soiled fingers. There was a sudden burst of stifled giggles from the students watching the exchange, but when Brencis stared around him, they all averted their gaze and hid smiles behind lifted hands. Brencis glowered at Tavi, his eyes flat with anger.

"Come on, Ehren," Tavi said. He pushed the smaller boy behind him, toward the dining hall. Ehren stumbled, then hurried that way. Tavi started to follow him without turning his back on Brencis.

"You," Brencis snarled. "How *dare* you."

"Leave it, Brencis," Tavi said. "Ehren's never done you any harm."

"Tavi," Ehren hissed, warning in his tone.

Tavi sensed the presence behind him just as Ehren spoke, and ducked. He darted to one side, in time to avoid a pair of heavy-handed swipes from Brencis's second crony, Renzo.

Renzo was simply huge. Huge across, huge up and down, built on the same scale as barns and warehouses—big, roomy, and plain. He had dark hair and the scruffy beginnings of a full beard, and tiny eyes set in his square face. Renzo's academy tunic was made of unexceptional cloth, but its very size meant that it had to have cost twice what a normal outfit would

have. Renzo had only heavy brown beads on his lanyard—lots and lots of
them. He took another step toward Tavi and drove a huge fist forward.

Tavi hopped out of the way of that blow as well, and snapped, "Ehren,
find Maestro Gallus!"

Ehren let out a startled cry, and Tavi looked over his shoulder to see
Varien holding the little scribe, his arms around Ehren's shoulders, twisting
painfully.

Distracted, Tavi was unable to avoid Renzo's next lunge, and the big,
silent boy picked him up and threw him without ceremony into the fountain.

Tavi splashed into the water, and a shock of cold stole the breath from
his lungs. He floundered for a minute, trying to tell up from down, and got
himself more or less righted in the two-foot depth of water in the fountain.
He sat up, spluttering.

Brencis stood over the fountain, mud dripping from one ear and staining
his beautiful clothing. His handsome face twisted into an expression of an-
noyance. He lifted one hand and flicked his wrist in a languid gesture.

The water around Tavi surged on its own accord. Steam, searing heat,
washed up and away from the surface of the fountain's water, and Tavi let
out a choked breath, lifting a hand to shield his eyes while the other sup-
ported him upright. The flood of heat passed as swiftly as it had come.

Tavi found himself completely unable to move. He looked around him
and saw, as the steaming cloud cleared, that the fountain's water had trans-
formed completely into solid, frozen ice. The cold of it began to chew into
his skin a moment later, and he struggled to get a deep breath through the
grip of the ice.

"H-how," he muttered, staring at Brencis. "How did you do that?"

"An application of furycrafting, freak," Brencis said. "Firecrafting is all
about arranging heat, after all. I just moved all the heat out of the water. It's
an advanced application, of course. Not that I would expect you to under-
stand how it works."

Tavi looked around the courtyard. Varien still held Ehren in a painful
lock. The scribe was breathing in short, pained gasps. Many of the students
who had been there a few moments before had left. Of the half dozen or so
who remained, none were looking at the fountain, suddenly engrossed in
their books, their breakfasts, or in the details of the roof of a building across
the campus.

The cold's teeth became painful fangs. Tavi's arms and legs throbbed in

pain, and it became harder to breathe. Fear raced through him, making his heart labor.

"Brencis," Tavi began. "Don't do this. The Maestros—"

"Won't care about *you*, freak." He regarded Tavi with a relaxed, calculating expression. "I am the eldest son of a High Lord of Alera. You're no one. You're nothing. Haven't you learned that by *now*?"

Tavi knew that the other boy was trying to hurt him, to anger him, and had chosen his words carefully. He knew that Brencis was deliberately manipulating him, but it seemed to make little difference. The words hurt. For most of his young life, Tavi had dreamed of leaving his aunt and uncle's steadholt, of coming to the Academy, to make something of himself despite his utter lack of ability in furycrafting.

Fate, it seemed, had delivered her most cruel stroke by granting his request.

The cold made it hard to speak, but Tavi did. "Brencis, we're both going to get demerits if the Maestros see this. Let me out. I'm sorry about the m-m-mud."

"You're sorry? As if that should matter to me?" Brencis said. "Renzo."

Renzo drew back his fist and hit Tavi in the mouth. Pain flashed through him, and he felt his lower lip split open and tasted coppery blood on his tongue. Anger joined his fear, and he stammered, "Crows take you, Brencis! Leave us alone!"

"He still has teeth, Renzo," Brencis noted.

Renzo said nothing, but hit Tavi again, and harder. Tavi tried to jerk his head away from the blow, but the ice held him fast, and he could no more avoid it than he could turn a cartwheel. The pain made his vision blur with tears he tried furiously to hold away.

"Let him go!" Ehren panted, but no one listened to him. The pain in Tavi's limbs continued to swell, and he felt his lips go numb. He tried to shout for help, but the sounds came out only feebly, and no help came.

"Well, freak," Brencis said. "You wanted me to leave you alone. I think I will. I'll stop by after lunch and see if there's anything else you have to say."

Tavi looked up and saw an opportunity approaching—but only if he could keep the bully's attention. He fixed his gaze on Brencis and snarled something under his breath.

Brencis tilted his head to one side, taking a step forward. "What was that?"

"I said," Tavi rasped, "that you're pathetic. You're a spoiled mama's boy who is too much a coward to face anyone strong enough to hurt you. You have to pick on people like Ehren and me because you're weak. You're nothing."

Brencis narrowed his eyes, leaning forward intently. "You know, freak. I don't have to leave you alone." He rested one hand on the ice, and it began to twitch and shift, letting out creaks and groans. Tavi felt a sharp twinge of pain in one shoulder, cutting through the frozen agony of the ice.

"If you like," Brencis said, "I can just stay right here with you."

Variens blurted, "Brencis!"

Tavi leaned forward and growled, "Go ahead, mama's boy. Go ahead and do it. What are you afraid of?"

Brencis's eyes flashed with anger, and the ice shifted more. "You've had this coming to you, paganus."

Tavi gritted his teeth over a pained scream.

"Good morning!" boomed a boisterous voice. A large, muscular young man in a *legionare*'s close-cropped haircut loomed up behind Brencis and casually seized him by the back of his coat and his long hair. Without pre-amble, the young man drove Brencis's head down into the ice, cracking his skull against the frozen surface near Tavi with a solid thump. Then the young man hauled Brencis back, and tossed him away from the fountain, sending the young lord sprawling bonelessly onto the green grass.

"Max!" Ehren shouted.

Renzo took a lumbering swing at the back of Max's neck, but the tall young man ducked under it and drove a stiff punch into the hulking Renzo's belly. Renzo's breath exploded from his chest, and he staggered. Max seized one of his arms and sent Renzo sprawling beside Brencis.

Max looked over at Varien and narrowed his eyes.

The young nobleman went pale, let go of Ehren, and backed away with his hands held before him. He and Renzo hauled the stunned Brencis onto his feet, and the three bullies retreated from the courtyard. Excited mutters and whispers from the academs in the courtyard rose as they left.

"Furies, Calderon," Max called to Tavi, loudly enough to be heard by anyone who wasn't deaf. "I am so clumsy in the morning. Look at how I went blundering right into those two." Without further delay, he moved over to the fountain and regarded Tavi's plight. Max nodded once, took a deep breath, and narrowed his eyes in concentration. Then he drew back his fist and slammed it down onto the ice near Tavi. A spiderweb of cracks

exploded through it, and stinging chips struck against Tavi's numbed skin. Max pounded his fist down several more times, his fury-assisted strength more than equal to the task of pulverizing the ice imprisoning Tavi. Within half a minute, Tavi felt himself come loose from his icy bonds, and Ehren and Max both hauled Tavi up from the ice and out onto the ground.

Tavi lay for a moment, gasping and gritting his teeth at the numbing cold still in his limbs, unable to speak.

"Crows," Max swore idly. He started rubbing briskly at Tavi's limbs. "He's near frostbitten."

Tavi felt his arms and legs twitch as fiery pins and needles started prickling against his skin. As soon as he could get his voice back, he gasped, "Max, forget this. Get me to breakfast."

"Breakfast?" Max said. "You're kidding, Calderon."

"I'm going to get a decent b-b-breakfast if it kills me."

"Oh. You're doing pretty well then," Max observed. He started helping Tavi up off the ground. "Thanks for keeping his attention off me until I could hit him, by the way. What happened?"

"B-Brencis," Tavi spat. "Again."

Ehren nodded earnestly. "He was going to bury me up to my neck again, but Tavi threw a bunch of mud at his face."

"Hah," Max said. "Wish I could have seen that."

Ehren bit his lip, then squinted up at the larger boy, and said, "If you hadn't been out all night, maybe you would have."

The large academ's face flushed. Antillar Maximus's features were not beautiful by anyone's standards, Tavi thought. But they were clean-cut, rugged, and strong. He had the wolfish grey eyes of the northern High Houses and combined a powerful build with a casual feline grace. Though usually he shaved scrupulously every day, he evidently hadn't had time to this morning, and shadowy stubble gave his features a roguish cast that went well with the dents in his twice-broken nose. Max's robes were plain and wrinkled, and had to struggle to contain his shoulders and chest. His lanyard, randomly arrayed with a hefty number of colored beads, had been carelessly knotted in several places where it had broken.

"I'm sorry," Max mumbled, as he helped Tavi stagger towards the dining hall. "It just kind of happened. There are some things that a man shouldn't miss."

"Antillar," murmured a female voice, a low and throaty purr drawling out

consonants with an Attican accent. Tavi opened his eyes to see a ravishing young woman, her dark hair worn in a long braid that fell over her left shoulder. She was surpassingly lovely, and her dark eyes smoldered with a sensuality that had long since enraptured nearly every young man at the Academy. Her academ's robes did not manage to conceal the lush curves of her breasts, and the southern silks they were made from clung to her hips and hinted at the outlines of her thighs as she walked across the courtyard.

Max turned to face her and gave her a gallant little bow. "Good morning, Celine."

Celine smiled, the expression a lazy promise, and let Max take and kiss her hand. She let her hand rest on Max's and sighed. "Oh, Antillar. I know it amuses you to beat my fiancé unconscious, but you're so much . . . larger than he. It hardly seems fair."

"Life isn't fair," said a second female voice, and a second beauty, indistinguishable from Celine except that she wore her hair braided over the opposite shoulder, joined them. She slid one hand over Max's shoulder, on his other side, and added, "My sister can be such a romantic."

"Lady Celeste," Max murmured. "I'm just trying to teach him manners. It's for his own good."

Celeste gave Max an arch look, and said, "You are a vile brute of a man."

Max swept his arm back as he gave the young noblewomen a gallant bow. "Celeste," he said. "Celine. I trust you slept well last night? You've almost missed breakfast."

Both of their mouths curved up into identical small smiles. "Beast," said Celine.

"Cad," her sister added.

"Ladies," Max bid them with another bow, and watched them walking away as he stood with Tavi and Ehren.

"You m-make me sick, Max," Tavi said.

Ehren glanced back over his shoulder at the twins, then to Max, his expression puzzled. Then he blinked, and said, "That's where you were all night? *Both* of them?"

"They *do* share the same quarters. Hardly would have been polite to only have one, and leave the other all lonely," Max said, his voice pious. "I was merely doing what any gentleman would."

Tavi glanced over his shoulder, his eyes drawn to the slow sway of the girls' hips as they walked away. "Sick, Max. You make me sick."

Max laughed. "You're welcome."

The three of them entered the dining hall in time to get the last of the food prepared by the kitchens that morning, but just as they found a place at one of the round tables, running footsteps approached. A girl no older than Tavi, short, stocky, and plain, came to a halt at their table, her small scattering of green and blue beads flashing in a stray beam of sunlight against her grey robes. Her fine, mouse brown hair waved around her head where tiny strands had escaped their braid. "No time," she panted. "Put that down and come with me."

Tavi looked up from his plate, already laden with slices of ham and fresh bread, and scowled at the girl. "You would not believe what I had to go through to get this, Gaelle," he said. "I'm not moving an inch until my plate is empty."

Gaelle Patronus Sabinus looked around them furtively, then leaned down closer to their table to murmur, "Maestro Killian says that our combat final is to begin at once."

"*Now?*" stammered Ehren.

Max cast a longing glance down at his own heaping plate, and asked, "Before breakfast?"

Tavi sighed and pushed his chair back. "Blighted crows and bloody carrion." He stood up, wincing as his arms and legs throbbed. "All right, everyone. Let's go."

▭▭▭ CHAPTER 2

Tavi went first into the old grey stone study—a building of only a single story and perhaps twenty paces square residing in the western courtyard of the Academy, which was otherwise unused. No windows graced the study. Moss fought a silent war with ivy for possession of its walls and roof. It looked little different from the storage buildings but for a plaque upon its door that read in plain letters, MAESTRO KILLIAN—REMEDIAL FURYCRAFTING.

Several worn but well-padded old benches sat around a podium before a large slateboard. The others followed Tavi inside, Max last. The big Antillan shut the door behind them and glanced around the room.

"Everyone ready?" Max asked.

Tavi remained silent, but Ehren and Gaelle both answered that they were. Max put his hand flat against the door, closing his eyes for a moment.

"All right," he reported. "We're clear."

Tavi shoved the heel of his hand firmly against a particular spot on the slateboard, and a sudden crack appeared, straight as a plumb line. He set his shoulder to the slate, and with a grunt of effort pushed open the hidden doorway. Cool air rushed over him, and he peered down at a narrow stone stairway, that wound down into the earth.

Gaelle passed him a lamp, and each of the others took one as well. Then Tavi set off down the stairs, the others close behind.

"Did I tell you? I found a way down to Riverside through the Deeps," Max mumbled.

Tavi snorted. The stone walls turned it into a hissing sound. "Down to the wine houses, eh?"

"It makes sneaking out to them simpler," Max said. "It's almost too much work to be bothered with, otherwise."

"Don't joke about such things, Max," Gaelle said, her voice somewhat hushed. "The Deeps run for miles, and great furies only know what you might run into down here. You should keep to the paths laid out for us."

Tavi reached the bottom of the stairway and turned left into a wide passage. He started counting off open doorways on his right. "It isn't all that bad. I've explored a little."

"Tavi," said Ehren, his tone exasperated. "That's the whole reason Master Killian loads you up with so much extra work. To keep you from getting into trouble."

Tavi smiled. "I'm careful."

They turned down another hall, the passage slanting sharply downward. Ehren said, "And if you make any mistakes? What if you fell into a fissure? Or into an old shaft filled with water? Or ran into a rogue fury?"

Tavi shrugged. "There's risk in everything."

Gaelle arched an eyebrow, and said, "Yet one so seldom hears of some fool drowning, starving, or falling to his death in a library or at the baker's."

Tavi gave her a sour look as they reached the bottom of the slope, where

it intersected another hallway. Something flickered in the corner of his vision, and he turned to his right, staring intently down the hall.

"Tavi?" Max asked. "What is it?"

"I'm not sure," Tavi said. "I thought I saw a light down there."

Gaelle had already started down the hallway to the left, in the opposite direction, Ehren following her. "Come on," she said. "You know how much he hates to be kept waiting."

Max muttered, "He knows how much we hate to miss a meal, too."

Tavi flashed the larger young man a quick grin. The hallway led to a pair of rust-pitted iron doors. Tavi pushed them open, and the four academs moved into the classroom beyond.

The room was huge, far larger than the Academy's dining hall, its ceiling lost in shadow. A double row of grey stone pillars supported the roof, and fury-lamps mounted on the pillars lit the room in a harsh, green-white radiance. At the far end of the hall was a large square on the floor, composed of layers of reed matting. Beside it sat a heavy bronze brazier, its coals glowing, giving the room its only warmth. To one side of one row of pillars was a long strip marked out on the floor for training in weaponplay. On the opposite side of the room was a cluster of ropes, wooden poles, beams, and various structures of varying heights—an obstacle course.

Maestro Killian sat on his knees beside the brazier. He was a wizened old man, his hair little more than a nimbus of fine white down drifting around his shining pate. Thin, small, and seemingly frail, his black scholar's robe was so old it had faded to a threadbare grey. Several pairs of woolen stockings covered his feet, and his cane rested on the ground beside him. As the group came closer, Killian lifted his face, his blind, filmy eyes turning toward them. "That was as soon as possible?" he asked, his voice annoyed and creaking. "In my day, Cursors-in-Training would have been lashed and laid down in a bed of salt for moving so slowly."

The four of them moved forward to the reed matting and sat down in a row, facing the old man. "Sorry, Maestro," Tavi said. "It was my fault. Brencis again."

Killian felt for his cane, picked it up, and rose to his feet. "No excuses. You're just going to have to find a way to avoid his attention."

"But, Maestro," Tavi protested. "I just wanted some breakfast."

Killian poked his cane at Tavi's chest, thumping him lightly. "Going hungry until lunch wouldn't have hurt you. It would at least have demonstrated

self-discipline. Better yet, you might have demonstrated forethought and saved some of last night's dinner to eat in the morning."

Tavi grimaced, and said, "Yes, Maestro."

"Were you seen coming in?"

The four answered together. "No, Maestro."

"Well then," Killian said. "If you all don't mind too terribly, shall we begin the test? With you, first, Tavi."

They stood to their feet. Killian doddered out onto the matting, and Tavi followed him. As he went, he felt the air tighten against his skin, grow somehow thicker as the old teacher called the wind furies that let him sense and observe movements. Killian turned toward Tavi, and nodded to him. Then the old man said, "Defend and counter."

With that, the little man whipped his cane at Tavi's head. Tavi barely ducked in time, only to see the old Maestro lift his stockinged foot and drive it down in a lashing kick aimed for Tavi's knee. The boy spun his body away from it, and used the momentum of the motion for a straight, driving kick, launched at Killian's belly.

The old Maestro dropped the cane, caught Tavi's foot at the ankle, and with a twist stole Tavi's balance and sent him flat down to the mat. Tavi hit hard enough to knock the wind from him, and he lay there gasping for a moment.

"No, no, no!" Killian scolded. "How many times do I need to tell you? You have to move your head as well as your legs, fool. You cannot expect an unaimed attack to succeed. You must turn your face to watch the target." He picked up his cane and rapped Tavi sharply on the head. "And your timing was less than perfect. Should you be on a mission one day and attacked, that kind of poor performance would mean your death."

Tavi rubbed at the spot on his head where Killian had reprimanded him, scowling. The old man had hardly needed to strike him that firmly. "Yes, Maestro."

"Go sit down, boy. Come, Antillar. Let's see if you can manage anything better."

Max went out onto the mat, and went through a similar sequence with Maestro Killian. He performed flawlessly, grey eyes flashing as he whipped his head around, keeping an eye on his target. Gaelle and Ehren went in their turns, and all of them responded better than Tavi had.

"Barely adequate," Killian snapped. "Ehren, fetch the staves."

The skinny boy got a pair of six-foot poles from a rack on the wall and brought them to the Maestro. Killian set his cane aside and accepted them. "Very well, Tavi. Let's see if you have managed to learn anything of the staff."

Tavi took the other staff from the Maestro, and the two saluted, staves lifted vertically before they both dropped into a fighting crouch.

"Defend," Killian snapped, and the old man spun his staff through a series of attacks, whirling, sweeping blows mixed with low, lightning thrusts aimed at Tavi's belly. He backed away from the Maestro, blocking the sweeping blows and slipping the thrusts aside. Tavi struck out with a counterattack, but he could feel an iron tension in his shoulders that slowed his thrust.

Killian promptly knocked aside Tavi's weapon, delivered a sharp thrust to the boy's fingers, and with a flick sent Tavi's staff spinning across the room to clatter against one of the stone pillars.

Killian thumped the end of his staff onto the mat, his expression one of frustrated disapproval. "How many times have I told you, boy? Your body must be relaxed until the instant you strike. Holding yourself too tightly slows your responses. Life and death are measured by the breadth of a hair in combat."

Tavi gripped his bruised hand into a fist, and grated out, "Yes, Maestro."

Killian jerked his head toward the fallen staff, and Tavi went to retrieve it. The old man shook his head. "Gaelle. Attempt to show Tavi what I mean."

The others followed in turn, and they all did better than Tavi had. Even Ehren.

Killian passed the staves to Tavi and picked up his cane. "To the strip, children."

They followed him to the combat strip laid out on the floor. Killian walked to the center of the strip and thumped the floor with his cane. "And once more, Tavi. We might as well get it out of the way now."

Tavi sighed and walked to stand before Killian.

Killian lifted his cane into a guard position used for swords. "I am armed with a blade," he said. "Disarm me without leaving the strip."

The cane's tip darted at Tavi's throat. The boy lightly slapped the attack aside with one hand, retreating. The old man followed, cane sweeping at Tavi's head. Tavi ducked, rolled backward to avoid a horizontal slash, and

came to his feet to brush aside another thrust. He closed, inside the tip of the theoretical sword, hands moving to seize the old man's wrists.

The attack was too tentative. In the bare instant of delay, the Maestro avoided Tavi's attempt to grapple. The old man whipped the cane left and right, branding sudden pain into Tavi's chest in an x-shape. He thrust the heel of one wrinkled hand into Tavi's chest, driving the boy a step back, then jabbed the tip of the cane firmly into Tavi's chest, sending him sprawling to the floor.

"What is wrong with you?" Killian snapped. "A sheep would have been more decisive than that. Once you decide to close range, you are committed. Attack with every ounce of speed and power you can muster. Or die. It's as simple as that."

Tavi nodded, not looking at the other students, and said, very quietly, "Yes, Maestro."

"The good news, Tavi," Killian said in an acid tone, "is that you won't need to worry about the entrails currently spilling over your knees. The fountain of blood spraying from your heart will kill you far more quickly."

Tavi climbed to his feet, wincing.

"The bad news," Killian continued, "is that I see no way that I can grade your performance as anything close to acceptable. You fail."

Tavi said nothing. He walked over to lean against the nearest pillar, rubbing at his chest.

The Maestro rapped his cane on the strip again. "Ehren. I hope to the great furies you have more resolve than he does."

The exam concluded after Gaelle had neatly kicked aside the Maestro's forearm, sending the cane tumbling away. Tavi watched the other three succeed where he had failed. He rubbed at his eyes and tried to ignore how sleepy he felt. His stomach rumbled almost painfully as he knelt beside the other students.

"Barely competent," Killian muttered, after Gaelle had finished. "You all need to spend more time in practice. It is one thing to perform well in a test on the training mat. It is quite another to do so in earnest. I expect you all to be ready for the infiltration test at the conclusion of Wintersend."

"Yes, Maestro," they replied, more or less in unison.

"Very well then," Killian said. "Off with you, puppies. You might become Cursors yet." He paused to glower at Tavi. "Most of you, at any rate. I spoke to the kitchen staff this morning. They're keeping some breakfast warm for you."

The students rose, but Killian laid his cane across one of Tavi's shoulders, and said, "Not you, boy. You and I are going to have words about your performance in the exam. The rest of you, go."

Ehren and Gaelle looked at Tavi and winced, then offered him apologetic smiles as they left.

Max clapped Tavi's shoulder with one big hand when he walked by, and said, quietly, "Don't let him get to you." Max and the others left the training hall, closing the huge iron doors behind them.

Killian walked back over to the brazier and sat down, holding his hands out toward its warmth. Tavi walked over and knelt down in front of him. Killian closed his eyes for a moment, his expression pained as he opened and closed his fingers, stretching out his hands. Tavi knew that the Maestro's arthritis had been troubling him.

"Was that all right?" Tavi asked.

The old man's expression softened into a faint smile. "You mimicked their weaknesses fairly well. Antillar remembered to look before he struck. Gaelle remembered to keep herself relaxed. Ehren committed without hesitation."

"That's wonderful. I guess."

Killian tilted his head. "You aren't happy that you appeared to your friends to be unskilled."

"I guess so. But . . ." Tavi frowned in thought. "It's hard to deceive them. I don't like it."

"Nor should you. But I think that isn't all."

"No," Tavi said. "It's because . . . well, they're the only ones who know that I'm undergoing Cursor training. The only ones I can talk to about most of the things I really care about. And I know they only mean to be kind. But I know what they aren't saying. How careful they are about trying to help me without letting me know that's what they're doing. Ehren thought he had to protect me from Brencis today. *Ehren.*"

Killian smiled again. "He's loyal."

Tavi scowled. "But he shouldn't have to do it. It isn't as if I'm not helpless enough already."

The Maestro frowned. "Meaning?"

"Meaning that I can learn all the unarmed combat I like and it won't help me against a strong furycrafter. Someone like Brencis. Even if I'm using a weapon."

"You do yourself an injustice."

Tavi said, "I don't see how."

"You are more capable than you know," Killian said. "You might not ever be the swordsman a powerful metalcrafter can become, or have the speed of a windcrafter or the strength of an earthcrafter. But furycrafting isn't everything. Few crafters develop the discipline to hone many skills. You have done so. You are now better able to deal with them than most folk who have only minor talents at furycrafting. You should take some measure of pride in it."

"If you say so." Tavi sighed. "But it doesn't feel true. It doesn't feel like I have very much to be proud about."

Killian laughed, the sound surprisingly warm. "Says the boy who stopped a Marat horde from invading Alera and earned the patronage of the First Lord himself. Your uncertainty has more to do with being seventeen than it does with any fury or lack thereof."

Tavi felt himself smile a little. "Do you want me to take the combat test now?"

Killian waved a hand. "Not necessary. I have something else in mind."

Tavi blinked. "You do?"

"Mmm. The civic legion is having trouble with crime. For the past several months, a thief has been stealing from various merchants and homes, some of which were warded by furycrafting. Thus far, the legion has been unable to apprehend the thief."

Tavi pursed his lips pensively. "I thought that they had the support of the city's furies. Shouldn't they be able to tell who circumvented the guard furies?"

"They do. They should. But they haven't."

"How is that possible?" Tavi asked.

"I cannot be certain," Killian said. "But I have a theory. What if the thief was managing the thefts without using any furycrafting? If no furies are brought into play, the city's furies could not be of any help."

"But if they aren't using any furies, how are they getting into warded buildings?"

"Precisely," Killian said. "And there is the substance of your test. Discover how this thief operates and see to it that he is apprehended."

Tavi felt his eyebrows shoot up. "Why me?"

"You have a unique perspective on this matter, Tavi. I believe you well suited to the task."

"To catching a thief the whole civic legion hasn't been able to find?"

Killian's smile widened. "This should be simple for the mighty hero of the Calderon Valley. Make sure it's done—and discreetly—before Winters-end is over."

"What?" Tavi said. "Maestro, with all of my courses, and serving in the Citadel at night, I don't know how you expect me to get this done."

"Without whining," Killian said. "You have real potential, young man. But if you are daunted by the difficulty of arranging your schedule, perhaps you would like to speak to His Majesty about returning home."

Tavi swallowed. "No," he said. "I'll do it."

The Maestro tottered back onto his feet. "Then I suggest you begin. You've no time to lose."

CHAPTER 3

Amara spread her arms and arched her back as she finally cleared the heavy cloud cover along the coast of the Sea of Ice, and emerged from the cold, blinding mist into the glorious warmth of the sunrise. For a few seconds, the edges of the clouds swirled as her wind fury Cirrus lifted her out of them, and she could see the fury's appearance in the motion of the clouds—the ghostly form of a lean, long-legged courser of a horse, swift and graceful and beautiful.

Clouds rose in peaks and valleys like vast mountains, an entire realm of slow grace and breathtaking beauty. The golden sunshine of spring turned them to flame, and in turn they shattered the light into bands of color that danced and spun around her.

Amara laughed for the sheer joy of it. No matter how often she flew, the beauty of the skies never ceased to fill her heart, and the sense of freedom and strength only grew more intense. Amara called to Cirrus, and the fury bore her straight up with such speed that the wind tightened her face to her cheekbones and a portion of cloud the size of the Citadel in Alera proper was drawn into a column in her wake. Amara angled her arms so that the

wind of her passage spun her in dizzying circles, until her head spun, and the air began to grow thin and cold.

Cirrus's presence allowed her to breathe without difficulty, for a time at least, but the blue of the sky above her began to darken, and a few moments later she began to see the stars. The cold intensified, and Cirrus itself began to tire as the fury struggled to draw in enough air to keep her aloft.

Her heart pounding with excitement, she signaled Cirrus to cease.

She felt her ascent slow, and for a single delicious second she was suspended between the stars and the earth. And then, she twisted her body like a diver and fell. Her heart hammered with electric apprehension, and she closed her legs together and her arms in tight to her sides, her face toward the ground below. Within seconds, she was rushing down more swiftly even than she had risen, and her eyes blurred with tears in the wind, until Cirrus slid a portion of its being over them to protect her.

As the air thickened, she willed Cirrus back into propelling her, and her speed doubled and redoubled, a faint nimbus of light forming around her. The rolling green hills of the Calderon Valley came into sight, already defying the winter with new growth. The Valley grew larger with deceptive deliberation.

Amara poured on the speed, focusing every ounce of her will to strengthen her furycrafting, and she picked out the causeway that ran the length of the Valley to the fortified steading at its east end. Then the outpost of Garrison itself came into sight.

Amara howled her excitement and stretched her power to its limits. There was a sudden and deafening thunder. She gasped and spread her arms and legs to slow her fall, only a thousand feet from the Valley's floor. Cirrus rushed to place himself in front of her, helping to slow her even more, then she and Cirrus pulled out of the dive, redirecting her momentum to send her flashing along the causeway in a howling cyclone of wind. Exhausted and panting from the effort of producing that much speed, Amara shot toward the gates of Garrison, swifter than an arrow from the bow. She drew the winds about her as she approached the gates, and the guard standing watch over them waved her in without rising from his stool.

Amara grinned, and altered her course to bring her down on the battlements over the gate. The winds around her sent dust and debris whirling up in a billowing cloud all around the guard—a grizzled centurion named Giraldi. The stocky old soldier had been peeling away the wrinkled skin of a winter-stores apple with his dagger, and he flipped a corner of his scarlet

and azure cloak over it until the dust settled. Then he resumed his peeling.

"Countess," he said casually. "Nice to see you again."

"Giraldi," she said. She loosened the straps of the sealed courier's pack she carried on her back and slid it off. "Most soldiers rise and salute when nobility visits."

"Most soldiers don't have an ass as grey as mine," he replied cheerfully.

Nor do most bear the scarlet stripe of the Order of the Lion, the mark of the First Lord's personal award for valor on their uniform trousers, Amara thought, and fought not to smile. "What are you doing standing a watch? I thought I brought the papers for your promotion last month."

"You did," Giraldi confirmed. He ate a wrinkled stripe of apple skin. "Turned it down."

"Your commission?"

"Crows, girl," he swore with a certain merry disregard for the delicacy tradition demanded be accorded her sex. "I made fun of officers my whole career. What kind of fool do you think I am to want to *be* one?"

She couldn't help it any longer, and laughed. "Could you send someone to let the Count know I'm here with dispatches?"

Giraldi snorted. "I reckon you already told him yourself. There ain't so many people that make great pounding bursts of thunder rattle every dish in the valley when they arrive. Everyone who ain't deaf knows you're here already."

"Then I thank you for your courtesy, centurion," she teased, slinging the pack over one shoulder and heading for the stairs. Her flying leathers creaked as she did.

"Disgraceful," Giraldi complained. "Pretty girl like you running around dressed like that. Men's clothes. And too tight to be decent. Get a dress."

"This is more practical," Amara called over her shoulder.

"I noticed how practical you look whenever you come to see Bernard," Giraldi drawled.

Despite herself, Amara felt her cheeks flush, though between the wind and cold of her passage, she doubted it would show. She descended into the camp's western courtyard. When Bernard had taken over command of Garrison from its previous Count, Gram, he had ordered it to be cleansed of the signs of the battle now two years past. Despite that, Amara always thought that she could still see stains of blood that had been overlooked. She knew that the spilled blood had all been cleaned.

What remained were the stains it had left in her thoughts, and in her heart.

The thought sobered her somewhat, without really marring her sense of happiness in the morning. Life here, on the eastern frontier of Alera, she reminded herself, could be harsh and difficult. Thousands of Alerans had met their deaths on the floor of this valley, and tens of thousands of Marat. It was a place that had been steeped in hardship, danger, treachery, and violence for nearly a century.

But that had begun to change, in large part due to the efforts and courage of the man who oversaw it for the Crown, and whom she had braved the dangerous high winds to see.

Bernard emerged from the commander's quarters at the center of the camp, smiling. Though the cut of his clothing was a bit more stylish, and the fabrics more fine, he still wore the sober greens and browns of the free Steadholder he had been, rather than the brighter colors proclaiming his bloodlines and allegiance. He was tall, his dark hair salted with early grey, and like his beard cropped close in Legion fashion. He paused to hold the door open for a serving maid carrying an armload of laundry, then approached Amara with long, confident strides. Bernard was built like a bear, Amara thought, and moved like a hunting cat, and he was certainly as handsome as any man she had seen. But she liked his eyes best. His grey-green eyes were like Bernard himself—clear, open and honest, and they missed little.

"Count," she murmured, as he came close, and offered her hand.

"Countess," he responded. There was a quiet smoldering in his eyes that made Amara's heart race a bit more quickly as he took her hand in gentle fingers and bowed over it. She thought she could feel his deep voice in her belly when he rumbled, "Welcome to Garrison, lady Cursor. Did you have a nice trip?"

"Finally, now that the weather is clearing," she said, and left her hand on his arm as they walked to his offices.

"How are things at the capital?"

"More amusing than usual," she said. "The Slavers Consortium and the Dianic League are all but dueling in the streets, and the Senators can barely show their faces out of doors without being assaulted by one party or another. The southern cities are doing everything they can to run up the prices of this year's crops, screaming about the greed and graft of the Wall lords, while the Wall cities are demanding an increase in levies from the miserly south."

Bernard grunted. "His Majesty?"

"In fine form," Amara said. She made it a point to inhale through her nose as she walked. Bernard smelled of pine needles, leather and woodsmoke, and she loved the scent of him. "But he's made fewer appearances this year than in the past. There are rumors that his health is finally failing."

"When aren't there?"

"Exactly. Your nephew is doing well at the Academy, by all reports."

"Really? Has he finally . . ."

Amara shook her head. "No. And they've called in a dozen different craftmasters to examine him and work with him. Nothing."

Bernard sighed.

"But otherwise, he's performing excellently. His instructors are uniformly impressed with his mind."

"Good," Bernard said. "I'm proud of him. I always taught him not to let his problem stand in his way. That intelligence and skill would carry him farther than furycrafting. But all the same, I had hoped . . ." He sighed, tipping a respectful nod to a pair of passing *legionares callidus,* walking from the mess hall with their officially nonexistent wives. "So, what word from the First Lord?"

"The usual dispatches, and invitations for you and the Valley's Steadholders to Festival."

He arched a brow. "He sent one to my sister as well?"

"Particularly to your sister," Amara said. She frowned as they went inside the command residence and up the stairs to Bernard's private offices. "There are several things you need to know, Bernard. His Majesty asked me to brief you both on the situation surrounding her attendance. In private."

Bernard nodded and opened the door. "I thought as much. She's already packed for the trip. I'll send word, and she should be here by this evening."

Amara entered, looking back over her shoulder, her head cocked. "By this evening, is it?"

"Mmm. Perhaps not until tomorrow morning." He shut the door behind him. And casually slid the bolt shut, leaning back against it. "You know, Giraldi's right, Amara. A woman shouldn't dress in tight leathers like that."

She blinked innocently at him. "Oh? Why not?"

"It makes a man think things."

She moved slowly. At his heart, Bernard was a hunter, and a man of great patience when need be. Amara had found that it was a distinct pleasure to test that patience.

And even more of a pleasure to make it unravel.

She started unbinding her honey brown hair from its braid. "What sorts of things, Your Excellency?"

"That you should be in a dress," he said, voice edged with the slightest, low tone of a beast's growl. His eyes all but glowed as he watched her let her hair down.

She undid the plaits in her hair with deliberate precision and began to comb them out with her fingers. She'd worn her hair much shorter in the past, but she'd been growing it out since she found out how much Bernard liked it worn long. "But if I was in a dress," she said, "the wind would tear it to shreds. And when I came down to see you, milord, Giraldi and his men would all get to stare at what the shreds didn't cover." She blinked her eyes again and let her hair fall in mussed waves down around her face and over her shoulders. She watched his eyes narrow in pleasure at the sight. "I can hardly run around like that in front of a crowd of *legionares*. As I told the good centurion. It's merely practical."

He leaned away from the door and approached, a slow step at a time. He leaned close to her, and took the courier's pack from her. His fingertips dragged lightly over her shoulder as he did, and she almost felt that she could feel them through her jacket. Bernard was an earthcrafter of formidable power, and such people always carried a certain sense of purely instinctive, mindless physical desire around them like a tactile perfume. She had felt it when she first met the man, and even more so since.

And when he made the effort, it could cause her own patience to vanish first. It wasn't fair, but she had to admit that she could hardly complain about the results.

He set the pack of dispatches aside and kept stepping forward, and bodily pressed her hips against his desk and forced her to lean back a little from him. "No, it isn't," he said in a quiet voice, and she felt a slow, animal thrill course through her at his presence. He lifted a hand and touched her cheek with his fingertips. Then gently slid his hand down over her shoulder and flank to her hip. The touch of his fingers lingered and made her feel a little breathless with sudden need. He rested his hand on her hip, and said, "If they were practical, I could slide them out of my way at once. It would save time." He leaned down and brushed his lips against her cheek, nuzzling his nose and mouth in her hair. "Mmmm. Having you at once. That would be practical."

Amara tried to draw things out, but she hadn't seen him in weeks, and almost against her will she felt the sinuous pleasure of her body yielding and molding to his, one leg bending to slide her calf along the outside of his own. Then he bent his mouth to hers and kissed her, and the slow heat and sensual delight of the taste of his mouth did away with any thought whatsoever.

"You're cheating," she whispered a moment later, panting as she slipped her hands beneath his tunic to feel the heavy, hot muscles on his back.

"Can't help it," he growled. He parted the front of her jacket, and she arched her back, the air cool on her thin linen undershirt. "I want you. It's been too long."

"Don't stop," she whispered, though it was edged with a low moan. "Too long."

Boots thumped up the stairs outside Bernard's office.

One at a time.

Loudly.

Bernard let out an irritated groan, his eyes closed.

"Ahem," coughed Giraldi's voice from outside. "Achoo. My but what a cold I have. Yes, sir, a cold. I'll need to see a healer about that."

Bernard straightened, and Amara had to force her fingers to move away from him. She stood up and her balance wavered. So she sat down on the edge of Bernard's desk, her face flushed, and tried to get all the clasps on the jacket fastened closed again.

Bernard tucked his tunic more or less back through his belt, but his eyes smoldered with quiet anger. He went to the door, and Amara was struck by how *large* the man was as he unlocked it and stood in it, facing the centurion outside.

"Sorry, Bernard," Giraldi said. "But . . ." He lowered his voice to a bare whisper, and Amara couldn't hear the rest.

"Crows," Bernard spat in a sudden, vicious curse.

Amara jerked her head up at the tone in his voice.

"How long?" the Count asked.

"Less than an hour. General call to arms?" Giraldi asked.

Bernard clenched his jaw. "No. Get your century to the wall, dress uniform."

Giraldi frowned, head cocked to one side.

"We aren't preparing to fight. We're turning out an honor guard. Understand?"

"Perfectly, Your Excellency," Giraldi answered, his often-broken nose making the words thick. "You want our finest century on the wall in full battle gear so that we can beat some Marat around if they've got a mind to tussle, and if they don't, you want your most beautiful and charming centurion doing the greeting to make them feel all welcome."

"Good man."

Giraldi's smile faded, and he lowered his voice, his expression frank but unafraid. "You think there's a fight brewing?"

Bernard clapped the old soldier on the shoulder. "No. But I want you personally to tell Knight Captain Gregor and the other centurions it might be a good idea to run a weapons and arms inspection in their barracks for a while, in case I'm wrong."

"Yes, Your Excellency," Giraldi said. He struck his fist to his heart in a crisp Legion salute, nodded at Amara, and marched out.

Bernard turned to a large, sturdy wooden armoire and opened it. He drew out a worn old arming jacket and jerked it on with practiced motions.

"What's happening?" Amara asked.

He passed her a short, stout blade in a belted scabbard. "Could be trouble."

The *gladius* was the side arm of a *legionare,* and the most common weapon in the Realm. Amara was well familiar with it, and buckled it on without needing to watch her fingers. "What do you mean?"

"There's a Marat war party on the plain," Bernard said. "They're coming this way."

CHAPTER 4

Amara felt a slow, quiet tension enter her shoulders. "How many?"

Bernard shrugged into the mail tunic and buckled and belted it into place. "Two hundred, maybe more," he answered.

"But isn't that far too small to be a hostile force?" she asked.

"Probably."

She frowned. "Surely you don't think Doroga would attack us at all, much less with so few."

Bernard shrugged, swung a heavy war axe from the cabinet, and slung its strap over his shoulder. "It might not be Doroga. If someone else has supplanted him the way he did Atsurak, an attack is a possibility, and I'm not taking any chances with the lives of my men and holders. We prepare for the worst. Pass me my bow."

Amara turned to the fireplace and took down a bow from its rack above it, a carved half-moon of dark wood as thick as her ankles. She passed it to him, and the big man drew a wide-mouthed war quiver packed with arrows from the armoire. Then he used one leg to brace the bow, and without any obvious effort he bent recurved staves that would have required two men with tools to handle safely, and strung the weapon with a heavy cord.

"Thank you."

She lifted her eyebrows at the bent bow. "Do you think that is necessary?"

"No. But if something bad happens, I want you to get word to Riva immediately."

She frowned. She would hate to leave Bernard's side in the face of danger, but her duty as a messenger of the First Lord was clear. "Of course."

"Shall I find you some mail?" he asked.

She shook her head. "I'm already tired from the trip in. If I need to fly, I don't want to carry any more weight than I must."

He nodded and stalked out of the office, and she kept pace with him. Together they headed through the eastern courtyard, to the looming, enormous expanse of the wall facing the spreading plains of the lands of the Marat. The wall was better than thirty feet high and thick, all black basalt that seemed to have been formed of a single, titanic block of stone. Crenellation spread seamlessly along the battlements. A gate high and wide enough to admit the largest gargants was formed of a single sheet of some dark steel she had never seen before, called from the depths of the earth by the First Lord himself, after the battle two years ago.

They mounted the steps up to the battlements, where Giraldi's eighty grizzled veterans, the men who had survived the Second Battle of Calderon, were assembling in good order. The bloodred stripe of the Order of the Lion was conspicuous on the piping of their trousers, and though they were

dressed in their formal finery, each of the men wore his working weapons and armor of simple, battle-tested steel.

Far out on the plain, moving shapes approached the fortress, little more than dark, indistinct blotches.

Amara leaned into the space between two of the stone merlons and lifted her hands. She called to Cirrus, and the fury whirled between her hands, forming the air into a sheet of bent light that enlarged the image of the distant travelers.

"It's Doroga," she reported to Bernard. "If I'm not mistaken, that's Hashat with him."

"Hashat?" Bernard asked, frowning. "He needs her to patrol their eastern marshes and keep Wolf in line. It's dangerous for them to travel together in such a small company."

Amara frowned, studying them. "Bernard, Hashat is walking. Her horse is limping. There are more Horse on foot. They've got stretchers, too. Riderless horses and gargants. Wounded animals."

Bernard frowned, then nodded sharply. "You were right, centurion," he said. "It's a war party."

Giraldi nodded. "Just not here to fight us. Could be that they've got someone chasing them."

"No. Their pace is too slow," Bernard said. "If someone was after them, they'd have caught them by now. Stand down and get the healers into position."

"Yes, sir." The centurion signaled his men to sheathe their weapons, then started bawling out orders, sending men to fetch out bathing tubs to be filled with water, and summoning Garrison's watercrafters in order to care for the wounded.

It took more than an hour for Doroga's wounded band to reach the fortress, and by that time the cooks had the air filled with the smell of roasting meat and fresh bread, setting up trestles laden with food, stacking a small mountain of hay for the gargants, and filling the food and water troughs near the stables. Giraldi's *legionares* cleared out a wide area in one of the warehouses, laying out rows of sleeping pads with blankets for the wounded.

Bernard opened the gates and went out to meet the Marat party. Amara stayed at his side. They walked up to within twenty feet or so of the vast, battle-scarred black gargant Doroga rode, and the pungent, earthy smell of the beast was thick in her nose.

The Marat himself was an enormous man, tall and heavily built even for one of his race, slabs of thick muscle sliding under his skin. His coarse white hair was worn back in a fighting braid, and there was a cut on his chest that had closed itself with thick clots of blood. His features were brutish, but dark eyes glittering with intelligence watched Bernard from beneath his heavy brows. He wore the tunic the holders of Calderon had given him after the battle, though he'd torn it open down the front and removed the sleeves to make room for his arms. The cool wind did not seem to make him uncomfortable.

"Doroga," Bernard called.

Doroga nodded back. "Bernard." He hooked a thumb over his back. "Wounded."

"We're ready to help. Bring them in."

Doroga's wide mouth turned up into a smile that showed heavy, blocky teeth. He nodded his head at Bernard in thanks then untied a large pouch with a cross-shoulder sling on it from a strap on the gargant's saddle-mat. Then he took hold of a braided leather rope, and swung down from the beasts' back. He closed on Bernard and traded grips with him, Marat fashion, hands clasping one another's forearms. "I'm obliged. Some of the wounds are beyond our skill. Thought maybe your people would be willing to help."

"And honored." Bernard signaled Giraldi to take over seeing to the injured among the Marat, while grooms came forth to examine wounded horses and gargants, as well as a pair of bloodied wolves. "You're looking well," Bernard said.

"How is your nephew?" Doroga rumbled.

"Off learning," Bernard said. "Kitai?"

"Off learning," said Doroga, eyeing Amara. "Ah, the girl who flies. You need to eat more, girl."

Amara laughed. "I try, but the First Lord keeps me busy running messages."

"Too much running does that," Doroga agreed. "Get a man. Have some babies. That always works."

A sickly little fluttering stab of pain went through Amara's belly, but she did her best to keep a smile on her face. "I'll think about it."

"Huh," Doroga snorted. "Bernard, maybe you got something broken in your pants?"

Bernard's face flushed scarlet. "Uh. No."

Doroga saw the Count's embarrassment and burst out into grunting, guffawing laughter. "You Alerans. Everything mates," Doroga said. "Everything likes to. But only your people try to pretend they do neither."

Amara enjoyed Bernard's blush, though the pain Doroga's words had elicited prevented her from blushing herself. Bernard would probably think she was just too worldly to be so easily embarrassed. "Doroga," she said, to rescue him from the subject, "how did you get that wound? What happened to your people?"

The Marat headman's smile faded, and he looked back out at the plains, his countenance grim. "I got it being foolish," he said. "The rest should first be for your ears only. We should go inside."

Bernard frowned and nodded at Doroga, then beckoned him. They walked together into Garrison and back to Bernard's office.

"Would you like some food?" Bernard asked.

"After my people have eaten," Doroga said. "Their *chala* too. Their beasts."

"I understand. Sit, if you like."

Doroga shook his head and paced quietly around the office, opening the armoire, peering at the bricks of the fireplace, and picking up several books off the modest-sized shelf to peer at their pages.

"Your people," he said. "So different than ours."

"In some ways," Bernard agreed. "Similar in many others."

"Yes." Doroga flipped through the pages of *The Chronicles of Gaius*, pausing to examine a woodcut illustration on one of them. "My people do not know much of what yours know, Bernard. We do not have these . . . what is the word?"

"Books."

"Books," Doroga said. "Or the drawing-speech your people use in them. But we are an old people, and not without our own knowledge." He gestured at his wound. "The ground powder of shadowwort and sandgrass took the pain, clotted the blood, and closed this wound. You would have needed stitches or your sorcery."

"I do not question your people's experience or knowledge, Doroga," Bernard said. "You are different. That does not make you less."

Doroga smiled. "Not all Alerans think as you."

"True."

"We have our wisdom," he said. "Passed on from one to another since the first dawn. We sing to our children, and they to theirs, and so we remember what has been." He went to the fireplace and stirred the embers with a poker. Orange light played lurid shadows over the shape of his muscles and made his expression feral. "I have been a great fool. Our wisdom warned me, but I was too foolish to see the danger for what it was."

"What do you mean?" asked Amara.

He drew a deep breath. "The Wax Forest. You have heard of it, Bernard?"

"Yes," he said. "I went there a time or two. Never down into it."

"Wise," Doroga said. "It was a deadly place."

"Was?"

The Marat nodded. "No longer. The creatures who lived there have departed it."

Bernard blinked. "Departed. To where?"

Doroga shook his head. "I am not certain. Yet. But our wisdom tells us of them, and warns of what they will do."

"You mean your people have seen such things before?"

Doroga nodded. "Far in the past, our people did not live where we live today. We came here from another place."

"Across the sea?" Amara asked.

Doroga shrugged. "Across the sea. Across the sky. We were elsewhere, then we were here. Our people have lived in many lands. We go to a new place. We bond with what lives there. We learn. We grow. We sing the songs of wisdom to our children."

Amara frowned. "You mean . . . is that why there are different tribes among your people?"

He blinked at her as her Academy teachers might have done at slow-witted students, and nodded. "By *chala*. By totem. Our wisdom tells us that long ago, in another place, we met a creature. That this creature stole the hearts and minds of our people. That it and its brood grew from dozens to millions. It overwhelmed us. Destroyed our lands and homes. It stole our children, and our females gave birth to its spawn."

Bernard sat down in a chair by the fire, frowning.

"It is a demon that can take many forms," the Marat continued. "It tastes of blood and may take the shape of creature it tasted. It gives birth to its own brood of creatures. It transforms its enemies into . . . things. Things

of its own creation, that fight for the creature. It keeps taking. Killing. Spawning. Until nothing is left to fight it."

Bernard narrowed his eyes, intent on Doroga. Amara took a few steps to stand behind his chair, her hand on his shoulder.

"This is not a campfire tale, Aleran," Doroga said quietly. "It is not a mistake. This creature is real." The big Marat swallowed, his expression ashen. "It can take many shapes and forms, and our wisdom warns us not to rely solely upon its appearance to warn us of its presence. That was my mistake. I did not see the creature for what it was until it was too late."

"The Wax Forest," Bernard said.

Doroga nodded. "When your nephew and Kitai returned from the Trial, something followed them."

"You mean wax spiders?" Bernard asked.

Doroga shook his head. "Something larger. Something more."

"Wait," Amara said. "Are you talking about many creatures or one creature?"

"Yes," Doroga said. "That is what makes it an Abomination before The One."

Amara almost scowled in frustration. The Marat simply did not use language the same way as Alerans did, even when speaking Aleran. "I don't think I've ever heard of anything like that here, Doroga."

Doroga shrugged. "No. That is why I have come. To warn you." He took a step closer to them, crouching down, and whispered, "The Abomination is here. The wisdom tells us the name of its minions. The *vordu-ha*." He shuddered, as if saying the words sickened him. "And it tells us the name of the creature itself. It is the vord."

There was heavy silence for a moment. Then Bernard asked, "How do you know?"

Doroga nodded toward the courtyard. "I gave battle to a vord nest yesterday at dawn with two thousand warriors."

"Where are they now?" Amara asked.

The Marat's expression stayed steady and on the fire. "Here."

Amara felt her mouth open in shock. "But you only had two hundred with . . ."

Doroga's features remained feral, stony, as her words trailed off into silence. "We paid in blood to destroy the vord in that nest. But the wisdom tells us that when the vord abandon a nest, they divide into three groups to

build new nests. To spread their kind. We tracked and destroyed one such group. But there are two more. I believe one of them is here, in your valley, hiding on the slopes of the mountain called Garados."

Bernard frowned. "And where is the other?"

In answer, Doroga reached into his sling pouch and drew out a battered old leather backpack. He tossed it into Bernard's lap.

Amara felt Bernard's entire body go rigidly tense as he stared down at the pack.

"Great furies," Bernard whispered. "Tavi."

꘎CHAPTER 5

Whirls of dust from the collapse filled the inside of Isanaholt's stables, and made the sunshine slipping here and there through the roof into soft, golden rods of light. Isana stared at the enormous crossbeam in the steadholt's stables. It had broken and fallen without any warning whatsoever a moment after she had entered the barn to distribute feed to the animals. If she had been facing the wrong way, or if she had been any slower, she would be lying dead under it with the crushed and bloodied bodies of a pair of luckless hens instead of shaking with startled terror.

Her first thought was of her holders. Had any of them been in the barn, or the loft? Furies forbid, had any of the children been playing there? Isana reached out for her fury, and with Rill's help created a crafting that slid through the air of the barn—but the barn was empty.

Which was probably the point, she thought, suddenly struck with a possible explanation for the accident. She stood up, shaking still, and went to the fallen beam, examining it.

One end of the beam was broken, snapped off with ragged spikes and splinters of wood standing out from it. The other end was far smoother, almost as clean as if it had been trimmed with a mill-saw. But no blade had done it. The wood was crumbling and dusty, as if it had been attacked

by an army of termites. A furycrafting, Isana thought. A deliberate fury-crafting.

Not an accident. Not an accident at all.

Someone had tried to kill her.

Isana suddenly became more intensely aware of the fact that she was alone in the stables. Most of the holders were out in the fields by now—they had only a few more days to plow and sew, and the herders had their hands full with keeping track of mating cycles, assisting in the delivery of the new lambs, calves, kids, and a pair of gargant digs. Even the kitchens, the nearest building to the stables, were empty at the moment, while the steadholt women working there took time for a meal of their own in the central hall.

In short, it was unlikely that anyone heard the beam fall—and even more unlikely that they could hear her should she call for them. For a moment, Isana wished desperately that her brother still lived at the steadholt. But Bernard didn't. She would have to look out for herself.

She took a deep, steadying breath and stole a couple of steps to a wall where a pitchfork hung by a hook set into a beam. She took the tool down, straining to be silent, willing Rill's presence to continue sweeping through the barn. The furycrafting was hardly precise—and even if there was a murderer lurking nearby, if he was a man of enough detachment, he might not have enough of a sense of emotion for Rill to detect. But it was better than nothing.

Woodcrafters could, when they needed to, exert the power of their furies to hide their presence from other's eyes, if enough vegetable matter was nearby to use as material. At the behest of a woodcrafter, trees would shift their shadows, grass would twist and bend to conceal, and all manner of subtle illusions of light and shadow could hide them from even skilled, wary eyes. And the barn was almost ankle deep in the rushes laid to help keep it warm during the winter.

Isana remained in place for several silent moments, waiting for any sign of another's presence. Patience could only help her—it would not be long before the steadholt began to fill with holders returning from the fields for their midday meal. Her attacker, if he was here, would already have come for her if he thought her vulnerable. The worst thing she could do would be to lose her head and run headlong into a less subtle attack.

Outside, the beat of running hooves approached the steadholt, and someone rode a horse in through the gates. The animal chafed and stamped for a moment, then a young man's voice called, "Hello, the steadholt! Holder Isana?"

Isana held her breath for a moment, then let it out slowly, relaxing a little. Someone had come. She lowered the pitchfork and took a step toward the door she had entered.

There was a small, thumping sound behind her, and a rounded pebble bounced once and then fell into the straw. Rill suddenly warned her of a wave of panic coming from immediately behind her.

Isana turned, raising the pitchfork by instinct, and only barely saw the vague outline of someone in the half-shadowed barn. There was a flash of steel, a hot sensation on one of her hips, and she felt the tines of the pitchfork bite hard into living flesh. She choked out a scream of terror and challenge and drove the pitchfork hard forward, throwing the weight of her entire body behind it. She drove the attacker back against the heavy door of one of the horse stalls, and she felt in exquisite detail the sudden burst of pain, surprise, and naked fear that came from her attacker.

The tines bit hard into the wooden door, and her attacker's crafting of concealment wavered and vanished.

He wasn't young enough to be called a youth, but not yet old enough to be considered a man, either. He seemed to be at that most dangerous of ages, where strength, skill, and confidence met naïveté and idealism; when young men skilled at the crafts of violence could be manipulated into employing those skills with brutal efficiency—and without questions.

The assassin stared at her for a moment, eyes wide, his face already pale. His sword arm twitched, and he lost his grip on the weapon, an odd blade slightly curved rather than the more typical *gladius*. He pushed at the tines of the pitchfork, but his fingers had no strength in them. One of the steel tines had severed a blood vessel in his belly, she judged, some part of her mind operating with clinical detachment. It was the only thing that could have incapacitated him so quickly. Otherwise, he would have been able to strike her again with the sword, even though wounded.

But the rest of her felt like wailing in sheer anguish. Isana's link to Rill was too open and too strong to set aside easily. All of what her attacker felt flowed into her thoughts and perceptions with a simple, agonizing clarity. She felt him, the screaming pain of his injuries, the sense of panic and despair as he realized what had happened, and that he had no way to avoid his fate.

She felt him as his fear and pain faded to a sense of dim, puzzled surprise, quiet regret, and a vast and heavy weariness. Panicked, she withdrew her senses from the young man, her thoughts screaming at Rill to break the

connection with the young killer. She all but sobbed with relief as the sensations of his emotion faded from her own, and she looked him in the face.

The young man looked up at her for a moment. He had eyes the color of walnuts and a small scar over his left eyebrow.

His body sagged, the weight pulling the tines of the pitchfork free of the door. Then his head lolled forward and a little to one side. His eyes went still. Isana shivered and watched him die. When he had, she pulled on the pitchfork. It wouldn't come out, and she had to brace one foot against the young man's chest to get enough leverage to withdraw the pitchfork. When it finally came free, lazy streams of blood coursed down from the holes in the corpse's belly. The corpse fell to its side, and its glazed eyes stared up at Isana.

She had killed the young man. She had killed him. He was no older than Tavi.

It was too much. She fell to her knees, and her belly lost control of its contents. She found herself staring down at the floor of the stables, shuddering, while waves of disgust and loathing and fear washed over her.

Footsteps entered the stables, but they meant nothing to her. Isana lowered herself to her side once her stomach had ceased its rebellion. She lay there with her eyes closed, while holders entered the stables, sure of only one thing: If she hadn't killed the man, he would certainly have killed her.

Someone with the resources to hire a professional killer wanted her dead.

She closed her eyes, too weary to do more, and was content to ignore the others around her and let oblivion ease her anguish and terror.

⊏⊐⊏⊐⊏⊐⊏⊐CHAPTER 6

"How long has she been down?" rumbled a deep, male voice. Her brother, Isana thought. Bernard.

The next voice was old and quavered slightly. Isana recognized old beldame Bitte's quiet confidence. "Since just before midday."

"She looks pale," said another male voice, this one higher, less resonant. "Are you sure she's all right?"

Bernard answered, "As sure as I can be, Aric. There are no wounds on her." He let out a slow breath. "It looks like she might have collapsed, pushing her crafting too hard. I've seen her work herself into the ground before."

"It might also be a reaction to the struggle," Amara said. "Shock."

Bernard grunted agreement. "Green *legionares* do that after their first battle, sometimes. Great furies know it's a terrible thing to kill a man." Isana felt her brother's broad, warm hand on her hair. He smelled like sweating horses, leather, and road dust, and his voice was quietly anguished. "Poor 'Sana. Is there anything more we can do for her?"

Isana took a deep breath and made an effort to speak, though it came out at hardly more than a whisper. "Begin with washing your hands, little brother. They smell."

Bernard let out a glad cry, and she was immediately half-crushed in one of his bear hugs.

"I may need my spine unbroken, Bernard," she rasped, but she felt herself smiling as she did.

He laid her back down on the bed immediately, carefully restraining his strength. "Sorry, Isana."

She laid her hand on his arm and smiled up at him. "Honestly. It's all right."

"Well," said Bitte, her tone crisp. She was a tiny old woman, white-haired and hunched but with more wits than most, and she had been an institution in the Valley for years before the First Battle of Calderon had ever taken place, much less the more recent events. She stood up and made shooing motions. "Out, everyone, out. You all need to eat, and I daresay Isana could use a few moments of privacy."

Isana smiled gratefully at Bitte, then told Bernard, "I'll come down in a few moments."

"Are you sure you should—" he began.

She lifted a hand, and said, more steadily, "I'll be fine. I'm starving."

"All right," Bernard relented, and retreated before Bitte like an indulgent bull from a herding dog. "But let's eat in the study," he said. "We have some things to discuss."

Isana frowned. "Of course, then. I'll be right there."

They left, and Isana took a few moments to pull her thoughts together

while she freshened up. Her stomach twisted in revulsion as she saw the blood on her skirts and tunic, and she got out of the clothes as quickly as she possibly could, throwing them into the room's fire. It was wasteful, but she knew she couldn't have put them on again. Not after seeing the darkness close in on the young man's eyes.

She tore her thoughts away from that moment and stripped her underclothing off as well, changing into clean garments. She took her long, dark hair down from its braid, idly noting still more strands of grey. There was a small dressing mirror upon a chest of drawers, and she regarded herself in it thoughtfully as she brushed out her hair. More grey, but to look at her one would not know her age, of course. She was slim (far too much so, by fashionable standards), and her features were still those of a girl only a bit more than twenty years of age—less than half of the years she had actually lived. If she lived to be Bitte's age, she might look as old as a woman in her midthirties, but for the grey hairs, which she refused to dye into darkness. Perhaps that was because between her too-thin body, and the apparent youth gifted to watercrafters, the grey hairs were the only things that marked her as a woman rather than a girl. They were a dubious badge of honor for what she had suffered and lost in her years, but they were all she had.

She left her hair down, rather than braiding it again, and frowned at herself in the mirror. Taking dinner in the study instead of the hall? It must mean that Bernard—or more likely Amara—was concerned about what might be overheard. Which meant that she had come with some kind of word from the Crown.

Isana's stomach twisted again, this time in anxiety. The killer in the barn had arrived with quite improbable timing. What were the odds that such a thing would happen only hours before the Crown's messenger arrived in the Valley? It seemed that the two could hardly be unrelated.

Which begged the question—who had sent the killer after her? The enemies of the Crown?

Or Gaius himself.

The thought was not as ridiculous as others might think, given what she knew. Isana had met Gaius and felt his presence. She knew that he was a man of steel and stone, with the will to rule, to deceive and, when necessary, to kill to protect his position and his people. He would not hesitate to order her slain should she become a threat to him. And for all that he knew, she might be one.

She shivered, and pushed her worries down, forcing herself to wrap her fears with thoughts of confidence and strength. She'd been keeping secrets for twenty years, and she knew how to play the game as well as any in the Realm. As much as she liked Amara, and as much as she liked seeing that she made Isana's brother happy, Amara was a Cursor and loyal to the Crown.

She could not be trusted.

The stone halls of the steadholt would be cold as the evening blanketed the valley, so she drew a heavy shawl of dark red about her shoulders to add to the deep blue dress, donned her slippers, and moved quietly through the hallways to Bernardholt—no, to *Isanaholt's* study. To *her* study.

The room was not a large one, and this deep in the stone walls of the steadholt there were no windows. Two tables filled up most of the space, and a slateboard and shelves filled the walls. In the winter, when there was more time than could be filled with work, the children of the steadholt learned their basic arithmetic, studied records of furycrafting for guidance in the use of their own furies, and learned to do at least a little reading. Now, Bernard, Amara, and Aric, the Valley's youngest Steadholder, occupied one table, which was laid out with the evening meal.

Isana slipped in quietly and shut the door behind her. "Good evening. I'm sorry I wasn't on hand to greet you properly, Your Excellencies, Steadholder."

"Nonsense," Aric said, rising and smiling at her. "Good evening, Isana."

Bernard rose as well, and they waited for Isana to sit down before they did themselves.

They ate in quiet conversation for a while, chatting about little of consequence, until the meal was finished. "You've hardly spoken at all, Aric," Isana said, as they pushed plates aside and sat sipping at cups of hot tea. "How did you and yours weather the winter?"

Aric frowned. "I'm afraid that's why I'm here. I . . ." He flushed a little. "Well. To be honest, I'm having a problem, and I wanted to consult with you before I bothered Count Bernard with it."

Bernard frowned. "For fury's sake, Aric. I'm still the same man I was two years ago, title or no. You shouldn't worry about bothering me when it's hold business."

"No sir," Aric said. "I won't, Your Excellency, sir."

"Good."

The young man promptly turned to Isana, and said, "There have been some problems, and I'm concerned that I may need the Count's help."

Amara covered her mouth with her hand until she could camouflage the smile behind a cup as she drank. Bernard settled back with a tolerant smile, but Isana felt something else from him—a sudden stab of anxiety.

Aric poured a bit more wine into his cup and settled back from the table. He was a spare man, all arms and legs, and still too young to have the heavier, more muscular build of maturity. For all of that, he was considered to be uncommonly intelligent, and in the past two years had worked hard enough on the two steadholts under his authority to separate himself entirely from what was now generally considered to be an unfortunate blood relation with his late father, Kord.

"Something's been hunting on the eastern steadholt," he said in a serious tone. "We were missing nearly a third of the cattle we had to turn out to wild forage over the winter, and we assumed that they'd been taken by thanadents or even a herdbane. But we've lost two more cows from our enclosed pastures since we've brought them in."

Isana frowned. "You mean they've been killed?"

"I mean they've been lost," Aric said. "At night, they were in the pasture. In the morning they weren't. No tracks. No blood. No corpses. Just gone."

Isana felt her eyebrows lift. "That's . . . odd. Cattle thieves?"

"I thought so," Aric said. "I took two of my woodcrafters, and we went into the hills to track down whoever it was. We searched for their camp, and we found it." Aric took a large swallow of wine. "It looked like there might have been as many as twenty men there, but they were gone. The fires were out, but there was a spit of burnt meat sitting over one of them. There were clothes, weapons, bedrolls and tools lying out as if they'd all gotten up and walked away without taking anything with them."

Bernard's frown deepened, and Aric turned earnestly to face him.

"It was . . . *wrong*, sir. It was frightening. I don't know how else to describe it to you, but it made the hair on our necks stand up. And dark was coming on, so I took my men and headed back for the steadholt as quickly as we could." His face grew a little more pale. "One of them, Grimard—you remember him, sir, the man with the scar over his nose?"

"Yes. Attican *legionare*, I think, retired out here with his cousin. I saw him cut down a pair of Wolf warriors at Second Garrison."

"That's him," Aric said. "He didn't make it back to the steadholt."

"Why?" Isana asked. "What happened?"

Aric shook his head. "We were strung out in a line, with me in the middle.

He wasn't five yards away. One minute he was there, but when I turned around to look a moment later, he was gone. Just . . . gone, sir. No sound. No tracks. No sign of him." Aric looked down. "I got scared, and I ran. I shouldn't have done that."

"Crows, boy," Bernard said, still frowning. "Of *course* you should have done that. That would have scared the hairs right off my head."

Aric looked up at him and down again, shame still on his features. "I don't know what to tell Grimard's wife. We're hoping he's still alive, sir, but . . ." Aric shook his head. "But I don't think he is. We aren't dealing with bandits, or Marat. I don't have a reason why. It's just . . ."

"Instinct," Bernard rumbled. "Never discount it, lad. When did this happen?"

"Last night. I've ordered the children kept in the steadholt walls, and that no one should leave in groups of less than four. I left first thing morning to speak with Isana."

Bernard exhaled slowly and glanced at Amara. The Cursor nodded, stood up, and went to the door. Isana heard her whisper something while she touched the wood of the door, and her ears pained her briefly, then popped.

"We should be able to speak freely now," Amara said.

"Speak freely about what?" Aric asked.

"About something I learned from Doroga this morning," Bernard said. "He says that there is some manner of creature he called a vord. That it was dwelling in the Wax Forest, and that something happened that caused it to leave its home." Isana frowned, listening as Bernard told the rest of what Doroga had confided to him regarding the creature.

"I don't know, sir," Aric said, his voice dubious. "I've never heard of anything like this. A blood-drinking shapeshifter? We would have heard of such a thing, wouldn't we?"

"According to Doroga, by the time you hear about it, it might already be too late," Bernard said. "If he's correct about the location of the nest on Garados, it could explain the losses at your steadholt, Aric."

"Are you sure he isn't telling you stories?" Aric asked.

"I saw our healers patch up better than two hundred Marat and at least as many of their beasts, Aric. That wasn't done as a practical joke. If Doroga says he lost nearly two thousand warriors, I believe him." He went on to relay the rest of what Doroga had told him.

Isana folded her arms and shivered. "What about the third nest?"

Bernard and Amara traded another one of those looks, and she hardly needed any of her furycrafting gifts to know that her brother lied when he said, "Doroga has trackers on its trail. As soon as we find it, we'll hit it. But I want to focus on the nest we know about first."

"Two thousand men," Aric muttered. "What will you do to assault this nest? There aren't that many in the whole valley, Bernard."

"The Marat didn't have any Knights with them. We do. I think we should at least be able to contain these vord until reinforcements can arrive from Riva."

"If help arrives from Riva," Isana said.

Bernard looked at her sharply. "What do you mean?"

"You saw how Aric reacted when you told him your source of information, and he's actually met Doroga. Don't let it shock you if High Lord Riva discounts a barbarian's word altogether."

Amara chewed on her lip, eyes narrowed. "She could be right. Riva hates the Marat for a variety of reasons."

"But Alerans are dying, Amara," Bernard said.

"Your argument is reasonable," Amara said. "Riva might not be. He's already strapped for funds after rebuilding Garrison and assisting with repairs in the steadholts. He's going to find himself with empty pockets if he is forced to mobilize his Legions. He'll want to avoid that unless it's absolutely necessary, and he'll almost certainly drag his feet rather than waste money on the ghost stories of some furyless barbarian. It's even possible that he has already left to attend Wintersend ceremonies in the capital."

"It's also possible he hasn't."

Amara held up her hand in a pacifying gesture. "I'm only saying that it's going to be difficult to secure assistance based on the observations of a Marat hordemaster. Riva holds Doroga in contempt."

"I'd rather do something than nothing. And in any case, I've already sent the messenger. It's done. There isn't any time to waste."

"Why not?" Aric asked.

"According to Doroga, this nest will reproduce and divide into three more within a week's time. If we don't catch this one now, the vord may be able to spread more rapidly than we can find and destroy them. That being the case, if Riva doesn't respond at once, we may have to fend for ourselves."

Aric nodded, though he didn't look happy. "What can I do to help?"

"Return to your steadholt," Amara said. "Start filling containers with drinking water, preparing tubs for the healers, bandages, the like. We'll use Aricholt as our base of operations while we locate the nest."

"Very well," Aric said, rising from the table. "In that case, I wish to return immediately."

"It could be dangerous for you, after dark," Amara warned.

"I'll swing wide around the mountain," Aric said. "My place is with my holders."

Bernard stared at him for a moment, then nodded. "Be careful, Steadholder."

They murmured their good-byes, and Aric left the study.

After the door had shut, Amara turned to Isana and offered her an envelope.

"What's this?" Isana asked.

"An invitation to Wintersend, from the Crown."

Isana lifted her eyebrows. "But that's in a few days."

"I am given to understand that His Majesty has already set several Knights Aeris aside to fly you in."

Isana shook her head. "I'm afraid that isn't possible," she said. "Especially not before this vord situation is settled. Healers will be needed."

Amara frowned at her. "This isn't precisely a request, Steadholder Isana. You are needed in the capital. You've become quite the bone of contention."

Isana blinked. "I have?"

"Indeed. By elevating you to a position of equality with the male members of the gentry, Gaius has tacitly declared a sort of equality of status between men and women. As a result, many folk have taken it as permission to establish a number of equities formerly denied women. And others have taken shameless advantage of the opportunity. Various cities have begun to tax the sale of female slaves as heavily as males. The Slaver's Consortium is furious and demands legislation to reestablish the previous status quo, and the Dianic League has rallied against them."

"I don't see what that has to do with me attending Festival in the capital."

"The balance of power has begun to shift in the Senate. Gaius needs the support of the Dianic League if he is to prevent it from flying out of control. So he needs you there, at Festival, highly visible to everyone in the Realm, to show how strongly you support him."

"No," Isana said flatly. "I have more vital duties here."

"More vital than protecting the stability of the Realm?" Amara asked in a mild tone. "My. You must be very busy."

Isana rose sharply to her feet, her eyes narrowed, and snarled, "I don't need a child like you to tell me my duty."

Bernard rose, staring at Isana in shock. " 'Sana, please."

"No, Bernard," Isana said. "I am not Gaius's pet dog to sit up and hop through hoops when he snaps his fingers."

"Of course not," Amara said. "But you *are* the only person who might give him the advantage he needs to prevent the Realm from falling into a civil war. Which is *why* someone ordered you killed in the first place—or hadn't that occurred to you?"

Bernard put a warm hand on Isana's shoulder to steady her, but Amara's words struck her like a cup of icy cold water. "Civil war? Has it come to that?"

Amara pushed her hair back tiredly. "It grows more likely each day. The Slaver's Consortium is supported by several of the southern cities, and the northern and Shieldwall cities favor the Dianic League. It is imperative that Gaius maintains control over the Senate's majority, and the Dianic League is the lever he needs. My orders were to give you this information, then accompany you and your brother to the capital."

Isana sat down again slowly. "But that has now changed."

Amara nodded. "If Doroga is right about the vord, they could be a deadly threat. They must be dealt with without delay, so Bernard and I will stay here and do so, and join you as soon as we are able."

"And," Bernard rumbled, "we think we know where the third group of vord is going."

Isana arched an eyebrow.

Bernard reached into a sack he'd brought with him and drew out an old, battered leather pack. "Doroga's scouts found this along a trail leading directly toward the capital."

Isana blinked at the pack. "Isn't that Fade's old pack?"

"Yes," Bernard said. "But Fade gave it to Tavi before he entered the Wax Forest. Tavi lost it during the battle there. His scent is all over it."

"Blood and crows," Isana swore. "Are you telling me that this creature is *following* him?"

"It appears so," said Amara. "The Knights Aeris will arrive in the morning. Isana, you need to get to the capital and gain an audience with Gaius as

soon as possible. Tell him about the vord, and make him believe you. He needs to find their nest and stop them."

"Why can't you send a courier to him instead?"

"Too risky," Bernard answered. "If the courier is delayed, or if Gaius is preoccupied with preparations, we'd be better off having the extra help here."

Amara nodded. "He *will* see you, Holder Isana. You may be the only one who will be able to cut through protocol and get to him immediately."

"All right. I'll do it. I'll talk to him." Isana said. "But not until I am sure Tavi is safe."

Amara grimaced but nodded. "Thank you. It was never my intention to send you into that snake pit alone. There will be a lot of people interested in you. Some of them can be quite deceptive and dangerous. I can provide you with an escort—a man I trust, named Nedus. He'll meet you at the Citadel and should be able to help you."

Isana nodded quietly and rose. "Thank you, Amara. I'll manage." She took a step toward the door and wavered, nearly falling.

Bernard caught her before she could. "Whoa. Are you all right?"

Isana closed her eyes and shook her head. "I just need to rest. It will be an early morning." She opened her eyes and frowned up at her brother. "You *will* be careful?"

"I'll be careful," he promised. "If you promise that you will."

She smiled faintly at him. "Done."

"Don't worry, 'Sana," he rumbled. "We'll make sure everyone is kept safe. Especially Tavi."

Isana nodded, and started for the door again, steadier. "We will."

Presuming, of course, that they weren't already too late.

CHAPTER 7

Between the time he saw Steadholder Isana found by her people and the time the sun set, Fidelias had run more than a hundred miles and left the Calderon Valley behind him. The furycrafted stones of the causeway lent their strength to his own earth fury, and through it to Fidelias. Though he was a man of nearly threescore years, the long run had cost him comparatively little effort. He slowed down when the hostel came into sight and walked the last several hundred yards, panting, his legs and arms burning lightly with exertion. Grey clouds rolled across the flaming twilight, and it began to rain.

Fidelias flipped his cloak's hood over his head. His hair had grown even thinner in the past few years, and if he didn't cover it, the cold rain would be both unpleasant and unhealthy. No self-respecting spy would allow himself to catch cold. He imagined the deadly consequences had he sneezed or coughed while inside the barn with Isana and her would-be assassin.

He didn't mind the thought of dying on a mission, but he'd stake himself out for the crows if he would ever allow it to happen because of a petty mistake.

The hostel was typical of its kind in the northern half of the Realm—a ten-foot wall surrounding a hall, a stables, a pair of barracks houses and a modest-sized smithy. He bypassed the hall, where travelers would be buying hot meals. His stomach rumbled. The music, dancing, and drinking wouldn't start until later in the evening, and until they did, he would not risk being recognized by bored diners with nothing better to do than observe and converse with their fellow travelers.

He slipped up the stairs of the second barracks house, opened the door to the room farthest from the entrance, and bolted it behind him. He eyed the bed for a moment, and his muscles and joints ached, but duty came before comfort. He sighed, built the fire laid in the fireplace to life, tossed aside his cloak and poured water from a pitcher into a broad bowl. Then he

withdrew a small flask from his pouch, opened it, and poured a few splashes of water from the deep wellsprings beneath the Citadel in Aquitaine into the bowl.

The water in the bowl stirred almost immediately, rippling, and a long blob of liquid extruded from the surface of the contents in the bowl, wavering slowly into the miniature form of a woman in evening robes, striking rather than beautiful, apparently in her late twenties. "Fidelias," the woman's form said. Her voice sounded faint, soft, very far away. "You're late."

"My lady Invidia," Fidelias replied to the image, inclining his head. "I'm afraid the opposition wasn't overly considerate of our time constraints."

She smiled. "An agent had been dispatched. Did you learn anything of him?"

"Nothing stone solid. But he was carrying a Kalaran gutting knife, and he knew what he was doing," Fidelias said.

"A Kalaran bloodcrow," said the image. "Then the rumors are true. Kalarus has his own breed of Cursor."

"Apparently."

She laughed. "Only a man of great integrity could resist saying, 'I told you so.'"

"Thank you, my lady."

"What happened?"

"It was a near thing," Fidelias said. "When his first plan failed he panicked and went after her with that gutting blade."

"The Steadholder was slain?"

"No. She sensed him just before he struck, and killed him with a pitchfork."

The image's eyebrows shot up in surprise. "Impressive."

"She's a formidable woman, my lady, watercrafting aside. If I may ask, my lady, what were the results of the League's summit?"

The woman's image tilted her head, regarding him thoughtfully. Then said, "They have elected to support and promote Steadholder Isana's status."

Fidelias nodded. "I see."

"Do you?" the image asked. "Do you really see what this could mean? How it could affect the course of our history?"

Fidelias pursed his lips. "I suppose in the long term, it could mean an eventual state of legal and political parity between genders. I try not to think in terms of history, my lady. Only in practical cause and effect."

"Meaning?"

"Meaning that the most immediate effect will be economic, and there-
fore political. The establishment of a woman as a full Citizen in her own
right will have immediate effects on the slave trade. If it becomes as costly
to sell and purchase female slaves as male, it will have an enormous detri-
mental effect on the economy of the southern cities. Which is why, pre-
sumably, Kalarus dispatched an agent to remove Isana of Calderon."

"High Lord Kalarus is a debauched pig," Invidia said, her tone matter-
of-fact. "I'm sure he went into some sort of seizure when he heard the news
about Steadholder Isana."

Fidelias narrowed his eyes. "Ah. The First Lord knew precisely how
High Lord Kalarus would react."

Her mouth curled up in an ironic smile. "Indeed. Gaius rather neatly di-
vided his enemies by introducing this issue. My husband's alliance in the
north, and Kalarus's in the south—and if the Steadholder appears in sup-
port of him, he may sweep the support of the Dianic League from my hus-
band, as well."

"Would they not follow your lead, my lady?"

Invidia's image waved a hand. "You flatter me, but I do not control the
League so completely. No one could. My husband simply understands the
advantage that the support of the League gives him, and they see what they
gain in return. Our relationship is one of mutual benefit."

"I assume your associates and allies are aware of the situation."

"Very," Invidia replied. "The woman's fate will be a demonstration of my
husband's competence." She shook her head wearily. "The outcome of this sit-
uation is absolutely critical, Fidelias. Our success will solidify my husband's
alliances while weakening the faith of Kalarus' followers. Failure could fatally
cripple our plans for the future."

"In my judgment, the time seems premature for a confrontation with
Kalarus."

She nodded. "I certainly would not have chosen this time and place, but
by granting Citizenship to this woman, Gaius has forced Kalarus's hand." She
waved her hand in a dismissive gesture. "But confrontation with Kalarus's
faction was inevitable."

Fidelias nodded. "What are my orders, my lady?"

"You're to come to the capital at once for Wintersend."

Fidelias stared at the image for a moment. Then said, "You're joking."

"No," she said. "Isana will be presented formally to the Realm and the Senate at the conclusion of Wintersend, in public support of Gaius. We must stop it from happening."

Fidelias stared at the image for a moment, frustration welling up in his chest too sharply to keep it wholly from his voice. "I am a wanted man. If I am recognized in the capital, where many know my face, I will be captured, interrogated, and killed. To say nothing of the fact that the woman herself will know me on sight."

The image stared at him. "And?"

He kept his voice bland. "And it may somewhat hamper my ability to move around the city."

"Fidelias," the image chided, "you are one of the most dangerous men I know. And you are certainly the most resourceful." The image gave him a very direct, almost hungry look. "It's what makes you so attractive. You'll manage. It is my husband's command as well as my own."

Fidelias ground his teeth, but inclined his head. "Yes, my lady. I'll . . . think of something."

"Excellent," the image responded. "Isana's support for Gaius could cost my husband the support of the Dianic League. You must prevent it at any cost. Our future—and yours—hinges upon it."

The watery image slid smoothly back down into the bowl and vanished. Fidelias grimaced at it for a moment, then cursed and threw it across the room. The ceramic bowl shattered against the stones of the hearth.

Fidelias mopped his hands over his face. Impossible. What the Lord and Lady Aquitaine were asking was impossible. It would be the death of him.

Fidelias grimaced. There would be little point in trying to rest this night, and even the desire to eat had vanished with the tension that had filled him in the wake of his conversation with Lady Invidia.

He changed into dry clothing, seized his cloak and his belongings, and headed back out into the night.

CHAPTER 8

Tavi's legs burned from where he crouched on a rooftop overlooking the Domus Malleus, a building formerly a large smithy that had been rebuilt into one of the most popular dining houses in the trade quarter of the city of Alera. Twilight was laying siege to the day, and shadows had begun to fill the streets. Shops and merchants were closing their windows and doors for the night and rolling their goods away until the market opened again the next morning. The scent of fresh bread and roasting meat filled the air.

Tavi's leg twitched, threatening to begin cramping. Stillness and patience were necessities for any hunter, and his uncle had taught Tavi all that he knew about tracking and hunting. Tavi had trailed the enormous sheep his uncle raised through rocky mountain trails, hunted down stray horses and calves, stalked the trails and learned the habits of the wildcats and thanadents that would prey upon his uncle's flocks.

As a final lesson, Bernard had taught him to stalk wild deer, creatures so quiet, alert, and swift that only the most skilled and persistent hunters would have any chance of taking one. This thief was not a mountain buck; but Tavi reasoned that someone so wily, so impossible to catch by even experienced civic *legionares* would have many of the same habits. The thief would be supremely wary, cautious, and swift. The only way to catch that kind of quarry was to determine what he needed, and where he would go to get it.

So Tavi had spent the afternoon speaking to officers of the civic legion, learning where the thief had struck and what he had taken. The perpetrator had eclectic tastes. A jeweler had lost a valuable silver cloak-pin and several ebony combs—though more valuable trinkets stored in the same location had not been touched. A clothier had been taken for three valuable cloaks. A cobbler had lost a set of garim-hide boots. But most distinctively, a number of dining houses, grocers, and bakeries had suffered from frequent nocturnal robberies.

Whoever the thief was, he wasn't after money. In fact, from the wildly varying list of items taken, it was almost as though he was stealing his prizes purely on impulse, for enjoyment. But the reoccurring burglaries of kitchens and larders indicated a single common fact that he shared with the mountain bucks of Tavi's wild home.

The thief was hungry.

Once Tavi knew that, the rest was much less difficult. He had simply waited for the dining houses to begin preparing their evening meals, then followed his nose to the most delicious-smelling building he could find. He found a spot where he could watch the kitchen entrance, and settled down to wait for the deer to forage.

Tavi neither heard nor saw the thief coming, but the hairs on the back of his neck rose and an odd, tingling ripple washed down his spine. He froze, hardly daring to breathe, and a moment later he saw a slow, silent shape covered in a dark cloak slip over the peak of the Domus Malleus's roof and descend to leap lightly to the ground beside the kitchen door.

Tavi descended to the street and darted across the street to the alley behind the restaurant. He stalked deeper into the alley and concealed himself in a patch of thick shadows, waiting for his quarry to reappear.

The thief emerged from the kitchen a pair of heartbeats later, sliding something beneath his cloak.

Tavi held his breath as the thief ghosted down the alley toward him and passed within a long step of Tavi's hiding place. Tavi waited until the thief went by, then lunged out of the shadows, seized the thief's cloak and hauled hard.

The thief reacted with the speed of a wary cat. He spun as Tavi pulled on his cloak, and threw a clay pot of scalding soup at Tavi's head. Tavi darted to one side and out of the way, and the thief hurled a plate laden with the remains of a roast at him, striking him hard on the chest. He staggered and fell back, sent off-balance. The thief spun and sprinted away down the walkway.

Tavi regained his balance and set off in pursuit. The thief was light on his feet, and Tavi could barely keep up. They ran in silence down darkened streets and walkways, in and out of the colored, warm spheres of the furylights. The thief hauled a barrel to its side as he passed a cooper's shop, and Tavi had to jump it. He gained ground, and threw himself at the thief's back. He missed, but got the man on a leg, and wrenched, throwing him off-balance and to the ground.

There was a silent, mad struggle only a few seconds long. Tavi tried to pin one of the thief's arms behind him, but his opponent was too quick and writhed until he could throw an elbow at Tavi's head. Tavi ducked it, but the thief spun and struck him in the chin with the edge of one hand. Stars flashed in Tavi's eyes, and he lost his hold on the thief, who rose and vanished into the dark before Tavi could regain his feet.

He set off in pursuit, but it was vain. The thief had made good his escape.

Tavi snarled a curse and stormed back out of the darkened alley, heading for the Domus Malleus. At least, he thought, he'd get himself a decent meal for all of his trouble.

He turned back out onto the street, scowling, and slammed directly into a large pedestrian.

"Tavi?" Max said, surprise in his tone. "What are you doing here?"

Tavi blinked at his roommate. "What are *you* doing here?"

"I'm being attacked by scowling academs from Calderon," Max said, a smile on the edges of his words. He shrugged his dark cloak to settle more solidly around him and brushed off his tunic.

The evening's mists were gathering thick and cold. Tavi felt himself start to shiver as the cold found its way to his sweating skin. He shook his head. "Sorry. I suppose I'm not at my most alert. But seriously, what are you doing down here?"

Max grinned. "There's a young widow a couple of streets down. She gets lonely on misty nights."

"This time of year, every night is misty," Tavi said.

Max beamed. "I noticed that, too."

"There's a reason people hate you."

"Jealousy is common among lesser men," Max agreed magnanimously. "My turn. What are *you* doing down here? Wouldn't do for Gaius's golden boy to get caught sneaking out past curfew."

"Meeting someone," Tavi replied.

"Sure you are," Max agreed amiably. "Who?"

"You aren't the only one who sneaks out of the Academy after dark."

Max burst out into a rolling laugh.

Tavi scowled at him. "What's so funny?"

"Obviously you aren't seeing a girl."

"How do you know?" Tavi demanded.

"Because even a virgin like you would try to look better than you do. Clean clothes, combed hair, freshly bathed, all that sort of thing. You look like you've been rolling around in the street."

Tavi flushed in embarrassment. "Shut up, Max. Go see your widow."

Instead, Max leaned against the wall of the dining house and folded his arms. "I could have rapped you on the head instead of letting you bump into me. And you'd never have known it happened," Max said. "It's not like you. You okay?"

"I'm just too busy," Tavi said. "I did calculations homework all day, after the test this morning—"

Max winced. "I'm sorry about how that went, Tavi. Killian might be able to furycraft his way around being blind, but he bloody sure doesn't see your strengths."

Tavi shrugged. "I expected it to go that way. And I've got to attend Gaius tonight."

"Again?" Max said.

"Yeah."

"So why aren't you back at the dorm getting some shut-eye?"

Tavi began to wave his hand vaguely, but then narrowed his eyes and smiled. "Ah-hah. Why aren't you running off to your eager widow, Max?"

"It's early. She'll keep," Max said, frowning.

"She'll keep until you complete your test for Killian?" Tavi asked.

Max's shoulders stiffened. "What are you talking about?"

"Your own test," Tavi said. "Killian gave you one of your own. He sent you to find out what I was doing."

Max couldn't hide an expression of surprise. Then he rolled his eyes. "Killian probably told you to keep yours secret, whatever it is."

"Of course. And no, I'm not telling you about it."

"Crows, Calderon. When you get this clever it makes me want to put a nice dent in your face."

"Jealousy is common among lesser men," Tavi said, with a small smile. Max mimed a punch, and Tavi ducked his head a little. "How long have you been shadowing me?"

"A couple of hours. Lost you when you moved off the roof."

"If Killian knew you'd shown yourself to me, he'd fail you on the spot."

Max rolled one shoulder in a shrug. "It's just a test. I've been dealing with tests of one kind or another since I could walk."

"High Lord Antillus wouldn't be pleased if you failed."

"I'm sure to lose sleep now," Max drawled.

Tavi half smiled. "Is there really a widow?"

Max grinned. "Even if there wasn't, I'm pretty sure I could find one. Or make one, if it came to that."

Tavi snorted. "What are your plans for the night, then?"

Max pursed his lips. "I could follow you around some more, but it doesn't seem fair." He drew an X over his belly. "Soothword. I'll leave you alone instead of making you spend an hour of your sleep shaking me."

Tavi nodded and gave his friend a grateful smile. Max had sworn himself to truth, an old northern custom. He would never so much as consider breaking a promise given under his soothword. "Thank you," Tavi said.

"But I *will* find out what you're up to," Max said. "Not so much for Killian, as it is because someone needs to show you that you aren't nearly as clever as you think you are."

"Better get to bed then, Max. That's only going to happen in your dreams."

Max's teeth flashed in the dimness as Tavi accepted the challenge. He struck his chest lightly with a fist, the salute of a *legionare,* then vanished into the misty night.

Once Max was gone, Tavi rubbed at his aching chest, where the hurled plate had struck him. From the feel of it, there was going to be a bruise. A big one. But at least he'd get a decent meal for his pains. He stepped up onto the threshold of Domus Malleus.

The enormous chimes upon the top of the Citadel began to toll out the hour, each stroke sending out a low, vibrating pressure that could shake water within a bowl, accompanied by a shower of high, shivering tones, beautiful and somehow sad.

The chimes sounded nine times, and Tavi spat an oath. There would be no time to stop for a meal. If he set out at his best pace, it would take him nearly another hour to wind his way up through Alera's streets to the First Lord's Citadel, and subsequently descend into the depths beneath the stronghold. He would arrive smudged and stained from his skulking, covered in sweat and most of an hour late to his duties to the First Lord.

And he had a history examination in the morning.

And he still hadn't caught Killian's thief.

Tavi shook his head and started jogging back up through the capital.

He'd only gone a couple of hundred yards when the skies rumbled, and drops of slow, heavy rain came down in sheets.

"Some hero of the Realm you are," Tavi muttered to himself, and set off to attend the First Lord.

Panting, dirty, and late, he paused at the door to the First Lord's chamber. He tried to straighten his cloak and tunic, then regarded them helplessly. Nothing short of a legion of cleaning experts could make him presentable. He chewed on his lip, shoved his dark mop of wet hair back from his face, and went inside.

Gaius stood upon the whirling colors of the mosaic tiles again. He stooped, as though with great weariness or pain. His face was ashen, and the stubble of his beard no longer seemed to contain any hairs but those gone white. But it was his eyes that were the worst. They were sunken, dark pits, the whites shot with blood around eyes whose colors had become faded and dull. Fell, sickly fires burned within them—not the determination, pride and strength to which Tavi had become accustomed, but something more brittle, more frightening.

Gaius scowled down at him, and snapped, "You're late."

Tavi bowed his head deeply and left it that way. "Yes, sire. I have no excuse, and offer my apologies."

Gaius was silent for a moment, before he began to cough again. He waved an irritated hand at the tiles, dispersing the shapes and colors rising from them, and sat down at the little bureau against one wall until the coughing had passed. The First Lord sat with his eyes closed, his breath too shallow and too fast. "Go to the cupboard, boy. My spicewine."

Tavi rose immediately and went to the cupboard near the bench in the antechamber. Tavi poured and offered him the glass, and Gaius drank it with a grimace. He studied Tavi with a sour expression. "Why were you late?"

"Finals," Tavi replied. "They've taken up more of my time."

"Ah," Gaius said. "I seem to remember several such incidents during my own education. But it's no excuse for failing in your duties, boy."

"No, sire."

Gaius coughed again, wincing, and held out his glass for Tavi to refill.

"Sire? Are you well?"

The bitter, brittle flare of anger returned to Gaius's eyes. "Quite."

Tavi licked his lips nervously. "Well, sire, you seem to be . . . somewhat peaked."

The First Lord's expression grew ugly. "What would you know of it? I think the First Lord knows better than a bastard apprentice shepherd whether he is or is not well."

Gaius's words hit Tavi harder than a fist. He dropped back a step, looking away. "Your pardon, sire. I did not intend to offend you."

"Of course you didn't mean to," Gaius said. He sat his wineglass down so hard that the stem snapped. "No one ever means to offend someone with power. But your words make your lack of respect for my judgment, my office, my *self* abundantly clear."

"No, sire, I don't mean that—"

Gaius's voice crackled with anger, and the ground itself quivered in reaction. "Be *silent,* boy. I will *not* tolerate further interruptions with good grace. You know *nothing* of what I have had to do. How *much* I have had to sacrifice to protect this Realm. This Realm whose High Lords now circle me like a pack of jackals. Like crows. Without gratitude. Without mercy. Without respect."

Tavi said nothing, but the First Lord's words rambled in pitch and tone so badly that he began to have trouble understanding Gaius's speech. He had never heard the First Lord speak with such a lack of composure.

"Here," Gaius said. He seized Tavi's collar with a sudden and terrifying strength and dragged the boy after him into the seeing chamber, out onto the whirling mosaic of tiles whose lights and colors pulsed and danced, creating a cloud of light and shadow that formed into a depiction of the lands of the Realm. At the center of the mosaic, Gaius slashed his other hand at the air, and the colors of the map blurred, resolving abruptly into the image of a terrible storm lashing some luckless coastal village.

"You see?" Gaius growled.

Tavi's fear faded a bit in the face of his fascination. The image of the town grew clearer, as though they were moving closer to it. He saw holders running inland, but the seas reached out for them with arms of black water. The waters rushed over the village, the holders, and all of them vanished.

"Crows," Tavi whispered. Tavi's belly quivered and twisted, and he was glad he hadn't eaten. He could barely whisper. "Can't you help them?"

Gaius screamed. His voice rolled out like the furious roar of some beast. The furylamps blazed to brilliant light, and the air in the chamber rolled and

twisted in a small cyclone. The stone heart of the mountain shook and trembled before the First Lord's rage, bucking so hard that Tavi was thrown to the floor.

"What do you *think* I've been *doing,* boy!" Gaius howled. "Day! Night! AND IT ISN'T ENOUGH!" He whirled and snarled something in a savage tone, and the chair and table on one side of the room did more than burst into flame—there was a howling sound, a flash of light and heat, and the charred embers of the wooden furnishing flew throughout the room, rattling from the walls, leaving a fine haze of ash in the air. "ALL GONE! ALL! I HAVE NOTHING LEFT TO SACRIFICE, AND IT ISN'T ENOUGH!"

The First Lord's voice broke then, and he staggered to one knee. Wind, flame, and stone subsided again, and he was suddenly just an old man once more—his appearance that of someone aged too fast and too hard in a harsh world. His eyes were even more deeply sunken, and he trembled, and Gaius clutched at his chest with both hands, coughing.

"My lord," Tavi breathed, and went to the old man. "Sire, please. Let me find someone to help you."

The coughing wound down, though Tavi thought it was more a result of a weakening of Gaius's lungs than an improvement in his condition. The old man stared at the image of the coastal village with hazy eyes, and said, "I can't. I've tried to protect them. To help them. Tried so hard. Lost so much. And failed."

Tavi found tears in his eyes. "Sire."

"Failed," Gaius whispered. "Failed."

His eyes rolled back. His breaths came quick and shallow, rasping. His lips looked rough, chapped, dry.

"Sire?" Tavi breathed. "Sire?"

There was a long silence in which Tavi tried to rouse the First Lord, calling him by both title and name.

But Gaius did not respond.

CHAPTER 9

In that moment, Tavi understood a single, terrifying fact; the fate of the First Lord, and therefore of all Alera, was utterly in his hands.

What he did in the next moments, he knew, would have repercussions that would echo throughout the Realm. His immediate impulse was to run screaming for help, but he stopped himself and as Maestro Killian had taught them, he forced himself to slow down and set his emotion aside to work through the problem with cold logic.

He could not simply call for the guards. They would come, of course, and physicians would care for the First Lord, but then it would all be out in the open. If it became widely known that the First Lord's health had failed, it could prove disastrous in dozens of ways.

Tavi was not privy to the private counsels of the First Lord, but neither was he dull of ear or mind. He knew, from bits of conversation overheard while on his duties, more or less what was going on in the Realm. Gaius was in a tenuous position before several of the more ambitious High Lords. He was an old man without an heir, and should they begin regarding him as a *failing* old man with no heir, it could trigger uprisings, anything from the official processes of the Senate and Council of Lords to a full-fledged military struggle. That was precisely why Gaius had re-formed the Crown Legion, after all, to increase the security of his reign and reduce the chances of a civil war.

But it also meant that anyone determined to take power from Gaius would almost certainly be forced to fight. The very idea of the Legions and Lords of Alera making war on one another would have been incomprehensible to Tavi before the events of the Second Battle of Calderon. But Tavi had seen the results of furies wielded against Aleran citizens and soldiers, and those images still haunted his nightmares.

Tavi shuddered. Crows and furies, not that. Not again.

Tavi checked the old man. His heart was still beating, though not in

steady rhythm. His breathing was shallow, but sure. Tavi could do nothing more for him, which meant that he had to have someone's help. But whom could he trust with this? Who would Gaius have trusted?

"Sir Miles, fool," he heard himself say. "Miles is captain of the Crown Legion. The First Lord trusts him, or Gaius wouldn't have given him command of five thousand armed men inside his own walls."

Tavi had no choice but to leave the fallen man's side to send for the grizzled captain. He rolled his cloak beneath Gaius's head, then tore a cushion from the First Lord's chair to elevate the old man's legs. Then he turned and sprinted up the stairs to the second guardroom.

But as he approached, he heard raised voices. Tavi stopped, heart pounding. Did someone already know what had happened? He slipped forward cautiously, until he could see the backs of the guards at the second duty station. The *legionares* were all standing, and all had hands on their weaponry. Even as Tavi watched, he heard boots hitting the floor in unison, and the men who had been taking their turns in sleep came out of the bunk room in hastily donned armor.

"I am very sorry, sir," said Bartos, the senior *legionare* at the station. "But His Majesty is unavailable while in his private chambers."

The voice that spoke next was not human. It was too vastly deep, too resonant, and the words twisted and oddly stretched, as if they'd been torn and rent by the fanged mouth where they'd been born.

One of the Canim had come down the stairs, and towered over the *legionares* in the guardroom.

Tavi had seen one of the Realm's deadliest enemies only once in two years, and that had been from a distance. He had heard the tales of them, of course, but they had not adequately impressed upon him the effect of the creatures' presence. Not adequately at all.

The Cane stood at its full height, and the ten-foot ceiling barely allowed it. Covered with fur the color of the darkest depths of night, the creature stood upon two legs, with the mass of two or three big *legionares*. Its shoulders looked too narrow for its height, and its arms were longer than human proportions. Its long, blunt fingers were tipped with dark claws. The Cane had a head that reminded Tavi unpleasantly of the direwolves that had accompanied the Wolf Clan of the Marat, though broader, its muzzle shorter. Massive muscles framed the Cane's jawline, and Tavi knew that its sharp, gleaming white-yellow teeth could snap through a man's arm or leg without

particular effort. The Cane's eyes were amber yellow set against dark scarlet, and it gave the creature the look of something that saw everything through a veil of blood.

Tavi studied the creature more closely. This Cane was dressed in clothing similar to Aleran in fashion, though made with far greater lengths of cloth. It wore colors of grey and black exclusively, and over that the odd Canim-style circular cloak that draped over the back and half of the Cane's chest. Where fur showed through, thin spots and white streaks marked dozens of battle scars. One triangular ear, notched and torn to ragged edges with old wounds, sported a gleaming golden ring hung with a skull carved from some stone or gem the color of blood. A similar ring glittered amidst the dark fur covering its left hand, and at its side the Cane wore one of the huge, scything war swords of its kind.

Tavi bit his lip, recognizing the Cane from its clothing, demeanor, and appearance. Ambassador Varg, the local packmaster of the Canim embassy and the spokesman for its people to the Alerans.

"Perhaps you did not hear me, *legionare,*" the Cane literally growled. More teeth showed. "I require counsel with your First Lord. You will conduct me to him at once."

"With respect, Lord Ambassador," Bartos replied, his teeth clenched over the words, "His Majesty has not apprised me of your coming, and my standing orders are to see to it that he is not disturbed during his meditations."

Varg snarled. Every *legionare* in the room leaned slightly away from the Cane—and they were some of the best the Realm had to offer. Tavi swallowed. If veteran fighting men who had actually faced the Canim in battle were afraid of Ambassador Varg, it would be with good reason.

Anger and scorn rang in Varg's snarling words. "Obviously, Gaius could not know of my coming when it is an unexpected visit. The matter is of import to both your folk and mine." Varg took a deep breath, lips lifting away from an arsenal of fangs. One clawed hand fell to the hilt of its blade. "The commander at the first station was most polite. It would be polite for you to also stand out of my way."

Bartos's gaze flickered around the room as though searching for options. "It simply is not possible," the *legionare* said.

"Little man," said Varg, its voice dropping to a barely audible rumble. "Do not test my resolve."

Bartos did not respond at once, and Tavi knew, knew it by sheer instinct, that it was a mistake. His hesitation was a declaration of weakness, and to do such a thing before any aggressive predator was to invite it to attack. If that happened, the situation could only become worse, not better.

Tavi had to act. His heart thudded in fear, but he forced his face into a cold mask, and strode briskly into the guardroom. "*Legionare* Bartos," he said in a ringing tone. "The First Lord requires the presence of Sir Miles, immediately."

The room fell into a started silence. Bartos turned his head and blinked at Tavi, his face covered in surprise. Tavi had never spoken in that tone of voice to the *legionares*. He'd have to apologize to Bartos later.

"Well, *legionare*?" Tavi demanded. "What is the delay? Send a man for Miles at once."

"Uh," Bartos said. "Well, the Ambassador here desires to meet with the First Lord as quickly as possible."

"Very well," Tavi said. "I will so inform him when I return with Sir Miles."

Varg let out a basso snarl that vibrated against Tavi's chest. "Unacceptable. You will lead me down to Gaius's chambers and announce me to him."

Tavi stared at Varg for a long and silent moment. Then slowly arched an eyebrow. "And you are?"

It was a calculated insult, given the Ambassador's notoriety in the Citadel, and Varg had to know it. Its amber eyes burned with fury, but it snarled, "Ambassador Varg of the Canim."

"Oh," Tavi said. "I'm afraid I did not see your name on the list of appointments for this evening."

"Um," Bartos said.

Tavi rolled his eyes and glared at Bartos. "The First Lord wants Miles *now, legionare*."

"Oh," Bartos said. "Of course. Nils."

One of the men edged his way around the furious Cane and set off up the stairs at a slow jog. He'd have a hard time of it in full armor, Tavi knew. Miles wouldn't get there anytime soon. "Have the captain report to the First Lord the moment he arrives," Tavi said, and turned to leave.

Varg snarled, and Tavi whirled in time to see it sweep out one arm and toss Bartos aside like a rag doll. The Cane moved with unearthly speed, and with a single bound landed beside Tavi and seized him in one clawed

and long-fingered hand. Varg thrust its mouth down at Tavi's face, and the
boy's vision filled with a view of wicked fangs. The Cane's breath was hot,
damp, and smelled vaguely of old meat. The Cane itself smelled strange, an
acrid but subtle scent like nothing Tavi had known before. "Take me to him
now, boy, before I tear out your throat. I grow weary of—"

Tavi drew the dagger at his belt from beneath his cloak with liquid
speed, and laid the tip of the blade hard against Ambassador Varg's throat.

The Cane stopped talking for a startled second, and its bloody eyes nar-
rowed to golden slits. "I could tear you apart."

Tavi kept his voice in the same hard, commanding, coldly polite tone.
"Indeed. After which you will shortly bleed to death, Lord Ambassador."
Tavi glared back hard into Varg's eyes. He was terrified, but knew that he did
not dare allow it to show through. "You would ill serve your own lord by dy-
ing in such an ignominious fashion. Slain by a human cub."

"Take me to Gaius," Varg said. "Now."

"It is Gaius who rules here," Tavi said. "Not you, Ambassador."

"It is not Gaius whose claws rest near your heart, human cub." Tavi felt
the Cane's claws press harder against his flesh.

Tavi showed his teeth in a mirthless grin. He pressed the dagger a bit
more heavily into the thick fur beneath Varg's muzzle. "I, like His Majesty's *le-
gionares,* obey his commands regardless of how inconvenient it may be to you.
You will release me, Lord Ambassador. I will take your request to His Majesty
at the earliest opportunity, and I will bring you his reply personally the instant
he releases me to do so. Or, if you prefer, I can open your throat, you can tear
me to bits, and we will both die for no reason. The choice is yours."

"Do you think I am afraid to die?" the Cane asked. Varg's dark nostrils
flared, and it continued to study Tavi's face, teeth exposed.

Tavi stared back, praying that his hands didn't start shaking, and kept
the pressure on the tip of his knife. "I think your death here, like this, will
not serve your people."

A snarl bubbled in Varg's words. "What do you know of my people?"

"That they have bad breath, sir, if you are any indication."

Varg's claws twitched.

Tavi wanted to scream at himself for being a fool, but he kept his mask
on, his dagger firm.

Varg's head jerked up, and it let out a barking sound. It released Tavi.
The boy fell a step back, and lowered the knife, his heart pounding.

"You smell of fear, boy," Varg said. "And you are a runt, even of your kind. And a fool. But at least you know of duty." The Cane tilted its head to one side, baring a portion of its throat. The gesture looked exceedingly odd, but it reminded Tavi of a respectful nod of the head, somehow.

He dipped his head slightly in his own nod, never letting his gaze waver, and put the dagger away.

The Cane swept its eyes across the *legionares,* contempt in its expression. "You will all regret this. Soon."

And with that, Varg settled its cloak about it and stalked back out of the room to the winding staircase up. It made that same barking sound again, but the Cane did not look back.

Tavi's legs shook hard. He half stumbled to a trestle-bench, and sank down onto it.

"What the crows was that all about?" Bartos stammered a second later. "Tavi, what do you think you were playing at?"

Tavi waved his hand, trying not to let it tremble. "Bartos, sir, I'm sorry. I shouldn't have spoken to you like that. I offer you my apologies, but I felt it was necessary to appear to be your superior."

The *legionare* traded looks with some of his companions, then asked, "Why?"

"You hesitated. He would have attacked you."

Bartos frowned. "How do you know?"

Tavi fumbled for words. "I learned a lot on my steadholt. One of the things I learned was how to deal with predators. You can't show them any hesitation or fear, or they'll go for you."

"And you think I was showing him fear?" Bartos demanded. "Is that it? That I was acting like a coward?"

Tavi shook his head, and avoided looking at the *legionare.* "I think the Cane was reading you that way, is all. Body language, stance and bearing, and eye contact, it's all important to them. Not just words."

Bartos's face turned red, but one of the other *legionares* said, "The boy is right, Bar. You always try to slow down when you feel a stupid fight coming on. Try to find a way around it. Maybe today that was just the wrong thing."

The *legionare* glared at the speaker for a moment, then sighed. He went to the ale keg, drew a pair of mugs, and set one of them down in front of Tavi. The boy nodded to him gratefully, and drank the bitter brew, hoping it

would help him calm down. "What did he mean?" Tavi asked. "When he said that we would regret this?"

"Seems pretty plain," Bartos said. "I'd be careful walking down dark passages alone for a while, lad."

"I should go back to the First Lord," Tavi said. "He seemed concerned. Could you please ask Sir Miles to hurry?"

"Sure, kid," Bartos said. Then he let out a low laugh. "Crows and furies, but you've got a set of balls on you. Pulling that knife."

"Bad breath," said one of the other *legionares,* and the room burst into general laughter.

Tavi smiled, got his hair rumpled by half a dozen soldiers, and made his exit as quickly as he could, to hurry down the stairs to the First Lord's side.

He hadn't made it all the way when he heard slow, hard, thudding boots on the stairs above him. He slowed down and Sir Miles appeared above him, leaping down stairs half a dozen at a step. Tavi swallowed. The pace had to be hideously painful to Miles's wounded leg, but the man was a strong metalcrafter, and the ability to ignore pain was a discipline of furycrafting the strongest among them often developed.

Tavi started hurrying down as well, and he managed to arrive at the bottom of the stairs just behind Miles, who stopped in shock and stared at the still form of Gaius on the floor. He went to his side, felt the First Lord's throat, then peeled back an eyelid to peer at his eyes. Gaius never stirred.

"Bloody crows," Miles said. "What happened?"

"He collapsed," Tavi panted. "He said that he'd tried as hard as he could and that it wasn't enough. He showed me where a town by the ocean was torn apart by storms. He was . . . I'd never seen him like that, Sir Miles. Screaming. Like he wasn't . . ."

"Wasn't in control of himself," Miles said quietly.

"Yes, sir. And he was coughing. And drinking spicewine."

Miles winced. "It isn't spicewine."

"What?"

"It's a health tonic he uses. A drug that dulls pain and makes you feel as if you aren't tired. He was pushing himself past his limits, and he knew it."

"Will he be all right?"

Miles looked up at him and shook his head. "I don't know. He might be fine after he gets some rest. Or he might not live the night. Even if he does, he might not wake up."

"Crows," Tavi said. A pain shot through his stomach. "Crows, I didn't do the right thing. I should have sent for a healer at once."

Miles's eyebrows shot up. "What? No, boy, you did exactly the right thing." The grizzled soldier raked his fingers back through his hair. "No one can know what has happened here, Tavi."

"But—"

"I mean *no one*," Miles said. "Do you understand?"

"Yes, sir."

"Killian," Miles muttered. "And . . . crows take it, I don't know if there's anyone else who can help."

"Help, sir?"

"We'll need a healer. Killian doesn't watercraft, but he has some skill as a physician, and he can be trusted. But I've got to have the Legion ready for review at Wintersend. It would cause too many questions if I did not. And Killian can't care for Gaius alone."

"I'll help," Tavi said.

Miles gave him a brief smile. "I had already assumed you would be willing. But you can't suddenly vanish from the Academy during the week of your finals. The absence of the First Lord's favorite page will not go unremarked."

"Then we'll need more help," Tavi said.

Miles frowned. "I know. But I don't know any others I can absolutely trust."

"None?" Tavi asked.

"They died twenty years ago," Miles said, his voice bitter.

"What about the Cursors?" Tavi said. "Surely they can be trusted."

"Like Fidelias?" Miles spat. "The only one of them I might take a chance on is Countess Amara, and she isn't here."

Tavi stared at the unconscious First Lord. "Do you trust me?"

Miles arched a brow sharply.

"Tell me what you need. Maybe I know someone who could help us."

Miles exhaled slowly. "No. Tavi, you're smart, and Gaius trusts you, but you're too young to know how dangerous this is."

"How dangerous will it be if we *have* no one to help, sir? Do we let him lie there and hope for the best? Is that less dangerous than taking a chance on my judgment?"

Miles opened his mouth, then closed it, clenching his teeth. "Crows. You're right. I hate it, but you are."

"So what do you need?"

"A nurse. Someone who can do all the day-to-day feeding and caring for him. And a double, if we can get one."

"Double?"

Miles clarified. "An imposter. Someone who can appear at events Gaius would attend. To be seen walking around. To eat the First Lord's breakfasts and otherwise make sure everyone thinks things are business as usual."

"So you need a strong watercrafter. Someone who can alter his appearance."

"Yes. And not many men have that much skill at water. Even if they have the talent. It's just . . . not masculine."

Tavi sat down on his heels, facing Miles. "I know two people who can help."

Miles's eyebrows went up.

"The first one is a slave. His name is Fade. He works in the kitchens and the gardens at the Academy," Tavi said. "I've known him since I was born. He doesn't seem very bright, but he hardly ever talks, and he's good at not being noticed. Gaius brought him here with me when I came."

Miles pursed his lips. "Really? Fine. I'll have him transferred to me to help with last-minute work. No one will notice something like that before Wintersend. The other?"

"Antillar Maximus," Tavi said. "He's got almost as many water beads on his lanyard as anyone at the Academy, and he's lost a bunch of them."

"High Lord Antillus's bastard?" Miles asked.

Tavi nodded. "Yes, sir."

"Do you really believe you can trust him, Tavi?"

Tavi took a deep breath. "With my life, sir."

Miles let out a rough laugh. "Yes. That's precisely what we're speaking about. Is he skilled enough to alter his form?"

Tavi grimaced. "You're asking exactly the wrong person about furycrafting, sir. But he hardly ever practices his crafting and still scores the highest in his classes. You might also consider letting me contact—"

"No," Miles said. "Too many people will know already. No more, Tavi."

"Are you sure?"

"I'm sure. You are to tell no one anything, Tavi. You are to make sure no one gets close enough to realize what has happened. You are to take any measures necessary to do so." He turned his face up to Tavi, and Miles's flat

eyes chilled him to the core. "And I am going to do exactly the same thing. Do you understand me?"

Tavi shivered and looked down. Miles hadn't laid his hand on his sword for emphasis. He hadn't needed to. "I understand, sir."

"Are you sure you want your friends to be involved in this?"

"No," Tavi said, quietly. "But the Realm needs them."

"Aye, boy. It does." Miles sighed. "Though who knows. With luck, maybe it will work without trouble."

"Yes, sir."

"Now. I'll stay here. You fetch Killian and the others." He knelt by the First Lord again. "The Realm itself may be depending on us, boy. Keep everyone away from him. Tell no one."

"I'll keep everyone away from him," Tavi repeated dutifully. "And I'll tell no one."

CHAPTER 10

"Stop worrying," Bernard said. "So long as you speak to Gaius right away, we should be fine."

"Are you sure?" Isana asked. "That it won't come to fighting?"

"As sure as anyone can be," Bernard assured his sister from the door to her bedroom. Morning sunlight slanted across the floor in golden stripes through the narrow windows. "I'm not eager to see more good people get hurt. All I want to do is make sure these vord stay where they are until the Legions arrive."

Isana finished binding her dark, silver-threaded hair into a tight braid, and regarded her reflection in the dressing mirror. Though she wore her finest dress, she knew perfectly well that the clothing would be laughably crude and lacking in style in Alera Imperia, the capital. Her reflection looked lean, uncertain, and worried, she thought. "Are you sure they won't attack you first?"

"Doroga seems confident that we have a little time before they'd be ready to do that," Bernard said. "He's sent for more of his own tribesmen, but they're in the southern ranges, and it may be two or three weeks before they arrive."

"And what if the First Lord does not order the Legions to help?"

"He will," Amara stated, her voice confident as she entered the room. "Your escorts are here, Isana."

"Thank you. Does that look all right?"

Amara adjusted the fore of Isana's sleeve and brushed off a bit of lint. "It's lovely. Gaius has a great deal of respect for Doroga, and for your brother. He'll take their warning seriously."

"I'll go to him at once," Isana replied. Though she by no means relished the notion of speaking to Gaius. That old man's eyes saw too much for her comfort. "But I know that there are many protocols involved in gaining an audience. He *is* the First Lord. I'm only a Steadholder. Are you sure I'll be able to reach him?"

"If you aren't, speak to Tavi," Amara said. "No one could deny you the right to visit your own nephew, and Tavi often serves as His Majesty's page. He knows the First Lord's staff and guards. He'll be able to help you."

Isana looked aside at Amara and nodded. "I see," she said. "Two years. Will I recognize him?"

Amara smiled. "You may need to stand a few stairs above him to get the same perspective. He's put on height and muscle."

"Boys grow," Isana said.

Amara regarded her for a moment, then said, "Sometimes the Academy can change people for the worse. But not Tavi. He's the same person. A good person, Isana. I think you have every right to be proud of him."

Isana felt a flash of gratitude toward Amara. Though she had never shared any such words or emotions before, Isana could feel the woman's sincerity as easily as she could see her smile. Cursor or not, Isana could tell that the words were precisely what they seemed to be—honest praise and reassurance. "Thank you, Countess."

Amara inclined her head in a gesture that matched the sense of respect Isana felt from the younger woman. "Bernard?" Amara said. "Would you mind if I had a few words with the Steadholder?"

"Not at all," Bernard said amiably.

Isana stifled a laugh that threatened to bubble from her mouth.

After a moment, Amara arched an eyebrow, and said, "Privately?"

Bernard blinked and stood up at once. "Oh. Right, of course." He looked back and forth between them suspiciously. "Um. I'll be out at the barn. We should be on the move in an hour. I've got to make sure Frederic— excuse me, *Sir* Frederic hasn't wandered off and forgotten his head."

"Thank you," Isana said.

Bernard winked at her, touched Amara's hand, and left the room.

Amara shut the door and laid her fingers against it. She closed her eyes for a moment, and then Isana again felt that odd tightness to the room. There was a brief pain in her ears.

"There," Amara said. "I apologize. But I must be sure we are not over-heard."

Isana felt her eyebrows rise. "Do you expect spies in my household now?"

"No. No, Steadholder. But I needed to speak with you about something personal."

Isana rose and tilted her head slightly to one side. "Please explain."

Amara nodded. The shadows under her eyes were deeper than they had been before. Isana frowned, studying the young woman. Amara was only a few years out of the Academy herself, though Isana was sure the Cursor had led a more difficult life than most. Amara had aged more quickly than a young woman should, and Isana felt a surge of compassion for her. In all that had happened, she sometimes forgot how very young the Countess was.

"Steadholder," Amara said, "I don't know how to ask this, but simply to ask it." She hesitated.

"Go on," Isana said.

Amara folded her arms and didn't look up. "What have I done to wrong you, Isana?"

The sense of raw pain and despair that rose from the girl closed around Isana like a cloud of glowing embers. She turned away and walked to the far side of the room. It required a significant effort to control her expression, and to keep her thoughts calm. "What do you mean?"

Amara shrugged with one shoulder, and Isana's sense of the young woman became tinged with embarrassment. "I mean that you don't like me. You've never treated me badly. Or said anything. But I also know that I am not welcome in your home."

Isana took a deep breath. "I don't know what you mean, Amara. Of course you're welcome here."

Amara shook her head. "Thank you for trying to convince me. But I've visited you several times over the past two years. And you've never once turned your back on me. You've never sat at the same table as me, or taken a meal with me—you serve everyone else instead. You never meet my eyes when you speak to me. And until today, you've never been alone in a room with me."

Isana felt her own brow furrow at the young woman's words. She began to answer, then remained silent. Was the Cursor right? She raked back through the memories of the past two years. "Furies." She sighed. "Have I really done that?"

Amara nodded. "I thought that . . . that I must have done something to warrant it. I was hoping that a little time would smooth things over, but it hasn't."

Isana gave her a fleeting smile. "Two years isn't much time when it comes to healing some hurts. It can take longer. A lifetime."

"I never meant to hurt you, Isana. Please believe me. Bernard adores you, and I would never intentionally do you wrong. If I have said or done anything, please tell me."

Isana folded her hands in her lap, frowning down at the floor. "You've never done anything of the sort. It was never you."

Frustration colored Amara's voice. "Then why?"

Isana pressed her lips together hard. "You're a loyal person, Amara. You work for Gaius. You are sworn to him."

"Why should that offend you?"

"It doesn't. But Gaius does."

Amara's lips firmed into a line. "What has he shown you other than generosity and gratitude?"

A stab of hot, bitter hatred shot through Isana, and her words crackled with it. "I was nearly killed today because of his gratitude and generosity. I'm only a country girl, Amara, but I'm not an idiot. Gaius is using me as a weapon to divide his enemies. Bernard's appointment to Count Calderon over the heads of the noble Houses of Riva is a direct reminder to them that Gaius, not Rivus, rules Alera. We are simply tools."

"That isn't fair, Isana," Amara said, but her voice was subdued.

"Fair?" Isana demanded. "Has he been fair? The status and recognition

he gave us two years ago was not a reward. He created a small army of ene-
mies for my brother and me, then whisked Tavi off to the Academy under
his patronage—where I am certain my nephew has found others who
strongly dislike and persecute him."

"Tavi is receiving the finest education in Alera," Amara stated. "Surely
you don't begrudge him that. He's healthy and well. What harm has that
done to him?"

"I'm sure he is healthy. And well. And learning. It's a marvelously polite
way to hold Tavi hostage," Isana replied. The words tasted bitter in her
mouth. "Gaius knows how much Tavi wanted to go to the Academy. He
knows that it would destroy him to be sent away. Gaius manipulated us. He
left us with no alternative but to throw in our lot with him as strongly as pos-
sible if we were to survive."

"No," Amara said. "No, I won't believe that of him."

"Of course you won't. You're loyal to him."

"Not mindlessly," Amara said. "Not without reason. I've seen him. I
know him. He's a decent man, and you're interpreting his actions in the
worst possible light."

"I have reason," Isana said. Some part of her felt shocked at the venom
and ice in her voice. "I have reason."

Amara's expression and bearing flickered with concern. Her voice re-
mained gentle. "You hate him."

"*Hate* is too mild a word."

Amara blinked several times, bewildered. "Why?"

"Because Gaius killed my . . . younger sister."

Amara shook her head. "No. He isn't that way. He is a strong Lord, but
he is no murderer."

"He didn't do it directly," Isana said. "But the fault lies on him."

Amara fretted her lower lip. "You hold him responsible for what hap-
pened to her."

"He *is* responsible. Without him, Tavi might still have a mother. A father."

"I don't understand. What happened to them?"

Isana shrugged one shoulder. "My family was a poor one, and my sister
did not wed by her twentieth birthday. She was sent to the Crown Legion
camp for a term of domestic service. She met a soldier, fell in love, and bore
him a child. Tavi."

Amara nodded slowly. "How did they die?"

"Politics," Isana said. "Gaius ordered the Crown Legion moved to the Calderon Valley. He was making a statement to Riva during a period of turmoil, and patronizing the Senate by placing a Legion in a position to deter a Marat horde from invading while simultaneously giving Lord Rivus a warning that his Legion was at hand."

Amara made a quiet, hissing sound. "The First Battle of Calderon."

"Yes," Isana said quietly. "Tavi's parents were there. Neither survived."

"But Isana," Amara said, "the First Lord did not mandate their deaths. He placed a Legion in harm's way. That's *why* they *exist*. The loss was tragic, but you can't blame Gaius for not foreseeing the Marat horde that even surprised his own commanders in the field."

"They were there on his orders. It was his fault."

Amara squared her shoulders and set her jaw. "Great furies, Steadholder. His own *son* was killed there."

"I know that," Isana spat. More words struggled to flow from her mouth, but she shook her head and stopped them. It was a struggle, so intense was the tide of hatred in her heart. "That isn't all that I blame him for." She closed her eyes. "There are other reasons."

"And they are?" Amara asked.

"My own."

The Cursor was silent for a long moment, then nodded. "Then . . . I suppose we must agree to disagree on this matter, Steadholder."

"I knew that before this conversation began, Amara," Isana said. The sudden tide of rage was failing, draining away, leaving her tired and unhappy in its wake.

"I know him as a disciplined, capable lord. And as an honorable and forthright man. He has sacrificed much for the sake of the Realm—even his own son. I am proud to serve him as best I may."

"And I will never forgive him," Isana said. "Never."

Amara nodded stiffly, and Isana could feel her distress beneath the polite expression she held on her face. "I'm sorry, Steadholder. After what you went through yesterday . . . I'm sorry. I shouldn't have pushed you."

Isana shook her head. "It's all right, Countess. It's good to have this in the open."

"I suppose," Amara said. She touched the door, and the tense pressure in the very air of the room vanished. "I'll make sure your litter is ready and that your escorts have eaten."

"Wait," Isana said.

Amara paused, her hand on the door.

"You make Bernard very happy," Isana said in a quiet voice. "Happier than I've seen him in years. I don't want to come between you, Amara. We needn't agree about the First Lord for you to stay with him."

Amara nodded and gave her a silent smile, then left the room.

Isana stared at her mirror for a moment, then rose. She went to the chest at the foot of her bed and opened it. She took out piles of bedding, her extra pair of shoes, a spare pillow, and a small wooden box containing bits of silver jewelry she'd acquired over the years. Then she pushed hard on one end of the bottom of the chest, willing Rill to draw the water from the boards there, which shrank and came loose. She removed the dried slats, revealing a small and hidden space beneath them.

She picked up a small silk jewel-pouch. She untied and opened it, and upended the pouch into her palm.

An elegant ring of gleaming silver upon a slender silver chain fell into her palm. It was heavy and cool. The ring was set with a single gem that somehow changed from a brilliant blue diamond to a bloodred ruby down its seamless center. Two carved silver eagles, one slightly larger than the other, soared toward one another to form the setting, holding the gem aloft on their wings.

That old pain and loss filled her as she stared down at the ring. But she did not ask Rill to stop her tears.

She draped the chain over her head, and tucked it away into her dress. She stared at herself in the mirror for a moment, willing the redness from her eyes. She had no more time to waste looking back.

Isana lifted her chin, composed her expression, and left to go to the assistance of the family she loved with all of her heart and the man she hated with all of her soul.

CHAPTER 11

Amara was waiting when the Knights Aeris sent by the Crown swept down from the dark grey clouds overhead. Spring this far north of the capital could be unpleasantly cold and damp, but the rain promised by occasional rumbles of thunder had not yet arrived. Amara recognized the man leading the contingent and briefly considered trying to provoke the water-laden clouds into emptying themselves a bit earlier. Onto his bloated head.

Sir Horatio flew in front of the enclosed litter, his ornamented armor doing its best to gleam on the cloudy day, his red velvet cloak spread behind him. A Knight in a travel harness flew at each corner of the litter, supporting its weight, and four more flew in a loose escort around it. The contingent descended more swiftly than was necessary, and their furies stirred up a miniature cyclone of wild wind that threw Amara's hair around her head and sent a herd of sheep in a nearby pen crowding to its far side for shelter. The holders rushing around preparing supplies and sundries for Bernard's cohort had to shield their eyes against flying straw and dust.

"Idiot," Amara said, sighing, willing Cirrus between herself and the flying debris. Horatio touched down lightly. As a subtribune and Knight of the Crown Legion, he was permitted the gold-and-silver filigree on his armor and the glittering gems on both his helmet and the hilt of his sword, but the gold embroidery on his velvet cloak was a bit much. Horatio had made a fortune winning the Wind Trials, the yearly race of aircrafters during Wintersend, and he liked everyone to know it.

Of course, he was less eager for them to know that he had lost the lion's share of his riches the first year Amara had entered the event. He would never let her forget that, though she supposed she might not feel inclined to be particularly polite to a person who had cost her that much money, either. She waited until the Knights had settled in the steadholt's courtyard, then approached.

"Good day, sir!" boomed Horatio in a brassy baritone. "Oh, wait. Not sir,

at all. That's you, Countess Amara. Forgive me, but from there you looked like a young man."

A few years before, the insult to her physique would have stung her sorely. But that was before she'd become a Cursor. And before Bernard. "That's perfectly all right, Sir Horatio. We all expect men of your age to begin experiencing certain deficiencies." She bowed to him with courtly grace, and did not miss a low round of chuckles from the other Knights.

Horatio returned her bow with a brittle smile and glared at the men behind him. All eight Knights found other places to direct their gazes and assumed professionally bored expressions. "Of course. I assume our passenger is ready to leave?"

"Shortly," Amara said. "I'm sure the kitchen will have something hot for your men to eat while you wait."

"That isn't necessary, Countess," Horatio said. "Please inform Holder Isana that we await her arrival so that we may depart."

"You await *Steadholder* Isana's convenience," she said, deliberately letting her voice carry through the courtyard. "And as you are a guest at her steadholt, subtribune, I expect you to behave with the courtesy expected of a Knight and soldier of the Crown Legion to a Citizen of the Realm."

Horatio's eyes narrowed, hot with anger, but he gave her the smallest of bows in acknowledgment.

"Furthermore," she continued, "I strongly advise you to let your men rest and eat while they have the opportunity. If the weather worsens, they will need their strength."

"I do not take orders from you regarding the disposition of my command, Countess," Horatio snapped.

"Goodness," said a woman's voice from within the litter. "Perhaps we should hand you each a bone, and you can simply bludgeon one another to death. I can't think of a faster way to end this unseemly display. Rolf, please?"

One of the Knights immediately stepped to the side of the litter, opened the door, and offered a polite hand to assist as a tiny woman emerged into the grey light. She might have been almost five feet tall, but even at that height, she looked frail and delicate, as light-boned as a Parcian swallow. She had skin the color of dark honey, and fine, shining hair darker than wet coal. Her gown was made of rich silk, though in subtle shades of brown and grey, and its neckline plunged far more deeply than would be considered

proper to any woman of any station whatsoever. Her features were haunt-
ingly lovely, with dark eyes almost too large for her face, and twin ropes of
the sunset-colored pearls from the seas near her home province wound
through her hair and were matched by a second pair of strands around
her throat.

The pearls of the necklace were priceless and lovely—but they did not
conceal the fact that they were mounted to an elegant slave's collar.

"Amara," the woman said, her mouth parting in a wide smile. "Only a
few years out of the civilized south, and you've turned savage." She extended
her hands. "You've probably forgotten all about me."

Amara felt a laugh ripple from her mouth as she replied. "Serai," she
said, stepping forward to take her hands. As always, standing before Serai's
exquisite beauty made her feel tall and awkward, and, as always, she did not
at all mind. "What are you doing here?"

Serai's eyes sparkled with silent laughter, and she swayed a little on her
feet. "Oh, darling, I am simply perishing of fatigue. I thought I would be
fine, but I've been so frail of late." She leaned on Amara's arm, and turned a
gaze on Horatio that would have melted the heart of an Amaranth mer-
chant. "Subtribune, I apologize for my weakness. But would it be all right
with you if I sat down for a bit and perhaps had some refreshment before we
depart?"

Horatio looked frustrated for a moment, glowered at Amara, then said,
"Of course, Lady Serai."

Serai smiled wanly at him. "I thank you, milord. I hate to see you and
your men suffer on my account. Will you not join me at the table?"

Horatio rolled his eyes and sighed. "I suppose a gentleman could do lit-
tle else."

"Of course not," Serai said, patting his arm with a tiny hand, then lightly
tracing the pearls at her throat. "The obligations of station enslave us all at
times." She turned to Amara, and said, "Is there somewhere I could freshen
up, darling?"

"Of course," Amara said. "This way, Lady Serai."

"Bless you," Serai said. "Subtribune, I will join you and your men in the
dining hall presently." She walked out, a hand still on Amara's arm, and gave
a winsome smile to the Knights Aeris as she passed them. The men returned
smiles and speculative looks as the slave passed.

"You're an evil woman," Amara murmured, once they were out of

earshot. "Horatio will never forgive you for manipulating him like that in public."

"Horatio only has his continued command because of talented subordinates," Serai responded, laughter dancing in her words. A wicked glint touched her eyes. "In Rolf's case, *very* talented."

Amara felt her cheeks redden. *"Serai."*

"Well, darling, what do you expect? One can hardly be a courtesan without indulging in certain improprieties." She touched her lips with her tongue. "In Rolf's case, quite a bit of indulgence. Suffice to say that Horatio is no threat to me, and how well he knows it." Serai's smile faded. "I almost wish Horatio would try something. It would be a pleasant diversion."

"What do you mean?"

Serai glanced up at her, her eyes opaque, and said, "Not outdoors, darling."

Amara frowned, then fell silent and led Serai into the steadholt, and to the guest quarters above the main hall. She gave Serai a few moments inside, then slipped in behind her, and asked Cirrus to seal off the room from potential listeners. Once the air had tightened around them, Serai sank down onto a stool, and said, "It's good to see you again, Amara."

"And you," Amara answered. She knelt on the floor beside Serai, so that their eyes were on a level. "What are you doing here? I expected the Cursor Legate to send Mira or Cassandra."

"Mira was murdered near Kalare three days ago," Serai responded. She folded her hands, but not before Amara saw how the courtesan's fingers shook. "Cassandra has been missing from Parcia for several days. She is presumed dead or compromised."

Amara felt as though someone had punched her in the belly. "Great furies," she breathed. "What has happened?"

"War," Serai responded. "A quiet war fought in alleyways and service corridors. We Cursors are being hunted and killed."

"But who?" Amara breathed.

Serai moved a shoulder in a slow shrug. "Who? Our best guess is Kalare," she said.

"But how did he know where to hit us?"

"Treachery, of course. Our people have been killed in their beds, their baths. Whoever these people are, someone who knows us is telling them where to strike."

"Fidelias," Amara said. The word tasted bitter.

"Potentially," Serai said. "But we must assume that there may be some-one else within the Cursors—and that means that we cannot trust anyone, Cursor or otherwise."

"Great furies," Amara breathed. "What about the First Lord?"

"Communications have been severely disrupted throughout the southern cities. Our channels to the First Lord have gone silent."

"What?"

"I know," Serai said. The tiny woman shivered. "My initial orders from the Cursor Legate were to dispatch an agent to your command to escort Steadholder Isana to Festival. But once this began happening it became clear that attempting to make contact with other Cursors would be dangerous. I had to speak to someone I trusted. So I came here."

Amara took Serai's hands in her own and squeezed tightly. "Thank you."

Serai answered with a wan smile. "We must assume that word has not reached the First Lord about the situation."

"You intend to use Isana to approach him in person," Amara said.

"Precisely. I can't think of a safer way to go about it."

"It might not be so safe," Amara said. "An assassin attempted to kill Steadholder Isana yesterday morning. He was using a Kalaran knife."

Serai's eyes widened. "Great furies."

Amara nodded with a grimace. "And she's lived her entire live in the provinces. She can't enter the capital unguided. You'll need to show her around the political circles." She exhaled. "And you must be very careful, Serai. They'll try to remove her before the presentation ceremony."

Serai chewed on her lip. "I'm no coward, Amara, but I'm not a body-guard, either. There's no way I can protect her from trained assassins. If that is the situation, I need you to come with us."

Amara shook her head. "I can't. Matters have developed locally." She explained what Doroga had told them about the vord. "We can't afford to let them spread and multiply. The local garrison will need every crafter they can get to make sure these creatures do not escape again."

Serai arched an eyebrow. "Darling, are you sure about this? I mean, I know you've had some contact with these barbarians, but don't you think that they might be exaggerating the truth?"

"No," Amara said quietly. "In my experience, they don't know how to

exaggerate. Doroga arrived here yesterday with fewer than two hundred survivors from a force of two thousand."

"Oh come now," Serai said. "That must be an outright lie. Even a Legion's morale would break well before that."

"The Marat are not *legionares,*" Amara said. "They aren't like us. But consider this—they fight, men and women and children together, beside their family and friends. They will not desert them, even if it means dying beside them. They consider the vord to be the same sort of threat—not just to their territory, but to their families and lives."

"Even so," Serai said. "You aren't a battlecrafter, Amara. You're a Cursor. Let those whose duties call them to a soldier's work do their part. But you must serve your calling. Come with me to the capital."

"No," Amara said. She paced to the window and stared out of it for a moment. Bernard and Frederic were lifting a pair of vast hogsheads of preserved foodstuffs onto racks on either side of a gargant's pack harness. The bull yawned, scarcely noticing what must have been half a ton of burden the two earthcrafters had casually lifted into place. "The garrison here lost most of its Knights Aeris at Second Calderon, and it has been difficult to replace them. Bernard may need me to help him by carrying messages or flying reconnaissance."

Serai let out a small gasp.

Amara turned, frowning, to find the tiny courtesan staring at her with her mouth open.

"Amara," Serai accused. "You're his lover."

"What?" Amara said. "That isn't what—"

"Don't bother trying to deny it," Serai said. "You were *looking* at him out there, weren't you?"

"What does that have to do with anything?" Amara asked.

"I saw your eyes," Serai said. "When you called him Bernard. He was out there doing something manly, wasn't he?"

Amara felt her face heat up again. "How did you—"

"I know these things, darling," she said airily. "It's what I do." The little woman crossed the room to stare out the window at the courtyard, and arched an eyebrow. "Which is he?"

"Green tunic," Amara supplied, stepping back from the window. "Loading the gargant. Dark hair, beard, a little grey in them."

"My," said Serai. "But hardly old. Went silver early, I'd say. That's always attractive in a man. It means he has both power enough to have responsibilities and conscience enough to worry over them. And—" She paused and blinked. "He's rather strong, isn't he?"

"He is," Amara said. "And his archery is amazing."

Serai gave her an oblique look. "I know it's petty and typical, but there *is* an undeniable, primal attraction in a man of strength. Wouldn't you agree?"

Amara's face burned. "Well. Yes. It suits him." She took a breath. "And he can be so gentle."

Serai gave her a dismayed look. "Oh, my. It's worse than I feared. You're not his lover. You're in *love*."

"I'm not," Amara said. "I mean. I see him fairly often. I've been Gaius's courier to the region since Second Calderon and . . ." Her voice trailed off. "I don't know. I don't think I've ever been in love."

Serai turned her back to the window. Over her shoulder, Amara could see Bernard giving directions to a pair of men hitching up heavy work horses to a wagon of supplies, then checking the beast's hooves. "Do you see him often enough?" Serai asked.

"I . . . I wouldn't mind being near him more."

"Mmmhmm," she said. "What do you like best about him?"

"His hands," Amara said at once. The answer came out before she'd had time to think it through. She felt herself blush again. "They're strong. The skin a little rough. But warm and gentle."

"Ah," said Serai.

"Or his mouth," Amara blurted. "I mean, his eyes are a lovely color, but his mouth is . . . I mean, he can . . ."

"He knows how to kiss," Serai said.

Amara stammered to a silence and simply nodded.

"Well," Serai said, "at this point, I think it's safe to say that you know what love feels like."

Amara bit her lip. "You really think that?"

The courtesan smiled, something wistful in it. "Of course, darling."

Amara watched the courtyard as a pair of boys, no more than six or seven years of age, leapt from hiding places in the wagon to Bernard's back. The big man roared in feigned outrage, and went spinning around for a few moments as though trying to reach them, until the boys lost their grips and fell to the ground, lurching dizzily and laughing. Bernard grinned at them,

ruffled their hair, and sent them on the way with a wave of his hand. Amara found herself smiling.

Serai's voice became lower and very gentle. "You must leave him, of course."

Amara felt her spine stiffen. She stared past the other woman, out the window.

"You are a Cursor," Serai said. "One with the trust of the First Lord himself. And you have sworn your life to his service."

"I know that," Amara said. "But—"

Serai shook her head. "Amara, you can't do that to him if you truly love him. Bernard is a peer of the Realm, now. He has duties, responsibilities. One of them will be to take a wife. A wife whose first loyalty will be to him."

Amara stared at Bernard and the two children. Her vision suddenly blurred with hot tears.

"He has duties," Serai said, her voice compassionate, but resolute. "And among them is the duty to sire children so that the furycraft in his blood will strengthen the Realm."

"And I was blighted," Amara whispered. She pressed her hand against her lower belly, and could almost feel the nearly invisible scars from the pockmarks the disease had left. She tasted bitter bile on her tongue. "I can't give him children."

Serai shook her head and turned to stare out the window down at the courtyard. Frederic herded a second pair of enormous gargants into the yard and began hitching up their cargo harnesses with Bernard, while other holders came and went in a constant stream, placing sacks and boxes on the ground to be loaded on the beasts once they were ready. Then Serai stood on tiptoe, and gently drew down the shade.

"I'm sorry, darling."

"I never thought it through," Amara said. More tears fell. "I mean. I was just so happy, and I never . . ."

"Love is a fire, Amara. Draw it too close and be burned." Serai stepped over to Amara and touched her cheek with the back of her hand. "You know what you must do."

"Yes."

"Then best to make it quick. Clean." Serai sighed. "I know what I'm talking about. I'm so sorry, darling."

Amara closed her eyes and leaned her head miserably against Serai's touch. She couldn't stop the tears. She didn't try.

"So much is happening, and all at once," Serai said after a moment. "It can't be a coincidence. Can it?"

Amara shook her head. "I don't think it can."

"Furies," Serai breathed. Her expressive eyes looked haunted.

"Serai," Amara said quietly, "I believe there is a real threat to the Realm here. I'm going to stay."

Serai blinked up at her. "Darling, of *course* you're going to stay. I don't need a bodyguard who is pining over a man like this—you're useless to me."

Amara choked on a small roll of laughter that came up through her at Serai's words, and she folded her arms around the courtesan in a tight hug. "Will you be all right?"

"Of course, darling," Serai said. But though her voice was warm, amused, Amara felt the little courtesan trembling. Serai probably felt Amara's shivering in return.

Amara drew back, her hands on Serai's shoulders, and met her gaze. "Duty. The vord may be inside the capital. More killers are probably looking for the Steadholder even now. Cursors are being murdered. And if the Crown doesn't send reinforcements to the local garrison, more holders and *legionares* are going to die. Likely me with them."

Serai's eyes closed for a moment, and she bobbed her head in a brief nod. "I know. But . . . Amara, I'm afraid . . . afraid I am not suited for this kind of situation. I work in grand halls and bedchambers with wine and perfume. Not in dark alleyways with cloaks and knives. I don't like knives. I don't even *own* a knife. And my cloaks are far too expensive to risk bloodying."

Amara gently squeezed her shoulders, smiling. "Well. Perhaps it will not come to that."

Serai gave Amara a shaky smile. "I should hope not. It would be most awkward." She shook her head and smoothed the anxiety from her expression. "Look at you, Amara. So tall and strong now. Nothing like the farm girl I saw flying over the sea."

"It seems so long ago," Amara said.

Serai nodded, and touched a stray hair back from her cheek. Her expression became businesslike. "Shall we?"

Amara lifted her hand and the pressure of Cirrus's warding vanished. "Isana should be ready to leave shortly. Be cautious and swift, Serai. We are running out of time."

CHAPTER 12

It took Tavi three hours to find Max, who was indeed at a young widow's house. He spent another hour finding a way into the house, and half an hour more to get his friend conscious, dressed, and staggering back up through the furylit streets of the capital to the Citadel. By the time the lights of the Academy loomed up above them, it was the most silent hour of the night, in the hollow, cold time just before dawn began to color the sky.

They entered through one of a sprinkling of unseen entrances provided for the use of the Cursors-in-Training at the Academy. Tavi dragged his friend down to the baths straightaway, and without ceremony shoved him into a large pool of cold water.

Max, of course, had the phenomenal recuperative abilities of anyone with his raw furycrafting power, but he had developed a correspondingly formidable array of carousing talents by way of compensation. It wasn't the first time Tavi had administered an emergency sobering after one of Max's nights on the town. The shock of the water had the large young man screaming and thrashing in a heartbeat, but when he lurched to the stairs up out of the water, Tavi met him, turned Max around, and pushed him back into the pool.

After a dozen more plunges into the freezing pool, Max pressed his hands against the sides of his head with a moan. "Great furies, Calderon, I'm awake. Would you let me out of the blighted, crows-begotten ice water?"

"Not until you open your eyes," Tavi said firmly.

"Fine, fine," Max growled. He turned a bloodshot glare upon Tavi. "Happy now?"

"Joyous," Tavi replied.

Max grunted, lumbered from the icy pool, and fumbled his clothes off, then shambled into the warm, sun gold furylit waters of one of the heated baths. As always, Tavi's eyes were drawn to the crosshatched network of scars on his friend's back—the marks of a whip or a ninecat that could only have been formed before Max came into his furycrafting power. Tavi winced

in sympathy. No matter how many times he saw his friend's scars, they remained something startling and hideous.

He glanced around the baths. The room was enormous, with several different bathing pools trickling falls of water filling up a vast room with white marble walls, floor, pillars, and ceiling. Batches of plants, even trees, softened the severe, cold marble surroundings, and lounges were laid out in a dozen different areas, where bathers might idle in one another's company while awaiting their turn at a pool. Soft furylamps of blue, green, and gold painted each pool, giving an indication of its temperature. The sound of falling water bounded back and forth from the indifferent stone, filling the air with sound enough to mask voices more than a few steps away. It was one of the only places in the capital where one could be reasonably certain of a private conversation.

The baths were yet empty—the slaves who attended bathers would not arrive for more than an hour. Tavi and Max were alone.

Tavi stripped, though much more self-consciously than his friend. Back at the steadholt, bathing was a matter of privacy and practicality. It had been an adjustment to engage in the more metropolitan practice of bathing followed in most of the cities, and Tavi had never managed to lose entirely the twinge of discomfort he felt when disrobing.

"Oh for crying out loud, bumpkin," Max said, without opening his eyes. "It's the men's baths. There's no one else here, and my eyes aren't even open." He gave Tavi another glare, though it was less intense than the first. "If you'd left me where you found me, you could have had the baths to yourself."

Tavi slid into the pool beside Max and pitched his voice low, barely audible over the obscuring sounds of water. "There's trouble, Max."

Max's glower vanished, and his reddened eyes glittered with sudden interest. "What kind of trouble?"

Tavi told him.

"Bloody crows!" Max roared. "Are you trying to get me *killed?*"

"Yes. To tell you the truth, I never had much use for you, Max." Tavi watched his friend blink at him for a second, then scowl.

"Hah-hah," said Max. "You're hilarious."

"You should know better than that," Tavi replied. "If there was anyone else I thought could do this, I wouldn't have gotten you involved."

"You wouldn't?" Max asked, his tone suddenly offended. "Why not?"

"Because you've known what's going on for ten seconds, and you're already complaining."

"I like complaining. It's every soldier's sacred *right*," Max growled.

Tavi felt a smile tug at his lips. "You're not a *legionare* anymore, Max. You're a Cursor. Or a Cursor-in-Training, anyway."

"I'm still offended," Max declared. After a moment, he added, "Tavi, you're my friend. If you need help, just expect me to be there whether you want me there or not."

Tavi chewed at his lip, regarding Max. "Really?"

"It'll be simpler that way," Max drawled. "So. I'm to double for Gaius, eh?"

"Can you?" Tavi asked.

Max stretched out in the hot water with a confident smile in answer. "No idea."

Tavi snorted, went to the waterfall, took up a scrubber, and began raking it over his skin, cleaning the sweat and toil of the day from him before taking up a soaped comb and raking it quickly through his hair. He rose to rinse in a cooler pool and emerged shivering to towel himself dry. Max emerged from the pools a few moments later, similarly scrubbed, and the pair of them changed into the clean clothes they'd last left with the bath attendants, leaving their soiled garments behind on their respective shelves.

"What do I do?" Max asked.

"Go to the Citadel, down the south gallery and to the west hall to the staircase down."

"Guard station there," Max noted.

"Yes. Stop at the first station, and ask for Sir Miles. He's expecting to hear from you. Killian will probably be there, too."

Max raised his eyebrows. "Miles wanted to bring in the Cursors? I'd have thought he wouldn't hold with too much of that."

"I don't think Miles knows that Killian is still on active duty," Tavi said. "Much less that he's the current Legate."

Max slapped an annoyed hand at his head, sprinkling water out of his close-cropped hair. "I am going to lose my mind, trying to keep track of who is allowed to know what."

"You're the one who agreed to Cursor training," Tavi said.

"Stop walking on my sacred right, Calderon."

Tavi grinned. "Just do what I do. Don't tell anyone anything."

Max nodded. "That's a solid plan."

"Let's move. I'm supposed to bring someone else down. I'll meet you there."

Max rose to leave, but paused. "Tavi," he said. "Just because I'm not complaining doesn't mean this won't be dangerous. Very dangerous."

"I know."

"Just wanted to make sure you did," Max said. "If you get in trouble . . . I mean, if you need my help. Don't let your pride keep you from asking for it. I mean, it's possible that some serious battlecrafting could start happening. If it does, I'll cover you."

"Thank you," Tavi said, without much emotion. "But if it comes to that, we've probably failed so badly that my own personal legion wouldn't help."

Max gave a rueful laugh of agreement, squared his shoulders, and stalked out of the baths without looking behind him. "Watch your back."

"You too."

Tavi waited a moment until Max had left the baths, then hurried out of them and toward the servants' quarters. By the time he'd arrived, a swath of light blue on the eastern horizon of the night sky had arrived to herald the coming dawn, and the staff of the Academy was beginning to stir. Tavi wound his way cautiously down service corridors and cramped staircases, careful to avoid being seen. He moved in silence through the darkened corridors, bearing no lamp of his own, relying upon infrequent, feeble hallway lights. Tavi stalked down a final cramped corridor, and to a half-sized door that opened into a crawl space in the walls—Fade's chamber.

Tavi listened intently for any approach, and once he was sure he was not being idly observed, he opened the door and slipped inside.

The slave's room was musty, cold, and dank. It was nothing more than an inefficiency of design, bounded on two walls with stone of the Academy and on the others with rough plaster. The ceiling was barely five feet high and contained nothing more than a battered old trunk with no lid and an occupied sleeping palette.

Tavi moved in silence to the palette, and reached down to shake its occupant.

He realized half a breath later that the form under the blankets was simply a bundle of bedding, piled into place as a distraction. Tavi turned, crouched, his hand moving to his dagger, but there was swift and silent motion in the darkness, and someone smoothly took the weapon from his belt, slammed Tavi hard with a shoulder, and sent him off-balance to the ground. His attacker followed closely, and in another breath, Tavi found himself pinned by a knee on his chest, and the cold edge of his own weapon was pressed to his throat.

"Light," said a quiet voice, and an ancient, dim furylamp on the wall shone scarlet.

The man crouched over Tavi was of unremarkable height and build. His hair fell in ragged strands to his shoulders and over most of his face, brown streaked through with much grey, and Tavi could barely see the gleam of dark eyes behind it. What Tavi could see of the man's visage was hideously marred with the brand the Legions used upon those judged guilty of cowardice. His forearms were as lean and sinewy as the ancient leather slavebraid on his throat, and they were covered in white scars. Some were the tiny, recognizable pockmarks of burns gained at a smith's forge, but others were straight and fine, like those Tavi had seen only upon the arms of old Giraldi back at Garrison and on Sir Miles.

"Fade," Tavi said, his chest tight with the panic caused by the swift attack. His heart pounded hard and fast. "Fade. It's me."

Fade lifted his chin for a moment, staring down at him, then his body eased, moving away from the young man. "Tavi," Fade said, his voice thick and heavy with recent sleep. "Hurt you?"

"I'm fine," Tavi assured him.

"Sneaking," Fade said, scowling. "Sneaking into my room."

Tavi sat up. "Yes. I'm sorry if I startled you."

Fade reversed his grip, taking the dagger by its blade, and offered the hilt across his wrist to Tavi. The young man reclaimed his knife and slipped it back into its sheath. "Sleeping," Fade said, and yawned, adding a soft, slurring hooting sound to the end of it.

"Fade," Tavi said. "I remember the battlements at Calderon. I know this is an act. I know you aren't a brain-addled idiot."

Fade gave Tavi a wide and witless smile. "Fade," he stated in a vacantly cheerful tone.

Tavi glared at him. "Don't," Tavi said. "Keep your secrets if you want. But don't insult me with the charade. I need your help."

Fade became completely still for a long moment. Then he tilted his head to one side and spoke, his voice now low and soft. "Why?"

Tavi shook his head. "Not here. Come with me. I'll explain."

Fade let out his breath in a long exhalation. "Gaius."

"Yes."

The slave closed his eyes for a moment. Then he went to the trunk, and removed a handful of objects and a spare blanket. He pushed hard on the

bottom of the trunk and there was a hollow-sounding crack. He withdrew a scabbard from the trunk, and drew a short, straight blade, the *gladius* of a *legionare*. Fade examined the weapon in the dim light, then sheathed it again, donned a voluminous old robe of worn sackcloth, and slipped the weapon beneath it. "Ready."

Tavi led Fade out into the corridors of the Academy, made his way toward the nearest of the secluded routes that led down into the uppermost layers of the Deeps, and emerged near the Citadel. The entrance to the Deeps wasn't precisely a secret door, but it lay within the deep shadows of a particularly cramped and crooked hallway, and if one didn't know where to look, the low, narrow opening to the stairwell was all but invisible.

Tavi led Fade down a series of little-traveled hallways, thick with moisture and chill air. His route led them briefly into the shallowest levels of the Deeps, then crossed beneath the Citadel's walls. They came to the stairway leading down to the First Lord's meditation chamber, and descended, challenged by alert *legionares* at each station. Tavi's legs throbbed with a brutal ache on every beat of his heart, but he forced himself to ignore the complaints of his tired body and kept moving.

Fade, Tavi noticed, studied the ground without looking up. His hair fell around his face and blended with the rough fabric of his robe. His gait was that of an older man's—stiff with apparent arthritis, halting and cautious. Or at least it was passing through each guard station. Once out of sight on the curving stairs, he moved with feline silence.

At the bottom of the stairs, the door to the First Lord's chamber was firmly closed. Tavi drew his knife and struck the hilt against the dark steel door in a set, staccato rhythm. After a moment, it opened, and Miles stood glowering in the door. "Where the crows have you been, boy?" he demanded.

"Um. Getting the man I told you about, Sir Miles. This is Fade."

"Took you long enough," Miles growled. He swept a cool gaze over the slave. "In four hours, Gaius must appear in his box at the preliminaries for the Wind Trials. Antillar isn't having much luck with his mimicry, but Killian can't stop to help him learn until he is sure the First Lord is attended. You should have brought the slave first."

"Yes, sir," Tavi said. "Next time this happens I'll be sure to remember."

Miles's expression turned sour. "Get in then," he said. "Fade, is it? I've had some bedding and a cot brought down. You'll need to assemble it and help me get Gaius into it."

Fade froze, and Tavi saw his eyes bright with shock behind his hair. "Gaius?"

"It looks as though he was trying to do too much furycrafting," Tavi said. "He may have broken his health on it. He collapsed several hours ago."

"Alive?" Fade asked.

"So far," Tavi said.

"But not if we don't get him into a proper bed and have him taken care of," Miles growled. "Tavi, you've got some messages to carry. Business as usual. Make everyone believe it. All right?"

There went the possibility of actually getting any sleep, Tavi thought. And at the rate things were going, he might well end up missing the test altogether. He sighed.

Fade shuffled into the chamber and went over to the bedding Miles had mentioned. The cot was a simple framework, standard Legion issue, and it didn't take Fade long to assemble it.

Miles went to Gaius's bureau against one wall and picked up a small stack of envelopes. He returned and gave them to Tavi without comment. Tavi was about to ask him which should be delivered first when Miles's eyes narrowed, and a frown wrinkled his brow.

"You," he said. "Fade. Turn around here."

Tavi saw Fade lick his lips and rise, turning to face Miles with his head down.

The Captain strode over to Fade. "Show me your face."

Fade made a quiet sound of distress, bowing in a panicked fashion.

Miles reached out a hand and flicked the hair from one side of Fade's face. It revealed the hideous scars of the coward's brand, and Miles frowned severely at it.

"Sir Miles?" Tavi asked. "Are you all right?"

Miles raked his fingers through his short-cropped hair. "Tired," he said. "Maybe I'm seeing things. He looks familiar, somehow."

"Perhaps you've seen him working, Captain," Tavi said, careful to keep his tone neutral.

"That's probably it," Miles said. He took a deep breath and squared his shoulders. "There's still a new Legion to run. I'm off for morning drills."

"Business as usual," Tavi said.

"Precisely. Killian will handle things until I can return. Obey him without question. Do you understand?"

Miles turned and left without waiting for an answer.

Tavi sighed and crossed the tiles to help Fade finish assembling the cot and bedding. On the other side of the room, Gaius lay on his back, his skin grey and pale. Killian knelt over him, his tea brazier alight, and some noxious-smelling steam drifted up from the coals.

"Tavi," Fade said, his voice low. "I can't do this. I can't be near Miles. He'll recognize me."

"That would be bad?" Tavi whispered back.

"I'd have to fight him." The words were simple, gentle, unadorned with anything but a faint tone of sadness or regret. "I must leave."

"We need your help, Fade," Tavi said. "Gaius needs your help. You can't abandon him."

Fade shook his head, then asked, "What does Miles know about me?"

"Your name. That I trust you. That Gaius sent you here to the Academy with me."

"Blighted furies." Fade sighed. "Tavi, I want you to do something for me. Please."

"Name it," Tavi said at once.

"Tell Miles nothing more about me. Even if he asks. Lie, make excuses, whatever you need to do. We can't afford for him to fly into a rage now."

"What?" Tavi asked. "Why would he do that?"

"Because," Fade said, "he's my brother."

⋈⋈⋈⋈ CHAPTER 13

Though she had been unconscious for much of the day, by the time Isana had packed and settled into the covered litter, she was exhausted.

She had never flown in a litter before, either open to the elements or closed, and the experience felt far too familiar to be so terrifying. It looked little different than any covered coach, at least from the inside, which made it all the more disconcerting to see, out the coach's windows, the

occasional soaring bird of prey or feathery tendril of cloud tinted dark gold by the deepening evening. She stared out at the gathering night and the land far below for a time, her heart beating too quickly in her chest.

"It's been getting dark for so long," Isana murmured, only half-aware that she'd said it out loud.

Serai looked up from the embroidery in her lap and glanced out the window. The light colored the pearls on her collar in shades of rose and gold. "We're flying into the sunset, Steadholder, high and quickly at that. The sun will outpace us in time. I've always loved evenings, though. I rather enjoy spending more time in them."

Isana turned her attention to the woman, studying her profile. Serai's emotional presence was barely there—something feather-light and nebulous. When the slave spoke, there was very little of the depth of emotional inflection Isana was used to feeling from those around her. Isana could count the people who had successfully concealed their emotions from her on the fingers of one hand.

Isana lifted her fingers to the front of her dress, touching them thoughtfully to the hidden ring on its chain. Serai was obviously more formidable than she appeared. "Do you fly often?" Isana asked her.

"From time to time," Serai replied. "The journey may take until this time tomorrow, possibly longer. We'll not stop until Rolf's men need to change places in the harness, Steadholder, and that may be long after dark. You should rest."

"Do I look ill?" Isana asked.

"Amara told me of your encounter this morning," Serai replied. Her expression never changed, and the flicker of her needle did not slow, but Isana felt a faint current of trepidation in the courtesan's bearing. "It would be enough to exhaust anyone. You're safe now."

Isana regarded Serai quietly for a moment, and asked, "Am I?"

"As safe here as in your own home," Serai assured her, a dry edge lurking beneath the lightly given words. "I'll watch, and wake you if anything happens."

Serai's voice, presence, and manner rang with the subtle tone of truth, something few honest folk could ever hide successfully, and Isana felt herself relax, at least for a moment. The woman meant to protect her—of that much, at least, she felt certain. And Serai was right. The shock and startled

fear on the face of the young man Isana had killed still tainted her every thought. She leaned her head back and closed her eyes.

She didn't expect to be able to sleep, but when she opened her eyes again, there was pale light flowing into the litter from the opposite windows, and her neck and shoulders felt stiff and uncomfortable. She had to blink her eyes for several moments to clear the unexpected sleep from them.

"Ah," Serai said. "Good morning, Steadholder."

"Morning?" Isana said. She fought back a yawn and sat up. There was a rolled cloak behind her head and a heavy, soft blanket covering her. "Did I sleep?"

"Most deeply," Serai confirmed. "You wouldn't stir when we stopped last night, and Rolf was a dear and loaned you his cloak when we got moving again."

"I'm sorry," Isana said. "Surely you rested as well?"

"Not just yet," the courtesan said. "I've been here, as I said I would—but for a few necessary moments, and Rolf sat here with you until I returned."

"I'm sorry," Isana repeated, embarrassed. She offered the cloak to Serai. "Here, please. You should rest."

"And leave you without conversation?" Serai said. "What kind of traveling companion would I be if I did such a thing." She gave Isana a small smile. "I've a touch of metalcrafting in my family's blood. I can go for a few days without."

"That doesn't mean it's good for you," Isana said.

"I must confess that as a rule, things which may not be good for me seem to hold an unwholesome attraction," she said. "And in any case, we should be arriving in the capital within the hour."

"But I thought you said it would take at least a full day."

Serai frowned, staring out the window. The blue-white light of dawn, pure and clear, made her skin glow, and her dark eyes seemed all the deeper. "It should have. Rolf said that we were fortunate to be flying with an unusually swift wind at our backs. I've never experienced such a thing before, between any of the cities, much less flying from the far provinces."

Isana collected her thoughts for a moment. This development changed things. She had less than an hour to prepare herself for the capital, and it might be the only chance she had to speak with Serai in relative privacy. There was little time to discover whatever she could from the woman through conversation—which meant that there was little point to subtlety.

Isana took a breath and addressed the courtesan. "Do you travel this way often?"

"Several times each season. My master finds all sorts of reasons to send me to visit other cities."

"Master. You mean Gaius," Isana said.

Serai's lips pursed thoughtfully. "I am a loyal subject of the Crown, of course," she said. "But my owner is the Lord Forcius Rufus. He is the cousin to the High Lord of Forcia, and holds estates at the northern end of the Vale."

"You live in the Amaranth Vale itself?" Isana asked.

"At the moment, yes," Serai replied. "I'll be missing the orchards in bloom, which is a pity. It makes the whole Vale smell like paradise. Have you seen it?"

Isana shook her head. "Is it as beautiful as everyone says?"

Serai nodded and sighed. "If not more so. As much as I love to travel, I find that I miss my home there. Still, I suppose that I am glad to travel and even more glad to return. Perhaps I am doubly fortunate."

"It sounds like a lovely place." Isana folded her hands in her lap. "And an even lovelier conversational diversion."

Serai looked back to Isana, smiling. "Does it?"

"You are one of the Cursors, then?"

"Darling, I'm merely a glorified pleasure slave, doing Gaius a favor on behalf of her master. And even if I was free, I don't think I'd have the temperament for the profession. All the heroism and duty and so on. Exhausting."

Isana arched an eyebrow. "I suppose a spy for the Crown would be largely useless if she walked around announcing the fact."

Serai smiled. "That seems a reasonable statement, darling."

Isana nodded, her crafting senses once more all but blind to Serai's presence. It was an acutely frustrating sensation. Her companion was one of the First Lord's followers—of that much she was certain. Why else would the Cursors have chosen her to accompany Isana? That meant that she couldn't afford to let down her guard. Serai's duty would be to protect Gaius's interests, and not Isana's.

But at the same time, Isana wasn't so foolish as to think that she did not need an escort in Alera Imperia, capital of all the Realm. She had never been to one of the great cities that formed the heart of Aleran society. She knew that Wintersend in the capital was a time rife with the plotting of various political and economic factions. She had heard tales of such groups

indulging in blackmail, extortion, murder, and worse, and her life in the countryside had not prepared her to deal with such matters.

Isana was fully aware that by coming to the capital, she was certain to face deadly peril. Gaius's enemies would strike at her not because of anything she had done, but because of what she represented. Isana was a symbol for the support for the First Lord. Gaius's enemies had already tried to destroy that symbol once. They would certainly do so again.

A sickly, wrenching sensation rippled through Isana's stomach.

Because Tavi was a symbol, too.

Isana would need an escort to navigate the treacherous waters of the capital, and Serai was her only guide and most vital ally. If she was to succeed in protecting Tavi from whatever deadly plots were afoot, Isana needed to secure the courtesan's support and cooperation in any way that she could. Flashes of sincerity were not enough.

"Serai," Isana said. "Do you have family?"

The little courtesan's face and bearing became abruptly opaque. "No, darling."

Isana felt nothing from Rill, but her eyes widened with sudden intuition. "You mean, not anymore."

Serai arched a brow, her expression surprised, but lifted her chin without looking away. "Not anymore."

"What happened?" Isana asked gently.

Serai was silent for a time, then said, "Our steadholt was blighted one year. Blighted badly. The blight took the lives of my husband and my daughter. She'd been born only three weeks before. My brother and my parents died as well. And the other holders. Of them all, I survived, but there will be no more family for me."

Serai looked away and out the window. She moved one hand to rest low on her belly, and her sudden pang of raw anguish struck Isana like a wave of scalding water.

"I'm sorry," she said to the courtesan. She shook her head. "I would never have thought you a holder."

Serai smiled without looking back at Isana, her eyes clear. "I entered into bondage after I recovered. To pay for decent arrangements for them. It was there that I became a"—she left a slight but deliberate pause—"courtesan. Many are found, just as I was."

"I'm so sorry," Isana said. "To make you remember the pain."

"You needn't be, darling. It was long ago."

"You don't look it."

"My family had—has a touch of watercraft in it as well," Serai said, her voice brightening with cheer that Isana knew must be forced. "Nowhere near as strong as you, Steadholder, but I can manage the occasional wrinkle."

The litter lurched, and Isana felt her head spin a little. She looked desperately out the window, but saw only thick, white fog. One of her feet lifted slightly from the floor, and fear froze her breath in her throat.

"It's all right," Serai said, and put a hand on Isana's knee. "We're descending. We're almost there. We'll land in moments."

Isana covered Serai's hand with her own. The courtesan's fingers felt fever-warm. Isana's hand must have been like ice. "There's not much time."

"What do you mean?"

Isana forced her eyes from the dizzying view out the window and to the other woman's. "Serai," she said, her voice shaking, "if you could have them back, would you?"

Serai's eyes widened in shock that quickly became a cool, agate-hard anger. "What sort of question is that, darling?" she replied, her tone unchanged. "Of course I would."

Isana covered Serai's hand with both of hers, and leaned forward, staring directly into her eyes. "That's why I'm coming to Festival. My family is in danger. I don't care about Gaius. I don't care about what man sits on the throne. I don't care about politics or plots or power. I only care that the child I raised is in danger, my brother may die if I cannot send him aid. They are all that I have in the world."

Serai tilted her head to one side in a silent question.

Isana felt her voice waver as she spoke. "Help me."

Serai straightened slowly, comprehension dawning in her eyes.

Isana squeezed her hand. *"Help me."*

Serai's presence became acutely pained, but her face and her eyes remained calm. "Help you. At the expense of my duty to my master?"

"If need be," Isana said. "I'll do anything necessary to help them. But I don't know if I can do it alone. Please, Serai. They are my family."

"I am sorry, Steadholder, that your kin are in danger. But the servants of the Crown are the only family I know. I will do my duty."

"How can you say that?" Isana asked. "How can you be that indifferent?"

"I am not indifferent," Serai said. "I know what is at stake—better than anyone. Were it up to me, I would ignore the greater concerns of the Realm to save the lives of your family."

Silvery truth resounded in that whisper, but so did resolution. Another agonized stab of fear for her kin wrenched at Isana's chest. She bowed her head and closed her eyes, trying to sort through the courtesan's complex but shrouded tangle of emotion. "I don't understand."

"If it was up to me, I would help you. But it is not up to me," Serai replied. Her voice was both compassionate and unyielding. "I have sworn myself to the service of the Realm. The world of Carna is a cold, cruel place, lady. It is filled with danger and enemies to our people. The Realm is what keeps them safe."

Sudden and bitter scorn filled her throat with flame. Isana let out a breath, not quite a derisive laugh. "The irony. That someone the Realm failed to keep safe would be willing to sacrifice other families in service to it."

Serai withdrew her hands from Isana's, cold, controlled anger now in her voice and presence. "Without the Realm to protect them, there will be no families."

"Without families," Isana spat, "there is nothing for the Realm to protect. How can you say that when you may have the power to help them?"

Serai's bearing and tone remained aloof and unreadable. "As a woman using her own power to dredge up the most painful moment of my life in an attempt to manipulate me to her will, Isana, I hardly think you are in a position to criticize."

Isana clenched her hands in frustration. "I only ask you to help me protect my family."

"At the expense of my loyalty," Serai said, voice steady. "It isn't because I don't want to help you, Steadholder. Or your kin. But there are many women in the Realm with families. And if I could save ten thousand of them by sacrificing yours, I would do so. It wouldn't be right. But it would be necessary. And it is my duty. I have taken an oath as a servant to the Realm, and I will not be foresworn."

Isana looked out the window. "Enough. I understand." After a moment, she added, "And you're right. I apologize to you, lady. I shouldn't have tried to use the pain of your loss against you."

"Perhaps," Serai said, her tone matter-of-fact. "Or perhaps not. I have

buried a family, Steadholder. It hurts more than I could ever have imagined. I might not be particular, either, were I trying to protect them."

"I'm terrified. What if I can't do it alone?"

Serai suddenly smiled. "That won't be an issue, darling. Hear me." She leaned forward, eyes intent. "I will do my duty to my master. But I will die myself before I allow you or yours to be harmed. That is my oath to you."

Sincerity rang in the words, a clear and silver tone of truth that not even Serai's composure could wholly contain.

"You do not have to make such an oath," Isana said.

"No," Serai said. "I do not. But it would make no difference in any case. I could not live with myself if I allowed it to happen to another family. Nor would I wish to." She shook her head. "I know it isn't what you wanted to hear, but I can do nothing more. Please believe that I will do nothing less."

"I believe you," Isana said quietly. "Thank you."

Serai nodded, her expression serene, her presence once more quiet and contained.

"Ladies," called a voice from outside the litter. One of their escorting Knights appeared at the window, a young man with sharp features and dark, intense eyes. He was unshaven, and looked beaten with weariness. "The currents can be unpredictable as we descend. There are a pair of restraining belts you should use."

Serai looked up with a sudden smile. "Yes, Rolf. I seem to remember having this conversation before. Where is the subtribune?"

The Knight grinned and bowed his head. Then he leaned closer, and whispered, "Sleeping on the roof. He got tired in the night. All but fell out of the sky."

"How humiliating to the great racing champion should he arrive in such a condition. Didn't he tell you to wake him before you fly into the capital?" Serai asked.

"It's odd," Rolf said. "I can't remember. I'm just that tired." He flicked a contemptuous glance up at the roof of the litter, then said, "If you please, ladies, strap in. Just a moment more."

Serai showed Isana how to secure herself with a pair of heavy woven belts that laced together, and a moment later the litter began to jostle, sway, and shake. It was a terrible sensation, but Isana closed her eyes and held on to the belts with both hands. There was a sudden, bone-rattling thud, and Isana realized that they were safely on the ground.

Serai let out a happy sigh and folded her sewing into a small cloth bag. They unfastened the belts and emerged from the litter into blinding golden sunlight.

Isana stared around her at Alera Imperia, heart of all the Realm.

They stood upon a platform of white marble, larger than the whole walled enclosure of Isanaholt. The wind was almost violent, and Isana had to shield her eyes against it. All around her, other litters were descending, the largest of them borne by a dozen windcrafters. The Knights Aeris were clad in the brilliant livery of the High Lords of each city, and men and women dressed in fantastically rich clothing, sparkling with jewels and embroidered with gold and silver emerged from them, their hair and garments untouched by the whirling winds.

Several men in brown tunics rushed around the litters as they touched down, where they immediately began picking up the litters with furycrafted strength and carrying them to a broad staircase leading down from the platform, so that others could land. Other men in brown tunics arrived, bearing food and drink for the newly arrived Knights, many of whom, including Rolf and the other Knights who had borne Isana and Serai, were sitting on the platform in sheer exhaustion.

"Isana," Serai called through the heavy winds. She stood on tiptoe to speak to the bent ear of another man in a brown tunic, who nodded and accepted a few gleaming coins from the courtesan with a polite bow. Serai beckoned. "Isana, come with me. It's this way."

"But my bag," Isana called back.

Serai approached and leaned up to half shout, "It will be delivered to the house. We need to get off the platform before someone lands on—*Isana*."

Serai suddenly drove herself hard against Isana's side. Utterly surprised, Isana fell—and so saw a short, heavy dagger as it swept past where her head had been an instant before.

There was a cracking sound, loud even over the wind's constant roar. Heads whipped around toward them. The tumbling dagger's hilt had struck one side of the litter with such force that it shattered the lacquered wood, shooting it through with splits and cracks.

Serai looked around wildly and pointed at the back of another man in a brown tunic, disappearing down the stairs. "Rolf!"

The Knight looked up from where he sat, exhausted, startled for a second, then rose unsteadily to his feet.

"Crows and bloody furies!" thundered a furious voice from atop the litter. Horatio sat up atop it, slipped, and fell from the litter's roof to the ground, screaming oaths at the top of his lungs.

Rolf hurried to the top of the stairs, breathing hard after only a few steps, and stared down them for a moment. He looked back at Serai and shook his head, his expression frustrated.

"I'll have your rank for this!" Horatio bellowed, struggling to his feet. All around them, Citizens of the Realm were pointing at the sleep-muddled subtribune, smiling and laughing. Few, if any, had realized that someone had just attempted bloody murder.

Serai's face was pale, and Isana could both see and feel the terror in her. She rose to her feet, offering Isana her hand. "Are you all right?"

"Yes," Isana said. She stumbled and lost her balance in the gale winds, nearly knocking down a tall woman in a red dress and black cloak. "Excuse me, lady. Serai, who was that?"

"I don't know," Serai said. Her hands were shaking, her dark eyes wide. "I saw stains on his tunic. I didn't realize until the last moment that they were blood."

"What?"

"I'll explain it later. Stay close."

"What do we do?"

The courtesan's eyes narrowed, fear replaced by hard defiance. "We hurry, Steadholder," Serai said. "Keep your eyes open and come with me."

⊢⊡⊡⊡⊣CHAPTER 14

"Very well," snapped Maestro Gallus in his querulous tenor. "Time is up."

Tavi's head snapped up from the surface of the table, and he blinked blearily around the lecture chamber. Nearly two hundred other academs sat in crowded rows at low tables, seated on the floor and writing furiously on long sheets of paper.

"Time," Gallus called again, an edge of anger in his voice. "Stop writing. If you haven't finished your proofs by now, another breath's worth of scribbling won't help you. Papers to the left."

Tavi rubbed at his mouth, blotting the drool from his lip with the sleeve of his grey tunic. The last few inches of his page remained conspicuously blank. He waited for the stack of papers to reach him, added his to it, and passed it to Ehren. "How long was I out?" he muttered.

"The last two," Ehren replied, straightening the pile with a brisk motion of his skinny arms before passing it on.

"You think I passed?" Tavi asked. His mouth felt gummy, and he ached with weariness.

"I think you should have slept last night," Ehren said primly. "You idiot. Did you want to fail?"

"Wasn't my idea," Tavi mumbled. He and Ehren stood and began shuffling out of the stuffy lecture chamber along with all the other students. "Believe me. Do you think I passed?"

Ehren sighed, and rubbed at his eyes. "Probably. No one but me and maybe you would have gotten the last two anyway."

"Good," Tavi said. "I guess."

"Calculations study is important," Ehren said. "In the greater sense, it's essential to the survival of the Realm. There are all sorts of things that make it absolutely necessary."

Tavi let irony creep into his tone. "Maybe I'm just tired. But calculating the duration of a merchant ship's voyage or tracking the taxation payments of outlying provinces seems sort of trivial to me at the moment."

Ehren stared at him for a moment, his expression shocked, as if Tavi had just suggested that they should bake babies into pies for lunch. Then said, "You're joking. You *are* joking, aren't you Tavi?"

Tavi sighed.

Outside the classroom, students burst into conversation, complaints, laughter, and the occasional song, and filed down the nearest walkway toward the main courtyard in a living river of grey robes and weary minds. Tavi stretched out the moment he got into the open air. "It gets too hot in there after a long test," he told Ehren. "The air gets all squishy."

"It's called humidity, Tavi," Ehren said.

"I haven't slept in almost two days. It's squishy."

Gaelle was waiting at the archway to the courtyard, standing up on

tiptoe in a useless effort to peer over the crowd until she spotted Tavi and Ehren. The plain girl's face lit up when she saw them, and she came rushing over, muttering a string of apologies as she swam against the grey tide. "Ehren, Tavi. How bad was it?"

Tavi made a sound halfway between a grunt and a groan.

Ehren rolled his eyes and told Gaelle, "About what I thought it would be. You should be fine." He frowned and looked around. "Where's Max?"

"I don't know," Gaelle said, her eyes looking around with concern. "I haven't seen him. Tavi, have you?"

Tavi hesitated for a moment. He didn't want to lie to his friends, but there was too much at stake. Not only did he have to lie, but he had to do it well.

"What?" he asked blearily, to cover the pause.

"Have you seen Max?" Gaelle repeated, her voice growing exasperated.

"Oh. Last night he said something about a young widow," Tavi said, waving a hand vaguely.

"The night before an *exam?*" Ehren sputtered. "That's just . . . it's so wrong that . . . I think maybe I should lie down for a moment."

"You should too, Tavi," Gaelle said. "You look like you're about to fall asleep on your feet."

"He did during the test," Ehren confirmed.

"Tavi," Gaelle said. "Go to bed."

Tavi rubbed at an eye. "I wish I could. But I couldn't finish all the letter-running before the test started. One more, then I can get some sleep."

"Up all night, then taking a test, and he's still got you running letters?" Gaelle demanded. "That's cruel."

"What's cruel?" Ehren asked.

Tavi started to answer, then walked straight into another student's back. Tavi stumbled backward, jolted from the impact. The other student fell, shoved himself up with a curse, and rounded on Tavi.

It was Brencis. The arrogant young lord's dark hair was mussed and stringy after the long exam. The hulking Renzo hovered behind him and a little bit to one side, and Varien stood to Brencis's left, eyes glittering with anticipation and malice.

"The freak," Brencis said in a flat voice. "The little scribe. Oh, and their sow. I should leave you all neck deep in a cesspool."

Varien said, "I should be pleased to help you with that, my lord."

Tavi tensed himself. Brencis wouldn't forget how Max had humiliated him the previous morning. And since there was little he could do to take vengeance on Max, he would have to find another target for his outrage. Like Tavi.

Brencis leaned down close to Tavi and sneered. "Count yourself lucky, freak, that I have more important matters today."

He turned around and swept away without looking back. Varien blinked for a moment, then followed. Renzo did the same, though his placid expression never changed.

"Huh," Tavi said.

"Interesting," Gaelle mused.

"Well. I wasn't expecting *that*," Ehren said. "What do you suppose is wrong with Brencis?"

"Perhaps he's finally growing up," Gaelle said.

Tavi exchanged a skeptical look with Ehren.

Gaelle sighed. "Yes, well. It could happen, you know. Someday."

"While we're all holding our breath," Tavi said, "I'm going to get this last letter delivered and get some sleep."

"Good," Gaelle said. "Who are you taking it to?"

"Uh." Tavi rummaged in his pockets until he found the envelope and glanced at the name on it. "Oh, bloody crows," he swore with a sigh. "I'll catch up to you later." He waved at his friends as he broke into a weary jog and headed for Ambassador Varg's quarters.

It wasn't a long way up to the Citadel, but Tavi's tired legs ached, and it seemed to take forever to reach the Black Hall—a long corridor of dark, rough-quarried stone very different from the rest of the First Lord's marble stronghold. The entrance to the hall had an actual gate upon it, bars of dark steel as thick and hard as the portcullis to any stronghold. Outside the gate stood a pair of soldiers from the Royal Guard in red and blue—younger members, Tavi noted, in full arms and armor as usual. They stood facing the gate.

On the other side of the gate, a single candle cast just enough light to show Tavi a pair of Canim crouched on their haunches. Half-covered in their round capes, Tavi could see little of them beyond the sharper angles of their armor at the shoulders and elbows, the gleam of metal upon the hilts of their swords and on the tips of their spears. The shape of their heads was half-hidden in their hoods, but their wolfish muzzles showed, and their

teeth, and the faint red-fire gleam of their inhuman eyes. Though they squatted on the floor, their stance was somehow every bit as rigid, alert, and prepared as the Aleran guards facing them.

Tavi approached the gate. The scent of the Canim embassy surrounded him as he did—musky, subtle, and thick, somehow reminding him of both the smithy at his old steadholt and the den of a direwolf.

"Guard," Tavi said. "I bear a letter for His Excellency, Ambassador Varg."

One of the Alerans glanced over his shoulder and waved him past. Tavi approached the gate. On the other side, a leather basket sat in its usual place on the rough floor, an arm's length away from the bars, and Tavi leaned through to drop the letter into the basket. In his mind, he had already completed his task and was looking forward, finally, to sleeping.

He barely saw the Cane nearest him move.

The inhuman guard slid forward with a sudden, sinuous grace, and a long arm flashed out to snare Tavi's wrist. His heart lurched with a sudden apprehension too vague and exhausted to be proper panic. He could have swept his arm in a circle toward the Cane's thumb, to break the grip and draw back, but doing so would surely have caused him to lash open his own arm on the Cane's claws. There was no chance he could have pulled away from the guard by main force.

All of that flashed through his mind in the space of a heartbeat. Behind him, he heard the sharp intake of breath from the two Aleran guards and the sound of steel hissing against leather as they drew swords.

Tavi left his arm where it was in the Cane's grip, and raised his free hand to the guards. "Wait," he said, voice quiet. Then he looked up—a great deal up—to fix the Cane guard with a flat stare. "What do you want, Guard?" Tavi demanded, his tone impatient, peremptory.

The Cane regarded him with unreadable, feral eyes and released his wrist in a slow, deliberate motion that trailed the tips of the Cane's claws harmlessly against Tavi's skin. "His Excellency," the Cane growled, "requests the messenger to deliver the letter directly to his hands."

"Stand away from him, dog," snarled the Aleran guard.

The Cane looked up and bared its yellow fangs in a silent snarl.

"It's all right, *legionare*," Tavi said quietly. "It's a perfectly reasonable request. It is the Ambassador's right to receive missives directly from the First Lord should he wish."

Both the Canim started letting out low, stuttering growls. The one who had seized Tavi's arm opened the gate. Tavi stared for a moment, at how easily the enormous Cane opened the massive steel portal. Then he swallowed, took up the single candle, clutched the envelope, and entered the Black Hall.

The Cane guard paced Tavi, slightly behind him. Tavi paused and slowed his steps until he could see the Cane in the corner of one eye. The guard prowled, each step sinuous and relaxed, regarding Tavi with what seemed to be open curiosity as they walked to the end of the Black Hall. They passed several open, irregular doorways on the way, but the shadows filling them were too thick to allow Tavi to see what lay beyond.

At the end of the hall was the only door Tavi had seen, made of some thick, heavy wood of some dark color that shone with deep red and heavy purple highlights in the light of Tavi's candle.

Tavi's guard strode past him in those too-long stalking steps of a grown Cane, and drew its claws slowly down the dark wood. Whatever it was, the wood was hard. The Cane's heavy claws scraped loudly, but no indentation or mark appeared on the wood.

There was a snarl from the room beyond, a sound that sent a quick chill racing down Tavi's spine. The guard replied with a similar sound, though higher in pitch. There was a brief silence, then a chuckling growl, and Varg's voice rumbled, "Send him in."

The guard opened the door and stalked away without giving Tavi a second glance. The boy swallowed, took a deep breath, and strode into the room.

As he crossed the threshold, a draft struck his candle and snuffed it out.

Tavi stood in utter darkness. There were a pair of low growls this time, one coming from either side of him, and Tavi became acutely aware of how entirely vulnerable he was, and how strongly the chamber smelled of musk and meat—the scent of predators.

It took his eyes a long moment to adjust, but he began to make out details of deep, scarlet light and black shadow. There was a bed of barely glowing coals in a shallow depression in the center of the floor, and some kind of heavy pads made from material he could not identify lay around the coals. The room was shaped like an overturned bowl, the walls curling up to a ceiling that was not much higher than Tavi could have reached with his hands. Several feet back in the shadows, there were what Tavi took to be two more

guards, but upon second glance he recognized them as arming dummies—though taller and broader than the stands that typically bore the armor of off-duty *legionares*. One of the dummies bore the odd outline of a suit of Canish armor, but the other stood empty.

Against the back wall of the room, Tavi heard the trickle of water, and could barely see the shimmer of the dim red light against a pool, its surface broken by small and regular ripples.

On instinct, Tavi turned and faced almost directly behind him.

"Ambassador," he said in a respectful tone. "I've a message for you, sir."

Another low growl rippled through the room, oddly twisted by the shape of the walls, or by the composition of the stone, bouncing about as though from several sources at once. There was a gleam of red eyes two feet above Tavi's own, then Varg slid forward out of the darkness into the bloody light.

"Good," said the Cane, still dressed in cloak and armor. "The controlled use of instinct. Too often your kind are either ruled by them or pay them no mind."

Tavi had no idea how to respond to that, other than to offer Varg the envelope. "Thank you, Your Excellency."

Varg took the envelope and opened it with a single, negligent swipe of a claw that cut the paper with barely a whisper of sound. It flicked the missive inside open and scanned over it, growling again. "So. I am to be ignored."

Tavi regarded it with a blank expression. "I only carry the messages, sir."

"Do you," said Varg. "Let it be on your own heads, then."

"You see, my lord," hissed a higher-pitched growling voice from the doorway. "They have no respect for you or for our people. We should be rid of this place and return to the Blood Lands."

Tavi and Varg both turned to face the doorway, where a Cane Tavi didn't recognize crouched. It wore no armor, but was draped in long robes of deep scarlet. Its pawlike hands were far thinner and more spidery than Varg's, and its reddish fur looked thin and unhealthy. The muzzle, too, was narrow and pointed, and its tongue lolled out to one side, flickering nervously.

"Sarl," Varg growled. "I did not send for you."

The second Cane drew its hood back from its head and tilted it to one side in an exaggerated gesture that Tavi suddenly understood. The Cane was baring its throat to Varg—a gesture of deference or respect, evidently.

"Apologies, mighty lord," Sarl said. "But I came to report to you that word has come, and that the change of guard would arrive in two days' time."

Tavi pursed his lips. He had never heard a Cane speak Aleran, except for Varg. He could not imagine that Sarl had addressed its superior in language Tavi could understand by mere chance.

"Very good, Sarl," Varg growled. "Out."

"As you wish, lord," Sarl replied, baring its throat again, hunching low. The Cane backed away, scraping, and hurried back into the corridor.

"My secretary," Varg said. Tavi could only guess, but he thought the Ambassador's growling tone was somewhere between pensive and amused. "He attends to matters he thinks beneath my notice."

"I am familiar with the concept," Tavi answered.

Varg's teeth showed as its muzzle lolled open. "Yes. You would be. That is all, cub."

Tavi began to bow, but then a thought struck him. The gesture might not be the same from the Cane's point of view. What was a motion of respect to Alerans might be something very different in a society whose members might fight to tear out one another's throats with their teeth, like wolves. A wolf who crouched and ducked its chin in closer to its body was preparing to fight. Certainly, Varg was aware of the difference in gestures, as it obviously didn't seem to regard bows as a challenge to combat, but it still seemed, to Tavi, to be impolite to make the gesture the Ambassador's instincts surely twinged at whenever it saw.

Instead, Tavi tilted his head a bit to one side, mimicking the gesture Varg himself had made earlier, and said, "Then I take my leave, Excellency."

He started to walk past Varg, but the Cane suddenly put out a heavy paw-hand and blocked Tavi's way.

Tavi swallowed and glanced up at the Cane. He met the Ambassador's eyes for a moment.

Varg regarded him, fangs gleaming, and said, "Light your candle at my fire before you go. Your night eyes are weak. I'll not have you stumbling in my corridor and bawling like a puppy."

Tavi exhaled slowly and tilted his head again. "Yes, sir."

Varg shifted its shoulders, an odd motion, and prowled back to the pool.

Tavi went to the coals and lit his candle against them, this time shielding the flame with his hand. He watched as the Cane crouched, as easy on all fours as upright, and drank directly from the pool. But he dared not simply stare, as fascinating as it might be. Tavi turned and hurried out.

Just before he crossed the threshold again, Varg growled, "Aleran."

Tavi paused.

"I have rats."

Tavi blinked. "Sir?"

"Rats," Varg growled. It turned its head to look over one armored shoulder. Tavi could see little more than the gleam of fangs and red eyes. "I hear them at night. There are rats in my walls."

Tavi frowned. "Oh."

"Out," said Varg.

Tavi hurried back into the hallway and started retreating back toward the Citadel proper. He walked slowly, mulling over the Ambassador's words. Clearly, it wasn't simply speaking about a rat problem. The rodents could be a nuisance, of course, but surely one the Cane could deal with. Even more puzzling was the reference to walls. The walls of the Canim enclosure in the Black Hall were made of stone. Rats were industrious tunnelers and gnawers, but they could not bore through solid rock.

Varg struck Tavi as the sort of being who did not spend his words idly. Tavi had already sized up the Ambassador as the kind of warrior who would fight with simple, deadly efficiency. It seemed reasonable to assume that given any choice in the matter, Varg would waste no more effort on words than on bloodshed.

Tavi's eyes fell to the flame on his candle. Then to the walls. He took a pair of quick steps to stand beside the wall nearest him and lowered his hand.

In the still air of the hallway, his candle flickered and leaned, very slightly.

His heart started pounding faster, and Tavi followed the direction of the flame, moving slowly down the wall. In only a moment, he found the source of the small draft—a tiny opening in the wall, one he had not seen before. He placed the heel of his hand against it and pushed.

A section of the stone wall slid open soundlessly, previously unseen seams splitting into visibility. Tavi held up the candle. Just beyond the hidden passageway, stairs led down into the stone.

The Canim had a passageway into the Deeps.

Tavi was still too far from the entrance to the Black Hall to see its guards clearly, and he could only hope that they could not see him clearly, either. Shielding the light of the candle in his hand once more, he slipped onto the stairs and went down them as silently as he possibly could.

Voices from ahead made him stop, listening.

The first speaker was Canim—Sarl, Tavi was sure of it. He recognized the cringing tone to its snarling voice. "And I tell you that all is in readiness. There is nothing to fear."

"Talk is cheap, Cane," said a human voice, so quiet that Tavi could hardly hear it. "Show me."

"That was not a part of our agreement," the Cane said. There was a shivering, flapping sound, like a dog shaking its chops. "You must believe my words."

"Suppose I don't?" asked the other.

"It is too late to change your mind now," said Sarl, a nasty slur to the words. "Let us not discuss what cannot—" The Cane's words cut off suddenly.

"What is it?" asked the second voice.

"A scent," Sarl said, a hungry little whine coloring his tone. "Someone near."

Tavi's heart raced, and he fled up the stairs as quietly as his weary legs could manage. Once in the hall, he all but sprinted down it, back toward the Citadel. As he approached, the Canim guards rose, growling, eyes intent upon him.

"His Excellency dismissed me," Tavi panted.

The guards traded a look, then one of them opened the gate. No sooner had Tavi fled out it and heard it shut behind him than the shadows stirred, and Sarl appeared in the Black Hall, hurrying along in a hunched shuffle. Its pointed ears went flat to its skull when he spied Tavi, and the Cane crouched a little, lips lifting away from the fangs on one side of its muzzle.

Tavi stared back at the Cane. He needed no intuition to understand the flash of raw, hungry hatred he saw in the Canim secretary's eyes.

Sarl spun and shuffled back into the shadows, motions purposeful. Tavi fled, fear making his legs tremble, to put as much distance as possible between himself and the residents of the Black Hall.

Amara nudged her horse up to walk beside Bernard's in the morning sun-
light, and murmured, "Something's wrong."

Bernard frowned and glanced at her. They were riding at the head of the
column of *legionares* from Garrison. Two dozen local holders, veterans of
the Legions themselves, rode armed and armored as auxiliary cavalry troops,
and two dozen more bore the great hunting bows common to the holders of
the region and marched in file behind the *legionares*. Behind them rumbled
a pair of heavy gargant-drawn carts, followed by Doroga on his massive
black gargant, and the column's rear guard, most of the knights Bernard had
under his command, mounted and grim.

Bernard himself had donned his helmet in addition to his mail, and car-
ried his strung bow across his saddle in one hand, an arrow already on the
string. "You noticed it, then."

Amara swallowed and nodded. "There are no deer."

Bernard nodded, a barely perceptible gesture. His lips scarcely moved
when he spoke. "This time of year, the column should be scaring them out
every few hundred yards."

"What does it mean?"

Bernard's shoulders shifted in a slight shrug. "Ordinarily, I'd think it
meant that another body of troops had already driven them out, and that
they may be preparing a surprise attack."

"And now?" Amara asked.

His lips lifted up away from his canines. "I think these creatures may al-
ready have driven them out, and that they may be preparing a surprise attack."

Amara licked her lips, glancing at the rolling woodlands around them.
"What do we do?"

"Relax. Trust our scouts," Bernard said. "Keep an eye out. There might
be a number of other explanations for some missing deer."

"Such as?"

"Aric's holders may have slaughtered all they could shoot quickly in preparation for our arrival, to help feed the troops, for one. I've had to put down a number of herdbane who remained in the valley after the battle. One of those could have killed the local does during birthing over the winter. They do that sometimes."

"What if that hasn't happened?" Amara asked.

"Then be ready to take to the air," Bernard said.

"I've been ready to do that since before we left the steadholt," she replied, her voice wry. "I'm not much one for feeling hunted."

Bernard smiled, and shared the warmth of it with her, meeting her eyes. "I'll not be hunted in my own home, dear Countess. And I'll not suffer my guests to be hunted, either." He gestured back toward the column with a tilt of his head. "Patience. Faith. Alera's Legions have seen her through a thousand years in a world where enemies of all sorts have tried to destroy her. They will see us through this, too."

Amara sighed. "I'm sorry, Bernard. But I've seen too many threats to Alera that a Legion could do precisely nothing about. How much farther to Aricholt?"

"We'll be there before midday," Bernard told her.

"You'll want to see the camp Aric told us about, I take it?"

"Naturally," Bernard said. "Before nightfall."

"Why not let your Knights Aeris handle it?"

"Because in my experience, wind rider, Knights Aeris miss a very great deal of what happens underneath branch and bough since they're soaring several dozen yards above them." He smiled again. "Besides, what fun would that be?"

Amara raised her eyebrows. "You're enjoying this," she accused.

Bernard's eyes returned to their casual, careful scan of the woods around them, and he shrugged. "It was a long winter. And I haven't been out in the field for more than a few hours at a time since I became Count Calderon. I hadn't realized how much I missed it."

"Madman," Amara said.

"Oh come now," Bernard said. "You have to admit, it's exciting. A mysterious, dangerous new creature. A possible threat to the Realm. The chance to challenge it, defeat it."

"Dear furies." Amara sighed. "You're worse than a boy."

Bernard laughed, and there was both joy and something unpleasant in it.

The corded muscles in his neck tightened and relaxed with the horse's movements, and his broad hands held the great bow steady. Amara was again struck by the sheer size of the man, and well remembered the deadly skill and power in him. There was something wolfish in his manner, something that suggested that his quiet smile was only a mask. That something far more grim, and far more ready to taste blood lay just beneath.

"Amara," he rumbled. "Something threatens my home. After what happened before, I know what is at stake. And I wouldn't want anyone else to be in charge of dealing with that threat." His hazel green eyes reflected bark and newly sprouted leaves in equal measure, dangerous and bright. "I am a hunter. I will hunt this creature down and hold it. And when the First Lord sends help enough, I will destroy it."

The words were calm, matter-of-fact, barely laced with that lurking ferocity, and Amara found herself feeling irrationally comforted by it. Her shoulders loosened a little, and the trembling that had been threatening her hands receded.

"Besides," Bernard drawled, "it's a lovely morning for a ride in the country with a pretty girl. Why not enjoy it?"

Amara rolled her eyes and began to smile, but Serai's words echoed quietly in her heart.

Of course you'll have to leave him.

She drew in a breath, forced her expression into a neutral mask, and said, "I think it's better for all of us if I remove any potential distraction, Your Excellency. Your mind should be upon your duty."

Bernard blinked and looked at her with open surprise on his face. "Amara?"

"If you will excuse me, Count," she said in a polite voice, and nudged her horse out of line, letting him nibble at new grass while she waited for the column to pass her. She felt Bernard's eyes on her for a moment, but she did not acknowledge him.

She waited until the carts had passed, then nudged her horse to pace alongside Doroga's giant gargant. The horse refused to move within twenty feet of the beast, despite Amara's best efforts.

"Doroga," she called up to the Marat chieftain.

"I am," he called back. He watched her struggle with the nervous horse, his expression amused. "You wish something?"

"To speak to you," she said. "I was hoping—" She broke off as a low

branch slapped her in the face, a stinging annoyance. "Hoping to ask you some questions."

Doroga rumbled out a rolling laugh. "Your head will get knocked off. Your chieftain Gaius will come take it from my hide." He shifted an arm and tossed a rope of braided leather over the side of the saddle-mat to dangle five feet from the earth. "Come up."

Amara dipped her head to him and passed the reins of her horse off to a nearby holder. She dismounted, and jogged over to pace Doroga's gargant. She seized the saddle rope and hauled herself carefully up to its back, where Doroga clamped a big fist down on her forearm and hauled her to a more stable perch.

"So," Doroga rumbled, turning back to face forward. "I see that Bernard ate the wrong soup."

Amara blinked at him. "What?"

Doroga smiled. "When I was young and had just taken my wife as mate, I woke up the next morning, went to my fire, and ate the soup there. I declared it the best soup that any woman ever made for a man. To everyone in the camp."

Amara lifted her eyebrows. "Your wife hadn't made it?"

"She had not," Doroga confirmed. "Hashat did. And after our wedding night, I spent the next seven days sleeping on the ground outside her tent to apologize."

Amara laughed. "I can't imagine you doing that."

"I was very young," Doroga said. "And I very much wanted her to be happy with me again." He glanced over his shoulder. "Just as Bernard wants you to be happy with him."

Amara shook her head. "It isn't anything like that."

"Yes. Because Bernard does not know he ate the wrong soup."

She sighed. "No. Because we aren't married."

Doroga snorted. "You are mates."

"No, not like that."

"You have mated," he said, patient as if he spoke to a small child. "Which makes you mates."

Amara's cheeks flamed. "We . . . did. We have. But we aren't."

Doroga looked back at her, his expression scrunched into a skeptical frown. "You people make everything too complicated. Tell him he ate the wrong soup and have done."

"It's nothing Bernard has done."

"You ate the soup?" Doroga asked.

"No," Amara said, exasperated. "There was no soup. Doroga, Bernard and I . . . we can't be together."

"Oh," Doroga said. He shook his head in a mystified gesture and briefly put his hand over his eyes, mimicking a blindfold. "I see."

"I have obligations to Gaius," Amara said. "So does he."

"This Gaius," Doroga said. "To me he seemed smart."

"Yes."

"Then he should know that no chieftain can command the heart." Doroga nodded. "He gets in the way of that, he will learn that love will be love, and he can do nothing but kill everyone or stand aside. You should learn that, too."

"Learn what?" Amara said.

Doroga thumped a finger against his skull. "Head got nothing to do with the heart. Your heart wants what it wants. Head got to learn that it can only kill the heart or else get out of the way."

"You're saying it would kill my heart to turn away from Bernard?" Amara asked.

"Your heart. His too." Doroga rolled a shoulder in a shrug. "You get to choose."

"Broken hearts heal in time," Amara said.

Something washed over Doroga's features, making them look heavier, more sad. He lifted a hand to one of his braids, where he had braided his pale hair together with plaits of fine reddish tresses Amara had assumed were dyed. "Sometimes they do. Sometimes they don't." He turned to face her, and said, "Amara, you got something not everyone finds. Those who lose it would gladly die to have it again. Do not cast it away lightly."

Amara rode in silence, swaying in the rhythm of the gargant's long, slow steps.

It was difficult to consider Doroga's words. No one had ever spoken to her of love in that way before. She had believed in it, of course. Her own mother and father had been very much in love, or so it had seemed to her as a small child. But since she had been taken in by the Cursors, love had been something that existed as a means to an end. Or as the lead player in a sad story about loss and duty. The only love a Cursor could allow herself to feel was for lord and Realm. Amara had known this since before she completed her training. What's more, she had believed it.

But in the past two years, things had changed. She had changed. Bernard had become, not so much important to her as he was natural to her whole being. He was as much a part of her thoughts as breath, food, and sleep. At once present and not present, conspicuous with his absence and filling her with a sense of completion when he was there.

For a man so strong, he was gentle. When his hands, his arms, his mouth were on her, he moved as if afraid she might shatter if held too tightly. Their nights together had been, and remained a blaze of passion, for he was a wickedly patient lover who took delight in her responses to him. But more than that, in the quiet hours after he would hold her, both of them weary, content, sleepy. She would lie in his arms and feel no worry, or sadness, or anxiety. She only felt beautiful. And desired. And safe.

Safe. She had to make a sharp effort to keep tears from her eyes. She knew well how little safety truly existed in the world. She knew how much danger threatened the Realm; how a single mistake had the potential to bring it down. She could not allow emotions to cloud her judgment.

No matter how much she might want them to.

She was a Cursor. Sworn vassal of the Crown, a servant of the Realm of Alera, entrusted with its direst secrets, guarding against its most insidious foes. Her duty called for many sacrifices so that others could be safe and free. She had long ago given up the notion of a life of safety. Her duty called her to give up such luxuries as love as well.

Didn't it?

"I will consider your words," she told Doroga quietly.

"Good," he responded.

"But now is not the time for such things," Amara said. Already, her emotions were distracting her. She needed to know more about the dangers they currently faced, and for the moment Doroga was their sole source of information. "We have a more immediate problem."

"We do," Doroga agreed. "The ancient enemy. The Abomination before The One."

Amara looked from the Marat chieftain up to the sun and back, frowning. "Before the One. You mean, before the sun?"

Doroga looked at her blankly.

"The sun," Amara explained, adding a gesture. "That is what you mean by the One, yes?"

"No," Doroga said, laughter in his tone. "The sun is not The One. You do not understand."

"Then tell me," Amara said, exasperated.

"Why?" Doroga asked. The question was a simple one, but there was a weight behind the word that made Amara hesitate and think before answering.

"Because I want to understand you," she said. "I want to know more about you and your people. What makes you what you are. What we share and what we do not."

Doroga pursed his lips. Then he nodded once, to himself, and turned around completely, facing Amara, and crossing his legs. He folded his hands in his lap, then after a moment, began to speak to her in a tone that reminded her of several of her better teachers at the Academy.

"The One is all things. He is the sun, yes. And the sunlight on the trees. And the earth, and the sky. He is the rain in the spring, the ice of winter. He is the fire, the stars at night. He is the thunder and the clouds, the wind and the sea. He is the stag, the wolf, the fox, the gargant." Doroga put a broad hand on his chest. "He is me." Then he reached out and touched Amara's forehead with a finger. "And he is you."

"But I've seen your folk refer to The One, and indicated the sun by gesture."

Doroga waved a hand. "Are you Gaius?"

"Of course not," Amara said,

"But you are his sworn servant, yes? His messenger? His hand? And at times you command in his name?"

"Yes," Amara said.

"So it is with The One," Doroga replied. "From the sun comes all life, just as from The One. The sun is not The One. But it is how we give him our respect."

Amara shook her head. "I've never heard that of your people."

Doroga nodded. "Few Alerans have. The One is all that is, all that was, all that will be. The worlds, the heavens—all a part of The One. Each of us, a part of The One. Each of us with a purpose and a responsibility."

"What purpose?" she asked.

Doroga smiled. "The gargant to dig. The wolf to hunt. The stag to run. The eagle to fly. We are all made to be for a purpose, Aleran."

Amara arched an eyebrow. "And what is yours?"

"Like all my people," Doroga said. "To learn." He leaned a hand down to

rest on the steadily pacing gargant's back, almost unconsciously. "Each of us feels a call to other pieces of The One. We grow nearer to them. Begin to feel what they feel, and know what they know. Walker thinks all of this rusty metal your folk wear stinks, Aleran. But he smells winter apples in the wagons and thinks he should get a barrel. He is glad the spring is coming quickly, because he is tired of hay. He wants to dig down to find the roots of some young trees for his lunch, but he knows that it is important to me that we keep walking. So he walks."

Amara blinked slowly. "You know this about your gargant?"

"We are both a part of The One, and both stronger and wiser for it," Doroga said. He smiled. "And Walker is not mine. We are companions."

The gargant let out a rumbling call and shook its tusks, making the saddle-mat lurch back and forth. Doroga burst out into rumbling laughter.

"What did he say?" Amara asked, somewhat awed.

"Not so much say," Doroga said. "But . . . he makes me know how he feels. Walker thinks we are companions only until he gets too hungry. And then I can either give him more food or stand clear of those apples."

Amara found herself smiling. "And the other tribes. They are . . ."

"Bonded," Doroga provided.

"Bonded with their own totems?"

"Horse with horse, Wolf with wolf, Herdbane with herdbane, yes," he confirmed. "And many others. It is how our people learn. Not just the wisdom of the mind." He put a fist on his chest. "But the wisdom of the heart. They are equally important. Each of them part of The One."

Amara shook her head. The beliefs of the barbarians were a great deal more complex than she would have believed possible. And if Doroga was telling the literal truth about the Marat bond with their beasts, it meant that they might be a great deal stronger than the Alerans had previously believed.

Hashat, for example, the chieftain of the Horse Clan, wore the cloak pins of three Royal Guardsman on her saber belt. Amara had assumed they had been looted from the field after the first day of First Calderon, but now she was not so sure. If the Marat woman, then a young warrior, had challenged the Princeps's personal guardsman on horseback, her bond with her animal may have given her a decisive advantage, even over Aleran metalcrafting. At Second Calderon, Doroga's gargant had smashed through walls built to withstand the pressures of battle of all kinds, from the great mauls of earthcrafter-borne strength to furycrafted blasts of fire and gale winds.

"Doroga," she said, "why have your people not made war on Alera more often?"

Doroga shrugged. "No reason to do it," he said. "We fight one another often. It is a test The One has given us, to see where the greatest strengths lie. And we have differences of thought and mind, just as your own folk do. But we do not fight until one side is dead. Once the strength is shown, the fight is over."

"But you killed Atsurak at the battle two years ago," Amara said.

Doroga's expression darkened with what looked like sadness. "Atsurak had become too savage. Too steeped in blood. He had betrayed his own purpose before The One. He had stopped learning and began to forget who and what he was. His father died at the Field of Fools—what my tribe call First Calderon—and he grew to manhood lusting for vengeance. He led many others with him in his madness. And he and his followers killed an entire tribe of my people." Doroga tugged at the braid again and shook his head. "As he grew, I had hoped he would learn to forget his hate. He did not. For a time, I feared I would hate him for what he did to me. But now it is over and done. I am not proud of what I did to Atsurak. But I could do nothing else and still serve The One."

"He killed your mate," Amara said quietly.

Doroga closed his eyes and nodded. "She hated spending winters with my tribe, in our southlands, in the dunes by the sea. Too much sleeping, she said. That year, she stayed with her own folk."

Amara shook her head. "I do not want to disrespect your beliefs. But I must ask you something."

Doroga nodded.

"Why do you fight to destroy the ancient enemy if we are all a part of The One? Aren't they as much a part of it as your people? Or mine?"

Doroga was silent for a long moment. Then he said, "The One created us all to be free. To learn. To find common cause with others and to grow stronger and wiser. But the ancient enemy perverts that union of strengths. With the enemy, there is no choice, no freedom. They take. They force a joining of all things, until nothing else remains."

Amara shivered. "You mean, joined with them the way you are with your totems?"

Doroga's face twisted in revulsion—and, Amara saw with a sense of unease, the first fear she had ever seen on the Marat's face. "Deeper. Sharper.

To join the enemy is to cease to be. A living death. I will speak no more of it."

"Very well," Amara said. "Thank you."

Doroga nodded and turned around to face forward.

She untied the saddle rope and dropped it over the gargant's flank, preparing to climb down it, when a call went down the column to halt. She looked up to see Bernard sitting his nervous horse with one hand lifted.

One of the scouts appeared on the road, his horse running at top speed toward the column. As the rider closed on Bernard and slowed, Bernard gave the man a curt gesture, and the two of them cantered side by side down the length of the column, until they were not far from Doroga's gargant.

"All right," Bernard said, gesturing from the scout to Amara and Doroga. "Let's hear it."

"Aricholt, sir," the man said, panting. "I was just there."

Amara saw Bernard's jaw clench. "What has happened?"

"It's empty, sir," the scout replied. "Just . . . empty. No one is there. There are no fires. No livestock."

"A battle?" Amara asked.

The scout shook his head. "No, lady. Nothing broken, and no blood. It's as if they all just walked away."

Bernard frowned at that and looked up at Amara. It didn't show on his face, but she could see the worry behind his eyes. It matched the worry and the fear she was feeling herself. Missing? An entire steadholt? There were more than a hundred men, women, and children who called Aricholt their home.

"It is too late to save them," Doroga rumbled. "This is how it begins."

CHAPTER 16

"I don't understand this," Isana said. "He's an academ. He's at the Academy. It isn't all that enormous. What do you mean that you can't find my nephew?"

The runner Serai had hired grimaced. He was a boy too young to labor

on the docks but too old to be free of the need to work, and his sandy hair was limp with sweat from running back and forth between the Citadel and the private manor in the Citizens' Quarter.

"Pardon, my lady Citizen," the boy panted. "I did as you asked and inquired after him in every place in the Academy visitors are allowed."

"Are you sure you checked his quarters in the dormitories?"

"Yes, my lady," the boy said, apology in his tone. "There was no answer. I slipped your note under his door. He may be in examinations."

"Since *dawn?*" Isana demanded. "That's ridiculous."

Serai murmured, from nearby, "Antonin's suggestion has merit, Steadholder. Final examination week is extremely demanding."

Isana settled down lightly onto the raised wall of flagstones surrounding the garden's central fountain, her back straight. "I see."

Birds chirped in the background, bright and cheerful in the warm afternoon that almost had the feel of spring to it. The manor to which Serai had brought Isana was a small one, by the standards of the capital, but its designer had crafted the home with an elegance that made the larger, richer homes surrounding it seem gaudy by comparison.

Isana opened her eyes. Though still marked by the chill of winter night, the garden had begun to awaken to the spring. Buds had already formed on the early-blooming plants and upon all three of the carefully pruned trees. Like the house, the garden was modest and beautiful. Surrounded upon all sides by the three-story manor, hanging and climbing vines hid the silvery marble of the building almost completely, so that the garden seemed more like a glade in a heavy forest than part of a metropolitan household. The bees had not yet awakened from their winter slumber, nor had most of the birds returned from their yearly journey, but it would not be long before the garden would be full of motion, bustling with the business of life.

Spring had always been her favorite time of year, and her own happiness had been infectious. Isana always felt her family's emotions quite clearly, regardless of the season, but in the spring they were the most happy.

That thought led her to Bernard. Her brother was walking into danger, and leading holders she had known for most of her life as he did. He would arrive at Aricholt today—and perhaps he already had. His men might be facing the danger the vord represented as early as the next morning.

And Isana could do nothing but sit in a garden, listening to the rustling waters of an elegant marble fountain.

She rose and paced the length of the garden and back, while Serai paid Antonin with five shining copper rams. The boy pocketed the coin in a flash, bowed to Isana and Serai, and retreated quietly from the garden. Serai watched him go, then settled down at the fountain again with her sewing. "You're going to wear a path in the grass, darling."

"This is taking too long," Isana said quietly. "We have to do something."

"We are," Serai said, her tone placid. "Our host, Sir Nedus, has dispatched word to the proper channels to request an audience."

"That was hours ago," Isana said. "It seems simple enough. How long can it take to give an answer?"

"The Wintersend ceremonies are extensive, Steadholder. There are thousands of Citizens visiting the capital, and there are quite literally hundreds of them also seeking an audience for one reason or another. It is quite prestigious to be granted an audience with Gaius during the festivities."

"This is different," Isana snapped. "He sent for me. And you are his envoy." Serai's eyes snapped up in a warning glance, and she cast a significant look at the house around them. Isana felt a flash of foolish embarrassment. "It is different," she repeated.

"Yes, it is," Serai said. "Unfortunately, the First Counselor's staff is not privy to the details of why. We must approach him through the usual channels."

"But we might not get through to him," Isana said. "We should present our request in person."

"Isana, only this morning a professional assassin attempted to take your life. If you leave this house, your chances of reaching the Citadel without further attempts are dubious, at best."

"I am prepared to take that risk," Isana replied.

"I am not," Serai said placidly. "In any case, it simply isn't how one approaches the First Lord of Alera, Steadholder. Were we to do as you suggest, it is most likely that we would be ignored."

"Then I will be insistent," Isana answered.

Serai's fingers moved with steady, calm speed. "In which case we would be arrested and held for trial until the end of the Festival. We must have patience."

Isana pressed her lips together and regarded Serai levelly for a moment. Then she forced herself to walk back to the fountain. "You're sure this is the fastest way?"

"It is not the fastest way," Serai said. "It is the only way."

"How much longer must we wait?"

"Nedus has friends and allies in the Citadel. We should have some kind of answer soon." She set the sewing down and smiled at Isana. "Would you care for a bit of wine?"

"No, thank you," Isana said.

Serai glided to a small table nestled in a nook of the garden, where glasses and a crystal decanter of wine rested. She poured rose-colored wine into a glass and sipped very slowly.

Isana watched her, and it was only with an effort that she could sense the woman's apprehension. Serai carried her wine over to the fountain, and settled beside Isana.

"May I ask you something?" Isana said

"Of course."

"At the landing port. How did you know that man was an assassin?"

"The blood on his tunic," Serai said.

"I don't understand."

The tiny courtesan moved her free hand, to touch her side lightly, just under her arm. "Bloodstains, here." She glanced up at Isana. "Probably the result of a knife thrust to the heart, between the ribs and up through the lungs. It's one of the surest ways to kill a man quietly."

Isana stared at Serai for a moment, then said, "Oh."

The courtesan continued, her tone quiet and conversational. "If it isn't done perfectly, there can be quite a bit of excess blood. The assassin must have needed a second thrust to finish the dockworker whose tunic he stole. There was a long stain down the length of the fabric, and that was what made me take a second look at him. We were quite fortunate."

"A man died so that someone could try to murder me," Isana said. "In what way is that fortunate?"

Serai rolled her shoulder in a shrug. "His death was no doing of yours, darling. We were fortunate in that our assassin was both inexperienced and hurried."

"What do you mean?"

"He went to considerable lengths to acquire a tunic in order to disguise himself. With time to plan, he would never have jeopardized his mission with an unnecessary killing, nor approached with his disguise marred with a suspicious stain. It sharply limited his ability to be part of the background,

and an older, more experienced operative would not have attempted it. We were also fortunate in that he was wounded."

"How can you know that?"

"The assassin was right-handed. He threw the knife at you with his left."

Isana frowned, then said, "The bloodstain was on the right side of the tunic."

"Precisely. The assassin approached the dockworker from behind and struck with the blade in his right hand. We know that the kill was not a clean one. We know that the dockworker was probably an earthcrafter. It is reasonable to assume that he struck back at his attacker with furycrafted strength—likely a glancing blow back with his right arm or elbow, striking the assassin's arm in the process."

Isana stared down at Serai. The practical, quiet tone of the courtesan's voice in discussing calculated violence and murder was chilling. A current of fear coursed through Isana, and she sat down at the fountain again. Men of terrible skill and intent were determined to end her life, and her only protection was a frail-looking slip of a woman in a low-cut silk gown.

Serai sipped again at her wine. "Had he been able to get any closer before being seen, or had he been throwing with his preferred arm, you would be dead, Steadholder."

"Great furies preserve us," Isana whispered. "My nephew. Do you think that he is in danger?"

"There's nothing to suggest that he is—and within the Citadel he's as safe as anywhere in the Realm." Serai touched Isana's hand with hers. "Patience. Once we contact Gaius, he will protect your family. He has every reason to do so."

Bitter, old sadness washed through Isana, and the ring on the chain about her throat suddenly felt very heavy. "I'm sure he has the best of intentions."

Serai's back straightened slightly, and Isana sensed a sudden wash of comprehension and suspicion from the courtesan. "Isana," Serai said quietly, dark eyes intent, "you know Gaius. Don't you."

Isana felt a flutter of panic in her belly, but she held it from her voice, expression, and posture as she rose and paced away. "Only by reputation."

Serai rose to follow her, but before she could speak the courtyard was filled with the sound of the house bells ringing. Voices called out from the street outside, and only a moment later, an elderly but robust-looking man in fine robes limped quickly into the garden.

"Sir Nedus," Serai said, performing a graceful curtsey.

"Ladies," Nedus replied. Tall and slim, Nedus had been a Knight Captain for thirty years before retiring, and his every precise and efficient movement still reflected it. He bowed slightly to each of them, and grimaced, an expressive gesture given his bushy silver eyebrows. "Did you drink all my wine again, Serai?"

"I may have left a splash in the bottle," she said, walking to the little table. "Please, my lord, sit down."

"Steadholder?" Nedus asked.

"Of course," Isana replied.

Nedus nodded his thanks and thumped down on the stone bench around the fountain, rubbing at his hip with one hand. "I hope you don't think me rude."

"Not at all," she assured him. "Are you in pain?"

"Nothing that doesn't happen every time I spend hours on my feet dealing with fools," Nedus said. "I must have talked for hours." Serai passed Nedus a glass of wine, and the old knight downed it in a long swallow. "Furies bless you, Serai. Be a dear child and—"

Serai drew the bottle from behind her back, smiling, and refilled Nedus's glass.

"Wonderful woman," Nedus said. "If you could cook, I'd buy your contract."

"You couldn't afford me, darling," Serai said, smiling, and touched his cheek in a fond gesture.

Isana refrained from voicing a curse aloud and settled for asking, "What happened, sir?"

"Bureaucracy," Nedus spat. "The First Counselor's office was packed to the roof. If someone had set the building on fire, half the fools of the Realm would have burned to ash together and left us the richer for it."

"That many?" Serai asked.

"Worse than I've ever seen," Nedus confirmed. "The office wanted every request in writing, and they weren't supplying paper and ink to manage it with. The Academy refused to give any away during examinations, every shop in the Citadel was sold dry of them, and errand boys were gouging applicants for a bloody fortune to run and get them in the Merchants' Quarter, bless their avaricious hearts."

"How much did it cost you?" Serai asked.

"Not a copper ram," Nedus replied. "Something strange was up. The First Counselor's demands were just an excuse."

"How do you know?" Isana asked.

"Because I bribed a scribe in the office with a dozen golden eagles to find out," Nedus replied.

Isana blinked at Nedus. Twelve golden coins could buy supplies for a steadholt for a year or more. It was a small fortune.

Nedus finished the second glass of wine and set it aside. "Word came down that no further audiences with the First Lord were to be granted," he replied. "But that he'd commanded the First Counselor not to reveal the fact. The fool was stuck with figuring out how to prevent anyone from seeing the First Lord without giving them an excuse as to why. And from the looks of the folk in the office, he didn't expect to last the day without someone setting his hair on fire."

Serai frowned and exchanged a long glance with Isana.

"What does it mean?" Isana asked quietly.

"That we cannot reach him that way," Serai said. "Beyond that, I am not sure. Nedus, did you learn anything at all about why the First Lord would do such a thing?"

Nedus shook his head. "Rumor was strong among the Counselor's staff that the First Lord's health had finally broken, but no one knew anything solid." He took the bottle from Serai's hand and drained the rest of it in a single pull. "I tried to find Sir Miles and speak to him, but he was nowhere to be found."

"Sir Miles?" Isana asked.

"Captain of the Royal Guard and the Crown Legion," Serai supplied.

"He was a water boy for Gaius's Knights, back in the my day," Nedus added. "He and his brother Araris. Miles was a hopeless squire, but he grew up pretty good. He remembers me. Might have helped out, but I couldn't find him. I'm sorry, child. I failed you."

Serai murmured, "Of course you didn't, darling. Gaius is making himself scarce, and his captain is nowhere to be found. Clearly something is afoot."

"Not all that scarce," Nedus said. "He presided over the qualifying runs of the Wind Trials this morning, as always."

"Perhaps," Serai said, her brow furrowed in thought. She glanced back at Isana, and said, "We must now consider more dangerous means of reaching

him." She opened a small purse affixed to her belt, withdrew a folded piece of paper, and offered it to Isana.

"What is this?" she asked.

"An invitation," Serai replied. "Lady Kalare is hosting a garden party this evening."

Nedus's bushy eyebrows shot up. "Crows, woman. How did you manage to get an invitation?"

"I wrote it," the courtesan replied serenely. "Lady Kalare's hand is quite simple to reproduce."

Nedus barked out a laugh, but said, "Dangerous. Very dangerous."

"I don't want to go to a party," Isana said. "I want to reach the First Lord."

"Without being able to schedule an audience or reach your nephew, we must attempt something less direct. Each of the High Lords has an audience with the First Lord every year, as do the Senator Primus, the Regus of the Trade Consortium, and the head of the Dianic League. Most, if not all of them will be at the fete."

Isana frowned. "You want to talk one of them into letting us accompany them on their audience?"

"It isn't uncommon," Serai said. "You would not be privileged to speak to the First Lord under normal circumstances, but then once we are actually in Gaius's presence, we should be able to resolve matters in short order."

"Very. Dangerous," Nedus said.

"Why?" Isana asked.

"Gaius's enemies will be there, Steadholder."

Isana inhaled slowly. "I see. You think someone might take the opportunity to kill me."

"It's possible," Serai confirmed. "Lord and Lady Kalare will be in attendance. Kalare is at odds with both Gaius and the Dianic League, and is probably the man behind the attempts upon your life. And you are already, I believe, acquainted with the political leanings of Lord and Lady Aquitaine."

Isana felt her hand clench into a fist. "Indeed. They will be there as well?"

"Almost certainly," Serai said. "Gaius's most loyal High Lords rule the Shield cities in the north. It is a rare year that more than one can attend, and this winter has been a particularly hard one on the northern High Lords."

"You mean that Gaius's supporters may not be there to protect me."

"In all probability," Serai said.

"Is there any chance at all of successfully reaching Gaius if we go to this party?"

"Slim," Serai said, her tone frank. "But it definitely exists. And your favor with the Dianic League should not be forgotten, either. They have long waited for a woman to attain Citizenship outside the structure of marriage or the Legions. It is in their interest to preserve and support you."

Nedus growled, "Is the League going to walk the street next to her and make sure your assassin doesn't take her on the way there?"

Isana felt her fingers shaking. She pressed them against her forehead, and said, "You're sure we can't reach Gaius by any other means?"

"Not quickly," Serai said. "Until Wintersend is over, our options are severely limited."

Isana forced herself to ignore her fear, her worry. She had no desire to die, but she could not allow anything to stop her message, regardless of the danger. Wintersend would not conclude for days. Tavi could be in danger even now, and her brother would surely face it before another day had passed. She did not have time to wait. They did not have days.

"Very well," Isana said. "It would appear that we must go to a party."

CHAPTER 17

It was late afternoon by the time Fidelias returned from gathering information from his contacts in the rougher parts of Alera Imperia. He emerged from the labyrinthine passages in the Deeps into the wine cellar of Aquitaine's manor, and it was a relief to arrive in an area where prying eyes were most unlikely to single him out for attention. He moved directly up the servant's staircase to the top floor of the mansion, where the lavish master suite of High Lord and Lady Aquitaine lay sprawled in luxurious splendor.

Fidelias entered the sitting room of the suite, walked across to the cabinet where a selection of spirits was kept, and helped himself to the contents of an ancient bottle of blue glass. He poured the clear liquid within into a broad,

shallow glass, and took it over to a thickly padded chair before broad windows.

He sat down and closed his eyes, sipping slowly at the liquid that felt ice-cold to his lips.

A door opened behind him. Light footsteps moved into the room. "Icewine," murmured Lady Aquitaine. "You never struck me as the type."

"I arranged signals with my contacts a long time ago—in this case, ordering a drink. Back then I was fool enough to drink five or six firewines in a night."

"I see," Lady Aquitaine said, and sat down in the chair facing his own. Her personal presence was magnetic. She had the kind of beauty that most women would not know to envy—not that of transient youth, though her skill at watercrafting certainly allowed her to appear as young as she would wish. But instead, Invidia Aquitaine's beauty was something that could only be emphasized by the passing of years. It was founded on a rock-solid strength that carried through the lines of her cheekbones and jaw, and continued in the dark granite of her eyes. Lady Invidia's entire bearing and mien was one of elegant power, and as she sat down in her scarlet silk dress and faced Fidelias, he sensed that strength and felt the coolly restrained edge of anger that touched her voice as lightly as autumn's first frost. "And what did you learn?"

Fidelias took another slow sip of the cold drink, refusing to be rushed. "Isana is here. She is in the company of Serai."

Lady Aquitaine frowned. "The courtesan?"

"The Cursor," Fidelias said. "Or so I suspect her to be."

"One of Gaius's secret hands?"

Fidelias nodded. "Highly probable, though like the Cursor Legate, their identities are never openly revealed. She is staying with Isana in the home of Sir Nedus, on Garden Lane."

Lady Aquitaine arched an eyebrow. "Not in the Citadel?"

"No, my lady. And thus far I have not been able to discover why."

"Interesting," she murmured. "What else?"

"I'm certain that the assassin at the windport was one of Kalare's men."

"How can you be so sure?"

"He wasn't a local cutter," Fidelias answered. "My informants in the city would have known something—not necessarily who had done it, but *something*. They knew nothing. So it had to have come from out of town. Between that and the information gained from the assassin at Isanaholt, I'm convinced of it."

"I take it you have learned nothing that could be proven in court," Invidia said.

"I hadn't realized you were preparing a suit."

She gave him a smile as slim and fine as a dagger's edge.

"Kalare is still trying to remove Isana," Fidelias said. "I suspect that his operatives are using the Deeps to facilitate their movements."

Invidia frowned. "The caverns beneath the city?"

"Yes. Every source I spoke with reported men going missing in the Deeps. I presume that the bloodcrows are removing witnesses before they have a chance to spread word about them."

Invidia nodded. "Which would indicate multiple members of Kalarus's band."

"It would."

"But that hardly seems to make sense," Invidia said. "The attempt on Isana's life today was hurried—even sloppy. Why strike with one injured and wounded agent if others were available?"

Fidelias raised his eyebrows, impressed. "And I didn't even need to coach you to ask the right question."

"I'm not my husband, dear spy," she said, her mouth curving into a smile. "Well?"

He exhaled slowly. "You aren't going to like the answer, lady. But I do not know. There are other factors at work. These disappearances—I can't account for them. And . . ."

She leaned forward a little, arching an eyebrow. "And?"

"I can't be certain," Fidelias said. He took another drink of the burning cold liquid. "But I believe that there has been a disruption among the Cursors."

"What makes you think so?"

He shook his head. "Obviously, I couldn't speak to anyone directly connected to them. But those I spoke to should have known something about their recent movements, activities. But there was nothing. Not to mention that Serai is becoming very publicly involved in what is going on at great risk of revealing her allegiance."

"I don't understand," Invidia said.

"I'm not sure I do, either," Fidelias said. "There's a taste to the air." He fixed his gaze on Invidia's. "I think someone has declared war on the Cursors themselves."

Invidia arched an eyebrow. "That . . . would strike a crippling blow to Gaius."

"Yes."

"But who would have the knowledge to do such a thing?"

"Me," he said.

"That *had* crossed my mind," Invidia said. "Have you done it, then?"

Fidelias shook his head, glad that he had no need to veil his emotions in order to confound Invidia's ability at watercrafting. "No. I left the Cursors because I believe the Realm needs a strong leader—and that Gaius can no longer perform his duty as the First Lord. I bear no grudges or malice against the Cursors who serve him in good faith."

"Like the girl? What was her name?"

"Amara," Fidelias said.

"No grudge, my spy? No malice?"

"She's a fool," he said. "She's young. I have been both in my time."

"Mmmm," Invidia said. "How carefully you veil yourself from me when you speak of her."

Fidelias swirled the last bit of icewine around in his cup. "Did I?"

"Yes."

He shook his head and finished the drink. "I will learn whatever else I may. And I will move on Isana tonight."

"There are entirely too many mysteries here for my comfort," Lady Aquitaine said. "But keep in mind, my spy, that my primary concern is the Steadholder. I will not have the Realm know that Kalarus had her removed. I will be the one to weave her fate."

Fidelias nodded. "I have watchers around Sir Nedus's manor. When she steps outside, I'll know it, and be there."

"But why is she not in the Citadel?" Lady Aquitaine murmured. "Surely Gaius knows how vital she is to his continued authority."

"Surely, Your Grace."

"And with Serai." Invidia smiled faintly and shook her head. "I would never have guessed her to be Gaius's tool. I've spoken with her many times. I've never sensed any such thing about her."

"She's quite deadly at the arts of deception, my lady, and a valuable tool of the Crown. She has been sending messengers to the Citadel all during the day on behalf of the Steadholder."

Invidia frowned. "To Gaius?"

"To the boy at the Academy."

Invidia sniffed. "Family. Sentiment, I suppose."

"Word has it that he is one of Gaius's personal pages. Perhaps it is an attempt to reach the First Lord through him."

Lady Aquitaine pursed her lips. "If the palace guard is on heightened alert, and if, as you believe, the Cursors themselves are in disarray, then the channels of communication to Gaius may be entirely severed." A faint line appeared between her brows, then she smiled. "He's frightened. On the defensive."

Fidelias set his empty glass aside and nodded, rising. "It's possible."

"Excellent," she said, and rose with him. "Well. I have another dreary little gathering to prepare for, Fidelias—and at Kalarus's manor, no less. Perhaps I might glean some more information. I will leave you to see to the Steadholder."

Fidelias bowed to Lady Aquitaine and stepped back to withdraw.

"Fidelias," she said, just before he reached the door.

He paused, and looked over his shoulder.

"The Steadholder represents a significant political threat to our plans. You will deal with her tonight," she said. "Failure is unacceptable."

The last words held a frosted edge of steel.

"I understand, my lady," he told her, and paced back toward the shadowed entrance to the Deeps.

⊏▭⊏▭⊏▭⊐CHAPTER 18

Tavi slept like the dead and woke when someone gave his shoulder a brisk shake. He stirred slowly, his muscles tight with the discomfort of hours of motionless sleep, and wiped drool from his mouth.

"What?" he mumbled. The dormitory room he shared with Max was only dimly lit. From the quantity of light, it had to have been near dusk. He'd been asleep for hours.

"I said," replied a stern, rich voice, "that you should arise at once."

Tavi blinked and looked up at who had woken him.

Gaius fixed him with a stern glare. "I have no time to waste on apprentice shepherds who sleep too soundly to serve the First Lord of the Realm."

"Sire," Tavi blurted, and sat up. He shoved his hair from his eyes and tried to blink the sleep from them as well. "Forgive me."

"I expected better of you," Gaius said, his expression severe. "Behavior more like . . . like Antillus's bastard, for example. Fine figure of a young man, he is. An excellent reputation for loyalty. Honor. Duty. And handsome to boot."

Tavi rolled his eyes and slugged "Gaius" lightly in the stomach with one fist.

"Ooof," the false Gaius said, his voice sliding back into Max's usual pitch and cadence. The First Lord's features slid and changed, melting back into Max's own broken-nosed, rough good looks. The older boy's mouth was set in a wide grin. "Pretty good, eh? I had you going for a moment."

Tavi rubbed at the back of his neck, trying to work out a tight muscle. "Only for a moment."

"Ah," Max said. "But you *know* where he truly is, as well as his condition. No one else does—or that is the idea, anyway." He stretched out his legs and regarded his toes. "Besides, I've already attended the opening ceremonies to the Wind Trials and half a dozen smaller functions. All I have to do is look grumpy and keep my verbal exchanges to one or two syllables, and everyone goes leaping out of their way to keep from angering me." Max bobbed his eyebrows. "It is good to be the First Lord."

"Quiet," Tavi warned his friend, glancing around. "These quarters aren't safe for such discussion."

"They aren't exactly the first place spies are going to be looking, either," Max said, with a careless flip of one booted foot. "You got some rest?"

"So it would seem," Tavi said, wincing.

"Time to get back to work then," Max said. "Change your clothes and come with me."

Tavi rose at once. "What are we doing?"

"I'm continuing my brilliant performance," Max said. "After we two pages attend the First Lord in his chambers, at any rate. You are advising me."

"Advising you?"

"Yes. You were the one who had the big thesis paper on furycrafting theory first year, and I'll be speaking to the . . . Board of someone or other."

"The Board of Speakers of the Crafting Society?" Tavi asked.

Max nodded. "Those guys. They're meeting with the First Lord to get approval for more studies of, uh . . ." Max squinted up his eyes. "Arthritic Beer, I keep thinking, but those aren't the right words."

Tavi blinked. "Anthropomorphic Theorem?"

Max nodded again, in exactly the same unconcerned way. "That's it. I've got to learn all about it by the time we walk up to the palace, and you're to teach it to me."

Tavi glared at his roommate and started ripping off his old clothes, changing into fresh ones. He hadn't even bothered to undress before he collapsed on his bed, after fleeing the Black Hall that morning. He started to awaken more thoroughly before he finished re-dressing and raked his comb through his hair. "I'm hurrying."

"Oh," Max said. He bent over and picked up an envelope on the floor. "Someone slid this under the door."

Tavi took the envelope and recognized the handwriting at once. "My aunt Isana."

Outside, the evening bells began to ring, signaling the coming of twilight.

"Crows," Max swore. He rose and started for the door. "Come on. I've got to be there in a quarter hour."

Tavi folded the envelope and thrust it into his belt pouch. "All right, all right." They left the room and started across the campus toward one of the hidden entries to the Deeps. "What do you need to know?"

"Well," Max said after a few steps. "Um. All of it."

Tavi stared at the larger boy in dismay. "Max, that class is required. Essentials of Furycrafting. You took that class."

"Well, yes."

"In fact, we had it *together*."

Max nodded, frowning.

"And you were *there* most of the time," Tavi said.

"Certainly," Max said. "It was in the afternoon. I have no objection to education as long as it doesn't interfere with my sleep."

"Did you *listen*?" Tavi asked.

"Um," Max said. "Keep in mind that Rivus Mara sat in the row in front

of us. You remember her. The one with the red hair and the big . . ." He
coughed. "Eyes. We spent some of those lectures seeing who could earth-
craft the other the most."

Which explained both why Max had shown up nearly every day, and
why he headed straight off for parts unknown after class, Tavi thought
sourly. "How many is some?"

"All of them," Max said. "Except that day I was hungover."

"*What*? How did you manage to write a passing paper?"

"Well. You remember Igenia? That blonde from Placida? She was good
enough to—"

"Oh, shut up, Max," Tavi growled. "That was a three-month course.
How in the crows am I supposed to give you all of that in the next fifteen
minutes?"

"Cheerfully and without complaint," Max replied, grinning. "Like a true
and resourceful member of the Realm and servant of the Crown."

Tavi sighed as they made sure they weren't being observed, then slipped
into an unlocked toolshed and down through the hidden trapdoor in its floor
to the stairs that led into the Deeps. Max lit a furylamp and handed it to
Tavi, then took one for himself.

"You ready to listen?" Tavi asked him.

"Sure, sure."

"Anthropomorphic Theorem," Tavi said. "Okay, you know that furies are
the beings that inhabit the elements."

"Yes, Tavi," Max said drily. "Thanks to my extensive education, I did
know that one."

Tavi ignored the remark. "There's been debate among furycrafters since
the dawn of Aleran history as to the nature of those beings. That's what the
various theories try to describe. There are a number of different ideas about
how much of the furies are truly intrinsic to their nature, and how much is
something that we cause them to become."

"Eh?" Max said.

Tavi shrugged. "We command furies with our thoughts." He went ahead
using the inclusive plural. *We*. Though he was arguably the only Aleran alive
who could have said *you* instead. "That's what Imposed Anthropomorphic
Theory states. Maybe part of our thoughts also shape how our furies appear
to us. Maybe a wind fury on its own doesn't look like anything much at all.
But when a crafter meets it and uses it, maybe that crafter, somewhere in

his head, believes that it should look like a horse, or an eagle or whatever. So when that fury manifests in a visible form, that's what it looks like."

"Oh, oh, right," Max said. "We might give them form without realizing, right?"

"Right," Tavi said. "And that's the predominant view in the cities and among most Citizens. But other scholars support the Natural Anthropomorphic Theory. They insist that since the furies are each associated with some specific portion of their element—a mountain, a stream, a forest, whatever—that each has its own unique identity, talents, and personality."

"Which is why a lot of folks in the country name their furies?" Max guessed.

"Right. And why the city folk tend to sneer at the idea, because they regard it as *paganus* superstition. But everyone in the Calderon Valley named their furies. They all looked different. Were good at different things. They're also apparently a lot stronger than most city furies. Certainly the Alerans living in the most primitive areas of the Realm tend to command much more powerful furies than in other areas."

"Then why would anyone think that the Imposed Theory was correct?"

Tavi shrugged. "They claim that because the crafter is imagining a separate creature with a form and personality and range of abilities, even if he won't admit to himself that he is, that he is capable of doing more because so much less of it relies totally upon his own thought."

"So the crafter with a named fury can do more because he's too stupid to know he can't?" Max asked.

"That's the view of those in favor of Imposed Anthropomorphic Theory."

"That's stupid," Max said.

"Maybe," Tavi said. "But they may be right, too."

"Well. How do the Natural theorists explain why so many people have furies without a specific identity?"

Tavi nodded at the question. It was a good one. Max might not have had an ounce of self-discipline, but there wasn't a thing wrong with his wits. "Natural theorists say that the furies of increasingly domesticated lands tend to break down. They lose their specific identities as they get passed down from generation to generation and as the natural landscape becomes more and more settled and tamed. They're still present, but instead of being there in their natural form, the furies have been broken down into countless tiny bits that a crafter calls together when he wants to get something done.

They aren't as strong, but they don't have the quirks and foibles, either, so they're more reliable."

Max grunted. "Might make some sense," he said. "My old man had some things to say when I named one of my furies." Max's voice took on a hard, bitter edge that Tavi could only barely hear. "Insisted that it was childish nonsense. That he had to break me of the habit before it ruined me. It was harder to do things, his way, but he wouldn't hear of anything else."

Tavi saw the pain in his friend's eyes and thought of all the scars on his back. Maybe Max had his reasons not to pay attention in that particular class that had nothing to do with his carousing. Tavi had thought himself alone in his painful sense of isolation when listening to the basic theory and history of furycrafting. But perhaps it dredged up as many painful memories for Max as it had for him.

"So"—Max sighed after a moment—"which is it?"

"No clue," Tavi said. "No one knows for sure."

"Yeah, yeah," Max said impatiently. "But which one does Gaius think it is? The Board of Speakers is going to be having some kind of debate."

"They do that every year," Tavi said. "I was there last year. Gaius doesn't take sides. They all get together to try to convince him with whatever they think they've learned, and he always listens and nods and doesn't make anyone angry and doesn't take sides. I think that the Board of Speakers really just wants the excuse to drink the First Lord's best wine and to try to one-up their opponents and rivals in front of him."

Max grimaced. "Crows. I'm glad I'm not the First Lord. This stuff would drive me insane in about a day and a half." He shook his head. "What do I do if someone tries to pin me down for an answer?"

"Evade," Tavi suggested, enjoying the heartlessly vague answer.

"What if they start talking about some kind of theory I have no clue about?"

"Just do what you do when the Maestros ask you a question during lecture and you don't know the answer."

Max blinked. "Belch?"

Tavi sighed. "No. No, Max. Divert the attention. Stall for time. Only try not to use any kind of bodily function to accomplish it."

Max sighed. "Diplomacy is more complicated than I thought it would be."

"It's just a dinner party," Tavi said. "You'll do fine."

"I always do," Max said, but his voice lacked some of its usual arrogance.

"How is he?" Tavi said.

"He hasn't moved," Max replied. "Hasn't woken up. But Killian says his heartbeat is stronger."

"That's good," Tavi said. He chewed at his lip. "What happens if . . ."

"If he doesn't wake up," Max said grimly.

"Yeah."

Max inhaled slowly. "Legions fight for the crown. A lot of people die."

Tavi shook his head. "But there is law and precedent for the death of a lord without an heir. The Council of Lords and the Senate would put forward candidates and determine the most fit to take the lordship. Wouldn't they?"

"Officially, sure. But whatever they decided, it wouldn't stick. The High Lords who want the throne might play nice for a little while, but sooner or later one of them would lose the political game and take it to a military venue."

"Civil war."

"Yeah," Max said. He grimaced. "And while we waited for it all, the southern cities would just love to cut the Shield cities loose. And without that support . . ." Max shook his head. "I served two tours on the Shieldwall. We hold it against the Icemen, but we aren't as invincible as everyone down in the rest of the Realm seems to believe. I've seen more than one near breach of the Shieldwall with my own eyes. Without Crown support, it would fall within three years. Four, at the most."

They walked in silence through the tunnels for a few moments. Tavi tended to forget that Max's knowledge of the military disposition of the various High Lords and their Legions was a match for his own knowledge of Aleran society, politics, and history, or for Gaelle's knowledge of the trade crafts and the movement of money, or for Ehren's knowledge of calculations and statistics. Each of them had their strengths, in accordance with their inclinations. It was one reason why they had been chosen to train for the Cursors.

"Max," Tavi said quietly, "you can do this. I'll be there. I'll help if you get into trouble."

His friend inhaled deeply and looked down at him. His mouth quirked in a half smile. "It's just that a lot depends on this act, Tavi. If I get this

wrong, a lot of people could die." He sighed. "I almost wish I'd been paying attention in class."

Tavi arched one eyebrow.

Max winked. "I said almost."

All in all, things could have gone worse.

"Gaius" received the Board of Speakers in his own private reception chambers—which were as large as one of the Academy's lecture halls. Between the Board of Speakers, their wives, assistants, and *their* wives, there were fifty or sixty people in attendance, plus a dozen members of the Royal Guard. Max played his role well, circulating among the guests and chatting pleasantly while Tavi watched and listened from an unobtrusive seat in a curtained alcove. Max faltered once, when one particularly intent young Speaker brought up some obscure technical point of furycrafting, but Tavi promptly interceded, hurrying to pass the false First Lord a folded piece of paper with a scribbled missive. Max opened the paper, looked at it, then smoothly excused himself from the conversation to draw Tavi aside and issue apparent instructions.

"Thanks," Max said. "What the hell does inverted proportional propensity mean, anyway?"

"No idea, really," Tavi said, nodding as though in acknowledgment to a command.

"At least now I don't feel quite so stupid. How am I doing?"

"Stop looking down Lady Erasmus's bodice," Tavi said.

Max arched an eyebrow and sniffed. "I didn't."

"Yes, you did. Stop it."

Max sighed. "Tavi, I'm a young man. Some things just aren't in my control."

"Get them there," Tavi said, and inclined his head deeply, taking two steps back, then withdrawing to the alcove.

Beyond that, things had gone fairly well, until the midnight bell rang, signaling the guests that it was time to depart. Guests, serving staff, then guards cleared out of the reception chamber, leaving a pleasant quiet and stillness behind them.

Max exhaled noisily, picked a bottle of wine from one of the tables, and promptly flopped into a chair. He took a long pull from the bottle, then winced and stretched his back a little.

Tavi emerged from the curtained alcove. "What are you doing?"

"Stretching," Max growled. The tone sounded decidedly odd coming from the First Lord's mouth. "Gaius is about my size but his shoulders are narrower. After a while it starts to hurt like hell." He guzzled some more wine. "Crows, but I want a good long soak."

"At least get back into your own clothes and such before you start acting like that. Someone could see."

Max made a rude noise with his lips and tongue. "These are the First Lord's private chambers, Tavi. No one is going to come wandering into them uninvited."

No sooner had the words left Max's mouth than Tavi heard footsteps and the soft click of a doorknob turning from an unobtrusive doorway on the far side of the room. He reacted without thinking, and ducked back into the curtained alcove, peeking through a small gap.

The door opened, and the First Lady walked calmly into the room.

Gaius Caria, the First Lord's wife, was a woman not ten years older than Tavi and Max. It was widely known that her marriage to Gaius had been a political matching rather than one of romance, and Gaius had used it to drive a wedge between the High Lords of Forcia and Kalare, shattering a political alliance that had threatened even the power of the crown.

Caria herself was a young woman of impeccable breeding, formidable skill at furycraft, and stark, elegant beauty. Her long, straight, fine hair hung in a heavy braid worn over one shoulder, a strand of gleaming firepearls woven through the black tresses. Her gown was of the finest silks, the pure, ivory cream of her dress accented with royal blue and scarlet, the colors of the House of Gaius. Jewels gleamed upon her left hand, both wrists, her throat, and her ears, sapphires and blood-colored rubies that matched the colors in the dress. Her skin was very pale, her eyes dark, and her mouth was set in a hard, dangerous line.

"My lord husband," she said, and gave the false Gaius a little curtsey. There was restrained fury vibrating from every fiber of her.

Tavi's heart stuck in his throat. Stupid, stupid. Of course the First Lord's wife would be admitted to his presence. Their private chambers were linked by a number of hallways and doors, which had been the practice of the House of Gaius for centuries.

And crows take it all, in all that had happened he had never stopped to consider that Max might have to deceive Gaius's own wife. They were about

to be discovered. Tavi hovered on the brink of emerging, telling the First Lady everything, before she discovered it on her own.

But he hesitated. His instincts screamed warnings at him, and though he had no reason at all to do so, he found himself feeling almost certain that exposing the charade to the First Lady would be a disastrous idea.

So he waited behind the curtains and did not move. He barely breathed.

Max managed to rise to a more believable seated position on the chair before the First Lady had entered the room. His expression became reserved and sober and he rose with a polite little bow that duplicated Gaius's own dignity perfectly. "My lady wife," he replied.

Her eyes flicked from his face down to the bottle and back. "Have I displeased you in some way, my lord?"

"Gaius" frowned, then pursed his lips thoughtfully. "And why should you think that?"

"I awaited your summons to the reception, my lord. As we discussed weeks ago. It never came."

Max raised both eyebrows, though it was an expression with more weariness than genuine surprise in it. "Ah. That's right. I'd forgotten."

"You forgot," Caria said. Her voice rang with scorn. "You forgot."

"I'm the First Lord of Alera, my lady," Max told her. "Not an appointments calendar."

She smiled and inclined her head, though the expression was a bitter one. "Of course, my lord. I'm sure that everyone will understand why you have insulted your own wife in front of the whole of the Realm."

Tavi winced. Not once had anyone asked about the First Lady's absence. Indeed, if the First Lord had apparently forbidden her to appear at his side at such a comparatively unimportant function, word of it would rapidly spread.

"It was not my intention to humiliate you, Caria," Max said, and rose from his chair to walk over to her.

"You never do anything without a reason," she spat back. "If that was not your intention, then why did you do this to me?"

Max tilted his head to one side and regarded her appraisingly. "Perhaps I wanted to keep the sight of you to myself. That gown is lovely. The jewels exquisite. Though neither as much so as the woman wearing them."

Caria stood there for a moment in perfect silence, her lips parted in total surprise. "I . . . thank you, my lord."

Max smiled down at her, stepped close. He lifted a hand and put a fore-finger under the tip of her chin. "Perhaps I wanted you to be here when I could have your attention to myself."

"My . . . my lord," she stammered. "I do not understand."

"If an enormous, boring crowd was standing around us right now," Max said, his eyes on hers, "I would hardly be able to do something like this."

Then he leaned down and kissed the First Lady of Alera, the wife of the most powerful man in the world squarely, heatedly, upon the lips.

Tavi just stared at Max. That idiot.

The kiss went on for an utterly untoward amount of time, while Max's hand slid to the back of Caria's head, holding her there in the kiss in an utterly proprietary fashion. When he withdrew his mouth from the First Lady's, her cheeks were flushed pink, and she was breathing very quickly.

Max met her eyes, and said, "I apologize. It was an honest mistake, my lady. Truly. I'll find some way to make it up to you." As he said it, his eyes trailed down the front of her silken gown and then back to Caria's, heavy and warm.

Caria licked her lips and seemed to fumble for words for a few moments. Then she said, "Very well, my lord."

"My page should arrive at any moment," he said. His thumb caressed her cheek. "I've some business to attend. With luck, I'll have some of the night left when it is finished." He arched a brow in a silent question.

Caria's cheeks colored even more. "If duty permits, my lord. That should please me."

Max smiled. "I had hoped you would say that." He lowered his hand, then bowed slightly to her. "My lady."

"My lord," she replied, with another curtsey, before withdrawing through the door by which she'd entered.

Tavi waited for several long breaths before he came out of the alcove, staring at Max. His friend half staggered to the nearest chair, sat down in it, lifted the wine bottle to his mouth in a shaking hand, and drank the rest of it in a single, long pull.

"You're insane," Tavi said quietly.

"I couldn't *think* what else to do," Max said, and as he spoke the tenor of his voice changed, sliding back toward his own speaking voice. "Bloody crows, Tavi. Did she believe it?"

Tavi frowned, glancing at the door. "You know. I think she might have. She was totally off-balance."

"She'd better have been," Max growled. He closed his eyes and frowned, and the shape of his face began to change, slowly enough to make it difficult to say precisely what dimensions were shifting. "I hit her with enough earth-craft to inspire a gelded gargant bull to mate."

Tavi shook his head weakly. "Crows, Max. His *wife*."

Max shook his head, and in a few seconds more looked like himself again. "What else could I have done?" he demanded. "If I'd argued with her, she would have started bringing up past conversations and subjects that I would have no idea how to respond to. It would have given me away within five minutes. My only choice was to seize the initiative."

"Is that what you seized?" Tavi asked, his voice dry.

Max shuddered and stalked over to the alcove, tearing off the First Lord's clothing as he went to don his own once more. "I had to. I had to make sure she wasn't doing too much thinking, or she would have noticed something." He stuck his head through the neck of his own tunic. "And by the furies, Tavi, if there's anything I can do like a high lord, it's kiss a pretty girl."

"I guess that's true," Tavi said. "But . . . you'd think she'd know her own husband's kiss."

Max snorted. "Yeah, sure."

Tavi frowned and arched an inquisitive brow at Max.

Max shrugged. "It's obvious, isn't it? They're all but strangers."

"Really? How do you know?"

"Men of power, men like Gaius, have two different kinds of women in their life. Their political mates, and the ones they actually want."

"Why do you say that?" Tavi asked.

Max's expression became remote and bleak. "Experience." He shook his head and raked his fingers through his hair. "Believe me. If there's one thing a political wife doesn't know, it's what her husband's desire feels like. It's entirely possible that Gaius hasn't kissed her since the wedding."

"Really?"

"Yes. And of course, there's no one in the Realm who would risk crossing Gaius by becoming lovers with her. In that kind of situation, it's going to cause the poor woman considerable, ah, frustration. So I exploited it."

Tavi shook his head. "That's . . . that's so wrong, somehow. I mean, I can

understand the political pressures when it comes to marriages among the lords, but . . . I guess I always thought there would be *some* kind of love."

"Nobles don't marry for love, Tavi. That's a luxury of holders and freemen." His mouth twisted in bitterness. "Anyway. I didn't know what else to do. And it worked."

Tavi nodded at his friend. "It looks that way."

Max finished dressing and licked his lips. "Um. Tavi. We don't really need to mention this to anyone, do we?" He glanced up at him uncertainly. "Please?"

"Mention what?" Tavi said, with a guileless smile.

Max let out a sigh of relief and smiled. "You're all right, Calderon."

"For all you know, I'll just blackmail you with it later."

"Nah. You don't have it in you." They headed for the door that led to a small stair down to the nearest portion of the Deeps. "Oh, hey," Max said. "What did your aunt's letter say?"

Tavi snapped his fingers and scowled. "Knew I was forgetting something." He reached into his pouch and withdrew his aunt Isana's letter. He opened it and read it in the light of the lamp at the top of the stairs.

Tavi stared at the words, and felt his hands start shaking.

Max noticed, and his voice became alarmed. "What is it?"

"I have to go," Tavi said, his voice choked almost to a whisper. He swallowed. "Something's wrong. I have to go see her. Right now."

CHAPTER 19

Amara reached Aricholt by midday. The column halted half a mile from the steadholt's walls, on a rise overlooking the hollow that held the steadholt's wall and buildings cupped in a green bowl of earth. Bernard overrode the objections of both his Knight Captain and First Spear, and stalked down into the deserted steadholt to search for any potential threat. Moments later, he returned, frowning, and the column had proceeded to march through Aricholt's gate.

The place had changed, and for the better, since Amara had first seen it. Years ago, under the rule of Kord, a slaver and murderer, the place had been little more than a collection of run-down buildings around a single stone storm shelter that had to hold the residents of the steadholt and their beasts as well. Since that time, Aric had attracted new holders to move to the potentially rich and certainly beautiful area. One of his new holders had found a small vein of silver on Aric's land, and not only had the revenue from the find paid off his father's enormous debts, but left him with money enough to last a lifetime.

But Aric hadn't hoarded the money away. He had spent it on his holders and his home. A new wall, as thick and solid as Isanaholt's now shielded the steadholt's buildings, all of them also made of solid stone, including a large barn for the animals—even the four gargants Aric purchased for the heavy labor his steadholt needed to prosper. Over the past years, the steadholt had changed from a ragged, weed-choked cluster of shacks and hovels housing miserable no-accounts and pitiable slaves into a prosperous and beautiful home to more than a hundred people.

Which made it all the more eerie to look down upon it now. There was no bustle of activity within the walls or in the nearest fields outside. No smoke rose from the chimneys. No animals milled in the pens or in the pasture nearest the steadholt. No children ran or played. No birds sang. In the distance to the west of the settlement, the enormous, bleak bulk of the mountain called Garados loomed in gloomy menace.

There was only a silence, as still and as deep as an underground sea.

Almost every door in the building hung open, swinging back and forth in the wind. The gates to the cattle pen stood open as well, as did the doors to the stone barn.

"Captain," Bernard said quietly.

Captain Janus, a grizzled veteran of the Legions and a Knight Terra of formidable skill nudged his horse from the head of the column of Knights that had accompanied them to Aricholt. Janus, the senior officer of the Knights under Bernard's command as Count Calderon, was a man of under average height, but he had a neck as thick as Amara's waist, and his corded thews would have been tremendously powerful, even without furycrafting to enhance them. He was dressed in the matte black plated mail of the Legions, and his rough features sported a long, ugly scar that crossed one cheek to pull up his mouth at one corner in a perpetual, malicious smirk.

"Sir," Janus said. His voice was a surprisingly light tenor, marked with the gentle clarity of a refined, educated accent.

"Report, please."

Janus nodded. "Yes, milord. My Knights Aeris swept this entire bowl and found no one present, holders or otherwise. I put them on station in a loose diamond at a mile from the steadholt, to serve as sentinels in the event that anyone else attempts to approach. I have instructed them to observe extreme levels of caution."

"Thank you. Giraldi?"

"My lord," said the First Spear, stepping forward from the ranks of the infantry to slam his fist sharply against his breastplate in salute.

"Establish a watch on the walls and work with Captain Janus to make this place defensible. I want twenty men working in teams of four to search every room in every building in this steadholt and make sure that they are empty. After that, round up whatever stores of food you can find here and get them inventoried."

"Understood, milord." Giraldi nodded and saluted again, then spun around to draw his baton from his belt and began bawling orders to his men. Janus turned to his subordinate, his voice much quieter than Giraldi's, but he moved with the same quality of purpose and command.

Amara stood back, watching Bernard thoughtfully. When she met him, he had been a Steadholder—not even a full Citizen himself. But even then, he had the kind of presence that demanded obedience and loyalty. He had always been decisive, fair, and strong. But she had never seen him in this setting, in his new role as Count Calderon, commanding officers and soldiers of Alera's Legion with the quiet confidence of experience and knowledge. She had known that he served in the Legions, of course, since every male of Alera was required to do so for at least one tour lasting two to four years.

It surprised her. She had regarded Gaius's decision to appoint Bernard the new Count of Calderon as a political gambit, mostly intended to demonstrate the First Lord's authority. Perhaps Gaius, though, had seen Bernard's potential more clearly than she. He was obviously comfortable in his role, and worked with the intent focus of a man determined to discharge his duties to the best of his ability.

She could see the reactions of his men to it—Giraldi, a grizzled old salt of a *legionare,* respected Bernard immensely, as did all of the men of his

century. Winning the respect of long-term, professional soldiers was never easy, but he had done it. And amazingly enough, he enjoyed the same quiet respect with Captain Janus, who clearly regarded Bernard as someone competent at his job and willing to work as hard and face exactly the same situations he asked of his men.

Most importantly, she thought, it was evident to everyone who knew him what Bernard was: a decent man.

Amara felt a warm current of fierce pride flow through her. In spare moments of thought, it still seemed an amazing stroke of luck to her that she had found a man of both kindness and strength who clearly desired her company.

You must leave him, of course.

Serai's gentle, inflexible words killed the rush of warmth, turning it into a sinking in the pit of her stomach. She could not refute them. Bernard's duties to the Realm were a clear necessity. Alera required every strong furycrafter it could get to survive in a hostile world, and its Citizens and nobility represented the prime of that strength. Custom demanded that Citizens and nobility alike seek out spouses with as much strength as possible. Duty and law required the nobility to take spouses who could provide strongly gifted children. Bernard's strength as a crafter was formidable, and with more than one fury, to boot. He was a strong crafter and a good man. He would be a fine husband. A strong father. He would make some woman very, very happy when he wed her.

But that woman could not be Amara.

She shook her head, forcing that line of thinking from her thoughts. She was here to stop the vord. She owed it to the men of Bernard's column to focus all of her thought on her current goals. Whatever happened, she would not allow her personal worries to distract her from doing everything in her power to protect the lives of the *legionares* under Bernard's command, and to destroy what would be a most deadly threat to the Realm.

She watched Bernard kneel on the ground, his palm flat to the earth. He closed his eyes and murmured, "Brutus."

The ground near him quivered gently, then the earth rippled and broke like the still surface of a pool at the passing of a stone. From that ripple, an enormous hound, bigger than some ponies and made entirely of stone and earth rose up from the ground and pushed his broad stone head against Bernard's outstretched hand. Bernard smiled and thumped the hound

lightly on the ear. Then Brutus settled down and sat attentively, its green eyes—real emeralds—focused on Bernard.

The Count murmured something else, and Brutus opened his jaws in what looked like a bark. The sound that came from the earth fury was akin to that of a large rockslide. The fury immediately sank back into the earth, while Bernard stayed there, hunkered down, his hand still on the earth.

Amara approached him quietly and paused several steps away.

"Countess?" Bernard rumbled after a moment. He sounded somewhat distracted.

"What are you doing?" she asked.

There was another low shudder in the earth, this one sharp and brief. Amara felt it ripple out beneath her boots. "Trying to see if anyone is moving around out there. On a good day, I could spot something three or four miles out."

"Really? So far?"

"I've lived here long enough," Bernard said. "I know this valley. That's what makes it possible." He grunted, frowning for a moment. "That isn't right."

"What isn't?"

"There's something . . ." Bernard suddenly lurched to his feet, his face gone white, and bellowed, "Captain! Frederic!"

In seconds, booted feet pounded on the stones of the courtyard, and Frederic came sprinting toward them from outside the walls, where the column's gargants, with Doroga's, waited for the steadholt to be searched for hidden dangers before entering. Seconds later, Captain Janus leapt from the steadholt's wall directly to the courtyard, absorbing the shock of the fall with furycrafted strength, and jogged over without delay or excitement.

"Captain," Bernard said. "There's been a chamber crafted into the steadholt's foundation, then sealed off."

Janus's eyes widened. "A bolt-hole?"

"It must be," Bernard said. "The steadholt's furies are trying to keep it sealed, and it's too much stone for me to move alone as long as they're set against me."

Janus nodded once, stripping his gloves off. He knelt on the ground, pressed his hands to the stones of the courtyard and closed his eyes.

"Frederic," Bernard said, his voice sharp, controlled, "when I nod, I

want you to open a way to that chamber, large enough for a man to walk through. The Captain and I will hold off the steadholt furies for you."

Frederic swallowed. "That's a lot of rock, sir. I'm not sure I can."

"You're a Knight of the Realm now, Frederic," Bernard said, his voice crackling with authority. "Don't wonder about it. Do it."

Frederic swallowed and nodded, a sheen of sweat beading his upper lip.

Bernard turned to Amara. "Countess, I need you to be ready to move," he said.

Amara frowned. "To do what? I don't know what you mean by bolt-hole."

"It's something that's happened on steadholts under attack before," Bernard said. "Someone crafted an open chamber into the foundation of the steadholt, then closed the stone around it."

"Why would anyone do—" Amara frowned. "They sealed their children in," she breathed, suddenly understanding. "To protect them from whatever was attacking the steadholt."

Bernard nodded grimly. "And the chamber isn't large enough to hold very much air. The three of us will open a way to the chamber and hold it open, but we won't be able to do it for very long. Take some of the men down and pull out whoever you can as quickly as you can."

"Very well."

He touched her arm. "Amara," he said. "I can't tell how long they've been there sealed in there. It could be an hour. It could be a day. But I can't feel anything moving around."

She got a sickly, twisting feeling in the pit of her stomach. "We might be too late."

Bernard grimaced and squeezed her arm. Then he went to Janus's side and knelt, placing his own hands on the ground near the Captain's.

"Centurion!" Amara called. "I need ten men to assist possible survivors of the steadholt!"

"Aye, milady," Giraldi answered. In short order, ten men stood ready near Amara—and ten more, weapons drawn, stood next to them. "Just in case they *aren't* holders, my lady," Giraldi growled under his breath. "Doesn't hurt to be careful."

She grimaced and nodded. "Very well. Do you really think they could be the enemy?"

Giraldi shook his head, and said, "Sealed up in rock, for furies know

how long? I doubt it will matter even if it is the vord." He took a deep breath, and said, "No need for you to go down when they open it, Countess."

"Yes," Amara said. "There is."

Giraldi frowned but said nothing else.

Bernard and Justin spoke quietly to one another for a few moments. Then Bernard said, his voice strained, "Almost there. Get ready. We won't be able to hold it open long."

"We're ready," Amara said.

Bernard nodded, and said, "Now, Frederic."

The ground trembled again, then there was a grating, groaning sound. Directly before Frederic's feet, the stones of the courtyard suddenly quivered and sank downward, as if the ground beneath them had turned to soupy mud. Amara stepped over to the opening hole, and took in the rather unsettling sight of stone running like water, flowing down to form itself into a steeply sloping ramp leading down into the earth.

"There," Bernard grated. "Hurry."

"Sir," Frederic said. He spoke in an anguished groan. "I can't hold it open for long."

"Hold it as long as you can," Bernard growled, his own face red and beginning to sweat.

"Centurion," Amara snapped, and she started down the ramp. Giraldi bawled out orders, and the sound of heavy boots on stone followed hard on Amara's heels.

The ramp went down nearly twenty feet into the earth and ended at a low opening into a small, egg-shaped room. The air smelled stale, thick, and too wet. There were shapes in the dimness of the room—limp bundles of cloth. Amara went to the nearest and knelt—a child, scarcely old enough to walk.

"They're children," she snapped to Giraldi.

"Move it," Giraldi barked. "Move it, boys, you heard the Countess."

Legionares stomped into the chamber, seized the still forms in it at random, and hurried out again. Amara left the chamber last, and just as she did, the smooth stone floor suddenly bulged upward just as the ceiling swelled downward. Amara shot a look over her shoulder, and was uncomfortably reminded of the hungry maw of a direwolf as the bedrock flowed and moved like a living thing. The opening to the room contracted, and the walls on either side of the ramp suddenly got narrower. "Hurry!" she shouted to the men ahead of her.

"I can't!" Frederic groaned.

Legionares sprinted up the ramp, but the stone was collapsing inward again too quickly. Scarcely noticing the weight of the limp child she carried, Amara cried out to Cirrus, and her fury came howling down into the slot in the stone like a hurricane. Vicious, dangerous winds abruptly swept down the ramp beneath and behind them, and then rushed up toward the surface like a maddened gargant. The winds threw Amara into the back of the *legionare* in front of her before it caught the man and his charge up, and sent them both into the next man in line, until in all a half dozen *legionares* flew wildly up the ramp and out of the grasp of the closing stone.

The ground grated again, a harsh, hateful sound, and the stone closed seamlessly back into its original shape, catching the end of Amara's braid as it did. The braid snared her as strongly as any rope, and the winds propelling her swung her feet out and up into the air as her hair was seized by the rock. She thumped back down to the stone flat on her back, and got the wind knocked out of her in a rush of breathless, stunned pain.

"Watercrafter!" bellowed Giraldi. "Healers!"

Someone took the child gently from Amara's arms, and she became vaguely aware of the infantry's watercrafter and several grizzled soldiers with healer's bags draped over one shoulder rushing over to them.

"Easy, easy," Bernard said from somewhere nearby. He sounded winded. Amara felt his hand on her shoulder.

"Are they all right?" she gasped. "The children?"

"They're looking at them," Bernard said gently. His hands touched her head briefly, then ran back around the back of her head, gently probing. "You hit your head?"

Amara shook her head. "No. My braid caught in the rock."

She heard him let out a slow breath of relief, then felt him feeling his way along the length of the braid. When he got to the end of it, he said, "It's only an inch or two. It's right at the tie."

"Fine," Amara said.

She heard the rasp of Bernard's dagger being drawn from his belt. He applied the honed edge of the knife to the end of her braid and cut it loose from the rock.

Amara sighed as the pressure on her scalp eased. "Help me sit up," she said.

Bernard gave her his hand and pulled her to sit on the courtyard. Amara
tried to get her breath back, and began methodically to work the now-loose
braid out before it started tangling in knots.

"Sir?" Janus said. "Looks like we got here in time."

Bernard closed his eyes. "Thank the great furies. Who do we have
here?"

"Children," Janus reported. "None of them over the age of eight or nine,
and two infants. Four boys, five girls—and a young lady. They're uncon-
scious but breathing, and their pulses are strong."

"A young lady?" Amara asked. "The steadholt's caretaker?"

Bernard squinted up at the sun and nodded. "It would make sense." He
got up and paced over to the recumbent forms of the children and of one
young woman. Amara rose, paused while her balance swayed a little, then
followed him over.

Bernard grimaced. "It's Heddy. Aric's wife."

Amara stared down at a frail-looking young woman with pale blond hair
and fair skin, only lightly weathered by sun and wind. "Sealed them in," she
murmured. "And set their furies to make sure they stayed that way. Why
would they do such a thing?"

"To make it impossible for anyone to get to them but the people who put
them there," Bernard rumbled.

"But why?"

Bernard shrugged. "Maybe the holders figured that if they weren't around
to get their children out, they didn't want whoever was attacking them to have
the chance."

"Even if they died?"

"There are worse things than death," Doroga said. His rumbling basso
startled Amara into a twitch of reflexive tension. The huge Marat headman
had moved up behind them more silently than an Amaranth grass lion.
"Some of them much worse."

One of the babies started squeaking out a stuttering little cry of
complaint, and a moment later the infant was joined by the exhausted sobs
of another child. Amara glanced up to find the children all beginning
to stir.

Giraldi's watercrafter, a veteran named Harger, rose from the child be-
side Heddy and knelt over the young woman. He put his fingertips lightly on
Heddy's temples, his eyes closed for a moment. Then he glanced up at

Bernard, and said, "Her body is extremely strained. I don't know that her mind is straight right now, either. It might be better to give her the chance to sleep."

Bernard frowned and glanced at Amara, an eyebrow lifted.

She grimaced. "We need to talk to her. Find out what happened."

"Maybe one of the children could tell us," Bernard said.

"Do you think they could have understood what was going on?"

Bernard glanced at them, his frown deepening, and shook his head. "Probably not. Not well enough to risk more lives on what a small child remembers."

Amara nodded her agreement.

"Wake her up, Harger," Bernard said gently. "Careful as you can."

The old watercrafter nodded, his misgivings clear in his eyes, but he turned back to Heddy, touched her temples again, and frowned in concentration.

Heddy awoke instantly and violently, screaming in a raw, tortured wail. Her pale blue eyes flew open—torturously wide—the panicked eyes of an animal certain that its hungry pursuer had moved in for the kill. She thrashed her arms and legs wildly, and a sharp and sudden breeze, strong but unfocused, swept through the courtyard. It spun wildly, throwing up dust, straw, and small stones. "No!" Heddy shrieked. "No, no, no!"

She went on screaming the same word, over and over, and it sounded like she was tearing her own throat raw as she did.

"Heddy!" Bernard rumbled, eyes half-squinted against the wind-driven debris. "Heddy! It's all right. You're safe!"

She went on screaming, struggling, kicking, and bit the hand of one *legionare* who knelt along with Harger and Bernard in an attempt to restrain her. She struggled with a strength born of a fear so severe that it was its own kind of madness.

"Crows take it!" Harger snarled. "We'll have to sedate her."

"Wait," Amara snapped. She knelt beside the struggling holder. "Heddy," she said in the softest voice she could to be heard over the screams. "Heddy, it's all right. Heddy, the children are all right. The Count is here with the guard from Garrison. They're safe. The children are safe."

Heddy's panicked eyes flicked over to Amara, and her eyes focused on someone for the first time since she'd awoken. Her screams slowed a little, and her expression was tortured, desperate. It raked at Amara to see a

woman in so much pain. But she kept her voice gentle, repeating quiet reassurances to the terrified holder. When Heddy had quieted even more, Amara put her hand on the young woman's head, stroking her cobweb-fine hair back from her forehead, never stopping.

It took nearly half an hour, but Heddy's screams died out into cries, then into groans, and finally into a series of piteous whimpering sounds. Her eyes stayed locked on Amara's face, as if desperate to find some kind of reference point. With a final shudder, Heddy fell silent, and her eyes closed, tears welling.

Amara glanced up at Bernard and Harger. "I think she'll be all right. Perhaps you gentlemen should leave me here with her for a little while. Let me take care of her."

Harger nodded at once and rose. Bernard looked less certain, but he nodded to Amara as well and walked over to Captain Janus and Centurion Giraldi, speaking in low tones.

"Can you hear me, Heddy?" Amara asked quietly.

The girl nodded.

"Can you look at me, please?"

Heddy whimpered and started trembling.

"All right," Amara soothed. "It's all right. You don't have to. You can talk to me with your eyes closed."

Heddy's head twitched into a nod, and she kept on shaking with silent sobs. Tears bled down over her cheekbones to fall upon the courtyard's stones. "Anna," she said after a moment. She twitched her head up off the ground, looking toward the sounds of crying children. "Anna's crying."

"Shhh, be still," Amara said. "The children are fine. We're taking care of them."

Heddy sank down again, trembling from the effort it had taken to partially sit up. "All right."

"Heddy," Amara said, keeping her voice smooth and quiet. "I need to know what happened to you. Can you tell me?"

"B-bardos," Heddy said. "Our new smith. Large man. Red beard."

"I do not know him," Amara said.

"Good man. Aric's closest friend. He sent us down into that chamber. Said that he was going to make sure that we weren't . . ." Heddy's face twisted in a hideous grimace of agony. "Weren't taken. Like the others."

"Taken?" Amara said quietly. "What do you mean?"

The young woman's voice became agony grinding in her throat. "*Taken*. Changed. Them and *not* them. Not Aric. Not Aric." She curled into a tight ball. "Oh, my Aric. Help us, help us, help us."

A huge, gentle hand settled on her shoulder, and Amara glanced back up at Doroga's quiet frown.

"Let her be," he said.

"We've got to know what happened."

Doroga nodded. "I will tell you. Let her rest."

Amara frowned up at the big Marat. "How do you know?"

He rose and squinted around the steadholt. "Tracks outside," he said. "Leading away. Shoes, no-shoes, male and female. Cattle, sheep, horses, gargants." He gestured around the steadholt. "Vord came in here two, maybe three days ago. Took the first. Not everyone at once. First they take a few."

Amara shook her head, her hand still resting on the curled form of the weeping holder. "*Took*. What do you mean?"

"The vord," Doroga said. "They get inside you. Go in through the mouth, nose, ear. Burrow in. Then you die. But they have your body. Look like you. Can act like you."

Amara stared at Doroga, sickened. "What?"

"Don't know what they look like exactly," Doroga said. "The vord have many forms. Some like the Keepers of Silence. Like spiders. But they can be little. Mouthful." He shook his head. "The Takers are small, so they can get inside you."

"Like . . . some sort of worm? A parasite."

Doroga tilted his head, one pale war braid sliding over a massive shoulder. "Parasite. I do not know this word."

"It's a creature that attaches itself to another creature," Amara said. "Like a leech or a flea. They feed on a host creature to survive."

"Vord are not like this," Doroga said. "The host creature doesn't survive. Just look like they do."

"What do you mean?"

"Say a vord gets into my head. Doroga dies. The Doroga that is in here." He thumped his head with his thumb. "What Doroga feels. That is gone. But *this* Doroga"—he slapped his chest lightly with one hand—"this remains. You don't know any better, because you only know the true Doroga"—he touched his head—"through the Doroga you can see and talk to." He touched his chest.

Amara shivered. "Then what happened here?"

"What happened among my people," Doroga said. "Takers came. Took just a few. Looked around, maybe deciding who to take next. Then taking them. Until more were taken than were themselves. Took more than seven hundred Wolf Clan like that, one pack at a time."

"Is that what you fought?" Amara asked. "Taken Marat?"

Doroga nodded, his eyes bleak. "First, them. Then we found the nest. Fought the Keepers of Silence. Like big spiders. And their warriors. Bigger. Faster. They killed many of my people, our *chala*." He inhaled slowly. "And then we took the vord queen at that nest. A creature who . . ." He shook his head, and Amara saw something she never thought she might in Doroga—the shadow of fear in his eyes. "The queen was the worst. From her, all the others are born. Keepers. Takers. Warriors. We had to keep going, or the queen would have escaped. Founded another nest. Started over."

Amara pursed her lips and nodded. "That's why you fought as you did. To the end."

Doroga nodded. "And why the queen near this place must be found and destroyed. Before she spawns young queens of her own."

"What do you think happened here?" Amara said.

"Takers came in," Doroga said. "That was what she meant when she said them and not them. This Aric she speaks of was one who was taken. This other man, who sealed her into the stone, must have been free. Maybe one of the last of your people still free."

"Then where is he now?" Amara asked.

"Taken. Or dead."

Amara shook her head. "This isn't . . . this is too incredible. I've never heard of such a thing. No one has ever known anything like this."

"We have," Doroga rumbled. "Long ago. So long ago that few tales remained. But we have seen them."

"But it can't be," Amara said quietly. "It can't be like that."

"Why not?"

"Aric couldn't have been taken. He was the one who came to warn Bernard. If he was one of these vord now, then they would know . . ."

Amara felt a slow, vicious spike of cold lodge in her belly.

Doroga's eyes narrowed to slits. Then he spun to one side and took up the enormous war club he had left leaning against a wall. "Calderon!" he

bellowed, and outside the walls of the steadholt, his gargant answered with a ringing trumpet of alarm. "Calderon! To arms!"

Amara staggered to her feet looking around wildly for Bernard.

And that was when she heard *legionares* begin to scream.

⋈⋈⋈ CHAPTER 20

Amara snapped an order to the nearest healer to watch over Heddy, then called to Cirrus. Her fury gathered around her, winds swirling up a cloud of dust that outlined the vague form of a long-legged horse in the midst of the winds. Amara cried out and felt Cirrus sweep her clear of the ground and into the open sky above Aricholt.

She spun in a circle, eyes flickering over the ground beneath her and the skies about her, taking in what was happening.

In the steadholt below her, she saw *legionares* emerge sprinting from the enormous stone barn. The last man out let out a cry and abruptly fell, falling hard to the stony ground. Something had hold of his ankle and began hauling him back into the barn. The soldier shouted, and his fellow *legionares* immediately turned back to help him.

Amara held up her hands to the level of her eyes, palms facing each other, and willed Cirrus into the air before her face, concentrating the winds to bend light and draw her vision to within several yards of the stone barn.

The *legionare*'s sword slashed through a shining, black, hard-looking limb like nothing that Amara had ever seen, save perhaps the pinching claws of a lobster. The sword bit into the vord's claw—but just barely. The *legionare* struck again and again, and even then only managed to cripple the strength of the claw, rather than severing it completely.

The men dragged their wounded companion away from the barn, his boot flopping and twisting at a hideous angle.

The vord warrior followed them into the sunlight.

Amara stared down at the creature, her stomach suddenly cold. The

vord warrior was the size of a pony, and had to have weighed four or five hundred pounds. It was covered in slick-looking, lacquer-gloss plates of some kind of dark hide. Four limbs thrust straight out to the sides from a humpbacked central body, rounded and hunched like the torso of a flea. Its head extended from that body on a short, segmented stalk of a neck. Twists and spines of chitin surrounded its head, and a pair of tiny eyes recessed within deep grooves glared out with scarlet malevolence. Massive, almost beetlelike mandibles extended from its chitinous face, and each mandible ended in the snapping claw that had crippled the *legionare*.

The vord rushed out of the doorway, hard on the heels of its prey, its gait alien, ungainly, and swift. Two of the *legionares* turned to face it, blades in hand, while the third dragged the wounded man away. The vord bounded forward in a sudden leap that brought it down on top of one of the *legionares*. The man dodged to one side, but not swiftly enough to prevent the vord from knocking him to the earth. It landed upon him and seized his waist between its mandibles. They ground down, and the man screamed in agony.

His partner charged the vord's back, screaming and hacking furiously with his short, vicious *gladius*. One of the blows landed upon a rounded protrusion upon the creature's back, and it sprayed forth some kind of greenly translucent, viscous liquid.

A string of clicking detonations emerged from the vord, and it released the first *legionare* to whirl on its new attacker and bounded into the air as before. The *legionare* darted to one side, and when the vord landed, he struck hard at its thick neck. The blow struck home, though the armored hide of the vord barely opened. But it had been enough to hurt it.

More liquid, nauseating greenish brown, spurted from the wound, and more explosive clicks crackled from the monster. It staggered to one side, unable to keep its balance despite its four legs. The *legionare* immediately seized his wounded companion, and began to drag the other man away from the wounded, unsteady vord. He moved as quickly as he could.

It wasn't enough.

Another half dozen of the creatures rushed out of the barn like angry hornets from a nest, and the buzzing click of the wounded vord became a terrifying, alien chorus. The vibrating roar increased, and the humped, round backs of the things abruptly parted into broad, blackened wings that let them leap into the air and come sailing at the fleeing *legionares*.

The vord tore them to shreds before Amara's horrified eyes.

It happened quickly—start to finish in only a handful of seconds, and there was nothing anyone could have done to save the doomed *legionares*.

More vord emerged from other buildings in the steadholt, and Amara saw three of them leaping forth from the steadholt's well. She heard Giraldi bellowing over the rumble of angry clicking, and a sudden flash of fire boomed into the air as one of Commander Janus's Knights Ignus unleashed furies of fire upon a charging vord.

Another scream, this one very near, snapped Amara's gaze upward, to see one of the Knights Aeris struggling against a pair of winged vord warriors. The man slashed a hand at the air, and a burst of gale-force wind sent one vord tumbling to the side, spinning end over end as it fell toward the earth. But the second vord flared its wings at the last second and it struck him belly first, legs wrapping him, jaw-claws gripping and tearing. The Knight screamed, and the pair of them plummeted toward the ground.

Below her, the veterans of Giraldi's century had immediately linked up to stand together, their backs to one of the steadholt's stone walls and the nearest building securing one flank. Eight or nine of the vord bounded forward, only to be met by a solid wall of heavy Legion tower-shields and blades in the first rank, while the two ranks behind plied their spears in murderous concert with the front row. Supporting one another, Giraldi's veterans stopped the vord charge cold, steel flashing, men screaming defiance. Blood and nauseating vord-fluid sprinkled on the courtyard's stones.

The other century was in trouble. Only half of them had managed to draw together in concentration, and pockets of a half dozen *legionares* or a handful of armed holders were scattered on the walls and within the courtyard. The vord had already left a dozen dismembered corpses draining blood onto the stones. Trapped and on their own, Amara knew that the other isolated groups of Alerans would die within minutes.

There was another scream almost directly below her, a child's wail, and Amara's gaze snapped down to see three of the vord wheeling in perfect unison toward the healers and the survivors below. There was no one close enough to help them.

With a howl of terror and rage, Amara drew her sword and flung herself into a dive that could have outraced a hungry falcon. She swept her dive to the horizontal at the last possible instant, and swept in front of the lead vord. She struck with her sword as she passed, and though she was not

herself particularly strong, the sheer speed of her dive delivered her blow with the force of a charging bull. The shock of the impact went all the way up her arm to her shoulder, and her fingers exploded with tingling sensation and went partially numb.

Amara swept past and immediately turned to go to the defense of the endangered children and healers. The lead vord had been staggered by Amara's blow, which had taken off one of its mandibles cleanly halfway up its length. Sludgy brown-and-green ichor spurted from the broken limb.

The vord shook its head wildly, regained its balance, and turned to charge at Amara while its two companions assaulted the healers.

The vord bounded up into the air, attempting to land upon Amara, but the Cursor had seen the tactic already. As the vord leapt, she flung out one arm and called to Cirrus. A sudden flood of howling wind met the vord in midair and drove it hard into the outer wall of the steadholt. Snarling, Amara flicked her hand again, and the winds drove the creature's back straight down to the stones. When it hit, there was a snapping, crunching sound. The vord writhed and managed to roll back to its four feet, but now luminous green fluid dribbled down its outer plates to the ground. Within seconds, the vord settled smoothly to the earth, like a sail going limp as it lost the wind.

A scream behind Amara made her turn to see one of the vord seize Harger by the leg with its jaw-claw, breaking bone with a shake of its misshapen head. Amara could clearly hear the sickly snap.

The other vord snapped its mandibles around the waist of another healer, shook him hard, whipping back and forth until the man's neck broke. Then it dropped him and charged the terrified children and Heddy.

Amara wanted to scream with frustration—but then she shot a glance at the vord she had killed, and another at the one which had died beside the barn, realization dawning upon her.

If she was correct, she had found a weakness she could attack.

Amara snarled to Cirrus again, and shot across the stones of the courtyard, closing in upon the second vord, eyes seeking her target. She found it, and as she shot by the vord she lashed out with her short blade to strike the bulbous protuberance at the base of the rounded shell.

The sword bit through the vord's hide, and a sudden spray of green ichor splattered the air and the courtyard stones. The vord chattered and clicked in that bizarre fashion she had heard before, then it lurched back and forth

in confusion, giving the children a chance to scramble frantically away from the creature. Amara somersaulted in midair, reversing her direction, and shot past the second vord, which had released Harger's ankle and attempted to seize him by the waist.

Amara lashed out as she passed, her sword again striking true. Half-glowing green ichor flowed. Harger rolled from beneath the vord's wildly flexing mandibles, face white with the pain of his injury. The vord whirled to charge drunkenly at Amara, but she swept herself up into the air before it could reach her. The vord staggered the last several feet, as though unable to see that its target was no longer there, and floundered down to the courtyard stones.

Amara came down near the children. Heddy and the remaining healer were trying to get them up and moving. Amara dashed to Harger's side.

"No!" Harger growled at her. Blood flowed from his ankle. "My lady, get these children clear. Leave me."

"On your feet, healer," Amara spat, and bent to seize the man's right arm and drag it over her shoulder so that she could help support him as he rose. "Head for Giraldi's century!" she shouted to the other two adults.

A shadow fell across her.

Amara looked up and saw more vord descending from above, their stiff wings buzzing in a tidal wave of furious sound. At least a dozen of the creatures were descending straight toward her, so swiftly that there was no time to flee, even had she been alone. She watched the vord coming down in a long and endless moment of fear and realized that she was about to die.

And then there was an explosion, and fire blossomed in the air, directly amidst the ranks of the descending formation of vord. They tumbled and fell, chattering clicks sharp and deafening even among the thrum of blurred wings. Two of them burst into flame outright and were blasted from the sky. They tumbled and fell to their deaths in a drunken spiral, trailing black smoke and clouds of flesh charred to fine ash.

More deadly bursts of flame killed more of the vord, but one of the creatures managed to land on the stones a few steps away from Amara and the wounded Harger. It turned to leap at her, and as Amara tried to dodge, Harger's weight suddenly dragged her down.

Then there was the deep thrum of the heavy bow of a master woodcrafter, and an arrow buried itself into the vord's recessed left eye, striking so deeply that only the brown-and-green fletching showed. The vord rattle-clicked in

what looked like agony, convulsing, and a breath later, a second arrow struck home into the creature's other eye.

Captain Janus charged the blinded vord, a heavy, two-handed greatsword held lightly in his right hand alone. Janus bellowed, whipped the sword with superhuman power, and struck cleanly through the vord's armored neck, severing its head from the body. Stinking ichor spewed.

"Come on!" Bernard shouted, and Amara looked up to see him running to her, his bow in hand, green-and-brown arrows riding in the war quiver at his hip. He seized Harger, dragged the man to his own shoulder, and hauled him toward the doorway of the steadholt's great hall.

Amara rose to follow him, and looked up to see two of the Knights Ignus under Bernard's command standing in the open doorway. One of them focused on a flying vord, suddenly clenched his fist, and another booming blossom of fire roared to life, charring the creature to dead, blackened flesh.

Amara made sure all the children were accounted for, and stayed close to Bernard. Behind them, she heard Janus bellow an order, and looked over her shoulder to see the Knight Captain trotting backward after them, sword in hand and ready to defend their backs. Two more firecraftings roared above them as Amara ran into the great hall, and other explosions, farther away, added their own sullen roars to the deafening chaos of battle.

Amara dropped to her knees once they were safely inside, her body suddenly too weak and tired to support her anymore. She lay there for a few moments, panting hard, until she heard Bernard approach her and kneel next to her. He touched her back with one broad hand.

"Amara," he rumbled, "are you hurt?"

She shook her head mutely, then managed to whisper, "Tired. Too much crafting today." Dizziness and nausea, brought on by her fatigue, made it unthinkably difficult even to consider rising. "What's happening?"

"Isn't good," Bernard said, his voice grim. "They caught us unprepared."

Another set of boots approached quickly, and Amara looked up to see Janus standing over them. "Your Excellency, my Knights have saved everyone they could who had been cut off from Felix's century, but he's lost half his men so far. Giraldi's formation is holding for now."

"The auxiliaries?" Bernard asked, his voice tense.

Janus shook his head.

The Count's face went pale. "Doroga?"

"The Marat and that gargant of his have joined with what is left of Felix's century, along with my fighting men. Their defenses are firming."

Bernard nodded. "The Knights?"

"Ten down," Janus said, in a bleak, quiet voice. "All of our Knights Aeris fell trying to slow that second wave that came in. And Harmonus is dead."

Amara's belly quivered nervously. A full third of Garrison's Knights were dead, and Harmonus had been the most powerful watercrafter in Garrison. The Knights and the Legions both relied heavily upon the abilities of their watercrafters to return the wounded to action, and Harmonus's death would come as a crushing blow to both the troops' tactical capabilities and to their morale.

"We're holding them for now," Janus continued. "Giraldi's veterans haven't lost a man, and the Marat's stinking gargant is crushing these things like bugs. But my firecrafters are getting tired. They can't keep this pace up for long."

Bernard nodded sharply. "We have to concentrate our forces. Signal Giraldi to meet up with Felix's century. Get them here. We won't find a better place to defend."

Janus nodded and snapped his fist to his heart in salute, then turned to stalk out into the screaming chaos of the fighting again.

But even as he did, Amara heard a single, high-pitched squealing sound, almost like the shriek of a hawk. Before the sound had died away, buzzing thunder rolled over the entire steadholt. Amara lifted her head to the doorway, and without a word Bernard took her arm and helped her to her feet, then walked beside her to the door.

As they did, the thunder began to recede, and Amara looked up to see the vord in flight, dozens of them rising into the air and sailing away toward Garados.

"They're running," Amara said softly.

Bernard shook his head, and said quietly, "They're withdrawing the sortie. Look at the courtyard."

Amara frowned at him and did. It was a scene from a nightmare. Blood had run through the cracks in the cobblestone courtyard, outlining each stone in scarlet and leaving small pools of bright red here and there in the sunshine. The air stank of blood and offal, and of the acrid, stinging aroma of burnt vord.

The torn and mangled corpses of Knights and *legionares* littered the

ground. Wherever she looked, Amara saw the remains of a soldier who had been alive under the morning sunshine. Now the dead lay in a hopelessly confused tangle of lifeless flesh that would make it impossible to lay them to rest in anything but a single grave.

Of the vord, fewer than thirty had been killed. Most of those had been blown out of the air by the Knights Ignus, though Giraldi's men had accounted for two more, and four lay crushed and dead on the far side of the courtyard, at the clawed feet of the chieftain's gargant, Walker.

She counted twenty-six dead vord. At least twice as many had risen into the skies when the vord retreated. Surely others must lie dead outside the steadholt's walls, but there could not have been many of them.

Amara had seen blood and death before. But this had been so savage, so abrupt and deadly that she felt as if what she had seen had entered her mind before she had the chance to armor it against the horror. Her stomach twisted with revulsion, and it was all that she could do to control herself. She did not have enough will to stop the tears from blurring her vision and mercifully shrouding the horrific scene in a watery haze.

Bernard's hand tightened on her shoulder. "Amara, you need to lie down. I'll send a healer to you."

"No," she said quietly. "We have wounded. They must be seen to first."

"Of course," Bernard rumbled. "Frederic," he said. "Get some cots out and set up. We'll bring the wounded in here."

"Yes, sir," Frederic said, somewhere behind them.

The next thing Amara knew, she was lying on a cot, and Bernard was pulling a blanket over her. She was too tired to protest it. "Bernard," she said.

"Yes?"

"Take care of the wounded. Get the men some food. Then we need to meet and decide our next step."

"Next step?" he rumbled.

"Yes," she said. "The vord hurt us badly. Another attack could finish us. We need to consider falling back until we can get more help."

Bernard was silent for a few moments. Then he said, "The vord killed the gargants and the horses, Countess. In fact, I suspect that was the purpose of this attack—to kill the horses, our healers, and cripple whatever *legionares* they could."

"Why would they do that?" Amara asked.

"To leave us with plenty of wounded."

"To trap us here," Amara said.

Bernard nodded. "We could run. But we'd have to leave our wounded behind."

"Never," Amara said at once.

Bernard nodded. "Then best take your rest while you can get it, Countess. We aren't going anywhere."

CHAPTER 21

"I feel ridiculous," Isana said. She stared at the long dressing mirror and frowned at the gown Serai had procured for her. "I *look* ridiculous."

The gown was of deep blue silk, but cut and trimmed after the style of the cities of the northern regions of the Realm, complete with a beaded bodice that laced tightly across Isana's chest and pressed even her lean frame into something resembling a feminine bosom. She'd been forced to remove the ring on its chain, and now carried it in a cloth purse tucked into an inside pocket of the gown.

Serai produced plain, if lovely silver jewelry—rings, a bracelet, and a necklace, adorned with stones of deep onyx. After a calculating look, she unbound Isana's hair from its braid and brushed it all out into dark, shining waves threaded with silver that fell to her waist. After that, Serai insisted upon applying cosmetics to Isana's face, though at least the woman had done so very lightly. When Isana looked into the mirror, she scarcely recognized the woman looking back out at her. She looked . . . not real, somehow, as though someone else was simply pretending to be Isana.

"You're lovely," Serai said.

"I'm not," Isana said. "This isn't . . . it isn't . . . me. I don't look like this."

"You do now, darling. You look stunning, and I insist upon being given full credit for the fact." Serai, this time dressed in a silken gown of deep amber, touched a comb to several spots in Isana's hair, making adjustments, a wickedly amused glint in her eye. "I'm told that Lord Rhodes likes a girlish

figure and dark hair. His wife will go into a fit when she sees him staring at you."

Isana shook her head. "I am not at all interested in making anyone stare at me. Particularly at a party hosted by a man who dispatched assassins to kill me."

"There's no proof that Kalare is behind the attacks, darling. Yet." The courtesan turned from Isana to regard her own flawless appearance in the mirror, and smiled in pleasure at her own image. "We're stunning— and we need to be, if we're to make a good impression and accomplish our goals. It's vain, it's stupid, and it's shallow, but that makes it no less true."

Isana shook her head. "This is all so foolish. Lives are in danger, and our only hope of getting anyone to do anything about it is to bow our knee to fashion in order to curry favor at a garden party. There isn't time for this nonsense."

"We live within a society, Isana, that has been built by a thousand years of toil and effort and war. We are by necessity victims of its history and its institutions." Serai tilted her head to one side for a moment, thoughtfully regarding her reflection, then artfully plucked a few curling strands from the clasps that held most of her hair back, so that they dropped to frame her face. The courtesan smiled, and Isana felt her squeeze her hand, her own fingers warm. "And admit it. That gown is perfect on you."

Isana felt herself smiling despite her concerns and turned back and forth in front of the mirror. "I suppose there's no harm in wearing something nice."

"Precisely," Serai said. "Shall we go then? Our carriage should arrive in a few moments, and I want to have time to gloat over the look on Sir Nedus's face when he sees you."

"Serai," Isana protested, gently. "You know I have no such interest, or any such intentions of getting that sort of attention."

"You should try it. It can be quite satisfying." She paused, glancing at Isana, and asked, "Is there a man you'd prefer to see you tonight?"

Isana rested the fingers of her hand lightly on the ring, hidden in its pouch. "Once there was."

"He is not a part of your life?" Serai asked.

"He died." Isana hadn't meant her voice to sound quite so flat and hard, but it had, and she could not say that she regretted it. "I don't discuss it."

"Of course," Serai said, her voice thoughtful. "Forgive me for intruding." Then she smiled as though the exchange had never happened and took Isana's arm to walk her to the front of Sir Nedus's manor.

Serai took a few steps ahead of Isana at the last moment, to the top of the staircase leading down into the house's main hall, the better to gain their host's attention and make a dramatic little flourish of presentation as Isana stepped self-consciously into view.

The white-haired old Knight's seamed face immediately broke into a wide smile. "Furies, lass. I would never have guessed you cleaned up so well."

"Nedus!" Serai chided, and shook a finger at him. "How dare you under-estimate my cosmetic skills."

Isana found herself smiling again and came down the stairs with Serai. "She tells me that I have you to thank for the gown, Sir Nedus. I am grateful for your generosity, and look forward to repaying it as soon as I may."

The old Knight waved his hand. "It is nothing, Steadholder. Foolish old men are wont to spend their gold on pretty girls." He flicked a glance at Serai. "Or so I am told. Ladies, permit me to escort you to the carriage."

"And I suppose you'll have to do," Serai sniffed. She took Nedus's of-fered arm with graceful courtesy, and Isana followed them out the front door of the house. A white-and-silver carriage drawn by four grey horses waited there, a driver in grey livery holding the reins while another stepped down from the stand at the back of the carriage, folded down its mounting steps, and opened its door for the women.

"Very nice," Serai murmured to Nedus. She glanced at the Knight, and said, "I notice that you wear your sword tonight, sir."

Nedus looked baffled. "Furies. Do I?"

"Indeed. And I further notice that your clothing looks a rather great deal like the livery of the coachmen."

"Astonishing," Nedus said, smiling. "Some sort of fascinating coinci-dence, no doubt."

Serai stopped and frowned firmly up at the old man. "And the seat be-side the driver is empty of an armsman. What are you playing at?"

"Why, whatever do you mean?"

Serai sighed. "Nedus, darling, this isn't what I asked for. You've done more than enough for the Realm in your day. You're retired. I have no inten-tion of dragging you into something dangerous. Stay here."

"I'm afraid I'm not sure what you're getting at, Lady Serai," Nedus replied affably. "I'm merely walking you to the carriage."

"You are *not*," Serai said, scowling.

The old Knight glanced up at Isana and winked. "Well. Possibly not. But it occurs to me that if I did intend to ride arms upon that carriage, there would really be nothing you could do about it, lady. Once you get in, I could mount the carriage and you'd be none the wiser for the extra protection, re-gardless of what you might be willing to accept from me."

Serai's mouth firmed into a line. "You aren't going to let me talk you out of this, are you."

Nedus smiled guilelessly.

Serai let out an exasperated breath and touched his arm. "At least prom-ise me you'll be careful."

"There are old swordsmen and bold swordsmen," Nedus said, idly em-ploying the old Legion maxim. "But very few old, bold swordsmen." He opened the carriage door, and said, "Ladies, please."

Serai and Isana settled into the richly appointed carriage. Nedus shut the door and a moment later the carriage got under way. Isana watched Serai's face, sensing the Cursor's anxiety despite the habitual detachment she maintained.

"You fear for him," Isana murmured.

Serai gave her a pained smile. "In his day, he was one of the most dan-gerous men alive. But that was long ago."

"He adores you," Isana murmured. "Like a daughter."

Serai's smile became a little sad. "I know." The tiny courtesan folded her hands in her lap and stared pointedly out the carriage's window, and the re-mainder of the short trip to the garden party passed in silence.

The town house of Lord Kalare was larger than the whole of Isanaholt, and rose seven stories into the air. Balconies and stairs wound all over the outside of the building, thickly planted with broad-leafed plants, flowers, and small trees, all laid out in beautiful, miniature gardens, complete with several beautifully lit fountains. The coachman could have driven through the house's front doors without ducking his head or being particularly care-ful about the position of the carriage's wheels. Wintersend streamers and bunting in the green and grey of the city of Kalare festooned every balcony railing, window, and pillar, and had been wound round twin rows of statuary that led up to the front doors.

Forged invitation held in a confident hand, Serai led Isana up the lit walk toward the house's doors. "His house says something about our host, I think," Serai said. "Rich. Large. Gaudy. Indulgent. I'd say more, but I suppose it would sound unkind."

"I take it you do not care for Lord Kalare?" Isana asked.

"Nor ever have," Serai replied cheerfully. "Quite aside from his recent activities, I have always found the man to be a spineless, venomous boor. I have often hoped that he would contract some wasting disease that would expose him to lethal levels of humiliation."

Isana found herself laughing. "Goodness. But you're coming to his party anyway?"

"Why shouldn't I?" Serai said. "He adores me."

"He does?"

"Of course, darling. Everyone does. I'll be welcome here."

"If he adores you so much, why weren't you invited in the first place?"

"Because *Lady* Kalare made the lists," Serai said. "She does not adore any attractive woman whom her husband *does,* as a general rule." The courtesan sniffed. "She's quite petty about it, really."

"Why do I get the impression that you love to cast that dislike back into her face?"

Serai waved a hand airily. "Nonsense, darling. Gloating is hardly ladylike." She approached the doorman waiting at the threshold and presented her invitation. The man gave it only a brief glance and returned Serai's smile with a bow and a polite murmur of welcome. Serai led Isana into an immense entry hallway lined with statuary. They passed down it, slippers whispering quietly on the stone floor. They passed through pools of light from colored furylamps hung here and there among the statues, and it was very quiet within the hall.

Doubtless, the dimness and quiet had been intentionally established, for when Isana reached the end of the hallway, it opened up onto the sprawling garden that made up the heart of the manor house. The garden was a fabulous one, including topiary cut into the shape of horses and gargants, a section of the thick, green-purple foliage of the exotic trees of the Feverthorn Jungle, and dozens of fountains. Furylamps in every color blazed with light, and spark imps leapt rhythmically from lamp to lamp in long jets of color and light, each imp precisely following the steps of an impossibly complex dance—one echoed by jets of water leaping gracefully from one fountain to the next in rhythmic counterpoint.

The color of light falling upon any part of the garden changed between one breath and the next, and it left Isana feeling dazzled. Music floated throughout the garden, pipes, strings, a slow drum, and a wooden flute full of merry dignity.

And the people. Isana had rarely seen so many people in one place, and every one of them wore clothing that could have paid the taxes on her stead-holt for a month, at the very least. There were folk with the golden coloring of the sunny southern coast, folk with the thin, somewhat severe features of the mountains west of the capital, and folk with the darker skin of the sailing folk of the western coast. Jewels flashed from their nests within rich clothing, rings, and amulets, their colors clashing and striking chords with the light as it continually changed.

The delicious odor of baking pastries and roasting meat filled the air, as did the fresh scents of flowers and new-cut grass, and Isana's nose touched upon half a dozen exotic perfumes as the attendees passed back and forth before them. In one nook of the garden, a juggler entertained half a dozen children of various ages, and in another drums beat more swiftly and intently, while three slave women sinuously weaved through the complex and demanding motions of traditional Kalaran dance.

Isana could only stare at it all, her mouth falling open. "Furies," she breathed.

Serai patted her hand. "Remember. As rich and powerful as they are, they're only people. And this house and garden—they're bought with mere money," she murmured. "Kalare is making an effort to display his wealth, his prosperity. Doubtless he is attempting to outdo whatever gatherings Aquitaine or Rhodes is planning."

"I've never seen anything like this," Isana said.

Serai smiled and looked around. Isana saw something wistful in her eyes. "Yes. I suppose it is quite lovely." She kept smiling, but Isana felt the faintest taint of bitterness as she spoke. "But I've seen what goes on in places like this, Steadholder. I can't appreciate the facade anymore."

"Is it truly so horrible?" Isana asked quietly.

"It can be," Serai said. "But after all, this is where I do my work. Perhaps I'm jaded. Here, darling, let's stand to one side for a moment so that those coming in behind us don't walk on your gown."

Serai pulled Isana aside and spent a moment peering around the garden. A small line appeared between her brows.

"What is it?" Isana asked quietly.

"Attendance tonight is quite a bit more partisan than I expected," Serai murmured.

"How so?"

"A great many of the High Lords are conspicuous by their absence," Serai replied. "Antillus and Phrygia aren't here, naturally, nor have they sent representatives. Parcia and Attica have not come—but they've sent their senior Senators as proxies. That's going to anger Kalare. It's a calculated insult." The little courtesan's eyes swept around the garden. "Lord and Lady Riva are here, as is Lady—but not Lord—Placida. Lord and Lady Rhodes are over there by the hedges. And my, it would seem that the Aquitaines are here as well."

"Aquitaine?" Isana said, her voice flat.

Serai gave her a sharp glance. Except for her eyes, the courtesan's smile was a firm and impenetrable mask. "Darling, you must contain your emotions. Very nearly everyone here has at least as much skill at watercraft as you. And while some feelings are better when shared with others, rage really isn't one of them—particularly when very nearly everyone here is hideously skilled at firecraft as well."

Isana felt her lips press tightly together. "His ambitions killed some of my friends, my holders, my neighbors. But for good fortune, they would have killed my family as well."

Serai's eyes widened with apprehension. "*Darling,*" she said, voice emphatic. "You must *not.* There are doubtless a dozen windcrafters listening to everything that they can. You must not say such things in public, where they might be overheard. The consequences could be dangerous."

"It's only the truth," Isana said.

"No one can prove that," Serai replied. Her hand tightened on Isana's arm. "And you are here in your capacity as a Steadholder. That means that you are a Citizen. And it means that if you slander Aquitaine in public, he will be forced to challenge you in the *juris macto.*"

Isana turned to blink at Serai, startled. "Duel? Me?"

"If you fought him, he'd kill you. And the only way out of the duel would be to retract your statement in public—which would be an excellent way to help make sure that he can never be effectively accused." The courtesan's eyes became cold and hard as stones. "You *will* control yourself, Steadholder, or for you own good I will knock you senseless and drag you back to Nedus's manor."

Isana could only stare at the tiny woman, her mouth open.

"There will be a time of reckoning for those who have sought to under-mine the authority of the Crown," Serai continued, iron in her eyes. "But it must be done properly if it is ever to be done at all."

In the face of Serai's reasoned determination, Isana forced her bitter anger aside. She'd had a lifetime of practice, resisting the influence of the emotions she could sense from others, and it afforded her some small ad-vantage in containing her own. "You're right. I don't know what got into me."

The courtesan nodded, and her eyes softened to match her smile. "Fu-ries, look what you've done. You've made me threaten you with physical vio-lence, darling, which no proper lady would ever do. I feel so brutish."

"I apologize," Isana said.

Serai patted her arm, and said, "Fortunately, I am the most gracious and tolerant woman in the Realm. I will forgive you." She sniffed. "Eventually."

"Who should we talk to in the meanwhile?" Isana asked.

Serai pursed her lips thoughtfully, and said, "Let us begin with Lady Placida. She is the annalist of the Dianic League, and her husband has made it a point to remain rather distant from Kalare or Aquitaine."

"He supports the Crown, then?" Isana asked.

Serai arched a brow. "Not precisely. But he pays his taxes without com-plaining, and he and his sons have served terms in the Shieldwall Legions of Antillus. He'll fight for his Realm, but he's mostly concerned with managing his lands with as little interference as possible. So long as he has that, he is unconcerned with the identity of the next First Lord."

"I shall never understand politics. Why would he help us?"

"He likely wouldn't, on his own," Serai said. "But there's a chance his wife will. I suspect the Dianic League will be most interested in establish-ing relationships with you."

"You mean, they want me to owe them favors as rapidly as possible," Isana said in a dry voice.

"Your understanding of politics seems sound enough to me," Serai replied, her eyes sparkling, and she led Isana over to meet Lady Placida.

Lord Placida's wife was an exceptionally tall woman with a thin, severe face and heavy-lidded brown eyes that bespoke the exceptional intellect be-hind them. She wore the single, deep color of the ruling house of Placida, a rich, deep emerald green whose dye was derived from a plant found only in the high reaches of the mountains near Placida. She wore golden jewelry set

with emeralds and amethyst, each piece beautiful in its elegant simplicity. She looked no older than a girl in her midtwenties, though her medium brown hair, like Isana's, was touched lightly with silver and grey. She wore it bound up in a simple net that fell to the base of her neck, and she smelled of rose oil.

"Serai," she murmured, and smiled at the courtesan as she approached. Her voice was surprisingly light and sweet. She came forward, hands held out, and Serai took them, smiling. "It's been too long since you've visited us."

Serai inclined her head in a bow of deference to Lady Placida's station. "Thank you, Your Grace. And how is your lord husband, if I may ask?"

Lady Placida rolled her eyes the tiniest bit, and drily murmured, "He was not feeling well enough to attend tonight's festivities. Something in the air, no doubt."

"No doubt," Serai replied, her voice grave. "If I may be so bold, would you convey my best wishes to him for a speedy recovery?"

"Gladly," the High Lady said. She turned her face to Isana and smiled politely. "And you, lady. Would you happen to be Isana of Calderon?"

Isana bowed her head in reply. "If you please, Your Grace, just Isana."

Lady Placida arched a brow and studied Isana with intent, alert eyes. "No, Steadholder. I'm afraid I must disagree. Indeed, of all the women in the Realm, it would seem that you might be the one who most deserves the honorific. You've done something no other woman in all the history of Alera has ever done. You've earned rank and title without resorting to marriage or murder."

Isana shook her head. "The First Lord deserves the credit, if anyone. I had little say in the matter."

Lady Placida smiled. "History seldom takes note of serendipity when it records events. And from what I have heard, I suspect an argument could be made that you very much did earn the title."

"Many women have earned titles, Your Grace. It doesn't seem to have been a factor in whether or not they actually received them."

Lady Placida laughed. "True enough. But perhaps that is beginning to change." She offered her hands. "It is a distinct pleasure to meet you, Steadholder."

Isana clasped the other woman's hands for a moment, smiling. "Likewise."

"Please tell me that Serai is not your guide here in the capital," the High Lady murmured.

Serai sighed. "Everyone thinks the worst of me."

"Tut, dear," Lady Placida said calmly, her eyes shining. "I don't *think* the worst of you. I happen to *know* it. And I shudder to think to what kinds of shocking experiences the good Steadholder is about to be exposed."

Serai thrust out her lower lip. "Few enough. I'm staying at Sir Nedus's manor. I've got to be on my best behavior."

Lady Placida nodded in understanding. "Isana, have any of the Dianic League's council spoken to you yet?"

"Not yet, Your Grace," Isana replied.

"Ah," said Lady Placida. "Well, I'll not bore you with a recruiting speech here at the party, but I should enjoy the chance to discuss matters with you before the conclusion of Wintersend. I think there are many things that you and the League might have to offer one another."

"I don't know what I could offer, Your Grace," Isana said.

"An example, for one," Lady Placida replied. "Word of your appointment has spread like wildfire, you know. There are thousands of women in the Realm who have been shown that there are doors that might now be open to them that were not before."

"Your Grace," Serai lied smoothly, "I am afraid that the Steadholder's time is by and large accounted for, as a guest of the First Lord's—but I happen to know the outrageously beautiful slave in charge of her calendar, and I should be glad to speak to her on your behalf to see if we can open up a time."

Lady Placida laughed. "My own time is somewhat limited, you know."

"I do not doubt it," Serai said. "But perhaps something might be arranged. What are your mornings like?"

"Filled with endless receptions for the most part, but for my lord husband's audience with the First Lord."

Serai arched a thoughtful brow. "There is usually quite a bit of walking involved during the audience. Perhaps you might permit the Steadholder to accompany you for conversation?"

"An excellent notion," Lady Placida said. "But two days too late, I am afraid. My lord husband was first on the list this year." Her words were light and pleasant, but Isana saw something shrewd and calculating in her eyes for a moment. "I'll have one of my staff contact you to find a time to take tea with the Steadholder—if that is all right with you, of course, Isana."

"Oh. Yes, of course," Isana said.

"Excellent," Lady Placida said, smiling. "Until we meet again, then." She turned away to take up a conversation with a pair of grey-bearded men, each wearing the deep purple sash of a Senator.

Isana's stomach clenched in frustration and worry. She glanced at Serai, and said, "There must be someone else."

Serai frowned at the High Lady's back for a moment, and murmured to Isana, "Of course, darling. If at first you don't succeed, pick the next most likely course of action." The courtesan looked around the garden. "Mmm. Lord and Lady Riva probably aren't going to be very interested in helping you, I'm afraid. They very much resent how the First Lord appointed your brother as the new Count Calderon without consulting them on the matter."

"Who does that leave?" Isana asked.

Serai shook her head. "We'll keep trying until we've heard no from everyone. But let me go speak to Lord Rhodes."

"Shouldn't I come with you?"

"No," Serai said, firmly. "Remember, I think he's going to rather enjoy the look of you. I'd like to spring that on him as a surprise. It may warm him to the idea of taking you with him. Just watch me and come over when I wave, darling."

"All right," Isana said.

Serai glided through the attendees, smiling and exchanging courtesies as she went. Isana watched her, and felt suddenly vulnerable without the Cursor's presence and guidance. Isana glanced around, looking for a place she could wait without jumping like a frightened cat every time someone walked behind her. There was a long stone bench beside a nearby fountain, and Isana settled lightly down on it, making sure that she could see Serai.

A moment later, a woman in a red gown settled on the other end of the bench and nodded pleasantly at Isana. She was tall, her hair dark though shot with silver. She had clear grey eyes and lovely, if remote features.

Isana nodded back with a smile, then frowned thoughtfully. The woman seemed familiar, and a moment later she recognized her from the attack at the windport. She was the woman Isana had stumbled into.

"My lady," Isana said, "I'm afraid I didn't get the chance to beg your pardon at the windport this morning."

The woman arched a brow, expression quizzical, then she suddenly smiled. "Oh, on the landing platform. There were no broken bones—hardly a need to apologize."

"All the same. I left without doing so."

The woman smiled. "Your first time at the capital's windport?"

"Yes," Isana said.

"It can be overwhelming," the woman said, nodding. "So many windcrafters and porters and litters. All that dust blowing around—and, of course, no one can see anything. It's madness during Wintersend. Don't feel bad, Steadholder."

Isana blinked at the woman startled. "You recognize me?"

"A great many would," the woman said. "You are one of the more famous women in the Realm this year. I am sure the Dianic League will be falling all over itself to welcome you."

Isana forced herself to smile politely, keeping a tight rein on her emotions. "It's quite flattering. I've spoken to High Lady Placida already."

The woman in red laughed. "Aria is many things—but none of them are flattering. I hope she was pleasant to you."

"Very," Isana said. "I had not expected this kind of . . ." She hesitated, searching for a phrase that would not give the noblewoman offense.

"Courtesy?" the woman suggested. "Common politeness uncommon in a noblewoman?"

"I would not describe it using any of those terms, lady," Isana replied, but she couldn't keep the wry humor out of her voice.

The woman laughed. "And I suspect that is because you have a conscience, whereas a great many of the people here would only be moved to it by their political ambitions. Ambitions are incompatible with consciences, you know. The two strangle one another straightaway and leave an awful mess behind them."

Isana laughed. "And you, lady? Are you a woman of conscience or of ambition?"

The lady smiled. "That's a question rarely asked here at court."

"And why is that?"

"Because a woman of conscience would tell you that she is a person of conscience. A woman of ambition would tell you that she is a person of conscience—only much more convincingly."

Isana arched a brow, smiling. "I see. I shall have to be more circumspect in my questions, then."

"Don't," the lady said. "It's refreshing to encounter a new mind with new questions. Welcome to Alera Imperia, Steadholder."

Isana inclined her head to the lady, and murmured, with genuine grati-tude, "Thank you."

"Of course. It's the least I can do."

Isana looked up to see Serai speaking to a hollow-cheeked man in gold and sable, the colors of the House of Rhodes. The courtesan was laughing at something the High Lord was saying as she glanced over at Isana.

The smile froze on Serai's face.

She turned back to Rhodes, and said something else, then turned and immediately crossed the garden to Isana and the woman in the red gown.

"Steadholder," Serai said, smiling. She curtseyed deeply to the woman in red. "Lady Aquitaine."

Isana's glance snapped from Serai to the woman in red, the heated anger she had felt before struggling to burst free. "You." She choked on the sentence and had to take a breath and begin again. "You are Lady Aquitaine?"

The lady regarded Serai with a cool glance, and murmured, voice dry, "Did I not mention my name? How careless of me." She nodded to Isana, and said, "I am Invidia, wife to Aquitainus Attis, High Lord Aquitaine. And I should very much like to discuss the future with you, Steadholder."

Isana rose to her feet and felt her chin lift as she glared down at Lady Aquitaine. "I don't see what point there would be to that discussion, Your Grace," she said.

"Why ever not?"

Isana felt Serai step next to her, and the courtesan's fingers tightened on Isana's wrist, urging restraint. "Because in every future I can imagine, you and I have nothing to do with one another."

Lady Aquitaine smiled, a cool, self-contained expression. "The future is a winding road. It is not possible to foresee all of its turns."

"Perhaps not," Isana replied. "But it *is* possible to choose one's traveling companions. And I will not walk with a tr—"

Serai's nails dug hard into Isana's arm, and the Steadholder barely kept herself from saying the word "traitor." She took a deep breath and steadied herself before resuming. "I will not walk with a traveling companion I have small reason to like—and even less to trust."

Lady Aquitaine looked quietly from Isana to Serai and back. "Yes. I can see that your taste in companions and mine differ significantly. But bear in mind, Steadholder, that the road can be a dangerous one. There are many

hazards both overt and unseen. It is wise to walk with someone who is able to protect you from them."

"And even wiser to choose companions who will not turn upon you when the opportunity presents itself," Isana replied. She lowered her voice to barely above a whisper. "I saw your husband's dagger, Your Grace. I buried men and women and children who died because of it. I will *never* walk willingly with such as you."

Lady Aquitaine's eyes narrowed unreadably. Then she nodded once, and her gaze moved to Serai. "I take it, Serai, that you are the Steadholder's guide within the capital?"

"His Majesty made a request of my master, who loaned me out to do so," Serai replied, smiling. "And if I happen to take in the new season's fashion in the course of my duties, well, I shall simply have to bear it."

Lady Aquitaine smiled. "Well, it isn't like our Midsummer ball, but it will have to do."

"Nothing compares to Midsummer at Aquitaine," Serai said. "And your gown is quite gorgeous."

Lady Aquitaine smiled in what looked like genuine pleasure. "This old thing?" she asked artlessly, and waved a hand. The scarlet silk of her dress swept through a haze of colors, then settled on a shade of amber like Serai's own dress, but more deeply steeped in crimson.

Serai's lips parted, and she smiled. "Oh, my. Is it difficult to do that?"

"No more so than any faucet or oven," Lady Aquitaine replied. "It's a new line of silks my Master Weaver has been working on for years." Another gesture returned the silk to its original hue, though it deepened from scarlet to black by gentle degrees at the ends of the sleeves and the hem of the skirts. "My lord husband suggested it be used to reflect the mood of its wearer, but for goodness sake, it isn't as though we don't have trouble enough dealing with men. If they suddenly actually became able to gauge our moods, I'm sure it would be an utter disaster. So I insisted on mere fashion."

Serai regarded the dress wistfully. "Expensive, I take it, the new silk?"

Lady Aquitaine shrugged a shoulder. "Yes, but not grotesquely so. And I might be able to arrange something for you, darling, should you join us at Midsummer."

Serai's smiling mask returned. "That's very generous, Your Grace. And certainly tempting. But I fear I must consult with my master before making any decisions."

"Naturally. I know how highly you value your loyalty. And he who commands it." There was a sudden silence, and Lady Aquitaine's smile put a mild but definite emphasis on it. "Are you sure you wouldn't like to come? These gowns are going to be all the rage in the next season or two. I'd love to see you in one—and you are, after all, an invaluable consultant on such matters. It would be a true shame were you not to be recognized as a leader in the newest styles."

Isana felt the courtesan's fingers tighten on her arm again. "You are very generous, Your Grace," Serai replied. She hesitated so briefly that Isana barely heard the awkward pause. "I'm afraid I'm still all turned about from all the travel I've done. Let me sleep on it and consider the possibilities."

"Of course, dear. Meanwhile, do good service to your master and to the Steadholder, Serai. The capital can be a dangerous place to those new to it. It would be a great loss to the League should anything happen to her."

"I assure you, Your Grace, that Isana is in the care of more hands than are easily seen."

"Of that," Lady Aquitaine said, "I am certain." She rose smoothly and inclined her head to Isana and Serai. Her steady grey eyes remained on Isana's. "Ladies. I am sure we will speak again."

It was a dismissal. Isana narrowed her eyes and prepared to stand her ground, but Serai's silent tugs on her arm drew her away from Lady Aquitaine to another part of the garden.

"She knew," Isana said quietly. "She knew how I would react to her had she introduced herself."

"Obviously," Serai said, and her voice was shaking.

Isana felt a thrill of apprehension flow into her from the courtesan, and she blinked at the smaller woman. "Are you all right?"

Serai looked around them, then said, "Not here. We'll speak again later."

"Very well," Isana said. "Did you speak to Lord Rhodes?"

"Yes."

"Where is he?"

Serai shook her head. "He and the other High Lords have gone to the far garden to bear witness to Kalare's official duel with his son, Brencis, for Citizenship. His audience with the First Lord is on the morrow, but his party is already overlarge." She licked her lips. "I think we should leave, Steadholder, as soon as possible."

Isana felt herself tensing again. "Are we in danger?"

Serai looked across the garden at Lady Aquitaine, and Isana felt her start trembling more severely. "Yes. We are."

Isana felt Serai's fear creep into her own belly. "What should we do?"

"I . . . I don't know . . ." The little courtesan took a deep breath and closed her eyes for a moment. Then she opened them, and Isana could feel her forcing steel into her voice. "We should leave as soon as possible. I'll make you enough introductions to satisfy courtesy, then we will return to the House of Nedus."

Isana felt her throat tighten. "We've failed."

Serai lifted her chin and patted Isana's arm firmly. "We have not yet succeeded. There is a difference. We'll find a way."

The courtesan's confident manner had returned, but Isana thought she could feel the faintest trembling yet in her hand. And she saw Serai spare another glance in Lady Aquitaine's direction, her eyes moving too quickly to be anything but nervous.

Isana looked back and met Lady Aquitaine's cool grey eyes from across the garden.

The Steadholder shivered and turned away.

⋈⋈⋈⋈⋈ Chapter 22

Within half an hour, Serai had introduced Isana to more than a dozen nobles and prominent Citizens of the capital, charmed and complimented every one of them, and had somehow managed to leave each conversation with pleasant brevity. The courtesan was, Isana realized, a master fencer in the arts of wit and conversation. One friendly old Senator had threatened to drag the conversation out for hours, but Serai had deftly slipped in a joke that caused him to boom into a belly laugh in the middle of a sip of wine, requiring immediate steps to save the tunic he wore. A young Attican Lord had spoken to Serai in beautifully polite—and lengthy—phrases that were

entirely out of sorts with his predatory eyes, but the Cursor had stood upon tiptoe to whisper something into his ear that made a slow smile curl one side of his mouth, and he had taken his leave "until later."

There were half a dozen other such incidents, and the courtesan reacted to each with precision, poise, wit, and blinding rapidity of thought. Isana was quite certain that with Serai's help, she had just set some kind of speed record for making a good first impression upon the cream of Alera's society. She'd done her best to smile, say polite things, and avoid tripping over either the nobles at the party or the hem of her silk gown.

Serai asked a servant to tell her coachmen to pick them up in front of the house. She and Isana had just turned to leave the garden when a man in a granite grey tunic salted with beads of green semiprecious stones stepped into their path, smiling pleasantly. He was not as tall as Isana, nor was he built with any particularly significant amount of athleticism. He had a weak chin hidden under a neatly trimmed goatee, rings on every finger, and wore a steel circlet across his brow. "Ladies," he said, and bowed very slightly. "I must apologize to you both for being remiss in my duties as a host. I must have overlooked your names on the guest list, or I would have made the time to visit with you both."

"Your Grace," Serai murmured, and dropped into a deep curtsey. "It is good to see you again."

"And you, Serai. You are as lovely as ever." The man's eyes were narrow and suspicious—not so much from active thought, Isana thought, as from ingrained habit. "I am surprised that my lady wife extended her invitations to you, I must admit."

Serai smiled winsomely up at him. "I suppose happy accidents can happen. High Lord Kalare, may I present Steadholder Isana of the Calderon Valley."

Kalare's narrowed eyes flicked to Isana and ran over her. There was no sense of emotion from him. He looked at Isana as other men might a column of numbers. "Ah. Well, this is a pleasant surprise." He smiled. There was no more emotion to that than there had been to his gaze. "I've heard so many things about you," he said.

"And I you, Your Grace," Isana murmured.

"Have you now. Good things, I hope?"

"Many things," Isana said.

Kalare's false smile vanished.

"My lord," Serai said, stepping into the silence before it could become more uncomfortable. "I fear that my recent travel has left me at somewhat less than perfect health. We were just leaving, before I fell down asleep and made a fool of myself."

"A fool of yourself," Kalare murmured. He stared at Serai for a moment, then said, "I have been considering purchasing you from your current master, Serai."

She smiled at him, somehow making it artless and vulnerable with fatigue. "You flatter me, my lord."

Kalare's voice was flat. "I do not offer it as a compliment, slave."

Serai lowered her eyes and curtseyed again. "Of course not, Your Grace. Please forgive my presumption. But I do not think my master has set a price for me."

"There's always a price, slave. Always." His mouth twitched at one corner. "I do not like to be made the fool. And I do not forget my enemies."

"My lord?" Serai asked. She sounded bewildered.

Kalare let out a harsh bray of bitter laughter. "You do your master good service, I think, Serai. But you will exchange his collar for another's, sooner or later. You should give careful thought to whom you might next serve." His eyes flicked to Isana, and he murmured, "And you should give careful thought to the company you keep. The world is a dangerous place."

Serai never lifted her eyes. "I will do so, my lord."

Kalare looked up at Isana, and said, "It was a pleasure to meet you, Steadholder. Allow me to wish you a safe journey home."

Isana faced him without smiling. "Certainly, my lord. And believe me when I say that I wish your own road to be of a kind."

Kalare's eyes narrowed to slits, but before he could speak a servant in the grey and green of House Kalarus approached him, carrying an arming jacket and a wooden practice sword. "My lord," he murmured, bowing. "Your son stands ready to face you, with Lords Aquitaine, Rhodes, and Forcia to bear witness."

Kalare's eyes snapped to the servant. The man paled a little and bowed again.

Serai licked her lips, looking from the servant to Kalare, and said, "My lord, is Brencis ready to challenge for Citizenship already? The last I saw of him, he wasn't so tall as me."

Kalare, without so much as glancing at Serai, struck her a blow to the

cheek with his open hand. Isana knew that had he used fury-born strength to do so, the blow could have killed Serai—but it was merely a heavy, contemptuous slap that rocked the courtesan to stumble to one side.

"Lying bitch. Do not presume to speak to me as if you were my peer," Kalare said. "You are in my house. Your master is not here to speak for you. Keep to your place, or I will have that gown whipped from your flesh. Do you understand?"

Serai recovered herself. Her cheek had already began to flush red where the blow had landed, and her eyes looked a bit glassy, stunned.

A startled silence settled over the garden, and Isana felt the sudden pressure of every gaze at the party being directed toward them.

"Answer me, slave," Kalare said, his voice quiet, even. Then he stepped toward Serai and lifted his hand again.

Isana's body was flooded with sudden, cold fury. She stepped forward between them, and raised one arm vertically, to intercept Kalare's swinging hand.

Kalare bared his teeth. "Who do you think you are, woman?"

Isana faced him, that same chill anger transforming her quiet speaking voice into a steely sword. "I think I am a Citizen of the Realm, my lord. I think that striking another Citizen is an offense in the eyes of the law of the Realm. I think that I am here at the invitation of my patron, Gaius Sextus, First Lord of Alera." She locked eyes with Kalare and stepped forward again, facing him from a handbreadth. "And, my lord, I think that you are neither foolish nor arrogant enough to believe for a single moment that you could strike *me* in public without repercussions."

The only sound in the garden was the gentle splash of water in the fountains.

Kalare shifted his weight uncomfortably, and his narrowed eyes relaxed, becoming more sleepy than suspicious. "I suppose so," he said. "But do not think I will forget this."

"That makes two of us, Your Grace," Isana said.

Muscles tightened along Kalare's jaw, and he spoke through clenched teeth. "Get out of my house."

Isana tilted her head in the barest nod of acknowledgment. She stepped back from Kalare, touched Serai's arm, and left the garden with her.

Instead of heading for the front door, Serai glanced around the hallway, took Isana's hand, and decisively led her into a side passage.

"Where are we going?" Isana asked.

"To the kitchen doors at the rear of the house," Serai said.

"But you told Nedus and his men to meet us at the front."

"I told the servant that for the benefit of whoever might be eavesdropping, darling," Serai said. "The better to keep anyone from following us home. After all, it *is* Kalare's house, and his servants will certainly report your movements. Nedus will know to meet us in the back."

"I see," Isana said, and in a moment the courtesan led her through the busy kitchens and out the back door of the house, to a dark, quiet street where Nedus and the coach waited. They hurried into the carriage without a word, and Nedus shut the door behind them. The driver clucked to the horses at once, and the carriage lurched forward into hurried motion.

"Lady Aquitaine," Isana said quietly. "She was not what I expected."

"She's the sort to smile while she twists the knife, Steadholder. Don't be deceived. She is a dangerous woman."

"You think she might be behind the attacks."

Serai stared at the curtains over the coach's windows and shrugged, her expression remote. "She is certainly capable of it. And she knows things she shouldn't."

"That you are one of the Cursors," Isana said.

Serai drew in a slow breath and nodded. "Yes. It would seem that I have been compromised. She knows, and from the way Kalare spoke, I would judge that he does as well."

"But how?"

"Remember that someone has been killing Cursors left and right, darling. It's possible that the information was extracted from one of them."

Or, Isana thought, *that one of them is a traitor.*

"What does it mean for you?" she asked Serai quietly. "Exposure."

"Any enemy of the Crown might take satisfaction in removing me," she said, her voice calm, matter-of-fact. "It will only be a matter of time. Secrecy was my greatest defense—and Gaius's enemies will face few, if any, consequences for murdering a slave. If nothing else, Kalare will do it simply to spite the First Lord."

"But wouldn't Gaius protect you?"

"If he could," Serai said. She shook her head. "He's been slowly losing power among the High Lords, and he isn't getting any younger. He won't be First Lord forever, and once he isn't . . ." The courtesan shrugged.

Isana felt sick at her stomach. "That's what that talk about the gown was all about. Lady Aquitaine was offering you a position with her, wasn't she."

"More than that. I should think she meant to offer me my freedom, a title, and most likely a position in whatever would pass for the Cursors under her husband's rule."

Isana was quiet for a moment. "That's quite an offer," she said.

Serai nodded, silent.

Isana folded her hands in her lap. "Why didn't you take it?"

"Her price was too high."

Isana frowned. "Price? What price?"

"Isn't it obvious, darling? She knew that I was your guardian. She offered me power in exchange for you. And made it known that the results might be unpleasant if I denied her."

Isana swallowed. "Do you think she wants me dead?"

"Perhaps," Serai said, nodding. "Or perhaps only within her control. Which might be worse, depending on the next several years. From what she said, it seems obvious that her husband is very nearly ready to move against the Crown."

They rode in silence for a moment, then Isana said, "Or it might not have been a threat."

Serai arched a brow. "How so?"

"Well," Isana said slowly, "if word of your true allegiance has gotten out, and you didn't know about it . . . could what she said have been a warning? To point it out to you?"

Serai's eyebrows lifted delicately. "Yes. Yes, I suppose it could have been, at that."

"But why would she warn you?"

Serai shook her head. "Difficult to say. Assuming it was a warning, and assuming that Kalare and Aquitaine are not working together to bring Gaius down, it would be most likely that she warned me in an effort to deny Kalare the chance to kill me. Or capture me to learn what secrets I keep."

"We're both in the same oven, then. Whoever is killing Cursors would not mind seeing the pair of us dead."

"Indeed," Serai said. She glanced at her hands. Isana did as well. They were trembling harder. Serai folded them and held them tight against her lap. "In any case, given how little we know about the current climate, it seemed best to me that we leave before something unpleasant happened."

She paused, then said, "I'm sorry we didn't manage to gain the First Lord's ear."

"But we must," Isana said quietly.

"Yes. But remember, Steadholder, that my first duty is to protect you—not to try to manage affairs in the Calderon Valley."

"But there's no *time*."

"You can't gain the support of the First Lord from the grave, Steadholder," Serai said, her tone frank, serious. "You're of no use to your family dead. And just between you and me, if I die before I get a chance to wear a gown of those new silks from Aquitaine, I will never forgive you."

Isana tried to smile at her attempt at levity, but it was too strongly underscored by an emotional undertow of anxiety. "I suppose. But what is our next step?"

"Get back to the house all in a piece," Serai said. "And from there, I think a nice glass of wine might soothe my nerves. And a hot bath."

Isana regarded her evenly. "And after that?"

"After wine and a steaming bath? I should be surprised if I didn't sleep."

Isana pressed her lips into a line. "I don't need you to try to amuse me with clever evasions. I need to know how we're going to get to Gaius."

"Oh," Serai said. She pursed her lips thoughtfully. "Going out of Nedus's house is a risk, Steadholder. For both of us, now. What do you think our next move should be?"

"My nephew," Isana said firmly. "In the morning, we'll go to the Academy and find him so that he can carry the message to the First Lord."

Serai frowned. "The streets aren't safe enough for you to—"

"Crows take the streets," Isana said, the barest trace of an angry snarl in her voice.

Serai sighed. "It's a risk."

"One we have to take," Isana said. "We don't have time for anything else."

Serai frowned and looked away.

"And besides," Isana said, "I'm worried about Tavi. The message must have reached him by now—it was left in his own room, after all. But he hasn't come to see me."

"Unless he has," Serai pointed out. "He might well be waiting at Nedus's manor for us to return."

"Either way, I want to find him and make sure he's all right."

Serai sighed, and said, "Of course you do." She lifted a hand to press her fingers lightly against her reddened cheek, her eyes closed. "I hope you'll excuse me, Steadholder. I'm . . . somewhat shaken. Not thinking as clearly as I should." She looked up at Isana, and said, simply, "I'm afraid."

Isana met her eyes and said, in her gentlest voice, "That's all right. There's nothing wrong with being afraid."

Serai waved her hands in a frustrated little gesture. "I'm not used to it. What if I start chewing my nails? Can you imagine how horrid that would be? A nightmare."

Isana almost laughed. The courtesan might be afraid, but for all that she was playing in an unfamiliar field against lethally violent opponents, a mouse among hungry cats, she had the kind of spirit that refused to be kept down. The feigned vapid mannerisms and dialogue was her way of laughing at her fears. "I suppose we could always tie mittens onto your hands," Isana murmured. "If it is all that important to the security of the Realm to preserve your nails."

Serai nodded gravely. "Absolutely, darling. By any means necessary."

A moment later the coach came to a halt, and Isana heard the footman coming around to open the door. Nedus muttered something to the driver. The door opened, and Serai stepped out onto the folding stair. "It's a shame, really—all the politics. I hate it when I am forced to leave a party early."

The assassins came without sound or warning.

Isana heard a sudden, harsh exhalation from the driver of the coach. Serai froze in place on the stair, and a frozen gale of sudden fear swept over Isana's senses. Nedus shouted, and she heard the steely rasp of a sword being drawn. There were shuffling footsteps, and the ring of steel on steel.

"Stay back!" Serai cried. Isana saw a dark figure, a man with a sword, step up close to the coach. His blade thrust at Serai. The courtesan batted the blade aside with her left hand, and the flesh of her forearm parted, sending blood sprinkling down. The courtesan's other hand flew to her hair, to what Isana had taken as the handle of a jeweled comb. Instead, Serai drew forth a slender, needle-sharp blade and thrust it into the assassin's eye. The man screamed and fell away.

Serai leaned out to catch the handle of the coach's door and began to close it.

There was a hissing sound, a thump of impact, and the bloodied, barbed

steel head of an arrow burst from Serai's back. Blood flooded over the ripped silk of her amber gown.

"Oh," Serai said, her voice breathless, startled.

"Serai!" Isana screamed.

The courtesan toppled slowly forward and out of the coach.

Isana rushed out of the coach to go to the woman's aid. She seized Serai's arm and hauled on it, trying to draw the Cursor back into the coach. Isana slipped in Serai's blood and stumbled. A second arrow sped past her shoulder as she did, driving itself to the feathers in the heavy oak wall of the coach.

She heard another scream to her right, and saw Nedus standing with his back to the wall of the coach, facing a pair of armed assassins, hard-looking men in drab clothing. A third attacker lay bleeding on the cobblestones, and even as Isana looked, the old metalcrafter's sword whipped up into a high parry and dealt back a slash that split open the throat of his attacker.

But the blow had left the old Knight open, and the other assassin lunged forward, his short, heavy blade thrusting sharply into Nedus's vitals.

Nedus whirled on the third man, showing no sign of pain, and seized his sword-arm wrist in one hand. Instead of pushing the man away, though, Nedus simply clamped down an iron grip, and with grim determination, rammed his sword into the assassin's mouth.

Assassin and Knight both collapsed to the ground, their blood pouring out like water from a broken cup.

Terrified, Isana pulled at Serai, struggling to get the Cursor back into the coach, before—

Something bumped into her, and there was a nauseating flash of sensation in her belly. Isana looked down to see another heavy arrow. This one had struck her, in the curl of her waist above her hipbone. Isana stared at it in shock for a moment, and then looked to see six inches of bloodied shaft emerging from her lower back.

Pain came next. Horrible pain. Her vision went red for a second, and her heart beat like thunder. She blinked down at Serai and reached for her again, unsure of what to do but doggedly determined to draw the fallen woman from beneath the hidden archer's shafts.

Serai rolled limply to one side, her eyes open and staring. The arrow had taken her through the heart.

Isana heard footsteps coming toward her. She looked up, agony making

her vision almost seem to throb, and saw a man emerge from the darkness with a bow in his hand.

She recognized him. Shorter than average, grizzled with age, balding, stocky, and confident. His features were regular, unremarkable, neither ugly nor appealing. She had seen him once before—on the walls during the horrible battle at Garrison. She had seen him slaughter men with arrows, throw Fade from the walls with a noose tight around his neck, and attempt to murder her nephew.

Fidelias, a former Cursor Callidus, now a traitor to the Crown.

The man's eyes flicked around him as he walked, careful, wary and alert. He drew another arrow from his quiver and slipped its nock over the bowstring. He regarded the corpses dispassionately. Then his unreadable, merciless eyes fell upon Isana.

Pain took her.

⋈⋈⋈ CHAPTER 23

"Slow down," Max complained. "Furies, Calderon, what's all the crows-eaten rush?"

Tavi glanced back over his shoulder as he paced swiftly down the street from the Citadel. Colorful Wintersend furylamps lit the way in soft hues of pink, yellow, and sky-blue, and despite the late hour the streets were busy. "I'm not sure. But I know something is very wrong."

Max sighed and broke into a lazy lope until he caught up with Tavi. "How do you know? What does that letter say?"

Tavi shook his head. "Oh, the usual. How are you doing, little things that happened at home, that she's staying at the manor of someone named Nedus on Garden Lane."

"Oh," Max said. "No wonder you panicked. That's one horrifying letter. It certainly merits sneaking out on Killian and possibly endangering the security of the Crown."

Tavi glared at Max. "She wrote in details that weren't right. She called my uncle Bernhardt. His name is Bernard. She told me my little sister was doing well with her reading lessons. I don't have a sister. Something is wrong—but she didn't want to put it down on paper."

Max frowned. "Are you sure the letter is genuine? I can think of a few people who wouldn't mind catching up with you in a dark alley somewhere late at night."

"It's her handwriting," Tavi said. "I'm sure of it."

Max walked beside him in silence for a while. "You know what? I think you should go see her and find out what's going on."

"You think?"

Max nodded gravely. "Yeah. Better take someone large and menacing with you, too, just to be careful."

"That's a good idea, too," Tavi said. The pair turned onto Garden Lane. "How do we know which one is Nedus's house?"

"I've been there before," Max said.

"Is there a young widow?" Tavi asked.

Max snorted. "No. But Sir Nedus was the finest swordsman of his whole generation. He trained a lot of the greats. Princeps Septimus, Araris Valerian, Captain Miles of the Crown Legion, Aldrick ex Gladius, Lartos and Martos of Parcia, and dozens of others."

"You studied with him?" Tavi asked.

Max nodded. "Yes, all through first year. Solid man. Still a fair sword arm, too, and he's got to be eighty years old. Best teacher I ever had, including my father."

"You studying with him now?"

"No," Max said.

"Why not?"

Max shrugged. "He said that there wasn't anything else he could teach me on the training floor. That I'd have to learn the rest on my own in the field."

Tavi nodded, chewing on his lower lip thoughtfully. "Where does he stand with the Crown?"

"He's a hard-line loyalist to the House of Gaius and the office of the First Lord. But if you ask me, I'd say that he detests Gaius, personally."

"Why would he do that?"

Max shrugged, but he spoke with absolute confidence. "There's some

history between them. I don't know any details. But he'd never involve himself with traitors to the Crown, either. He's solid." Max nodded at a nearby house that was large and lovely but dwarfed by its neighbors. "Here it is."

But when they went to the door, they were informed that Lord Nedus and his guests were no longer there. Tavi showed the porter at the door the letter from his aunt, and the man nodded and returned with a second envelope, which he offered to Tavi.

Tavi took it and read it as they walked back down the street. "She's . . . oh great furies, Max. She's at the garden party being given by Lord Kalare."

Max's eyebrows shot up. "Really? From what you said of her, she never seemed like a socialite."

"She isn't," Tavi said, frowning.

"I bet the Dianic League is going to swarm over her like a pack of Phrygian waterpike." Max took the letter and read it, frowning. "She says she's hoping to get the chance to tour the palace with one of the High Lords." Max squinted up his eyes, frowning. "But the only time the High Lords are actually in the palace during Wintersend is during their meetings with the First Lord."

"She's trying to get to Gaius," Tavi said quietly. "She can't just come out and say it for fear of interception. But that's why she's been trying to contact me. To get to Gaius."

"Well that isn't going to happen," Max said calmly.

"I know," Tavi said quietly. "That's the problem."

"What?"

"My aunt . . . well, I get the impression that she and Sir Nedus would agree when it comes to the First Lord. She never wanted to come within a mile of him."

"So why is she trying to get to him now?" Max asked.

Tavi shrugged. "But she wouldn't do it if she wasn't desperate to get to Gaius. The coded messages. She's staying in the house of a Crown loyalist, instead of in the Citadel—and going out to noble functions."

"At Kalare's house, no less. That's dangerous."

Tavi frowned, thinking. "Kalare and Aquitaine are the strongest High Lords, and rivals. They both hate Gaius, too. And my aunt is in Gaius's favor."

"Yes," Max said. "She isn't going to get a warm welcome there."

"Surely she knows that. Why would she *go* there?" He took a deep

breath. "I can't put my finger on it, but this really bothers me. I . . . it's like it was at Second Calderon. My instincts are screaming at me that this is serious stuff."

Max studied Tavi for a long minute, then nodded slowly. "Could be you're right. It was like this for me on the Wall a couple of times. Bad nights. But your aunt isn't going to get to Gaius, Tavi. Not even to me. Killian wouldn't hear of it."

"She doesn't have to," Tavi said. "Come on."

"Where to?" Max asked cheerfully.

"Kalare's manor," Tavi said. "I'll speak to her. I can pass word on to the First Lord for her. We keep the security intact, Killian's happy, and if she's here with something serious, then . . ."

"Then what?" Max asked pointedly. "You planning on issuing some royal commands to fix it?" Max met Tavi's eyes. "To tell you the truth, I'm scared as hell, Tavi. Whatever I do when I'm in costume, it's Gaius who will have to deal with the consequences. And I am *not* the First Lord. I don't have the authority to order Legions into action, or dispatch aid or Crown support."

Tavi frowned. "Killian would say that the Legions and the bursar legate don't know that."

Max snorted. "I know it. That's enough."

Tavi shook his head. "Do you think Gaius would prefer us to stand around doing nothing while his subjects and lands were jeopardized?"

Max gave Tavi a sour look. "You did better than me in Rhetoric. I'm not going to get into this with you. And no matter what you say, I'm not going to start setting policies and issuing proclamations in Gaius's name. Disobeying Academy rules meant to protect students' families from embarrassment is one thing. Sending men into harm's way is another."

"Fine. We go talk to my aunt," Tavi said. "We find out what's wrong. If it's something serious, we take it to Killian and let him and Miles decide what to do. Okay?"

Max nodded. "Okay. Though the furies help you if Brencis spots you at his father's party."

Tavi let out an irritated groan. "I'd forgotten about him."

"Don't," Max said. "Tavi, I've been meaning to talk to you about him. I don't think Brencis is quite right. You know?"

Tavi frowned. "In the head?"

"Yes," Max said. "He's dangerous. It's why I've always made it a point to

smash him up a bit whenever I had the excuse. Establishing that he should be afraid of me and stay clear. He's fundamentally a coward, but he isn't afraid of you. Which means he probably enjoys thinking about hurting you—and you're going to be walking around in his family's home."

"I'm not afraid of him, Max."

"I know," Max said. "You idiot."

Tavi sighed. "If it makes you feel better, we'll get in and out fast. The sooner we get back to the Citadel, the less murderous Killian is going to be, in any case."

Max nodded. "Good thinking. This way he'll only murder us a little."

CHAPTER 24

Tavi paused outside Lord Kalare's manor on Garden Lane and studied it for a long moment, frowning. If he had not spent so much time in the First Lord's palace in the Citadel, Kalare's manor would have impressed him. The place was ridiculously large, Tavi thought. The whole of Bernardholt—Isanaholt now, he reminded himself—could have fit inside the manor, and there still would have been enough room to provide a pasture for the sheep. The place was richly appointed, lit, gardened, landscaped, and decorated, and Tavi could not help but be uncomfortably reminded of the harlots down near the river, with painted faces, gaudy clothes, and false smiles that never reached jaded eyes.

He took a deep breath and started toward the house down its double lines of statuary. Four men in plain, common clothing walked by him. They had hard faces, wary eyes, and Tavi saw the hilt of a sword beneath the cloak of the third man. He kept an eye on them as he approached the manor, and saw a harried-looking servant come running to meet them at the street, drawing four saddled horses with him.

"You see that?" Max murmured.

Tavi nodded. "They don't look much like visiting dignitaries, do they."

"They look like hired help," Max said.

"But there's a valet rushing to bring them horses," Tavi murmured. "Cutters?"

"Probably."

The men mounted up, and at a quiet word from one of them, they kicked their horses into an immediate run.

"And in a hurry," Max said.

"Probably running off to wish someone a happy Wintersend," Tavi said. Max snorted quietly.

The doorman stepped forward to meet them, his chin uplifted. "Excuse me, young masters. This is a private gathering."

Tavi nodded, and said, "Of course, sir." Then he held up the dispatch pouch he normally carried documents in, a fine piece of blue-and-scarlet leather bearing the golden image of the royal eagle. "I'm bearing dispatches on behalf of His Majesty."

The doorman relaxed his arrogant posture a bit, and said, "Of course, sir. I shall be pleased to deliver them on your behalf."

Tavi smiled at him and shrugged. "I'm sorry," he said, "but my orders are to place my charge directly into the hands of its recipient." He gestured back at Max. "I think it must be something sensitive. Captain Miles even sent a guard with me."

The doorman frowned at both of them, then said, "Of course, young sir. If you will come with me, I will take you to the garden while your escort waits."

Max said, in a voice of flat, absolute certainty, "I stay with him. Orders."

The doorman licked his lips and nodded. "Ah. Yes. This way please, gentlemen."

He led them through more of the same lavish decadence to the gardens at the center of the manor. Tavi walked along behind the man, trying to look bored. Max's boots hit the floor with the steady, disciplined cadence of a marching *legionare*.

The doorman—or rather, majordomo, Tavi supposed—paused at the entrance to the garden and turned to Tavi. Shifting colored lights flickered and flashed behind the man, and the garden buzzed with conversation and music. The aroma of food, wine, and perfume drifted through Tavi's breath. "If you will tell me the name of your party, sir, I will invite them to come receive your letter."

"Certainly," Tavi said. "If you would invite Steadholder Isana here, I would be most grateful."

The majordomo hesitated, and Tavi saw something shift uncertainly in his eyes. "The Steadholder is no longer here, young sir," the man said. "She departed not a quarter hour ago."

Tavi frowned and exchanged a glance with Max. "Indeed? For what reason?"

"I'm sure I could not say, young sir," the man replied.

Max gave Tavi the slightest nod, then rumbled, "The second missive is for High Lady Placida. Bring her."

The majordomo eyed Max suspiciously and glanced at Tavi. Tavi gave the man a between-us-servants roll of his eyes, and said, "Please invite her, sir."

The man pursed his lips in thought and shrugged. "As you wish, young sir. A moment." He vanished into the garden.

"Lady Placida?" Tavi muttered to Max.

"I know her," Max replied. "She'll know what is going on."

"We'll need some privacy," Tavi said.

Max nodded, then frowned in concentration and waved a hand vaguely at the air. Tavi felt a sudden pressure on his ears, sharp at first, but it subsided. "Done," Max said.

"Thank you," Tavi said. In only a moment, a tall woman with severe, distant features approached, wearing simple, elegant jewelry and a rich gown of a deep, compelling green, the majordomo at her elbow. She paused, studying them, and Tavi felt the weight of her gaze as palpably as the touch of a gentle hand. She frowned at him, and then frowned more deeply upon seeing Max. She dismissed the majordomo with a word and a curt flick of her wrist, and approached them.

She stepped into the area Max had protected from eavesdropping via wind furies and arched her eyebrow. Then she walked forward to stand over Tavi and murmur, "This isn't a missive from the First Lord, is it?"

Tavi opened the pouch and passed her a folded piece of paper. There was nothing written on it, but Tavi went through the motions for the benefit of those watching. "No, Your Grace. I'm afraid not."

She accepted the paper and opened it, glancing at it as if to read. "Oh how I love Wintersend in the capital. Good evening, Maximus."

"Good evening, my lady. Your gown is lovely."

One corner of her mouth quirked into a tiny smile. "It's nice to see you took my advice about offering compliments to ladies."

"I have found it to be a most effective tactic, my lady," Max replied.

Lady Placida arched an eyebrow, and said, "I've created a monster."

"Ladies sometimes scream," Max said loftily. "But other than that, I would hardly say that I was a monster."

Her eyes hardened. "Which is something of a miracle. I know your father is on the Wall, but I expected to see your stepmother here."

"She was forbidden," Max said. "Or that's what I hear on the grapevine."

"They don't write," Lady Placida said, more than asked. "I suppose they wouldn't, though." She folded up the letter, and offered Max a brief smile. "It's nice to see you, Maximus. But would you very much mind telling me why you've very publicly associated me with the First Lord in front of half of the Lords Council and members of the Senate?"

"Your Grace," Tavi said. "I came here to speak to my aunt Isana. I think she's in some kind of trouble, and I want to help her."

"So you are he," Lady Placida murmured, and narrowed her eyes in thought.

"Tavi of the Calderon Valley, Your Grace," Max said.

"Please, lady," Tavi said. "Can you tell us anything you know of her."

"I would take it as a favor, lady," Max added, and put a solid hand on Tavi's shoulder.

Lady Placida's eyebrows rose sharply at the gesture. Then she studied Tavi again, and more intently. "She was here, along with the Amaranth Courtesan, Serai. They spoke to several different people."

"Who?" Tavi asked.

"Myself, Lady Aquitaine, any number of nobles and dignitaries. And Lord Kalare."

"Kalare?" Tavi said, frowning.

A strident male voice boomed in the garden, and was followed by a polite round of cheering and applause.

"Well," Lady Placida said. "It would seem that Brencis has won his duel to claim Citizenship. What a surprise."

"Brencis couldn't duel his way through a herd of sheep," Max snorted. "I hate show duels."

"Lady, please," Tavi said. "Do you know why she left early?"

Lady Placida shook her head. "Not for certain. But they had a less

than pleasant discussion with Lord Kalare immediately prior to their departure."

Tavi glanced aside in the passageway as he felt a sudden attention on him. Two young men stood not ten feet from him, and Tavi recognized them both. They were dressed in their nicest clothes, but blond and watery-eyed Varien and the hulking Renzo could not be mistaken for anyone else.

Varien blinked at Tavi for a second, then at Max. Then he muttered something to Renzo, and the two of them hurried away into the garden. Tavi's heart pounded. There was about to be trouble.

"How unpleasant a discussion?" Max asked.

"He struck Serai, openly." Lady Placida's lips pressed into a firm line. "I've little use for a man who strikes a woman simply because he knows he can."

"I can think of one or two things," Max growled.

"Be careful, Maximus," Lady Placida said in instant warning. "Guard your words."

"Crows," Tavi spat.

Both of them stopped to stare at Tavi.

"You say they left in a rush, Your Grace?" he asked.

"Very much so," Lady Placida answered.

"Max," Tavi said, his heart pounding, "those cutters we saw on the way in. They're going after my aunt."

"Bloody crows," Max said. "Aria, please excuse us?"

Lady Placida nodded once, and said, "Be careful, Maximus. I owe you my son's life, and I would hate to miss the chance to repay the debt."

"You know me, Your Grace."

"Indeed," Lady Placida said. She inclined her head to Tavi, smiled again at Max, then turned back to the garden, dismissing them with the same flick of her hand she'd used for the majordomo.

"Come on," Tavi said, his voice tense, and started trotting back through the house. "We have to hurry. Can you get us there any faster?"

Max hesitated for a second, then said, "Not in quarters this close. If I tried to windcraft us both there, I'd fly us into a building for sure." His face flushed with color. "It, uh, isn't my strong suit."

"Crows," Tavi spat. "But you could take yourself?"

"Yes."

"Go. Warn them. I'll catch up whenever I can."

"Tavi, we don't know that those cutters were after her," Max pointed out.

"We don't know that they *weren't*. She's my family. If I'm wrong, and she's safe, you can make fun of me for a year."

Max nodded sharply as they emerged from the front door. "What does she look like?"

"Long hair, dark with some grey, very thin, looks early twenties in the face."

Max paused. "Pretty?"

"*Max,*" Tavi snarled.

"Right, right," Max said. "I'll see you there." The young man took a pair of long steps and flung himself into a leap, bounding straight up into the air as sudden wind rose in a roar to carry him into the night sky, his hand on his sword the whole way.

Tavi stared bitterly after Max for a second, his emotions in a wash of fear, worry, and the raw and seething jealousy he rarely let himself feel. Of all the people of the Realm, comparatively few of them commanded enough power with wind furies to take flight. More young people were killed in windcrafting accidents than any other form of furycrafting as they attempted to push the limits of their skills and emulate those who could take to the skies. Tavi was hardly alone in his jealousy. But the possible danger to Aunt Isana made it a particularly bitter realization of his lack of power.

Tavi didn't let the sudden surge of emotion keep him from breaking into a dead run toward Nedus's house. He could not possibly match Max's time back to it, but he couldn't do less than his utmost, either. Not when it was Aunt Isana. He had never been a slow runner, and the years he'd spent in the capital had given him inches of height and pounds of muscle, all of it lean and hardened by his constant duties to the First Lord. There might have been a dozen men in the city who could have matched his pace without furycrafting, but no more. The boy all but flew down the festively lit and decorated Garden Lane.

If the cutters were there, they would almost certainly be skilled swordsmen, most likely metalcrafters, who tended to outshine all but the deadliest and most talented of swordsmen with no metalcrafting of their own. From the hard-bitten look of them, they were experienced, and that meant that they would work together well. Were it only one such man, Tavi might be able to steal upon him or arrange to bluff his way close enough to attempt some sort of surprise attack. But with four men, that would not be an option—and simply assaulting them, even had he been armed with more than the knife at his hip, would have been suicide.

Max, Tavi knew from experience in the training hall, was the kind of swordsman that might become a fencer of song and legend—or who might be killed by foolish overconfidence before he had the chance. Max was an absolutely deadly blade, but the training hall was far different than the street, and fencing partners were not likely to behave in the same way as professional killers. Even Max's experience in the Legions might not have prepared him for the kind of nasty fighting that might be used on the streets of the capital. Max had more confidence than any three or four other people Tavi knew, except perhaps for the First Lord, but Tavi was frightened for his friend.

Even so, he was more frightened for his aunt. Isana had, Tavi knew, spent her entire life in steadholts, and she had little idea of how treacherous the capital could be. He could not imagine that she would be keeping company with a courtesan if she knew the woman's profession. Tavi also could not imagine his aunt coming to the capital without *some* kind of guardian or escort, especially if she was here at Gaius's invitation. Surely she would have had the company of her younger brother Bernard at the very least. For that matter, why in the world hadn't the First Lord assigned Amara or one of the Cursors to accompany her while she guested in the palace? Gaius would have no reason at all to bring her to the capital only to allow her to be harmed. She was too much a symbol of his authority.

All of which meant that communications had to have broken down somewhere. Isana was vulnerable, perhaps unguarded, perhaps under the guidance of someone who would lead her into danger. Once Tavi found her, he would get her to the safety of the palace immediately. Even if he could tell her nothing of what was happening with the First Lord, it was in Gaius's best interests to protect her, and Tavi was sure that he could talk Killian into putting her into guest chambers where the presence of the Royal Guard would cover her from mortal danger.

Assuming that she was all right.

Cold fear ran through him, and lent still more speed to his limbs as he ran, tireless and focused and terrified for the woman who had raised him as if he had been her own.

When Renzo stepped out from behind a parked, riderless coach, Tavi barely had time to register it before the hulking boy struck him with a sweep of one enormous arm. Tavi twisted and caught the blow on both of his own arms, but the larger boy's fury-assisted strength was vicious, and sent Tavi

into a running stumble that fetched him up hard against the stone wall sur-
rounding the environs of another enormous manor.

He managed to avoid slamming his head or breaking his shoulder in the
impact, but beyond that, Tavi did little more than fall to the ground. He
could taste blood in his mouth. Renzo stood over him in his brown tunic, pig
eyes narrowed, both hands clenched into fists the size of hams.

Someone let out a tittering laugh, and Tavi turned his head to see Varien
approaching him from the same hiding place. "Good one," Varien said.
"Look at him. I think he's going to cry."

Tavi tested his arms and legs, then pushed his hands down to rise from
the ground. As he did, his fear and worry and humiliation coalesced into
something made of nothing but hard edges and serrated blades. His aunt
was in danger. The *Realm* could be in danger. And these two arrogant idiots
had chosen now, of all times, to interfere.

"Varien," Tavi said, quietly. "I don't have time for this."

"You won't have to wait long," Varien told him, his tone taunting. "I flew
the two of us in front of you, but Brencis will be along shortly to talk to you
about your rudeness in coming to his party uninvited."

Tavi straightened and faced Varien and Renzo. When he spoke, a
stranger's voice came from his lips, the tone hard, cold, ringing with com-
mand. "Get out of my way. Both of you."

Varien's sneer wavered and his watery blue eyes blinked several times as
he stared at Tavi. After an uncertain pause, he began to speak.

"Open your mouth again," Tavi said, in that same, cold voice, "and I will
break your jaw. Stand aside."

Varien's face flickered with fear, then with sudden anger. "You can't speak
to me li—"

Tavi snapped his boot up into Varien's belly and the blow struck home,
hard. The taller boy doubled over with a gasp, clasping at his stomach. With-
out pausing, Tavi seized him by the hair, and with all the weight of his body
forced the boy down to the stones of the street, so that their combined weight
landed at an oblique angle to Varien's chin. There was a sickly cracking
sound, and Varien let out a wailing shriek of agony.

Tavi bounced back to his feet as a surge of exultation and savage joy
flooded through him. Renzo rolled forward and slammed his arm at Tavi in
another broad, sweeping blow. Tavi stepped under it and came up with his
fist moving in a short, vertical blow, his arm and elbow in a single line with

his forward leg. Every ounce of power in Tavi's body thudded into the tip of Renzo's jaw. The larger boy's head snapped back and up, but he didn't drop. He wobbled on his feet, eyes blinking in startled confusion, and drew back his huge fist to swing again.

Tavi gritted his teeth, took a step to one side, and kicked straight down and into the side of the larger boy's knee. With its crackling pop, Renzo let out a bellow and fell, roaring and cursing and clutching both hands at his wounded knee.

Tavi rose to his feet and stared down at the boys who had tormented him as they writhed and screamed in pain. Their yelling had already begun to attract attention from the nearby manor and from passersby on the street. Someone had already raised a cry for the civic *legionares,* and Tavi knew that they would arrive momentarily.

Varien's screams had subsided to wracking, moaning sobs of pain. Renzo wasn't in much better shape, but he managed to clench his teeth over the sounds of agony, so that they came out like the cries of a wounded beast.

Tavi stared down at them.

He had seen horrible things during the Second Battle of Calderon. He had looked down as Doroga rode his enormous bull through a sea of burned and bleeding Marat corpses, while the wounded screamed their agony to the uncaring sky. He had seen the battle-wise crows of Alera descending in clouds to feast upon the eyes and tongue of the dead and the dying, Marat and Aleran alike, with a gruesome lack of preference between corpse and casualty. Tavi had seen the walls of Garrison almost literally painted in blood. He had seen men and women die crushed, slashed, pierced, and strangled while they fought for their lives, and he had splashed through puddles of still-hot blood as he ran through the carnage.

For a time, nightmares had haunted him. They had become less frequent, but the details had not faded from his memory. Too often, he found himself looking back at them, staring in a kind of fascinated revulsion.

He had seen terrible things. He had faced them. He hated them, and they terrified him still, but he had faced the simple existence of such hideous destruction without letting it control his life.

But this was different.

Tavi had harmed no one during Second Calderon—but the pain Renzo and Varien now suffered had been dealt to them by his own hands, his own will, his own choice.

There was no dignity in what he had done to them. There was nothing in which to take pride. The abrupt joy that had sung through his body during the swift, brutal fighting faded and vanished. He had looked forward to this moment, in some ways—to a time when he could put his skills to use against those who had always made him feel so helpless and small. He had expected to feel satisfaction, triumph. But in its place, he felt only an emptiness that filled with a sudden and sickening nausea. He had never hurt anyone so badly before. He felt stained, somehow, as if he had lost something valuable that he hadn't known he had possessed.

He had hurt the other boys, and hurt them terribly. It was the only way he could have beaten them. Anything less than a disabling injury would have left them able to employ their furies against him, and there would have been nothing he could have done but suffered whatever they intended for him. So he had hurt them. Badly. In the space of a few seconds, he had visited back all the misery and pain they had inflicted on him over two years twice over.

It had been necessary.

But that did not mean that it was right.

"I'm sorry," Tavi said quietly, though the ice in his voice yet filled the words. "I'm sorry I had to do that." He began to say more, but then shook his head, turned away, to resume running toward Sir Nedus's manor. He could sort out charges and legal problems with the civic legion once he was sure his aunt was safe.

But before he had gone more than a few steps, the stones beneath his feet heaved and flung him hard into the nearest stone wall. He had no warning of it at all, and his head smacked solidly against the rock, a flash of phantom light blinding him. He felt himself fall, and tried to rise, but a rough hand gripped him and threw him with a terrible, casual ease. He sailed through the air and landed on stones, and by the time he finished tumbling the stars had begun to clear from his eyes.

He looked up in time to see that he was in a darkened, blind alleyway between an expensive little wine shop and a goldsmith's. Inexplicably, a fog had risen, and as he blinked it built up, covering his face. Tavi pushed himself up to his knees to see Kalarus Brencis Minoris standing over him, dressed in a magnificent doublet of grey and green, a circlet of iron set with a green stone on his brow, and formal jewelry glittering on his fingers and throat. Brencis's hair had been drawn back into the braid the long-haired

southern cities employed in their fighting men, and he wore a sword and dagger upon his belt. His eyes were narrow and cruel, and burned with something feral and unpleasant that Tavi could not begin to give a name.

"So," Brencis said quietly, as the fog continued to rise. "You thought it would be amusing to mock me by sneaking into my father's party? Perhaps drinking his wine? Pilfering a few valuables?"

"I was delivering a missive from the First Lord," Tavi managed to say.

He might as well not have spoken. "And now you have attacked and injured my friends and boon companions. Though I suppose you will claim that the First Lord instructed you to do so, eh coward?"

"Brencis," Tavi said through clenched teeth, "this isn't about you."

"The crows it isn't," Brencis snarled. By then, the mist had risen in a thick blanket around them, and Tavi could see little more than a pair of running paces through the fog. "I've endured your insolence for the last time." Brencis casually drew the sword at his side, then took his dagger into his left hand. "No more."

Tavi stared at that disquieting light dancing behind Brencis's eyes and forced himself back to his feet. "Don't do this, Brencis. Don't be a fool."

"I will *not* be spoken to that way by a furyless freak!" Brencis snarled, and lunged at Tavi, sword extending into a clean thrust for Tavi's belly.

Tavi drew his own knife, managed to catch the thrust on it, and slide it away so that the tip of Brencis's sword went cleanly past him. But it had been a lucky parry, and Tavi knew it. Once Brencis began slashing, there was no way his little blade could help, and Tavi sprang back from his attacker, desperately looking for a way out of the alley. There was none.

"Stupid *pagunus*," Brencis said, smiling. "I've always known you were a gutless, stinking little pig."

"The civic *legionares* are already on the way," Tavi responded. His voice shook.

"There's time enough," Brencis said. "No one will see through the fog." His eyes glittered with an ugly amusement. "What an odd coincidence that it came up just now."

He came in again, the bright steel of his blade darting toward Tavi's throat. Tavi ducked under it, but Brencis's boot swept up to meet his head. Tavi managed to take part of the kick on his shoulder, but Brencis's fury-assisted strength was at least a match for Renzo's, and Tavi staggered to one side. Only the wall of the goldsmith's kept him from falling, and the world

spun rapidly around him as Brencis raised his sword for a powerful, down-sweeping death blow.

Tavi's instincts screamed at him, and he some how managed to stagger back as the sword came down. He felt a hot flash of pain on his left arm. He swept his dagger in a cut at Brencis's sword hand, but the taller boy avoided it with contemptuous ease. Then Brencis lifted a hand and flicked his wrist, and a blast of sudden wind threw Tavi bodily to the ground. It drove him back down the alley to the wall at its end. He fought his way back his feet, only to have the wind flatten his back to the wall, where ugly, misshapen hands emerged smoothly from the stone and caught his wrists and legs in a crushing grip.

Brencis paced calmly down the alley and stared at Tavi, his expression smug. He sheathed his dagger and casually slapped Tavi across the face, then on the other side with his backhand swing. The blows, even delivered with an open hand, hit him like heavy fists, and the entire world narrowed down into a tunnel filled by the lean, arrogant shape of Kalarus Brencis Minoris.

"I can't believe how stupid you are. Did you think you could insult and defy me over and over again? Did you think that you could possibly survive such a thing? You're nothing, Tavi. You're no one. Not a crafter. Not even a Citizen. Just a favored pet dog of a senile old man." Brencis pressed the tip of his sword against Tavi's cheek. Tavi felt another sting of pain, and felt blood trail down over his jawline. Brencis stared into Tavi's eyes. The young noble's eyes were . . . strange. His pupils were far too wide, and his face shone with a sheen of perspiration. His breath reeked of wine.

Tavi swallowed and struggled to focus his thoughts clearly. "Brencis," he said quietly. "You're drunk. Intoxicated. You've taken drugs. You aren't in control of yourself."

Brencis slapped him twice more, contemptuous little blows. "I beg to differ."

Tavi reeled with disorientation, his stomach turning and twisting within him. "Brencis, you have to stop and think. If you—"

This time Brencis drove his fist into Tavi's belly, and though the boy managed to tighten his abdomen and let out a harsh breath in time with the blow, lessening its impact, it landed with more power than Tavi had ever felt before. It drove the breath from him.

"You don't tell me what I must do!" Brencis shrieked, his face white with fury. "You do as I will it. You *die* as I will it." He licked his lips and tightened

his grip on the sword in his hand. "You have no idea for how long I've been looking forward to this."

Somewhere in the mist behind Brencis, there was the rasp of steel as a sword was drawn from its scabbard.

"Funny," Max said, and Tavi's friend stepped forward from the mist, *legionare's* blade in hand. "I was just thinking that very thing."

Brencis went rigid, and though he did not take the sword's tip from Tavi's cheek, he looked over his shoulder.

"Get away from him, Brencis," Max said.

Brencis's lip twisted up into a sneer. "The bastard. No, Antillar. *You* get away. Walk away now, or I'll kill your little paganus friend."

"You just said that you intend to kill him anyway," Max said. "How stupid do I look to you?"

"Back off!" Brencis screamed. "I'll kill him! Right now!"

"I'm sure you would," Max said, his expression empty. "But then I would kill you. You know it. I know it. Be smart, Brencis. Leave."

Tavi saw Brencis's body start to quiver, and he looked swiftly back and forth between Tavi and Max. His eyes, too wide, too bloodshot, burned with desperate, alien fire, then abruptly narrowed.

"Max!" Tavi shouted, struggling to warn his friend.

At the same instant, Brencis turned from Tavi, his hand extended, and fire filled the narrow alley in a sudden and deadly storm that came from nowhere and howled down upon Max.

For a second, Tavi could see nothing, but then a shadow resolved within the flame, a dark shape dropped into a crouch, one arm up as though to shield his eyes. The flame abruptly vanished, and left Max crouched on one knee, his left forearm up to shield his eyes, his blade still in hand. The tip of the sword glowed cherry red, and Max's clothing had been blackened and burned away in places, but he came to his feet again, apparently unharmed, and started walking toward Brencis. "You'll have to do better than that," Max said quietly.

Brencis turned his back on Tavi and faced Max with a snarl. He gestured, and cobblestones before his feet tore themselves free of the ground and flew at Max in a heavy, deadly cloud.

Max lifted his left hand and clenched it into a fist, his expression grim. One of the stone walls of the alley abruptly flowed like water, stretching out between Max and the oncoming stones. They slammed into the sheet of stone before Max, shattering into gravel as they struck. A second later, the

wall snapped back into its original position. Max lowered his arm and kept walking forward.

Brencis snarled again, and a larger patch of stones began to rip their way from the ground, but Max gestured sharply at an almost-depleted pile of firewood stacked neatly against one wall, and a dozen logs, each the size of Tavi's thigh, suddenly flexed and bounded toward Brencis.

Brencis released the stones he had begun to raise, and his sword blurred into a web of steel that intercepted each log and cleanly severed it, sending the pieces spinning harmlessly away. Max charged forward, sword in hand, and with a cry of frustrated anger and fear, Brencis advanced to meet him. Blades rang harshly in the alley, steel chiming, sparks flowering into drizzling clouds of fiery rain where blade met blade. The two clashed and flowed past one another, then turned to do it again and again, their movements as graceful and smooth as any pair of dancers.

Tavi saw startled shock on Max's face for a second, after their third pass. He was a skilled fencer, Tavi knew, but he had evidently underestimated Kalare Brencis. The other boy was his match, and another pair of passes resulted in more ringing steel and no blood.

And then Brencis, facing toward Tavi, gave Max an ugly smile, lifted a hand, and cast it at Tavi. Fire lanced from his fingertips and screamed toward the helpless boy.

"No!" Max cried. He turned with a flick of his hand, and a wave of raw wind rose up before Tavi, holding the flames at bay, shielding Tavi from the fire, though the air grew hot enough to sear his lungs.

"Max!" Tavi screamed.

Brencis drove his glittering sword into Max's back. Its tip emerged from Max's belly.

Max's face went white, his eyes wide in shock.

Brencis twisted the blade once, twice, and then whipped it clear.

Max exhaled slowly, and crumpled to his hands and knees. Sudden silence filled the alley.

"Yes," Brencis said, panting, his eyes bright. "Yes. Finally." He gestured sharply, and a vicious lash of wind landed across Max's back in a line so fine that it sliced through his shirt and opened a long, bloody furrow in his skin. "Bastard. So smug. So sure of yourself." Brencis flicked his wrist again and again, opening the horrible scars on Max's back into fresh agonies and blood.

Max let out a groan, each blow driving him farther down. But when he

looked up at Tavi, there was defiant determination in his face as well as agony and fear. Tavi felt the bonds on his wrists and ankles suddenly begin to loosen, and his frustrated fear and rage surged to new heights as he understood Max's intention.

Brencis paid Tavi no attention at all, utterly focused upon continuing to lash at Max, snarling and cursing at him the entire while. Max let out a harsh groan and sagged almost completely to the ground, and Tavi was abruptly free of the stone.

He set his feet, flicked his knife's handle, caught the flat of its blade between his fingers, and with a practiced, instinctive motion, threw the knife at Brencis's throat. It spun end over end through the air, and Brencis didn't know it was coming until the last instant. He flinched from the knife, and its blade struck home hard, drawing blood from one of Brencis's cheeks and sinking entirely through the boy's ear. Brencis screamed in sudden pain.

Tavi knew he had only seconds, if that, before Brencis recovered and killed them both. He launched himself forward, leaping over Max and driving his shoulder into Brencis's chest. They both went down. Brencis reached for his dagger, but Tavi drove his thumb into the other boy's eye with vicious desperation, and Brencis screamed.

There was no time for thought, for technique, for complex tactics. The struggle was too ugly, elemental, brutal. Brencis got his free hand on Tavi's throat and started to squeeze, trying to crush Tavi's windpipe with fury-born strength, but Tavi countered by getting his teeth into Brencis's forearm and biting down until blood filled his mouth. Brencis screamed. Tavi started hitting the other boy, pounding his fists down like clumsy sledgehammers while Brencis tried uselessly to bring his sword to bear in the close quarters of their grapple.

Tavi screamed and did not relent, terror and fury lending him more strength. Brencis tried to crawl away, but Tavi seized him by his braid and started slamming the other boy's face down onto the stones. Again and again he drove Brencis's face into the cobblestones, his weight on the other boy's back, until the body underneath him suddenly went limp and loose.

And then a hammer slammed into the top of his head and threw him back and away from Brencis.

Tavi landed in a heap, hardly able to see. But he looked up, his head pounding with nauseating throbs, and saw a man emerge from the mist, dressed in green and grey. Tavi dimly recognized him as High Lord Kalare.

The man stared contemptuously at Tavi, then walked over to Brencis. He prodded his son with the tip of his boot.

"Get up," said Kalare, his voice seething with bitter anger. Behind him, Tavi saw the pathetic, hunched forms of Varien and Renzo, leaning on one another to keep from falling.

Brencis stirred, then slowly lifted his head. He sat up, his face a mass of cuts, blood, and bruises. His bloodied mouth hung open, and Tavi could see broken teeth.

"You are pathetic," Kalare said. There was neither compassion nor concern for his son in his voice. "You had them. And you allowed this . . . freakish little nothing to overcome you."

Brencis tried to say something, but it came out as a mush of sounds and sobs that meant nothing.

"There is no excuse," Kalare said. "None." He looked up at the two boys at the back of the alley. "No one can ever know that you, my son, were bested by this paganus. Never. We cannot allow word of this humiliation to leave this alley."

Tavi's heart lurched. Max, though breathing, was not moving, and he lay in a welter of his own blood. Tavi tried to gain his feet, but it was all he could do to keep from throwing up, and he knew High Lord Kalare was about to kill them. He watched helplessly as Kalare raised one hand and the earth began to shake around him.

But then light flooded the alley, a searing, golden light that burned away the mist and fog as swiftly as though the sun itself had come to Alera Imperia. The light stabbed at Tavi's eyes, and he lifted his hand to shield them against it.

Placida Aria, High Lady of Placida, stood at the other end of the alley with half a century of the civic Legion behind her. One slender arm was lifted, wrist parallel to the ground, and upon it perched the form of a hunting falcon made of pure, golden fire. That light fell onto the alley, illuminating everything there.

"Your Grace," Lady Placida said, her voice ringing with the clarity of a silver trumpet, calm and unmistakably strong. "What passes here?"

The tremors in the ground abruptly ceased. Kalare stared at Tavi for a moment with empty eyes, and then turned to face Lady Placida and the *legionares*. "An assault, Your Grace. Antillar Maximus has attacked and badly injured my son and his companions from the Academy."

Lady Placida narrowed her eyes. "Indeed?" She looked from Kalare to

the boys on the ground, to Brencis, Renzo, and Varien. "And you observed this assault?"

"The last of it," Kalare said. "Swords were drawn. Antillar was trying to murder my son after badly beating these other boys. My son and his friends can all testify to the facts."

"N—no," Tavi stammered. "That isn't what happened."

"Boy," Kalare snapped, fury in his voice. "This is Citizens' business. Hold your tongue."

"No! You aren't—" The air suddenly tightened in Tavi's throat, choking him to silence. He looked up to see Kalare frowning faintly.

"Boy," Lady Placida said in a cold voice. "You will hold your tongue. The High Lord is quite correct. This is Citizens' business." She stared at Tavi for a second, and Tavi thought he saw some expression flicker in her face, one of apology. Her next words were quieter, less frozen. "You must be silent here. Do you understand?"

The pressure in his throat eased, and Tavi could breathe again. He stared at Lady Placida for a moment, then nodded.

Lady Placida nodded back at him, then turned to the man next to him. "Captain, with your permission, I will see to the immediate wounds of those involved, before you take the accused into custody."

The *legionare* beside her said, "Of course, lady, and we are grateful for your assistance."

"Thank you," she told him, and started down the alley toward Tavi and Max.

As she did, Kalare turned to face her, clearly standing in her way.

Placida was inches taller than Kalare. She looked down at him with a serene, unreadable expression. The fire falcon on her wrist, still very much present, fluttered its wings restlessly, sending campfire sparks drifting to the ground. "Yes, Your Grace?"

Kalare spoke very quietly. "You do not wish me as an enemy, woman."

"Given what I know of you, Your Grace, I don't see how you could be anything else."

"Leave," he told her, his voice ringing with command.

Lady Placida laughed at him. It was a sound both merry and scornful. "How odd that Antillar Maximus inflicted all of these injuries with his hands. He does, you know, have considerable strength available to him at furycrafting."

"He is the bastard son of a stinking barbarian. It is to be expected," Kalare replied.

"As would be injuries to his knuckles after such barbarity. But his hands are unwounded. And what injuries Antillar does have are all upon his back."

Kalare stared at her in silent fury.

"Strange that the hands of the other boy are a frightful mess, Your Grace. Split knuckles on either hand. It seems odd, does it not? It is almost enough to make one think that the boy from Calderon overcame not only your son, but his companions as well." She pursed her lips in mock thought. "Is not the boy from Calderon the one with no ability whatsoever at furycraft?"

Kalare's eyes blazed. "You arrogant bitch. I will—"

Lady Placida's grey eyes remained as calm and as hard as distant mountains. "You will *what*, Your Grace. Challenge me to the *juris macto*?"

"You would only hide behind your husband," Kalare sneered.

"On the contrary," Lady Placida replied. "I will meet you here and now if that is Your Grace's desire. I am hardly a stranger to duels. As you remember from my own duel for Citizenship."

Kalare's cheek started a steady twitch.

"Yes," Lady Placida noted. "You do remember." She glanced at Brencis and his companions. "See to your son, Your Grace. This round is over. So if you would please stand aside and let me assist the wounded . . . ?" The question was a polite one, but her eyes never wavered from Kalare's.

"I will remember this," Kalare murmured, as he stepped aside. "I promise you that."

"You would hardly believe how little that matters to me," Lady Placida responded, and walked past him without another glance, the fire falcon trailing falling sparks behind them.

She came to Tavi and Max and placed the falcon on the ground beside her, her expression businesslike. Tavi watched as Kalare helped his son to his feet and led him and his companions away and out of sight.

Tavi exhaled slowly, and said, "They're gone, Your Grace."

Lady Placida nodded calmly. Her eyes went flat for a moment as they saw the reopened scars on Max's back. She found the sword thrust through his lower back and winced.

"Will he live?" Tavi asked quietly.

"I think so," she replied. "He managed to close the worst of it on his own. But he isn't out of danger. It's fortunate that I followed Kalare when he

left." She moved a hand, laying it across the wound, then slipped her other hand beneath Max, covering the wound where the sword had emerged on that side. She closed her eyes for two or three silent moments, then carefully drew her hands back. The sword wound had been closed, heavy with pink skin and scar tissue.

Tavi blinked slowly at it, and said, "You didn't even use a bath."

Lady Placida smiled slightly. "I didn't have one handy." She glanced back at the *legionares,* and asked, "What really happened?"

Tavi told her about the fight itself, as quietly and succinctly as he could. "Your Grace," he said, "it's important that Max return to the Citadel with me. Please, he cannot be arrested tonight."

She shook her head. "I am afraid that is impossible, young man. Maximus has been accused of a crime by a High Lord and three Citizens. I am sure that any reasonable court will acquit him, but there is no avoiding the process of a trial."

"But he *can't*. Not right now."

"And why not?" Lady Placida asked.

Tavi stared at her in helpless frustration.

"You'll be quite safe, at least from legal accusation," Lady Placida said. "There's no chance at all that Kalare would let his son accuse *you* of half-killing him."

"That isn't what I'm worried about," Tavi said.

"Then what is?"

Tavi felt his face flush, and he looked away from Lady Placida.

She sighed. "I suggest you be grateful that you are both alive," Lady Placida said. "It's something of a miracle that you are."

"Tavi?" asked Max. His voice was weak, thready.

Tavi turned to his friend immediately. "I'm here. Are you all right?"

"Had worse," Max murmured.

"Maximus," Lady Placida said firmly. "You must be silent until we can get you to a proper bed. Even if it is in a cell. You're badly hurt."

Max shook his head a little. "Need to tell him, Your Grace. Please. Alone."

Lady Placida arched a brow at Max, but then nodded and rose. At her gesture, the fire falcon took wing toward her, vanishing into nothingness as it did. She walked calmly back to the *legionares* and began speaking with them.

"Tavi," Max said. "Went to Sir Nedus's."

"Yeah?" Tavi leaned closer, his heart pounding in time with his head.

"Attacked outside his house. Sir Nedus is dead. So are the coachmen. The courtesan. So are the cutters."

The bottom fell out of Tavi's stomach. "Aunt Isana?"

"Never saw her, Tavi. She's gone. There was a blood trail. Probably took her somewhere." He started to say something else, but then his eyes rolled back into his head and closed.

Tavi stared numbly at his friend as the *legionares* gathered around him and carried him away to imprisonment. Afterward, he went to Sir Nedus's manor, to find the civic legion already moving over the grisly scene there. The bodies had all been laid out in a line. None of them were his aunt.

She was gone. Probably taken. She might already be dead.

Max, the only person who could maintain the illusion of Gaius's strength, was in jail. Without his presence as Gaius's double, the Realm might already be destined for a civil war that would let its enemies destroy them entirely. And it was Tavi's decision that had led to it.

Tavi turned and began to walk, slowly and painfully up the streets to the Citadel. He had to tell Killian what had happened.

Because there was nothing else that he could do for either his family, his friend, or his lord.

⋈⋈⋈⋈ CHAPTER 25

Amara woke to the sensation of something small brushing past her foot. She kicked her leg at whatever it was, and heard a faint scuttling sound on the floor. A mouse, or a rat. A steadholt was never free of them, regardless of how many cats or furies were employed to keep them at bay. She sat up blearily and rubbed at her face with her hands.

The great hall of the steadholt was full of wounded men. Someone had

gotten the fires going at the twin hearths at either end of the hall, and guards stood by both doors. She rose and stretched, squinting around the hall until she located Bernard at one of the doors, speaking in low voices with Giraldi. She crossed the hall to him, skirting around several wounded on cots and sleeping palettes.

"Countess," Bernard said with a polite bow of his head. "You should be lying down."

"I'm fine," she replied. "How long was I out?"

"Two hours or so," Giraldi replied, touching a finger to the rim of his helmet in a vague gesture of respect. "Saw you in the courtyard. That wasn't bad work for a, uh . . ."

"A woman?" Amara asked archly.

Giraldi sniffed. "A civilian," he said loftily.

Bernard let out a low rumble of a laugh.

"The survivors?" Amara asked.

Bernard nodded toward the darker area in the middle of the hall where most of the cots and palettes lay. "Sleeping."

"The men?"

Bernard nodded toward the heavy tubs against one wall, upended now and drying. "The healers have the walking wounded back up to fighting shape, but without Harmonus we haven't been able to get the men who were intentionally crippled back up and moving. Too many bones to mend without more watercrafters. And some of the bad injuries . . ." Bernard shook his head.

"We lost more men?"

He nodded. "Four more died. There wasn't much we could do for them—and two of the three healers left were wounded as well. It cut down on what they could do to help the others. Too much work and not enough hands."

"Our Knights?"

"Resting," Bernard said, with another nod at the cots. "I want them recovered from this morning as soon as possible."

Giraldi snorted under his breath. "Tell the truth, Bernard. You just enjoy making the infantry stay on their feet and go without rest."

"True," Bernard said gravely. "But this time it was just a fortunate coincidence."

Amara felt herself smiling. "Centurion," she said, "I wonder if you would be willing to find me something to eat?"

"Of course, Your Excellency." Giraldi rapped his fist against the center of his breastplate and headed for the nearest hearth and the table of provisions there.

Bernard watched the centurion go. Amara folded her arms and leaned against the doorway, looking outside at the late-afternoon sunshine pouring down upon the grisly courtyard. The sight threatened to stir up a cyclone of fear and anger and guilt, and Amara had to close her eyes for a moment to remain in control of herself. "What are we going to do, Bernard?"

The big man frowned out at the courtyard, and after a moment, Amara opened her eyes and studied his features. Bernard looked weary, haunted, and when he spoke, his voice was heavy with guilt. "I'm not sure," he said at last. "We only got done securing the steadholt and caring for the wounded a few moments ago."

Amara looked past him, to the remains in the courtyard. The *legionares* had gathered up the fallen, and they lay against one of the steadholt's outer walls, covered in their capes. Crows flitted back and forth, some picking at the edges of the covered corpses, but most of them found plenty to interest them in the remains too scattered to be retrieved.

Amara put her hand on Bernard's arm. "They knew the risks," she said quietly.

"And they expected sound leadership," Bernard replied.

"No one could have foreseen this, Bernard. You can't blame yourself for what happened."

"I can," Bernard said quietly. "And so can Lord Riva and His Majesty. I should have been more cautious. Held off until reinforcements arrived."

"There was no time," Amara said. She squeezed his wrist. "Bernard, there *still* is no time, if Doroga is right. We have to decide on a course of action."

"Even if it is the wrong one?" Bernard asked. "Even if it means more men go to their deaths."

Amara took a deep breath and responded quietly, her voice soft, her words empty of rancor. "Yes," she said quietly. "Even if it means every last one of them dies. Even if it means you die. Even if it means I die. We are here to protect the Realm. There are tens of thousands of holders who live between here and Riva. If these vord can spread as swiftly as Doroga indicated, the lives of those holders are in our hands. What we do in the next few hours could save them."

"Or kill them," Bernard added.

"Would you have us do nothing?" Amara asked. "It would be like cutting their throats ourselves."

Bernard looked at her for a moment, then closed his eyes. "You're right, of course," he rumbled. "We move on them. We fight."

Amara nodded. "Good."

"But I can't fight what I haven't found," he said. "We don't know where they are. These things laid a trap for us once. We'd be fools to go charging out blind to find them. I'd be throwing more lives away."

Amara frowned. "I agree."

Bernard nodded. "So that's the question. We want to find them and hit them. What should our next step be?"

"That part is simple," she said. "We gather whatever knowledge we can." Amara looked around the great hall. "Where is Doroga?"

"Outside," Bernard said. "He refused to leave Walker out there by himself."

Amara frowned. "He's the only person we have who has some experience with the vord. We can't afford to risk him like that."

Bernard half smiled. "I'm not sure he isn't safer than we are, out there. Walker seems unimpressed by the vord."

Amara nodded. "All right. Let's go talk to him."

Bernard nodded once and beckoned Giraldi. The centurion came back over to the doorway bearing a wide-mouthed tin cup in one hand. He took his position at the doorway again and offered the steaming cup to Amara. It proved to be full of the thick, meaty, pungent soup commonly known as "*legionare*'s blood." Amara nodded her thanks and took the cup with her as she and Bernard walked outside to speak to Doroga.

The Marat headman was in the same corner he'd defended during the attack. Blood and ichor had dried on his pale skin, and it lent him an even more savage mien than usual. Walker stood quietly, lifting his left front leg, while Doroga examined the pads of the beast's foot.

"Doroga," Amara said.

The Marat grunted a greeting without looking up.

"What are you doing?" Bernard asked.

"Feet," the Marat rumbled. "Always got to help him take care of his feet. Feet are important when you are as big as Walker." He looked up at them, squinting against the sunlight. "When do we go after them?"

Bernard's face flickered into a white-toothed grin. "Who says we're going after them?"

Doroga snorted.

"That depends," Amara told Doroga. "We need to know as much as we can about them before we decide. What more can you tell us about the vord?"

Doroga finished with that paw. He looked at Amara for a moment, then moved to Walker's rear foot. Doroga thumped on Walker's leg with the flat of one hand. The gargant lifted the leg obligingly, and Doroga began examining that foot. "They take everyone they can. They destroy everyone they can't. They spread fast. Kill them swiftly or die."

"We know that already," Amara said.

"Good," Doroga answered. "Let's go."

"There's more to talk about," Amara insisted.

Doroga looked blankly up at her.

"For instance," Amara said. "I found a weakness in them—those lumps on their backs. Striking into them seemed to release some kind of greenish fluid, as well as disorient and kill them."

Doroga nodded. "Saw that. Been thinking about it. I think they drown."

Amara arched an eyebrow. "Excuse me?"

"Drown," Doroga said. He frowned in thought, looking up, as though searching for a word. "They choke. Smother. Thrash around in a panic, then die. Like a fish out of water."

"They're fish?" Bernard asked, his tone skeptical.

"No," Doroga said. "But maybe they breathe something other than air, like fish. Got to have what they breathe or they die. That green stuff in the lumps on their backs."

Amara pursed her lips thoughtfully. "Why do you say that?"

"Because it smells the same as what is under the *croach*. Maybe they get it there."

"Tavi told me about the *croach*," Bernard mused. "That coating that gave the Wax Forest its name. They had the stuff spread out all over that valley."

Doroga gave a grunt and nodded. "It was also spread over the nest my people destroyed."

Amara frowned in thought. "Then perhaps this *croach* isn't simply something like . . . like beeswax," she said. "Not just something they use to build.

Doroga, Tavi told me that these things, the wax spiders, defended the *croach* when it was ruptured. Is that true?"

Doroga nodded. "We call them the Keepers of Silence. And yes. Only the lightest of my people could walk on the *croach* without breaking it."

"That might make sense," Amara said. "If the *croach* contained what they needed to survive . . ." She shook her head. "How long was the Wax Forest in that valley?"

Bernard shrugged. "Had been there as long as anyone could remember when I came to Calderon."

Doroga nodded agreement. "My grandfather had been down into it when he was a boy."

"But these spiders, or Keepers—they never appeared anywhere else?" Amara asked.

"Never," Doroga said with certainty. "They were only in the valley."

Amara looked over at one of the dead vord. "Then they couldn't leave it. These things have been swift and aggressive. Something must have kept them locked into place before. They had to stay where the *croach* was to survive."

"If that's true," Bernard said, "then why are they spreading now? They were stationary for years."

Doroga put Walker's foot back down and said, quietly, "Something changed."

"But what?" Amara asked.

"Something woke up," Doroga said. "Tavi and my wh—and Kitai awoke something that lived in the center of the *croach*. It pursued them when they fled. I threw a rock at it."

"The way Tavi told it," Bernard said, "the rock was the size of a pony."

Doroga shrugged. "I threw it at the creature that pursued them. It struck the creature. Wounded it. The creature fled. The Keepers went with it. Protected it."

"Had you seen it before?" Amara asked.

"Never," Doroga said.

"Can you describe it?"

Doroga mused in thought for a moment. Then he nodded toward one of the fallen vord. "Like these. But not like these. Longer. Thinner. Strange-looking. Like it was not finished becoming what it would be."

Bernard said, "Doroga, your people had run this race for many years. How could Tavi and Kitai have wakened this creature?"

Doroga said, without expression, "Maybe you have not noticed. Tavi does things big."

Bernard arched an eyebrow. "How so?"

"He saw how the Keepers see the heat of a body. Saw how they respond to damage on the *croach*. So he set it on fire."

Bernard blinked. "Tavi . . . set the Wax Forest on *fire?*"

"Left out that part, did he," Doroga said.

"Yes he did," Bernard said.

"The creature bit Kitai. Poisoned her. Tavi was climbing out. But he went back down for her when he could have left her there. They had been sent to recover a mushroom that grew only there. Powerful remedy to poison and disease. They each had one. Tavi gave his to Kitai to save her from the poison. Even when he knew it would cost him the race. His life." Doroga shook his head. "He saved her. And that, Bernard, is why I killed Atsurak in the battle. Because the boy saved my Kitai. It was bravely done."

"Tavi did that?" Bernard said quietly.

"Left out that part, did he," Doroga asked.

"He . . . he has a way of coloring things when he describes them," Bernard said. "He didn't speak of his own role in things quite so dramatically."

"Doroga," Amara asked. "If Tavi gave up the race to save your daughter, how did he win the trial?"

Doroga shrugged. "Kitai gave him her mushroom to honor his courage. His sacrifice. It cost her something she wanted very much."

"Left out that part, did you," Bernard said, smiling.

Amara frowned and closed her eyes for a moment, thinking. "I believe I know what is happening." She opened her eyes to find both men staring at her. "I think that Tavi and Kitai woke up the vord queen. My guess is that it had been sleeping, or dormant for some reason. That somehow, whatever they did allowed it to wake up."

Doroga nodded slowly. "Maybe. First queen wakes. Spawns two new, lesser queens. They split up and found new nests."

"Which means they would need to cover new areas with the *croach*," Amara said. "If they truly need it to survive."

"We can find them," Bernard said, voice tight with excitement. "Brutus knew the feel of the Wax Forest. He can find something similar here."

Doroga grunted. "So can Walker. His nose better than mine. We can find them and give battle."

"We don't have to do that," Amara said. "All we really need to do is destroy the *croach*. If our guess is right, that will smother them all, sooner or later."

"If you're right," Bernard said, "then they will fight like mad to protect it."

Amara nodded. "Then we need to know what we're likely to face there. These wax spiders. What kind of threat are they?"

"Poison bite," Doroga said. "About the size of a small wolf. Bad enough, but nothing like these things." He nudged the shattered, flattened shell of a crushed vord with his foot.

"Do you think an armored *legionare* would be able to handle one?" Amara asked.

Doroga nodded. "Metal skin would stop Keeper fangs. Without the bite, they aren't much."

"That leaves the warriors," Amara said. She glanced around the courtyard. "Which are slightly more formidable."

"Not if we have the initiative," Bernard said. "Giraldi's century stood them off pretty well, working together."

"Yes," Doroga said, nodding. "Impressive. You people must get bored stupid practicing for that kind of fight, close together."

Bernard grinned. "Yes. But it's worth it."

"I saw," Doroga said. "We should think about going in at night. Keepers were always slowest then. Maybe the other vord are the same way."

"Night attacks," Bernard said. "Dangerous business. A lot can go wrong."

"What about their queen?" Amara asked. "Doroga, did you fight the queen at the nest you destroyed?"

Doroga nodded. "Queen was holed up under a big tangle of fallen trees with two queen whelps. Too many warriors guarding her for us to go in. So Hashat fired the trees and we killed everything as it came out. Queen whelps went down easy. The queen came last, vord around her. Hard to get a good look at her. Smaller than the vord, but faster. She killed two of my men and their gargants. All smoke and fire, couldn't see anything. But Hashat rode into it, called to me where to strike. Walker stomped on the queen. Wasn't much left."

"Could he do it again?" Amara asked.

Doroga shrugged. "His feet look fine."

"Then maybe we have a plan. We can handle the spiders, the vord, the

queen," Amara said. "We move in and use the *legionares* to shield our Knights Ignus. They put fire to the *croach*. Once that is done, we can fall back and let the vord drown."

Doroga shook his head. "You are forgetting something."

"What?"

"The taken," Doroga said. The Marat leaned back against the wall, as far into the shadows of the wall as he could get, and glanced apologetically up at the sky. "The taken. They belong to the vord now. We'll have to kill them."

"You've talked about your folk being taken several times," Amara said. "What do you mean by it, exactly?"

"Taken," Doroga said. He seemed at a loss for a moment, searching for words. "The body is there. But the person is not. You look into their eyes and see nothing. They are dead. But the vord have partaken of their strength."

"They're under the vord's control?" Amara asked.

"Hardly seems possible," Bernard said, frowning.

"Not at all," Amara said. "Have you ever seen what discipline collars can do to slaves, when taken to extremes? Enough of it will make anyone easy to control."

"This is more than that," Doroga said. "There is nothing left on the inside. Just the shell. And the shell is fast, strong. Feels no pain. Has no fear. Does not speak. Only the outside is the same."

Amara's stomach did a slow twist of sickened horror. "Then . . . the holders here. Everyone who is missing . . ."

Doroga nodded. "Not just the men. Females. The old. Any children taken. They will kill until they are killed." He closed his eyes for a moment. "That was what made our losses so heavy. Hard to fight things like that. Saw a lot of good warriors hesitate. Just for an instant. They died for it."

The three of them were silent for a moment. "Doroga," she said quietly, "why did you call them shapeshifters, earlier?"

"Because they change," Doroga said. "In the stories, my people have met the vord three times. Each time, they looked different. Different weapons. But they acted the same. Tried to take everyone."

"How is the taking accomplished?" Amara pressed. "Is it some kind of furycrafting?"

Doroga grunted and shook his head. "Not sure what it is," he said. "Some stories, the vord just look at you. Control you like some kind of stupid beast."

Walker made the ground shake with a basso rumble ending in a snort, and bumped Doroga with one thick-furred leg.

"Shut up, beast," Doroga said absently, recovering his balance and leaning against the gargant. "Other stories, they poison the water. Sometimes they send something to crawl inside you." He shrugged. "Haven't seen it happening. Just saw the results. Whole hunting tribes all gone together. Doubt they knew it was happening until it was over."

They were all silent for a long moment.

"I hate to say it," Bernard said quietly. "But what if the holders who were taken . . . what if the vord can use their furies?"

A slow sliver of apprehension pierced Amara's spine. "Doroga?" she asked.

The Marat shook his head. "Don't know. Furies are not my world."

"That could change everything," Bernard said. "Our Knights' furies are our decisive advantage. Some of those holders are strongly gifted. You have to be, this far from the rest of the Realm."

Amara nodded slowly. "Assuming the vord do have access to furycraft," she said. "Does it change anything about our duty?"

Bernard shook his head. "No."

"Then we have to plan for the worst," Amara said. "Hold our Knights in reserve to counter their furycraft, until we are sure one way or another. If they do have it, the Knights may be able to counter them, at least long enough for the Knights Ignus to burn off the *croach*. Can we do it?"

Bernard frowned for a moment, then nodded slowly. "If our reasoning is sound," he said. "What do you think, Doroga?"

Doroga grunted. "I think we got too many *ifs* and *maybes*. Don't like it."

"Neither do I," Amara said. "But it's what we have."

Bernard nodded. "Then we'll move out. We'll take the Knights and Giraldi's century. I'll leave Felix's here to guard the wounded."

Amara nodded, and her stomach growled. She lifted the forgotten cup of soup and drank. It tasted too salty but was pleasant going down. "Very well. And we'll need to establish passwords, Bernard. If taken Alerans can't speak, it will let us sort out friend from foe if there is any confusion. We can't assume we're any more immune to it than the holders were."

"Good idea," Bernard said. He looked around the courtyard, his eyes bleak. "Great furies, but this doesn't sit well on my stomach. Everything ran

from those things. Except for the crows and us here, there isn't an animal stirring for half a mile. No birds. Not even a crows-begotten rat."

Amara finished the soup, then looked sharply at Bernard. "What?"

"It's got me spooked," he said. "That's all."

"What do you mean, there aren't any rats?" she demanded, and she heard her voice shaking.

"I'm sorry," he said. "Just thinking out loud."

Terror made the fingers in her hand go numb, and the tin cup fell to the ground. The tactile memory of something small creeping over her feet as she woke flooded through her thoughts in bright scarlet realization and fear.

Sometimes they send something to crawl inside you.

"Oh no," Amara breathed, whirling toward the darkened great hall, where weary knights, *legionares* and holders lay wounded, resting, sleeping. "Oh no, no, no."

CHAPTER 26

Behind her, Amara heard Bernard let out a startled oath, and then two sets of heavy steps following her back to the great hall, where Giraldi stood a laconic watch. The old centurion frowned as Amara came running up.

"Your Excellency?" he asked, frowning. "Is something wrong?"

"Get everyone," Amara snapped. "And get them all outside. Now."

Giraldi blinked. "Ev—"

"Do it!" Amara snarled, and Giraldi automatically went rigid at the sound of unwavering authority in her tone and banged a fist to his breastplate. Then he spun about and started barking out a string of booming orders.

"Amara?" Bernard asked. "What is this?"

"I felt a rat or a mouse brush past my foot as I woke," Amara said. Her hands were clenched into impotent fists. "But you said that there aren't any left."

Bernard frowned. "Maybe you dreamed it?"

"Great furies," Amara breathed. "I hope so. Because if the vord are taking people by sending things to crawl into them as they sleep, we have a problem. Most of the Knights were sleeping near me, on the cots where the lights were dimmest."

Bernard sucked in a sudden breath. "Crows and bloody carrion," he swore quietly. "You mean that you think that there were . . . things . . . crawling around in the hall?"

"I think that this is part of their first attack," Amara said. "It's just happening more quietly."

Doroga grunted. "Makes sense why the vord withdrew early, now. Gave you wounded to care for. Knew you would take them inside. Then they send takers."

Inside the hall, Giraldi continued bellowing orders. Every furylamp in the place had been brought to its most brilliant, and the hall was bright enough to hurt Amara's eyes. She stepped to one side of the door as the *legionares* nearest it took up their weapons and shields and headed outside at a quick jog. Several men limped painfully. The wounded had to be carried out on their cots, one man lifting either end.

Amara fought down an urge to scream for more haste in exiting the building. Giraldi was already doing plenty of that. Amara hoped desperately that she had leapt to an incorrect conclusion and that the evacuation of the building was an unnecessary measure. But something in her guts told her that she hadn't been wrong. That the carefully laid trap had already been sprung.

Two men carried the first of the cots outside, and Amara frowned down at them, chewing on one lip. Several of the heavily armored Knights Terra went out next, still carrying pieces of their armor to the courtyard. A few of the men were milling around in knots of two and three, speaking quietly, their expressions uncertain. Giraldi started to bellow an order at them, then stopped himself with a visible effort and turned around to continue berating the young *legionares* of Felix's century.

Amara frowned and studied the idle men whom Giraldi had declined to order around. They were Knights, every one of them. Why weren't they leaving?

"Gentlemen," Amara called to them. "With the rest of us, please."

The Knights glanced up at her, and several of them thumped a fist to

their breastplate in response. They all headed for the door, falling into line behind those bearing stretchers.

They'd just been waiting for an order, Amara thought. *Surely Captain Janus would have deduced that the evacuation order was intended for everyone.*

Another cot went by, and Amara almost didn't notice that the man carrying the foot of the cot was Captain Janus. The captain's mouth started an irregular tic on one corner, and he glanced around until his eyes met Amara's.

She stared at him in shock. The man's eyes were . . . wrong. Simply wrong. Janus was an excellent, conscientious officer, whose mind was continually occupied with how best to lead and protect his men, attend to his duty, and serve the Realm. Even when he had been eating or at weapon's practice, whether relaxed or angry, there had always been a sense of reflection to his eyes, his expression, as his mind assessed, planned, and weighed advantages.

That reflection had vanished.

Time stopped. Janus's eyes were half-hooded, unblinking, his expression oddly slack. He met Amara's gaze and whatever it was that now looked at her, it was *not* Captain Janus.

Great furies, Amara thought. *He's been taken.*

Something alien and mad flickered through the taken man's eyes in response to Amara's realization. He shifted his grip on the cot, then tore it bodily from the hands of the man at the other end. The wounded man in the cot screamed as he tumbled from it to the stone floor.

Janus swept the heavy cot in a two-handed swing that clipped Amara's shoulder and spun her to the floor. Then he turned, and with another swing of the cot shattered the skull of the cot-bearing man walking backward in line behind him. The man went down without making a sound. Janus hurled the heavy cot at the next man, and the missile hit hard, knocking down several more.

Janus turned back to the door and broke into a run, but as he went past Amara, she thrust out her foot and deftly caught it on the man's ankle, sending him into a sprawling trip that carried him out the door.

"Bernard!" Amara shouted, rising to her feet to follow him. "Giraldi! Janus has been taken!" She came outside to find Janus walking calmly in a straight line toward Harger. "Stop him!" she shouted. "Stop that man!"

A pair of *legionares* near Janus blinked at her, but then stepped into the

man's path. One of the men held up a hand, and said, "Excuse me, sir. The Countess would like to—"

Janus reached for the *legionare*'s upraised hand and with a single motion of casual, savage strength he crushed it to pulp and splintered bone. The *legionare* screamed and staggered as Janus released him. The second *legionare* stared for an instant, then his hand flashed toward the hilt of his sword.

Janus swept a fist at the *legionare*'s head and struck with such force that Amara clearly heard the man's neck snap. He dropped to the ground in a boneless heap.

"He's heading for Harger!" Amara shouted. "Protect the healer! Get him out of here!" She drew her sword, called to Cirrus to lend to her of his swiftness, and rushed at Janus from behind.

Just before she closed to within reach of her blade, Janus spun to face her and threw a crushing fist at her head. Amara saw it as a lazy, slow swing rather than the pile-driving blow that she knew had to have lashed at her as swiftly as a slive's tongue. She altered her balance, her own movements sluggish and dreamlike, and let the blow slip past her head without landing. Then she slashed downward with the short, heavy *gladius*, and the blade bit deep into the muscle of Janus's right thigh.

From the reaction the taken captain showed, she might have struck him with a handful of down feathers. Without pausing, another blow swept at her head.

Amara let her legs go out from under her, diving to Janus's right, and hoped that the wound in his thigh would slow him down as she dropped into a forward roll and came back to her feet several paces away.

Janus stared at her for a blank second, then turned and walked toward Harger again. The exhausted healer, himself in a cot, had not awakened in the commotion. His face looked sunken, his iron grey beard shot through with white. Two more *legionares* bore him away while half a dozen others set themselves in a line of shields facing Janus, weapons in hand.

Janus lashed out with one boot in a stomping kick that landed in the middle of a *legionare*'s shield. The blow hurled the man several yards backward, and he landed awkwardly on the stones. The *legionare* beside the stricken man laid open Janus's arm from shoulder to elbow with a hard slash, but the taken man ignored it, seized that *legionare*'s shield in both hands, and threw him with bone-crushing force into the next man in the line.

And then Bernard appeared, facing Janus, his hands empty. Amara's heart leapt into her throat in sudden fear for him. Bernard growled a curse under his breath and swept his fist at Janus with the incredible fury-born strength Brutus gave him. The blow hit Janus like a battering ram and he arched up and landed on his back on the cobblestones. Bernard pointed at the taken man and called, "Brutus!"

The cobblestones heaved, then the jaws of the earthen hound emerged from them and clamped down hard on Janus's leg before the taken man could rise.

Janus's eyes widened, and his head snapped around to examine the stone hound that had him locked into place. His head tilted to one side, a slow and oddly rubbery movement. Then he looked back at Bernard and pushed the heel of his hand toward the Count.

The earth heaved and bucked up into a ripple a full two feet high. The stone wave leapt at Bernard with impossible speed, striking him hard on one leg and sending the Count to the ground.

Amara's heart leapt into her throat.

The taken could furycraft.

She dashed forward and drove her sword down at Janus's throat. The man turned as she approached, and her thrusting blade shot cleanly through Janus's upraised palm. He twisted his arm to one side in a half circle, and the blade, caught in the flesh and the bones of his hand, twisted from her grasp.

Amara darted to one side as Janus tried to seize her with his other hand.

"Amara!" Doroga bellowed.

She whipped her head around to see the Marat headman cast his heavy cudgel into the air from behind a crowd of confused *legionares* who blocked his way. The heavy end of the club hit the ground, and Amara seized the long club's grip as it bounded toward her. She could not afford to waste the momentum the cudgel provided, for it was far too heavy for her to wield with deliberate focus. Instead, she held on to the handle with both white-knuckled hands, spun in a full circle with the heavy, deadly weapon, and brought it down squarely on Captain Janus's head.

She felt the crackling, brittle fragility of the taken man's skull breaking under the incredible force the cudgel delivered in the blow. She staggered, the weight of the cudgel pulling her off-balance. The impact all but crushed Janus's skull down into his chest, and after several seconds of twisting, spasmodic motion, he slowly went still.

Amara heard other screams and cries. A *legionare* lay in the doorway to the great hall, shrieking in a horrible, high voice, a sound of agony and terror that could not have been recognized as coming from a human mouth. His left arm was missing from its socket and his blood became a spreading pool beneath him until his cries dwindled to silence seconds later. Amara head the ring of steel on steel, more shouts, and Giraldi's barking, confident voice of command.

She looked around the courtyard, panting. The action had lasted for only seconds, but she felt exhausted and weak. Harger, now surrounded by *legionares,* appeared to be unharmed. Amara hurried over to Bernard and knelt beside him. "Are you hurt?"

"Wind knocked out of me," Bernard replied, his voice soft. He sat up stiffly and rubbed groggily at his head. "See to the men."

Amara nodded once, and rose.

Doroga came over to them and frowned at Bernard. "You dying?"

Bernard winced, the heel of his hand against the back of his skull. "I almost wish I was."

Doroga snorted. He recovered his cudgel and studied the end of it, then showed it to Bernard. "Your head is better off than his."

One side of the cudgel's striking end was covered in scarlet and dark hairs that clung to the blood. Amara saw it, and it made her feel sickened. Janus. She'd known the man for two years. Liked him. Respected him. He had been unfailingly courteous and thoughtful, and she knew how much Bernard valued his experience and professionalism.

And she'd killed him. She'd crushed his skull.

Amara fought not to throw up.

Doroga regarded her steadily, and said, "He was taken. Nothing you could do."

"I know."

"He would have killed anyone he could have."

"I know that, too," Amara said. "It doesn't make it any easier."

Doroga shook his head. "You did not kill him. The vord did. Just like the men who died during the ambush."

Amara didn't answer him.

A moment later, Giraldi strode over and snapped one hand to his breastplate. "Countess. Count Bernard."

"What happened?" Bernard rumbled quietly. "I heard more fighting."

Giraldi nodded. "Three of the wounded men just . . . sat up and started killing people. They were all almost earthcrafter strong. We had to kill them—which took some doing." He took a deep breath, staring at Janus's corpse for a second. "And Sir Tyrus went mad, too. Started in on Sir Kerns. Killed him. He made a pretty fair run at Sir Jager, and cut his leg up pretty well. I had to kill Tyrus."

Bernard stared at Giraldi for a moment. "Crows."

Giraldi nodded grimly, looking around the crow infested courtyard with distaste. "Yes."

Doroga looked back and forth between them, frowning. "What does that mean?"

"We had three firecrafters with our Knights," Bernard said quietly. "They're our most powerful offensive assets. And now two of them are dead, one wounded. How mobile is he, Giraldi?"

Giraldi shook his head. "Lucky he's alive. There wasn't a watercrafter to handle the injury. I've got my best medic on him with needle and thread now. But he isn't going to be able to travel."

"Crows," Bernard said quietly.

"What happened?" Giraldi asked.

Amara listened as Bernard explained what they knew of vord takers. "So we think some of them must have been waiting inside the great hall, until some of our people went to sleep."

Footsteps thumped over the cobblestones and the young Knight, Frederic, came running from the great hall, holding a tin cup in his hands. "Sir!" Frederic said.

"A moment, Fred," Bernard said, turning back to Giraldi. "How did Tyrus kill Kerns?"

"Gladius," Giraldi said. "Right in the back."

Amara frowned. "Not firecrafting?"

"Thank the furies, no," Giraldi said. "Firecrafting in there would have killed everyone."

"What about the others who were taken?" Amara pressed.

"Bare hands," Giraldi said.

Amara stared at the centurion, then traded a puzzled glance with Bernard. "But Janus used an earthcrafting out here. Why didn't the taken inside the hall use furycraft?"

Bernard shook his head, baffled. "You think there's a reason for it?"

"Sir," Frederic said. His palm was pressed flat over the cup, and his expression was impatient or strained.

"Not now, please," Amara told Frederic. "It doesn't get us anywhere if we assume there was no logical reason for it," she told Bernard. "Something happened out here that was different than what happened inside. We need to discover what that was."

Bernard grunted. "Giraldi, what else can you tell me about the taken in the great hall?"

Giraldi shrugged. "Not much, sir. It was fast, bloody. Swords and knives. One of the men used the haft of his spear and broke one of the taken's necks with it."

"Weaponplay," Amara said. "Centurion, was there any crafting involved?"

Giraldi frowned. "Nothing overt, my lady. I've some metalcrafting, but it's never been something I actually *do* anything to use, if you follow me. One of the men maybe used some earthcraft to throw a trestle at one of the taken to slow it down when it went for one of the children."

Amara frowned. "But drawing upon a fury for strength is an internalized use of furycraft—just like your enhanced skills of swordplay. Or Bernard's archery." She glanced up at Bernard. "But you actually manifested Brutus to pin Janus down. It was after you did that he . . ." She frowned. "He almost seemed surprised when it happened, as if he could feel it, somehow. And then he loosed his own furycrafting against you, Bernard."

Bernard frowned. "But what does that mean?"

"I don't think he could have called upon any furycrafting when he first came outside," Amara said. "If he could have, I think he'd have turned it on Harger at once."

Bernard nodded slowly. "You think he couldn't have used it until . . . what? Until someone showed him how? Until someone else initiated a crafting?"

Amara shook her head. "Perhaps. I don't know."

Giraldi growled. "Janus was after our last healer? Crows."

Bernard nodded. "Our healers. Our firecrafters. These vord, whatever they are, are not stupid. They lured us into a trap, and they're striking deliberately at our strongest crafters. They've predicted several of our moves. Which means that they know us. They know us a lot better than we know them." Bernard grunted and hauled himself unsteadily to his feet. "That's bad news, people."

"Sir," Frederic said.

"Wait a moment," Bernard said, holding up a hand to Frederic. "Amara, you said you felt something brush your foot while you were sleeping?"

"Yes," she said.

Bernard nodded. "So. Let's assume that these takers are something very small—about the size of a mouse or a small rat. We all must sleep sooner or later. We're still vulnerable to them. We need to work out some kind of defense."

"Can't we just make sure the great hall is emptied of them?" Amara asked.

"Not for certain," Bernard said. "In the first place, we don't even know what they look like. And secondly, something mouse-sized is going to be able to find cracks in the stone, holes in the walls, places to get in and places to hide. The rats do."

"And I don't think camping outside is an option," Amara mused.

"Definitely not."

"We need to know more about these takers," Amara said. "If we could get a look at one, it might help us work out a plan."

Frederic let out an explosively frustrated sigh, stepped forward between them all, and slammed the open mouth of the cup down onto the cobblestones in a swift gesture. Amara blinked at him in surprise. The young Knight looked up at them, and said, "They look like this."

He jerked the cup up off the ground.

Amara stared at the taker. It was as long as her hand and very slender. Its flesh was a sickly, pale color, streaked with scarlet blood, and its body was covered in overlapping segments of translucent chitin. Dozens of legs protruded from either side of its body, and antennae fully as long as its body sprouted from either end of the creature. Its head was a barely discernible lump at one end of the body, and was armed with short, sharp-looking mandibles .

The taker flinched into a writhing ball when the light touched it, as if it could not stand its brightness. Its legs and chitinous plates scraped against the stones.

"Look," Amara murmured, pointing at the taker. "Its back."

There were two lumps there, as there had been on the warriors. Amara reached down to touch one, and with blinding speed the taker's body whirled and those heavy mandibles snapped down upon Amara's finger. The

Cursor let out a hiss and flicked her wrist. The taker's grip was surprisingly strong, and it took her several tries to dislodge the creature and fling it away from her.

Bernard spun around and stomped down with one boot. The taker's body made a crackling sound as he crushed it.

"Crows," Giraldi breathed quietly.

Everyone turned to look at Frederic.

"I was moving one of the corpses," Frederic said quietly. "Tyrus. His head had been chopped off. That thing crawled out of . . ." Frederic swallowed and looked a little green. "It crawled out of the head's mouth, sir."

An odd and unpleasant burning sensation had begun to throb through Amara's finger scarce seconds after the taker had bitten down. Over the next several heartbeats, the burning numbness spread to her entire finger and hand, to the wrist. She tried to clench her fingers, and found them barely able to move. "Its bite," she said. "Some kind of poison."

Frederic nodded and held up his own weakly flapping hand. "Yes, ma'am. Bit me a few times when I caught it, but I don't feel sick or anything."

Amara nodded with a grimace. "It wouldn't make sense for a taker's venom to be lethal. We'll have to hope for the best. These things must have approached men who were sleeping. Crawled into their mouths." She started to feel queasy herself. "And then took control of them."

Giraldi frowned. "But you'd feel it crawling into your mouth. Those things are big enough to choke you."

"Not if it bit you," Amara responded. "Not if you'd gone numb, so you couldn't feel it on you. Especially if you were asleep to begin with."

"Great furies," Bernard breathed.

Amara continued to follow the line of logic. "They didn't pick random targets, either. Janus. Our Knights." She took a steadying breath. "And me."

Frederic said, "Steadhold—uh, that is, Count Bernard. We've taken a head count inside. We're missing four other men."

Bernard arched an eyebrow. "They aren't in the steadholt?"

"We haven't found them," Frederic said. "But the far door of the hall was open."

"They were taken," Amara murmured. "Must have been. They went out the door on that side so that they could leave the steadholt without us or Doroga seeing them go." She took a deep breath. "Bernard. The longer we

wait around, the more likely it is that we will suffer additional losses. We need to wipe out that nest immediately."

"Agreed," Bernard said quietly. "But can we do it? Without the firecrafters to set it ablaze and assist us in any fighting, I'm not sure how effective we can be."

"Do we have a choice?" Amara asked quietly.

Bernard folded his arms across his chest, squinted up at the sun, and shook his head. "I don't suppose we do," he rumbled. "Every advantage. We must create what we need." Bernard nodded once, sharply. He turned to Giraldi, and said, "I want your century ready to march in ten minutes. Tell Felix about the takers, and make sure all the men know about them. Have him create a record of what we've learned so far and leave it where any relief troops will find it in case we . . . aren't able to tell anyone ourselves. They'll need to stand watch for one another against the takers, and sleep in shifts."

Giraldi banged his fist on his breastplate and stalked off, bellowing orders again.

Bernard turned to Amara. "Countess, I'm appointing you Knight Commander. We'll need to make the most of our Knights' strength. I want you to do it."

Amara licked her lips and nodded. "Very well."

"Frederick," Bernard said, "get every Knight Terra we have left and have them cover you while you go through some of the buildings. I want every furylamp outside of the steadholt's great hall ready to go with us when we march. Move."

Frederic nodded and dashed off.

"Furylamps?" Amara murmured.

Bernard traded a look with Doroga, and the big Marat smiled broadly.

"Furylamps," Bernard said. "We attack the vord nest at nightfall."

Fidelias opened the door of the room and stepped aside, letting in a haze of smoke and incense, the sound of reed pipes, and the low murmur of human sound that drifted through the halls of the brothel like cheap perfume. The cloaked and hooded figure on the other side slipped into the room and drew back her hood. Invidia Aquitaine looked around the room, her expression remote, and while she felt around her for any intrusive furycraftings, Fidelias shut and locked the door.

Lady Invidia nodded to herself in satisfaction, and Fidelias felt her own furycraftings rise up to keep their conversation private. Her voice was low, tense. "What happened? The streets were a madhouse of rumors."

"Kalare's men followed them back to Sir Nedus's manor," Fidelias reported. "Three cutters and an archer. They attacked as Isana dismounted from the carriage."

Invidia looked at the very still form lying on the room's bed. "And?"

"Sir Nedus was killed, along with Serai and the coachmen. The Steadholder was shot."

Invidia's cold, hard gaze flicked to Fidelias. "The assassins?"

"Dead. Sir Nedus killed the cutters, but the archer was well hidden. It took me longer than I thought to find him and kill him."

"And the Steadholder was shot as a result." Invidia crossed the room to the bed, staring down at the pale, unconscious face of Isana of Calderon. "How badly is she wounded?"

"Barring infection, she'll live, even without crafting. She was very lucky. I've removed the arrow and cleaned and dressed the wound." He shrugged. "I can't imagine she'll be very comfortable when she wakes up, though."

Invidia nodded. "We'll have to get her into a bath as soon as possible. Kalare's people won't give up now. Better if she's not an invalid." She frowned. "And I suppose it might engender some feeling of gratitude."

Fidelias arched an eyebrow. "For something she could do herself, once awake?"

Invidia shrugged a shoulder. "For offering her something Gaius did not: safety. She was here at his bidding, I am certain. Whatever has happened, the simple fact that he did not provide her with sufficient protection will weigh heavily against him."

"Against Gaius does not necessarily mean toward you, Your Grace," Fidelias pointed out. "If she is like many holders, she will wish to have nothing to do with any ranking nobility—much less with the wife of the man who orchestrated the attack that nearly destroyed her home and family."

"That wasn't personal," Invidia said.

"For Isana it was," Fidelias said.

She waved a hand and sighed. "I know, I know. When I met her at Kalare's garden party, I thought for a moment that she was about to assault me. I tried to warn them that they were in danger and that Serai's identity might be known. I had thought that they listened. They left quite quickly."

"It might have been a moot point by then," Fidelias said. "In any case, we have to assume that Kalare will have his people looking for her when her body doesn't turn up."

Invidia nodded. "How secure is this location?"

"Not as much as I would like," Fidelias said. "I should have ample warning in the event I need to leave. That's as much as I can realistically expect without moving into the Deeps—or to your manor."

"Definitely not," Invidia said. "Kalare's bloodcrows haunt the Deeps, if your suspicion is correct—and it would be embarrassing for you to be discovered at my husband's manor. And I am sure that there are more than a few people looking for you. If the Cursors are not so rattled as you seem to think, they would make it a point to assume that if you were in town, you might well be in the manor."

Fidelias nodded. "I suggest, Your Grace, that you consider bringing Isana to your manor to stay, if not me."

"She does not care for me, dear spy."

Fidelias half smiled. "I promise you that she cares for me even less."

"I trust you to deal with that," Invidia replied. "I want you to care for her personally until she wakes. Do whatever you must—but make sure she understands her vulnerability before you contact me again." She paused for a moment. "The messages that she has been sending, the company she has

kept. Isana has . . . the sense of a desperate woman about her. Find out why."

"She is unlikely to take me into her confidence," he said in a dry voice.

"If I am right, it might not matter," Invidia said. She drew the hood back over her face. "She is motivated by powerful emotions. I suspect that she believes her family is in danger. To protect them, she might willingly lend me her support."

"Perhaps," Fidelias agreed. "But I do not think that you will find her as forgiving as other players in the game, Your Grace. You and I understand the necessity of allying oneself today with the political opponent of yesterday. But for someone like her, you will always be the wife and helpmate of the man who attempted to destroy her home and kin. That is the way of folk in the country."

"She isn't in the country anymore, Fidelias. She needs to realize that. Impress it upon her if you can. Contact me when you judge her as willing as she is likely to be."

"Very well."

"She's critical to us, dear spy. If she is killed, the lords will understand that Kalare has won the round. If she appears to the Senate under Gaius's oversight, the First Lord will have controlled the situation. She must appear before the Senate, and in my lord husband's colors. Then we will have out-maneuvered Kalare and Gaius alike."

"I understand, Your Grace," Fidelias said. "But I don't know if this victory is possible."

"Now, now, Fidelias. Of course it is possible, if we work hard enough and intelligently enough." She crossed to the door and opened it slowly. "And don't take too long, my spy," she cautioned him. "Time is fleeting."

"When is it not?" he replied.

Invidia's teeth gleamed white as she smiled from within her hood. Then she slipped out of the room and closed the door behind her.

Fidelias locked the door and sank down into the room's only chair. He ached all the way to his bones, and he was more than a little tired, but he didn't dare let his guard down. Those interested in claiming the reward for him offered by the Crown would certainly be looking for him. But bounty hunters were a secondary concern. Kalare's bloodcrows would be more organized, more formidable, and much more capable trackers. The fact that they had, in fact, seemingly stretched their influence into the Deeps, traditionally

the haunt of the Cursors and the criminal underworld of the capital, spoke volumes about how they must have prospered.

Not only did Fidelias have to worry about bounty hunters and rival assassins, but the Steadholder had already proven herself capable of decisive, deadly action. If he went to sleep with her yet wounded and senseless, when she woke she might well prove it again, and he did not care to be on the receiving end of further violence. He had been weary before. He could wait for her to waken.

Beyond that, he was not sure. What Invidia required of him might well be impossible. But she was not the kind to suffer failure lightly. It could be worth as much as his life if Isana of Calderon refused to cooperate.

Fidelias tried not to think about that. He had not survived a lifetime of service in the shadows by allowing his fears and doubts to rule his mind.

So he settled back in his chair, listened to the music and talk and cries of those enjoying the hospitality of the brothel, and waited for the Steadholder to waken, so that he could convince her to help topple the First Lord of Alera on behalf of Lord and Lady Aquitaine.

CHAPTER 28

Killian lifted a shaking hand to his face and leaned his forehead down against his palm. He was silent for a moment, but to Tavi that moment seemed days long. Maybe longer.

Tavi licked his lips and glanced at Fade, apparently asleep on the floor beside Gaius's cot. He wasn't sleeping. Tavi wasn't sure how he knew, but he felt certain that Fade was awake and listening carefully. The First Lord looked little different than when Tavi had last seen him. Gaius still seemed shrunken in upon himself, his face colorless and frail.

Sir Miles, who had been sitting at the replacement desk in one corner of the meditation chamber, methodically reading the messages sent to the First Lord, looked as though someone had kicked him in the stomach.

"I didn't mean for any of that to happen," Tavi said into the silence. "Neither did Max."

"I should hope not," Killian said in a mild voice.

"You . . ." Miles took a deep breath, clearly struggling to restrain his anger. Then he bared his teeth, and just as clearly lost the struggle. "You *idiots!*" he shouted. "You stupid, crows-begotten *fools*! How could you *do* something like this? What treacherous moron dashed the *brains* from your witless *skulls?*" He clenched his hands into fists and opened them again several times, as though strangling baby ducks. "Do you have any idea what you've *done?*"

Tavi felt his face heat up. "It was an accident."

Miles snarled and slashed his hand at the air. "It was an accident that the two of you left the Citadel when you *knew* you should stay close at hand? When you *knew* what was at stake?"

"It was my aunt," Tavi said. "I went to help her. I thought she was in trouble." Tavi felt his eyes blur with frustrated tears, and he scrubbed savagely at them with one sleeve. "And I was right."

"Your aunt," Miles growled, "is one person, Tavi. What you've done may have endangered the whole of Alera."

"I'm not related to the whole of Alera," Tavi shot back. "She's almost my only blood relation. My only family. Do you understand what that means? Do you have any family, Sir Miles?"

There was a heavy silence. Some of the anger faded from the captain's face.

"Not anymore," Miles said, his voice quiet.

Tavi's eyes went back to Fade, who lay in exactly the same position. Tavi thought he could feel a kind of quivering attention in him at Miles's mention of family.

Miles sighed. "But furies, boy. Your actions may have endangered us all. The Realm is only barely holding together. If word of Gaius's condition gets out, it could mean civil war. Attack from our enemies. Death and destruction for thousands."

Tavi physically flinched at the captain's words. "I know," he said. "I know."

"Gentlemen," Killian said, raising his head, "we all know what is at stake. Recriminations are useless to us for the time being. Our duty now is to assess the damage and take whatever steps we can to mitigate it." His blind eyes turned toward Tavi, and his voice took on a faint, but definite

edge of frost. "After the crisis is past us, we will have time to consider appropriate consequences for the choices made."

Tavi swallowed. "Yes, sir."

"Damage," Miles spat. "That's a pretty way to phrase it. We don't have a First Lord to appear at the highest profile social functions of the entire Realm. When he doesn't show up, the High Lords are going to start asking questions. They're going to start spreading money around. Sooner or later, someone is going to realize that no one knows where Gaius is."

"At which point," Killian mused, "we can expect them to attempt some sort of action to test the First Lord's authority. Once that is done, with no response from Gaius, an attempt to seize the Crown will only be a question of time."

"Could we find another double?" Miles asked.

Killian shook his head. "It was little short of a miracle that Antillar was able to impersonate him at all. I know of no other crafter both capable and trustworthy enough. It may be best to make excuses for the First Lord for the remainder of Wintersend and focus on ways to respond to any probes from the High Lords."

"You think we can cow them?" Miles asked.

"I think that they will need time to become certain that they have an opportunity," Killian said. "Our response would be designed to extend that time in order to give the First Lord a chance to recuperate."

Miles grunted. "If the First Lord does not appear at Wintersend—or to the presentation of new Citizens to the Senate and Lords—his reputation may never recover."

"I'm not sure that we can reasonably hope to attain anything better," Killian replied.

"Um," Tavi said. "What about Max?"

Killian arched an eyebrow. "What about him?"

"If we still need him so badly, can't we get him out of holding?" Tavi shook his head. "I mean, we have the First Lord's signet dagger. We could issue an order."

"Impossible," Miles said flatly. "Antillar is accused of the deadly assault and attempted murder of a Citizen—and the son of a High Lord at that, not to mention two other young men who are already being groomed as Knights for Kalare's Legions. Antillar must be held by the civic legion until his trial. Not even Gaius can defy that law."

Tavi chewed on his lip. "Well. What if we . . . sort of got him out unofficially?"

Miles frowned. "A jailbreak." He scrunched up his nose in thought. "Killian?"

"Lord Antillus has never made Maximus's heritage a secret," Killian answered. "They'll hold him in the Grey Tower."

Miles winced. "Ah."

"What's the Grey Tower?" Tavi asked. "I haven't heard of it."

"It isn't a place one discusses in polite company," Killian replied, his voice tired. "The Tower is meant to be capable of containing any crafter in the Realm—even the First Lord, if necessary—so that not even the High Lords would be beyond the reach of the law. The Lords Council itself crafted the security measures around the Grey Tower."

"What kind of measures?" Tavi asked.

"The same as you might find around the palace, prominent jewelers, or a lord's treasury—only a great deal more potent. It would take several High Lords working in concert to furycraft a way in or out. And the Grey Guard stand watch on the conventional thresholds."

"Who are they?" Tavi asked.

"Some of the finest metalcrafters and swordsmen in the Realm," Miles said. "To get in without furycrafting, we'd have to kill some damned decent men to get Antillar out. And doing so during Wintersend would set half the Realm on our trail. He'd be useless to us."

Tavi frowned. "Bribery?"

Miles shook his head. "The Grey Guard are handpicked specifically because they have enough integrity to resist bribery. Not only that, but the law states that the Crown will pay a bonus of double the amount of any attempted bribe if the guardsman turns in whoever tried it. In the past five hundred years, not one Grey Guardsman has taken a bribe, and only a handful of idiots have attempted to give them one."

"There must be some way in," Tavi said.

"Yes," Killian said. "One can go through furycrafted guardians and wards too powerful to simply overcome, or one can fight his way through the Grey Guard. There are no other ways in or out." He paused for a beat, and said, "That's rather the point in having a prison tower in the first place."

Tavi felt himself flush again. "I only mean that there must be some

course of action we could take. He's only there because he saved my life. Brencis was going to murder me."

"That was noble of Maximus."

"Yes."

Killian's voice turned severe. "The unpleasant truth is that the Cursors have little need of nobility. We desire foresight, judgment, and intelligence."

"Then what you're saying," Tavi said, "is that Max should have left me to die."

Miles frowned, but said nothing, watching Killian.

"You both should have brought the information to me first. And you certainly should not have left the Citadel without consulting me."

"But we can't leave him there. Max didn't even—" Tavi began.

Killian shook his head and spoke over him. "Antillar has been taken out of play, Tavi. There is nothing we can do for him."

Tavi scowled down at the floor and folded his arms. "What about my aunt Isana? Are you going to tell me that there's nothing we can do for her, either?"

Killian frowned. "Is there a viable reason for us to divert our very limited current resources to assist her?"

"Yes," Tavi said. "You know as well as I do that the First Lord was using her to divide what he suspected was an alliance of several High Lords. That he appointed her a Steadholder without consulting Lord Rivus in the matter. She has become a symbol of his power. If he has invited her to Wintersend, and something happens to her, it will be one more blow to his power base." Tavi swallowed. "Assuming she isn't dead already."

Killian was quiet for a moment. Then he said, "Normally, you would have a point. But we are now in the unenviable position of choosing which of Gaius's assets to sacrifice."

"She is *not* an asset," Tavi said, and his voice rang with sudden strength and authority. Miles blinked at him, and even Killian tilted his head quizzically. "She is my aunt," Tavi continued. "My blood. She cared for me after my mother died, and I owe everything in my life to her. Furthermore, she is an Aleran Citizen here at the invitation and in support of the Crown. He *owes* it to her to provide protection in her hour of need."

Killian half smiled. "Even at the expense of the rest of the Realm?"

Tavi took a deep breath through his nose. Then he said, "Maestro. If the First Lord and we his retainers are no longer capable of protecting the

people of the Realm from harm, then perhaps we should not be here at all."

Miles growled, "Tavi. That's treason."

Tavi lifted his chin and faced Miles. "It isn't treason, Sir Miles. It's the truth. It isn't a pretty truth, or a happy truth, or a comfortable truth. It simply is." He stared at Miles's eyes levelly. "I'm with the First Lord, Sir Miles. He is my patron, and I will support him regardless of what happens. But if we aren't living up to the obligations of the office of First Lord, then how can we pretend to be justified in holding its power?"

Silence reigned.

Killian sat perfectly still for a long moment. Then he said, quietly, "Tavi, you are morally correct. Ethically correct. But to best serve the First Lord we must make a difficult choice. No matter how horrible it seems." Killian let Tavi absorb the words for a moment, then turned his head vaguely toward Miles in search of support. "Captain?"

Miles had fallen silent, and now stood leaning against the wall, studying Tavi with his lips pursed. His thumb rapped a quiet rhythm on the hilt of his sword.

Tavi met the old soldier's eyes and did not look away.

Miles took a deep breath, and said, "Killian. The boy is right. Our duty in this hour is to perform as the First Lord would wish us to—not to safeguard his political interests. Gaius would never abandon Isana after asking her here. We therefore owe it both to the First Lord and to the Steadholder to protect her."

Killian's lips shook a little as he pressed them together. "Miles," he said, a gentle plea in his tone.

"It's what Gaius would want us to do," Miles said, unmoved. "Some things are important, Killian. Some things cannot be abandoned without destroying what have we and our forebears have worked all our lives to build."

"We cannot base our decision on passion," Killian said, his voice suddenly raw. "Too much depends upon us."

Tavi lifted his head suddenly, staring at Killian as comprehension dawned. Then he said, "You were his friend. You were friends with Sir Nedus."

Killian answered quietly, his voice smooth, precise, and steady. "We served our Legion terms together. We entered the service of the Royal Guard together. He was my friend for sixty-four years." Killian's voice did not change as tears slid down from his sightless eyes. "I knew that she was coming to the

capital, and that given our circumstances that she might not be secure in the palace. Nedus was protecting your aunt because I trusted him. I asked him to. He died because I put him in harm's way. And all of that changes nothing about our duty."

Tavi stared at him. "You knew my aunt was here? That she might be in danger?"

"Which is why I made sure Nedus knew to offer his hospitality," Killian said, his voice suddenly brittle and sharp. "She was supposed to stay in his manor until this situation settled. She would have been as safe there as anywhere. I cannot imagine what drove her to leave the manor—or why Nedus permitted it. He must have been trying to contact me, but . . ." He shook his head. "I didn't grasp what was happening. I didn't see."

"What if he had good reason to take the chance?" Tavi asked quietly. "Something he judged to be worth the risk?"

Killian shook his head and didn't answer.

"The boy is right," Miles said. "He was a Royal Guard in his own day and was never a fool. He was my *patriserus* of the blade. Rari's too. He knew better than anyone the risks in exposing the Steadholder. If he did so, he did it only because it was a necessity."

"Don't you think I know that?" Killian said quietly. "If I allow this to distract our focus, we may lose all of Alera. And if I ignore Nedus's sacrifice, it may mean that we are exposed to some unforeseen threat he was desperate to warn us about. I must choose. And I must not let my feelings, however strong, dictate that choice. Too much is at stake."

Tavi stared at Killian and suddenly perceived not the razor intellect and deadly calm of the Cursor Legate, but the deep and bitter grief of an old man struggling to hold himself together in the face of an overwhelming storm of anxiety, uncertainty, and loss. Killian was not a young man. The future of literally the entire Realm rested on his slender shoulders, and he had found them more brittle than strong beneath so heavy a burden. His fight to retain his control, to rely upon pure intellect to guide his choices, was his only defense against the storm of danger and duty that demanded that he act—and which instead held him pinned and motionless.

And Tavi suddenly understood what might tip that balance. He hated himself for thinking of the words. He hated himself for even considering saying them. He hated himself for drawing the breath that would carry them to the wounded, bleeding soul within the old man.

But it was the only way he could help Aunt Isana.

"Then the question is whether or not you trust Sir Nedus's judgment. If you do, and if we leave the Steadholder to her fate," Tavi said quietly, "then he will have died for nothing."

Killian bent his head sharply, as though to stare at a dagger suddenly buried in his guts.

Tavi forced himself to watch the old man's pain. The pain he'd driven hard into Killian in his moment of weakness. The pain he knew would compel Killian to act. There was another silence, and Tavi felt suddenly sick with an anger directed nowhere but at himself.

He looked up to find Miles staring at him, something hard in the captain's eyes. But he never stirred and did not speak, letting his silence stand substitute for his support.

"I don't know how we can help her," Killian said at last, his voice a croak. "Not with only the three of us."

"Give me Ehren and Gaelle," Tavi said at once. "Free them of their final exercise. Let them investigate and see what they can find. They don't have to know anything about Gaius. Isana is my aunt, after all. Everyone knows that already. It would be natural for me to ask for their help in finding her. And . . . I might be able to ask Lady Placida as well. She's one of the leaders in the Dianic League. The League has a vested interest in keeping my aunt safe. They might be willing to expend some effort to locate her."

Killian's shaggy white brows knitted together. "You know that she may already be dead."

Tavi inhaled slowly. His tactics, the topic of the discussion, and the horrible images running through his head were terrifying. But he kept his breathing steady, and spoke of nightmarish scenarios in a calm, reasoned tone, as if discussing theoretical situations in a classroom. "Logically, it is likely that she is alive," he said. "If the cutters we saw wanted her dead, they would have found her body next to Sir Nedus's and Serai's. But she was taken from the scene. I think someone hopes to make use of her somehow, rather than removing her entirely."

"Such as?" the old Cursor asked.

"Asking for her support and allegiance, perhaps," Tavi said. "Hoping to gain the support of a very visible symbol if possible, rather than simply destroying it."

"In your estimation, will she do so?" Miles asked.

Tavi licked his lips, thinking through his answer as carefully as he possibly could. "She has little love for Gaius," he said. "But even less for those who arranged the Marat attack on the Calderon Valley. She'd rather gouge out her own eyes than stand with someone like that."

Killian exhaled slowly. "Very well, Tavi. Ask Ehren and Gaelle to help you, but do not tell them it is my desire that they do so, and reveal nothing further to them of the situation. Contact Lady Placida to request her help—though I wouldn't expect her to be terribly eager to assist you. By delivering a message from Gaius to her in public, you have tacitly claimed that Lord and Lady Placida are loyalists."

"Are they not loyal?" Tavi asked.

"They are not interested in choosing sides," Killian replied. "But you may have forced them to do it. In my judgment, they will not be appreciative of your actions. Walk carefully when you see them."

Miles grunted. "Maestro, I have some contacts in town. Retired Legion, mostly. There are two or three men who I could ask to look into Isana's disappearance. I'd like to contact them at once."

Killian nodded, and Miles pushed off the wall and headed for the door. He paused beside Tavi and glanced at the young man. "Tavi. What I said earlier . . ."

"Was completely justified, sir," Tavi said quietly.

Miles regarded the boy for a moment more, then the pain in Killian's features. "Maybe it wasn't enough."

The captain gave Tavi a stiff, formal nod and strode from the room, his boots thudding in a swift, angry cadence.

He left Tavi with Killian, Fade, and the unconscious Gaius.

They sat in silence for a moment. Gaius's breathing sounded steadier and deeper to Tavi, but it could have been his imagination. Fade stirred and sat up, blinking owlishly at Tavi.

"With the captain gone," Killian said, "I'll have to handle the First Lord's mail. I know you want to move immediately, Tavi, but I'll need you to read it to me before you go. It's on the desk."

"All right," Tavi said, rising and forcing himself not to give voice to an impatient sigh. He paced to the desk, sat on the chair, and took up a stack of about a dozen envelopes of various sizes, and one long, leather tube. He opened the first letter and scanned over it. "From Senator Parmus, informing the Crown of the status of the roads in—"

"Skip that one for now," Killian said quietly.

Tavi put that letter down and went to the next. "An invitation from Lady Riva to attend her yearly farewell gathering in—"

"Skip it."

He opened the next letter. "From Lord Phrygius, bidding the First Lord a merry Wintersend in his absence, which is due to military considerations."

"Details?" Killian asked. "Tactical intelligence?"

"Nothing specific, sir."

"Skip it."

Tavi went through several more routine letters such as those, until he came to the last one, in the leather scroll tube. He picked it up, and the case felt peculiar against his hand, sending a slow shiver up his spine. He frowned at the peculiar leather, then suddenly understood the source of his discomfort.

It was made from human skin.

Tavi swallowed and opened the tube. The cap made an ugly, quavering scraping sound against the substance of the tube. Tavi gingerly drew out a sheet of leather parchment, trying not to touch the case any more than he absolutely had to do so.

The parchment, covered in large, heavy letters, was also made from thin-scraped human skin. Tavi swallowed uncomfortably, and read over the message.

"From Ambassador Varg," he read. "And in the Ambassador's own hand, it says."

Killian's heavy white brows furrowed. "Oh?"

"It advises the First Lord that the Canim courier ship has arrived with the change of his honor guard and will depart the capital to sail down the Gaul in two days."

Killian thumped his forefinger against his chin. "Interesting."

"It is?" Tavi asked.

"Yes."

"Why?"

Killian rubbed at his chin. "Because it is absolutely not interesting. It is an entirely routine notification."

Tavi began to follow the Maestro's line of thought. "And if it is entirely routine," he said, "then why is it in the Ambassador's own hand?"

"Precisely," Killian said. "The Canim courier passes back and forth every

two months or so. The Ambassador is permitted six guards at any one time, and four replacements are brought with every ship, so that no two guards spend more than four months on duty here. It is a common enough sight." He waved vaguely at his blind eyes. "Or so I am told."

Tavi frowned. Then he said, "Maestro, when I took that message to the Ambassador, he made it a point to tell me that he was having problems with rats. He . . . well indirectly pointed me at a hidden doorway, and I found an entry to the Deeps in the Black Hall."

Killian's frown darkened. "They found it, then."

"It was always there?" Tavi asked.

"Obviously," Killian said. "Gaius Tertius, I believe, made sure a way in was available to us, in the event that we needed to force entry. But I thought it undiscovered."

"Why would Varg take the time to tell us that he knew about it?" Tavi asked.

Killian mused for a moment and then said, "Honestly, I don't know. I can't think of any reason but for spite, to show us that he had not been deceived. But our knowledge of *his* knowledge could only have reduced any advantage he gained from knowing about the door—and it isn't like Varg to give away an advantage."

"I went down the passage a little," Tavi said. "I heard Varg's second, Sarl, speaking with an Aleran."

Killian's head tilted. "Indeed. What did they say?"

Tavi thought about it for a moment, then repeated the conversation.

"How nonspecific," Killian murmured.

"I know," Tavi said. "I'm sorry I didn't bring this to you at once, sir. I was scared when I left and I hadn't slept and . . ."

"Relax, Tavi. No one can go on forever without rest. Young men your age seem to need more than most." The old Cursor blew out a breath. "I suppose it's true for all of us. It bears thinking on, later, when there is less urgent business at hand," he said. "Is there any more mail?"

"No, sir. That's all."

"Very well. Then be about your assignment."

Tavi rose. "Yes, sir." He started for the door and paused. "Maestro?"

"Mmm?" Killian asked.

"Sir . . . do you know who the captain meant when he said that Nedus had also trained 'Rari'?"

Tavi saw Fade's attention snap toward him in the corner of his vision, but he didn't look at the slave.

"Araris Valerian," Killian replied. "His older brother."

"There was bad blood between them?" Tavi asked.

Killian's expression flickered with irritation, but his answer was in a patient voice. "They had a falling-out. They hadn't recovered from it when Araris was killed at First Calderon, with the Princeps."

"What kind of falling-out?" Tavi asked.

"The famous duel of Araris Valerian and Aldrick ex Gladius," Killian replied. "Originally, you see, Miles was to duel Aldrick over . . ." He waved a hand. "I forget. Some kind of disagreement over a woman. But on the way to the duel, Miles slipped and fell into the street into the path of a water wagon. It ran over his leg and shattered his knee so badly that not even watercrafters could make it entirely whole again. Araris, as Miles's second, fought the duel in his place."

"And that came between them?" Tavi asked. "Why?"

"Miles accused Araris of pushing him in front of the wagon," Killian said. "Said he did it out of a desire to protect him."

Tavi watched Fade in the corner of his eye, but the slave had gone completely still. "Is it true?"

"Had they faced one another, Aldrick would have killed Miles," Killian stated. There was no doubt whatsoever in his tone. "Miles was very young, then, not even fully grown, and Aldrick was—is—a terror with a blade."

"Did Araris really push Captain Miles?" Tavi asked.

"I doubt anyone will ever know the truth of it. But Miles was wounded too badly to accompany the Princeps and his Legion to the Battle of the Seven Hills. He was on the way to the Calderon Valley to rejoin the Princeps when the Marat attacked and began the First Battle of Calderon. Araris died beside the Princeps. Miles and his brother never saw one another again. Never had the chance to reconcile. I suggest you avoid the topic."

Tavi turned to look at Fade.

The slave averted his eyes, and Tavi could not read the man's marred features. "I see," he said quietly. "Thank you, Maestro."

Killian lifted a hand, cutting Tavi off. "Enough," the old man murmured. "Be about your duties."

"Yes, sir," Tavi said, and retreated from the meditation chamber to seek out Ehren and Gaelle.

"Do you have any idea what time it is?" Ehren mumbled. "And we have a history examination at third bell." He turned his back, resettled himself onto his pillow, and mumbled, "Come back after the exam."

Tavi glanced across the cot at Gaelle, then the two of them reached down and hauled Ehren bodily up out of bed. The skinny boy let out a yelp as they dragged him toward the door of his dorm room. On the way, Tavi scooped up a pair of trousers, stockings, and boots, neatly laid out in preparation for the morning.

"Quiet," he said to Ehren. "Come on. We don't want the night watchman to come looking for us."

Ehren subsided and began to stagger along with them, keeping pace, until after several dozen paces he blinked, and murmured, "What's going on?"

"Tell you in a minute," Tavi said. He and Gaelle steered Ehren toward the overgrown area of the campus where Killian's supposed classroom was located. Tavi snagged the key to its door from beneath a nearby stone, unlocked it, and the three young people hurried inside.

Once there, Tavi made sure the shades were drawn tight closed, and murmured, "All right," to Gaelle, who coaxed the flame of a furylamp to dim life.

Ehren gave Gaelle a self-conscious glance, reached for his clothing, and started jerking it on with considerable haste, even though his nightshirt came to well below his knees. "We're going to get in trouble," he said. "Tavi, what are you doing?"

"I need your help," he said quietly.

"Can't it wait?" Ehren asked.

Tavi shook his head, and Gaelle suddenly frowned at him. "Tavi," she murmured. "What's wrong? You look awful."

At that, Ehren frowned and studied him as well. "Tavi? Are you all right?"

"I am," Tavi replied. He took a deep breath. "My aunt isn't. She came to the capital for the presentation at the conclusion of Wintersend. Her party was attacked. Her companion and her armsmen were murdered. She's been taken."

Gaelle drew in a quick breath. "Oh, furies, Tavi, that's horrible."

Ehren pushed his fingers idly through his tangled hair. "Crows."

"She's in danger," Tavi said quietly. "I have to find her. I need your help."

Ehren snorted. "Our help? Tavi, be reasonable. I'm sure the civic Legion is looking for her already. And the Crown is going to turn the Realm upside down and shake it until she falls out. Gaius can't afford to let something happen to Steadholder Isana."

Gaelle frowned. "Ehren's right, Tavi. I mean, I'm your friend, and I want to do whatever I can to help you, but there are going to be much more capable people handling your aunt's disappearance."

"No," Tavi said quietly. "There aren't. At least, I don't think anyone with a real chance of success is going to look for her."

Ehren's expression became uncertain. "Tavi? What do you mean?"

Tavi took a deep breath. Then he said, "Look. I'm not supposed to tell you about this. But the Crown is, for the moment, extremely limited in what it can do to help."

"What does that mean?" Gaelle asked.

"I can't share specifics," Tavi said. "Suffice to say that the Crown isn't going to be turning anyone upside down looking for my aunt."

Gaelle blinked in slow surprise. "What about the Cursors? Surely they will be able to help?"

Tavi shook his head. "No. There . . ." He grimaced. "I can't tell you any more. I'm sorry. The only help my aunt is going to get is whatever I can bring to her myself."

Ehren frowned. "Tavi, don't you trust us?"

"It isn't that," Tavi said. "Because I do."

Gaelle stared at him, then mused, aloud, "Which means you are under orders not to speak to us about it."

Ehren nodded thoughtfully. "And the only one who could give you an order like that is Maestro Killian."

"Or the First Lord," Gaelle murmured. "Which means . . ." Her face went a little pale.

Ehren swallowed. "Which means that something very serious is happening—something serious enough to divert the entire resources of the Cursors and the Crown elsewhere. And that whoever gave him the order is afraid of treachery from within the Citadel, because even we aren't getting the whole story."

Gaelle nodded slowly. "And as students newly introduced to matters of intelligence, we present less risk to security matters." She frowned at Tavi. "Has something happened to the First Lord?"

Tavi used every ounce of experience he'd gained growing up with a powerfully sensitive watercrafter watching over him to keep any kind of expression from his face or voice as he answered. "I can't tell you anything more than I have."

"But if we do this," Gaelle said, "we will be in danger."

"Probably," Tavi said quietly.

Ehren shivered. "I would have thought you'd ask Max first," he said. "Why isn't he here?"

"I'm not sure where he is," Tavi said. "But as soon as I see him, I'm going to ask him, too."

Ehren frowned and glanced down at the floor. "Tavi, we have examinations for two more days—and we still have to complete our final exercises for Killian. There's no way I can do that and an investigation, too."

"I know," Tavi said. "I'm asking for a lot—from both of you. Please believe me when I say that I wouldn't do it if I wasn't desperate. We've got to find my aunt—both for her own sake and to help the Crown."

"But . . ." Ehren sighed. "History."

"I think we can get the Academy to give us special consideration later," Tavi said. "But I can't promise you anything, Ehren. I'm sorry."

"My admittance to the Academy was conditional. If I fail any courses, they're going to send me back home," Ehren said.

Tavi shook his head. "You've been training as a Cursor, Ehren. The Crown won't let them send you away if you were pulled away from your studies by duty."

Gaelle arched her brows. "But *is* this duty, Tavi?"

"It is," Tavi said.

"How do we know that?" Gaelle asked.

"You'll just have to trust me." Tavi gazed at her steadily.

Gaelle and Ehren traded a long look, then Gaelle said, "Well, of course

we'll help you, Tavi." She took a shaking breath. "You're our friend. And you are right about your aunt's importance to the Crown." She grimaced. "I wasn't exactly having a good time with my assignment for Killian in any case."

"Oh, dear." Ehren sighed. "Yes, of course we'll help."

"Thank you," Tavi told them. He smiled a little. "If you like, I'll even help you with your assignments for the Maestro. We'll make it our own little secret."

Ehren let out a wry laugh. "I can hardly imagine where *that* could lead," he said. He finished lacing his boots. "So, tell us whatever you can about the attack on your aunt."

Tavi told them about the visit to Lord Kalare's garden party and what they had learned there and after, omitting any mention of Max or Brencis and his cronies from the tale.

"It would appear," Ehren said, "that Kalare dispatched these cutters who killed your aunt's entourage."

"It seems a rather glaringly obvious conclusion," Gaelle replied. "It may have been a deliberately planted encounter for Tavi's benefit."

"It hardly matters," Tavi said. "The men who took her wouldn't bring her back to Kalare's property in any case. He'd be protecting himself from any association with the murders and kidnaping."

"True," Ehren said. He glanced at Gaelle. "The staff of Kalare's household may have seen something. And odds are very good the house's chef employed the services of caterers for some of the food. They might also have seen something without realizing it."

Gaelle nodded. "There were any number of people on the streets nearby. We could knock on doors, speak to people still there. There are bound to be rumors flying about, too. One never knows when they might be useful. Which do you prefer?"

"Streets," Ehren said.

Gaelle nodded. "Then I will approach Kalare's staff and the caterers."

"If she's been taken," Tavi said, "they might be preparing to leave with her. I'll take the riverfront and check in with the dockmaster and the causeway wardens to make sure they know to keep an eye out." He half smiled. "Listen to us. We sound almost like Cursors."

"Amazing," Gaelle said, mouth curving into a small smile.

The three young people looked around at one another, and Tavi could

feel the quivering nervousness in his own belly reflected in his friends' eyes.

"Be careful," he said quietly. "Don't take any chances, and run at the first sign of trouble."

Ehren swallowed and nodded. Gaelle rested her hand briefly on his.

"All right," Tavi said. "Let's go. We should leave separately."

Gaelle nodded and doused the light of the furylamp. They waited until their eyes had adjusted to the low light, then she slipped out of the class-room. A few moments later, Ehren breathed, "Good luck, Tavi," and van-ished into the late-night darkness himself.

Tavi crouched in the darkness with his eyes closed, and suddenly felt very small and very afraid. He had just asked his friends to help him. If they were harmed, it would be his fault. Max now languished in the Grey Tower, a prisoner because he had tried to help Tavi. That, too, was his fault. And no matter what he told himself, he felt responsible for what had happened to Aunt Isana as well. If he had not become involved in the matters leading up to the Second Battle of Calderon, the First Lord might never have seen an opportunity to use her by appointing her a Steadholder.

Of course, if he hadn't gotten involved, his aunt might well be dead, too, along with everyone else in the Calderon Valley. But even so, he couldn't keep the heavy, ugly pressure of guilt from weighing on him.

If only Max hadn't been taken, Tavi thought. If only Gaius could waken. Direct orders from the First Lord could galvanize the Civic Legion to furi-ous action, dispatch the Crown Legion to help search, call in favors owed by Lords, High Lords, and Senators alike, and generally change the entire situ-ation.

But Gaius was unable to take action. Max was locked away behind the heaviest security in the Realm, furycraftings that no one could overcome . . .

Unless there was someone who could.

Tavi jerked his head upright in sudden, astonished realization. There was indeed someone capable of circumventing the kinds of security craft-ings that kept Max locked away in the Grey Tower. Someone who had, with-out using craftings of his own, managed to outmaneuver, circumvent, or render impotent the furycraftings that protected the businesses of jewelers, goldsmiths, and more humble bakeries and smithies alike.

And if the those furycraftings had been so effortlessly overcome, then perhaps he might be able to enter the Grey Tower as well. If someone could reach Max and withdraw him quietly from his prison, the guards might

remain ignorant for time enough to enable Max to return to the Citadel and resume the role of Gaius Sextus. And *then* there would indeed be a First Lord able to have the city turned upside down in order to recover Aunt Isana from her captors.

Which meant that Tavi's next move was obvious.

He had to find and catch the Black Cat.

This was no mere exercise, upon which hung nothing more than his final grade. Tavi had to convince the thief to help him enter the Grey Tower and liberate his friend Max. And soon. Every moment that the stars wheeled overhead was a moment in which whoever had his aunt might dispose of her.

Tavi narrowed his eyes in thought, then rose from the floor, left the classroom, and locked the door behind him. He returned the key to its resting place, and hurried with silent, determined paces into the night.

CHAPTER 30

Tavi didn't know quite what it was that made him decide to head for the Craft Lane at the base of the mountain crowned by the Citadel high above. It was far from the elegant celebrations and garden parties of the streets that rose above the rest of the city. No jeweler's shop or goldsmith would be found there. Craft Lane was inhabited by those who worked with their hands for a living—blacksmiths, farriers, carters, weavers, bakers, masons, butchers, vendors, carpenters, and cobblers. By the standards in the countryside, any one of the households there was extremely prosperous, and yet Craft Lane was still poor compared to the Citizens Lanes above them, and the ascending ranks of the nobility that followed.

But what Craft Lane lacked in extravagance, it made up for in enthusiasm. For folk who toiled every day to earn their keep, the celebration at Wintersend was one of the most anticipated times of the year, and great effort went into the planning of celebrations. As a consequence, there was

literally no hour of the day or night that some (if not all) of Craft Lane would be host to street gatherings where food, drink, music, dance, and games ran with a constant, merry roar.

Tavi had dressed in his darkest clothes, and wore his old green cloak with its hood pulled forward to hide his face. Upon reaching Garden Lane, he studied it for a moment with a kind of half-amused dismay. The celebrations were running in full swing, with furylamps brightening night to near day. He could hear at least three different groups of musicians playing, and numerous areas along the crowded streets had been marked out on the cobblestones with chalk to reserve space for the dancers who whirled and reeled through their steps.

Tavi wandered down the Lane, looking up only occasionally. He focused his attention on what his ears and his nose told him of his surroundings, then at the intersection with Southlane he abruptly stopped.

The first thing he noticed about the background was the difference in music. Rather than instruments, there was a small vocal ensemble singing a complex air that rang down the street with merry energy. At the same time, the overwhelming scent of baking sweetbread flooded his senses and made his mouth water. He hadn't eaten in hours and hours, and he looked up to stare hungrily at the baker's shop, which by all rights should have been locked up and quiet, and was instead turning out sweetbread and pastries by the bushel.

Tavi glanced around him, ducked to one side of the road and between two of the shops, and found a box to stand on. He used it to reach up for the top of the windowsill, and with a carefully directed explosion of effort, he heaved himself up, grabbing at the eaves of the roof and hauling himself swiftly up to the rooftop. Once there, he was able to turn and spring lightly from that roof to the next, which offered a split level that rose another story into the air. Tavi scaled that as well, then started down Crafter Lane, springing lightly from one closely spaced rooftop to the next, his eyes and ears and nose open.

A sudden quivering excitement filled him for no reason whatsoever, and Tavi abruptly felt certain that his instincts had not led him astray. He found a pocket of deep shadows behind a chimney and slipped into it, crouching into cautious immobility.

He didn't have long to wait. There was a flicker of motion on the far side of Crafter Lane, and Tavi saw a cloaked and hooded figure gliding over the

rooftops just as lightly and quietly as he. He felt his lips tighten into a grin. He recognized the grey cloak, the flowing motion. Once again, he had found the Black Cat.

The figure eased up to the edge of the roof to stare down at the vocalists, then dropped into a relaxed crouch, hands reaching down to rest his fingers lightly on the rooftop. Beneath the cloak's hood, the Cat's head tilted to one side, and he went completely still, evidently fascinated by the singers. Tavi watched the Cat in turn, an odd and nagging sense of recognition stirring briefly. Then the Cat rose and ghosted down to the next rooftop, his covered face turned toward the bakery, with its tables piled high with fresh, steaming sweetbread while a red-cheeked matron did a brisk business selling the loaves. A quality of tension, of hunger, entered the Cat's movements, and he vanished over the far side of the building upon which he stood.

Tavi waited until the Cat was out of sight, then rose and leapt to the roof of the bakery. He found another dark spot to conceal his presence just as the dark-cloaked Cat emerged from between the two buildings across the street and walked calmly through the crowded street, feet shuffling in a rhythmic step or two as he passed the vocal ensemble. The Cat slowed his steps by a fraction and passed the table just as the matron behind the table turned to deposit small silver coins into a strongbox. The Cat's cloak twitched as he passed the table, and if Tavi hadn't been watching carefully he would never have seen the loaf vanish under the thief's cloak.

The Cat never missed a step, sliding into the space between the bakery and the cobbler's shop beside it and walking quietly and quickly down the alleyway.

Tavi rose and padded silently along the rooftop, reaching to his belt for the heavy coil of tough, flexible cord looped through it. He dropped the open loop at the end of the lariat clear of his fingertips, and opened the loop wider with the practiced, expert motions his hands had learned through years of dealing with the large, stubborn, aggressive rams of his uncle's mountain sheep. It was a long throw and from a difficult angle, but he crouched by the edge of the roof and flicked the lariat in a circle before sending it sharply down.

The loop in the lariat settled around the Cat's hooded head. The thief darted to one side, and managed to get two fingers under the loop before Tavi could snap the line tight. Tavi planted his feet and hauled hard on the line. The line hauled the Cat from his feet and sent him stumbling to one side.

Tavi whipped the cord twice around the bricks of the bakery's chimney, slapped it through a herder's loop in a familiar blur of motion, then slid down the roof to drop to the alley, landing in a crouch that bounced into a leap that carried him into the Black Cat's back. He hit hard, driving the Cat into the wall with a breath-stealing slam.

The Cat's foot smashed down hard on his toes, and if he hadn't been wearing heavy leather boots, it might have broken them. Tavi snarled, "Hold still," and hauled at the rope, trying to keep his opponent from finding his balance. There was a rasping sound and a knife whipped at the hand Tavi had on the rope. He jerked his fingers clear, and the knife bit hard into the tightened lariat. The cord was too tough to part at a single blow, but the Cat reached up with his free hand to steady the rope and finish the cut.

The lariat parted. Tavi slammed the Cat against the wall again, seized the wrist of the thief's knife hand and banged it hard against the bakery's stone wall. The knife tumbled free. Tavi drove the heel of his hand into the base of the Cat's neck, through the heavy cloak, a stunning blow. The Cat staggered. Tavi whirled and threw the thief facedown to the ground, landing on his back and twisting one slender arm up far behind him, holding the Cat in place.

"Hold *still*," Tavi snarled. "I'm not with the civic legion. I just want to *talk* to you."

The Black Cat abruptly stopped struggling, and something about the quality of that stillness made him think it was due to startled surprise. The Black Cat eased away the tension in the muscles that quivered against Tavi, and they softened abruptly.

Tavi blinked down at his captive and then tore the hood back from the Black Cat's head.

A mane of fine, silvery white curls fell free of the cloak, framing the pale, smooth curve of a young woman's cheek and full, wine-dark lips. Her eyes, slightly canted at their corners, were a brilliant shade of green identical to Tavi's own, and her expression was one of utter surprise. "Aleran?" she panted.

"Kitai," Tavi breathed. "*You're* the Black Cat?"

She turned her head as much as she could to look up at him, her wide eyes visible even in the dimness of the alley. Tavi stared down at her for a long moment, his stomach muscles suddenly fluttering with excited energy. He became acutely conscious of the lean, strong limbs of the young Marat

woman beneath him, the too-warm fever heat of her skin, and the way that her own breathing had not slowed, though she had ceased to struggle against him. He slowly released her wrist, and she just as slowly withdrew her arm from between their bodies.

Tavi shivered and leaned a little closer, drawing in a breath through his nose. Strands of fine hair tickled his lips. Kitai smelled of many scents, faint perfumes likely stolen from expensive boutiques, the fresh warmth of still-warm sweetbread and, beneath that, of heather and clean winter wind. Even as he moved, she turned her head toward him as well, her temple brushing his chin, her breath warm on his throat. Her eyes slid almost closed.

"Well," she murmured after another moment. "You have me, Aleran. Either do something with me or let me up."

Tavi felt his face flare into a fiery blush, and he hurriedly pushed his arms down and lifted his weight from Kitai. The Marat girl looked up at him without moving for a moment, her mouth curled into a little smirk, before she rose with a thoughtless, feline grace to her own feet. She looked around for a moment and spotted her ill-gotten loaf of sweetbread on the ground, crushed during their struggle.

"Now look what you've done," she complained. "You've destroyed my dinner, Aleran." She frowned and stared at him for a moment, annoyance flickering in her eyes as she looked him up and down, then stood directly before him with her hands on her hips. Tavi blinked mildly at her expression and stared down at her. "You've grown," she accused him. "You're taller."

"It's been two years," Tavi said.

Kitai made a faint, disgusted sound. Beneath the cloak she wore a man's tunic of dark, expensive silk, hand-stitched with Forcian nightflowers, heavy, Legion-issue leather trousers, and fine leather shoes that would have cost a small fortune. The Marat girl had changed as well, and though she was obviously little taller than before, she had developed in other, extremely interesting ways, and Tavi had to force himself not to stare at the pale slice of smooth flesh revealed by the neckline of the tunic. Her cheek had a reddened patch of abraded flesh sharing space with a steadily darkening bruise, where Tavi had first slammed her into the wall. There was a similar mark upon her throat, though it was slender and precise, from where Tavi's lariat had caught her.

If she felt any pain, it didn't show. She regarded Tavi with intelligent, defiant eyes, and said, "Doroga said you would do this to me."

"Do what?" Tavi asked.

"Grow," she said. Her eyes raked him up and down, and she seemed to feel no compunction at all about staring at him. "Become stronger."

"Um," Tavi said. "I'm sorry?"

She glowered at him, and looked around until she spotted her knife. She reclaimed it, and Tavi saw that the blade was inlaid with gold and silver, the handle set with a design of amber and amethysts, and would probably have cost him a full year's worth of the modest monthly stipend Gaius permitted him. More jewelry glittered at her throat, on both wrists and in one ear, and Tavi gloomily estimated that the value of the goods she had stolen would probably merit her execution should she be captured by the authorities.

"Kitai," he said. "What in the world are you doing here?"

"Starving," she snapped. She poked at the ruined loaf with the tip of her shoe. "Thanks to you, Aleran."

Tavi shook his head. "What were you doing before that?"

"*Not* starving," she said with a sniff.

"Crows, Kitai. Why did you come here?"

Her lips pressed together for a moment before she answered. "To stand Watch."

"Uh. What?"

"I am Watching," she snapped. "Don't you know anything?"

"I'm starting to think that I don't," Tavi said. "Watching what?"

Kitai rolled her eyes in a gesture that conveyed both annoyance and contempt. "You, fool." She narrowed her eyes. "But what were you doing on that roof? Why did you attack me?"

"I didn't know it was you," Tavi said. "I was trying to catch the thief called the Black Cat. I suppose I did."

Kitai's eyes narrowed. "The One sometimes blesses even idiots with good fortune, Aleran." She folded her arms. "You have found me. What do you want?"

Tavi chewed on his lip, thinking. It was dangerous for Kitai to be in Alera at *all*, much less in the capital. The Realm's experiences with other races upon Carna had invariably been tense, hostile, and violent. When the Marat had wiped out Princeps Gaius Septimus's Legion at the First Battle of Calderon, they had created an entire generation of widows and orphans and bereaved families. And since the Crown Legion had been recruited

from Alera Imperia, there were thousands, tens of thousands of individuals in this city with a bitter grudge against the Marat.

Kitai, because of her athletic build, pale skin, and hair—and *especially* because of her exotically slanted eyes—would be recognized immediately as one of the barbarians from the east. Given all that she had stolen (and the humiliation she had inflicted upon the civic legion in the process), she would never see the inside of a jail or a court of law. If seen, she would probably be seized by an angry mob and stoned, hanged, or burned on the spot, while the civic legion looked the other way.

Tavi's neglected stomach gurgled a complaint, and he sighed. "First thing," he said, "I'm going to get us both some food. Will you wait here for me?"

Kitai arched an eyebrow. "You think I cannot steal food for myself?"

"I'm not going to steal it," Tavi said. "Think of it as an apology for ruining your sweetbread."

Kitai frowned at that for a moment, then nodded cautiously and said, "Very well."

He had just enough money to purchase a couple of heavy wildfowl drumsticks, a loaf of sweetbread, and a flagon of apple cider. He took them back into the dim alley, where Kitai waited in patient stillness. Tavi passed her a drumstick and broke the loaf in half, then let her choose one. Then he leaned back against the wall, standing beside her, and got down to the serious business of eating.

Evidently, Kitai was at least as ravenous as Tavi, and they demolished meat and bread alike in moments. Tavi took a long drink from the flask and offered the rest to Kitai.

The Marat girl drank and wiped her mouth with one sleeve, then turned to Tavi, exotic eyes glittering. She dropped the empty flask and studied him while she licked the crumbs and grease from her fingers. Tavi found it fascinating, and waited in silence for a moment.

Kitai gave him a slow smile. "Yes, Aleran?" she asked. "Is there something you want?"

Tavi blinked and coughed, looking away before he started blushing again. He reminded himself sternly of what was at stake and that he did not dare allow himself to be distracted when it could cost so many people their lives. The terrifying weight of his responsibility drove away thoughts of Kitai's fingers and mouth, replacing them with twisting anxiety. "Yes, actually," he said. "I need your help."

Kitai's playful little smile vanished, and she peered at him, her expression curious, even concerned. "With what?"

"Breaking into a building," he said. "I need to learn how you've managed to get around all the security precautions in the places you have raided."

Kitai frowned at him. "For what reason?"

"A man is locked inside a prison tower. I need to get him out of the Grey Tower without tripping any furycrafted alarms and without anyone seeing us. Oh, and we need to do it so that no one knows that he's missing for at least a quarter of an hour."

Kitai took that in stride. "Will it be dangerous?"

"Very," Tavi said. "If we're caught, they will imprison or kill us both."

Kitai nodded, her expression thoughtful. "Then we must not be caught."

"Or fail," Tavi said. "Kitai, this could be important. Not just for me, but for all of Alera."

"Why?" she asked.

Tavi furrowed his brow. "We don't have much time for explanations. How much do you know about Aleran politics?"

"I know that you people are all insane," Kitai said.

Despite himself, a low bark of laughter flew from his lips. "I can see how you'd think that," Tavi said. "Do you need a reason other than insanity, then?"

"I prefer it," Kitai said.

Tavi considered it for a moment, then said, "The man who is locked away is my friend. He was put there for defending me."

Kitai stared at him for a moment and nodded. "Reason enough," she said.

"You'll help me?"

"Yes, Aleran," she answered. She studied his features with thoughtful eyes. "I will help you."

He nodded seriously. "Thank you."

Her teeth shone white in the dim alley. "Do not thank me. Not until you see what we must do to enter this tower."

CHAPTER 31

Tavi stared across an enormous span of empty air at the Grey Tower, and his heart pounded with what some people might characterize as abject terror.

It was not difficult to find someone who would tell Tavi where to find the Grey Tower. He simply asked a civic *legionare* with a little too much good cheer showing in his reddened nose and nearly flammable breath, explaining that he was visiting from out of town and would like to see it. The *legionare* had been obliging and friendly, and given Tavi directions made only marginally unintelligible by all the mushy, slurred S sounds. After that, Tavi and Kitai slipped through the streets of the capital, taking care to avoid the more energetic celebrations like the ones on Crafter Lane.

Now, they stood atop an aqueduct that carried water from a wellspring in the mountains outside the capital to run through the great green bowl of fields and steadholts that surrounded the city. There the aqueduct diverted into a dozen offshoots that directed clean water to reservoirs around the city. From where they stood, Tavi could look down the almost imperceptible slope of the aqueduct, where it passed over entire neighborhoods, its stately arches holding up the stone trough, gurgling water a constant babble as he and Kitai paced steadily forward. Only a few hundred yards ahead, the aqueduct swept past the headquarters and barracks of the civic legion upon the one side and the Grey Tower upon the other.

Kitai glanced over her shoulder at him, her steps never slowing, walking with perfect confidence despite the evening breezes and the narrow, water-slicked stone footing of the aqueduct's rim. "Do you need me to slow down?"

"No," Tavi said irritably. He focused on their destination, trying not to think about how easy it would be to fall to a humiliating death. "Just keep going."

Kitai shrugged, a small, smug smile playing on her lips, and turned away from him again.

Tavi studied the Tower as they approached it. It was a surprisingly simple-looking building. It didn't look terribly towerlike, either. Tavi had imagined something suitably elegant and grim, maybe something bleak and straight and menacing, where the prisoners would be lucky to be able to throw themselves off the top of the tower to fall to humiliating deaths of their own. Instead, the building looked little different than the Legion barracks nearby. It was taller, and featured very narrow windows, and there were fewer doors in evidence. There was a wide lawn around the tower and a palisade around the lawn. Guards were in evidence at the gate in the fence, at the front doors to the building, and patrolling around the exterior of the fence.

"It looks . . . nice," Tavi murmured. "Really rather pleasant."

"There is no pleasant prison," Kitai replied. She abruptly stopped, and Tavi nearly bumped disastrously into her. He recovered his balance and glowered at her as another group of wandering singers passed on the street beneath the aqueduct they stood upon. Each member of the group held a candle as they walked, performing one of the traditional airs of the holiday.

Kitai watched the group closely as they passed.

"You like the music?"

"You all sing wrong," Kitai said, eyes curious and intent. "You don't do it properly."

"Why do you say that?"

She flipped a hand irritably. "Among my people, you sing the song on your lips. Sometimes many songs together. Everyone who sings weaves their song with the ones already there. At least three of them, or it is hardly worth the trouble. But you Alerans only sing one. And you all sing it the same way." She shook her head, her expression baffled. "All the practice you need to do that must bore your folk to death."

Tavi grinned. "But do you like the results?"

Kitai watched the group pass out of sight, and her voice was wistful. "You don't do it properly."

She started moving again, and Tavi followed her until they had drawn even with the Grey Tower. Tavi looked over the edge of the stone aqueduct. There was a good fifty-foot drop to the boot-packed, hardened earth of a Legion training field that butted up against the wall around the Tower. A fresh spring wind whipped down from the mountains, cold and swift, and Tavi had to lean back to keep from swaying off the edge and into a fall. He forced his eyes to remain on the roof of the tower, instead of looking down.

"That's got to be fifty feet," he told Kitai quietly. "Not even you could jump that."

"True," Kitai said. She cast her cloak back from her arms and opened a large, heavy pouch of Marat-worked leather. She drew out a coil of greyish, almost metallic-looking rope.

Tavi watched, frowning. "Is that more of that rope made from Iceman hair?"

"Yes," she replied. Her hand dipped into her pouch again, and came out with three simple metal hooks. She slid them together, small grooves and tabs locking the hooks' spines together, and linked them solidly with a piece of leather cord, so that the hooks reached out with steely fingers in a circle around the spine.

"That grappling hook isn't Marat-made," Tavi said.

"No. An Aleran thief had it. I watched him rob a house one night."

"And stole it from him?"

Kitai smiled, fingers flying as they knotted the cord to the hook. "The One teaches us that what one gives to others, one receives in return." She flashed him a sharp-toothed grin, and said, "Get down, Aleran."

Tavi dropped to one knee just as Kitai raised the hook and whirled it in a circle, letting out the line and gathering speed. It didn't take her long. Four circles, five, and she let out a hiss and flung the hook and the line across the distance to the roof. Metal clinked faintly on stone.

Kitai began drawing the cord in, very slowly and carefully. The rope suddenly tightened, and she continued to lean back, steadily increasing the pressure. "Here," she said. "In the pouch. There is a metal spike there, a hammer."

Tavi slipped his hand into the pouch and found them. The spike had an open ring set into the butt end, and Tavi grasped its use at once. He knelt with the spike and the hammer. He took off his cloak and folded it a few times, then drove the spike carefully into the stone of the aqueduct, the cloth muffling the sound of the hammerblows. Tavi drove it in at an angle opposite the pull of the rope, and when he was finished he glanced up to find Kitai looking down at the spike with approval.

She passed him the end of the Marat rope, and Tavi threaded it through the eye on the end of the spike. He took in the last few feet very slowly, with Kitai careful to keep the pressure against the grappling hook, until he was able to lean his full weight against it, holding it in place.

Kitai nodded sharply and her hands flew through another knot, one Tavi was not familiar with. She tied off the rope, using the knot to draw it tight and to tighten it even more before she released it, leaned back, and nodded to Tavi.

The boy released the rope slowly. It made a faint, strong thrumming sound, and stretched out between the aqueduct and the Tower, glistening like spider silk in the ambient radiance of the city's thousands upon thousands of furylamps. "So," he said. "We cross on the rope to avoid the earth and wood furies in the lawn. Right?"

"Yes," Kitai said.

"That's going to leave wind furies on watch around the roof," he said. "And it looks like there might be a gargoyle at either end. See, those lumps there?"

Kitai frowned. "What is this, gargoyle?"

"It's an earth fury," Tavi explained. "A statue that is able to perceive and to move. They're not very fast, but they are strong."

"They will try to harm us?"

"Probably," Tavi said quietly. "They'll respond to movement on the roof."

"Then we must not touch foot to the roof, yes?"

Tavi nodded. "It might work. But I don't see how else we're going to get inside but the door on the roof. There are guards at all the lower doors."

"Give me your cloak," Kitai said.

Tavi passed it over to her. "What are you doing?"

"Seeing to the wind furies," she said. She slipped her cloak off and thrust them both into the cold current of water running through the aqueduct, soaking them. Then she opened another pouch and drew out a heavy wooden canister, which proved to be full of salt. She started spreading it heavily over the damp cloaks.

Tavi watched that, frowning. "I know salt is painful to wind furies," he said. "But does that actually work?"

Kitai paused and gave him an even look. Then she glanced down at her clothing and jewelry and back up to Tavi.

He lifted his hands. "All right, all right. If you say so."

She rose a moment later and tossed him the cloak. Tavi caught it, and drew the wet, sodden mass on. Kitai did the same. "Are you ready, Aleran?"

"Ready for what?" Tavi asked. "I'm still not sure how we're going to get in without touching down on the roof."

Kitai nodded at the narrow windows on the topmost floor. "I will go in through there. Wait until I am all the way across before you start. The rope is not designed to hold two."

"Better let me go first," Tavi said. "I'm heavier. If it's going to collapse, it will be for me."

Kitai frowned at him, but nodded. She gestured to the rope, and said, "Go on. Leave me space to work when I get there."

Tavi nodded, then turned to look at the slender rope stretching across to the Grey Tower. He swallowed and felt his fingers trembling. But he forced himself to move, sliding over to the rope and taking it in his hands. He let himself drop down, head toward the Grey Tower, hands on the rope, his heels crossed in an X to hold up his legs. The wind blew, the rope quivered, and Tavi prayed that the grappling hook would not slip from its purchase. Then, as carefully and smoothly as he could, he started pulling himself over the gap to the Grey Tower. He glanced back once to see Kitai watching him, her eyes glittering with mischief, one hand covering her mouth without really hiding the amusement on it.

Tavi forced himself to concentrate on his task, upon the steady, sure motion of arms and legs and fingers and hands. He did not hurry, but moved with deliberate caution until he had crossed the gap. He was able to spot a window ledge, and dropped his feet carefully down to rest on it until he was sure it would hold his weight. Then he stepped more firmly onto the ledge and looked back at Kitai, one hand steadying himself on the rope.

The Marat girl did not lower herself to the rope as he had. Instead, she simply stepped out onto it as though it were as wide and steady as a cross-beam of heavy timber. Her arms akimbo, she moved with a kind of casual arrogance for the deadly drop beneath her, crossed the rope in a third the time it had taken Tavi, and hopped down, turning in midair and landed with her heels steady on the ledge beside him.

Tavi stared at her for a moment. She cocked an eyebrow at him. "Yes?"

He shook his head. "Where did you learn that?"

"Rope walking?" she asked.

"Yes. That was . . . impressive."

"It is a whelp's game. We all play it when we are young." She grinned. "I was better at it when I was younger. I could have run along it." She turned to the window and peered through the glass. "A hall. I see no one."

Tavi looked. "I don't either," he said. He drew his knife from his belt and

tested the edges of the glass over the window. It was a single pane, crafted directly into the stone. "We'll have to break it," he told Kitai.

She nodded sharply, then drew a roll of some kind of thick cloth from another pouch. She rolled it out with a flick, then drew out a small bottle and opened it. There was a sharp stench as she poured some kind of thick, oily substance onto her palm and smeared it all over her window. She hurriedly scrubbed the substance from her skin with the cloth, then frowned, her lips moving.

"What are you doing?" Tavi asked.

"Counting," she replied. "You'll make me lose my place." She went on that way for another minute or so, then flattened the cloth against the window, where it adhered almost instantly. Kitai smoothed the cloth out as much as she could, waited a moment more, then drew her knife and brought the rounded hilt sharply down onto the glass in a short, precise blow.

The glass broke with a crunching snap. Kitai hit it again, in several different places, and drew the cloth out slowly. The window glass, Tavi saw, stuck to the cloth. Kitai then took the portion of the cloth she had wiped her hand upon and pressed it to the wall beside the window, where it clung as strongly as it had to the glass.

She glanced at Tavi as she broke off a few jagged pieces of glass the cloth had missed, dropped them, then bent nimbly and slid through the window and into the Grey Tower.

Tavi shook his head and made his way over to the next window, carefully holding the rope as he did it. He felt clumsy and slow in comparison to the Marat girl, which was vaguely annoying. But at the same time, he took a real sense of pleasure in seeing her ability and confidence. Like himself, she had no furycraft of her own, but it was clear to him that she did not think herself disadvantaged. And she had reason not to, having spent the last several months sneering at furycrafted security measures and defeating them with intelligence and skill.

Tavi filed away that trick with the adhesive and the cloth for future reference and slid inside to drop into a crouch beside Kitai.

They were in a hallway, one side lined with windows, the other with heavy wooden doors. Tavi crossed to the nearest door and tested the handle. "Locked," he reported in a whisper, and dipped a hand into his own belt pouch. He drew out a roll of leather containing several small tools.

"What are you doing?" Kitai whispered.

"Unlocking," he replied. He slipped the tools into the keyhole, closed his eyes, and felt his way through the lock's mechanism. A moment later, he locked his grip on the tools and twisted slightly, springing the lock open.

Tavi opened the door on a small and barren bedchamber. There was a bed, a chair, a chamber pot, and nothing else but smooth stone walls.

"A cell," he murmured, and closed the door again.

Kitai plucked the tools from his hand and stared at them, then at him. "How?" she asked.

"I've been learning this kind of thing," Tavi replied. "I can show you later. How did you steal all of that without learning how to open a lock?"

"I stole the keys," Kitai said. "Obviously."

"Obviously," Tavi muttered. "Come on."

They went down the hall, and Tavi checked every door. Each room was the same—drab, plain, and empty. "He must not be on this floor," Tavi murmured, as they reached the end of the hall. There was a door there, and Tavi opened it, to reveal a stairway curling down, lit by dim orange furylamps. Sound would bounce merrily around the stairs, and Tavi made a motion cautioning Kitai to silence, before slipping out the door and to the stairs. He hadn't gone down more than three or four when he heard the sound of song ringing through the tower below, another Wintersend round, though this one performed with the benefit of far more drink than practice.

Tavi grinned and moved a little more quickly. If the guards were that raucous below, it would be a far simpler matter to move around the tower.

They took the stairs to the next floor, and Tavi opened the door on the landing, only to find another row of holding rooms just as there had been on the top floor. They left that one to slip down one floor more, when Kitai suddenly seized Tavi's shoulder, the tight grip of her fingers a warning.

Then just below him was the sound of a heavy door bolt opening, and men's voices speaking to one another. Tavi froze. Their footsteps started down the stairs toward the singing.

Tavi waited until they were gone before stealing down the rest of the stairs, struggling to keep his excitement from making him sloppy. He handled the lock on the door to the stairway as easily as the others and opened it onto a very different area than on the floors above.

Though still furnished very plainly, the whole floor was given over to a single, large suite. There was an enormous bath, several bookshelves complete with simple couches and chairs upon which to sit while reading, a table for

four where food might be served, and a large bed—all of which were behind a heavy grid of steel bars with a single door. The windows were likewise barred.

"Told you I'm fine," said a heavy, tired voice, from somewhere beneath a large lump under the bed's covers. "Just need to rest."

"Max," Tavi hissed.

Max, his short hair still damp and plastered to his head, sat bolt upright in bed, and his jaw dropped open. "*Tavi?* How the crows did you get in here? *What* the crows are you doing here?"

"Breaking you out," Tavi said. He crossed to the barred door, while Kitai left the stairway door open a crack and stood watch. He started on the lock.

"Don't bother," Max said. "It's on the table on the north wall."

Tavi looked around, spotted the key, and fetched it. "Not terribly secure of them."

"Anyone who winds up in this cell is being held by politics more than any-thing," Max said. "The bars are just for show." He grimaced. "Plus furycrafting doesn't work in here."

"Poor baby, no furycrafting," Tavi said, taking the key to the lock. "Come on. Get dressed and let's go."

"You're kidding, right?"

"No. We need you, Max."

"Tavi," Max said. "Don't be insane. I don't know how you got in here, but—"

"Aleran," Kitai hissed. "We have little time before dawn." She turned her head to Tavi, and her hood had fallen back from her face. "We must leave, with or without him."

"Who is that?" Max asked. He blinked. "She's a *Marat.*"

"That's Kitai. Kitai, this is Max."

"She's *Marat*," Max breathed.

Kitai arched a pale brow, and asked Tavi, "Is he slow in the head?"

"There are days when I think so," Tavi replied. He entered the cell and went to Max's side. "Come on. Look, we can't let that idiot Brencis send the entire Realm into chaos. We get you out of here. We go down into the Deeps and come up near the palace and get you to Killian without anyone being the wiser. You get back to work and help my aunt."

"Fleeing custody is a Realm offense," Max said. "They could hang me for it. More to the point, they could hang *you* for helping me. And great bloody furies, Tavi, you're doing it with a *Marat* at your side."

"Don't mention Kitai to Killian and Miles. We'll fix the rest of it," Tavi said.

"How?"

"I don't know. Not yet. But we will, Max. A lot of people could get hurt if this situation goes out of control."

"Can't be done," Max said. "Tavi, you might have gotten in here, but the craftings to block the way out are twice as thick and strong. They'll sense anything I try to do, and—"

Tavi picked up a pair of loose linen trousers and flung them at Max's head. "Put these on. We got in here without using any furies at all. We'll go out the same way."

Max stared at Tavi for a second, skeptical. "How?"

Kitai made a disgusted sound. "Everyone here thinks nothing can happen without sorcery, Aleran. I say it again. You are all mad."

Tavi turned to Max, and said, "Max, you saved my life once already tonight. But I need more of your help. And I swear to you that once my family is safe, I will do everything in my power to help make sure that you are not punished for it."

"Everything in your power, huh?" Max said.

"I know. It isn't much."

Max regarded Tavi evenly for a second, then swung his legs down to the side of the bed and put on the linen trousers. "It's enough for me." He let out a hiss of discomfort as he rose, unsteady on his feet. "Sorry. They healed the wounds, but I'm still pretty stiff."

Tavi stuffed the bed's pillows under the blankets in a vague Max-sized lump, then got a shoulder under his friend's arm for support. With luck, the guards would leave "Max" to sleep in peace for hours before they noticed that the prisoner was no longer in his cell. They left, and Tavi locked the cell behind them and replaced the key.

"Tavi," Max mumbled, as they went up the stairs again, Kitai pacing along behind them. "I've never had a friend who would do something like this for me. Thank you."

"Heh," Tavi said. "Don't thank me until you see how we're going to leave."

"And then we left the same way we came in, Maestro, and now we're here. We were not seen entering the Deeps or moving here, except at the guard post on the stairs." Tavi faced Killian, working hard to keep his expression and especially the tone of his voice steady and calm.

Killian, sitting in the chair beside Gaius's bed, drummed his fingers on his cane, slowly. "Let me see if I understand you correctly," the old teacher said. "You went out and found the Grey Tower. Then you entered through the seventh-floor window, by means of a grappling hook and rope thrown from the top of the aqueduct, shielding yourself from air furies with a salted cloak, and from earth furies by not touching the ground. You then searched for Antillar floor by floor and found him, freed him and extracted him, all without being seen."

"Yes, Maestro," Tavi said. He nudged Max with his hip.

"He didn't seem to leave much out," Max said. "Actually, the room they had me in was quite a bit nicer than any I've ever had to myself."

"Mmmm," Killian said, and his voice turned dry. "Gaius Secondus had a prison suite installed when he arrested the wife of Lord Rhodes, eight hundred years ago. She was charged with treason, but was never tried or convicted, despite interrogation sessions with the First Lord, three times a week for fifteen years."

Max barked a laugh. "That's a rather extreme way to go about keeping a mistress."

"It avoided a civil war," Killian replied. "For that matter, the records suggest that she actually *was* a traitor to the throne. Which makes the affair either more puzzling or more understandable. I'm not sure which."

Tavi exhaled slowly, relieved. Killian was pleased—and maybe more than pleased. The Maestro only turned raconteur of history when he was in a fine mood.

"Tavi," Killian said. "I'm curious as to what inspired you to attempt these methods."

Tavi glanced aside at Max. "Um. My final examination with you, sir. I had been doing some research."

"And this research was so conclusive that you bet the Realm on it?" he asked in a mild voice. "Do you understand the consequences if you had been captured or killed?"

"If I succeeded, all would be well. If I'd been arrested and Gaius didn't show up to support me, it would have exposed his condition. If I'd been killed, I wouldn't have to take my final history examination with Maestro Larus." He shrugged. "Two out of three positives aren't terrible odds, sir."

Killian let out a rather grim little laugh. "Not so long as you win." He shook his head. "I can't believe how reckless that was, Academ. But you pulled it off. You will probably find, in life, that successes and victories tend to overshadow the risks you took, while failure will amplify how idiotic they were."

"Yes, sir," Tavi said respectfully.

Killian's cane abruptly lashed out and struck Tavi in the thigh. His leg buckled, nerveless and limp for a second, and he fell heavily to the floor in a sudden flood of agony.

"If you ever," Killian said, his voice very quiet, "disobey another of my orders, I will kill you." The blind Maestro sat staring sightlessly down at Tavi. "Do you understand?"

Tavi let out a breathless gasp in the affirmative and clutched at his leg until the fire in it began to pass.

"We aren't playing games, boy," Killian went on. "So I want to make absolutely sure that you realize the consequences. Is there any part of that statement that you don't comprehend?"

"I understand, Maestro," Tavi said.

"Very well." The blind eyes turned toward Max. "Antillar, you are an idiot. But I am glad you have returned."

Max asked, warily, "Are you going to hit me, too?"

"Naturally not," Killian said. "You were injured tonight. Though I will hit you when the crisis is past if it makes you feel better."

"It doesn't," Max said.

Killian nodded. "Can you still perform the role?"

"Yes, sir," Max said, and Tavi thought his voice sounded a great deal more

steady than his friend looked. "Give me a few hours to rest, and I'll be ready to go."

"Very good," Killian said. "Take the cot. We can't have you seen running back and forth to your room."

"Maestro?" Tavi asked. "Now that Max is here . . ."

Killian sighed. "Yes, Tavi. I will write up orders to begin a full-scale search for Steadholder Isana. Will that be satisfactory?"

"Perfectly, sir."

"Excellent. I have some more missives for you to deliver. After that, I want you to get some more rest. Report back to me after your history examination. Dismissed."

"Yes, sir," Tavi said. He took up the stack of letters and turned to walk toward the door, favoring his still-throbbing leg.

Just as he got there, Killian said, "Oh, Tavi?"

"Sir?"

"Who else entered the Grey Tower with you?"

Tavi suppressed a rush of surprise and adrenaline. "No one, sir. Why do you ask?"

Killian nodded. "You stated that 'we' exited the way 'we' came in. It implies that someone else was with you."

"Oh. Slip of the tongue, Maestro. I meant to say that I was alone."

"Yes," Killian murmured. "I'm sure you did."

Tavi said nothing to that, and the old Maestro stared at him with those unseeing eyes for a solid minute of silence.

Killian chuckled then, and lifted a hand, his voice mild and not at all amused. "As you wish. We can take this up again later." He flicked his hand in a curt dismissal.

Tavi hurried from the meditation chambers and set about delivering the letters. Before the morning's second bell tolled, he delivered his last letter, another missive to Ambassador Varg in the Black Hall.

Tavi approached the guard post and found the same pair who had been there the day before. There was something about their expressions and bearing that seemed odd, somehow, and Tavi stared around the entrance to the Canim embassy until it dawned on him what was out of place.

The Canim guards were not present. The Alerans stood as always, facing the Canim embassy, but their Canim mirrors were gone. Tavi slipped in and nodded to them, dropping the letter through the bars and into the basket

waiting there. Then he turned to the Alerans on duty and asked, "Where are the guards?"

"No idea," one of them said. "Haven't seen them all morning."

"That's odd," Tavi said.

"Tell me about it," the guard said. "This place is odd enough without adding anything else to it."

Tavi nodded to the men and hurried out of the palace, back to the Academy to return to the room he shared with Max.

On the way, he suddenly found himself trembling, and his breathing started coming swiftly, though he was only walking. His belly twisted around inside him.

Aunt Isana, taken and missing. And if he'd been faster, or more clever, or if he had slept a little more lightly to hear her messenger arrive, she almost certainly would not have been abducted. Assuming she *had* been abducted. Assuming she hadn't simply been taken elsewhere to be killed.

Tears blurred his vision, and his steps faltered for a second. His mind had run out of things to occupy it, he thought dully. As long as he'd been in motion, hunting Kitai, entering the Grey Tower, rescuing Max, and lying to Maestro Killian, he had been focused on the task at hand. Now, though, he had a temporary respite from those duties, and all the feelings he had forced down rose up into his thoughts, inevitable as the tides.

Tavi slammed open the door to his room, swung it shut, and leaned his back against it, eyes lifted to the ceiling. The tears wouldn't stop. He should have been able to control himself, but he couldn't. Perhaps he was simply too strained, too tired.

In the unlit room, Tavi heard movement, and then a moment later Kitai asked softly, "Aleran? Are you unwell?"

Tavi swept his sleeve over his eyes and looked at Kitai, who stood before him with a puzzled expression. "I . . . I'm worried."

"About what?"

He folded his arms over his stomach. "I can't tell you."

Kitai's pale eyebrows shot up. "Why not?"

"Security," he replied.

She looked at him blankly.

"Dangerous secrets," he clarified. "If Gaius's enemies learned them, it could get a lot of people hurt or killed."

"Ahhh," Kitai said. "But I am not Gaius's enemy. So it is all right to tell me."

"No, Kitai," Tavi began. "You don't get it. It . . ." He blinked for a second and thought it over. Kitai obviously was not a threat to Gaius. In fact, of everyone in Alera Imperia, she was probably the *only* person (other than Tavi himself) who he could be sure was not an enemy of the Crown. Obviously, Kitai would have no political leanings, no power or authority at stake, no conflicts of interest. She was a stranger to the Realm, and because of that, Kitai was immune to the influence of political and personal pressures.

And he wanted to talk to someone, very much. If only to get the twisting knot of serpents out of his belly.

"If I tell you," he said, "will you promise me never to speak of it with anyone but me?"

She frowned a little, her eyes intent on his face, then nodded. "Very well."

Tavi breathed out very slowly. Then he let himself slide down the length of the door to sit on the floor. Kitai settled cross-legged in front of him, her expression a mixture of interest, concern, and puzzlement.

Tavi told her all that had happened to him in recent days. She sat patiently through it, stopping him only to ask questions about words or people she didn't know.

"And now," Tavi finished, "Aunt Isana is in danger. It may already be too late to help her. And what's worse is that I'm almost certain that she wanted to reach the First Lord because there was some kind of trouble back in Calderon."

"You have friends there," Kitai said quietly. "And family."

Tavi nodded. "But I don't know what to do. That bothers me."

Kitai leaned her chin against the heel of one of her hands and studied him, frowning faintly. "Why?"

"Because I'm worried that there's something I'm missing," he said. "Something else I could be doing that would help. What if there's a way to solve this whole situation, and I'm just not smart enough to think of it?"

"What if a stone falls from the sky and kills you where you sit, Aleran?" Kitai said.

Tavi blinked. "What is that supposed to mean?"

"That not all things are in your control. That worrying about those things will not change them."

Tavi frowned and looked down. "Maybe," he said. "Maybe."

"Aleran?"

"Yes?"

Kitai chewed on her lower lip thoughtfully. "You say this creature, Varg, has been acting strangely?"

"Looks that way," Tavi said.

"Is it possible that he does so because he is involved in what is happening to your headman?"

Tavi frowned. "What do you mean?"

Kitai shrugged. "Only that of all the things you describe, Varg is the one with no stomach to match his hands."

Tavi blinked. "What?"

She grimaced. "It is a Horse Clan saying. It does not translate well. It means that Varg has no reason to act as he has. So the question you must ask is why does he do this?"

Tavi frowned, mind racing. "Because maybe he does have a reason to do all these things. Maybe we just can't see it from where we're standing."

"Then what might that reason be?" Kitai asked.

"I don't know," Tavi said. "Do you?"

"No," Kitai said, undisturbed. "Perhaps you should ask Varg."

"He isn't exactly the type to engage in friendly conversation," Tavi said.

"Then watch him. His actions will speak."

Tavi sighed. "I'll have to speak to Maestro Killian about it. I don't think he can spare me to follow Varg around. And in any case, it isn't important to me."

"Your aunt is," Kitai said.

Aunt Isana. Tavi suddenly ached from head to foot, and his anxiety threatened to overwhelm him once more. He felt so helpless. And he hated the feeling with a burning passion of a lifetime of experience. His throat seized up again, and he closed his eyes. "I just want her to be safe. I want to help her. That's all." He bowed his head.

Kitai moved quietly. She prowled over to sit down beside him, her back against the door. She shifted, pressed her side to his, and settled down, relaxing, saying nothing but providing the solid warmth of her presence in a silent statement of support.

"I lost my mother," Kitai said after a time. "I would not wish that pain on anyone, Aleran. I know that Isana has been a mother to you."

"Yes. She has."

"You once saved my father's life. I am still in your debt for that. I will help you if I am able."

Tavi leaned against her a little, unable to give a voice to the gratitude he felt. After a moment, he felt warm fingertips on his face and opened his eyes to stare into Kitai's from hardly a handbreadth away. He froze, not daring to move.

The Marat girl stroked her fingers over his cheek, the line of his jaw, and tucked errant, dark hairs into place behind his ears. "I have decided that I do not like it when you hurt," she said quietly, her eyes never leaving his. "You are weary, Aleran. You have enemies enough without tearing open your own wounds over things you could not have prevented. You should rest while you have a chance."

"I'm too tired to sleep," Tavi said.

Kitai stared at him for a moment, then sighed. "Mad. Every one of you."

Tavi tried to smile. "Even me?"

"Especially you, Aleran." She smiled back a little, luminous eyes bright and close.

Tavi felt himself relaxing a little, leaning more toward her, enjoying the simple warmth of her presence. "Kitai," he asked. "Why are you here?"

She was quiet for a moment, before she said, "I came here to warn you."

"Warn me?"

She nodded. "The creature from the Valley of Silence. The one we awoke during the Trial. Do you remember?"

Tavi shivered. "Yes."

"It survived," she said. "The *croach* died. The Keepers died. But it left the Valley. It had your pack. It had your scent."

Tavi shivered.

"It came here," Kitai said quietly. "I lost its trail in a storm two days before I came here. But it had run straight for you the entire way. I have been looking for it for months, but it has not appeared."

Tavi thought about it for a moment. Then he said, "Well something like that could hardly have gone unnoticed in the capital," he said. "A giant, hideous bug would tend to stand out."

"Perhaps it also died," Kitai said. "Like the Keepers."

Tavi scratched at his chin. "But the Black Cat has been stealing for months," he said. "You've been here for months. If you'd only come to warn me, you could have done it and been gone. Which means there must be another reason you stayed."

Something flickered in her deep green eyes. "I told you. I am here to

Watch." Something in her voice lent the word quiet emphasis. "To learn of you and your kind."

"Why?" Tavi asked.

"It is the way of our people," Kitai said. "After it is known that . . ." Her voice trailed off, and she looked away.

Tavi frowned. Something told him that she would not take well to him pressing the question, and he did not want to say anything to make her move away. Just for a moment, he wanted nothing more than to sit there with her, close, talking.

"What have you learned?" he asked her instead.

Her eyes came back to his, and when they met, Tavi shivered. "Many things," she said quietly. "That this is a place of learning where very few learn anything of value. That you, who have courage and intelligence, are held in contempt by most of your kind here because you have no sorcery."

"It isn't really sorcery," Tavi began.

Kitai, never changing expression, put her fingertips lightly over Tavi's lips, and continued as if he hadn't spoken. "I have seen you protect others, though they consider you to be weaker than they. I have seen a very few decent people, like the boy we took from the tower." She paused for a moment in consideration. "I have seen women trade pleasure for coin to feed their children, and others do the same so that they could ignore their children while making themselves foolish with wines and powders. I have seen men who labor as long as the sun is up go home to wives who hold them in contempt for never being there. I have seen men beat and use those whom they should protect, even their own children. I have seen your kind place others of their own in slavery. I have seen them fighting to be free of the same. I have seen men of the law betray it, men who hate the law be kind. I have seen gentle defenders, sadistic healers, creators of beauty scorned while craftsmen of destruction are worshiped."

Kitai shook her head slowly. "Your kind, Aleran, are the most vicious and gentle, most savage and noble, most treacherous and loyal, most terrifying and fascinating creatures I have ever seen." Her fingers brushed over his cheek again. "And you are unique among them."

Tavi was silent for a long moment. Then he said, "No wonder you think us mad."

"I think your kind could be great," she said quietly. "Something of true worth. Something The One would be proud to look down upon. It is within

you to be so. But there is so much hunger for power. Treachery. False masks. And intentional mistakes."

Tavi frowned faintly. "Intentional mistakes?"

Kitai nodded. "When one says something, but it is not. The speaker is mistaken, but it is as though he intends to be incorrect."

Tavi thought about it for a second and then understood. "You mean lies."

Kitai blinked at him in faint confusion. "What lies? Where does it lie?"

"No, no," Tavi said. "It is a word. Lies. When you say what is not true, intentionally, to make another think it *is* true."

"Lies means to . . . recline. For sleep. Sometimes implies mating."

"It also means to speak what is not so," Tavi said.

Kitai blinked slowly. "Why would you use the same word for these things? That is ridiculous."

"We have a lot of words like that," Tavi said. "They can mean more than one thing."

"That is stupid," Kitai said. "It is difficult enough to communicate without making it more complicated with words that mean more than one thing."

"That's true," Tavi said quietly. "Call it a falsehood instead. I think any Aleran would understand that."

"You mean all Alerans do this?" Kitai asked. "Speak that which is not correct? Speak falsehood."

"Most of us."

Kitai let out a faintly disgusted little breath. "Tears of The One, *why?* Is the world not dangerous enough?"

"Your people do not tell li—uh, falsehoods?" Tavi asked.

"Why would we?"

"Well," Tavi said, "sometimes Alerans tell a falsehood to protect someone else's feelings."

Kitai shook her head. "Saying something is not so does not cause it to *be* not so," she said.

Tavi smiled faintly. "True. I suppose we hope that it won't happen like that."

Kitai's eyes narrowed. "So your people tell falsehoods even to themselves." She shook her head. "Madness." She traced light, warm fingers over the curve of his ear.

"Kitai," Tavi asked, very quietly. "Do you remember when we were coming up the rope in the Valley of Silence?"

She shivered, her eyes steady on his, and nodded.

"Something happened between us. Didn't it." Tavi didn't realize he had lifted a hand to Kitai's face until he felt the warm, smooth skin of her cheek under his fingertips. "Your eyes changed. That means something to you."

She was silent for a long moment, and, to his astonishment, tears welled up in her eyes. Her mouth trembled, but she did not speak, settling instead for a slow, barely perceptible nod.

"What happened?" he asked gently.

She swallowed and shook her head.

Tavi felt a sudden intuition and followed it. "That's what you mean when you say that you came to Watch," he said. "If it had been a gargant, you'd be Watching gargants. If it had been a horse, you'd be Watching horses."

Tears fell from her green eyes, but her breathing stayed steady, and she did not look away.

Tavi ran his fingers lightly over her pale hair. It was almost impossibly fine and soft. "Your people's clans. Herdbane, Wolf, Horse, Gargant. They . . . join with them somehow."

"Yes, Aleran," she said quietly. "Our *chala*. Our totems."

"Then . . . that means that I am your *chala*."

She shuddered, hard, and a small sound escaped her throat. And then she sagged against him, her head falling against one side of his chest.

Tavi put his arm around her shoulders without thinking about it, and held her. He felt faintly surprised by the sensation. He'd never had a girl pressed up against him like this. She was warm, and soft, and the scent of her hair and skin was dizzying. He felt his heart and breath speed, his body reacting to her nearness. But beneath that was another level of sensation entirely. It felt profoundly and inexplicably *right*, to feel her against him, beneath his arm. His arm tightened a little and at the same time Kitai moved a little closer, leaned against him a little harder. She shook with silent tears.

Tavi began to speak, but something told him not to. So he waited instead, and held her.

"I wanted a horse, Aleran," she whispered, in a broken little voice. "I

had everything planned. I would ride with my mother's sister Hashat. Wander over the horizon for no reason but to see what is there. I would race the winds and challenge the thunder of the summer storms with the sound of my Clanmates running over the plains."

Tavi waited. At some point, he had found her left hand with his, and their fingers clasped with another tiny shock of sensation that was simply and perfectly *right*.

"And then you came," she said quietly. "Challenged Skagara before my people at the *horto*. Braved the Valley of Silence. Defeated me in the Trial. Came back for me at risk to your own life when you could have left me to die. And you had such beautiful eyes." She lifted her tear-stained face, her eyes seeking out Tavi's once more. "I did not mean this to happen. I did not choose it."

Tavi met her gaze. The pulse in her throat beat in time with his own heart. They breathed in and out together. "And now," Tavi said quietly, "here you are. Trying to learn more about me. Everything is strange to you."

She nodded slowly. "This has never happened to one of my people," she whispered. "Never."

And then Tavi understood her pain, her heartache, her fear. "You have no Clanmates," he said softly. "No Clan among your people."

More tears fell from her eyes, and her voice was low, quiet, steady. "I am alone."

Tavi met her eyes steadily and could all but taste the anguish far beneath the calm surface of her words. The girl still trembled, and his thoughts and emotions were flying so fast and thick that he could not possibly have arrested any one of them long enough for consideration. But he knew that Kitai was brave, and beautiful, and intelligent, and that her presence was something fundamentally *good*. He realized that he hated to see her hurting.

Tavi leaned forward, cupping her face with one hand. Both of them trembled, and he hardly dared move for fear of shattering that shivering moment. For a little time, he did not know how long, there was nothing but the two of them, the drowning depths of her green eyes, the warmth of her skin pressed against his side, smooth under his fingertips, her own fever-hot fingers trailing over his face and throat, and through his hair.

Time passed. He didn't care how much. Her eyes made time into something unimportant, something that fit itself to their needs and not the other

way around. The moment lasted until it was finished, and only then was time allowed to resume its course.

He looked into Kitai's eyes, their faces almost touching, and said, his voice low, steady, and certain, "You are *not* alone."

⊶⊡⊡⊶CHAPTER 33

Amara stared down at the outlaw's cave through the magnifying field of denser air Cirrus created between her outstretched hands. "You were right," she murmured to Bernard. She beckoned him with her head, and held her hands out so that he could lean down and peer over her shoulder. "There, you see, spreading out from the cave mouth. Is that the *croach*?"

The ground for two hundred yards in every direction from the cave mouth was coated with some kind of thick, viscous-looking substance that glistened wetly in the light from the setting sun. It had engulfed the heavy brush in front of the cave entrance, turning it into a semitranslucent blob the size of a small house. The trees near the cave, evergreens mostly, had been similarly engulfed, with only their topmost branches free of the gummy coating. All in all, it gave the hillside around the cave a pustuled, diseased look, especially with the ancient mass of the mountain called Garados looming over it in the background.

"That's the stuff from the Wax Forest, all right," Bernard said quietly. "This cave has always been trouble. Outlaws would lay up there, because it was close enough to Garados that none of the locals would be willing to go near it."

"The mountain is dangerous?" Amara asked.

"Doesn't like people," Bernard said. "I've got Brutus softening our steps so that the old rock won't notice us. As long as we don't get any closer, the mountain shouldn't give us any trouble."

Amara nodded, and exclaimed, "There, do you see that? Movement."

Bernard peered through her upheld hands. "Wax spiders," he reported.

He swallowed. "A lot of them. They're crawling all over the edges of the *croach*."

Doroga's heavy steps approached and paused close beside them. "Hngh," he grunted. "They are spreading the *croach*. Like butter. Grows out by itself but I figure they are trying to make it grow faster."

"Why would they do that?" Amara murmured.

Doroga shrugged. "It is what they do. If they get their way, it will be everywhere."

Amara felt a cold little chill run down her spine.

"They won't," Bernard said. "There's no sign of any of our people, taken or otherwise. I don't see any of their warriors, either."

"They are there," Doroga said, his rumbling voice confident. "They get in there in the *croach,* you can't see them. Blend right in."

Bernard put his hand on Amara's shoulder and stood, inhaling slowly. "I'm of a mind to go ahead with our plan," he told her. "We'll wait for dark and hit them hard. Get close enough to make sure the vord are in there, and finish them. Countess?"

Amara released Cirrus and lowered her hands. "We can hardly stand about and wait for them to come after us," she said. She glanced back at Bernard. "But these are your lands, Count. I'll support your decision."

"What is there to decide?" Doroga asked. "This is simple. Kill them. Or die."

Bernard's teeth showed. "I prefer hunting to being hunted," he said. "Doroga, I'm going to go circle that cave a good ways out. See if I can find out if they've got any other surprises hidden in there waiting for us. Want to come along?"

"Why not," Doroga said. "Walker is foraging. Better than standing around watching him root things up."

"Countess," Bernard said, "if you're willing, I'd like to see what you can spot from the air before we lose the light."

"Of course," she said.

"Three hours," Bernard said after a moment. "I'm telling Giraldi to be ready to hit them in three hours, just after full dark. If we don't find any surprises waiting, that's when we'll take the fight to them."

Amara inhaled and exhaled deeply, then rose with a forced calm and poise she did not feel, and called Cirrus to carry her up and into the air. She was still weary from an excess of windcrafting, but she had enough

endurance for a short flight over the proposed battlefield. It would take her only a few moments.

And once it was done, the remaining hours before they moved would feel like an eternity.

Once Amara returned from her uneventful (and unenlightening) flight over the vord nest, she had settled down with her back to a tree to rest. When she woke, she was lying on her side, half-curled, her head pillowed on Bernard's cloak. She recognized the scent without needing to open her eyes, and she lay there for a moment, breathing slowly in and out. But around her, Giraldi's veterans were stirring, and weapons and armor made quiet sounds of metal clicking on metal and rasping against leather as they secured their arms and gear and prepared to fight. No one spoke, except for short, hushed phrases of affirmation as they checked one another's gear and tightened buckles.

Amara sat up slowly, then rose to her feet. She stretched, wincing. The mail hadn't been made to fit her, though it was tolerably close to functional, but her muscles weren't used to the weight of the armor, and they twitched and clenched painfully at odd moments and places as she put the strain on them again. She looked for the man closest to the vord nest and walked toward him.

"Countess," rumbled Bernard. There was a weak half-moon in the sky, occasionally veiled by clouds, and there was barely enough light for her to recognize his profile as he stared at the vord nest. His eyes glittered in the shadows over his face, steady and unblinking.

The vord nest, by night, looked eerie and beautiful. Green light flowed up from the *croach,* a faint, spectral color that created shapes and swirls of color while not managing to give much in the way of illumination. The green werelight pulsed slowly, as though in time to some vast heartbeat, making shadows shift and roil in slow waves around it.

"It's beautiful," Amara said quietly.

"Yes," he said. "Until you think about what it means. I want it gone."

"Absolutely," she said quietly. She stepped up beside him and stared at the nest for a while, until she shivered and turned to Bernard. "Thank you," she said, and held out his rolled cloak.

Bernard turned to her to accept it, and she heard the smile in his voice. "Anytime." He slung the cloak around his shoulders and clasped it again,

leaving his left arm clear for shooting. "Or maybe not anytime," he said then. His voice was thoughtful. "You've changed your mind. About us."

Amara suddenly went very still and was glad that the darkness hid her expression. She could keep her voice steady. She could tell that much of a lie. She couldn't have looked him in the face as she did it. "We both have duties to the Realm," she said quietly. "I was blighted when I was a child."

Bernard was silent for a very long time. Then he said, "I didn't know."

"Do you see why it must be?" she asked him.

More silence.

"I could never give you children, Bernard," she said. "That alone would be enough to force you to seek another wife, under the law. Or lose your Citizenship."

"I never sought it to begin with," Bernard said. "For you, I could do without it."

"Bernard," she said, frustration on the edges of her voice, "we have few enough decent men among the Citizenry. Especially among the nobles. The Realm needs you where you are."

"To the crows with the Realm," Bernard said. "I have lived as a freeman before. I can do it again."

Amara inhaled, and said, very gently, "I have oaths, too, Bernard. Ones that I still believe in. That I will not disavow. My loyalty is to the Crown, and I cannot and will not set aside my duties. Or take upon myself others that could conflict with them."

"You think I am in conflict with the Crown?" Bernard asked quietly.

"I think that you deserve someone who can be your wife," Amara said. "Who can be the mother of your children. Who will stand at your side no matter what happens." She swallowed. "I can't be those things to you. Not while my oaths are to Gaius."

They both stood there for a time. Then Bernard shook his head. "Countess, I intend to fight you about this. Tooth and nail. In fact, I intend to wed you before the year is out. But for the time being, both of us have more pressing business, and it's time we focused on it."

"But—"

"I want you to get with Giraldi and make sure every man has his lamps," Bernard said. "And after that, get into position with Doroga."

"Bernard," Amara said.

"Countess," he interrupted, "these are my lands. These men are in my

command. If you will not serve with them, then you have my leave to go. But if you stay, I expect to be obeyed. Clear?"

"Perfectly, Your Excellency," Amara replied. She wasn't sure if she was more annoyed or amused at his tone, but her emotions were far too turbulent to allow herself to react other than professionally. She inclined her head to Bernard and turned to walk back toward the *legionares* and to find Giraldi. She confirmed that each *legionare* carried two furylamps with him, and after that she found her way to the rear of the column, where the pungent scent of Walker, Doroga's gargant, provided almost as good a guide as the feeble light.

"Amara," Doroga said. He stood in the dark, leaning against Walker's flank.

"Are you ready?" Amara asked him.

"Mmm. Got him loaded up easy enough. You sure about this?"

"No," she said. "But then, what *is* sure in this life?"

Doroga smiled, his teeth a sudden white gleam. "Death," he said.

"That's encouraging," she said, her voice dry. "Thank you."

"Welcome," he said. "You afraid to die?"

"Aren't you?" she asked.

The Marat headman's head tilted thoughtfully. "Once I would have been. Now I am not sure. What comes after, no one knows. But we believe that it is not the end. And wherever that path leads, there are those who went before me. They will keep me company." He folded his massive arms over his chest. "My mate, Kitai's mother. And after our battle last night, many of my people. Friends. Family. Sometimes, I think it will be nice to see them again." He looked up at the weak moon. "But Kitai is here. So I think I will stay for as long as I can. She might need her father, and it would be irresponsible to leave her alone."

"I think I will also try not to die," Amara told him. "Though . . . my family is waiting there, too."

"Then it is good you ride with me tonight," Doroga said. He turned, seized a heavy braided mounting cord, and swarmed easily up it onto Walker's back. He leaned over, tossing the line down to Amara and extending his hand to help her up, grinning. "No matter what happens, we have something to look forward to."

Amara let out a quiet chuckle and climbed up to settle behind Doroga on the woven saddle-mat stretched over Walker's broad back. The gargant

shifted his weight from side to side, restless. Liquid sloshed in the wooden barrels attached to either side of the gargant's saddle.

Doroga nudged Walker forward, and the beast lumbered with slow, silent paces toward the area where the *legionares* were forming into their ranks. Amara watched as Giraldi prowled up and down their lines, baton in hand, giving each man an inspection in the wan moonlight. There was none of the centurion's usual bluster and sarcasm. His eyes were intent, his expression hard, and he pointed out flaws on two different *legionares* with a hard rap of the baton. The men themselves did not speak, jostle, or silently roll their eyes as the centurion passed. Every face was intent, focused on the task at hand. They were afraid, of course—only fools wouldn't be, and the veteran *legionares* were not fools. But they were professional soldiers, Aleran *legionares*, the product of a thousand years and more of tradition, and fear was one enemy to whom they would never surrender or lose.

Giraldi glanced up at her as the gargant lumbered quietly by and touched his baton to his chest in salute. Amara returned it with a nod, and the gargant went by to stop near Bernard and his remaining Knights—half a dozen each of earth and wood, none of them as gifted as Janus or Bernard, but each of them a solid soldier of several terms in the Legions. Shields had been abandoned entirely, the woodcrafters bearing thick bows while the earthcrafters bore heavy mauls and sledgehammers—except for the young Sir Frederic, who had opted to carry his spade into battle instead.

Bernard glanced up at Amara and Doroga. "Ready?"

Doroga nodded.

"Centurion?" Bernard asked the shadows behind him.

"Ready, my lord," came Giraldi's quiet reply.

"Move out," Bernard said, and rolled his hand through a short circle in the air that ended with him pointing at the nest.

The gargant's broad back swayed as the beast began walking forward, at no visible signal from Doroga. Amara heard a few soft creaks of worn leather boots and one rattle of what must have been a shield's rim against a band of steel armor, but beyond that the *legionares* and Knights moved in total silence. Glancing around, she could barely see the front rank of the *legionares* behind them, though they were no more than a dozen steps away. Shadows bent and blurred around them, the results of layers of subtle woodcraftings.

Amara's heart started pounding harder as they drew closer to the spectral

green light of the *croach*. "Is this what your people did?" she asked Doroga in a whisper.

"More yelling," Doroga said.

"What if they come early?" she whispered.

"Won't," Doroga said. "Not until the Keepers warn them."

"But if they do—"

"We make them pay to kill us."

Amara's mouth felt dry. She tried to swallow, but her throat didn't feel as though it could move. So she fell silent and waited as they walked in tense, ready silence.

Bernard and his Knights reached the forward edge of the *croach*. He paused there, giving the *legionares* behind a chance to settle into their formation, then took a deep breath. He lifted his bow even as he knelt, a broad-bladed hunting arrow lying across the straining wood. He lined up the edge of the arrow with the surface of the *croach,* then released the arrow. The great bow thrummed. The arrow swept across the ground and, thirty or forty yards in, started cutting a long, fine incision in the surface of the *croach*. The waxy substance split, bursting like a boil, and luminous green fluid bubbled up out of the yards-long wound.

The vord nest erupted into violent motion, an alien wailing, whistling chorus rising into the night sky. Wax spiders, creatures as big as a medium-sized dog, burst up out of the *croach*. Their bodies were made of some kind of pale, partially translucent substance that blended in with the *croach*. Plates overlapped one another to armor their bodies while chitinous, many-jointed legs propelled them into leaps and jumps that covered twenty yards at a bound. The spiders emitted wailing shrieks and keening whistles, rushing for the long cut in the *croach*. Amara flinched in shock. She would never have *believed* that so many of them could have been so close, virtually under her nose, but invisible. There were dozens of them, moving over the *croach,* and as she watched the dozens became scores, then hundreds.

Bernard and his Knights Flora bent their bows and went to work. Arrows hissed unerringly into the wax spiders as they scuttled and leaped across the *croach,* these mounted with stiletto-shaped heads for piercing through armor. Launched from the heavy bows only a woodcrafter could bend, they proved deadly. Arrows flew home over and over again, ripping through the spiders, leaving them thrashing and dying, and they did not realize that they were being attacked at all for better than a minute.

Some of the nearer spiders spun to face the Aleran troops, eyes whirling with more luminous light and began bobbing up and down, letting out more whistling shrieks. Others picked up the call, and in seconds the whole horde of them had turned from the wounded *croach* and began rushing at their attackers.

"Now!" Bernard roared. The bowmen fell back, still shooting, arrows striking wax spiders out of the air even as they flew toward the Alerans. Half of Giraldi's infantry advanced onto the surface of the *croach,* grounded their shields hard on the waxy substance, and stood fast as the wave of wax spiders rolled into their shieldwall.

The *legionares* worked together, their usual spears discarded in favor of their short, heavy blades that hacked down upon the spiders without mercy or hesitation. One man faltered as three spiders overwhelmed him. Venomous fangs sank into his neck, and he staggered, creating a dangerous breach in the line of shields. Giraldi bellowed orders, and fellow *legionares* in the ranks behind the first seized the wounded man and hauled him back, then stepped into his place in the line. The slaughter went on for perhaps half a minute, then there was a brief hesitation in the wax spiders' advance.

"Second rank!" bellowed Giraldi. As one, the *legionares* in the shieldwall pivoted, allowing the second rank of fresh soldiers to advance, ground their shields a pace beyond the first, and ply their blades with deadly effect. Endless seconds later, another break in pressure allowed the third rank to advance in their turn, then the fourth, each one allowing more rested *legionares* to advance against the tide of wax spiders.

Their heavy boots broke through the surface of the *croach* so that the viscous fluid within oozed and splashed around every step, and made for poor footing—but they had drilled, maneuvered and fought in mud before, and Giraldi's veterans held their line and steadily advanced toward the cave, while Bernard's archers warded their flanks, arrows striking down the spiders that attempted to rush from the sides.

"Just about halfway there," Doroga rumbled. "They'll come soon. Then we—"

From the mouth of the cave there came another shriek, this one somehow deeper, more strident and commanding than the others. For a second there was silence, then motion. The spiders began bounding away from the Alerans, retreating, and as they did the vord warriors boiled forth from the cave's mouth.

They rushed the Aleran line, dark plates of armor rattling and snapping, vicious mandibles spread wide.

"Doroga!" Bernard bellowed. "Giraldi, fall back!"

The Marat headman barked something at Walker, and the gargant hauled himself around and began to lumber back the way they had come, following the channel crushed through the *croach*. As he did, Amara leaned over the barrels mounted on Walker's saddle and struck away the plates that covered large tap holes at their bases. Lamp oil mixed with the hardest liquor Giraldi's veterans could find flooded out in a steady stream as Walker retreated, leaving two wide streams that spread out through the channel of broken *croach*. Giraldi's veterans broke into a flat-out run, racing toward the edge of the *croach,* and the vord followed in eager pursuit.

As the first *legionares* came to the end of the *croach,* Giraldi snapped another order. The men whirled, snapping into their lines again, this time on either side of the channel, shieldwalls aligned to funnel the vord warriors between them. The vord, reckless and aggressive, flooded directly toward the Alerans, their course guided by the shieldwalls, which channeled them directly into Doroga, Walker, and the crushing strength of Bernard's Knights Terra.

Walker let out a fighting bellow, rising up onto his rear legs to slash one vord from the air as it tried to take wing, and the gargant's crushing strength was more than a match for the vord's armor. It fell broken to the ground, while Amara clutched desperately on to Doroga's waist to keep from falling off the beast's back entirely.

The Knights Terra held the gargant's flanks, and ripples of earth, furycrafted by the Knights, lashed out at the vord as they closed, shattering the momentum of their charge and exposing them to well-timed blows from the savage hammers that crushed vord armor plates like eggshells.

And all of it was nothing but a prelude to the true attack.

"Giraldi!" Bernard cried.

"Fire!" the centurion bellowed. "Fire, fire, fire!"

Along the whole of the Legion shieldwall, furylamps blazed into full and blinding brilliance.

And as one, the *legionares* hurled the lamps down into the viscous liquid of the broken *croach* mixed with lamp oil and alcohol.

Flames spread with astonishing speed, the individual fires in nearly a hundred places rapidly meeting, melding, feeding one another. Within seconds, the fire blazed up and began to consume the entrapped vord warriors.

Now the *legionares* had to fight in earnest, as desperate vord tried to bat-
ter their way out of the trap. Men screamed. Black smoke and hideous
stench filled the air. Giraldi bellowed orders, hardly audible over the fren-
zied rattling and clicking of the armored vord.

And the lines held. The vord at the rear of the trap managed to reverse
their direction, streaming back toward the cave.

"Countess!" Bernard cried.

Amara reached out for Cirrus and felt the sudden, eager presence of her
wind fury. She took a deep breath, focused her concentration, and shouted,
"Ready!"

"Down, down, down!" Giraldi barked.

Amara saw everything moving very, very slowly. All along the lines, *le-
gionares* abruptly drew back a pace and dropped to one knee, then to their
sides, their curving tower shields closing over them like coffin lids. Desper-
ate vord staggered and thrashed their way to their deaths, while those who
had managed to retreat drove directly for the cave.

Amara drew Cirrus into her thoughts and sent it, with every ounce of
her will, to fly toward the fleeing vord.

A hurricane of violent wind swept down from the air at Amara's com-
mand. It caught up the blazing liquid and hurled it in a sudden, blinding
storm of blossoming flame. Fire engulfed the air itself, fed wildly by the
wind, and the heat burned away the *croach* wherever it touched, melting it
like the wax it resembled. *Croach*-covered trees burst into individual infer-
nos, and still the frantic fire, driven by Amara's wind, rolled forward.

It engulfed the last of the vord who had attacked fifty feet short of the
mouth of the cave—and then kept right on going, fires spreading and whirling
madly, burning away the *croach* wherever it touched it.

Amara's concentration and will faltered in a sudden, nauseating spasm of
fatigue, and she slumped hard against Doroga's back. Without the gale winds
to feed and push them, the fires began to die down into individual blazes.
There was no sign whatsoever of any *croach* anywhere upon the surface—
only blackened earth and burning trees.

They'd done it.

Amara closed her eyes in exhaustion. She didn't feel herself listing to
one side until she actually began to fall, and Doroga had to turn and catch
her with one heavily muscled arm before she pitched off Walker's back and
to the ground.

Things were blurry for a few moments, then she heard Bernard giving orders. She forced herself to lift her head and look around until she spotted Bernard.

"Bernard," she called weakly. The Count looked up from where he knelt, supporting a wounded soldier while a healer removed a broken shard of vord mandible from the man's leg. "The queen," Amara called. "Did we kill the queen?"

"Can't say yet," he replied. "Not until we check the cave, but it's a death trap. Has a high ceiling, but it isn't deep. It wouldn't surprise me if the firestorm cooked everything inside."

"We should hurry," she said, while Doroga slowly turned Walker around to face away from the cave. "Finish it before it has the chance to recover. We have to kill the queen or it's all for nothing."

"Understood. But I've got men dying here, and no watercrafter. We see to them first."

"Hey," Doroga growled. "You two. The queen is not in the cave."

"What?" Amara lifted her head blearily. "What do you mean?"

Doroga nodded grimly toward the crest of the hill behind them, back toward Aricholt.

The taken holders were there in a silent group, a simple crowd of people of all ages and both sexes who stood there in the weak moonlight and stared down at the Aleran forces with empty eyes.

Beside them stood Felix's century, together with what looked like every single *legionare* they'd been compelled to leave behind at Aricholt.

And all of them had been taken.

At the head of the silent host, something crouched low, and Amara had no doubts whatsoever as to what she was looking at. It was man-sized, more or less, and little more than an oddly shaped shadow. If it hadn't been for the luminous glow of its eyes, Amara would have thought that the vord queen was only an illusion of bad light and heavy shadows.

But it was real. It took a slow, steady pace down the slope of the hill, moving weirdly, as if walking on four legs when it was meant for two, and at precisely the same instant the entire taken host stepped forward as well.

"Furies," Amara breathed, almost too tired to be terrified at what she saw. Even as they had sprung their trap on the vord, the vord had been circling behind them to strike at the weaker target. Back at Aricholt, even a

few taken had proved to be deadly—and now they outnumbered the *le-gionares* still left to face them.

"Bernard," she said quietly. "How many wounded?"

"Two dozen," he said tiredly.

The taken poured down the hill, in no great hurry, led by the glowing-eyed shadow at their forefront. Something like hissing, moaning laughter echoed through the night, dancing among the popping sparks of the burning trees.

"There are too many of them," Amara said quietly. "Too many. Can we run?"

"Not with this many wounded," Bernard said. "And even if we could move them, we've got our backs pinned to Garados. We'd have to retreat over his slopes, and no one could conceal that much movement from the mountain."

Amara nodded and drew in a deep breath. "Then we have to fight."

"Yes," Bernard said. "Giraldi?"

The centurion appeared. He had blood on his leg, and there was a savage dent in the overlapping plates guarding one shoulder, but he struck his fist to his breastplate sharply. "Yes, my lord."

"Get everyone moving," he said quietly. "We'll fall back to the cave. We can fight in shifts there. Maybe hold out for a while."

Giraldi looked at Bernard for a moment, and there was no expression on his face but for troubled eyes. Then he nodded, saluted again, turned, and started giving quiet orders.

Amara closed her eyes wearily. Some part of her wondered if it might not be better to just go to sleep and let events take their course. She was so very tired. She tried to find some reason to keep herself moving forward, to keep pushing away despair.

Duty, she thought. She had a duty to do her utmost to protect the nobles, *legionares,* and holders of the Realm. That duty did not permit simple surrender to death. But it felt hollow. More than anything, she wanted to be someplace warm and safe—but duty was a cold and barren shelter for a wounded spirit.

She looked up again and saw Bernard helping a wounded man rise and hobble along to the cave while leaning on the haft of his spear. He helped the man get started, encouraging him, and turned to the next man in need of help while he organized their retreat—however temporarily it might extend their lives.

He was reason enough.

Doroga abruptly started laughing.

"What is so amusing?" she asked him quietly.

"Good thing we talked before this," Doroga rumbled, eyes merry. "Otherwise, I might have forgotten that no matter what happens, we got something to look forward to." He was still laughing to himself under his breath as he turned Walker to bring up the rear of the Aleran column.

Amara turned her head as they rode and watched the vord queen and the taken slowly closing in behind them.

⊡⊡⊡⊡ CHAPTER 34

Tavi frowned at Ehren, and whispered, "What do you mean, nothing?"

"I'm sorry," Ehren whispered back. "I did as much as I could in the time I had. During the attack, someone apparently killed the streetlamps. Several people heard fighting, two even saw the beginning of the attack, but someone put the lamps out and after that, nothing."

Tavi exhaled slowly and leaned his head back against the wall. The examination room was more than mildly stifling. The history examination's written portion had begun after the noon meal and concluded a mere four hours later—to be followed by individual oral examinations. Sunset light slipped orange fingers through the upper windows of the hall, and there wasn't one of the hundred-odd students present who wasn't wild to leave.

Maestro Larus, a slump-shouldered man with an impressive mane of silver hair and an immaculate white beard, nodded to the student standing before his chair and flicked his hand in curt dismissal. He took a moment to make a note on the uppermost of a stack of parchments, then glared at Tavi and Ehren.

"Gentlemen," he said, sonorous voice edged with annoyance. "I would hope that you would show enough courtesy to your fellow students to remain politely silent during their examination. Just as I hope they will do for

you." He narrowed his eyes at Tavi, specifically. "In fact, if that is not the case, I would be obligated to speak to the gathering on the subject of academic courtesy—at some length. I trust it will not be necessary?"

There was a rustle of clothing as the class turned to face them. A hundred irritated, threatening glares focused on Tavi and Ehren, the silent promise of mayhem lurking behind them.

"No, Maestro," Tavi replied, trying to sound contrite.

"Sorry, Maestro," Ehren said. Either he was better at it than Tavi, or else he actually *did* feel contrite.

"Excellent," Larus replied. "Now then, let us see. Ah, Demetrius Ania, if you would approach the front. You are next. If you would, please account for me the economic advances of the rule of Gaius Tertius and their effect upon the development of the Amaranth Vale . . ."

The young woman started fumbling for an answer under Larus's steady, menacing gaze.

Tavi leaned back to Ehren, and whispered, "It doesn't make sense. Why would an attacking *archer* put the lights out? He couldn't see to shoot."

Ehren gave Tavi a look of protest, bobbing his eyes toward Larus.

Tavi scowled. "Just keep your voice down. He won't hear it over everyone's stomach growling."

Ehren sighed. "I don't know why someone would do that, Tavi."

Gaelle, standing on the far side of Ehren from Tavi, leaned over, and whispered, "I didn't find much more. None of the staff I talked to remembered these cutters you mentioned. But I looked in their refuse bin and found several sets of perfectly serviceable clothing, some bedding, some cups and other such articles, as if they'd thrown out everything in a room or two. Breakfast refuse was on top of them, so it must have happened late last night."

"Crows," Tavi muttered. He settled back against the wall, restless. The examination had gone on for entirely too long. Kitai had agreed to remain quietly in Tavi's room until night fell to cover her exit from the Academy grounds, but he had told her he would be back well before now. Every moment made it more likely that she would take it upon herself to leave.

"Tavi?" Ehren asked. "Didn't the civic legion find out anything?"

Tavi shook his head in frustration. "Not when I came in here two hundred years ago," he muttered. He glowered at the student fumbling to cover

the simple question. "Crows, Tertius's policies arrested inflation, which made the domestication of silkbats feasible and began the entire silk industry. The crows-eaten apple orchards didn't have anything to do with it."

"Be nice, Tavi," Gaelle murmured. "She's from Riva, and I hear the people from up that way are none too bright."

Ehren frowned. "I never heard that. I mean, Tavi's from near Riva and . . ." He blinked, then rolled his eyes, and said, "Oh."

Tavi glared at Gaelle, who only smiled and listened as Ania finally mentioned something about silk farms in her rambling answer. Maestro Larus dismissed her with another flick of his hand and an acidic look, before he marked his paper again and turned it over to the last page.

"Well then," Larus murmured. "That leaves us with only one more student. Tavi Patronus Gaius, please come to the front." He shot Tavi a hard look, and said, "If you can spare the time from your conversation, that is."

Tavi felt his face flush but said nothing as he stepped away from his place by the wall and walked up to the front of the room and stood before Maestro Larus.

"Very well then," the Maestro drawled. "If it isn't too much trouble, I wonder if you might enlighten me about the so-called Romanic Arts and their supposed role in early Aleran history."

A low murmur ran through the hall. The question was a loaded one, and everyone knew it. Tavi had argued the point with Maestro Larus on four separate occasions over the past two years—and now the Maestro had brought it into an examination. Clearly, he intended to force Tavi to surrender the point they had argued before, or else fail his course. It was a deliberate bully's tactic, and Tavi found it incredibly petty and annoying in the face of the matters that had ruled his life over the past few days.

But he felt his jaw setting, and the calm and logical part of his mind noted with some alarm that the stubborn apprentice shepherd in him had no intention of surrendering.

"From which perspective, sir?"

Maestro Larus blinked his eyes very slowly. "Perspective? Why, from the perspective of history, of course."

Tavi's mouth set into a harder line. "Whose history, sir? There have, as you know, been several schools of thought upon the Romanic Arts."

"I hadn't realized," Larus said mildly. "Why don't we begin with an explanation of precisely what the Romanic Arts were?"

Tavi nodded. "It is, in general, a reference to the collection of skills and methods embraced by the earliest Alerans of historical record."

"Reportedly embraced, I believe you mean," Larus said smoothly. "As no authentic records of their generation are known to survive."

"Reportedly embraced," Tavi said. "They included such areas of knowledge as military tactics, strategic doctrine, philosophy, political mechanics, and engineering without the use of furycraft."

"Yes," Larus said, his warm, mellow voice turning smug. "Furyless engineering. They also included such matters as the reading of the intestines of animals in order to predict the future, the worship of beings referred to as 'gods,' and such ridiculous claims as that their soldiers were paid with salt, not coin."

Low titters of laughter ran through the room.

"Sir, the ruins of the city of Appia in the southern reach of the Ameranth Vale, as well as the old stone highway that runs ten miles to the river, seem to indicate that their ability to build without the benefit of furycraft was both certain and considerable."

"Really," asked Maestro Larus mildly. "According to whom?"

"Most recently," Tavi said, "Maestro Magnus, your predecessor, in his book, *Of Ancient Times*."

"That's right. Poor Magnus. He really was quite the moving speaker, in his day. He remained so, right until he was dismissed by the Academy Board in order to prevent his insanity from influencing the youth of Alera." Larus paused, then said, with insulting patience, "He was never very stable."

"Perhaps not," Tavi said. "But his writings, his research, his observations, and conclusions are both lucid and difficult to controvert. The ruins of Appia feature architecture comparable both in quality and scale to modern construction techniques, but were clearly made from hand-quarried blocks of stone that were—"

Maestro Larus waved a hand in casual dismissal. "Yes, yes, you would have us all believe that men without any furycraft carved marble blocks with their bare hands, I suppose. And that next, again without fury-born strength, they proceeded to lift these massive blocks—some of which weighed as much as six or seven tons—with nothing but their backs and arms, as well!"

"Like Maestro Magnus—"

Larus made a rude, scoffing sound.

"—and others before him," Tavi continued, "I believe that the capabilities of men using tools and heavy equipment, combined with coordinated effort, have been vastly underestimated."

"You do sound a great deal like Magnus, toward the end," Larus replied. "If such methods were indeed as feasible as you claim, then why do workmen not still employ them?"

Tavi took a calming breath, and said, "Because the advent of furycrafting made such methods unnecessary, costly, and dangerous."

"Or perhaps such useless methods never existed at all."

"Not useless," Tavi said. "Only different. Modern construction techniques have not proven themselves substantially superior to the ruins of Appia."

"Oh for crying out loud, Calderon!" someone shouted from the center of the hall. "They couldn't have done it without furycrafting! They weren't as useless as you! And the nonfreaks in the room are hungry!"

Nervous laughter flitted around the room. Tavi felt a flash of sudden rage, but he didn't let it touch his face or look away from Maestro Larus.

"Academ," Larus said. "The position is an interesting—and romantic one, I suppose—from your point of view. But the fact of the matter is that the small, primitive, limited society of the earliest Alerans was clearly unable to support the kind of mass, collective effort that would have been required for such construction. They simply did not have the means to build it without furycrafting—which in turn makes it fairly obvious that Alerans have never been without furycraft, even if their more limited skill at it, in their day, mandated the use of assembled-parts construction, rather than modern methods that extrude all stone from the bedrock. It is the only reasonable view."

"It is *your* view, Maestro," Tavi replied. "There are many scholars and historians beyond Magnus who would disagree."

"Then they should be at the Academy sharing their views, shouldn't they," Larus said, and his eyes had gone flat. "Well. I suppose allowances must be made for your . . . unique perspective."

Tavi's face burned again, anger and humiliation making it hard to keep his expression calm.

"While you are clearly misguided in your knowledge, Academ, I must admit that you have indeed read the material. I suppose that's more than many have done." Larus looked down to his sheaf and marked down Tavi's

final grade—an absolutely minimum acceptable mark. He flicked his wrist at Tavi. "Enough."

Tavi gritted his teeth, but withdrew back to his place on the wall, while Maestro Larus looked over his sheets, then asked, "Have I overlooked anyone?" he asked. "If you haven't had the oral portion of the exam, you will receive a failing mark." He looked around the room, which had already begun to buzz with talk and movement. "Very well, then," he said. "Dismissed."

Before he got to "then" every student in the room was on their feet and crowding toward the door.

"Petty tyrant," Gaelle told Tavi on the way out. "Furies, but that man is an arrogant ass."

"He's an idiot," Tavi said. "He's never been to Appia, never studied it. Magnus might be insane, but that doesn't make him *wrong*."

"That wasn't what his question was about," Ehren said quietly. "Tavi, you can't just argue with a Maestro of the Academy like that. He wanted to put you in your place."

Tavi snarled under his breath and drove his fist savagely against his palm several times. Then he winced. The bruises on his knuckles throbbed, and the torn skin reopened in a couple of places.

"Furies, Tavi," Gaelle said, her voice worried. "How did you get those?"

"I don't want to talk about it," Tavi answered.

"Let's just get something to eat," Ehren said.

"You go ahead," Tavi replied. "I've got to report to Gaius immediately. He'll probably be mad the test ran over so long."

"Maybe they'll have found your aunt," Ehren suggested. "She might even be waiting for you."

"Sure," Tavi said. "See what else you can find out, all right? I'll talk to you as soon as I can."

He turned away and stalked back toward his rooms, ignoring looks of concern from both of his friends. He thought he heard one or two sniggers from students who watched him going by, but he could have been imagining them, and he didn't have the time or the inclination to take issue with them in any case. Only the very last light of day was in the sky, and he had to get Kitai out of the Academy before Killian started snooping around to find out who had been with Tavi. He didn't think that Killian would do anything dangerous, at least not once things were explained, but he would feel better once Kitai had gotten clear of the Citadel, at least.

He walked back to his rooms, stomach growling along the way, and hoped that she had remained in the room as he'd asked her to.

Tavi turned the corner that led to the room he shared with Max and stopped himself short. He frowned, staring ahead at the already-deep shadows down the row of doors to individual student quarters. This tier of student housing was flush up against the outer wall of the Citadel, and between the dark wall of stone and the doorways of the rooms the darkness was already complete.

Tavi could see nothing ahead of him, but his instincts warned him not to proceed. He licked his lips. He had not been carrying so much as his knife when he went to the test, as such things were not permitted in lecture halls, and he missed the comforting weight of the modest weapon.

He stepped quickly from the walkway to stand against the outer wall, where he, too, would be in shadow, not backlit from the feeble light falling through the more open areas behind him. He closed his eyes for a moment and tried to focus on his senses, to understand what had caused his instinctive alarm.

He heard steps, long and very soft, somewhere head of him in the darkness, retreating. And then a breath later, he caught the acrid, caged-animal scent of the Black Hall.

His heart leapt into his throat. One of the Canim was waiting in the darkness before his door His first instinct was to flee, a simple reaction of terror, but he repressed it ruthlessly. Not only was Kitai nearby, possibly unaware of the danger, but to one of the Canim, such flight would have been an invitation to attack. In fact, even had he been carrying his knife and a dozen like it besides, it would have made little difference. A fight would be very nearly suicide. He had only one choice of action that seemed likely to protect him from a lurking Canim—bold confidence.

"You there!" Tavi spat into the shadows, his voice ringing with authority. "What business do you have here? Why have you wandered from the Black Hall?"

From the darkness, there was a low, rumbling, stuttering growl that Tavi interpreted as a Cane's chuckle. And then there was a snarl and the shockingly loud sound of splintering wood—a door breaking inward. A slice of candlelight fell through the shattered door into the darkness outside, and Tavi saw something huge and furred outlined in that lonely spill of light as it surged through the broken door and into Tavi's room.

There was a cry from inside the room, and Tavi's ears abruptly sang with the thrill of battle. He raced forward. There was a rasp of a blade being drawn, the sound of something being knocked over, then a bestial roar of surprise and anger and pain. Kitai's voice trilled out a battle cry, scornful laughter in it, until a rising, bubbling snarl drowned it out; and then Tavi was at the doorway.

Ambassador Varg filled the room with its bulk, its hulking form doubled down, its crouch so low that it might have looked painful if the Cane had not moved with such incredible, lithe agility as it darted at Kitai.

The Marat girl faced Varg, crouched on top of Max's dresser, her eyes glittering, her mouth set in a sneer. Her knife was in one hand, its blade wet with dark blood, and she grasped Tavi's blade in the other. As Varg reached for her, she whipped both knives at the extended claws, and one of the cuts swept drops of blood onto the ceiling.

Varg's bellowing snarl shook the room, and with casual strength the Ambassador kicked the dresser out from under Kitai. The girl let out a shocked sound and fell, landing on all fours like a cat. Quick though she was, she was not fast enough to avoid Varg's claws, and the Cane hauled her from the floor and shook her as a terrier might a rat. The knives clattered from her hands, and Varg whirled to face the door.

Tavi did not pause a beat on his way into the room. When Varg turned to him, he had already picked up the heavy clay water pitcher from its place on the table beside the door, and he threw it with all the strength of both hands and his entire upper body. The pitcher shattered on Varg's snout, driving its weight back onto its rear foot. The Cane's blood-colored eyes widened with actual surprise, pain, and anger, and the dark lips pulled back from yellow-white fangs in a snarl of outrage.

"Let her go!" Tavi snarled, already throwing the plate the pitcher usually rested upon, but Varg swept it out of the air with casual precision and leapt at Tavi in a blur of fur, fangs, and bloodred eyes.

The Cane hit him, and Tavi felt the sheer power as a shock of utter surprise. Varg bulled through him as if he had weighed no more than a few feathers, and the force of the impact sent Tavi flying up from the ground to land clumsily on his back and elbows ten feet away.

"Aleran!" Kitai gasped.

Varg growled, crouched over Tavi with his naked teeth gleaming white in the dark. "Follow or she dies."

Varg turned and bounded down the shadowed row of doors, then across the open courtyard beyond it, down a servant's path which, Tavi knew, led to a grate that could be pulled up to gain entrance to the Deeps.

Tavi stared after Varg for a second, then let out a snarling curse. He picked himself up and snatched up both knives. He seized the lit candle and slapped it into his little tin lantern, then burst out of the room, sprinting along on Ambassador Varg's trail.

It was madness, Tavi knew. He could not fight Varg and win. For that matter, he could not fight Varg and *survive*. But neither could he allow the Canim to take Kitai from him, nor abandon the Marat girl to her fate when she had trusted him to shelter her for the day.

He knew that Varg would outrun him easily, and that Tavi would only be able to catch up to him when he was allowed to do so, but he had no choice.

He had promised Kitai that she was not alone, and though it cost him his life, he would make good on it.

꘏꘏꘏꘏ CHAPTER 35

Amara stared out of the mouth of the cave and murmured, "What are they waiting for?"

Outside, the silent host of taken had descended the hill and advanced to the edge of the blackened earth that had been the *croach*. For a time, they had been visible in the light of the burning trees, but as those fires slowly died down, the trees crashing one by one to earth, darkness swallowed them until the silent forms of the taken were now no more than motionless outlines in the gloom. The moon sank from the sky, deepening the night's blackness dramatically.

Standing in the cave itself was like standing in a vast fireplace long overdue for cleaning. Soot covered every surface, where the wind-driven firestorm had roared into the cave, consuming whatever had been inside. All that was left when the Alerans entered had been ugly, blackened lumps

and scorched bits of heat-warped vord armored hide. A sickly-sweet scent filled the cave, a noxious cloud of unseen fumes, and even though it had been hours since they entered, the smell had not faded or become unnoticeable.

"Waiting for sunrise, maybe," Doroga rumbled.

"Why?" Amara said, staring out at the silent enemy.

"So they can see," Doroga said. "Vord can see in the dark pretty good. So can Marat. Your people, not so good. So taken, they don't see so good."

"That might be it," Amara murmured. "But if that was the case, they should have assaulted us immediately, while they still had the light from the fires and the moon."

"They got to know we don't have much water," the Marat headman rumbled. "Or food. Maybe they think they can wait us out."

"No," Amara said, shaking her head. "They've behaved intelligently all along—very intelligently. They've been aware of their enemy, of our capabilities, of our weaknesses. They have to be aware that we are only a small part of a much larger nation. They have to know that a relief force will arrive within days at the most. They don't have time for a siege."

"Maybe they are sending more takers," Doroga said.

"They'd have moved by now," Amara said. "I've got you and Walker guarding the cave mouth. Everyone wounded or sleeping has a partner to watch for more takers. No one has seen any of them."

Doroga grunted, folded his arm, and leaned against Walker's shoulder, where the great gargant bull rested placidly on his belly, chewing cud from his earlier foraging. The beast filled up most of the cave's mouth and regarded the silent enemy outside without particular fear. Amara envied the gargant that. The strength of a mere Aleran was no match for the berserk power of a taken Aleran, but both were of little consequence to something the gargant's size, and Doroga seemed to share Walker's calm.

Bernard moved up from the rear of the cave, silent for all of his size. Though they had placed several furylamps on the ground outside the cave to illuminate any possible approach, lights within the cave were kept dim to hide them from observation. It took Amara a moment to sense the weariness and worry in him.

"How is he?" she asked quietly.

"Giraldi is a tough old bastard," Bernard replied. "He'll make it. If we get out of this." He stared out at the silent forms of the vord for a moment,

and said, "Three more dead. If we'd had a watercrafter, they all would have made it. But the rest look like they'll pull through."

Amara nodded, and the three of them stared out at the silent foe.

"What are they waiting for?" Bernard sighed. "I don't mind if they keep doing it, but I wish I knew why."

Amara blinked, then said, "Of course."

Bernard said, "Hmmm?"

"They're afraid," Amara murmured.

"Afraid?" Bernard said. "Why would they be, now? They've got us by the throat. If they storm this cave, they can probably finish us. They've got to know how hurt we are."

"Bernard," she said. "Don't you see? They made it a point to attack our Knights early on—first the watercrafters, then the firecrafters. They understood what kind of threat they represented and eliminated them."

"Yes," Bernard said. "So?"

"So we just wiped out the vord nest with fire," Amara said. "When they thought they had killed our firecrafters. We've done something that they didn't expect, and it's shaken them."

Bernard shot a glance out at the enemy and lowered his voice to a bare whisper. "But we don't have any firecrafters."

"They don't know that," Amara replied as quietly. "They probably expect us to come out to them and do it again. They're waiting because they think it's their smartest option."

"Waiting for what?" Bernard said.

Amara shook her head. "Better light? For us to be weaker or more tired? For our wounded to expire? I don't know enough about them to make a better guess."

Bernard frowned. "If they think we've got firecrafters here, then they must think it's suicide to come into the cave. We'd fry them here at the mouth, before they ever got to close to combat range. They're waiting for us to come out to burn them down, out where they can use the advantage of numbers against us." He let out a quiet chuckle. "They think they're the ones in trouble."

"Then all we have to do is wait them out," Amara said. "Surely a relief force will be here soon."

Bernard shook his head. "We have to figure that they'll understand that, too. Sooner or later, when we don't come out to them, they're going to realize it's because we don't have what they think we have. And then they'll come in."

Amara swallowed. "How long will they wait, do you think?"

Bernard shook his head. "No way to tell. But they've been too bloody smart all along."

"Dawn," Doroga said, his voice lazy and confident.

Amara looked at Bernard, who nodded. "His guess is as solid as anyone's. Probably more so."

Amara stared out at the darkness for several moments. "Dawn," she said quietly. "Had the First Lord dispatched Knights Aeris to us, they would have been here already."

Bernard stood beside her and said nothing.

"How long until then, do you think?" Amara asked.

"Eight hours," Bernard said quietly.

"Not time enough for the wounded to recover without crafting."

"But time enough to rest," Bernard said. "Our Knights needed it. As do you, Countess."

Amara stared out into the darkness, and it was then that the vord queen stepped into the light of the furylamps.

The queen walked upon two legs, but something in its motion was subtly off, as though it were performing a trick rather than moving naturally. A worn old greatcloak covered all but a few portions of the queen. Its feet were long, the toes spreading out and grasping at the ground as it moved. Its face, where not covered by the cloak's deep hood, was strangely shaped—its features almost human, but carved from some kind of rigid green material incapable of changing expression. Its eyes emitted a soft green-white glow, round orbs of color with no detectable lids or pupils.

Its right hand was raised above its head. Its arm was too long, jointed strangely, but the hand that grasped a broad strip of white cloth was also nearly human.

Amara just stared stupidly for a moment.

The vord queen spoke, its voice a slow, wheezing wail of sound, painful to hear and difficult to understand. "Alerans," the creature said.

Amara shuddered in reaction to the creature's voice, the alien tones and inflections.

"Aleran leader. Come forth. White talk, of truce."

"Crows," Bernard breathed quietly. "Listen to that. Makes my blood cold."

Doroga regarded the queen with flat eyes, and Walker let out a rumbling

sound of displeasure. "Do not trust the words of the queen," he said. "It is mistaken and knows it."

Amara frowned at Doroga. "Mistaken?"

"It's lying," Bernard clarified. He squinted at Doroga. "Are you sure?"

"They kill," the Marat said. "They take. They multiply. That is all that they do."

Bernard squinted out at the vord queen, now remaining perfectly, unnaturally still as it waited. "I'm going to talk to it," he said.

Doroga's frown deepened. He never took his eyes from the vord queen. "Unwise."

"If it's busy talking to me," Bernard said, "it isn't leading an attack on us. If I can buy us some time with talks, it might make a difference."

"Doroga," Amara said. "These queens are dangerous, are they not?"

"More so than a warrior," Doroga said. "Speed, power, intelligence, sorcery if you get too close."

Amara frowned. "What sorcery?"

Doroga stared at the vord through eyes that appeared to be lazily unconcerned. "They command the vord without need for speech. They can make phantoms appear, distract, and blind, create images with no substance. Trust nothing you see when a vord queen is near."

"Then you can't risk it, Bernard," Amara said.

"Why not?"

"Because Giraldi is wounded. If something happens to you, command falls to me, and I am no soldier. We need your leadership too badly for you to take chances." She shook her head. "I'll go."

"The crows you will," Bernard spat.

Amara lifted a hand. "It makes sense. I can speak for us. And frankly, between the two of us I suspect I have more experience in manipulating conversations and evaluating responses."

"If Doroga's right, and it is a trap—"

"Then I am the most likely to be able to escape," she pointed out.

"Doroga," Bernard growled, "tell her how stupid it is."

"She's right," Doroga said. "Fast enough to escape a trap."

Bernard stared hard at Doroga, and said, "Thank you."

Doroga smiled. "You Alerans pretty stupid about how you treat your females. Amara is not a child to be protected. She is a warrior."

"Thank you, Doroga," said Amara.

"A *stupid* warrior to go out there," Doroga said. "But a warrior. Besides. If she goes, you can stay here with your bow. Queen tries anything, shoot it."

"Enough," Amara said. She flicked her cloak back to clear her sword arm, loosened her weapon in its sheath, then strode forward out of the cave and into the steady light of the furylamps. She stopped about ten feet in front of the vord queen, enough to one side to give Bernard a clear line of fire to the creature. She regarded the vord queen in silence for a moment. The entire while, the creature did not move, its luminous eyes tracking her.

"You asked for a talk," Amara said. "So talk."

The vord queen's head rotated oddly within the hood, eyes coming to rest at a slant. "Your people are trapped. You have no escape. Surrender and spare yourselves pain."

"We will not surrender," Amara said. "Attack us at your own peril. Once battle is joined, we will show no mercy."

The vord queen's head tilted in the opposite direction. "You believe that your First Lord will dispatch forces to save you. That will not happen."

There was something about the vord's statement, a certainty about the way it spoke that shook Amara's confidence. She kept her face and voice steady, and replied, "You are mistaken."

"No. We are not." The vord queen shifted in place, and the cloak stirred and moved inhumanly. "Your First Lord lies near death. Your messengers are dead. Your nation will soon be divided by war. No help comes for you."

Amara stared at the vord queen for a moment, fear a sudden, steady sensation at the base of her spine. Again, the creature spoke with total certainty. If it was telling the truth, it meant that the vord were working in several places at once. That the vord queen Doroga worried about had, in fact, reached the capital.

More pieces fell into place, and Amara's sense of horror rose as they did. The Wintersend festival was attended by most of the nobility of the Realm. Public victories during Wintersend were that much more valuable—and public defeats that much more disastrous. It was surely no coincidence that the Cursors had come under attack at this time. If Gaius truly was incapacitated, his intelligence forces reeling, it would be an almost laughably easy matter to engineer the revelation of his weakness, and after that it would be a short step indeed to open civil war.

Amara stared at the vord queen with a rising sense of despair. Oh yes,

the vord had fought intelligently. They had taken the time to get to know their enemy. Amara could not make more than vague guesses as to the extent of what the vord were doing, but if they were truly working in concert with disruptive efforts within the capital . . .

Then they might very well *be* doomed.

Amara stared at the vord queen as the thoughts reeled through her mind.

"Intelligent," said the vord queen. "Intuitive. Rapid analysis of disparate facts. The logic of the hypothesis is sound. Surrender, Aleran. You will make an excellent addition to the Purpose."

Cold horror drove Amara back a pair of steps and sent her heart into frantic racing.

It had heard her thoughts.

"You have fought commendably," the vord queen said, and it seemed that with every word the vord's pronunciation became more clear. "But it is over. This world is now part of the Purpose. You will perish. I offer you the opportunity for a painless end. It is the most you can hope for. Yield."

"We do *not* yield," Amara snarled, shocked at how high and thready her voice sounded. "Our Realm is not yours. Not today." She lifted her chin, and said, "We choose to fight."

The vord queen's glowing eyes narrowed, pulsing from green-white to a deep shade of golden red, and it rasped, "So be it." It opened its hand and released the white cloth to fall to the ground. Then it turned and bounded with inhuman grace and speed into the darkness. Amara retreated quickly to the cave, her legs shaking almost too much to walk.

Bernard, bow in hand, kept watching the shadows beyond the fury-lamps, frowning. "What happened?"

"It . . ." Amara sank down to the ground abruptly and sat there shivering. "It . . . looked into my thoughts. Saw what was going on in my mind."

"*What?*" Bernard said.

"It saw . . ." She shook her head. "I never said a word about some of the things, and it talked about them anyway."

Bernard chewed on his lips. "Then . . . it saw that we didn't have a fire-crafter with us."

"Told you," Doroga observed. "Stupid."

Amara blinked. "What?" She stared at him for a moment, then said, "Oh, no. No, I didn't even consider that possibility. Which I suppose is just as well." She rubbed her arms with her hands. "But it claimed that Gaius had

been incapacitated. That our messengers had been killed. That no help was coming, so we might as well give up. Bernard, it claimed to be working together with others of its kind inside the Realm—perhaps even in the capital."

Bernard exhaled slowly. "Doroga," he said. "I wonder if you would go tell Giraldi what has passed? And ask him to pick a squad for duty. I want us ready to repel an attack at any time."

Doroga looked between Bernard and Amara skeptically, but then nodded and rose, thumped Walker on the shoulder, and headed deeper into the cave.

When he was gone, Amara slumped against Bernard and abruptly started sobbing. It felt humiliating, but she was unable to stop herself. Her body was shivering severely, and she could barely get a breath between her lips.

Bernard held her, drawing her into his arms, and she just shuddered against him for a while. "It . . . it was so alien. So certain, Bernard. We're going to die. We're going to die."

He held her, but said nothing, arms strong and warm around her.

She couldn't stop crying, or babbling. "If it was telling the truth, it could be over, Bernard. Over for everyone. The vord could spread everywhere."

"Easy," he told her. "Easy. Easy. We don't know anything yet."

"We do," Amara said. "We do. They're going to destroy us. We fought them as hard as we could, but they only grew stronger. Once they begin to spread out, nothing can stop them." She shuddered again, and felt like something was tearing apart inside her. "They'll kill us. They'll come for us and kill us."

"If it comes to that," Bernard said quietly, "I want you to leave. You can take flight and warn Riva, and the First Lord."

She lifted her head to stare at him through a blur of tears. "I don't want to leave you behind." She suddenly froze, panicked. She had tried so hard to push him away from her, for both their sakes. But the finer concerns of duty and loyalty had become grossly insignificant in the past hours and moments. Her voice dropped to a whisper as she met his eyes, and said, "I don't want to be without you."

He smiled, only with his eyes. "Really?"

She nodded, her breathing too shaky to risk speech.

"Then don't be," he said quietly. One thumb gently brushed tears from her cheek. "Marry me."

She stared at him, her eyes widening in shock. "What?"

"Right here," he said. "Right now."

"Are you mad?" she said. "We'll be lucky to live the night."

"If we don't," he said, "then at least we'll have some of the night together."

"But . . . but you have to . . . your vows of . . ."

He shook his head. "Countess. We'll be lucky to live the night, remember? I do not think the First Lord would begrudge a few hours of not-quite-approved marriage to his sworn vassals who have given their lives in service to the Realm."

She had to stifle a sudden burst of laughter that fought with the tears for space in her throat. "You madman. I should kill you for asking me at a time like this. You're heartless."

He captured her hand between his. Her own hand felt so slender and fragile between his. His fingers were callused, warm, strong, and always so gentle. "I am only heartless, Countess, because I have given mine to a beautiful young woman."

She suddenly couldn't look away from his eyes. "But . . . you don't want . . . don't want *me*. I . . . we've never spoken of it, but I know you want children again."

"I don't know everything that is going to happen tomorrow," he said. "But I know I want to see it happen with you, Amara."

"You madman," she said quietly. "Tonight?"

"Right now," he said. "I've checked the bylaws. Doroga qualifies as a visiting head of state. He can pronounce us wed."

"But we . . . we . . ." She gestured outside the cave.

"Are not needed to stand watch," he said quietly. "And we'll serve when it comes time. Did you have anything else planned before morning?"

"Well. No. No, I suppose not."

"Then will you, Amara? Marry me."

She bit her lower lip, her heart still surging, her hands now shaking for an entirely different reason. "I don't suppose it will matter, in the long run," she whispered.

"Maybe not," Bernard said. "I have no intention of lying down to die, Amara. But if this is to be my last night as a man, I would have it be as your man."

She lifted her hand to touch his cheek. Then said, "I never thought anyone would want me, Bernard. Much less someone like you. I would be proud to be your wife."

He smiled, mouth and eyes, the expression warm, his eyes bright, the gleam in them a sudden and potent defiance of the despair around them. Amara smiled back at him, and hoped he could see the reflection of that strength in her own eyes. And she kissed him, most gently, most slowly.

Neither of them had noticed Doroga's silent return, until the Marat headman snorted. "Well," he said. "Good enough for me. I pronounce you man and wife."

Amara twitched and looked up at Doroga, then at Bernard. "What?"

"You heard the man," Bernard said, stood up, and scooped Amara into his arms.

She began to speak, but he kissed her again. She was dimly aware of him walking, and of a small alcove that someone had crafted into the back of the cave, curtained off with Legion cloaks hung from a spear behind a wall of stacked shields. But most of all, she was aware of Bernard, of his warmth and strength, of the gentle power of his hands and his heart. He kissed her, undressed her, and she clung as tightly as she could to him, cold and eager to feel his warmth, to share the heat between them in the darkness.

And for a time, there was no deadly struggle. No waiting enemy. No certain death awaiting them somewhere in the night. There was only their bodies and mouths and hands and whispered words. Though her life would soon be over, she at least had this time, this warmth, this comfort, this pleasure.

It was terrifying, and it was wonderful.

And it was enough.

CHAPTER 36

Isana awoke to pain and a sense of smothering confinement. Dull fire burned in her side. She struggled, pushing against something soft that held her close, and only after several seconds of flailing was she able to escape it. It took long seconds after that for her to come to her senses and realize that she was in a bed, upon a lumpy mattress, in a darkened room.

"Lights," murmured a male voice, and a pink-tinted furylamp on a battered card table against one wall came up to low, sullen life.

Isana began to sit up, but the pain flashed into a blaze of agony and she subsided, settling for twisting her neck until her eyes fell upon the form of the assassin sitting in a chair in front of the door. She stared at the middle-aged man for a silent moment, and he returned her look with veiled eyes that somehow made her feel off-balance. It took her a moment to realize that it was because she had no emotional sense of him whatsoever. Her skills as a watercrafter cursed her with the constant empathy that came with them—but from him she felt an utter void of emotions. It took her a moment to realize that he was concealing his emotions from her, and doing it better than even Tavi had ever managed.

Isana stared at the man, at his expression, his eyes, searching for some clue about his emotions, his intentions. But there was nothing. He might have been made from cold, featureless stone.

"Well," she spat. "Why don't you go ahead and finish the job?"

"Which job is that?" he responded. His voice was mild, and matched his unremarkable appearance admirably.

"You killed them," she said quietly. "The coachmen. Nedus. You killed Serai."

His eyes flickered with something, and there was a very brief sense of regret from him. "No," he said quietly. "But I did kill the archer who shot Serai. And you, for that matter."

Isana looked down to find herself clothed only in the silk shift she'd worn beneath her gown. It was stained with blood where she had been wounded and had been sliced open along the side to make room for someone, presumably the assassin, to clean and bind her wounds. Isana closed her eyes, touching upon Rill to feel her way through her body to the injury. It could have been a great deal worse. The arrow had ruptured flesh and fat and injured muscles, but it hadn't broken through into her vitals. The man had done a competent job of removing the arrow, cleaning the wound, and stopping the bleeding.

Isana opened her eyes, and asked, "Why should I believe you?"

"Because it's the truth," he said. "By the time I found the archer it was too late to help Serai. I regret that."

"Do you," Isana said, her voice flat.

Fidelias arched an eyebrow. "Yes, actually. She was someone I respected,

and her death served no purpose. I hit him just as he loosed at you, Stead-holder."

"Which saved my life?" Isana asked. "I suppose now I should feel grate-ful to you for rescuing me from my would-be killer."

"I think you'd rather send me to join him," Fidelias said. "Especially given what happened in Calderon two years ago."

"You mean when you tried to murder my family, my holders, and my neighbors."

"I was doing a job," Fidelias said. "I did what I had to do to complete it. I took no joy in that."

Isana could sense the man's apparent sincerity, but it only made her anger sharper, more clear. "You got more joy of it than the folk of Aldoholt. More than Warner and his sons. More than all the men and women who died at Garrison."

"True enough," Fidelias agreed.

"Why?" Isana demanded. "Why did you do it?"

He folded his arms over his chest and mused for a moment. "Because I believe that Gaius's policies and decisions over the past decade or so are leading our Realm to disaster. If he remains as First Lord or dies without a strong heir, it will only be a matter of time before the strongest High Lords attempt to seize power. That kind of civil war would destroy us."

"Ah," Isana said. "To save the people of Alera, you must kill them."

He gave her a wintry smile. "You could put it that way. I support the High Lord I regard as the most likely to provide leadership for the Realm. I don't always agree with his plans and methods. But yet I deem them less damaging to the Realm in the long term."

"It must be nice to have so much wisdom and confidence."

Fidelias shrugged. "Each of us can only do as he sees best. Which brings us to you, Steadholder."

Isana lifted her chin, and waited.

"My employer would like you to pledge your public support to his house."

Isana let out a pained laugh. "You can't be serious."

"On the contrary," Fidelias said. "You should consider the advantages such an alliance would bring you."

"Never," Isana said. "I would never betray the Realm as you have."

Fidelias arched an eyebrow. "Exactly which part of the Realm is it you feel deserves such loyalty?" he asked. "Is it Gaius? The man who made you

and your brother into symbols of his own power and made you targets of all of his enemies? The man who holds your nephew virtually hostage in the capital as a guarantee of your loyalty?"

She stared at him, and said nothing.

"I know you've come here to seek his help in something. And I know that you have had no luck in making contact with him—and that he has clearly made no effort at all to protect you from harm, despite the danger he placed you in by inviting you here. If not for the intervention of my employer, you would now be dead beside Nedus and Serai."

"That changes nothing," she said quietly.

"Doesn't it?" Fidelias said. "What has he done, Steadholder? What action has Gaius ever taken to command your loyalty and respect?"

She did not answer him.

After another silent moment, he said, "My employer would like you to meet with his second-in-command."

"Do I have a choice?" Isana spat.

"Of course," Fidelias said. "You are not a prisoner here, Steadholder. You are free to leave at any time you wish." He shrugged. "You need not meet with my employer, either. The room is paid for until sunrise, at which point you will need to either leave or make your own arrangements with the mistress of the house."

Isana stared at him for a moment, eyebrows lifted. "I . . . see."

"I assumed you would wish to care for your injury, so I've taken the liberty of having the house prepare a bath for you." He nodded toward a broad copper tub on the floor beside the fireplace. A heavy kettle bubbled on a hook over the fire. "Steadholder, you're free to do as you wish. But I would ask you to give serious consideration to the meeting. It might present you with some options you don't currently have."

Isana frowned at the tub, then at Fidelias.

"Do you need help getting to the tub, Steadholder?" he asked.

"Not from you, sir."

He smiled faintly, rose, and gave her a small bow of his head. "There is a change of clothes for you in the trunk beside the bed. I will be in the hall. You should be safe here, but if you become at all suspicious of an intruder, call me at once."

Isana arched a brow. "Be assured, sir," she said, "that if I feel myself in danger, you will certainly weigh heavily in my thoughts."

The faint smile warmed to something almost genuine for a moment. Then he bowed and left the room.

Isana grimaced down at her wounded flank and pushed herself heavily upright on the bed. She closed her eyes against a wave of pain and waited for it to recede. Then she rose, slowly and carefully, and walked deliberately across the room, one step at a time. She pushed the bolt on the door to, and only then did she make her way to the copper tub. The kettle on the fire was mercifully mounted on a swinging arm, and Isana swung it slowly out over the tub and poured from the kettle until the bathwater was comfortably warm. Then she slid the stained slip from her shoulder, loosened the bandages about her waist, and made her way painfully into the tub.

She felt Rill's presence at once, closing about her in a gentle cloud of concern and affection. Isana cleared the injury of bandages and directed Rill to her flank, carefully willing the fury through the process of repairing the injury. There was burning pain at first, then a tingling numbness as the fury went to work, and after several moments of concentration Isana sank back into the tub with a languid weariness. The pain was all but gone, though she still felt stiff and brittle. The water had been stained with blood, but the skin that now covered the wound was pink and new as a baby's. She added a little more hot water from the kettle and sank into the tub.

Nedus was dead.

Serai was dead.

They had died trying to protect her.

And she was now alone, far from any friends, any family, anyone she could trust.

No, not far from any family. Tavi was in the city, somewhere. But he was, it would seem, beyond her reach, as had been everyone else since she arrived. Even if her letters had found him, they would only have directed him to Nedus's house.

Oh furies. If he had been at Nedus's house, if he had come in response to her letter, if he had been there waiting when the assassins had taken position . . .

And Bernard. She had a horrible intuition that he was facing danger enough to kill him and his entire command, and yet she still had not reached the First Lord with word of the danger. For all the good she had done her brother and her nephew, she might as well have died in the barn when the first assassin had attacked her.

Isana closed her eyes and pressed the heels of her hands against them. The fear, the worry, the wrenching hopelessness of her futile efforts over- whelmed her, and she found herself curling up in the tub, arms around her knees as she wept.

When Isana lifted her head again, the water in the tub had become tepid. Her eyes felt heavy and sore from weeping.

Her purpose, she realized, had not changed since coming to the capital. She had to secure help for those she loved.

By whatever means necessary.

As soon as she was dressed, she unbolted the door and opened it. Fidelias—assassin, traitor, murderer, and servant to a ruthless lord—waited politely in the hallway. He turned to her with an inquiring expression.

She faced him, chin lifted, and said, "Take me to the meeting. At once."

⊷⊷⊷CHAPTER 37

Ambassador Varg fled through the tunnels of the Deeps, and Tavi fol- lowed.

For the first hundred steps, Tavi had been frantic with fear. Without weapons, position, *something* he could use to his advantage, Varg would tear him to pieces, and so actually catching up to the Cane would be suicide. And yet, Varg still carried Kitai. How could Tavi do anything else?

But then another thought occurred to him. Even carrying his prisoner, Varg could have outpaced Tavi on foot without more than moderate effort. Canim battlepacks could often outmarch even the Legions in the field, un- less the Alerans countered their natural speed by using the roads to lend speed and endurance to their troops. And yet, while Varg fled at great speed, it never quite pulled away from Tavi. The young man actually slowed his steps for a time, but Varg's lead did not lengthen.

Suspicion came over him, and his brain started chewing furiously over the facts. As Tavi pelted along the tunnels, he used his knife to strike the

stone walls at each intersection, drawing small bursts of sparks and leaving the stone of the tunnels clearly marked. He knew the tunnels near the Citadel well, but Varg swiftly descended through a gallery Tavi had never explored and began working his way deeper into the mountain, to the tunnels that connected to the city below, the walls growing slick with moisture the lower they went.

Tavi rounded a final corner, to find the tunnel opening up into a long and slender chamber. He slid to a halt, lantern in hand, only to feel a sudden impact on the lantern that tore it from his hands and extinguished the candle in it.

Tavi got his back to the nearest wall and gripped his knife tightly, while struggling to keep his labored breathing quiet enough to allow him to hear. There was a quiet, steady trickling of water, where runoff from above the mountain escaped cisterns and flowed into the subterranean channels beneath the mountain's skin. After a long moment, he made out a dim red glow, the same as from one of the barely visible Canim lamps in Varg's chambers. Over another moment or two, his eyes adjusted, until he could make out the silent, enormous form of Ambassador Varg, crouched a dozen yards in front of Tavi, one hand holding Kitai's back to its front by the waist, the other pressing black claws against her throat.

The Marat girl looked more angry than frightened, a fierce glitter in her green eyes, and her expression was proud and cold. But she did not struggle against the vastly more powerful Cane.

Varg stared at Tavi, its eyes hidden in the shadows of its muzzle and fur. Varg lifted black lips from his fangs.

"I'm here," Tavi said, very quietly. "What do you want me to see?"

Varg's tongue lolled over its fangs for a moment in what looked like a pleased grin. "Why do you think that, pup?"

"You don't need something this complicated to kill me. You could have done it already, without bothering to lead me somewhere first. So I figure you wanted to show me something. That's why you took Kitai."

"And if it is?" Varg growled.

"You wasted your time. You didn't have to do this to get me here."

"No?" Varg asked. "Sooth, pup, would you have followed me deep into these tunnels simply because I asked it of you?" The Cane's white teeth showed. "Would you have walked this far from any help with me, given any choice?"

"Good point," Tavi said. "But I'm here now. Release her."

A bone-rattling deep growl rolled up from Varg's chest.

"Release her, Ambassador," Tavi said, and kept his tone even and uninflected. "Please."

Varg stared for a moment more, then nodded and released Kitai with a little shove. She stumbled away from the Cane and to Tavi's side.

"You all right?" Tavi asked her.

She seized her knife from where he had thrust it through his belt and turned around to face the Cane with murder in her eyes.

"Wait," Tavi told her, and clasped his hand down over her shoulder. "Not yet."

Varg let out a coughing, snarling laugh. "Ferocious, your mate."

Tavi blinked, then said, "She is not my mate."

At the same time, Kitai said, "He is not my mate."

Tavi glanced at Kitai, cheeks flushing, while she favored him with an acidic look.

Varg barked another laugh. "Plenty of fight in both of you. I can respect that."

Tavi frowned. "I assume you are the one who broke my lantern."

Varg made a guttural, affirmative sound.

"Why?"

"The light," Varg said. "Too bright. They would see it."

Tavi frowned. "Who would?"

"We put our fangs away for now," Varg said, white teeth still gleaming. "Truce. And then I will show you."

Tavi nodded sharply and without any hesitation. He sheathed his knife, and said, "Kitai, please put it away for the moment."

Kitai glanced at him, wary, but slipped her knife back into its own sheath. Varg's stance changed to something more relaxed, and it let its lips fall over its teeth. "This way."

Varg stooped to pick up the Cane lamp, a small affair of glass that looked like a bottle full of liquid embers only moments from dying. As it did, Tavi took note of the fact that Varg now wore the armor he'd seen on the mounting dummy in the Black Hall, and wore its enormous sword on its belt. Varg set the bottle on the floor next to an irregular opening in the cavern wall, and growled, "No light past here. We crawl. Stay to the left-side wall. Look down and to your right."

Then he dropped to all fours and wriggled his long, lean frame through the opening and into whatever lay beyond.

Tavi and Kitai exchanged glances. "What is that creature?" she asked him.

"A Cane," Tavi said. "They live across the sea to the west of Alera."

"Friend or enemy?"

"Their nation is very much an enemy."

Kitai shook her head. "And this enemy lives in the heart of your head-man's fortress. How stupid *are* you people?"

"His nation may be hostile," he murmured, "but I'm starting to wonder about Varg. Wait here. I'll feel better if someone is watching my back while I'm in there with him."

Kitai frowned at him. "Are you sure you should go?"

Varg's growl bubbled out of the opening in the wall.

"Um. Yes. I think I'm sure. Maybe," Tavi muttered. He dropped down into the opening, which led to a very low passage and started forward before he could think too much about what he was doing. Had he tried, he could have crawled forward with his knees on the floor and his back brushing the rough spots in the ceiling.

Within a few feet, the cave became completely black, and Tavi had to force himself to keep going, his left shoulder pressed against the wall on that side. Varg let out another, almost inaudible growl in front of him, and Tavi tried to hurry, until Varg's feral scent and the odor of iron filled his nose. They went on that way for a time, while Tavi counted his "steps," each time he moved and planted his right hand. The sound of falling water grew louder as they proceeded. At seventy-four steps, Tavi's eyes made out a faint shape in front of him—Varg's furry form. Ten steps beyond that, he saw pale, green-white light ahead of him.

And then the wall on his right fell away, and the low tunnel they were in became a dangerously narrow shelf at the back of a gallery of damp, living stone. The Cane rose to a low hunting crouch, glanced at Tavi, and jerked its muzzle at the cavern beneath them. Tavi drew himself up beside Varg, in-stinctively keeping every move silent.

The cavern was enormous. Water dripped steadily down from hundreds of stalactites above, some of them longer than the outer walls of the citadel were tall. Their floor-level counterparts rose in irregular cones, many of them even longer than those above. A stream spilled out of a wall on the far

side of the gallery, fell several feet into a churning pool, and rushed on down a short channel and beneath the back wall, continuing down toward the river Gaul. Tavi stared at the scene illuminated in green-white light, and his mouth dropped open in sickened horror.

Because every surface in the cavern was covered in the *croach*.

It had to be. It was exactly the same as he had seen in the Wax Forest two years before. It did not look as thick as the wax that had covered that alien bowl of a valley, but it gave off the same pulsing, white-green glow. Tavi saw half a dozen wax spiders gliding with sluggish grace over the *croach*, pausing here and there, their luminous eyes glowing in shades of green, soft orange, and pale blue.

Tavi stared down at them for a moment, too shocked to do anything more. Then his eyes picked out an area where the *croach* had grown up into a kind of enormous, lumpy blister that covered several of the largest stalagmites. The surface of the blister pulsed with swirling green lights and was translucent enough to reveal shadows moving within it.

Outside the blister were Canim. They crouched in the Cane four-legged guard stance along the base of it in a steady perimeter, no more than four or five feet apart, every one of them armed and armored, their heads mostly covered by the deep hoods of their dark red mantles. Not one of them moved. Not a twitch. From where he crouched, Tavi could not see them breathing, and it made them look like full-color statues rather than living beings. A wax spider made its slow way across the *croach* and climbed over a crouching Cane as if it was a simple feature of the landscape.

There was a sudden snarling bellow that rattled off the cavern walls, and from somewhere almost directly beneath them, several Canim appeared. Tavi watched as three of them hauled a bound and struggling Cane into the cave. The Cane was wounded, and its steps left bloody footprints on the cave floor. Its hands had been bound at the wrists, fingers interlaced, and several twists of rope bound its jaws shut. There was a mad gleam in its bloody eyes, but struggle as it might, the Cane could not shake the grip of its captors.

By contrast, the Canim dragging the prisoner were silent and calm, letting out no snarls, no growls, and wearing no expression whatsoever on their ferocious faces. They stepped onto the *croach*, dragging their prisoner, crushing the surface of the material as they went. Wax spiders moved with lazy grace to the damaged area and began repairing it, multiple legs stroking and smoothing the *croach* back into its original form.

Beside him, Varg's chest rumbled with another, quietly furious growl.

They dragged the prisoner forward to what proved to be an opening in the wall of the blister. They hauled the Cane inside. A second later, another shrill, smothered snarl erupted from within the blister.

Beside him, stone crunched as Varg's claws dug into it. The Cane's ears were laid flat back, and it bared its teeth in a vicious, silent snarl.

For a moment, nothing happened. And then four Canim emerged from the blister. They paced along the wall of the blister until they reached the end of the row of Canim, where they settled down into identical crouches and went still. The last Cane was the prisoner, now freed of its bonds. A pair of wax spiders appeared and began crawling lightly over the Cane, legs smoothing gelatinous *croach* into the Cane's wounds.

"Rarm," Ambassador Varg growled, in a voice barely audible over the sound of the cascading stream. "I will sing your blood song."

A moment later, more shadows stirred in the blister, and another Cane emerged from within it. Sarl still looked thin, furtive, and dangerous. His scarlet eyes flicked around the chamber, and when a wax spider brushed against him on the way to repairing the *croach* he had broken, Sarl let out a snarl and kicked the wax spider into the nearest stalagmite. It struck with a meaty-sounding splat and fell to the *croach,* legs quivering.

Without so much as hesitating, two more spiders diverted their course and began sealing the dying spider into the *croach,* where Tavi knew it would be dissolved over time into food for the creatures.

A second form emerged from the blister, this one smaller, no more than human-sized. It wore a deep grey cloak, and its hood covered its head altogether—but the way it moved was eerily inhuman, too graceful and poised.

"Where is the last?" the cloaked figure asked. Its voice was absolutely alien in tone and inflection, and revealed nothing about what might be concealed beneath the cloak.

"He will be found," Sarl growled.

"He must be," the figure said. "He could warn the Aleran leader of us."

"Varg is hated," Sarl said. "He was unable to so much as gain an audience with the Aleran leader. Even if he managed to speak to him, the Alerans would never believe him."

"Perhaps," the cloaked figure said. "Perhaps not. We must not chance discovery now."

Sarl gave its shoulders an odd shake and said nothing.

"No," the figure said. "I am not afraid of them. But there is little logic in allowing our chances of success to be endangered."

Sarl gave the cloaked figure a sullen look and eased a step away.

"Are your allies prepared?" the figure asked.

"Yes. Storms will strike the whole of the western coast this night. It will force him to his chamber to counter them. There is only one path to the chamber. He will not escape."

"Very well," the figure said. "Find your packmaster. If he cannot be found before the setting of the moon, we will strike without him."

"He is dangerous," Sarl objected. "As long as he lives we will not be safe."

"He is no threat to me," the figure said. "Only to you. We will strike at the setting of the moon. After which—"

The cloaked figure broke off and turned abruptly, staring up at the ledge and seemingly directly at Tavi.

Tavi froze, and his mouth went dry.

The moment passed in silence, then the cloaked figure turned to Sarl again. As it did, a pair of Cane rose from their stance beside the blister and moved to take position beside Sarl. "Take these. Hunt him down."

Sarl's teeth snapped in a sharp clash of bone on bone, and the Cane whirled to stalk out of the chamber.

The hooded figure stared up at the ledge for a moment more, then turned and glided back into the blister.

Varg pressed against Tavi and nodded toward the tunnel. Tavi turned and dropped to crawl back along it, to the chamber where Kitai waited with her knife and the Canim lamp. Tavi rose immediately, unnerved at the silent, dangerous presence of the Cane behind him, and stepped over to stand with Kitai, their backs to a wall, facing Varg.

"What did you see?" she whispered.

"Keepers of the Silence," he replied. "*Croach*. A great big nest, a lot like the one in the old Wax Forest."

Kitai inhaled sharply. "Then it *did* come here."

"Yes," Tavi said.

The Cane emerged from the tunnel and rose to its full height, stretching. Though it wasn't showing its teeth, Varg's ears were still laid flat back against its skull, and rage boiled off it in an invisible cloud.

Tavi looked at Varg and asked, "What happened to them?"

Varg shook its head. "They are bewitched, somehow."

"But who are they?"

"Members of my battlepack," Varg replied. "My guards."

Tavi frowned. "But you are only allowed six. There were twenty there."

"Twenty-one," Varg corrected him. "Garl got a belly wound when the others came for us. I sent him to the blood lands ahead of us before those things could take him as they did Rarm."

"You knew they were coming for you?" Tavi asked.

Varg nodded. "Started to figure it out two days ago, when four of my guards were getting ready to leave. They mentioned rats in their quarters. Hadn't ever been any. But the month before, Morl and Halar said the same thing. Next day, when they left, they acted strange."

"Strange how?" Tavi asked.

The Ambassador shook its head. "Silent. Distant. More than usual." His eyes narrowed. "Their ears didn't look right."

Tavi frowned, and said, "Then . . . the departing guards, the ones you thought were going back to your lands, did not actually leave. They've been going down here into the Deeps instead."

Varg grunted. "And Sarl is behind it. With the cloaked one working witchery on my wolves."

"Why would he do that?" Tavi asked.

Varg growled. "Among my kind are several . . . castes, your word is. Warriors are the largest, the strongest caste. But also very strong are the Ilrarum. The blood prophets. Sorcerers. Deceivers, treacherous. Sarl is one of the Ilrarum, though he pretends to be of lower caste, working for me in secret. As if I did not have a brain in my head. The blood prophets hate your kind. They are determined to destroy you by whatever means."

"Then Sarl's working together with the cloaked one," Tavi said.

"And coming to kill Gaius," Varg said. "He wants to cripple your leadership. Leave you vulnerable." Varg rested a hand on the hilt of its sword and showed its teeth in an easy grin. "I attempted to warn your First Lord. But some pup with more guts than brains stopped me with a knife."

"So you tried to point me at it," Tavi said. "And hoped I would figure it out for myself. That's why you sent the letter to Gaius like that, too. So that he would investigate the ship and see that the guards weren't actually leaving."

Varg let out a growl that somehow sounded affirmative. "Didn't work. So I brought you here."

Tavi tilted his head and studied Varg closely. "Why?"

"Why what?"

"Why expose this to us at all? You are an enemy of my people."

Varg looked at Tavi for a moment, then said, "Yes. And one day my people will come for you, pup. And when I rip the throat from your First Lord, it will be on the battlefield, when I have burned your lands, destroyed your homes, and slain your warriors—and you. There will be no secrets. No sorcery. No betrayal. One day I will tear the belly from the whole of your breed, Aleran. And you will see me coming all the while."

Tavi swallowed, suddenly very afraid.

Varg continued. "I have no stomach for Sarl's methods. He would sacrifice the lives of my pack for the sake of a treachery he thinks will give us your lands. He defies my authority. He makes pacts with unknown forces employing strange witcheries. He would rob our victory of honor, of passion." Varg held up the claws of its right hand and regarded them for a moment. "I won't have it."

"He wants you dead, too," Tavi pointed out.

Varg's teeth showed again. "But I found him out too late. All but two of my battlepack had already been bewitched. They are now gone. They will hunt me. They may well kill me. But I will not let Sarl say that he bested me entirely. So the next step is yours, pup."

"Me?" Tavi asked.

Varg nodded and growled, "There is not much time before Sarl moves. And we both know that even if I spoke to Gaius, he would be slow to believe me." Varg pulled up the hood on his cloak and strode to a side passage leading off from the long gallery. "It will not be long before Sarl is on my trail. I will lead him away. You are the only one who can stop them now, pup."

Varg vanished into the darkness of the tunnels, leaving the dim scarlet lamp behind.

"Crows," Tavi said weakly. "Why does this keep happening to me?"

Fidelias had to give Steadholder Isana credit: The woman had courage. Only hours ago, she had been wounded in an attack that had killed virtually everyone she knew within the capital. She had missed death by the width of a few fingers and by the fraction of a second it had taken Fidelias to steady his aim on the assassin-archer and release his own shaft. She was, as far as she was concerned, consorting with murderers and traitors to the Realm, even now.

And yet she walked with a quality of quiet dignity as they left the relative security of the room within the brothel. She had covered herself in a large cloak without complaint, though upon entering the raucous main hall of the house, her face had turned a decided shade of pink upon observing the activities there.

"This second-in-command," Isana asked as they walked outdoors. "Will he have the support of your employer?"

Fidelias mused over the woman's choice of words. She could as easily have said, "Lady Aquitaine" and "Lord Aquitaine," but she had not. She had understood that Fidelias had avoided mentioning their names where it might be overheard, and had respected that. It gave him hope that the woman might actually have enough flexibility of thought to work with them.

"Completely," he told her.

"I have conditions," she warned him.

Fidelias nodded. "You will need to take it up at the meeting, Steadholder," he replied. "I'm only a messenger and escort. But I think it likely that some sort of exchange can be negotiated."

Isana nodded within her hood. "Very well. How far must we walk?"

"Not much farther, Steadholder."

Isana let out an exasperated little breath. "I have a name. I'm getting tired of everyone calling me Steadholder."

"Think of it as a compliment," Fidelias advised her. The hairs on the back

of his neck abruptly rose, and he forced himself not to turn and stare around like a spooked cat. Someone was following him. He had played the game long enough to know that. For the moment, at least, he did not need to know the details. He had shown his face too often the previous day, and one of any number of opportunists would love to turn him in to the Crown and collect his bounty prize. "No other woman in the Realm can lay claim to the same title."

"No other woman in the Realm knows my recipe for spicebread, either," Isana said, "but no one says anything about that."

Fidelias turned to smile briefly at her. He used the moment to catch sight of their followers in the corner of his vision. Two of them, large rough types, doubtless river rats for one of the hundreds of riverboats now docked at the city for the festivities. He could see little more than that they were not dressed well, and one of them had a drunken hesitation to his step. "Do you mind if I ask you a question?"

"Yes," she said. "But ask."

"I cannot help but take note that you have no husband, Steadholder. Nor any children. That is . . . unusual, for a woman of our Realm, given the laws. I take it that you did spend your time in the camps when you came of age?"

"Yes," she said, her tone flat. "As the law requires."

"But no children," he said.

"No children," she replied.

"There was a man?" Fidelias asked.

"Yes. A soldier. We were together for a time."

"You bore him a child?"

"I began to. It ended prematurely. He left me shortly after. But the local commander sent me home." She glanced aside at him. "I have fulfilled my duties under the law, sir. Why do you ask?"

"It's something to pass the time," Fidelias said, trying for an amiable smile.

"Something to pass the time while you look for a place to deal with the two men following us, you mean," she said.

Fidelias blinked up at her, for the Steadholder was a hand taller than he and more, but this time his smile was genuine. "You've a remarkable eye for a civilian."

"It isn't my eyes," she said. "Those men are putting off greed and fear like a sheep does stink."

"You can feel them from here?" Fidelias felt himself grow even more

impressed with the woman. "They must be fifty feet away. You have a real gift for watercrafting."

"Sometimes I think I would prefer not to have it," she said. "Or at least not quite this much of it." She pressed fingers against her temple. "I do not think I shall go out of my way to visit cities in the future. They're far too loud, even when most are asleep."

"I sympathize to some degree," Fidelias said, and turned their path down a side lane that wandered among several homes and was thick with shadow. "I've seen watercrafters who were unable to maintain their stability when their gifts were as strong as yours."

"Like Odiana," she said.

Fidelias felt disquieted at the mention of the mad water witch's name. He did not care for Odiana. She was too much of an unknown quantity for his liking. "Yes."

"She told me about when she first came into her furies," Isana said. "Frankly, I'm surprised she's as stable as she is."

"Interesting," Fidelias said, and found a nook between two buildings. "She's never spoken to me about it."

"Have you asked?" Isana said.

"Why would I?"

"Because human beings care about one another, sir." She shrugged. "But then, why would you?"

Fidelias felt a faint twist of irritation as the Steadholder's words bit home. His reaction surprised him. For a moment, he considered the possibility that the woman might be speaking more accurately than he was prepared to admit. It had been quite some time since he'd had occasion to behave according to motives other than necessity and self-preservation.

Since the day he had betrayed Amara, in fact.

Fidelias frowned. He hadn't thought of her in some time. In fact, it seemed a bit odd that he had not done so. Perhaps he had been pushing her out of his mind, deliberately forgetting to consider her. But for what reason?

He closed his eyes for a step or two, thinking of the shock on Amara's face when she had been buried to her chin in rough earth, captured by Aquitaine's most capable henchmen. She had deduced his change in loyalties like a true Cursor, but her logic had not prepared her for her emotional reaction. When she accused him, when he admitted that her accusation was true, there had been a flash of expression in her eyes he could not

seem to forget. Her eyes had been filled with pain, shocked anger, and sadness.

Something in his chest twisted in a sympathetic reaction, but he ruthlessly forced it away.

He wasn't sure he regretted that he had pushed his emotions so completely aside, and it was that lack of regret that caused him concern. Perhaps the Steadholder was correct. Perhaps he had lost something vital, some spark of life and warmth and empathy that had been extinguished by his betrayal of the Crown and his subsequent actions in the Calderon Valley. Could a man's heart, his soul, perish and yet leave him walking and talking as if alive?

Again, he pushed the thoughts aside. He had no time for that kind of maudlin introspection now. The bounty hunters had begun to close the distance on Fidelias and Isana.

Fidelias drew his short, heavy bow clear of his cloak and slipped a thick and ugly arrow onto the string. With the practiced speed of a lifetime of experience as an archer and woodcrafter, he turned, drew, and sent his shaft home into the throat of the rearmost bounty hunter.

The bounty hunter's partner let out a shout and charged, evidently unaware that the first man was already dead, Fidelias noted. Amateurs, then. It was an old archer's trick, shooting the rearmost foe so that his companions would continue advancing in the open unaware of the danger instead of scattering for cover. Before the would-be bounty hunter had closed the distance, Fidelias nocked another arrow, drew, and sent the heavy shaft through the charging man's left eye at a range of about five feet.

The man dropped, already dead. He lay on the ground, one leg twitching steadily. The first bounty hunter thrashed around for a few more seconds, his spraying blood pattering on the cobblestones. Then he went still.

Fidelias watched them for a full minute more, then set down his bow, drew his knife, and checked the pulse in their throats to be sure they were dead. He had few doubts that they were, but the professional in him hated sloppy work, and only after he was sure both men were dead, did he take up his bow again.

Perhaps Isana was more right than she knew.

Perhaps he had lost the capacity to feel.

Not that it mattered.

"Steadholder," he said, turning to face her. "We should keep moving."

Isana stared at him in total silence, her face pale. Her schooled mask of confidence was gone, replaced with an expression of sickened horror.

"Steadholder," Fidelias said. "We must leave the streets."

She seemed to shake herself a little. She looked away from him, narrowed her eyes, and assumed her mask again. "Of course," she said. Her voice shook a little. "Lead on."

CHAPTER 39

"Come on," Tavi said. "We've got to go."

"Not yet," Kitai said. She turned to the entry of the tunnel and slipped down into it.

"Crows," Tavi muttered. He set the bottle aside and followed her, hissing, "It drops off on the right. Stay to your left."

He followed Kitai back into the ledge above the alien chamber, and crouched beside her as she stared down at the *croach,* the slow-moving wax spiders, the motionless Canim.

"By the One," she whispered, her eyes wide. "Aleran, we must go."

Tavi nodded and turned to go.

A wax spider appeared over the rim of the ledge, between them and the way back, and moved with lazy grace down the stone ledge toward Tavi.

Tavi froze. The wax spiders were venomous, but, more to the point, they worked with others of their kind. If this one signaled its companions, they would all come after him together—and while he might escape the slow-moving spiders, he would never outrun the bewitched Canim. He might be able to kill the spider, but not without its alerting the rest of its kind.

He glanced back over his shoulder at Kitai. She could only stare back at him, her eyes wide.

And then the spider's front leg touched lightly down on Tavi's hand, and he had to clench his teeth over a scream.

The spider stopped, luminous eyes whirling. It touched his hand with one forelimb for a moment, then used two of its front legs to gently run over his arm and shoulders. He remained rigidly still. The spider's limbs traced

lightly over him, darting from his skin to the underside of its head and back several times, before it simply moved forward, stepping on his hand, elbow, then shoulder and crawled over him without attacking, without raising its whistling alarm cry, and without seeming otherwise to notice him.

Tavi turned his head slowly, only to watch the spider repeat its performance upon Kitai, then glide over her and down to the end of the ledge where it crouched and vomited out a patch of pale green *croach,* which it then began spreading over the ledge.

Tavi traded a long stare with Kitai, perplexed, and wasted no more time in heading back into the tunnel and away from the *croach*-filled cavern.

"Why did it do that?" Tavi blurted as soon as he had left the tunnel. "Kitai, it should have raised a warning and attacked. Why didn't it?"

Kitai emerged from the tunnel a second later, and even in the sullen light of the Canim lamp, he could see that she was pale and trembling violently.

Tavi stood absolutely motionless for a second. "Kitai?" he asked.

She rose, her arms wrapping around herself as if cold, and her eyes did not focus upon anything. "It must not be," she whispered. "It must not be."

Tavi reached out to her, laying his hand upon her arm. "What must not be?"

She looked up at him, her expression fragile. "Aleran. If . . . the old tales. If my people's tales are correct. Then these are the vord."

"Um," Tavi said. "The what?"

"The vord," Kitai whispered, and shuddered as she did. "The devourers. The eaters of worlds, Aleran."

"I haven't ever heard of them."

"No," Kitai said. "If you had, your cities would lie in ashes and ruin. Your people would be running. Hunted. As ours were."

"What are you talking about?"

"Not here, Aleran. We must go back." Her voice rose in panic. "We cannot stay here."

"All right," Tavi said, trying to sound soothing. "All right. Come on." He took up Varg's lamp and headed back up out of the Deeps, looking for the markings he'd left on the walls at intersections as they walked.

It took Kitai several moments to slow her breathing again. Then she said, "Long ago, our people lived elsewhere. Not in the lands we have today. Once we lived in a manner like your own people. In settlements. In cities."

Tavi arched an eyebrow. "I've never heard that. I didn't think your folk had any cities."

"No," Kitai said. "Not anymore."

"What happened to them?"

"The vord came," Kitai said. "They took many of our people. Took them as you saw those wolf-creatures in that cavern. They, too, had been taken."

"Taken," Tavi said. "You mean controlled? Enslaved, somehow?"

"More than that," she said. "The wolf-creatures you saw have been devoured. Everything within them that made them who they were is gone. Their spirit has been consumed, Aleran. Only the spirit of the vord remains—and the taken are without pain, or fear, or weakness. The vord spirit gives them great strength."

Tavi frowned. "But why would the vord do such a thing?"

"Because that is what they do. They spawn. Make more of themselves. They take, devour or destroy all life, until there is nothing else under the sky. They create themselves into new lives, new forms." She shuddered. "Our people have kept the tales of them. Dozens of horrible stories, Aleran, preserved over lifetimes beyond knowing. The kind that make even Marat stay close to their fires and huddle shivering in their blankets at night."

"Why keep those stories, then?" he asked.

"To help us remember them," Kitai said. "Twice, the vord all but destroyed our people, leaving only small bands running for their lives. Though it was long ago, we keep the stories to warn us should they come again." She bit her lip. "And now they have."

"How do you know? I mean, Kitai. If the Marat have worked so hard to remember them, why didn't you just point at them two years ago, and say, 'Oh look, it's the vord'?"

She let out an impatient hiss. "Am I speaking only to myself?" she demanded. "I told you, Aleran. They renew and reshape their forms. They are shapechangers. Each time the vord destroyed my people, they appeared as something different."

"Then how do you know it's them?"

"By the signs," she said. "Folk going missing. Being taken. The vord begin their work in secret, so that they are not discovered before they have a chance to multiply and spread. They strive to divide those who oppose them so that their enemies may be weakened." She shuddered. "And they are led by their queens, Aleran. I understand it only now: That creature, the one from within

the heart of the Valley of Silence, the one you burned—it was the vord queen."

Tavi paused to look for the next marking. "I think I saw it. Here."

"In the cavern?"

"Yes. It was covered in a cloak, and issuing orders to a Cane who had not been . . . been . . ." He made a vague gesture.

"Taken," Kitai said.

"Taken." Tavi told her about the conversation between the cloaked figure and Sarl.

Kitai nodded. "You saw it. The vord plans to kill your headman. It wishes to create enough chaos to increase their numbers without being noticed. Until it is too late."

Tavi found his paces quickening. "Crows. Could they do such a thing?"

"The second time they ravaged my people, we were not able to stop them—and we had faced them before. Your people know nothing of them. So they seek to weaken you, divide you."

"The vord queen is using Sarl," Tavi murmured. "Divide and conquer. He provided her with soldiers to begin her work, and his caste has been hurling storms at Gaius in order to weaken him and force him to spend most nights in his mediation chamber, so that they have an idea of where he will be when they try to kill him. And the queen knows that if Alera is weakened, the Canim will attack us. She wants the Canim to attack and weaken us further—and in the process they will take losses as well. They'll leave themselves more vulnerable to the vord."

Kitai nodded. "In our tales they turned our peoples upon one another in much the same way."

"Crows," he swore quietly. Tavi thought of the long stair down to the First Lord's meditation chamber. After the first guard station, there were no other entrances or exits from the stairwell or the chambers below.

It was a death trap.

Tavi walked even faster. "They know where Gaius is. Twenty Canim might be able to fight their way to him. We have to stop them."

Kitai kept pace. "We will warn your warriors, lead them here, and destroy the vord."

"Sir Miles," Tavi said.

Kitai looked at him blankly.

"He's a war leader," Tavi clarified. "But I'm not sure he'll attack."

"Why would he not?"

Tavi clenched his jaw and pressed ahead, in a hurry but not stupid enough to go sprinting through the tunnels until he was hopelessly lost. "Because he doesn't like me very much. He might not believe me. And if I tell him I got the information from a Marat, I'll be lucky if he only storms out of the room."

"He hates us," Kitai said.

"Yes."

"Madness," Kitai said. "The vord are a threat to one and all."

"Sir Miles will understand that, too," Tavi said. "Eventually. I'm just not sure there's enough time for him to be stubborn." Tavi shook his head. "Maestro Killian is the one to convince. If I do that, he'll order Miles to do it."

They reached the last marking Tavi had left on the wall and entered familiar tunnels again. Tavi picked up his pace to an easy run, mind racing over what he had to do, how best to get it done.

He registered a sudden motion in front of him, and he flinched to one side just as a hooded attacker with a heavy truncheon appeared from behind a veil of furycrafting and swung it at him. The club glanced off his left arm, and Tavi felt it go suddenly numb. Kitai snarled somewhere behind him. Tavi hit the wall, stumbled, and barely managed to keep from falling. He drew his knife and turned to confront the attacker, just in time to see the truncheon in motion only inches from his face.

There was a flashing burst of bright lights, then everything went black.

CHAPTER 40

Dawn had not yet come when Amara and Bernard woke together. They shared a slow, soft kiss, then without a word they both rose and began to don their arms and armor. Just as they finished, there was a step outside the makeshift room, and Doroga pushed the curtain of cloaks aside. The Marat's broad, ugly face was grim.

"Bernard," he rumbled. "It is dawn. They come."

CHAPTER 41

Isana accompanied the assassin to a wine club on a quiet, dimly lit section of Mastercraft Lane, where the finest craftsmen in all of Alera plied their trades to the wealthy clientele of the city. The wine club itself was located between a small complex of buildings specializing in statuary and a furylamp-maker's workshop. There was no sign over its door, no indication that it was anything but a service entrance or possibly the entrance to a countinghouse or some other business that did not require walk-in customers.

Despite the late hour, the door opened promptly when the assassin knocked, and a liveried servant conducted them down a hall and into a private room without speaking to them.

The room was cozy and lavishly appointed—a circle of small divans meant to be lounged upon on one's side while chatting and sipping wine. One of the divans was occupied.

Invidia Aquitaine lay upon her side, beautiful in the same silk gown she had worn at Kalare's fete. A crystal goblet in her hand was half-filled with a pale wine. Additionally, she wore a translucent drape of fabric over her features—a veil, Isana judged, meant to provide the legal pretense of anonymity should the evening's discussion somehow come under the scrutiny of the law.

Lady Aquitaine looked up as they entered and inclined her head pleasantly. "Welcome, Steadholder. I presume that my associate talked you into the meeting."

"He was persuasive—under the circumstances," Isana replied.

Lady Aquitaine gestured toward the divan across from her. "Please, relax. Would you care for a taste of wine? This is an excellent vintage."

Isana stepped over to the indicated divan but did not recline upon it. Instead, she sat upon its very edge, her back rigidly straight, and frowned at Lady Aquitaine. "I've no stomach for most wine," she replied. "Thank you."

Lady Aquitaine's pleasant smile faded into a neutral mask. "This might be easier for you if you indulged somewhat in the pleasantries, Steadholder. They do no harm."

"Nor serve any purpose, except to waste time," Isana replied. "And time is of importance to me at the moment. I came here to discuss business."

"As you wish," Lady Aquitaine replied. "Where would you like to begin?"

"Tell me what you want," Isana said. "What would you have of me?"

She took a slow sip of wine. "First, your public support of Aquitaine and my lord husband," she said, "who would become your political patron. It means that you would appear in public wearing the colors of Aquitaine— particularly at the presentation at the conclusion of Festival. You may be asked to attend dinners, social functions, that sort of thing, with my husband providing transport and covering any of your expenses."

"I work for a living," Isana said. "And I am responsible for a steadholt with more than thirty families in it. I'd do poor service to them constantly running off to social occasions."

"True. Shall we negotiate upon a reasonable number of days each year, then?"

Isana pressed her lips together and nodded, forcing herself to contain her emotions carefully.

"Fine. We'll work that out. Secondly, I would require your support as a member of the Dianic League, which would require you to attend a convocation of the League once each year and engage in written discourse over the course of the rest of the year."

"And within the League, you wish me to support you."

"Naturally," Lady Aquitaine said. "And finally, we may ask you to support certain candidates for the Senatorial elections in Riva. As your home city, you will be able to vote in the elections, and your opinion will inevitably carry some weight with your fellow Citizens."

"I want something understood, Your Grace," Isana said quietly.

"What might that be?"

"That I know full well the extent of you and your husband's ambitions, and have no intention of breaking the laws of the Realm to help you. My support and participation will extend as far as the letter of the law—and not an inch farther."

Lady Aquitaine raised both eyebrows. "Of course. I wouldn't dream of asking you for that."

"I'm sure," Isana said. "I simply want us to understand one another."

"I think we do," Lady Aquitaine replied. "And what would you ask in re-turn for your support?"

Isana drew in a deep breath. "My family is in danger, Your Grace. I came here to contact the First Lord and get help sent back to Calderon, and to warn my nephew of a potential threat to his life. I have been unable to contact either of them on my own. If you would have my support, then you must help me protect my kin. That is my price."

Lady Aquitaine took another slow sip of wine. "I shall need to know more about what you require, Steadholder, before I can make any promises. Please explain the circumstances in greater detail."

Isana nodded, then began to recount everything Doroga had told them about the vord, the way they spread, where they had gone, and the danger they represented to the whole of the Realm. When she finished, she folded her hands in her lap and regarded the High Lady.

"That's . . . quite a tale," she murmured. "How certain are you of its truth?"

"Completely," Isana said.

"Even though what you know of it came from, if I understand you cor-rectly, a barbarian chieftain."

"His name is Doroga," Isana said quietly. "He is a man of integrity and intelligence. And his wounds were real enough."

Lady Aquitaine murmured, "Fidelias, what assets have we near Calderon?"

The assassin spoke up from where he had taken an unobtrusive position against the wall beside the door. "The Windwolves are on training maneu-vers in the Red Hills, Your Grace."

"That's . . . twenty Knights?"

"Sixty, Your Grace," he corrected her.

"Oh, that's right," she said, her tone careless, though Isana did not be-lieve for a moment that she hadn't remembered precisely what resources she had, and where. "They've been recruiting. How long would it take them to reach Calderon?"

"As little as three hours, Your Grace, or as long as seven, depending upon wind currents."

Lady Aquitaine nodded. "Then please inform His Grace, when you re-port to him, that I am dispatching them to the relief and reinforcement of Calderon's garrison on behalf of our new client."

Fidelias regarded her for a moment, then said, "Lord Riva might not appreciate our sending troops into action in his own holdings."

"If Riva was doing his job, his own troops would already be there to reinforce the garrison," Lady Aquitaine said. "I am quite certain he would much rather snub the new Count Calderon than respond with a swift and expensive mobilization, and I should dearly love to openly humiliate Riva in front of all the Realm. But assure my husband that I will order the men to keep the lowest profile possible, and thereby only humiliate him in front of all the peerage."

The assassin smirked. "Very good, Your Grace."

She nodded. "The next order of business will be to find the Steadholder's nephew and make sure that he is safe from both this vord creature and from Kalare's bloodcrows."

"Alleged bloodcrows, Your Grace," Fidelias corrected her. "After all, we don't know for a fact that they belong to Lord Kalare."

Lady Aquitaine gave Fidelias an arch look. "Oh yes. How thoughtless of me. I presume you have Kalare's holdings in the capital under surveillance?"

Fidelias gave her a mildly reproachful look.

"Of course you do. Find out what your watchers have seen most recently and put absolutely anyone you can spare on this matter at once. Secure the boy and ensure his safety."

He ducked his head into a polite bow. "Yes, Your Grace. Though if I may offer a thought before I leave?"

Lady Aquitaine waved her hand in an acquiescing gesture.

The assassin nodded. "My investigation since arriving here revealed a pattern of unusual activity in the Deeps. A significant number of people have gone missing over the winter, and in my judgment it wasn't as a result of infighting between the local criminal interests. These creatures the Marat warned about could be involved."

Lady Aquitaine arched an eyebrow. "Do you really think so?"

Fidelias shrugged. "It certainly seems possible. But the Deeps are extensive, and given our limitations in manpower, it would require a considerable amount of time to search them."

Lady Aquitaine flicked her finger in a gesture of negation. "No, that will not be for us to accomplish. The security of the Deeps will certainly be of concern to the Royal Guard and Crown Legion. We will advise them of the

potential danger at the first opportunity. For now, focus on the boy. He is our interest here."

"Yes, my lady." The assassin inclined his head to her, nodded to Isana, and departed the room.

Isana sat in silence for a moment and found her heart pounding too swiftly. She felt her hands shaking and clasped them together, only to feel a clammy sweat prickling over her brow, her cheeks.

Lady Aquitaine sat up, frowning as she stared at Isana. "Steadholder? Are you unwell?"

"I am fine," she murmured, then swallowed a bitter taste from her mouth, and added, "my lady."

Lady Aquitaine frowned, but nodded to her. "I'll need to go shortly in order to contact our field commander via water."

Isana paused in startled shock. She herself had been able to send Rill out through the streams of most of the Calderon Valley—but that was largely because she had lived there for so long and knew the local furies so well. With effort, Isana could perhaps have communicated through Rill as far as Garrison, but Lady Aquitaine was casually speaking about sending her furies five hundred times as far as the extreme limits of Isana's talents.

Lady Aquitaine regarded Isana for a moment more, before saying, "You really do believe that they are in mortal danger. Your family."

"They are," Isana said simply.

Lady Aquitaine nodded slowly. "You would never have come to me, otherwise."

"No," Isana said. "No, I would not."

"Do you hate me?" she asked.

Isana took a slow breath before answering, "I hate what you represent."

"And what is that?"

"Power without conviction," Isana replied, her tone lifeless, matter-of-fact. "Ambition without conscience. Decent folk suffer at the hands of those like you."

"And Gaius?" Lady Aquitaine asked. "Do you hate the First Lord?"

"With every beat of my heart," Isana replied. "But that is for a different reason entirely."

Lady Aquitaine made a noise in her throat to indicate that she was listening and nodded, but Isana did not continue. After a moment of silence,

the High Lady nodded again, and said, "You seem to be one who appreciates forthright honesty. So I will offer you that. I regret what happened in Calderon two years ago," she said. "It was a senseless waste of life. I opposed it to my husband, but I do not rule his decisions."

"You opposed it out of the goodness of your heart?" Isana asked. She tasted the faint sarcasm on her words.

"I opposed it because it was inefficient and could too easily fail and recoil upon us," she said. "I would much prefer to gain power through the building of solid alliances and loyalties, without resorting to violence."

Isana frowned at her. "Why should I believe you?"

"Because I'm telling you the truth," Lady Aquitaine said. "Gaius is old, Steadholder. There is no need for violence to remove him from the throne. Time will eventually play the assassin for us, and he has no heir. Those in the strongest position to rule when Gaius passes may be able to assume the throne without allowing matters to devolve into an armed struggle for power." She offered Isana her hand. "Which is why I am quite serious when I tell you that your loyalty places upon me an obligation to protect your family as if it was my own. And I will do so by every means at my disposal." She nodded to her hand. "Take it and see. I'll not hide myself from you."

Isana stared at the High Lady for a moment. Then she reached out and took her hand. She felt nothing for a second, then there was a sudden gentle pressure of emotion from Lady Aquitaine.

"Are you telling me the truth?" Isana asked her quietly. "Do you intend to help me and my kin?"

"I am," Lady Aquitaine said. "I do."

Through their clasped hands, Isana felt Lady Aquitaine's presence as a subtle vibration on the air, and her words rang with the clarity of truth and confidence. It was not an affectation of furycrafting. That tone of truth was not something that could be falsified, not to someone of Isana's skill. Lady Aquitaine might have been able to conceal falsehoods behind vague clouds of disinterest and detached calm, but there was the quivering power of sincerity in her statements, and nothing cloudy about it.

She might be ambitious, calculating, relentless, and merciless—but Invidia Aquitaine meant what she said. She fully intended to do everything in her power to help Bernard, to protect Tavi.

Isana shuddered and could not stop a slow sob of relief from surging through her. The past days had been a nightmare of blood and fear and

helpless frustration, a struggle to reach the man with the power to protect her family. She had reached Lady Aquitaine instead.

But, Isana realized, if Invidia could do as she claimed, if she could make certain that Bernard and Tavi were safe, then Isana would have no choice but to return that loyalty in good faith. She would become a part of something meant to tear down the First Lord, and willingly, if that was the price for protecting her own. She had committed herself.

But that didn't matter. As long as Tavi and her brother were safe, it was worth the price.

Lady Aquitaine said nothing, and did not withdraw her hand, until Isana finally looked up again. The High Lady then rose, glanced down at her gown, and frowned at it until its color darkened from scarlet to a red so deep it was almost black and better suited to avoiding notice in the night. Then she regarded Isana with cool eyes not entirely devoid of compassion, and said, "I must see to our communications, Steadholder. I've arranged for you to be taken under guard to my manor, where quarters await you. I will bring you word of your brother and your nephew the moment I have it."

Isana rose. Her head's pounding had eased significantly, and the lack of pain was a powerful soporific. She wanted little more than to get some rest. "Of course, my lady," she said quietly.

"Come with me, then," she said. "I'll walk you to the coach."

Isana followed Lady Aquitaine out of the building and found a coach waiting outside. It featured positions for half a dozen footmen, and each was occupied by an armed man with a hard expression and confident hands. Lady Aquitaine steadied Isana with one hand as she mounted the steps into the coach, and the footman closed the door behind her.

"Rest if you are able," Lady Aquitaine said, making a curt gesture to the night with one hand. A tall grey steed walked amicably out of the darkness, stopping to nuzzle Lady Aquitaine's shoulder. She pushed the beast's head away from her dress with an expression of annoyed fondness. "I will do all in my power to act immediately, and I will do everything I am able to get immediate word to the First Lord regarding the dangers here and in Calderon. You have my promise."

"Thank you," Isana said.

"Do not thank me, Steadholder," Lady Aquitaine said. "I do not offer this to you as a gift of patron to client. We have entered into a contract as peers—and one that I hope will benefit us both for years to come."

"As you wish, my lady."

Lady Aquitaine mounted gracefully, inclined her head to Isana, and said to the driver, "Martus, be cautious. Hired cutters have already sought her life once this night."

"Yes, Your Grace," the driver answered. "We'll see her there safe."

"Excellent." Lady Aquitaine turned her horse and set off at a brisk trot down the street, veil and gown flowing around her. One of the footmen drew down heavy leather curtains over the side of the coach, plunging it into darkness and preventing anyone from getting a look at its passenger. The driver clucked to his team, and the coach jolted into motion down the streets.

Isana leaned her head back against a cushion and lay limp, too exhausted to do more. She'd done it. She had paid a price that she knew would haunt her, but it was done. Help was on its way to Tavi and Bernard. Everything else was immaterial.

She was asleep before the coach was out of sight of the wine club.

⋈⋈⋈⋈ CHAPTER 42

Tavi woke up with his head pounding, but his instincts screamed warnings, and he most carefully did not move or alter the patterns of his breathing. If he was still alive, it meant that his captors intended him to be that way. Announcing that he was alert would profit him nothing. Instead, he kept himself limp and passive and sought to learn whatever he could about his surroundings and his captors.

He was sitting in a chair. He could feel the hard wood under him, and his legs were bound, one to each leg of the chair. His elbows rested at the right height for the arms of a chair, though he could not feel his hands. He surmised that his wrists were bound, and that his bonds had cut off the circulation to his hands.

He could hear the creaking of wood around him. Most of the buildings in the city were constructed of stone. The only wooden structures were outside

the walls of the capital itself, or else were the storage houses and ship-wrights down at Riverside. He took part of a breath through his nose and caught the faint smell of water and fish. The river, then, and not outside the capital's walls. He was in a warehouse or a shipwright's—or, he amended, upon a ship. The Gaul was a wide, deep river, the largest in all Alera, and even deepwater vessels could sail up it to the capital.

"Were you able to fix him?" growled a male voice. From the sound of it, it was coming to him from an adjacent room, or possibly from the other side of a thin door or heavy screen. The voice itself had the quality of one shut indoors. His captors, then, most likely.

"I stopped the bleeding," said a voice, a woman's. It had an odd accent, from somewhere in the south of the Realm, Tavi thought, perhaps Forcian. "He'll have to see a professional about getting his nose back, though."

The man let out a laugh that had nothing to do with merriment. "That's rich. Serves him right for letting a little girl get to him."

There was an oppressive silence.

"You aren't little, Rook," the man said, his tone defensive.

"Bear in mind," Rook said, "that the girl is a Marat. They are physically stronger than most Alerans."

"Must be good exercise, bedding all those animals," he said.

"Thank you, Turk, for reminding me why some of us attend to the jobs that require intelligence, while others are restricted to the use of knives and clubs."

Turk snorted. "I get the job done."

"Then why is the Steadholder not dead?"

"Someone interfered," Turk said. "And no one told us that the old man was that good with a blade."

"Very true," Rook said. "The armsman protecting the coach was, good-ness, skilled at arms. I can see why you were taken off guard."

Turk growled out a vitriolic curse. "I got the boy, didn't I?"

"Yes. The old crow might even decide not to make you sorry you weren't with the men at Nedus's manor."

"Don't worry," Turk said, sullen. "I'll get her."

"For your sake, I hope you are correct," Rook said. "If you will excuse me."

"You're not staying? I thought you were done."

"Try not to think too much," she said. "It doesn't do anyone any favors. I have a few loose ends to trim before I go."

"What do you want us to do with these two?"

"Keep them until the old crow arrives to question them. And before you ask, the answer is no. You aren't to touch either one of them meanwhile. He'll tell you how he wants you to handle it afterward."

"One of these days," Turk said in an ugly tone, "someone is going to shut your mouth for you."

"Possibly. But not today. And never you."

A door opened and closed, and Tavi chanced a quick peek up through the veil of his hair. He was in a storage house, surrounded by wooden shipping crates. A muscular, ill-favored man, dressed in a sleeveless river rat's tunic, stood glaring at the door as it closed. To Tavi's right, there was another chair, and Kitai was tied into hers just as he was into his—except that she'd had a leather satchel drawn over her head and tied loosely shut around her neck.

Tavi lowered his head again, and a second later Turk, the ugly man, turned and walked across the floor toward him. Tavi remained still as the man pressed fingers against his throat, grunted, and stepped over to Kitai. Tavi opened an eye enough to see him touch her wrist, then turn and stalk out of the warehouse. He slammed the door shut behind him, and Tavi heard a heavy bolt sliding into place.

Tavi agonized for a moment over what to do. The place may have had some sort of furycrafted guardian set to watch him—but on the other hand, the presence of any kind of formidable guardian would have drawn the attention of the civic legion's furycrafters, who regularly inspected the warehouses in Riverside. That meant that if there were any furies set to watch him, they would probably only raise the alarm, rather than attacking.

Tavi tested his bonds, but there was not an inch of the ropes that were not inescapably tight. If he'd been conscious when tied, he could have attempted to keep his muscles tight so that when he relaxed them there would have been some margin of slack in the ropes to allow him to wriggle out of them. But it hadn't happened that way, and there seemed little he could do now.

Even if he had been free, it might not have done him any good. There was only one door to the storage house—the one Turk had just walked out. Tavi tested his chair. It wasn't fastened down, and the legs thumped quietly on the floorboards as he wiggled back and forth.

Kitai's head jerked up, lifting the leather satchel. Her voice was muffled. "Aleran?"

"I'm here," he said.

"You are all right?"

"Got a headache I'm going to remember for a while," he responded. "You?"

She made a spitting sound from inside the hood. "A bad taste in my mouth. Who were those men?"

"They were talking about trying to kill my aunt Isana," Tavi said. "They probably work for Lord Kalare."

"Why did they take us?"

"I'm not sure," he said. "Maybe because getting rid of me will make Gaius look weak. Maybe to use me to try to lure Aunt Isana into a trap. Either way, they aren't going to let us go after this is over."

"They will kill us," she said.

"Yes."

"Then we must escape."

"That would follow, yes," Tavi said. He tensed up, testing his bonds again, but they were secure. "It's going to take me hours to get out of these. Can you get loose?"

She shifted her weight back and forth, and Tavi heard the wood of her chair creaking under the strain. "Perhaps," she said, after a moment. "But it will be loud. Are we guarded?"

"The guard left the building, but there might be furies watching us. And the men who took us won't be far away."

The satchel tilted suddenly, and Kitai said, "Aleran, someone comes."

Tavi dropped his head forward again, as it had been when he awoke, and a second later the bolt rattled and the door opened. Tavi caught a quick glimpse of Turk and another, taller man entering the warehouse.

". . . sure you can see that we'll have her before sunrise, my lord," Turk was saying in an unctuous tone. "You can't listen to everything Rook has to say."

The other man spoke, and Tavi had to force himself not to move. "No?" asked Lord Kalare. "Turk, Turk, Turk. If Rook had not asked me to give you a second chance, I'd have killed you when we came through the door."

"Oh," Turk mumbled. "Yes, my lord."

"Where is he?" Kalare asked. Turk must have answered with a gesture, because a moment later, footsteps approached. From a few feet in front of him, Tavi heard Kalare say, "He's unconscious."

"Rook rang his bells pretty good," Turk replied. "But there shouldn't be any lasting damage, my lord. He'll be awake in the morning."

"And this?" Kalare asked.

"Barbarian," said Turk. "She was with the other one."

Kalare grunted. "Why is she hooded?"

"She put up a fight before we got her bound. She bit Cardis's nose off."

"*Off?*" asked Kalare.

"Yes, my lord."

Kalare chuckled. "Amusing. The spirited ones always are."

"Rook said to ask you what you wanted done with them, my lord. Shall I detach them?"

"Turk," Kalare said, his tone pleased. "You've employed a euphemism. Next thing you know, you'll be showing signs of sagacity."

Turk was silent for a blank second, then said, "Thank you?"

Kalare sighed. "Do nothing yet," he said. "Live bait will do us more good than a corpse."

"And the barbarian?"

"Her too. There's a chance she's the result of some kind of fosterage agreement between the barbarians and Count Calderon, and until there is leisure to extract the information from them, there's little point in making myself a blood enemy of the Marat. Not until it will profit me."

Suddenly fingers tangled in Tavi's hair, painfully strong, and jerked his face up. Tavi managed to keep himself totally limp.

"This little beast," Kalare said. "If the woman wasn't a greater threat, I think I would enjoy seeing him flayed and thrown into a pit of slives. That such a waste of a life could have dared to lay a finger on *my* heir." His voice shook with anger and disdain, and he released Tavi's hair with a flick of his wrist that made the muscles in Tavi's neck scream.

"Shall I arrange for his transport, my lord?"

Kalare exhaled. "No," he decided. "No. There's no point in giving him a chance to survive, given what I have planned for his family. Even something like this could grow into a threat, given time. We'll throw them all into the same hole."

His boots thudded on the floor as he walked back to the door. Turk's heavier, clumsier steps followed, and the door opened and closed again, the bolt fastening.

Tavi checked to make sure that they were alone, then said, to Kitai, "You bit off his *nose?*"

Her voice was muffled by the satchel as she replied. "I couldn't reach his eyes."

"Thank you for the warning."

"No," she said. "I said someone was coming. I didn't mean through the door."

"What?"

"The floor," she said. "I felt a vibration. There, again," she murmured.

Tavi could hardly feel his feet, but he heard a faint, scraping noise from somewhere behind him. He twisted his head enough to see a floorboard a few feet away quiver and then suddenly bow upward, as if made from supple, living willow rather than dried oak. He saw someone beneath the floor work the floorboard free and draw it down out of sight. Two more floorboards followed it, and then a head covered with a shock of tousled and dusty hair emerged from the hole in the floorboards and blinked owlishly around.

"Ehren," Tavi said, and he had to labor to control his excitement and keep his voice down. "What are you doing?"

"I think I'm rescuing you," Ehren replied.

"There are guards here," Tavi told his friend. "They'll sense what you've done to get in here."

"I don't think so," Ehren said. He gave Tavi a shaky smile. "For once it's a good thing my furies are so weak, huh? They don't make much noise." He winced and began to wriggle up through the hole in the floor.

"How did you find us?" Tavi asked.

Ehren looked wounded. "Tavi. I've been training to be a Cursor as long as you have, after all."

Tavi flashed him a fierce grin, which Ehren struggled to return as he gave up on crawling up through the hole, and lowered himself to start passing a hand steadily over another of the boards, which quivered and slowly began to bend. "I was out asking questions, and I noticed that a man was following me. It stood to reason that whoever took your aunt might have an interest in following me around. So I went back up to the Citadel, turned around once I was out of his sight—"

"And tailed him back here," Tavi said.

Ehren coaxed the board into bending still more. "I swam out under the pier and listened to a couple of men talking about the prisoners. I thought maybe it could have been your aunt, so I decided to take a look."

"Well done, Ehren," Tavi said.

Ehren smiled. "Well. It was sort of a happy accident, wasn't it. Here, almost got it."

The board creaked and began to move, when Kitai hissed, "The door."

The bolt on the warehouse door rattled, and the door opened.

Ehren hissed and dropped down into the hole and out of sight, except for the white-knuckled fingers of one hand, holding the warped board flat against the floor with his weight.

Tavi licked his lips, thinking furiously. If he remained inert, the guards would have nothing better to do than notice the missing boards.

He lifted his head to face Turk. The broad-chested man wore a curved Kalaran gutting knife on his belt, and his eyes were stormy. Behind him walked a lean, skinny man in the same river sailor's clothing, and another curved knife rode on his belt. He was bald and looked as though he had been made from lengths of knotted rawhide—and his nose was missing. Watercrafting had left what remained a shade of fresh pink, but it gave him a skeletal look, his naval cavities reduced to a pair of oblong slits in his face. Cardis, then.

"Well," Turk said. "Look at that. Kid's awake."

"So what," Cardis snarled, stalking over to the bound and hooded Kitai. He tore off the leather hood, took a fistful of the girl's hair, and savagely tore it out of her scalp. "I don't give a bloody crow about the boy."

Kitai's eyes blazed with emerald fire, something wild and furious rising up behind them. Her face bore bruises on one cheek, and dried blood clung in brown-black clots to the lower half of her face.

"Don't touch her!" Tavi snarled.

Cardis almost idly dealt Tavi's face a sharp, stinging blow with his open hand, then turned back to Kitai.

The Marat girl stared at Cardis without flinching or making a sound, then deliberately slipped her tongue between her lips and licked at the blood on her upper lip, a slow and defiant smile crossing her face.

Cardis's eyes went flat and dangerous.

"Cardis," Turk snapped. "We're not to harm either of them."

The other man stared down at Kitai and tore out another heavy lock of hair. "So we don't mark them up. Who's to know?"

Turk growled, "My orders are from the old crow himself. If I let you cross him, he'll kill you. And then he'll kill me for not stopping you."

Cardis's voice rose to a furious scream as he gestured at his face. "Do you *see* what that little bitch did to me? Do you expect me to just stand here and *take* that?"

"I expect you to follow orders," Turk spat.

"Or what?"

"You know what."

Cardis bared his teeth and drew his knife. "I've had about as much of this dung as I'm going to take for one day."

Turk drew his knife as well, eyes narrowed. He flicked a glance aside at Tavi, then his eyes paused on the floor behind them. "Bloody crows," he muttered. "Look at this." He took a couple of steps to stand over the hole in the floor.

"What?" Cardis asked, though his voice was less angry.

"Looks like someone is trying to—"

Ehren's head and shoulders popped up out of the hole, and the little scribe drove his knife straight down through Turk's heavy leather boot and the foot inside it to bury its tip in the floor. Turk let out a startled cry and tried to dodge, but his pinned foot could not move with him, and he fell to the ground.

Kitai let out a sudden and bloodcurdling howl of primal wrath. Her body jerked once, twice, and the chair she was tied to shattered into pieces still attached to her limbs. She swung one arm in a broad arc, and smashed the heavy wooden arm of the chair still tied to her wrist into Cardis's knife arm. The knife tumbled free and rang as it hit the floor.

Ehren shouted and the fourth board popped free. Then he swarmed up out of the hole in the floor and started kicking Turk in the head. Turk managed to slash clumsily at Ehren's leg with his curved knife, and scored. Ehren staggered back, his leg unable to support his weight. He fell to the ground just behind Tavi, scrambled to seize Cardis's dropped knife, and hacked desperately at Tavi's bonds.

Tavi saw Turk jerk the dagger impaling his foot clear of his flesh, tossed the knife into a half flip, seized the blade, and flung it at Ehren's back.

"Down!" Tavi snarled. Ehren might not have been physically imposing, but the young scribe was quick. He dropped to the floor and the flung knife struck flat against the back of Tavi's chair and clattered down.

The ropes came free from his arms as Turk charged toward them. Tavi hopped in the chair to twist it around, then overbalanced himself to land hard on his side. He'd been too slow. Turk darted in with his curved Kalaran knife.

Kitai let out a shriek and swung at Turk. She missed, but it forced the man to dodge and bought Tavi a precious second. He seized Ehren's knife from the floor and turned just as Turk seized his hair. The knife flashed down. Tavi blocked the slash by interposing his forearm with Turk's wrist, simultaneously slashing up with his knife.

The blow whipped across Turk's inside upper thigh and bit deep. Blood sprayed.

Kitai seized Turk from behind, her encumbered hands gripping the back of his skull and the point of his chin. She howled and twisted her body in a sudden, savage motion, and broke the man's neck. He fell in a jellylike heap to the floorboards. Kitai promptly seized Turk's knife in one hand, and ripped his shirt clear of his chest with the other, her eyes wild, focused on his heart as she drove the knife down and started cutting.

"Kitai," Tavi panted, cutting the bonds on his legs free. "Kitai!"

Her face snapped up toward him, a terrifying mask of rage and blood. Blood dripped from the curved knife, and the fingers of her other hand were already set inside the opening she had cut, ready to tear the body open and take the heart.

"Kitai," Tavi said again, more quietly. "Listen to me. Please. You can't do this. There's no time."

She stared, frozen, the wild light in her eyes fluttering uncertainly.

"My legs," he said. "I can't feel them. I need you to help me get out of here before more of them come."

Her eyes narrowed with an anticipation that was almost lustful. "More. Let them come."

"No," Tavi said. "We have to leave. Kitai, I need to cut you loose. Give me the knife." He offered her his hand.

She stared at him, and the wild energy seemed to recede, leaving her panting, bruised, and covered in welts, small cuts, and rope burns. After a second of hesitation, she reversed her grip on the knife and passed him its hilt before kneeling beside him.

"Great furies," Ehren breathed quietly. "Is . . . is that a Marat?"

"Her name is Kitai," Tavi said. "She's my friend." He started cutting the ropes from her as gently as he could. She simply sat, waiting passively, her eyelids drooping lower and lower as the wild and furious energy that had filled her ebbed away.

"Ehren," Tavi said. "Can you walk?"

The other boy blinked, nodded once, and cut cloth from the hem of his tunic. He wound it several times around his calf and tied it off. "Thank goodness they didn't have any furies."

"Maybe they did," Tavi said. "Thugs like that tend to be earthcrafters, and this warehouse is on the pier. They aren't touching the ground. But we've got to get out of here before someone else shows up." He rose and tugged on Kitai's hand. "Come on. Let's go."

She rose, and hardly seemed conscious of her surroundings.

"There's a knotted rope on your left," Ehren said. "Take it down to the water. Go in as quietly as you can and head for shore. I'll be along in a moment."

"What are you going to do?" Tavi asked.

Ehren gave him a tight smile. "Put those boards back and let them wonder what the crows happened in there."

"Good thinking," Tavi said. "Well done." He climbed down to the rope, got his feet steadily on one of the knots, and paused. "Ehren?"

"Yes?"

"What time is it?"

"Not sure," Ehren replied. "The moon's going down, though."

Tavi's flesh went cold and crawled with goose bumps. He started down the rope, encouraging Kitai to follow him, desperate to hurry but forced to move deliberately, quietly, until he was safely away from Lord Kalare's killers.

The moon was going down.

The Canim were coming for the First Lord.

⊡⊡⊡⊡ CHAPTER 43

Amara stared out of the mouth of the cave at the taken as the morning light grew. "Why aren't they moving faster? It's as though they want us to come out and slaughter them before they're in position."

"We should already be doing it," grumbled a new voice from behind Amara.

"Giraldi," Bernard growled. "You shouldn't be standing on that leg. Get back with the rest of the wounded."

Amara glanced aside as the centurion limped heavily to the front of the cave to stand beside Bernard, herself, and Doroga. "Yes, sir. Right away sir." But he found a place on the wall and leaned on it with no evident intention of moving anywhere, and regarded the enemy line of battle—such as it was.

"Giraldi," Bernard said, his voice a warning.

"If we get through this, Count, you can demote me for insubordination if it makes you feel better."

"Fine." Bernard grimaced and nodded reluctantly to Giraldi, then turned to watch the enemy.

The taken had been forming into a column of a width approximately equal to that of the cave's mouth for several minutes. The formation was not complete yet, and the front ranks, well out of bow range even for Bernard and his Knights Flora, consisted of the largest of the taken holders and *legionares*, the youngest and strongest of the men the vord had captured. The queen simply crouched at the head of the column, never moving, unsettling and shapeless in her dark cloak.

"Looks like they're going for quick and dirty," Giraldi growled. "Form up a column and push it right down our throats."

"The taken are very strong," Doroga rumbled. "Even Aleran taken. And we are outnumbered."

"We'll take a stand ten feet down the tunnel," Bernard said. "That will keep our fronts matched, reduce the advantage of numbers." He drew his heel across the dirt floor. "We form the shieldwall here, on this side of the tunnel, and leave the other to Walker and Doroga."

Giraldi grunted. "Three shields across, it looks, sir."

Bernard nodded. "Swords on the front rank. Spears in the next two." He nodded to a slightly raised shelf along one wall that had been used as a place for sleeping mats. "I'll be there with the archers and take what shots we can. We're low on shafts, though, so we'll have to be cautious. And you'll have our Knights Terra on the ground level in front of us, ready to assist either Doroga or the *legionares* if they need the pressure taken off them."

Giraldi nodded. "Nine men fighting at a time. I suggest six squads, Count. Each of them can take ten minutes of every hour. That will keep them as rested as we can get them and let us hold out the longest."

"Doroga," Bernard asked. "Are you sure you and Walker won't need resting time?"

"Walker can't back much farther down this tunnel," Doroga said. "Get us a couple minutes to breathe now and then. That will be as much as we can ask for."

Bernard nodded. "We'll need to give some thought to what craftings we'll want to use, Giraldi," Bernard began. "Brutus is still hiding us from Garados. What have your men got that isn't on the official list?"

"All of them have some metalcraft, sir," Giraldi said. "I've got one man who's a fair hand at firecrafting. He was a potter's apprentice for a while, and managed the fires there. I'm not saying he could call up a firestorm, but if we set up a trench with fuel and a low flame, he could maybe turn it into a barrier for a little while. Two men with enough windcraft to blow up a lot of smoke and dust. I daresay that they could probably help the Countess, if she's of a mind to try another windstorm. We've got a man who knows enough water to be damned good at poker, and he says that there's a stream at the back of the cave he might be able to call out when we run short on water. And I've got one more man who had a smart mouth when he first signed on, and he wound up digging most of the latrine trenches for about three years."

Bernard snorted. "He get his mouth under control?"

"No," Giraldi said. "He built up enough earthcraft that it wasn't a challenge for him anymore. With your permission, I thought I would have him help me prepare a fallback position deeper in the cave. Trench, earthwork, nothing fancy. If we need it, it won't save anyone, but it might make them pay more to get to us."

"Fine," Bernard said. "Go ahead and—"

"No," Amara said. Everyone stopped to blink at her, and she found herself fumbling for a way to put her thoughts into words. "No overt crafting," she said, then. "We don't dare use it."

"Why not?"

"Because I think it's what they are waiting for," she said. "Remember, that the taken could indeed employ crafting, but that they only did so after we had called up craftings of our own. After we had set forces in motion."

"Yes," Bernard said. "So?"

"So what if they waited because they *couldn't* initiate a crafting?" Amara said. "We all know how critical confidence and personality is to initiating a

furycrafting. These taken may have Aleran bodies, but they aren't Alerans. What if they can only use their talent at furycraft once someone else gathers enough furies into motion?"

Bernard frowned. "Giraldi?"

"Sounds pretty thin to me," the centurion said. "No offense, Countess. I'd like to believe you, but there's nothing to suggest that your guess is anything more than that."

"Of course there is," Amara said. "If they could use crafting, why haven't they? Wind or firecraft could have taken or burned the air from this cave and left us all unconscious. A woodcrafter could have grown the roots of the trees over this cave down and choked us on dust, and an earthcrafter could manage the same and worse. A watercrafter could have flooded the cave from that stream your *legionare* sensed, Giraldi. We know that the vord are under time pressure to finish us and vanish before the Legions arrive. So why haven't they used crafting to bring things to a swift conclusion?"

"Because for some reason they can't," Bernard said, nodding. "It explains why they didn't attack last night. They wanted to draw us out so that we would call up our battlecraftings and assault them. Especially since the vord believe that we still have a strong firecrafter with us. That many taken holders—maybe even a Knight or two, now—could turn all that energy against us and finish us in minutes."

Giraldi grunted. "It would also explain why they are forming up so slow now, and right where we can see them. Crows, if it was my command and we *did* have a firecrafter, I'd hit them right now, before they got themselves into order. Hope to knock them all out at once."

"Exactly," Amara said. "They're an intelligent foe, gentlemen. If we continue to react as predictably as we have been, they'll kill us for it."

Outside, the sky flickered with silver light, and thunder rumbled down from the looming peak behind the cave. Everyone paused to look up, and Amara took a few steps outside the mouth of the cave to send Cirrus questing through the air and the winds.

"It's a furystorm," she reported a moment later. "Something is building it up awfully quickly."

"Garados and Thana," Bernard said. "They're never happy when the holders are moving around their valley."

"The cave should offer us some shelter from the windmanes," Amara said. "Yes?"

"Yes," Bernard said. "If we last that long. Even Thana can only build up a storm so fast."

"Will the windmanes attack the vord?"

"Never bothered my people," Doroga said. "But maybe they got good taste."

"Giraldi," Bernard said. "Organize the fighting squads and get the first two teams up into position. Get that stream brought up for water and that trench dug now."

"But—" Amara began.

"No, Countess. The men will need water if they're fighting. So we do it now, before the taken come any closer, and while we're at it, we dig those last ditch fortifications. Move, centurion."

"Yes, my lord," Giraldi said, and limped heavily back into the cave.

"Amara," Bernard said. "Get our Knights into position by that shelf, and get whatever water containers we have available up here for the fighting men."

"Yes, Your Excel—" Amara paused, tilted her head, and smiled at Bernard. "Yes, my lord husband."

Bernard's face brightened into a fierce smile, his eyes flashing. "Doroga," he said.

The Marat headman settled onto the ground between Walker's front claws. "I will sit here and wait for you people to stand in lines so that we can fight."

"Keep an eye on the queen," Bernard said. "Make sure she doesn't pass a cloak off to one of her taken and use them as a false target. Call me if she gets to within arrow range."

"Maybe I will," Doroga agreed laconically. "Bernard. For the only man here who had a woman last night, you are strung pretty tight."

Amara let out a nervous little laugh, and her cheeks flushed hot. She took two steps to Bernard and leaned up to kiss him again. He returned it, one hand touching her waist, a possessive gesture.

She withdrew from the kiss slowly, and searched his eyes. "Do you think we can hold out?"

Bernard began to speak, then stopped himself. He lowered his voice to a bare whisper. "For a little while," he said quietly. "But we're outnumbered, and the enemy has no fear of death. The men will get injured. Tired. Spears and swords will break. We'll soon run out of arrows. And I'm not so confident that Giraldi's man can bring up any water. With furycrafting, we might hold out for several hours. Without it . . ." He shrugged.

Amara bit her lip. "You think that we should use it after all?"

"No," Bernard said. "You've made your case, Amara. I think you've seen what we haven't. You're one damned sharp woman—which is one of the reasons I love you." He smiled at her, and said, "I want you to have something."

"What?" she asked.

"It's an old Legion custom," he said quietly, and took the thick silver band set with a green stone from his right hand. "You know that *legionares* aren't allowed to marry."

"And that most of them have wives," Amara said.

Bernard smiled and nodded. "This is my service ring. Marks my time with the Rivan Fourth Legion. When a *legionare* has a wife he isn't supposed to have, he gives her his ring to hold for him."

"I could never wear that," Amara said, smiling. "It's not quite big enough for my wrist."

Bernard nodded and drew a slender silver chain from his pocket. He slipped the ring through it, and placed the necklace gently about her throat, clasping it with a dexterity surprising for a man so large. "So a soldier will put his ring on a chain like this," he said. "It isn't a marriage band. But he knows what it means. And so does she."

Amara swallowed and blinked back sudden tears. "I'll be proud to wear it."

"I'm proud to see it on you," he said quietly. He squeezed her hands and glanced past her as a light drizzle began to come down. "Maybe it will make them miserable."

She half smiled. "It's a shame we don't have another, oh, thirty or so Knights Aeris. With that many, I might be able to do something with that storm."

"I wouldn't mind another thirty or forty earth and metalcrafters," Bernard said. "Oh, and perhaps half a Legion to support them." His smile faded, eyes sharpening as he watched the vord. "Better get moving. They'll be here in a moment."

She squeezed back hard, once, then hurried into the cave to round up their knights, as grim-faced veteran *legionares* began to arise, weapons and armor prepared, and fell into ranks with quiet, confident purpose. Giraldi hobbled by, using a shield as a kind of improvised crutch, giving quiet orders, tightening a buckle here, straightening a twisted belt there. He broke the century into its "spears," its individual files, ordering each file into its own squad.

The men of the first squad marched in good order to the front of the cave, while the others formed up behind them, ready to move forward if needed.

Amara rounded up the Knights, placing the archers on the elevated shelf and setting their remaining four Knights Terra on the ground before them. Each of the large men had strapped on their heavy armor and bore the monstrously heavy weaponry that only fury-born strength could wield. When those men cut into the unarmored ranks of the taken, it would be pure carnage.

Thunder rolled again, loud enough to shake the cave, and on the heels of the thunder, an eerie howl rose up through the morning air and sent rivulets of cold fear rippling over Amara's spine. Her mouth went dry, and she took a step up onto the elevated shelf to be able to see.

Outside, the file of taken was on the march, moving swiftly toward the cave. It was an eerie sight. Men, women, even children, dressed in Aleran clothing and Legion uniforms, all the clothing stained, twisted, rumpled, dirty, with no effort made to correct it. Faces stared slackly through the rain, eyes focused on nothing, but they moved in inhumanly perfect unison, step for step, and each of them bore weapons in their hands, even if they gripped only a heavy length of wood.

"Furies," breathed one of the *legionares*. "Look at that."

"Women," said another man. "Children."

"Look at their eyes," Amara said, loudly enough to be heard by everyone around her. "They aren't human anymore. And they all will kill you if you give them the chance. This is the fight of your lives, gentlemen, make no mistake."

The queen prowled along aside the lead rank until they reached bow range, at which time she fell back along the far side of the column, shielded from view by the file of taken. From behind the file, that eerie call rose up again, and Walker shook himself as he rose from his crouch, enormous claws flexing, and answered the call with a rumbling, trumpeting battle call of his own.

Bernard came up from the back of the cave and leapt up onto the shelf, his great bow in hand. "Men, you'll be happy to know that we'll have plenty of water to drink, compliments of Rufus Marcus. And it only tastes a little bit funny."

There was a rumble of low laughter from the readied *legionares*, and a couple of calls of, "Well done, Rufus!"

Outside, the column of empty-eyed taken grew closer, marching with steady speed through the rain.

"Careful now," Bernard said. "Front rank, keep your shields steady,

mind your bladework, and don't get greedy with the spears. Second rank, if a man goes down, do not pull him back. That's for third rank to do. Get your shield into place."

The steady tramp of hundreds of feet striking in unison grew louder, and Amara felt her heart begin to race again.

"Keep them from closing if you can!" Bernard called over the noise. "They're all going to be stronger than they look! And by the great furies, don't let any of your swings hit the allied auxiliaries."

"Just me and you," Doroga rumbled to Walker. "But they are calling us allied auxiliaries."

The gargant snorted. Another low round of chuckles rustled among the *legionares*.

The tramp of feet grew louder.

And hundreds, if not thousands, of crows came flashing over the crown of the hill outside the cave in a sudden, enormous, raucous cloud.

"Crows," breathed a number of voices in a whisper, including Amara's. The dark fliers always knew when there was a slaughter in the making.

Crows screamed.

Thunder rumbled.

The tread of feet shook the earth.

Doroga and Walker bellowed together.

The Alerans joined them.

And then the first rank of the taken raised their weapons, crossed into the cave, and slammed into a wall of Legion shields and cold blades.

▭▭▭▭▭ CHAPTER 44

Tavi had already done so many foolish things for one evening that he decided that stealing three horses wasn't going to significantly change the amount of grief he would receive whenever official attention finally settled on him. There was an ostler's filled with riding horses brought in from all

over the countryside around the capital, some from as far as Placida and Aquitaine.

One step upon the property revealed the presence of an unfriendly earth fury, and Ehren warned them that there was a watchful wind fury around the barn. Tavi and Kitai, not without a certain amount of smug satisfaction, used the methods Kitai had shown him and broke into the barn as they had the prison. Within moments, furies circumvented, locks picked, horses and gear liberated from the dark quiet of the stables, Tavi and Kitai rode out, leading a third horse for Ehren, who swung up into the saddle as they came out of the ostler's. They were half a block away before the furylamps around the burgled stable started flashing on, and though the proprietor attempted to raise a proper hue and cry, the attempts were lost amidst the general merry confusion of Wintersend.

"Do you understand me, Ehren?" Tavi demanded. He held the horses to a canter or a high trot at the very slowest, as they cut through the streets of the city, finding the swiftest way back up to the Citadel. "It's important that you tell her exactly what I said."

"I've got it, I've got it," Ehren said. "But why? Why go to *her* of all people?"

"Because the enemy of my enemy is my friend," Tavi said.

"I hope so," Ehren said. The scribe managed to stay mounted, which given the pain of the wound in his leg was no small feat. A canter seemed easier for him, but the bouncing trot they kept to most of the time had to have been sheer torture. "I'll manage," he said. "I'm slowing you down. Go on without me."

Tavi tilted his head. "You don't want to know what we're doing?"

"You're on the First Lord's business, obviously. I'm studious, Tavi, not blind. It's obvious that he's been keeping you close since Festival started." Ehren's face whitened, and he clutched at his saddle. "Look, just go. Tell me later." He half smiled. "If they'll let you."

Tavi stopped long enough to lean across his saddle and offer Ehren his hand. They traded a hard grip, and Tavi realized that Ehren's grip, while lacking the crushing power of Max's paws, was easily Tavi's equal. He hadn't been the only one who had been holding back around other Cursors.

Ehren turned off on Garden Lane, while Tavi and Kitai kicked their horses to a headlong run. Tavi gritted his teeth at the reckless pace, and had to hope that no one was too full of holiday spirit (or spirits) to get out of their way.

Kitai communicated in short sounds and curt gestures, as she had since leaving the warehouse. She seemed alert enough, but followed Tavi's lead without comment, and once he caught her staring down at her hands with exhausted eyes.

They drew up to the final approach to the gates of the Citadel, a long walkway flanked on either side by high walls of stone from which terrors of every sort could be rained down upon an invading army—as though any force would ever draw *near* the capital of all the Realm. Every few paces were heavy statues of bleak stone on either side of the walkway. They were of odd, part-human creatures that the oldest writings had called a "sphinx," though nothing like it had ever been seen in Alera, and historians considered them an extinct species if not an outright hoax. But each statue posed a very real danger to enemies of the Realm, as a few of a legion of earth furies bound into stone statues all over the Citadel and under the direct command of the First Lord himself. A single gargoyle, it was said, could destroy a century of Aleran infantry before it was brought down—and the Citadel had hundreds of them.

Of course, they would not be bringing down anything without a First Lord to loose them from their immobility. Tavi clenched his teeth and reined his horse in, slowing the beast to a jog, and Kitai followed suit.

"Why do we slow?" she murmured.

"This is the approach to the gate," he told her. "If we come in at a full gallop in the dark, the guards and furies here might try to stop us. Better put your hood up. I have the passwords to get us into the Citadel, but not if they see you."

"Why do we not use the tunnels?" she asked.

"Because the vord are running around down there," Tavi said. "And for all we know, Kalare's men might still be watching the tunnels like they were before. They'd be watching some of the key intersections, and if we had to go around them, it would take us hours out of our way."

Kitai pulled up her hood. "Can you not simply tell the guards what is happening?"

"I don't dare," Tavi said. "We have to assume that the enemy is watching the palace. If I try to raise the alarm here, it might take me time we don't have to convince them, and they sure as crows won't let me leave to go to the First Lord until everything is sorted out. Once the alarm goes out, the enemy will hurry to strike, and the First Lord still won't be warned."

"They might not believe you," Kitai said, disapproval in her tone. "This entire falsehood concept among your people makes everything a great deal more complicated than it needs to be."

"Yes it does," Tavi said. The horses' breath steamed in the night air, and their steel-shod hooves clicked on the stones of the entryway, until they drew up even with the Citadel gates.

A centurion on guard duty challenged them from over the gate. "Who goes there?"

"Tavi Patronus Gaius of Calderon, and companion," Tavi called back. "We must enter immediately."

"I'm sorry, lad, but you'll just have to wait for morning like everyone else," the centurion said. "The gate is closed."

"Winter is over," Tavi called to the man. "Respond."

There was a second of blank, startled silence.

"Winter is over," Tavi called again, more sharply. "Respond."

"Even summer dies," the centurion called back. "Bloody crows, lad." His voice rose to an orderly bellow. "Open the gate! Move, move, move! Osus, get your lazy tail out of that chair and craft word to the stations ahead of the messenger!"

The great iron gates swung open with a low, quiet groan of metal, and Tavi kicked his horse forward into a run, passing through the gates and into the city-within-a-city of the Citadel. Two more tiers upon the Citadel consisted of housing for the Royal Guard and Crown Legion, the enormous support staff needed to keep the palace, the Hall of the Senate, and the Hall of Lords running smoothly. The road ran in a straight line until it reached the base of another tier, sloped into a zigzagging ramp up to the new level, then straightened out again, into the upper level where the Senate, Lords, and Academy lay.

Tavi passed them all, to reach the final, fortified ramp. Guards at the base and head of the ramp alike waved them through without stopping them, and Tavi reined his horse in sharply at the palace gates, which were opening even as he dismounted. Kitai followed suit.

Several guardsmen came forth, two of them taking the horses, while the centurion on duty nodded briskly to Tavi—but his eyes were more than a little suspicious. "Good evening. I just got word from the Citadel gates that a Cursor was coming through with tidings of a threat to the Realm."

"Winter is over," Tavi replied. "Respond."

The centurion scowled. "Yes, I know. You're using the First Lord's personal passwords. But I can't help wondering what the crows you think you're doing, Tavi. And who is this?" He looked at Kitai and flipped his wrist lightly. A little breath of wind blew the hood back from Kitai's face, her canted eyes, her pale hair.

"Crows," spat one of the guardsmen, and steel grated on steel as half a dozen swords hissed from their scabbards. In an eyeblink, Tavi found himself facing a ring of bright swords and soldiers on guard and about to use them. He felt Kitai tense beside him, her hand dropping to the knife on her belt.

"Drop the blade!" barked the centurion.

Guardsmen quivered on the edge of battle, and Tavi knew that he had only seconds to find a way to stop them before they attacked.

"Stop this at once," Tavi trumpeted. "Unless you would prefer to explain to the First Lord why his guardsmen murdered the Marat Ambassador."

Stillness settled on the scene. The centurion lifted his left hand, slowly, fingers spread, and the guardsmen eased out of their fighting stances—but they did not sheathe their blades.

"What is this?" he asked.

Tavi took a deep breath to keep his voice steady. "Gentlemen, this is Ambassador Kitai Patronus Calderon, daughter to Doroga, Headman of the *Sabot-ha,* Chieftain of the Marat. She has only now arrived in the capital, and my orders are to escort her inside at once."

"I haven't heard anything of this," the centurion said. "A female ambassador?"

"Centurion, I've given you my password, and I've explained more than I should have. Let us pass."

"Why are you in such a hurry?" he said.

"Listen to me," Tavi said, lowering his voice. "Ambassador Varg's chancellor has spent the last six months smuggling Canim warriors into the Deeps. As we speak, at least a score of them are on their way to the First Lord's meditation chamber to kill him."

The centurion's mouth dropped open. "What?"

"There may be a spy within the palace, so I want you to get every fighting man you have as quietly as you possibly can and head for the stairs to the mediation chamber."

The centurion shook his head. "Tavi, you're only a page. I don't think—"

"*Don't* think," Tavi snapped. "Don't ask questions. There is no time for either. If you want the First Lord to live, just *do* it."

The man stared at him, evidently shocked at the authority in his tone. Tavi had no more time to waste on the centurion. The guards in the stations on the stairs had to be alerted at once, and they were too deep in the mountain for a windcrafting to carry word to them. He turned and sprinted into the palace, calling over his shoulder, "Do it! Hurry!"

He went up the long, smooth slope of broad marble stairs leading into the palace, into a reception hall topped with a rotunda the size of a small mountaintop, turned right, and went flying through the dimly lit halls. It seemed that it took him forever to reach the stairs, and he was terrified that he might already be too late. He slammed open the door to the first guard station, his heart in his teeth.

Four guardsmen lurched up from their card table, coins and placards scattering as the table overturned and they drew their weapons. Two more men, one sharpening a blade and another mending a torn tunic, also came to their feet, weapons in their hands.

Centurion Bartos opened a door and emerged from the jakes, his sword in one hand while the other held up his trousers. He blinked for a moment at Tavi, then his face darkened into the beginnings of a thunderous rage. "*Tavi,*" he snarled. "What is the meaning of this?" He stared from Tavi to Kitai. "A *Marat? Here?* Are you *insane?*"

"Winter is over," Tavi said. "Respond. No, wait, don't bother, there's no time. Centurion, there are more than twenty Canim on their way here as we speak. They're coming to kill Gaius."

No sooner had Tavi spoken the words than a wailing scream of pain and terror echoed down the hall behind him. His heart leapt into his throat and he whirled, eyes wide, his knife in his hand though he hadn't realized he'd drawn it.

"Was that Joris?" muttered one of guardsmen. "It sounded like Joris."

Another scream, this one closer, louder, came echoing through the halls. It was followed by shrieking, pleading babbles of sound that abruptly ended. Then, from the direction of the Black Hall, an enormous, lean form stepped around the corner at the end of the hall with lupine grace. It dropped into a crouch, the Cane's muzzle all but hidden in the deep cowl of its cloak. Blood dripped from its nose, muzzle and fangs. The Cane was spattered in scarlet, and its blade of crimson steel shone wetly. It stood

motionless for a moment, then a second Cane came around the corner. And another. And another. They prowled forward, their lazy-seeming steps deceptively swift, and the hall filled with silent Canim warriors.

The Royal Guard's alarm bells began belatedly ringing throughout the Citadel.

Bartos stood at Tavi's shoulder for a second, staring at them in wide-eyed shock. "Great furies be merciful," he whispered. Then he whipped his head around, and shouted, "Shields! Prepare for battle!"

Tavi grabbed the iron door and swung it shut, then shoved the three heavy bolts into position, locking it. Guardsmen slapped on their helmets, strapped on their shields, and kicked an open area around the doorway, clearing it so they had a place to fight. Tavi and Kitai backed away to the far side of the room, where the stairs down began.

"Tavi," Bartos snarled, "get down to the next station and send them up here. Then get down to the First Lord. This door should hold until he's here, then we'll get him out of—"

There was a sound like a shock of thunder, a screaming of metal as the heavy bolts and hinges tore, and the heavy iron door was smashed nearly flat to the stone floor.

It crushed Centurion Bartos beneath it.

Blood splattered over the entire room, slapping against Tavi like a burst of hot rain. The torn metal of the bolts and hinges glowed orange-red with heat where they had torn.

The bloody-mouthed lead Cane, one of its pawlike hands now crushed to swollen pulp, stepped onto the door with lethal grace and slashed at the nearest guardsman. The guardsmen hesitated for no longer than a panicked heartbeat, but in that time a second Cane came through the door. The guardsmen formed a line in front of the Canim, their shields smaller than standard Legion issue, their swords glinting wickedly.

One guardsman struck at the nearest Cane, his sword blurring with fury-born speed. The thrust sank home in the Cane's belly; but the taken Cane did not seem to notice, and its return stroke nearly took the guardsman's head from his shoulders before the man could draw his sword back and raise his shield. A second guardsmen caught a downstroke on his upraised shield, only his fury-born strength allowing him to hold the blow from his body, then swept his *gladius* in a scything upward arch, striking the Cane's weapon arm several inches from the wrist and sending its hand and weapon spinning through the air.

The Cane never so much as blinked. It simply slammed the stump of its arm into the guardsman's shield, the force of it driving his boots across the floor, and leapt at him, jaws snapping. The guardsman went down, desperately trying to interpose his shield between his throat and the Cane's teeth. Kitai's hand blurred as she drew her knife and threw it all in the same motion. The blade tumbled end over end and sank into the Cane's left eye. The Cane convulsed with a spasm of reaction, perhaps even with pain, and in that moment the man beside the downed guardsman struck cleanly through the Cane's neck, taking its head clear off its shoulders.

But more Canim pressed through the doorway, driving the guardsmen back step by step. Each step made more room for an attacking Cane to fight, and now three of them were battling the guardsmen instead of two. Tavi realized that the disparity of numbers and raw power meant that there was no way the guardsmen would be able to hold the room for long.

"Go!" screamed another of the guardsmen. "Warn the First Lord!"

Tavi nodded at him, his heart pounding with fear, and turned to bound down the long staircase as swiftly as he had ever done it in his life. Kitai followed close behind.

⊡⊡⊡⊡ CHAPTER 45

Screams followed them down the stairs. Defiant, angry shouts blended in with shrieks of agony, and steel rang on steel. Just before they reached the second guard station, Tavi nearly ran headlong into a guardsman coming up the stairs, his expression concerned.

"Tavi," the guardsman said. "What's going on up there?"

"Canim," Tavi panted. "They're trying to get to the First Lord."

"Crows," the guardsman said. "Bartos is holding them?"

"He's dead," Tavi said, his voice flat and bitter. "They're in bad shape up there, but the alarm has been raised. If they hold, they can keep the Canim

in the hallway until reinforcements arrive, but if the Canim can get onto the
stairs . . ."

The guardsman nodded, and his eyes flicked to Kitai.

"She's with me," Tavi said hurriedly.

The guardsman hesitated, then gave him a sharp nod, ducked back into
the second guardroom, and started snapping orders, getting the men on their
feet and heading on up the stairs. Tavi stayed out of their way and continued
down, the faint sounds of battle and alarm fading to silence by the time he
reached the bottom. Tavi flew through the antechamber into Gaius's medi-
tation room.

Gaius lay as he had before, unmoving, with Fade crouching close by.
Max was stretched out on the cot in the same position Tavi had left him in,
more unconscious than asleep. As Tavi came through the door, Maestro Kil-
lian came to his feet in a single smooth motion, his cane gripped tight. Sir
Miles stood up at the desk, sword in hand.

"Marat!" Miles snarled, and bounded forward, sword extended.

"No!" Tavi cried.

Kitai dodged the thrust, whipped her cloak from her shoulders and
flung it wide, like a net, at Sir Miles. He cut it out of the air, but in the time
it took him to do it, Kitai had darted out of the room, back to the stairway,
and crouched there, her pose feline, her eyes bright and unafraid.

Tavi got between Miles and the door. "She's unarmed!" he shouted. "Sir
Miles, she is not our enemy here."

"Miles." Killian's voice cracked like a whip. "Stay your hand."

Sir Miles, his eyes flat with hatred, halted in place, but his eyes never
left Kitai.

"Tavi," Killian said. "I presume this is your partner in Maximus's jailbreak."

"Yes, Maestro," Tavi said. "This is Kitai, the daughter of the Marat Chief-
tain, Doroga. And my friend. Without her help tonight, Max would still be in
jail, and I would be dead, and there is no time to discuss this."

Killian's face clouded with anger, but Tavi could almost see him force
himself to remain calm, and ask, "And why is that?"

"Because twenty Canim are coming down the stairs to kill the First
Lord," Tavi said, trying not to let the mild vindictive satisfaction he felt show
in his voice. "The alarm has been raised, but they were already at the first
guard station when I came down. Centurion Bartos is dead, and I don't
think that they can hold them in the stairway for long."

Miles spat out a sulfurous curse and started for the doorway.

"No, Miles," Killian said.

"The men are in danger," the captain growled.

"As is the First Lord," Killian said. "We leave together. Miles, you'll lead. Tavi, get Max up. He'll be next. You and Fade put Gaius on Max's cot and carry it up."

Tavi crossed the room to his friend before Killian had finished talking, and simply picked up one edge of the cot and dumped Max onto the floor. The large young man landed on the ground with a grunt and thrashed his way to wakefulness. "Oh," he said. "It's you."

"Max, get up," Tavi said quietly. "Get a sword. There are Canim warriors coming down the stairs." He grabbed the cot and dragged it over to the bed, where Fade rose up and lifted Gaius without evident effort. The slave settled him on the cot and wound blankets around the old man. Tavi glanced up and saw that Fade wore his sword on his belt, though it was largely hidden by the fall of his long, ragged overtunic.

Max pushed himself to his feet, tugged his shirt back on, and muttered, "Where's a sword?"

"Antechamber," Killian provided. "Lower drawer of the liquor cabinet. It's Gaius's."

Max paused, and said, "If you give me a minute, I can get into costume. It might . . . I mean, If they're here for Gaius, and they think they get him . . ." He let his voice trail off.

Killian's expression was nothing but stone. He nodded, and said, "Do it."

"Right," Max said. He exchanged a look with Tavi that couldn't hide his fright, then stalked out into the antechamber.

Tavi took a moment to take a sheet from the bed and loop it around the unconscious First Lord, then tied it as tightly and securely as he could, to help hold the old man on the cot, should it tilt. "We're ready to move him," Tavi said quietly.

"Very well," Killian said. "Maximus?"

Tavi and Fade picked up the cot and carried it from the meditation chamber. There was a pause, a quiet groan, then Max, wearing Gaius's form, appeared in the doorway. He bore the First Lord's long, heavy blade naked in his hand. "Ready," he said, though his voice was still Maximus's. He frowned, coughed a couple of times, one hand touching his throat, and said,

this time speaking as Gaius, "Ready. Not sure how much crafting I can do, Maestro."

"Do your best," Killian said quietly.

Kitai made a hissing sound from the stairway, her eyes focusing up the steps. Without really thinking about it, Tavi drew his knife from his belt and flipped it through the air to her. She glanced aside, caught it by the handle as it came to her, and dropped it into a low fighting grip, her eyes searching up the stairway.

Killian tilted his head to one side a second later, blind eyes narrowing. "Good ears, girl," he murmured. "Miles."

The captain slipped up to stand a few steps above Kitai and crouched down low, sword ready. Then something came around the corner, and Miles rose, blade in hand. There was a flash of steel, a ringing sound, and a panicked cry. Then Miles grunted, and said, "Prios, man, it's me. Easy, easy."

Miles came back down, half-supporting a wounded guardsman. Prios was a man of medium height and build who was better known for his sharp eyes than his sword arm. His right arm was dangling limply and covered in blood, and he had lost his helmet. A scalp wound matted his hair to his skull on the left side. He bore his sword in his left hand, and was pale.

Tavi surreptitiously drew a blanket up to conceal most of Gaius's face. There was a moment of silence, then Killian nudged Max with his elbow.

Max coughed again, and said, "Report, guardsman. What is happening?"

"They're mad," the guardsman panted. "Mad, sir. They don't bother to defend themselves. They ignore wounds that should put them on the ground. It's as if they don't care about living."

Max put a hand on the man's shoulder and said, "Prios. I need you to tell me the tactical situation."

"Y-yes, my lord," the guardsman panted. "The Canim pushed us out of the first room, and some of them are holding it against the reinforcements. There are at least dozen more coming down. My sword arm was out, and Red Karl was the senior spear. He ordered me to head to the second position, bolt all the doors behind me, then report to you, my lord."

Which meant, Tavi thought, that the guardsmen on the stairs above had just trapped themselves with the Canim and thrown their lives away in an effort to buy the First Lord more time. Max inhaled sharply and shot a glance at Killian. "They've lost, then. And they knew it."

"My lord," Miles said. "If we can beat them to the second room, it will give us the best chance to hold them. They'll have to come through the doorway, and we'll be facing them on even ground instead of on the stairs."

"Agreed," Max said. "Move out."

Miles nodded sharply and started up the stairs. Prios and then Max followed him, then Killian. As the Maestro took the stairs, he paused, and said, "The Marat girl goes last."

Fade glanced at Tavi, then took the stairs behind Killian, carrying the cot without apparent effort. Tavi had to grunt and strain for a moment as more of the weight settled on him, but he held his end up and kept pace with Fade.

Kitai pressed closely behind him, and hissed, "Will your warriors' sorceries not simply burn them?"

Tavi grunted and panted, answering as they climbed. "They don't dare in quarters this close. A firecrafting would suck out most of the air and heat the rest until it scorched our lungs. And we're so deep that an earthcrafting could bring the roof down on us, and an aircrafting would be so weak it's useless. We have to fight."

"Quiet," Miles snarled.

Tavi gritted his teeth and set his mind to keeping his end of the cot lifted and moving steadily. A hundred stairs later, his arms and shoulders began to quiver and ache. Kitai promptly stepped up beside Tavi on the stairway, and said, "Let me take this corner."

Too out of breath to argue, Tavi shifted his grip to allow Kitai to take half of his load, and they continued on up.

"Halt," came a low order from up the stairs. "We're close. Wait here."

Tavi heard Miles's boots on the stairs once, then silence. A moment later, Miles called, "We're clear to the second station. Both doors are still up. Hurry."

They resumed their pace and spilled into the guardroom. "Stay clear of the door," Tavi warned Miles. "They smashed the other one straight down to the floor. That's how they killed Centurion Bartos."

Miles eyed Tavi, then stayed to one side of the iron door, placed his left hand on it, and closed his eyes. There was a low, deep hum. Miles frowned, eyes still closed, and said, "Sire, I recommend we do everything we can to strengthen this steel before the Canim get here."

"Of course," Max replied. He went to the other side of the door and

leaned his own hand against it in a mirror image of Miles. The humming sound grew louder.

"Fade, this corner," Tavi said. He, Fade, and Kitai carried the First Lord into the back corner of the room and set the cot down carefully. Tavi then dragged the heavy table over to the corner and dumped it onto its side to set up a makeshift barrier. Fade hurried around to crouch behind the barrier, dull eyes unfocused, his mouth open in a witless expression.

"Good," Killian approved, then swept the tip of his cane up to point at the weapons rack on the wall. "Arm yourselves."

Kitai went to the rack and seized a pair of short, heavy blades and a short-hafted spear. She tossed the latter to Tavi, who caught it and tested its balance. Killian took a sword as well, keeping his cane in his left hand.

There was no warning. Just a thundering roar of impact and a shriek of warping metal, as a section of the door the size of a Wintersend ham bulged out under the force of a blow. It happened twice more, enormous dents driven into the bolted door, but the bolts held.

"Won't be able to hold this for long. Bending the metal is heating it up," Miles grunted.

Dents continued to erupt from the door, one every four or five seconds. Tavi set his spear aside, fetched a ewer, and dipped it into the water barrel against the wall, then splashed cold liquid over the door without ceremony. Steam rose in a hissing cloud.

"Well done, boy," Miles said. "It might buy us time."

Tavi rushed back to the barrel and returned with more water, slopped it over the door, and repeated the exercise. More dents bloomed up from the steel, and others grew under repeated blows, until the frame of the door itself groaned, the steel bent and warped until it no longer matched the doorway. Tavi glimpsed a cloaked Cane on the other side as he threw more water onto the heated metal.

There was a sudden acrid, burnt odor in the air, and Miles ground his teeth. "Can't hold it. Have to pull off the door in half a minute, then they'll be in here. Everyone stand ready."

Tavi's heart pounded in his chest, and he exchanged the ewer for the spear. Fade crouched behind the table. Prios stood several feet back from the door. He had bound his mangled right arm into a sling and held his *gladius* in an awkward left-handed ready position. Kitai, her expression unconcerned,

twirled the sword in her right hand, then the one in her left, and stood beside Tavi, just in front of the overturned table.

"You know how to use one of those?" Tavi murmured to her.

"How difficult could it be?" Kitai replied.

Tavi arched an eyebrow.

"Hashat showed me how once," Kitai explained.

"Oh," he said. "Well. When it starts, try to stay close to me. I'll look after you."

Kitai threw back her head and burst into a silvery belly laugh. It belled through the room in a wave of utterly incongruous amusement, and everyone but Miles and Max paused to look back at her.

"You will protect me. That is funny," Kitai said, shaking her head, laughter bubbling under her words. "That is very amusing, Aleran."

Tavi's cheeks heated up.

"All right," Miles said to Max, his voice strained. "After the next hit, we back off, let the door fall, hit the first one as he comes in."

"I have a better idea," Max panted.

The door shuddered under another impact, and Miles shouted, "Now!" and whipped his hand away from the door.

But Max didn't do that. Instead, he drew back his right hand, teeth clenched, and as he did the stone around him quivered with sudden tension. Max let out a roaring shout and drove his fist forward.

The door, no longer made stronger and more flexible by Max's and Miles's furycrafting, tore from its hinges in a shriek of shearing metal. The door slammed straight down, just as it had before the fists of the Canim in the first guardroom, and the Cane standing before it was crushed flat. There was a single beat of stunned silence, then Miles bounded out over the fallen door, his sword whirling in an all-out attack.

There was as much difference between Sir Miles's swordplay and that of the average guardsman as there was between a burrowbadger and its enormous cousin, the gargant. His sword sheared through mail, flesh, and bone with contemptuous ease, shattered the scarlet steel swords of two Canim, and spattered the stairs and walls with blood. Before any of the Canim could regain their balance, Miles had already danced back over the fallen door and back into the guardroom. One Cane followed on Miles's heels, but Max was ready, and the First Lord's sword swept straight down from an overhand grip, and all but split the Cane's torso in two.

Gouting blood and dying, the silent Cane's head snapped around to view its slayer. Then the Cane's eyes widened and a weak, bubbling snarl rippled from its muzzle. The Cane threw itself at Max, slammed hard against the young man wearing Gaius's features, and crushed him against the stone wall. It started ripping and tearing at Max with its fangs.

Miles shot a glance at Max and began to step his way, but a second Cane came through the doorway, and Miles was forced to engage it before it could escape the hampering confines of the doorway and fully enter the room.

Prios leapt forward, sword cutting hard at the horribly wounded Cane. The swing was clumsy but powerful, and it bit deep into the Cane's near thigh, drawing even more blood.

The Cane didn't seem to notice. The mangled warrior should already have died, but the horrible will of the vord refused to surrender to mere death and imbued the Cane with increasing ferocity as more savage blows struck home. Max screamed.

"Max!" Tavi shouted, and ran forward. He darted to the left flank of the Cane and charged, driving his spear home between the Cane's ribs. The spear's crosspiece struck hard, and the weight of Tavi's charge shoved the Cane away from Max. It twisted and fell, snapping at the spear in its flank, but the gesture was a futile one. The Cane collapsed abruptly to the ground, jaws still clashing.

Tavi jerked the spear out of the fallen Cane and whipped his head around to look at Max. In Gaius's form still, he was covered in blood. There was a savage wound on his left forearm, bleeding profusely, and there was blood running from his head. One of his legs was twisted so that his foot faced opposite the way it should have. Tavi seized the collar of Max's shirt and hauled him back toward the makeshift barrier. Max was limp and heavy, and Tavi had all that he could do to move him a couple of feet at a time, until Fade showed up at Tavi's side and seized Max beneath the arms and drew him back behind the barricade.

Maestro Killian followed them behind the barricade, grimacing as he stared down with blind eyes and let his fingers run over Max's form. He drew a knife, slashed Max's sleeve away, then used it to bind the wound on his forearm tightly closed to stop the bleeding. "Tavi, help Miles and Prios. That door must be held at any cost."

Tavi nodded and dashed back to the doorway, already gasping for breath and growing no less terrified. Miles had already opened a dozen wounds on

the Cane trying to batter its way into the room. The bloody-eyed wolf-warrior showed no signs of pain, nor of fear, and fought in silent, steady fe-rocity. The Cane's sword was no match for Miles's speed and skill, and Miles was untouched, but the heavy blows raining down on him were forc-ing him back, inch by inch.

As Tavi got close, Miles snarled, "Tavi, bind him high."

Tavi reacted with instinctive, thoughtless speed. The Cane's sword swept down, and Tavi reached over Miles's shoulder to catch the blade on the cross brace of the spear and sweep it to one side, pinning the sword against the doorway.

"Good!" Miles barked, already moving. He closed in and slashed in an upward arch that opened the Cane from groin to throat, spilling blood and worse into the doorway as the Cane thrashed uselessly and collapsed to the floor dead. The next Cane on the stairs leapt forward with reckless speed, only to be met by the glinting silver arcs of Miles's deadly slashes. Tavi had to duck to one side to be out of the path of the Cane's leap, and it fell writhing wildly to the floor—in three separate pieces.

And then there was a flash of motion on the stairs and a blur of grey cloak. Tavi only had time enough to be astounded that *anything* could move that fast, then the figure leapt to one side, bounded off the wall, and vaulted up, over Miles's head. The captain whipped his sword through another at-tack, but was a hair too slow, and the figure went right by him. It turned in midair to meet the ceiling with all fours and propelled itself down upon the wounded Prios.

The guardsman never had time to shriek before a slender hand, skin a shining and reflective green-black, fingers tipped with gleaming claws, tore his throat open to the spine.

Tavi drove his spear at the figure, but it was simply too swift, and the spearhead struck sparks against the stone floor as the figure leapt again, floor to wall, kicking off the wall to drive at Sir Miles. Miles's sword lashed out and struck the figure with a sudden shower of sparks. The figure screamed, a hor-rible, metallic scream that had haunted Tavi's nightmares, off and on, for two years.

"Aleran!" Kitai snapped. "Ware! The vord queen!"

Claws lashed at Miles, literally too quickly to see, but the Captain of the Crown Legion had a lifetime of experience, and his sword was there to counter the vord queen, his feet shuffling to keep the deadly balance of

distance from falling to the queen's favor, circling to one side—and Tavi suddenly realized that Miles was forcing the vord queen to turn her flank and back to Tavi.

Miles danced another two steps to one side and Tavi drove the tip of his spear at the vord queen's back—only to be astounded again at the creature's speed as she spun, seized the haft of the spear, and in a surge of motion hurled Tavi away.

Tavi's vision blurred as he flew through the air. He had a flickering glimpse of Prios's sightless, terrified eyes, then he bounced off something hard, fell, and landed on stone.

His head spinning, Tavi fought to lift his head, looking around wildly. He was sprawled upon the steel door Max had crushed to the floor, and it was painfully hot.

He was also surrounded by Canim.

Two had already entered the guardroom. Another had one foot on the fallen door, and its empty scarlet eyes stared directly down at Tavi. Even as he watched, another taken Canim appeared behind that one, scarlet eyes flat. And another beyond that one.

Every single one of them bared bloody fangs and gripped bloodier weapons.

Every single one of them could tear him to literal pieces in a heartbeat.

And every single one of them turned to Tavi.

CHAPTER 46

Amara clenched her sword until her knuckles ached as the taken holders assaulted the cave. The fighting was elemental, brutal. Empty-eyed holders attacked the Legion shield front with spades and farm implements and their naked fists, with axes and old swords and hammers from the smithy. The heavier weapons struck with unbelievable force, deforming shields, denting helmets, crushing bones even through the *legionares'* heavy armor.

Two men in the first squad were killed when the first taken holders with hammers attacked, and after that Bernard began allowing his archers to expend arrows on the taken armed with heavy weaponry. Only a hit in the eyes or mouth would put one of them down reliably, but Bernard himself was an archer of nearly unbelievable skill, and he demanded that the woodcrafters in his command keep pace. When one of Bernard's archers shot, their arrows struck home and one of the taken went down.

Though she hadn't yet lifted her blade, Amara found herself panting in sympathy with the struggling *legionares,* and she started shooting looks at Bernard when the men began to tire. After what seemed like a small eternity, Bernard called, "Countess, drive them back."

Amara nodded sharply to the Knights Terra with her, and the *legionares* parted as they came through. Amara's arm flashed up, her blade intercepting a descending club and sliding it away from her before it struck her helm. Then her Knights Terra waded into the fray with fury-born strength, heavy swords ripping through the taken with hideous efficiency while Amara watched their flanks and backs. Within a minute, they had driven the taken back to the cave's mouth, and Amara called them to a halt before her Knights advanced outside the cave, where the taken could have enfolded them and swamped them under sheer numbers.

Getting back took longer. They did not dare simply retreat, allowing the enemy to follow them closely, building up deadly momentum and risking confusion in their own ranks during frantic movement. It had to be slow, controlled, to enable them to hold their lines, so Amara and the Knights Terra fought a steady, deliberate retreat back to their original position. The second squad had taken up the defensive line while the first squad retreated to breathe, drink, and rest.

She was panting and badly winded even from the brief engagement. It was one of the fundamental truths of battle that there was nothing, absolutely *nothing* more wearying than the exertion, exhilaration, and terror of combat. Amara made sure the fighting men had water before taking a tankard of it herself, and watched the battle. Second squad lost a man when a stray blow from an axe split his foot like a stick of cordwood and he had to be hauled back to what passed for their hospital. A second man hesitated when a taken holder who looked like a middle-aged woman came at him, and it cost him his life when she threw him out of the shieldwall and into the midst of the taken attackers. Moments later, another man was struck

senseless by a blow to his helmet, but before his companions could haul him back, the taken holders seized his wrist, and in the ensuing tug-of-war ripped his arm from the socket.

The plan called for second squad to last at least another four or five minutes. Amara didn't see how they could possibly do it without losing more men. The taken holders had no interest in self-preservation, and they were willing to die to cripple or kill a *legionare*—and there were three or four times as many of them as there were Alerans. They could absorb the losses, and there was very little that the Alerans could do about it.

The sun had fully risen by then, and no Aleran relief force had come roaring down from the skies or across the fields. Nor, she thought, was it likely that any was coming. The rain began to fall more heavily, the wind to gust and howl, and crows haunted every tree in sight, settling down in the frigid wind to wait for corpses to fall.

Their fight was a hopeless one. If the rate of casualties remained steady—and it wouldn't, as the *legionares* grew more winded and wounded, and as Bernard's archers ran entirely out of arrows—then half of the combat-capable *legionares* would be out of action by late morning. And when the decline came, it would come swiftly, a sudden collapse of discipline and will under the relentless violence of the taken holders' assault.

They were unlikely to live until midday.

Amara forced that cold judgment from her thoughts and attempted to focus on something more hopeful. The most stable factor in the engagement was, surprisingly, Doroga and his companion. Walker proved a dominating, even overwhelming presence in the battle, his immense power in the confines of the tunnel unmatched by anything the vord had to throw at them. The Gargant seemed to operate under a very simple set of ground rules: He crouched more or less at his ease on his side of the cavern. Anything that walked within reach of his vast sledgehammer paws and stone-gouging claws got crushed or torn apart in swift order. Doroga, meanwhile, crouched between Walker's front paws with his war cudgel, knocking weapons from the hands of the taken and dispatching foes crippled to immobility by Walker's claws. The taken never slacked in their assault, but they began to show more caution about approaching Walker, attempting to draw the gargant out with short, false rushes that did not manage to lure him into the open.

Amara watched in awe as the gargant's paw batted a taken *legionare*

through the air to land thirty feet from the mouth of the cave, and thought that even though they could not furycraft the cave's entrance into a narrower, more defensible position, Doroga and Walker, savagely defending half the cave's mouth on their own, were in fact more effective than a wall of stone. A stone wall would only have stopped the taken holders. Doroga and Walker were doing that and additionally dispatching enemies very nearly as swiftly as the Alerans. It had never occurred to Amara how the confined space of the cave would magnify the gargant's combat ability. Gargants in an open field of combat were largely unstoppable, but not generally difficult to avoid or to flank. But in the cave's confines, that changed. There was simply nowhere to run to get out of the beast's way, no way to encircle it, and the gargant's raw, crushing power made Walker much more dangerous than Amara had assumed he would be.

Amara had barely finished her water when Bernard ordered her into the fray again, moments short of the time that had been allotted to second squad to hold. She and the Knights Terra once again bought the *legionares* time to switch fresh bodies for winded ones.

Third squad did better than either second or first, but the fourth simply ran into a patch of horribly bad luck and lost their entire front rank in the space of a few seconds, necessitating an early advance from the fifth squad, and Amara and her Knights had to enter the battle again before they'd had a chance to breathe properly. Doroga took note of the situation and guided Walker into a short rush forward in time with Amara's Knights, and the gargant's bellowing challenges shook dust from the cave's roof.

It was only with Walker's help that they managed to successfully press the enemy back to the cave mouth again, giving the *legionares* behind them a chance to change out with fresh fighters. There was a quivering quality to the fight now, an uncertainty in the movements of her Knights. They were tiring, their movement hampered by the remains of fallen foes and *legionares* alike, making it more difficult to move and fight together. Worse, each drive forward only showed them how many of the enemy yet remained outside. For all their efforts, there were still too many of the taken to count easily, and no sign at all of the queen.

They reached the mouth of the cave, and Amara called a halt. They began their steady, ordered withdrawal back to their original positions.

An abrupt blur of grey cloak streaked into the cave along the ceiling, crawling like some unthinkably huge and swift spider.

The vord queen.

Amara had seen it the instant it appeared, but before she could draw a breath to shout a warning, the shape flung itself from the ceiling of the cave and hammered into the Knight on the left end of their line, a large and good-natured young man with red hair bleached to straw by hours in the sun. He was in the middle of a backswing, warding off a taken *legionare* with his blade, and never saw the queen coming. The vord hit him in a tangle of whipping limbs. There was a sound like a small cloud of whip cracks, and the queen flung itself to the opposite wall, behind Walker, only to bound off it like a coiled spring and pounce upon the rightmost Knight in the same fashion, while blood blossomed up in a sudden shower from the redheaded Knight.

The second Knight was an older man, a career soldier, and he had enough experience to dodge away from the queen and whip the crown of his heavy mace in an overhand, shattering blow.

The vord caught the mace in one hand, and stopped it cold. The queen's skin was a shade of deep green-black, shining and rigid-looking, and with a twist of its body it threw the Knight off-balance and sent him staggering into the waiting taken. Before the Knight could regain his balance, they seized him and mobbed him as slives did a wounded deer, while the queen bounced to the left-hand wall again, barely avoiding a crushing kick from Walker's left hind leg. More taken, this time moving with some kind of hor-rible excitement, began to press recklessly into the cave.

The creature was so *fast,* Amara thought in a panic, and called upon Cirrus, borrowing of the fury's fluid speed.

Time did not slow—not precisely. But she suddenly became aware of every detail of her surroundings. She could see the gleam of light and the stains of blood upon the vord queen's claws. She could see and smell the pulsing fountain of blood pouring from the first Knight's throat, slashed open to the bone. She saw individual raindrops as they fell outside, and the sway of the vord queen's rain-soaked cloak.

Amara's head turned to follow the queen, as she shouted, "Bernard!" The queen bounded off the wall and flew at Amara, an alien nightmare of grace and ferocity and power.

Amara slipped to one side, as legs of the same green-black chitin ex-tended, their claws poised to rake in tandem with the claws upon the queen's

hands. Amara's sword swept up to strike at the nearest leg, sweeping it away from her and biting into green-black chitin, and the queen went into a tumble as the blow robbed her of balance. One claw flailed at Amara as it went by, missing her eye by inches, but she felt a sudden fire high on her cheek.

The queen landed on all fours, recovering its balance in an instant, and even with Cirrus's help, Amara was too slow to change her stance to defend against an attack from the opposite side of the first. She turned desperately, sword raised, but the vord queen was already coming, deadly talons set to rend and rip.

Until the last of the Knights Terra, Sir Frederic, whipped his spade straight down across the queen's back, a sledgehammer blow that drove her into the cave floor. The queen twisted like a snake, claws raking at Frederic's near leg, and the young Knight screamed in agony and fell to his knees. The queen tried to roll closer, claws poised to strike at the arteries in Frederic's thigh, but Frederic had bought Amara enough time to complete her turn and thrust her sword into the queen's back.

The blow struck savagely, enhanced with fury-born speed, and would have spit a man in mail clean through. The vord queen, however, was another matter. The tip of Amara's blade barely sank in, not even to the full width of the sword. The queen changed directions, horribly swift, one leg sweeping a cloud of dirt on the cave floor into Frederic's eyes while the other three flung her at Amara.

"Down!" Bernard roared, and Amara dropped to the cave floor like a stone. An arrow swept by her, so close that she felt the wind of its passing, and the broad, heavy head bit into the vord queen's throat.

She let out a deafening shriek and fell into a roll. Amara struck again, inflicting no greater injury than the last; then the queen, Bernard's arrow protruding from both sides of her neck, shot between the ranks of the taken and out of the cave. The queen shrieked again as she went, and the taken let out wailing howls in unison and charged forward with a sudden, vicious ferocity.

Amara heard Bernard order an advance, and the *legionares* screamed their defiance as they came on. Frederic, blood streaming from his wounded leg, could not rise. He swept the edge of his spade along at ground level, the steel cutting hard into the knee of the nearest Taken, sending it crashing to the floor. Another taken dived and hit Amara at the thighs, knocking her

down, and she saw three more already leaping toward her. Beside her, more taken flung themselves upon Frederic.

The *legionares* were still a dozen strides away. She tried to cut the nearest, but the taken were simply too strong. They smashed her sword arm to the floor, and something slammed into the side of her head with a flash of nauseating pain. Amara could only scream and struggle uselessly as the taken Aric, former Steadholder of Aricholt, bared his teeth and went for her throat with them.

And then Aric went flying away from her, hitting the wall with a bone-crushing impact. There was an enormous roar of sound, and Walker's foot slammed another of the taken holders to the cave floor. Amara saw a heavy war club descend and crush the back of the last Taken attacking her, then Doroga kicked the creature off her, lifted his war cudgel, and finished it with a blow to the skull.

Doroga whirled to strike at another taken before it could crush Frederic's throat, while Walker turned his enormous body about to the front of the cave again, more lithe than Amara would have thought possible. The gargant rumbled its battle cry and slammed into the incoming taken with rage and abandon, ripping and tearing and crushing in a frenzy. The taken attacked with mindless determination, swinging blades, clubs, stones, or simply ripping out scoops of flesh from the gargant with their naked hands.

The *legionares* thundered forward to support the gargant, but the corpses and spilled blood made it impossible for them to maintain ranks, and the taken that got around Walker tore into them with insane fury.

A strong hand closed on the back of Amara's hauberk, and Giraldi hauled her along the floor, seized Frederic's hauberk in the same way, and pulled them both toward the back of the cave, wounded leg and all.

"They're breaking through!" someone shouted from directly behind her, and Amara looked up to see a *legionare* fall and half a dozen taken spill past the lines, while outside the cave, even more of them pressed in with inevitable determination, pushing their way through with sheer mass.

"Loose at will!" Bernard called, and suddenly the air of the cave hummed with the passing of the woodcrafters' deadly shafts. The half dozen taken who had broken through fell in their tracks. Then the woodcrafters started threading shots through the battle lines, passing in the space under a *legionare*'s arm when he lifted his sword to strike, sailing over one's head

when he ducked a swing from a clumsy club, flitting between another's shield and his ear when he lunged forward, changing his center of balance.

It was, barely, enough. Though the Knights Flora's few arrows had been quickly spent, they had checked the taken's assault long enough for more *legionares* to advance from the rear of the cave, and they filled the weakness in the line, fighting with desperate strength.

The vord queen shrieked again from somewhere outside the cave, the sound loud enough to drown out the noise of battle and put painful pressure on Amara's ears. Instantly, the taken who had been fighting turned to retreat from the cave at a dead run, and the *legionares* pressed forward with a roar, cutting down the enemy as they fled.

"Halt!" Bernard bellowed. "Stay in the cave! Fall back, Doroga, fall back!"

Doroga flung himself in front of the furious gargant, shoving against Walker's chest while he tried to pursue the enemy. Walker bellowed his anger, but a few feet outside the cave he came to a halt, and at Doroga's urging retreated back to their original position.

The cave was suddenly silent, except for the moans of wounded men and the heavy breathing of winded soldiers. Amara stared around the cave. They'd lost another dozen fighting men, and most of the rest who had engaged the taken were wounded.

"Water," Bernard growled, then. "First spear, collect flasks and fill them up. Second spear, get these wounded to the rear. Third and fourth spears, I want you to clear the floor of these bodies." He turned to the Knights Flora with him, and said, "Help them, and recover every arrow you can while you're at it. Move."

Legionares set about the tasks given them, and Amara was appalled at how few of them were in condition to be up and moving. The wounded at the rear of the cave now outnumbered those still in fighting condition. She simply sat and closed her eyes for a moment.

"How is she?" she heard Bernard rumble.

Her head hurt.

"Lump on her head, there," Giraldi drawled. "See it? Took a pretty good hit. She hasn't been responding to my questions."

"Her face," Bernard said quietly. There was a note of pain in his voice.

Fire chewed steadily, ceaselessly at her cheek.

"Looks worse than it is. Nice clean cut," Giraldi replied. "That thing's claws are sharper than our swords. She was lucky not to lose an eye."

Someone took her hand, and Amara looked up at Bernard. "Can you hear me?" he asked quietly.

"Yes," she said. Her own voice sounded too quiet and weak to be her. "I'm . . . starting to come back together now. Help me up."

"You've got a head wound," Giraldi said. "It will be safer if you didn't."

"Giraldi," she said quietly, "there are too many wounded already. Bernard, help me up."

Bernard did so without comment. "Giraldi," he said. "Find out who is fit to fight and re-form the squads as necessary to fight in rotation. And get everyone some food."

The grizzled centurion nodded, rose to his feet, and withdrew to the back of the cave again. Moments later, the *legionares* at the front finished their gruesome task and retreated to the back of the cave, leaving Amara, Bernard, and Doroga the only people near the cave mouth.

Amara walked over to Doroga, and Bernard kept pace.

Walker was lying down again, and breathing heavily. Patches of his thick black fur were plastered down to his body, wet with blood. His breaths sounded odd, raspy. Blood made mud of the dirt floor beneath his chest and chin. Doroga crouched in front of the gargant with a stone jar of something that smelled unpleasantly medicinal, examining Walker's injuries and smearing them with some kind of grease from the jar.

"How is he?" Amara asked.

"Tired," Doroga replied. "Hungry. Hurting."

"Are his injuries serious?"

Doroga pressed his lips together and nodded. "He's had worse. Once." Walker moaned, a low, rumbling, and unhappy sound. Doroga's broad, ugly face contorted with pain, and Amara noticed that Doroga himself had several minor injuries he had not yet seen to.

"Thank you," Amara said quietly. "For being here. You didn't have to come with us. We'd all be dead right now but for you."

Doroga smiled faintly at her and bowed his head a little. Then he went back to his work.

Amara walked to the mouth of the cave and stared out. Bernard joined her a moment later. They watched taken moving purposefully around in a stand of trees on one of the nearby hills.

"What are they doing?" Bernard asked.

Amara wearily called Cirrus to bend light, and she watched the taken for a moment. "They're cutting trees," she reported quietly. "Working with the wood somehow. It's difficult to tell through the rain. I'm not sure what their aim is."

"They're making long spears," Bernard said quietly.

"Why would they do that?"

"The gargant is too much of a threat to them," he said. "They're making the spears so that they can kill him without paying as dearly to do it."

Amara lowered her hands and glanced back at Doroga and Walker. "But . . . they're not even proper spears. Surely they won't be effective."

Bernard shook his head. "All they need to do is carve sharp points. The taken are strong enough to drive them home if Walker doesn't close with them. If he does, they'll set the spears and let him do the work."

They stood watching the rain for a time. Then Bernard said quietly, "No one is coming to help us."

Amara said quietly, "Probably not."

"*Why?*" Bernard said, one fist clenched, his voice frustrated. "Surely the First Lord sees how dangerous this could be."

"There are any number of reasons," Amara said. "Emergencies elsewhere, for one. Logistics issues delaying the departure of any of the Legions." She grimaced. "Or it could be a problem in communications."

"Yes. No help has come," Bernard said. "Which means that Gaius never got the word. Which means that my sister is dead. Nothing else would stop her."

"That is only one possibility, Bernard," Amara said. "Isana is capable. Serai is extremely resourceful. We can't know for certain."

Doroga stepped up to stand beside them. He squinted at the taken, and said, quietly, "They are making spears."

Bernard nodded grimly.

Doroga's eyes flashed with anger. "Then this is almost over. Walker will not hide in the cave and let them stab him to death, and I will not leave him alone."

"They'll kill you," Amara said quietly.

Doroga shrugged. "That is what enemies do. We will go out to them. See how many of them we can take with us." He looked up at the clouds. "Wish it wasn't raining."

"Why not?" Amara asked.

"When I fall, I would like The One to look on." He shook his head. "Bernard, I need a shield so I can bring Walker some water."

"Certainly," Bernard said. "Ask Giraldi."

"My thanks." Doroga left them at the mouth of the cave.

Thunder rolled. Rain whispered.

Amara said, "We'll be lucky to have three squads, now."

"I know."

"The men will tire faster. Less time to rest and recover."

"Yes," he said.

"How many arrows did your Knights Flora recover?"

"Two each," he said.

Amara nodded. "Without Walker and Doroga, we can't hold them."

"I know," Bernard said. "That's why I've decided that I have to do it."

Amara shook her head. "Do what?"

"I led these men here, Amara. They're my responsibility." He squinted outside. "If we are to die . . . I don't want it to be for nothing. I owe them that. And I owe Doroga too much to let him go out there alone."

Amara stopped and looked at him. "You mean . . ."

"The queen," Bernard said quietly. "If the queen survives, it won't matter how many taken we've killed. She'll be able to start another nest. We must prevent that. At any cost."

Amara closed her eyes. "You mean to go out to them."

"Yes," Bernard said. "Doroga and Walker are going anyway. I'm going with them, along with any man who can walk and hold a weapon and is willing. We'll head for the queen and kill her."

"Outside the cave, we won't last long."

Bernard gave her a bleak smile. "I'm not so sure that's a bad thing."

She frowned and looked away from him. "It will be difficult to force our way through them without any Knights Terra left to us."

"Walker can do it," Bernard said.

"Can we reach her before they kill us?"

"Probably not," Bernard confessed. "I put an arrow right through that thing's neck, and all it did was startle her away. I saw how hard you hit it." He shook his head. "It's so fast. And with all those taken around it, it's unlikely that we'll have the time to land a killing blow. But we have no choice. If we don't kill the queen, everyone who gave his life has died for nothing."

Amara swallowed and nodded. "I . . . I think you're right. When?"

"I'll give the men a few moments more to breathe," Bernard said. "Then call for volunteers." He reached out to her and squeezed her hand. "You don't have to go with me."

She squeezed back as tightly as she could and felt tears blur her eyes. "Of course I do," she said quietly. "I'll not leave your side, my lord husband."

"I could order you to," he said quietly.

"I'll not leave your side. No matter how idiotic you are."

He smiled at her and drew her against him. She stood there in the circle of his arms for a moment, her eyes closed, breathing in his scent. Moments went by. Then Bernard said, "It's time. I'll be right back."

Thunder and rain filled the world outside, and Amara's head and her face hurt horribly. She was afraid, though so tired that it hardly seemed to matter. Bernard spoke quietly to the *legionares*.

Amara stood staring up the hill at the implacable enemy intent on tearing them all to pieces, and prepared to go out to meet them.

⊶⊶⊶ CHAPTER 47

The nearest Cane reached down, seized the front of Tavi's tunic, and hauled him up close to its muzzle. It sniffed at him once, twice, drool and blood dripping from its fangs.

And then the Cane simply dropped him.

It ignored him and continued on into the guardroom.

Its companions followed suit.

Tavi stared in utter confusion as the Canim simply ignored his presence, but gritted his teeth and kicked himself into motion, darting between a pair of the enormous wolf-warriors and back into the guardroom, where Miles still fought against the cloaked creature, the vord queen. There was blood dripping from his left elbow, but his face was smooth and utterly

expressionless as he fought, his battle with the queen one of constant, flowing grace and technique pitted against raw power and speed.

Nearer him stood another Cane, facing Kitai, while Fade hovered nervously in the background. Evidently, the two of them had immediately run to try to reach Tavi when the queen had thrown him out of the room, but the Cane had blocked their path. Even as Tavi watched, the Cane swept its sword in an overhand arch intended to split Kitai in half down the middle. The Marat girl crossed the blades of her swords and caught the blow upon them, sliding it to one side with a dancer's grace and struck out with one of her blades, drawing a flash of blood from the Cane's abdomen. The Cane didn't fall, but Tavi could see several other similar wounds upon it—painful but not debilitating.

Fade let out a hooting sound when he saw Tavi. The slave held up a second spear and flung it at Tavi. Tavi sidestepped and caught the spear in flight, set his grip, and spun to drive the weapon hard at the back of the vord queen.

The steel head of the spear penetrated the queen's green-black hide only modestly—that had not been Tavi's intent. The strike inflicted little injury upon the vord queen, but the force of the blow drove her forward and off-balance, if only for an instant.

It was all the time Sir Miles needed.

The captain snarled in sudden exultation, and his fluid retreat reversed itself in a heartbeat. His blade whipped in two savage slashes, each one scattering droplets of strange, dark blood, and the vord queen shrieked, the sound metallic, high-pitched, and deafening, filled with pain. Miles followed up, sword flashing through a whirling web of cold steel, striking the queen twice more, driving the creature into a corner.

Then the queen let out a strange, eerie hiss of sound, her head snapping toward Miles, eyes a glow of furious scarlet within the hood of her cloak.

Miles's eyes widened and he faltered, head snapping left and right, sword darting in uncertain parries of no visible attacks. One of the Canim turned and lunged at his back, but Miles gave no sign of noticing.

"Sir Miles!" Tavi shouted.

The captain spun in time to deflect the Cane's sword, but before he could whirl back to the queen, she had recovered her balance and attacked him. Dark claws struck simultaneously with the captain's sword.

With another eerie hiss, the queen leapt away from Miles and clung up high on the wall over the door. Her head whirled around to Tavi, who saw

two scarlet eyes blazing within the cloak's hood, and abruptly the two Canim nearest him turned toward Tavi, blades slashing toward him. The queen howled again, and the remaining Canim surged through the doorway toward the makeshift barrier in the back corner.

"The stairs!" Maestro Killian called. "Take the wounded down the stairs!"

Tavi ducked under a curved blade and thrust his spear against the guard of the other Cane's sword, fouling the stroke before it could properly land, and retreated to stand shoulder to shoulder with Miles. More Canim stalked into the room and advanced on Tavi and Miles, half a dozen of the enormous warriors now in the room. The vord queen dropped down to the floor behind the screen of Canim warriors, out of sight.

"Captain?" Tavi asked. "Are you all right?"

"I can fight." Miles looked up defiantly at the oncoming Canim. The near side of his face was a mask of blood and torn flesh, and all that remained of his eye was a sunken socket. There was no expression of pain on his face, the discipline of metalcrafting allowing him to ignore distractions such as agony and weariness.

One of the Canim swung its blade, and Miles blocked the blow almost contemptuously. Tavi lashed out with the spear as he did, and the blade struck the Cane's weapon arm, drawing blood. The queen shrieked again, from somewhere beyond the room, and the Canim snarled, weapons sweeping and cutting. The cramped space—for things so large as the Canim, at least—gave them only a few angles on which they could attack, and Tavi managed to dance and weave in place, dodging or fending off most strikes with the spear. Miles's blade never slowed, intercepting every strike, lashing out to bite deep into the foe. Tavi's heart pounded in terror, but he did not leave Miles's blind side.

"Kitai, Fade," Tavi shouted. "Help Killian! Get them down the stairs!"

Miles struck down another of the foe, but a second Cane drove the tip of its sword hard into Miles's chest. The captain turned, catching the blow on the keel of his breastplate, but the impact staggered him. Tavi let out a scream and assaulted the Canim with wild, repeated thrusts of his spear, trying to buy enough time for Miles to recover. The Canim did not retreat. A sword swept by, so close that it cut locks of hair from the top of Tavi's head. Another blow came at him, and Tavi had to block with the spear's shaft. It held, but only barely, the scarlet steel of the Canim's sword biting almost entirely through the length of oak. The Cane jerked its weapon clear to swing again, and the haft of the spear buckled.

Killian entered the fight in total silence. His cane struck the Cane's weapon arm, driving it up enough that the next blow missed Tavi altogether. The Maestro's sword slashed down, cutting through the tendon low on the Cane's leg, and the wolf-warrior faltered and staggered to one side. "They're through!" Killian called, shoving the hilt of his sword at Tavi. "Fall back!"

Tavi took the sword and obeyed, helping the staggering Sir Miles back to the door. Killian dodged another attack, brought his cane down sharply on the very tip of one of the wolf-warrior's sensitive nose, and drew a pouch from his pocket and whipped it out, scattering sand and iron filings into the air. He clenched his hand into a fist, a grunt of effort sliding from him as he did, and a sudden, tiny tempest arose, whirling the grains of sand and metal into the sensitive eyes and noses of the Canim. It neither lasted long nor inflicted any real harm, but it bought them time enough to hurry to the stairs. Once everyone was through the doorway, Fade slammed the door shut and threw the bolts, before jumping back away from it.

"That won't hold them for long," Tavi panted. He looked back down the stairs to see Kitai gently settling Max down on the stairs. Gaius was still tied to his cot, and it lay across several stairs. Neither of them moved.

"Doesn't matter," Miles replied, also breathing heavily. "Stairs are our best chance now. They'll have to come single file. That's how we'll hold them back longest."

"We'll fight in order," Killian said. "Miles, then me, then you, Tavi. But first I want you to get Gaius back down to the meditation chamber."

"Max, too?" Tavi asked.

"No," Killian said. His voice sounded rough. "Leave him there."

Tavi stared at the blind Maestro. "What?"

"If these things think they've killed Gaius, it's possible that they won't continue to the bottom of the stairs," Killian said.

"You'll . . . sir, but Max. He's unconscious. He can't fight them."

"He knew what he was doing when he crafted himself into that form," Killian said quietly.

"At least let me move him to the bottom of the stairs," Tavi said. "If the trick works, it will work there as well as up here."

Killian hesitated, but then gave him a sharp nod. "Take the Marat and the slave to help you, and get back here as quickly as you can. Will your slave fight?"

Tavi swallowed. "I don't think he likes to, sir. But if you need him to, tell

him." He glanced back over his shoulder at Fade and met the man's eyes. "He's loyal, sir."

"Very well. Miles," Killian said. "What happened to you when you fought that creature? I thought you had it."

"So did I," Miles replied. "It must have done some kind of crafting on me. For a second, I saw two more of them, there with it, and I lost focus."

"Your injuries?" Killian asked.

"It took one of my eyes," Miles said, his voice calm. "It's going to limit how aggressively I can attack."

"Did you slay the thing?"

Miles shook his head, then said, "Doubtful. I struck its throat, but it didn't bleed the way it should have. Between the two of us, the queen may have gotten the better of the trade."

Above them, the steel door shook under a heavy impact.

"Tavi," Killian said, his voice urgent, "go on down. Miles, don't focus on cutting them down. Fight defensively and retreat as you need to. Buy us time for the Guard to break through."

"Understood," Miles said, his tone grim. "Tavi, give me that sword, please."

Tavi passed the sword he held to the captain, and Miles stood with one blade in either hand. He twirled each once, then nodded sharply and turned to face the door.

"Go, Tavi," Killian said, quietly. "There's no more time."

ᐊ▭▭▭ CHAPTER 48

Fidelias knocked twice on the doors to Lady Aquitaine's private chambers in the Aquitaine manor, paused for a beat, then opened them. "My lady," he began.

Lady Aquitaine stood in profile before the room's great hearth, naked except for the fine silk gown she pressed to the front of her body with both hands. Her dark hair had been let out of its pins and dressing, and spilled to

her hips. Her long limbs were fit and lovely, her pale skin flawless, and a small and wicked smile curled one corner of her mouth.

Standing behind her, his hands on her hips, was Lord Aquitaine, naked to the waist. A leonine man, built with as much grace as power, his dark golden hair fell to his shoulders, and his black eyes glittered with intelligence—and annoyance.

"One wonders," he said, his voice mellow and smooth, "why my spymaster feels comfortable with a single knock upon my wife's private chamber door, followed by an immediate entrance."

Fidelias paused and bowed his head, keeping his eyes down. "In point of fact, my lord," he replied, "I knocked twice."

"Well. That changes everything then, doesn't it," Aquitaine murmured, his tone dry. "I assume that there is a very good reason for this intrusion that will convince me not to kill you in your tracks."

Aquitaine's voice was mild, but there was a current of amusement in it which Fidelias knew removed most of the danger from the threat.

Most of it.

"Attis," Lady Aquitaine chided gently. Fidelias heard silk sliding on naked skin as she slipped her robe back on. "I'm quite certain only an urgent matter would bring him here like this. Very well, Fidelias, I am decent."

Fidelias looked up again and bowed his head to Lady Aquitaine. "Yes, my lady. Some information has come to my attention that I feel merits your immediate attention."

"What information?"

"If you would accompany me to the library, my lady, the people in question can give it to you directly and respond to your questions."

Lady Aquitaine arched an eyebrow. "Who?"

"A young man I am not acquainted with and Lady Placida Aria."

"Placida?" Lord Aquitaine murmured. "I never expected Placida or his wife to involve themselves in politics. Why would she be here?"

"Shall we ask her?" Lady Aquitaine said.

Lord Aquitaine idly pulled his loose white shirt over his head. Lady Aquitaine reached up to untuck a few errant locks that hadn't come all the way through, and the two of them left the room. Fidelias held the door, then followed them to the library.

The room wasn't large by the standards of the rest of the house, and it had seen more use than most of the rest. The furniture there was of excellent

quality, of course, but it was warm and comfortable as well. A fire blazed in the hearth, and two people rose to their feet as the Aquitaines entered.

The first was a tall woman with vibrant red hair and a rich dress of emerald green. "Invidia, Attis," she murmured as they entered. She arched an eyebrow at them, and said, "Oh, dear. I must apologize for the awkward timing."

She exchanged a polite embrace with Lady Aquitaine and offered her hand to Lord Aquitaine, who kissed it with a small smirk on his mouth. "It will be the sweeter for the anticipation," he replied, then gestured for her to sit and waited for his wife to do the same before seating himself. "What brings you here?"

Fidelias remained standing in the background, against the wall.

"He does," Lady Placida replied, and gestured at the boy, still standing awkwardly, fidgeting. He wore plain but well-made clothing, and an academ's lanyard hung around his neck with but three small beads to vouch for his crafting ability. "This is Ehren Patronus Vilius, a student at the Academy, who came to me with an unusual message." She smiled at Ehren, and said, "Please tell them what you told me, young man."

"Yes, Your Grace," Ehren replied. He licked his lips nervously, and said, "I was bid tell Lady Placida by Tavi Patronus Gaius ex Calderon that he sends his most respectful greetings and sincere apologies for the ruse he used to speak to you at Lord Kalare's garden party. He further bids me say that one hour ago, he and a companion were taken by force to a warehouse on Pier Seven, Riverside, and held there by agents calling themselves bloodcrows, whom he believed to be in the employ of Lord Kalare or someone in his household."

Lord Aquitaine's expression darkened. "Tavi Patronus Gaius. The same boy from Second Calderon?"

"Yes, dear," Lady Aquitaine told him, patting his arm. She tilted her head. "How is it that he was able to send this message, if he was held prisoner?"

"He effected an escape, Your Grace," Ehren said.

Aquitaine shot a look at his wife. "He escaped the bloodcrows?"

"I told you he was resourceful," Lady Aquitaine murmured. She regarded Lady Placida, and asked, "Aria, this is fascinating, but I cannot help but wonder why you brought this news to us."

"I assume you know of the attack upon Steadholder Isana and her retinue

here in the city," Lady Placida said. "And I thought it quite intriguing that she and her kin were both attacked in the same evening. Clearly, someone is attempting to embarrass Gaius before the Lords Council and Senate by killing them here, virtually under his nose."

"Clearly," Lady Aquitaine said, her expression serene.

"I know how loyal you and your husband are to the First Lord, and how highly you value the welfare of the Realm," Lady Placida went on, and there was not a trace of either sarcasm or humor in her voice. "And I thought it might be a matter of concern to you, as steadfast supporters of the Realm, that one of our own might be raising their hand against Gaius."

There was an utter silence in the room for several long seconds, then Lady Placida rose, all grace and polite reserve. "Ehren, I believe we have imposed upon our hosts long enough. I must thank you for taking the time to come here."

"Of course, Your Grace," the young man answered, rising.

"Come along. I will have my driver take you up to the Academy."

The Aquitaines rose and exchanged polite farewells with Lady Placida, and she and the young man left the room.

"Earlier today," Fidelias said, "one of my sources discovered that the Canim were mysteriously absent from the Black Hall. Fifteen minutes before Lady Placida's arrival, word reached me of unusual activity in the Deeps. One of my sources saw a pair of Canim warriors battling in the alley behind the Black Hart on Riverside, leaving one of them dead. The Cane who won the battle was almost certainly Ambassador Varg. According to my source, the dead Cane had fought in total silence, without any sort of emotional reaction—not even to his own death. He said it was like the fighting spirit had simply been taken from the Cane."

"Taken," Lady Aquitaine breathed. "These vord the Steadholder spoke of?"

Fidelias nodded grimly. "A possibility. Five minutes ago, word reached me of fighting in the highest tunnels of the Deep, near the Citadel, and that the alarm bells have been ringing within the palace."

Aquitaine let out a hiss. "That fool, Kalare. He strikes at the First Lord *now?*"

"Too bold," Lady Aquitaine replied. "He would never try something so overt. This is a move that begins with the Canim, I think."

"Then why would their leader be killing his own guards in fights in dark alleys?" Aquitaine asked.

She shook her head. "It is possible that their loyalty has been taken." She frowned in thought. "But if there is alarm enough and confusion enough, Kalare will take the opportunity to strike. The man is a slive."

Lord Aquitaine nodded, continuing the thought to its conclusion. "He would never pass up the opportunity to strike at a weakened foe. We must therefore ensure that he does not profit from this situation." He frowned. "By preserving Gaius's rule. Crows, but that doesn't sit well with me."

"Politics make strange bedfellows," Lady Aquitaine murmured. "If Gaius is slain now, before we've dealt with Kalare, you know what will happen. In fact, it would not surprise me if the Canim are attempting to kill Gaius in order to foment an open civil war between Kalare and Aquitaine—"

"—in order to weaken the Realm as a whole." Aquitaine nodded once. "It is time we relieved Kalare of his bloodcrows. Pier Seven, I believe the boy said, Fidelias?"

"Yes, my lord," Fidelias replied. "I dispatched observers who reported increasing activity. In my estimation, Kalare has sent out word to his agents, and they are gathering there to move in concentrated force."

Aquitaine exchanged a glance with his wife, then gave her a bleak smile. "Tunnels or river?"

She wrinkled her nose. "You know I hate the smell of dead fish."

"Then I'll handle the warehouse," Aquitaine said.

"Take one of them alive if you can, Attis," Lady Aquitaine said.

Lord Aquitaine gave her a flat look.

"If I don't tell you," she said calmly, "and you don't think to save one, afterward you'll complain that I didn't remind you, darling. I'm only looking after your best interests."

"Enough," he said. He leaned over to kiss Lady Aquitaine on the cheek, and said, "Be careful in the tunnels. Take no chances."

"I'll be good," she promised, rising. "Fidelias knows his way around them."

Aquitaine arched an eyebrow at Fidelias, and said, "Yes. I'm sure he does." He kissed her mouth and growled, "I'll expect to resume our conversation later."

She returned the kiss and gave him a demure smile. "I'll meet you in the bath."

Aquitaine's teeth flashed in a flicker of a smile, and he stalked from the room, intensity blazing from him like an unseen fire.

Lady Aquitaine rose, her own eyes bright, and crossed to an armoire beside the liquor cabinet. She opened it and calmly drew out a scabbarded sword on a finely tooled leather belt. She drew the sword, a long and elegantly curved saber, slipped it back into its sheath, and buckled it on. "Very well, dear spy," she murmured. "It would seem we must enter the Deeps."

"To save Gaius," Fidelias said. He let the irony color his tone.

"It wouldn't do to let Kalare poach him, now would it?" She drew a cloak of dark leather from the armoire and donned it, then slipped a pair of fencing gauntlets through the sword belt.

"I'm not an expert in fashion," Fidelias said, "but I believe steel is generally considered more tasteful than silk for any event that involves a sword."

"We're going to be near the palace, dear spy, with hundreds of angry, paranoid members of the Royal Guard. Better to appear as a conscientious Citizen happening by to help in a moment of crisis than as an armed and armored soldier creeping through the dark toward the palace." She swiftly bound her hair back into a tail with a dark scarlet ribbon. "How quickly can you get us to the palace?"

"It's a twenty-minute walk," Fidelias said. "But there's a long shaft that drives almost all the way up to the palace. It can't be climbed, but if you can lift us up it, I can have you there in five minutes."

"Excellent," she said. "Lead on. We have work to do."

CHAPTER 49

Tavi gritted his teeth as the door shook again under another blow from the taken Canim. He turned to Fade and Kitai. "Carry the cot," he said. "I'll get Max, go down ahead of you so if I lose him, he doesn't fall onto Gaius."

Kitai frowned. "Are you strong enough?"

"Yeah." Tavi sighed. "I haul him home like this all the time." He went to his senseless friend and got his weight underneath one of Max's shoulders. "Come on, Max. Move it. Got to walk you back to bed."

One of Max's eyes opened part of the way and rolled around blearily. The other had been sealed shut with crusted blood. Blood dripped from his badly wounded arm, but the bandages had held the loss to a trickle rather than a stream. His legs moved as Tavi started down the stairs. It could not by any means have been confused with actually walking, but Max managed to support enough of his own weight that Tavi's strained body could manage the rest. They went down steadily, if not swiftly.

Somewhere above them, iron screamed protest again, and a hollow, thumping boom swept down the staircase. A few seconds later there was the clash of steel on steel, which faded as they went on down away from where the wounded captain fought to hold the Canim at bay.

For the first time since he had escaped the warehouse, Tavi had a spare moment for thought. Dragging Max around was a familiar task, and while not exactly easy, it did not require his attention, either. He started piecing together the things he had seen, trying to get an idea of what might happen next.

And suddenly he couldn't breathe. It wasn't an issue of labor or lack of air. He simply could not seem to get enough air into his lungs, and his heart was pounding with such terror that he could not distinguish individual beats.

They were trapped.

Though the Royal Guard was no doubt trying to fight their way down to the First Lord, some of the Canim had to have been holding them off. The wolf-warriors were deadly in such closed spaces, where there was less room to avoid them or circle to their flanks, and where their superior reach and height made them more than a match for all but the most seasoned *legionare*. Without a doubt, the Knights of the Royal Guard would use furycrafting against them, but they would be sharply limited in what they could do for the same reasons Tavi had explained to Kitai. Not only that, but it was entirely possible that most of the Knights had not yet arrived at the top of the stairway. The attack had come in the darkest hours of the night, when most were abed, and it would take long moments for them to awaken, arm, and rush to the fight.

They were moments the First Lord simply did not have. Eventually, the Guard would overcome the Canim, of course. But the Canim only needed to hold them off for a few moments more, and in a mortal struggle those moments seemed like hours. They would simply throw themselves at Miles,

exchanging themselves for blows that would merely cripple the captain. They had numbers enough to do it and still leave more to finish Miles off and tear apart those behind him.

There was no way out of the deep chamber but for the stairs. There was nowhere to run. The Canim were still coming, and Sir Miles had not managed to kill the queen. Miles, the only one of them who could hope to stand up to the Canim for long, was already wounded, bleeding, and half-blind. The smallest of mistakes or misjudgments could cost him his life, and while Tavi was confident Miles could have handled it at any other time, with his injuries it would only be a matter of minutes before he was too slow or too hampered by his damaged vision to fight perfectly.

When Miles fell, the Canim would kill the Maestro. They would kill Tavi and Kitai. They would kill Max, of course. And, unless they were extremely stupid, they would kill Gaius, as well, despite Max's willing sacrifice as the First Lord's decoy.

Gaius was still unconscious. Max was incoherent. The Maestro was an excellent teacher of the fighting arts, but he was an old man, and no soldier. Kitai had seemed to handle herself in a fight at least as well as Tavi, but she was simply not a match for one of the Canim, much less a dozen of them. Tavi himself, while a trained fighter, could hardly hope to face one of the Canim with any significant chance of victory. The disparity in size, reach, experience, power, and training was simply too great.

If the First Lord died, it would provoke a civil war—a civil war the Canim would gleefully use to their advantage. Gaius's death could quite possibly prove to be the event that signaled the end of the Aleran people.

More thoughts bounced and spun through his head, and he gritted his teeth, trying to clear his mind and focus. The best he could do was to isolate two concrete thoughts.

Gaius had to be saved regardless of the cost.

Tavi did not want to die, nor see his friends and allies harmed.

There was only one person trapped in the First Lord's defense who could make a difference.

They reached the bottom of the stairs, and Tavi settled Max down as gently as he could beside the cabinet. The larger boy, though he looked identical to the First Lord, slumped down at once, sinking into immobility and unconsciousness again. A heavy snore rattled from between his lips. Tavi laid his hand on his friend's shoulder for a moment, then rose as Kitai and

Fade emerged from the meditation chamber and shut the door behind them. They started for the base of the stairs, but Tavi stepped into Fade's way, his teeth clenched, and glared at him from a handbreadth away.

"Fade," Tavi said, his voice hard. "Why didn't you fight?"

The slave eyed him, then looked away, shaking his head. "Couldn't."

"Why *not?*" Tavi demanded. "We needed you. Max could have been killed."

"I *couldn't,*" Fade said. His eyes shifted warily, and Tavi saw real fear in them. "Miles was fighting that thing, that vord. It was too fast. If I'd drawn steel, he would have recognized me immediately." Fade took a slow breath. "The distraction would have killed him. It still might."

"He's hurt," Tavi said. "And we have no idea how long he can fend them off."

Fade nodded, his expression bleak, full of old pain. "I . . . Tavi, I don't know if I can. I don't know if I could bear it if . . ." He shook his head and said, "I thought I could, but being back here . . . So *much* will change, and I don't want that."

"Dying is a change," Kitai put in. "You don't want that, either."

Fade shrank a little.

Tavi made a gesture to Kitai to let him do the talking. "Fade, the First Lord needs you."

"That arrogant, pompous, egotistical old *bastard,*" Fade spat, his voice suddenly filled with an alien, entirely vicious hatred, "can go to the bloody crows."

Tavi's fist caught the ragged slave on the tip of his chin and knocked Fade onto his rear on the smooth stone floor. Fade lifted his hand to his face, his expression one of pure shock and surprise.

"Since you don't seem to be thinking well," Tavi said, his voice cold, "let me help you. Your feelings toward Gaius are irrelevant. He is the rightful First Lord of Alera. If he dies here tonight, it will cast our entire people into a civil war that will be a signal to our enemies to attack us. The vord pose a threat that could be worse than the Canim, Marat, and Icemen combined if it is left to fester, and we need a strong and unified central command to make sure it doesn't happen."

Fade stared up at Tavi, his expression still stunned.

"Do you understand what is happening here? Millions of lives depend on the outcome of this hour, and there is no time to be distracted by personal

grudges. To save the Realm, we *must* save Gaius." Tavi leaned down, seized the hilt of Fade's worn old sword, and drew it from its scabbard. Then he knelt on one knee and stared into Fade's eyes while he reversed his grip on the blade and offered the hilt to the slave over one arm.

"Which means," Tavi said quietly, "that the Realm needs Araris Valerian."

Fade's eyes brimmed with tears, and Tavi could almost feel the terrible old pain that brought them, the fear that filled the scarred slave's haunted eyes. He lifted his hand and touched his fingers to the coward's brand on his maimed cheek. "I . . . I don't know if I can be him again."

"You were him at Calderon," Tavi said. "You saved my life. We'll work something out with your brother, Fade. I promise that I'll do everything I possibly can to help you both. I don't know the details of what came between the two of you. But you're his brother. His blood."

"He'll be angry," Fade whispered. "He might . . . I couldn't hurt him, Tavi. Not even if he killed me."

Tavi shook his head. "I won't allow that to happen. No matter how angry he might be, underneath it he loves you. Anger subsides. Love doesn't."

Fade folded his arms over his chest, shaking his head. "You don't understand. I c-can't. I can't. It's been too long."

"You must," Tavi said. "You *will*. You gave me your sword. And you didn't mean it as a present for me to hang on my wall. You meant it as something more. Didn't you? That's why Gaius was so disapproving when he saw it."

Fade's face twisted with some new agony, but he nodded.

Tavi did, too. "With or without you, I'm going back up those stairs," he said, "and I'm going to fight those animals until I'm dead or until the First Lord is safe. Take up your sword, Fade. Come with me. I need your help."

Fade exhaled sharply and bowed his head. Then he took a deep breath, lifted his right hand, and took the sword Tavi offered him. He met Tavi's eyes, and said, quietly, "Because you ask it of me."

Tavi nodded, clasped Fade's shoulder with one hand again, and they rose together.

CHAPTER 50

"They're forming up again," Amara reported, staring out at the taken holders. A score of them held long, rough spears of raw wood, crude points hacked into them with knives and sickles and swords. "Looks like they're using the *legionares'* shields, too."

Bernard grunted and came up to the front of the cave to stand beside her. "They'll use the shields to cover the spears from our archers. That volley must have been worse than they expected." The rain came down in steady, heavy drops outside the cave. Flashes of green-tinged lightning continued to dance through the clouds veiling the summit of Garados, and the air had grown steadily thicker and more oppressive, a sense of old, slow malice permeating every sight and sound. "And the furystorm is about to break, if I'm any judge. We'll have windmanes coming down on us in half an hour."

"Half an hour," Amara mused. "Do you think it will matter to us by then?"

"Maybe not," Bernard said. "Maybe so. Nothing is written in stone."

A wry smile twisted Amara's mouth. "We might survive the vord to be killed by windmanes. That's your encouragement? Your reassurance?"

Bernard grinned, staring out at the enemy, defiance in his eyes. "With any luck, even if we don't take them, the furystorm will finish what we started."

"That really isn't any better," Amara said. She laid a hand on his shoulder. "Could we wait here? Let the furystorm take them?"

Bernard shook his head. "Looks to me like they know it's coming, too. They've got to take the cave before the storm breaks."

Amara nodded. "Then it's time."

Bernard looked over his shoulder, and said, "Prepare to charge."

Behind him, waiting in ranks, was every *legionare* still able to stand and wield a blade. Twoscore swords hissed from their sheaths with steely whispers that promised blood.

"Doroga," Bernard called. "Give us twenty strides before you move."

The Marat chieftain lay astride Walker's broad back, the cave's ceiling forcing his chest to the gargant's fur. He nodded at Bernard, and said something in a low voice to Walker. The gargant's great claws gouged the floor of the cave, and his chest rumbled an angry threat for the enemy outside.

Bernard nodded sharply and glanced at the archers. The Knights Flora each held an arrow to the bowstring. "Wait until the last moment to shoot," he told them quietly. "Clear as many of those spears from Walker's path as you can." He fit a string to his own bow and glanced at Amara. "Ready, love?"

She felt frightened, but not so much as she had thought she would be. Perhaps there had simply been too much fear over the past hours for it to overwhelm her now. Her hand felt steady as she drew her sword from its scabbard. Really, she felt more sad than afraid. Sad that so many good men and women had lost their lives. Sad that she could do nothing better for Bernard or his men. Sad that she would have no more nights with her new husband, no more silent moments of warmth or desire.

That was behind her now. Her sword was cold and heavy and bright in her hand.

"I'm ready," she said.

Bernard nodded, closed his eyes, and took a long breath, then opened them. In his left hand, he held his great bow, arrow to the string. With his right, he drew his sword, lifted it, and roared, "*Legionares!* At the double, forward march!"

Bernard stepped forward into a slow jog, and every *legionare* behind him started out in that same step, so that their boots struck the ground in unison. Amara followed apace, struggling to keep her steps even with Bernard's. Once the *legionares* were all clear of the cave mouth, Bernard lifted a hand and slashed it to his left.

Amara and the Knights Flora immediately peeled away, to the left of the column's advance, making their way up a low slope that would allow them to shoot over the heads of the column almost until they engaged the taken.

Once they were clear of the column's path, Bernard lifted his hand and roared, "*Legionares!* Charge!"

Every Aleran throat opened in a roar of, "Calderon for Alera!" The *legionares* surged forward in a wave of steel, and their boots were a muffled thunder upon the rain-soaked earth as they followed the Count of Calderon

into battle. At the same time, Walker emerged from the cave mouth, the bloodied gargant's battle roar joining that of the *legionares* as it accelerated into a lumbering run, deceptively swift for all its apparent clumsiness, his claws biting into the earth. Walker began to gain on the *legionares* at once, gathering momentum while Doroga whirled his long-handled cudgel over his head, howling.

An unearthly yowl rolled out from the stand of trees, and the taken moved in abrupt, silent, and perfect concert. They formed into a loose half circle, shields in the front rank, while those holding spears set them to receive the charge, making the taken shieldwall bristle with the crude weapons.

Amara beckoned Cirrus as she ran, struggling to exert the bare minimum of effort necessary for the fury to bend light and let her see the enemy. She had only one duty in this battle—to find the vord queen and point her out to Bernard.

Beside her, the Knights Flora raised their bows. Arrows flashed out through the rain, striking eyes and throats with unerring precision, and over the next ten seconds half a dozen of the spearmen fell despite the use of the Legion shields. The taken moved at once, others picking up the spears and moving into the place of the fallen—but the disruption was enough to create an opening in the fence of rude spears, allowing the *legionares* to drive their charge home.

Shield met shield with a deafening metallic thunder, and the *legionares* hewed at the crude spears with their vicious, heavy blades, further widening the opening and disrupting the formation of the taken.

"Shift left!" Bernard cried. "Shift left, left, left!"

The *legionares* immediately moved together, a sudden lateral dash of no more than twenty feet.

And a heartbeat later, Doroga and Walker crashed onto the breach in the thicket of spears.

Amara stared in utter shock for a moment at the gargant's impact. She had never heard a beast so loud, never seen anything so unthinkably strong. Walker's chest slammed into the shieldwall, crushing several of the taken who bore them. His great head swung left and right, slamming more of the taken around like an angry child with his toys, and Doroga leaned far over the saddle-mat with his cudgel, striking down upon the skulls of the taken. The gargant plowed through the ranks of the taken without slowing, leaving

a corridor of destruction behind him, halted, whirled, and immediately laid into the ranks of the taken with savage claws.

Before the charge was complete, the *legionares* roared together and slammed forward in a frenzied, all-out attack, catching the taken between them and the blood-maddened gargant.

Amara bit her lip, sweeping her gaze around the battle, desperate to find the queen, to do *something* to help Bernard and his men. She could only watch the battle, seeing flashes of it in horrible clarity as she searched for the queen.

After the initial shock of the gargant's charge, the taken moved together into a counterattack. Within a minute, several with spears had spread out to either side of Walker, and thrust the weapons at the gargant while Doroga attempted to parry them away with his great club. The others focused on the *legionares,* and though the men fought with undeniable skill and courage, the numbers against them were simply too great, and their momentum began to falter.

She watched as Bernard ducked the swing of an axe wielded by an old grey-haired man, and the *legionare* beside him struck a killing blow upon his attacker with a downsweep of his sword. Seconds later, a child, a girl of no more than ten or twelve summers, hauled a *legionare*'s leg out from beneath him and twisted with savage power, breaking it. The *legionare* screamed as other taken hauled him away and fell upon him with mindless savagery. An ancient crone thrust a wooden spear into Walker's shoulder and the gargant whirled with a scream of pain, swatting at the spear and shattering its shaft.

And then Amara saw a flicker of motion, behind Doroga and Walker, something darting out of the shadow of the trees, covered by the folds of a dark cloak and hood.

"There!" she cried to the archers, pointing. "There!"

Moving swiftly, two Knights touched their last arrows, bound with oiled cloths just beneath the heads, so the embers in the small firepots on their belts set the arrows aflame. They drew and loosed, sending twin streaks of fire hissing through the rain. One arrow struck the shape directly, shattering as if it had impacted upon a heavy breastplate. The other arrow missed striking anything solid, but lodged in the folds of the vord queen's cloak.

That was the signal. Bernard's head whipped around to trace the flight of the fire arrows, and he roared commands to his *legionares,* who wheeled and surged toward the vord queen with desperate power. Doroga whipped

his head around as the vord queen leapt at him. He threw himself to one side, rolled off the gargant's back, and landed in a heavy crouch. The vord queen whirled and rushed him, only to alter her course when Walker threw himself into the queen's path.

"Swords!" Amara snapped to the Knights with her. "With me!" They drew steel and sprinted forward, circling the chaos of the melee to head for the queen. Amara sprinted ahead of the Knights, swifter than they on foot, sidestepping a clumsy grab from one of the taken and striking it down as she flew past it. She saw the queen leap again, claws flashing in an effort to put out one of the gargant's eyes. Walker turned his head into the leap, gashing the queen with his tusks, and sending her bouncing across the earth not ten yards from Amara.

The Cursor shouted a wordless battle cry, sword raised, and called to Cirrus for swiftness enough to challenge the queen. The queen whirled to face Amara, claws spread, and let out another shriek. Half a dozen taken peeled away from the fight to charge Amara, but the Knights with her intercepted them, swords raised, and kept them from moving forward.

Amara swept her sword in a feinting cut, then reversed direction and drove her blade in a thrust aimed for the queen's eyes. The queen swatted the blade away, but not before it bit into the creature's face, tearing the hood away and giving Amara a full look at the vord queen's features for the first time.

It looked human.

It almost looked familiar.

Though its skin was green-black, shining and hard, the creature's face looked almost Aleran, but for slightly canted eyes like the Marat. Curly black hair writhed in a mussed wreath around the vord queen's head. Fangs dimpled full feminine lips. But for the fangs, the shade of its skin, and its luminous eyes, the vord queen could have been a young and lovely Aleran girl.

The queen recoiled, and a trickle of a thick, greenish fluid oozed from the cut across her cheekbone. The queen touched her cheek and stared at the blood on her fingers, raw and somehow childlike amazement on her face. "You harmed me."

"That makes us even," Amara said, her voice grim. She shouted and closed again, her sword whipping fast and hard at the queen.

The vord queen darted away from the blow and came back toward Amara with a counterattack of blinding speed that the Cursor barely avoided.

The queen shrieked as they fought, and Amara heard and felt the sudden presence of more taken at her back, breaking off from the melee to assist the queen. She ruthlessly suppressed a sudden urge to call Cirrus and sail above the battle to engage the queen in classic flying passes, and stayed focused on her enemy. She exchanged another rapid series of attack and counter with the vord queen, all too aware that the taken were closing on her with every second that passed.

"Countess!" called one of the Knights, and she turned in time to see one of them struck down by a swing of a worn woodsman's axe. Not a heartbeat later, a taken fist slammed against the neck of a second Knight, and he dropped into a limp heap.

The third Knight panicked. Half a dozen taken closed on him, and in obvious desperation he looked back at the outstretched branches of a nearby oak. He made a sharp gesture and one of those branches bent and stretched down enough for him to seize it in one hand. The branch sprang back, hauling him out and away from the hands and weapons of the taken.

But the instant he gestured, at least a dozen taken faces whirled toward the desperate Knight. Amara could almost *feel* a sudden, alien pressure against her eyelashes as the taken holders focused on the Knight.

Every branch of that tree, and every branch of every tree within twenty yards began to whip and thrash madly, bending and smashing and wrenching.

Seconds later, what was left of the doomed man pattered down from branch and bough in a grisly rain. None of the remains could ever have been identified as belonging to a human being.

The vord queen smiled at Amara then, as two dozen taken flung themselves toward her back.

And Amara smiled at the queen as Doroga spun in a running circle to gather terrible momentum into his war cudgel and struck.

The queen turned at the last second, and while unable to avoid the blow entirely, she slipped enough of it to survive the terrible impact of the war club, though it threw her across twenty feet of muddy ground. She rolled and came to rest crouched oddly, her weight upon her toes and her left hand. The other hung uselessly. The queen hissed and whirled to retreat—only to see Walker crash into the ranks of the taken. To one hand, Doroga closed in, his cudgel held ready, cold fury in the barbarian's eyes. To the other Amara waited, cold and bitter blade in hand, already stained with the queen's blood. And as the queen turned toward the last quarter, Bernard's

legionares cut the last taken from their lord's path, and the Count of Calderon, his men holding back the taken behind him, drove his sword into the soft earth and raised the great black bow.

The queen turned to the nearest of her foes, Amara, wild eyes staring—and Amara suddenly felt an alien presence against her thoughts, like a blind hand reaching out to touch her face. Time slowed and Amara understood what was happening—earlier, the queen had listened to her thoughts. Now she was attempting to rake through them, though in doing so, she revealed her own to Amara.

Amara could all but see the queen's mind. The queen was simply stunned at what was happening. Though the Alerans had managed to entrap the queen, they had doomed themselves to do so. There was no way they would be able to escape the wrath of the taken around them, no chance that they would survive—and it had never occurred to the queen that her foe's tactics would simply decline to take survival into account.

Sacrifice.

The vord queen's thoughts locked upon the word, found there in Amara's mind.

Sacrifice.

She did not understand. Though the vord queen could comprehend that those facing it were willing to give up their own continuation to destroy hers, she did not understand the thought behind it, beneath it, motivating it. How could they regard their own deaths as a victory, regardless of what happened to their foe? It was not reasonable. It was not a manner of thought that promoted survival. Such deaths could serve no Purpose whatsoever.

It was madness.

And as she gazed upon the vord queen, Amara suddenly found herself entangled in the racing thoughts of the creature. She saw the vord queen tense, saw her leap forward, saw fangs and claws gleaming as the queen came—and Amara *felt* the queen decide upon her as the weakest target, the most likely path of escape. She felt the queen's detached certainty, the gathering tension as claws swept toward Amara's throat.

There was heavy thrumming sound, a thud of impact, then Bernard's first arrow struck the vord queen beneath the arm and sank to the fletchings in her flesh. The power of the impact threw her to one side and cast her to the ground, and Amara was abruptly freed from the horrible entanglement of her thoughts with the queen's.

She watched as the queen rose again, and Bernard's last arrow hammered into her throat, bloodied head erupting from her armored flesh. Again, the queen was thrown down. Again, she staggered erect, blood pouring from her wounds. She wavered, then those luminous eyes focused on Amara, and the queen flung herself into one last, desperate leap toward the Cursor.

"Amara!" Bernard cried.

Amara lifted her sword, and as the queen leapt upon her, she stood her ground, legs wide and steady. She ignored the deadly talons and claws, though she knew the queen intended to kill until no life remained in her body, and focused instead on the distance between them, on the glimmer of fangs in the queen's shrieking mouth.

And then Amara moved, all at once, a concentrated explosion of every nerve and muscle fiber that moved her sword arm alone. She drove the sturdy *legionare*'s blade forward, and its tip dived into the queen's mouth, into her throat, and on through, parting bone and tissue. There was a horrible sensation of impact, hot pain in her arm, her leg, and a shattering collision with the ground.

Amara lay stunned for a confused moment, unable to understand why she suddenly could not see, and why someone was pouring water into her face. Then a weight was lifted from her, and she remembered the cold rain falling from the sky. Bernard lifted her, helped her sit up, and Amara stared for a moment at the unmoving corpse of the queen beside her, a *legionare*'s blade driven to the hilt into her mouth.

"You did it, love," Bernard said. "You did it."

She leaned wearily against him. Around them, she could see perhaps twenty *legionares* fighting shield to shield. Doroga, wounded with a dozen small cuts, stood beside Walker. Though the beast shook its tusks defiantly, it hardly seemed able to remain standing, much less to fight, and when it lunged at one of the taken, the thing easily evaded the clumsy, limping motion.

Amara blinked the rain out of her eyes and watched as scores of taken fought to overwhelm the exhausted, outnumbered Alerans.

"We did it," she said, and just speaking the words was exhausting. "We did it."

Thunder rolled again, amidst angry lightning, and the firelit clouds of the furystorm rolled down the mountainside toward the embattled scene.

"Hold me?" Amara asked quietly.

"All right," Bernard said.

And then a storm of fire and deafening sound roared down from the low clouds and charred two dozen of the taken holders to ash and blackened bones.

Amara gasped, leaning weakly against Bernard.

"Close in!" Bernard bellowed. "Close in, stay together, stay low!" Amara was aware of the *legionares*, struggling to obey Bernard's orders, of Doroga urging Walker in one of the Marat tongues. But mostly she was conscious of another flicker of light in the clouds, an eight-pointed star formed of lightning that danced from point to point so swiftly to make it seem a wheel of sudden fire—a fire that coalesced, flashed down, and charred another, even broader swath of the taken to corpses.

She had to have been imagining it. From the furious sky appeared dozens of forms—Knights Aeris, both flying formation and serving as bearers for open aerial litters. Twice more, lightning tore from the heavens, rending the ranks of the taken, and then another eight Knights Aeris descended low enough to be seen, gathering a final burst of lightning into an eight-pointed star between them, and hurling it down at the taken.

Men in armor, mercenaries she thought, dismounted from the litters and engaged the remaining taken. There was a stunned moment of shock. And then came a roar from the surviving *legionares* as impossible hope washed over them.

Amara struggled to rise, and Bernard supported her, his sword held still in one hand, as the mercenaries and the *legionares*, between them, shattered the rest of the taken and put them down. Most of the fighting mercenaries wielded blades with the devastating grace and skill of master metalcrafters.

"Knights," Amara whispered. "They're all Knights. Every one of them."

A man cut down three of the taken in as many strokes, then casually turned and began walking toward Bernard before the last one had fully fallen to the ground. He was a giant of a man, heavily armored, and as he approached he took off his helmet and bore it under one arm. He had dark hair, a beard, an angry scar, not too old on one cheek, and his eyes were calm, detached, passionless.

"You," Bernard said to the man.

"Aldrick ex Gladius," Amara said. "Of the Windwolves. In service to the High Lord Aquitaine. I thought you were dead."

The captain of the mercenaries nodded his head. "That was the idea," he said. He gestured around at the mercenaries now engaged in mopping up the last of the enemy and looking for wounded in need of assistance. "Compliments of Steadholder Isana, Lord Count, Countess Amara."

Bernard pursed his lips. "Really? Then she did find help at the capital."

Aldrick nodded once. "We were dispatched here to aid the garrison by whatever means we could. I apologize we were not here sooner, but bad weather slowed us. Though I suppose it meant we had a nice, ripe storm to play with when we did arrive." He glanced up at the skies and mused, "It takes the fun out of things, but it isn't professional to let that kind of resource go to waste."

"I cannot say that I am sorry to have your help, Aldrick," Bernard said. "But neither can I say that I am glad to see you. The last time we met, you all but gutted me on the walls of Garrison."

Aldrick tilted his head to one side, and said, "You've been a soldier. That wasn't personal, Your Excellency. I neither offer you any apology nor take any particular pleasure in what I did. But I need you to tell me if you can live with that, right now. One way or another, it's got to be settled immediately."

Bernard frowned at the man and nodded once. "I can. I would have word of Steadholder Isana."

Aldrick nodded. "Of course, though I have little enough to give you. But first, Your Excellency—"

Bernard slashed a hand at the air. "Bernard. You've saved my men's lives. You don't need to use the title."

Aldrick tilted his head to one side, and his expression changed by some subtle degree. He inclined his head, a minor but significant gesture of respect, and continued, "I suggest that we take shelter in that cave, then. My Knights Aeris stole a great deal of a powerful wind fury's thunder, and it will send windmanes to seek vengeance. With your permission, Count, we'll move into the caves to shelter until the storm is past. My watercrafters can see to your wounded while we are there."

Amara frowned steadily at Aldrick, but when Bernard glanced at her she nodded weakly. "We can sort out our past differences after we've all survived the storm."

"Excellent," Aldrick said, turning away with professional preoccupation. He flipped his hand in a short series of gestures at one of his fellow mercenaries, who spread word to the rest of them. Bernard passed on orders to

gather up the Aleran wounded and make for the cave in order to find shelter from the still-coming storm.

"I can walk," Amara told Bernard. She took a step to prove it and almost fell down.

He caught her, and said, "Gently, love. Let me take you. You've hit your head."

"Mmmm," Amara murmured with a sigh. Then she blinked her eyes slowly open and said, "Oh, dear."

"Oh dear?" Bernard asked.

She reached up and touched her throat, where Bernard's ring still hung by its chain. "Oh, dear. We've survived. We're alive. And . . . and we're wed."

Bernard blinked a few times, then mused, "Why, yes. I suppose that's true. We've lived. And we've married. I suppose now we'll have to stay together. Perhaps even be in love."

"Exactly," Amara repeated, closing her weary eyes with a sigh and leaning against the broad strength of his chest. "This ruins everything."

He walked several steps, carrying her without apparent effort, before he said, "Will you still have me, then?"

She lifted her face to press a kiss against his throat, and murmured, "Forever, my lord, if you will have me."

He answered her with his voice thick with emotion. "Aye, my lady. And honored to."

CHAPTER 51

Tavi went first, rushing back up the winding stairway. The clash of steel on steel warned them that they were drawing near, and several steps later, the steps went dark and slick with spilled blood. Tavi looked up to see Captain Miles holding the stairs against the Canim. One Cane was down, crumpled lifelessly to the stone stairs, and its blood had formed the stream that stained them. The dead Cane's companions had simply walked over the

corpse, digging clawed toes into it to secure their footing on the treacherous, slick stairway.

Miles had been driven slowly down the stairs by the sheer power of his foes, and he had been wounded again; his left leg was soaked in blood from the knee down. As a result, his balance was awkward and precarious on the curl of the stairway, and he had to shuffle his balance clumsily to retreat down another step, while his opponent showered blow after blow down at the wounded captain.

Behind Miles, leaning heavily against a wall, was Maestro Killian. His sword lay several steps below where he stood, and he clutched his cane tightly to his chest. His chest and shoulder were soaked with blood: He'd been wounded as well.

"Tavi?" Killian gasped. "Hurry. Hurry, boy!"

"Fade," Tavi snapped, and pressed his back to the wall to give the scarred slave room to pass.

Fade lifted his eyes to Tavi, then past him, to Miles, widening as they saw the man's injuries, and how obviously he'd been slowed and weakened by them. Fade's eyes narrowed, then he was in motion, darting past Tavi to rush forward to Sir Miles.

"Miles!" Fade barked. "Step out low!"

Captain Miles moved with the kind of instant response that can only come from training and long practice. He feinted high with his blade, then just as Fade reached him, he dropped into a crouch and rolled to his left, bumping awkwardly down several stairs.

Fade did not draw his sword until Miles first dropped, then it sprang from its sheath in a strike that cut the air with a vicious hiss. It struck the Cane's weapon at its weakest point, just above the hilt, and shattered it into shards of scarlet steel that struck sparks from the stone wherever they hit. A second strike removed the Cane's leg at the knee, and as it fell a third blow struck the creature's head from its neck. Fade delivered a kick to the falling body's belly, and it tottered backward, blood spraying in a fountain into the noses and eyes of the next Cane in the line.

Fade advanced, stepping on the fallen Cane to keep his footing, and his blade slithered through the guard of the blinded Cane, opening its belly in an S-shaped cut that spilled blood and worse onto the stairs. The Cane fell, snapping with its jaws and slashing with its blade as it died, but Fade blocked both with almost contemptuous skill, and finished the Cane with a

flickering cut to the throat that flowed directly into another step forward and up, coupled with a sweeping stroke aimed at the next Cane in the line.

Tavi ran up to the Maestro, checking Killian's injuries. He'd taken a nasty blow to the slope of muscle between neck and shoulder, and had been fortunate that the blow had cut no deeper than it had. Tavi drew his knife and cut off a section of his cloak, folded it into a pad, and pressed it to the injury. "There," he said. "Hold this there."

Killian did so, though his face was pale with pain. "Tavi. I can't see them," he said, voice tight. "I can't . . . tell me what is happening."

"Fade is fighting," Tavi said. "Miles is hurt, but he's alive. Three Canim are down now."

Killian let out a soft groan. "There are ten more beyond them," he said. "Felt them earlier. One of them tore up Miles's leg when he struck it down. Got his teeth into him before he died, and Miles fell. I had to step in until he could rise. Stupid. Too old to be thinking I can do this nonsense."

"Ten," Tavi breathed. The shock of Fade's arrival to the fight had worn off, and now he fought without any sort of forward movement, his blade clashing with that of the snarling Cane, each striking and parrying with deadly speed.

There was a sudden rush of air sweeping up from the stairway beneath them, then a hollow, deafening boom that shook the stone beneath them.

"Bloody crows," Tavi swore, bracing himself against the wall. "What was that?"

Killian tilted his head, blind eyes focused on nothing. "Firecrafting," he said. "A big one. Maybe in the hall at the top of the stairs."

"The Guard," Tavi said, sudden hope a surge in his chest. "They're coming."

"H-have to hold—" Killian said. "Must—" Then the Maestro sagged and almost fell.

Tavi caught his slight weight with a curse. "Kitai!" he called.

She came up to him immediately, sword in hand, her eyes on the fight a few steps above them. "Is he dead?"

"Not yet," Tavi said. "Take him. Get him back down the stairs, by Max."

Kitai nodded once and slipped the sword through her belt, before picking up Killian at least as easily as Tavi had. "Wait," he told her, and hurriedly cut another strip from his cloak, using it to bind the blood-soaked pad he'd fashioned over the Maestro's injuries. "There," he said. "Go, go."

Kitai nodded, and met his eyes. Her own were worried. "Be cautious, Aleran."

"Don't be gone long," Tavi replied, and she nodded shortly before turning to descend the stairs.

Tavi went to Miles next. The captain had hauled himself up to a sitting position, back against the wall, and lay there panting, his eyes closed. He looked almost violently weary, chest heaving, his face bloodied and horrible with its empty eye socket, and creased with pain despite his crafting. Tavi knelt near him, and Miles's sword arm twitched seemingly of its own volition, blade darting out to touch its tip to Tavi's throat.

Tavi froze, eyes wide, and said, "Sir Miles, it's Tavi."

The wounded captain opened his eye and blinked blearily at Tavi. The sword wavered and dropped. Tavi knelt immediately, examining Miles's injuries. The wounds on his face looked hideous, but they weren't deadly. Some of them had already clotted with blood. His wounded leg was much worse. The Cane's teeth had sunk into the meat of his thigh, just above his knee, and then ripped savagely through his flesh, until it looked like so much raw meat. Tavi jerked his cloak off and used the remaining material to fashion another thick pad and tie it tight.

"Guard?" Miles muttered. His voice was thready and weak. "The Guard got here?"

"Not yet," Tavi said.

"Wh-who, then? That's . . . that's old battlespeak. Step out low. Haven't heard it in years." He blinked his eye at Tavi, then turned his head almost drunkenly to the battle raging only a few stairs away.

Miles froze. His eye opened wider, and then his lips parted to let out a soft, weak little sound. He started trembling, so violently that Tavi could feel it in his hands as he finished with the bandage on the captain's thigh. "This isn't . . ." His face twisted into a grotesque grimace. "No, this isn't possible. He's dead. He died with Septimus. They all died with Septimus."

Fade dodged a sweeping blow of the Cane's sword by the width of a blade of grass, then struck out in a pair of blows that maimed the Cane's weapon arm, then struck its muzzle from its skull. The Cane fell toward him in a sudden frenzy of motion, trying to seize him with its remaining pawhand, but Fade ducked away, retreating down three steps as the Cane fell, and struck a blow that sheared off a portion of its skull and killed it at once. He barely got his blade up fast enough to block the next Cane's sword, and

the creature's vicious attack put him on the defensive, driving him down another step.

"Now draw him out," Miles said in a dull voice. "Make him overextend, and take the weapon arm and leg."

The Cane missed a throat slash by a hair, nearly struck Fade with the scything return stroke, and had Fade wobbling on the edge of the next step as the Cane surged forward. In the instant before it struck, Fade recovered his balance, so quickly that Tavi knew it had been a ruse from the outset, ducked under the Cane's blade, then surged inside its guard, struck a crippling blow to its weapon arm, then down to its forward leg in one single circular motion. The Cane fell, but not before Fade's sword had circled around again, using the Cane's own weight to add power to its upswing and all but severing the wolf-warrior's head as it fell.

"Perfect," Miles said quietly. "Perfect. He was always perfect." He blinked his eye several times, and Tavi saw a tear slice down through the blood on Miles's face. "Furies. He's gotten better since that day. But it can't be. It can't be."

"Miles," Tavi said quietly. "You aren't seeing things. It's your brother."

"Araris is *dead*," Miles snarled.

"He looks fairly lively to me," Tavi said.

Miles shook his head again, weeping, as Fade's sword wove an impenetrable sheet of steel between himself and the next Cane warrior. "See, there," he mumbled, his tone suddenly distant again. "That was Septimus's favorite defense. He learned it from pirates, for fighting on slick decks in rough seas. The Princeps taught it to all of us. Or tried to. Only Aldrick and Araris really understood it. How could I not have seen him?" He turned his eye from Fade to Tavi, his expression bewildered. "How could this be? How can he be here?"

"He came with me," Tavi said quietly. "From Calderon. He'd been a slave in my uncle's steadholt since I was a child. Gaius brought him here when I came."

"Gaius. Why would Gaius . . ." His voice suddenly trailed off, and his eye widened again. Beneath the blood on his face, Miles's skin went white, and he stared at Tavi. "Great furies," he whispered. "Great bloody furies."

Tavi frowned at Miles. "What is it?"

Miles open his mouth, then hesitated, his expression an anguish of pain, exhaustion, and shock.

"Tavi!" Fade shouted suddenly, and Tavi whipped his eyes upward.

Fade still fought furiously, his plain old blade striking sparks from the bloodsteel of the Canim weapons, but motion on the ceiling drew Tavi's eyes as spindly, many-legged forms glided swiftly and gracefully along the stone.

Wax spiders. Keepers.

Miles gripped his sword, but the wax spiders did not attack them. They simply flowed overhead, moving in an undulating line of a dozen or more, and vanished around the curve of the stairs below them.

The First Lord. Max. The Maestro. They all lay helpless down there. The deadly venom of the wax spiders would finish them. Only Kitai was capable of defending herself, and she did not know that the spiders were coming. She would never be able to defend all the wounded if they caught her unawares. She would be lucky to survive it herself.

"Gaius," Miles hissed. "They're going down for Gaius." He tried to get his leg underneath him and rise—but Tavi suddenly realized that the Cane had savaged Miles's good leg. His other, the one that had never fully healed, that had given him a permanent limp, could not support him entirely on its own. Even had his injuries left his leg functional, Tavi was unsure Miles could have risen on his own. Exhaustion and loss of blood had taken a horrible toll, and Tavi realized that it was everything Miles could do simply to remain conscious.

Tavi pushed Miles back against the wall, and said, "Stay here. I'll go."

"No," Miles growled. "I'm coming with you."

He tried to rise again, but Tavi slammed him back against the wall with ease. "Captain!" He met Miles's eyes, and said, without rancor, "You're no good to anyone in this condition. You'll slow me down."

Miles closed his eyes for a moment, mouth pressed into a bitter line. Then he nodded once, took his sword, and offered its bloody hilt to Tavi.

Tavi took the captain's sword and met his eyes. Miles tried to smile at him, then grasped Tavi's shoulder with one hand, and said, "Go, lad."

Tavi's heart pounded with terror more pure and awful than anything he had felt in all of his life—not fear for himself, though he certainly was afraid. He was terrified not so much by the prospect of his death as by the possibility that he was insufficient to the task. He was the only one who might warn Kitai and defend the wounded from the wax spiders.

The consequences of failure were too horrible to contemplate, and every second that passed counted against him.

Even as those thoughts played through his mind, Tavi laid the sword back along his forearm in case he should slip on the stairs, then flung himself down them with wild abandon.

◁▭▭▭▷ CHAPTER 52

Fidelias hated flying.

Granted, shooting up the long shaft in the Deeps had little in common with soaring above the countryside, at least superficially, but cut each of the experiences to the bone and the only real difference was that outdoor flight had a better view. He was still traveling at a terrifying rate of speed, and he had no control whatsoever over either his speed or his course—and, most importantly, his life was utterly dependent upon someone else.

Lady Aquitaine could kill him at any moment, simply by doing nothing at all. Gravity would hammer him to the floor far below, and it was unlikely anyone who found his corpse would be able to identify it, much less trace it to her. He would be helpless to stop her, and he knew perfectly well that she was capable of a calculated murder. If ever he became a liability to her ambitions, she might well decide to remove him.

Of course, he mused, Lady Aquitaine could arguably murder him at any moment, for any reason or none at all, and there would be as little he could do to stop her. He had turned against the Crown and committed himself to the cause of her husband's house, and only their continued satisfaction with his service prevented them from turning him over to the Crown or, more likely, quietly doing away with him. There it was. His reaction to the flight up the long shaft was irrational. He was in no more danger now than at any other given moment.

But he still hated flying.

He glanced aside at Lady Aquitaine as they rose on a column of wind. The dark banner of her hair whipped back and forth like a pennon in the gale, and her silk dress did the same, offering the occasional flash of her pale

and shapely legs. Fidelias had long since dispensed with the natural hesitation of most people to treat watercrafters as contemporaries despite the apparent youth of their features. He had dealt with far too many outwardly youthful men and women who possessed the experience and judgment far exceeding what their appearance suggested. Lady Aquitaine was little younger than Fidelias, but her face, form, and figure was that of a young woman in her prime.

Not that Fidelias hadn't seen her legs and a great deal more before now.

She saw him looking and quirked a small smile at him, her eyes sparkling. Then she nodded above them, to where the distant pinpoint of light that marked the end of the shaft had grown steadily nearer, until Fidelias could see the iron bars placed over the opening of the shaft.

They slowed to a halt, just below the bars, and Fidelias counted out to the third from the right, then gave it a twist and a sharp tug. The bar slid from its mounting, and Fidelias pulled himself up through the gap, then leaned down to offer Lady Aquitaine his hand to help guide her through as well.

They emerged into a hallway inside the palace itself, a service corridor that ran from the kitchens to the banquet halls and the royal apartments. Alarm bells rang, and Fidelias knew the sound would be carrying through virtually every hallway in the palace. At this time of night, the service corridor would probably be deserted, but there was always the chance that a guard, responding to the alarm, might use it as a shortcut. Not only that, but within the hour the first few servants would head for the kitchens to begin readying the morning meals. The more quickly they left, the better.

"I still regard this as unwise," Fidelias murmured. He strung his short, heavy bow, laid an arrow to its string, and checked to make sure the rest were at hand. "It's foolish for you to risk being seen with me."

Lady Aquitaine made a clucking sound and waved a hand in airy dismissal. "All you need do is guide me to the disturbance, then depart," she said. She winced, and touched a hand to her forehead.

"Are you well?" Fidelias asked.

"Windcrafting sometimes gives me headaches," she replied. "I had to draw that air all the way from the river and up through the Deeps to lift us. It was extremely heavy."

"Air?" Fidelias asked. "Heavy?"

"When you're trying to move enough it is, dear spy, believe me." She lowered her hand and looked around, frowning. "A service corridor?"

"Aye," Fidelias said, and started down it. "We're close to the royal suites and the stairway down to the meditation chamber. There are several ways down to the Deeps throughout that portion of the palace."

Lady Aquitaine nodded and kept pace, following slightly behind Fidelias. He led her down the hall a short distance, to an intersection that would allow them to bypass a sentry post—though he suspected that the entire Royal Guard was responding to the alarm bells, there was no point in taking chances. Fidelias took the servant's entrance into a richly appointed sitting room, dim and quiet since Gaius's first wife had died some twenty years before, now opened only for dusting and tidying. Inside the sitting room, a section of the oak paneling over the stone walls swung out to reveal a small passageway.

"I love these," Lady Aquitaine murmured. "Where does this one lead?"

"To Lady Annalisa's old chambers," Fidelias murmured. "This room here used to be Gaius Pentius's study."

"With a direct passage to his mistress's chambers, hmm?" Lady Aquitaine shook her head, smiling. "Palace or not, it's all so petty once you've scratched the surface."

"True enough." They shut the hidden panel behind them and emerged into a large bedroom suite centered around an enormous bed on a slightly elevated section of floor. This room, too, had the look of something that had been largely discarded, and Fidelias crossed to the door, cracked it open very slightly, and peered out into the hallway.

The crash and cry of combat rang out as soon as he had opened the door. Not thirty feet away, the Royal Guard crowded against the doorway leading down to the First Lord's meditation chamber. Fidelias sucked in a quick breath. The metal door had been smashed flat to the floor inside the room by some unthinkably powerful impact. Even as he watched, a guardsman went through the door, weapon at the ready, and stumbled back a breath later, clutching his hands to a long wound across his abdomen. He was hauled to one side, where other wounded were being seen to by a harried-looking healer, who kept trying to craft the worst injuries closed enough to keep the wounded alive until more could be done for them. The

other members of the Guard struggled to fight their way through the door, but it was clear that the alarm had found them unprepared, and there didn't seem to be any organization to their efforts.

"Wait here," Lady Aquitaine said, and strode out into the hallway. She walked purposefully over to the nearest guardsman, and said, tone steady and crackling with authority, "Guardsman, who is in charge of this riot?"

The man whipped his head around and blinked at the High Lady. His mouth worked a couple of times, and he said, "This way, Your Grace." He led her over to the healer, and said, "Jens! Jens! Lady Aquitaine!"

The healer looked up sharply, studying Lady Aquitaine for a brief second, before nodding to her and returning to his work. "Your Grace."

"You are the commanding officer here?" she asked.

A spear flew out of the guardroom as though cast by some enormous bow, spitting another one of the guardsmen. The man started screaming.

"Get him over here!" the healer shouted. He glanced up at the High Lady again, and said, "The captain is nowhere to be found. Every regular centurion on duty has been killed, but technically I carry the rank of centurion." The guardsmen brought the impaled man to him, and the healer seized his kit and whipped out a bone saw. He started hacking through the spear's shaft with it. "Crows take it," he snarled, "hold him still!" He grimaced as he cut the spear shaft and slid the weapon out of the wounded guardsman. "If you will excuse me, Your Grace. If I don't give these men all my attention, they'll die."

"If someone doesn't lead them, you're going to have a great deal more of them to tend to," Lady Aquitaine said. She frowned down at the healer, then said, "I'm assuming command until one of your centurions or the captain arrives, healer."

"Yes, fine," the healer said. He looked up at the guardsmen, and said, "Let Lady Aquitaine get things organized, Victus."

"Yes, sir," the guardsman said. "Uh, Your Grace. What are your orders?"

"Report," she said sharply. "Exactly what is happening here?"

"There are four or five Canim holding the first guard station against us," the guardsman said. "They've killed the guards in the room, and about a dozen who have tried to get in, including Centurion Hirus. More of the men are on the way, but our Knights were off duty tonight, and we're still trying to find them."

"Who is down there?"

"We can't be sure," the guardsman replied. "But the First Lord's page came through and warned us of an attack, and Gaius is usually in his meditation chamber at this time of night. The men in the first room went down fighting, so he must have warned them."

"The Canim left some to hold the door against you while the others go after the First Lord," Lady Aquitaine said. "How long have the alarms been sounding?"

"Ten minutes, perhaps, Your Grace. Give us another ten, and our Knights will be here."

"The First Lord doesn't have that long," she said, and spun toward the doorway. She spoke in what seemed a normal tone of voice, but it rang clearly over the sounds of battle and carried the tone of absolute authority. "Guardsmen, clear the doorway at once."

Lady Aquitaine strode to stand in front of the doorway, the guardsmen falling back as she did so. She faced the room, frowned, and raised her left hand, palm up. There was a sullen flash of red light, then a sphere of fire the size of a large grape swelled into life there.

"Your Grace!" the guardsman protested. "A firecrafting could be dangerous for those below."

"A large fire would," Lady Aquitaine replied, and then she hurled the sphere of fire through the doorway.

From where he was standing, Fidelias couldn't see precisely what happened next, but there was a thunderous sound, and wildly dancing light spilled from the room. He saw the sphere flash past the doorway several times, moving in a swift blur and rebounding off every surface within. Lady Aquitaine stood staring at the room for perhaps a minute, then nodded once, decisively. "The room is clear. Gentlemen, to the First Lord at once!"

Something set Fidelias's instincts screaming, and he opened the door enough to look the other way down the hall as the Royal Guard poured forward into the room.

It was the first time he had seen the vord.

A pair of hunchbacked, black shapes were coming down the hall, each one the size of a small horse and covered in chitinous black plates. They had legs like those of an insect, and moved with an awkward, scuttling gait that nonetheless covered ground very swiftly. On the floor beside them, on the walls around them, even on the ceiling above they were accompanied by dozens and dozens of pale forms the size of a wild dog,

also covered in chitinous plating, gliding along on eight graceful, insect limbs.

He stared at them for half a second, and began to shout a warning. He clamped down on the urge. There were thirty or forty guardsmen in the hallway and more arriving at every moment. If one of them saw him, odds were good that he would never leave the palace alive. The only rational thing to do was remain silent.

The creatures drew closer, and Fidelias saw the heavy mandibles on the larger beasts, the twitching fangs on the smaller ones. Though it seemed impossible, no one in the hall had seen them yet. Everyone was focused on getting forward through the doorway to aid the First Lord. Lady Aquitaine had her back to the oncoming vord, listening to an appeal from the frantic healer.

The vord drew closer.

Fidelias stared at them, then realized something. He was afraid for the men in the hall. He was afraid for those wounded lying helplessly on the marble floor, for the desperate healer trying to care for them, and afraid for Lady Aquitaine, who had acted with such decisive precision to control the chaos she had found there when she arrived.

One of the pale spiders made a gliding, twenty-foot jump, landing ahead of its fellows on the marble, and only twenty feet from Lady Aquitaine's back. Without pause, it flung itself through the air at her.

To expose himself would be the height of irrationality. Suicide.

Fidelias raised his bow, drew the string tight, and shot the leaping spider out of the air three feet before it touched Lady Aquitaine. The arrow impaled the spider and sank into the wooden paneling of the wall, where the creature writhed in helpless agony.

"Your Grace!" Fidelias thundered. "Behind you!"

Lady Aquitaine turned, her eyes flashing in time with the blade of her sword as she drew and saw the oncoming threat. The guardsmen, once warned, reacted with trained speed, weapons appearing as if by magic, and a cloud of pale spiders flung themselves forward through the air in an alien flood.

Men started screaming, their voices joining with a chorus of shrill, whistling shrieks. Steel tore into the pale spiders. Fangs found naked flesh of throats and calves and anywhere else not protected by armor.

Fidelias had seen many battles. He had seen battlecrafting on both

large and minor scales. He had worked closely with units of Knights, pitted himself against other furycrafters of various levels of strength, and he had seen the deadly potency of such crafting.

But he had never seen one of the High Blood of Alera enter into open battle.

Within seconds, he understood the vast chasm of power that yawned between a Knight's power, or his own, and that of someone of the blood and skill of Lady Aquitaine.

As the spiders hurled themselves forward, the hallway dissolved into chaos, but for the area near Lady Aquitaine. Her sword moved like a shaft of light, intercepting one spider after another and striking with lethal precision. Her expression never altered from the serene mask she habitually wore, as she weathered the initial wave of leaping creatures, and the instant she had bought herself a few seconds free of attack, she lifted a hand and cried out, her eyes flashing.

Half the hallway beyond exploded into flame, consuming the vord in blinding heat. A furnace-hot gale exploded through the halls in another rattling detonation, but the crafting had stopped the tide of spiders only briefly. Those that survived the fires flung themselves onward over the smoldering remains of their kin.

And then their larger kin arrived.

One of the warrior vord seized a guardsman, its armor turning aside several blows from the man's heavy sword, and shook him back and forth like a dog with a rat. Fidelias heard the man's neck break, and the vord threw him aside and lunged for the next in line—Lady Aquitaine.

The High Lady dropped the sword as the vord warrior closed, and caught the creature's mandibles in her gloved hands as it tried to close them on her neck.

Lady Aquitaine's mouth quirked into an amused little smile, and the earth shook as she called forth power from it and slowly shoved the creature's jaws back open. It began to struggle frantically, but the High Lady of Aquitaine did not release it, pushing its jaws wider until there was a sickly cracking sound, and the vord began flailing its limbs wildly. Once that happened, she seized one of the mandibles in both hands, spun, and hurled the warrior fifty feet down the hall, into a tall marble pillar, where its armor shattered and it fell like a broken toy, gushing alien fluid, twitching, and dying.

The second warrior flung itself directly at her. Lady Aquitaine saw it

coming, and with that same amused little smile, she leapt back and up into the air into graceful flight, a sudden wind rising to support her, just out of reach of the vord warrior.

But for all her power, she did not have eyes in the back of her head. Spiders she had not seen dropped down toward her from the ceiling. Fidelias did not waste his time in thinking. He focused on his task, sending a pair of heavy arrows flashing over the distance between them, tacking one of the spiders to the ceiling before it had fallen six inches, and hammering the other away from Lady Aquitaine a bare foot above her head.

She snapped her head around and saw the results of Fidelias's shooting, then flashed him a fierce, heated smile. Below her, the guardsmen were fighting together now, after the initial shock of the vord attack, and reinforcements were arriving, including two Knights Flora and half a dozen Knights Ferrous, whose archery and swordplay brought the second vord warrior down in short order.

Lady Aquitaine darted over to hover above the wounded guardsmen on the ground, almost casually striking down spiders that approached them with fists of wind and flame. Once more guardsmen arrived, she alighted to the marble floor outside the doorway of the room Fidelias remained within.

"Well done, Fidelias," she said quietly. "Your archery was superb. And thank you."

"Did you think I would not support you when the action began, my lady?"

She tilted her head. Then she said, "You exposed yourself to warn me, Fidelias. And to warn the guard. These men, if they didn't have larger worries at hand, would hunt you down and kill you."

Fidelias nodded. "Yes."

"Then why did you risk yourself for them?"

"Because, my lady," he said quietly, "I turned against Gaius. Not Alera."

She narrowed her eyes and nodded thoughtfully. "I see. It wasn't something I had expected of you, Fidelias."

He inclined his head to her. "Some of those spider creatures got through, my lady. They went on down the stairway."

"There's little to be done for that," she replied. "Best you take your leave now, before the fighting is finished and someone remembers seeing you. Guardsmen are already on the way down to the stairs. We are fortunate to have had your warning. Without it, their attack might have succeeded."

"I don't believe it was meant to succeed," Fidelias said, frowning. "It was meant to delay us."

"If so, it only did so for a few minutes," Lady Aquitaine said.

Fidelias nodded and withdrew from the doorway toward the hidden passage. "But critical minutes, my lady, in a desperate hour," he said. "Great furies grant that we are not now too late."

CHAPTER 53

As he ran full tilt down the stairs, Tavi thought to himself that it was probably just as well Gaius had him running up and down the crows-eaten things over and over for the past two years. Because if he had to run down them one more time, he was going to start screaming.

He reached the last several dozen yards of them and caught up to the wax spiders. "Kitai!" he screamed. "Kitai, more Keepers! Look out!"

He heard the sudden clash of breaking glass, then he came down the last of the stairs and into the antechamber.

Kitai had evidently heard Tavi's warning in time, and her response had been to fling herself at the First Lord's liquor cabinet, where she seized bottles of hundred-year-old wine and started flinging them with deadly accuracy at the oncoming wax spiders. By the time Tavi's feet hit the floor, three of them were already lying on their backs, partially crushed by Kitai's missiles. Even as Tavi ran forward, a pair of spiders dropped down onto Max's recumbent form, and three more headed for Maestro Killian.

Kitai leapt to protect Killian, whipped her swords out of her belt, and shouted a challenge at the wax spiders. Tavi rushed over to Max and seized the sword nearby him—Gaius's blade, which Max had been using earlier. One of the spiders ducked down to bite at Max. Tavi swung the sword before he'd really gotten a good grip on it, and he struck mostly with the flat of the blade. The blow at least knocked the spider off Max, and Tavi followed it with a hard kick aimed at the second beast.

"What's happening?" Killian demanded, his voice thready and thin. "Tavi?"

"Wax spiders!" Tavi shouted. "Get into the meditation chamber!"

Kitai drove one of her blades into a spider. The creature convulsed, tearing the blade from her hand as it dashed drunkenly across the room. She swung a kick at another, which bounded backward in a dodge, but the third leapt upon Killian and sank its fangs into the old Maestro's bloodied shoulder.

Killian screamed.

Kitai seized the spider and try to pull it off the old man. It hung on stubbornly, and every time she tugged on the beast it drew another cry of pain from the Maestro.

Tavi took two steps over to Killian and snapped a swift warning. Before he'd gotten the words fully out, Kitai had dropped the spider and rolled to one side. Tavi swept the First Lord's blade at the spider, and the razor-edged steel cut cleanly through the body of the spider, severing it at what passed for the creature's neck. "More bottles!" Tavi snapped aloud, and knelt to help the old man.

Killian thrashed and shoved the Keeper's body aside, and Tavi reached down to jerk the head—still biting—from the old man's shoulder. He had deep puncture wounds, and they were already swollen. Some kind of yellow-green slime oozed out of the punctures. Poison.

Tavi bit his lip, seized the handle of the door to the inner chamber, and shoved it open. Then he grabbed the old Maestro by the collar and hauled him across the floor and into the room. The old man cried out with pain when Tavi moved him, the sound pitiable, undignified, and Tavi had to steel himself against it. He got the Maestro inside the room as more glass began breaking in the antechamber, then dashed back out.

Kitai, back at the liquor cabinet, flung a heavy bottle at one of the spiders near Max, striking it and sending it flying. Another leapt at her, and she seized another bottle and swung it like a club, shattering it and crushing the spider.

"Here!" Tavi barked. "Break them right here, in front of the door!" He grabbed Max's collar and started pulling. His friend weighed twice what Killian did, but Tavi found that he could move him. It was an enormous strain, but Tavi's additional training and conditioning with the Maestro was paying off, and the fear and heat of battle made him stronger yet.

A spider leapt at Max, and Tavi took a clumsy swing at it with the First Lord's blade. To his shock, the spider simply caught the blade in its jaws, then swarmed up it in a blur of spindly legs to Tavi's arm.

It didn't bite him. It only swarmed up over his shoulders and down the other arm, toward Max. Tavi released his friend and flapped his arm around wildly, tossing the spider upward and away from him, precisely in time to see a deep green bottle crash into the beast, taking it down.

"Hurry!" Kitai cried. "I am running out of bottles!"

Tavi seized Max, dragged him through, and screamed, "In front of the door, hurry!"

Glass shattered upon the floor, splattering wine and harder liquors everywhere, as Tavi pulled Max into the inner chamber.

"Aleran!" Kitai shouted.

"Come on, get in here!" Tavi yelled. He ran back to the door.

Kitai flung herself across the antechamber, scooping up her dropped blade on the way. Two more spiders came down the stairs, joining the half dozen or so remaining, and flung themselves through the air toward Kitai.

"Look out!" Tavi screamed.

Again, before he'd completed the first word, Kitai was in motion, ducking to one side—but she slipped on the spilled liquids and fell to one knee.

Both spiders landed upon her and started biting viciously. She let out a wail of terror and rage, tearing at them, but she had no more luck peeling them off her than she had with Killian. She struggled to rise and slipped again.

A third spider hit her.

And a fourth.

They were killing her.

A rage like nothing he had ever felt engulfed Tavi in a sudden cloud. His vision misted over with scarlet, and he felt the fury run like lightning through his limbs. Tavi launched himself forward, and the First Lord's sword was suddenly not too heavy for him to wield effectively. His first strike split one of the spiders in half and knocked another one clear.

He thrust the blade through one of the remaining spiders, then had to kick it off the end of the sword. He killed the other in the same way, grabbed the girl by the wrist, and hauled her into the inner chamber.

The remaining spiders were right behind them, chirruping in those eerie whistles. Tavi whipped around to the doorway, seized a furylamp off the wall, and hurled it down onto the liquor-covered floor in front of the door.

Flame exploded in a rush, engulfing the remaining spiders. They let out shrieking whistles and dashed mindlessly around the room. One of them bounded through the doorway, evidently by blind chance. Tavi knocked it to the floor with his first slash, crippling it, then finished it with a swift thrust, impaling it on Gaius's sword. Then he spun and hurled the dying spider from the blade, at the partly open door to the outer chamber. The spider hit it in a burst of greenish gore, and its weight slammed the door shut.

Tavi dashed to the door, threw the bolt, then ran to Kitai.

She lay there shivering, bleeding from a dozen small wounds. Most of them were swollen and stained with poison, as Killian's was, but others were more conventional injuries, cuts from the broken glass littering the floor.

"Kitai," Tavi said. "Can you hear me?"

She blinked green eyes up at him and nodded, a bare motion. "P-poison," she said.

Tavi nodded, and sudden tears blinded him for a moment. "Yes. I don't know what to do."

"Fight," she said, her voice a bare whisper. "Live." She looked like she might have said something else, but her eyes rolled back, and she went limp except for tiny, random twitches.

A few feet away, Killian had managed to partially sit up, leaning on one elbow. "Tavi?"

"We're all in the meditation chamber, Maestro," Tavi said, biting his lip. "You've been poisoned. So has Kitai." Tavi bit his lip, looking around desperately for something, anything that could help them. "I don't know what to do now."

"The First Lord?" Killian asked.

Tavi checked the cot. "Fine. Breathing. The spiders never got close to him."

Killian shuddered and nodded. "I'm very thirsty. Perhaps the venom. Is there any water?"

Tavi grimaced. "No, Maestro. You really should lie down. Relax. Try to conserve your strength. The guard is sure to be here soon."

The old man shook his head. The pulse in his throat fluttered wildly, and there were veins on his forehead and temple swelling into twitching visibility. "Too late for that, lad. Just too old."

"Don't say that," Tavi said. "You're going to be all right."

"No," he said. "Come closer. Hurts to talk." He moved his hand and beckoned Tavi.

Tavi leaned close to him to listen.

"You must know," he said, "that I have been involved with Kalare. Working with his agents."

Tavi blinked down at Killian. "What?"

"It was meant as a ploy. Wanted them close, where I could see them moving. Feed them false information." He shuddered again, and tears ran from his blind eyes. "There was a price. A terrible price. To prove myself to them." A sob escaped his throat. "I was wrong. I was wrong to do it, Tavi."

"I don't understand," Tavi said.

"You must," Killian hissed. "Spy. Kalare's . . ." He suddenly fell back to the floor, and his breath started coming faster, as though he'd been running. "H-here," he gasped. "Kalare. His chief assassin. You m—"

Suddenly Killian's blind eyes widened and his body arched up into a bow. His mouth opened, as if he was trying to scream, but no sound came out—nor any breath, either. His face purpled, and his arms worked frantically, clawing at the floor.

"Maestro," Tavi said quietly. His voice broke in the middle of the word. He caught one of Killian's wrinkled hands, and the old man clutched Tavi's fingers with terrified strength. Not long after, his contorted body began to relax, deflating like a leaking leather flask. Tavi held his hand and laid his hand on the Maestro's chest, feeling his frantically beating heart.

It slowed.

And stopped a moment later.

Tavi gently put Killian's hand back down, frustration and pain a storm in his chest. Helpless. He had watched as the old man died, and there was not a bloody thing he could have done to help him.

He turned away and went to Kitai. She lay on her side, half-curled upon herself. Her eyes were closed now, her breath coming in swift rasps. He touched her back, and could feel the frenzied pounding of her heartbeat. Tavi bit his lip. She'd been bitten many more times than the Maestro. She was younger than Killian, and unwounded, but Tavi did not know if it would make any difference in the end.

He took Kitai's hand, and now he did weep. His tears fell to the tiled mosaic floor. Pain stabbed at his heart with every beat. Rage followed close behind it. If only he could perform watercrafting like Aunt Isana. He might be able to help Kitai. Even if he wasn't as powerful as his aunt, he might be able to help her remain alive until help came. If he had even a

laughable talent with watercrafting, he could have at least given Killian some water.

But he had none of that.

Tavi had never felt more useless. He'd never felt more powerless. He held her hand and stayed with her. He had promised her that she would not be alone. He would stay with her to the end, regardless of how painful it would be to watch her die. He could, at least, do that.

And then the door to the meditation chamber exploded from its hinges and slammed flat to the stone floor.

Tavi jerked his head up. Had the Guard arrived at last?

The taken Cane stepped onto the fallen door and swept its bloodred gaze around the chamber. The Cane was wounded, blood wetting the fur of its chest and one thigh. It was missing one ear completely, and a slash to its face had opened one side of its muzzle to the bone and claimed one of its eyes.

For all of that, it moved as if it felt no pain at all. Its eye settled on Max. Then on Gaius. It looked back and forth between them for a moment, then turned and stalked forward, toward Max.

Tavi's heart erupted with pure terror, and for a moment he thought he might swoon. The Canim had gotten by Fade and Miles. Which meant that they were probably dead. And it meant that the guard was not closing in to save them.

Tavi was on his own.

CHAPTER 54

Tavi looked down at Kitai. At Max. At Gaius.

The Cane stalked forward with a predator's deadly beautiful grace. It was so much larger than he, stronger, faster. He had little chance of surviving a battle with the Cane, and he knew it.

But if it was not stopped, the Cane would kill the helpless souls behind

him. Tavi's imagination provided him a vivid image of the carnage. Max's throat torn out, his corpse grey-skinned from blood loss. Gaius's entrails spilling forth from his ravaged body. Kitai's head lying a few feet away from her body, cut away by the Cane's curved blade.

Tavi's fear vanished utterly.

All that remained was the red-misted haze of rage.

He released Kitai's hand. His fingers closed hard around the hilt of the First Lord's blade as he rose, and he felt his mouth stretch into a fighting grin. He raised the sword to a high guard, both hands on the hilt. A healthy Canim warrior would have torn him limb from limb, literally. But this one was not healthy. It was injured. And while he could never hope to overpower the Cane, his sword was sharp, his limbs were quick, and his mind quicker. He could outthink the creature, fight it with not only strength but with guile. His eyes flicked around the room, and his grin became fiercer.

And then he gave his rage a voice, howling at the top of his lungs, and attacked.

The Cane bared its teeth and swept its curved blade at Tavi as he came in, its height giving it a deadly advantage in reach. Tavi met the slash with his sword, both hands gripping it as tightly as he could. The Cane's scarlet blade rang against Aleran steel. Tavi felt the bone-deep shock of the impact all the way up to both shoulders, but he stopped the Cane's heavy blade cold, beat it aside, and reversed the sword into a horizontal slash. The blow struck sparks from the Cane's mail, severing a dozen links that sprang away from the armor and rang tinnily as they struck the stone floor.

Tavi dared not close to more exchanges of main force. His fingers were already tingling. Another blow or two like that from the Cane and he wouldn't be able to hold a sword—but the first such attack had been necessary.

Tavi had proven himself a threat, and the Cane turned to engage him.

The Cane's counterattack was quick, but Tavi continued his movement past the wolf-warrior, circling to the side of the Cane's wounded leg to force it to turn on the injured limb. It slowed the Cane, and Tavi ducked under the scything blade and struck again, a heavy slash that landed hard on the foot of the Cane's unwounded leg. Tavi rose from that strike in a two-handed upward slash that might have opened his foe from groin to chest— but the Cane blocked Tavi's attack, flicked his sword to one side, and surged toward him in a primal assault, teeth snapping.

The Cane was far too swift for its size; but with both legs injured, its

balance was precarious, and Tavi managed to jerk his face back and away from the Cane's jaws before they snapped shut. He felt a flash of heat over one eye, then fell into a backward roll, toward Killian's body, tucking himself into a ball until he came back up to his feet. Tavi brought his sword up to guard almost before he was finished with the roll, and he managed to deflect the Cane's sword as it swept straight down at his skull.

The Cane snapped at his face once more. Tavi ducked under the Cane's foaming jaws to come up on the creature's opposite side—its blind side. The Cane slashed wildly toward him, but the blow came nowhere close, and it whirled to snap at him with its teeth once more, swift and monstrously strong—and blind. Tavi shifted his grip on the First Lord's blade and drove its pommel forward with another battle cry. The weighted metal hammered into the Cane's snapping jaws, and fragments of broken teeth flew up from the blow.

The taken Cane whipped its head back and forth with a high-pitched snarl of pain, evidently more than even the vord taker could totally suppress. Tavi took the opportunity to drive a short, hard slash into the Cane's muzzle. The blow was not a forceful one, but it sliced into the Cane's blunt nose, and drew another howl of agony from the creature. It staggered back, as Tavi had intended, slipping on the blood beside Killian's corpse. Its feet slipped and twisted treacherously as it snarled in maddened rage and raised the curved sword again.

In the time that took, Tavi danced once more to its blind side, out onto the tiles of the map-mosaic of Alera itself. He struck across the Cane's throat, splitting its leather war collar with the First Lord's blade. The flesh beneath opened it in a fountain of gore. The taken Cane swept its blade in a wide slash, but slowed by its injuries and its uncertain footing, Tavi ducked it easily enough—and then he screamed out his defiance as he drove the tip of the sword into the Cane's chest.

Mail rings shattered and scattered over the tiles as the First Lord's sword bit deep. The Cane hacked down at him, but Tavi pressed in close, inside the effective arc of the blade. He felt a fiery flash on the calf of one leg, and heard himself screaming and howling as he forced himself hard against the Cane, driving his sword deeper, shoving the much larger creature into a backward stumble.

The Cane, lamed in both legs, slipping on bloody tiles, went down with a crash of mail. Tavi, holding on to the hilt of the sword, came down on top

of his opponent. The Cane tried once more to tear at Tavi with its teeth, but the vicious power of the thing was fading by the heartbeat, as blood spilled from its throat.

Still screaming, Tavi slammed himself against the sword, trying to drive it deeper, to pin the Cane down to the stone of the floor if need be. If he let it rise, the Cane could still murder Gaius or Max or Kitai, and he was determined that it would not happen.

He wasn't sure how long he struggled to keep the thing down, but at some point he found himself lying still atop an unmoving foe, his breathing labored. The Cane's lips were peeled back from its fangs in death, and its remaining eye was glassy. Tavi rose slowly, aching in every limb. The wild energy of the battle fever he'd felt was gone, and he was cut both on his forehead and on his leg. He wasn't bleeding badly from either injury, but he felt himself shaking in sheer exhaustion.

He'd done it. Alone. Had the Cane not been already injured, or had he not exploited its injuries, he might not have survived the battle. But he, Tavi, alone, without furies of his own, without allies, had overcome one of the monstrous warriors in open battle.

He heard footsteps outside, coming down the stairway.

Tavi took a deep breath. He reached down to the sword, and with an enormous effort he hauled it from the Cane's corpse. His wounded leg buckled, but he brought the sword upright into his hands, most of the weight on his back leg, the other planted on the fallen Cane's chest as he waited for whatever else might come.

The footsteps grew louder, and Fade, his slave's rough clothing covered in blood, leapt down the last several steps, blade in hand. He let out a cry and threw himself toward the doorway, but came to a sharp halt as he saw the room beyond. Behind him, several of the Royal Guard, one of them assisting Sir Miles, came running down the stairs as well. Miles hobbled over to the door at once, ordering guards out of his way—and then he, too, stopped, staring at Tavi with his mouth open.

Tavi faced them all for a second, sword in hand, and it registered slowly on him that it was over. The battle was over, and he had survived it. He let out a slow breath, and the sword fell from his suddenly nerveless hands. His balance wobbled, and he abruptly forgot how to stand upright.

Fade's sword clanged as it hit the floor, and he was underneath Tavi before the boy could fall.

"I've got you," Fade said quietly. He lowered Tavi gently to the floor. "You're wounded."

"Kitai," Tavi panted. "Poisoned. She'll need help. Max still wounded. Killian . . ." Tavi closed his eyes, to avoid looking at the Maestro's still form. "The Maestro is dead, Fade. Poisoned. The spiders outside. Nothing got to Gaius."

"It's all right," Fade said. He murmured something, then pressed the mouth of a flask to his lips. Tavi drank the lukewarm water thirstily. "Not too fast. Thank the great furies, Tavi," Fade said as he drank. "I'm sorry. One of the Canim threw himself on my sword to let another go past me. I got here as swiftly as I could."

"Don't worry about it," Tavi told him. "I got him."

Tavi could hear the sudden, fierce smile on Fade's mouth as he spoke. "Yes. You did. There are watercrafters and healers on the way, Tavi. You'll be all right."

Tavi nodded wearily. "If it's all the same to you, I'm just going to sit here for a minute. Rest my eyes until they get here." He leaned his head back against the wall, exhausted.

Tavi didn't hear if Fade made any reply before he gave himself to sleep.

⋈⋈⋈⋈⋈CHAPTER 55

". . . absolute mystery to me how the girl survived it," Tavi heard a sonorous male voice saying. "Those creatures poisoned two dozen guardsmen, and even with watercrafters at hand, only nine of them survived."

"She is a barbarian," replied a voice Tavi recognized. "Perhaps her folk aren't as susceptible."

"She seemed more like one who has endured it before," the first voice said. "Gained a resistance to it through exposure. She was already conscious again by the time we began to treat her, and she needed almost no assistance. I'm certain she would have been all right without our help."

The first voice grunted, and Tavi opened his eyes to see Sir Miles speaking quietly with a man in an expensive silk robe worn over rather plain, sturdy trousers and shirt. The man glanced at him and smiled. "Ah, there you are, lad. Good morning. And welcome to the palace infirmary."

Tavi blinked his eyes a few times and looked around him. He was in a long room lined with beds, curtains hung between each. Most of the beds were occupied. The windows were open, a pleasant wind stirring them gently, and the scent of recent rain and flowering plants, the scent of spring filled the room. "G-good morning. How long have I been asleep?"

"Nearly a full day," the healer replied. "Your particular injuries were not threatening, but you had so many of them that they amounted to quite a strain. You'd gotten some of that spider venom into some of your wounds as well, though I don't think you'd been bitten. Sir Miles ordered me to let you sleep."

Tavi rubbed his face and sat up. "Sir Miles," he said, inclining his head. "Is Kitai . . . the First Lord . . . Sir, is everyone all right?"

Miles nodded to the healer, who took it as a hint to depart. The man nodded and clapped Tavi's shoulder gently before making his way down the row of beds, attending to other patients.

"Tavi," Miles asked quietly, "did you slay that Cane we found you on top of?"

"Yes, sir," Tavi said. "I used the First Lord's blade."

Miles nodded, and smiled at him. "That was boldly done, young man. I expected to find nothing but corpses at the bottom of the stairs. I underestimated you."

"It had already been wounded, Sir Miles. I don't think that . . . well. It was half-dead when it got there. I just had to nudge it along a little."

Miles tilted his head back and laughed. "Yes. Yes, well. Regardless, you'll be glad to know that your friends and the First Lord are all well."

Tavi's back straightened. "Gaius . . . He's . . . ?"

"Awake, irritable, and his tongue could flay the hide from a gargant," Miles said, his expression pleased. "He wants to speak with you as soon as you're strong enough."

Tavi promptly swung his legs off the side of the bed and began to rise. Then froze, looking down at himself. "Perhaps I should put some clothes on, if I'm to see the First Lord."

"Why don't you," Miles said, and nodded to a trunk beside the bed. Tavi

found his own clothes there, freshly cleaned, and started slipping into them. He glanced up at Sir Miles as he did, and said, "Sir Miles. If . . . if I may ask. Your brother—"

Miles interrupted him with an upraised hand. "My brother," he said, with gentle emphasis, "died nearly twenty years ago." He shook his head. "On an unrelated note, Tavi, your friend Fade, the slave, is well. He distinguished himself for his valor on the stairway, assisting me."

"Assisting you?"

Miles nodded, his expression carefully neutral. "Yes. Some idiot has already composed a song about it. Sir Miles and his famous stand on the Spiral Stair. They're singing it in all the wine clubs and alehouses. It's humiliating."

Tavi frowned.

"It makes a much better song than one about a maimed slave," he said quietly.

Tavi lowered his voice to almost a whisper. "But he's your brother."

Miles pursed his lips, looked at Tavi for a moment, then said, "He knows what he's doing. And he can't do it as well if every loose tongue in the Realm can wag on about how he has returned from the grave." He nudged Tavi's boots over to him from where they sat near the foot of the bed, and added, so quietly that Tavi could barely hear him, "Or why."

"He cares for you," Tavi said quietly. "He was terrified that . . . that you would think ill of him, when you saw him."

"He was right," Miles said. "If it had happened any other way . . ." He shook his head. "I don't know what I might have done." His eyes went a bit distant. "I spent a very long time hating him, boy. For dying beside Septimus, off in the middle of nowhere, when my leg was too badly injured to allow me to be there beside him. All of them. I couldn't forgive him for dying and leaving me behind. When I should have been with them."

"And now?" Tavi asked.

"Now . . ." Miles said. He sighed. "I don't know, lad. But I have a place of my own. I have my duty. There seems to be little sense in hating him now." His eyes glittered. "But by the great furies. Did you *see* him? The greatest swordsman I've ever known, save perhaps Septimus himself. And even then, I always suspected that Rari held back so as not to embarrass the Princeps." Miles's eyes focused elsewhere, then he blinked them and smiled at Tavi.

"Duty?" Tavi suggested.

"Precisely. As I was saying. Duty. Such as yours to the First Lord. On your feet, Acad—" Then Miles paused, head tilted to one side as he regarded Tavi. "On your feet, man."

Tavi pulled his boots on and rose, smiling a little. "Sir Miles," he asked, "do you know if there's been any word of my aunt?"

Miles's expression became remote as he started walking, his limp now more pronounced. "I've been told that she is safe and well. She is not in the palace. I don't know more than that."

Tavi frowned. "What? Nothing?"

Miles shrugged.

"What about Max? Kitai?"

"I'm sure Gaius will answer any questions you have, Tavi." Miles gave him a faint smile. "Sorry to be that way with you. Orders."

Tavi nodded and frowned even more deeply. He walked with Miles to the First Lord's personal chambers, passing, Tavi noted, three times as many guardsmen as normal. They reached the doors to Gaius's sitting room, where he received guests, and a guard let them in, then vanished behind curtains at the end of the room to speak quietly to someone there.

The guard reemerged, and left the room. Tavi looked around at the furniture, really rather spartan for the First Lord, he thought, everything made of the fine, dark hardwoods of the Forcian forests on the west coast. Paintings hung on one wall—one of them only half-finished. Tavi frowned at them. They were of simple, idyllic scenes. A family eating a meal on a blanket in a field on a sunny day. A boat raising sails to meet the first ocean swells, a dim city somewhere in the fog behind it. And the last, the unfinished one, was a portrait of a young man. His features had been painted, but only about a third of his upper body and shoulders were finished. The portrait's colors stood out starkly against the blank canvas beneath.

Tavi looked closer. The young man in the portrait looked familiar. Gaius, perhaps? Take away the weathering of time in his features, and the young man could perhaps be the First Lord.

"Septimus," murmured Gaius's deep voice from somewhere behind Tavi. Tavi looked back to see the First Lord step out from behind the curtain. He was dressed in a loose white shirt and close-fitting black breeks. His color was right again, his blue-grey eyes bright and clear.

But his hair had turned stark white.

Tavi bowed his head at once. "Beg pardon, sire?"

"The portrait," Gaius said. "It's my son."

"I see," Tavi said, carefully. He had no idea what the proper thing to say in this sort of situation might be. "It's . . . it's not finished."

Gaius shook his head. "No. Do you see that mark on the neck of the man in the portrait? Where the black has cut over onto his skin?"

"Yes. I thought perhaps it represented a mole."

"It represents where his mother was working when we got word of his death," Gaius said. He gestured at the room. "She painted all of these. But when she heard of Septimus, she dropped her brushes. She never picked them up again." He regarded the painting steadily. "She took sick not long after. Had me hang it in the room near her, where she could see it. She made me promise, on that last night, not to get rid of it."

"I'm sorry for your loss, sire."

"Many are. For many reasons." He glanced over his shoulder. "Miles?"

Miles bowed his head to Gaius and backed for the door. "Of course. Shall I have someone bring you food?"

Tavi started to agree very strongly but held off, glancing at Gaius. The First Lord laughed, and said, "Have you ever known a young man who wasn't hungry—or about to be so? And I should be eating more, too. Oh, and please send for those others I mentioned to you?"

Miles nodded, smiling, and retreated quietly from the room.

"I don't think I've seen Sir Miles smile so much in the past two years as I have today," Tavi commented.

The First Lord nodded. "Eerie, isn't it." He settled in one of the two chairs in the room and gestured for Tavi to take the other. "You want me to tell you about your aunt," Gaius said.

Tavi smiled a little. "Am I that predictable, sire?"

"Your family is very important to you," he replied, his tone serious. "She is unharmed, and spent the entire night sitting beside your sickbed. I've sent word to her that you've woken. She'll come up to the Citadel to visit you shortly, I should imagine."

"To the Citadel?" Tavi asked. "Sire? I had thought she'd be staying in guest quarters here."

Gaius nodded. "She accepted the invitation of Lord and Lady Aquitaine to reside in the Aquitaine manor for the duration of Wintersend."

Tavi stared at the First Lord in shock. "She *what?*" He shook his head.

"Aquitaine's scheme nearly destroyed every steadholt in the Calderon Valley. She despises him."

"I can well imagine," Gaius said.

"Then in the name of all the furies, *why?*"

Gaius twitched one shoulder in a faint shrug. "She did not speak to me of her motivation for such a thing, so I can only conjecture. I invited her to stay here, near you, but she politely declined."

Tavi chewed on his lower lip in thought. "Crows. It means more, doesn't it?" His belly suddenly felt cold. "It means she's allied herself with them."

"Yes," Gaius said, his tone neutral and relaxed.

"Surely she . . . Sire, is it possible that she has been coerced in some way? Furycrafted into it?"

Gaius shook his head. "No such thing was affecting her. I examined her myself. And that kind of control is impossible to hide."

Tavi racked his mind frantically to find an explanation. "But if she was threatened or intimidated into it, then couldn't something be done to help her?"

"That is not what has happened," Gaius said. "Can you imagine fear moving your aunt to do anything? She showed no signs of that kind of fear. In fact, in my judgment she traded her loyalty as part of a bargain."

"What kind of bargain?"

There was a polite knock at the chamber door, and a porter entered pushing a wheeled cart. He placed it near the chairs, opened its sides into the wings of a table, and began placing silver-covered dishes and bowls on the table, until he had laid out a large breakfast, complete with a ewer of milk and another of watery wine. Gaius remained silent until the porter took his leave and shut the door again.

"Tavi," Gaius said, "before I tell you more, I would like you to go through everything that happened in as much detail as you can recall. I don't want my explanations to muddy your own memories before you've had the chance to tell them to me."

Tavi nodded, though it was frustrating to be forced to wait for answers. "Very well, sire."

Gaius rose, and Tavi did as well. "I imagine you're even hungrier than I am," he said with a small smile. "Shall we eat?"

They piled plates with food and settled back down into the chairs. After the first plateful, Tavi went back for more, then started recounting events to

the First Lord, beginning with his confrontation with Kalarus Brencis Mi-
noris and his thugs. It took him most of an hour. Gaius interrupted him a
few times to ask for more details, and in the end he leaned back in his chair,
a cup of mild wine in his hand.

"Well," he said. "That explains Caria this morning, at any rate."

Tavi's cheeks flushed so hot that he thought they must surely blister at
any moment. "Sire, Max was only—"

Gaius gave Tavi a cool look, but he could see the smile at the corners of
the First Lord's eyes. "In most of my life, I would not have minded a lovely
wife inviting herself to join me in my bath. But this morning was . . . I was
taxed enough. I'm nearly fourscore years, for goodness sake." He shook his
head gravely. "I adjusted to the demands of my station, of course, but when
you speak to Maximus, you might mention to him that in the future, should
this situation arise again, he should seek some course *other* than to fondle
my wife."

"I'll let him know, sir," Tavi said, his own voice solemn.

Gaius chuckled. "Remarkable," he murmured. "You acquitted yourself
rather well. Not perfectly, but you might have done a great deal worse, too."

Tavi grimaced and looked down.

Gaius sighed. "Tavi. Killian's death was not of your making. You needn't
punish yourself for it."

"Someone should," Tavi said quietly.

"There was nothing you could do that you had not already done," the
First Lord said.

"I know," Tavi answered, and was surprised by the bitter anger in his
own voice. "If I wasn't a freak, if I'd had even a little skill at furycraft—"

"Then, in all likelihood, you would have relied upon your crafting rather
than upon your wits, and died because of it." Gaius shook his head. "Men,
good soldiers and good crafters alike, died in fighting these foes. Furycraft is
a tool, Tavi. Without a practiced hand and an able mind behind it, it's no
more useful than a hammer left on the ground."

Tavi looked away from the First Lord, staring at the floor to one side of
the fireplace.

"Tavi," he said, deep voice quiet, "I owe you my life, as do the friends
you protected. And because of your actions, countless others have been
saved as well. Killian died because he chose a life of such service, to put
himself between the Realm and danger. He knew what he was doing when

he entered that fight, and the risk he was taking." Gaius's voice became more gentle. "It is childishly arrogant of you to belittle his choice, his sacrifice, by attempting to take responsibility for his demise upon your own shoulders."

Tavi frowned. "I . . . hadn't thought of it in those terms."

"There's no reason you should have," Gaius said.

"I still feel as if I failed him somehow," Tavi said. "His last words to me were important, I think. He was trying so hard to get them to me, but . . ." Tavi remembered the last seconds of Killian's life and fell silent.

"Yes," Gaius said. "It is unfortunate that he did not manage to reveal the identity of the assassin—though I suspect that with Killian dead, Kalare's agent will depart."

"Isn't there any way for us to tell who it is before he—or she—leaves?"

The First Lord shook his head. "There is a great deal for me to do to repair some of the damages done. To exploit an advantage or two. So, young man, I'll pass the search to you. Can you apply your mind as ably to finding this assassin as you did to stopping the attack? I should think Killian would like that."

"I'll try," Tavi said. "If I'd only been a few seconds faster it might have helped him."

"Perhaps. But one might as easily say that if you had been a few seconds slower, all of us would be dead." Gaius waved a hand. "Enough, boy. It's done. Remember your *patriserus* for his life. Not his death. He was quite proud of you."

Tavi blinked his eyes a couple of times, fought back tears, and nodded. "Very well."

"Upon the subject of your aunt," Gaius said. "You should know two things. First, that there was an attack of these creatures within the Calderon Valley. Your uncle and Countess Amara led a force against it, while your aunt carried word to me to ask for reinforcements."

"An attack?" Tavi said. "But . . . what happened? Is my uncle all right?"

"I dispatched two cohorts of Knights Aeris and Ignus to their aid about twelve hours ago, as well as informing Lord Riva of the issue and strongly suggesting that he take steps to investigate, but there hasn't yet been time enough for word to reach us of what they found."

"Great furies," Tavi murmured, shaking his head. "When will you know?"

"Perhaps by tomorrow morning," Gaius said. "Certainly before tomorrow sunset. But I suspect that they have already received aid."

Tavi frowned. "But how?"

"The Aquitaines," Gaius said. "They control a formidable number of Knights Aeris and other Knight-quality mercenaries. I believe that was one of the things your aunt secured in exchange for her political support."

"One of them?"

"Indeed," Gaius said. "When the vord and the taken Canim attempted to storm the stairway, time had become a critical issue. The Royal Guard would have ultimately prevailed, but in the confusion it was unlikely that they could have done so in time. Until Invidia Aquitaine arrived, took command of the counterattack, destroyed most of attacking vord creatures, then broke the Canim rear guard so that the guards could descend the stairs."

Tavi blinked. "*She* was protecting *you?*"

Gaius's mouth quirked. "I suspect she was preserving me from death in order to prevent Kalare from attempting a coup of his own until she and her husband were ready for theirs. It's remotely possible that she was concerned that a succession war could have erupted and left the Realm vulnerable to its foes." He smiled. "Or perhaps she was simply protecting you, as part of her bargain with your aunt. In either case it's a winning tactic for her. By the crows, I'm going to have to give her a medal for it, right in front of everyone— the First Lord saved by a woman. The Dianic League may collapse in a fit of collective ecstasy at the opportunity."

"And she'll use Aunt Isana to help rally the League around her, too." Tavi shook his head. "I just can't believe it. Aunt Isana . . ."

"It isn't hard to understand her, boy. She came to me to ask my help and protection. I did not give them to her."

"But you were unconscious," Tavi said.

"And why should that matter?" Gaius asked. "Her home was in danger. Her family was in danger. She was not able to reach me for help, so she took it where she could find it." He frowned down at his glass, his brow troubled. "And it was given to her."

"Sire," Tavi asked, "do you know who slew the vord queen? After the initial attack, I did not see her again."

Gaius shook his head gravely. "No. So far as we know, the creature escaped—as did the Canim chancellor. Miles already has the Crown Legion sweeping the Deeps, which I should think will put a large dent in the

smuggling business for the year, but, I suspect, little else. All the shipping that has left in the past two days has been hunted down and searched, but to no avail."

"I think Sarl was using the courier ships and working with the vord."

Gaius tilted his head. "Oh?"

"Yes, sire," Tavi said. "Canim guards changed out every month. There were always a couple of them coming or going at least, and all of them in those big, heavy capes and hoods. My guess is that Sarl and the vord would take the largest and tallest men they could find, dress them up in a Cane's armor, drape the hood over them, then take them to the ship, while the two Canim who were supposed to be going back home were taken instead, and stored at the vord nest in the Deeps. That's how they built up that many Canim."

Gaius nodded slowly. "It makes sense. This information about factional struggles within the Canim nation is rather encouraging. It's nice to know that our enemies can be as fractious as we are."

"Sire?" Tavi asked. "What of Ambassador Varg?"

"He returned to the palace last night and surrendered his sword, accepting full responsibility for the actions of his chancellor. He's under house arrest."

"But he helped us, sire, when he need not have done so. We owe him our thanks."

Gaius nodded. "I know that. But he's also a war leader of a nation whose warriors just tried to openly murder the First Lord of Alera. I believe I can ensure that his life is spared, for the time being at any rate. But I can promise him little more."

Tavi frowned but nodded. "I see."

"Oh," Gaius said. He picked up an envelope and passed it to Tavi. "I think you've very nearly outgrown your position as my page, Tavi, but this is a last message to deliver to the new Ambassador, in the northern hall."

"Of course, sire."

"Thank you," he said. "I've arranged to take dinner with your aunt and your fellow trainees this evening, as well as with the Ambassador. I'd like you to be there as well."

"Of course, sire."

Gaius nodded, the gesture one of dismissal.

Tavi turned to go to the door—but once there, he paused and turned. "Sire, if I may ask about Fade?"

Gaius frowned and lifted a hand to pinch the bridge of his nose between thumb and forefinger. "Tavi," he said tiredly, "there are some questions in life only you can answer for yourself. You have a mind. Use it." He waved a hand vaguely. "And use it elsewhere, hmm? I'm growing fatigued quite easily, and my healers tell me that if I am not cautious, I might have another episode."

Tavi frowned. Gaius hadn't seemed to be getting more weary as they talked, and he suspected it was merely an excuse to avoid the subject. But what could he do? One didn't try to pin the First Lord of Alera down in a conversation. "Of course, sire," Tavi said, bowing at the waist and departing.

He left the First Lord's suites and walked slowly into the north hall. He paused to ask a passing maid where the new Ambassador's quarters were located, and she directed him to a large set of double doors at the far end of the hall. Tavi walked down to them and knocked quietly.

The door opened, and Tavi found himself facing Kitai as he had never seen her before. She was dressed in a robe of dark emerald silk that fell to her knees and belted loosely at the waist. Her hair was down, brushed out into long and shining waves of white that fell to her hips. Her feet were bare, and fine, glittering chains of silver wrapped one ankle, both wrists, and her throat, where the necklace was set with another green stone. The colors were a perfectly lovely complement to her large, exotic eyes.

Tavi's heart suddenly beat very quickly.

Kitai studied Tavi's expression, her own face somewhat smug, and she smiled slowly. "Hello, Aleran."

"Um," Tavi said. "I have a message for the Ambassador."

"Then you have a message for me," she said, and held out her hand. Tavi passed the envelope to her. She opened it and frowned at the letter within, then said, "I cannot read."

Tavi took the letter and read it. "Ambassador Kitai. I was pleased to hear from the crown guardsman you passed on the way into the palace yesterday morning that Doroga had dispatched an envoy to Alera to serve as an ambassador and emissary between our peoples. While I did not expect your arrival, you are most welcome here. I trust your quarters are satisfactory, and that your needs have been adequately attended to. You have only to inquire of any of the serving staff if you have need of anything else."

Kitai smiled, and said, "I have my own pool, in the floor. You can fill it with hot water or cold, Aleran, and there are scents and soaps and oils of every

kind. They brought me meals, and I have a bed that could fit a mother gargant giving birth." She lifted her chin and pointed at the necklace. "You see?"

Tavi saw very soft, very fair skin, more than anything—but the necklace was lovely, too.

"Had I known of this," Kitai continued, "I might have asked to be an Ambassador before now."

Tavi coughed. "Well. I, uh. I mean, I suppose you *are* an Ambassador, if the First Lord says so, but for goodness sake, Kitai."

"Keep your opinions to yourself, message boy," she said disdainfully. "Continue to read."

Tavi gave her an even look, then read the rest of the note. "In order to help you better understand your duties here, I suggest that you take the time and effort to learn to understand the written word. Such a skill will be an immense advantage to you in the long run, and enable you more accurately to record your experiences and knowledge so that you may pass it on to your people. To that end, I am placing at your disposal the bearer of this message, whose sole duty for the next several weeks at least will be to teach you such skills with words as he may possess. Welcome to Alera Imperia, Ambassador, and I look forward to speaking with you in the future. Signed, Gaius Sextus, First Lord of Alera."

"My disposal," she said. "Hah. I think I like that. I can have you do anything, now. Your chieftain said so."

"I don't think that's what he meant when—"

"Silence, errand boy!" she said, green eyes sparkling with mischief. "There are horses here, yes?"

"Well. Yes. But . . ."

"Then you will take me to them, and we will go for a ride," she said, still smiling.

Tavi sighed. "Kitai . . . perhaps tomorrow? I need to make sure Max is all right. And my aunt. We're having dinner this evening."

"Of course," she said at once. "Important things first."

"Thank you," he said.

She bowed her head to him a little. "And you, Aleran. I saw you against the Cane. You fought well. It was cleverly done."

And then she stepped up to him, stood on tiptoe, and kissed him on the mouth.

Tavi blinked in surprise, and for a second he couldn't move. Then she

lifted her arms and twined them around his neck, drawing him closer, and everything in the world but her mouth and her arms and the scent and fever-hot warmth of her vanished. It was sometime later that the kiss ended, and Tavi felt a little wobbly. Kitai looked up at him with languid, pleased eyes, and said, "Cleverly done. For an Aleran."

"Th-thank you," Tavi stammered.

"My disposal," she said, satisfaction in her tone. "This promises to be a pleasant spring."

"Uh," Tavi said. "Wh-what?"

She made a little sound, half of impatience, half of disgust. "When will you stop talking, Aleran?" she said in a low, throaty growl and kissed him again, drawing him back into the room, until Tavi could kick the door closed behind them.

CHAPTER 56

Amara stood beside Bernard as the *legionares* who had survived the battle fell into neat ranks facing the mound they'd raised over the battlefield.

The mercenaries and their commander had departed as soon as their healers had done their work. Before the day was out, two hundred Knights had arrived at the direct command of the First Lord, and a relief force on a swift march from Riva's Second Legion arrived the next morning, to ensure the security of Garrison and the valley. They had brought with them word of a minor miracle. Healer Harger had kept his head in the face of the vord's surprise attack on the wounded at Aricholt, and though wounded had managed to lead the children who had survived the first attack from the doomed steadholt. It was a small ray of light in the gloom of death and loss, but Amara was grateful for it.

Bernard had never given any such order, but those men who had survived did not mention the presence of the Windwolves or their outlaw commander. They owed their lives to the mercenaries, and they knew it.

There were far more dead to bury than living capable of digging graves, and so they had decided to use the cave as a resting place for the fallen. *Legionares* and taken holders alike were carried into the cave and composed with as much dignity as possible, which generally meant little. Those fallen on the battlefield seldom met death in positions like those of gentle sleep, but whatever could be done for them was done.

Once the bodies had been taken into the cave, the survivors of the battle gathered to say their farewells to fallen acquaintances, sword-brethren, and friends. After a silent vigil of an hour's passing, Bernard walked to the front of the formation and addressed the men.

"We are here," he said, "to lay to rest those who have fallen in defense of this valley and this Realm. Not only those *legionares* who fought beside us, but also those holders and soldiers alike who fell to our enemy and whose bodies were used as weapons against us." He was silent for a long moment. "They all of them deserved better than this. But they gave their lives to stop this threat from spreading and growing into a plague that could have ravaged all the Realm, and it is only by the whims of chance that we stand over their graves rather than them standing over ours."

Another long silence fell.

"Thank you," Bernard said quietly. "All of you. You fought with courage and honor, even when wounded, and when the fight seemed hopeless. You are the heart and soul of Aleran *legionares,* and I am proud, honored, and privileged to have commanded you." He turned to the empty mouth of the cave. "To you," he said, "I can offer only my apologies, that I could not protect you from this fate, and my promise that your deaths will make me more vigilant and dedicated in the future. And I ask that whatever power governs the world after this one to look upon our fallen with compassion, mercy, and gentleness that was not given them by their slayers."

Then Bernard, Sir Frederic, and half a dozen Knights Terra who had arrived with the relief force knelt upon the ground, calling to their furies. Some kind of rippling wave ran through the earth, toward the cave, and with a low rumble, the shape of the hillside the cave was in began to change. It was a slow, even gentle motion, but the sheer scale of it made the ground tremble under Amara's feet. The mouth of the cave sank and began to close, the motion slow, ponderous, inevitable, until the opening in the rock was gone, and only the hillside remained.

Silence settled over the valley, and the earthcrafters rose to their feet

together. Bernard turned to face the fifty-odd surviving veterans of Giraldi's century. "*Legionares,* fall out. Pack up your gear and make ready to march back to Garrison."

Giraldi gave a few subdued orders, and the weary men began the walk back to Aricholt. Bernard stood watching them go. Amara remained beside him until they were out of sight.

Walker came pacing slowly out of the sheltering trees, Doroga padding along beside him, his cudgel over one shoulder. They walked over to Bernard and Amara, and Doroga nodded to them. "You fight well, Calderon. The men who serve you are no cowards."

Bernard smiled a bit, and said, "Thank you for your help, Doroga. Again." Then he faced Walker, and said, "And thank you as well, Walker."

Doroga's broad, ugly face spread into an honest grin. "Maybe your people can learn something," he said. Walker let out a rumbling snort. Doroga laughed.

"What did he say?" Bernard asked.

"Not say, so much as . . . mmph. It is something like, spoiled fruits all taste the same. He means your people and mine shared a common enemy. He allows that you are passably good substitutes for the *Sabot-ha,* my clan, if there is fighting to be done."

"He's the reason we survived that rush in the cave," Bernard said. "I won't forget it."

The big Marat rolled his massive shoulders in a shrug, smiling. "Send him some apples. Maybe not spoiled."

"My word on it." He offered Doroga his hand. Doroga traded grips with him without hesitation.

"And you, Windrider," he said, turning to Amara. "You will not make a good Aleran wife, I think."

She smiled at him. "No?"

He shook his head, gravely. "I will wager that you will not clean much. Or cook much. Or make blankets and things. I suspect you will find yourself in trouble, all the time."

"It's possible," she agreed, smiling.

"Good in bed, though, from the sound of it."

Amara's face heated until she thought steam must surely rise from it. "Doroga!"

"Woman of trouble," Doroga said. "But good to hold. My mate was one

such. We were happy." He struck his fist lightly to his heart, Aleran style, and bowed his head to them. "May you be. And may your fallen people be at peace."

"Thank you," Amara stammered.

Bernard inclined his head as well. Without further words, Doroga and Walker departed, walking slowly and steadily without looking back.

Amara watched him, standing close beside Bernard. She didn't remember when she'd twined her fingers with his, but it felt natural and right. Bernard sighed. She could feel the pain in him, even without looking at him, without speaking to him.

"You did all that you could," she said quietly.

"I know," he answered.

"You should not blame yourself for their deaths."

"I know that, too," he said.

"Any decent commander would feel what you do now," Amara said. "They'd be just as wrong as you are to feel it. But all the best ones do."

"I lost the folk of an entire steadholt under my protection," he said quietly, "and almost three quarters of my *legionares*. I'm hardly one of the best."

"Give it time," she said quietly. "It will hurt less."

His fingers squeezed back, very gently, and he made no other answer. He stood looking at the hillside where the cave had been for a time, then turned and walked away. Amara kept pace with him. They were halfway back to Aricholt before she said, "We need to talk."

He exhaled through his nose and nodded. "Go on."

"Bernard," she said. She sought for the right words. None that she found seemed equal to the task of conveying what she felt. "I love you," she said finally.

"And I, you," he rumbled.

"But . . . my oath to the Crown, and yours . . . they both have prior claim on us. Our vows . . ."

"You wish to pretend that they did not happen?" he asked quietly.

"No," she said at once. "No, not that. But . . . have we not foresworn ourselves?"

"Perhaps," he said. "Perhaps not. If you could bear children—"

"I can't," she said, and she hadn't meant it to fly out from her mouth so harshly, so bitterly.

"How do you know?" Bernard asked quietly.

Her face flushed. "Because . . . you and I have . . . bloody crows, Bernard. If I could have I'm sure I would have by now, with you."

"Perhaps," he said. "Perhaps not. We see each other perhaps one night or two in every moon. At the most. It isn't the best way to assure children."

"But I was blighted," she said quietly. "Even if you can hardly see the scars."

"Yes," Bernard said. "But there are women who have contracted the blight and yet borne children. Not many, perhaps, but it has happened."

She let out an exasperated breath. "But I am not one of them."

"How do you know?" Bernard asked. "How do you know for certain?"

She looked at him for a moment and shook her head. "What are you driving at?"

"That it is at least possible that you might yet be able to bear children. And that until we know that it is not so, there is no reason for us not to be together."

She looked at him uncertainly. "You know what the laws say. You have an obligation to the Realm, Bernard, to produce heirs of your blood and to pass on the strength of your furycraft."

"And I intend to fulfill that obligation," he said. "With you."

They walked in silence for a while, before she said, "Do you really think it might be possible?"

He nodded. "I think it is possible. I want it to happen. The only way for it to happen is to make the effort and see."

Amara was quiet for a time, then said, "Very well." She swallowed. "But . . . I do not want Gaius to know of it. Not unless—" She cut herself off and began the sentence again. "Not *until* we bring forth a child. Before that, he could command us to part. But if there is a child, he will have no legal or ethical grounds to object."

Bernard studied her for several steps. Then he stopped, lifted her chin with one broad hand, and kissed her, very slowly and very gently, on the mouth.

"Agreed," he murmured, after that. "For now. But the day may come when we can no longer hide our marriage vows from others. On that day, I want to know that you will stand beside me. That if it comes to that, we will defy the will of the First Lord and the law together."

"Together," she said, the word a promise, and kissed him again.

He half smiled. "What's the worst that could happen? To be dismissed

from service. To have our Citizenships revoked. At which point, well, we'd not have to worry about the legal obligations of the Citizenry, would we."

"We'd be ruined, but together," Amara said, a dry smile on her lips. "Is that it?"

"So long as I had you, I wouldn't be ruined," he said.

Amara wrapped her arms around her husband's neck and held on very tightly. She felt his arms around her, strong and caring.

Perhaps Bernard was correct. Perhaps everything would be all right.

┣━┫┣━┫ CHAPTER 57

Fidelias finished brushing out the leather of his boots and sat them beside the bed. His pack, already filled and buckled shut, sat beside them. He looked around the room for a moment, musing. The servant's quarters he occupied in the basement of the Aquitaine manor were, he realized, almost precisely the same dimensions as those he had formerly occupied in the Citadel. The bed was softer, perhaps, the sheets and blankets finer, the lamps of slightly better quality. But otherwise, almost the same.

He shook his head and stretched out on the bed, for the moment too tired to take the effort to get undressed and under the blankets. He stared up at the ceiling instead, listening to the dim sounds of movement and conversation in adjacent rooms and in the halls above.

The door opened without a knock, and Fidelias did not need to look to see who was there.

Lady Aquitaine was quiet for a moment, before she said, "Already packed, I see."

"Yes," he said. "I'll leave before first light."

"Not staying for the presentation ceremony?"

"You don't need me for that," Fidelias said. "I saw the gown you bought the Steadholder. I'm sure it will make the impression you wanted. I have other business to occupy my attention."

"Oh?" she asked. "I have not even given you your next assignment."

"You'll be sending me to Kalare," Fidelias said. "To get into touch with my contacts there. You'll want to know what links Kalare has to the southern High Lords and get an idea of how to disrupt or sever them."

She let out a low laugh. "Should I feel this smug about going to the effort to recruit you, my spy?"

"Don't bother," he said. "I chose you and your husband. It wasn't the other way around."

"How cynical," she murmured. "A gentleman would have danced around the point."

"You didn't hire me to dance," Fidelias said quietly.

"No. I didn't." She was quiet for a moment, before she said, "You'll take water from the font here?"

"Yes. As long as I don't get too thirsty. Southern summers are hot."

"Have a care, Fidelias," Lady Aquitaine said. "You are a valuable asset. But my tolerance for your occasional insubordination will only last so long."

"If I were you, Your Grace," Fidelias said, "I would give a thought to conserving your intelligence resources."

"Meaning you?" she asked.

"Meaning me."

"And why is that?" There was a dangerous edge to her voice.

Fidelias lowered his eyes from the ceiling for the first time. She stood in his doorway, tall and elegant and lovely, covered in a voluminous grey cape, light slippers on her feet. Her dark hair was pinned up with a number of ivory combs. He regarded her beauty for a moment, and felt a stir of both desire and anger. No man could see a woman of such beauty and feel nothing, of course. But his anger was a mystery to him. He kept it carefully contained, hidden from her.

Instead of answering her, he nodded to the dresser beside the door.

She frowned and looked. She tilted her head for a moment and reached out to take a worn traveling cloak from the top of the dresser. "It is a cloak," she said, slightly exaggerated patience in her tone. "And what possible threat does this represent?"

"It isn't a cloak," Fidelias said quietly. "It's a seacloak. They're made in Kalare, Forcia, and Parcia. The hides are taken from a breed of large lizard that feeds on bulbs and roots in the swamps and rivers. Get them a little wet and they swell, become waterproof. Anyone traveling there needs one of

these cloaks, either for wear on board ships or for protection during the rainy season. Without a seacloak, it's very easy to be taken sick."

Lady Aquitaine nodded patiently. "I still do not perceive how it might be a danger to us, dear spy."

"This cloak is my cloak," Fidelias said.

She regarded him, expression remote.

"I left it in my quarters in the Citadel, the day I left for the south with Amara, for her graduation exercise. The day I abandoned Gaius." He shook his head. "I found it here this evening."

A line appeared between her brows. "But . . . that would mean . . ."

"It would mean that Gaius himself was here, in your own manor, and you never had an inkling of it. It means that he knows where I am. It means he knows whom I serve. It means that he is perfectly aware that you are sending me to the south to stir up trouble for Kalare—and that I have his blessing to do so." He crossed his arms behind his head and went back to staring at the ceiling. "Beware, my lady. The lion you hunt may be old—but he is neither dotard nor weak. Miss a step, and the huntress may become the prey."

Lady Aquitaine stared at him in silence for a moment, then left without a word, shutting the door behind her. Her steps as she walked away were a very little bit quicker than usual. She was frightened.

For some reason, that pleased Fidelias, just as it had pleased him to shout a warning to Aleran guardsmen when the vord had been stealing up upon them. There were thoughts tied up in it, dangerous thoughts, dangerous feelings he did not wish to examine too closely lest they cripple him. So he accepted the feelings for what was upon their surface alone.

It had pleased him.

As feelings went, it was not an intense one—but it was far, far better than nothing.

That night, he fell asleep easily for the first time in nearly three years.

Isana folded her hands in her lap and tried not to let them shake too much. She was alone in the carriage, but it would not do to allow herself to be seen in such a state when she arrived at the palace.

Even if, at least in spirit, she was now a traitor to the Crown.

She closed her eyes and breathed slowly in and out. It was only a dinner, and doubtless the First Lord would not linger after the meal. And she would get to see Tavi again, whole and well. She had thought she might have strained her chest to sickness, so hard had she wept when she came to the infirmary and found him there, wounded, exhausted, unconscious, but whole. She had brushed away the Citadel's healers in irritation and healed his wounds herself, the hard way, through wet cloths and slow, grueling effort.

She had stayed beside Tavi until she began to drift off to sleep herself, then Gaius had arrived. The First Lord moved very slowly and very carefully, like a weary old man—though he did not look older than a man in his late prime, but for his hair, which had gone entirely grey and white since the last time she had seen him. He had offered her a room, but she had declined, telling him of Lady Aquitaine's offer of hospitality.

He had stared at her then, his eyes steady, piercing, and she knew that he had understood far more than the simple statements she had made. He made no objection to her leaving—and in fact, had gone out of his way to invite her to the palace for a meal with himself and her nephew.

He'd known she would come, of course, if it was to see Tavi. Lady Aquitaine was not to be trusted, but there was some truth in her accusation that Gaius was holding Tavi as a prisoner to her good behavior. In this instance, at least, he was using the boy to make sure she would come to the palace.

But at least she had gotten what she wanted. Word had come back from Aquitaine's mercenaries that her brother was whole, though the people of an

entire steadholt had been slain along with many of her brother's soldiers. They had destroyed the vord nest.

The coach drew to a halt, and the footman folded down the stepladder and opened the door. Isana closed her eyes and took a deep breath, willing herself into at least a semblance of calm. Then she descended from the coach, under the watchful eyes of the hard-faced armsmen of Aquitaine, and was escorted by a centurion of the Royal Guard—very young, for his rank, she thought—into the palace and to what was, by the standards of the highborn of Alera, a cozy, intimate dining room.

It was larger than the great hall back at Isanaholt, and may have been almost the size of the steadholt's stone barn. An enormous table had been laid out, with places evenly spaced every bowshot or so along it, but someone had evidently decided that the arrangement wouldn't do. The chairs had all been dragged down to an uneven clump at one end of the table, the plate settings similarly rearranged, and several voices were raised in laughter.

Isana paused for a moment at the door, studying the scene. The large young man in the midst of a tale had to be Antillar Maximus, about whom Tavi had written much in his letters home. He had the kind of rugged good looks that made him look something of the rogue now, but which would, in time, weather into something stronger, more solemn, if no less appealing, and he was telling a story of some kind with the panache of a practiced raconteur. Beside him sat a slight young man with intelligent eyes and a wide smile, though there was something of a mouselike quality to the way he sat, and listened, as if he expected to be overlooked and liked it that way. Ehren, by Tavi's letters. A girl, plain but pleasant-looking, sat across from Max and Ehren, beside Tavi, her cheeks pink with laughter.

On Tavi's other side sat an exotic beauty, and it took Isana a moment to recognize her as Kitai, the daughter of the Marat chieftain. She was dressed in a fine silken shirt and closely fitting pants, and her pale feet were bare. Her long, white hair had been plaited into a braid that fell straight down her spine, and silver gleamed on her throat and her wrists. There was mischief in her eyes—eyes precisely the shade of Tavi's, Isana noted.

And Tavi sat listening to Max. He had grown, she saw at once, and in more than just height. There was a quality to his quiet that had nothing to do with insecurity. He sat listening to Max with a silent smile that rested partly upon his mouth but mostly in his eyes, and he held himself with an

easy confidence she had not seen before. He interjected some comment when Max paused to take a breath, and the table exploded in laughter again.

Isana felt a sudden presence beside her, and Gaius Sextus murmured, "It's a good sound. Laughter like that, from the young. It's been far too long since it has been heard in these halls."

Isana felt her back stiffen as she turned to face the First Lord. "Your Majesty," she said, making the little curtsey Serai had taught her. *On the day she died,* Isana thought.

"Steadholder," he said. He looked down her and back up and said, in a neutral, pleasant tone, "That's a lovely gown."

The dress Lady Aquitaine had provided her was of the same exotic and expensive silk she'd shown off at the garden party, though in a much more modest cut. The deep scarlet of the silk darkened by degrees to black at the ends of the sleeves and the hem of the skirt. Scarlet and sable, the colors of Aquitaine.

Gaius's own tunic was of red and blue, of course—the colors of the royal house of the First Lord.

"Thank you," she replied, keeping her voice steady. "It was provided me by my host. It would have been impolite not to wear it."

"I can see how that would be," Gaius said. There was both reserve and compassion in his tone. Again, she was struck with the impression that he understood much more than she said—and that she, in turn, understood much more than the overt meaning of his words. "You may be interested to know that I had Maximus pardoned and cleared of the charges against him. I offered Kalare an in-depth investigation of the happenings that night, and he shied away from it quite swiftly. So, in the absence of a willing accuser, I had the charges dismissed."

"Does this matter to me?" Isana asked.

"Perhaps not to you," Gaius said. "Perhaps someone you know would find it interesting."

By which he meant the Aquitaines, of course. "Shall we join them?" she asked.

Gaius looked up at the group of young people, still laughing. He watched them, his face unreadable, and though her own skill at watercraft-ing was insufficient to sense truly what he felt, Isana was struck with the sudden impression that his life, as the First Lord, had to have been, more

than anything else, a horribly lonely one. "Let's wait a moment more," he said. "Their laughter would never survive our arrival."

She regarded him for a moment, then nodded. The unspoken tension between them did not vanish, but it dwindled for a time.

When they finally did enter the hall, she spent a very long time holding Tavi to her. He had grown unbelievably, and when before she had been a half hand taller than he, he was now at least half a foot taller than she was. His shoulders had widened by a similarly preposterous measure, and his voice was no longer the warbling tenor he'd had when he left home, but a steady baritone.

But for all of that, Amara had been right. He was still Tavi. She could feel it in his warmth and smile, in the love for her as he hugged her in turn. The sparkle in his eyes, his sense of humor, his smile—though more serious, more thoughtful, it was all still his own. His time at the Academy had not taken anything from him. It had, perhaps, made him even more of what he had been: a young man with a swift mind, occasionally questionable judgment, and a good heart.

The meal was excellent, and the conversation pleasant until the First Lord asked Tavi to share his story of the events of the past few days. Isana suddenly understood why the gathering had been as small as it was. Not even servants were allowed in the hall, as Tavi spoke.

She could hardly believe what she heard, and yet it was all true. She could feel that much from him. Isana sat stunned that Tavi should have held so very, very much power in his hands. He had been only a young student, but the fate of the Realm itself had hung upon the choices he had made. Not solely upon him, to be sure, but by the great furies, he had once more acted as a hero.

She sat bemused by the tale, hardly surprised that Tavi had been training as a Cursor. It was very much in line with what she had supposed would happen when he came to the capital. She listened to Tavi, but spent much of the time judging the expressions and emotions of the others at the table. She suspected, as well, that Tavi was leaving things out, here and there, though she was not sure why he would conceal portions of Max's masquerade as the First Lord or the death of the Maestro, Killian.

The hour was very late when the First Lord suggested that the evening had gone on long enough. Isana loitered until everyone had departed but Tavi and the First Lord.

"I had hoped," she said quietly to Gaius, "to speak to Tavi alone for a while."

Gaius arched an eyebrow and regarded her gown for a time. Isana had to have Rill's help to keep her face from flushing, but met Gaius's gaze without moving.

"Steadholder," he said gently, "this is my house. I would hear what you have to say to one of the Cursors."

Isana pressed her lips together, but inclined her head. She had no wish to speak of this in front of Gaius—but that was part of the price she would now have to pay to have secured the aid of the Aquitaines. So be it.

"Tavi," she said quietly, "I have concerns about your friend. Gaelle, I believe. I can't pinpoint it, but there is something . . . not right, about her."

Tavi glanced at Gaius, to Isana's annoyance. The First Lord nodded to him. "I know, Aunt Isana," he said, his voice quiet and very serious. "She isn't Gaelle. Or at least she isn't the real Gaelle."

Isana frowned. "How do you know?"

"Because the men who took me and Kitai in the tunnels were Kalare's," he said, "and they were waiting for us. Maestro Killian told me, as he died, that Kalare's chief assassin was still close, and that he had paid a terrible price to establish the assassin within the Citadel. He was playing the traitor to Kalare, hoping to learn more about the enemy through his contact with the chief assassin—a woman named Rook. Whoever Rook was, it had to be a woman, someone often in contact with the Maestro to avoid arousing suspicion, and someone who had seen me enter the tunnels that night, and who knew where I would have to start marking the walls to find my way. In short, it almost had to have been one of the trainees."

"That was the price Killian mentioned," Gaius murmured. "The actual girl selected for the training was replaced by Rook, by means of watercrafting herself into a double. She was probably killed a few days after her selection as a trainee."

Isana shook her head. "That's . . . Your Majesty, you know as well as I that anyone with that much watercraft would have a strong contact with the emotions of those around them."

"It would be an enormous advantage in convincing those around you that you are merely a harmless girl," Gaius murmured.

"Yes. And if one killed often enough, it would almost certainly drive one mad."

"More than likely," Gaius said, nodding.

"You allowed that poor girl to be killed," Isana said, "so that you could gain some kind of advantage?"

"Killian never spoke to me of it," Gaius said. "He did it on his own."

Isana shook her head, disgusted. "All the same. It's monstrous."

"Yes," Gaius said, without a trace of shame. "It is. But Killian felt it necessary."

Isana shook her head. "This killer. Rook. When will you arrest her?"

"We won't," Tavi said quietly. "Not at once, in any case. Right now, Rook does not know we are aware of her identity. We can use that against her, and against Kalare."

"She's an assassin," Isana said quietly. "Quite likely a madwoman. And you would have her roaming loose?"

"If the First Lord removes her," Tavi said, "has her arrested or exiled, Kalare will only recruit someone else and try it again—and this time we might not be lucky enough to discover them. There is less danger in leaving her than not. At least for the moment."

"Monstrous," Isana said. She felt tears in her eyes and did not bother to hide them.

Tavi saw her expression and flushed, looking down. Then he looked up, and said, "I hope you are not too much disappointed in me, Aunt Isana."

She smiled slightly. "I hope you are not too much disappointed in me, Tavi."

"Never," he said quietly. "I understand why you . . ." He waved a vague hand. "You did what was necessary to protect the people you loved."

"Yes," Isana said quietly. "I suppose I should not be the first to cast stones." She stepped up close to him, cupped his face in her hands, kissed his forehead, and said, "Promise me that you will be careful."

"I promise," he said quietly.

She held him again, and he hugged her back. Gaius made an unobtrusive exit, while Tavi escorted her down to the entrance, where the Aquitaines' coach was waiting once more. She walked with her hand on Tavi's politely extended arm, and he provided a supporting hand when she stepped up to the carriage.

"Tavi," she said, before the door closed.

"Yes, Aunt Isana?"

"I love you very much."

He smiled. "I love you, too."

She nodded. "And I am proud of you. Never think that I am not. I worry for you. That's all. But you're growing up so tall."

He grinned. "Cost the First Lord a fortune keeping me in pants," he said.

Isana laughed, and he leaned up to kiss her cheek again. She ruffled his hair and said, "Write often. Regardless of where we find ourselves, it will never change what you mean to me."

"I feel that, too," he assured her. He stepped back and nodded with a quite natural authority to the coachmen, who began closing it up. "Write me as often as you can. Be safe."

She nodded and smiled at him, then the coachmen had closed things up, and the carriage was rolling away from the palace. She leaned slowly back in her seat, her eyes closed. She felt very, very alone in the Aquitaines' carriage.

She *was* alone there.

"Be safe," she whispered, her eyes closing, holding the image of his smile in her mind. Her hand drifted to the shape of the ring, still on its chain around her neck, still hidden. "Oh, be safe, my son."

EPILOGUE

Miles came down the last few steps and crossed the antechamber to the First Lord's meditation chamber. There were still scorch marks on the floor from the fires Tavi and Kitai had started, but the various kinds and colors of blood had been cleaned away. The door to the meditation chamber was half-open, but Miles paused outside it and knocked quietly.

"Come in, Miles," came Gaius's voice.

Miles pushed the door open and went in. Gaius sat in a chair by the little desk, lips pursed thoughtfully as he wrote something on a page. He finished it, signed it, and calmly folded the page and sealed it shut with wax and the hilt of his signet dagger. "What brings you here, Miles?"

"The usual," Miles said. "We have found nothing in the Deeps, beyond that odd cavern the vord had taken as a nest. There has been no sign of them elsewhere, but I have dispatched word to the Legions of every city to exercise extreme caution should anything happen that might indicate a vord presence."

"Fine," Gaius said. After a moment, he mused, "Did you know that the vord, in one form or another, utterly ignored Tavi's presence in at least three instances?"

Miles frowned. "I saw him scamper out of a crowd of them. At the time, I just assumed he'd been quick enough to get away. And they did attack him immediately after."

"But not until he struck at the queen with a spear," Gaius mused.

"You aren't suggesting that the boy is in league with them, are you?" Miles said.

Gaius arched an eyebrow. "Naturally not. But it is an anomaly which I do not yet understand. Perhaps it was nothing—mere luck. But what if it wasn't? It might tell us something important about them."

"Do you think they are yet here?"

"I am not entirely certain. It's odd," Gaius said, thoughtfully. "I've looked for their presence. I haven't sensed it."

"According to Count Calderon, they were very difficult to detect with crafting, sire."

Gaius nodded and waved a hand. "Well. We are aware of them. We are on the watch for them. It is all we can do for the time being."

"Yes, sire." He looked around the room. "It cleaned up nicely."

Gaius sighed. "I can't believe those two employed my entire liquor cabinet as a weapon against the enemy."

Miles pursed his lips and frowned. "Sire, may I—"

"Speak candidly, yes, yes." He waved an irritated hand. "How many times must I tell you that you do not need to ask?"

"Once more at least, Sextus," Miles said. "I don't mourn your liquor cabinet. Blessing in disguise. You were drinking too much."

The First Lord frowned pensively, but did not dispute the captain.

"You did it on purpose, didn't you?" Miles said.

"Did what?"

"You brought Fade here. You arranged for Tavi to share a room with Antillar Maximus. You wanted them to become friends."

Gaius smiled faintly, but he said nothing.

"Is he what I think he is?" Miles asked.

"He's a Cursor, Miles. He's a former apprentice shepherd."

"Crows, Sextus," Miles said, irritated. He scowled at the First Lord. "You know what I mean."

The First Lord gave Miles a very direct look. "He has no crafting, Miles. So long as that is true, he will never be anything more than what he is."

Miles frowned and looked away.

"Miles," Gaius chided, "is it such a bad thing, what he is now?"

"Of course not," Miles said, and sighed. "It's just that . . ."

"Patience, Miles. Patience." Gaius took the letter he'd written in hand and rose. Miles fell in beside him as the First Lord walked to the door. "Oh," Gaius said. "Which reminds me. Don't restock that liquor cabinet. Have it removed."

Miles stopped in his tracks and blinked. "You aren't . . ." He gestured vaguely at the mosaic.

Gaius shook his head. "I need my rest."

Miles frowned faintly at the First Lord. "I don't understand."

"I must bear up a little longer, Miles. To do that, I need my health." He looked back at the mosaic, and there was sudden grief in his expression. "It

was arrogant of me, to behave as if I had no limits. If I don't respect them now . . ." He shrugged. "The next time I might not wake up."

"Bear up a little longer?" Miles asked.

Gaius nodded. "Hold on. Prevent Aquitaine and Kalare from sinking us into a war of succession—and there *will* be one, Miles, once I am gone. But I can buy time."

"For what?"

"For a change in the boy."

Miles frowned. "If he doesn't change?"

Gaius shook his head. "Then he doesn't. Unless matters change, no one hears of this, Miles. Even rumor and suspicion would make him a marked man. We must protect him, inasmuch as we can."

"Aye, sire," Miles replied.

Gaius nodded and started walking steadily up the stairway.

Miles followed the First Lord back up the steps to the palace, silently afraid of the future.

THE DRESDEN FILES

Wizards are cool.

I mean, come on. When it comes to fantasy, you can't swing a cat without hitting a wizard somewhere, striding through the shadows and wars of epic battles of light and darkness, uncovering lost knowledge, protecting, inspiring, and guiding others toward the future. Merlin, Gandalf, Allannon, Dalben, Belgarath, Raistlin, Goblin, and One-Eye—and their darker counterparts like Morgana, Arawn, Soulcatcher, and Saruman. Wizards wield secrets as warriors do swords, driven by a vision that lets them see and know more than mere mortals, gifted with a power that makes them treasured allies—and terrifying foes. Throughout fantasy fiction, when the need is most dire it is the wizard who stands to face balrogs and dragons, dark spirits and fearsome beasts, natural catastrophes and dark gods.

Harry Blackstone Copperfield Dresden, wizard for hire, is happy if he manages to pay the rent for another month. He's in the Chicago Yellow Pages, under "Wizards." He's the only entry there. Most people think he is some kind of harmless nutball at best, and a charlatan-psychic at worst.

But then, most people haven't seen what Harry's seen. Most people don't know the truth: that the supernatural is perfectly real, existing quietly side by side with most of humanity's perceptions of reality. Trolls lurk under bridges, and faeries swoop down to kidnap children. Vampires prowl the shadows by night, restless ghosts rise up from the darkness of the grave, and demons and monsters to boggle the mind lurk in the shadows, ready to devour, maim, and destroy.

A few people know the truth, of course. Wizards such as Harry know. So do a few of the cops, like Lt. Karrin Murphy, head of Chicago P.D.'s Special Investigations division, who knows the touch of the supernatural when she sees it, and who hires Chicago's only professional wizard to come

in as a consultant when an investigation begins to look like an episode of *The X-Files*.

And other people learn the truth the hard way, when something out of a bad dream shows up at the front door. For those poor mortals, the supernatural becomes a sudden, impossible, terrifying nightmare come true—a nightmare no one can help them wake up from.

No one but Harry Dresden, that is. Hauntings, disappearances, missing persons, murders, curses, monsters—you name it, and Harry knows something about it. More than that, he shares the convictions of his literary ancestors—a deep and genuine commitment to use his power to protect those who cannot protect themselves, to stand between the darkest beings of the supernatural and his fellow man.

When the need is most dire, when the night is most deadly, when no one else can help you, give Harry Dresden a call.

He's in the book.

Jim Butcher's newest Harry Dresden novel, *Dead Beat*, is now available in hardcover from Roc Books.

The Christmas Angel

*Also by Thomas Kinkade and
Katherine Spencer in Large Print:*

Cape Light
A New Leaf
A Christmas Promise

This Large Print Book carries the
Seal of Approval of N.A.V.H.

The Christmas Angel

A Cape Light Novel

THOMAS KINKADE
& Katherine Spencer

Thorndike Press • Waterville, Maine

Published in 2005 by arrangement with
The Berkley Publishing Group,
a division of Penguin Group (USA) Inc.

Thorndike Press® Large Print Americana.

The tree indicium is a trademark of Thorndike Press.

The text of this Large Print edition is unabridged.
Other aspects of the book may vary from the original edition.

Set in 16 pt. Plantin by Liana M. Walker.

Printed in the United States on permanent paper.

Library of Congress Cataloging-in-Publication Data

Kinkade, Thomas, 1958–
 The Christmas angel : a Cape Light novel / by Thomas
Kinkade & Katherine Spencer. — Large print ed.
 p. cm. — (Thorndike Press large print Americana)
 ISBN 0-7862-8128-6 (lg. print : hc : alk. paper)
 1. Cape Light (Imaginary place) — Fiction. 2. New
England — Fiction. 3. Foundlings — Fiction. 4. Christmas
stories. 5. Domestic fiction. 6. Large type books.
I. Spencer, Katherine. II. Title. III. Thorndike Press large
print Americana series.
PS3561.I534C46 2005
 813′.54—dc22 2005027328

The *Christmas Angel*

As the Founder/CEO of NAVH, the only national health agency solely devoted to those who, although not totally blind, have an eye disease which could lead to serious visual impairment, I am pleased to recognize Thorndike Press★ as one of the leading publishers in the large print field.

Founded in 1954 in San Francisco to prepare large print textbooks for partially seeing children, NAVH became the pioneer and standard setting agency in the preparation of large type.

Today, those publishers who meet our standards carry the prestigious "Seal of Approval" indicating high quality large print. We are delighted that Thorndike Press is one of the publishers whose titles meet these standards. We are also pleased to recognize the significant contribution Thorndike Press is making in this important and growing field.

Lorraine H. Marchi, L.H.D.
Founder/CEO
NAVH

★ Thorndike Press encompasses the following imprints: Thorndike, Wheeler, Walker and Large Print Press.

Dear Friends

When I was a young boy, one of my favorite Christmas traditions was trimming the tree. We had many ornaments, but the ones I liked best were those that had been handed down from generation to generation, and I hung them with great care, selecting very special places on the tree for their display.

But there was one ornament that everyone in my family agreed was the most beautiful. It was the angel ornament that topped the tree. I can still picture her. She wore a red velvet gown. Her long blond hair sparkled under a golden halo, and her gossamer wings shimmered with a silver glow. She was unquestionably our most treasured ornament, the one that made the tree complete.

That Christmas ornament was my first vision of an angel, and since then, I've seen many like her, and I've met many too, but the ones I've actually known didn't have golden halos and shimmering wings.

An angel may be a stranger who lends a helping hand or a friend who knows when you're in need. Or it may be someone who reminds you of your own capacity for goodness and love.

In Cape Light, as in my life, angels take many forms. Emily Warwick realizes she's been blessed by an angel when she finds an abandoned baby in the church crèche, a baby who changes her life, challenging her to reexamine and deepen her bonds of love.

Reverend Ben, struggling with self-doubt, will find angels at work in his own congregation.

As you enter Cape Light, I hope you enjoy your time with the good people there and the angels they meet, and my Christmas wish for you is that God's angels will bring the gift of hope and faith and love into your life too.

— Thomas Kinkade

Chapter One

~⁊

Emily found the baby purely by accident. Later, looking back, she decided it hadn't been an accident at all. It was one of those things that was simply meant to be.

She'd nearly skipped her morning run that day, and realized later that a few minutes on the clock either way would have made all the difference. She could have turned onto a different path. Or she could have been so caught up in her rambling thoughts, she would have missed that tiny flicker of movement in a place where it definitely shouldn't have been.

It was the day after Thanksgiving, an unofficial holiday with schools and many offices closed and most people sleeping off the bounty of the day before. Emily had

rolled over when the alarm sounded, snuggling deep under the down quilt. But finally she forced herself to get up out of bed, pull on running clothes, and creep downstairs, shoes in hand.

She sipped a quick cup of coffee and pictured her husband, Dan, still sound asleep. She sighed and double knotted her laces. Better run now than regret it later when her clothes felt too tight. She did some quick stretches, grabbed her gloves, and headed out the door.

The cold morning air was like a slap in the face. She stretched and started at a slow pace, drawing in deep breaths, exhaling frosty clouds. There had only been a dusting of snow so far, but the legendary New England winter was quickly setting in.

Emerson Street was empty; the only sound was her own breath and the beat of her steps on the pavement. She pushed herself around the corner and headed down the long hill on Beacon Road to the village. She liked to run to the village green and along the harbor before looping back. As the mayor of Cape Light, she sometimes felt her early morning treks were a way of checking up on things, a quiet surveillance of her domain. It was silly to

10

think that, she knew. You couldn't tell much by merely glancing at the outside of houses or stores. But still she felt as if this tour kept her in touch with the beating heart of the place.

She rounded the turn onto Main Street. The wide thoroughfare stood silent, the Victorian buildings and old-time store-fronts like a painting on a Christmas card that captured an elegant, bygone era. The shops and restaurants were decorated for the holidays, the window displays filled with gentle slopes of fake snow, sparkling stars, and gilded-winged angels. Bright pine wreaths with red bows brightened the wrought-iron lampposts. Holiday garlands swooped across the avenue, and each of the parking meters had been covered with red and white stripes, creating a row of free-parking-for-shoppers candy canes. The village maintenance crew hadn't reached the end of the street yet, but she knew they'd complete the job today. To-night was the annual Christmas tree lighting on the green. Everything had to be ready by then.

It was hard to believe the holidays were here again. It felt as if she and Dan had held their highly original and very public New Year's wedding ceremony on the

11

green just weeks ago. Now here they were, almost a year later. The months had passed in such a happy blur, it was impossible to describe.

It was one thing to find love when you were young: that was expected. But when you've all but given up and it comes at you out of the clear blue, you appreciate it in a different — and deeper — way.

How many tree lightings had she presided over now? Into her second term as mayor, she was losing track. But she loved her job, the demands and challenges of it, too. She loved feeling she made the lives of people in this town better in some small way. That was a privilege, she knew, and a blessing.

Where Main Street met the harbor, Emily turned right and ran along the far side of the green. Out at the end of the dock that ran to her left, she spotted a lone but familiar figure — a black knit cap pulled over his head, his body huddled against the cold in a thick coat, a yellow Labrador sitting patiently at his feet.

Digger Hegman and Daisy were a common sight at the waterfront in the early morning. But Emily didn't call out a greeting. She knew Digger was deep in his contemplations, appraising the harbor and

even the birds for his daily forecast, or maybe lost in recollections of his own days at sea.

She headed instead toward the stone facade of Bible Community Church, which faced the green. As usual, the church's decorations this year were beautiful in their simplicity, a thick pine wreath on the wooden doors out front and a large crèche, with almost life-size figures, sheltered by tall trees.

Emily ran past, giving the display a quick glance. Her thoughts raced ahead to the workday. Village Hall would be empty today; it would be a good time to catch up on the paperwork that seemed to flow up from some inexhaustible stream below her in-box.

A few steps past the church doors, she slowed and looked back over her shoulder. Had she seen something moving in the crèche? Something in the cradle?

It couldn't have been the plaster figure of the infant Jesus, she reasoned. The figure of the baby wasn't added until Christmas Eve night. Except for some straw, the wooden cradle should have been empty.

But she was almost positive she'd seen something in there. A squirrel or maybe a

cat? No, whatever it was it had looked too big, even for a cat.

Emily glanced back again at the display, sure now that there was something odd about it.

She turned and retraced her path, then slowed to a walk as she reached the crèche. She stood stone still, mesmerized by the sight of a tiny hand rising out of a bundle of rags and straw in the carved wooden cradle.

It couldn't be. Yet there it was again, as clear as the sun above. A tiny hand. Popping up out of a mound of cloth.

Emily ran forward and pushed the corner of a tattered blanket aside. A rosy cheeked baby wearing a pink wool cap stared up at her.

The baby blinked huge blue-grey eyes. Then suddenly its tiny face crumpled and it began to cry.

Emily scooped up the child and the wad of blankets that cocooned it. Bits of straw clung to the precious bundle.

"There, there. It's okay. It's all right now," she soothed the baby.

She lifted the child to her shoulder and gently patted its back. *Who in the world would do such a thing? How long had the child been out here? The poor little thing must be freezing.*

A hundred questions raced through her head as Emily jogged to the church, the baby clutched to her chest. She yanked open one heavy door and slipped into the dark, sheltering warmth. She walked into the sanctuary and sat down in the last pew, resting the baby across her lap.

The baby had stopped crying but still fussed in her arms. Though Emily loved children, she knew next to nothing about taking care of them, especially tiny babies.

"Are you hungry? Is that it?" Emily said aloud. "I wish I had something for you."

As if on cue, the baby started wailing again, louder this time, putting all the force of its tiny body into the effort. The cries echoed around the empty sanctuary, and Emily jumped to her feet and started pacing up and down the middle aisle.

She bounced, patted, and cooed to no avail. Suddenly she noticed a pacifier hanging from a long string that was attached someplace inside the blankets. She took out her water bottle, cleaned off the pacifier, and stuck it in the baby's mouth.

The baby sucked eagerly, eyelids drooping in contentment. The church was instantly silent again.

Emily sat down with the baby in her lap once more and examined the wrapping,

wondering what else she might discover. The outer blanket looked like a piece cut off a larger comforter. White acrylic stuffing trailed out of one end. Beneath that layer, she found smaller blankets, none very thick. The baby was dressed in one-piece, terry cloth pajamas, which at least covered its feet. The pajamas were worn and stained, with a hole in one elbow and a faded yellow duck embroidered on the chest. The baby's nails were dirty and jagged. The child wasn't well cared for at all. A wave of sadness filled Emily's heart.

"God bless this poor child," she whispered.

Fumbling with the blankets again, she felt something else stuck in the folds: a piece of paper. She pulled it out and unfolded a small note written in blue ink. The handwriting was childish looking, she thought, round with looping script letters. The message was just a few lines long.

Please help my baby, Jane. She's a good girl. I can't keep her no more. I am so sorry. Please find her a good home. God bless you.

Staring down at the little girl, Emily couldn't imagine how anyone could have

abandoned her. The pink hat had slipped off entirely and Emily set it aside. Tufts of reddish gold hair covered the baby's head. With her huge eyes and cherubic face, the child was positively beautiful.

What would it take to give up such a sweet, innocent little girl? The simple note suggested the baby's mother was not a monster. She must have been desperate, though, with some serious reasons for avoiding the usual process of giving up a child for adoption.

Emily didn't condemn her; she didn't even judge her. She understood the situation too well. Over twenty years ago, Emily had made the momentous decision to give up her own newborn daughter, and now the mother's scribbled note stirred up long-buried feelings.

As if sensing Emily's distraction, the baby reached out and clutched at the air. Emily stuck out her finger. The baby latched on, surprisingly strong, and Emily felt the force of their connection deep in her heart, like an electric circuit closing its loop.

"Don't worry, Jane. I'll help you," Emily whispered. "I promise."

She stared down at the child another moment and sighed. But how? What to do

now? A call to the police seemed in order, though for some strange reason, she felt reluctant about the idea.

She shifted the baby to one side and felt around her jacket pocket for her cell phone, then fumbled with it in one hand.

"Emily? Are you okay?"

Emily jumped at the sound of Reverend Ben's voice. She turned to see the minister standing at the end of the pew, staring curiously.

"Reverend Ben, you won't believe it. I was jogging through the green this morning and I found this baby. Right in front of the church, tucked into the cradle of the crèche."

Reverend Ben stepped closer, squinting at her through his gold-rimmed glasses. "Found a baby? In the crèche?"

Emily nodded.

"That's . . . unbelievable."

"Isn't it?" Emily turned back to the baby. "Her name is Jane. See, there was a note." Emily handed him the note and watched as he quickly read it.

"How sad. Sad for the child and for the mother." He came closer, eager to get a better look at the baby. "Is she all right? It's awfully cold out there."

"She seems to be okay. She was wrapped

in a few layers of blankets. I think she's just hungry right now and probably needs her diaper changed."

"My, she's a beauty."

"Yes, she is."

"Have you called anyone yet?"

"I was just about to dial the police." Emily stood up. "Here, could you hold her a moment?"

"Yes, of course." Ben took the baby easily into his arms. "Hello, little girl. You poor little thing," he crooned.

Emily dialed the local police department, a number she knew by heart. She quickly reported the situation to the officer at the front desk, who was more than surprised to hear the story, especially coming from the town's mayor.

"We'll send a car and an ambulance right away, Mayor."

Emily hadn't realized an ambulance would come, too. But it made sense. The baby would need to be examined by a doctor.

"Thanks. I'll be waiting." Emily ended the call and turned back to Ben, who now struggled a bit with his tiny charge.

"Here, I'll take her," Emily offered. Ben handed the baby back, and Emily cradled her in one arm, using her free hand to find

the pacifier again. The baby calmed and Emily felt like a genius.

"I think she's hungry," she said quietly.

"Yes, she must be." Ben was quiet, watching Emily with the baby. "You've made friends quickly. I think she likes you."

Emily didn't know what to say. She looked down at Jane, who seemed to be smiling.

Emily heard the big wooden doors open and saw Officer Tucker Tulley walk in. "What have we here? I heard the call but I didn't believe it. Thought someone on the radio was pulling my leg."

"It's a baby, all right, Tucker," Reverend Ben said. "A little girl."

Tucker shook his head and stared down at the child. "I don't think we've ever had a baby abandoned in this town. Not since I've been on the force, anyway."

Emily couldn't recall such a thing either, though her mother, who was a great authority on town history — especially the transgressions of local citizenry — might be able to cite a precedent.

"There was a note. But I don't think you can tell much from it." Emily handed the note to Tucker. He looked at it briefly, then stuck it in his pocket.

20

"Not much. I'll keep it for the report, I guess."

They all turned at the sound of the ambulance siren outside. Emily felt the baby's body grow tense in her arms.

Tucker turned back to Emily. "Would you like me to take her from you now?"

She didn't know what to say. She knew she had to give the baby up, yet her arms couldn't seem to let go of the child, who now rested so comfortably against her shoulder.

"I . . . I can carry her out. It's all right."

She felt Tucker and Ben watching as she stood up and stepped out of the pew. The two men moved aside and let her walk out first. She felt self-conscious, as if she were playing a part in a strange play. Even the warm weight of the baby in her arms seemed somehow unreal.

Tucker reached forward and pushed open the church door. Emily paused and glanced back toward the pew. "Her blankets. She'll get cold."

"I'd better take those. They might be needed as evidence," Tucker said. "They'll have plenty of clean blankets in the ambulance."

"Yes, of course." Emily nodded and finally stepped outside. She walked quickly

toward the ambulance, which was parked on the green. A stretcher stood on the sidewalk in front of the church.

One of the paramedics met her and, without a word, took the baby. Emily stepped back, feeling surprised and suddenly left empty, as if something had been stolen from her.

"Where will you take her?" she asked.

"To the hospital at Southport. She'll be checked in and examined. A social worker will meet us there to take care of all the paperwork."

"Yes . . . of course." Everything was happening so fast now. *Too fast,* Emily thought. Reverend Ben stood beside her, watching.

The EMS attendant placed the baby on the stretcher, in a baby-size foam form. He pulled belts across her body, securing her. The baby started to cry and Emily grew concerned.

"Can I ride with you to the hospital?"

She could tell from Ben's look that he was surprised.

The paramedic looked at her and then at Officer Tulley.

"She can go along if she wants. No rule against that." Officer Tulley rested his hand for a moment on Emily's shoulder.

The paramedic nodded. "Hop up in back. It will probably be easier anyway for the social worker to get the story first-hand."

Emily climbed into the back of the ambulance and positioned herself close to the baby. She wasn't sure why she felt so relieved to go along. She just did.

Ben watched the ambulance pull away, then returned to his office, where he saw the light on his answering machine blinking. He leaned over the desk and pressed the button to play back the message.

"Reverend Ben? I'm sorry to cancel on such short notice," the thin voice of Vera Plante began, "but I'm not able to come tomorrow morning to that coat-drive meeting. I just had my whole family here for Thanksgiving and I'm beat. I am sorry. I do want to help. I'll be working on the Christmas Fair this year, though. On the bake sale. I'm just thinking now that volunteering for both is a bit too much for me. Hope you understand."

He did understand. Vera wasn't young, of course she was tired after a houseful of company. Still he had to resist the temptation to call her back and tell her that

baking cookies for the Christmas Fair was well and good, but it wasn't going to put decent coats on the poor kids in Wood's Hollow this winter.

When he asked for volunteers to run a coat drive for the community center at Wood's Hollow, a run-down area on the edge of Cape Light, only Vera and Grace Hegman had come forward. Ben had a meeting penciled in for this morning, at nine thirty. The two women were to meet him at the church and they'd drive together to the Wood's Hollow community center to figure out the details and how to get the word out around town.

He realized now that he hadn't heard from Grace all week either. Not a good sign. But it was barely eight o'clock. Too early to call, he thought. He would wait a few minutes, at least until a quarter after.

His office seemed so quiet. The church secretary had the day off and so did the sexton, Joe Tulley. Finding Emily and the baby in the sanctuary had been a rousing start to the day. But now the silence closed in on him, feeling oppressive.

He picked up a letter that sat open on his desk. The postmark was from a Native American reservation in Wyoming. The handwriting was tight and neat, deter-

mined and efficient, much like Reverend James Cameron, the man who had penned it.

Dear Ben,

Sorry I haven't been in touch. We've been so busy, it's hard to know where to begin. Life here is interesting and the work full of challenges. I try not to push it but there are so many in need, so much to be done. Day by day, we make progress in small steps. Leigh is a terrific help — the best wife in the world, far better than I deserve. And our little Julia is the joy of my heart. She'll be a year old in just a month or so, as I'm sure you remember. I am truly blessed.

Ben stopped reading for a moment, picturing Leigh, the woman who had arrived in Cape Light last year, on the run from an abusive ex-husband, and Julia, the beautiful baby she had given birth to on Christmas Day. James had wanted to help Leigh and wound up falling in love and marrying her.

The letter continued for several pages, with James describing his mission work on the reservation. As usual, he sounded fo-

cused and productive. Ben envied him that. It was hard to admit, but he did.

He missed having James around, a colleague and a confidante and a good friend. More than that, he missed the younger man's energy. Even in poor health, James's spirit never failed him.

Ben sighed and leaned back in his chair. He'd always been perfectly content in Cape Light, preaching at this church. But the letter from James had gotten under his skin. James's work seemed so meaningful, while lately life at this church seemed routine and, frankly, uninspiring.

How had that happened? He wasn't sure. Certainly, serving a small congregation like this was a world away from the hands-on missionary work James was called to. And yet each calling had value in its own way. The people of Cape Light needed spiritual nourishment as much as those in any far-off corner of the globe.

But maybe he'd lost his zeal, Ben reflected. Maybe this wonderful, comfortable place was just too comfortable for him after all these years. He'd gone soft, lost his inner fire. Lately, it seemed he couldn't even rouse his congregation to help their own neighbors in Wood's Hollow. They seemed far more interested in debating

whether red or gold bows should be used to decorate the garlands at the annual Christmas Fair.

This Sunday was the first in the season of Advent, the beginning of preparation for Christmas. It was a phase of the holy calendar that always energized him. This year, however, Ben felt strangely distant, unmoved. What had come over him? He was never prone to such dark thoughts.

And what did he have to complain about? Two winters ago, his wife, Carolyn, had been at death's door and their son, Mark, had been almost a stranger to them. Now Carolyn was completely recovered from her stroke and Mark was happily living at home, working at a bookstore and preparing to start college again. *I should be counting my blessings this Christmas season,* Ben thought, *not indulging in self-pity.*

He knew he could never run out to some desolate place and do what James is doing. He could never leave this church. No, that would be impossible.

I'll stay here until I retire or die . . . or for as long as they'll have me. I'm just caught in preholiday blues . . .

He bent his head and closed his eyes. *Dear God, I'm not sure what this strange*

27

mood is about. Please help me be mindful of my blessings and help me shake off this self-indulgent malaise. I know there's always meaningful work for me here. Please help me regain my focus and feel productive again.

Ben checked his watch, then picked up the telephone and dialed the Hegmans'. The phone rang several times. He was just about to give up when Grace answered.

"Good morning, Grace. I'm glad I caught you. I just wanted to confirm our meeting at nine thirty."

"A meeting?" Grace sounded confused, and his heart sank.

"About the coat drive for Wood's Hollow?"

"Oh . . . oh yes. I remember now. I'm so sorry, Reverend. I can't make it down there today. My dad's come down with a chest cold. I told him not to go out walking this morning, but you know, there's no stopping him. He doesn't sound good at all. He can't watch the store for me today, and I hate to leave him alone feeling so poorly."

Ben took a breath, struggling to mask his disappointment. Grace was devoted to her father, Digger, who was not in good health these days. She also ran a business single-

handedly. Perhaps it had been asking too much to have her head this outreach, but everyone was so busy all the time. At least she'd volunteered. At least her spirit was willing.

"I understand, Grace. I hope Digger is feeling better soon. Keep me posted, okay?"

"Yes, I will."

"I suppose tomorrow isn't any good for you either?"

"Gee . . . no, I'm sorry. It's a big weekend at the store. The Christmas shoppers will be out in force, you know."

"So I've heard. Why don't you check your calendar and see if there's some time next week that will work for you. The cold weather is setting in fast. The kids down there do need coats," he reminded her.

"Oh, yes. I know," she said solemnly. "I will get back to you," she promised.

Grace hung up and Ben sat at his desk a moment, feeling deflated and ineffectual. Was there anyone in the congregation he could call on such short notice to help out? Many faces came to mind — Lucy Bates, Sophie Potter, Jessica Morgan, Fran Tulley — but he eliminated each in turn, knowing they were either too busy with their lives and responsibilities, already

taking part in some church activity, like the Christmas Fair, or simply not interested in donating their time to this type of effort.

He couldn't help but think the lack of spirit in the congregation somehow reflected back on him, on his own failure to inspire them and to open their eyes to the needs of their neighbors, families who lived in the shadow of their relative affluence. It was not a good feeling.

There were a few families from Wood's Hollow who had recently joined the church, making Ben more aware of the pressing needs there. It was a forlorn and mostly forgotten corner, one many residents of Cape Light didn't even acknowledge. The last few months Ben had been trying to arouse some awareness in his congregation for the people living there. So far, he had to admit, without great results.

Vera and then Grace both bailing at the last minute on the coat-drive meeting was just the most recent in a string of frustrations. He would go down to the community center on his own, he decided. Maybe once he got the ball rolling, Grace and Vera would help, or someone else would step forward. It wasn't ideal, but it was the best he could do this morning.

Determined to see the thing through,

even if nobody else in the congregation was interested, Ben slipped on his coat and scarf and set out.

Emily sat in the emergency room waiting area in a hard plastic chair, a tattered copy of *National Geographic* in her lap. Her sight was fixed on a pair of swinging doors that opened to the examining rooms, where the paramedics had taken the baby.

The ride to Southport had taken about an hour. After the baby had been brought in, medical personnel had taken over. She'd been more or less brushed aside and told to wait for the social worker, a Mrs. Preston.

Emily shifted on her chair. She wished she could see what was happening. She wondered if the social worker would let her see Jane again, take one last look.

The baby's face filled her mind's eye, and she could almost feel her warm weight in her arms. She thought again of the brief note, the mother's sadness and desperation.

She might speculate, but she would probably never know what had driven the baby's mother to such a desperate act. In her heart, though, she knew the feelings

that woman had experienced. She knew them far too well.

When she was eighteen, right after high school graduation, Emily had eloped with Tim Sutton, a local fisherman. The pair had run away to live on the Maryland shore. She had had no contact with her family for over a year when she and her young husband were in the car accident that took Tim's life. Widowed and eight months pregnant, with no place to turn for help, Emily finally called home. Her mother came down and stayed by her bedside while Emily lay in the hospital, trying to heal from both the injuries that complicated her pregnancy and the shock and grief at losing Tim.

Her mother had been no great comfort, though: all the while she insisted Emily was too young to take care of a baby. How would she support it or raise it properly on her own? She hadn't gone to college, choosing to run off and get married instead. She couldn't even support herself, her mother pointed out. Emily was not only naive but also selfish to think only of what she wanted, Lillian Warwick claimed. Making sacrifices is the first lesson of motherhood, she'd told Emily.

And Lillian made it very clear that Emily

couldn't expect to bring the child back home to Cape Light and have her family take both of them in as if nothing had happened. Not after the way she had defied her parents and run off to get married.

It was her mother's way of getting even, of punishing Emily for defying her wishes — all presented in the best interests of the child, of course.

Finally, sick, weak, and confused, Emily had given in to her mother's arguments. Memories of that dark time now brought familiar pain. It was a choice she had made and then regretted for the rest of her life.

Two years ago, in answer to her prayers, Emily's daughter, Sara, had found her. Having Sara in her life again seemed like a gift from heaven above for which Emily was forever thankful. But the reconnection with Sara, now in her mid-twenties, had never fully made up for the loss of giving her up as an infant.

How could it? The wound was still there, barely healed over. Now this baby and her plight drew all those painful, submerged feelings to the surface again.

The doors swung open and two women walked toward her, the admitting doctor, whom Emily had spoken to briefly, and a tall woman in a long blue overcoat. Her

short brown hair was mixed with silvery grey, worn in a short, no-fuss hairstyle. She walked quickly and carried an overstuffed briefcase. Emily guessed it was Mrs. Preston.

The doctor quickly made introductions and left Emily and Nadine Preston alone together.

The social worker sat down next to Emily and took out a notebook and pen. "Thank you for waiting, Ms. Warwick. I won't take much of your time."

She proceeded to ask Emily questions about when and how she'd found the baby. There wasn't much to tell.

"Did you see anyone else nearby? Did you pass anyone while you were running?"

"Hardly a soul. Only Digger Hegman, out on the dock. He lives in town over the Bramble Antique Shop with his daughter, Grace. He's out on the dock every morning with his dog."

Nadine Preston noted the information on her pad. "I'll have to speak with him, too, I suppose."

It was possible that Digger saw the person who left the baby, Emily realized. Though Digger was so confused lately, she wasn't sure if any information he offered would be reliable.

"What will happen now?" Emily asked.

"The baby will be given a complete examination, blood tests, X-rays, and all that. She may need to stay in the hospital for treatment if some problem is uncovered."

"Such as?"

"Well . . . any number of things. She might be dehydrated or anemic. Or she might have more serious problems, like hepatitis or being HIV positive. It's likely that the child's mother had a problem with drug use."

"Oh . . . I see." Emily thought she should have realized that.

"She'll be treated, of course. There are some great drugs now for pediatric HIV. Very effective," the social worker went on.

Such sobering possibilities for the baby made Emily feel sad. "I hope there's nothing that seriously wrong with her, though."

"Yes, let's hope so."

"What happens if she's healthy? Where will she go?"

"She'll be placed in foster care while we look for her mother or a close relative. The investigation takes about a month. If we don't find anyone after that time, the baby will be put up for adoption."

Emily considered the child's fate. Nei-

ther possibility seemed that positive to her.

Nadine Preston smiled briefly and gave Emily a curious look. "I haven't covered many cases of abandoned children, thank goodness, but I have seen enough. I can imagine it's been a trying experience for you."

"For me? Well, certainly an unusual start to the day." Emily was caught off guard by the question, but Nadine Preston's quick smile put her at ease again.

"I guess what I'm trying to say is, it's only natural to feel concerned. To feel involved with the child. But you have nothing to worry about. We're going to take good care of her."

"Yes, I'm sure you will." Emily watched Nadine Preston closing her notebook and stowing it in her briefcase. The interview appeared to be over.

"Would it be okay if I called you in a few days, to see how she's doing?" Emily asked.

"There are privacy issues. We're really not supposed to give information to anyone outside of the case . . ."

"I just want to know how the tests come out, if she's healthy and all that," Emily said quickly. She wasn't used to being in this subordinate position. Civil servants

like Nadine Preston were usually eager to accommodate her.

The other woman hesitated a moment before answering. "I suppose you could call for an update if you really want to, Ms. Warwick." She took out a card from her briefcase and handed it to Emily.

Emily quickly slipped it into her pocket. "Thanks."

"It's all right. I understand." Nadine Preston smiled kindly. Then she stood up and slung her heavy bag over her shoulder. "Thanks for your help."

"You're very welcome."

The two women said good-bye, and Emily watched Nadine Preston push through the swinging doors and disappear. She'd really hoped to see the baby one more time before she left, but it seemed best not to push her luck. The social worker had already granted her one favor and also hinted she didn't think Emily should get too involved.

I can't help the way I feel, Emily reasoned. The situation was . . . unusual. Extreme. It's only natural to feel interest in the child's fate. The social worker even said so herself.

"Emily? Are you all right?"

Emily looked up to find her husband,

Dan, striding toward her across the waiting area. Tall and lean, he was easy to spot even in this crowd. He looked as if he'd dressed in a hurry, wearing his down jacket over a grey sweatshirt and jeans, a baseball cap covering his thick, silvery blond hair. His pale blue eyes searched for her in the crowd. He looked concerned, as if she'd been in an accident.

She'd called him earlier for a ride back to town, but the phone connection had been full of static and she'd barely explained about the baby.

"Hi, honey. Thanks for picking me up. I'm fine," she assured him. He hugged her hello, holding on a little longer than usual.

"I don't like getting calls from a hospital emergency room first thing in the morning. And what's all this about a lost baby?"

She could tell that her ex-reporter husband, "just-the-facts Dan," wanted the whole story.

"I was jogging through the village green, past the church, and I saw something move in the big crèche, in the cradle. I went back and it turned out to be a baby. A little girl," she added. "Her name is Jane."

Dan frowned. "How did you figure out her name?"

"There was a note. Not much else though. It's so sad. She's really a beautiful baby, about three months old. I wish you could see her." Emily glanced wistfully at the swinging doors that now separated her from the baby.

Dan stared at her a moment. "That's quite a story. Quite an experience."

"It was . . . odd. I took her into the church. Reverend Ben helped me call the police."

He touched her shoulder. "You've had some morning. Are you all done here?"

Emily nodded. "I guess so."

Dan slipped his arm around her shoulders and they walked out into the parking lot. Although there was nothing more she could do, Emily felt strangely reluctant to go. But it was hard to put her feelings into words.

Once they were in Dan's car and driving away, she said, "I wish I could have seen her one more time, just to say good-bye. But I didn't want to ask the social worker. I had a feeling she would have put me off, so I didn't ask."

"It's probably just as well. I'm sure the baby will get good care now. You don't have to worry."

"That's what the social worker told me.

Her exact words." Emily stared out the passenger side window.

Dan reached over and touched her hand. "You've been through a strange experience, honey, like helping out at the scene of an accident. I think you're a little in shock."

Emily didn't know what to say. She certainly felt . . . not quite herself.

"Are you still going in to the office?" he asked.

"Yes, I need to catch up. I can get a lot done this afternoon."

"Let's stop in town for lunch first. I bet you haven't eaten all day."

She was hungry, she realized. Maybe some real food in her stomach would relieve the floaty, unreal sensation she'd been feeling ever since she'd found the baby. Emily felt as if she were in a trance. Maybe Dan was right; maybe she was in shock from finding the baby.

But it had been a wonderful kind of shock, she reflected. And one of the most amazing moments of her life.

She already knew she wouldn't have missed the experience for the world.

Chapter Two

Although Dan didn't ask any more questions about the baby on the way back to Cape Light, the child's image was never far from Emily's mind. How, Emily wondered, could this little being whom she'd known so briefly have made such a deep impression?

Dan drove into the village and parked in front of the Clam Box. Emily was sure that by now everyone in town knew about the baby and she'd be barraged with questions at the diner, the town's unofficial news hub. Then again, she would be answering questions wherever she went today.

It was already past twelve and the Clam Box was nearly full. Emily spotted Charlie Bates, the diner's owner and cook, second generation. He was at his usual post,

working hard at the grill behind the counter. He deftly slipped a burger onto a waiting roll, added a side of fries, and then spun around and dropped the dish under the heat lamp at the service station.

"Order up." He slammed the little bell on the countertop.

His wife and head waitress, Lucy Bates, ignored him, greeting Emily and Dan with a warm smile. "I have your favorite table by the window set up."

"Thanks, Lucy." Emily took a seat as Lucy handed down the menus. "I'll just have a bowl of chowder today and a salad."

"Me, too," Dan said. "I'll have the same."

Lucy laughed. "Soup and salad seems to be everyone's choice today. I guess we all ate too much turkey and pumpkin pie yesterday." She jotted down the order on her pad. "Hey, Emily, Tucker said you found a baby on the village green this morning. Is that really true?"

Emily took a sip of water. "It's true, all right."

"I can't believe it. I thought Tucker was joking." Lucy's blue eyes widened, and then her expression grew more serious. "What an awful thing, to abandon a child like that. What did they say at the hos-

pital? Is the baby okay?"

"They're running some tests. They won't know for a few days. But she seemed pretty healthy to me," Emily added.

"Lucy? Baconburger? Table five? The dish can't walk across the restaurant on its own, you know."

Charlie stood at the end of the counter, scowling at his wife. Emily wasn't sure how Lucy put up with him. She had left him about two years ago but had come back, for the sake of their children, Emily suspected. Someday when the two boys were grown, Charlie might not be so lucky.

Charlie was Emily's only real political rival. He'd made a run for mayor in the election two years ago when Emily ran for her second term. His defeat had only sharpened his ambitions. He'd remained active in town politics, never letting an opportunity pass by to stir up trouble for her.

Emily tried to imagine how Charlie would interpret her finding the baby. Undoubtedly, he would figure out some way to put a negative spin on it.

Emily came to the diner anyway. The food was reliable if not gourmet, and she needed to show Charlie she wasn't afraid of him. Besides, she liked and admired Lucy, who managed to put up with her

onerous husband, work full time at the diner, raise two boys, and go back to school for a nursing degree. Though she was only able to take a few courses each semester, and was still years away from finishing her degree, Lucy plugged doggedly away.

"Catch you later. Charlie's on the warpath." The pretty redhead rolled her eyes. "But I want to hear more about that baby," she said over her shoulder as she walked away.

Emily felt Dan watching her. "Are you okay?"

She looked up at him. "Me? Sure. I'm fine. I guess everyone's heard by now. Better to answer all the questions and get it over with."

He smiled mildly at her. "It might be more efficient to hold a town meeting and invite the press. But I guess that would be a little extreme."

He glanced out the window and his smile widened. "Speaking of the press, look who's coming this way. Now you'll really be interrogated. I've heard this girl is tough."

Emily turned to see her daughter, Sara Franklin, rush toward the restaurant and pull open the door. Sara glanced around,

spotted Emily and Dan, then quickly walked over. She looked very professional and smart, Emily thought, in a knee-length tweed coat and high black boots. Sara slipped off her coat and swung her long, dark hair over her shoulder. Her blue turtleneck matched her eyes perfectly. Emily realized that Sara — who always seemed to have her mind on more idealistic matters — didn't really know how pretty she was.

"Hi, guys." Sara leaned over and kissed Emily's cheek, then slipped into the booth beside her. "I lucked out and saw your car parked outside."

"Luck had nothing to do with it. She's like a little bloodhound, tracking down a story," Dan teased.

Though he claimed to be perfectly happy retired now for almost two years, Dan still missed running the newspaper and running after stories. He had given Sara her first chance writing professionally and liked to take credit for teaching her the ropes. She had done well on her own merit, though, with a talent for writing and an intuition for ferreting out news.

"You want to know all about the baby, I guess," Emily said.

"Everything." Sara pulled a notebook

45

out of the leather knapsack that also served as her purse and sometimes seemed to contain everything but the kitchen sink. "What time did you leave your house this morning?"

Emily sat back. She could tell this was going to take awhile. She had been interviewed by Sara before: her daughter was relentless in her quest for detail.

Emily answered Sara's questions right through her soup and salad and into coffee. Finally, Sara seemed satisfied.

"Now please don't make a big deal out of it, Sara. I didn't do anything heroic, just what anyone would have done in the situation."

"Okay, but how many people find a real live baby in a manger scene? It's practically . . . a miracle," Sara pointed out.

Emily didn't reply, because Sara's casual use of the word struck a chord in her.

"I wouldn't go that far. This isn't a piece for the grocery-store tabloids," Dan cut in. "It seems pretty logical to me that someone chose a cradle as a place to park a baby."

"Logical, perhaps," Sara agreed, "but it still makes great copy. Maybe some relatives will see the story and come forward. Maybe I can help find the mother or who-

ever abandoned her."

Emily hadn't thought of that. The idea of finding the mother disturbed her. If the mother was found, would she be allowed to have the baby back after abandoning her? And what about relatives? Emily hoped that if any came forward, they would be more responsible than the child's mother.

Sara took a last sip of coffee and excused herself to go write up the article.

"She'll get good copy out of this," Dan predicted as Sara disappeared out the door. "Everybody wants to read about an abandoned baby. Front page, above the fold."

"You sound as if you wish you were writing this one yourself."

"Been there, done that." Dan grinned at her; then his expression turned serious again. "Are you sure you're all right? You just don't seem like yourself."

Emily was about to claim again that she felt perfectly fine, but instead she shrugged, touched that he'd noticed. "I feel a little . . . unsettled, I guess."

"You want to talk about it?" he asked gently.

Emily sensed that he knew old feelings about Sara had been stirred up — how

hard it had been to give her up so many years ago, and the shame, guilt, and regret that were with her still.

"No. I mean . . . I'm not ready to talk about it right now," she admitted. "But thanks for asking."

"All right, I'm here when you're ready." He reached across the table and touched her hand. "Do you still want to go in to the office? Why don't you just come home with me and relax?"

"That's a tempting offer, but I really need to take care of a few things on my desk today," Emily insisted.

The truth was, her office was the best place to hide away. There she could bury herself in work, her foolproof method for avoiding her painful memories.

"It wasn't my first front-page story, of course. But I think it came out pretty good. I got a great quote from Officer Tulley," Sara added. "He said something like, 'I thought the dispatcher was playing a joke, but I knew it wasn't April Fool's Day.' "

"Yes, I read it. I read it twice," her boyfriend Luke McCallister teased her. "I've saved it in a scrapbook for you."

Sara shrugged and smiled slyly. "You

ought to get together with Lillian. You could have a scrapbooking party. I hear it's the latest thing."

Sara's grandmother, Lillian Warwick, actually did collect Sara's articles and paste them into books. But Lillian openly disdained Luke and told anyone who would listen that he wasn't good enough for her granddaughter. The very thought of sitting in Lillian's parlor and working on scrapbooks together was so bizarre, it made Luke laugh out loud.

"Now you're scaring me," he joked, slinging his arm around her shoulder as they walked steadily up a steep hill in the village of Newburyport. Filled with shops and restaurants, bookstores, galleries, and even a movie theater that showed foreign films, Newburyport was a popular destination on Saturday nights, and the sidewalks were crowded with couples. "But even the idea of scrapbooking with Lillian won't dim my appetite. I'm starving," he said. "Where do you want to eat?"

Sara shrugged, feeling comfortable and warm cuddled up against him. Luke was tall, though not quite six feet. He wore his brown hair short, almost in a crew cut. With their faces so close, she could just about discern the thin, faded scar that ran from the corner

of his eye down his lean cheek. His change-able, hazel eyes matched his temperament, introverted and often moody. Luke had a rough-around-the-edges quality she found incredibly attractive.

"I'm not sure what I'd like to eat," she said honestly. "Let's walk a bit." She slowed her steps to look at a shopwindow and Luke stopped alongside her.

"Do you want to go inside?"

She shook her head. "Not really. I'm not ready to start Christmas shopping yet. I can't believe it's the holidays already."

"Neither can I. Doesn't it seem time goes faster when you get older than when you were a little kid?"

"Yeah, it really does." Sara nodded, won-dering if it went even faster for Luke, who was ten years older than she was. "Listen, I've been meaning to tell you, my folks want me to come down to Maryland this year for the holidays."

"Are you going?"

"I think so. Would you like to come with me? They said to ask you," she added quickly.

Luke glanced down at her for a moment. "How about you; do you want me to come?"

She nudged him in the ribs with her

elbow. "Of course I do, silly. But it's pretty boring. Family stuff. My town makes this place look like New York City."

Luke laughed. "I'm sure it's not that bad. Besides, I like your parents," he added. "They're cool."

Sara rolled her eyes. "I don't think *cool* is a word I'd use to describe Barbara and Mike. But it's sweet of you to say."

Her adoptive parents, she meant, Barbara and Mike Franklin, who had raised her in the small town of Winston, Maryland. All through college Sara had been obsessed with finding her birth mother. Right after graduation, she came to Cape Light on her own and located Emily. Their relationship had been rocky at first and Sara had nearly gone back home. She had felt so angry, as if she could never forgive Emily for giving her up. But Emily's sincere love and understanding had eventually won her heart.

As much as Sara loved her adoptive parents and knew that no one could replace them, she now couldn't imagine her life without Emily. Sara had carved out a place for herself in Cape Light these past years and rarely thought of returning to Maryland anymore, though she did sometimes dream of someday moving to other,

more exciting places.

Sara paused to gaze into another window where colorful ski sweaters with matching scarves were cleverly displayed on a row of fake snowpeople.

"I just dread all the holiday shopping," she confessed. "I'm not a shopping kind of person. I start off pretty good. Then about an hour or two into it, I panic and end up buying everyone sweaters or calendars."

Luke laughed. "You need a good list. That's the whole secret. Plan your attack and don't deviate."

She glanced at him curiously. "You sound as if you're already done."

"Not exactly. But I have started my list," he admitted. "It's shaping up nicely."

The glint in his hazel eyes made her even more curious, but she didn't pursue it. They'd come to a jewelry store and Luke made them stop.

"How about jewelry?" he asked casually.

"How about it?"

"Would you like some for Christmas?"

"It's not necessary," she said. Luke always got her lovely gifts, but this suggestion seemed extravagant. "Come on." She tried to tug him away. "You don't have to buy me jewelry. It's a sweet thought, but this store is way too expensive."

Luke wouldn't budge and, as he was much bigger and stronger, it was hard to get him moving again.

"Let's go inside," he said, tugging Sara along in his wake. "I want to see something."

"I thought we were going to have dinner," she protested. "I don't really feel like shopping right now."

"We're not shopping; we're browsing. I just want to get some ideas of what you like. For my list," he reminded her.

They were inside the store now. A tall saleswoman with bright red lipstick and glossy dark hair seemed to swoop down on them. "Can I help you with something, sir?" Her bright smile was fixed on Luke, Sara noticed.

"We're just browsing," Sara said.

"We'd like to see some rings," Luke said, almost at the same time.

The saleswoman ignored Sara. "Anything in particular?"

"Not really. That case would be a good place to start, I guess." Luke pointed at a nearby glass case and Sara's mouth dropped open. It was filled with diamond engagement rings.

The woman's smile widened. "Just a moment. I'll get the keys." She walked away

quickly as Sara grabbed Luke's arm.

"What are you doing?"

He patted her hand. "Calm down. This is going to be fun."

"Luke, I'm serious. We can't waste this woman's time. She's trying to make a living. This isn't a joke."

"I'm not joking. Didn't you ever want to try one of those on? Hey, that one looks like your taste, and it's a good size, about two carats, wouldn't you say?"

"I have no idea," Sara sighed. Almost against her will, her gaze was drawn to the case, zeroing in on the ring he was talking about.

It was a beautiful ring, a sparkling round stone in a simple setting that blended platinum and gold. Classic, but with a slightly unexpected, artful touch, just the kind she would like, if she ever wanted a diamond. Luke did know her taste by now; she had to grant him that much.

The saleswoman appeared again with a big key ring. "Have you found something you like?" she asked cheerfully.

Sara smiled through gritted teeth. "I don't think so. Sorry we —"

"That round solitaire in the second row caught my eye," Luke told the saleswoman. "May we see it?"

"Yes, of course." Before Sara could protest again, the saleswoman had the ring out on a dark blue velvet cushion and was describing the stone and setting in great detail.

Luke picked it up and held the diamond to the light. Then he looked at it under a magnifying lens, all the while asking the saleswoman questions.

Sara realized there was no way to get him out of the store before he was good and ready. She just had to play along.

And where had Luke learned so much about diamonds? He was asking some very informed questions about weight and flaws and countries of origin.

The saleswoman stepped away for a moment and Sara nudged him. "When did you turn into a diamond expert?"

Luke shrugged. "I was at the dentist last week. There was an article about diamonds in *Smithsonian*. Fascinating stuff."

Right. *Smithsonian* magazine. More like *A Guy's Guide to Buying Chicks Expensive Stuff.* That would be more Luke's speed, Sara thought.

The saleswoman suddenly appeared again, smiling coaxingly at Sara. "Would you like to try on the ring now?"

Sara stared at her, feeling like a deer

caught in the headlights. Luke picked up the ring, then picked up Sara's hand. "Don't be shy. I want to see how it looks, Sara."

He slipped the ring on her finger and met her glance. There was a sexy teasing glint in his eyes that touched her heart. She wasn't sure what it was about Luke that drew her, but it worked every time.

She glanced down at her hand. The ring did look lovely. It was just the right size, too.

"What do you think?" he asked, smiling at her.

"I . . . it's . . . so . . ." Sara found herself atypically at a loss for words.

She looked down at the ring again. This wasn't a piece of costume jewelry. It was a real diamond, the kind people wear when they plan to get married.

What was happening here?

She suddenly felt smothered, as if she couldn't get a breath of air. She yanked the ring off her finger and tossed it on the velvet mat.

"I can't do this." She felt the saleswoman staring at her, as though she'd gone mad, but there was nothing she could do. She turned and bolted out of the shop.

With her hands jammed in her pockets

and her head ducked down, Sara walked at a quick pace down the crowded street toward Newburyport's waterfront. She couldn't think straight; she could hardly even see straight. She wasn't sure if she felt shocked or just plain angry at Luke. Had that all been a huge joke? Or was it his not-so-subtle way of hinting he wanted to get engaged?

She hadn't even reached the corner before she felt a hand tug her shoulder and turn her around. Luke stared down at her, breathing quickly from his chase.

"Sara, wait up. Where are you rushing to?"

She didn't answer him. She turned and started walking again, and he fell into step beside her. They walked along in tense silence for a while.

Finally Luke asked, "Mad at me?"

She glanced at him but didn't answer. She wasn't sure. It was hard to be mad at a guy for wanting to buy you a two-carat diamond. Still, there was something that had happened back there that just didn't sit right.

"You took me by surprise," she said finally. "More than surprise, you tricked me into going in there. We've never even talked about getting engaged or any of that

stuff. Now, all of a sudden, you want me to pick out a diamond ring?"

Luke stood back and crossed his arms over his chest. He was wearing his favorite leather jacket with a dark grey turtleneck sweater underneath. He looked very attractive, which was an annoying thing to notice at a moment like this.

"How else could I do it? You never want to talk about 'that stuff.' Every time I bring it up, you change the subject. You start talking about your job, your landlady, your cat —"

"Okay, okay. I get the idea."

Sara sighed. She couldn't deny it; the accusation was true. Luke did try to talk about their relationship and where it was going, about making a real commitment. She was the one who always avoided the conversation.

"Just tell me one thing; would you have gone into the store with me if I had been up front with you?"

Sara didn't answer for a long moment. "No," she said at last. "I wouldn't have."

Luke winced, then said quietly, "See, that's what I mean."

"No, I don't see," she insisted. "It seems to me if I wouldn't have gone in willingly, that's all the more reason not

to . . . bamboozle me."

He rubbed the corner of his eye with his fingertip. It was a nervous gesture he had when he didn't want to lose his temper.

"The thing is, once you went in and tried on the ring, you seemed to enjoy it, Sara. I was there. I saw you. It wasn't exactly torture."

He had a point. What was she complaining about? Most of her single girlfriends were stuck in just the opposite situation, trying to figure out a way to trick their boyfriends into the jewelry store. And she *had* enjoyed trying on the ring. She'd never worn a diamond before. She understood now why they were so special and symbolized so much.

All the more reason to be upset at Luke for tricking her.

"That just isn't the way I want to choose a ring or get engaged to someone. I want to do it in a thoughtful way. I'm not an impulsive person. If you don't know that about me by now —"

Luke raised his hands in surrender. "Okay, I get the point. That was too spur of the moment for you, too off the cuff."

"That's right. You know I'm not like that."

"Yeah, I know," he said. "It's just that

sometimes you can miss out by trying to plan everything so carefully. Sometimes you just jump in feet first and it feels right. Didn't you ever feel that way, Sara?"

Yes, getting involved with you, she wanted to say. But she didn't tell him that. Instead, she twined her arm through his. "I know what you mean, but this is too important."

They continued down the street to the harbor. She could tell he wasn't happy and probably not done talking about the situation, but at least they weren't arguing anymore.

The night was clear and calm. Sara found the chilly air refreshing, clearing her head after the stuffy little shop.

Built on a large hill during the colonial era, the village of Newburyport rose up behind them like a folk art painting, the famous gilded steeple a focal point, the winding streets paved with stone, and millions of glittering white lights rimming rooftops and trees, setting the town aglow for the holidays.

They walked along the harbor for a while, then sat close together on a bench facing the bay. Settled under Luke's arm, Sara nestled against his warm, strong body. She didn't need to talk. She didn't want to.

If only they could stay just like this, without any conflicts or changes, without taking any huge, life-altering steps. What was wrong with just being together? Why did their relationship have to change?

"I'm sorry, Sara. I guess I should have brought this all up even if it's difficult to talk about. I want us to get engaged for Christmas. That's what I've been thinking of. That's what this is all about."

Sara sat without answering. She was surprised and not surprised. Certainly their trip into the jewelry store had given her some hint. Still, the idea of taking such a momentous step made her stomach clench. She knew in an instant that she wasn't ready, and wouldn't be in time for Christmas.

Finally, she looked up at him, her eyes wide. "Luke . . . I just don't know . . ."

"No, wait. Let me talk first. When I came here two years ago and we first met, I was a mess. My life was a big blank. I wasn't a cop anymore. I'd lost my identity, my reason for getting up in the morning. I had no idea what was going to happen to me. But I came to this place and I found myself here. My real self, not just the cookie-cutter identity my father had stamped on me." He turned to her and

smiled into her eyes. "I couldn't have done that without you, Sara. I would never have stayed if you weren't here. You know that, don't you?"

She nodded slowly, feeling almost moved to tears by his heartfelt admission. When she thought back to the days when they first met, she saw it much differently, casting herself as the wounded one who had come to Cape Light in search of her birth mother, Emily Warwick. She had felt too frightened and conflicted to confront Emily and confess her real identity.

Luke was the only one who knew her secret, who encouraged but never judged her. He wasn't the only reason she had stayed in Cape Light, but she couldn't imagine her life without him, without his loyalty and love.

"I could never say this to you before," Luke went on. "But I finally realized I'm in a good place now. I'm happy with my life and proud of what I've accomplished with New Horizons."

Luke had set up a center in Cape Light to help at-risk inner-city kids before they wound up in trouble. After some initial local resistance, the program was now thriving.

"I'm ready to take a new step in my life

with you," he went on. "I want to get married and have some kids of our own. I love you, Sara. I want us to start a real life together."

Sara swallowed hard. She didn't know what to say. It wasn't that she didn't love Luke. Since meeting him, she had never seriously considered dating anyone else. She had had a brief flirtation with Dan's son, Wyatt Forbes, during the short time he ran the newspaper, but Wyatt had never really mattered to her. It was always Luke.

But marriage? Children? Those were words for someday, a place far off in her life agenda.

Before she could put her feelings into words, Luke leaned forward and gripped her shoulders. "I know why you got so mad at me. I forgot to propose. That was it, right?"

He slipped down on one knee and took both her hands in his own. "Sara —" he began.

"No, don't." Sara took his face in her hands and kissed him hard on the mouth. "I love you, Luke," she said, drawing him to his feet. "I love you so much . . ."

They kissed again, holding each other close. But as Luke pulled back, she could see that he thought she had been saying

yes to his still unspoken proposal.

Sara bit her lip and looked down, unable to meet his gaze.

"You don't want to. Is that it?" His voice was soft, but she heard the sharp edge of hurt and sadness.

She looked up at him again. "I'm the one who wouldn't have made it all this way without you."

He shook his head slowly. "That's not what I'm asking you."

She took a breath. "I'm just not ready yet. I know it's hard for you to understand, but you're in a different place than I am right now."

Luke was ten years older, a difference that usually didn't matter between them. She knew that he didn't like to be reminded of it, but maybe it was more important than they had realized.

Sara chose her words carefully. "Please try to understand. This is all coming at me so quickly. So out of the blue."

"We've been together for two years now, Sara. We've talked about the future, spending it together. It can't be that much out of the blue."

"Luke, please. You know what I mean. I need some time. Christmas is just too soon for me."

He stepped back and stuck his hands in the pockets of his leather jacket. His brooding look reminded her of the past, of the expression he wore when they first met. She had been drawn to him despite it. Or maybe because of it.

"I thought that's what I've been doing, giving you time. How much time do you need? Do you even know?"

She shook her head mutely. What a question. Unanswerable.

He let out a long breath and turned away, walking farther down the dock. She didn't follow. She didn't know what more she could say. She knew that despite her professions of love, she had hurt him. And now she didn't know how to make it better.

She caught up with him, took his hand. "There's no one else in the world I'd rather be with, Luke. I don't know what I'd do without you. Please, just be patient with me?"

He stared down at her, his expression unreadable. She couldn't tell what his reaction was going to be and felt her heart beating hard against her ribs.

Finally, he sighed and touched her cheek with his hand.

"All right. Since we aren't going to buy any diamond rings tonight, I guess we

ought to have dinner. Any ideas?"

"You choose. I'm hungry for anything," she said quickly.

He took her hand in his warm, reassuring grip, and they started back up the hill toward the town and lights. "How about that little Indian place on Choate Road?"

"I was just thinking of that place. I'm really in the mood for tandoori chicken and those yummy breads."

"I knew that," he said smugly. "See how well I know you?"

Sara smiled despite herself. Why even answer when it seemed he could read her thoughts?

"There's dessert and coffee if everyone's ready," Emily announced, resisting her own urge to get up from the table.

Sunday lunch at her mother's house was often a challenge to her nerves, but today the gathering seemed particularly trying, maybe because they'd all been together just three days ago, on Thanksgiving. Or maybe because she dreaded more talk about the abandoned baby and was hoping today to outrun it.

Emily tried to keep the momentum going — salad course, entree, dessert,

coffee, and then home.

"Coffee and dessert already? I've hardly touched my food," Lillian complained, waving her silver fork in the air. Emily was not surprised. Her mother was the world's slowest eater and much preferred airing her views to finishing her lunch. "It's hard to eat with those children raising such a ruckus. Always fussing and jitterbugging around. They can't seem to sit still for a minute," Lillian added, glowering down the long table at her two grandsons, Jessica and Sam's boys. Born in mid-September, Tyler was a little over two months and their adopted son, Darrell, was now eleven.

"They're just little boys," Dan said. "I think they've been very good sitting at the table all this time."

"Maybe so, but it unsettles the digestion. I hardly feel as if the food is going all the way down."

Lillian glanced to her right at her old friend, Dr. Elliot, for confirmation. He chortled into his napkin. "Nonsense. Having children around keeps you young, keeps the blood flowing, Lillian. Didn't you ever hear that?"

"Mere common consensus hardly makes a statement true," she replied.

"You ought to talk less while you're

dining then," Ezra told her bluntly. "Too much talking. That's what makes you dyspeptic."

Lillian's eyes widened. "Is that your diagnosis?"

Dr. Elliot pushed up his gold-rimmed glasses with the tip of one finger. "Yes, ma'am, it is. But I won't bother to offer you my remedy for your troubles, at the risk of being asked to leave the table before dessert is served."

Dan laughed out loud, then deftly turned the sound into a cough. Emily saw her sister, Jessica, and her husband, Sam, both smother their reactions with their napkins over their mouths. No one but Dr. Elliot seemed able to speak to Lillian so boldly and get away with it, and even he didn't always escape unscathed by her rapier tongue.

A clattering from the far end of the table drew everyone's attention. Sam jumped up. "Don't worry. It's just water."

He grabbed some linen napkins and quickly started to wipe up a wet spot on the table. It seemed that Darrell had tipped over his water glass.

"I'm sorry." Darrell stood up and stared around, looking embarrassed.

"That's all right, Darrell," Emily said

kindly. She grabbed a hand towel from the sideboard and quickly covered the wet spot. She placed a reassuring hand on her nephew's shoulder. He did try so hard to behave well in his grandmother's house. He had caused havoc the first time he had been here, though, and her mother had never forgotten it.

"Is it broken? Is the glass broken?" Lillian stood up and glared at the boy. "That's antique Waterford crystal, you know. That pattern is discontinued. It's irreplaceable."

"Nothing is broken, Mother, thank goodness." Jessica stood up and righted the glass, showing her mother it was in one piece. "I don't know why you won't just give them plastic, or at least some ordinary glasses that aren't irreplaceable."

Lillian sniffed and sat down again in her armchair. "Why don't we all just eat in the kitchen, off paper plates?"

Good idea, why don't we? Emily nearly retorted. But she held her tongue. Sam picked up the baby from Jessica's arms and then took Darrell by the hand. "I'll take the kids into the living room. They can play for a while."

Lillian's eyebrows shot up. "Play? In my living room?"

"We brought a few plastic baby toys, Lillian," Sam said. "Tyler is a little young yet for touch football."

Her mother replied with a heavy throat-clearing sound as her son-in-law and the boys left the room.

Emily cleared some plates and carried them into the kitchen. Jessica soon followed with another stack. "Is the coffee ready?" Her tone was desperate and Emily felt sorry for her.

"It's all done," she said, pouring the coffee from the electric coffeemaker into the silver coffeepot her mother preferred. "Can you take the sugar and cream? I brought a pie and ice cream from the bakery." She touched her sister's arm as she brushed by. "I'm sorry Mother's such a pill about the boys. I love having them here."

Jessica smiled quickly at her. "Thanks. I guess I have to stop expecting her to be any different. Sam's family makes such a fuss over Tyler. You would think he was the first baby ever born in the world."

Emily laughed. "As it should be."

"Any news about the baby you found on the green?"

Emily picked up the tray that held the coffee, pie, and ice cream and started to-

ward the dining room. "Nothing more to report. She's undergoing tests. I guess they'll know more tomorrow." Emily set the tray on the table and started to pour the coffee. "The social worker said I could call her and get an update."

"What social worker? Who are you talking about? That baby you found on the village green?" Her mother peered up at her.

"Yes, we were just talking about the baby, Mother," Emily explained calmly. She had hoped to avoid her mother's views on the topic, but there didn't seem much chance of that now.

"Such a horrid story, abandoning a child that way. I don't know what society is coming to."

"Now, now, Lillian. Foundlings are hardly a modern invention," Dr. Elliot reminded her.

"It's unheard of in this town, Ezra. I assure you that there's never been such a disgraceful incident in Cape Light. And I can tell you exactly where that child came from. I don't see what all the mystery is about."

"Where do you think the baby came from, Lillian?" Dan asked evenly.

"Why, from that trashy little pocket

down near the lake, Wood's Hollow. Where else?" Lillian said definitively. "It's not really even part of our village. Just over the borderline toward Rawly, I believe."

"It's definitely within our town limits," Emily corrected her.

Lillian's head popped up again. "It wasn't always. The town line must have been moved recently."

Of course the town line hadn't been moved. Neither had the equator. But Emily didn't argue with her. Few in the village wanted to acknowledge the neighborhood — or trashy little pocket, as her mother called it — of Wood's Hollow.

Set off from the main road, the area consisted mainly of two or three ancient hulking structures standing beside a small lake. They had been hotels and boardinghouses in a bygone era and not even the best accommodations the town had to offer back then. In the 1960s, the buildings had been turned into small apartments and furnished rooms. Since then the residents had all been low income, many of them transients. There were also two or three stores there, a laundromat, and grocery, Emily recalled, and a small storefront community center that mostly stood empty and inactive for lack of funds and volun-

teers willing to work there.

Investors would periodically come to Cape Light and stir up talk of developing Wood's Hollow, inspiring debates at town-council meetings about knocking down the buildings considered a blight on the community, perhaps by changing the zoning laws. But no one was ever sure how it would be done.

As if on cue, her mother now expressed the popular sentiment. "The place should be cleaned out. Those old buildings should be knocked down before they fall down. You'll get rid of that unsavory element living there. You won't have any abandoned babies around here then. I guarantee it."

"Most of those families are just poor people who work hard but can't afford anything better. Where would they go, Lillian?" Dan asked.

"Who cares where they go? They would leave our town; that's all I'm concerned about. They would go away, back where they came from; that's where they'd go. And they would take their babies with them, one would hope."

Emily stopped pouring the coffee and stared down at her mother. "It's not a crime to be poor, Mother. At least, not yet,

thank goodness. I have to think that the child's mother, wherever she came from, had to be absolutely desperate. Even respectable people fall on hard times."

Her mother looked as if she was about to deliver some scathing reply, and then her mouth puckered. She drew in a long breath and sat back in her chair.

Bull's-eye, Emily thought. *I finally hit her "off" button.*

Her reply had been a not-so-subtle reminder of the time during Emily's adolescence when their own family faced financial hardship due to her father's imprudence and misjudgment. Her mother had bravely faced the situation and taken control, selling off just about everything at a humiliating public auction, including the mansion and estate that had been in the Warwick family for generations. Though Lillian's present home on Providence Street was one of the finest Victorians in town, it was more than a step down from the family's former glory.

Emily hadn't meant to hurt her mother's feelings, but she could only tolerate so much of Lillian's closed-minded braying.

Her mother glared at her with narrowed eyes. "Just don't get so involved all

74

the time, Emily. You can't save the world."

"Involved with the baby, you mean? I'm just going to follow up with a phone call. I don't consider that overly involved."

Emily sensed Dan watching her. She knew he shared her mother's opinion and concerns about the baby — one of the few times they had ever agreed. She was grateful that he didn't chime in.

"You know very well what I mean," her mother insisted. "I know that look in your eye better than anyone," she added in a cutting tone. "It's best to let the social workers take care of it now. That's their job. That's what they get paid for."

Before Emily could reply, a loud crash sounded from the living room. Everyone turned and stared at the doorway as Tyler's piercing wail broke the silence.

Jessica jumped up and ran toward the noise. "Sam, is everything all right in there?"

Lillian got to her feet and grabbed for her cane. "Let's survey the damage. I feel like the Red Cross walking through a disaster area," she said dramatically.

In a strange way, she sounded almost pleased, Emily thought. Pleased to be proven right about the children being destructive?

Ezra rose and slowly followed. "Don't worry, Lillian. You can cover your losses on eBay, even the discontinued china patterns."

Emily watched as the others left the room. She stood at the table, her mother's pronouncements echoing in her mind. Did the baby come from Wood's Hollow? She had thought of that herself, then dismissed it. Now she couldn't seem to get the thought out of her mind. Was the baby's mother that close — only a few miles away? If she were to go down there, could she possibly find her? Did she even want the child's mother to be found?

Don't get so involved, she heard her mother's words again. *You can't save the world. Leave it to the social worker.*

Emily sat down slowly, feeling suddenly tired. The trouble was, every time she thought of the baby now, she didn't know what she wanted, or what she should do. Or even if she should do anything at all.

Chapter Three

~⌒

Emily was in meetings all Monday morning, but that didn't prevent her from calling Nadine Preston. Eager to hear about Jane's test results, she called twice before noon, reaching the voice mail both times and leaving a message.

She was wrapping up a weekly briefing with the town's attorney, Warren Oakes, when her intercom buzzed. "It's someone named Nadine Preston, returning your call," her secretary said.

"I'm sorry, I need to take this, Warren," Emily apologized.

Warren picked up his folders and waved a quick good-bye. Even before he'd left the room, Emily grabbed the phone and quickly said hello.

"Sorry it took so long to get back to you, Mayor Warwick. I was making some home visits this morning."

"That's quite all right. Please call me Emily. I didn't mean to bother you. I just wanted to check on Jane. How did her medical tests turn out?"

"No serious conditions like HIV or hepatitis."

"That's good news," Emily said, feeling relieved.

"Yes, of course," the social worker agreed. "But she will need to stay in the hospital a bit longer."

Emily sat up sharply. "Oh? Why is that?"

"She seems to have a respiratory infection. Her doctor is treating it with some strong antibiotics. She should show improvement in a day or two, but she can't be released until it's completely cleared up."

"That's too bad. Is she in any discomfort? Any fever?"

"She has trouble getting a full breath at times, and they're giving her oxygen. The fever is very mild though, so that's not a grave problem."

Taking oxygen? The poor little thing. Emily's heart went out to her. She felt suddenly sad and helpless, wanting to do something for the baby but having no idea

of what that something might be.

"How do you think she got the infection?" Emily asked, unwilling to let the conversation end.

"It's hard to say. Most likely she had a cold that wasn't treated properly, so it developed into something more serious. We did catch it before it turned into pneumonia, though."

"Yes, that's one good thing," Emily said. "Can I come and see her?"

The question just popped out. Emily surprised herself, and she could tell by the stunned silence on the other end of the line that Mrs. Preston was surprised as well.

"Visit her at the hospital, you mean? I'm not sure we can do that . . ."

"I read somewhere that it's good for babies that age to be held a lot, especially if they're in a hospital environment. I read that there are even people who come into hospitals to do that — volunteer baby holders. It helps the babies' brain development or something like that."

Though she'd never raised a child, Emily knew a lot about child development. Long after she had given Sara up, Emily had read countless books on the subject in a subtle form of self-torture, while she won-

dered what stage her daughter had reached. Could she roll over yet? Sit up? Grab a block? Call out for her mommy in the middle of the night? Was she getting enough care, enough nurturing and stimulation?

Of course, once she met Sara, she realized those worries had been needless. Sara's adoptive mother and father had been the most caring of parents.

"It helps in any number of ways," the social worker finally answered.

"It might be good for her, don't you agree? I mean, all things considered, I suspect that her mother's care was lacking, and now, being in the hospital all alone . . . I'm sure the nurses are attentive, but nurses are so overworked these days . . ."

"I understand what you're saying, Ms. Warwick," Nadine Preston interrupted her. "I suppose if you really want to visit, you may. I'll let the hospital know you have my permission."

"Thank you. Thank you very much," Emily said quickly.

"But you really ought to . . . to be careful."

"About the baby? Is she contagious?"

"I don't mean that way." Nadine Preston paused. "Never mind. Perhaps I'll see you

at the hospital. I have to run. I'm late for a meeting."

"Of course. Thanks again." Emily said good-bye and quickly hung up the phone.

As she anticipated seeing the baby that night, she felt a wave of happiness well up inside. Then she thought about calling Dan to let him know she would be home late. She knew she could call his cell and speak to him directly, but instead she decided to call the house and leave a message there. She suspected he wouldn't be happy to hear she was driving to Southport tonight to visit Jane. He would probably try to talk her out of it, so better to avoid the confrontation.

Her mind was made up. She was going.

When Ben pulled into the driveway on Monday night, the house was ablaze with lights. The seasons had once again brought the shortest days of the year, and at six o'clock inky blue night had fallen. The rectory, a cozy retreat flanked by evergreens, looked warm and welcoming. Hanging from the front door was a large pine wreath decorated with dried flowers and a satin bow. That hadn't been there this morning, he mused. It was getting to look more like Christmas around here by the hour.

"Hello? Anybody home?" he called from the foyer.

"Back here," Carolyn called from the kitchen. Ben hung up his coat and scarf and followed the enticing smells to the heart of the house. There he saw pots and pans covering the stove and his wife peering at something in the oven. It looked like a holiday dinner was in the making.

Then he remembered: the children were coming. Rachel and her husband, Jack, and little William. Between his job at the bookstore and his social life, Mark was rarely around, but was making a point of coming home tonight to visit with his sister and her family.

Normally, Ben loved seeing his children and grandson. He loved having the house full of activity and watching the way Carolyn became so animated and joyful. But for some reason he wasn't in the mood tonight. He was more inclined toward a quiet dinner followed by a good book. But there was no help for it.

"Hi, dear. You're late. I thought you'd be home in time to set the table," Carolyn called out to him.

"Oh, sorry. I can help now if you need me," he offered as he walked into the kitchen. "Let me wash the pots," he said.

He slipped off his sports jacket and rolled up his sleeves, then stepped up to the sink. "What time will they be here?"

"Any minute." She glanced up at the kitchen clock, her chin-length blond hair flopping across her eyes. She checked another pot, then finally sat down in a kitchen chair. "I was out all day, shopping for Mark."

"Christmas shopping?"

"Not really. For school. He needs so much. It's hard to know where to start."

Ben laughed. "Mark needs just about what he can fit in that backpack of his, dear. He's a grown man who lived on his own for years before coming back home to us. I don't think you have to exhaust yourself shopping for him."

"Well, I suppose you're right. I'm just anxious for him. I hope he enjoys school this time. I hope he sticks with it."

Ben paused in his scrubbing and glanced at her. "I think he will. In fact, I'm sure of it."

Carolyn sighed. "I wish he didn't need to go so far away. Portland, Oregon, for goodness sakes. It will be like before. We'll hardly see him anymore."

"Not exactly. It won't be like that," Ben said gruffly.

For several years after Mark quit Brown University in Rhode Island, he wandered around the country taking odd jobs and remaining completely out of touch with his family. All attempts to make contact with him, by Ben or Carolyn or even his sister, Rachel, were rebuffed. But when Carolyn fell critically ill with a stroke two years ago, Mark was summoned home and finally made amends with his family.

"No, of course not," Carolyn agreed. "I liked having him home though," she admitted.

Ben felt wistful. He knew Mark couldn't stay with them forever, even if he wasn't starting school again. Though he was thankful to have finally made peace with his prodigal son, thankful to see him back on track, he still felt an edge of envy for his son's youth and flexibility. So many choices ahead, so many possibilities. Mark could pick up and go wherever he pleased, without any responsibilities or commitments tying him down. Ben wondered if he had ever felt that footloose and free. Yes, of course he had. He just couldn't remember quite when, though.

Ben rinsed off a large pot cover and set it on the drain board, then picked up a fry pan and scrubbed away.

Mark had already lived and worked in more places in his short life than Ben had in his sixty-odd years. With the exception of going to school in the South, where he'd met Carolyn, Ben had barely made it from his hometown of Gloucester up the coast to Cape Light.

But it's the depth of experience that counts most, isn't it? He didn't need a big city to dazzle him. He believed in microcosms: all levels of life and complex society could be found in a tidepool. Even the tide-pool community of Cape Light bore infinite variety if you looked long and closely enough.

Why was he feeling this twinge of envy over his son's departure? Why did he feel lately as if his ministry in this congregation was draining him? *Dear Lord, please help me understand and overcome this . . . negativity.*

"Ben, are you all right, dear?" Carolyn's voice broke through his silent prayer.

"Yes, of course. I'm fine." He scrubbed down the sink with a sponge and sprayed off the soap.

"Is there anything going on at church?" she persisted.

"The usual." Which was the trouble. "I'm just tired."

"Maybe I shouldn't have asked the kids on a Monday night. Mondays are hard for you. You're still tired from Sunday."

"No, it's all right. I'm looking forward to seeing them."

He was, too. Once they all arrived and filled the house with their talk and laughter, he'd be distracted from his murky thoughts.

"I had a frustrating morning," he admitted. He told Carolyn how both Grace and Vera had canceled at the last minute on the meeting to start the coat drive and how he had then gone to Wood's Hollow on his own. "There was a volunteer from the neighborhood association at the community center, and we talked a bit. They really need so much help — more than just a coat drive. I wish the congregation would take a stronger interest. I can't do it all myself. That's not what it's about."

Carolyn nodded. "I'm sure it's just timing, Ben. Everyone's distracted now with Christmas and getting ready for the fair."

"That's just the problem. It's easy to work on the fair. That's fun. This is harder work but more important. Why can't they see that? Why can't I make them see?"

Carolyn's gaze was sympathetic. "Don't blame yourself, Ben. You've been trying. It

might take more time than you think to get the message across. As you would say, let God into it. Ask Him for tolerance and patience."

It was hard to hear his own tried-and-true spiritual counsel coming back at him. Ben nodded, placing the last pot on the drain board. "Yes, I have prayed about it. I'll continue to, of course."

He sat in a chair across from Carolyn at the kitchen table. "Maybe these *are* challenges I'm meant to face for some reason I don't understand right now. But I'm starting to wonder if God is trying to tell me something through all this, trying to send me a message. I mean, I wonder sometimes if the congregation can even hear me anymore. Maybe I'm just too familiar. Maybe God is trying to tell me that it's time to move on."

"Oh . . . well, I didn't mean that," Carolyn said.

"Have you ever thought about moving away from here, to someplace new?" he asked.

Now his wife looked positively shocked. "Move away? What are you talking about, Ben? Why would we want to move?"

He shrugged. "I was just thinking out loud. That's all."

"I guess I'd like to see more of the world on vacations . . . but you said, move away."

"Yes, well, I didn't mean a vacation. I meant a real move. But maybe not forever. Just temporarily, see how it is to live someplace new and give service in some different way."

Carolyn stared at him curiously. She didn't say anything at first. "What would we do?"

"Oh, I don't know. Maybe some sort of mission work. Something more hands on, like James is doing right now. I just got a letter from him last week."

"How is James?" Carolyn asked with interest. "And how are Leigh and the baby?"

"They're all doing well. James sounds very happy, very productive. I think he thrives on hard work."

"Bring the letter home. I'd like to read it."

"Yes, I will," Ben promised. "You know, James said he could use some help there. Well, he hinted at it anyway."

"I can see how that type of work might draw you, Ben. But I think I'd miss the kids too much, especially William. And Rachel is talking about having another baby. She'll need me more than ever then."

"Of course she would." Ben nodded. He

could sense that though she had tried to keep her tone calm, his vague talk had scared Carolyn. She had been so happy when he'd come in. Now she looked sad and confused.

He reached across the table and patted her hand. "I was just talking off the top of my head, dear. Don't look so worried."

She sighed. He could see she wanted to believe him, but she wasn't quite convinced. "We are getting close to retirement age, Ben. I suppose we have to figure all this out sooner or later."

"Sooner or later, but not tonight," he assured her. "We have time. I don't feel old, not when I look at you."

He smiled at her and had finally coaxed a smile in return when the doorbell rang.

"I'll get it," she said, rising from her chair.

"Let's go together," Ben said, following her.

The children came in all in a rush, Rachel and her husband, Jack, leading a waddling little William wrapped in so much winter wear all Ben could see at first were his big brown eyes and the tip of his nose.

"Look, Grandpa." As his mother peeled off his coat, William held up a ragged stuffed tiger.

"My, my. He looks fierce. Does he bite?"

"Only if he's hungry." William shook the tiger at Ben, making everyone laugh. "His name is Willie, too."

Ben picked up his grandson, who held the tiger up to face him. "Are you hungry, Willie?" Ben asked the tiger in a scared voice.

"Cookies, please," William answered in his tiger voice.

"We can find some of those for you. Not a problem," Ben promised respectfully.

The door opened and Mark came in. "Am I late? Hope not."

"Right on time," Carolyn called out. "Everything's ready. Why don't we go right into the dining room?"

Following the appetizing smells that filled the warm house, they traipsed into the dining room. Ben came last, leading his grandson by the hand. He felt a wave of love and happiness. His family's laughter and energy seemed to suddenly fill the house, burning away his dour mood like sunshine burns away the fog on a summer day.

Perhaps the truth was that deep down inside he felt just the way Carolyn did about moving away. He really couldn't do it. He couldn't leave his family or his con-

gregation; he would miss them all too much. Surely his calling and work here were as important and worthwhile as in any far-off place.

This strange, restless mood will pass, Ben told himself. *I need to focus here, where I belong.*

It's hard not to love the guy, Sara thought with a secret smile.

She stood watching Luke from a distance as he played volleyball with a group of kids in the gym at New Horizons. He was so involved in the game, he didn't even notice her.

He'll be a great father, Sara thought. Kids loved Luke because he had a special way of talking to them, of figuring out what they needed and encouraging the best in them.

Would she be a great mother? She worried about that sometimes. She liked children. She had been tutoring at the center since it opened and always grew very attached to her students. She missed them when they returned to the city. But those were big kids, usually at least ten years old.

Sara had to admit, she didn't feel quite the same about babies. They seemed so fragile, their needs so hard to figure out.

She could hardly imagine being responsible for a baby or being pregnant. Sometimes she wondered if being adopted and searching so long for her birth mother had left her with mixed emotions about becoming a mother herself. Some women her age already seemed quite sure about wanting children. But she definitely was not.

Luke's pressing for a commitment had made her think about it lately. But even before that, she had been secretly quite interested in her aunt Jessica's pregnancy. As eager as Jessica had been to have a baby, when her body began changing, Sara could see it had come as a shock. Now, though her figure was trim and sleek once more, Jessica seemed different. Motherhood changed a woman, Sara knew, though she couldn't exactly say how.

Was she ready for those changes? She knew in her heart that she wasn't. Would she ever be?

"That's it. You got it, Valdez. Point for blue team!" Luke cheered on the kids.

Luke said he was ready for fatherhood, ready to start a new stage of his life. Sara knew that was true. He had come such a long way since moving to Cape Light.

It was still amazing to her that Luke had

managed to build this place: the gym and classrooms, the cottages turned into dorms. He had truly made something out of nothing. She remembered the night he told her about his plan, when it was just an idea he had, an inspiration to do some good in the world.

They were both living on these grounds, each renting a cottage when the land was still owned by Dr. Elliot. She had been working at the Clam Box as a waitress while she figured out how to approach her birth mother, Emily Warwick.

Luke had come to town drawn by child-hood memories. His family had spent sum-mers at the cottages in Cape Light, and he remembered it as a place where he would find peace at times when his life was totally at loose ends.

He had quit the Boston police force under a cloud of suspicion and humiliation after a shoot-out that left his partner dead and Luke with permanent scars and a metal rod in one leg. But the physical damage was the least of his injuries; stripped of his identity as one of Boston's finest, Luke was adrift, feeling his life was meaningless.

Then he got the idea to buy the Cran-berry Cottages and property when Dr.

Elliot put them up for sale. Soon after, Luke heard of an organization devoted to helping at-risk inner-city kids — kids who got in trouble at school or had minor scrapes with the law, kids who still could be guided from moving in the wrong direction. The idea intrigued him: preventing crime by preventing kids from choosing those wrong turns in life.

Suddenly, it all made sense to him. He found what he wanted to do with his life. But even after he made the connection with the New Horizons foundation and found the funding, many town residents fought long and hard to keep the center from opening.

Luke persisted and, with Emily's help, won that battle, too. Cape Light was now proud to be the home of a New Horizons center and many, including Sara, volunteered there.

Maybe he had never been a supercop on the streets of Boston, but in Sara's eyes, Luke was a real hero where it really counted. She knew she was lucky to have him in her life.

"Hey, Sara. What's up?" Luke waved to her and started to walk over. The game was still going strong, but another coach took his place.

"I just finished tutoring. Thought I'd say hello."

"Hello." He smiled and kissed her on the cheek. "Want to stay for dinner? I'm having mystery meal — whatever doesn't walk out of the fridge when I open the door."

She laughed. "Sounds good to me. I was having the same at my place."

They left the gym and started down the path to Luke's cottage. He still lived in the same one he rented when Dr. Elliot had owned the place, but he had substantially renovated it.

Luke had saved the wood-burning stove in the living room. As Sara entered, he picked up a few logs from the pile near the front door and quickly built a fire.

The cottage had an open floor plan: one large room with a sitting area on one end and a small kitchen on the other. A kitchen counter broke up the space. The vaulted ceiling and new, large windows gave the rooms an airy feel. The wooden floors had been refinished and covered with area rugs.

"Okay, let's take a look in here if we dare," Sara joked as she pulled open his refrigerator door.

"My, aren't you the brave one." He

walked up beside her and rested his hand on her shoulder.

It wasn't too bad, she thought. Though the pickings were spare, they did manage to find the makings of a cheese omelet, a salad, and a bag of frozen French fries.

They cooked together in the small kitchen, with Luke teasing Sara about her lack of culinary skills. "You modern women," he said. "How will you ever hook a guy if you don't know how to cook?"

"I thought I'd already hooked a guy. He didn't seem to notice."

Luke grinned and kissed her quickly as she beat the eggs. "He noticed. He just didn't mind that much."

Sara turned back to the eggs, her mind troubled. Luke was so sweet; he always made her feel so well loved. Why did she have to be so contrary, so stubborn? She should just tell him, yes, let's get engaged. What in the world was her problem?

But she couldn't do that. It might feel good for a moment to make him happy, but she knew in her heart she just wasn't ready. She had to tell him tonight. She had to try to make him understand why.

They ate at the small table, sitting across from each other. "This isn't bad," Luke said, tasting a bite of the omelet.

"At least I didn't burn it this time. Well, not your half," she added.

"You'll have to make this for us at least once a week when we're married." She could tell from the glint in his eyes he was teasing, but not entirely. More like testing the water. The thought made her uneasy.

She moved a bite of food around her plate without picking it up. "Luke, there's something I'd like to talk about," she began.

He didn't answer at first, just kept looking down at his food. Finally, he picked his head up, his expression unreadable. "I hate when people say that," he quipped without smiling.

"Yeah, so do I," she admitted. "It's just that I've been thinking a lot about Saturday night, what happened at the jewelry store. I need to talk about it more with you."

His expression softened and he sat back. "What's on your mind? I have a feeling you're not going to ask me to run over to Newburyport tomorrow and buy you that ring."

That was Luke. Making it easy for her, even when it probably hurt him to say such a thing. She reached across the table and touched his hand.

"I've been thinking about our talk, about your proposal —"

"You never actually let me propose," he pointed out, "but go ahead."

"Honestly, I love you so much and I love the way we are together. I feel so good with you. I can't see myself with anyone but you. But I'm not ready to get engaged, not for Christmas. My life is just still too un-settled to make that commitment."

"Unsettled?" He sat back with a puzzled expression. "How is it unsettled? You have a good job on the paper; you're doing well there. And you have a great relationship with Emily now."

She shrugged. "I can't see myself writing for the *Messenger* my whole life."

"Of course not, but you haven't been there all that long."

"I know. But a small paper in a small town — it gets tiring quickly." She paused. "I've been thinking of applying for a job on a bigger paper, in Boston maybe or some larger market. I sent some of my clips around just to see if anyone's interested."

"Why didn't you tell me?" She could see the admission had stung him. They usually told each other everything.

"I don't know," she said honestly. "I just did it on the spur. I was going to tell you if

anyone answered. So far, I haven't gotten any replies."

"So you want to be a reporter in Boston. What about me?" Now he was angry; she heard it in his voice. "We'd see each other on weekends? Maybe? Even less than we see each other now?"

Sara took a breath and looked down at the table. "Well . . . actually, I thought maybe you might move back to Boston with me. I mean, if anything ever came of it — and so far, nothing has — you could take that job at New Horizons, the one they offered you awhile back?"

Earlier, when they went through other problems as a couple, Luke had considered an offer from the main office of the New Horizons foundation as a liaison who would find new sites and start up centers around the country. Finally, they had made up and he had turned down the job, preferring to stay close to Sara.

"That was two years ago, Sara. Besides, even if they still wanted me, I'm not interested in working at the main office. There's a lot more I want to do right here. I can't just drop everything and run into Boston because you feel restless and want to work for a bigger paper." He shook his head, looking distressed. "I don't know,

Sara. Where would that leave us? You haven't said a word about getting engaged or married. Does that fit into your agenda at any point?"

Sara didn't know what to say. She hadn't thought this conversation would be easy, but she hadn't expected him to be so hurt and angry. She was trying to be honest with him. Didn't that count for anything?

"I've never thought of moving on without you in my life, Luke. That's the truth. I do want to marry you . . . someday. But I just can't get there in my head right now. I don't know exactly why. Maybe I need to feel I've accomplished more in my career before I make that commitment. Maybe I have to do more with my life. You're older than me," she said finally. "You're at a different place."

"Oh, the age thing now." Luke rolled his eyes. "I should have seen that one coming."

"Luke, please. Don't make it sound ridiculous. It's just a fact. Ten years is a big difference. You know you were different when you were in your early twenties."

He let out a long breath. Although he was trying to hear her out, it was hard for him to come up against this particular stumbling block. Luke had always been

100

protective of her, a handsome guardian angel who seemed to swoop in when needed most. He had never acted condescending or treated her like a child. If anything, she often felt like the more mature one. They just seemed to suit each other from the start. Their age difference never seemed to matter, though Emily had once warned her that someday it might.

Well, it looked like her mother was right. *Someday is here,* Sara thought.

"Yes, I am in my thirties and you're still in your twenties," he acknowledged. "But honestly, Sara, if we weren't more or less at the same place emotionally, if this didn't work for us, do you think we would have stayed together this long? Let's not measure our relationship against whatever the *typical* thing to do is, okay? I don't think we're the typical couple. But maybe that's a good thing. Maybe it just works for us."

"I'm not trying to turn us into the typical anything," Sara protested. "You know that's not what I want. But you're at a different place in life than I am."

Luke stood and left the table. He walked over to the stove, tossed another log inside, then poked the embers around until they glowed.

"I hear what you're saying. I just don't

think that's true. I think you're just scared of making a commitment, or marrying me, or something. As far as accomplishing more with your career, I would never hold you back, Sara. You know that. But plenty of women manage to work and have a marriage. It's the latest thing, haven't you noticed?"

"Is it really? Wow. Maybe we'll even get the vote," she said, matching his facetious tone.

"Okay, that was a little out of line, but give me a break. You make it sound as if the two are just impossible to reconcile. Besides, I don't understand all these newspaper ambitions. You used to tell me how all you wanted to do was write a good novel or a book of short stories. If you're bored at the paper, maybe you should go back to your real writing."

Sara felt stung by his remark. Who was he to say what was real writing and what wasn't? Who was he to decide how she would spend her time or her talent? "Writing for a newspaper *is* real writing," she corrected him sharply. "Some might say fiction isn't."

He rubbed his cheek with his hand. "So you're not interested in writing a novel anymore? Is that it?"

"It's just not what I want right now. I'll get back to it someday, when I've lived longer and have more to write about. I'm a reporter. I like it. Besides, what difference does it make what kind of writing I do? That doesn't solve anything between us."

"If you were focused on your own writing, you wouldn't be talking about moving to Boston," Luke pointed out. "It would solve that problem at least."

When Sara didn't answer, he added, "So you don't want to get engaged for Christmas. I got it. We won't talk about this anymore until you're ready, okay?"

She nodded, feeling let off the hook but still upset and unsettled. She hated fighting with him.

"Okay, fine," she said quietly.

"If you want to talk about it, if you want this discussion to go any further, you'll have to be the one to bring it up. I'm done," he said simply, but his words had an ominous ring.

"I will bring it up," she promised. "You'll see."

"I guess we will have to wait and see." His look gave her a chill. Had she gone too far and damaged their relationship beyond repair? She suddenly felt so scared of losing him, she nearly ran across the room

and threw herself into his arms. At that moment, she was willing to agree to get engaged, get married, even have a dozen kids if that's what he wanted.

But she didn't. She stood up slowly and cleared their dirty plates from the table. The phone rang, but Luke made no move to pick it up. Sara brought the plates to the sink and started washing them. The answering machine picked up on the third ring, and Sara heard a woman's voice come on the line.

"Hi, Luke, it's Christina." Her tone was somehow breathy and energetic at the same time. Though Sara didn't mean to eavesdrop, she found herself listening. "Sorry I didn't catch you in. I'm just working out my schedule for this week and wanted to make a date for our interview. Give me a call when you get a chance. You can call late. I'm a night owl, remember?"

The caller laughed and Sara paused in her task, caught by the intimate note in the woman's tone. Who in the world was Christina? She turned to look at Luke, but he was sitting on the sofa, reading the newspaper.

"I'm really looking forward to seeing you," Christina added in her warm, velvety voice. "It will be great to catch up."

Finally, the mysterious siren hung up.

Sara rinsed the last dish and shut off the water. "Who was that?" she asked.

Luke kept his eyes on the paper. "Just an old friend, an old girlfriend, actually — Christina Cross. I mentioned her to you."

"No, I don't believe you ever did. The name doesn't ring a bell." Sara winced inwardly at the jealous note in her voice.

"Sure I did. Christina and I went out years ago. We totally lost touch, but she found me on the Internet or something. She's writing a book and wants an interview."

"Oh, she's a writer?"

"She used to be a reporter, covered the courthouse. That's how we met. She gave it up a few years ago. She's doing a book now on cops who have left the force and what they've done with their lives since. She thinks the way I started a New Horizons center out here will make a good chapter."

"Yes, it definitely would," Sara said evenly. She walked over to the armchair and sat down, facing him.

This woman was going to devote an entire chapter to Luke in her book? That was going to take more than one get-together, Sara thought.

Luke peeked at her over his newspaper. He patted the seat beside him. "Why don't you come over here and sit next to me?"

She met his gaze but didn't budge. "It's nice and warm by the stove," he coaxed her.

She stood up, walked the short distance to the couch, and sat down next to him. He put his arm around her shoulder and pulled her close. "See, I told you it was warmer."

She turned and grinned up at him despite herself. She rested her head against his shoulder and felt his fingers twine in her long hair, stroking it back from her cheek.

"I'm sorry we had a fight," she said quietly.

"I'm sorry, too." He leaned down and kissed her on the forehead. "You don't think I'm too old for you, do you?"

She looked up at him, surprised by the question. "No, of course not. That's just . . . ridiculous."

He sighed and smiled again a little. "Okay. If you say so."

She settled her head on his shoulder again. She felt his strong heartbeat against her cheek, his warmth and strength enfolding her.

"I love you, Luke. Please don't be angry. I don't want to lose you."

He didn't answer for a long time, and she wondered if he had even heard her.

"Don't worry. I'm not going anywhere," he said finally. "You know me."

He leaned his head down and kissed her, a long lingering kiss that made everything feel right between them again.

I do know you, Sara thought. She could depend on his love, his patience, his loyalty. He would wait for her to make up her mind, however long it took.

He would wait.

"She's off the oxygen now. She only needs to wear the tube when she's sleeping," the nurse explained. "It's all right to pick her up. It's good for a baby to be held."

"Yes, I know. That's why I came." Emily's gaze was fixed on Jane lying in her plastic hospital crib. She'd been cleaned up, was dressed in a pale yellow gown with a drawstring bottom, and wore a tiny plastic bracelet on her wrist.

She was in a small room with four other such cribs. The glass wall that looked out onto the corridor had a few paper Christmas decorations taped on it, lending

some cheer to the sterile environment.

Some of the other babies were attached to monitors and machinery, probably with much worse medical conditions, Emily realized. The sight of so many sick children saddened her. It didn't seem fair for illness to touch the young.

Jane was lucky. It was only an infection, Emily reminded herself. She would be better soon and able to leave this place.

"We try to cuddle them when we can. But we rarely have time," the nurse admitted quietly. She picked up the baby in a knowing manner and handed her over to Emily.

Emily took her in both arms and cradled her across her chest. She looked down at the baby's small face. Jane stared back with big blue-grey eyes, a quizzical expression on her face. For a moment Emily thought the infant might cry, but she just lifted her fist and stuck it in her mouth.

"It's me. Emily. Do you remember me?" Emily asked in a small voice.

The baby blinked and puckered up her mouth a bit.

"Is she hungry?" Emily asked.

The nurse checked the chart. "She could use a feeding. Here, sit in that chair. I'll get a bottle."

Emily walked over to a comfortable-looking rocker. She sat down slowly, mindful of the baby as she sank into the cushions and eased into the rocker's rhythmic motion. Soon she felt Jane relax in her arms.

"Here you go. You know the correct way to feed her, don't you?"

Emily looked up at the nurse, embarrassed to admit that she didn't really know there was a right way and a wrong way. Didn't you just stick the nipple into the child's mouth?

The nurse leaned forward and demonstrated. "Try to keep the bottle at an angle like this, so she won't be sucking in too much air. When she's finished about a third or so, take a break and burp her."

Burp her? Well, I'll worry about that when I get to it, Emily thought. She nodded and took the bottle.

The baby never missed a beat in her sucking, she noticed. Soon her big eyes drifted closed, her thick brown lashes curling softly against her cheek. She was so beautiful, Emily thought, such a darling.

"You're a gorgeous girl," Emily whispered. "A real showstopper. I wish Dan could have seen you the other day."

Dan. She had left a message but hadn't

spoken to him directly. He hadn't called on her way to the hospital, and she had shut her phone off as soon as she entered the nursery. Well, she would call him on her way back to town, or explain when she got home if he wasn't already asleep.

She looked down to see that the bottle was more than a third empty. Emily scolded herself for not watching more closely, though she guessed this baby-care business wasn't an exact science.

"My, you're a speedy one, aren't you?" she asked the infant.

She set the bottle aside and lifted the baby to a sitting position. Jane looked a bit confused and put out to have lost her bottle, Emily thought.

"Time for a little burp. Nurse's orders, sweetie," she added kindly.

She sat there a moment, wondering how to get the baby to burp, when the nurse breezed by again. "That's it, sit her on your knee and just pat her back a bit. Toward the bottom is good."

The nurse gave Jane a gentle pat or two, producing instant results.

"Wow, that was fast." Emily stared down at the baby. "You get right down to business, don't you? I'm like that myself. A job begun is a job half done, I always say."

The nurse breezed by again. She smiled at Emily. "Having a nice conversation?"

Emily nodded, moving the baby back into feeding position again. "Yes, we are. A very nice little visit."

Jane quickly consumed the rest of her bottle, had her appropriate burps, and promptly fell asleep in Emily's arms.

Emily sat with the baby resting against her chest for a long time. Jane seemed so peaceful, Emily was afraid to shift her arm or even breathe too deeply for fear of disturbing her. Yet she liked being the baby's soft resting place.

Visiting hours had ended, and the lights on the floor were dimmed. Emily hummed and rocked and found that she, too, was nearly falling asleep in the darkened nursery.

Finally, the nurse returned. "She probably needs to be changed and then I'll put her back in her crib," she said in a soft voice.

Emily looked up and forced a smile. She really didn't want to give the baby up quite yet. But it was probably best for Jane to return to the crib and take her oxygen again, she reasoned.

She followed the nurse back to the crib, where she changed the baby's diaper with

quick efficiency, wrapped her in a blanket, and had her back in the crib in no time flat.

"How long will she stay here, do you think?" Emily asked the nurse.

"Hard to say exactly. She's doing well. A few days more. Until the end of the week, I'd guess." She looked up at Emily. "Will you come back to see her again?"

"May I?"

The nurse shrugged. "You can check with Mrs. Preston, but I don't see why not. Volunteers come through here all the time. You're good with her, nice and calm. Do you have any children of your own?"

Emily hesitated before answering. "One daughter. She's grown up now though. She's twenty-four."

The nurse looked surprised. "You must have been a young mother."

"Yes . . . I was," Emily admitted.

"You ought to come visit again," the nurse said. "We can always use the help."

"I'll call Mrs. Preston to make sure it's okay. I'm the one who found her."

The nurse smiled knowingly. "I know. I read about it in the newspaper, and I recognized your name when you signed in. You can stay with her until she falls asleep if you like."

"Thanks. I will stay." Emily smiled at the nurse as she walked away.

Then she stood by the crib alone, looking down at the baby, watching her breathe. The nurse had inserted plastic oxygen tubes in her nose, but the sound of her breathing was still a little raspy, a bit labored, she thought. The poor little thing. Hadn't she had enough struggle?

Emily reached out and touched Jane's soft, wispy hair with her fingertips. It felt like feathers, like an angel's wing.

The closest I'll ever get to one in this lifetime, Emily thought with a small smile.

Chapter Four

Emily returned from her run on Wednesday morning to find Dan sitting at the kitchen table in his usual pose, sipping coffee from a big mug and paging through the morning papers. He subscribed to three and read them all quite thoroughly.

She'd married a newshound . . . and a handsome man, she noticed, though not for the first time. Even unshaven with his hair rumpled and still in his blue plaid bathrobe, he was awfully cute. Long and lean, a few inches over six feet, his height and build suited Emily fine. At five-ten herself, she often felt self-conscious, towering over many of the men she knew. Dan's hair had remained full, a straw blond color that had gone mostly silver

grey complemented by a complexion colored by the sun and wind during hours spent aboard his beloved sailboat.

She leaned over as she passed his chair, put her arm around his shoulder, then kissed his cheek. "So what are you up to today?"

"The library in Salem. Research for the book."

Dan was writing a book about local history, the shipbuilding industry mostly, but it included the histories of famous families and folklore of the region. It was the second book he had worked on since his retirement. He finished the first last year, just before their wedding. That book was going to be published soon.

"I'll probably stay in Salem and meet up with a buddy of mine for dinner," Dan explained. "We worked together on our first newspaper jobs. I won't be home until about ten or eleven."

"Oh? That's fine."

Emily poured herself a cup of coffee while her two cats, Lucy and Ethel, twined around her legs, begging for their breakfast.

With Dan out until late she was free to visit the baby again. Yesterday she had called Nadine Preston to ask about Jane's

condition, and the conversation soon evolved to more than a simple update.

She knew she had to fill Dan in on the news. During her run, she had thought about just the right way to begin, but though she drummed up her courage and adrenalin outdoors, now that she was back in the house she seemed to have lost her nerve.

But Dan wouldn't be home tonight, and this conversation really couldn't wait.

She turned and sat down at the table across from him. "Can you put down the paper a minute, Dan? I want to ask you something."

"Oh?" Dan folded the paper and stared at her curiously. "This sounds serious. What have I done now?" he teased her.

"It's just something I've been meaning to talk to you about. Something important." She folded her hands on the tabletop. "You remember that I went to visit the baby at the hospital on Monday night, right?"

"Yes, I remember."

"Well, I spoke to the social worker yesterday, Nadine Preston. I called to see if I could go see Jane again —"

"Again?" Dan stopped himself. "Go on, I'm listening. I didn't mean to interrupt you."

"We got to talking about what's going to happen next to Jane. After she's released from the hospital, I mean. Mrs. Preston told me that she'll be released in a few days and the court will appoint a temporary guardian."

"A foster parent, you mean?"

"More or less. Of course, they want to find the mother. That's their primary focus. But they're also looking for any relatives now, any family who can take the baby. That should take about a month. In the meantime, she'll be placed with a temporary guardian until they either find her family or someone to adopt her."

Dan folded his glasses and slipped them into the case. "What does this have to do with us, Emily? Or dare I ask that question?"

He was still almost smiling, but she sensed he was terrified of her answer.

"Nadine Preston asked me if we would be interested in applying. To be the baby's temporary guardians, I mean."

"And what did you say?" he asked in a guarded tone.

"Well . . . I said yes." Dan's eyes widened in shock and his jaw dropped. Emily swallowed and plunged ahead. "But I told her

that I had to discuss it with you first, of course."

"Well, thanks. I'm glad you remembered that I exist." The words came out with a sharp edge.

"Dan, please? Can't we just discuss this calmly without getting into an argument?"

Dan rose from his chair and tossed the newspaper on the table. "What is there to discuss? You know how I feel about this. We agreed when we got married: no children. You have Sara and I have Wyatt and Lindsay. We're past that stage of our lives."

"We're too old, you mean," she finished for him.

"I wasn't going to put it that way but since you did, yes."

"I'm not too old. And neither are you. I'm only forty-four. And a half," she added, since she would be forty-five at the end of May. "Women my age are having children every day."

Dan pressed his hand to his forehead. "You're serious, aren't you?"

"Of course I am. We have to sign the papers and send them back today. Most of it's done, just routine information. But there are still a few things to fill in —"

"You've already started the paperwork? Without even asking me?" Dan's voice rose

on every word. "How could you do such a thing, Emily?"

She took a breath. He didn't understand. He didn't want to. He was thinking only of himself, not about the baby at all.

"I had to. The social worker said we had to apply right away. I was afraid she would find another couple."

"There, don't you see? That means that there are lots of highly qualified couples willing to take this child."

"I'm not sure that's the case," Emily corrected him.

"Whether or not it is, is beside the point. I can't understand how you could rush ahead like this without me. That isn't at all fair, Emily."

"I agree. It was impulsive and not fair to you," she admitted. "But I was afraid if we waited to talk about it, we would argue. Like we're doing now. And then we would miss out."

"This isn't like you," Dan said, "this jumping-in business. Is this what I can expect for the rest of our marriage? You'll feel free to make these major decisions without consulting me whenever you think I will disagree?"

He had a point. She would feel the same way if the situation were reversed. She was

too used to political life, perhaps. She had cleverly circumvented her husband and, in doing so, had undermined her cause.

Emily sighed. "Dan, please try to understand. I admit I got a bit carried away, asking her to send the forms before talking it over with you. But this is something I want very much. So much . . . I can hardly express it. I didn't even realize how I really felt until she asked me."

She looked up at her husband, everything she was feeling welling up in her eyes. She didn't want to cry. Dan might even suspect she was using tears to persuade him. But she could barely hold them back.

He stared at her and then looked away. "I know this is hard for you, Emily. It's only natural to feel involved, to feel responsible for the baby, especially being the kind of person you are. Your empathy, your compassion — those are some of the things I love about you most," he added quietly. "But I just can't see it. How would we ever manage to take this on?"

"We could do it. And it wouldn't be forever. We'll just be taking care of her until the investigation is completed. Mrs. Preston said that would take about a month. If a close relative isn't found, the

baby will be placed with adoptive parents."

"That could take a very long time," Dan pointed out. He sighed and jammed his hands into his pockets. "Try to think logically about this, Emily. Why would we ever take on this commitment? It's just insane. You're in an office all day and at meetings most nights. Who's going to take care of this baby — me?"

"Of course not. I've thought this out. It's not impossible. I'll rearrange my hours. You're always saying I work too much. I'm sure I can cut back if I try. And I'll get a nanny. Jessica will help us, too. I'm sure of it. I can even take the baby to work sometimes. In a pinch, I mean," she added, noticing his doubtful expression.

Dan paced across the room and stared out the window. She could see he was trying to gather his composure so that he wouldn't lose his temper again. She knew it was probably best to wait and say nothing, but she couldn't help herself.

"Dan, please try to keep an open mind about this. Most women who have children work. Besides, I just can't stand the idea of some questionable stranger taking Jane. You hear horror stories about children in foster care all the time," she pointed out. "I just couldn't sleep, worrying where she

might end up next."

Dan turned to her and sighed. "Emily, I think you're getting a bit dramatic now. You're letting your imagination run away with you. The social worker will do her job. The baby will be placed in a safe environment. Why turn our lives upside down? I don't think you understand what you would be getting us into. There's a reason why they say, 'It takes a village,' " he reminded her. "I know what it means to have a baby around. Normal life, as we know it, will be over."

What's so great about normal life? Emily wanted to rail at him. She felt thoroughly upset and frustrated. Dan was so logical, so practical. Most of the time she admired those traits, even identified with them. But sometimes they caused a big blind spot. The important things in life weren't always logical.

She forced a measure of calm into her voice. "Listen, I can't argue with you. Everything you've just said is true. But my feelings about this aren't logical or practical in any way," she admitted. "They're just very real and very important to me. I want to take care of this baby, even if it's only for a short time. I feel . . . it's meant to be. Can't you just see this as a compromise?"

"A compromise? A compromise to what?" He frowned at her, looking more confused than angry.

"Do you remember that time you took me out for New Year's Eve? We were dating but we hadn't made any commitment. You were still planning to sail off into the sunset without me," she reminded him with a small smile.

He groaned and made a face. "Oh, yes. The blockhead phase. How could I forget?"

Emily tried not to laugh. "I told you flat out that night that I wanted to get married again and have another baby. Do you remember?"

He nodded. "You were very up front with me. You put your cards right on the table, and I admired your honesty. I also remember that I ran the other way. We didn't speak to each after that for several weeks."

"But you couldn't live without me. You definitely couldn't leave on your long-awaited sailing trip."

"No, not without you I couldn't." He sighed. "But you have Sara now. You have a wonderful relationship with her. Doesn't that change things?"

"I thought it would, honestly. But it's not that simple."

"I guess not," he said with more tenderness in his tone. He walked over and sat at the table again, facing her. "Emily, I don't want to seem like an ogre. I don't want to disappoint you. But we talked all this out before we got married. We agreed that we weren't going to start a family. I thought this was all settled between us."

"I remember. And I'm sorry to go back on my word. But things change. Feelings change. Finding a baby — practically falling over one — changes things for me, Dan."

She tried hard to keep the impatience and frustration she felt from seeping into her voice. From the flicker in Dan's eyes, she could see that she hadn't been entirely successful.

"I know I should be grateful just to have Sara back and have such a wonderful connection with her. You know how much I love her. She's a miracle to me, honestly. But for so many years, I felt a hole inside after giving her up. And now, even though I have my daughter back, I still feel . . . violated. Like something was stolen from me. Especially when I see Jessica with Tyler," she added. "It makes me realize how much I've missed. Twenty-two years of being a mother, to be exact."

Dan moved closer and put his arm around her. He pressed his cheek to her hair and kissed her. "I'm so sorry, dear. But you can never make up for that."

"Maybe not." Emily put her hand over his where he held her shoulder. "But it doesn't mean it doesn't still hurt."

Dan had no answer. He tugged her to her feet, put his arms around her, and hugged her close.

"You've caught me between a rock and a hard place, my love," he said finally. "I feel for you, Emily, for all the years and all you went through. I wish I could make it right for you, believe me. But I just can't see taking on the responsibility of a baby. And taking her temporarily seems like an even worse idea. Once we had the baby here, do you honestly think you could give her up when she's adopted? Wouldn't we be setting ourselves up for the same painful situation you went through with Sara?"

Emily pulled back from his embrace. Secretly she had been hoping that once they had the baby, Dan's feelings would soften and he would agree to applying to adopt. But she could see now that was just a wild fantasy.

Emily did not cry easily. There were countless times when she had felt as if her

heart were splitting open yet she had remained dry eyed, holding her grief inside. But now she felt the tears start to flow, and there was nothing she could do to stop them. She covered her eyes and then turned to grab some tissues from the counter.

Dan stood behind her and put his hands on her shoulders. "Honey, please. Don't cry. I'm just trying to do the right thing, to do what's best for everyone — you especially. And the baby."

She knew he was sincere and did have her best interests at heart, or what he thought were her best interests. Dan wanted the safest course for them, though not necessarily the path that would yield the richest rewards a life fully lived had to offer.

She sniffed loudly and wiped her eyes. "I know you don't want to see me get hurt again. I agree, that's a risk. But this isn't about being safe or logical or even practical. I know this baby wasn't in our plans, but life can't always be planned down to the last detail."

With her back still turned, she couldn't see his reaction to her words, but she sensed it in his touch.

This was an issue that came up often be-

tween them. Dan could be too faithful to his plans at times, like a lemming diving over a cliff just because he was too stubborn to change direction. She had nearly lost him entirely because of that trait. He had grown more flexible since their marriage, she thought, but obviously not flexible enough.

"I know what you mean, Emily," he answered quietly. He gently rubbed her shoulders. "But this isn't just a question of me being more laid back and carefree, you know. It's much more complicated than that —"

"Not at all," she cut in quickly and turned to face him. "It's a matter of the heart, plain and simple." She touched the center of her chest. "After you ran away from me that time, and I thought our relationship was over, my heart was broken. But I wouldn't have changed a thing. It *is* better to have loved and lost than never to have loved at all. That's really true.

"This is about loving — experiencing love and giving it, Dan. Even for a short time. Can't we see our way clear of all the practicalities and reasons why this won't work, and just take this risk? Can't you do that for me?"

She stood staring up at him for what

seemed like a very long time, not knowing what he would say and dreading the worst.

He let out a long breath and looked down at the floor. For a minute she thought he wasn't going to answer her at all. Finally he looked up again.

"Oh, Emily. . . ." He sighed. "How soon would we need to decide?"

She could hardly believe his answer and felt a jolt of shock and joy through her entire body. She wanted to jump into his arms.

"Right away. We have to sign the forms and send them back today. You can come down to my office later and we'll take care of it. Then we need some references from people who know us, and we also get interviewed. We might not even qualify," Emily added.

"Of course we'll qualify. You're a shoo-in." He smiled slightly. "I should have known something like this was going to happen. But honestly, I've been completely blindsided. This is a lot to lay on a guy. You're not asking to bring home a puppy. This is a real live baby we're talking about, a miniature person."

"Yes, I know. She's a precious little thing," Emily said. "Wait until you see her. You can come with me tonight to

Southport. You won't believe how beautiful she is."

"I believe you." He put his arms around her and pulled her close. "I'm doing this for you, Emily. Because I love you and I can see how much it means to you. I just hope we're doing the right thing."

Emily hugged him back with all her might, pressing her cheek against his strong shoulder. "We are, Dan. Trust me . . . and thank you. You'll never know how much this means to me."

Jessica and Sam's house was a few miles from the village center. Located down the winding Beach Road, it was challenging to reach in bad weather, but whatever the old Victorian house lacked in convenience, it more than made up for in beauty. Trimmed with pine garlands and tapers glowing in each window, it looked even more inviting than usual.

Set on a span of property that included a pond and a flowering meadow, the house had been abandoned for many years when Sam bought it at a bank auction. He had rescued and renovated the place, not realizing that before he was done, he would live there with a wife, and now a family.

Emily normally didn't pass their house

on her way home from Village Hall, but on Thursday afternoon she had been at a meeting in Essex, and she wanted to return one of Jessica's special cake pans that she borrowed for Thanksgiving. Her cake hadn't turned out that well, she reflected, though the expensive pan could hardly be blamed.

Once I have the baby around, maybe I'll learn to be a better cook. The thought made her smile as she turned and steered her Jeep up the long, narrow drive. She parked in front, then noticed the van from Willoughby's Fine Foods parked farther up the gravel drive. Molly Willoughby, Sam's sister, was often here at this time of day. Jessica often watched Molly's two girls after school, and now that Darrell and Tyler had come along, the older kids were helping Jessica with the baby.

Emily liked Molly, a straight-talking, hardworking single mother who had been a Jill-of-all-trades for many years before starting her own gourmet shop and ca-tering business, which was now quite suc-cessful. Jessica and her sister-in-law were like night and day in many ways, but over time they had learned to appreciate each other and had become fast friends. It was nearly dinnertime, and Emily guessed the

two women were bound to be in the kitchen, chatting and cooking together.

The back door was open. Emily knocked and then poked her head inside. "Hi, everyone. May I come in?"

"Emily, what a nice surprise!" Jessica came to greet her quickly. She wore a long apron over her work clothes, a slim grey skirt and pale pink silk blouse. After the baby was born, Jessica had managed to keep her job at the bank by cutting back to part time. Those were the two sides of Jessica's personality, Emily thought: her sharp business side and her homemaker side. She seemed to find the time and room for both.

"You look great in that color," Emily said, kissing her sister hello. She did, too, with her long, dark curly hair and pearly complexion. "You should wear it more often."

"Didn't you hear? It's a law now," Molly called out from the kitchen. "Everyone has to wear pink at least twice a week."

Emily laughed as she followed Jessica into the kitchen. "I heard the bill passed the House but is still in the Senate." She handed Jessica her pan, which was wrapped in a paper bag. "I just wanted to return your pan."

"Oh, thanks. Why don't you sit and have some coffee or something?" Jessica coaxed her.

Emily glanced at her watch. "I can stay a few minutes, I guess." She sat at the big kitchen table, an antique oak pedestal with matching chairs.

Molly was sitting there, too, chopping vegetables on a cutting board.

"What are you two cooking?" Emily asked. "It smells great."

"Molly's teaching me how to make a braised pork roast. With sage and leeks," Jessica added.

Molly kept her focus on the cutting board. "It simmers on top of the stove so it doesn't dry out."

"That would be a huge improvement at our house," Emily said. "Everything I cook tastes like sawdust."

"Why don't you call Dan and have him meet you here?" Jessica suggested. "We have plenty."

"Oh, we can't. But thanks. Another time," she added, smiling at her sister. She paused. "I really shouldn't stay long. I have to get home. We're having some company tonight, too. Well . . . not company exactly . . ."

The two women glanced at her, their cu-

riosity aroused. "Sara and Luke?" Jessica guessed.

Emily shook her head. "No, it isn't anything. Well, it is something but . . ."

Molly stopped her chopping and gave Emily a long, mock serious look. "Give it up, Emily. You're not leaving until you spill the beans."

Emily took a breath. "Dan and I have applied to be temporary guardians of the baby I found. A social worker is coming tonight to interview us and do a home visit." She stopped and waited, watching their expressions.

Molly smiled and nodded, then started chopping again. "I had a feeling it was something good. That's terrific, Emily. I hope it all works out for you."

Jessica leaned over and hugged her. "That's great news. Wow, what a surprise." She sat down near Emily and glanced at her. "Why didn't you tell me sooner?"

Emily could see her sister felt hurt that she hadn't been let in on the process. They usually told each other everything.

"It just happened so fast, that's all." Emily reached out and touched Jessica's hand. "Dan and I only decided yesterday. I guess I'm a little worried about how it will all turn out."

"I think it will be fine," Molly said with great certainty. "Who wouldn't like you and Dan?"

"Thanks, but I think they look at more than social skills. Dan thinks we might be too old."

Jessica didn't respond for a moment. "Well, it is hard work taking care of a baby, harder than I ever expected. I'm just exhausted at the end of the day. I'd much rather go in to the bank and work on loan applications," she added with a laugh.

Emily knew that wasn't completely true. Since Jessica had returned to work part time, she felt torn about every minute she spent away from Tyler and Darrell.

Still, her reply hadn't been the vote of confidence Emily had expected. In fact, her sister sounded surprisingly like Dan. And Jessica was ten years younger. *Maybe she thinks I'm too old, but doesn't want to come right out and say it,* Emily realized.

"What about your job? Are you going to take a leave of absence?" Jessica asked

"I didn't even think of that. I'm not sure if I'm eligible. I would probably have to step down altogether if I wanted that much time off."

Jessica shook her head sympathetically.

"It's going to be hard for you. such long hours."

"I'll cut back, that's all. I'm in th... too much as it is. I'll have to learn to gate more."

"What about Dan?" Molly asked cu... ously. "How does he feel about it?"

"He wasn't in favor at first," Emily admitted. "In fact, I think he said it was totally insane. But he's come around. He's willing to be a temporary guardian at least."

"Don't worry. That baby will have him wrapped around her little finger in no time." Molly had finished cutting the pile of leeks and whisked them from the board into a large bowl.

"That's what I'm hoping," Emily said wistfully.

Lauren, Molly's older daughter, came to the doorway. "Tyler needs his diaper changed. And it isn't pretty, gang." She made a face that made the women laugh.

Jessica started to get up from the table but Molly was faster. "I'll go. You sit and visit with Emily. This is big news. She needs some pointers from a pro."

Jessica hesitated a moment, but then sat down again. "Thanks, Molly. That's sweet of you."

at with Jessica for a moment
either of them talking.

don't seem that happy for me,
," she said at last. "Do you really
I'm too old? Lots of women have ba-
s in their mid-forties these days."

Jessica shook her head. "No, that's not it.
I'm sorry, Em. I am happy for you. It's a
surprise, though, I must say. I thought that
with Dan retired, you two were going to
have a different sort of life — more trav-
eling and being carefree."

"Dan just got tired of running the news-
paper. Calling him retired makes him
sound like a senior, for goodness sake.
He's only fifty-one," Emily pointed out.
"We did have a different plan about what
our lives would be like, and it didn't in-
clude an infant," she added truthfully.
"Dan and I argued about this, too. But I
couldn't turn my back on this baby."

"I can see that," Jessica said quietly. "Do
you think it has something to do with me
having Tyler? I often thought that must be
hard for you, considering what happened
with Sara."

Emily nodded, moved by her sister's
honesty. "Yes, that was part of it. I won't
deny it . . . but it was more than that.
Something seems to be pushing me in this

direction. Did you ever feel that way? asked her sister. "As if something wa... ally meant to be? As if God was trying tell you something? Even when you resi... you find yourself back in the same plac... again."

Jessica nodded. "I guess I've felt that way once or twice. But you need to be careful, too, Emily. You said this was only a temporary arrangement. What happens after that? Will Dan agree to adopt the baby if that's what you really want?"

Emily shrugged. "I don't know. I'm just hoping I'll know the right thing to do when the time comes to decide."

"I hope so, too. I hope you don't end up getting hurt and disappointed if this doesn't work out. It's not just Dan you need to worry about. Someone could come forward any day and claim the child."

"Yes, I've thought about that a lot." Emily sighed. "You know me, Jessica. I'm not exactly Miss Impulsive. But sometimes you just have to take a chance."

Jessica nodded and smiled warily. "Yes . . . I guess you do." She stood up and quickly hugged Emily. "I hope this works out. I really do. I'm going to say a prayer for you."

"Thanks, Jess. It is a little overwhelming.

feel like such a novice about all the stuff. Will you help me?"

"Of course I will. I thought that went without saying," her sister assured her. "I'm new at this game myself, but I probably have every baby book ever written," she added with a grin.

Emily laughed. "Great, you'll be hearing from me."

When Emily arrived home a short time later, she called to Dan from the front door.

"I'm back here, in the kitchen," he replied.

She quickly walked through the house, pleased and even surprised to see that Dan had straightened things up, picked up his trail of newspapers and coffee mugs, and tidied up the living room. The kitchen was in surprisingly good shape, too. He had the table set for dinner and was warming something on the stove.

"We'd better eat. That woman will be here in about half an hour, right?" he greeted her.

"Yes, just about." Emily walked over and kissed him on the cheek. He smelled good, fresh from a shower and smoothly shaven. He was dressed in khaki pants, a dark blue sweater, and a good shirt.

"Thanks," she said, smiling at him.

"It's just some spaghetti sauce you had stashed in the freezer. Don't get too excited."

"No, I mean for going through with this interview. I know it's all happened very suddenly."

He glanced at her. "I still have my reservations, Emily, you know that. But I'm willing to do this for your sake. Don't worry. I'll put my best foot forward for this social worker."

Emily smiled at him. "I'm not worried. She'll adore you . . . but I saw you first."

The corner of Dan's mouth turned up in a reluctant smile. "You're a very charming, persuasive woman. You'd be great in politics. Did anyone ever tell you that?"

Emily laughed but didn't answer. Hopefully her charms would work as well on Mrs. Preston.

They ate hurriedly, and Dan cleaned the kitchen while Emily ran around the house and cleaned up a bit more. The doorbell rang promptly at seven, and she felt her stomach flutter nervously.

Dan squeezed her hand as they headed to answer the door together. "Don't worry. It will be fine," he whispered to her. She glanced at him and forced a smile, grateful

for his encouragement, all things consid-
ered.

"Mrs. Preston, please come in," Emily
welcomed her. She quickly introduced
Dan, who took their visitor's coat. Then
they all walked into the living room.

"Please, call me Nadine." The social
worker took a seat on the couch and re-
moved a large leather binder from her
briefcase. "This won't take all that long. I
have another appointment tonight at nine.
Perhaps you could show me around the
house first, before we talk?"

"Oh, sure. Just follow me." Emily fixed
her face in what she hoped was a pleasant
smile and gave a quick tour of their house,
upstairs and down, all the while wondering
if this other appointment meant some
other couple was applying to be Jane's
guardians. She wanted to ask but sensed it
wasn't appropriate.

When they came to the master bedroom,
Emily said, "We thought we could put the
crib in here with us at first. We also have
an extra bedroom we can turn into a
nursery . . . eventually."

She glanced at Dan, wondering if he
would show some negative reaction to the
suggestion of having the baby for a pro-
longed period of time, but he had a calm,

composed expression on his face. He didn't look wildly eager to take in a baby, Emily thought, but he didn't seem totally averse to the idea. But suddenly his hair looked so grey to her, the blond, flaxen color faded out in the low light. Did Nadine Preston think they were too old for this assignment?

She hoped not. She truly hoped not.

Back in the living room, Nadine sat on the couch with Emily while Dan took an armchair. Nadine made some notes in her binder, then started to review their application. "So, Dan, you have two children?"

"Yes, a daughter, Lindsay, who's married and lives in Hamilton. She runs the newspaper here in town now. And a son, Wyatt, he's a photojournalist on the West Coast for the *Los Angeles Times*," Dan added proudly.

Nadine smiled. She turned to Emily. "And your daughter, Sara, she's also a reporter?"

"Dan gave her a job on the paper before he left. It's worked out well for her. And it's been wonderful having Sara in town these past two years so that we could get to know each other."

"Emily has a terrific relationship with Sara. They're very close," Dan cut in

quickly. "Sara adores her. Really . . ."

Emily cringed under the weight of his exuberant compliments. "We do have a good relationship. I'm very grateful for that. Sara is a special person, though," Emily added.

"Yes, I understand." Nadine smiled at Emily, then looked down at her book again.

Emily had already told the social worker the story of how she had given Sara up for adoption and then how they had been re-united two years ago. Nadine had seemed sympathetic and understanding, yet Emily still wondered again if that act — that hor-rible mistake she had made when she was so young — was going to count against her.

"And how will you manage the child care?" Nadine asked. "I see you work at home, Dan. Would you be watching the baby?"

"Why, no. That wasn't our plan. I didn't think it was anyway." Dan coughed into his hand and glanced nervously at Emily. She felt her heart sink. She had never even sug-gested that on the application, though it was certainly a fair question.

"I'm going to take a week off from work at first," Emily rushed in. "At least a week.

Just to get Jane comfortable in her new surroundings. And then we're going to hire a babysitter. Dan will be home some days, too, to help out. But he does a lot of research for his writing, and his deadlines are very demanding, so it wasn't our plan to have him responsible for child care, too."

Oh, dear. Here we are, sounding like a dual-career couple with no time in our lives for a baby. What must this woman be thinking?

"And you would be willing to take childcare classes at the hospital, Emily?" Nadine asked.

Emily had already indicated on the application that she would. "Oh, yes, absolutely."

"And you, Dan? Would you be going also?"

Once again, poor Dan looked totally taken by surprise. Emily realized she had probably checked that box off for him and hadn't mentioned it.

"Uh . . . sure. Sure I would," he said, working up a hearty sounding voice. He sat up straight in his chair and cleared his throat again. "I did raise two kids awhile back," he added in a lighter tone. "But I know ideas about child rearing change. I

143

wouldn't mind brushing up on a few things."

Emily stifled a sigh. He made it sound as if his fatherhood days dated back to the Victorian era.

"Theories about raising children do change," Nadine agreed. "But the fundamental principle never changes. Children thrive on love and encouragement."

"Yes, they do." Dan nodded solemnly. "I know that Emily and I would make that our priority, especially considering the poor little girl's circumstances. We know that taking in this baby will change our lives, and she will be the most important person around here."

Nadine smiled at him, looking impressed.

Emily was impressed, too. She beamed at her husband with a wide, warm smile. Maybe they wouldn't be chosen to be Jane's guardians, but it warmed her heart to see Dan making his best case for them. She knew he was doing it for her.

The social worker concluded her interview and packed up her briefcase. Emily felt half relieved and half anxious to see her go. Had they made the right impression? Had they given the right answers to her questions?

Nadine paused by the door, and Dan helped her put on her coat. "I should have a decision for you tomorrow or the next day."

Emily tried to read her expression but couldn't get a hint one way or the other what that decision would be.

Nadine smiled and shook her hand. "I'll certainly call by Saturday. That's when Jane should be released from the hospital."

"Oh, of course." Emily felt a little jolt in her heart.

Dan stood behind her, and she felt him rest his hand on her shoulder. "We'll be waiting to hear from you," he replied. "Thanks again for stopping by."

Nadine Preston said good-bye, then stepped out into the cold night. They watched as she got into her car, and then Dan closed the door.

Emily turned to him. "Well, what do you think?" she asked.

"I think it went all right. I think we were honest."

Emily swallowed hard, suddenly feeling a lump in her throat. "Thank you, Dan. I appreciate everything you said and how you sounded so positive — and committed."

"You don't have to thank me. We're in this together. I know you'll be disap-

pointed if we're not chosen, but at least we tried our best, right?"

She nodded, unable to hold his gaze any longer. "Now we just have to wait to hear what the social service agency decides."

"Yes, it's probably not up to her entirely," Dan added. He slipped his arms around Emily and pulled her close. The hug was some comfort, though she knew nothing would really take the edge off her nerves until she heard back from Nadine Preston.

It's basically up to God now, she thought. She closed her eyes and said a silent prayer, hoping she and Dan would be allowed to take Jane home and care for her, even for a little while.

By Friday night, Ben felt he had pushed himself through a long week, but the Christmas Fair committee was holding an important meeting that he didn't want to miss. He took a seat near the back of the group, which was gathered in the Fellowship Hall on folding chairs set in rows. Sophie Potter sat up front, calling the group to order.

He knew tonight would mostly feature talk about the nitty-gritty details of running the event, but he hoped that at some

point he might steer the group around to discussing Wood's Hollow, at least to propose that some of the money raised by the fair be donated there, maybe to the community center.

The Christmas Fair raised a considerable amount of money each year, but most of it was earmarked for the church budget. From time to time, however, the congregation decided to donate some, or even all, of the proceeds to a worthy cause. Last year, they had sent several thousand dollars to a mission project in Central America where James had been the director. Perhaps this year their hearts would be awakened to a cause much closer to home.

"I think we're covered on the pageant costumes," Sophie Potter said, checking her list. "We still have all the wonderful costumes Vera and Leigh Baxter made last year. So that saves us a lot of work."

Sophie paused and checked her clipboard again. As usual, she was the Christmas Fair coordinator, organizing every detail from the golden halos on each pageant angel to the red and green sprinkles on the bake sale cupcakes. She had done it so splendidly for so many years now, no one else even thought to volunteer for the post.

Ben sat listening to this year's plans. He couldn't help feel that this fair would be no different from the last, or the one before that, a thought he found a bit depressing.

Traditions were important, there was no doubt. Traditions gave a sense of continuity and connection with the past, and even the future. But in a situation like this there seemed a fine line between tradition and just plain rote behavior. Where was the spark of imagination or even inspiration that could set this fair apart, he wondered.

"Now we always put the cake sale on the far wall of the Fellowship Hall, and then the table with the wooden crafts is set up to the left," Sophie noted, showing a chart of the room setup. "Can we have a show of hands for volunteers to build the crafts? We'll do the wooden boats, birdhouses, and pinecone centerpieces again. Those always sell well."

Sophie glanced at Fran Tulley, Tucker's wife, who was waving her hand frantically, nearly falling off her chair.

"Yes, Fran? Did you want to say something?"

Fran stood up. "I don't mean to criticize, Sophie, but those craft items are getting a little tired. Everyone in town must already

own one of those centerpieces. Can't we do something different this year?"

Bravo, Fran, Ben seconded silently.

Sophie looked taken aback. "Well, I don't know. We always do boats, birdhouses, and centerpieces. What do the rest of you think?"

"I saw some very pretty painted boxes at a fall fair in Hamilton," Lucy Bates called out. "They looked easy to make, too. All you do is use a stencil and some ribbon."

"That sounds nice," Sophie said. "But ribbon can get tricky . . ."

Ben shifted in his chair, feeling weary. He was eager to bring up Wood's Hollow but couldn't see how he would ever work it into this meeting. The whole Christmas Fair discussion was starting to seem petty and silly to him, and he struggled to hold on to his patience and not be so judgmental.

Grace Hegman, who sat with her father, Digger, in the front row, stood up to speak. "People like our items. I don't see that we should change, especially now. Why, it's December second, only three weeks to the fair, and we've already ordered the kits." She glanced at Fran, her voice a bit sharp and agitated, then sat down, smoothing the front of her brown cardigan.

Grace was usually in charge of the handcrafts assembly. She was quite good at it, Ben recalled. But she did get a bit anxious when volunteers didn't show up, and then she felt obliged to do it all herself. It was understandable that she would veto the idea of taking on something new.

"Yes, we have ordered the kits." Sophie flipped her papers. "Let me see . . . they should be delivered this coming week. Doesn't give us much time, I guess."

"Three weeks is long enough," Fran argued. "I don't see why we can't do some stenciled boxes, too."

Grace stood up again, looking stricken. "It will take time enough to put together what we've ordered. We were here all hours last Christmas. I don't think we should try to take on even more. And stenciling besides . . ."

Ben considered offering a conciliatory word, but before he could speak, Sophie called a vote, and it was decided by a narrow margin to skip the new craft items this year.

Sophie then suggested the group take a coffee break. There were several more items on her agenda, Ben noticed. He wouldn't be able to talk to them about Wood's Hollow tonight; he'd have to save it

for some other meeting. He decided to make an early, inconspicuous departure. It was almost ten o'clock. He wasn't sure if he was tired, bored, or simply frustrated.

"Did your meeting end early, dear? I didn't expect you home so soon."

Carolyn stood in the living room, surrounded by boxes of Christmas ornaments. They had bought the tree the other night and he promised to help decorate over the weekend. But Carolyn had been determined to get started on her own. At least Mark had strung the lights before he went out to meet friends.

"I decided to leave at the coffee break. It's been a long week." They all seemed long lately, Ben thought.

He sat down in the armchair next to the sofa, picked up the TV remote, then put it down again. He wasn't in the mood for television. And he certainly wasn't in the mood to decorate a tree now. "I guess I'll go straight up to bed. I'm beat."

Carolyn hooked an ornament on a pine branch, then walked over and sat on the sofa beside him.

"Do you feel all right? You look as if you might be coming down with something."

"I'm okay. I feel a bit guilty, ducking out

like that on Sophie. There was a debate about what type of craft items to sell, but she handled it well. She didn't need me."

"I'm sure she didn't mind you leaving. She's been running that fair so long, she could do it with her eyes shut."

"Yes, and that's both a blessing and a problem. I was sitting there tonight thinking that the fair is getting so . . . predictable. Every year, the same tables of gifts and foods and the same pageant. Maybe it's unfair to say, but it all started to sound very trivial to me. What I mean is, there are more important things to worry about than whether we sell birdhouses or stenciled boxes, don't you think?"

His words trailed off, Carolyn's concerned look distracting him. "Yes, of course there are, Ben."

"Oh, I don't know. It just seems to be getting under my skin this year. I don't know why it should, after all this time. I don't think this year is any different, and I don't think the congregation has changed. Maybe I have. What kind of minister has no patience for his flock?"

"You're only human, Ben. You're allowed to occasionally lose your patience, just like the rest of us," Carolyn reminded him. "The holidays are hard on you.

There's so much going on at church, you're exhausted by Christmas. Maybe we ought to plan a vacation for January — go somewhere warm and sunny for a week?"

Ben forced a small smile. "It might help to get away for a while. But I don't know. I don't think I need a real vacation. I'm feeling unproductive enough as it is. Sitting on a beach somewhere will only make me feel worse. I feel as if I've just lost the thread at church somehow. Does that make any sense?"

"You're an excellent minister, Ben. You know that. But you sound as if you're losing perspective. You sound depressed, dear," she said finally. "I'm concerned."

Serious words coming from his wife, who had battled that demon long and hard during her thirties and forties.

"I don't think we should just ignore it," she went on. "Maybe you should speak to somebody, a therapist. It might help to talk to someone and sort out your feelings."

Good advice, as always. He had thought of that himself, of course. But it was different hearing it from Carolyn.

He'd prayed about it, of course, asking God for some direction, some insight into these feelings. But so far, no insight had come.

"Maybe some counseling would help," he allowed. "I'm not sure what I need right now," he added honestly. "Perhaps a spiritual retreat of some kind."

Carolyn's warm gaze remained on him. "That sounds good, too. Just promise me you'll look into it. You won't just brush this aside?"

Ben nodded. "Don't worry. I'll find someone to talk to. Maybe another clergyman who understands my situation."

It was hard to admit that he had come to that point, that this mood was more than just the result of a bad day or a bad week. It was, he thought, due to growing frustration over feeling his message wasn't being heard. Or perhaps heard, but not heeded, which was even worse. He felt a little better admitting his feelings to Carolyn.

"It's good to talk to you about this. I should have told you sooner."

She leaned over and took his hand. "You're always there for everyone else. You always give so much. I'm here for you, Ben."

"Yes, you are. I ought to be counting my blessings instead of complaining."

Carolyn smiled, her easy, winsome smile that had won his heart so long ago. "You

can always complain to me if it makes you feel better."

He felt better just holding her hand, as always. She was right, though. He couldn't let this go too far. He had to face it squarely and find someone to help him sort things out. There was a minister up in Princeton he could talk to, an old friend. He would call tomorrow and see when they could visit. The thought lifted his spirits just a notch or two.

Carolyn leaned over and suddenly shut out the lamp. The room was dark, except for the lights twinkling on the Christmas tree.

"Look at the tree. It's lovely, isn't it?"

"Oh, yes, we picked out a good one this year, nice and full."

"I like the way it looks with just the lights on."

"I do, too. Why don't we skip the ornaments? That would save you some work."

"That would be something different." Carolyn laughed, though she didn't sound at all convinced it would be better.

Maybe that was all he needed in his life right now, Ben thought. Just something different.

Chapter Five

~⤳

Sara walked into the Beanery, deep in a conversation on her cell phone with her editor, Lindsay Forbes. "I think I got a good shot, too, right while he was waving the canceled checks."

In the midst of a routine meeting of the county building commission — a meeting Sara dreaded covering since it was usually so deadly boring and devoid of any interesting news — a longtime commissioner was accused of assigning contracts for road repair to his brother-in-law and taking kickbacks.

It was a scandal in the making and certainly worthy of the front page in tomorrow's edition.

If she wrote the story up quickly.

"I'm just picking up some lunch. I'll be back in five minutes," she promised Lindsay before ending the call.

It was already past three. Another gobbled meal at her desk. Such was her lot in life these days. But she wasn't complaining; a front-page byline was more important than food any day.

Sara snapped her cell phone closed and dropped it into her cavernous leather knapsack. She'd already made her way to the take-out counter and now faced a waitress ready to take her order.

"Sara! Over here!" She turned quickly at the sound of Luke's voice. He was sitting at a table near the back of the café. He waved her over, and she walked toward him, smiling. But she felt the expression freeze on her face when she noticed a woman sitting at his table, an extremely attractive woman with sun-streaked blond hair cut in shaggy layers and large brown eyes that pinned her with an interested stare. Forget extremely attractive; the woman was flat-out gorgeous.

Sara approached warily, wishing she had run a comb through her hair and freshened her lipstick when she had had a chance.

"Hey, Sara, what are you up to?" Luke greeted her.

Sara felt like smacking him. How dare he sit there with that bombshell and sound so perfectly casual?

"Just picking up some lunch. What are you up to?" She tried to keep the sarcasm from her tone but somehow couldn't.

"Just visiting with my friend Christina. She called the other night, remember?"

"Sure, I remember." Sara looked directly at Luke's old friend. "Nice to meet you. I'm Sara."

Christina smiled slowly. Not unkindly but in a somewhat patronizing manner, Sara thought.

"Nice to meet you, Sara. Luke tells me you're a reporter on the local paper."

"Yes, I am. Luke tells me you're writing a book."

"Trying to. It's sort of miserable at the beginning, like pushing a rock uphill," Christina said with a self-deprecating laugh. "But every time I write one, it does get a bit easier."

Every time? How many books had she written? Well, she was older, about Luke's age, Sara guessed. That was some comfort, or not, depending on how you looked at it.

Sara resolved to Google Christina Cross as soon as she got back to the office.

"I was just showing Christina around,"

Luke explained. "Want to sit down and have some lunch with us?"

From the look of the table, it seemed they were just about finished. Sara didn't want to join them anyway.

"No thanks. I've got to get back to the office. Lindsay wants my copy right away. Seems some commissioner awarded his brother-in-law lots of juicy contracts. There could be an investigation."

"That's a good story. I guess you have your little scandals here, too, don't you?" Christina sounded surprised, as if she'd found some otherwise well-behaved children fighting in a sandbox.

"Yes, we do," Sara said evenly. "But the crooks are usually shorter than the ones in the city. I mean, on average."

Luke stared at her a minute and then laughed. Christina smiled mildly but didn't reply.

"Well, sorry to run. See you," she said, meaning Luke. She had little desire to see more of Christina Cross.

Luke met her gaze a moment and waved. He had a rather dopey look on his face, she thought, as she turned and headed for the door.

Sara was halfway to the newspaper office when she realized she never got to order

her lunch. Oh . . . bother. She'd have to call out for something and starve in the meanwhile.

Another reason to be mad at Luke. He had some nerve sitting there so smugly with that — that Christina. He probably planted himself there just hoping Sara would run into them so he could make her jealous. That's what it was, Sara decided. Just because she told him she wasn't ready to get engaged.

And he jumps on the first log that floats by!

Couldn't he see through that Christina? She was about as sincere as the blond streaks in her hair. How dumb was Luke, anyway?

Fuming, Sara stomped into the newspaper office, nearly walking right into the editor in chief.

"There you are. I was just about to call you again."

Eager for Sara to start her article, Lindsay was practically breathing down her neck as she followed Sara back to her desk.

"So, tell all." Lindsay perched on the edge of Sara's desk, her arms crossed over her chest.

Sara related the events of the meeting

and the accusation and argument that had taken center stage. "So this commissioner is denying flat out that he's taken any kickbacks and then this other county official, an attorney, pulls out copies of canceled checks. You should have seen the guy's face. I thought he was going to have a heart attack or something."

"Sounds good. But watch the editorializing. The guy isn't even officially charged with anything yet. Did you get any statements when the meeting broke up?"

"I tried, but they cleared out pretty quickly. Ducked out, more like. I'll make some calls, see if anyone will talk to me."

"See what you can get. But start the piece right away. We don't want to be here all night."

Sara felt the same way. She had tentative plans with Luke that night. On Friday evenings they usually got together late, after her art class. But Luke had looked pretty busy in the Beanery. Maybe he had forgotten. Or maybe his dear old friend was staying on into the evening. They had a lot of catching up to do, Sara was sure, feeling upset and annoyed all over again. She would wait and see if he called.

She stared at her computer screen, momentarily forgetting what she was sup-

posed to be writing about. Then she pulled out her notepad and forced herself to settle down.

Covering news like this was tricky business. So far it was only a lot of accusations flying around. If she wasn't careful in her reporting, the paper could get in trouble. Lindsay would go over her article, of course, but the real responsibility rested with her. She wasn't going to let Luke and that Christina person mess up her story. She had to focus.

Several hours later, Sara and Lindsay were the only ones left in the office. Lindsay was going over Sara's story for about the third time. It was getting to be a long day.

Despite Sara's efforts to be careful, Lindsay had found more than a few errors. Sara took it on the chin and kept returning to her desk. She wasn't about to explain what had thrown her off track.

"All right, this is better. I think that's everything." Lindsay looked up from the copy. "Good job, Sara. You should go home and get some rest."

Grateful for the reprieve, Sara went back to her desk and gathered up her knapsack and belongings. Her cell phone rang. It was probably Luke, she guessed, trying to

catch her at the last minute.

"Hello?" she said curtly.

"Hi, honey. Are you coming to class tonight? I just wanted to check," Emily asked.

Sara took a class in watercolor painting with Emily on Friday nights. They were both so busy, it was usually the only time they got see each other. Sara felt beat but knew their time together meant a lot to her mother. She glanced at her watch. She was already late.

"Yes, I'm coming. I got stuck at work. I'm just leaving now."

"Were you working on a good story?"

"A doozy. I'll tell you all about it later."

"All right. Don't rush. Did you eat anything?"

Sometimes Emily sounded so motherly, Sara practically laughed at her. But it felt good to know she cared so much. "I'll pick something up on the way," she promised.

Emily would appreciate the story. She wouldn't think it was "cute and small town."

Sara grabbed her jacket and called out a last good night to Lindsay before she headed out the door. She was looking forward to seeing Emily. Her mother was a good listener and wise about relationships,

too. She'd surely say something that would make her feel better about Luke and this Christina episode.

The painting class was held in an old school building that had been turned into a community center. At night the classrooms were filled with adults studying everything from yoga to car repair.

Sara normally enjoyed taking a break from real life — work, Luke, and even the writing she did for herself. But tonight she felt tired and out of sorts, not in the mood to focus on the bowl of yellow pears on a blue satin scarf set up for a still life. She quietly slipped into the class, spotted her mother, and headed across the room. Emily was busy at work, blocking out her page with broad strokes. She looked up at Sara and smiled.

"Another fruit bowl." Emily's tone was hushed. She glanced over her shoulder at the instructor who stood a few aisles away. "I'm not sure if my painting talents are improving, but at least I'm getting some intellectual fiber."

"That's about all the fiber I've had all day," Sara quipped in return. She took a to-go cup of tea and a container of yogurt out of a paper bag and set them on the table,

then set up her paints and easel. She stared at the fruit bowl, not sure where to start.

Emily dabbed at her painting with quick strokes. "Tell me about your story."

"You're going to like this one. Looks like a scandal is brewing in the county building commission."

What Sara really wanted to tell Emily about was meeting up with Luke and his old girlfriend. That was the biggest story on her mind. And he hadn't called her tonight either, she realized. He always called at night to check in, even when he knew she was working late or had this class.

Before Sara could go further with her story, their instructor, Sylvia Cooper, appeared. In her mid-sixties, Sylvia was a former high school art teacher and now a professional artist. Her specialty was watercolor landscapes, mostly beach scenes. She'd won a number of awards and her pictures were exhibited in galleries throughout New England. She was dressed tonight in a long, loose tunic top and skirt in deep purple tones that made a striking contrast to her pure silver hair. She wore several large silver rings on each hand; strands of bright beads around her neck and an array of silver and copper bracelets made a jangling sound as she

moved through the room.

Sylvia was always very encouraging. Overly so in some cases, Sara thought. She now cast an appraising glance over Emily's picture.

"I like the way you've outlined the fruit. Nice and bold. The paint is getting too opaque in here, though." She pointed to a section on the bowl. "Keep it transparent, fluid," she coached. "Remember the light."

Her usual warning. Sara suppressed a smile.

"Oh, by the way. I read about your episode with the abandoned baby. What an experience."

"It was pretty unbelievable." Emily cast a quick look at the instructor.

"What's become of the child? Is she in an orphanage?"

"She's been in the hospital the past week, being treated for a respiratory infection."

"Oh, that's too bad. Is she better now?"

"She's coming along. She won't be placed with adoptive parents until the county completes an investigation. But Dan and I have applied to be her temporary guardians."

Sara had been half listening as she started her painting, but at that last sen-

tence her head turned toward Emily. She could barely hide her shocked expression.

"That's wonderful of you and Dan to step forward like that and help the child," Sylvia said.

"It's something we really wanted to do."

Something Emily wants to do, Sara decided. She knew Dan wasn't interested in taking on a baby, not that he didn't like children: he was great with Darrell and Tyler. But once Jessica and Sam's kids had come along, Sara had heard him comment often enough that he was glad his child-rearing years were behind him.

"Well, best of luck." Sylvia glanced at Sara's blank canvas and shot her a puzzled look.

"I had to work late," Sara said apologetically.

"That's all right, dear. I'll come back and check at the break." She touched Sara's arm as she walked past to the next student.

Sara turned to Emily. "So you applied to be guardians? I didn't realize —"

"It's all happened very quickly. We just decided to go ahead with the paperwork on Wednesday and had the home visit last night. I just didn't get a chance to tell you," Emily explained. "We don't even

know for sure if it's going to work out."

"That's great. I hope it does."

"So do I," Emily said.

For some reason, it hurt a little to hear the excitement and anticipation compressed in the simple reply.

Sylvia called for attention and gave the class some pointers. A welcome interruption to the conversation, Sara thought. She turned to her blank sheet of paper and dabbed some paint on. She wasn't sure why, but she didn't think Emily's news was so great. She was certainly surprised, though.

Emily was going to take in a baby. Her birth mother was going to care for another child.

The last time she'd seen Emily with that look of excitement and particular glow was when Sara had finally agreed to stay in Cape Light so they could get to know each other better.

You're jealous. That's the problem. You're jealous of a poor, homeless little baby. Sara felt a wave of guilt.

No, I'm not. That's not it at all, she argued with herself.

No? Then what is it?

I just think it's a bad idea. Emily's too old and too dedicated to her job to take on

*a baby. Dan will freak. She might even
end up messing up her marriage over this.
But who can tell her that? Look at her.
She's on cloud nine.*

*Exactly. You're not going to be Emily's
number one anymore. You're not going to
be her "can do no wrong" princess. You've
been dethroned,* the little voice pointed
out.

Sara plunked her brush into a container
of water and turned to the snack she'd
brought along in lieu of dinner. She flipped
the lid off the yogurt and took a spoonful.
She should have skipped the art class and
gone straight home to eat a real meal,
crash in front of the TV, and go to bed
early.

She had come to see Emily, seeking
some comfort from her problems with
Luke, and now she felt even worse.

Then again, she would have heard the
news sooner or later.

Sylvia began circulating around the
room again. "Finish whatever you're
working on, and we'll take a ten-minute
break," she announced.

"So, when will you find out?" Sara asked
Emily.

Emily, who was swirling her brush in a
long curvy line, didn't look up for a mo-

ment. "Tomorrow," she said finally. "The social worker said she'll call early if it's a go. We may have to pick the baby up right away. I don't think I'll be able to sleep tonight," she confessed.

Sara forced a smile. "Get used to it. I hear babies keep you up all night."

Emily nodded and turned back to her work. "We'll see," she said wistfully.

Sara felt suddenly ashamed of her snide comment, though Emily hadn't seemed to notice. She should be more supportive, more positive. Emily was doing a good deed, an admirable act of charity.

And Sara fully understood Emily's motivation. *She never mothered me as a baby, so she needs to make up for it this way. She's never gotten over having to give me up.*

How ironic that she would be the one who begrudged her own mother the experience.

Sara made another halfhearted try at starting her painting and grimaced. She had exactly two brushstrokes on the paper and they were all wrong.

"Having trouble focusing tonight?" Emily asked kindly.

"Looks like it. Those pears aren't inspiring me much," Sara admitted.

"You never told me about your story," Emily reminded her.

"Oh, right." Sara paused. "It's pretty good stuff. You'll see it tomorrow though." She sighed and cleaned off a brush.

"Sara, is something wrong? Did you have a problem at work today?"

Sara shook her head. "No, but Luke and I have been arguing. Things are sort of shaky between us right now."

"What did you argue about?"

"He wants to get engaged for Christmas," Sara confided. "He had me trying on rings and everything. I guess I shouldn't have been so surprised. We've been together forever, as he kept reminding me. But I really thought it over and I had to tell him I wasn't ready. We had a fight. I think I really hurt his feelings."

Emily looked surprised, Sara thought. Then her expression turned serious again.

"I'm sure it was hard to tell him you weren't ready. That took guts. But if that's how you feel, Sara, you did the right thing. I'm proud of you. Most young women your age would have seen the ring and said yes automatically."

"It was a nice ring," Sara admitted with a small smile.

Emily patted her hand. "All good things

come in their own time. Marriage is a huge commitment, honey. You can't afford not to be honest with each other right now. Luke is being honest with you about what he wants. Just don't stop talking to each other. It takes time to work these things out."

"If Luke can fit me into his schedule. There's this old friend of his who's come to town. An old girlfriend," Sara corrected herself. "I ran into them in the Beanery. They were hanging out the whole day together and she's probably still here now. Luke never called me and he promised he would."

"Why would he get in touch with an old girlfriend?" Emily asked curiously.

"She found him. She's writing a book about police officers who have left the force and how their lives have turned out. She came to interview him. I think it's more like she came to check him out again."

"Come on, Sara. Don't jump to conclusions. You only saw them together once. She might have gone back to wherever she came from by now. You might never hear about her again."

"I doubt that very much. She looked to me like she was . . . digging in," Sara said

honestly. *Digging her hooks into Luke,* she wanted to add.

Emily cast her a concerned look. "Don't worry, honey. He may be just trying to get your attention, make you jealous."

"Well, it worked."

Emily laughed. "Luke loves you. He wants to marry you. You just told me that. You're not going to lose him in one day to some old girlfriend."

"You haven't seen her. She's tall, thin, blonde, and sort of all-around gorgeous . . . although the hair is definitely chemically enhanced," she added.

Emily shook her head. "You're all-around gorgeous, too. A total knockout, with brains and talent to boot. So there."

"Thanks, but you have to say that. You're my mother," Sara pointed out, only a tiny bit cheered by the reinforcement.

"Yes, I know. It's in my contract." Emily gave her a tender look. "I'm also the mayor, don't forget. Maybe I can figure out some way to run her out of town. Too much flirting with other women's boyfriends? We have laws against that sort of thing around here," Emily said firmly. "Or we can . . . if it's convenient."

Sara finally had to smile. "Thanks. That would be a help."

"I'll put Officer Tulley on it right away." Emily glanced at Sara's mostly blank page. "Want to pack up and go over to the Beanery?"

"You don't mind? Your painting is coming out pretty good tonight."

"That's all right. I can finish some other time. I only come here to hang out with you, you know."

Emily's admission was touching. Sara sighed. "I guess that fruit bowl is making me hungry."

"Let's go then," Emily said. "If we run into Luke and his old flame, I'll give that upstart a piece of my mind."

Sara knew that if the circumstances should arise, Emily would be perfectly polite and would never embarrass her.

But it was nice to know Emily sympathized and was in her corner. Of course, Emily always was. Sara had come to rely on her gentle counsel and unflagging encouragement.

Tonight, of all nights, she appreciated it even more.

Chapter Six

~א

"Here she is." Nadine Preston stepped closer and handed Emily the baby. Jane wore a pink velour onesie and was wrapped in a white blanket, both of which Emily had brought from home. Emily was sure she'd never seen anything sweeter, cuter, or more beautiful in her life.

She had worried and fretted nonstop until Nadine called late Friday night to tell them that they would be Jane's temporary guardians. She and Dan had jumped out of bed Saturday morning and driven as fast as they dared up to Southport. They'd met Nadine and signed the final papers in the hospital waiting room. Now they stood together in the hospital nursery. The big moment had arrived.

"Isn't she beautiful?" Emily glanced at Dan and then back at the baby.

"That she is," Dan agreed, peering over her shoulder. "Look at her little outfit. How cute."

"I bought it yesterday, just in case," Emily admitted. "It's nice and warm. I have her snowsuit, too, in this bag."

She showed them a big blue bag filled with all sorts of baby necessities she had picked up.

Nadine smiled at her. "She's all yours now. You can put it on whenever you want to."

"Yes, of course." Emily smiled nervously. She was sure she seemed in a state. She did feel overwhelmed, more than even she expected. She looked up at Dan, who seemed subdued, though she could tell he was making an effort to be enthusiastic and say all the right things.

"Well, I'll leave you three to get acquainted. I'll be in touch. Call me if you have any problems, though."

"Thank you, Nadine. Thanks for everything," Emily said.

"No thanks necessary. I think you'll be fine," the social worker added.

Emily watched her go, then turned to Dan. "Hold the baby a minute and I'll

get her snowsuit out."

Wordlessly, Dan took the baby. Emily thought he looked a little nervous and held Jane a bit stiffly, but it would take time for them to get acquainted. He wasn't a natural at this.

The baby fussed a bit and Dan bounced her in his arms. "There, there. It's all right. You're coming home with us. How do you like that?"

Apparently, Jane wasn't thrilled at the idea. She immediately crinkled up her face and started crying. Dan stared at Emily with a "What now?" look.

Emily restrained her instinct to rush in and take over.

"Try talking to her some more. She's just a little fussy. She doesn't know us yet. Babies need to get accustomed to your smell," she added, repeating something she'd read last night in one of Jessica's baby books.

Dan turned back to the baby. "Come on, Jane. Stop crying now. It's okay," he soothed her.

He put the baby up on his shoulder and patted her back. Jane's cries rose in intensity and volume. Emily thought she saw him actually wince, though he kept on pacing around the room, patting the baby's back.

"It's all right. I'll take her. Let me put this snowsuit on and we'll go."

The suit was more like a down-filled sack that, luckily, went on easily. Dan grabbed the rest of the baby's belongings and they headed out of the hospital.

Once in Emily's arms, Jane stopped crying. Emily hoped she would fall asleep. It wouldn't be a good start to things if she cried all the way from Southport to Cape Light.

In the parking lot, Dan opened the back door of Emily's Jeep. Emily leaned inside and checked the car seat. They had bought it at a Shop-Mart on the way up to the hospital, and Emily wasn't sure they had put it in the car correctly.

"I don't think this is right. It shouldn't shift around so much. Maybe the seat belt goes through a different spot?"

"Honey, I read the directions. It's in right," Dan insisted. He leaned inside the car and yanked on the seat. It came free of the strap in his hand.

Emily hid a grin. "Where are the directions? Let's take another look."

Dan rubbed his forehead. "I think I threw them out."

"You threw them out? What did you do that for?"

"Now, now. Don't panic," Dan said, an edge to his voice. "It's just a car seat, Emily. We'll figure it out."

Emily was about to reply, then stopped herself. She didn't think it was good for the baby to be out in the cold like this.

"Here, you take the baby. I'll fix the seat," she said in a calm but firm tone. "I think I remember how to do it. It's just like Jessica's."

She handed Dan the baby so that he had no choice. Jane stared around, looked at Dan, and started crying again. Dan took a deep breath and tilted his head back, staring at the sky for a moment. Emily knew he wasn't a praying man but had a feeling he'd resorted to making a heavenly appeal for patience.

They hadn't even had the baby an hour yet. *Not a good sign,* she thought.

She got into the Jeep and started working on the seat. It took a bit longer than she expected to figure it out, and she had to rethread the straps. But finally the seat seemed secure.

"Okay, it's good now. Hand her over." Dan quickly handed the baby back. Emily gently placed Jane in the seat, fastened the straps, and got in beside her.

"Why are you riding back there?" Dan asked.

"She has to face backwards. It's safer. I want to see her while we're driving, make sure she's okay."

"Oh, all right." Dan sighed and got into the front seat. "I'll be the chauffeur, I guess. Where to, madam?" he joked half-heartedly.

"Home, James." Emily ignored his tone. She was bringing Jane home, and the thought filled her with happiness.

The baby slept most of the ride home, as Emily had hoped. When they finally got back to the house, Emily gave her a bottle while Dan looked on. Emily invited him to have a turn feeding the baby, but he said, "I think I'll pass this round. You can show me later. I'm sure she'll be having another meal soon."

True enough, Emily thought. She had a head start bonding with the baby while visiting at the hospital, and now Dan needed to catch up. But she sensed it was wiser not to force him. Emily took Jane into their bedroom, changed her, and then walked back and forth with her, humming a vague little tune. She felt the baby's body grow heavy, her head falling limply on Emily's shoulder. When Jane was sound asleep,

Emily carefully put her in the portable crib she had borrowed from Jessica.

Emily stood by the crib a moment, watching the baby sleep. She lay on her side, her cheek pressed flat against the white sheet, her fist curled to her mouth. Emily thought she could stand that way for hours, watching her. But she pulled herself away and returned to Dan, who sat in the living room reading the newspaper.

"How's it going?" he asked.

"Everything is under control. So far, so good," Emily reported. "She ate, dirtied a diaper, and is now fast asleep."

"Sounds about right," Dan said approvingly. "Babies are programmed on a loop, as I recall. I think you'll be seeing a lot of that routine."

"You'll" be seeing, he said, not "we." Emily ignored the distant tone and smiled at him.

"It's going to be fun having her around for Christmas, don't you think? It makes me more excited for the holidays."

Dan glanced at her. "Yes, Christmas. It will be here before we know it. Didn't the social worker say their investigation would be over about that time?"

She knew what he was hinting at. The baby might be released for adoption by

then, which wouldn't make for a very happy Christmas at all. Emily didn't want to think that far ahead and ruin her happiness here and now. "I think we should just take it one day at a time," she said.

He nodded. "Good plan."

The doorbell rang. Dan looked over at her. "Expecting company?"

Emily shrugged and stood up. "No, I wonder who it could be."

She glanced out the window as she walked to the front door and spotted Betty Bowman's white Volvo in the driveway. Emily's step quickened and she pulled open the door.

Betty peered inside curiously. "I hope I'm not being a pest, but I was passing by and I just wondered if I could see the baby. Just a peek," she promised. "I won't stay long."

"Don't be silly. Come in, please. What a nice surprise." Emily hugged her best friend and stepped back, smiling. "I just put her down for a nap, but we can sneak in. I don't think she'll wake up."

"Sounds great." Betty smiled at Dan as she walked through the living room.

"Hi, Betty. Did you come to meet our new houseguest?"

Emily cringed at his terminology but let it slide.

"I couldn't resist," Betty admitted. "How's it going?"

Dan shrugged. "Seems to be going fine. Emily's doing all the work so far."

"We just got home about an hour an ago. There's not much to report," Emily said honestly.

"Here, I brought her a little something." Betty handed Emily a small pink gift bag with a big chiffon bow. Emily peered inside and found a beautiful hand-knit outfit made with pale yellow fine-gauge yarn, pants and jacket and matching hat, all trimmed with white. The tiny buttons on the jacket looked like daisies.

"Betty, this is beautiful. You shouldn't have gone to all that trouble."

"No trouble. I hope it's the right size."

"Seems perfect. She'll look adorable in this."

Emily led Betty back to the bedroom, noticing that Dan was already sunk deep behind his newspaper again.

Inside the darkened bedroom, Betty quietly crept up to the crib and peered inside. She gazed at the baby a long moment.

"Oh my. She's beautiful." She took hold of Emily's hand but didn't seem able to say more.

Emily and Betty had been friends since

high school. Betty knew everything and understood everything.

Emily stepped closer to the crib and adjusted the blanket, tucking it up over the baby's shoulder again.

"It's not forever. But it's something," she said softly.

"You never know," Betty said. "How is Dan doing with all this?"

"Keeping his distance. He can do that pretty well when he wants to," Emily confessed, even though it hurt a bit to admit it. "I'm not sure what I expected," she went on ruefully. "Maybe I had some fantasy that he would take one look at the baby and just flip head over heels. That hasn't happened so far."

"Give him time."

"As much as I can," Emily said, again hoping that Jane wouldn't be taken from them quickly. "I think it's just going to be harder than I realized. But I was willing to take the risk. So here I am."

"Yes, here you are." Betty sighed and looked down at the baby again. "Whatever happens, you're doing the right thing."

Emily looked up at her friend. "Do you really think so?"

Betty nodded, still watching the baby. "Yes, Emily, I really do. Besides, you know

how Dan is. It may take him awhile, but when he does fall, he falls pretty hard."

She knew that too. Dan didn't bestow his love easily, but once he gave his heart to a person or even a project, he gave it completely. Irrevocably. She knew that for a fact.

It was some comfort, some hope, Emily thought. But it wasn't only Dan's doubt she had to worry about. Taking in this child was complicated, maybe more than she'd allowed herself to consider. It was all just hitting her now.

Had she rushed into this too quickly?

Closing her eyes, Emily sent up a quick, silent prayer that she had done the right thing and not just acted on the selfish, impulsive whim of a middle-aged woman who had missed out on an important path in life.

Saturday morning, Sara cleaned her apartment in a frenzy, trying not to watch the clock or listen for the phone. There hadn't been any message from Luke on her answering machine last night, and he hadn't called all morning. Sara had been on the phone twice, talking to Emily about the baby. She had made plans to go over there for a quick visit that afternoon. She

wondered if Luke had called and found the line busy. She knew he would call back if that was the case. He would call here and then try her cell phone. But he was sure taking his sweet time about it.

They always went out on Saturday nights unless some emergency came up. It was simply understood. But they usually spoke to each other by now to catch up and figure out their plans. She often called him; she wasn't one of those women who had a "rule" about men doing all the calling. That was silly. It didn't matter.

But this morning Sara felt odd each time she picked up the phone and started to dial his number, as if she were checking up on him. All things considered, she felt he should call her. Maybe it was silly and immature, but she couldn't help it.

She finished cleaning and jumped in the shower, wondering if she should make plans with a girlfriend. What was Luke's problem anyway? One minute he's begging her to get married, and the next minute he pulls this disappearing act.

Get a grip, Sara; you just saw him yesterday. He's not exactly a candidate for the FBI missing person's list.

She just hated waiting like this. It was annoying, like being in high school again.

She had thought they were well past that "Will he call?" stage. *If he doesn't call by the time I get home from Emily's house, I'm going to do something drastic — like make plans with my grandmother.*

She was turning off the shower when she heard the phone ring. *Finally! Let him talk to the machine. I'll call back,* she decided. But once she stepped out of the shower and heard Luke's voice rambling on for what seemed like the longest message in history, she couldn't help herself. She wrapped a towel around her middle and skidded across the wooden floors on wet feet, risking life and limb, until she reached the phone in her bedroom.

"Hello? I'm here," she interrupted him.

"Oh, I thought you were out. I've been talking into this machine for about an hour."

"I was in the shower."

"Sorry. I just wanted to say hello. How was your art class last night?"

"I got there late and Emily and I left early. We just hung out at the Beanery." *Why didn't you call me at work, like you promised?* she wanted to demand. But she held her tongue, waiting to hear what he had to say for himself.

"Skipping class, Sara? How are you ever

187

going to learn to paint vegetables, or whatever?" he teased.

"Emily had some big news. She and Dan applied to take in the baby, as temporary guardians."

"That *is* news. I guess you had a lot to talk about."

"Yeah, we did." *Mostly about you,* she wanted to say.

"When will they know?"

"They found out late last night that they were approved. This morning they picked her up at the hospital. They got home a little while ago. I'm going to stop over later and say hello."

"Wow . . ." Luke didn't say anything more, but his simple expletive summed up Sara's feelings exactly. "I'd offer to go with you, but I'm sort of tied up at the center today."

"Oh? What's going on?" She braced herself, imagining the worst, then immediately chided herself for her overactive imagination. *Don't be silly. Christina Cross is long gone, back to Boston. She was here for an interview, not a vacation.*

"Well, Christina's still here," he said blandly, as if he had gorgeous former girlfriends hanging around all the time. What a bore. "I'm not sure what to do with her.

188

We might go out to the beach or something. It's chilly but clear, not too windy either. Should be a nice day for a walk."

A winter beach walk! Sara immediately pictured the two of them strolling along the shore, their arms around each other. The image was totally infuriating. How dare he take Christina for a walk on the beach? That was their special thing to do on a Saturday afternoon. She knew how cold it got out there, and how Luke had a positive talent for keeping a girl warm.

She felt so hurt, she was speechless.

"I guess some of the kids and counselors will come. We can play Frisbee or touch football."

Sara took a breath. They weren't going to be alone. That was a little better.

"Want to meet us out there?" Luke added.

"No thanks. I promised Emily I'd go see the baby." Sara didn't need to tag along on that outing. She knew it would feel awkward, even with others there. "So what's with Christina?" she couldn't helping asking. "Doesn't she have a life?"

Luke laughed softly. "She needs to hang out and get material for her book. She stayed in one of the empty cabins last night. She'll probably go back to Boston

Monday or Tuesday. I'm not really sure."

He wasn't sure? Was this woman going to move in? That just proved her theory. This Christina was unattached and looking up Luke as a possible rekindled relationship.

No wonder he hadn't been in touch all this time; he'd been too busy hanging out with Christina. Sara struggled to keep a grip on her temper. She didn't want to sound like a jealous shrew, at least not any more than she already had.

"So what about tonight?" she asked. "Are you busy being interviewed?"

"Of course not. Don't be silly." His tone was warm and reassuring, and Sara felt a little silly for sounding so snide. "I thought we could take Christina up to Newburyport. She hasn't been there yet. It will be fun to show her around, right?"

Sure, loads of fun. Like getting a double root canal.

What was he thinking? Was he thinking at all?

Sara squelched an almost uncontrollable urge to tell him what a turkey he was being. But what would that accomplish, besides making her feel a whole lot better? They'd end up in a big fight and he'd go off and have a romantic dinner with Christina.

"So." He seemed uncomfortable with her silence. "Where should we take her?"

How about down to the waterfront? We can push her off the dock . . .

"I was thinking about that French bistro," he went on. "I think she likes French food. Or she used to."

The French place? Not the French place! It was way too romantic.

"I'm in the mood for sushi myself," Sara said quickly. The pleasant, well-lit Japanese restaurant in the same neighborhood was ideal for a fast, no-frills meal.

"We'll see. Let me think about it."

Since Sara wasn't sure what time she would get back from Emily's house, they arranged to meet in Newburyport at seven. Sara finally hung up, feeling totally exhausted. How would she ever get through this? It was going to be pure torture.

But what were her alternatives? Begging off with a headache or some preposterous ailment and letting Luke take the woman out alone? No way. She was *chaperoning* this outing if it killed her.

While talking to Luke, Sara had slipped on her bathrobe. Now she stood in front of the mirror, combing out her wet hair. She needed a haircut; her split ends were terrible. And what should she wear tonight?

191

Her good black pants were at the cleaners, and she hadn't bought anything new for the winter yet. All her sweaters and tops looked so last year.

She and Luke were at that comfortable stage in their relationship, after that point when you know the person so well, you don't fuss over your appearance anymore.

She winced at her reflection. Just when she thought the beauty pageant had ended, she was strolling down the runway again. And this time, the competition was serious.

Sara glanced at the clock and pulled on jeans and a cotton turtleneck. She could run over to the mall, look for a new outfit, and get her hair trimmed and blown out. She would have to put off her visit to the new baby. She honestly had mixed emotions about that outing, anyway, and was relieved to postpone it a day or so. When she explained the situation, she was sure Emily would understand.

As Sara tugged on her sneakers and set off for the mall, the wise words of Henry David Thoreau, her favorite New England philosopher, came to mind. "Beware of all enterprises that require new clothes."

Sara was wary of this outing. She was also determined to arrive in Newburyport

looking jaw-droppingly fabulous.

"Wow, you look great." Luke stared wide eyed at Sara, then leaned over and kissed her soundly. "What did you do to your hair?"

"I just had a trim," she said as he helped her off with her coat.

"That sweater looks great on you. Is it new?"

"Not at all. I've had it awhile," she fibbed. At least two or three hours.

She had wanted to grab his attention, but Luke's reaction made her feel as if she must look pretty ragged the rest of the time. Besides, she hadn't wanted Christina to think she had made any special effort. *By now she must be thinking I had a complete makeover,* Sara mused.

Luke politely pulled out a chair, and Sara took the seat next to him at the small table. He had decided on the French café and it was just as lovely as she remembered from their former dates, an elegant setting with French country decor, low lighting, and a romantic ambiance.

Christina sat on the other side of the table, opposite Luke. She wore a black cashmere sweater with a low, shawl collar that swooped across her neckline, revealing

flawless skin and rounded shoulders. Her large topaz earrings complemented her golden hair and sun-kissed complexion. She looked tasteful, stylish, and quite sexy. *Is this what she usually packs for her research outings?* Sara wondered.

Maybe it was a good thing that I made such an effort with my appearance, Sara decided. *This is serious competition.*

"So how are you enjoying your visit, Christina?" Sara asked pleasantly. "Did you guys go out to the beach today?"

She had worked hard to come up with several neutral conversation openers. She even practiced them while getting dressed. She wanted to sound cool, confident, unruffled. That was Emily's advice. When Sara had called to explain her situation, Emily had been totally understanding, cheering Sara on like a coach in a boxer's corner.

Don't let her get under your skin, honey. Remember, you're with Luke. She's the guest. She's on your turf. You have the home-field advantage.

"We had a great afternoon. The shore is beautiful up here. We had a lot of fun, didn't we?" Christina glanced at Luke; a warm, intimate look, Sara thought.

"It was great. Too bad you couldn't join

us, Sara," Luke said. "But I guess you were pretty busy with your hair."

Sara felt a jolt of embarrassment. He made it sound as if it had taken a team of stylists, working around the clock, for her to look this good.

"No, not at all." She struggled to change the subject. Next question. "How is your research going, Christina? What do you think of Cape Light?"

"It's going great. Luke's story is so compelling, so inspiring. I knew him way back when. I had no idea what he'd been through since then."

Now it was Luke's turn to look embarrassed and self-conscious. "Everybody faces challenges and hard times. My life isn't that different from anyone else's."

Sara was about to contradict him, offering an admiring comment about how he had not only faced his challenges courageously, but in finding his own way, found a way to help so many others.

Christina got there first. "He's so modest," she said with a warm smile. "He's put together this fantastic learning center that helps so many kids, and fought your entire town to do it."

My town? How is it my town? Sara wanted to blurt out. She had stood by

Luke's side every step of that battle, even at the risk of her personal safety.

"It wasn't the entire town," Luke corrected Christina. "More like a small, very vocal group. You want to get your facts straight, right?"

"Sorry." Christina smiled at him. "I don't mean to exaggerate. It certainly isn't necessary for your story, Luke. It's already the most amazing one in the book. In fact, I think I might block it out and submit it as an article somewhere. It's great copy."

Luke looked embarrassed again, Sara thought. He also looked pleased with all the attention and compliments.

"There's the waiter. Maybe we should order," Sara suggested, picking up her menu.

Someone had to keep this dinner moving along. She wasn't sure how she was going to last through the meal. If she could just suffer through it, hopefully she would never have to see this woman again.

She felt her stomach churn as Christina turned to her with that brilliant smile. "So, Sara, you must tell me. What's it like working on a small-town paper?"

At some point during the main course, Sara gave up trying to be cool, confident,

unruffled and settled for plain old quiet and boring.

Christina did most of the talking anyway, so no one seemed to notice. *She* wasn't at all boring, though, which was part of the problem. She had led an interesting life and had lively, funny stories about her adventures as a reporter in several major cities — New Orleans, Denver, and Miami — before returning to Boston, where she was raised.

Christina seemed able to talk about any topic, from the Red Sox's chances of winning the World Series again this year to the hole in the ozone layer. She was widely published and had written several books of nonfiction that were well reviewed. Sara knew all this because she had researched her rival on the Internet.

While Sara knew she was bug eyed with jealousy, she was thoughtful enough to realize that it was partly because she admired Christina and her accomplishments.

If they had met under different circumstances, Sara thought, she might have even liked the other woman and sought her friendship. They had a lot in common. It wasn't surprising, when you considered it, that Luke had been attracted to both of them at different points in his life.

The question is, Sara realized, *which one of us is he attracted to now?*

"So I heard from Luke that your mother took temporary custody of the baby she found. That's a great story, especially since she's the town's mayor," Christina noted. "Do you think she would give me an interview? I thought it would make a great piece for the *Globe*, or even a magazine."

She wanted to squeeze a publishing credit out of Emily? Did the woman have no conscience? No sense of boundaries? Who did she think she was talking to?

Any sense of admiration or even toleration Sara had been musing about quickly evaporated.

"She can't give you a story. Sorry." Sara gave her rival a tight smile. "I've already started it, an exclusive."

That was an out-and-out lie. Sara had given a moment of vague thought to the idea then gotten distracted by her own conflicted feelings. But she had to take a page from Ace Reporter Christina Cross's handbook and go for the jugular.

"She's a public figure, fair game. Anyone can write about her." Christina sounded perfectly cool and unruffled. "Let's see who can get it into print faster, okay?"

"I don't think so," Sara said, trying to

198

laugh off the challenge.

"Why not? It will be fun. Like the *Iron Chef* cook-off. Two chefs, same ingredients. Ever see that show?"

"This is my mom we're talking about," Sara reminded her, "not some stranger."

"Look, I don't mean to step on your toes, but it's a little naive to think you have a patent on that idea just because Emily Warwick is your mother. We both might open the newspaper and see it in print tomorrow." Christina met Sara's infuriated glare with a bland smile, then glanced at Luke, as if sharing a joke at Sara's expense.

Sara knew that what Christina said was true, and that made her even madder. "Right, someone might be tapping it out as we speak, and we might both lose your little contest." She stood up abruptly and grabbed her bag. "Be right back."

Her voice was deadly calm. Even Luke noticed the ominous note. He stared up at her but she ignored him and stalked off towards the ladies' room. She faced the door, but didn't push it open.

Instead, Sara made a sharp turn toward the front of the restaurant. She retrieved her coat from the coat check, pulled it on, and walked out. Maybe leaving this way was a bit dramatic, but she knew that if she

had to sit through another minute of Christina Cross, she couldn't be held responsible for her actions.

Outside the cold air cleared her head a bit. She walked with her hands jammed in her pockets and paced up and down the street, wondering if she should just leave or go back inside. She half expected Luke to come running out after her.

But he didn't.

She didn't want to go in again, she decided. *If I'm going to lose Luke to that woman this way, I never really had him to begin with.*

Feeling desperately sad and defeated, Sara trod down the hill to her car and started the drive back to Cape Light.

"Go ahead, go after her. I'm sure she didn't get too far." Christina took a sip of her water, gazing at Luke with her large, liquid brown eyes.

Luke had an impulse to get up and follow Sara, just as Christina advised. But for some reason, he remained in his seat, gazing across the table at the other woman. He was always chasing after Sara, it seemed. That was the story of their relationship. He didn't feel like it tonight. She would be all right, he told himself.

"I'm sorry . . . I think I upset her," Christina apologized. "It's all my fault."

Luke waved his hand at her. "It's not your fault. Sara can be sensitive about Emily, though. You had no way of knowing that."

"I should have realized. I need to watch what I say sometimes. I'm too honest. It scares people."

Luke smiled at the admission. Christina could be startlingly frank at times. That was one of the things he always liked about her. "So be honest," he said. "You were pouring on the compliments a little thick. If you think I'm such a natural wonder, why did you break up with me?"

Christina's smile widened. "Now the conversation is getting interesting. Want the real answer?"

"Yes," he nodded. "I do."

"I was young and stupid. Sure, you've changed a lot since you left the police force. But inside, you've always been the same. A sweet, smart, decent guy. I don't know what was wrong with me. I wasn't ready to settle down, I guess. I didn't appreciate you."

She wasn't ready. Where had he heard that before, Luke thought.

"Have you ever forgiven me for dumping you?"

"Sure I have." He laughed and shrugged. "I don't think it would have worked out anyway, for a lot of reasons. My head wasn't really together back then, either."

"You seem to have gotten it all together now," she said quietly. She traced a line on the tablecloth with her fingertip. "So here's confession number two. I did want to include you in this book when I came across your story. It's compelling, inspiring, all that stuff. But I could have interviewed you over the phone and with e-mail. I didn't have to come up here."

"I know that. I'm not that thick, Christina."

She smiled at him, her long bangs falling across her eyes. "I wanted to see you. I got to thinking about you, Luke. About the time we spent together. Guys like you aren't growing on trees back in Boston, you know."

He sat back. He didn't know how to react to that one. This woman really knew what she wanted and knew how to go after it. He wasn't used to this direct approach, not that he didn't like it.

"What about Sara?" she asked.

"What about her?"

"That looks pretty serious to me."

"It is," he said honestly. "We're having a

rough time right now . . ."

"I sort of sensed that." Christina always had good insight and intuition about people. That was part of what made her a good reporter and a good writer. It wasn't hard for her to guess at the problems brewing between him and Sara.

"But we have a commitment," he said. "I'm not about to mess that up."

"I didn't think you would," she said quickly. She shrugged a smooth shoulder.

"You're terrific, Christina. You could get any guy you want. What's so special about me?" He laughed, trying to make light of the charged moment.

"I told you. You are special. You don't realize it, though, and that's part of your charm."

Luke felt himself almost blush at her compliments.

Christina leaned toward him and her voice became softer, more intimate. "Listen, I respect your relationship with Sara. Honestly, she's a catch. But so much of life is timing, Luke. You have to meet someone on the same page, or else it just doesn't work. At least, that's what I've figured out."

Luke swallowed hard. He wanted to argue, to defend his relationship with Sara.

But Christina had hit the nail right on the head.

"I think I'm on your page. That's all I'm trying to say." Christina paused, took a breath, and then met his gaze, the candlelight casting her face in a warm glow. "And maybe Sara just isn't there yet."

Chapter Seven

The light snowfall on Sunday morning slowed Emily and Dan down, but it didn't deter them altogether from church. That morning would be their first time there together with Jane. As they drove through the snow-covered village, Emily realized she was feeling tired from all the visitors the day before. They had come and gone throughout the day, stopping by to see Jane and bring baby gifts. First Betty, then Jessica. Next had been Molly and Matthew Harding, her boyfriend, with their three girls all together. "You have a stable of babysitters here, standing by for your calls," Molly had teased her.

It was good to know. With the snowy weather that had started yesterday, Emily

was already feeling a bit housebound. It was good to get out, even if just to church and back.

As Dan carefully steered the car through the icy streets, Emily knew that they'd be late.

They slipped into the sanctuary from a side door, Emily carrying the baby. The service had already begun and Reverend Ben was making announcements about a Christmas Fair meeting and other church business. They walked in quietly and found a place in the rear row. Still, many heads turned and Emily saw the news fly through the congregation.

She spotted her sister, Sam, and their children sitting several rows ahead alongside her mother. Jessica turned and smiled at her. Finally, her mother's head turned toward her. Lillian passed a swift cool glance over Emily, as if they'd never been properly acquainted.

Emily held the baby a little closer and met her mother's grey gaze with a calm expression. She was sure Lillian had heard the news from Jessica by now — or from any number of people. Of course, her mother hadn't even bothered to call to wish her luck.

It hurt but it was no more — and no

less — than she expected.

The service went by quickly. When it came time for the congregation to share their joys and concerns of the week, Emily was feeling self-conscious about announcing their news, though it was indeed a great joy to her. Reverend Ben cast her an expectant glance, but she couldn't do it. She glanced at Dan. He sat staring straight ahead, his hands folded in his lap over a hymnal. He wasn't going to do it, either, she realized.

Suddenly, Jessica stood and turned in their direction. "We have some happy news to share. My sister, Emily, and her husband, Dan, are temporary guardians of the baby Emily found outside the church about two weeks ago. Her name is Jane and she's just beautiful."

Now everyone felt free to turn and openly look at Dan and Emily. She sat and smiled, holding up the baby, who now slept in her arms.

"Congratulations, Emily," Reverend Ben said, and everyone smiled and clapped.

Everyone except her mother, who stared down at her prayer book in her lap and didn't even deign to glance Emily's way.

A short time later, when the service was over, Emily carefully made her way down

the middle aisle and out of the sanctuary. It took awhile, though. People kept stopping her to admire the baby and wish them all good luck.

"What a yummy little thing," Sophie Potter said. "Look at those apple cheeks."

Emily had to smile at the compliment. Sophie, who had lived on an orchard her whole life, thought all babies had apple cheeks.

"I guess you won't have time this year to work on the Christmas Fair, Emily," Sophie went on.

Every year Emily volunteered for the fair and was usually stationed at the wreath and garland table with Jessica.

"I'll have to come as a customer this year, Sophie. Don't worry, I'll be sure to buy lots of things."

"Oh, don't be silly, dear. I'm not complaining. On the contrary, it's nice to see you with new priorities." Sophie gently patted her arm. "Now if you need any help with that baby, if you have any babysitting or questions about anything at all, you feel free to call on me. Maybe I can be her spare grandma. Most of my grandchildren live so far away, I don't have any little ones left to fuss over."

Emily was touched by the offer. Sophie

would certainly know how to fuss over a baby. But *spare grandma* was not the term she'd use. Only *grandma* was more appropriate, considering what her own mother's interest was likely to be.

"I'm taking next week off," Emily said. "Maybe we'll take a ride out to the orchard and visit."

"That would be lovely, dear. You know me; I'm always there unless I'm over here at church. Drop in anytime."

Emily and Dan soon met with Reverend Ben, who stood by the doorway sharing a word or two with the congregants as they left the sanctuary. His smile beamed as he took in the baby. "My, my. Look at her. She looks so healthy and clean, maybe even bigger than when you found her?"

"She's a bit below average weight and height, they say," Emily noted. "I don't believe she grew at all in the hospital last week with that infection. But I think she'll catch up fast."

"She sounds like a mom already, doesn't she?" Dan remarked with an indulgent smile. He slipped his arm around Emily's shoulder.

Reverend Ben and Emily shared a private glance. He knew the worst and best of her, her torment over Sara and her joy at

finding her daughter again. "Changing diapers doesn't make you a mother," he'd once told her. "Loving a child does, even at a great distance." He knew that she was already a mother and didn't have to tell her so.

"I was so pleased to hear that you and Dan had stepped in to be Jane's guardians," Ben told them. "How did all this come about?"

"I'm not exactly sure," Emily said honestly. "I went to visit her in the hospital a few times. And it evolved from there. I just feel so relieved having her with us. I was afraid of where she might end up, so I had to do something."

"I understand. Good for you, Emily. It's a big step. And you and Dan both look very happy."

Emily met his warm smile, then felt a bit guilty. She had never called Reverend Ben to tell him the news personally or even to consult him about the decision. Her minister had always been a close confidante, especially in the days when she had felt so troubled and weighed down by her feelings of loss over Sara.

She hadn't turned to Reverend Ben for counsel in a long time, she realized, not even over this question of taking tempo-

rary custody. Well, it had all happened so fast. She hadn't asked anyone's advice. She would have to let Reverend Ben know that his take on things was still important to her. She wanted him to baptize the baby. She would discuss it with him soon, she decided, once things felt more settled.

The reverend looked down at Jane again and placed his hand gently on her forehead. "Let me give her a blessing," he said. "Dear Lord, please watch over this dear child, lend her the grace of Your divine love, and aid her foster parents in her care."

"Amen," Dan said solemnly.

Emily stood silently a moment gazing at Jane, who stared back at them wide eyed. She looked from Emily to Dan and suddenly seemed to smile, making little cooing sounds as she looked up at them and blew a giant spit bubble.

"Good job," Reverend Ben said to the gurgling baby. "That was a beauty."

Laughing, they all said good-bye. Dan and Emily moved on into the crowded sanctuary, where people were putting on coats, hats, and scarves, bundling up for the cold weather outside.

"Day two . . . drum roll," Sam said, coming up beside them. "How are you

guys doing? Are you surviving the 'Invasion of the Baby'?

"We're taking this one hour at a time," Dan replied. "So far, so good."

"Come on now, Dan," Emily said. "It's not such a big deal. Everything is basically the same —"

"Except that it's a lot more complicated," he finished for her. "Just take getting out of the house in the morning. The car seat, the baby bag, the pacifier we forgot to put in the baby bag . . . I thought we'd never get here."

"It's a different routine," Emily argued. "We'll get used to it."

"The question is not when or how, but why. Why on earth have you done such a thing? Taking in this child, from unknown origins besides?" Lillian stepped up beside them. "Have you lost all perspective? All common sense and reason?"

"Lillian, calm down. This is a temporary arrangement. We're interim guardians," Dan began to explain.

"Interim, my foot. I know how these things work. One thing leads to another. You're both too old for this. When the child is applying to college, you'll be checking out nursing homes."

"You don't seem to understand. We

won't be raising her," Dan insisted. "We're trying to help out, to do a good deed."

"A good deed, indeed. You'd better not get sucked into raising her. She looks innocent enough now, surely. But this little baby will most likely grow up to have all kinds of problems, mentally, physically, emotionally. Bad genes, bad chromosomes — they used to call it bad blood in my day. Same difference. The mother was most likely a drug addict. Have you even given a thought to that reality?"

As if reacting to Lillian's insults, the baby suddenly started crying. Emily soothed her, rocking her in her arms. She wanted to take Jane away, but there seemed no place to go.

All she could do was turn her body to the side, shielding the baby from her mother's outburst.

Dan stepped forward and put himself between Emily and her mother. He rested his hand on Lillian's birdlike shoulder, towering over her.

"This isn't the time or the place, Lillian," he began in a firm tone. "You're upsetting Emily. I won't stand by and —"

Lillian shrugged off his touch. "As if either of you care what I think. She never did." Lillian raised her cane a few inches

off the floor and pointed it at Emily. "She probably did this just to spite me. To shame me, more precisely."

Emily could only stare in disbelief. "Mother, this is not about you. How unbelievably . . . egocentric."

"Foolish girl, you're well on your way to fifty and you have so little insight into your own actions."

Reverend Ben suddenly came into view, obviously summoned by Sam. The two men walked quickly in their direction. Emily felt relieved at the sight. Even her mother would be mollified by the sight of her minister. Wouldn't she?

"Lillian . . ." Reverend Ben called to her from the other side, making her turn away from Emily to face him. "Would you care to go into my office for a visit? We could talk over your feelings about Emily and Dan taking in this baby. Maybe your daughter and son-in-law would like to come and explain their side of it to you."

Lillian stood up ramrod straight, her head tilted back as she peered at Reverend Ben through half-closed eyes. "I have neither the time nor the interest for such touchy-feely nonsense. I know why she did this. It's perfectly clear to me. As for my views, there's no secret about how I feel,

214

Reverend. It seems to me my entire family has lost all common sense, all judgment. . . ."

She was going off on another diatribe, Emily feared, keenly aware of the other parishioners staring at them.

Jessica rushed up beside her mother and held out her coat, like a bullfighter waving a cape at the charging beast. She spoke in a hushed, embarrassed tone. "Mother, I have your coat. Put this on. We're taking you home."

Lillian stared at Jessica defiantly a moment, then straight at Emily. Finally, she held out one arm and allowed her younger daughter to help her put on the coat.

"I'm just an old woman. Nobody listens to me. What does it matter what I say?" she muttered as Jessica took her arm and led her out of the church. Sam followed, carrying Tyler and leading Darrell by the hand.

"Emily, I'm so sorry." Dan leaned forward and hugged her, gently enfolding the baby as well. "I didn't know what to do. I didn't know how to stop her."

She rested her hand on his arm. "I know you tried. I expected something like that, just not here. I thought she'd wait until we were somewhere private."

Dan sighed. "Well, at least we got it over with."

Emily stared at him, feeling she might laugh out loud. "You've known my mother all these years and really think that's the end of it?"

Dan's expression changed to one of amusement. "You've got a point, as always."

She forced a small smile in answer but could tell he knew she felt shaken by the encounter. He reached out and touched her shoulder. "Let's go home now."

"Yes," she said. "Let's."

Reverend Ben watched Dan and Emily leave, feeling he should go after them but at the same time at a loss for words. He knew he shouldn't have been shocked by Lillian Warwick's outburst. It had been as easy to predict as snow in the wintertime around here. Still, the contempt and anger behind the cold, stinging words had dismayed him. This was a woman who rarely missed a Sunday service, who listened intently to his sermons each week, a woman who most likely considered herself a "good Christian."

And no matter what one might say about Lillian, Ben felt that the deeper failing lay

not with her, but with him. He'd failed her as a minister. All these years, he'd failed to reach her, to touch her heart. He'd failed to even coax her into his office for some counsel.

Ben sighed and turned toward the sanctuary. It stood empty now, though the space seemed to echo with Lillian's harsh words and his own feelings of futility.

On Monday morning Emily found fat white flakes that looked like feathers falling from the low grey sky. She didn't mind at all. She wasn't going to work and was in no hurry to start the day. Still wearing her bathrobe and nightgown, she sat by the kitchen window with Jane and showed her the snow.

Dan was getting ready to leave the house, driving up to Boston for the day to work in a research library. He'd made special arrangements to examine some historic documents and didn't want to miss the appointment despite the weather.

Emily wished he would skip the trip and stay home with her and the baby. She was worried about him driving all that way in the bad weather and also felt a bit apprehensive about being alone all day for the first time with Jane. She struggled not to

show it, though, and kept up a calm front. She didn't want Dan to think they'd made a mistake, that she couldn't handle the baby.

"So I'm off," he said, taking a last sip of coffee. He wore his down jacket, a Red Sox baseball hat, and a scarf and gloves.

"I'll keep my cell phone on, in case you need to call me," he promised. "I'm not sure about the reception in the library, though. It might not get the signal."

"I won't need to call," she assured him. "I can handle the baby."

"I know that. I just mean, if there's an emergency."

"Well, you'll be too far away to do anything if there is one." She held Jane to her shoulder as she glanced out the window. "Honestly, I don't know why you have to go all the way to Boston in this weather. Can't you do it another day?"

"I really have to go," he insisted. "I checked the reports. It looks bad here, but it's fine on the interstate. And there isn't much snow toward the city."

She couldn't persuade him to stay, she realized, so she gave up. "All right. Drive safely."

"I'll be fine. Don't worry. I might be late, though." He leaned over and kissed

218

her. He gazed at the baby a moment, but didn't kiss her, too, Emily noticed. He walked out the back door in the kitchen. "I'll call you later," he promised.

"We'll be here." Emily held up Jane's hand to wave good-bye. It was silly, she knew, but she couldn't help it.

The baby's infant seat was set up on the kitchen table and Emily strapped her in. Then she sat at the table and started to eat the bowl of cereal she seemed to have poured for herself hours ago. It was soggy and the milk was warm. She thought about tossing it out and starting over, then decided to just finish it. Who knew when she would get another chance?

With one eye on Jane, she began to skim that morning's headlines. She had scanned the first page of the news when Jane began fussing. Emily put everything down and picked her up again.

She checked the baby's diaper. Wet again. She took her into the bedroom for a change. Dan hadn't made the bed. She would do it later, she decided.

She changed Jane's diaper, then changed her onesie, too, which had also gotten wet. The baby's clothes drawer was ominously empty, and Emily saw that Jane's laundry had mounded up, overflowing the basket.

In two short days? Babies sure went through clothing, she realized. She would have to do wash later.

Jane was still fussing, so Emily sang to her and talked to her, then waved around a few toys, seeing if any of them would interest her. No, not a bit. Emily checked her list. It was close enough to feeding time. Maybe that was it. She was hungry again.

She took a bottle out of the fridge and heated it in some water on the stove. She needed to make more bottles; there was only one left. She had to sterilize the bottles first, though, she remembered. She had a list for that somewhere that she had copied from one of Jessica's baby books. When Jane took her long nap later, she would take care of everything, Emily decided. For goodness sake, she ran an entire town. She could manage a little baby.

Then the phone rang. It was a man Dan had interviewed for his book, asking if Dan had received the deeds he faxed over; his machine indicated a problem. Emily's eyes widened as she realized he was talking about old deeds that Dan had been searching for for months. "Just a minute," she told the caller. Still holding the baby, Emily rushed up to Dan's office, saw that

the fax machine's paper feed was jammed, and managed to clear it while Jane lay in Dan's big armchair, protesting the fact that she was being ignored.

Ten minutes later, back in the kitchen, Emily realized that she had left Jane's bottle in the water too long and that it had gotten too hot. Jane was crying in earnest now, she was so hungry. Emily felt bad for her. She ran the bottle under cold water, but it was taking a long while for the formula to cool down again.

This can't be all that complicated, Emily told herself. She just had to figure out the right timing for heating formula.

Finally, she had the bottle at the proper temperature and gave it to Jane. Silence was truly golden, she thought. And Jane looked so cute drinking her formula, Emily forgave her instantly for all the raucous crying.

The phone rang again. This time Emily decided to let the machine pick up. She wasn't about to disturb Jane while she was happily eating.

"Ms. Warwick, this is Carla Nickerson. I was supposed to stop by your place this morning to talk about that babysitting job? Well, all the snow has put me off. I don't drive in the bad weather. I'll call you back

and maybe I can come some other day, okay?"

Carla Nickerson, Emily thought. That was too bad. She had such good references, recommended by a friend of Jessica. Emily was practically counting on the lady working out, desperately hoping she wouldn't have to go through a long search for a babysitter.

But it was definitely a problem if Carla didn't drive in bad weather. There was nothing *but* bad weather in the winter, and the other seasons weren't that reliable either. Carla would be missing work every other day.

"So you won't be interviewing Carla Nickerson today," Emily said, acting as if she were Jane's private secretary. "Let me check the rest of your schedule, dearest girl. We have a feeding, a bath, a nap, another bottle. Another diaper, I suspect. Some playtime on the baby mat — build up those muscles?" Emily tickled the baby's bare foot and watched it curl.

The phone rang again and this time Emily answered it.

"Mayor Warwick?"

"Yes?" she said, switching quickly to her dignified, official voice.

"It's Ralph Clancy, from the Public

222

Works Department. I'm calling about those documents from the government, the grant the town was awarded. You need to sign those papers, Mayor. They have to be returned to Washington today."

"Oh, yes. I completely forgot. It's been a busy weekend . . ." Everyone in town seemed to know that she and Dan had picked up the baby on Saturday. Ralph Clancy, however, didn't reply.

"The papers are sitting right on my desk," she told him.

"Well, can you come in a minute and sign them? It's important."

"That would be . . . difficult right now." The baby had fallen asleep on her lap. It wasn't her nap time, Emily thought with a quiet panic. What now? Was she supposed to let her sleep or keep her awake awhile?

Could she take her out in the snow? That didn't seem wise. Emily glanced out the window. It was still snowing, and Dan had taken her Jeep because it had four-wheel drive. She only had Dan's little compact, which she didn't trust in the snow, even for the short distance to Village Hall. "Can you have someone bring them over? I'll sign them and they can bring them right back."

"I suppose so. Wait, you need to be wit-

nessed by a notary. I'll have to find one who'll come." He sounded annoyed at her now, but it couldn't be helped. She had expected to go in to her office for a few hours on Saturday; then the call about Jane came, and she had dropped everything.

"I'll see what I can do, Mayor. I'll call you back," he said curtly.

"Yes, please do," she said and hung up the phone.

She suddenly realized she was still in her bathrobe. She really should shower and dress before someone from Village Hall showed up. But what to do with Jane? Put her in her crib? Or maybe her infant seat, just outside the bathroom door?

They never mentioned this kind of dilemma in the child-care books, she realized.

Emily put the baby in her infant seat again, and Jane started to cry. Emily knew she wasn't wet or hungry, so she had to assume she just wanted to be held. Sure enough, the moment she lifted the baby into her arms, the crying stopped. But how could she get anything done around the house if she had to hold Jane all day?

She didn't want Jane to be upset, so she decided to put off the shower until the baby slept. Resting the baby against one

shoulder, Emily walked through the house, trying to get a few chores done. She hauled the laundry basket one-handed into the laundry room, then filled the washer with Jane's clothes and started up the water.

But there was no soap. Now what was she going to do? Jane didn't have that many outfits yet. If she dirtied this one, which was only a matter of time, she would be down to a diaper and an undershirt.

"We can't go shopping, so I guess I'll have to rinse out a few things by hand," she told the baby.

She fished out some necessary items and took them to the kitchen sink. Still balancing the baby on her hip, she hand washed the clothes with some dishwashing liquid, wrung them out, and tossed them in the dryer. They would likely take all day to dry, considering that she wasn't able to squeeze that much water out. But what could she do? She had all day to wait, she realized.

It was only nine thirty. Emily felt as if she had been up for hours, but nothing around the house was done. The breakfast dishes were still on the table, the living room was littered with newspapers, and the bed upstairs was still unmade.

The phone rang again, and a familiar voice said, "Hi, honey, how's it going?"

Emily felt a surge of happiness go through her. Had he decided to turn around and come home? She hoped so.

"Fine, it's going fine," Emily told her husband. "Everything's great. How are you doing? How are the roads?"

"The roads are clear as soon you leave our area. No problem at all," he said in an annoyingly cheery tone. "I'm making good time."

"Oh. That's good."

"Listen, I'm sorry, but it looks like I took the car seat by accident. I didn't even notice it. You weren't planning on going out today, right?"

"Well, if I was, I can't now, can I? Unless I take her out in her stroller."

"The snow is too high for a stroller. You won't be able to roll it. You'll get stuck, Emily."

"Oh, of course." She hadn't been planning on leaving the house, but now that she couldn't, she felt caught. Trapped, actually. "When will you be back?"

"I don't know. Depends on how my appointments go. I'll call you later, when I have a better idea."

"All right. I'll be here."

"Sure you're okay? Is the baby doing all right?"

"Oh sure. She's just fine. She wants me to hold her all the time, though."

Dan seemed to think that was sweet. He didn't understand the implications. "Well, you enjoy your time with her. You'll be back in the office soon enough."

Yes, she would be, Emily realized. She considered the comment with mixed emotions.

They both hung up, and she tried to settle Jane in her infant seat for what seemed the umpteenth time. This time, however, she set the seat near a mobile so Jane would have something distracting to grab at. The mobile did the trick, and Emily actually managed to clear the table, get the dirty dishes into the dishwasher, and clean out the sink. Jane seemed content to sit in the infant seat, with an occasional bounce from Emily as she passed to and fro.

Emboldened by this success, Emily decided she would tackle the bottle situation. She gathered up all the empties and filled a big pot of water to sterilize them. She knew she could be using disposable plastic bottle liners, but Jessica had insisted that the plastic was bad for babies — too many

chemicals leaching into the formula. You certainly didn't want that.

Jessica had turned out to be a bit extreme in her precautions, Emily thought, making her own baby food for Tyler from strictly organic, unprocessed foods. Well, that was very healthy, Emily was sure, but it certainly took time. She wasn't sure she would have either the time or the motivation to make organic baby food.

Jane was still so young. The only solid food she ate now was a little cereal, so it wasn't really a question. Yet.

Emily glanced in the cupboard, searching for more cans of Jane's formula. She didn't see any and felt slightly panicked. Dan had probably put them in some other closet. She pulled open one door after another, searched above and below, behind boxes and cans that hadn't been moved for years. Still no formula.

Now she felt really panicked. What would Jane eat all day? She only had one bottle left that the baby would take in a short time. Dan wouldn't be home until late tonight, and she had no car seat to go out to the store. She would have to find a place that delivered.

The idea almost made her laugh. None of the markets or drugstores delivered in

Cape Light. More likely, she needed to call someone to help her. Emily wasn't used to calling on anyone for help, even friends. She was used to being the one people in trouble called up to help them.

The pot of bottles bubbled and boiled away. Emily wasn't sure how long it took for them to be officially sterilized. She found one of Jessica's baby books in the living room, one with yellow Post-its on critical pages, but couldn't find the page she marked about bottle boiling.

She smelled something funny and rushed back into the kitchen. The water boiling in the smaller pot that held rubber nipples and bottle caps had all but boiled away. The nipples were scorching and melting at the bottom of the pot!

Oh . . . bother! Emily grabbed the pot, nearly burning her hand, and tossed it in the sink, then ran cold water over the mess. A huge mushroom cloud of steam erupted in her kitchen.

Startled by all the excitement, the baby started wailing. Emily ran over and picked her up. She had nearly forgotten poor little Jane was sitting there all this time.

"Oh, sweetie pie. Don't worry. It's nothing . . ." Emily ran into the next room to escape from the smell in the kitchen.

Now what would she do about nipples? She hoped she hadn't ruined all of them. Nipples, formula, and she still needed laundry detergent. And if she didn't sign those federal documents today the village might miss out on the funds for road repair.

Jane continued crying fiercely as Emily cooed and soothed, waltzing around the living room. She hoped the baby hadn't breathed in too much of that awful smell in the kitchen. Could it have hurt her? Emily bit her lip. One little baby seemed to generate at least a hundred new worries.

The sound of the ringing phone penetrated her thoughts and Emily ran to answer it, shifting the crying baby to one hip, away from the receiver. It was hard to hear who was on the other end over the sound of Jane and the water still running in the kitchen.

"Yes? Who is it?" Emily called out over the noise.

"Emily? It's me, Sara. Can you hear me?"

"Sara! Where are you?" Emily felt instant relief at the sound of her daughter's voice.

"I'm on my cell, driving back to the village from a meeting in Peabody. I won-

dered if I could swing by and see the —"

"Come right over! That would be great. I'll make you lunch. Listen, could you pick up a few things for me on the way? Dan took my car this morning and forgot to leave the car seat and I'm sort of stuck here."

"No problem. What do you need?"

Emily gave Sara a quick list, talking over the crying baby. Simultaneously, she ran back into the kitchen and shut off the running water, but realized she'd now left the bottles to boil too long. She shut off the stove and pushed the pot back on another burner.

This baby business wasn't as simple as it looked, not by a long shot. Thank goodness Sara was coming over. Her call felt like a gift from above.

"Thanks," Emily said quietly, looking heavenward. "Looks like I need all the help I can get around here today."

Sara arrived a short time later. By then Emily had managed to put Jane on the bed for a few minutes while she changed into real clothes, foregoing a shower. When the doorbell rang, she picked up the baby and ran through the house to answer it. She gently placed Jane on her play mat, then quickly passed through the living room, re-

alizing the place was still a total mess. She had had no chance to pick up. She never entertained company this way but, as they say, a baby changes things.

Sara walked in holding the grocery bags and a gift box wrapped with pink paper and a big bow.

Emily hugged her and took the bags. "I'm so glad you called. I was having a rough morning. You really rescued me."

"Good timing then. I've been dying to see the baby. Where is she?"

"Right over here on her play mat." Emily led the way to Jane, who was set up on the floor surrounded by baby toys.

"Oh, she's adorable!" Sara walked over and sat down on the floor beside the baby. "Hello, Jane!" Sara picked up a plush toy lamb and waved it in Jane's direction. The baby gurgled and kicked her feet, grabbing at it. "Oh my, you're so cute. Can I take you to work with me?"

"Would you? I mean, just for an hour or two?" Emily laughed at her desperate admission.

Sara looked up at her. "You don't really mean that?"

"No, of course not. But this baby care hasn't been as easy as I thought. It's not the baby. It's all the routines and equip-

ment. I can't believe we ran out of formula. I feel like such an airhead. But we used it up much quicker than I thought over the weekend. I just didn't realize."

Sara picked up the baby and held her in her lap. "It's all new," she reminded her mother. "You never did all this before."

"No." Emily's voice was barely audible. "No, I didn't." She smoothed her hands over her jeans and stood up. "Want some lunch? I can heat up some soup and make you a sandwich."

"Sounds good, but don't go to any trouble."

"No trouble. Why don't you bring Jane into the kitchen?"

"Sure." Sara got up with the baby and followed Emily. Though the kitchen looked like a war zone, Emily found a can of soup and a clean pot and started the soup. She took out a cutting board and bread for the sandwiches, but Jane started whimpering and squirming in Sara's arms.

"Maybe she wants you," Sara said, holding up the baby. "I can fix us lunch."

Emily took Jane and gave her daughter a rueful, apologetic glance. "I didn't invite you here so you could do my shopping and make me lunch, you know."

Sara laughed. "I don't mind helping out. It's no big deal."

Emily knew that logically it wasn't. Still, it felt odd to be reversing roles with Sara like this. Sara didn't seem to mind, yet Emily sensed a certain disquiet in her daughter's demeanor. Did she feel displaced by the baby? It was possible. Emily thought she and Sara should talk about things, but this didn't seem the right time.

Sara set out the bowls of soup and sandwiches for each of them and then sat at the table across from Emily, who held Jane in her lap, feeding her a bottle.

"So what's new with you and Luke? Did that old flame of his finally leave town?"

Sara rolled her eyes. "I don't know and I don't care. Well, I do care," she admitted. "But everything is such a mess now with Luke and me. We all went out together on Saturday night and it was just awful."

Emily felt alarmed at Sara's tone. She could see Sara trying to speak reasonably but quickly melting down, her eyes on the verge of tears.

"Oh, honey . . ." Emily wanted to get up and give her a hug, then realized she had Jane in her lap, firmly attached to her bottle. "What happened, exactly?"

Sara nodded bleakly and wiped her eyes

on a paper napkin. "It went all right at first and then that woman went too far. She was pushing my buttons all night, and I finally just lost it. I got up to take a break in the ladies' room and I just kept going."

"You walked out on them?" The baby squirmed and Emily lifted her up to her shoulder, patting her for a burp.

"I couldn't help it. I was so mad, I didn't know what to do. It wasn't just Christina. She was just being her fabulous, condescending self. I was so mad at Luke for putting us together like that. I think he wanted to sit back and watch two women fight over him or something. It was really twisted."

Jane began whimpering and wiggling on Emily's shoulder. Emily tried to set her upright in her lap and pat her lower back, but the baby wasn't having any of it.

"Don't think the worst, Sara. Luke isn't like that. Maybe he just didn't realize."

"He knew," Sara insisted. She waited, watching Jane. Emily could tell she wanted to say more. She really needed to talk to someone about this but now felt short-circuited by the baby's fussing.

Emily stood up and paced around the small kitchen with the baby, who was now whimpering fitfully. She couldn't figure it

out. Maybe Jane ate her food too quickly and had a gas bubble. The pediatric nurse said that could be painful. If only babies could talk and tell you what was going on. Meanwhile, she had a grown daughter sitting here who wanted to tell her what was wrong, and she could barely give her three minutes of attention. Emily suddenly felt stretched like a rubber band between Sara's needs and those of the baby.

"Have you and Luke talked at all? Did he call you?"

Sara nodded. "He called yesterday. I wasn't home. I haven't called him back yet. I just didn't feel ready to talk." She glanced at the baby, raising her voice to talk over Jane's sharp, fitful cries. "I guess I might see him tonight. I tutor at the center, so I might run into him, but I'm not going out of my way . . ." Sara suddenly looked up at Emily, as if wondering if her mother heard her at all.

"I'm listening," Emily insisted. "Go on."

"It's all right. We don't have to talk about this right now. Why don't you just take care of the baby?"

Emily didn't answer for a moment, feeling torn in two. The baby squalled and she had no choice but to focus on her. "I'm going to take her into the bedroom.

Maybe she needs to be changed or something. Wait right here. Finish your lunch," she said.

Emily took Jane into the bedroom and changed her diaper. She should have realized that was the problem. After she did, the baby still fussed a bit but more or less stopped crying. Emily carried her back to the kitchen where Sara had finished her lunch and now read the newspaper.

Sara looked up and offered a thin smile. "Is she feeling better now?"

"Just a dirty diaper . . . duh. I'll catch on sooner or later. There really aren't that many choices."

Sara laughed. "It's pretty simple at that stage."

"Just let me finish giving her this bottle and then she'll go down for a nap. We'll be able to talk. She's just tired. That's why she's so cranky. She's really not like this normally. She has a beautiful temperament. Even the nurses at the hospital thought so. One of them said —" Emily cut herself off as she realized she was going on about the baby.

Sara nodded encouragingly, but there was something else in her expression, something at odds with her mild smile.

"I'm sorry, Emily. I can't stay. I have to get back to work."

"I wish you didn't have to go."

"Call me if you need anything else, okay?"

"I'll be fine. Dan can stop for me."

Sara leaned over and kissed her good-bye and then lightly kissed Jane on the forehead. "I'll come by and visit again soon," she promised.

"I'm sorry we got sidetracked. I'll call you tonight and we can catch up some more."

Sara nodded. "Sure. Don't get up. I'll let myself out."

Sara waved good-bye and moments later Emily heard her go out the front door. She sighed and sat back in her chair, watching the baby finish her bottle.

"I'll call her later, when you go to bed, young lady," Emily told the baby. She looked up and noticed the pink gift box on the table. She hadn't even opened Sara's gift to the baby. She hoped Sara's feelings weren't hurt by that slight, too.

Emily felt sad. She'd disappointed Sara, failed to be there at a moment when her daughter needed her. But she didn't know what to do. She hadn't anticipated this.

She would make it up to Sara somehow.

Chapter Eight

~⁊

Reverend Walter Boyd Jones was a retired minister of the same denomination as Ben. He lived in the small town of Princeton, just northwest of Cape Light. It was an easy drive up to Princeton on Monday afternoon, when Ben usually took a few hours to visit members of the congregation who were in nursing homes or the hospital. Today he took the time to visit Reverend Jones, to minister to himself a bit.

The older minister had been a great support years ago when Ben was just starting out in Cape Light with his first congregation and Reverend Walter was leading a large, thriving congregation in Princeton. *Time passes so quickly,* Ben thought as he drove down the reverend's street and

picked out the small saltbox-style colonial that dated back to the late 1700s.

The Reverend Walter's wife had died a few years ago and he now lived alone. He had been pleased to hear from Ben and eager to meet. Ben realized that he had neglected his old friend lately; he really should be more attentive to him, not just calling when he needed advice or help. That wasn't being a very good friend. Though it was very much the way many people related to God, he reflected, calling only when they had a problem.

Reverend Walter greeted him at the door and led Ben into the small living room, which was lined with bookshelves and filled with old, comfortable-looking furniture. A small dog was curled on one armchair, an old tabby cat on another. A fire glowed in the hearth beneath a mantle covered with framed photos.

Reverend Walter was a short, stocky man, bald on top with a fringe of white fuzzy hair. He wore an old grey cardigan, leather slippers, and black pants that appeared to be left over from his clergy days, though Ben didn't think that could be possible.

Walter took Ben's coat and brought him some coffee. He settled back in a wing-

backed armchair while Ben made himself comfortable on the couch.

"Thank you for seeing me, Walter. I hardly know where to start."

"It's hard to talk about these things. Ministers are expected to be superhuman. It's hard to admit we have problems and setbacks and flaws just like everyone else. We can forgive and accept all types of human frailties except our own."

"True enough. I also feel so . . . disloyal to my congregation, admitting how I really feel lately."

"Which is?"

Ben looked up at him. "Unmotivated. Uninspired. Distant, as if it's all happening on a stage far away, and I'm just going through the motions. The same old events, the same old sermons, more or less. I have nothing new to say to them, nothing new to offer. And they have nothing new to offer me, which is perhaps not only irrelevant to our work but also unfair."

Walter listened to him thoughtfully, then said, "Let's not worry about being fair or unfair right now, Ben. Just tell me what's in your heart and in your soul. I'm not here to judge. I want to help."

Ben knew that was true. "Maybe I've gotten too comfortable, Walter, too com-

placent. I've thought and prayed a lot about this lately. Maybe God has set this as a challenge for me. And if that's the case, I don't think I'm meeting it very well."

"Is this a crisis of faith, Ben? Questions are only natural, you know. They're actually essential. There is no real faith without questions."

"It's not my faith in God that's been shaken, Walter. It's my faith in myself, to carry out His work, to energize my congregation with His word and His spirit with my own example."

"I see."

"Everywhere I turn lately, I feel frustrated, blocked. I'm starting to wonder if God is trying to send me a message. Maybe my time in Cape Light is drawing to a close. Maybe I am being called to move on, to serve someplace new, in some new capacity."

He watched Walter's expression carefully. His friend frowned, considering the idea. "I suppose that's possible. But we need to be very careful about how we interpret messages from above."

Ben heard the echo of his own advice to Emily Warwick. "Indeed. I'm only saying it's a possibility. Do you remember that

young missionary who was at my church last year?"

Walter nodded. "Yes, I do. He's gone back to mission work, you say?"

"Yes, I got a letter from him about two weeks ago. He's out in Wyoming on a reservation. He took his new wife and their baby along, too. Nothing holds James back. He's always got a goal for the greater good.

"That letter from him seemed almost like a sign to me, a sign that I should at least start asking myself, what are my larger goals?" Ben stared at his friend, knowing full well that he was posing questions Walter couldn't answer. "I mean, aside from delivering a spiritual message each week in my sermon and serving the congregation when there's sickness or a death or other hardships."

"Aren't those all important and meaningful ways of serving them, Ben?"

"Yes, of course. I didn't mean to say that they weren't. But after so many years, I wonder what it all adds up to. Is this place changed in any way, improved in any way, after I've passed through?"

Walter rose and stirred the fire with a metal poker. Sparks danced and orange-yellow flames shot up from the heart of the

fire and licked the white-hot logs.

"What about Joe Tulley, your church steward? He was a lost man, Ben, a homeless man with no hope. You saved his life."

"I didn't save his life, Walter. I just helped him get back on his feet."

"You reunited him with his brother; you gave him a job. You believed in him when everyone else was accusing him of being a thief. Even when he ran away to Portland, you were the only one he trusted enough to contact."

Ben nodded. "I'll chase after the wandering sheep whenever possible, but that's part of the job description, too, Walter. And a man like Joe is really the exception. Most of the congregants I counsel have more ordinary problems."

"Not enough challenges for you, is that what you're saying?"

"I suppose. Mostly I've been wondering: Am I even really helping them anymore? Am I giving my best to the congregation, or would they be better served by a new pastor — someone who can see them with a fresh perspective, wake them up on Sunday morning with a new voice?"

"Do they need waking up, Ben?"

"Yes, I think so," Ben said honestly. "So, in a way, that seems my failure or short-

coming. They're a generally kind, good-hearted group. People are willing to help each other out when there's a need, most of the time. But I feel so ineffectual lately. I've been trying to interest them in doing some outreach in a poor neighborhood in our village, Wood's Hollow —"

"Yes, I know the place." Walter nodded.

"A few families from the area have come to church lately. I thought it would be good for our congregation to get more involved there, lend some support. I tried to start with something simple, a coat drive." Ben shook his head. "I can't even get one congregant committed. They're all too busy now, baking cookies and making birdhouses for the Christmas Fair."

He swallowed hard — swallowing back his anger, he realized.

Walter glanced at him. "What did you do? Did you read them the riot act, like Moses scolding the Israelites?"

Ben laughed. "Hardly. Don't get me wrong. They're all good people," he added quickly. "There's genuine fellowship and goodwill. But are they really spiritually committed? Is there any real difference between the church gatherings and the gatherings at the boat club down the street from us?"

Walter laughed at the comparison. "I know what you mean. I often wondered the same thing. But we can't lose sight of the big picture, Ben, our higher role. You make it sound as if we're recreation directors on a cruise ship."

"Sometimes that's how I feel."

"Well, that's honest." Walter stared into the fire. "Did you ever read Dante's *Inferno*?" he asked. Ben nodded. Of course he had; it was required reading for divinity students. "Maybe you're just reaching the dark wood of middle age, Ben. It can be a frightening place."

"Yes, it is, and that might be part of the problem."

"Maybe these issues have existed in your church for a while, but you're just now noticing them. You've come to a certain point in your career as a minister when it's normal to ask, 'Is that all there is? What's next? Is there more?' "

Ben pondered that. He did feel as if he had reached a spiritual crossroads. "I think you're right. But what *is* next? Do I pick up and plow on, or is it time for something different?"

"I'm not saying I agree with your message-from-above theory, but maybe a change of scene would do you good. A sab-

batical — you must be long eligible for one. Consider your options. You could get involved in a mission opportunity that will really renew you spiritually and give you something to take back to your congregation when the time comes. Sounds to me as if you need renewal, Ben. You need to have your spirit recharged. Some hard work, digging wells, building a school — some hands-on service you can step back from and take pride in. That might be just the cure."

Ben shook his head. "I thought of that, a temporary assignment someplace. I even tried to bring it up with Carolyn, but she doesn't want to budge. She thinks we should take a vacation to Florida." It was hard to keep the dry, sarcastic tone from his voice.

"Have you really talked to her about it? Maybe she doesn't understand what it means to you, what you're going through."

"Maybe not. We talked more the other night, when I thought of coming to see you. I think she's starting to see that I need more than a vacation. But how can I expect her to understand what's going on with me when I don't know myself?"

"You're working on it. You're not just brushing it under the rug. That's impor-

tant. Talk more with Carolyn," Walter urged him. "Ask God to grant her greater understanding. And continue your own prayers. Maybe some insight will come to you. I'll be praying for you, too."

"Thank you, Walter. And thanks for seeing me today, for hearing me out."

"No need for thanks. I hope it's helped."

"It has," Ben said. "It's helped me a lot."

Though he still didn't see a clear solution, he felt the relief that comes from unburdening oneself of honest feelings. And he trusted Walter's advice. As his friend had reminded him, he needed to have more faith, to show greater trust in God.

Maybe he was in the dark wood of middle age and had to take some drastic steps to find his way to the other side. With the Lord's help, he would find his way.

"Roxanne's knees shook under her desk. Mrs. Newton was going to call on her next. She just knew it. She stared down at her math workbook, wishing she was in . . . vi . . ."

Sara's student, Shania Watson, looked up from her paperback as she stumbled over the word. Sara suddenly snapped to attention.

"Try to sound it out, Shania. You can do it."

Her expression doubtful, Shania looked back at the book. "In . . . vi . . . zi . . . ball? Invisible!" she said.

"Very good." Sara nodded. "Keep going."

Looking proud and pleased, Shania continued. Sara tried hard to focus, but her eyes kept moving to the big clock on the wall of the New Horizons study center. Only five minutes to go, and then she could run to her car and go home, hopefully avoiding an encounter with Luke.

She still didn't feel ready to see Luke or talk about what had happened on Saturday night. That is, talk to him reasonably, without losing control.

But she couldn't disappoint Shania. That was part of the program, showing these kids that adults could be consistent and counted on, building trust.

Sara had always trusted Luke, but now she wasn't so sure. Maybe her disappearing act at the French restaurant had pushed him right into Christina's arms.

". . . . *Roxanne had to sit with Zachary Oster, who was always tapping away on a big cal . . . kool . . .*"

"I know it's a tough one," Sara said

quickly. "Let's break it down by syllables."

With a few prompts from Sara, Shania finally said, "Cal-cu-la-tor."

"Good job. That was a hard word. Why don't you read to the end of that page and then we'll be done."

"Okay." Shania took a breath and started again.

As she listened to Shania reading, Sara heard the sound of singing coming from some other part of the building. She felt a little melancholy, recognizing the tune of "Deck the Halls." She always went out caroling with Luke and the students. This year, he hadn't even called to let her know they were practicing. She wondered if he was part of the group, merrily singing along, not giving her a thought at all.

"*. . . . Roxanne walked toward the bus. Something gooey made her sneakers stick to the ground, but she didn't care. It had been a terrible day and she could not wait to get home.*"

Boy, can I ever relate to that, Sara thought. She smiled at Shania. "Sounds good. Why don't we stop there for tonight? You worked very hard. I'm proud of you."

Shania glowed but seemed partly embarrassed by Sara's praise. "Are you coming back next week?"

"I wouldn't miss it," Sara promised.

She walked Shania to her dorm and then turned down a path to the parking lot. She was just about to congratulate herself on escaping without meeting up with Luke when she saw his SUV pull into the lot. He got out, carrying bags of groceries.

Nice. He knows I'm here tonight so he runs out and goes grocery shopping. What does that tell you?

She stood by her car, her arms crossed over her chest, and waited for him to walk up to her.

"So you had your tutoring tonight. How did it go?"

"Fine."

"I had to go into town this afternoon. I'm glad I didn't miss you." When Sara didn't say anything, he added, "I think we should talk."

"About Christina, you mean?"

"About everything. Want to come back to my cottage?"

Sara considered the offer for a moment. "No, I have to get home. I have work to do."

"Okay. We'll talk right here then."

Sara shrugged. "Do you want to get back together with Christina? Because if you do, that's fine. I just want to know."

Luke pulled back as if slapped across the face. "Wow. You get to the point, don't you?"

"Just answer, yes or no."

"No. I don't want to date Christina. I'm dating you. We have a relationship, re-member?"

"You seem like the one who forgot," Sara prodded him.

"I love you. I want us to get married. How much clearer do you want me to make it?"

"It's not very clear to me at all lately. You weren't with me Saturday night. You were with Christina!"

"You were the one who ran out and left us alone together," Luke reminded her. "Maybe you expected me to run after you, like always. But I just didn't feel like it."

"Obviously. With Christina sitting in your lap, how could you? Do you want to start seeing other people now?"

"No, I don't." Something like under-standing flickered in Luke's dark eyes. "Maybe you do. Maybe that's what this is all about."

"Don't turn this around on me, Luke. You're the one acting like you want out. It seems as if you've already started some-thing with your old girlfriend."

Luke straightened, his body tense with anger. "Is that what you really think? I thought you had a little faith in me, Sara, a little more trust."

Sara looked down at the icy ground. She had thought she trusted him, but now she felt so upset and jealous, she wasn't sure what to think.

"So where is Christina?" she finally asked. "Did she go back to Boston yet?"

"She left yesterday, but she's coming back. She likes it around here," he added.

"Yes, I'm sure she enjoys the scenery." Sara turned, pulled open her car door, and then got inside. "I'll see you."

"So long, Sara." Luke watched her pull out of the parking lot and drive away. She saw him in her rearview mirror. His expression was bleak, exactly the way she felt inside.

She wanted to believe that he had no special feelings for Christina and had been faithful to her. But she didn't feel reassured by anything he just said. Why was Christina coming back here if there was absolutely nothing going on and if she had no hope of winning Luke back?

Christina didn't strike Sara as the type of person who wasted her time or got swept up in unrequited love affairs.

Sara drove toward the village on the dark, empty road. The woods were covered in snow; the bare branches, coated with silvery ice, arched over the narrow road, glittering against the black sky. The passing scenery looked magical and mysterious. She recognized its beauty while at the same time feeling lost inside. She felt empty and adrift now that she didn't know where she stood with Luke.

"Yes, I'll be there, one way or the other," Emily promised.

She ended the call with Warren Oakes and sat for a moment, wondering who would be available to watch Jane on such short notice. She had interviewed a few sitters during the week, but here it was Thursday morning, and she still didn't have any solid prospects to take over on Monday, when she was due back at work.

Meanwhile, an emergency meeting of the village zoning board had been called. A legal challenge to the zoning in Wood's Hollow had been filed and the board had to meet.

As Emily understood the story from Warren, a local developer had a pending deal to buy the land where the old hotels stood — only to knock them down, of

course, and build luxury minimansions on the lake. The firm, Acorn Development, couldn't go ahead unless the zoning was changed from multiple- to single-unit housing. Acorn Development had backers in town, Emily knew. They'd once tried to build condos on the Cranberry Cottages property.

A request to change the zoning would normally be considered at the regular monthly meeting. But Lionel Watts, who was in favor of development, had called an impromptu emergency meeting, hoping to force it through behind her back, Emily suspected. Luckily, Warren had figured out the scheme and alerted her in time.

She paced back and forth in the living room, bouncing Jane gently in her arms. The meeting was at ten, and it was already five past nine. She still needed to shower and dress in real clothes, not just her sweats or jeans. And worst of all, she didn't have a sitter.

She picked up the phone and dialed Dan's cell. He was off at another library doing research. This one was a private collection but it was fairly close, in Newburyport. He could definitely get back in time if he hustled.

"Hi, it's me," she began when Dan

picked up. "I have a little problem."

"What's wrong? Is the baby okay?'

The concerned note in his voice was encouraging. "Jane's fine, but they've called me in for a meeting at ten. It's a zoning vote, and I have to be there. Could you come home and watch Jane — just for an hour or two?"

She heard Dan take a deep breath. "I'm sorry, Emily, I really can't. I've waited four months to get this appointment with the curator. If I leave now, it could take four more months before I get another crack at viewing this collection. And I'm on a deadline. I have to finish this research and get out the outline by next Friday."

"Yes, I know. But it would only be for a few hours."

"I'm sorry, but I warned you that this wouldn't be easy. I told you I wasn't going to babysit while you went in to the office."

Emily sighed. He had said that. Dan had made it very clear that he wasn't going to be Mr. Mom and that working out child-care arrangements was her responsibility. That had been the deal.

"How about those sitters you interviewed this week?" Dan suggested, sounding sympathetic. "Maybe one will come over."

"There were only two and I didn't like either of them." Carla Nickerson never did find a day when the weather was clear enough for her to drive. And the other two, one too old and one too young, hadn't filled Emily with confidence.

"Well, don't wait for Mary Poppins. I hear she's already taken."

"Thanks for the tip."

"I'm sorry, honey. I would help you if I could. But I think you need to figure this out yourself."

"Okay, I will. I'll talk to you later." Without waiting for him to say good-bye, she hung up the phone. She didn't have time for editorial comments today, and, though she couldn't say he hadn't warned her, she was annoyed at him for not dropping everything and helping her.

She picked up the phone and dialed Jessica next, the closest thing to Mary Poppins in the neighborhood.

Jessica picked up on her tone at once. "Anything wrong? You didn't melt the bottles again, did you?"

"Nothing like that. But I need to run in to work this morning. There's a zoning-board meeting that I can't miss. Do you think I could drop Jane with you, just for an hour or two?"

"I'm sorry, Emily; that won't work out today. I have to be at the bank and I'm bringing Tyler to Sam's mother. She's taking him for a checkup, so I don't think she could handle two little babies in the doctor's office. That would be a bit much, even for Marie. I'm sorry. Any other time I would do it for you."

"Sure, I know you would." Emily sighed. "I'll find someone; don't worry."

"How about Betty or Molly?" Jessica suggested. "Maybe Molly will come over if she's not in the store."

"Good idea, I'll try them next."

Emily quickly made another call to Betty, but her secretary said she was out, busy showing properties to someone from out of town. Emily left a message on Betty's voice mail, then called Molly. Just about the same story — Molly was off with a catering client; no telling when she'd return.

Emily considered trying Sara next, but knew that even if her daughter could come for a little while, her time was too tight. She didn't even want to ask and put her in an awkward position. Then her mother came to mind, and she nearly laughed out loud at the thought.

"Don't worry, sweets. I wouldn't leave

you with her for a million dollars," she promised Jane.

Sophie Potter was her last resort. Hadn't Sophie offered to take the baby if Emily needed help? Maybe she was just being polite, but Emily was going to take her up on it. Besides, Sophie was perfect. She was great with children, kind, gentle . . . and she worked at home, Emily thought, picturing Potter's Orchard, where Sophie lived.

But there was no answer at the Potter house despite Sophie's promise that she never left except to go to church. The answering machine picked up, and Emily left a halfhearted message.

It was half past nine. Time was up. She had to get cleaned up and get out of there.

"Practice that big smile, honey pot. You're going into politics."

Jane gurgled at Emily, looking pleased at the idea.

For the next half hour, Emily ran around frantically, getting showered and dressed in record time. She wore a navy blue suit with pants and a fitted jacket that looked appropriately serious, she thought. With no time to blow dry her short, auburn hair, she did her best fluffing it out with her fingertips and hoped the heat vent in the car would

do the rest. She skipped all extras, like makeup and jewelry entirely.

She spent far more time on the baby's appearance, she realized later, dressing Jane up in one of her cutest outfits and gathering her wisps of baby hair into a tiny ponytail on the top of her head. There was also considerable packing to do — diapers, formula, wipes, rattles, toys, blankets, a change of clothes in case there was an accident.

Finally dressed and ready, she scooped up the baby and bag and headed for the door, turning back briefly to snatch up her briefcase. Luckily, the stroller was in her trunk and the middle section popped out into a portable infant seat. Emily planned to wheel Jane, kit and caboodle, into the meeting and then use the infant seat later in her office.

"Maybe you'll take a nice nap in that boring meeting for me, won't you, Jane?"

Emily breezed into the Village Hall and headed for the meeting room, wheeling Jane down the corridor. She was already nearly ten minutes late, but that was her usual style and couldn't be blamed on the baby.

She looked for Helen, her secretary, who sat at a desk outside her office, but she was nowhere in sight. That was a snag in her

plans; she had hoped Helen would watch Jane for a bit.

With no help for it, Emily opened the door to the meeting room and entered backward, tugging in the stroller and big baby bag.

"Good morning, everyone. I couldn't find a sitter on such short notice and had to bring Jane along. Hope you don't mind."

The zoning board was made up of older men, mainly retired engineers and businessmen, and one woman who had been on the school board. They took themselves and their jobs on the board very seriously. None of them had a great sense of humor, or much humor at all, come to think about it.

Lioncl Watts was the chair and called the meeting to order. He didn't even glance at the baby, though Emily sat right next to him. "Let's begin, shall we?"

Emily reviewed the pile of handouts that sat on the table at her seat. She reached into her bag for her reading glasses, but came up with a baby thermometer, which she quickly stuck back inside. It seemed she had forgotten her glasses altogether. Well, she had to remember to pack nearly everything else in the house. It was only

the law of probability that she would forget something.

She tried not to be too obvious as she leaned back and forth in her seat, trying to bring the important memos into focus.

The meeting went from bad to worse. Just as the discussion started, Jane began whimpering and squiggling around in her seat in the stroller. Emily leaned over and tried to distract her with a rattle toy. The sound made everyone stop talking and stare at her.

"Oh, sorry." She put the rattle down on the table next to her pile of memos. "Go on, Lionel. I didn't catch that last part. You were saying?"

Lionel Watts gave her a chilly stare and continued his lugubrious commentary. ". . . and the fact that most of the residents in that area are not property holders and not paying taxes to our town supports the position that the land-use definition should be altered so that the village can reassess and thus collect a higher revenue . . ."

Jane started crying. Something about Lionel's droning tone upset her, Emily was almost sure of it. She leaned over and peered at the baby, realizing that she had better check her diaper, just in case. "So sorry for the interruption. She's fine. She'll

stop in just a second. I just want to check . . . something."

All clear in the diaper area, thank goodness. Emily unclipped Jane from the stroller and picked her up. She held her in her arms and patted her back, trying to quiet her. Twelve impatient stares fastened on her, making Emily feel a little nervous. Gosh, it was just a baby. More important, it was just a meeting. *Get over yourselves already,* she nearly said out loud.

She paced back and forth near her chair, trying to soothe the baby and get her to fall asleep. Jane seemed to like it when she sang "You Are My Sunshine," so Emily started off in a whispery tone. Then realizing that everyone was watching her with raised eyebrows, she stopped, too self-conscious to finish the song in front of her audience.

"I think she's just tired," Emily explained. "She needs a nap."

George Gunther, a crusty old man in his eighties, made a disgusted face. "So do a lot of us here. But we're managing not to cry about it."

This brought a few reluctant smiles from the others.

Lionel cleared his throat very loudly. "Well, then . . . as I was saying . . ."

The baby's cries were growing louder.

Emily quietly started the song again, singing in a whisper, ". . . my only sunshine . . ."

Martha Dodge heard her and sat back with eyebrows raised haughtily. "Maybe you ought to see if your secretary can sing to her, *Mayor*," she suggested. She put special emphasis on Emily's title, as if to remind her of it.

"Yes, of course. I'll just be a minute." Emily ran outside with Jane, tugging the stroller behind her. Fortunately, Helen had returned to her desk and was sitting at her keyboard, typing.

"Helen, could you help me out just for a few minutes? I couldn't find a sitter, so I brought Jane in with me this morning to the zoning meeting. It's not going well. Could you watch her, just until the meeting is over?"

Helen held out her arms with a smile. "Sure thing. Here, let me have the little doll." She folded Jane in her soft embrace and the baby seemed calmer instantly. "Just go on to your meeting," Helen said. "She'll be fine with me."

Emily gave Jane one last gaze, then went back to the meeting room. Helen, who was in her mid-fifties and had raised three children, did seem to have a good touch with

her. Too bad she was such a great secretary and liked her job. She would make a terrific babysitter, Emily thought.

From then on, the meeting proceeded without interruption, and arguments for both sides were heard. Those who favored a change in the zoning argued that the area of Wood's Hollow would suddenly triple in value, becoming a builders' bonanza. Many in the town would be in favor of a pocket of luxury real estate replacing the dilapidated apartment buildings that now bordered the lake. If nothing else, the town would get far more revenue in taxes from the area.

"And what would become of the people who live there?" asked Warren Oakes. "There are families with children, not to mention seniors who've lived there their entire lives."

"Exactly," Emily said firmly. "I don't see how we can just toss people out of their homes because other people want to 'clean up' the area. You're talking about people who don't have other options, who wouldn't have another place to go."

The discussion grew more heated until, finally, a motion was made to table the vote. It seemed that some legality in the petition had to be researched and clarified.

Emily was relieved. She didn't think the important question should be voted on so quickly. She really wanted to find some way to bring the issue to the town council and the villagers themselves.

Just as windy Lionel Watts was winding up the meeting with a long, windy summation, Helen poked her head in the room. "Sorry, Emily. There's an important call for you."

"Oh, sure. Sorry, everyone, I have to run. Thanks for your patience."

Emily ran out of the room, following her secretary down the hall.

"It's the baby. I didn't want to say," Helen admitted. "She needs her diaper changed and I couldn't find any spares."

"Oh, thanks. I'll take care of it." Emily had had a feeling the important call was something along these lines. Not for the first time, she found herself glad of Helen's discretion.

She had just finished changing Jane's diaper, using her desk for a changing table, when Warren knocked on the half-closed door.

"Come on in." Emily picked up Jane and rested her on her hip. Jane was all dressed again, but the desk was littered with diaper-changing paraphernalia.

Emily hurried to clean it up.

Warren came in and closed the door. He surveyed the scene and frowned.

Emily sat down in the chair behind her desk with Jane on her lap and took a bottle out of the baby bag. "What's on your mind, Warren?"

Warren looked unnerved. "Do you have to feed the baby right now?"

Emily looked up at him, surprised by his tone. "Well, she's hungry and it's time for her bottle. Yes, I do." She looked back at Jane, making sure she was eating all right. "Don't worry, I can give her a bottle and listen to you at the same time."

Emily and Warren had a special relationship. Warren had worked in town government for ages, and she owed a lot to him. Although they had their differences, he was one of her biggest supporters and had even run her last campaign. He was a canny and trusted confidante who always managed to watch her back. Warren was prickly, though, and sometimes a little too concerned about her image.

"Is this going to be a usual thing now?" he asked. "The baby in the office? Because if it is, Emily, you're going to have some trouble on your hands. It's not going to fly around here. This isn't a movie on

the Lifetime channel."

Emily had to laugh at the last remark. "Do you really watch that station, Warren? I would never have guessed."

"You know what I mean," he said. "They weren't very happy in there. You should have heard the comments when you left."

"I'm glad I didn't."

"They don't find this baby thing so adorable. I don't either. Now you tried it out once, on a small board. Let's not push our luck with another meeting."

"I've been interviewing sitters this week, Warren. It's harder than you think to find somebody reliable."

"Well, you'll have to by next week. You were elected to do a job."

"Yes, I know that, Warren," she said evenly, though she was starting to get angry. She didn't need to be lectured. "Is that all you wanted to talk about?"

"Yes," he said curtly. "That's it. I'm going to lunch. Will I see you here later?"

"No, I'm going home now. I just came in for the meeting." She picked up one of the memos from the meeting. "We have to fight this rezoning, Warren. We can't let them tear down those old buildings to make way for minimansions. I don't care how much it will up the town's real estate value."

He nodded but avoided her gaze. "Yes, I know. It's a complicated question."

"It's not complicated; it's very simple. It's wrong to just toss people out so other people can make money. The people who live in those old buildings can't afford to go anyplace else. I want you to look at the legal grounds for this petition."

Warren shifted in place a moment, then turned and headed for the door. "I'll let you know what I find."

After Warren left, Emily finished feeding Jane, then dressed her up in her snowsuit and strapped her into the stroller. She left Village Hall with all her bags and stowed them in the car outside. Then she wheeled Jane down Main Street and stopped at the Clam Box.

As she opened the door and started to maneuver the stroller inside, Lucy Bates rushed up to help her. "Here she is! Here she is!" Lucy announced in a singsong voice. "I've been dying to see this little baby. I couldn't really get a close look in church," she added, peering into the stroller. "Oh, she's beautiful. Look at those eyes."

She looked up at Emily. "How's it going? Did you come out for a little stroll around town today?"

"I had to go in to work, a meeting. I don't have a sitter yet, so I had to take Jane with me. It didn't work out very well," Emily reported, rolling her eyes. "Don't tell Charlie, but one more visit from Jane at my office and I could get impeached."

Lucy laughed. "Don't worry, I won't tell him. Don't want to get his hopes up. Now, come sit down. What can I get for you?"

Emily knew the menu so well she didn't need to look. She ordered a turkey sandwich on rye toast with lettuce and tomato. Lucy put her order in and brought a cup of coffee.

The baby was perfectly calm now and content to sit in the stroller, gazing quietly out at the world around her. Emily loved to watch her. She was such a wonder.

"You know, it's really funny how you never hear a man say he's having trouble juggling his family and his job," Lucy said with a wry grin.

"Isn't it," Emily replied. "Dan isn't any great help. He likes the baby, but he's keeping his distance. I think he's afraid of getting too attached because the arrangement is only temporary."

"And you aren't afraid?" Lucy asked.

Emily couldn't answer that question. "How do you do it?" she asked instead.

"You have two kids, work here, and go to school."

Lucy shrugged. "Some days I feel certain I'm going to wind up in the hospital, either in the emergency room or the psych ward. But it all works out. The boys are big now. I can even leave them on their own now and again. My mother was a big help when they were little. I could drop them off there anytime."

Emily knew she didn't have that safety net available to her and never would. "I'll find a good sitter sooner or later. It's going to take time."

"Why don't you ask around church? You might find somebody to help you out there."

Lucy's suggestion was a good one. Emily wondered why she hadn't thought of it herself. "Good idea. I'll post a sign on the bulletin board."

Charlie wasn't on duty that day; it was the part-time cook, Jimmy. He rang the little bell on the service counter, and Lucy left to retrieve an order.

A short time later, after Emily had finished her sandwich and was on to a second cup of coffee and a slice of lemon meringue pie, she spotted her friend Betty coming toward the diner. Betty was

walking and talking in her usual animated fashion with another woman whom Emily didn't recognize. Emily realized this must be the client Betty had taken out to view properties. She always brought them over to the Clam Box. Newcomers to Cape Light found the diner quaint and charming, until they got to know Charlie Bates, of course.

Betty swept in with her client and spotted Emily at her table near the window. "Emily, how are you? My secretary said you called this morning. Why didn't you try my cell?"

"Oh, that's all right. I didn't want to bother you while you were working." Emily glanced at the other woman. She looked to be in her early thirties, strikingly attractive, dressed in a golden brown suede jacket and a colorful striped scarf, with jeans and neat brown leather boots.

"Did you take Jane out for lunch today?" Betty peered into the stroller and gazed down at the baby, who was dozing off.

"I had to run in to work for a while. I couldn't find a sitter, so I took her along."

Betty's companion bent to look into the stroller, and her sun-streaked hair fell forward, gleaming. "What a sweet little baby," she said, then glanced up, her expression

curious. "Are you Emily Warwick?"

"That's me," Emily said easily; she was used to strangers recognizing her.

"Oh, I'm sorry," Betty said. "Let me introduce you. This is Christina Cross. She's writing a book and wants to rent a cottage for some peace and quiet."

"It's the perfect town for peace and quiet," Emily said amiably, but the name Christina had snagged her attention. Wasn't that the name of Luke's old girlfriend? Emily realized in a flash she'd come face-to-face with Sara's rival.

"I can't believe I've lived in Boston so long and never knew about this place. It's just so . . . perfect." Christina's praise sounded sincere, but Emily suspected that if Luke didn't live here, the little village that lacked stylish stores, good restaurants, and any nightlife except movies might seem inconvenient, dull, and rather provincial.

"Guess who's going to be in Christina's book? Luke McCallister," Betty said, answering her own question. "He's getting an entire chapter."

"I heard something about that," Emily admitted.

"I guess Sara told you. You're her mother, right?" Christina said. "She mentioned that her mother is the mayor. It

must be fun being mayor here."

"Most of the time," Emily answered carefully. "It's not all parades and tree-lighting ceremonies, though."

She didn't mean to sound defensive, but something in Christina's tone suggested Emily's job was about as demanding as presiding over a doll's tea party.

"I'm sure every little town has its intrigue," Christina said. She leaned down and looked at the baby again. "It's just amazing about you finding this baby and taking her in. I'd love to do an article on you sometime. It would be a perfect feature for the *Boston Globe*, or even one of the big women's magazines."

"Oh, wouldn't that be great, Emily? I could just see a picture of you and Jane on the cover of some magazine," Betty said. She leaned a bit closer. "Let's see Charlie Bates try to beat that publicity," she added in a laughing whisper.

Emily smiled, unswayed by the prospect of Christina Cross making her a star of the supermarket magazine racks.

If anyone is going to get a publishing credit out of this experience, it's going to be Sara, Emily thought. She had a good mind to stroll right over to the newspaper office this afternoon and have her get

working on the story right away. Before this blonde barracuda scooped her.

"That's a very nice idea," Emily said diplomatically. "I'm very flattered. But Dan and I would rather be low key about all this. We're only temporary guardians right now, and I don't think I'd feel right drawing such attention to the situation."

"Sure, I understand." Christina shrugged and smiled. She really was very pretty, Emily thought. Not as pretty as Sara, but a formidable contender.

Lucy walked over with menus. Finally, Emily thought.

"I'm sorry to keep you waiting, ladies. Can I show you to a table?"

"Thanks, Lucy." Betty turned to Emily. "See you later. Call me at the office if you get a chance."

"Yes, I will," Emily promised. "So long, Christina."

"Very nice meeting you, Emily. See you around town."

Emily just nodded. She couldn't honestly say, "Looking forward to it," or any of those other niceties.

She put some bills on the table and slipped on her coat, then made sure the baby was properly bundled up. She tugged the stroller out the door and headed down

Main Street toward the village green, church, and dock. She wanted to show Jane the place where they first met, even though it seemed a little silly.

She thought of dropping in at the newspaper office but decided not to disturb Sara at work. She needed to be low key about this Christina woman and not run over there, sounding alarmed after meeting her. That would just reinforce Sara's fears about the situation. She wondered if Sara even knew Christina Cross was moving into town. If not, she didn't want to be the one to tell her. Not just yet.

Still, Emily couldn't help but feel a wave of concern. Sara wasn't exaggerating. This Christina was a formidable adversary: intelligent, attractive, poised, and confident. Closer in age to Luke, too, she was the kind of woman who knows what she wants and isn't afraid to go after it.

"Poor Sara," Emily murmured to Jane. "She'd better watch out. That woman is trouble."

She pushed the stroller around the paths on the village green. It was a sunny, windless, cold day. She'd heard fresh air was good for babies. Way back when, during her own babyhood, mothers would leave their babies outside in their carriages for

hours to "air" them, like rugs getting a spring cleaning.

People didn't do that anymore, thank goodness. But there was some value to the fresh-air theory. She had a feeling Jane would sleep well tonight, and then so would she.

When they reached the crèche, Emily paused to gaze at the manger scene, particularly the empty wooden cradle where she had found Jane that frosty, momentous morning.

She lifted Jane up out of her stroller and showed her the scene. "Two weeks ago tomorrow," she whispered to the baby. "Can you believe it?" She turned Jane in her arms to look into her clear blue-grey eyes. "Seems as if I've known you forever. I suppose in my heart I have."

As Emily stood murmuring to the baby, she noticed Reverend Ben coming out of the church. He looked distracted, deep in thought until he noticed her. She smiled and waved as he walked over.

"Are you here to teach Jane the true meaning of Christmas before she gets corrupted by toy commercials?" he inquired.

"Not really," Emily admitted. "We were just reminiscing. It will be two weeks to-

morrow that I found her, right in this very spot."

Ben finally smiled. "We ought to commemorate the spot with a plaque or something."

"Perhaps." Emily's tone was cautious. So many remarks about the baby, kindly meant, only served to remind her of their temporary situation.

Ben seemed to sense her thoughts. He placed his hand gently on her arm. "You've taken quite a risk. You're out on the high trapeze without a net."

"Yes, that's what it feels like sometimes," she admitted.

"I'm proud of you," he said. "And I'm praying for you, too."

"Thank you, Ben. I think I need the prayers."

He shook his head. "No thanks necessary. You didn't ask my advice on this, I noticed. Were you afraid I'd be against it?"

"No, not really. It all happened so quickly, I didn't ask anyone. It was something I just felt I had to do . . . almost as if some power I didn't have any control over was pushing me forward." She met his gaze. "That sounds silly, doesn't it? I mean, we always have a choice over our actions."

"It doesn't sound silly. Not to me anyway." He looked at Jane again, touching her lightly under the chin with his fingertip until she smiled back at him. "We can't ignore our inner voice, our intuitive feelings. Some people might say that's the way angels advise us."

Emily was surprised. She had rarely heard Reverend Ben talk of angels or intuition.

Finally, he looked back up at Emily. "How will you make it home with that stroller? The side streets are still snowy. Do you need a lift?"

"My car is parked down the street. We'll be fine, thanks."

"All right then. See you soon, Emily." Ben dug his hands in his coat pockets and started off.

Emily watched his determined stride as he crossed the green. He had been in a thoughtful, subdued mood lately. She hoped everything was well with his family. He had been through so much in his private life the past few years. Their minister was an inspiring example of a man who navigated life's perilous seas with a compass of faith and a sail of solid character. She wondered if he knew how important he was to the congregation, how much he

was respected and needed.

Ben drove home, his mind not on the meeting he had just had with Emily but on the call he had received that day confirming that he was eligible for a sabbatical. He had spent the rest of the day researching his options: where he might go and what he might do. The notion of hard, meaningful mission work still drew him. He couldn't focus on much else.

It was the right time to tell Carolyn, he decided, while he still felt the urgency to take some action, before self-doubt and conflicted feelings set in.

He entered his house and shrugged off his coat and muffler, hanging them up on the rack in the foyer. He heard the piano in the living room. Dvořák, he thought, and not too bad — an advanced student, though not Carolyn's fluid, knowing touch. It had taken her some time to get back to giving lessons after her stroke, but she loved to teach and had been much happier once she returned to work.

Could she teach piano students if we lived in Tanzania? he wondered. Well, of course she could. Sharing her knowledge of music would be a rare and great gift

under those circumstances. He just hoped she would see it that way.

Ben drifted into the kitchen and made a cup of tea for himself, listening for the sounds of voices in the hallway and the front door opening. Ten minutes later the student was gone, and Carolyn came into the kitchen. She looked energized and cheerful, pleased with the student's progress, he thought.

"I thought I heard you come in." She walked over to him and kissed him on the cheek, then looked up at the clock. "You're home early," she said, turning on the kettle and putting a tea bag in a mug for herself. "Do you feel all right?"

"I feel fine, better than I have in a while," he told her. "I had some good news today. I looked into my eligibility for a sabbatical. I definitely qualify, so I started the process to apply."

Carolyn turned, her expression halfway between surprise and alarm. "A sabbatical? Really? I didn't know you were thinking of that."

"I told you I was thinking of something like that, dear. Remember the other night when we talked, the night the kids came over? I asked if you ever thought about moving away for a while, doing something

different with our lives."

"Yes, but I thought you meant . . . oh, I don't know, finding a new church maybe. You never said anything about a sabbatical."

He realized now that he hadn't. Not those exact words. He'd been carrying all this around so much in his own head, he needed to give Carolyn time to catch up a few steps.

"You're right. I never used the exact word, but Walter suggested the idea. And once I thought it over and prayed about it, it seemed like a good solution."

She stared at him. The kettle's shrill whistle sounded. She turned suddenly, shut off the stove, and then poured the water for her tea. "Have you made out an application?"

"The paperwork should be coming in the mail in a day or two. I expect I'll be approved without any problem."

Carolyn brought her cup to the table and sat down across from him. "Then what?"

"Well . . ." He hesitated. This was the hard part — persuading her to move away from here for a while. "I've looked into mission opportunities, some in Africa and Asia. I've also written to James, asking if he

needs help on the reservation."

Carolyn didn't reply. She sipped her tea, avoiding his gaze.

"Well?" he asked finally. "What do you think?"

"I'm surprised. I'm shocked, actually." She met his gaze, the bright look gone from her eyes.

"I'm sorry, Carolyn, but I thought you realized that I've been unhappy lately and thinking about making some real changes."

"Yes," she said slowly. "I know that you've been troubled, Ben. I've prayed that you would find some answer to your questions, some peace of mind and a new direction." He could see that she was trying hard to soften her reaction, to show him sympathy and understanding.

"Thank you, dear. It looks as if your prayers have been answered."

"You know what they say, 'Be careful of what you pray for. You just might get it.' " She forced a smile. "I never dreamed you would come home early one day and announce you want to move to the other side of the world." She took a sip of tea, as if needing the pause to organize her thoughts. "I've heard you, Ben. I really have been listening these last few weeks, and I've been concerned about you. I defi-

nitely think something serious is going on. But this idea seems . . . impulsive to me."

Impulsive? He sat back, at a loss for words. *Am I asking too much of her, Lord? Or is she not trying hard enough to understand?*

"Is this really the solution, Ben? Is there no other way?" she asked quietly.

Ben knew he couldn't soften the truth; he had to be completely honest. "I'm dissatisfied, unfulfilled," he said carefully. "I've fallen into a rut and I feel as if I've led the congregation into a spiritual rut, too. I've lost my sense of purpose, the sense that I'm making a difference. I feel as if I'm failing them, Carolyn. Even worse, I'm failing to keep the promises I've made to God."

"I don't agree. I don't see you as a failure at all. But I can see how the job might wear on you — the same events one season to the next, the same problems."

He nodded. At least she understood and acknowledged that much.

"But the idea of such a big move, Ben . . . it frightens me," she said plainly. "It seems as if our lives have just gotten back on track. First Mark leaving us, and then my stroke. It's taken awhile to recover, to get our wind back. We have a lot

to be thankful for, Ben. So much really."

"I'm not denying that, Carolyn. I am thankful. But that doesn't seem to mitigate or compensate for what I'm facing now. Do you understand at all?" he appealed to her.

"I think I do," she said, her words also carefully chosen. "But life isn't lived all at one speed or one level; there are peaks and valleys. You even told me that once. Maybe you're just in a valley right now. You may even be there for a reason, I don't know. But I do know it will pass. Something will happen and things will change. They always do."

It was hard for Ben to hear his own reasonable counsel tossed back at him. He had told Carolyn that once, and he did believe it.

He tried again. "I am in a valley, Carolyn. And I believe there's a reason for it. I believe God is directing me to some other place, at least for a while."

She didn't answer, but gazed at him levelly, her expression still and unreadable.

"I've been thinking about this a lot." He forced himself to go on, to say the words that were so difficult. "If you don't want to leave here, maybe I should consider going on my own."

She stared back as if he had struck her across the face.

"You would go anyway. Without me." It wasn't really a question. She said the words as if to clarify, as if the idea was so unbelievable she had to say it out loud to fully understand.

Ben felt sad. He knew he had hurt her, which was the last thing he wanted to do. But this was a serious moment in his life and he needed to help himself, or he knew he wouldn't be any good to anyone else.

"I can see all the reasons why you want to stay," he assured her. "If that's your choice, I'll understand and accept it. I just thought . . . well, that you would want to come with me. We've never really been apart more than a night or two our entire married life," he reminded her. "I need to do this, Carolyn. I wouldn't take such a step if I didn't feel so strongly. It's not just a whim."

She nodded quickly, staring down. "Yes, I know it's not a whim, Ben. Still, I feel a little hurt that you could really go without me."

She looked up at him, his dear wife and life's companion. He forced a small smile. "I haven't left yet," he reminded her.

He reached across the table and took her

hand. Neither spoke for what seemed a long time.

Finally she said, "When you asked me to marry you, I didn't know what to do. I loved you with all my heart, but I didn't think I had what it took to be a minister's wife. Do you remember?"

He nodded. "Yes, I do."

"But you talked me into it. You persuaded me that I would be just fine, that our family would be just like everyone else's. You said I didn't have to be some model of female perfection." She laughed, remembering. "And I wasn't."

He smiled, but didn't interrupt her.

"I knew when I married you that our lives would be different. No matter what you said, your job is . . . unusual. It's not even a job really. Not like some husband who's an accountant or a plumber. Your stock-and-trade is with the spirit; it's with God. If you believe you've been called to leave here, then I can't dig in my heels like some suburban housewife upset about a job transfer."

He nodded thankfully and squeezed her hand, too moved to speak.

"I knew what I was taking on when I married you," she said. "I made that promise. If you go, I'll go with you. Your

ministry is more than your job; it's you having dedicated your life to God's work. It's your heart and soul. I can't hold myself apart from that. What kind of marriage would that be?"

Ben gazed at his wife, his vision blurred with tears. His heart was filled with love for her. More than love, he thought. He felt they were as close at that moment as two people could ever be.

"What about Rachel and Jack, and little Will? I know you'll miss them."

"Oh, of course I will. But they'll be all right. They'll appreciate us more when we come back." She sighed, a little teary, too, he noticed. "When do you think this will all happen, Ben? Very soon?"

"I was thinking I would leave the church in February, if I can find an interim minister by then. But I don't want to tell anyone yet, not until the plans are firmer. I have to go to the church council first, then the congregation. I'd rather not say anything about it before Christmas, until I send in all the paperwork and the request is formally approved."

"I understand. I won't mention it. Not even to Rachel," she added.

He knew that would be hard for her, especially with Christmas coming. Carolyn

was already having a hard time with the idea of Mark leaving; now an even greater cloud had drifted overhead.

They would get through the holidays as best they could, Ben decided. The season didn't seem nearly so oppressive to him now, having made this plan.

Chapter Nine

"This is my office number, the direct line, and this is my secretary's. And this is my cell and Dan's. And here's my sister, Jessica's number, though I think she's working today, but you can call her if you have a problem. And this is the number for the doctor, Dr. Harding; he's right in town. And here's the phone number for the fire department, too."

Emily felt breathless, having worked her way down the list taped to the refrigerator door. The new babysitter, Liz Barrow, nodded, her expression calm and pleasant. She wasn't very old, Emily thought, only in her mid-twenties. But she'd come from an agency and had lots of experience, and all her references had checked out well.

Dressed for work in a black wool suit and black heels, her makeup done right and her hair blown out, Emily looked all business again. But she felt as if she were wearing a costume. It was funny how just one week away from the office and spending time with Jane had changed her perspective.

The only thing that felt right was the baby, balanced on her hip. She hated now to hand her over and wished there were some way Jane could come along with her. But she'd tried that last week and it hadn't gone over very well, she reminded herself.

Emily wasn't even going to be at the Village Hall for most of the day. She had a meeting at the county seat in Southport, more than an hour away. She wished that she could run home during lunch and check on the baby, but it just wasn't to be. Tomorrow for sure, she promised herself, she would try to find some way to come home early.

Dan had already left. He was going to a shipbuilding museum in Essex to interview the town historian. He wasn't very far, he reminded her. He would stop in at some point and make sure everything was going all right.

"Don't worry; the baby will be fine. Lots

of kids are left with sitters every day," he had said as he set off that morning.

Emily hadn't answered. It wasn't the same for him. He didn't understand.

Now she sighed, looking down at Jane, who seemed so content in her arms. Emily kissed the baby on the cheek and handed her over to the sitter, feeling a pang in her heart.

"All right. I'd better go. Make sure you lock the doors." She forced herself to put on her coat and grab her briefcase. "I'll call later when I have a break. And you can call me anytime. Don't even hesitate."

"No problem." The sitter followed Emily to the door. "I'm sure everything will go fine, but if I have any questions, I'll be sure to call." She turned to the baby and smiled widely. "We're going to have fun today, Janie. Aren't we?"

Emily took one last look at the baby, then turned and headed out to the car. For a few moments she sat in the driver's seat, letting the engine warm up. The car smelled of the baby, of hand wipes and formula. She felt that little twist again and tried to ignore it.

It was a good sign that Dan had offered to come home and check on the sitter, she thought. He was kind to the baby, if still a

bit aloof. At least he was showing an interest. She hoped that in time, Jane's charm would wear down his defenses. But she had to admit, Dan was good at keeping up his "force field" when he wanted to.

How much time did they have? She wasn't sure. The social worker had said the investigation would take about four weeks. That meant only two weeks more.

She hoped Dan's feelings would soften. The past week of caring for the baby had only confirmed her initial impulse: she was convinced they needed to apply to be Jane's adoptive parents if a relative didn't come forward. But she didn't dare mention it to Dan yet. It was just what she had promised not to do, argue for that next step. It would be going back on her word to him.

I'll bring it up when and if the time is right, she told herself, then added a quick prayer. "Oh, Lord, please let there be a right time and let us do the right thing for Jane."

Dan wrapped up his research at the museum in Essex much earlier than he'd planned. Just as he promised Emily, he called the sitter to check up three times, but had gotten an endless busy signal. He

even called the operator to see if the phone was off the hook. No, someone was using it, she said.

That annoyed him. They weren't paying this young woman to talk on the phone all day. Emily must be apoplectic if she had been trying to call, too. He wondered why Emily hadn't called him yet, but then realized she must still be hung up in her meeting.

The drive from Essex back to Cape Light didn't take long. Dan pulled into the driveway and walked in through the back door, which had been left unlocked, he noticed.

He was hungry and wanted some lunch. The kitchen was a mess, looking even worse than when he had left that morning.

"Hello? Anybody home?" he called out. "It's me, Liz. . . ."

He walked into the living room, the sound of the TV growing louder. Jane was in her portacrib, set up near the sofa. She was lying on her stomach, surrounded by toys and screaming her lungs out. The sitter was watching TV and talking on the phone, a bowl of popcorn in her lap.

No wonder she hadn't heard him come in. Dan walked right up to her and tapped her hard on the shoulder.

"Ahhh!" She screamed and jumped up, dropping the phone and spilling the popcorn in all directions.

Dan leaned over and picked up the receiver. "Liz has to go now. So long." He hung up and looked at the sitter, eyes narrowed.

"Mr. Forbes . . . I didn't hear you come in." She took a step back and started toward the baby. "I don't know why she's crying all of a sudden. Maybe she's teething or something."

"Don't bother, I'll get her." Dan literally pushed the young woman aside to reach Jane first. He leaned over and scooped up the baby, who was red faced and gasping.

"Now, now. It's all right, little girl. I'm here," he whispered. He held her close, tucking her head to his shoulder. She felt so hot, he thought. Her skin was on fire. Was it right for a baby to feel so warm? She never felt this way before when he held her. "She's so hot," he said to the sitter.

Liz peered at the baby. "She has a lot of clothes on. Maybe she's overdressed."

Dan stared at her. "You're fired. Don't come back here."

The young woman glared at Dan for a minute, then turned on her heel and picked up her purse and coat, which were

tossed on a chair. "Fine. Watch your own stupid baby."

She stalked out of the living room and slammed the door. Dan barely noticed. He clicked off the TV with one hand and carried Jane into the kitchen.

"Dr. Harding, Dr. Harding . . ." he mumbled nervously as he scanned Emily's endless list of phone numbers. Finally, Harding. Dan grabbed a phone and punched in the numbers with his thumb.

Busy signal. He dropped the phone and paced around the kitchen. Jane was crying fiercely. The sound of the child wailing and the mounting anxiety threw him back, way back to the days when he was a young father and this was Lindsay, in his arms. His little Lindsay, who was now running the newspaper. His wife, Claire, had gone somewhere, overnight to see her mother who was ill. She couldn't take the baby and she didn't trust Dan to watch her. Dan had never watched Lindsay on his own before, but he was willing to give it a try.

Claire had left angrily, as if daring him to take care of his daughter alone. And the baby had gotten sick, a high fever. By the time he noticed, she was going into convulsions. He didn't know what to do. He felt so helpless. He called Claire to come

home. She told him to meet her at the hospital. She had been so angry, saying he should have noticed Lindsay was sick. That it was just like him — in his own world, never thinking of anyone else.

But Claire had been strangely pleased to have been proven right, Dan realized later. In her mind, all her accusations had been validated. He wasn't a good father. The newspaper always came first, even before his own children. He was cold and selfish. So egotistical.

Dan sat down in a chair, trying to soothe the child, feeling overwhelmed by the wave of dark memories, of failures and disappointments. He was a success in his professional life, an award-winning publisher of a small-town paper, but he was a failure as a husband and a father. No wonder he had been a workaholic. Putting out a paper was the only thing he ever felt truly good at.

He glanced down at Jane, who had stopped crying, finally. Her eyes were glassy, her cheeks red. He had to do something; he would take her to the doctor. Right away. "Come on, little girl. Come with me. We're going to get you some help and make you better."

He found a big blanket and her baby bag and had her in the car moments later.

When they reached Dr. Harding's office, he found a parking space right in front. He ran into the doctor's office, Jane wrapped in a blanket and held close to his chest.

"My little girl is very sick. She has a high fever. I tried to call but the line was busy," he explained to the woman at the desk.

She barely glanced up. "Your name, please?"

"Dan Forbes. This is Jane. I'm not her real father. I'm her guardian . . ." Dan swallowed hard. He was trying not to scream. Couldn't this woman see this was an emergency?

She started typing on a computer keyboard. "I can't find anything under Forbes. You've been here before, you said?"

"Warwick. Try Warwick, then," he said through gritted teeth.

"Is the name Forbes or Warwick? I'm sorry, I don't understand."

"It's Forbes. My name is Dan Forbes. My wife's name is Emily Warwick. Ring a bell?" he asked tightly.

"Oh, of course, the mayor. Is she a patient here? I'm rather new." More typing on the keyboard. Dan nearly screamed in frustration. He wasn't trying to buy an airline ticket; he just wanted to see the doctor.

"Why don't you take a seat over there, Mr. Forbes? I'll call you when —"

"You don't seem to understand . . ." Dan could hear his voice getting louder. A woman reading a magazine in the waiting room frowned at him, her brows drawn together in disapproval.

Dan was about two seconds from exploding when Matt Harding stepped out from one of the exam rooms and came toward him.

"Dan, what's up?" He looked down at the baby swathed in the plaid blanket.

"She has a high fever. Emily is up in Southport. I didn't know what to do so I brought her here."

"Bring her right in. Let's have a look."

Dan followed Dr. Harding into an exam room. The doctor took the baby and gently placed her on the exam table. He unwrapped the blanket and opened her outfit, then listened to her heartbeat and felt her neck and abdomen.

"She has a rash on her stomach," he said. "Was this here this morning?"

"I'm sure it wasn't. Emily examines every inch of her. She would have stayed home from work if she saw anything like that."

The baby looked so small and helpless,

Dan's heart went out to her.

Matt stuck an electronic thermometer in Jane's ear, and it quickly started beeping. "One hundred four. That's high, even for an infant. How long has she been crying like this?"

"I don't know. I came back home about an hour ago. This nightmare of a sitter we hired had Jane stuck in her crib while she watched TV. The poor thing was screaming her lungs out."

"I see. Don't worry . . . we'll figure it out," Matt promised as he continued to examine the baby.

Finally, he pulled off his stethoscope and turned to Dan. "She has an ear infection. Her head is all clogged up. These things can come on suddenly, especially in babies this age. It's very painful for her, though. That's why she's crying every time you put her down."

"That sounds awful. Can you give her something for it?"

"Absolutely. I'm going to give her a shot, and then you'll need to give her some antibiotics. The medicine should work quickly. The rash is a symptom of the infection. That will go away, too. She can have some Tylenol for the fever, too. Watch her temperature. Don't let it get too high. She

should have a tepid bath if it spikes up tonight, and plenty of fluids around the clock, as much as she'll take."

"All right." Dan nodded. "Can you write this all down?"

"Yes, of course I will."

Matt called in the nurse, who helped him give the baby her shot. Dan could hardly watch. Jane cried so hard afterward, he thought he might cry himself. Finally, she was dressed again, and the nurse placed her back in his arms.

"She's all tired out. She'll probably fall asleep right away," the nurse said gently.

Dan didn't answer. He rocked the baby awkwardly, to and fro, as he'd seen Emily do. Then he dipped his head down and kissed her softly on the forehead. Her soft hair tickled his nose.

Jane looked up at him a moment, wide eyed and silent, then slowly closed her eyes, as if she recognized who was holding her now and knew she didn't have to cry anymore.

Dan tried Emily's cell phone on the ride home. He couldn't believe he had waited so long to call her. But he only got her voice mail, so he left a brief message telling her to call him.

Jane slept peacefully in her car seat all the way home. She continued to sleep even when he brought her inside and put her to bed. Her forehead felt cooler and he felt deeply relieved.

He meant to go into the kitchen to grab something to eat and call Emily, but instead he lingered in the dimly lit room, watching the baby sleep.

He thought of the episode with Lindsay and his ex-wife again. Claire had rarely missed a chance to remind him that he wasn't a very good father. Well, he was a good father in some ways, Dan told himself. Both his kids had told him that, now that they had grown up and gotten out from under his wife's thumb. He just wasn't good when they were very little. He hadn't known what to do. He left too much to Claire and then felt inept even trying to make a peanut-butter sandwich.

That was partly Claire's doing, though. She had shut him out, acted as if helping with homework or serving a bowl of cold cereal was rocket science. It was mainly his fault, of course. He could see that now. He was always at the paper, practically slept there some nights, dedicated to a fault. Then he came home late one night and realized he had entirely missed out. His kids

had grown up while he was chasing a big story. In the years since then, he had tried to make it up to them. But he never really could.

"I didn't do too badly for you today, did I, Jane? We got through it all right," he whispered to the baby.

He wondered what kind of father he would make now. He sensed that Emily, for all her talk, was headed in that direction, determined to tug him along, too. She didn't really understand his hesitation. You don't want to take on a job as important as fatherhood when you believe you failed at it, screwed things up entirely. It was different now, though. He was different.

The question was, was he different enough to do this? It was so hard. He had gotten through today by the skin of his teeth. Maybe the answer was, he just wasn't sure. He didn't want to think about it now, anyway. He was just relieved to have handled the crisis.

The phone rang and Dan picked it up in the bedroom.

"Dan? You're home already? I didn't think you'd be getting back until three."

"I came back early. I couldn't reach the sitter so I got worried. I had to fire her,

Emily. She was a total disaster."

"What happened? Is Jane all right?" Emily was not quite in a panic, but Dan could tell from her voice she was getting there.

"She had a fever. I took her right over to Matt, and it seems she has an ear infection. She's much better now. She's got some medicine and some Tylenol to take —"

"An ear infection? Poor thing. I'm coming right home."

"If you want to. But she's sleeping now. Everything's under control," he promised. "I can take care of her."

It felt good to say the words, he realized. He meant them, too.

Emily didn't answer right away. "I know. I would just feel better if I came right away. I'll see you soon."

Emily ended the call, and Dan hung up. Then he left the room, but only after taking one last peek at the baby.

Emily came in about an hour later, which gave Dan time to relax and compose himself. He greeted her at the door, then took her coat and briefcase while she rushed back to see Jane.

"She's still sleeping," Emily said when he quietly entered the room. Emily reached into the crib and touched the

baby's forehead. "I don't think she has a fever anymore."

"That's good." Dan stood next to Emily and put his arm around her shoulder.

"I feel awful," Emily confessed. "I should have been home. I should have noticed that something was wrong with her this morning. She's been with us less than two weeks, and I'm flunking out already."

Emily sounded as if she was about to cry. Dan knew what she was feeling. He hugged her closer to comfort her.

"It's okay, honey. Matt said these things come on very quickly. You can't be everywhere at once. I was here. I took good care of her."

Emily glanced up at him. "Yes, I know. Thank you, Dan. I don't know what would have happened if you hadn't come home when you did."

"Let's not think about that. And you don't have to thank me. I'm her guardian, too."

Emily didn't answer. She leaned up and kissed his cheek; then she reached down and smoothed the baby's blanket.

"I know she must have been screaming bloody murder before, but she looks like an angel now," Emily said softly.

"She is an angel." Dan's voice was quiet,

but emphatic, his gaze still fixed on the baby. Emily glanced at him. He rarely sounded so sentimental.

"So are you. Lucky for me I have a husband who can handle these things so well without getting rattled."

Sara had to spend a few hours at the newspaper office on Saturday, finishing up a story for Monday's edition. Afterward, she found herself with nothing to do. She didn't want to go home to her empty apartment and hang around waiting for Luke to call. That wait would be in vain, she knew. They hadn't spoken or seen each other all week. It was one of the longest stalemates in the history of their relationship. Did they even have a relationship anymore, she wondered?

She did some errands and some half-hearted Christmas shopping. A few hours later, she found herself climbing the steps to her grandmother's house on Providence Street.

The mansarded Victorian was a historic treasure, at least architecturally. It wasn't the type of house, though, that people pointed out and admired. Painted slate grey with black shutters and white trim, its only ornaments were two cement urns at

the top of the walk that held dark green ivy.

It could really be something, Sara thought, if her grandmother cheered it up a bit. It was the type of house that would look spectacular trimmed with Christmas lights, the kind that cling to the roof edges and look like icicles.

But her grandmother's house was bare of all holiday decorations. Sara held the only possibilities forever in her hand — a large pine wreath with a red satin bow and a small tabletop Christmas tree. She also carried a shopping bag with gifts for Lillian.

From her first year in Cape Light, Sara had brought her grandmother a wreath every holiday season along with an amaryllis bulb that eventually sprouted a huge, trumpet-shaped red flower. Lillian's husband used to buy her one each year, so she accepted the amaryllis as tradition. The tree was a new idea, though, a sudden impulse. Sara fully expected that Lillian would complain about it at length, and also secretly prize it.

Sara sometimes wondered why she went to so much trouble for her grandmother, who rarely seemed to appreciate the effort. Yet there were things about Lillian that she

not only respected but also enjoyed — her sharp intellect, for one thing, and her quick, surprising wit. Her audacity, too. Lillian was her only grandparent and despite her prickly nature, they had managed to forge a genuine relationship.

Sara rang the brass doorbell. The place looked deserted as usual, the windows dark except for one small light up in the bedroom. Sara waited a long time, then rang the bell again. She knew Lillian was in there. Her grandmother did need extra time to get to the door, but it was also her particularity about accepting visitors that made her reception so slow.

The corner of the curtain in the living room window shifted slightly, and Sara took that as an encouraging sign. "It's me — Sara," she said forcefully. "I know you're in there, Lillian."

She waited a few more minutes, thinking she might just leave everything on the doorstep. Finally a light clicked on in the foyer and the big door opened.

"What are you doing here? Did your mother send you to see if I was still breathing?"

Sara ignored her grandmother's play for sympathy. "Yes, exactly. I figured the wreath could be used either way," she said

lightly, hiding a small smile.

"Touché, young lady. You may enter," Lillian said grandly. She opened the door all the way and Sara stepped inside.

"What do you have there? Is that pathetic stalk of greenery supposed to be a Christmas tree?" Lillian reared back, taking in the tiny tree. "I hope you didn't pay much for it. And I don't want a tree in the house, for goodness sake. What a pagan tradition. They make a huge mess, and who's going to clean up those pine needles and do all the decorating?"

"Calm down, Lillian. It's hardly a tree. More like a Christmas . . . branch."

Sara brought the tree into the living room and looked for a good spot to set it up. The rooms in Lillian's house were spacious but crammed with furniture, large antique pieces that had come from the Warwick family estate — a real mansion that was now a historic site owned by the town.

When Lillian's husband, Oliver, was caught in a business scandal, they had been forced to sell everything. Lillian had kept the family together and courageously pulled them through the crisis, though not without a cost to her spirit, Sara knew.

"How about right here, by the window?"

Sara held the tree up over a small table that was covered with bric-a-brac. "I'll just move some of these photos and things. Then you can see it when you come in the room."

Lillian had followed her at a snail's pace, walking slowly with her cane. She waved her hand at Sara and sat in her favorite high-backed armchair, the one that made her look like an ancient queen on her throne, Sara thought.

"Why ask me? I only live here. You seem determined to plant that thing in my house, no matter what I say. You pick the spot. It clearly doesn't matter what I think about it."

"Okay then," Sara said brightly. She re-arranged the table, making space for the tree.

"For goodness sakes, don't break anything," Lillian called out sharply.

"Don't worry." Sara placed the tree in the middle of the empty table. It looked cute, but too bare.

"Don't you have any ornaments, Lillian? I thought a few years ago you put up a tree in here."

"Of course I have ornaments. Very fine ones, handblown glass. They don't make ornaments like that anymore." Lillian

shifted in her chair. "They're up in the attic, though. I have no idea where."

"I'll go up and get them," Sara offered. "It won't take long."

Sara had ventured into Lillian's attic on a few other occasions and actually liked exploring up there.

For once Lillian didn't object. "All right, you know the way. Just don't get lost up there. The boxes are marked Christmas, of course. Just bring down one or two. I don't want to turn this place into Santa's workshop, for goodness sakes."

"No chance of that," Sara said dryly. She ran up the three flights to the attic and pulled on the string that controlled the light. A weak light bathed the shadowy space; it was just enough to help her find her way around. Sara was tempted to peer inside the trunks of old clothes and cartons that held the history of the family. But she knew Lillian was waiting impatiently and would start calling if she took too long.

She found a dusty old box marked Christmas. Inside were ornaments wrapped in yellowed tissue paper. The tree was so small, a single box would do, she decided, and carefully carried it down the stairs.

"What took you so long? Did you get

311

lost up there?" Lillian watched her as she came down the last few steps into the foyer.

"It's a mess up there. You really ought to find someone to put it all in order for you, Lillian."

"Hire someone, you mean? Why should I? There will be plenty of volunteers when I'm dead and buried; you'll see."

Sara shook her head but didn't laugh. Her grandmother could connect the most innocent comment to her imminent demise. Reminding everyone of her fragile mortality seemed to be one of her favorite pastimes.

You're so stubborn, you'll probably outlive all of us, Sara often wanted to say.

Sara could have made short work of trimming the tiny branch of pine, but Lillian watched closely, micromanaging the placement of the antique ornaments and relating some long story about each one.

"Those round red balls with the reindeer design come from Switzerland. We spent Christmas there one year, when your mother was just a baby, in a chalet on Lake Lucerne. My husband, Oliver, was a great sportsman, loved to ski. I couldn't stand it — foolish sport, sliding around the snow

312

with planks of wood strapped to your feet. Ridiculous." She sighed, remembering. "The Alps are spectacular, though. You really ought to travel, Sara. That's what you should be doing at your age. I can show you some pictures someday."

Sara stood up and brushed off her hands. "I'd like to see them, Lillian. You know how I love your old photographs."

Lillian had made them some tea while Sara was working on the tree and served it on a silver tray alongside a dish of tea biscuits. Sara was familiar with the dry, hard cookies, which lived in a little tin in Lillian's kitchen. They must have taken up residence there about the year that she herself had been born.

There should be some music and a fire in the hearth, Sara thought, but the little tree had definitely brightened up the room and made it feel more like Christmas.

"I have some gifts for you in that bag, but you can't open them until Christmas," Sara teased her. "I'll put them under the tree."

"I have one for you, too . . . somewhere. Oh yes, over there on the dining room table. I wrapped it today. A premonition of your arrival, I suppose. It's not much," she warned Sara. "You know how I despise

holiday shopping, all the expense and fuss. It's just a big swindle that the shopping malls manage to put over every year. People are like sheep. They have no common sense."

"I agree there's too much commercialism this time of year, Lillian. But I wouldn't call the entire holiday a big *swindle*."

"Of course it is, silly girl. Open your eyes. This Christmas malarkey is about as genuine as the beard on a department store Santa. It's a corporate conspiracy. Conscienceless lot, too. The way they use the children, it's shameful. Making the parents feel guilty if they aren't buying their kids everything under the sun. My children were never spoiled at Christmas, I'll promise you that."

"I believe you." Sara couldn't even imagine Lillian spoiling a child.

"So." Lillian smoothed her skirt over her boney knees. "I hear your mother still has custody of that foundling. I hear she disgraced herself, too, carting the child into a very important meeting at Village Hall."

Lillian was obviously keeping a close eye on the situation despite her distant perch. Sara wasn't surprised. Lillian acted aloof but was actually quite interested, al-

ways fishing for news.

"You should have been a reporter, Lillian. Sounds like you have some good sources."

"Nonsense. Your mother is being gossiped about all over town, and not in a very kindly way. One more stunt like that and she'll be up in front of the town council. Then what? Is it worth losing her office over this . . . baby?"

"Lillian, you exaggerate. She's found a full-time sitter now, an older woman from church, Blanche Hatcher. I'm sure Emily can figure out how to be mayor and have a baby."

Lillian grunted with disapproval. "So she's going through with this then? I thought it was only temporary."

"The social service agency should be concluding their search for relatives soon, maybe by the end of the week," Sara explained. "Then the baby will be free to be adopted."

Sara paused. She didn't know how much she should share with Lillian. Since the scene at church, Emily hadn't spoken with her mother at all, though she did get reports from Jessica that all was well.

"I'm sure my daughter wants to proceed with this madness," Lillian said. "Though

I'm not so sure about her husband. He seems too settled in his ways for such an adjustment." A keen observation, Sara thought. Lillian was actually paying more attention than people realized.

"I know everyone thinks this is all so warm and wonderful, but it's not. For one thing, Emily is likely to get hurt," Lillian insisted. "There are probably a lot of younger couples who have been on these lists, waiting for a baby. Rich husbands with stay-at-home wives who are a far better bet than middle-aged newlyweds with a workaholic streak. What makes Emily think she's going to get this baby anyway?" Lillian asked. "Why is she so obsessed with the child?"

Sara put her teacup down and looked at her grandmother squarely. She had considered this question herself and could come to only one conclusion.

"Maybe because she had to give me up."

Lillian glared at her. "Because I made her. Isn't that what you mean to say?"

Her grandmother didn't seem the least bit rattled. She sat back in her chair, squared her shoulders, and lifted her chin. "That's the family legend anyway. Well, I won't apologize. I've said it before and I'll say it again. I did what I thought was best

for her. For everybody. It wasn't easy for me. When you have a child, you'll see. You'll have to make some hard calls," she said knowingly. "Emily might find she has to give this baby up, too. And she won't be able to blame me this time, thank goodness."

For all Lillian's anger, she did have a point. It would be ironic if that happened, Sara realized. Despite her own mixed feelings about the baby, she didn't want Emily to be hurt again.

"Let's hope it doesn't come to that," Sara said, wanting to put the subject aside.

"When will they know? By Christmas, do you think?"

"Probably," Sara answered.

"Well, it might not be such a happy holiday on that side of town," Lillian observed. "Where will you be? Will you stay here or visit your *other* family?"

The ironic note at the mention of her granddaughter's adoptive parents was not lost on Sara, though she pretended not to notice it.

"I'll be down in Maryland. My parents have asked me to come for a visit. I'm looking forward to it, actually."

She was looking forward to being back in her old house where she could have some

distance from her problems with Luke.

"And what about your boyfriend? Will he go with you?" Lillian asked curiously.

"No." After her initial invitation they hadn't talked again about Luke visiting Winston for Christmas. There's no way he was coming with her now, she realized.

"He'll probably just hang around here then," Lillian said, "looking to crash our family party with that hangdog expression of his."

Sara had to laugh. Luke didn't have a hangdog expression, but he had appeared uninvited at Lillian's doorstep more than once, which drove her grandmother crazy. Lillian had enough trouble welcoming guests into her home who were actually invited.

"I doubt he'll do that," Sara said finally. "I don't know what he's doing for Christmas."

Lillian looked surprised and stared at her curiously. "Hmm, that sounds rather ominous. Are you two getting tired of each other?" Lillian paused, but Sara didn't answer. "I've never thought he was at your level, Sara. I'm sure you could do better. This isn't the worst news I've heard lately, by any means."

"Yes, I know how you feel about Luke."

Sara hardly considered herself "too good" for Luke. He was about as good as good gets. She doubted she could ever do better, though it looked as if she would have a chance to test Lillian's theory, Sara thought glumly.

The last light had faded and Lillian moved about, turning on her little china lamps. Sara had no plans for the evening. She wondered if her grandmother wanted to go out for a bite of dinner or maybe to a movie. Had Lillian ever gone out to see a movie, Sara wondered. Not since she'd known her, and probably not since *Gone with the Wind* was in the theaters.

The doorbell rang. Lillian was in the dining room, holding Sara's present.

"That must be Ezra," she said, not sounding very cheered at his arrival. "He's persuaded me to be a fourth at bridge. Some group of old fogies he plays with on Saturday nights. I told him quite clearly I wasn't interested, but he wouldn't take no for an answer."

"Oh, go ahead," Sara encouraged her. "It will be good for you to get out of the house."

"Why is that? Why is everyone always trying to get me out of my house? I like my house. I'm comfortable here. Other peo-

ple's houses are not nearly as nice. I'm sure it will be a very tiresome evening with this geriatric bridge group. I'm sure half of them won't be able to remember any of the plays."

The bell rang again and finally Sara went to answer it. She couldn't stand arguing with Lillian all night while poor Dr. Elliot cooled his heels on the porch.

"Hello, Sara. Good to see you." Dr. Elliot looked neat and jaunty as usual, in a blue overcoat and a silk muffler. He put his coat and hat in the foyer on the long bench and followed Sara into the living room.

"Are you ready to go, Lillian? I thought we could stop for a bite to eat first."

Hmmm. Sounded like a real date, Sara thought with a secret smile. She wanted to tease her grandmother but didn't dare.

"I already told you, Ezra, I'm not going anywhere. I don't know why you even bothered to come here. . . ."

While Lillian and Dr. Elliot bickered about the bridge party, Sara gathered her things and headed for the door.

"Good night, Lillian, Ezra. I've got to run."

"Good night, Sara. Good to see you, dear," Dr. Elliot said. "Don't worry about your grandmother. I'll take it from here."

Lillian glared at him. "Good night, Sara," she said. "Thank you for the Christmas tree. I hope you'll return in the New Year to clean up the pine needles before they ruin my Persian rugs."

"I will," Sara promised, "and I'll call before I leave for Maryland."

"Yes, do." Lillian nodded regally. "I'd like to hear from you." Which was just about her limit of showing interest and affection, Sara realized, though she did believe that in some secret place Lillian harbored a great deal of affection for her.

Sara was soon outside, on her own again. She walked quickly to her car and drove away, though she didn't quite know where she was going. It was only six o'clock — too early to go home.

Even her grandmother had plans tonight and she was all alone. She wondered what Luke was up to but refused to break down and call him. She didn't want to get his answering machine, or call him on the cell phone and hear Christina's voice in the background. She'd be up all night speculating on what they were doing.

She'd be up all night speculating anyway, she realized. It wasn't a good feeling.

Chapter Ten

~❧

Warren Oakes handed Emily a thick sheaf of documents. "I've looked into this petition from the developers," he said. "It doesn't hold water. There are solid legal grounds to toss it out. It's a bit complicated, though. Do you want to go into it now?"

Emily skimmed the top document, her sight blurring at the dense lines of legalese. "It's all right, I believe you. I can look at this later." She leaned back in her chair and glanced at the clock. The hands were creeping toward twelve, when she would be free to run back home and check on Jane.

The hours away from the baby seemed to grow longer and longer. She found it especially hard this Monday, after she had

spent all weekend with Jane. She and Dan had enjoyed themselves, just puttering around the house, finally putting up the Christmas tree and decorations. While Emily knew the baby couldn't tell one way or the other, it just seemed much more fun preparing for the holiday with Jane around.

"The thing is," Warren continued, "do you really want to take on this fight? It could hurt you and undo all the good work we've managed so far. It's not only the zoning board who wants this. Go out and talk to anyone on the street. They'll all say they're in favor of knocking down those old hotels."

"Anyone who doesn't live there, you mean." Emily sat back in her chair and pulled off her reading glasses. "I'm all for getting after the landlords to improve those buildings, Warren. I'm all for reassessing the property taxes, too, if that's valid. Every neighborhood in this town should be clean, safe, and secure for our residents. But I won't sit by and watch a few greedy people profit while hundreds of others, who don't have any power or influence, get pushed right out of their homes."

Warren stared down at the yellow legal pad balanced on his knee and jotted something down.

When he didn't say anything, she added, "If that makes me unpopular, I'll live with it. I don't think I could be very happy with myself if I didn't try to stop this, even at the risk of losing support in the town council or the nomination next term."

"All right then." He sighed and stood up. "Don't say I didn't warn you."

Emily shrugged. "You knew where I stood. I don't think you expected me to change horses on this situation, did you?"

"No, I really didn't. Just thought I should warn you. Your pony is headed over a cliff, Emily." His tone was discouraging, but his smile strangely affectionate.

"Yes, Don Quixote's old horse. Or did he ride a donkey?"

Warren laughed quietly as he left her office. The phone light was blinking on her private line, and Emily quickly picked up, worried it might be the new sitter, Blanche Hatcher. They had spread the word through church and found the perfect candidate, a woman in her early sixties, energetic and sharp but a warm and loving grandmother type.

Emily answered the phone to find it wasn't Blanche at all, but Nadine Preston, Jane's social worker. Nadine had visited the house twice so far to check on Jane's

progress and often called for updates. Emily was starting to feel close to Nadine, as if they were longtime friends. Nadine was certainly an intimate witness to an emotionally challenging moment in her life.

"Sorry to bother you at work, Emily," Nadine began.

"That's all right. I'm just out of a meeting. What's up? Oh, before I forget, Jane had a doctor's appointment yesterday. She's gained two pounds and grown almost an inch since Thanksgiving. And Dr. Harding says the ear thing is totally cleared up."

"I'm glad to hear it. She looked very well cared for and alert when I saw you last." Nadine paused. Emily sensed she had something specific to talk about. This wasn't just a casual call.

"I have some news. We may have located a relative. We're not certain yet if this is so, or what it might mean for the baby. But I thought you and Dan should know."

Emily felt stunned, the breath knocked right out of her. She couldn't speak for what seemed like an endless moment.

"Is it Jane's mother? Have you found her?"

"No, there's no sign of Jane's mother.

That seems to be conclusive. But there may be some family connection."

"I see." Emily took a breath; her pulse was racing. "Is this relative someplace nearby?"

"I'm sorry, Emily. I'm not allowed to say."

"Yes, of course. I understand. When will you know for sure?"

"It will take awhile to see how this all sorts itself out. Then with Christmas coming, the office closes and everything stops. You know how that is."

"Yes, I do," Emily said glumly.

Christmas Eve was this coming Saturday, but offices would slow down for parties; many people would leave town for the holidays by midweek. She and Dan would be left in the dark, waiting and worrying all through Christmas. Emily had been enjoying such sweet fantasies of the holidays, with Jane free to be adopted and she and Dan somehow in agreement to do it.

"I'm sorry, Emily. I know this is a shock for you. I'll try to do all I can to get some definitive answer quickly."

"Thanks. I know you will, Nadine." Her tone subdued, Emily said good-bye and hung up the phone.

She turned in her chair and stared out the window. It was a clear, sunny day, remarkably mild for a few days before Christmas. Emily turned back to her desk, began clearing up paperwork, and then abruptly stopped.

What was she doing sitting here when she had so few hours left with Jane? She wasn't going to waste that precious time sitting in an office.

Let the town fire me if they want to, she decided in a misplaced, stormy huff. *I'm going home for the day to be with my little girl.*

My little girl — the thought caught her short. When had she started thinking of Jane that way? Well, at some point between the moment she found her and now. It was a foolish and dangerous way to be thinking, especially in light of Nadine's call. But Emily knew she couldn't help it. She was in love, plain and simple.

A short time later, Emily had Jane all to herself. Blanche was happy to have the rest of the day free, eager to finish her Christmas shopping. Emily knew the feeling. All of last week had been a frenzy of shopping and decorating, and she still wasn't finished. But today she wanted to devote her full attention to Jane. It was

hard to put her down even for a moment, Emily thought, as she snuggled the baby close and fed her a bottle.

She leaned over and softly kissed the baby's brow. *Dear God, please let Jane stay with us,* she prayed silently and quickly. *Please don't take her away like this.*

She wasn't in the mood to hang around the house, looking at all the boxes that needed to be wrapped and cards that needed to be written. So she dressed Jane in some warm clothes and her snowsuit and set out with the stroller.

She pushed the stroller down to the village and walked slowly along Main Street, admiring all the beautiful Christmas displays in the shopwindows. When they came to an educational toy store, Einstein's Toy Chest, Emily picked up Jane and went in. She picked out a few scientifically designed baby toys to help sharpen Jane's hand-eye coordination and "stimulate her nerve activity for enhanced neurological development."

She also picked out a stuffed dog that had totally captivated Jane's attention. Emily knew she was in a state of denial, going on a shopping spree as a bulwark against the bad news. It wasn't going to

change anything, but it made her feel better for just a moment.

She paid for the purchases and hooked the shopping bag on the stroller handle. Dan would really lose it if he saw one more gift under the tree. She might have to hide these last few gifts or maybe stick them in the baby's stocking.

If she was still around on Christmas morning to get a stocking . . .

Emily's vision went suddenly blurry with tears, but she kept walking, afraid that if she stopped she would break down altogether. She pushed the stroller to the village green and sat down on a bench facing the water. She turned the stroller so that she could see the baby and so that Jane would be out of the wind.

Jane was sound asleep, snug as a bug in her many protective layers. Emily tucked the heavy stroller blanket around her even though she knew the extra fussing wasn't necessary.

"Well, look who's here. That little girl gets out and about more than I do," Reverend Ben joked in greeting.

Emily looked up at Reverend Ben and forced a smile. She could tell from his expression, though, that he immediately saw her distress.

"Emily . . . what is it? What's wrong?" He sat down on the bench beside her.

"Jane's social worker called me a little while ago. They may have located a relative. We may have to give Jane up."

"Oh dear. That is difficult news for you."

Emily pulled a tissue from her pocket and wiped her eyes. "The social worker warned us that they might find somebody. But I guess I was just wishing so hard, I practically convinced myself they wouldn't . . ."

Ben reached over and patted her hand. He waited a few moments until she was able to stop crying. "What did Dan say?"

"He doesn't know yet. He's up in Maine today. It would be hard to tell him this over the cell phone. I wasn't ready yet anyway," she admitted. "I think he'll be disappointed, too. He's grown very fond of her."

"I'm sure he has. I saw the way he handled her in church on Sunday. It's been a good experience for him, no matter what happens."

"I guess so. It just seems so . . . unfair."

"Yes, I'm sure it does," Ben agreed. "But you took a great risk taking in this baby, Emily. Taking her into your home and your heart. I know it isn't any consolation, but from the moment they arrive, children are

constantly in the process of leaving us, every minute, by infinitesimal but sure degrees."

Emily nodded. She had already had that feeling in only a few weeks. It was a miracle to watch Jane grow but at the same time frightening in some way. It cut her to the quick now to think of having to give Jane up.

"I don't know if I can do it," she admitted to Ben. "Even to a relative — some stranger, who might not even really want to raise her. Maybe there's some way I can fight it in court. Maybe I have some rights in the matter as a temporary guardian."

"Maybe," Ben said, sounding doubtful.

Emily didn't reply. Dan probably wouldn't want to go that route, even if they did have grounds to fight. They hadn't even discussed adopting the child. She had been waiting for things to settle down, for a "good moment" to bring it up, and there really hadn't been one so far.

"This is so hard for me, Ben. It's hard to explain why. Mostly, I just have this feeling that Jane has come into my life for a reason, that she's really meant to be with me. I know it's a long shot, but the feeling is so strong. I've been praying about it, praying very hard, trying to understand

why God would send this baby into my life if I'm not meant to adopt her."

"Yes, I understand. This entire situation seems to have the fingerprints of the divine hand," he admitted. "If you really feel that way deep down inside, it's a hard thing to ignore. But sometimes it's hard to distinguish if those intimations are really from some greater source or from our own deepest longings, Emily."

She knew what he meant — her feelings of loss over Sara, the hole there that couldn't be filled or healed over. Ben wasn't accusing her, just posing the question — a question she asked herself time and again.

The reverend stared out at the harbor. The inlet was calm with small patches of ice floating near the shore. A gull dipped against the bright blue sky, out above the water.

Emily chose her words carefully. "I know what you're saying. That's certainly part of what makes caring for her so meaningful to me. But this feeling . . . I don't think it's that. Not entirely."

"All right then. There very well might be some higher purpose to the baby coming into your care, Emily. It certainly was a strange coincidence. I'd be the last one to

deny that. But the reason why this has all come about may not be at all what you or I or anyone would expect. We just don't know what God has in store for us. It's not only useless but frustrating to try to second-guess or," he added, "force our own will on a situation."

Emily smiled ruefully. "You know me, Ben. I'm the persistent type. Once I set my mind on something, it's hard to let go."

"Yes, I know that. Everyone in town knows that," he said affectionately. "It's always been a strength of yours, a key to your success. But every strong trait in a personality comes with pluses and minuses. There's a time to be persistent . . . and a time to let go. Perhaps we should pray for the best outcome for the baby, whatever that may be," he added quietly. "I know that it's hard for you to put this all in God's hands and trust Him to sort it out. It takes a lot of trust and faith and courage. And above all else, a great deal of love for this child."

"It's hard to do that, very hard." Emily took a steadying breath, not wanting to cry again. "I'll think about it. I'll try," she promised. She leaned over and gave Ben a quick hug. "Thanks for talking to me. You've helped a lot."

The reverend looked surprised, then gently smiled. "I'm the thankful one, Emily. Glad I ran into you out here. If you or Dan need to talk at all, please call or come and see me?"

"Yes, of course. I will," she said.

Ben rose and touched her shoulder then headed back to the church. Emily remained where she was, staring out at the water. She felt bleak and empty. Ben was right; she had taken a great risk, reached out for her heart's desire. Now it seemed it would end in heartache and disappointment.

Would God do this to her . . . again? It didn't seem right. She wavered between feelings of desperate hope, anger, and complete despair. She just had to try to see her way clear to the high ground, as Ben advised, and trust that God was working toward that goal as well: the best outcome for the baby . . . even if it didn't include her and Dan.

Sara sat at her desk wondering what to do. She was already late for her tutoring sessions at New Horizons. It wouldn't be right to cancel now. Yet she just couldn't face the prospect of running into Luke there again. Or worse, seeing him with Christina.

She had heard through the grapevine that Christina had rented a cottage on Beach Road and had moved into town last weekend. No wonder there had been no word from Luke. Obviously, he had been busy helping Christina get settled in.

Sara felt awful disappointing the kids, but she just couldn't do it. There would be a break in the schedule through Christmas; maybe after that she would feel better about things and be able to go back.

She called the center and spoke to one of the teachers, Craig North, concocting an excuse that she had to work late. She did have a ton of work to clear off her desk before the holiday, mostly because she had been so preoccupied lately with Luke.

"Don't worry, I can cover for you," Craig said.

"Thanks, I owe you one." Sara felt relieved. At least her students wouldn't miss out.

"They're pretty distracted right now with the holidays. You're coming to the Christmas party Thursday, aren't you?"

"No, I can't make it. I'm going out of town — to Maryland, to see my family."

"Oh . . . that's nice." Craig sounded surprised, probably since he knew Luke wasn't going anywhere for the holidays.

"Well, have a good trip. Merry Christmas and all that."

"Merry Christmas, Craig. Have a nice vacation."

Sara hung up feeling unsettled. It wasn't going to be easy untwining her life from Luke's in this small town.

She turned to her computer, ready to go back to work. There was a new e-mail in her box and she clicked it open. She recognized the address as the Philadelphia paper where she had sent her clips. She read the message quickly, a short note from the managing editor. He liked her clips and wanted to set up an interview. Sara felt jumpy with nerves. The news was exciting and stressful at the same time.

She quickly wrote back, saying she could meet with him on Thursday or Friday, on her way to Maryland, if he would let her know a convenient time.

She paused a moment before clicking the "send" command. Did she really want to do this? What if she got the job? Would she really move away from Cape Light?

Sara took a deep breath and sent the e-mail. She would do the interview, and figure the rest out later. After all, if she had plans to take a new job and move away, it would be easier to confront Luke and settle things

once and for all, she reasoned. If he was going to hook up with Christina, wasn't it better to move away?

A few hours later, Sara was the only reporter left in the office. She was concentrating on a revision and hardly noticed when Lindsay passed her desk on her way out, asking her to shut out the lights and lock the door when she left.

Sara didn't mind staying alone in the office. She liked the quiet. It helped her concentrate and made the work go faster.

She wasn't sure how long it was after that when she heard the sound of voices outside on the street. She picked up her head and listened. Carolers, coming toward the newspaper office.

She stood up and looked over the edge of the partitions that surrounded her desk. A group of carolers from New Horizons stood just outside the storefront window of the newspaper office. Her heart skipped a beat as she saw Luke among them.

She briefly considered ducking down again and hiding in her cubicle, like a prairie dog going back down its hole. But that would be ridiculous, she reasoned. She had to acknowledge them.

She slung a sweater around her shoulders, walked over to the door, and pulled it

open as they finished "Deck the Halls."

Sara clapped. "Thanks, that was great. We have a ton of Christmas cookies and some really stale coffee. Want to come in for a pit stop?"

"No, thanks, we've had enough free cookies for one night." Peggy, one of the teachers Sara knew well, grinned at her.

"We have to get the kids back to the center. You're our last stop," Craig added.

"Well, thanks for remembering me. Merry Christmas, everyone. Have a great holiday." Sara glanced around at the group, her gaze catching Luke's.

"I'll come in for a minute." Luke turned to Craig. "You guys go ahead without me. I'll catch you later."

Before Sara could protest or make some excuse, the group of strolling singers wandered off toward Main Street and she was left alone with Luke.

"So . . . can I come in? It's freezing out here," he added, rubbing his bare hands together.

Of course, instead of wearing a reasonable coat, gloves, scarf, and hat, like everyone else in town — like everyone in all of New England — Luke wore only a flannel shirt and his battered leather jacket. Sara didn't even bother to point out that he should

have dressed more warmly. She just pulled open the door and walked inside, knowing he would follow.

"The coffee is back by Lindsay's office. Help yourself."

"I'll skip the coffee, thanks. I really just wanted to talk to you. Craig North said you were working late so I figured you'd still be here."

"Yes, I had to miss the tutoring so I could catch up on work." She crossed her arms over her chest. "It's not really a good time. Maybe you should have called first."

Luke let out a long frustrated breath. She wasn't making this easy for him, but why should she? She had a good idea of what he wanted to talk about — how it was time to face things, how if she couldn't make a commitment, he would have to move on.

She didn't want to have that talk right now. She wasn't ready. And he wasn't going to drag her through it either.

Luke tilted his head to one side. "Okay then, why don't we make a date?" When she didn't answer, he added, "You know, that thing you do when you meet another person for a few hours. Maybe have a meal at a restaurant?"

"Sorry, I'm too busy this week. I'm going out of town."

"To see your folks, you mean? When are you leaving?"

"On Thursday morning. I have a job interview on the way down, in Philadelphia."

She wasn't sure why she blurted that out. The interview wasn't even confirmed. Maybe she just wanted to see his reaction. Would he be upset about her going, or relieved?

Luke looked so stunned, she almost felt sorry for him.

"I told you I sent out my clips. Maybe you don't remember —"

"I remember. You wanted to work on a bigger paper. I thought the bigger paper was going to be in Boston, though, where I was somehow worked into the picture."

"I sent my clips to a lot of places. This is the one that answered."

"Right. It's that simple, is it?" He dug his hands in his pockets and his gaze narrowed.

"I sent my clips to a few papers in Boston. They didn't answer. So I need to go to this interview, if only to hear them out. It might be a good opportunity."

It wasn't the entire reason she wanted to go, and both of them knew it. Sara sighed

and drifted back toward her desk.

She moved some pieces of paper around on the desktop but didn't sit down. When she looked up again, over the top of the dividers that surrounded her desk, Luke was still staring at her.

"Well, that settles that, I guess." His voice was clipped and falsely bright. "Good luck with your interview. Have a nice holiday and all that stuff. Have a nice *life* in Philadelphia," he added, not even bothering now to hide his sarcasm.

Sara nodded, just wishing he would go.

He turned away so quickly, she found herself saying good-bye to his back.

Just as well, she thought, sinking down into her chair. She hid her face in her hands and heard the front door to the office slam. She didn't know if he had bothered to look back at her. She didn't want him to see her crying anyway.

It was the only time she was ever glad that she worked in a cubicle.

"Emily? I'm home." Emily stirred in her sleep as Dan softly called her name.

When she opened her eyes, he leaned over and kissed her. His cheek was still cold from the outdoors.

"What time is it?" She sat up slowly and

wiggled her shoulders, which felt cramped from sleeping on the couch.

"About eleven. I called from the road. I guess you didn't get the message."

"I didn't hear it. I must have been sleeping."

"You should have gone to bed. You didn't have to wait up."

"That's all right. I wanted to." Emily watched him take off his jacket and cap.

He sat down next to her and put his arm around her shoulder. "How's the baby?"

"She's fine," Emily said slowly. "She should be up soon for a bottle."

"I can stay with her tomorrow night if you need to finish your shopping."

Emily remembered asking Dan if he would mind if she ran out to the stores tomorrow. It didn't seem to matter now, though.

She turned and looked at him. It was going to be hard to tell him the news from Nadine Preston. Telling Dan made it more real. But she knew she couldn't put it off any longer.

"I had a call from Nadine today," she began. "She told me the investigation may have turned up a relative. Not Jane's mother . . . but someone else. Someone who might take Jane."

There, she said it. Her throat was suddenly thick, her eyes watery again.

Dan's expression was instantly alarmed. "A relative? I thought they were done searching."

"Well, I guess not. Not completely."

He rubbed her shoulder, pulling her closer. "What about the timing of all this? Did she say when they would know?"

Emily shrugged. "She wasn't sure. Maybe before Christmas or maybe after. I'm not sure how quickly they would . . . take Jane away."

She couldn't stand it anymore and pressed her head to Dan's shoulder, crying freely now.

He stroked her hair and kissed her cheek. "Sweetheart, I know it's hard. But we knew she was only going to be with us temporarily. Even if they didn't find a relative, we would have to give her up at some point down the road, when she's finally adopted."

Emily couldn't answer. Didn't Dan see that if by some miracle Jane was available to them, they had to be the ones to adopt her?

But she felt too worn out and heartsick to argue about that now. She settled for saying, "It just doesn't seem fair. I thought

we would have more time with her."

Dan met her gaze but didn't answer.

"Don't you feel bad about losing her?"

He hesitated just a moment, then nodded his head. "Yes . . . yes, I do. You know that."

He sighed and brushed Emily's cheek with the back of his hand. "It will hurt us both if she goes, but it might be for the best, Emily."

"That's what Reverend Ben said. I saw him today, out on the green. He said I ought to try to let this go and trust that God will figure out what's best for the baby. Do you think that's true?"

Emily knew her husband wasn't the most religious man. He hadn't set foot in a church for years before they got together. Dan was very spiritual in his own way, though. He always said his church was the open sea and the sky above, and that he and God had their best talks while he was sailing.

"Yes, I do, dear." He leaned over and kissed her. "I think we have no choice now but to just wait and see."

Chapter Eleven

~🙰

"Sara, you bought way too many presents and spent much too much on us. Really, dear . . ." Emily shook her head, watching as Sara emptied out her two shopping bags of gifts and arranged them under Emily and Dan's Christmas tree.

"I found some really hip little outfits for Jane at a store in Newburyport, but I'm not going to tell you more. I want you to be surprised."

Emily gazed at her, a soft warm light in her eyes. Sara knew it was hard for her to talk about Jane, now that everything was up in the air with the investigation. It was partly the news that the baby might be leaving soon that caused Sara to run out and buy even more gifts for her.

She sat on the couch with Emily again. They had just finished dinner, and after coffee and dessert, Dan had disappeared into his study.

"The house looks beautiful." Sara gazed around at the elegant decorations. Though Emily wasn't usually big on holiday decorating, she had gone all out this year. "Are you sure one of those home makeover shows didn't sneak in here?"

Emily smiled. "No, I did it all myself. On a spree, I guess you could say."

A happy spree, inspired by the hope that she would adopt the baby, Sara knew. She felt so bad for Emily. Her feelings of being overshadowed by Jane seemed so immature now, so insignificant in comparison.

Emily took a sip of coffee. "So you leave tomorrow morning. Are you driving?"

Sara nodded. She hadn't told Emily yet about the job interview. It was difficult to find the right words, especially knowing all she was going through right now with Jane.

But Sara couldn't hide it from her. She didn't want to. They had always had a very honest relationship. That was one of the wonderful things about it.

"I'm going to stop off in Philadelphia," she began. "I sent my clips out to some newspapers a few weeks ago, and an editor

down there contacted me. I've got an interview."

Emily frowned as if she didn't understand. "An interview? Are you going to write freelance for them?"

Sara shook her head. "No, for a full-time job." She took a deep breath. This was even harder than she thought it would be. "I've been thinking about working on a bigger paper, Emily. I think I'm ready to leave Cape Light."

Emily sat back, looking surprised and dismayed. "I didn't know you were unhappy at the paper, Sara. You never complain about it."

"I am happy there," Sara said quickly. "It's a cool place to work and Lindsay is a great boss, really. I could probably stay there forever, if I wanted to. But sometimes I think I need something more challenging."

Emily was silent for a moment. Sara could see her gathering her thoughts. "I understand. I just wish you didn't have to go so far away. But I know reporters move around a lot. Maybe after Philadelphia you'll come back up to Boston or New York."

"Maybe," Sara said, grateful that Emily wasn't pressuring her to stay in Cape Light.

Emily cast her a concerned look. "It's also because of Luke, isn't it?"

"Not really. I sent all these clips out way before we started having problems. I do want to advance in my career, which means moving to a bigger paper. That was part of our argument actually . . . our first argument." Sara knew her voice sounded sad. She couldn't help it.

Emily leaned over suddenly and hugged her tight. "Oh, Sara, honey, I wish you didn't have to go through all this painful stuff. I hate to see you feeling so sad about Luke. I wish there was something I could do."

Sara closed her eyes and hugged Emily back. Emily loved her and would be there for her, always. How could she have ever doubted it? There was enough love in Emily's heart to go around, even if she adopted ten children.

They parted slowly. Sara felt a little teary but managed not to cry. Emily took her hand. "I wish you luck with the interview, honey, if this is what you really want."

"Thanks. It was hard for me to tell you."

"I know, and I'm glad you did. I can't say I like the idea of you moving away. But I know I've been lucky you wanted to stay in Cape Light as long as you did. Having

you here has been a great gift to me, Sara. You probably can't realize."

"I think I do . . ." Sara wanted to tell Emily how much their relationship meant to her, too. But somehow the words failed her.

She heard the baby crying in another room.

"Jane's up," Emily said. She started to get up from the couch.

"I'll get her," Sara said, and before Emily could argue, she rose and left the room.

Emily's bedroom was cast in soft shadows, lit by a small nightlight on the baby's changing table. Jane was lying on her back, wearing one-piece pajamas with covered feet. She was tangled in a blanket, but stopped crying as soon as she saw Sara.

Sara lifted her up and checked her diaper. All dry. Maybe she's hungry, she thought. Or just wants some company.

The baby felt so soft and smelled so good. She hugged her close and kissed the top of her feathery head.

She was such a dear. Maybe it wouldn't be so hard to have a baby if she had one as sweet as Jane. Sara felt shocked for a moment at the thought, but she knew it was true.

She held Jane close, the baby's head resting on her shoulder. She wondered if this would be the last time she'd see Jane, or hold her like this. The realization took her breath away, it was so stunningly final.

"Little Jane. You little sweet potato . . . I hope you don't go," Sara whispered. "I could have been your big sister. I would have loved that," she said honestly. "I really would have."

In the days after Nadine Preston's call, Emily knew she was hard to live with. She was depressed and distracted, jumping out of her skin every time the phone rang. When Christmas Eve arrived and they still hadn't heard from Nadine, she decided that she didn't feel up to her sister's big Christmas Eve party. There would be so many people, so much revelry; besides, she couldn't imagine facing all the questions about Jane.

Emily sat at the breakfast table with Dan, feeding Jane a bottle. "I hate to disappoint Jessica and Sam, but I don't think I can handle it," she admitted.

"Don't worry," Dan said. "Your sister will understand."

"Yes, she does." Jessica had been a great support ever since Emily had taken in the

350

baby. She had already told Emily not to give it a thought; she and Sam would understand if Emily and Dan didn't make the party.

Emily lifted Jane to her shoulder with a practiced motion. "What if Nadine calls today? She might, you know."

"I don't think we'll hear anything more until after Christmas. So many offices are closed," he said reasonably. "But I understand. I don't feel much in the mood for a party either. Let's have a quiet night here, just the three of us."

"I'll make a nice dinner," she promised.

"Where are you going to get takeout from, hon? Willoughby's?" he teased.

Emily made a face at him, and he laughed, then pulled her close for a comforting hug.

Emily appreciated Dan's understanding. She had been trying to prepare herself for the inevitable call, but she knew that no amount of preparation would make her truly ready.

This is all my doing, she realized. *Everybody warned me, and I went ahead and set myself up for all this heartache.*

But when she held Jane in her arms, she knew that, given a chance to decide all over again, she would have done ex-

actly the same thing.

The phone rang late that afternoon. Emily, who was sitting in the kitchen with Jane in her arms, nearly jumped out of the chair. It rang once, twice. Emily couldn't decide if she should answer it or let the machine pick up. Where was Dan? Couldn't he be the one to get the bad news first?

Finally, not able to stand it a second longer, she got up and grabbed the receiver.

"Hello?" she said, her heart hammering.

"Jessica? You don't sound yourself. Are you coming down with a cold? I really need to know because I can't afford to be catching all kinds of germs at my age, Christmas or not."

Emily reeled back at the sound of her mother's voice then forced herself to speak. "It isn't Jessica, Mother. It's Emily."

"Emily? What are you doing over there? I thought you weren't coming to the party."

Emily sighed and shook her head. She hadn't spoken a word to her mother since their scene in the church sanctuary almost three weeks ago. Now, being greeted by this "Who's on first?" routine felt absurd, but somehow not surprising.

"I'm at home, Mother. *My* home," Emily said with a calmness she didn't really feel. "You apparently dialed the wrong number."

"Oh, I see. It must be that new phone you picked out for me with the autodial. It doesn't work right, never did."

Naturally, Lillian couldn't even admit to having dialed a wrong number. It had to be the phone.

There was a long silence. Emily felt she should say something. After all, it was Christmas Eve; she ought to at least try to make amends with her mother. She had felt guilty not speaking to her these past few weeks, though she had kept up on her through Jessica's reports. Lillian hadn't called and Emily hadn't called her. Even though Lillian was the one at fault, Emily knew she ought to now turn the other cheek. That was the right thing to do.

Somehow, though, she just couldn't.

The baby squirmed and let out a little whimper.

"What was that?" her mother said. "Oh right, the *abandoned* baby." She gave a slight cough. "Your sister told me a relative may have been located. You might have to give the child up."

"Yes, we're waiting to hear," Emily said honestly.

"Well, I won't say I told you so. No good deed goes unpunished, though. Did you ever hear that expression?"

"No, I don't think so," Emily said.

"Well, think about it. The next time you try to run out and save the world, I mean." Her mother paused. Emily was about to say good-bye and hang up. "I'm sure you've done a good job caring for her, but the child should go to family if possible. It's only natural and logical."

Logical perhaps, Emily thought, but somehow not entirely right.

When Emily didn't reply, she heard her mother noisily clearing her throat. "I'm sure it will be hard to give the child up, after all the time and emotion you've invested."

"Yes, it will be. Very hard." Emily knew her words sounded thick, but she fought very hard not to cry.

She waited again, wondering if her mother was going to apologize for her outburst at the church.

Her mother sighed. "There's a price for loving, Emily. Sometimes it's very steep. But you know that already, I imagine." Her mother's voice trailed off, sounding as if

she was talking mainly to herself. "Well, I won't see you tonight. I won't wish you a Merry Christmas. I'm sure you won't be having one. Try to be realistic. Face the situation bravely," she advised.

"All right, Mother. Thanks for the advice." Emily's tone was edged with irony, but she also knew her mother was sincere, trying to offer some support. What she could, at any rate.

"Have a good time tonight," Emily added.

"Good time? With all that noise? All those children? You should see the way they go at the gifts, like a pack of piranhas in a feeding frenzy. That's hardly my idea of a relaxing holiday get-together."

As Emily well knew. Lillian's notion of celebration was so refined, it was hard to tell there even was a holiday going on.

"Good night, Emily. Give my regards to your husband," Lillian said. Emily thanked her and said good night, then hung up the phone.

She looked down at Jane and slowly rocked her in her arms. It wasn't the call she expected, and her mother hadn't even come close to apologizing. Then again, Lillian never would. At least Emily and her mother were on speaking terms again.

That was one less worry hanging over her head as Christmas quickly approached.

On Christmas morning, Emily and Dan got up early and opened some of their gifts. Emily opened Jane's packages, too, oohing and ahhing with delight over all the beautiful presents so many friends and relatives had given her.

Sara had picked out a box full of clothes — amazing, arty creations. Tiny purple leopard-skin stretch pants and a purple and black tunic top. A hot pink hooded sweater, trimmed with white fur, with little white ears on top. And most amazing of all, matching hot pink high-tops.

"Look Dan," Emily held up the sneakers. "Jane can shoot baskets with you now."

"As soon as the snow clears," Dan said, laughing at the fantastic little shoes.

They dressed quickly for church and made it right on time. They were getting better at this, Emily observed, noticing how they packed up all the necessary equipment without too much fuss and bother.

The sanctuary was crowded, with just about every pew filled. The choir was

singing a lively carol, their voices blending in harmony. Emily felt her spirit lifted by the music as she and Dan found a place in a rear row. Looking up front, she saw her sister and Sam, along with her two nephews and her mother, sitting with Dr. Elliot, who only came to church on Christmas and Easter.

"Merry Christmas, everyone," Reverend Ben greeted the congregation. "It's a wonderful day, Christmas Day. A day of miracles and fresh, new beginnings. Let us come together now and worship, rejoicing in God's word."

Emily tried to pay close attention to the service, but her thoughts kept drifting. She had been praying long and often the past few days, trying to give her problem up to God and asking only for the best outcome for Jane. It had been difficult though — nearly impossible.

Deep in her heart she felt she wasn't being totally sincere. Couldn't God see that? Did her prayers still count? She hoped they did. She hoped God was at least seeing that she was trying to do the right thing.

Ultimately, though, she couldn't change her real feelings about giving up the baby, not even for God, it seemed.

Reverend Ben was partway through his sermon. She realized she had missed some of the beginning. He was talking about the miracle of Christmas, about spiritual rebirth and renewal.

". . . and if you have ever been around small children — and most of us have at one point or another — then you know what I mean. Children have a way of making you feel new. Especially small children, babies, who are experiencing everything in this beautiful world for the first time. And watching them, we vicariously do, too. We rediscover and relearn. We lose our skepticism, our cynicism, our malaise. We see everything with new eyes, through their eyes. We taste and touch and smell everything as if for the first time, and the world seems so astounding, so magical.

"That's what Christmas is like. Each year when this day comes, we have the chance to feel new, to start new, like the infant Jesus. To be reborn in God's love and his promise. That's the miracle of Christmas. To believe again in miracles. To lose our skepticism and negativity and malaise. To see the world with new eyes, a fresh, energized perspective. To trust in God's love with the innocent, absolute trust of a child. To feel sheltered and pro-

tected in His hands . . ."

Emily sat in rapt wonder, the words hitting a perfect bull's-eye somewhere in her heart. That was the gift Jane had given her, both her and Dan. Jane had made them new again. She had refreshed and renewed their spirits. That was the magic of having a little baby. If there was some purpose in God's having sent Jane into their lives, maybe that was at the heart of it.

It would be hard to remain in this state without her, Emily reflected. But she would try.

At the end of the service, they drifted out toward the sanctuary. "Any news yet?" Reverend Ben asked them as they met him in the doorway.

"No, not yet." Emily tried to smile and shook her head.

"Still waiting," Dan added.

"Please call me when you hear something. I'd like to know." Reverend Ben hugged Emily briefly. "Have a peaceful, blessed Christmas," he said to them.

"Thank you, Reverend. We will call you," Dan promised.

Emily swallowed hard. She didn't know what to say. She met Reverend Ben's gaze and somehow knew he understood her feelings perfectly.

Out in the sanctuary, they were immediately surrounded by family and friends. Jessica came up and hugged her tightly.

"Merry Christmas, Emily. Oh . . . I know it isn't a happy one for you, though. How are you holding up?"

"I'm doing all right, as well as can be expected."

"Here, let me have Jane a minute." Jessica reached over and took the baby. She lifted her up in her arms and snuggled her, cheek to cheek. "Look at that pretty little dress. You look like a princess," Jessica cooed to her.

It was a beautiful dress, burgundy velvet with lace on the hem, sleeves, and collar. A matching lace headband with a velvet rose completed the ensemble, along with tiny patent leather shoes. Emily had bought it at a boutique in Newburyport. Price seemed no object when it came to Jane.

"I'm sorry we couldn't come last night," Emily apologized.

"That's all right." Jessica shook her head. "We understand. I made a big tray of leftovers for you. You won't have to cook for a week."

"Thanks, Jess. That was sweet of you."

Emily knew she would be in such a state next week, she probably wouldn't be able

to cook or even eat.

Emerging from the crowd, she noticed Sam leading her mother toward them. Emily was glad now that they had spoken yesterday, even though it had been by accident. Afterward, she had wondered if her mother's calling her number had really been an accident at all. Maybe it was her subconscious taking control, or even a ploy. Though, of course, Lillian would never admit to either.

"So here we all are." Her mother sniffed and looked around, obviously trying to be on her best behavior. "I'd wish you a happy Christmas, Emily, but I know that's hardly the case."

"Thank you, Mother . . . for your consideration."

Lillian glanced at her but didn't answer. She looked over at Jane, who sat comfortably in Jessica's arms. "Nice dress. That must have cost a pretty penny, especially these days. Reminds me of one I had for you, Emily, smocking on top, lace collar, all handmade. You were just that age. What a coincidence."

"I suppose," Emily said. Leave it to her mother to make more fuss over the dress than the child wearing it.

Dan soon joined them and they talked

for a while. Jessica invited them to come over later for a quiet dinner with just the close family, but once again, Emily and Dan begged off.

"If you change your mind and want some company, just give us a call." Jessica's expression was full of warmth and concern as she leaned over and hugged Emily good-bye. "Let us know if you hear anything?"

"I will," Emily said, hugging her sister back. "You'll be the very first."

Back at home, Jane went down for a nap and Emily cleared up the piles of wrapping paper and boxes littering the living room. She had a nap herself, though she had gone to bed early the night before and knew she shouldn't feel so tired. It was the stress of all this waiting, she thought.

That evening, she set the table with their best china and crystal, even though it was only for herself and Dan. She didn't want to ignore the holiday altogether, and trying to make things nice provided some distraction. She made a filet mignon roast, with string beans, mushrooms, and a special potato recipe she had gotten from Jessica. The meal was one of Dan's favorites, and despite his teasing, it came out just right.

They had just sat down to dinner and

were saying grace when the phone rang. Emily felt her heart skip a beat, but Dan kept tight hold of her hand. "Don't get up. Let the machine get it. We just started dinner."

She looked up at him for a moment, about to agree, then jumped up out of her seat. "Sorry, I have to go see who it is," she called over her shoulder as she ran into the kitchen.

She heard a woman's voice murmuring on the answering machine, but she didn't recognize it. She grabbed at the phone and greeted the caller breathlessly.

"Emily, I didn't think you were there," Nadine Preston said.

"I'm here." Emily tried to catch her breath but now her heartbeat raced. "We were just starting dinner."

"Oh, sorry to interrupt."

"No, that's okay. I guess this must be important if you're calling on Christmas."

"Yes . . . it is."

Emily felt so light headed all of a sudden, she thought she might pass out. She sat down quickly in a chair, her hands shaking. She hadn't realized, but Dan had followed her. He stood behind her with his hands pressed solidly to her shoulders.

"We did not find anyone related to

Jane," Nadine said. "I can't tell you much more than that, only that the information we had didn't lead to an appropriate guardian. The investigation isn't officially closed yet, but it will be shortly and Jane will be available for adoption."

Emily gripped the phone so hard, her hand shook. "She will? Do you really think so?"

"Yes, Emily. I wouldn't tell you if I thought it was in doubt. It will just take a few days more for the paperwork to go through. How do you and Dan feel about that?"

"Thrilled . . . overjoyed . . ." She suddenly remembered Dan standing behind her and realized she shouldn't speak for both of them. "I need to tell Dan about this," she said hurriedly. "Can we talk tomorrow?"

"Yes, of course. Call me at the home number or on my cell phone. I'm taking a few days off to be with my family."

"Good for you. Have a good holiday, Nadine. Thanks for calling. Merry Christmas!" Emily said in an ecstatic rush.

"Same to you, Emily. Same to you."

Emily hung up the phone and turned to Dan, who watched her with a questioning expression.

"I can guess from your reaction, Nadine didn't say social services was taking the baby any time soon."

"She said a relative wasn't found and that they're closing the investigation. Jane will be free to be adopted in a few days, after all the paperwork goes through."

She felt breathless again, waiting and watching for his reaction. "Isn't that great news?" she prodded him.

Dan swallowed hard. He looked stunned, she thought, like he was processing the news slowly. But that wasn't necessarily a bad sign, was it?

"I don't know what to say, Emily. It seems like a mixed blessing to me."

"What do you mean?" she asked incredulously. "It's just what I've been hoping for, praying for. I don't see anything mixed about it. Don't you want to adopt her?"

She hadn't intended to ask him so bluntly. The question had just popped out. But she needed to know. They needed to get this out on the table right now.

"Emily, this all puts me in a very difficult spot. Sending the child to a relative would have been hard, no question. But it would have been a solution to the problem that I think we both would have been able to live with in time." Dan paused, pacing across

the kitchen. "I don't think that you could have objected that strongly, when all was said and done, to sending the child to live with her own family. But now . . ." He shook his head, looking confused and upset. "Now we're forced to sort this out, between us. And I'm sorry, but I know we are not of one mind about this, Emily, though we may be of one heart."

Emily sighed. Why did she have to go and marry such an eloquent, intellectual man? It made it all the harder to win an argument.

"Dan, just think about it," Emily started off reasonably. "Jane isn't going to a family member. She'll be placed with perfect strangers, some couple like us or even not as caring. Why not us, Dan? I know what I promised. I know I said I wouldn't do this . . . but honestly . . . why not us?"

He rested his hands on her shoulders. "I know that deal you made, promising we would only keep her as temporary guardians, was a ploy from the start, Emily. Just a scheme to get this baby into the house. And I forgive you for it," he said tenderly. "How could I not? But I have a more objective perspective on this situation, dear. I'm looking at the bigger picture."

"Which is?" she asked quietly.

"Is it really fair to the baby to be stuck with such older parents? When Jane is eighteen, I'll be . . . almost seventy." She winced and pulled away. "Well, I will be. That's a plain fact."

"It's still not a good enough reason, Dan. Lots of older couples have children these days, and you'll probably live into your nineties."

"Emily, don't you think it will be painful for me to give her up when the time comes? But we have to be realistic. The baby has changed our lives, turned this place upside down. This isn't the way I planned to live when I gave up the paper. Is this fair to me?"

She sighed and let out a long frustrated breath. No, it wasn't fair to him. It wasn't what he planned at all.

"It would be a great sacrifice for you," she agreed. "I mean, unless you had a change of heart and it didn't feel like it really was a sacrifice. I mean, if you loved her and really wanted to do it . . ." Her voice trailed off. She could see that he was getting irritated.

"Don't make me out to be the villain here, please. You know that's not what's going on."

"Yes, I know. I'm sorry," she said quickly.

"I've already had the experience of raising children, Emily. I don't feel unfulfilled in that area. Some men my age do, but I don't," he told her. "I'm sorry if it sounds selfish to you, but we need to be honest. I've worked hard all my life and didn't envision my retirement years filled with homework and soccer games and band concerts. I want to travel, write. I want you to give up your office so we can have adventures together, maybe live in another country for a year or two —"

"We can do all those things, Dan. Just because we have a child doesn't mean we'll be stuck in the house for the rest of our lives, that you can't write or we can't travel."

"Emily, you don't understand. It's not that easy —"

"It doesn't have to be the way it was with you and Claire, raising your kids. It can be different. It can be anything we want it to be, Dan. Don't you see that?"

When he didn't answer, she pushed on. "We both love her. What's more important than that? Yes, it's been confusing and scary and hard work. And yes, it's totally turned our lives upside down. But for the good, Dan. All for the good, I feel."

He started to say something, but she

wouldn't let him interrupt her. He had had his turn; now it was hers. She felt as if she was fighting for her life — not just for Jane's fate, but the fate of her very marriage.

"What is a more worthy 'retirement' project than raising a child? Basically, saving this child's life? Writing a book? Taking a vacation?" she asked, meeting his gaze squarely. "There are many benefits to being an older parent. I've already seen it with me and Sara. You're calmer; you have more life experience and more to give the child. You're not chasing after your career goals anymore. Wasn't that the real problem when you were raising Lindsay and Wyatt? Isn't that really why you feel so overwhelmed by this idea?"

Dan faced her a moment, then stalked across the kitchen. He poured himself a glass of orange juice and drank it out of their best crystal. "I wasn't a very good father when the kids were young. You know that. I've told you," he said curtly.

"Perhaps, but you're good with Jane. Maybe it's different for you now."

"I've been a little better with her," he admitted. "But let's be realistic. It's only been a month. I was a washout as a father, Emily, plain and simple. It's not something

I really want to relive."

Emily walked closer to him and looked him in the eye. "You grieve over those years, Dan. I don't see why you wouldn't want to try again and do a better job this time. I know you could."

He stared at her, shocked by her frankness she realized.

"Do you love me?" She spoke in a clear, even voice.

He blinked and shook his head. "You know I do. For pity's sake, don't do this."

"I'm sorry, Dan. That's what it comes down to for me. If you really love me, you'll find a way to make this happen. I know you love the baby," she said simply.

"Yes, I do," he finally admitted. "Though, unlike you, I don't see how that changes the hard realities."

"The hard realities." She nearly laughed at him. "My hard reality was giving up Sara. You know that. Finding her again should have been the cure, but it hasn't been. The experience of raising her, which you take for granted, was stolen from me, Dan. It can never be replaced, I know that. But maybe this is a chance for both of us to do it over right. Did you ever think of that?"

"Emily —"

"I believe in my heart that finding this baby was meant to be, Dan. I believe she's meant to be with us. You and me."

Dan shut his eyes momentarily, rejecting the idea, she thought. But maybe — hopefully — just having a tough time letting it in?

"They say that when God closes a door, He always opens a window," Emily went on. "I closed the door on God, and now He's had to send Jane through a window. Don't you see that?"

"No, I don't." Dan's voice was even, not angry or emotional in any way. "I think it's easy for you to cling to some . . . some fantasy and say, 'This was meant to be. We just have to go through with this because I have this feeling,' instead of looking at it realistically, unemotionally. Then you'd see that there are plenty of couples out there, younger couples with lots of love and care to give, who would be good parents to Jane — just as good as we might be, if not better."

His words seemed harsh, almost cruel, and Emily reeled back, as if she had been struck. There didn't seem to be any hope left here. He would never budge an inch on this.

She suddenly wished that she was single

again and had her own life and could just do as she pleased. Then she felt shock at even thinking such a thing, it seemed such a betrayal of Dan. She had been so happy with him, so thrilled to have fallen in love with him. She had never once yearned for her old life, except for now. Wanting Jane so much, she couldn't help but think that when she was single, she never had to ask anyone's permission to do what she wanted. She never had to work for a consensus and compromise.

Now when it felt as if a gift from God had been placed at her doorstep, she couldn't embrace it without Dan's permission. She felt so frustrated at that moment, she wanted to scream.

"I'll tell you what your fantasy is, Dan," she said finally, unable to let it go. "You're always talking about adventure and the new experiences that are out there. The real adventure is right here, Dan, right under this roof. It is for me, anyway."

"That isn't fair, Emily."

"Why not?" she challenged him. "I think it's fair and true."

"What if the shoe were on the other foot? Can you try for just a minute to imagine that? How would you feel if I were trying to talk you into something so mo-

mentous by pulling every trick in the book?"

"If I saw how much it meant to you, I would do it," she told him. "That's what I think marriage is about. We can't split things right down the middle all the time; sometimes it's one person getting 100 percent of what they need, and the other getting zero."

He stared at her, his head tilted back. She knew that look. He had had enough.

"Are we done now?" he asked angrily.

Emily didn't answer. The phone rang. Maybe it was Nadine Preston again with more news. Emily didn't feel able to talk to anyone right now.

Dan didn't either. They both stood and listened as the machine picked up the call.

"Emily, it's Dick Sanborne." She recognized the town fire chief's voice. "There's a fire down at Wood's Hollow. We've sent two trucks and both ambulances, the equipment from the midstation, too."

Emily ran to the phone and picked it up. "I'm here, Dick. I heard what you said. Where are you calling from?"

"I'm down here at the site. We're working on it. It's bad. We have a call into Essex for more trucks and men. We came

up short on crew, with the holiday and all."

"I'll be right down."

Emily hung up the phone and turned to Dan. He'd heard the message, too, and his anger had vanished, replaced by deep concern.

"I'm going down to the fire," she said.

"Yes, of course. It sounds bad."

"I think it must be. Dick hardly ever calls me, and he sounds worried."

She sat in a kitchen chair and yanked off her heels, replacing them with a pair of heavy boots. She didn't have time to change out of her suit but pulled a heavy sweater she found in the mudroom over her silk blouse, and then put on her down jacket and woolen gloves.

Suddenly she remembered Jane, who was still napping. She would be up soon, though, and somebody had to take care of her. They couldn't call Blanche Hatcher, not on Christmas night.

She glanced at Dan as she pulled on her woolen gloves. "Can you take care of Jane? She'll need a bottle when she wakes up."

"Of course I can." Dan seemed almost insulted by the question, or maybe ashamed now of arguing so forcefully against adopting her.

She started out and then, on second

thought, turned back and quickly kissed him on the cheek. She was still angry, but you never knew what was going happen. The truth was, she still loved Dan, no matter what.

"Just be careful," he called after her. "And call me."

"I will," she promised.

Emily's ride to Wood's Hollow was in pitch-black darkness on a seemingly endlessly curving road. But when she finally reached the lake and the scene of the fire, it seemed as if someone had stuck a hundred-watt lightbulb in her face.

The scene was chaotic, the tall, burning wood building billowing with smoke and bright yellow flames licking out the windows. Burned beams were crashing through floors, walls were collapsing, and windows were exploding from the heat. Balconies that lined the old building were consumed by flames; they gradually crumbled and crashed as the fire roared. Men were running and shouting as the burning pieces flew down to the ground. Geysers of water from giant pumps converged on the flames, the spray and puddles turning quickly to ice in the frigid air.

The burning hotel reminded Emily of a

monster in an old science fiction movie, wounded but reeling and roaring, refusing to yield to the tiny men who ran frantically, trying to subdue its might.

It was an awesome, terrifying sight to behold. The two buildings nearby were also in danger, she knew, but it appeared that all the residents had been evacuated. Several ambulances stood at the scene, with people on stretchers or just sitting on the ground taking in oxygen, their faces and clothing soot covered. Some sat in groups, wearing overcoats over nightgowns and slippers. Others huddled in blankets, clutching black plastic bags that held the few possessions they grabbed as they were forced from their homes.

Emily walked around, trying to get her bearings. She spotted Tucker Tulley and several other officers from the police department. Everyone was so busy, no one noticed her.

She slowed as she saw a group of terrified residents being hustled away from the buildings. Most were in their pajamas, and many were barefoot. Young and old and middle aged, mothers with children, there had to be a hundred of them who had completely lost their homes, and as many more who couldn't return to their resi-

dences that night and would need shelter. Emily felt overwhelmed, wondering how to help them all.

Someone touched her arm and she turned around to see Luke McCallister. "Emily, are you all right?"

"I'm fine," she said distractedly. "But this fire — look at all these people out in the cold, Luke. What can we do? We have to take them somewhere, get them places to stay."

Tucker Tulley waved and started walking toward them. Harry Reilly, who owned the boatyard in town, was there too. He stood with Grace Hegman and Sophie Potter. The red lights of the police cars swirled around, illuminating their faces. Emily couldn't tell what they were saying, but Sophie was talking in an animated fashion, looking as if she were directing traffic.

"Tucker," Emily said, "what are all these people from church doing here?"

"I called Harry and Luke, and the word just spread. We've decided to bring most of the people here back to the church, put them up in Fellowship Hall. Some can even sleep in the sanctuary on the pews. Sophie is going take a group back to the orchard, and Luke is going to take a bunch over to the center. We're calling around,

too, to see if we can find some families in the congregation to take the others in."

"Do you think that will work?" she asked skeptically.

There were so many homeless, and it was Christmas night. Were people really going to interrupt their family get-togethers to take in a bunch of dirty, dazed strangers?

Tucker shrugged. "We already tried the hospital and the armory. Nobody will take them. It has to work."

"Does Reverend Ben know?"

"I tried to call him, but I guess he's not home. I left a message on his cell phone. I'm hoping he'll call back soon, but I think we just have to go ahead and do what we have to do. I *am* the senior deacon," Tucker reminded her. "I have some say in these things. Besides, do you think he would really object?"

"No, of course not." A siren screamed, adding to the noise and confusion. Emily realized she was wasting precious time. "I'll help, too. Let's get this organized. . . ."

Emily was used to being the one in control, especially in a situation that involved a crisis and public safety. But when she met up with the folks from her church, she

soon found herself taking directions from Sophie Potter. Sophie, along with her granddaughter Miranda, Grace Hegman and her father Digger, Harry Reilly, and a host of others were working on their cell phones, packing the fire victims into their cars and SUVs, figuring out places for everyone to spend the night.

As she was working, helping a group into her Jeep, she spotted her brother-in-law, Sam, riding up in his truck.

He pulled up beside her and called from the window, "Emily, are you okay?"

"I'm all right. It's awfully cold out here, though. We're trying to get these people into some shelter."

"I know. Luke called me. I brought some blankets."

Of course, Sam would be here. If he heard of someone in trouble, he was there, no questions asked. She wasn't surprised that Luke called him. They were good friends.

"Park your truck and check in with Sophie. There are plenty of people who will be awfully glad to see those blankets."

It was just past midnight when Ben reached the church. He had been spending Christmas Day with Rachel's in-laws,

Jack's parents, who lived over an hour away. His cell phone service was spotty out of the area, and it wasn't until they were nearly home that he noticed the call from Tucker Tulley. He and Carolyn bypassed the turn to the parsonage and headed straight to the church.

The church was ablaze with light. Even from a distance, Ben and Carolyn could see the activity. As they walked from the parking lot, cars were driving up as if it were the middle of the day. Members of the congregation hurried about, carrying bags of clothing and groceries and boxes filled with blankets, pillows, and towels.

"Ben, look at all this," Carolyn said, awe-struck.

Ben was speechless with astonishment, gazing around as if he had landed in some parallel universe. Everything and everyone looked familiar. Yet it wasn't at all.

Inside the church, he found Emily Warwick and Sophie Potter in charge. His church had somehow been transformed into an emergency shelter.

Sophie was in the Fellowship Hall, helping all the fire victims get settled down with bedding. There were long tables set up with cooked food and hot drinks — tea, coffee, hot cocoa. Carolyn went over to

speak to Sophie and Emily, but Ben wandered around, wanting to take in the entire situation.

There were other tables with piles of clothes, almost enough for a mini rummage sale, he thought. It was sorted, he noticed, for women, children, and men. Members of his congregation were helping the people from Wood's Hollow pick out what they needed. A long rack of coats and jackets stood just past the tables. And if that all wasn't enough, there was a small table at the end of the hall where Grace Hegman sat, collecting donations.

Where in heaven's name had all this come from? How had they organized and managed to produce such an abundance? It was like the story of the loaves and fishes, he thought. Only it was even more poignant to him. He'd never seen anything like this — this outpouring of kindness and neighborly love in action. He had never imagined it. The place that he'd so recently found stagnant and complacent was now brimming with God's love.

He was standing right in the midst of a miracle.

The fire victims gazed up at him as he walked through the big room. Some were

already sleeping, curled on their makeshift beds, feeling lucky to be alive, perhaps, but facing total devastation. Everything they owned was gone.

A mother with a little girl who seemed about four years old sat on the floor nearby, settled on a nest of blankets.

The little girl stared up at him, her face streaked with tears. He crouched down and tried to smile at her. "Don't be scared," he said. "It's going to be all right."

He glanced at the mother. She didn't smile or even try to. She was plainly in shock, and Ben knew that it wasn't going be all right for her, not for a very long time.

"Can I bring you anything? Some food or something to drink?"

She shook her head.

He didn't know what else to say to her. "I'm so sorry . . ."

She nodded. Ben wasn't sure she spoke English, but she seemed to understand him. She turned to her daughter and stroked her hair.

"I'll keep you both in my prayers," he promised.

She nodded again, as if to thank him. Ben stayed for a moment more and moved on.

Emily returned home at daybreak. She

staggered into the house through the back door, sooty and exhausted. Her good suit and blouse were ruined, but she didn't care.

She walked into the bedroom and found Dan sleeping in a rocking chair, dressed in his bathrobe. It looked as if he'd been up with the baby . . . or perhaps waiting for her.

She tried to be quiet as she got undressed, but he slowly opened his eyes and looked at her. "You're back, thank goodness. What time is it?"

"Almost five. It's going to be light out soon. I just want to grab an hour or two of sleep. I have to get in to the office and start working on this fire situation. Oh, Dan, you wouldn't have believed it. It was terrible."

He walked over to Emily and put his arms around her. "Were many people hurt?"

She nodded. "Lots in the hospital, smoke inhalation mainly. A few firefighters were injured, though nothing was serious. No deaths so far. That part's a miracle."

She gazed up at him. "The most amazing thing happened. All these people in town heard what happened and came out to help. They just up and left whatever

they were doing — their Christmas dinners, family whatever — and came down to the church with clothes and food. It was incredible."

She crawled into bed and he followed her. "Sounds so," he said. He put his arm around her and she rested her head on his chest.

"The old hotel building burned to the ground," she explained. "And the others had to be evacuated. Some people will be able to go back eventually, but the buildings that are still standing will have lots of damage from the smoke and water. All the tenants in the burned building are homeless. All of their possessions are lost." She turned her head to look at him. "They're not the type of people who carry insurance, you know? I don't think the building owner will come up with much help either. This is a real tragedy."

"Yes, it is. Get some sleep now. You're exhausted." He put his hand on her head and she rested it again on his shoulder.

"How is Jane?"

"She's fine. She hardly made a peep."

"I have to get in to the office early and start cutting through all the red tape to get these people some public assistance. There's so much to do. Mrs. Hatcher is off

for the week, though, Dan. I had planned on staying home." Emily paused for a moment. "Can you take care of Jane while I'm at work?" she asked carefully.

The question of adopting the baby had been tabled for now, but Emily still didn't know how Dan would react to this request.

"Of course I'll take care of her. You don't have to worry. It sounds as if you have a big job on your hands this week, Emily. I'll help you any way I can."

Emily smiled at him and kissed his cheek. She put her head down again and closed her eyes, her mind racing with the sights and sounds of the fire scene, as well as with lists of all she had to do — all the bureaucrats and agencies she had to call.

Still, within a few seconds, she fell into a deep, dreamless sleep.

Chapter Twelve

&

Ben caught a few hours of sleep at home and returned to church just before seven the next day. As he walked across the village green from his car, he wondered if last night had been a dream.

But no, it hadn't been a dream at all. He entered the church to find that the miracle continued.

There were dozens of people working in the kitchen, preparing breakfast — pancakes, eggs, bacon, piles of buttered rolls, and donuts. Coffee and tea, hot cocoa, and cereal for the kids were all being served on long tables in the Fellowship Hall. Other tables held piles of clean socks and underwear, toothpaste, toothbrushes, little bars of soap, and various hygiene items. The

room was filled with the fire victims and helpers. Most were still asleep of course, but a few were awake and even smiling. Maybe, he thought, they were just happy to be alive after their terrifying ordeal.

Curious as to what else was going on in the church, Ben left the hall. Later, when everyone was up, he would return, welcome everyone, and say a blessing.

Tucker Tulley met him in the hallway. "I've called a meeting of the deaconate, Reverend. Everyone is here. We're in one of the classrooms downstairs," he said, leading the way.

Reverend Ben followed Tucker downstairs to a church school classroom, where he found just about all the deacons assembled.

"Reverend, would you lead us in the invocation?" Tucker asked after calling the meeting to order.

Reverend Ben bowed his head. "Heavenly Father, please guide us, continue to give us the energy, resources, and wisdom to help the victims of this devastating fire. We thank You for the grace that has touched this church and all the people in it. We thank You for the amazing miracle we witnessed last night, the outpouring of love, kindness, and generosity. Please guide

us with Your light, keep our hearts open, and let this miracle of love and faith continue."

"Amen." Tucker lifted his head and surveyed the group seated before him. "We need to help these people upstairs," he began simply. "They're burned out of their homes and don't have clothes to put on their backs or shoes for their feet. They need clothing, money, and a place to stay until the town or whoever figures out what to do with them, which from my experience could take awhile."

He looked around, but no one interrupted him. "We did a good job last night. We can be proud of that effort. But we have to keep it up. This is going to take time. We can't get bored with it or lose momentum." He picked up a pad from one of the front-row desks. "Does anyone know how much money was collected?"

Harry Reilly raised his hand. "A little over three thousand dollars."

"That's a start," Tucker said, jotting down the figure. He went through some other categories of need, clothing and food donations. Someone else produced a list of church families who were inviting the displaced fire victims into their homes.

Ben was cheered by that response. It

didn't seem to matter that this group was the poorest in the community, with many who did not even speak English. His congregation was willing to take them in just because they were neighbors in need. They were willing to do it just because it was the right thing to do.

The meeting soon concluded, with everyone assigned their tasks to keep the miracle rolling. Ben went upstairs again, where he found the outpouring of love and generosity continuing in countless ways.

They had done all this without him at the pulpit spouting Scripture and reminding them of their Christian duty. Maybe he was right. He wasn't needed here, but not because his congregation didn't have spirit. He felt so ashamed for having misjudged them, thinking they had no spiritual vigor. Yes, they were a social community, but different from the Elks Club or the Rotary or the group at the country club.

They were very different. How had he been so blind and not seen that? He felt ashamed for finding them lacking and asked for God's forgiveness.

Lord, forgive me for misjudging these good people. Forgive me for losing faith in them . . . and myself. Thank You for all

You've done here — and continue to do — through us.

When he finally got home later that evening, Carolyn was waiting for him. She had also come to the church to help during the day, working mainly in the kitchen, but they had barely seen each other.

"You must be exhausted, Ben, up all night and working all day."

"I'm not tired at all." He smiled at her, following her into their own kitchen. "I feel like I've been charged up like an old battery by all this wonderful energy at church. It's still hard to take it all in, Carolyn, their acts of compassion and generosity."

"You're proud of them," she noted. She lifted a cover on a pot and stirred. "You should be."

"I am. But I hardly deserve any credit. I was wrong to sell them short. I was projecting my own malaise. The lack of spirit was in me, not them."

"Maybe this event woke everyone up."

Ben nodded. "I think it gave them a way to put their spiritual side into action. There's more to be done, though, than just providing food and shelter for a few days."

"Yes, you have to think of the long-term problems, too."

"Most of those people are at risk of ending up homeless," Ben said. "Emily Warwick is doing what she can, working with the county. But you know how that goes. The best the county might do is stick them all in some dumpy motel somewhere, where they'll be out of sight and soon forgotten. The community can't let that happen," he insisted. "The church can't let that happen."

"Agreed." Carolyn touched his wrist lightly, her expression thoughtful. "But what exactly can the church do?"

"I'm not sure, but that's a failure of imagination and knowledge on my part right now. Yesterday morning I never could have dreamed of what they've already accomplished."

"Well . . . at least you're honest."

"I'm not sure how to figure this all out. There are so many factors to consider. All I know is that the church must play a big role now in keeping these people on track. That much I'm very sure of." He sighed and leaned toward her. "Did you know that several of the men have already lost their jobs for missing one day's work? One day, because of a fire."

Carolyn's look of loving support turned to one of outrage. "How could their employers do that?"

"That's the situation we're dealing with. It's not enough that these poor people have lost their homes and everything they own." He stood up, feeling suddenly restless again. "Maybe the church can help build new housing, some affordable apartments. Maybe we can get the county to cooperate. . . ."

"That sounds like a big job, a real mission project. Too bad the church will have to do it without you."

Ben turned and looked at her, wondering at her comment. Then he remembered. The sabbatical . . .

"Didn't you want to leave at the end of January?"

"I've been reconsidering that plan, Carolyn. It might have been a bit impulsive. You know, I never actually filed the papers. Maybe I was depressed, self-indulgent, too." He shook his head regretfully.

"I think the feelings were very real to you, Ben. Don't be so hard on yourself. The thing is, suddenly, there's a lot of work for you here. A real opportunity, don't you think?"

She was so kind to him, always giving

him the benefit of the doubt. Even in his folly.

"Absolutely. I can't leave now. The congregation needs me. The fire victims need me."

"The sabbatical idea will have to be postponed, then," she said, a smile hovering on her lips.

"Yes . . . indefinitely," he added.

"Whatever you say, dear." Carolyn's tone was only slightly sarcastic. He knew he deserved far worse for what he had put her through.

"I think that's a wise choice," she continued, turning to the stove again to serve dinner. "There's a lot of work ahead if you plan to have the church help these people."

"Yes, there is. A mountain of work, and an abundance of energy to draw upon. The congregation has inspired me. They've renewed me, just as I was trying to say in my sermon. This is my Christmas miracle," he said quietly.

It wasn't until Wednesday night, three days after the fire, that Emily and Dan were able to sit down to a meal together. Emily had been up and out early every morning, not returning until late at night. The county and local Red Cross had taken

some action to help the fire victims, but the church congregation had done the lion's share so far, offering the kind of support and caring that government agencies could never provide. She was encouraged by the progress so far, but downright exhausted.

She sat at the table and took a sip of the soup Dan had prepared for them. There were toasted sandwiches on thick crusty bread and a big green salad.

"This looks like the best meal I've seen all week." She took a big bite of her sandwich as Dan looked on.

"The roast is from Christmas night. It didn't go to waste."

The mention of that debacle of a dinner reminded her of their awful argument. They hadn't talked about it all week. But the truth was, they hadn't had the chance. Dan had been very considerate of her these past few days, caring for Jane and doing nearly everything around the house.

But although they hadn't talked, she had had a chance to think things over. She could see now that she had been trying to impose her own feelings on him. It just wasn't fair, or right.

They talked about the fire victims awhile. Dan, too, had been at the church

helping out when he was able to leave Jane with Jessica for a few hours each day.

"So they don't think it was arson?"

Emily shook her head. "Reasonable to suspect, all things considered. But the fire department investigators all agree it was started by bad wiring. By the time anyone smelled the smoke inside the wall, it was too late."

"I suppose that proves the other buildings need to be renovated and upgraded." A familiar look of affection came into his eyes. "Maybe the mayor can do something about it. I hear she's good with things like that."

"I'm already on it," she assured him with a weary smile. "I had the county inspectors out there today."

Finally, Emily decided it was time to bring up the question that still hovered over them. "I had a call from Nadine today," she began carefully. "She wanted to know what we were thinking now about Jane. I told her that it's doubtful we'll apply to adopt." She stopped there and looked at Dan. His expression was blank, unreadable.

"I didn't blame it on you," she added in a conciliatory tone. "I didn't say much at all. I've been thinking it over the past few

days, what you said when we argued. And maybe it is unrealistic to think we're young enough to keep up with the demands of a child. Maybe it would be better for Jane to have younger parents," she said, though she felt her heart breaking as she said the words aloud. "If I can force myself to look at this objectively, like you asked me to, I know Nadine will find a loving couple who will be happy to give Jane a good home."

She paused, trying hard not to get overly emotional about this. There would be enough time for that later.

"We're not the only people in the world who could be good parents to her," Emily continued. "And I've thought about you — your needs and hopes. I know it's probably seemed as if those things don't matter to me at all, but they do," she assured him. "We agreed when we got married that we wouldn't start a family. It isn't fair to you for me to go back on my word. I don't want to force you into adopting this baby and then find out you regret it. That wouldn't be good for you or me or Jane."

She stared at him, waiting for some response. He had been listening to her with his head bowed, staring down at his plate.

Now he looked up again. "Wow . . . that

was some speech. No notes, either. I'm impressed."

She managed a small smile. "I told you, I've been thinking a lot about this."

Despite his small joke, she couldn't tell how he felt about what she'd said.

"Poor Nadine Preston," he said finally. "She must be extremely confused."

Emily frowned. "What do you mean?"

"I spoke to her today, too, and said we wanted to start the process to adopt Jane."

Emily felt her jaw drop. She just couldn't believe it. But she knew very well he would never joke about this.

"You don't have to do this, Dan," she said quickly. "I don't want to force you into it. I can see that now. It's not the kind of thing you can talk someone into. I was wrong to try —"

"Hush up now. You had the floor, my dear. Just let me finish," he said, giving her a mock stern look. "I've been thinking, too. I've had a lot of time here the past few days, alone with Jane. I've even talked it over with her from time to time," he confided. Emily had to smile, pleased to hear he talked aloud to the baby, too.

"You know me, I don't much believe in fate, but even I have to admit it was a conveniently strange turn of events that had

me stuck here, all alone, caring for her lately."

Emily had been thinking the same, but hadn't dared to say it.

"And I've had to conclude, I love her madly. I've tried to imagine giving her up. I even tried talking myself into believing it's the best thing for her. But my heart can't buy it, Emily. And I know for sure it's not the best thing for you."

He gazed at her fondly and paused for a moment. "I've come to really understand what this means to you. At least, I think I do. You're a wonderful mother to this child and to Sara. I can't deny you the chance to try to adopt this baby. We might not be chosen, you know," he added quickly. "That's still not certain."

"Yes, I know." Her heart was beating so hard it felt like a drum inside her chest. She felt so happy, she wanted to jump out of her skin.

"You were right when you told me I was grieving the past," he admitted. "I had a lot of shame about not being a good father. But it would be different now. I wouldn't be distracted by work, and you're nothing like Claire. I think I could be a good father now, Emily. I want to give it another go."

Emily blinked back tears of joy. "Dan,

I'm so happy, I don't know what to say. I don't know where to start . . ."

He got up, walked over to her, and pulled her up from her chair. "You can start by telling me you love me."

"You know I do." She jumped into his arms and held him close. "You just can't imagine how much."

"Thank you for seeing my side of it," he whispered in her ear. "Even though I was mostly wrong. I get that tunnel vision thing going sometimes. I nearly lost you once because of it. You would think I had learned my lesson."

Emily laughed softly. "Thank you for this . . . this amazing gift, Dan. I can never thank you enough."

He didn't answer, just gazed down into her eyes. He pulled her close and kissed her deeply, his strong embrace enfolding her completely.

Emily kissed him back. She loved him so much. Not just because he was willing to adopt Jane. But because of all that he was, right and wrong.

That's what marriage was all about. That's what love was all about.

Finally, he stood back, looking down at her, his arms looped around her waist. "You were right about something else, too,

Emily. The real adventure is being married to you, and whatever comes along with that, even if it's a baby. What I realized this week is that caring for Jane has deepened my love for you and made our marriage even stronger. Why would I ever want to give all that up?"

Emily hugged him close again and squeezed him so tight he practically cried out for mercy. "I have an idea," she said. "Let's go tell Jane."

He smiled and kissed her again. "I already did."

"Sara! When did you get back?"

Emily had just walked out of the church on Friday morning and could hardly believe it when she saw Sara walking in. She quickly hugged her daughter and leaned back to look at her.

"I just got here five minutes ago. Lindsay called and said they needed me back at the newspaper right away. There's so much going on because of the fire."

"It was terrible. But it's amazing the way the town has pulled together to help these people. That's the real story." Emily paused, feeling full of news and not knowing where to begin. She was also dying to know what happened with Sara's

job interview but was trying not to pounce on her about it. "How is everyone in Maryland?" she asked. "Did you have a good time?"

"It was great to see them. They want to come up here soon again for a visit. Maybe in February."

"Oh . . . will you still be here?" Emily was happily surprised. "What about Philadelphia?"

"That didn't turn out to be much. I would be back at square one, taking phone calls and bringing *real* reporters coffee. I don't need to work on a big paper that much."

Emily tried not to look as thrilled as she felt. "You'll know when the right opportunity comes along."

"This certainly wasn't it, believe me."

Emily took her hand. "I have some great news. Dan and I have applied to adopt Jane."

Sara's face lit up with happiness. "That's wonderful! When did you decide? I thought Dan was against the idea."

"He was," Emily said slowly, smiling. "But we talked it out — argued, really — and we both took some time to think things through. And then he decided he couldn't live without Jane, either. It's still

not certain, of course, but at least we're trying."

"Oh, I know you'll be the ones," Sara said, hugging her. "I have a feeling this will all work out for you, Emily."

"Thanks, honey, I hope so." Emily had a feeling, too, but she was too scared to say. So far her feelings in this matter hadn't been all that foolproof.

Prayer had helped, though, she was certain of it. And now her prayers were mostly full of gratitude.

"Listen, we're having a get-together on New Year's Eve. Will you come?"

"Sure. I don't have any plans," Sara said honestly. She hesitated a moment and then asked, "Is Luke around? I heard he's been helping." Sara's voice was tentative, shaky. Emily felt for her.

"He's been a tremendous help, as always. He's not at the church right now, though. A few families are staying at the center. He's been out there with them mostly."

"That makes sense." Sara nodded. "I guess Christina has been helping, too. Just to show what a good sport she is," she added. "Did she bang out some big feature about the fire for the *Globe*?"

Emily had to smile. "I haven't seen Christina around, Sara. As for that *Globe*

article, maybe you're the one who ought to get working on that." *In addition to getting back together with Luke,* Emily wanted to add. She didn't say that, though, just gazed at her daughter a minute. Then she hugged her quickly once more. "See you tomorrow night. Come around eight."

"I'll be there." Sara waved, ran up the steps to the big wooden doors of the church, and slipped inside.

Emily was so glad Sara was back, and even happier that she would be staying. She had a lot to celebrate this New Year's. *What in the world did I do to deserve all this happiness?* she wondered.

Emily and Dan worked all day, cleaning the house and rearranging the furniture to get everything set for their New Year's Eve party. Everyone was bringing a dish, so Emily didn't worry too much about the menu. It would all blend together somehow, she decided.

Dressed for the party in a gold satin top and black velvet pants, she hustled about, putting a few finishing touches on her decorating. She filled the living room and dining room with votive lights and sprinkled golden confetti and festive streamers on the white linen tablecloths. She set out

piles of silly Happy New Year's hats and noisemakers, hoping everyone would be inspired to make a racket at the stroke of midnight. And for the crowning touch, she let loose a huge bunch of helium balloons that had Happy New Year stamped all over them and let them float up to the ceiling.

When Dan came downstairs, dressed and ready to receive their guests, he gazed around in wonder. "What in the . . . balloons, too? What is this, Times Square?"

"Not quite, but not bad for Cape Light," Emily remarked, admiring her handiwork.

Dan walked over to her and took hold of her shoulders. "You're so happy, you're on cloud nine. That's a good start to the New Year."

Emily smiled up at him. "I haven't been this happy since . . . the day I married you."

"Me either," he agreed, pulling her close. "Hard to believe it's just been a year."

"It went by so quickly. So much has happened —"

"And keeps happening," he finished, drawing her to him for a kiss.

The doorbell rang and they slowly drew apart. "Meet me right here at midnight," Dan said softly.

"I will," Emily promised him.

Molly Willoughby and Matt Harding were the first to arrive. Molly was so impressed by the decorations, she jokingly offered to hire Emily to join her catering business. Jessica and Sam came in next, then Betty Bowman with her latest boyfriend, a lawyer named Scott Craft who lived in Hamilton. Scott seemed funny and smart and kind, and Betty looked radiant. Maybe, Emily thought hopefully, Betty had finally met the "one." Ever since her painful divorce, Betty had been very wary of commitment.

Emily sometimes wondered if that was Sara's problem, too — a fear of settling down. But Sara was so young, she certainly had time. Still, Emily hoped her daughter and Luke could resolve their differences and at least get on speaking terms again. She knew it wasn't right to interfere and had purposely not invited Luke so that Sara would be comfortable coming to the party. But Luke had a way of showing up at these events, invited or not. Emily was holding out hope for one of his infamous "party crashings," as her mother called them.

Dr. Elliot had driven Lillian over, and they entered bickering, as usual. "Watch

out, you two. You're standing right under the mistletoe," Dan teased them, hoping to break up the argument, Emily was sure. At Dan's words, her mother leaped so quickly out of the threshold, Emily half feared she'd fall and break her hip again.

Emily was trying not to laugh at her mother's sudden display of athleticism when Sam came up and drew Emily aside. "Listen, I ran into Luke today. He wasn't doing anything tonight, so I mentioned the party, told him to take a ride over later. I hope that's all right. I didn't think you and Dan would mind."

"Of course I don't mind. I like Luke." Emily's gaze strayed across the room to Sara, who stood chatting with Betty and Scott. "Does Sara know?" she asked quietly.

Sam shrugged. "No, should I tell her?"

Emily sighed, unsure of what to do. "Well . . . he might not even come. Why get her all concerned? Let's just wait and see what happens. I'll handle it." She patted her brother-in-law on the arm, acting far more confident than she really felt.

The hours passed quickly with lively music, good food, and good company. Even her mother seemed to be relaxed and

having a good time, telling stories about the days when she was a young girl growing up in Boston society — the coming-out parties and winter white balls and *peau de soie* silk gowns imported from Paris. Emily gazed at her wistfully. No wonder her mother sometimes seemed so out of step with everyone around her. Lillian had come from another world altogether, and now nearly all traces of that world had vanished.

Sara seemed subdued, Emily noticed, and the reason was no mystery. All alone on New Year's Eve. Emily had been there more than once; it wasn't a good feeling. Her heart went out to her daughter, but she promised herself she wouldn't meddle.

At eleven o'clock, Jane woke up for her late-night bottle, and Emily brought her out to the party. The guests flocked around the baby, happy to see her and happy for Dan and Emily's decision to go ahead with the adoption.

Jessica sat the nearest to Emily on the sofa and leaned over for an impulsive hug. "I'm so happy for you, Emily. This is really a miracle."

Emily nodded. "It is, isn't it?"

"She is an attractive child," Lillian said

quietly, "and appears to have a reasonable disposition."

Emily and Jessica turned to their mother, both looking shocked. Lillian shrugged. "Of course, you never know. They do go through so many stages," she added, quick to withdraw some of the good feeling generated by her prior comment. "You can never be sure what you're going to get."

Emily glanced at her sister, trying hard not to laugh. "I'll just have to roll with it, I guess, Mother," she said.

"Believe me, you will," Lillian promised her with a curt nod.

The doorbell rang and Dan quickly walked over to answer it. Emily was not surprised to see Luke standing there, though everyone else seemed to be. Her gaze flew to Sara, who was talking with Sam and didn't notice Luke at the door.

Sam did, though. He leaned over and said a few private words to Sara. She turned and stared at Luke and seemed to swallow hard. Then, with Sam at her side, she walked over to greet him.

Despite Dan's encouragement, Luke didn't come in. He looked a bit sheepish, Emily thought, standing around in the cold, his hands dug into

the pockets of his blue jeans.

Lillian spied him and gave a loud sniff. "That gate-crasher again. Of course. I could set my watch by his arrival."

Jessica laughed. "Sam told Luke about the party, Mother. It's okay."

"That's what I call hearsay, not an invitation. I thought I taught you better manners." Lillian sat back in her chair, looking disgusted.

Meanwhile, Sara had slipped outside with Luke, and Sam had closed the door. Emily glanced heavenward.

Dear God, I know it's not my place to meddle in Sara's relationships . . . but surely You can? Please help her sort things out with Luke. He's such a good guy and I know they really love each other. Please let them at least hear each other out?

Okay, I'll stop now, Emily said silently, ending her prayer.

Sara wore a wool sweater and a suede blazer but still felt cold outside. She crossed her arms over her chest, hugging herself for warmth. She felt shocked when she saw Luke in the doorway and then afraid to talk to him. Sam had more or less pushed her out the door.

"So . . . how was your holiday?" she

started off, not knowing what to say.

Luke shrugged. "All in all, pretty lousy. Though it was good to hang out with the kids at the center. Some of them didn't have anyplace to go, so we cheered each other up a little."

Sara nodded, staring down at her boots. "What about Christina? Didn't she cheer you up?"

"Not exactly. Christina left town. She wasn't around for Christmas."

"Oh?" Sara looked up at him, surprised. "I thought she rented a cottage, planned to write her book here."

He shrugged. "I guess Cape Light turned out to be too quiet for her."

Sara considered his words carefully. Christina had been disappointed, she gathered. But maybe not just by the town being too quiet.

"I thought she had her sights set on you," Sara said frankly. "She seemed pretty determined."

"I think she had some big fantasy about how great it would be if we got back together. I think the real me disappointed her," he said with a little laugh.

"Really? Now I know she's a complete idiot," Sara said.

Luke laughed. "That's the first nice

thing you've said to me in weeks. Does that mean there's some hope?"

"Some," she admitted. She met his gaze and looked away again. He stood apart from her but stared at her so intently, his steady focus seemed to draw her closer.

"So what about your holidays? How are your folks?"

"They're fine." *Asked a lot about you,* she almost added, but couldn't quite get the words out.

"And that job interview in Philadelphia? How did that go?"

"It was a complete dud," she admitted. "Sounds like I'd be a glorified secretary for years before they would even let me proof copy, much less write a story."

"Oh . . . that's too bad." He crossed his arms over his chest, finally smiling.

"Or not, depending on how you look at it." She met his gaze again, then smiled back at him. "I'm sorry I acted out about Christina, Luke. That night we went out to dinner . . . I acted like a child, the way I ran out and left you two there. That wasn't right. I shouldn't have been mad at you, either." She sighed. "I was just pretty jealous, I guess."

"So I gathered," he said quietly. "I didn't mind that part that much. Two gorgeous

women, fighting over me. That wasn't what I'd call a bad evening out."

She glared at him and he laughed. "Just kidding," he added. His expression grew serious. "Okay, so Christina's out of the picture. She never really was in it to begin with. That was all in your imagination, Sara."

She nodded, finally knowing what he said was true.

"So where does that leave us? Are you still scared of making a commitment? Do you still want to work at a bigger newspaper, no matter where that turns out to be?"

Sara swallowed. "I need to be honest with you, Luke. I am scared of making a commitment. You talk about getting married and having a family so easily. It's not that easy for me to see myself doing those things right now. Especially having a baby."

He nodded. "We don't have to start a family right away. I understand if you're not ready yet. Hey, look at Emily and Dan. If they're just starting off, we have loads of time left."

The comparison made Sara laugh in spite of herself. She felt relieved to see he really did understand. She took a step closer and took his hand. "I'm scared of

this engagement and marriage thing," she said quietly, "but I realized something down in Maryland. I don't want to be away from you, Luke. I don't want to make new plans, or take a new job, or do anything anymore without you. I want us to start a life together. I think I'm finally ready for that. Will you still have me?"

"Hmm . . . can I think about it a little?" he asked. His voice was serious but his expression was teasing. When he saw the crushed look on Sara's face, he laughed and drew her close in a tight embrace. "Of course I'll have you, you silly goose. Don't you get it yet? I don't want anyone but you. That's just the way it is for me."

Sara buried her face in his shoulder, crying with relief and love. She felt him suddenly pull away and didn't understand what was happening, until she saw him drop down on one knee.

He took her hand and looked up at her. "Sara, you are the most wonderful woman I've ever met in my life. The most remarkable person, really. I love you with all my heart and soul, and I'll do all I can to make you happy. Will you marry me? I'd be the happiest man on Earth."

Sara felt breathless, overcome with his words and his tender loving look. She took

his face in both of her hands. "Yes, I'll marry you, Luke. I love you more than anything."

He jumped up, put his arms around her, and kissed her deeply. Then he pulled back and dug his hand into his pocket. He pulled out a small blue velvet box and handed it to her. Sara was speechless.

"Go on, open it," he whispered.

Sara opened it slowly, knowing what she would find: the ring from the jewelry store, the round solitaire in the gold and platinum setting. But even knowing, she wasn't prepared for its beauty, its fire beneath the light of the winter moon. "Oh, Luke, you didn't have to get this ring. It was so expensive."

"That was the one you liked, wasn't it? We can change it if it's not right," he added quickly.

"Oh no . . . it's perfect. I love it." She took the ring out and he put it on her finger. He held her hand a moment, admiring it, then smiled into her eyes. "It is a nice ring."

"I adore it," she said, hugging him again. "Wait a minute. You came here with this ring, knowing you would propose to me?"

Luke shrugged. "I didn't know what was going to happen. I figured if not tonight, I

would just hang on to it and try again some other time."

Sara didn't know what to say. She couldn't believe that anyone could love her that much, could want her that much. She felt like the luckiest woman in the world to have a man like Luke so in love with her.

They held each other close for a long time, until Emily appeared at the door. "I'm sorry," she said, sounding embarrassed. "But I thought you'd want to know, it's almost midnight."

Luke and Sara quickly went inside and joined the rest of the party, who were now gathered around the TV in the small sitting room. They watched coverage from Times Square in New York, counting down the seconds along with the television as the end of the year drew nearer.

"Ten . . . nine . . . eight . . . seven . . . six . . . five . . . four . . . three . . . two . . . ONE!"

They blew their noisemakers, whooped and laughed, cried and hugged and kissed each other, stumbling around the small sitting room in a frenzy of good wishes.

Emily hugged Sara close. "Happy New Year, sweetheart," she said. Sara said the same, then pulled back, and silently showed Emily the engagement ring.

Emily screamed, causing everyone to turn in alarm. "Sara! Oh my goodness!" She turned to her guests. "Sara and Luke . . . they're engaged!" she announced, half laughing and half crying.

Luke stepped up beside Sara and slipped his arm around her shoulder. Emily hugged him, too. Then everyone else quickly gathered around, offering their heartfelt congratulations.

Everyone except Lillian, who stalked off, shaking her head. But no one seemed to notice.

Emily felt a special excitement in church on New Year's Day. She had expected to be too tired to get up for the service, but somehow it hadn't been much trouble at all to make it there on time. The weather was cold and dry, the sky clear and cloudless. *A clean slate for the year ahead,* she thought, glancing up as they walked toward the church's front doors.

The sanctuary was full, which was unusual for a service right on New Year's Day. She glanced around. It looked as if many of the displaced families from Wood's Hollow were there, filling the pews to capacity. She wondered if the congregation would attract new members now, after

the work they'd done helping the fire victims. It was a good feeling to see new faces and feel the church growing, like a living thing.

Reverend Ben had a certain bounce in his step as he walked up front to address the congregation. "First, I want to wish everyone a happy and blessed New Year. Our congregation enters the New Year as witnesses — and participants — in a miracle. There are simply too many of you to mention by name who came here on Christmas night and have continued to come here this past week, to help our neighbors who were forced from their homes by the fire in Wood's Hollow.

"The crisis was devastating and there is so much work still to be done, so much aid we can continue to give. But I, for one, stand in awe of the effort I've seen from all of you. Surely, our church has been touched by God's grace, and out of the rubble and ashes of that fallen building, we have risen here with new purpose and new life."

He paused, gazing around the congregation. Emily heard his voice go thick and strained with emotion, and for a moment, she thought Reverend Ben was about to cry.

"I have a confession to make to all of you. For the past few weeks, I've been feeling discouraged, even disappointed in the level of spiritual energy in our church. I blamed myself mostly, for not being able to lead and inspire all of you.

"The irony is that when the real moment to act came, you had no need of me. I was miles away, oblivious. You saw the problem and sprang into action. You shared whatever you could — more than you could, in some cases — food, clothing, money, even the roofs over your heads. This is the Christian spirit in action. This is what it means to live out the lessons of the Scriptures. This is God's spirit and love working through us."

He paused, taking a deep breath.

"I am humbled by what you have all accomplished, and I'm grateful. I was in a place of darkness and confusion, and your acts of compassion led me back to the light, or rather, to see the light that is always around us and part of our eternal spirit. I stand in awe of your miracle. I am proud to be your minister, to continue to learn from you, to serve you, and to serve with you.

"Let us come together now to worship and to ask God's help and blessing so that

we may continue this New Year to do the good work we have only just begun."

The sanctuary was absolutely silent.

Emily didn't dare take a breath. Reverend Ben stood a moment before them, his head bowed. Then he slipped a white hanky from his pocket, quickly dabbed his eyes under his glasses, and slipped them in place again.

Suddenly the organ sounded and the chorus began the choral introit. Everyone slowly came to their feet and began to sing. Emily stood up with Jane balanced on her hip while Dan held up the hymnal for them. She felt her own eyes growing misty for a moment and blinked the tears away. She agreed with Reverend Ben. The congregation's work for the people of Wood's Hollow had been a miracle, a strange and wonderful coming together of so many hands and hearts united by one purpose. There was no question in her mind that the work itself had been its own reward. Still, she couldn't help but feel that God was smiling down on them.

She was suddenly reminded of a quote from the New Testament: "Be not forgetful to entertain strangers; for thereby some have entertained angels unawares."

Angels, indeed. She looked down at

Jane, who gazed back at her with the kind of wise and knowing expression that babies seemed to have at times. Perhaps there were more angels around than she had ever realized.

The rest of the service seemed to pass quickly, with a light, joyful feeling. A feeling of unity, Emily thought.

At the end of the service, they walked to the back of the sanctuary where Reverend Ben stood greeting the congregants.

"Happy New Year," he said to them.

Emily smiled and wished him the same. "We have some good news. We've decided to apply to adopt Jane."

Ben's eyes widened with surprise and he beamed at her. "That is good news! Well, well . . . I'm very happy for you, Emily . . . for all of you," he added, his gaze taking in Dan and Jane as well. "How long will the process take?"

"Several months," Dan answered. "We're just starting to file the necessary papers this week. Then we'll be going before a judge to finalize everything and make it legal."

"It's a little nerve wracking," Emily admitted. "I wish it could be settled more quickly, but Jane's social worker said she thinks everything will go smoothly."

Ben nodded. "I think it will, too. I just have a feeling." He glanced down at Jane. "I'll keep you in my thoughts . . . and in my prayers."

"Thank you, Reverend." Emily squeezed his hand as they said good-bye. After all these years, Reverend Ben was perhaps the only one who knew just how much adopting Jane meant to her.

Lillian was not having her usual family gathering this Sunday. She had announced last night that she was too tired to have them all over, and also that the conversation would be too boring, since they had all been together for New Year's Eve.

Emily and Dan were both relieved. They had enjoyed entertaining but were now looking forward to a quiet afternoon — just the two of them and Jane — to celebrate their good news privately.

"So where to?" Dan said as he started up the car.

Emily clipped Jane into her car seat and then got in the car next to Dan. "Oh, I don't know. I thought we'd just go home and relax."

"We can relax later. I think we ought to do something special. We have a lot to celebrate — adopting Jane, Sara and Luke's engagement, our first anniversary. You

421

know I'm not much of a praying guy, but we do have a lot to be thankful for, Emily. We really do." He glanced at her.

She reached over and took his hand. "Yes, we do," she said quietly.

"You know, when I was listening to Reverend Ben today, I had to say to myself, 'Hey, I've had a few miracles in my life lately, too.' There's you, Emily. You made me feel happy again just to be alive." He gazed at her with a loving look that touched her heart. "And now there's our little girl." He glanced back at Jane, cozy in her car seat. "Definitely a miracle. She's made me feel young again, the way only a baby can."

"Me, too," Emily agreed happily.

"I can't believe we've only been married one year. It seems as if so much has happened." He shook his head. "I'm almost afraid to wonder what the next twelve months will bring."

Emily laughed, then leaned over and kissed him. "Me, too," she agreed again. "But that's the adventure."

The employees of Thorndike Press hope you have enjoyed this Large Print book. All our Thorndike and Wheeler Large Print titles are designed for easy reading, and all our books are made to last. Other Thorndike Press Large Print books are available at your library, through selected bookstores, or directly from us.

For information about titles, please call:

(800) 223-1244

or visit our Web site at:

www.gale.com/thorndike
www.gale.com/wheeler

To share your comments, please write:

Publisher
Thorndike Press
295 Kennedy Memorial Drive
Waterville, ME 04901